THE PELICAN HISTORY OF ART

Founding Editor: Nikolaus Pevsner

Joint Editors: Peter Lasko and Judy Nairn

Rudolf Wittkower

ART AND ARCHITECTURE IN ITALY 1600 TO 1750

Until 1956 Rudolf Wittkower was Durning-Lawrence Professor of the History of Art in the University of London, and a member of the Warburg Institute. From 1956 to 1968 he was Chairman of the Department of Art History and Archaeology at Columbia University, New York. After his retirement in 1969 he served as Kress Professor at the National Gallery, Washington, and as Slade Professor at Cambridge. He died in October 1971. Professor Wittkower was singularly well equipped to undertake this study. Among his many publications on the art and architecture of the period are his books on Bernini and on the Carracci drawings at Windsor Castle. In the present work is offered a summing-up of views formed during years of devoted research.

Rudolf Wittkower

ART AND ARCHITECTURE IN ITALY

1600 TO 1750

Penguin Books

Penguin Books Ltd, Harmondsworth, Middlesex, England
Viking Penguin Inc., 40 West 23rd Street, New York, New York 10010, U.S.A.
Penguin Books Australia Ltd, Ringwood, Victoria, Australia
Penguin Books Canada Limited, 2801 John Street, Markham, Ontario, Canada L3R 1B4
Penguin Books (N.Z.) Ltd, 182–190 Wairau Road, Auckland 10, New Zealand

First published 1958
Second revised edition 1965
Reprinted 1969
Third revised edition 1973
First integrated edition, based on third revised edition, 1973
Reprinted 1975, 1978
Reprinted with corrections and augmented bibliography 1980, 1982
Reprinted 1985, 1986

Library of Congress Catalog Card Number: 75-128578

ISBN 0 14 0561.16.1

Set in Monotype Ehrhardt
by Oliver Burridge Filmsetting Ltd, Crawley, Sussex
Printed and bound in Great Britain
by Richard Clay (The Chaucer Press) Ltd, Bungay, Suffolk

Designed by Gerald Cinamon and Anthony Cohen

TO MY WIFE

CONTENTS

FOREWORD TO THE FIRST EDITION

In all fairness, I feel the reader should be warned of what he will not find in this book. Such a first sentence may be psychologically unwise, but it is morally sound. I am concerned with the Italian Baroque period in the widest sense, but not with the European phenomenon of Neo-classicism. Thus Winckelmann and his circle as well as the Italian artists who followed his precepts fall outside the scope of my work. Nor will the struggle between the supporters of Greece and those of Rome be reported, a battle that was joined in the 1750s from Scotland to Rome and in which Piranesi took such an active part. In addition, little or next to nothing will be said about the festive life of the period: the Baroque stage and theatre, and the sumptuous decorations in easily perishable materials put up on special occasions often by first-rate artists. Finally, the development of the garden, of town-planning, and of interior decoration could hardly be touched upon, though I am only too well aware that all this is particularly relevant for a comprehensive picture of the Baroque age. My aim is narrower, but perhaps even more ambitious. Instead of saying little about many things, I attempted to say something about a few things, and so concerned myself only with the history of painting, sculpture, and architecture.

Even so, the subject and the space at my disposal dictated severe limitations with which the reader may want to be acquainted before turning to the pages of this book. It was necessary to prune the garden of history not only of dead but, alas, also of much living wood. In doing this, I availed myself of the historian's right and duty to submit to his readers his own vision of the past. I tried to give a bird's-eye view, and no more, of the whole panorama and reserved a detailed discussion for those works of art and architecture which, owing to their intrinsic merit and historical importance, appear to be in a special class. Intrinsic merit and historical importance – these notions may be regarded as dangerous measuring rods, and not every reader may subscribe to my opinions: yet history degenerates into chronicle if the author shuns the dangers of implicit and explicit judgements of quality and value.

At this point I make bold to express a view which may be unpopular with some students of the Italian Baroque. Excepting the beginning and the end of the period under review, i.e. Caravaggio, the Carracci, and Tiepolo, the history of painting would seem less important than that of the other arts and often indeed has no more than strictly limited interest – an ideal hunting-ground for specialists and 'attributionists'. This fact has been somewhat obscured by the great mass of valuable research made during the last forty years in the field of Italian Baroque painting at the expense of studies in the history of architecture and sculpture. Roughly from the second quarter of the seventeenth century on, the most signal developments in easel-painting lay outside Italy, and Italian painters became the recipients rather than the instigators of new ideas. It is, however, in conjunction with, and as an integral part of, architecture, sculpture, and decoration that Italian painters of the Baroque made a vital and internationally significant contribution with their large fresco cycles. The works without peer are Bernini's statuary, Cortona's architecture and decoration, and Borromini's buildings as well as those by Guarini, Juvarra, and Vittone. But it was Bernini, the greatest artist of the period,

who with his poetical and visionary masterpieces created perhaps the most sublime realization of the longings of his age.

Based on such considerations, I have placed the accents in the story that follows. Approximately one-fourth of the text is devoted to Bernini, Cortona, and Borromini; the chapter on Bernini alone takes up over ten per cent of the book. Another ten per cent is concerned with Caravaggio, the Carracci, and Tiepolo, while roughly the same space is given to Sacchi, Algardi, Duquesnoy, and the great Piedmontese architects. This accounts for more than two-fifths of the text. Since hundreds of artists, many of them of considerable stature, share between them as much text as I have given to a mere dozen of the greatest, my narrative may be criticized as lopsided. But I am prepared to accept the challenge. New and pregnant ideas have always been few and far between. It is the origin, unfolding, and expansion of these ideas with which I am here concerned. Their echo and transformation in the work of minor artists can be sketched with a large brush.

My story begins with the anti-Mannerist tendencies which arose towards the end of the sixteenth century in various Italian centres, and the curtain falls over the Baroque scene at different places in different decades. If one postulates the year 1750 roughly as the watershed between the Late Baroque and Neoclassicism, it appears that the three main sections of this book comprise spans of approximately thirty, sixty, and again sixty years. Two-fifths of the text have been devoted to the two generations limited by the beginning and the end of Bernini's career, since I consider the Roman High Baroque of Bernini, Borromini, and Pietro da Cortona the most exciting years of the century and a half under review and one of the most creative periods of the whole history of Italian art; the remaining three-fifths are equally divided between the first and third parts. Some readers may regret that this dis-

position has resulted in an all too brief discussion of eighteenth-century painting, particularly of the Venetian School, but a fairly full treatment would in any case have gone far beyond the space at my disposal; also I believe that the structure I wanted to give the book justified and even demanded this brevity.

For the main divisions of the whole period I have used the terms, by now well established, of Early, High, and Late Baroque. Only recently have we been reminded[1] that such terminological barricades contain fallacies apt to mislead the author as well as his public. Yet no historical narrative is possible without some form of organization, and though the traditional terminology may have – and indeed has – serious shortcomings, it conveniently and sensibly suggests chronological caesuras during one hundred and fifty years of history. If we accept 'Baroque' – like 'Gothic' and 'Renaissance' – as a generic term and take it to cover the most diverse tendencies between roughly 1600 and 1750, it will yet be seen in the text of the book that the subdivisions 'Early', 'High', and 'Late' indicate real historical caesuras; but it became necessary to expand the 'primary' terminology by such terms as 'transitional style', 'High' and 'Late Baroque classicism', 'archaizing classicism', 'crypto-romanticism', 'Italian Rococo', and 'classicist Rococo', all of which will be explained in their proper place.

I dictated a rough draft of large parts of the manuscript in the summer of 1950. Most of my spare time in the following seven years was given to elaborating, revising, and completing the work. The manuscript reached the editor in batches from the beginning of 1956 on; by the summer of 1957 almost the entire text had been dispatched. I mention these facts because they explain why recent research is not so fully incorporated as I should have liked. Since new and often important results appear in an uninterrupted stream, it was virtually impossible to keep the older chapters of the manuscript

permanently up to date. I have attempted, however, to incorporate in the Notes all the major publications until the autumn of 1957.

It is not possible to mention all the names of friends and colleagues who answered my inquiries. I am particularly indebted to Peggy Martin, Sheila Somers, and St John Gore, through whose assistance the manuscript made progress at a difficult period. Paolo Portoghesi and G. E. Kidder Smith allowed me to use some beautiful photographs. Howard Hibbard helped with the search for, and supply of, illustrations. In addition, I am greatly indebted to him for many corrections of facts and for allowing me to use some of the results of his researches in the Borghese archive. Philip Pouncey and Henry Millon emended some errors at proof stage. My gratitude goes above all to Ilaria Toesca and Italo Faldi, who year after year put their time and resources unflinchingly at my disposal. I am deeply grateful for what they have done for me by correspondence and during my regular visits to Rome. Milton J. Lewine took upon himself the self-denying task of reading one set of proofs. Ever watchful and scrupulously conscientious, he covered the galleys with comment; his many constructive suggestions as to content and style considerably improved my final text.

The book was prepared and written mainly with the resources of the Warburg Institute and the Witt Library (Courtauld Institute), London; the Bibliotheca Hertziana, Rome; the German Art Historical Institute, Florence; and the Avery Library, Columbia University, New York. I wish to put on record that without the loyal support of the directors and staffs of these excellent institutions the work could never have been finished in its present form.

Finally, I have to thank the editor, Nikolaus Pevsner, not only for constant advice and encouragement, but also for his infinite patience. Whenever my own spirit began to flag, the thought sustained me of how much easier it was to be an author than an editor.

New York, December 1957

FOREWORD TO THE SECOND EDITION

In the five and a half years since the appearance of the first edition of this book Italian Baroque studies have taken immense strides forward. Many key figures had then lacked modern monographs but this deficiency has now been partly overcome. Arisi's *Panini*, Bologna's *Solimena*, Briganti's *Cortona*, Constable's *Canaletto*, D'Orsi's *Giaquinto*, Enggass's *Baciccio*, and Morassi's *Tiepolo* indicate the breadth and importance of the research concluded in the intervening period. Moreover, minor masters such as Carneo, Carpioni, Cecco Bravo, and Petrini have recently found biographers. Exhibitions from the Venetian and Bolognese Seicento to the splendid Baroque Exhibition in Turin have brought together, sifted, and submitted to scholarly discussion an enormous mass of new material. One-man shows, often accompanied by bulky and monographic catalogues, have helped to clarify the *œuvre* and development of Cerano, Cigoli, Morazzone, Pellegrini, Pianca, Marco Ricci, Tanzio, and others. Scores of papers, many of them written by a rising generation of intensely active, perspicacious, and devoted scholars – among whom I gratefully name Borea, A. M. Clark, Ewald, Griseri, Hibbard, Honour, Noehles, Posner, and Vitzthum – have helped to correct old misconceptions and to expand the confines of our knowledge. In a word, much of the groundwork for

the book which I rashly undertook to write years ago has only in the last half decade been laid by the concerted endeavour of many scholars.

Confronted with this situation, I felt tempted to recast some of the old chapters. In the end, I decided against such a course, because I had regarded it as my primary task to submit a coherent historical vision of the entire period and, despite all the valuable work done in recent years, dismissed the need for a change or disruption of the original structure of the book. Nevertheless, a great many errors have been amended in the text, and facts, ideas, and judgements have been brought in line with new results wherever and whenever I found them convincing.

The bulk of the new research has been incorporated in the Notes, to which I have added about 15,000 words. In addition, the Bibliography has been brought up-to-date (until summer, 1964); in some cases I have listed weak and unsatisfactory writings for the sole purpose of saving time to students who might otherwise be misled by a promising title.

The reception of the first edition has been favourable beyond expectation. If the test of an author's success lies in the extent to which his ideas percolate and become, acknowledged as well as unacknowledged, common property, I have no reason to be dissatisfied. I hope that the considerably increased critical apparatus will make the book even more useful. But, as before, the text is meant to stand on its own and be perused by those who want to *read* a coherent narrative rather than *use* a textbook, without the constant and irritating turning of pages to the back of the book.

It only remains to thank the many friends who helped me with comments and corrections. Among them Julius Held and Howard Hibbard should be specially mentioned; their vigilant eye caught a number of blatant errors.

Judy Nairn watched over the new edition as she did over the old. Her whole-hearted cooperation spurred me to action. She also took upon herself the unenviable task of compiling a new and fuller index.

Florence, August 1964

FOREWORD TO THE THIRD EDITION

In some fields of the history of art and especially in the field of Baroque studies research has made and is making such giant steps forward that a book first vaguely envisaged more than a generation ago and written in the 1950s can only survive if the process of bringing it up to date never ceases. Once again, however, I had to abandon the temptation of recasting whole chapters of the text of the book and had to restrict myself to a few extensive and a vast number of minor corrections. The bulk of the new critical material, covering mainly the period between the spring of 1964 and the spring of 1971, has been incorporated in the Notes and the Bibliography. Both Notes and Bibliography have grown very considerably and have reached a size that, in my view, should not be transgressed. Even so, it was impossible (nor was it my intention) to aim at anything approaching completeness. The selection of the material newly incorporated in this edition was dictated not only by the importance of contributions, but also by my own interests and reading capacity. Moreover, I have to admit frankly that some fine studies may never have come to my knowledge. Thus I have to emphasize strongly

that omission only rarely implies refutation.

Once again, I have to point out that the notes and the bibliography supplement each other: a great deal of bibliographical material only appears in the notes, while a good many works are only mentioned in the bibliography, where I have often given fuller comments than in the previous editions. And once again I have to thank many friends who have helped me in one way or another, given me the benefit of their criticism and corrected mistakes. Among them I mention gratefully the names of Diane David, Howard Hibbard, C. Douglas Lewis Jr,

Carla Lord, Tod Marder, Jennifer Montagu, and Werner Oechslin.

Podere La Vescina, Lucignano,
June 1971

For notes and revisions for the reissue of this volume in 1980 the editors are most grateful to Professor Alice Bynion, Miss Laura Gilbert, Professor Howard Hibbard, Professor Henry Millon, and Mrs Margot Wittkower.

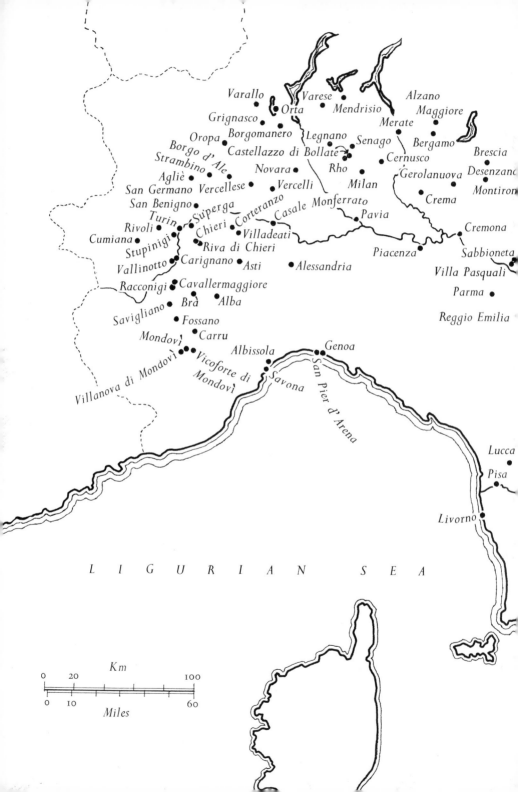

Varallo
Varese
Alzano
Maggiore
Grignasco
Orta
Mendrisio
Merate
Oropa
Borgomanero
Legnano
Senago
Bergamo
Brescia
Borgo d'Ale
Castellazzo di Bollate
Cernusco
Desenzano
Strambino
Novara
Rho
Gerolanuova
Montirone
Agliè
San Germano Vercellese
Vercelli
Milan
Crema
San Benigno
Casale Monferrato
Turin
Superga
Corteranzo
Pavia
Cremona
Rivoli
Chieri
Villadeati
Cumiana
Riva di Chieri
Piacenza
Sabbioneta
Stupinigi
Carignano
Asti
Alessandria
Villa Pasquali
Vallinotto
Racconigi
Cavallermaggiore
Parma
Savigliano
Brà
Alba
Reggio Emilia
Mondovì
Fossano
Carru
Albissola
Genoa
Vicoforte di
Mondovì
Savona
Lucca
Villanova di Mondovì
San Pier d'Arena
Pisa
Livorno

L I G U R I A N S E A

Km

0 20 100

0 10 60

Miles

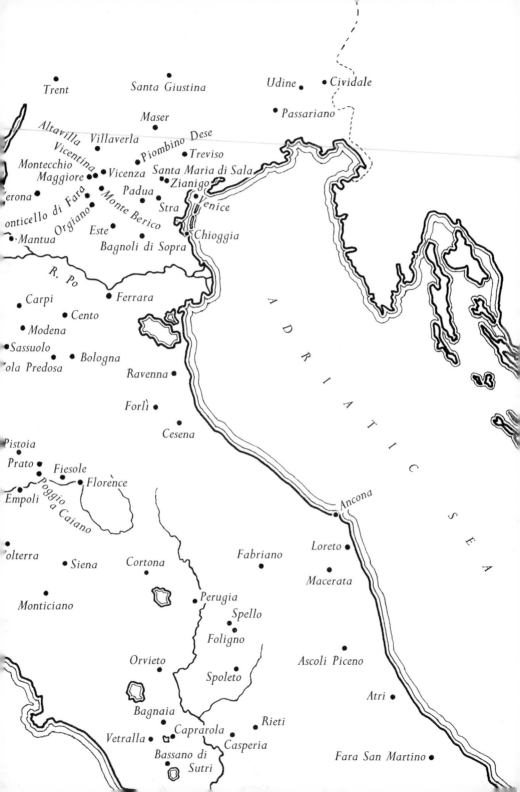

Trent

Santa Giustina

Udine • Cividale

Maser

Passariano

Altavilla
Vicentina Villaverla Piombino Dese

Treviso

Montecchio
Maggiore Vicenza Santa Maria di Sala

erona Zianigo

Padua

nticello di Fara Monte Berico Stra Venice

Orgiano Este

Mantua Bagnoli di Sopra Chioggia

R. Po

Carpi Ferrara

Cento

Modena

Sassuolo

ola Predosa Bologna

Ravenna

Forlì

Cesena

A D R I A T I C S E A

Pistoia

Prato Fiesole

Poggio a Caiano Florence

Empoli

Ancona

olterra Siena Cortona

Fabriano

Loreto

Macerata

Monticiano

Perugia

Spello

Foligno

Orvieto

Spoleto

Ascoli Piceno

Bagnaia

Rieti

Atri

Vetralla Caprarola

Casperia

Bassano di
Sutri

Fara San Martino

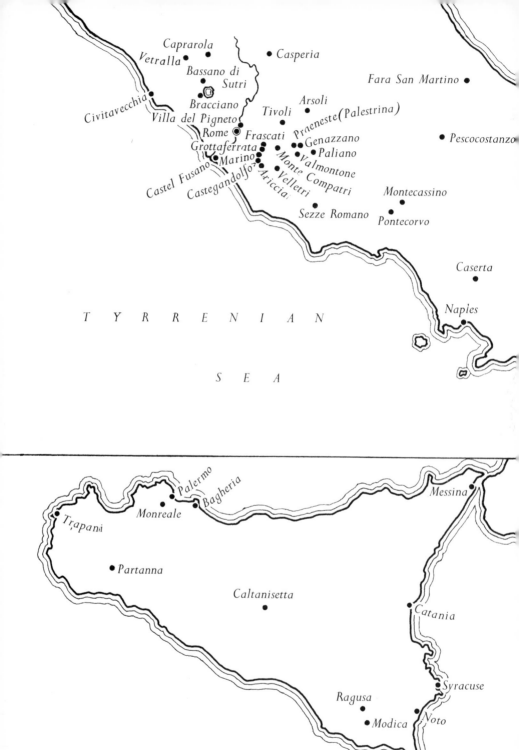

ART AND ARCHITECTURE IN ITALY
1600 TO 1750

Barletta

A D R I A T I C

S E A

Gravina ●

Francavilla
Fontana ●
Oria ●
● *Manduria*
Lecce ●
Nardò ●
● *Galatone*
Gallipoli ●

Catanzaro ●

Km

0 20 100

0 10 60

Miles

THE PERIOD OF TRANSITION
AND THE EARLY BAROQUE

CIRCA 1600-CIRCA 1625

CHAPTER I

ROME: SIXTUS V TO PAUL V

1585-1621

With the Sack of Rome in 1527 an optimistic, intellectually immensely alert epoch came to an end. For the next two generations the climate in Rome was austere, anti-humanist, anti-worldly, and even anti-artistic. The work of reform of the Church, begun at the Lateran Council in 1512 on Julius II's initiative, was seriously taken in hand and carried out with grim determination. During Pius IV's pontificate (1559-65) the Venetian envoy reported from Rome: 'Life at Court is mean, partly through poverty, but also owing to the good example of Cardinal Borromeo. . . . They [the clergy] have altogether withdrawn from every sort of pleasures. . . . This state of things has been the ruin of artisans and merchants. . . .' But the practice of art was far from being extinct: it was turned into an important weapon to further Catholic orthodoxy.

The Council of Trent and the Arts

At its last session in December 1563 the Council of Trent, which had accomplished the work of

reform over a period of almost twenty years, pertinently defined the role assigned to the arts in the reformed community. Religious imagery was admitted and welcomed as a support to religious teaching. One passage of the decree demands that 'by means of the stories of the mysteries of our Redemption portrayed by paintings or other representations, the people be instructed and confirmed in the habit of remembering, and continually revolving in mind the articles of faith'. Consequently strictest discipline and correctness in the rendering of the holy stories were required, and the clergy was made responsible for the surveillance of the artists. The terse deliberations of the Council were soon enlarged upon by a veritable flood of literature, produced by churchmen and reformers rather than by practising artists.

Leaving all details aside, the recommendations of such writers as St Charles Borromeo, Cardinal Gabriele Paleotti, the Fleming Molanus, Gilio da Fabriano, Raffaello Borghini, Romano Alberti, Gregorio Comanini, and Possevino may be summarized under three head-

ings: (i) clarity, simplicity, and intelligibility, (ii) realistic interpretation, and (iii) emotional stimulus to piety. The first of these points is self-explanatory. The second has a dual aspect. Many stories of Christ and the saints deal with martyrdom, brutality, and horror and, in contrast to Renaissance idealization, an unveiled display of truth was now deemed essential; even Christ must be shown 'afflicted, bleeding, spat upon, with his skin torn, wounded, deformed, pale and unsightly',[1] if the subject requires it. Truth, moreover, called for accuracy down to the minutest detail. On this level, the new realism almost becomes synonymous with the old Renaissance concept of decorum, which requires appropriateness of age, sex, type, expression, gesture, and dress to the character of the figure represented. The relevant literature abounds in precise directives. It is these 'correct' images that are meant to appeal to the emotions of the faithful and support or even transcend the spoken word.

And yet, in the decrees of the Council and in the expositions by its severe partisans, there is almost an iconoclastic streak. In no uncertain terms did the Council proscribe the worship of images: in the words of the decree 'the honour shown to them refers to the prototypes which those images represent'.[2] But it is easier to postulate the difference between idol and image than to control the reaction of the masses. We therefore find men like St Philip Neri warning his penitents not to fix their eyes too intently on images, and St John of the Cross advocating that the devout man needs few images and that churches, where the senses are least likely to be entertained, are most suitable for intense prayer.

It has long been a matter of discussion among art historians to what extent the art of the later sixteenth century expressed the exigencies of the reformed Catholic Church.[3] In one respect the answer is not difficult to give; artists of religious imagery had to comply with some of the obvious demands of counter-reformatory decorum, such as the avoidance of nude figures. In another respect the answer is more baffling. The Church was vociferous in laying down the rules, but how to sublimate them into an artistic language of expressive power – that secret could be solved only by the artists. This granted, are we at all capable to judge whether, where, and when the artists caught up with the spirit of the Council? Since apodictic statements in an area pertaining to individual sensibility are doomed to failure, our conclusions have relative rather than absolute value. After this proviso, it may be said that, with the exception of the Venetians and a few great individualists like the aged Michelangelo, most of the artists working roughly between 1550 and 1590 practised a formalistic, anti-classical, and anti-naturalistic style, a style of stereotyped formulas, for which the Italians coined the word *maniera*[4] and which we now call 'Mannerism' without attaching a derogatory meaning to the term. Virtuosity of execution and highly decorative surface qualities go with compositional decentralization and spatial and colouristic complexities; in addition, it is not uncommon that deliberate physical and psychic ambiguities puzzle the beholder. Finally, the intricacies of handling are often matched by the intricacies of content. Many ·pictures and fresco cycles of the period are obscure and esoteric, possibly not in spite of but because of the close collaboration between painter and priest. One is inclined to believe that this art, which not rarely reveals a hardly veiled licentiousness under the guise of prudery, was suited to please the refined Italian society, then following the dictates of Spanish etiquette, but it had hardly the power to stir religious emotions in the mass of the faithful. To be sure, Mannerism as it was practised during the later sixteenth century was not an answer to the artistic requirements of the counter-reformatory Church: it lacked clarity, realism, and emotional intensity.

It is only from about 1580 onwards, or roughly twenty years after the promulgation of the Council decrees, that we begin to discern a counter-reformatory art on a broad basis. So much may be said at present: the new art has not a clear-cut unified physiognomy. Either the realistic or the emotional component may be stressed; as a rule, clarity supersedes complexity and often, though by no means always, deliberate formal austerity provides the answer to the severe 'iconoclastic' tendencies which we have mentioned. Meanwhile, however, the Counter-Reformation moved towards a new phase. Before discussing in some detail the pattern of artistic trends in Rome, certain aspects of the historical setting must be sketched.

The Church and the Reformers

The period from Sixtus V (1585–90) to Paul V (1605–21) has a number of features in common which single it out from the periods before and after. Spanish influence, which Italy had nurtured in all spheres of life during the sixteenth century, began to decline. Paul IV's war against Spain (1556–7), though a disastrous failure, was a first pointer to things to come. Sixtus V renewed the resistance against Spanish predominance. Clement VIII (1592–1605) reconciled Henry IV of France to the Holy See, and from then on dates the ascendancy of France at the expense of Spain. This change is symptomatic. The rigours of the reform movement were over. Never again was there a pope so austere, so ascetic and uncompromising as Paul IV (1555–9), so humble and saintly as Pius V (1566–72). From the 1570s and 80s on Protestantism was on the defensive; Catholic stabilization and restoration began and in the following decades all of Poland, Austria, southern Germany, France, and parts of Switzerland consolidated their Catholic position or even returned to the old Faith. The deep sense of danger which pervaded the Church during the critical years

had passed, and with this returned an easier deportment and a determination to enjoy life such as had not existed in Rome since the days of the Renaissance. Moreover, progressive religious movements, born in the days of the Council of Trent but not always looked upon with approval by the reactionary faction of the reformers, were now firmly established. Protected and encouraged by papal authority, they developed into the most effective agencies of the Catholic Restoration.

The most important movements, St Philip Neri's Oratory and St Ignatius of Loyola's Society of Jesus, two seemingly opposed offshoots of neo-Catholicism, have yet much in common. Philip's Oratory grew out of informal meetings of laymen who preached and discoursed spontaneously, following only their inner voices. A cheerful but deeply devotional spirit prevailed among Philip's disciples, a spirit that reminded the learned Cardinal Baronius of early Christianity. It is clear that such an unorthodox approach to religion aroused awe and suspicion. But in 1575 Gregory XIII formally recognized the Oratory and in the same year its seat was transferred to the church of S. Maria in Vallicella. After that the Oratory soon became fashionable, and a pope like Clement VIII was very close to it. Although the rules were written in 1583 and a definite constitution, solemnly approved by Paul V, was drawn up in 1612, the democratic spirit of the original foundation was preserved. Philip's apostolate, as Ludwig von Pastor says, extended down from the pope to the smallest urchin in the streets. The Congregation remained a group of secular priests tied together by voluntary obedience and charity. Philip died in May 1595. It is characteristic of the universal reverence in which he was held that the process of canonization began as early as two months after his death.[5]

By contrast to the Oratory, the Society of Jesus was monarchical and aristocratic in its

constitution, pervaded by a spirit of military discipline, bound by strict vows, and militant in its missionary zeal. But, like the Oratory, the Society was designed to serve the common people; like the Oratorians, the Jesuits were freed from the bonds of monastic observance and replaced the traditional withdrawal behind the walls of the monastery by an active participation in the affairs of the world. Notwithstanding their determined opposition to the new scientific age that was dawning, their intellectualism, casuistry, and interest in education were as typical of the new spirit as their approach to the doctrine of Grace and the guide to devotion laid down by Ignatius himself in the *Spiritual Exercises*. The Dominicans were upholders of Thomism, which had seen such a powerful revival in the days of the Council of Trent, and championed the Pauline–Augustinian-Thomistic position, that Grace descended on man irrespective of human participation. The Jesuits, by contrast, taught that human collaboration was essential to render Grace efficacious. This point of view was advocated with great learning by the Spanish Jesuit Luis de Molina in his *Concord of Free Will with the Gifts of Grace*, published in 1588, and resulted in a long-drawn-out struggle with the Dominicans which ended only in 1607, by order of Paul V himself. Although the Holy See reserved judgement and sided neither with Thomism nor Molinism, the suspense alone was like a battle won by the Jesuits: the more positive and optimistic Jesuit teaching, that man has an influence on the shaping of his destiny, was admitted and broke the power of medieval determinism.

Although inspired by the ascetic writings of the past, St Ignatius's *Spiritual Exercises* were equally new and progressive. Their novelty was twofold. First, the method of guiding the exercitant through a four-weeks' course is eminently practical and adaptable to each individual case.

During this time the periods of contemplation are relatively brief and hardly interfere with normal duties. The cleansing of the soul does not prepare for, or take place in, cloistered seclusion; it prepares, on the contrary, for the active work as a soldier of the Church Militant. And secondly, all a man's faculties are employed to make the Exercises an extremely vivid personal experience. The senses are brought into play with almost scientific precision and help to achieve an eminently realistic awareness of the subjects suggested for meditation. The first week of the exercises is devoted to the contemplation of Sin, and St Ignatius requires the exercitant to see the flames of Hell, to smell the sulphur and stench, to hear the shrieks of sufferers, to taste the bitterness of their tears and feel their remorse. During the last two weeks the soul lives with equal intensity through the Passion, Resurrection, and Ascension of Christ. The *Spiritual Exercises* were written early in St Ignatius's career and, after many revisions, were approved by Paul III in 1548. Although large numbers of the clergy practised the Exercises at an early date, they became most effective in the course of the seventeenth century, after the publication in final form in 1599 of the Directory *(Directorium in Exercitia)*, drawn up by Ignatius as a guide to the Exercises.

The list of distinguished seventeenth-century artists who were Jesuits is longer than is generally realized.[6] Even among the others there were probably not a few who felt drawn towards Jesuit teaching. Bernini's close relations with the Jesuits are well known, and it has been noticed that there is a connexion between the directness of Loyola's spiritual recommendations, their tangibility and realism, and the art of Bernini and his generation.[7] At an earlier date the same observation can be made with regard to Caravaggio's art.[8] But there is no common ground between the spirit of the Exercises and the broad current of Late Mannerism.

Nor is it possible to talk of a 'Jesuit style',[9] as has often been done, or to construe a direct influence of the Jesuits on stylistic developments at any time during the seventeenth century.

Ignatius's practical and psychological approach to the mysteries of faith, so different from the abstract theological speculations of the Council discussions, was shared not only by men like St Philip Neri and St Charles Borromeo, but even by such true sixteenth-century mystics as St Teresa and St John of the Cross. Unlike the mystics of the Middle Ages, they controlled, ever watchful, the stages leading to ecstasy and supplied in their writings detailed analyses of the soul's ascent to God. It characterizes these counter-reformatory mystics that they knew how to blend the *vita activa* and *contemplativa*. No more practical wisdom and down-to-earth energy can be imagined than that shown by Teresa and John of the Cross in reforming the Carmelite Order.

Similarly, determination, firmness, and tenacity in translating into action the decrees of the Council guided St Charles Borromeo, the youthful Archbishop of Milan who was Pius IV's nephew. At the time of his death in 1584 (aged forty-six), he had, one is tempted to say, streamlined his large diocese, had modernized clerical education by founding his famous seminaries, and had prepared manuals for pupils, teachers, and artists. Charles Borromeo was a staunch supporter of both the Oratory and the Society of Jesus. He practised the *Spiritual Exercises* and leant heavily on Jesuit support in carrying through his reforms at Milan. It was he who formed the most important link between the papal court and the new popular movements, and who promoted the ascendancy of Jesuits and Oratorians. Both Philip and Ignatius had to struggle for recognition. In spite of the latter's fabulous success, external vicissitudes under the Theatine Pope Paul IV, the Dominican Pope Pius V, and the Franciscan Pope

Sixtus V ended only when Gregory XIV confirmed St Ignatius's original constitutions in 1591; but the internal difficulties were not resolved until Paul V's reign (1606).

Ignatius died as early as 1556; Francis Xavier, the great Jesuit missionary, the 'Apostle of the Indies', had died four years before; Teresa passed away in 1582, Charles Borromeo in 1584, and Philip Neri in 1595. The processes leading to their beatification and canonization were conducted during the first two decades of the new century. The inquiry into St Charles's life began in 1604, and he was canonized in 1610. Ignatius was beatified in 1609 after a long process begun under Clement VIII. Teresa's process of beatification was concluded after ten years in 1614, Philip Neri's in 1615, and Francis Xavier's in 1619. After protracted discussions initiated under Paul V, the four great reformers, Ignatius, Teresa, Philip Neri, and Francis Xavier, were canonized during Gregory XV's brief pontificate, all on 22 May 1622.

This date, if any, is of symbolic significance. It marks the end of the 'period of transition' here under review. When these reformers joined the empyrean of saints, the struggles were past. It was a kind of authoritative acknowledgement that the regenerative forces inside Catholicism had saved the Church. This date may also be regarded as a watershed in matters of art. The period from Sixtus V to Paul V has none or little of the enthusiastic and extrovert qualities of the exuberant Baroque which came into its own in the 1620s and prevailed in Rome for about fifty years. Moreover, during the earlier period the old and the new often exist indiscriminately side by side. This is one of the important characteristics of these forty-odd years, and it must be said at once that the official art policy of the popes tended to support reactionary rather than progressive artists. The reverse is true from Urban VIII's reign onwards.

The 'Style Sixtus V' and its Transformation

Compared with the second and third quarters of the sixteenth century, its last decades saw an immense extension of artistic activity. The change came about during the brief pontificate of the energetic Sixtus V (1585–90). It is well known that he transformed Rome more radically than any single pope before him. The urban development which resulted from his initiative and drive reveals him as a man with a great vision. It has rightly been claimed that the creation of long straight avenues (e.g. 'Strada Felice', linking Piazza del Popolo with the Lateran), of star-shaped squares (Piazzas S. Maria Maggiore and del Popolo, before Valadier), and the erection of fountains and obelisks as focusing points for long vistas anticipate seventeenth-century town-planning ideas. In the historic perspective it appears of decisive importance that after more than half a century a pope regarded it as his sacred duty – for the whole enterprise was undertaken 'in majorem Dei et Ecclesiae gloriam' – to turn Rome into the most modern, most attractive, and most beautiful city of Christianity. To be sure, this was a new spirit; it was the spirit of the Catholic Restoration. But the artists at his disposal were often less than mediocre, and few of the works produced in those years can lay claim to distinction. After the Sack of Rome a proper Roman school had ceased to exist, and most of the artists working for Sixtus were either foreigners or took their cue from developments outside Rome. In spite of all these handicaps something like a 'style Sixtus V' developed, remaining in vogue throughout the pontificate of Clement VIII and even to a certain extent during that of Paul V.

This style may be characterized as an academic *ultima maniera*, a manner which is not anti-Mannerist and revolutionary in the sense of the new art of Caravaggio and the Carracci, but tends towards dissolving Mannerist complexities without abandoning Mannerist formalism. It is often blunt and pedestrian, on occasions even gaudy and vulgar, though not infrequently relieved by a note of refined classicism. This characterization applies equally to the three arts. It is patently obvious in architecture. Sixtus gave the rebuilding of Rome into the hands of his second-rate court architect, Domenico Fontana (1543–1607), although the much more dynamic Giacomo della Porta was available to him. Fontana's largest papal building, the Lateran Palace, is no more than a dry and monotonous recapitulation of the Palazzo Farnese, sapped of all strength. A similar academic petrifaction is evident in a façade like that of S. Girolamo degli Schiavoni which Sixtus commissioned from Martino Longhi the Elder (1588–9). Without altogether excluding Mannerist superimpositions of motifs, this architecture is flat, thin, and timid. It is against such a background that Carlo Maderno's revolutionary achievement in the façade of S. Susanna (1603) [51] must be assessed. It is true that Clement VIII favoured Giacomo della Porta and that after the latter's death in 1602 Carlo Maderno stepped into his position as architect of St Peter's. But it is also true that the architect after Paul V's own heart was Flaminio Ponzio (1559/60–1613),[10] who perpetuated until his death a noble version of the academic Mannerism of the 1580s and 90s. And it is equally true that the Cavaliere d'Arpino, whose feeble classicism is the exact counterpart in painting of Longhi's and Ponzio's buildings, was in almost unchallenged command during the 1590s[11] and maintained a position of authority throughout Paul V's pontificate.

The frescoes of the Vatican Library (which Domenico Fontana had built), the papal chapel erected by Fontana in S. Maria Maggiore, and the frescoes in the transept of S. Giovanni in Laterano exemplify well the prosaic nature and vulgarity of official taste under Sixtus V and Clement VIII. Although varying somewhat in

style and quality, the painters engaged on such and other official tasks – Antonio Viviani, Andrea Lilio, Ventura Salimbeni, Paris Nogari, Giovan Battista Ricci, Giovanni Guerra, Arrigo Fiamingo (Hendrick van den Broeck), and Cesare Nebbia – fulfilled at least one require-ment of the Council decrees, namely that of clarity. At the same time, mainly two Flemings, Egidio della Riviera (Gillis van den Vliete) and Nicolò Pippi of Arras (Mostaert), and the Lom-bard Valsoldo (Giovan Antonio Paracca), were responsible for the flabby statues and narrative reliefs in Sixtus V's multicoloured chapel. The two former died in the early years of the seven-teenth century, while Valsoldo lived long enough to work again on the decoration of Paul V's chapel, the counterpart to that of Sixtus V. This 'pragmatic' style fulfilled its purpose and gratified the patrons, even when it sank down to the level of pure propaganda. The example that comes to mind is the many frightful scenes of martyrdoms in S. Stefano Rotondo, which invariably have a nauseating effect on the modern beholder. But Nicolò Circignani (called Pomarancio, 1516–96), who painted them, was the artist favoured by the Jesuits;[12] the church belonged to the German novices of the Order. It was just the unrelieved horror of these representations that was to in-flame missionary zeal. In the words of Cardinal Paleotti: 'The Church wants, in this way, both to glorify the courage of the martyrs and to set on fire the souls of her sons.'[13] Nor can it be denied that such paintings hardly evoke aes-thetic satisfaction.

If a bird's-eye view of the whole period from Sixtus V to the end of Paul V's reign shows some intrinsic common qualities, a closer in-quiry reveals the existence of a variety of trends. In addition, there is a slow but continuous shift even of official art policy away from Sixtus V's philistine counter-reformatory art towards a fuller, more vigorous, more poetical, and also more emotional manner.

Before the end of the century four principal tendencies may be differentiated in Rome itself, each having its roots far back and each having much wider, all-Italian implications. There was first the facile, decorative manner of the arch-Mannerist Federico Zuccari (1542/3–1609), who combined in his art elements from the latest Raphael and from Tuscan and Flemish Man-nerism with impressions which had come to him from Veronese and the Venetians. He was the truly international artist of the *fin de siècle*, con-stantly travelling from court to court, Olympian in demeanour, prone to esoteric intellectual speculations, superficial and quick in his pro-duction. Although he had no official commis-sions in Rome after 1589 and was indeed absent from the city most of the time after that year, his influence was yet great on the painters working for Sixtus V and Clement VIII.

A second trend was that of the Florentines, who had a considerable share in mid-sixteenth-century fresco-painting in Rome. Their com-plex Mannerism, tied to the old Florentine emphasis on rhythmic design, followed the general development and gave way towards the end of the century to a more simplified and solid academic manner, which is mainly repre-sented by Bernardino Poccetti. Artists such as Passignano and Ciampelli transplanted this Florentine manner to Rome, not without blend-ing it with Venetian colourism and Zuccari's *maniera facile*. For the third trend, there was Girolamo Muziano, who came into prominence under Sixtus V's predecessor, Gregory XIII. Coming from Brescia and steeped in the tra-ditions of Venetian painting, he never fell wholly for the *maniera* then in vogue. It was really he who introduced into Rome a sense for Venetian colour and a taste for rich landscape settings. This was taken up and developed by Flemings, mainly Paul Brill (1554–1626), whose 'picturesque' northern *vedute* were admitted even in churches and on the walls of the Vatican Palace in the reign of Paul V.[14] A good deal of

Muziano's chromatic approach to painting was assimilated in Rome. Artists like his pupil Cesare Nebbia (c. 1536–1614), one of the busiest and most slapdash practitioners of the period, showed how to reconcile it with Federico Zuccari's academic Mannerism. Finally, Federico Barocci's Correggiesque emotionalism must be mentioned, although he was working in Urbino. His pictures reached Rome at an early date, but his influence spread even more through the many artists who came under his spell.

Taken all in all, during the first decades of the new century the tendency of the older painters of all shades was to supplant Zuccaresque and late Tuscan Mannerism by a softer and warmer palette and a more sensitive characterization of figures. Caravaggio's and Annibale Carracci's revolts broke into this setting at the end of the nineties. But it must be emphasized that there was no immediate repercussion on papal art policy. Nor did the art of these masters appreciably influence the development of the older artists, although a painter like Cristoforo Roncalli (1552–1626) used a Carraccesque 'cloak' for his pictures at the end of his career[15] and Giovanni Baglione turned Caravaggesque for brief moments. Moreover while Annibale's Bolognese followers entrenched themselves firmly in Rome during the first two decades of the seventeenth century and public taste shifted decisively in their favour away from the older Mannerists, Caravaggism remained almost entirely an affair for eccentrics, connoisseurs, and artists and had run its course – as far as Rome was concerned – by the time Paul V died.

Paul V and Cardinal Scipione Borghese as Patrons

A brief survey of patronage during Paul V's reign will help the reader to assess the complexities which beset the historian who tries to define the art of the first quarter of the seventeenth century. Official patronage in Rome was concerned with three major tasks, St Peter's,

the Cappella Paolina in S. Maria Maggiore, and the Quirinal Palace. By far the greatest problem facing Paul V was the completion of St Peter's. Once he had taken the decision to abandon Michelangelo's centralized plan, the pope proceeded with great determination. Carlo Maderno began the façade in 1607 and the nave in 1609 and finished them both in 1612 (with the exception of the farthest bay at each end) [1]. Shortly after (1615–16) he built the Confessio, which opens in the form of a horse-shoe before the high altar under the dome. Although the pope himself supported Maderno's appointment in spite of strong competition from less progressive architects, the decoration of the new building went into the hands of steadfast Mannerists.

Paul V, it is true, was not responsible for the decoration of the dome, consisting of trite representations in mosaic of Christ and the Apostles, half-figures of popes and saints, and angels with the Instruments of the Passion. This commission, for obvious reasons unrivalled in importance and by far the largest available at the turn of the century, was handed over by Clement VIII to his favourite Cesari d' Arpino in 1603. Owing to its magnitude, it was not finished until 1612.[16] Clement VIII also chose most of the artists for the huge altarpieces, later transferred into mosaic. Roncalli, Vanni, Passignano, Nebbia, Castello, Baglione, and Cigoli were here given splendid opportunities, while neither Caravaggio nor Annibale had a chance of being considered.

Paul V's principal sculptor in St Peter's was the Milanese Ambrogio Bonvicino (c. 1552–1622),[17] the friend of Federico Zuccari and Cristoforo Roncalli. His is the classicizing relief of *Christ handing the Keys to St Peter* over the central entrance to the church. Giovan Battista Ricci from Novara (1545–1620), one of the least solid *maniera* painters under Sixtus V, was given the honourable task of painting frescoes in the Confessio, and he also designed the stucco

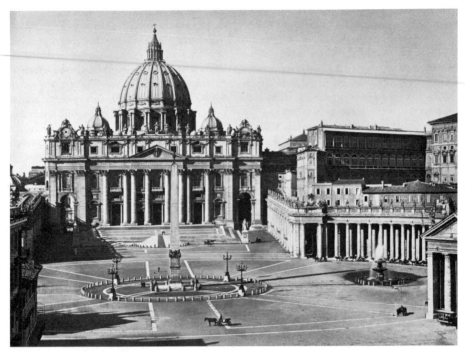

1. Rome, piazza and façade of St Peter's

decorations of the portico. Since elegant and rich stucco decorations were the only field in which Roman Mannerists under Gregory XIII and Sixtus V had shown real inventiveness and originality, Ricci here drew upon a vigorous, living tradition and created a work the excellence of which has always been acclaimed. Finally, it should be mentioned that Ferrabosco's famous clock-tower of 1616–17,[18] which had to be pulled down when Bernini built his colonnades, was not an impressive example of architectural grandeur. During the time it was standing, it must have clashed strangely with the early Baroque vigour of Maderno's façade.

The Cappella Paolina in S. Maria Maggiore [2], which the pope resolved to build as early as June 1605, supplies a more coherent idea of official taste than the vast complex of St Peter's. Almost the size of a church, the Greek-cross chapel with its high dome rose to the design of Flaminio Ponzio, who had to follow closely the model of the Chapel of Sixtus V. These two chapels, forming a kind of transept to the Early Christian basilica, are testimonies of the beginning and the end of an epoch. Ponzio's structure was completed in 1611, but the decoration was not finished until the end of 1616. Coloured marbles, gilding, and precious stones combine to give an impression of dazzling splendour which surpasses the harsher colour effects of Sixtus's Chapel. It was Sixtus V who with his multicoloured chapel began a fashion which remained in vogue far into the eighteenth century. One should be careful not to explain this

custom simply as the 'baroque' love for swagger and magnificence. Much of the coloured marble was taken from ancient buildings. This was an important part of Sixtus V's counter-reformatory programme of systematically transforming pagan into Christian Rome. Moreover, by placing this sumptuous spectacle before the eyes of the faithful, Sixtus fulfilled the neo-medieval demand, voiced by men like Molanus, that the Church, the image of heaven on earth, ought to be decorated with the most precious treasures in existence. Along the side walls of the Paolina rise the enormous tombs of Clement VIII and Paul V with the statues of the popes surrounded by painterly narrative reliefs – all set in a triumphal-arch-architecture which is so

massive and rich that it dwarfs the relatively small-scale sculptural decoration [3]. Compared with their models in the Chapel of Sixtus V, these tombs show a further accretion of decorative detail, to the detriment of the effectiveness of the sculpture. The artists responsible for the statues and reliefs belonged mainly to the older generation born about 1560: Silla da Viggiù, Bonvicino, Valsoldo, Cristoforo Stati, Nicolò Cordier, Ippolito Buzio, Camillo Mariani, and Pietro Bernini, Gianlorenzo's father. In addition, two younger artists, Stefano Maderno and Francesco Mochi, were employed.[19] In other words, practically every sculptor then working in Rome made some contribution. It is indicative of the change

2. Flaminio Ponzio: Rome,
S. Maria Maggiore, Cappella Paolina, 1605–11

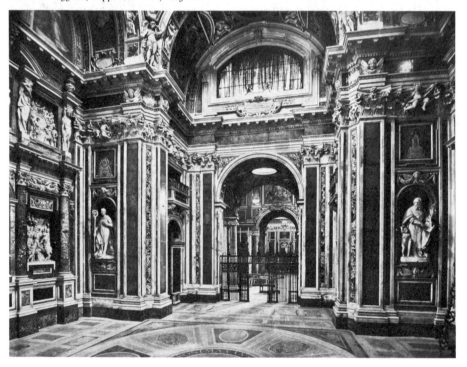

3. Rome, S. Maria Maggiore, Cappella Paolina, Tomb of Paul V, 1608-15

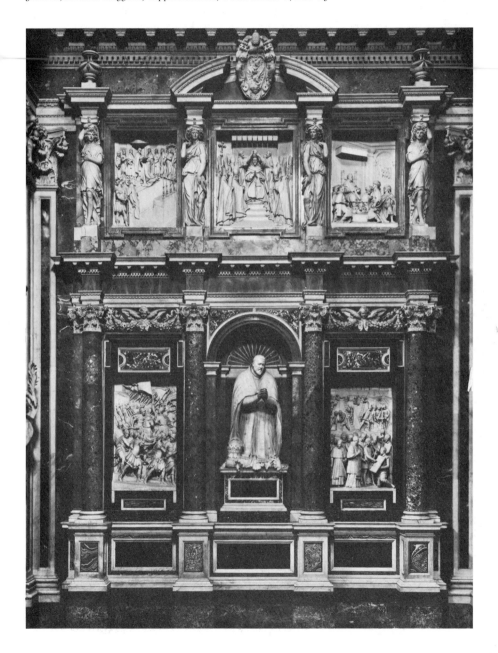

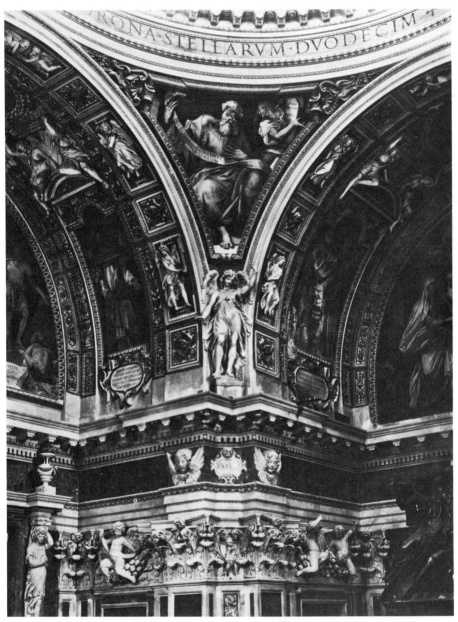

4. Rome, S. Maria Maggiore, Cappella Paolina.
One of the pendentives and arches with frescoes by the Cavaliere d'Arpino and Guido Reni, 1610–12

taking place that Italians should supersede the Flemings who were so prominent in Sixtus's Chapel. The Lombard element now prevailed. In spite of the uniformity of the sculptural decoration, style and quality differ; and it is probably not by chance that the most reactionary and timid among the sculptors, Silla da Viggiù, received the lion's share: to him fell the statues of Clement VIII and Paul V.

Sculpture at this moment lagged behind the revolutionary events in painting brought about by Caravaggio and Annibale Carracci. It is not astonishing that the schism between the old guard and progressive masters like Mariani and Mochi – obvious *post festum* to art-historically trained eyes – was hardly noticed in the pope's circle. But the situation in painting was vastly different, and here the compromise character of Paul V's policy cannot be overlooked. Characteristically, he gave the direction of the whole enterprise into the hands of the Cavaliere d'Arpino. The Cavaliere himself painted the pendentives of the dome [4] and the lunette above the altar; the Florentine Ludovico Cigoli decorated the dome, and Guido Reni, possibly on the initiative of the Cavaliere, executed ten smaller frescoes in all, among them the unsatisfactorily shaped lunettes flanking the windows (1610–12). In addition, the Florentine Passignano (frescoes in the sacristy),[20] and the Mannerists Giovanni Baglione and Baldassare Croce (1553–1628) were given a share, while Lanfranco joined them later.[21] It is typical of one facet of official patronage during the second decade that all these artists, Mannerists, 'transitionalists', and 'modernists', worked side by side, and that the academic eclecticist d'Arpino topped the list.

A study of the third great papal undertaking, the Quirinal Palace, allows one to revise to a certain extent the impression carried away from the Paolina. Late in 1605 the pope entrusted his court architect, Flaminio Ponzio, with the enlargement of the existing building, which Carlo Maderno was ordered to continue after the former's death in 1613.[22] A number of splendid new rooms were ready for decoration from 1610 onwards, two of which deserve special attention : the 'Sala Regia' (now 'Sala de' Corazzieri') and the pope's private chapel (Cappella dell'Annunciata). The decorative framework of the painted frieze along the walls of the Sala de' Corazzieri (1616–17)[23] was apparently designed by Agostino Tassi (*c.* 1580–1644). Its crowded organization on the short walls reveals Tassi's late Mannerist Florentine training, while the perspective openings into imaginary rooms on the long walls show him influenced by the North Italian illusionism that had had a home in Rome since the days of Gregory XIII. Lanfranco and Carlo Saraceni were the principal executants of the figures and scenes.[24] The division of hands between the artists participating is not easily established,[25] but the phenomenon is interesting enough: we are faced with an *entente cordiale* of a Carracci pupil and a Caravaggio follower under the direction of a Roman who had studied in Florence. It may be added that it was rare for a *Caravaggista* to be considered for public fresco commissions of this kind.[26] Tassi himself consolidated here his reputation as a specialist in illusionist architecture *(quadratura); in this* capacity he collaborated with Domenichino and later, above all, with Guercino.

The main glory of the place is the Cappella dell'Annunciata, which was decorated between 1609 and 1613[27] by Guido Reni assisted by Lanfranco, Francesco Albani, Antonio Carracci, and the less distinguished Tommaso Campana. Here at last is a fully fledged co-ordinated enterprise by the young Bolognese masters. It found enthusiastic approval at the papal court; one can, however, hardly doubt that the pope's preference for Reni in the Quirinal as well as in S. Maria Maggiore and the Vatican[28] was due to Cardinal Scipione Borghese's good offices.

The cardinal nephew, Paul V's favourite, was perhaps the most brilliant representative of

the Pauline era. Jovial, vivacious, worldly in his outlook, famed for his sumptuous banquets, he invested much of his immense wealth in his buildings, collections, and the patronage of living artists. He was a true enthusiast and, contrary to the admonitions of the Trent Council, loved art for art's sake. His rapacity was matched by a catholicity of taste which also seems to have been a hallmark of other aristocratic patrons of these years. Not only a vast number of ancient works, but also many of the finest jewels of the present Borghese Gallery, paintings by Titian, Raphael, Veronese, Dossi, and others, adorned his collection; but it is more interesting in this context that he bought with equal zest pictures by the Cavaliere d'Arpino, by Passignano, Cigoli, Barocci, Caravaggio, Domenichino, and Lanfranco.[29] In fact, he was one of the earliest admirers of Caravaggio, just as he discovered at a remarkably early period the genius of Bernini. In his munificent commissions of works in fresco, both for private and public buildings, he showed partiality to the Bolognese, particularly to Guido Reni, who belonged to his household from 1608 onwards, and later to Lanfranco. But he did not hesitate to employ even feeble Mannerists, men like Nicolò Pomarancio (St Andrew Chapel, S. Gregorio Magno) or the latter's pupil, Gaspare Celio (Caffarelli Chapel, S. Maria sopra Minerva).

After Ponzio's death, the architect Scipione Borghese favoured for ecclesiastical buildings sponsored and paid by him was Giovan Battista Soria (1581–1651), who continued an academic manner far into the seventeenth century. His façade of S. Maria della Vittoria (1625–7); his masterpiece, the façade and forecourt of S. Gregorio Magno (begun 1629) [5]; and the nave of the cathedral at Monte Compatri near Rome (1630), were all executed for Scipione Borghese. Though not without dignity, they testify to the latter's conservative views as far as church architecture is concerned. Soria's architecture is somewhat more forceful than Ponzio's, who,

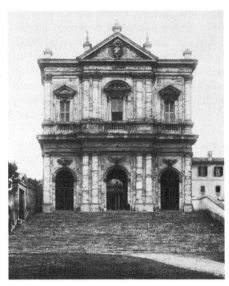

5. Giovan Battista Soria:
Rome, S. Gregorio Magno, 1629–33

on the cardinal's initiative, had executed the delicate classicist renovation of S. Sebastiano fuori le mura (1609–13, completed by Vasanzio)[30] [6, 7]. During his lifetime Ponzio remained the family architect and in this capacity continued the palace at which the elder Martino Longhi had worked for Cardinal Deza and which Paul V had purchased shortly before he was raised to the pontificate (February 1605). Irregular in shape, the western façade, the longest palace front in Rome, is largely the work of Ponzio. It follows the sombre tradition of the Palazzo Farnese, while the festive double-column courtyard (a novelty in Rome) points to the import of north Italian, probably Genoese, ideas.[31] The Palazzo Borghese was reserved by Paul V for the use of his brothers. In addition, Cardinal Scipione built for himself the present Palazzo Rospigliosi-Pallavicini in Piazza Montecavallo, begun in 1613. As in S. Sebastiano, the Dutchman Vasanzio (Jan van Santen), trained as a cabinet-maker and later Ponzio's col-

laborator and successor as papal architect, took over after his master's death.[32] It was Vasanzio who built the attractive Casino (1612–13), which Antonio Tempesta, Paul Brill, Cherubino Alberti, Passignano, Giovanni Baglione,[33] and, above all, Guido Reni decorated with frescoes. Agostino Tassi and Orazio Gentileschi painted the ceiling of the nearby 'Casino of the Muses' (1611–12) and Ludovico Cigoli a cycle of frescoes in yet another casino.[34] Thus this *ensemble,* created for Scipione Borghese, supplies once again a fascinating cross-section through the variety of tendencies existing side by side at the beginning of the second decade.

The cardinal's enthusiasm was concentrated on the erection of his villa on the Pincio (the present Galleria Borghese), which he wanted to be built by Ponzio.[35] But once again death interfered, and Vasanzio served as architect of

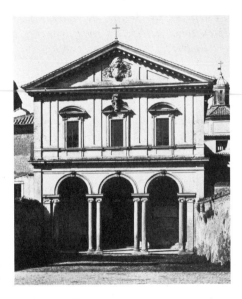

6 and 7. Flaminio Ponzio and Giovanni Vasanzio: Rome, S. Sebastiano, 1609–13

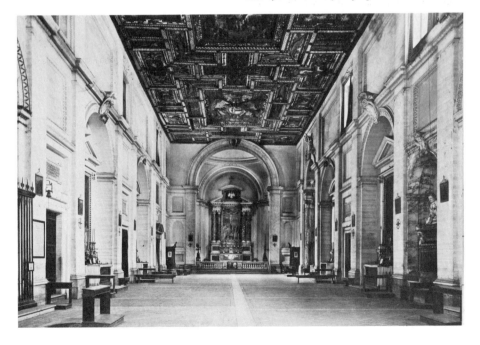

8. Giovanni Vasanzio: Rome,
Villa Borghese, 1613–15. Detail from a painting

9. Frascati, Villa Mondragone.
Garden front. Begun by M. Longhi, 1573,
continued by Vasanzio, 1614–21

the structure which rose between 1613 and 1615. If any building, it was this villa in its original condition that represented the quintessence of its patron's taste. The type follows that of the Roman *villa suburbana*, established a hundred years before in Peruzzi's Farnesina. But where Peruzzi used a classical severity, Vasanzio covered the whole U-shaped front with niches, recesses, classical statuary, and reliefs [8] (much of the decoration was stripped at the beginning of the nineteenth century) – a late example of that Mannerist *horror vacui* which had found its 'classical' expression in Pirro Ligorio's Casino of Pius IV and Annibale de' Lippi's Villa Medici on the Pincio. Vasanzio also enlarged Martino Longhi's Villa Mondragone at Frascati (1614–21)[36] for Scipione Borghese, and it is here, in the fountains and the beautiful loggia [9], so often erroneously attri-

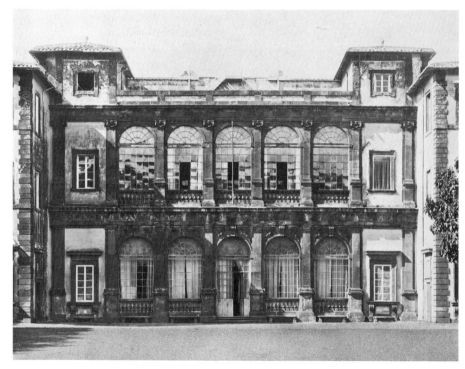

buted to Vignola, that his picturesque approach to architecture found a new, unexpected outlet.

Although far from exhaustive, our list of works executed for Paul V and his illustrious nephew is remarkable enough. But the impression of their lasting achievement as patrons of the arts would be incomplete without mentioning the many fountains with which they embellished Rome. Fountains rose in the squares of S. Maria Maggiore and the Lateran, in Piazza Scossa Cavalli and Piazza di Castello (destroyed). None of them can compete with the stateliness and elegance of Maderno's mushroom-shaped fountain in the Square of St Peter's or the monumentality of Ponzio's triumphal-arch front of the Acqua Paola (on the Janiculum) with its cascades of gushing water (1610–14) [10].[37] Ever since Sixtus V's days fountains had played an important part in Rome's urban development, but in contrast to

10. Flaminio Ponzio: Rome, Acqua Paola, 1610–14

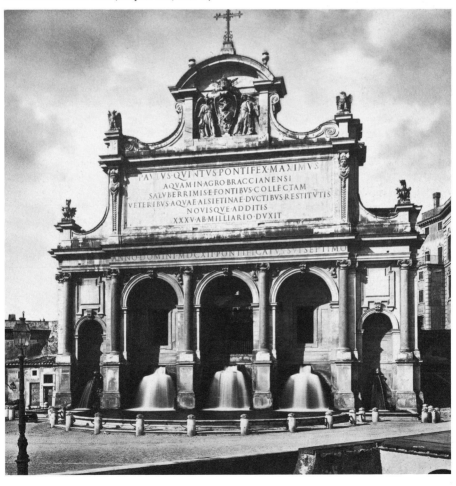

the tradition of Florentine fountains with their predominantly sculptural decoration, Roman fountains were either unadorned, consisting of a shaft which supported a combination of basins, or, if placed against a wall, were architectural and monumental. It is again a sign of the essential unity of the period from Sixtus V to Paul V that the approach to this problem remained basically unchanged. Ponzio's Acqua Paola was merely an improved version of Domenico and Giovanni Fontana's Acqua Felice (1587). As in so many other respects, the change came only during Urban VIII's pontificate when Bernini broke irrevocably with this Roman tradition [92].

Caravaggio's and Annibale Carracci's Supporters

The most distinguished patron in Rome after Scipione Borghese was surely the Marchese Vincenzo Giustiniani (1564-1637). As a young man he gave Caravaggio his unstinted support, and his courageous purchase of the *St Matthew*, refused by the priests of S. Luigi de' Francesi, probably prevented the shipwreck of Caravaggio's career as a painter of monumental religious pictures. But the Marchese collected with equal relish works of the Bolognese[38] and, moreover, reserved a special place in his household for the Mannerist Cristoforo Roncalli (called Pomarancio, 1552-1626), who began as a pupil of the older Nicolò Pomarancio and developed into a highly esteemed 'transitionalist'. It was this painter who served as Giustiniani's counsellor in artistic matters and who accompanied him in 1606 on his travels through Italy and Europe.[39] Later in Giustiniani's life the German Sandrart published for him his collection of ancient marbles (*Galleria Giustiniani*, 1631) to which Frenchmen, Duquesnoy and other Flemings as well as Lanfranco and Domenichino's pupil Giovan Battista Ruggieri contributed the designs and engravings.

If Caravaggio found devoted patrons among the nobility and higher clergy, it would yet be incorrect to talk of a distinct faction in his favour. The men who sided with him seem to have been enterprising, enthusiastic, and liberal in their outlook. This is certainly true not only of Scipione Borghese and Vincenzo Giustiniani, but also of Cardinal Francesco Maria del Monte, Caravaggio's earliest patron, who has been described as 'a kind of ecclesiastical minister of the arts in Rome';[40] it is true of the brothers Asdrubale and Ciriaco Mattei, who had 'fallen victim to the fashion for Caravaggio' (Baglione), but at the same time patronized artists like Cristoforo Roncalli and Gaspare Celio. These last artists were also favoured by the Crescenzi brothers, who were responsible for Caravaggio's getting the commission for the Contarelli Chapel; and this list might easily be continued.

Quite different were the fortunes of Annibale Carracci and his Bolognese friends and followers. Indeed, it is permissible in their case to talk of a faction, or rather two factions, determined to promote the Bolognese cause. There were the Farnese, in particular the powerful Cardinal Odoardo, under whose aegis Annibale painted the Farnese Gallery; he remained unfailingly loyal to his Bolognese *protégés*, employed Domenichino and Lanfranco in the palace, and must be credited with having collected most of the sixty-odd works attributed in the Farnese inventory of 1662 to the Carracci and their school. The second faction was associated with the circle of Cardinal Pietro Aldobrandini, Clement VIII's nephew and secretary of state, for a time the most influential man in Rome, and the political antagonist of Odoardo Farnese. The cardinal himself cherished the art of the Cavaliere d'Arpino. But his secretary, Monsignor Giovanni Battista Agucchi (1570-1632), born at Bologna, was Annibale's devoted admirer and Domenichino's close friend; to the same circle belonged Monsignor Giovanni

Antonio Massani and Francesco Angeloni, Cardinal Ippolito Aldobrandini's secretary.[41] Both Massani and Angeloni concentrated on collecting the Bolognese masters, and we happen to know that Angeloni possessed at least 600 Annibale drawings for the Farnese Gallery. It is at once evident that the men of this coterie, unlike Caravaggio's unbiased patrons, were guided by principles. Their single-minded partisanship was to become of ever greater importance in the early seventeenth century.

Agucchi himself tried his hand at a theoretical treatise, his *Trattato della Pittura*,[42] in which, among other ideas, he formulated anew the central principle of the classical doctrine, that nature is imperfect and that the artist has to improve upon her by selecting only her most beautiful parts. This empirical, Aristotelian theory was harnessed for an attack on two fronts: belief in it justified stricture of the *maniera* painters as much as of the *Caravaggisti*. From this point of view neither the Platonic concept of an *a priori* idea of beauty in the artist's mind (Zuccari's *disegno interno*) nor the exact imitation of imperfect nature (Caravaggio) was a defensible position. It is interesting that this new affirmation of the classical doctrine was written between 1607 and 1615, just after Zuccari's *Idea* had appeared (1607), which in a happy phrase has been called 'the swan song of the subjective mysticism of Mannerist theory'.[43] Agucchi and his circle found the realization of their theoretical approach – namely nature embellished and idealized – in the art of Annibale Carracci and Domenichino. They despised the older Mannerists and created the legend of Caravaggio's unbridled naturalism.

More than one distinguished scholar has pointed out that the period around 1600 was averse to theoretical speculations.[44] The essential truth of this cannot be contested. The artists themselves became tongue-tied. Federico Zuccari's elaborate programme of lectures to be delivered before the newly founded Academy

of St Luke was an anachronism even before it ingloriously petered out as a result of the artists' resistance. Both Caravaggio and Annibale Carracci derided the clever chattering about art of which the Mannerists were so fond. The liberal-minded patrons seem to have been interested in experiment and quality rather than in principles. Moreover, no important treatise extolling the new ideas was published during the first half of the seventeenth century. And yet the flame kindled in Agucchi's circle was never again extinguished. On the contrary, the classical-idealist theory, which guaranteed the dignity of painting on a level with Zuccari's academic eminence, was soon more or less vociferously championed, strengthened, and streamlined by amateurs and artists alike. It may be recalled that Domenichino sided, as one would expect, with the extreme classical point of view by exalting *disegno* (line) at the expense of *colore* (colour), and that later Francesco Albani planned a treatise the orthodoxy of which, judging from Malvasia's report, would have gone far beyond Agucchi's rather broad-minded exposition.[45] In any case, the *cognoscenti* of the early seventeenth century sided more and more determinedly with the opinions of the Agucchi circle and helped to bring about the climate in which the ascendancy of Bolognese classicism over Mannerism and Caravaggism was secured.

This ascendancy may be gauged by a glance at the list (p. 79) of important fresco cycles in palaces and churches executed by the Bolognese from 1608 onwards. Especially as regards the decoration of palaces, they enjoyed almost a monopoly during the second decade.

The new Churches and the new Iconography

No appreciation of the vast changes that came about in the artistic life of Rome from Sixtus V's days onwards is possible without due consideration of the hectic activity in the ecclesiastical field. Few churches had been built in

Rome during the first half of the sixteenth century. But as the century advanced the new intensity of devotion in the masses required energetic measures, and, above all, the new Orders needed churches to accommodate their large congregations. The beginning was made with the Gesù, the mother church of the Jesuit Order, rising from 1568 and consecrated in 1584. With its broad single nave, short transept, and impressive dome this church was ideally suited for preaching from the pulpit to great numbers of people. It established the type of the large congregational church that was followed a hundred times during the seventeenth century with only minor variations. During the next decades Rome saw three more large churches of this type rising, each surpassing the previous one in size. In 1575 the Chiesa Nuova (S. Maria in Vallicella) [135] was begun for St Philip Neri's Oratorians by Matteo di Città di Castello and continued by the elder Martino Longhi.[46] The building was consecrated in 1599, but Fausto Rughesi's traditional façade was not yet finished in 1605. S. Andrea della Valle, a stone's throw from the Chiesa Nuova, was designed by Giacomo della Porta (not by Pietro Paolo Olivieri) for the Theatines, whose Order had been founded during the early years of the religious strife (1524).[47] Begun in 1591, the building was taken over by Carlo Maderno in 1608 and completed in 1623 except for the façade. Finally, a second vast Jesuit church, S. Ignazio, was planned after the founder's canonization and begun in 1626. The canonization of St Charles Borromeo in 1610 was immediately followed by the dedication to him of no less than three churches in Rome: the very large S. Carlo al Corso, S. Carlo ai Catinari, built for the Barnabites, a congregation founded at Milan in 1533, and the small S. Carlo alle Quattro Fontane, which the Discalced Trinitarians later replaced by Borromini's structure.

In addition to these new buildings, owed to the counter-reformatory Orders and the new

saints, more medium-sized and small churches were erected during the three decades of Clement VIII's and Paul V's pontificates than in the preceding 150 years. One need only call to mind S. Maria della Scala (in Trastevere, 1592), S. Nicolò da Tolentino (1599–1614), S. Giuseppe a Capo le Case (1598, rebuilt 1628), S. Bernardo alle Terme (1598–1600), and S. Susanna (façade, begun 1597), all built during Clement VIII's reign, or S. Maria della Vittoria (1606), S. Andrea delle Fratte (1612), SS. Trinità de' Pellegrini (1614), S. Maria del Suffragio (1616), and S. Maria Liberatrice (1617), all rebuilt or newly raised under Paul V. To this list may be added such important restorations as Cardinal Baronius's of SS. Nereo and Achilleo,[48] Cardinal Pietro Aldobrandini's of S. Niccolò in Carcere, and Cardinal Sfondrate's of S. Cecilia in the days of Clement VIII as well as those of S. Francesca Romana, S. Crisogono, S. Sebastiano fuori le Mura, SS. Quattro Coronati, and S. Maria in Trastevere during Paul's pontificate. Finally, large and richly decorated chapels like that of Cardinal Caetani in S. Pudenziana (1595), of the Aldobrandini in S. Maria sopra Minerva (1600–5), of Cardinal Santori in the Lateran (begun before 1602), and of the Barberini in S. Andrea della Valle (1604–16) show that the first families of Rome competed in adding lustre to old and new churches.

In spite of solid and worthy achievement, the masters of the period here under review on the whole lack initiative, inventiveness, and a spirit of adventure. It seems to have been *bon ton* in those years not seriously to infringe established patterns. Thus a cloud of anonymity, if not of dullness, hangs over much ecclesiastical work of the time. One wonders how a Bernini, a Cortona, or a Borromini would have solved the problem of the large congregational church if such an opportunity had been offered them. In any case, the great masters of the post-Pauline era found stirring, imaginative, and highly personal solutions for traditional ecclesi-

astical tasks. The change effected during Urban VIII's pontificate is no less revolutionary in this than in other respects.

All the immense work of construction going on in the last decades of the old century and the first of the new required decoration by painters, sculptors, stucco workers, and crafts-men. As a rule, the direction remained in the hands of the architect. In the case of the Aldo-brandini Chapel in S. Maria sopra Minerva (begun 1600, consecrated 1611), Giacomo della Porta and, after his death, Carlo Maderno filled this post. But they were no more than the *primi inter pares* in co-ordinating the works of the painters Barocci (*Last Supper*, altar) and Cheru-bino Alberti (vault) and of the sculptors Camillo Mariani, Nicolò Cordier, Ippolito Buzio, Val-soldo, and Stefano Maderno. Collective enter-prises became the rule from Sixtus V to the end of Paul V's pontificate, even though the artists engaged on the same task often held very dif-ferent views. This trend was reversed under Urban VIII. Chapels such as those of the Raimondi and Cornaro families show through-out the imprint of Bernini's master-mind: co-workers were assistants rather than artists in their own right.

The new churches confronted painters in particular with a prodigious task. They had not only to cover enormous wall-spaces with fres-coes but had, above all, to create a new icono-graphical tradition. Saints like St Charles Bor-romeo, St Ignatius, St Francis Xavier, and St Teresa had to be honoured; their lives, miracles, and worldly and spiritual missions had to be solemnized. In addition, in the face of the Protestant challenge, the dogmas of the Catholic Church had to be reasserted in paintings which would strengthen the belief of the faithful and grip their emotions. Finally, as regards many scenes from the Old and New Testaments and from the lives of the saints, a shift was needed away from tradition towards an emphasis on heroic exemplars (David and Goliath, Judith

and Holofernes), on models of repentance (St Peter, the Prodigal Son), on the glory of martyr-dom[49] and saintly visions and ecstasies, or on hitherto unexplored intimate events from the childhood of Christ. These remarks indicate that one can truly talk about a counter-reformatory iconography.[50]

The rise of the new iconography may be ob-served from the last two or three decades of the sixteenth century onwards, but it must be stressed that in Rome the vast majority of the great cycles of frescoes, in the Gesù, S. Andrea della Valle, S. Carlo al Corso, the Chiesa Nuova, S. Ignazio, S. Carlo ai Catinari, and elsewhere were painted after the first quarter of the seven-teenth century. In other words, the decoration of these churches belongs to a stylistic phase later than the buildings themselves. The reason lies, partly in any case, in the time-lag between the early activities of the new Orders and the canonization of their founders. But this is not the whole story. It was, for instance, in keeping with the early austere 'iconoclastic' tendencies that St Philip Neri wanted the walls of the Chiesa Nuova whitewashed,[51] the same walls which half a century later were covered with Pietro da Cortona's exuberant decorations. Moreover, although it is true that one can hardly expect representations of the apotheoses of saints before they are canonized, the climate under Clement VIII and Paul V was not favour-able to the 'deification' in pictures of the great men of the Counter-Reformation. As we have mentioned, the popes themselves ordered the most meticulous inquiries into the cases of the prospective saints and the processes dragged on over many years. It is also important to notice that, as a rule, there is a considerable difference in the representation of the saints between the earlier phase and the later. In pictures of the second decade, such as those by Orazio Bor-gianni (S. Carlo alle Quattro Fontane, Rome) [25], Orazio Gentileschi (S. Benedetti, Fab-riano), or Carlo Saraceni (S. Lorenzo in Lucina,

Rome), the saints may be shown in a state of devotion and ecstasy, and in this exalted frame of mind they may see visions to which the beholder becomes a party. But rarely do they appear soaring up to heaven or resting on clouds in the company of angels, presupposing, as it were, that the entire image is the beholder's visionary experience [216].

Such scenes belong to the High Baroque, and for size and grandeur alone they establish a new artistic convention. When this happened, the great reformers had been dead for at least two generations, and it is evident even without any further comment that nothing could be more averse to the spirit in which they had worked.

No doubt is possible, then, that the Counter-Reformation made necessary a specific counter-reformatory iconography; nor that the iconographical pattern of the early seventeenth century changed to a certain extent during the post-Pauline period. But can one also talk of a specific counter-reformatory style? Summarizing what has been indicated in the foregoing pages, we may conclude that, of course, the Church made use of various artistic manifestations and stylistic trends which in turn were not independent of the religious temper of the age. In the coexistence of 'classical' reticence and 'vulgar' pomp one may be able to discern two different facets of counter-reformatory art. But above and beyond all this, it seems possible to associate a distinct style with the spirit of the reformers: a style which reveals something of their urgency and enthusiasm, of their directness of appeal and mystic depth of conviction. Since this is a matter concerning all Italy, a more explicit verdict must be postponed until the development of painting in the provinces has been surveyed (p. 109).

The Evolution of the 'Genres'

It is often said that a significant step in the slow and persistent shift from the primarily religious art of the Middle Ages to the primarily secular art of modern times was accomplished during the seventeenth century. There is truth as well as fallacy in this statement. It is fallacious to believe that an equation exists between the degree of naturalism and realism – in themselves highly problematical notions – and the profane character of works of art. Verisimilitude is no synonym for irreverence. Although the logic of this statement is unassailable, whether or not the beholder will regard the art of the seventeenth century as a truly religious art depends on his own, partly subconscious, terms of reference. But it cannot be denied that the largest part of artistic production during the period under review is of a religious nature. By comparison the profane sector remains relatively insignificant. This is correct, even though after Annibale Carracci's Farnese ceiling classical mythology and history become increasingly important in the decoration of palaces. In this respect Paul V's reign reveals an undeniable affinity with the Roman High Renaissance.

These observations may now be given more substance. It was in the years around 1600 that a long prepared, clear-cut separation between ecclesiastical and secular art became an established fact. Events in Rome hastened this division for the whole of Italy. Still life, genre scenes, and self-contained landscapes begin to evolve as species in their own right at this historical moment. None of these remarkable developments takes place without the active participation of northern, mainly Flemish, artists.[52] Rome, of course, was not the only Italian city where northern influence made itself felt. It may suffice to recall Florence, Bologna, and Genoa. Yet many northern artists were magically drawn to Rome, and Rome became the international meeting place where new ideas were avidly exchanged and given their characteristically Italian imprint.

The new species aroused such interest that even a man of Cardinal Federico Borromeo's

stern principles was much attracted by such 'trifles' as landscapes and still lifes. We are choosing him as an example because his case illustrates that around 1600 a collector had to turn to Rome for specimens of the new genres. It is well known that the cardinal owned Caravaggio's *Basket of Fruit* (now Ambrosiana, Milan); he admired, moreover, the art of Paul Brill and Jan Bruegel, both of whom he befriended and whose works figured prominently in his collection at Milan. Whenever he stayed in Rome he visited Brill's studio,[53] and on one occasion at least, in 1611, Giovan Battista Crescenzi acted as intermediary between artist and patron. The correspondence reveals that Crescenzi, the supervisor of Paul V's official artistic enterprises and thus a great power in matters of taste, had an eye for the qualities of Brill's seascapes.

Paul Brill, the younger brother of the less important Mattheus, held a key position in the process of assimilating Flemish landscape painting in Italy.[54] His early Flemish manner changed considerably, first under Muziano's and later under Annibale Carracci's influence. Thus monumentalized and italianized, his landscapes and seascapes became part of the broad stream of the Italian development. They lead on to Agostino Tassi's seascapes[55] and finally to those of Claude.

It is true that landscape painting had emerged as a specialized branch during the second half of the sixteenth century. Italians of the sixteenth and seventeenth centuries admitted the 'genre' as legitimate, probably not uninfluenced by the prominence Pliny gave to the work of the Roman landscape painter Studius.[56] But from Alberti's days on the noble art of history painting had pride of place in the hierarchy of values, and Italians, for the time being at any rate, regarded landscape painting as a pleasant recreation from the more serious business of 'high art'. This was precisely how an artist like Annibale Carracci felt. Exclusive specialization in the lower genres was therefore left to the foreigners. These remarks, of course, apply also to still life and the popular genre.

In spite of their theoretical approach, the contribution of Italians to the development of the genres in the early years of the seventeenth century was not negligible. The popular genre had a home in Bologna and was cultivated by the Carracci rather than by Caravaggio. Although working with essentially Mannerist formulas, the pupil of the Fleming Stradanus, Antonio Tempesta (1555–1630), who spent most of his working life in Rome, became instrumental in creating the realistic battle-piece and hunting-scene. In Caravaggio's circle the detailed realism of the Flemish fruit and flower still life was to a certain extent stylized and replaced by a hitherto unknown fullness of vision.[57] But during the period with which we are at present concerned all this was still in its beginnings.[58]

Only after the first quarter of the seventeenth century do we find that Italians are devoting themselves wholly to the practice of the specialized genres, that the market for these adjuncts to high art grows by leaps and bounds, and that each speciality is further subdivided into distinct categories. Foreigners again had a vital share in this process. The most patent case is that of landscape painting: the names of Poussin and Claude are forever associated with the full flowering of the heroic and pastoral landscape. But it was left to the Italian Salvator Rosa to establish the landscape type which the eighteenth century called 'sublime'.

CARAVAGGIO

Caravaggio, in contrast to Annibale Carracci, is usually considered a great revolutionary. From the mid seventeenth century onwards it has indeed become customary to look upon these two masters as being in opposite camps: the one a restorer of time-honoured tradition, the other its destroyer and boldest antagonist. There is certainly some truth in these characterizations, but we know now that they are much too sweeping. Caravaggio was less of an anti-traditionalist and Annibale Carracci more of a revolutionary than was believed for almost 300 years.[1]

Michelangelo Merisi, called Caravaggio, was born late in 1571, probably in Milan. Before the age of thirteen he was apprenticed in Milan to the mediocre painter Simone Peterzano and stayed with him for about four years. Peterzano called himself a pupil of Titian, a relationship not easily revealed by the evidence of his Late Mannerist work.[2] One has no reason to doubt that in this studio Caravaggio received the 'correct' training of a Mannerist painter. Equipped with the current knowledge of his profession, he reached Rome about 1590 and certainly not later than 1592.[3] His life there was far from uneventful. Perhaps the first consistent bohemian, he was in permanent revolt against authority, and his wild and anarchic character brought him into more than one conflict with the police.[4] In 1606 he had to flee from Rome because of a charge of manslaughter. During the next four restless years he spent some time at Naples, Malta, Syracuse, and Messina. On his way back to Rome he died of malaria in July 1610, not yet thirty-nine years old.

When he first reached Rome, he had had to earn his living in a variety of ways. But hackwork for other painters, among whom was perhaps the slightly older Antiveduto Gramatica (1571-1626),[5] left a youth of his temperament and genius thoroughly dissatisfied. For a short time he also worked for Giuseppe Cesari (later the Cavaliere d'Arpino) as a studio hand,[6] but soon started on his own. At first unsuccessful, his fortunes began to change when Cardinal Francesco del Monte bought some of his pictures.[7] It seems that through the agency of this same prince of the Church he was given, in 1599, his first commission for a monumental work, the paintings in the Contarelli Chapel of S. Luigi de' Francesi [15]. This event appears in retrospect as the most important caesura in Caravaggio's career. From then on he produced almost exclusively religious paintings in the grand manner. With these data at hand, the brief span of Caravaggio's activity may conveniently be divided into four different phases: first, the Milanese period; even though paintings of this period will probably never be discovered, it is of great consequence not only because of the conventional training with Peterzano, but also because of the lasting impressions made on him by older North Italian masters such as Savoldo, Moretto, Lotto, and the brothers Giulio and Antonio Campi; secondly, the first Roman years, about 1590-9, during which Caravaggio painted his *juvenilia*, for the most part fairly small pictures consisting, as a rule, of one or two half-figures [11]; thirdly, the period of monumental commissions for Roman churches, beginning in 1599 and ending

with his flight from Rome in 1606;[8] and finally, the work of the last four years, again mainly for churches and done in a fury of creative activity, while he moved from place to place.

A comparison between an early Roman and a post-Roman work [11 and 14] gives the measure of Caravaggio's surprising development. His uninhibited genius advanced with terrific strides into uncharted territory. If we had only his earliest and his latest pictures, it would be almost absurd to maintain that they are by the same hand. To a certain extent, of course, this is true of the work of every great master; but in Caravaggio's case the entire development was telescoped into about eighteen years. In fact, between the paintings shown in illustrations 11 and 14 there may not be more than thirteen years.

Not unexpectedly, the biographical caesuras coincide with the vital changes in his style, but these changes have too many ramifications to be described by a purely formal analysis. Much more may be learned about them by inquiring into his approach to mythological, genre, and religious subjects and by focusing on the character and meaning of his realism and his *tenebroso*, the two pillars on which his fame rests. Contrary to what is often believed, genre scenes play a very subordinate part in Caravaggio's production. They seem even more marginal than mythological and allegorical[9] themes and, may it be noted, almost all the non-religious pictures belong in the first Roman years. In contrast to genre painting, mythologies and allegories clearly indicate an artist's acceptance of a learned tradition; and it cannot be sufficiently emphasized that we find the young Caravaggio working within this tradition, of his own accord. It is fair to assume that in the Uffizi *Bacchus* [11] he represented himself in mythological disguise.[10]

Mythological or allegorical portraiture has, of course, a pedigree leading back to Roman times. Nor is the attitude of the sitter here new

in the history of portraiture. On the contrary, examples are legion showing the sitter addressing the beholder, as it were, from behind a table or parapet. What, then, is remarkable about this picture? Wine and wreath apart, there is little that is reminiscent of the god of antiquity. His gaze is drowsy, his mouth soft and fleshy; white, overfed, and languid, he holds the fragile glass with a dainty gesture. This well-groomed, pampered, lazy androgyne, static like the superb still life on the table, will never move or ever disarrange its elaborate coiffure and its precious pose. Contemporaries may have looked upon this interpretation as mythological heresy,[11] which was not Caravaggio's invention either. It originated in the era of Mannerism when artists began to play so lightly with mythological themes that the ancient gods could even become objects of derision.[12] But the Bacchic paraphernalia of Caravaggio's picture should not be regarded as mere supercilious masquerade: he chose the emblems of Bacchus to express his own sybaritic mood. When Bronzino represented Andrea Doria as Neptune, he conveyed metaphorically something about the admiral's mastery of the sea. Caravaggio's disguise, by contrast, makes sense only as a support to an emotional self-revelation. The shift from the statement of an objective message to the indication of a subjective mood adumbrates a new departure the importance of which hardly needs stressing.[13]

The sitter's dissipated mood is also clearly expressed by the key in which the picture is painted: bright and transparent local colours with hardly any shadows are set off against the shining white of the mass of drapery. The colouristic brilliance is combined with an extraordinary precision and clarity of design and a scrupulous rendering of detail, particularly in the vine leaves of the wreath and the still life of fruit on the table.[14] No atmosphere surrounds the figure; colour and light do not create space and depth as they do in Venetian painting.

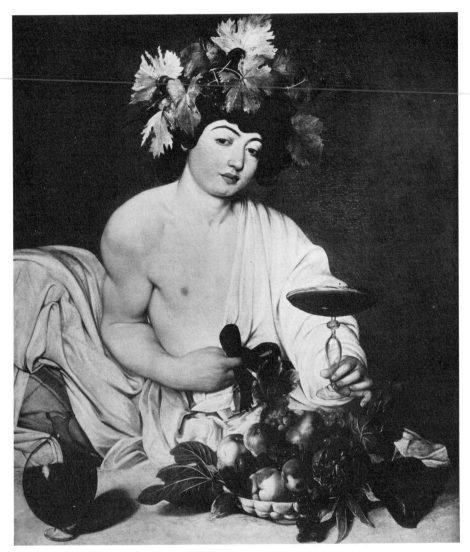

11. Caravaggio: Bacchus, *c.* 1595. *Florence, Uffizi*

Depth, in so far as it can be visualized, is suggested by foreshortenings such as those of the arm and hand holding the wine-glass. Other early pictures by Caravaggio may be similarly described, but in none of them are the tones so glassy, the whites so penetrating, and the pink of the flesh so obscene. Colours and tone values clearly sustain the precious mood of the picture.

At this period Caravaggio's method of stressing individual forms with local colour is as far removed from the practice of Venetian colourism as it is indeed from the elegant and insipid generalizations of the Mannerists. On the other hand, a marked Mannerist residue is perceptible in the Bacchus, not only in such details as the folds and the flaccid bare arm, but, above all, in the pervading quality of stylization, which proves that the old catchword of Caravaggio's realism should be used with caution, particularly in front of the early Roman works. Soon after the Bacchus, Caravaggio again represented himself in a mythological disguise, but this time appropriately expressing his own frenzy through the horrifying face of *Medusa* (Florence, Uffizi). The simple fact that he painted the picture on a round wooden shield proves his awareness of traditional literary associations, and those who quote this work as an extreme example of his realism unpermissibly divorce the content from the form. Nor is the formal treatment really close to nature, as anyone who tries to imitate the pose will easily discover. This image of terror has the power to 'petrify' the beholder just because it is unrealistic and reverts to the old expressive formula of classical masks of tragedy.[15]

Similarly, Caravaggio's few genre pieces can hardly be called realistic. Like other Italian artists of the period, he was indebted to Northerners who had long practised this branch of art and had begun to invade the Italian market in the later sixteenth century. But if their genre painting, true to the meaning of the word, shows anonymous people following their everyday occupations, it must be said that neither Caravaggio's *Card-Sharpers* nor his *Fortune-Teller* reflect fresh observations of popular contemporary life. Such slick and overdressed people were not to be found walking about; and the spaceless settings convey a feeling of the *tableau vivant* rather than of 'snapshots' of actual life.[16] One looks at these pictures as one

reads a romantic narrative the special attraction of which consists in its air of unreality.

It has been mentioned before that from 1599 onwards by far the greater part of Caravaggio's activity was devoted to religious painting, and henceforth very considerable changes in his approach to his art are noticeable. These changes may here be observed in a cabinet picture, the National Gallery *Supper at Emmaus* (c. 1600) [12].[17] Only the rich still life on the table links the picture to his early Roman period. But, as if his youthful escapades were forgotten and eradicated, suddenly and unexpectedly Caravaggio reveals himself as a great painter of religious imagery. The change is marked not only by a revision of his palette, which now turns dark, but also by a regression to Renaissance exemplars. Compositionally the work derives from such representations of the subject as Titian's *Supper at Emmaus* in the Louvre, painted about 1545. In contrast, however, to the solemn stillness in Titian's work, the scene is here enacted by means of violent gestures – intense physical reactions to a spiritual event. Christ is deeply absorbed and communicates the mystery through the slight bending of His head and His downcast eyes, both accompanied by the powerful language of the blessing hands. The sacramental gesture of these hands takes on an added emotional significance through their juxtaposition to the lifeless legs of the chicken on the table. The incomprehension of the inn-keeper is contrasted with the reaction of the disciples who recognize Christ and express their participation in the sacred action by rugged, almost compulsive movements. In keeping with the tradition stemming from Alberti and Leonardo, Caravaggio, at this stage of his development, regarded striking gestures as necessary to express the actions of the mind.

With Caravaggio the great gesture had another distinct meaning; it was a psychological device, not unknown in the history of art,[18] to draw the beholder into the orbit of the picture

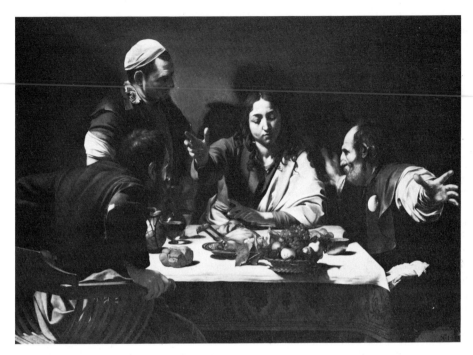

12. Caravaggio: Supper at Emmaus, *c.* 1600.
London, National Gallery

and to increase the emotional and dramatic impact of the event represented: for Christ's extremely foreshortened arm as well as the out-flung arm of the older disciple seem to break through the picture plane and to reach into the space in which we stand. The same purpose is served by the precarious position of the fruit-basket which may at any moment land at our feet. In his middle period Caravaggio often used similar methods in order to increase the participation of the worshipper in the mystery rendered in the picture. Special reference may be made to the first version of the *St Matthew and the Angel* painted for the Contarelli Chapel, where the saint's leg appears to jut right out of the picture, or to the second version with one leg of the stool dangling over the ledge into the beholder's space; and also to the extremely foreshortened body of the saint in the *Conversion of St Paul* in S. Maria del Popolo [13] and the jutting corner of the Stone of Unction in the Vatican *Deposition,* which is echoed by Joseph of Arimathea's elbow.[19]

Towards the end of his Roman period Caravaggio painted a second *Supper at Emmaus* (Milan, Brera). Here he dispensed with the still life acessories on the table and, even more significantly, with the great gestures. The picture is rendered in a much less dramatic key and the silence which pervades it foreshadows a trend in his post-Roman work.

In the works of the middle period Caravaggio takes great pains to emphasize the volume and corporeal solidity of the figures, and sometimes, packs them so tightly within the limits imposed by the canvas that they seem almost to burst the

frame [13]. In other paintings of this period, however, a tendency is stressed that was already noticeable in a few of the early pictures, namely the creation of a large spaceless area above the figures, an emptiness which Caravaggio exploited with tremendous psychological effect. Not only is the physical presence of the figures more vigorously felt by contrast with the unrelieved continuum, but the latter may even assume symbolic significance as in the *Calling of St Matthew*, where darkness lies menacingly over the table around which St Matthew and his companions sit. In the majority of the post-Roman pictures the relation of figures to space changes in one direction, the most telling examples being the Syracuse *Burial of St Lucy* and the Messina *Raising of Lazarus* [14].[20] Here the deeply disturbing and oppressive quality of the void is rendered more acute by the devaluation of the individual figures. Following Italian tradition, during the middle period each single figure was sharply individualized; in the late

pictures, by contrast, figures tend at first glance to merge into an almost amorphous mass. As one would expect, traditional gestures are abandoned and emotions are expressed by a simple folding of the hands, by a head held pressed between the palms or bowed in silence and sorrow. When ample gestures are used, as in the *Raising of Lazarus*, they are not borrowed from the stock of traditional rhetoric, as were the upraised hands of the Mary in the *Deposition* or the extended arms of St Paul in the *Conversion* [13]. The spread-out arms of Lazarus at the moment of awakening have no parallel in Italian painting.

In his early pictures, Caravaggio often created an atmosphere of peculiar still life permanency. During the middle period he preferred a transitory moment, stressing the dramatic climax of an event, as in the first *Supper at Emmaus*, the *Judith killing Holofernes* (Rome, Casa Coppi), and the *Conversion of St Paul*. In the late period, the drama is often transposed into a sphere of

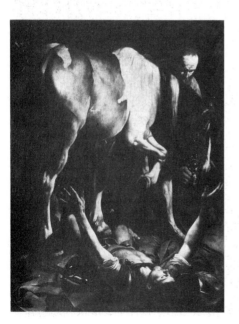

13 *(left)*. Caravaggio: Conversion of St Paul, 1600–1. *Rome, S. Maria del Popolo, Cerasi Chapel*

14 *(opposite)*. Caravaggio: Raising of Lazarus, 1609. *Messina, Museo Nazionale*

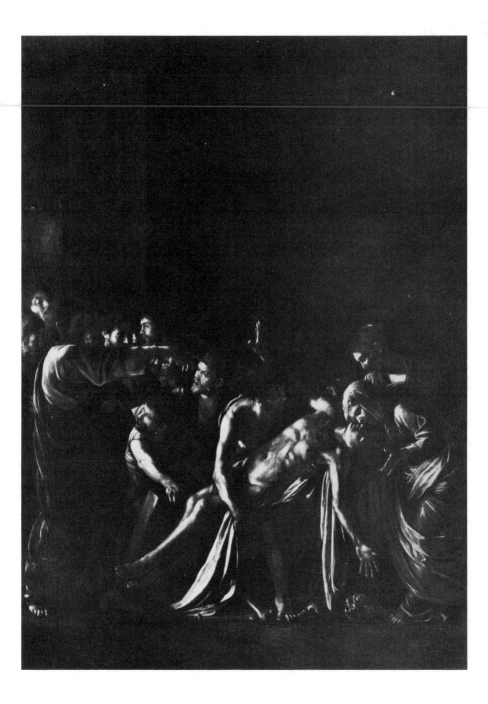

ghost-like unreality. Although in a picture like the Naples *Flagellation of Christ* no real action is shown and the hangmen do not strike, as was the rule in the iconographical tradition, the scene is more cruel and infinitely more gripping and Christ's suffering even more poignant than in any previous rendering of the subject in Italy.

Many of Caravaggio's pictures of the middle period are tied to tradition not only in their language of expressive gesture and in their iconography,[21] but even in their compositional arrangement. In this respect, perhaps none of his monumental works is more indebted to the past than the *Martyrdom of St Matthew* [15]. In this work he used to a considerable extent the Mannerist repertory of repoussoir figures together with compositional devices and refinements which were becoming rare at this moment in Rome.[22] The type of composition with the figures revolving, as it were, round a central pivot is dependent on works like Tintoretto's *St Mark rescuing a Slave*, while the group of the

15. Caravaggio: Martyrdom of St Matthew, 1600. *Rome, S. Luigi de' Francesi, Contarelli Chapel*

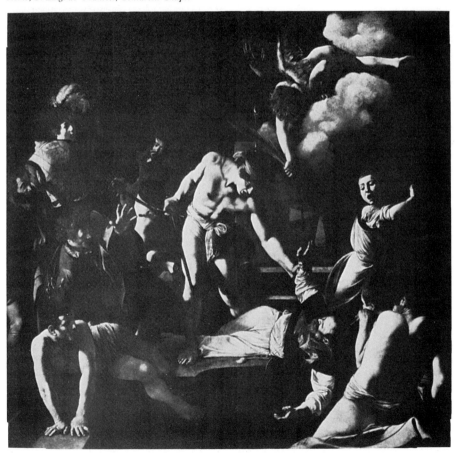

executioner, saint, and frightened acolyte is borrowed from Titian's *Death of St Peter Martyr* (destroyed). It is not unlikely that the present composition, painted over an entirely different earlier one, was a concession forced upon Caravaggio by the difficulties which he encountered during the work in the Contarelli Chapel. This explanation is also suggested by the unique occurrence in his *œuvre* of an angel appearing from heaven upon clouds. Clouds were the traditional emblem to be used for the representation of visions and miracles: Caravaggio never admitted them, with this one exception. Whenever he had to show angels, he robbed them of those soft props which by no stretch of the imagination can support a figure of flesh and blood in the air.

Most of the later Roman works are much more severely constructed than the *Martyrdom of St Matthew*, witness the *Deposition of Christ* or the *Death of the Virgin*. But the post-Roman paintings are by comparison even more austere, and their compositions are reduced to a seemingly artless simplicity. Reference may be made to the solid triangle of figures in the Messina *Adoration of the Shepherds*, the closely packed group of figures in the *Lazarus*, or the hieratic symmetry of the coactors in the *Decapitation of St John*.

Looking at his early work in particular, one may be inclined, as generations have been, to regard Caravaggio as an artist who renders what he sees with meticulous care, capturing all the idiosyncrasies of his models. Caravaggio himself seems to have spread this legend, but we have already seen how little it corresponds to the facts. Moreover, apart from his recognizably autograph style, he developed what can only be called his own repertory of idiomatic formulas for attitudes and poses, the recurrent use of which was surely independent of any life model.[23] In addition, he sacrificed by degrees the interest in a logical disposition and rational co-ordination of the figures in favour of the

emotional impact he wished to convey. This tendency is already noticeable in the early *Musical Party*, and is much more in evidence in the works after 1600. In one of the most striking pictures of this period, the *Conversion of St Paul*, it is impossible to say where the saint's lower right leg would be or how the attendant's legs can possibly be joined to his body. Later, in the post-Roman works, he was on occasions quite reckless, and nowhere more so than in the *Seven Works of Mercy*, one of his most moving and powerful pictures. The meaning of this procedure becomes patently clear in the *Burial of St Lucy*. By enormously exaggerating the size of the grave-diggers, sinister and obnoxious creatures placed painfully close to the beholder, and by representing them out of all proportion to the scale of the mourners only a few steps further back, the brutality and senselessness of the crime are more convincingly exposed than could ever have been done by a 'correct' distribution of figures in space.

All these observations lead one to conclude that Caravaggio progressively abandoned working from life models and that his post-Roman pictures, above all, were to a large extent painted from memory. This is also supported by the fact that no drawings by Caravaggio survive. He must, of course, have drawn a good deal in Peterzano's studio, but he seems to have reversed Mannerist procedure once he was on his own. Compared with the Renaissance masters, late Mannerists neglected studies from nature; they used stock poses for their preparatory designs and cartoons. It may be surmised that Caravaggio, by contrast, made many incidental sketches from nature, which one would not expect to survive, but dispensed with any form of cumbersome preparation for his paintings. In fact it is well known that he worked *alla prima*, straight on to the canvas, and this is the reason why his pictures abound in *pentimenti*, which can often be discovered with the naked eye. This procedure, admirably suited to his mercurial

temperament, makes for directness and immediacy of contact between the beholder and the picture, whereas distance and reserve are the obvious concomitants of the 'classical' method[24] of arriving at the finished work by slow stages.

Caravaggio's *ad hoc* technique stemmed from a Venetian tradition, but in Venice, where preparatory drawings were never entirely excluded, this 'impressionist' approach to the canvas had two consequences which seem natural: it led to a painterly softening of form and to an emphasis on the individual brush-stroke. In Caravaggio's work, however, the forms always remain solid, his paint is thin, and consequently the brushstroke is hardly perceptible. In his middle period it begins to be more noticeable, particularly in the highlights, while in his post-Roman pictures two new conflicting tendencies are apparent. On the one hand, forms harden and stiffen, and bodies and heads may be painted with little detail and few transitions between light and dark – resulting in near-abstractions. Certain passages in the *Seven Works of Mercy* illustrate this trend very fully. Side by side with this development can be found what is, by comparison, an extremely loose technique: the face of Lazarus, for example, is rendered by a few bold brush-strokes only. Instead of the careful definition of form still prevalent during the middle period, or the daring simplification and petrifaction of form in certain post-Roman works, one is faced in the *Raising of Lazarus* with shorthand patterns symbolizing heads, arms, and hands.

Little has so far been said about the most conspicuous and at the same time the most revolutionary element of Caravaggio's art, his *tenebroso*. With his first monumental commissions he changed from the light and clear early Roman style to a new manner[25] which seemed particularly suitable to religious imagery, the main concern during the rest of his life. Figures are now cast in semi-darkness, but strong light falls on them, models them, and gives them a robust three-dimensional quality. At first one may be inclined to agree with the traditional view that his lighting is powerfully realistic; it seems to come from a definable source, and it has even been suggested that he experimented with a *camera obscura*. Further analysis, however, shows that his light is in fact less realistic than Titian's or Tintoretto's. In Titian's as later in Rembrandt's pictures light and darkness are of the same substance; darkness only needs light to become tangible; light can penetrate darkness and make twilight space a vivid experience. The Impressionists discovered that light creates atmosphere, but theirs is a light without darkness and therefore without magic. With Caravaggio light isolates; it creates neither space nor atmosphere. Darkness in his pictures is something negative; darkness is where light is not, and it is for this reason that light strikes upon his figures and objects as upon solid, impenetrable forms and does not dissolve them, as happens in the work of Titian, Tintoretto, or Rembrandt.

The setting of Caravaggio's pictures is usually outside the realm of daily life. His figures occupy a narrow foreground close to the beholder. Their attitudes and movements, their sudden foreshortenings into an undefined void, heighten the beholder's suspense by giving a tense sensation of impenetrable space. But despite, or because of, its irrationality, his light has power to reveal and to conceal. It creates significant patterns. The study of a picture like the Doria *St John the Baptist* of about 1600,[26] which derives from the nudes of the Sistine ceiling, will clarify this point. The pattern created by light and darkness almost gainsays the natural articulation of the body. Light passages radiate from a darker centre like the spokes of a wheel. Thus by superimposing a stylized play of light and shade over the natural forms, an extraneous concept is introduced which contradicts Michelangelo's organic interpretation of the human

body. Caravaggio used wheel-patterns of light in some of the multi-figured compositions of his later Roman years, for instance the *Martyrdom of St Matthew*, the *Crucifixion of St Peter*, and the *Death of the Virgin*. A glance at the illustration of the *Martyrdom* [15] suffices to see that the abstract pattern of light is given precedence in the organization of the canvas. It is the radiating light that firmly 'anchors' the composition in the picture plane and, at the same time, singles out the principal parts of dramatic import. In pictures of the middle period the areas of light are relatively large and coherent and coincide with the centre of interest. In the late pictures darkness engulfs the figures; flashes and flickers of light play over the surface, heightening the mysterious quality of the event depicted. This is nowhere more striking than in the *Raising of Lazarus*, where heads, pieces of drapery, and extremities break through the surrounding darkness – a real-unreal scene over which broods an ineffable sense of mystery.

From the very beginning of Christian imagery light has been charged with symbolism. God's presence in the Old Testament or Christ's in the New is associated with light, and so is Divine Revelation throughout the Middle Ages, whether one turns to Dante, Abbot Suger, or St Bonaventura. Although from the fifteenth century onwards light is rendered naturalistically and even atmospherically, particularly in Venice, it never loses its supernatural connotation, and the Baroque age did not break with this tradition. Nevertheless, painters of religious imagery were always faced with the seemingly insoluble problem of translating visions into pictorial language. Describing St Francis's stigmatization, St Bonaventura says 'when the vision had disappeared, it left a wonderful glow in his [St Francis's] heart'. Giotto was quite incapable of translating the essence of these words into pictorial language. He and many after him had to express the human experience of mystical union with God by a descriptive,

narrative method. Language was far in advance of the visual arts. Seventeenth-century painters caught up with it. A painter like Cigoli was well able to render St Francis's psycho-physical reactions [42]. But although he made true in his painting the sensation described by Bonaventura, he was still tied to the traditional descriptive method: for the vision itself is shown bathed in heavenly light breaking through the clouds. It must be remembered that the ecstasy of vision is a state of mind to which no outsider is admitted; it is perception and revelation inside one man's soul. This was the way Caravaggio interpreted visions from the very beginning. In his *Ecstasy of St Francis* of about 1595[27] he showed the saint in a carefully observed state of trance; one eye is closed; the other, half open, stares into nothingness and the body, uncomfortably bent backward, seems tense and stiff. Mystery is suggested by the glimmer of light breaking through the dark evening sky. The invisible is not made visible, but we are allowed to wonder and to share; a wide scope is left for the imagination. It is the light alone that reveals the mystery, not light streaming down from the sky or radiating from the figure of Christ. The mature Caravaggio drew the last consequences. In his *Conversion of St Paul* he rendered vision solely on the level of inner illumination. Light, without heavenly assistance, has the power to strike Saul down and transform him into Paul, in accordance with the words of the Bible: 'Then suddenly there shone round about him a light from Heaven and he fell to the earth and heard a voice say unto him: Saul, Saul, why persecutest thou me?' Paul, eyes closed, mouth open, lies completely absorbed in the event, the importance of which is mirrored in the moving expression of the enormous horse.

By excluding a heavenly source, Caravaggio sanctified light and gave it a new symbolic connotation. One may return to the study of his symbolic use of light in the *Calling of St*

Matthew, where Christ stands in semi-darkness and the wall above him shines bright, while a beam of light falls on those who, still under the large shadow of darkness, are about to be converted. It is precisely the antithesis between the extreme palpability of his figures, their closeness to the beholder, their uncomeliness and even vulgarity – in a word, between the 'realistic' figures and the unapproachable magic light that creates the strange tension which will not be found in the work of Caravaggio's followers.

It has been shown in the first chapter that Caravaggio had devoted patrons among the liberally minded Roman aristocracy. And yet, his large religious pictures were criticized or refused with almost clockwork regularity.[28] The case of the *Death of the Virgin* throws an interesting light on the controversy which his works aroused and the fervour of the partisanship. It was rejected by the monks of S. Maria della Scala, the church of the Discalced Carmelites; but Rubens, at that time in Rome, enthusiastically advised his patron the Duke of Mantua to acquire the painting for his collection. Before it left Rome, however, the artist arranged a public exhibition and great crowds flocked to see the work. Caravaggio's opponents, it seems, were mainly recruited from the lower clergy and the mass of the people. They were disturbed by theological improprieties and offended by what appeared an irreverent treatment of the holy stories and a lack of decorum. They were shocked to find their attention pinpointed by such realistic and prominent details as the dirty feet in the *St Matthew* and the *Madonna di Loreto* or the swollen body of Mary in the *Death of the Virgin*. Only the *cognoscenti* were able to see these pictures as works of art.

It is a paradox that Caravaggio's religious imagery, an art of the people for the people, was heartily distrusted by the people; for it can scarcely be denied that his art was close in spirit to that popular trend in Counter-Reformation religion which was so marked in the activity of St Charles Borromeo in Milan and St Philip Neri in Rome as well as in St Ignatius's *Spiritual Exercises*.[29] Like these reformers, Caravaggio pleaded through his pictures for man's direct gnosis of the Divine. Like them he regarded illumination by God as a tangible experience on a purely human level. It needed his genius to express this aspect of reformed religion. His humanized approach to religious imagery opened up a vast new territory; for his work is a milestone on the way to the representation of those internalized 'private' visions which his own period was still unable and unwilling to render.

The aversion of the people to his truly popular art is not the only paradox in Caravaggio's life. In fact the very character of his art is paradoxical, and the resulting feeling of awe and uneasiness may have contributed to the neglect and misunderstanding which darkened his fame. There is in his work a contrast between the tangibility of figures and objects and the irrational devices of light and space; between meticulous study from the model and disregard for representational logic and coherence; there is a contrast between his *ad hoc* technique and his insistence on solid form; between sensitivity and brutality. His sudden changes from a delicacy and tenderness of feeling to unspeakable horror seem to reflect his unbalanced personality, oscillating between narcissism and sadism. He is capable of dramatic clamour as well as of utter silence. He violently rejects tradition but is tied to it in a hundred ways. He abhors the trimmings of orthodoxy and is adamant in disclaiming the notion that supernatural powers overtly direct human affairs, but brings the beholder face to face with the experience of the supernatural. But when all is said and done, his types chosen from the common people, his magic realism and light reveal his passionate belief that it was the simple in spirit, the humble and the poor who held the mysteries of faith fast within their souls.

THE CARRACCI

At the beginning of the last chapter it was noted that it is still customary to see Caravaggio and Annibale Carracci as the great antagonists in Rome at the dawn of the seventeenth century. The differences between them are usually summed up in pairs of contrasting notions such as naturalism–eclecticism, realism–classicism, revolt–traditional. This erroneous historical conception has grown over the centuries, but before the obvious divergencies to be found in their art hardened into such antithetical patterns, contemporaries believed that the two masters had much in common. Thus the open-minded collector and patron Marchese Vincenzo Giustiniani, who has often been mentioned in these pages, explained in a famous letter[1] that, in his view, Caravaggio, the Carracci, and a few others were at the top of a sliding scale of values, because it was they who knew how to combine in their art *maniera* and the study from the model: *maniera* being, as he says, that which the artist 'has in his imagination, without any model'. Vincenzo Giustiniani clearly recognized the *maniera* in Caravaggio and also implied by his wording that the mixture of *maniera* and realism (i.e. work done directly from the model) was different in Caravaggio and the Carracci. Even though our terminology has changed, we are inclined nowadays to agree with the opinions of the shrewd Marchese.

Nevertheless it was, of course, Annibale Carracci and not Caravaggio who revived the time-honoured values in Italian art and revitalized the great tradition manifest in the development of painting from Giotto to Masaccio and on to Raphael. Caravaggio never worked in fresco. But it was monumental fresco-painting that educated Italians of the seventeenth and eight-eenth centuries still regarded as the finest flower of art and the supreme test of a painter's competence. This approach, which was deeply rooted in their theoretical premises and historical background, was detrimental to the fortunes of the easel-painter Caravaggio. It helped, on the other hand, to raise Annibale Carracci to his exalted position, for, next to Raphael's Stanze and Michelangelo's Sistine Ceiling, his frescoes in the Farnese Gallery were regarded until the end of the eighteenth century as the most important landmark in the history of painting. And now that we are beginning to see rule rather than freedom in Caravaggio's work, we are also able once again to appreciate and assess more positively than writers of the last 150 years[2] the quality of Annibale's art and his historical mission. Once again we can savour those virtues in Annibale's bold and forthright 'classicism' which were inaccessible to the individualist and 'realist' Caravaggio.

One must study Annibale's artistic origins and see him in relation to the other painters in his family in order to understand the special circumstances which led up to the climax of his career in the frescoes of the Farnese Gallery. Among the various attempts at reform during the last decades of the sixteenth century Bologna soon assumed a leading position, and this was due entirely to the exertions of the three Carracci. Agostino (1557–1602) and Annibale (1560–1609) were brothers; their cousin Lodovico (1555–1619) was their senior by a few years. It was Lodovico without any shadow of doubt who first pointed the way to a supersession of the complexity, sophistication, and artificiality of Late Mannerism. In the beginning the three artists had a common studio, and during the

early period of their collaboration it is not always easy to distinguish between their works.[3] After 1582 they opened a private 'academy', which had, however, a quite informal character. This active school, in which special emphasis was laid on life drawing, soon became the rallying point of all progressive tendencies at Bologna.[4] At the same period, in the early 1580s, the personalities of the three Carracci become more clearly defined, and from about 1585 onwards a well-documented series of large altarpieces permits us to follow the separate developments of Annibale and Lodovico. Agostino, a man of considerable intellectual accomplishments, was primarily an engraver and also, so it seems, a devoted teacher with a real knack of communicating the elements of his craft.[5] As a painter he attached himself to Annibale rather than Lodovico. It is, therefore, justifiable to concentrate on the two latter artists and begin with a study of some of their fully developed Bolognese works as a springboard to a correct assessment of the pre-Roman position.

Annibale's *Virgin with St John and St Catherine* of 1593 (Bologna, Pinacoteca) [16][6] immediately calls to mind works of the Central Italian High Renaissance of 1510-15. Three powerfully built figures are joined by the compositional device of the triangle, well known from High Renaissance paintings, and are placed in front of a simple and massive classical architecture. Moreover the *contrapposto* is extended from governing the unit of each figure to determining the greater unit of the whole, for the two saints, left and right of the central axis, form balanced contrasts. This is the compositional method first practised by Leonardo and followed by Raphael, Fra Bartolommeo, and other High Renaissance masters. Also the firm stance and the clear, unequivocal gestures and expressions of Annibale's figures are reminiscent of early sixteenth-century Florentine art. But Annibale's deep, warm, and glowing colours, replacing the pale, often *changeant* hues of Man-

nerism, give his work a distinctly down-to-earth quality; by comparison, Central Italian High Renaissance paintings appear cold and remote. Annibale's rich and mellow palette derives from Correggio and the Venetians. These masters rather than Raphael were from the beginning of his career his consciously elected guides in the revolt against contemporary Mannerism. The *Virgin with St John and St Catherine* is, in fact, the first picture in which Annibale's turn to a Central Italian type of composition is evident.

Individual motives prove that even at this important moment Annibale was more indebted to North than to Central Italian models: the figure of St Catherine is borrowed from Veronese, the medallion on the throne from Correggio's throne in the *Virgin with St Francis* (Dresden), and the Child resting one foot on His Mother's foot from Raphael's *Madonna del Cardellino* (Louvre). These models were used almost undisguised, for everyone to see. At this juncture it may be asked whether such a picture is a sterile imitation, an 'eclectic' mosaic selected from acknowledged masterpieces. The reader hardly needs to be reminded that until fairly recently the term 'eclectic' was liberally employed to support the condemnation of post-Renaissance art in general and that of the Carracci in particular; nor has this designation disappeared from highly competent specialized studies.[7] If the term 'eclecticism' implies the following of not only one but more than one and even many masters, Annibale, like so many artists before and after him, availed himself of a traditional Renaissance method; a method advocated, for instance, by Leonardo as the proper road to a distinguished style. This procedure came into disrepute only with the adulation of the *naïveté* of genius in the Romantic era.[8] If 'eclecticism' is used, however, as a term to expose a lack of co-ordination and transformation of models – and in this sense it may justifiably be used – then it does not fit the case

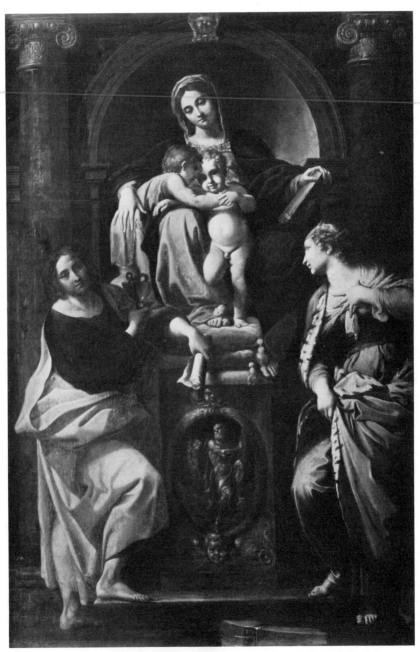

16. Annibale Carracci: The Virgin with St John and St Catherine, 1593. *Bologna, Pinacoteca*

under review; for, like every great artist, Annibale did create something entirely new from his models: he wedded Correggiesque *sfumato* and warm Venetian tone values to the severe compositional and figure conceptions of the Central Italian High Renaissance, while at the same time he gave his figures a sculptural quality and palpability which will be sought in vain during the High Renaissance, but which conform to the seventeenth-century feeling for mass and texture.

Some of the steps by which Annibale arrived at this important phase of his development may be retraced. The *Crucifixion* of 1583 (Bologna, S. Niccolò) illustrates his Mannerist beginnings. Two years later, in the *Baptism of Christ* (Bologna, S. Gregorio), the Correggiesque quality cannot be overlooked, although formally and colouristically Annibale is here still struggling against the older conventions. After that date he surrenders increasingly to Correggio's colour and emotional figure conceptions. This development may be followed from the Parma and Bridgewater House *Lamentations over the Body of Christ* (the latter destroyed) to the Dresden *Assumption of the Virgin* of 1587. From then on, Titian and Veronese begin to replace Correggio, with important consequences: Titian's dramatic colour contrasts replace the lighter Parmese tonality, and Venetian composure and gravity Correggio's impetuous sensibility. To assess this change, one need only compare the *Assumption* of 1592 (Bologna, Pinacoteca) with the earlier versions of the same subject. But already the Dresden *Virgin with St John, St Francis, and St Matthew* of 1588 was essentially Venetian, as the asymmetrical, Veronese-like composition immediately reveals. None the less Correggio's grace and charm pervade the picture, and it must be said at once that in spite of his reduced influence, the Correggiesque component remained noticeable even in Annibale's Roman years. The trend of his development is clear: the character of his late

Bolognese works continued to be pre-eminently Venetian right to his departure from Bologna; he moved away from Correggio towards solidity and clear definition of attitudes and expressions and towards an impressive structural firmness of the whole canvas.

His cousin Lodovico turned in a different direction. A study of his *Holy Family with St Francis* of 1591 (Cento, Museo Civico) [17] makes this abundantly evident. The basic conception of such a picture has little in common with Titian, as a comparison with the latter's *Pesaro Madonna* may show. The principal group recurs in both pictures: the Virgin on a high throne with St Joseph beneath and St Francis who recommends with a pleading gesture the donors in the right-hand corner. Yet how different is the interpretation! The mere bulk and weight of Lodovico's figures make his work different in essence from any Renaissance painting. Moreover, St Joseph and St Francis have exchanged places, with the result that, in contrast to Titian's work, the relation between the donors, St Francis, and the Virgin runs zigzag across the picture. Lodovico's figures are deeply engaged and their mute language of gestures and glances is profoundly felt – very different from Titian's reserve as well as from the cold correctness of the Mannerists. It is precisely this emphasis on gesture and glance that strikes a new note: St Francis's eyes meet those of the Virgin and emotions quiver; the mystery of Divine Grace has been humanized, and this is also implied in the spontaneity of the Child's reaction. All the registers are pulled to draw the beholder into the picture. He faces the Virgin, as does St Francis – indeed, he can imagine himself kneeling directly behind the saint; the close viewpoint helps to break down the barrier between real and painted space and, at the same time, the strong *sotto in su* ensures that the Virgin and Child, in spite of their nearness, remain in a world removed from that of the beholder. Titian, by contrast, has done every-

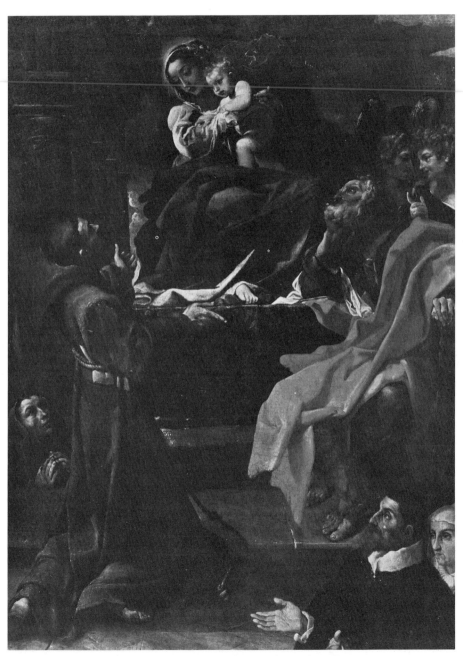

17. Lodovico Carracci: The Holy Family with St Francis, 1591. *Cento, Museo Civico*

thing to guarantee the inviolability of the picture plane and, compared with Lodovico's, his figures show the restraint and aloofness of a cult image.

Although for the sheer volume of the figures and the immediacy of their presence the two cousins form here in the early nineties what might be called a 'united Seicento front', the spirit informing Annibale's art is closer to that of the Renaissance masters than to Lodovico's, for Annibale lacks Lodovico's intense emotionalism. It is only to be expected that their approach to colour would also be fundamentally different. Annibale, conforming to the Renaissance tradition, used light and shade, even in his most painterly Bolognese works, primarily to stress form and structure. Lodovico, on the other hand, created patterns of light and dark often independent of the underlying organic form; and he even sacrificed clarity to this colouristic principle. One need only compare the right knee and leg of the Virgin in illustrations 16 and 17 to see how decisively Annibale's and Lodovico's ways part. It is evident that Lodovico owed much more than Annibale to the study of Tintoretto, in whose pictures one finds those brilliant and sudden highlights, that irrational flicker which conveys emotion and a sense of mystery. The basic quality of classic art, namely clear definition of space and form, meant very little to an artist steeped in this painterly tradition. It is characteristic of this approach that foreground stage and background scenery are often unrelated in Lodovico's pictures; in the Cento altarpiece [17] the colonnade looks like an added piece of stage property, and the acolyte behind St Francis emerges from an undefined cavity. Such procedure frequently makes the 'readability' of Lodovico's settings elusive.

For the sake of clarity, we may now define the difference between Annibale and Lodovico as that between the Classical and the Baroque, never forgetting of course that there is in their work that close affinity which we have noticed, and that I am, therefore, stretching the terms beyond their permissible limits. But with this proviso it may be said that Lodovico at the beginning of the nineties had evolved a painterly Baroque manner in contradistinction to Annibale's temperate classicism. Although pictures of such importance as the *Madonna dei Bargellini* of 1588 and the *Preaching of St John* of 1592 (both Pinacoteca, Bologna) are essentially Venetian with Correggiesque overtones – in the *St John* he followed Veronese for the composition and Tintoretto for the light – Lodovico's whole trend in these years is towards the colossal, the passionate, dramatic, and heroic, towards rich movement and surprising and capricious light effects; in a word, away from Venice and towards the style of Correggio's fresco in the dome of Parma Cathedral. The principal document of this tendency is the *Transfiguration* of 1593 (Bologna, Pinacoteca); pictures like the dramatic *Conversion of St Paul* of 1587-9, the *Flagellation* and *Crowning with Thorns* of 1594-5 (all three Bologna, Pinacoteca), even the ecstatic *St Hyacinth* of 1594 (Louvre), illustrate this Baroque taste. To a certain extent, therefore, Lodovico and Annibale after their common Mannerist beginnings developed in different directions.

With advancing age, however, and after the departure of his cousins from Bologna, Lodovico's work became by degrees retrogressive, and some of his late pictures show a return to patently Mannerist principles.[9] With some signal exceptions, there was at the same time a notable decline in the quality of his art. The better pictures of this period, like the *Meeting of St Angelus with St Dominic and St Francis,* the *Martyrdom of St Angelus,* and *St Raymond walking over the Sea* (all three 1608-10,[10] Bologna, Pinacoteca and S. Domenico), appeal by the depth of mystical surrender and by their linear and decorative grace; his failures show a studied,

superficial classicism, mask-like expressions, tired gestures, and a veneer of elegant sweetness.[11] Lodovico's sense for decorative patterns, his emotionalism, and above all his painterly Baroque approach to colour and light contained potentialities which were eagerly seized on by masters of the next generation, particularly by Lanfranco and Guercino; taken all in all his influence on the formation of the style of the younger Bolognese masters cannot be over-estimated. But it was mainly his earlier manner up to about 1600 which attracted them, while his less satisfactory later manner had often an irresistible appeal to minor masters who were directly or indirectly dependent on him, such as Francesco Brizio (1574-1643), Lorenzo Garbieri (1580-1654), and even Reni's pupil Francesco Gessi (1588-1649). It is then evident that Lodovico was not the man to lead painting back to classical poise and monumentality. Such qualities were, however, manifest in Annibale's work of the 1590s and were even implicit in his pictures of the 1580s. It was therefore more than mere chance that he, rather than Lodovico, accepted Cardinal Odoardo Farnese's invitation to come to Rome to paint monumental frescoes in his palace.

With Annibale's departure in 1595 the common studio broke up. Two years later Agostino followed him, leaving Lodovico alone in Bologna. During his ten active years in Rome, between 1595 and 1605, Annibale fulfilled the promise of his late Bolognese work: he became the creator of a grand manner, a dramatic style buttressed by a close study of nature, antiquity, Raphael, and Michelangelo. It was this style, equally admired by such antipodes as Poussin and Bernini, on which the future of 'official' painting depended for the next 150 years.

Annibale's first work in the Farnese Palace was the decoration with frescoes of a comparatively small room, the so-called Camerino Farnese, executed between 1595 and 1597,

before Agostino's arrival. On the ceiling and in the lunettes he painted scenes from the stories of Hercules and Ulysses, which have, in accordance with contemporary taste, not only a mythological but also an allegorical meaning: they illustrate the victory of virtue and effort over danger and temptation.[12] The decorative framework in which the stories are set is still dependent on North Italian models, in particular on the monochrome decorations in the nave of Parma Cathedral; but in the structure of the mythological scenes and in the treatment of individual figures the impact of Rome begins to be noticeable. It was fully developed in the Gallery of the same palace, the decoration of which began in 1597 and may not have been completely finished until 1608.[13]

The hall of about 60 by 20 feet has, above the projecting cornice, a coved vault which Annibale was asked to decorate with mythological love scenes chosen from Ovid's *Metamorphoses* [18]. It has been made probable that Cardinal Farnese's librarian, Fulvio Orsini, wrote the programme for the ceiling[14] and that in the final stages Annibale's learned friend, Monsignor Giovan Battista Agucchi, may have acted as adviser.[15] The theme is the power of all-conquering love, to which even the gods of antiquity succumb. In contrast to the emblematic character of most Mannerist cycles of frescoes the programme of this ceiling is centred on mythology, and Annibale painted the stories with such vigour and directness that the beholder is absorbed by the narrative and entertaining spectacle before his eyes rather than distracted by the less obvious symbolical and moralizing implications.[16] In this joyful and buoyant approach to classical antiquity a return will be noticed to the spirit of Raphael's *Cupid and Psyche* frescoes in the Farnesina.

It was precisely at the moment when Caravaggio began his career as a painter of monumental religious pictures that Annibale turned to

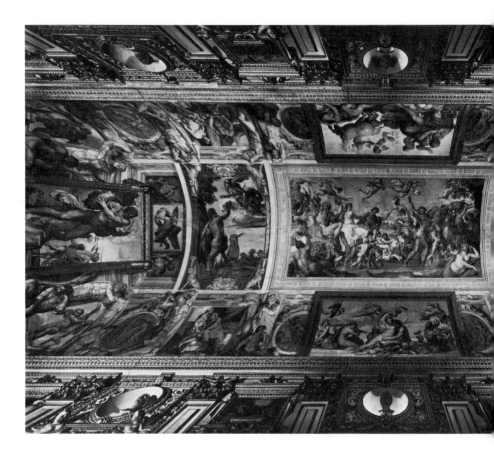

monumental mythologies on an unprecedented scale. And just as Caravaggio found a popular idiom for religious imagery, Annibale perfected his highly civilized manner to cater for the refined taste of an exclusive upper class. The very fact that his patron, a Prince of the Church and one, moreover, who bore that family name, surrounded himself with frescoes of this nature is indicative of a considerable relaxation of counter-reformatory morality. The frescoes convey the impression of a tremendous *joie de vivre*, a new blossoming of vitality and of an energy long repressed.

For the organization of the whole work Annibale experimented with a number of possibilities. He rejected simple friezes, suitable only for rooms with flat ceilings, a type of decoration used by him and his collaborators in the Palazzi Fava and Magnani-Salem at Bologna. Other Bolognese reminiscences,[17] however, were to have a more lasting influence, namely the Ulysses cycle in the Palazzo Poggi (now the University), where Pellegrino Tibaldi had combined pictures painted like easel-paintings with figures in the corners of the ceiling perspectively foreshortened for the view from below.

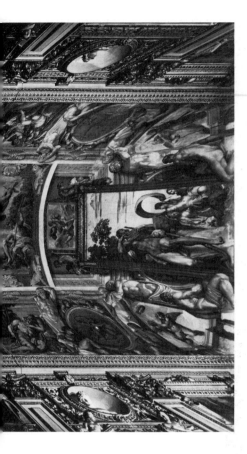

18. Annibale Carracci:
The Farnese Gallery, begun 1597. Frescoes.
Rome, Palazzo Farnese

This is a combination first found in Raphael's Logge in the Vatican,[18] which were, of course, well known to Annibale. Illusionist architectural painting *(quadratura)*, aimed at extending real architecture into an imaginary space, had existed ever since Peruzzi had 'opened up' the Sala delle Colonne in the Villa Farnesina about 1516, but it was not until the second half of the sixteenth century that *quadratura* on ceilings really came into its own. Bologna, *di scienze maestra* (Bellori), was the centre of this practice, which required an intimate knowledge of the theory of perspective. When the Bolo-gnese Pope Gregory XIII (1572–85) summoned Tommaso Laureti and Ottaviano Mascherino from Bologna to paint in the Vatican Palace, *quadratura* gained a firm foothold in Rome. It had its most resounding triumph in Giovanni and Cherubino Alberti's decoration of the Sala Clementina in the Vatican, executed between 1596 and 1598, that is exactly when Annibale began his Farnese ceiling.[19] *Quadratura* was then the last word in wall- and ceiling-painting, sanctioned, moreover, by the highest papal authority. Annibale, however, decided not to use pure *quadratura* but to follow the Palazzo

19. Annibale Carracci: Polyphemus.
Farnese Gallery [cf. 18]

Poggi type of 'mixed' decoration. Like Tibaldi, he painted the mythological scenes as *quadri riportati*, that is, as if they were framed easel pictures transferred to the ceiling, and incorporated them in a *quadratura* framework. His decision to use *quadri riportati* for the principal scenes was slmost certainly influenced by Michelangelo's Sistine ceiling, but he was doubtless also convinced that the mythological representation, as belonging to the highest class of painting,[20] should be rendered objectively and in isolating frames. Thus, although Annibale's ceiling is much more complex than Raphael's Logge or Tibaldi's Ulysses cycle, it remains in the same tradition of compromise solutions.

Annibale devised a *quadratura* framework consisting of a large cornice fully visible only in the four corners and supported all round the room by a carefully-thought-out system of herms and atlantes [19]. It is this whole framework, together with the sitting youths handling garlands, that is foreshortened for the viewpoint of the spectator. Since all this decoration is contrived as if it were real – the seated youths of flesh-and-blood colour, the herms and atlantes of simulated stucco, and the roundels of simulated bronze – the contrast to the painted pictures in their gilt frames is emphasized, and the break in consistency therefore strengthens rather than disrupts the unity of the entire ceiling. The crowding within a relatively small space of such great variety of illusionist painting, the overlapping and superimposition of many elements of the over-all plan, logical and crystal-clear and nowhere ambiguous as it would surely

20. Annibale Carracci: The Triumph of Bacchus
and Ariadne. *Farnese Gallery* [cf. 18]

be in a similar Mannerist decoration, the subtle build-up from the corners towards the centre – all this gives this work a dynamic quality quite different from the steady rhythm and comparative simplicity of Michelangelo's Sistine ceiling, to which Annibale evidently owed so many of his constituent ideas. There is here, moreover, for the first time a noticeable continuity leading on from the real architecture of the walls to the painted decorative figures of the ceiling, and this contributes perceptibly to the dynamic unity of the entire Gallery.

The centre of the ceiling is dominated by the largest and most elaborate composition in the scheme, the *Triumph of Bacchus and Ariadne* [20]. Surviving drawings show how closely Annibale had studied Bacchanalian sarcophagi; in fact, the train of revellers in the fresco has

retained something of the classical relief character, while individual figures can be closely paralleled by classical types. On the other hand, the fresco has a flowing and floating movement, a richness and exuberance which one would seek in vain either in antiquity or in the High Renaissance. The composition strikes a balance between firm classical structure and imaginative freedom; it consists of two crowded groups which rise gently from the centre of the two sides, and the caesura between them is bridged by a maenad and a satyr following the beat of the tambourine with an impetuous dance. The Bacchic retinue is compositionally enlivened and at the same time held together by the undulating rhythm of the flying cupids and by the telling *contrapposto* of the satyr and nymph below, reclining figures which have a framing as

well as a space-creating function. This richness of compositional devices heralds a new age. Each single figure retains a statuesque solidity unthinkable without a thorough study and understanding of classical sculpture, and Annibale imparted something of this sculptural quality to his many preparatory chalk drawings. Nevertheless these magnificent drawings remain at the same time close to nature, since, true to the traditions of the Carracci 'academy', every single figure was intensely studied from life. It is this new alliance between naturalism and classical models – so often in the past a life-giving formula in Italian art, but with what different results! – that accounts for the boisterous vitality of Annibale's Roman manner. His classical style, full-blooded and imaginative and buttressed by a loving study of nature, keeps the beholder at a certain distance, however, and he always remains conscious of a noble reserve. Clearly, Annibale's was a classical revival that contained many potentialities. From it a way led to Poussin's pronounced classicism as well as to the freedom of Rubens and the High Baroque. On the other hand, Annibale's combination of *quadratura* and the *quadro riportato* had only a limited following. The broad current of the Italian development turned towards a complete illusionist spatial unification.

During the execution of the Gallery, Annibale had the help of his rather pedantic brother Agostino for three years (1597–1600).[21] Contemporary sources attribute to him the two large frescoes of *Cephalus and Aurora* and the so-called *Galatea*,[22] and this is borne out by the cool detachment of these paintings, which lack the *brio* and energy of Annibale's manner. In 1600 Agostino fell out with his brother, left Rome, and went to Parma, where he decorated with mythological scenes a ceiling in the Palazzo del Giardino for the Duke Ranuccio Farnese.[23] Agostino's earlier manner may best be studied in his carefully constructed, strongly Venetian masterpiece, the *Communion of St Jerome*,

dating from the early 1590s (Bologna, Pinacoteca). His complete conversion to Annibale's Roman manner is evident in the Parma frescoes, which display a somewhat metallic and frozen classicism. His premature death in 1602 prevented the completion of this work.[24]

One other aspect of the Farnese ceiling should here be stressed. In his preparatory work Annibale re-established, after the Mannerist interlude, the method of Raphael and Michelangelo. Many hundreds of preparatory drawings must have existed, of which a fair number survive, and in these every single part of the ceiling was studied with the greatest care. Annibale handed down to his school this Renaissance method of slow and systematic preparation, and it is probably not too much to say that it was mainly through his agency that the method remained in vogue for the following 200 years. It broke down only in the Romantic era, when it was felt that such a tedious process of work hampered inspiration.

Annibale's development in Rome was rapid, and the few years left to him at the beginning of the new century were crowded with important works. Again, the fate and careers of Caravaggio and Annibale run strangely parallel. At about the time Caravaggio fled from Rome, never to return, Annibale retired from life stricken by a deep melancholia, and during his last years hardly touched a brush.[25] In his later canvases we can follow a progressive accretion of mass and sculptural qualities coupled with a growing economy in the compositions.[26] The *Assumption of the Virgin* of 1601 for the Cerasi Chapel in S. Maria del Popolo is a characteristic work of his fully developed Roman manner [21]. Here for the first and only time Annibale and Caravaggio worked on the same commission, and the visitor to the chapel naturally lets his eye wander from one master to the other. In such a comparison Annibale's *Assumption* may appear tame and even laboured, but it is worth observing that, just as in Caravaggio's *Conversion of St Paul*

21. Annibale Carracci:
The Assumption of the Virgin, 1601.
Rome, S. Maria del Popolo, Cerasi Chapel

[13] and his *Crucifixion of St Peter*, it is the over-powering bulk of Annibale's figures that domi-nates the canvas. In spite of this triumph of the massive sculptural figure, Annibale's *Assumption* shows that he never forgot the lesson learnt from Titian and Correggio. By fusing Venetian colour with Roman design, a painterly ap-proach with classical severity of form, Anni-bale demonstrated in practice – as was correctly seen in his own day[27] – that these old contrasts, about which so much ink had been spilt in theoretical discussions of the sixteenth century, were no longer irreconcilable.

In their measured and heroic expressions many of Annibale's late pictures, such as the London *Domine Quo Vadis*, the Naples *Pietà*, or the Paris *Lamentation*, are reminiscent of clas-sical tragedy. Contemporaries realized that Annibale was deeply concerned with the Aristo-telian problem (*Poetics*, 17) which, since Al-berti's days, had taken up a central position in any consideration of the highest class of painting, namely how to represent in an appropriate and forceful visual form the *affetti*, the emotions of the human soul. Annibale had neither the theo-retical mind of an Alberti nor the experimental passion of a Leonardo; he was, in fact, opposed to theorizing and a man of few words. But he sensed, as it were intuitively, the temper of the age, and in his concern for the telling use of gestures and expressions one has no difficulty in recognizing a new rationalist spirit of analysis. To base the rendering of the *affetti* on rational and generally valid findings became an import-ant preoccupation of seventeenth-century art-ists. Poussin learned his lesson from Annibale, and the same problems were later submitted to philosophical analysis by Descartes in his *Passions de l'Âme* of 1649.

A new sensibility characterizes the seven-teenth century, and this manifests itself not only in what may appear to us nowadays as the con-ventional language of rhetoric, but also in highly charged subjective expressions of feeling, grief and melancholy. The rational medium of design gives conventional gestures an objective quality, while the irrational medium of colour adds to conveying those intangible marks which are not readily translatable into descriptive language. The early Roman *Bacchus playing the Lute to Silenus* (London, National Gallery) exemplifies very well this important element in Annibale's *œuvre*. There is an atmosphere of melancholy pervading this little picture, and this is due to the wonderfully rich Titianesque evening sky casting a sombre mood over the wide deserted landscape behind the figures. Characteristically, this mood is transmitted through the landscape, and, as in Venice, landscape always plays an important part in Annibale's canvases as a foil

22. Annibale Carracci: The Flight into Egypt, *c.* 1604. *Rome, Galleria Doria-Pamphili*

against which to set off and underline a picture's prevailing spirit.[28] Considering this Venetian evaluation of the landscape element, it is not strange to find pure landscapes early in Annibale's career.

His first loosely constructed landscapes, peopled with huntsmen and fishermen (Louvre), are essentially Venetian. But in accordance with the general trend of his development and under the impression, it would seem, of the severe forms of the Campagna, Annibale in Rome replaced the freedom and rusticity of his early landscapes by carefully constructed landscape panoramas. The most celebrated example of this new landscape style is the lunette with a *Flight into Egypt* (Rome, Galleria Doria-Pamphili) [22], dating from about 1604.[29] An integral part of these panoramas is always the work of man – castles and houses, turrets and bridges, severely composed of horizontals and verticals and placed at conspicuous points in the landscape. The architectural motif in the centre of the Doria *Flight into Egypt* is framed by a cluster of large trees in the left foreground – such trees become *de rigueur* in this type of

landscape – and by the trees to the right in the middle distance; nor is the position of the Holy Family fortuitous: the group moves forward protected, as it were, by the firm lines of the castle above it and, in addition, it is placed at the meeting points of two spatial diagonals formed by the sheep and the river; thus figures and buildings are intimately blended with the carefully arranged pattern of the landscape. This is neither Nature untouched and wild where the role of man shrinks into insignificance – as in the landscapes of some contemporary northern artists working in Rome, above all Paul Brill and Jan Bruegel – nor is it on the other hand the fairy-lands which Elsheimer created in his Roman years; instead it is a heroic and aristocratic conception of Nature tamed and ennobled by the presence of man. It was Annibale's paintings of ideal landscapes that prepared the way for the landscapes of Domenichino and Albani, of Claude and Poussin.

Annibale's grand manner of the Roman years may rightly be regarded as his most important achievement, but the formal side of his art had an interesting counterpart of informality. Both

Annibale and Agostino had an intimate, genre-like idiom at their disposal. This, it seems, found expression more often in drawings than in pictures, although a number of genre paintings do exist and many more must have existed, judging from contemporary notices. A picture like the *Butcher's Shop* at Christ Church, Oxford, makes it evident that the Carracci at Bologna had come in contact with, and were deeply impressed by, northern genre painting in the manner of Pieter Aertsen.[30] Annibale's homely portrait sketch in oil of a smiling young man (Rome, Galleria Borghese) and, above all, the half-length of a *Man with a Monkey* looking for lice in his master's hair (Uffizi) [23] illustrate the trend with an admirable and entertaining candour. This last picture was probably painted

23. Annibale Carracci: Man with a Monkey, before 1595. *Florence, Uffizi*

two or three years before Caravaggio's *Bacchus* in the Uffizi [11]. Compared with it, Annibale's painting strikes one as 'impressionist' and progressive; it is, moreover, genre pure and simple.

It is clear from contemporary sources – in the first place from Malvasia, the biographer of Bolognese artists – that the two Carracci brothers regarded nothing as too insignificant or too uninteresting to be jotted down on paper on the spur of the moment. They were tireless draughtsmen and their curiosity was unlimited. They had an eye for the life and labours of the common people, for the amusing, queer, odd, and even obscene happenings of daily life, and something of this immediacy of approach will also be noticed in their grand manner. But with these two idioms, the official and the unofficial, at their command, a duality was possible which would have been unthinkable in the age of Raphael. By being able to work simultaneously on two levels, the Carracci reveal a dichotomy which from then on became more and more pronounced in the work of great artists and culminated in the dual activity or aspirations of a Hogarth or a Goya.

It is not at all astonishing that this mentality predestined the Carracci to become the originators of modern caricature: caricature, that is, in the pure sense, as a mocking criticism of other people's shortcomings. It is well attested that Annibale was the inventor of this new form of art.[31] The caricaturist substitutes a primitive, timeless technique for the established conventions of draughtsmanship, and an uninhibited personal interpretation for the objective rendering of reality which was the principal requirement of the Renaissance tradition. The artist who was acclaimed as the restorer of that tradition also forged dangerous weapons to undermine it.

CARAVAGGIO'S FOLLOWERS

AND THE CARRACCI SCHOOL IN ROME

Annibale Carracci alone had a school in Rome in the accepted sense of the term. Not only were he and the other members of his family good teachers, but his art, particularly his Roman manner, lent itself to being taught. The foundation of the school was, of course, laid in the Bolognese 'academy', and his young pupils and friends who followed him to Rome arrived there well prepared. Caravaggio on the other hand, a bohemian, turbulent and uncontrolled, never tried to train a pupil, nor indeed could he have done so since the subjective qualities of his style, his improvisations, his *ad hoc* technique, his particular mystique of light, and his many inner contradictions were not translatable into easy formulas. Yet, what he had brought into the world of vision was a directness, a power of immediate appeal that had an almost hypnotic fascination for painters, so that even Carracci pupils and followers fell under his spell at certain stages of their development. Moreover, generations of painters inside Italy and even more outside her confines sought inspiration from his work. Nevertheless when one contemplates the life and art of Caravaggio and of Annibale, the pattern of the development in Rome during the first quarter of the seventeenth century seems almost a foregone conclusion.

The Caravaggisti

Few of Caravaggio's followers actually met him in Rome, but most of them were deeply moved by his work while its impact was still fresh and forceful. The list of names is long and contains masters of real distinction. Among the older painters Orazio Gentileschi (1563–1639[1]) stands out. Next to him artists like Antiveduto Gramatica (1571–1626) and Giovanni Baglione (*c.* 1566–1643) are of only marginal interest. The most important younger artists were Orazio Borgianni (1578 or earlier–1616), Bartolomeo Manfredi (*c.* 1587–1620/1),[2] Carlo Saraceni (1579[3]–1620), Giovanni Battista Caracciolo (d. 1637), Giovanni Serodine (1600–30), and Artemisia Gentileschi (1593–*c.* 1652), apart from a host of northerners, among whom the Italo-Frenchman Valentin (1594–1632) should here be mentioned.[4]

These names make it at once apparent that Caravaggio's manner was taken up by painters with very different backgrounds, traditions, and training. Few among them were Romans; Gentileschi, for example, came from Pisa, Saraceni from Venice, Manfredi from near Mantua, and Serodine from Ascona. In contrast to the Bolognese followers of the Carracci who shared a common training and believed in similar principles, these artists never formed a homogeneous group. Caravaggio's idiom was a kind of ferment giving their art substance and direction for a time; but with most of them it was like a leaven not fully absorbed and which was to be discarded when they thought fit. In this respect Orazio Gentileschi's career is symptomatic. He was in Rome from 1576 on and came under Caravaggio's influence in the early years of the new century. But a typically Tuscan quality always remained noticeable in his work – so much so that his pictures are on occasions reminiscent of Bronzino and even of Sassoferrato: witness his clear and precise con-

tours, his light and cold blues, yellows, and violets as well as the restraint and simplicity of his compositions. Moreover, his lyrical and idyllic temperament is far removed from Caravaggio's almost barbaric vitality.

The chronology of Orazio's *œuvre* is not without problems, for dated pictures are few and far between. One of his chief works, the graceful *Annunciation* in Turin [24], painted for Charles

24. Orazio Gentileschi: The Annunciation, probably 1623. *Turin, Pinacoteca*

Emanuel I of Savoy, probably in 1623, clearly shows him developing away from Caravaggio, and the pictures painted after he settled in England in 1626 as Charles I's court painter carry this tendency still further. They are extremely light in colour, and the Florentine note supersedes his *Caravaggismo*. By contrast a work like the Dublin *David and Goliath* with its powerful movement, foreshortening, chiaro-

scuro, and its Caravaggesque types must have been created in Rome at an early period of his career.[5] Examples of Orazio's later manner may be seen in a picture such as the *Rest on the Flight into Egypt* (known in four versions in Birmingham; the J. Paul Getty Museum, Malibu, Cal.; Vienna; and the Louvre),[6] datable *c.* 1626, and in his principal work in England, the nine compartmental pictures for the hall of the Queen's House, Greenwich, probably executed after 1635, and now in a mutilated condition in Marlborough House.[7] The difference between the two latter works makes it evident that the longer he was away from Rome the thinner became the Caravaggesque veneer. It is undeniable that in the setting of the London Court, with its progressive tendencies represented by Rubens and Van Dyck, the work of Gentileschi appears almost outdated.[8]

The development of Orazio Gentileschi is characteristic of much of the history of the early *Caravaggisti*. But in the case of an artist such as Giovanni Baglione the emphasis is somewhat different. Baglione, nowadays chiefly known as the biographer of sixteenth- and early seventeenth-century Roman artists, belongs essentially to the late academic phase of Mannerism. An exact contemporary of Caravaggio's, he was that artist's bitter enemy. However, for a brief moment in his career, and even earlier than the rank and file of the *Caravaggisti*, he was overwhelmed by the impact, although never fully understanding the implications, of the great master's work. His *Sacred Love subduing Profane Love* (Berlin), painted after 1600 in competition with Caravaggio's *Earthly Love* for Cardinal Benedetto Giustiniani, is a hybrid creation where a Caravaggesque formula hardly conceals Late Mannerist rhetoric.[9]

The art of Orazio Borgianni, Carlo Saraceni, and Bartolomeo Manfredi represents very different facets of *Caravaggismo*. Borgianni, a Roman who grew up in Sicily and spent several years in Spain, returned permanently to Rome

in 1605,[10] where he painted a small number of great and impressive pictures. Their extraordinarily free handling and their warm and glowing colours are exceptional for an artist born in Rome. Some are reminiscent of the Bassani, in others there is a strong Tintorettesque note, others again, like the *Nativity of the Virgin* of *c.* 1613 (Savona, Santuario della Misericordia), seem to anticipate the Venetian work of Domenico Fetti. His best pictures, among which the *Virgin in Glory handing the Child to St Francis* of 1608 (Sezze Romano, Town Hall), the *St Charles Borromeo* of 1611–12 (S. Carlo alle Quattro Fontane) [25], and *St Charles attending the Plague-stricken* (*c.* 1613, formerly S. Adriano, now Chiesa della Casa Generalizia dei Padri Mercedari, Rome) may be mentioned, excel by a deep and mystical devotion which in its compassionate appeal differs from that of Caravaggio. What in fact Borgianni owed to Caravaggio was perhaps the strengthening of inherent realistic and chiaroscuro tendencies. Nevertheless before his pictures one feels compelled to believe that this highly talented artist, who, incidentally, was another personal enemy of Caravaggio's, would have developed as he did even without the great master's example before his eyes.

The art of Carlo Saraceni was to a large extent determined by his contact with the German Elsheimer, to whose close circle he belonged soon after his arrival in Rome, perhaps as early as 1598. Their pictures are sometimes so intimately related that the dividing line between them is not easily seen.[11] Elsheimer expressed his immensely poetical microcosmic view of the world in miniature format. Saraceni, although accepting the miniature style (and also the copper panel technique), toned down this Northern magic and invested his pictures with an almost Giorgionesque quality which revealed his Venetian upbringing. In his early Roman period there is, of course, an unbridgeable gulf between him and Caravaggio, as a

25. Orazio Borgianni:
St Charles Borromeo, 1611–12.
Rome, S. Carlo alle Quattro Fontane

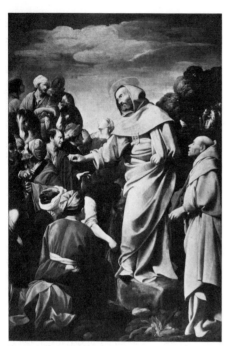

26. Carlo Saraceni:
St Raymond preaching, *c.* 1614.
*Rome, Chiesa della
Casa Generalizia dei Padri Mercedari*

comparison between the latter's *Rest on the
Flight into Egypt* with the former's similar work
of 1606 in Frascati[12] shows: Saraceni translated
Caravaggio's tense and mysterious scene into a
homely narrative enacted before a warm 'Elshei-
mer' landscape. One would, therefore, not
expect to find much of Caravaggio's spirit
during Saraceni's Caravaggesque period which
begins in the second decade, after Elsheimer's
death. Yet in these pictures the format as well
as his vision grows. One can follow this process
of monumentalization from the *St Raymond
preaching* (*c.* 1614, formerly S. Adriano, now
Chiesa della Casa Generalizia dei Mercedari)[13]
[26] to the *St Charles Borromeo and the Cross of*

the Holy Nail (*c.* 1615, S. Lorenzo in Lucina)
and the *Miracle of St Benno* and *Martyrdom of
St Lambertinus* (*c.* 1617–18, both S. Maria
dell'Anima). Saraceni, however, can never
compete with Caravaggio's dramatic Roman
manner; nor did he ever fully absorb the latter's
tenebroso. It remains true that even before these
monumental pictures one does not easily forget
that his real talent lay in the *petite manière*.[14] In
1620 Saraceni returned to Venice, where he
died the same year.

Manfredi's known work falls approximately
into the period 1610–20. He was one of the few
close imitators of Caravaggio and interpreted the
master in a rather rough style which later genera-
tions came to regard as characteristic of Caravag-
gio himself; for it was Manfredi possibly more
than anyone else who transformed Caravaggio's
manner into proper genre, emphasizing the
coarse aspects of the latter's art to the neglect of
his other qualities. Guard-room and tavern
scenes as well as religious subjects suffer this
metamorphosis. Valentin's choice of subjects is
similar to that of Manfredi, and indeed the two
artists have often been confused. The son of an
Italian, coming from France (Boulogne), Valen-
tin settled in Rome in about 1612. Most of his
known work seems to date from after 1620. His
pictures are not only infinitely more disciplined
than Manfredi's, but also exhibit an extensive
scale of differentiated emotions and passages of
real drama. Valentin carried on Caravaggio's
manner in Rome longer than almost any other
Caravaggista.[15]

Like Valentin, Serodine really belongs to a
younger generation, but both died so young
that they should be included among the first
generation of Caravaggio followers. Yet when
Serodine arrived in Rome in about 1615, Cara-
vaggio was little more than a legend. By far the
greatest colourist of the whole group, Serodine
can be followed in his rapid development from
the Caravaggesque *Calling of the Sons of Zebedee*
at Ascona (*c.* 1622), which combines remini-

scences of Caravaggio's *Madonna di Loreto* and of Borgianni's palette, to his masterpiece, the immensely touching *Almsgiving of St Lawrence* of the mid 1620s (Rome, Galleria Nazionale); thence to the freer *St Peter and St Paul* (Rome, Galleria Nazionale) and to the Edinburgh *Tribute Money*. The last-named picture, with its light background and its painterly handling recalling Bernardo Strozzi, prepares the way for the extraordinary *tour de force* of the *Portrait of his Father*,[16] painted in 1628 (Lugano, Museo Civico) [27], which is reminiscent of the mature works of Fetti and Lys. Still later is the *St Peter in Prison* (Rancate, Züst Collection) where he used Honthorst's candle-light but not his technique. The impasto calls to mind Rembrandt's advanced work, and the 'impressionist' freedom of the individual brush-stroke leads further away from Caravaggio than the work of any other of his followers in Rome. The rapidity of Serodine's development is equalled only by that of Caravaggio. The fact that it removed him from Caravaggio towards rich chromatic values ties him to the aspirations of a new age.

By about 1620 most of the *Caravaggisti* were either dead or had left Rome for good. Those who returned home quickly adjusted their styles to their native surroundings; some of them hardly reveal in their late work that they had ever had any contact with Caravaggio.[17] Not one of them had really understood the wholeness of his conception. They divested his realism of its irrational quality and his *tenebroso* of its mystique. They not only devitalized his manner, but as a rule they selected from his art only those elements which were congenial to their taste and ability. Some of them, like Gentileschi and to a certain extent Saraceni, were strongly attracted by Caravaggio's early Roman phase; others, like Manfredi and Valentin, who saw chiefly the plebeian side of his art, blended the genre subjects of his early Roman phase with the *tenebroso* of his later style. Soon after 1620 Caravaggism in Rome had lost its appeal. It

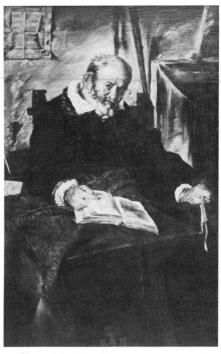

27. Giovanni Serodine: Portrait of his Father, 1628. *Lugano, Museo Civico*

remained successful only in the popular genre in cabinet format, the introduction of which was largely due to the Haarlem artist Pieter van Laer, who was in Rome from 1625 to 1639. His so-called *Bambocciate*[18] [28] survived as an undercurrent with a long history of their own.

In spite of the comparatively brief life of *Caravaggismo* in Rome and in spite of the toning down of the master's example, the diffusion of his style continued, either directly or indirectly, and by a variety of routes. Apart from Naples, where his work had a more lasting and invigorating effect than anywhere else in Italy, its penetration to Bologna and Siena, Genoa and Venice, and throughout Europe, is one of the most

28. Pieter van Laer(?):
The Brandy-Vendor, after 1625.
Rome, Galleria Nazionale

astonishing phenomena in the history of art. The names of Terbrugghen, Crabeth and Honthorst, Baburen, Pynas and Lastman, Jan Janssens, Gerard Seghers, Rombouts, and Vouet, most of them working in Rome at some time during the second decade of the century, indicate the extent of his influence; and we know now that neither Rubens, who had very early in his career experienced Caravaggio's direct influence in Rome, nor Rembrandt, Velasquez, and Vermeer, would have developed as they did without the Caravaggio blood-transfusion. But while elements of Caravaggism became a permanent feature of European painting, I must repeat that many of those who were responsible for its dissemination discarded it on their return to their home countries in favour of current styles. As an example, the Frenchman Vouet, after an intense early Caravaggesque phase, submitted entirely to an easy international Baro-

que style tempered by a classical note.[19] It is all the more remarkable that *Caravaggismo* did not begin to spread to any considerable extent until the third decade of the century, that is, at a moment when in Rome itself it was moribund or even dead.

The Bolognese in Rome and Early Baroque Classicism

I have already indicated that the Carracci school presents a picture vastly different from the *Caravaggisti*. A phalanx of young Bolognese artists, observing Annibale's success, chose to follow him to Rome; nor did events show that their assessment of the situation was incorrect. They had besides much to recommend themselves. First and foremost they were excellent artists. They had undergone a thorough training in the Carracci academy and had acquired a solid classical background even before they reached Rome. They were supported by Annibale's unrivalled authority and could rely on a circle of wealthy and powerful patrons. Moreover, they were all masters of the fresco technique and were, therefore, both able to assist Annibale in his own work and to execute monumental fresco commissions on their own account. In addition, during the short reign of Gregory XV (1621-3), who was himself born in Bologna, they were in undisputed command of the situation.

Guido Reni (1575-1642) and Francesco Albani (1578-1660) appeared in Rome shortly after April 1600, Lanfranco (1582-1647) and Domenichino (1581-1641) came soon after, and the much younger Guercino (1591-1666) arrived in 1621. Annibale used Domenichino for work in the Galleria Farnese,[20] and it was mainly Albani, assisted by the Parmese Lanfranco and Sisto Badalocchio, also from Parma, who carried out from Annibale's designs most of the frescoes in the S. Diego Chapel in S. Giacomo degli Spagnuoli between 1602 and

1607.[21] At the same time Innocenzo Tacconi,[22] another Bolognese of the second rank, executed the frescoes on the vault of the Cerasi Chapel in S. Maria del Popolo, for which Annibale painted the *Assumption of the Virgin.*

In the succeeding years these Bolognese artists firmly established a style in Rome which by and large shows a strengthening of the rationalist and classical tendencies inherent in the Farnese ceiling. With the exception of Domenichino and Lanfranco, however, the time spent in Rome by these artists was neither consecutive nor protracted. Domenichino stayed for a period of almost thirty years, though he returned to Bologna between 1617 and 1621, and Lanfranco, who was once absent from Rome between 1610 and 1612, left for Naples only in 1633-4. On the other hand Reni, after visits to Rome between 1600 and 1604 and again from 1607 to 1611 and from 1612[23] to 1614, made Bologna his permanent home, remaining there except for a few relatively brief intermissions until his death in 1642. Albani did not leave Rome until mid 1617,[24] to return only for short periods of time; and Guercino's years in the Holy City were confined to the reign of Gregory XV, from 1621 to 1623.

From about 1606 onwards these masters were responsible for a series of large and important cycles of frescoes. Their activity in this field is an impressive testimony to their rapidly rising star. A feeling for the situation is best conveyed by listing in chronological sequence the major cycles executed by the whole group during the crucial twelve years 1606-18.

1606-7: Palazzo Mattei di Giove, Rome. Three rooms with ceiling frescoes in the south-west sector of the *piano nobile*, by Albani: *Isaac blessing Jacob, Jacob and Rachel*, and *Jacob's Dream.*[25]

1608: Sala delle Nozze Aldobrandini, Vatican. Reni's *Stories of Samson* (repainted).[26]

1608: Sala delle Dame, Vatican. Reni's *Trans-figuration, Ascension of Christ*, and *Pentecost* on the vault of the room.

1608: Oratory of St Andrew, S. Gregorio Magno, Rome. The large frescoes of *St Andrew adoring the Cross* by Reni and the *Scourging of St Andrew* by Domenichino, commissioned by Cardinal Scipione Borghese.

1608-9: S. Silvia Chapel, S. Gregorio Magno, Rome. The apse decorated by Reni with *God the Father and Angels.*

1608-10: Abbey of Grottaferrata. Chapel decorated by Domenichino with scenes from the *Legends of St Nilus and St Bartholomew.* The commission was due to Cardinal Odoardo Farnese on Annibale's recommendation.

1609: Palazzo Giustiniani (now Odescalchi), Bassano (di Sutri) Romano. The ceiling of a small room painted by Domenichino with stories of the myth of Diana, in the manner of the Farnese Gallery. The frescoes of the large hall by Albani. On the ceiling of the hall Albani represented the *Fall of Phaeton* and the *Council of the Gods*, the latter placed in tight groups round the edges of the vault – the whole an unsuccessful attempt at illusionistic unification. Along the walls there are eight scenes illustrating the consequences of the *Fall.* The patron was the Marchese Vincenzo Giustiniani.[27]

1609-11: Chapel of the Annunciation, Quirinal Palace. The whole decorated by Reni and his Bolognese assistants, see p. 33.

1610, 1612; Cappella Paolina, S. Maria Maggiore. Reni is responsible mainly for single figures of saints.

1612-14: Choir, S. Maria della Pace. Albani completes the mariological programme begun in the sixteenth century.

1613-14: Casino dell'Aurora, Palazzo Rospigliosi, Rome. The *Aurora* ceiling painted by Reni for Cardinal Scipione Borghese [32].

1613-14: S. Luigi de'Francesi, Rome. Domenichino's scenes from the *Life of St Cecilia* [29].[28]

1615: Palazzo Mattei di Giove, Rome. Lanfranco *(Joseph interpreting Dreams* and *Joseph and Potiphar's Wife)*.[29] These frescoes are inspired by Raphael's Logge.

c. 1615 and later: Palazzo Costaguti, Rome. Domenichino: *The Chariot of Apollo* in the centre of the ceiling of the large hall, set in a Tassi *quadratura*.[30] Lanfranco: the ceiling with *Polyphemus and Galatea* (destroyed, replica in the Doria Gallery); the ceiling with *Justice and Peace* probably 1624[31] (*quadratura* by Tassi?); the third ceiling with *Nessus and Deianeira*, previously given to Lanfranco, is now attributed to Sisto Badalocchio.[32] The ceiling with Guercino's *Armida carrying off Rinaldo*, once again in a Tassi *quadratura*, was painted between 1621 and 1623. Mola's and Romanelli's frescoes belong to a later phase.

1616: S. Agostino, Rome. Lanfranco's decoration of the Chapel of St Augustine.[33]

c. 1616: Palazzo Verospi (now Credito Italiano), Corso, Rome. Albani: ceiling of the hall with *Apollo and the Seasons*. The artist's Carraccesque style has become more decidedly Raphaelesque, and reliance on the *Cupid and Psyche* cycle in the Farnesina is evident.[34]

1616–17: Sala de' Corazzieri, Quirinal Palace. For Lanfranco's contribution to the frieze of this large hall, see p. 33.

1616–18: Stanza di Apollo, Villa Belvedere (Aldobrandini), Frascati. Eight frescoes with scenes of the myth of Apollo, painted by Domenichino and pupils at the instance of Monsignor Agucchi for Cardinal Pietro Aldobrandini (now National Gallery, London).[35]

All these frescoes are closely connected by characteristics of style. Not only are most of the ceiling decorations painted as *quadri riportati*, but they are also more severely classical than the Farnese Gallery. Annibale's rich and complex framework, reminiscent of Mannerist decor-

ation, was dropped and, at the most classical moment between 1613 and 1615, the *quadro riportato* appears isolated on the flat centre of the vault. Thus, Guido's *Aurora* was framed with stuccoes, leaving the surrounding area entirely white. The principle was perhaps followed in the Palazzo Mattei and certainly in the *Rape of Dejanira* ceiling in the Palazzo Costaguti, probably the only room which survives undisturbed from the period around 1615. These examples are evidence that in the second decade of the century the Bolognese artists were inclining towards an extreme form of classicism. It is, of course, Domenichino in whose work this development is most obvious, and it typifies the general trend that his St Cecilia frescoes of 1613–14 are far more rigidly classical than his previous work.

Corresponding to the requirements of decorum, his *Scourging of St Andrew* of 1608 takes place on a Roman piazza; the carefully prepared stage is closed by the wall and columns of a temple placed parallel to the picture plane, and its rigidity contrasts with the somewhat freer arrangement of the ancient city and landscape in the left background. In order to safeguard the foreground scene against visual interference from the crowd assembled under the temple portico, Domenichino introduced an unusual device; disregarding the laws of Renaissance perspective, he made these figures unduly small, much smaller than they ought to be where they stand. The principal actors are divided into two carefully composed groups, the one surrounding the figure of the saint, the other consisting of the astonished and frightened spectators. Firmly constructed though these groups are, there is a certain looseness in the composition and, particularly in the onlookers, a distinct lack of definition. In the St Cecilia frescoes the depth of the stage has shrunk and the scenes are closed [29]. The figures have grown in size and importance; each is clearly individualized and expresses its mood by studied gestures. Many

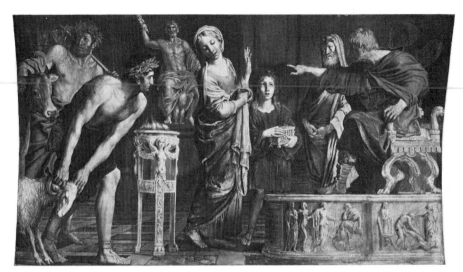

29. Domenichino:
St Cecilia before the Judge, 1613–14. Fresco.
Rome, S. Luigi de' Francesi

figures are directly derived from classical statues, archaeological elements are more conscientiously introduced, and the spirit of Raphael permeates the work to an even greater extent.[36] But at the same time Domenichino has seen all this through the eyes of Annibale.

At this moment Domenichino was probably acknowledged as the leading artist in Rome, and the circle of his friend Agucchi must have regarded the St Cecilia frescoes as the apogee of painting. One would have expected Domenichino to pursue the same course which accorded so well with Agucchi's and his own theoretical position.[37] History, however, is never logical and so, after his performance in S. Luigi de' Francesi, we find Domenichino beginning to turn in a different direction. In his most important commission of the next decade, the choir and pendentives of S. Andrea della Valle (1622, not 1624,–8),[38] this arch-classicist seemed to be tempted by the new Baroque trend. This is clearly visible in the Evangelists on the

pendentives, where a strong Correggiesque note is added to the reminiscences of Raphael and Michelangelo. It may be supposed that Domenichino wished to outshine his rival Lanfranco, who to the former's anguish was given the commission for the dome. A development towards the Baroque will also be noticed in the celebrated scenes from the life of St Andrew in the apse of the church (*c.* 1623–6). While the single incidents are still strictly separated by ornamented ribs, the stage is widened and on it the figures move in greater depth than formerly, some of them in beautiful co-ordination with the rich landscape setting. In addition, borrowings from Lodovico Carracci make their appearance,[39] another indication of Domenichino's drifting away from the orthodox classicism of ten years before.

In 1631 Domenichino left Rome for Naples,[39a] where he was under contract to execute the pendentives and dome of the Chapel of S. Gennaro in the cathedral. Here he built on the

tendencies already apparent in the pendentives of S. Andrea and amplified them to such an extent that these frescoes appear as an almost complete break with his earlier manner. He filled the spherical spaces to their extremities with a mass of turgid, gesticulating figures which at the same time seem to have become petrified. The principal interest of these paintings lies in their counter-reformatory content, which Émile Mâle has recounted; but it cannot be denied that Domenichino's powers, measured by the standard of his most perfect and harmonious achievements, were on the decline.[40] Nor was his attempt to catch up with the spirit of a new age successful. The hostility he met with in the course of executing his work in Naples and which may have contributed to his failure is well known; however, after his dramatic flight north in 1634 he returned once more to Naples, but left the work in the chapel unfinished at his death in 1641.

Domenichino's reputation has always remained high with the adherents of the classical doctrine, and during the eighteenth century he is often classed second only to Raphael. But this reputation was not based only on his work as a fresco-painter. Oil-paintings such as the Vatican *Last Communion of St Jerome* of 1614 or the Borghese *Hunt of Diana*[41] of 1617, done for Cardinal Pietro Aldobrandini but acquired by force by Scipione Borghese, reveal him as a more refined colourist than his frescoes would lead one to expect. These two works, painted during his best period, show the breadth of his range. The *St Jerome*, more carefully organized and more boldly accentuated than his model, Agostino Carracci's masterpiece, has never failed to carry conviction by its sincerity and depth of religious feeling.[42] Coming from Domenichino's frescoes, one may note with surprise the idyllic mood in the *Diana*, but that he was capable of it is attested by a number of pure landscapes which he painted.[43] These, and particularly the later ones, show a relaxing of

Annibale's more severe approach. By allying the pastoral and the grand, Domenichino created a landscape style which was to have an important influence on the early work of Claude.

The art of Albani follows a more limited course. Like Domenichino he had started as a pupil in Calvaert's school[44] and later removed to the Carracci. At first vacillating between dependence on Lodovico (e.g. *Repentance of St Peter*, Oratorio S. Colombano, Bologna, 1598) and on Annibale (*Virgin and Saints*, Bologna, Pinacoteca, 1599), his early work already shows a somewhat slight and lyrical quality which later on was to become the keynote of his manner. It is therefore not at all surprising that in Rome he was particularly captivated by Raphael (Palazzo Verospi frescoes) without abandoning, however, his connexion with Lodovico, as one of his ceilings in the Palazzo Mattei shows.[45] Although he worked for Reni in the chapel of the Quirinal Palace, he remained in these years essentially devoted to Domenichino's type of classicism, but lacked the latter's precision and unfailing sense of style. Even before returning

30. Francesco Albani:
Earth, one of a series of The Four Elements,
1626–8. *Turin, Pinacoteca*

to Bologna his special gift led him towards light-hearted and appealing representations of myth and allegory in landscape settings[46] of the sort that is perhaps best exemplified by the *Four Elements* in Turin, painted in 1626-8 [30]. In his later years Albani became involved in theoretical speculations of a strictly classical character. Although he had a relatively strong moment in the early 1630s (*Annunciation*, S. Bartolommeo, Bologna, 1633), during the last period his large canvases, many of which have little more than a provincial interest, often combine influences from Reni with an empty and boring symmetry of arrangement.

Guido Reni was an infinitely more subtle colourist than Domenichino. In retrospect it would appear that his vision and range far surpassed those of his Bolognese contemporaries. His fame was obscured by the large mass of standardized sentimental pictures coming from his studio during the last ten years of his life, the majority the product of assistants. It is only fairly recently, and particularly through the Reni Exhibition of 1954, that the high qualities of his original work have revealed him once again as one of the greatest figures of Seicento painting.

Guido was less dependent on Annibale than the other Bolognese artists, and from the beginning of his stay in Rome he received commissions of his own. Between 1604 and 1605 he painted the *Crucifixion of St Peter* (Vatican) in Caravaggio's manner. That even Reni, despite having gone through Lodovico's school at Bologna, would for a while be drawn into the powerful orbit of Caravaggio[47] might almost have been foreseen; but although the picture shows an extraordinary understanding of his dramatic realism and lighting - and that at a time before the *Caravaggisti* had come into their own - the basis of Reni's art was classical and his approach to painting far removed from Caravaggio's. The picture is composed in the form of the traditional classical pyramid and firmly woven into

balance by contrappostal attitudes and gestures. Moreover, Reni's essential unconcern for primary requirements is exposed by the irrational behaviour of the executioners: they seem to act automatically without concentration on their task.

Reni's first great fresco, the *St Andrew led to Martyrdom*, is in telling contrast to the static quality of Domenichino's fresco on the wall opposite. The figure of the saint, forming part of a procession from left to right which moves in an arch curving towards the front of the picture, is caught in a moment of time as he adores the Cross visible on the far-away hill. There is, however, a lack of dramatic concentration and a diffusion in the composition which, while allowing the eye to rest with pleasure on certain passages of superb painting, distracts from the story itself. How lucidly organized, by contrast, is the Domenichino! And yet one has only to compare the figure of the henchman seen from the back in both frescoes to realize Reni's superior pictorial handling. The classicism of Reni is in fact far freer and more imaginative than that of Domenichino. In addition, Guido was capable of adjusting his style to suit the subject-matter instead of conforming to a rigid pattern. This may be indicated by mentioning some works created during the same important years of his life.

In the *Music-making Angels* of the S. Silvia Chapel in S. Gregorio Magno, and still more in the denser crowds of angels in the dome of the Quirinal Chapel, Reni has rendered the intangible beauty and golden light which belong to the nature of angels. A few years later he painted the dramatic *Massacre of the Innocents* (Bologna, Pinacoteca).[48] Violence, of which one would have thought the artist incapable, is rampant. But the spirit of Raphael and of the ancient Niobids combine to purge this subtly constructed canvas of any impression of real horror. In the *Samson* (Bologna, Pinacoteca) [31][49] he mitigated the melancholy aftermath of the

bloodthirsty scene by the extraordinary figure of the hero, standing alone in the twilit landscape in a pose vaguely reminiscent of Mannerist figures, as if moving to the muffled sound of music, with no weight to his body. Triumph and desolation are simultaneously conveyed by the contrast of the brilliant warm-golden hue of the elegant nude and the cold tones of the corpses huddled on the field. The monumental *Papal Portrait*, probably painted a decade later,[50] now at Corsham Court, is a serious interpretation of character in the Raphael tradition, showing a depth of psychological penetration which is surprising after a picture like the *Massacre*, where the expressions of all the faces are variations on the same theme. Finally, Reni transmutes in the *Aurora* [32][51] a statuesque ideal of bodily perfection and beauty by the alchemy of his glowing and transparent light effects, weld-

31 *(top)*. Guido Reni: The Triumph of Samson, *c.* 1620. *Bologna, Pinacoteca*

32 *(above)*. Guido Reni: Aurora, 1613–14. Fresco. *Rome, Palazzo Rospigliosi, Casino dell' Aurora*

ing figures adapted from classical and Renaissance art into a graceful and flowing conception.

As early as 1610 it seemed that Reni would emerge as the leading artist in Rome. The road to supreme eminence was open to him, not least because of his favoured position in the household of Cardinal Scipione Borghese, through whose good offices he had been given the lion's share of recent papal commissions. But he

himself buried these hopes when in 1614 he decided to return to Bologna, leaving Domenichino in command of the situation. The change of domicile had repercussions on his style rather than on his productivity. One masterpiece followed the other in quick succession. Among them are the great *Madonna della Pietà* of 1616 (Bologna, Pinacoteca), which with its peculiar symmetrical and hieratic composition could never have been painted in Rome, and the *Assumption* in S. Ambrogio, Genoa, begun in the same year, in which evident reminiscences of Lodovico and Annibale have been overlaid with a more vivid Venetian looseness and *bravura* [33]. This rich and varied phase of Reni's activity reaches its conclusion with the

33. Guido Reni: The Assumption of the Virgin, 1616–17. *Genoa, S. Ambrogio*

Atalanta and Hippomenes (Prado) of the early 1620s. The eurhythmic composition, the concentration on graceful line, and the peculiar balance between naturalism and classicizing idealization of the figures, all reveal this work as an epitome of Reni's art. He has discarded his warm palette, and the irrational lighting of the picture is worked out in cool colours. The remaining years of his Bolognese activity, during which he developed this new colour scheme together with a thorough readjustment of general principles, belong to another chapter.

Reni's influence, particularly in his later years, was strongest in Bologna, from where it spread. Lanfranco, on the other hand, after having been overshadowed by Domenichino during the first two decades of the century, eventually gained in stature at the expense of his rival, and in the twenties secured his position as the foremost painter in Rome. Born at Parma in 1582, he first worked there, together with Sisto Badalocchio, under Agostino Carracci, and it was after Agostino's death in 1602 that both artists joined Annibale in the Eternal City. From the beginning Lanfranco was the antipode of Domenichino. Their enmity was surely the result of their artistic incompatibility; for Lanfranco, coming from Correggio's town, had adopted a characteristically Parmese palette and always advocated a painterly freedom in contrast to Domenichino's rigid technique. In fact the old antithesis between colour and design, which for a moment Annibale had resolved, was here resurrected once again.

In his early Roman years we find Lanfranco engaged on all the more important cycles of frescoes by the Bolognese group, often, however, in a minor capacity. Beginning perhaps as Annibale's assistant in the Farnese Gallery, he had a share in the frescoes in the S. Diego Chapel, in S. Gregorio Magno, the Quirinal Palace, and even in the Cappella Paolina in S. Maria Maggiore. Of the first cycle painted by Lanfranco on his own in about 1605 in the

Camera degli Eremiti of the Palazzo Farnese, three paintings detached from the wall survive in the neighbouring church of S. Maria della Morte.[52] This work shows him already following a comparatively free painterly course, remarkably untouched by the gravity of Annibale's Roman manner. But it was his stay from the end of 1610 to 1612 in his home-town Parma that brought inherent tendencies to sudden maturity. Probably through contact with the late style of Bartolommeo Schedoni[53] he developed towards a monumental and dynamic Baroque manner with strong chiaroscuro tendencies. It was the renewed experience of the original Correggio and of Correggio seen through Schedoni's Seicento eyes that turned Lanfranco into the champion of the rising High Baroque

34. Giovanni Lanfranco: The Gods of Olympus (repainted) and Personifications of Rivers, 1624–5. Detail of ceiling fresco. *Rome, Villa Borghese*

style. The change may be observed in the Piacenza *St Luke* of 1611. It appears there that Caravaggio's monumental Roman style helped to usher in Lanfranco's new manner. *St Luke* combines motifs from Caravaggio's two *St Matthews* for the altar of the Contarelli Chapel; a graceful angel in Lodovico's manner is added, and the whole is bathed in Lanfranco's new Parmese tonality. After his return to Rome he gradually discarded the traditional vocabulary, and in a daring composition such as the Vienna *Virgin with St James and St Anthony Abbot* of about 1615–20[54] his new idiom appears fully developed.

Lanfranco's ascendancy over Domenichino began with the frescoes in S. Agostino (1616) and was sealed with the huge ceiling fresco in the Villa Borghese of 1624–5 [34].[55] An enormous illusionist cornice is carried by flamboyant stone-coloured caryatids between which is seen the open sky. This framework, grandiose and at

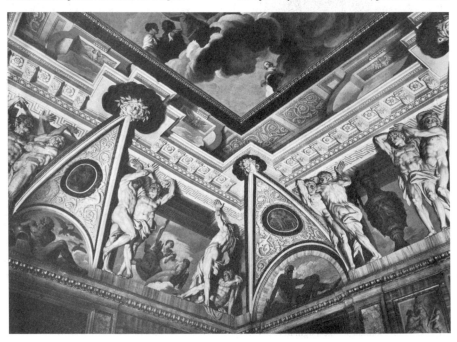

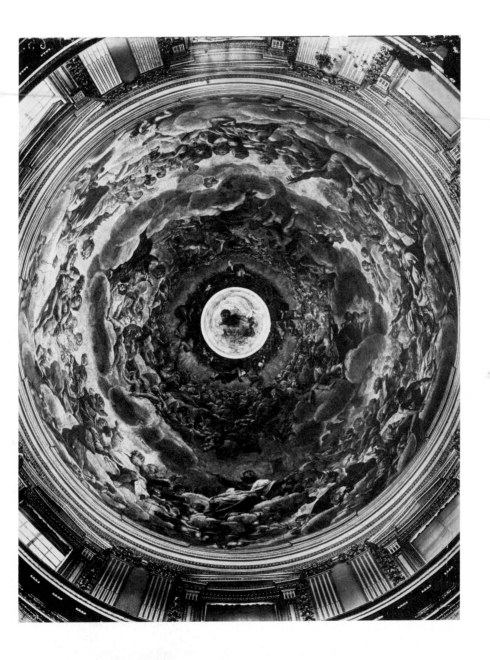

35. Giovanni Lanfranco: The Virgin in Glory, 1625-7. Fresco. *Rome, S. Andrea della Valle, dome*

the same time easy, reveals a decorative talent of the highest order. But although there is a Baroque loosening here, the dependence on the Farnese ceiling cannot be overlooked: the *quadratura* yields on the ceiling to the large *quadro riportato* depicting the Gods of Olympus. Compared with the Farnese Gallery, the simplification and concentration on a few great accents are as striking as the shift of visual import from the *quadro riportato* to the light and airy *quadratura* with the accessory scenes. Traditional *quadratura* of the type practised by Tassi was reserved for architecture only. By making use of the figures as an inherent part of his scheme Lanfranco revealed a more playful and fantastic inventiveness than his predecessors, excellently suited to the villa of the eminent patron who required light-hearted grandeur.

The next important step in Lanfranco's career, the painting of the dome of S. Andrea della Valle, 1625–7,[56] opens up a new phase of Baroque painting [35]. Correggiesque illusionism of the grandest scale was here introduced into Roman church decoration, and it was this that spelt the real end to the predominance of the classicism of the second decade.

A similar step had been taken a few years before by Guercino in the decoration of palaces. One should not forget that this artist belonged to a slightly younger generation; thus already in his earliest known work, carried out in his birthplace, Cento, he reveals a breaking away from the Carraccesque figure conception. Although these frescoes of 1614 in the Casa Provenzale are derived from those by the Carracci in the Palazzo Fava, Bologna, they contrast with their model in their flickering effect of light which goes a long way to dissolve cubic form. These atmospheric qualities, which to a certain extent Guercino shared with Lanfranco, were developed more fully during the next ten years. Between 1616 and his visit to Rome in 1621 Guercino painted a series of powerful altarpieces which entitle him to rank among the first artists

of his time. His *Virgin with Saints* of 1616 (Brussels Museum), the *Martyrdom of St Peter* of 1618 (Modena), the *Prodigal Son* of 1618–19 (Vienna), and the Louvre *St Francis and St Benedict*, the *Elijah fed by Ravens* (London, Mahon Collection), and particularly the *St William receiving the Habit* (Bologna, Pinacoteca), all of 1620, show a progression towards Baroque movement, the merging of figures with their surroundings, form-dissolving light effects, and glowing and warm colours. In addition, *contrapposto* attitudes become increasingly forceful, and there is an intensity of expression which is often carried far beyond the capacity of Lodovico, for whose early style Guercino felt the greatest admiration.[57]

When Guercino appeared in Rome in 1621, it seemed a foregone conclusion that his pictorial, rather violently Baroque manner would create a deep impression and hasten a change which the prevailing classical taste would be incapable of resisting. Between 1621 and 1623 he executed, above all, the frescoes in the Casino Ludovisi for the *Cardinale nipote* of Gregory XV [36]. The boldly foreshortened *Aurora* charging through the sky which opens above Tassi's *quadratura* architecture is the very antithesis of Guido's fresco in the Casino Rospigliosi. At either end the figures of *Day* and *Night*, emotional and personal interpretations with something of the quality of cabinet painting, foster the mood evoked by the coming of light. There is here an extraordinary freedom of handling, almost sketch-like in effect, which forms a deliberate contrast to the hard lines of the architecture and must at the time have appeared as a reversal of the traditional solidity of the fresco technique. This work, however, which might have assured Guercino a permanent place in the front rank of Roman painters, had for the artist an unexpected consequence. Under the influence of the Roman atmosphere, which was charged with personal and theoretical complexities, his confidence began to ebb.

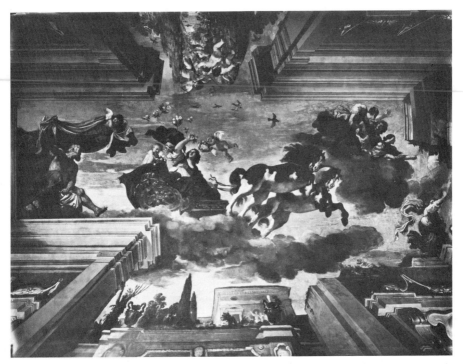

36. Guercino: Aurora, 1621-3. Fresco.
Rome, Casino Ludovisi

Already in the great *Burial and Reception into Heaven of St Petronilla* of 1622-3 (Rome, Capitoline Museum) there is a faint beginning of an abandonment of Baroque tendencies. The figures are less vigorous and more distinctly defined, the rich palette is toned down, and the composition itself is more classically balanced than in the pre-Roman works.[58] It is a curious historical paradox that Guercino who, it is not too much to say, sowed the seeds in Rome of the great High Baroque decorations, should at this precise moment have begun to turn towards a more easily appreciated classicism. But in the very picture where this is first manifest, the idea of lowering the body of the saint into the open sepulchre in which the beholder seems to stand has a directness of appeal unthinkable without the experience of Caravaggio.[59] Thus a painterly Baroque style, an echo of Caravaggio, and a foretaste of Baroque-Classicism combine at this crucial phase of Guercino's career. The aftermath, in the painter's home-town, Cento, must be mentioned later on and in a different context.

PAINTING OUTSIDE ROME

The Italian city-states and provincial centres looked back to an old tradition of local schools of painting. These schools lived on into the seventeenth century, preserving some of their native characteristics. In contrast to the previous two centuries, however, their importance was slight compared with Rome's dominating position. It is true they produced painters of considerable distinction, but it was only in Rome that these masters could rise to the level of metropolitan artists. It seems a safe guess that the Bolognese who followed Annibale Carracci to Rome would have remained provincial if they had stayed at home.

Before discussing the contributions of the local schools, the leading trends may once again (see p. 27) be surveyed. About 1600, Italian painters could draw inspiration from, and fall back upon, three principal manners. First, the different facets of Venetian and North Italian colourism: the warm, glowing and light palette of Veronese, the loaded brush-stroke of the late Titian, Tintoretto's dramatic flickering chiaroscuro, and Correggio's *sfumato*. Venetian 'impressionist' technique was surely the most important factor in bringing about the new Baroque painting. Its influence is invariably a sign of progressive tendencies, and it is hardly necessary to point out that European painting remained permanently indebted to Venice, down to the French Impressionists. Secondly, there was the anti-painterly style of the Florentine Late Mannerists, a style of easy routine, sapped of vitality, which remained nevertheless in vogue far into the seventeenth century. But this style contained no promise for the future. Florence, which for more than a hundred years had produced or educated the most progressive

painters in Europe, became a stagnant backwater. Wherever Florentines or Florentine-influenced artists worked at the beginning of the seventeenth century, it spelled a hindrance to a free development of painting.[1] Thirdly, Barocci (1528 or later–1612),[2] whose place is in a history of sixteenth-century painting, has to be mentioned. All that can be said of him here is that he always adhered to the ideal of North Italian colour and fused an emotionalized interpretation of Correggio with Mannerist figures and Mannerist compositions. Whenever artists at the turn of the century tried to exchange rational Late Mannerist design for irrational Baroque colour, Barocci's imposing work was one of the chief sources to which they turned. Among his direct followers in the Marches the names of Andrea Lilli (1555–1610),[3] Alessandro Vitale (1580–1660), and Antonio Viviani (1560–1620) may be noted. His influence spread to the Emilian masters, to Rome, Florence, Milan, and above all to Siena, where Ventura Salimbeni (c. 1567–1630) and Francesco Vanni (1563–1610)[4] adopted his manner at certain phases of their careers.

As the century advanced beyond the first decade three more trends became prominent, the impact of which was to be felt sooner or later throughout Italy and across her frontiers, namely the classicism of Annibale Carracci's school, Caravaggism, and Rubens's northern Baroque, the last resulting mainly from the wedding of Flemish realism and Venetian colourism. This marriage, accomplished by a great genius, was extraordinarily fertile and had a lasting influence above all in northern Italy.

At the end of the sixteenth and the beginning of the seventeenth centuries provincial painters

could not yet have recourse to the new trends which were then in the making. But provincial centres were in a state of ferment. Everywhere in Italy artists were seeking a new approach to painting. This situation is not only cognate to Barocci's Urbino, Cerano's and Procaccini's Milan, Bernardo Strozzi's Genoa, Bonone's Ferrara, and Schedoni's Modena, but even to Cigoli's Florence, and may be characterized as an attempt to break away from Mannerist conventions. On all sides are seen a new emotional vigour and a liberation from formulas of composition and colour.[5] Since the majority of these artists belonged to the Carracci generation, much of their work was painted before 1600. They were, of course, reared in the Late Mannerist tradition, and from this, despite their protest against it, they never entirely emancipated themselves. It was only in Bologna, due mainly to the pioneering of the Carracci 'academy', that at the beginning of the Seicento a coherent school arose which hardly shows traces of a transitional style. As regards the other provincial towns, it is by and large more appropriate to talk of a transitional manner brought about by the efforts of individual and often isolated masters, some of whose names have just been mentioned. The special position in the Venice of Lys and Fetti will be discussed at the end of this chapter, while the lonely figure of Caracciolo may more conveniently be added to the names of the later Neapolitan painters (see p. 356).

BOLOGNA AND NEIGHBOURING CITIES

The foremost names of Bolognese artists who did not follow Annibale to Rome are Alessandro Tiarini (1577–1668), Giovanni Andrea Donducci, called Mastelletta (1575–1655), Leonello Spada (1576–1622), and, in addition, Giacomo Cavedoni from Sassuolo (1577–1660).[6] They all begin by adopting different aspects of the Carracci teaching, on occasion coloured by Caravaggio's influence. It is, however, in the

second decade of the seventeenth century that these artists emerge as the authors of a series of powerful and vigorous masterpieces. Nevertheless their production is essentially provincial. Neither academic in the sense of the prevalent Domenichino type of classicism nor fettered to *Caravaggismo*, their work is to a certain extent an antithesis to contemporary art in Rome. The culmination of this typically Bolognese manner occurs about fifteen years after Annibale's departure to Rome, when the powers of Lodovico, both as painter and as head of the Academy, were on the wane. In the ten years between 1610 and 1620, above all, the artists of the Carracci school fulfilled the promise of their training; but on the return of Guido Reni to Bologna, they relinquished one by one their individuality to this much superior painter.

If Mastelletta was the most original of this group of artists, the most highly talented were undoubtedly Cavedoni and Tiarini. After a brief Florentine phase in his early youth[7] the latter returned to Bologna, where he soon developed a characteristic style of his own. His masterpiece, *St Dominic resuscitating a Child*, a many-figured picture of huge dimensions, painted in 1614–15[8] for S. Domenico, Bologna, is dramatically lit and composed [37]. Since he was hardly impeded by theoretical considerations, little is to be found here of the classicism practised at this moment by his compatriots in Rome. While the solidity of his figures and their studied gestures reveal his education in the Carracci school, his 'painterly' approach to his subject proves him a close follower of Lodovico, on whom he also relies for certain figures and the unco-ordinated back-drop of the antique temple and column. During the next years he intensified this manner in compositions with sombre and somewhat coarse figures of impressive gravity. Characteristic examples are the *Pietà* (Bologna, Pinacoteca) of 1617, and *St Martin resuscitating the Widow's Son* in S. Stefano, Bologna, of about the same period.

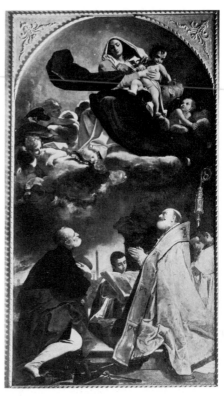

37. Alessandro Tiarini:
St Dominic resuscitating a Child, 1614-15.
Bologna, S. Domenico

38. Giacomo Cavedoni:
The Virgin and Child with SS. Alò and Petronius,
1614. *Bologna, Pinacoteca*

According to Malvasia's report he was deeply impressed by Caravaggio, and a version of the latter's *Incredulity of St Thomas*, at the time in Bologna, was gleefully copied by him. In the twenties Tiarini uses a lighter range of colours; his style becomes more rhetorical and less intense, and simultaneously an interest in Veronese and Pordenone is noticeable. His latest work, under the influence of Domenichino and above all Reni, hardly bears testimony to his promising beginnings.

Cavedoni lacks the dramatic power of Tiarini's early style, but he displays in the second decade a sense for a quietly expressive mood which he renders with a looser and more painterly technique. If his reliance on Lodovico Carracci is the dominant feature of his work, a Correggiesque note probably reaches him through Schedoni, with whom he has certain affinities – as can be seen in the frescoes of 1612-14 in S. Paolo, Bologna. In his masterpiece, the *Virgin and Child in Glory with SS. Alò and Petronius* of 1614 (Bologna, Pinacoteca) [38], his glowing palette shows him directly dependent on sixteenth-century Venetian painting. This is surely one of the most commanding

pictures produced at Bologna during the period. Cavedoni never again achieved such full-blooded mastery.

It seems difficult to discard Malvasia's circumstantial report that Spada accompanied Caravaggio to Malta.[9] His early manner is close to Calvaert's Mannerism (*Abraham and Melchisedek*, Bologna, *c.* 1605). In 1607 he was still in his home-town, as is proved by the fresco of *The Miracle of the Loaves and Fishes* in the Ospedale degli Esposti. There is no trace here of Caravaggio's influence, and it is Lodovico, as in Spada's later pictures, who is uppermost in the artist's mind. Only in the course of the second decade do we find him subordinating himself to Caravaggio, and although nowadays

this would appear slightly less conspicuous than his Bolognese nickname of *scimmia del Caravaggio* ('Caravaggio's ape') might lead one to suppose, the epithet was doubtless acquired by virtue of his liberal use of black and his realistic and detailed rendering of close-up figures in genre scenes (*Musical Party*, Maisons Laffitte) or in more blood-thirsty contexts (the *Cain and Abel* in Naples or the *Way to Calvary* in Parma). His use of Caravaggio's art, however, is always moderated by a substantial acknowledgement of the instruction of the Carracci academy. But he seems to have regarded Caravaggism as unsuited to monumental tasks, for there is no trace of it in *The Burning of heretical Books* of 1616 in S. Domenico, Bologna, where the

39. Mastelletta: The Rest on the Flight into Egypt, *c.* 1620. *Bologna, Pinacoteca*

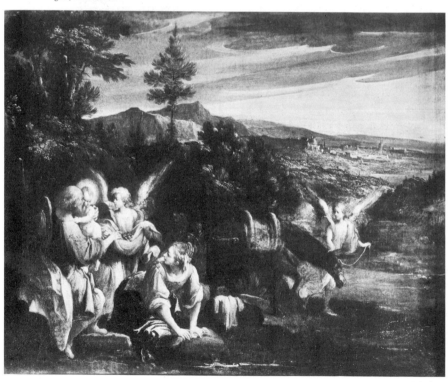

tightly packed and sharply lit figures before a columned architecture fall in with the style commonly practised at Bologna during these years. In his late period Spada worked mainly in Reggio and Parma for Ranuccio Farnese, and his *Marriage of St Catherine* (Parma) of 1621 shows that under the influence of Correggio his style becomes more mellow and that his Caravaggism was no more than a passing phase.

Together with Mastelletta, Pietro Faccini must be mentioned. Both these unorthodox artists are totally unexpected in the Bolognese setting. Faccini, a painter of rare talents who had been brought up in the Mannerist tradition, died in 1602 at the early age of forty. In the 1590s he followed the Carracci lead, but in his very last years there was a radical change towards an extraordinarily free and delicate manner, to the formation of which Niccolò dell' Abate, Correggio, and Barocci seem to have contributed. His *Virgin and Saints* in Bologna is evidence of the new manner which is fully developed in the self-portrait (Florence, Uffizi), possibly dating from the year of his death. This curious disintegration of Mannerist and Carraccesque formulas gives to his last works an almost eighteenth-century flavour. Mastelletta painted on the largest scale in a *maniera furbesca* (Malvasia), and the two huge scenes in S. Domenico, Bologna, reveal that in 1613-15 he was not bound by any doctrinal ties. His chief interest for the modern observer lies in his small and delicate landscapes in which the influence of Scarsellino as well as Niccolò dell' Abate may be discovered.[10] They are in a dark key, and the insubstantial, brightly-lit figures emerging from their shadowy surroundings contribute to give to these pictures an ethereal effect [39]. The most imaginative and poetical artist of his generation in Bologna remained, as might be expected, an isolated figure, and even today his work is almost unknown.[11]

At the same period Ferrara can claim two artists of distinction, Scarsellino[12] (1551-1620) and Carlo Bonone (1569-1632). The former belongs essentially to the late sixteenth century, but in his small landscapes with their sacred or profane themes he combines the spirited technique of Venetian painting and the colour of Jacopo Bassano with the tradition of Dosso Dossi. He thus becomes an important link with early seventeenth-century landscape painters, and his influence on an Emilian master like Mastelletta is probably greater than is at present realized. In Carlo Bonone Ferrara possessed an early Seicento painter who in his best period after 1610 shows a close affinity to Schedoni.

40. Carlo Bonone: The Guardian Angel, *c*. 1610. *Ferrara, Pinacoteca*

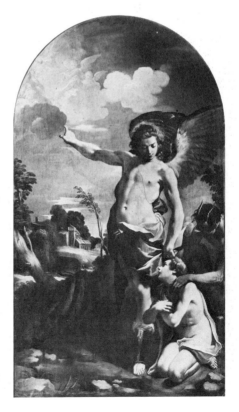

Though not discarding the local tradition stemming from Dossi, nor neglecting what he had learned from Veronese, he fully absorbed the new tendencies coming from Lodovico Carracci [40]. In his fresco in the apse of S. Maria in Vado, depicting the *Glorification of the Name of God* (1617-20), he based himself upon Correggio without, however, going so far towards Baroque unification as Lanfranco did in Rome. Parallel to events in the neighbouring Bologna, his decline begins during the twenties. In his two dated works in the Modena Gallery, *The Miracle of the Well* (1624-6) and the *Holy Family with Saints* (1626), he displays a provincial eclecticism by following in the one case Guercino and in the other Veronese. His last picture, *The Marriage at Cana* (Ferrara) of 1632,

41. Bartolommeo Schedoni: Christian Charity, 1611. *Naples, Museo Nazionale*

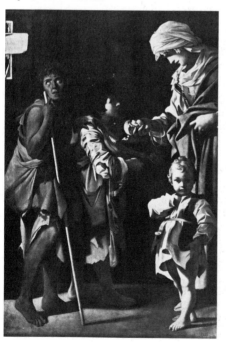

shows him not surprisingly returning to a typically Ferrarese Late Mannerism.

Bartolommeo Schedoni (1578-1615)[13] is in his latest phase certainly an artist of greater calibre. He was born in Modena and worked mostly at Parma, where he died. His frescoes in the town-hall at Modena of 1606-7 are still predominantly Mannerist in their dependence on Niccolò dell'Abate, although his style is already more flowing. But beginning in about 1610 there is an almost complete break with this early manner. Pictures of considerable originality such as the *Christian Charity* of 1611 in Naples [41], the *Three Maries at the Sepulchre* of 1614, and the *Deposition* of the same period, both in Parma, and the unfinished *St Sebastian attended by the Holy Women* (Naples) prove that it is Correggio who has provided the main inspiration for this new style. It is marked both by an intensity and peculiar aloofness of expression and by an emotional use of areas of bright yellows and blues which have an almost metallic surface quality. His colour scheme, however, is far removed from that of the Mannerists, for he limits his scale to a few tones of striking brilliance. The treatment of themes with low-class types as in pictures like the *Charity* probably resulted from the experience of Caravaggio or his followers. It is a pointer in the same direction that Schedoni often placed his figures before a neutral background. Yet how different from Caravaggio is the result! In Schedoni's case there is a strange contrast between the dark ground and the figures which shine like precious jewels.[14]

It appears from this survey that the Emilian masters owed more to Lodovico than to any other single personality, but it is equally evident that the style of the outsize canvases by artists like Tiarini, Spada, and Mastelletta, with the many narrative incidents, the massive figures, and the studied academic poses, did not join the broad stream of the further development. Only of Schedoni, the master less obviously

connected with the Carracci tradition, can it be said that he had a lasting influence, through the impression he made on the youthful Lanfranco.

FLORENCE AND SIENA

It has already been indicated that the role of Florence in the history of Seicento painting is disappointingly but not unexpectedly limited. Not a single artist of really great stature was produced there at this period. To a greater or lesser extent Florentines remained tied to their tradition of draughtsmanship, and their attempts to adjust themselves to the use of North Italian colour were more often than not halfhearted and inconsistent. Furthermore, neither the emotionalism of Barocci nor the drama and impetuosity of Lanfranco and the young Guercino were suitable to Tuscan doctrine and temperament. Bernardino Poccetti's (1548-1612) sober and measured narrations (Chiostro di S. Marco, 1602) remained the accepted style, and artists like Domenico Cresti, called Passignano (1558/60-1638), were faithful to this manner far into the seventeenth century. Passignano did, however, make concessions to Venetian colour, and his pictures tend to show a richer and warmer palette than those of his contemporaries. Similarly, Santi di Tito (1536-1603) softened his style towards the end of his career, but his paintings, though often simple and appealing, lacked vigour and tension and were never destined to transmit new life. This style was continued anachronistically by Tito's faithful pupil Agostino Ciampelli (*c.* 1568-1630, not *c.* 1575-1642).[15] It is likely that the Veronese Jacopo Ligozzi (1547-1626),[16] who spent most of his life in Florence, was instrumental in imposing northern chromatic precepts upon the artists in the city of his choice.

A painter of considerable charm, who deserves special mention, is Jacopo Chimenti da Empoli (1551/4-1640). He began in Poccetti's studio with a marked bias towards Andrea del Sarto and Pontormo, but the manner which he developed in the second and third decades of the new century is a peculiar compound of the older Florentine Mannerism and a rich, precise, and sophisticated colour scheme in which yellow predominates. Venturi was reminded before a picture such as the *Susanna* of 1600 (Vienna) of the palette later developed by Zurbaran, and similar colouristic qualities may also be found in his rare and attractive still lifes,[17] the arrangement of which is dependent on the northern tradition.

By far the most eminent Florentine artist of this generation, however, is Ludovico Cardi, called Il Cigoli (1559-1613). An architect of repute and a close friend of Galilei,[18] he went further on the road to a true Baroque style than

42. Cigoli: The Ecstasy of St Francis, 1596. *Florence, S. Marco, Museum*

any of his Florentine contemporaries. In the beginning he accepted the Mannerism of his teacher, Alessandro Allori. At a comparatively early date he changed under the influence of Barocci (Baldinucci). In his *Martyrdom of St Stephen* of 1597 (Florence, Accademia) Veronese's influence is clearly noticeable, while one of his most advanced works, the *Last Supper* of 1591 (Empoli, Collegiata), reveals him as colouristically, but not formally, dependent on Tintoretto. The clarity, directness, and simplicity of interpretation of the event show him almost on a level with the works of the Carracci at the same moment. In some of his later works, like the *Ecce Homo* (Palazzo Pitti), a typically Seicento immediacy of appeal will be found; in others, like his famous *Ecstasies of St Francis* [42], he gives vent to the new emotionalism. Nevertheless, he hardly ever fully succeeded in casting off his Florentine heritage. He went to Rome in 1604, returning to Florence only for brief intervals. His largest Roman work, the frescoes in the dome of the Cappella Paolina in S. Maria Maggiore (1610-13), are, in spite of spatial unification, less progressive than they may at first appear. In his last frescoes (1611-12), those of *Cupid and Psyche* from the Loggetta Rospigliosi (now Museo di Roma), he accepted the Carraccesque idiom to such an extent that they were once attributed to Lanfranco as well as to Annibale himself.

Even the best of Cigoli's followers, Cristofano Allori (1577-1621) and the Fleming Giovanni Biliverti (1576-1644), adhere to a transitional style.[19] More important than these masters is their exact contemporary Matteo Rosselli (1578-1650), a pupil of Passignano. He owed his position, however, not to his intrinsic qualities as a painter but to the fact that he was the head of a school which was attended by practically all the younger Florentine artists.[20]

Siena at this period had at least one painter worth recording apart from the Barocci followers Ventura Salimbeni and Francesco Vanni,

who have been mentioned. Rutilio Manetti (1571-1639), Vanni's pupil, was also not unaffected by Barocci's manner. But only with his conversion to Caravaggism in his *Death of the Blessed Antonio Patrizi* of 1616 (S. Agostino, Monticiano) does he emerge as an artist of distinction. In the following years his vigorous genre scenes are reminiscent of Manfredi and Valentin or even the northern *Caravaggisti*. From the beginning of the thirties there is a falling off in quality, for example in the *St Eligius* of 1631 at Siena; in his latest production, to a great extent executed with the help of pupils, the energy displayed during the previous fifteen years is exhausted.[21]

The popular Florentine narrative style of the Poccetti-Passignano type, which was adopted by Manetti early in his career, was a success not only in Rome but also in the North, particularly in Liguria and Lombardy. However, the use to which it was put was not everywhere the same. While in Genoa it was imported directly, without variation, in Milan it was blended with new tendencies in an effort to produce a distinctly 'native' manner.

MILAN

Seicento painting in Milan developed under the shadow of the great counter-reformer St Charles Borromeo (d. 1584), who was discussed in the first chapter. His spirit of devotion was kept alive by his nephew Archbishop Federico Borromeo. It was he who in 1602 commissioned a cycle of paintings to honour St Charles's memory. These large canvases depicting scenes from his life were increased in 1610, the year of St Charles's canonization, to over forty to include portrayals of his miracles (the whole cycle in Milan Cathedral). Many of these pictures were due to the three foremost Milanese painters of the early Seicento, Giulio Cesare Procaccini (1574-1625),[22] Giovanni Battista Crespi, called Cerano (c. 1575-1632), and Pier

Francesco Mazzucchelli, called Morazzone (1573–1626),[23] and a study of their work gives the measure of Milanese 'history painting' at this period: influences from Venice (Veronese, Pordenone) and from Florentine, Emilian (Tibaldi), and northern Mannerism (e.g. Spranger) have been superimposed upon a local foundation devolving from Gaudenzio Ferrari. To a lesser degree than Genoa, Milan at this historical moment was the focus of cross-currents from south, east, and north. But this Milanese art is marked by an extraordinary intensity which has deep roots in the spirit of popular devotion epitomized in the pilgrimage churches of the *Sacri Monti* of Lombardy. (See also illustrations 221, 222.)

Cerano, born at Novara, was the most comprehensive talent of the Milanese group. Architect, sculptor, writer, and engraver apart from his principal calling as painter, he became in 1621 the first Director of Federico Borromeo's newly founded Academy. In fact his relation to the Borromeo family dates back to about 1590, and he remained in close contact with them to the end of his life: no wonder, therefore, that he had the lion's share in the St Charles Borromeo cycle. Despite his long stay in Rome (1586–95), he shows, characteristically, in his early work a strong attachment to Gaudenzio,[24] Tibaldi, and Barocci as well as to Flemish and even older Tuscan Mannerists (*Archangel Michael*, Milan, Museo di Castello).[25] But he soon worked out a Mannerist formula of his own (*Franciscan Saints*, 1600, Berlin, destroyed) which is as far removed from the formalism of international Mannerism around 1600 as from the palpability of the rising Baroque. An often agonizing tension and an almost morbid mysticism inform many of his canvases, and the silver-grey light and clear scale of tones for which he is famed lend support to the spiritual quality of his work. Although he never superseded his mystic Mannerism, as may be seen in one of his greatest works, the *Baptism of St Augustine* of 1618 in S.

43. Cerano: The Virgin of the Rosary, *c.* 1615. *Milan, Brera*

Marco, Milan, and although no straight development of his style can possibly be construed, he yet produced during the second decade compositions of such impressive simplicity as the *Madonna del Rosario* in the Brera [43] and the *Virgin and Child with St Bruno and St Charles* in the Certosa, Pavia, both of about 1615, in which he humanized the religious experience by falling back on the older Milanese tradition. Few pictures are known of Cerano's latest period. In 1629 he was appointed head of the statuary works of Milan Cathedral, and from this time date the impressively compact monochrome *modelli* for the sculpture over the doors of the façade (Museo dell'Opera, Cathedral) which were translated into flaccid marble reliefs by Andrea Biffi, G. P. Lasagni, and Gaspare Vismara.[26]

Like Cerano, Morazzone had been early in his life in Rome (*c.* 1592–8), and some of his work in the Eternal City can still be seen *in situ* (frescoes in S. Silvestro in Capite). But Moraz-

44. Morazzone: Ecce Homo Chapel, 1609–13. Frescoes. *Varallo, Sacro Monte*

zone's style was even more radically formed than Cerano's on Gaudenzio Ferrari. Back home, he made his debut as a fresco painter in the Cappella del Rosario in S. Vittore at Varese (1599 and 1615–17). Large frescoes followed at Rho (c. 1602–4) and in the 'Ascent to Calvary' Chapel of the Sacro Monte, Varallo (1605). In the frescoes of the 'Flagellation' Chapel of the Sacro Monte near Varese (1608–9) and the 'Ecce Homo' Chapel at Varallo (1609–13) [44] Morazzone's characteristic style is fully developed. In 1614 he finished the frescoes of the 'Condemnation to Death' Chapel at Varallo, and between 1616 and 1620 he executed those of the 'Porziuncola' Chapel of the Sacro Monte at Orta.[27] It is at once evident that Morazzone, like his contemporary Antonio d'Enrico, called Tanzio da Varallo (1574/80–1635), was thoroughly steeped in the tradition of these collective enterprises, in which the spirit of the medieval miracle plays was revived and to the decoration of which a whole army of artists and artisans contributed between the sixteenth and eighteenth centuries.[28] Morazzone's reputation as a fresco painter, solidly founded on his achievements in the Sanctuaries, opened other great opportunities for him. In 1620 he painted a chapel in S. Gaudenzio at Novara and in 1625, shortly before his death, he began the decoration of the dome of Piacenza Cathedral, the greater part of which was carried out by Guercino. Morazzone as a master of the grand decorative fresco went further than his Milanese contemporaries in promoting the type of popular realism that was part and parcel of the art of the Sanctuaries. But that the intentions of Morazzone, Cerano, and Procaccini lay not far apart is proved by the famous 'three-master-picture', the *Martyrdom of SS. Rufina and Seconda* in the Brera of about 1620.[29]

The S. Rufina painted by Giulio Cesare Procaccini in the lower right half of this work carries the signature of a precious manner and a bigoted piety very different from those of his

collaborators. The more gifted brother of the elder Camillo (c. 1560–1629), Giulio Cesare had moved with his family from Bologna to Milan in about 1590; but if any traces of his Bolognese upbringing are revealed in his work, they point to the older Bolognese Mannerists rather than to an influence from the side of the Carracci. In Milan he began as a sculptor with the reliefs for the façade of SS. Nazaro e Celso (1597–1601),[30] and a statuesque quality is evident in his paintings during the first two decades. Apart from his contacts with Morazzone and Cerano, the important stages of his career are indicated by his renewed interest in sculpture after 1610, by his stay in Modena between 1613 and 1616, where he painted the *Circumcision* (Galleria Estense), and his sojourn at Genoa in 1618. After Modena he was at the mercy of Correggio and his Parmese followers,

45. Giulio Cesare Procaccini: St Mary Magdalen, c. 1616. *Milan, Brera*

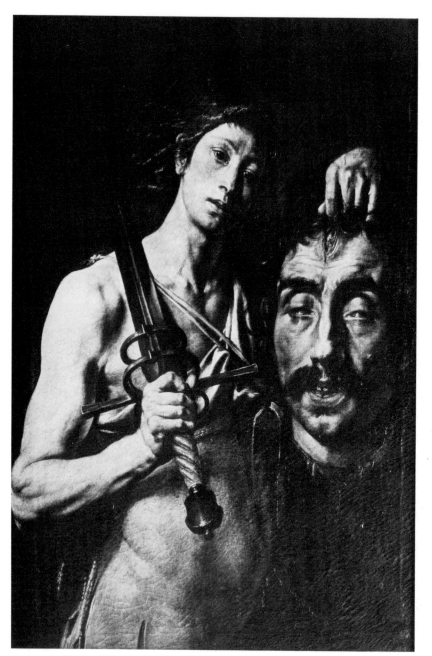

46. Antonio d'Enrico, il Tanzio: David, *c.* 1620. *Varallo, Pinacoteca*

above all Parmigianino, as his *Marriage of St Catherine* (Brera) and the *Mary Magdalen* (Brera) [45] prove. Genoa brought him in contact with Rubens, and the repercussions on his style will easily be detected in such works as the *Deposition* of the Fassati Collection, Milan, and the *Judith and Holofernes* of the Museo del Castello.

A word must be said about Tanzio, the most temperamental, tense, and violent of this group of Milanese artists. It is now fairly certain that he was in Rome some time between 1610 and 1615, and the impact of *Caravaggismo* is immediately felt in the *Circumcision* at Fara San Martino (parish church) and the *Virgin with Saints* in the Collegiata at Pescocostanzo (Abruzzi), works which appear deliberately archaizing and deliberately crude.[31] The important frescoes at Varallo as well as those in the

Chiesa della Pace, Milan,[32] show him returning to the local traditions, to Cerano and the Venetians; nevertheless, *Caravaggismo* seems to have kept a hold on him, as later pictures attest, among them the obsessed-looking *David* with the enormous polished sword and the almost obscene head of Goliath (Varallo, Pinacoteca) [46] and the most extraordinary *Battle of Sennacherib* (1627-9, S. Gaudenzio, Novara; bozzetto in the Museo Civico), where an uncompromising realism is transmuted into a ghostlike drama with frightfully distorted figures which seem petrified into permanence.[33]

To the names of these artists should be added that of the younger Daniele Crespi (c. 1598-1630), a prodigious worker who derived mainly from Cerano and Procaccini, but whose first recorded work shows him assisting Guglielmo Caccia, called Il Moncalvo (c. 1565-1625),[34] in

47. Daniele Crespi: St Charles Borromeo at Supper, c. 1628. *Milan, Chiesa della Passione*

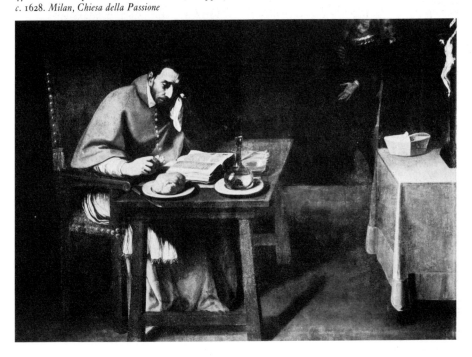

the frescoes of the dome of S. Vittore at Milan. In his best works Daniele combined severe realism and parsimonious handling of pictorial means with a sincerity of expression fully in sympathy with the religious climate at Milan. His famous *St Charles Borromeo at Supper* (Chiesa della Passione, Milan, *c.* 1628) [47] comes nearer to the spirit of the austere devotion of the saint than almost any other painting of the period and is, moreover, expressed without recourse to the customary religious and compositional props from which the three principal promoters of the early Milanese Seicento were never entirely able to detach themselves. The question has been raised if Daniele was indebted to Zurbaran's contemporary work. Whether or not the answer is in the affirmative, he certainly was impressed by Rubens and Van Dyck, as is revealed in his principal work, the cycle of frescoes in the Certosa at Garegnano, Milan (1629). A similar cycle painted in the Certosa of Pavia in the year of his death may be regarded as an anti-climax. Daniele's career was prematurely interrupted by the plague of 1630. This event, immortalized by Manzoni, spelled to all intents and purposes the end of the first and greatest phase of Milanese Seicento painting.

GENOA

While the most important period of Milanese painting was over by about 1630, a local Seicento school began in Genoa somewhat later but flourished for a hundred years. During the seventeenth century the old maritime republic had an immensely rich ruling class who made their money for the most part by world-wide banking manipulations; and the international character of their enterprises is also reflected in the artistic field. It is true that at the end of the previous century Genoa had possessed in Luca Cambiaso (1527–85) a great native artist. Capable of working on the largest scale, his influence remained a vital force far into the

Seicento, and among his followers must be numbered Lazzaro Tavarone (1556–1641), Battista Castello (1547–1637), and his brother Bernardo (1557–1629). But it was not these much sought-after, tame Mannerists who brought about the flowering of seventeenth-century Genoese art. Genoa grew to importance as a meeting place of artists from many different quarters. There was a Tuscan group to which the Sienese Pietro Sorri (1556–1622), Francesco Vanni, and Ventura Salimbeni belonged. Aurelio Lomi (1556–1622) from Pisa was in Genoa between 1597 and 1604, and Giovanni Battista Paggi (1554–1627), a Genoese who had worked in Florence with Cigoli, brought back the latter's manner to his hometown. In accordance with their training and tradition these artists represent on the whole a rather reactionary element. More vital was the contact with the progressive Milanese school, and the impact of Giulio Cesare Procaccini, working in Genoa in 1618, was certainly great. Of equal and even greater importance for the future of Genoese painting were the Flemings. They had long regarded Genoa as a suitable place to try their fortunes, and works by artists such as Pieter Aertsen were already collected there in the late sixteenth century. Snyders was probably in Genoa in 1608, and later Cornelius de Wael (1592–1667) became an honorary citizen and leader of the Flemish colony.[35] Their genre and animal pictures form an important link with the greater figure of G. Benedetto Castiglione, and in this context Jan Roos (Italianized: Giovanni Rosa) should at least be mentioned. But the names of all these Flemings are dwarfed by that of Rubens, whose stay in the city in 1607 (*Circumcision*, S. Ambrogio) and dispatch, in 1620, of the *Miracle of St Ignatius* (S. Ambrogio) were as decisive as Van Dyck's sojourns in 1621–2 and 1626–7. Caravaggio, in Genoa for a short while in 1605, left, it seems, no deep impression at that moment. Caravaggism gained a foothold, however,

through Orazio Gentileschi and Vouet, who were in Genoa at the beginning of the twenties. Finally it should not be forgotten that the Genoese appreciated the art of Barocci and of the Bolognese. The former's *Crucifixion* for the cathedral was painted in 1595; and pictures by Domenichino, Albani, Reni,[36] and others reached Genoa at an early moment. The impression Velasquez made in Genoa at the time of his visit in 1629 seems worth investigating. It can, therefore, be seen that in the first decades of the seventeenth century Genoa was in active contact with all the major artistic trends, Italian and foreign.

The development of the early seventeenth-century native Genoese painters Bernardo Strozzi (1581-1644), Andrea Ansaldo (1584-1638), Domenico Fiasella, called Il Sarzana (1589-1669), Luciano Borzone (1590-1645), and Gioacchino Assereto (1600-49) runs to a certain extent parallel. They begin traditionally enough: Fiasella and Strozzi deriving from Lomi, Paggi, and Sorri; Ansaldo from the mediocre Orazio Cambiaso, Luca's son; and Assereto from Ansaldo. Towards the twenties these artists show the influence of the Milanese school, and only Fiasella, who had worked in Rome from 1607 to 1617, is really swayed by the *Caravaggisti*.[37] In the course of the third decade they all attempt to cast away the last vestiges of Mannerism and turn towards a freer, naturalistic manner, largely under the influence of Rubens and Van Dyck. It should, however, be said that, lacking monographic treatment,

48. Gioacchino Assereto: The Supper at Emmaus, after 1630. *Genoa, Private Collection*

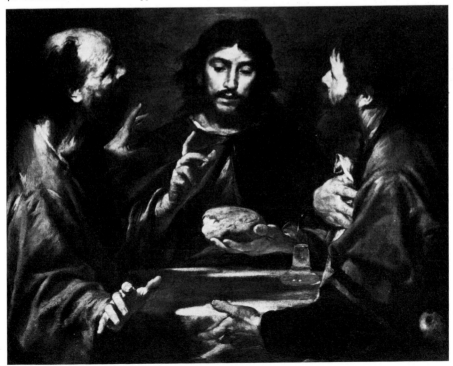

neither Borzone nor Ansaldo and Fiasella are clearly defined personalities; it would seem that the prolific Fiasella, who lived longest and was much in fashion with the Genoese aristocracy, must be regarded as the least interesting and original of this group of artists. By contrast Assereto, through Longhi's basic study, has become for us an artistic personality with clear contours.[38] In his work after 1630, for example in the Genoa *Martyrdom of St Bartholomew* or the Genoa *Supper at Emmaus* [48], he achieved a unification of composition and a complete freedom of handling which places him almost on a level with Strozzi in his Venetian period.

The genius of this generation, surpassing all his contemporaries, was Bernardo Strozzi. His early style, from his 'Tuscan' beginnings to his vacillations between Veronese, Caravaggio, and the Flemings, is not yet sufficiently clear [235].[39] In 1598 he became a Capuchin monk, but in 1610 he was allowed to leave the monastery. Between 1614 and 1621 he acted as an engineer in his home-town and from 1623 to 1625 he painted the frescoes in the Palazzo Carpanetto at San Pier d'Arena. Imprisoned by his Order, he went after his release in 1630 to Venice, where he lived until his death in 1644. Discussion of his work may be postponed, since his great Venetian period belongs to a later chapter.

VENICE

In the smaller centres of northern Italy a Late Mannerist style prevailed practically throughout the first half of the seventeenth century. This was primarily due to the influential position of Venice, where the leading roles were played by three eclectic artists, namely Jacopo Negretti, called Palma Giovane (1544–1628), Domenico Tintoretto (1560–1635), and Alessandro Varotari, called Padovanino (1588–1648). Domenico Tintoretto continued his father's manner with a strong dash of Bassani influence; Padovanino in his better pictures

tried not unsuccessfully to recapture something of the spirit of Titian's early period; Palma Giovane, basing himself on a mixture of the late Titian and Tintoretto, was the most fertile and sought-after but at the same time the most monotonous of the three.[40] Strangely enough, these masters had little understanding for the potentialities of the loaded brush-stroke. As a rule their canvases are colouristically dull, lacking entirely the exciting surface qualities of the great sixteenth-century painters.[41] Deeply under the influence of these facile artists, their contemporaries in the *Terra Ferma*, in Verona, Bergamo, and Brescia, bear witness to the popularity of what had by then become a moribund style. It was, in fact, the degeneration of the great Venetian tradition in Venice itself, together with the rise of Rome as the centre of progressive art, that determined the pattern of seventeenth-century painting for the whole of Italy.

In 1630 probably few Venetians realized that they had had two young artists in their midst who had aroused painting from its 'eclectic slumber'. They were neither Venetian by birth, nor were they ever entrusted with important commissions in the city in which they had settled. Giovanni Lys came to Italy in about 1620, and by 1621 was in Venice. In the same year Domenico Fetti had his first taste of Venice. Both artists excelled in cabinet pictures and both died young. They each developed a manner in which the spirited brush-stroke was of over-riding importance, and by this means they re-invigorated Venetian colour and became the exponents of the most advanced tendencies. They are the real heirs to the Venetian colouristic tradition; with their rich, warm, and light palette and their laden brush-work they are as far removed from the *tenebroso* of Caravaggio as from the classicism of the Bolognese. Lys was born in Oldenburg in North Germany in about 1597, and Fetti in Rome in 1589. Fetti died at the age of thirty-four in 1623; Lys was

even younger when he was carried off by the Venetian plague of 1629-30. Their *œuvres* are therefore limited, and their influence, although considerable – particularly on Strozzi – should not be overestimated.

Fetti's first master was Cigoli, after the latter came to Rome in 1604; but although their association remained close until 1613, little evidence of Cigoli's transitional style can be discovered in Fetti's work. In fact in Rome Fetti must have felt the influence, if not of Caravaggio himself, at any rate of those followers such as Borgianni and Saraceni who were more in sympathy with Venetian colour. Not much is known about Fetti's Roman period, but it would have been in this circle that he developed his taste for the popular genre. At the same time he must have been deeply impressed by the art of Rubens, whose transparent red and blue flesh tones he adopted. When in 1613 he went to Mantua as Court Painter to Duke Ferdinando, he again found himself under the shadow of Rubens, but while working there, he became increasingly dependent on Venetian art, particularly that of Titian and Tintoretto. Fetti was not a master capable of working on a large scale, and to a certain extent the official paintings he had to execute in the ducal service must have been antipathetic to him. Apart from the fresco of the *Trinity* in the apse of the cathedral, now attributed to Ippolito Andreasi (1548-1608),[42] the most massive of these commissions was the *Miracle of the Loaves and Fishes* (Mantua, Palazzo Ducale) where the intricate composition with its manifold large figures falls below the high standard shown in many passages of painting. Fetti's early work is rather dark, but slowly his palette lightened, while he intensified the surface pattern by working with complementary local colours.[43] It was only after his removal to Venice in 1622[44] and during the brief remainder of his life that he was able to devote himself entirely to small easel pictures [49]. These little works, many of them illus-

49. Domenico Fetti: The Good Samaritan, *c.* 1622. *New York, Metropolitan Museum*

trating parables set in homely surroundings, must have attracted the same public as the *Bambocciate* in Rome, and the numerous repetitions of the same subjects from the artist's own hand attest their popularity.[45] It was in these pictures with their loose and pasty surfaces punctuated by rapid strokes of the brush, giving an effect of vibrating light, that Fetti imparted a recognizably seventeenth-century character to the pictorial tradition of Venice. A decisively new stage in the history of art is reached at this point.

Although Fetti himself went a long way towards discarding the established conventions of picture-making, it was Lys who took a step beyond Fetti: his work opens up a vista on the future of European painting. Lys had started his career in about 1615 in Antwerp and Haarlem, where he came into contact with the circles of local painters, in particular Hals and Jor-

daens. In Venice he formed a friendship with Fetti and, after the latter's death, with the Frenchman Nicolas Regnier (*c*. 1590–1667), a follower of Caravaggio in Rome who moved to Venice in 1627. Only one of Lys's pictures is dated, namely the *Christ on the Mount of Olives* (Zürich, private collection), and the date has been read both as 1628 and 1629. For the rest it would appear that the longer he stayed away from Holland the more he dissociated himself from his Northern upbringing. Not only did he exclude from his repertory the rather rustic northern types, but he also tended towards an ever-increasing turbulence and freedom of handling. His development during his few Venetian years must have been astonishingly rapid. Such a picture as the *Fall of Phaeton* in the Denis Mahon Collection, London,[46] with its velvety texture and an intensity which may be compared with Rubens, must date from

50. Giovanni Lys: The Vision of St Jerome, *c*. 1628. *Venice, S. Nicolò da Tolentino*

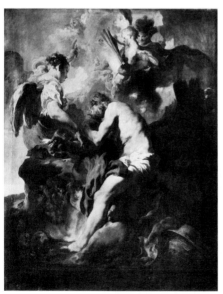

about 1625, since despite its softness it is still comparatively firm in its structure. On the other hand later pictures like the *Ecstasy of St Paul* (Berlin) or the *Vision of St Jerome* (Venice, S. Nicolò da Tolentino) [50] show a looseness and freedom and a painterly disintegration of form which call to mind even the works of the Guardi [355].[47]

CONCLUSION

The reader may well ask what the over-all picture is that emerges from this rapid survey. Almost all the artists mentioned in this and the previous chapters were born between 1560 and 1590. Most of them began their training with a Late Mannerist and retained throughout their lives Mannerist traces to a greater or lesser degree. Only the youngest, born after 1590, who were here included because, like Lys and Fetti, they died at an early age, grew up in a post-Mannerist atmosphere or were capable of discarding the Mannerist heritage entirely. The majority matured after 1600 and painted their principal works after 1610. What creates a common bond between all these provincial masters is a spirit of deep and sincere devotion. Viewed in this light, a Tiarini, a Schedoni, a Cerano, and a Cigoli belong more closely together than is generally realized. On this level it counts very little whether the one clings longer or more persistently to Mannerist conventions than the other, for they are all equally divorced by a deep rift from the facile international Mannerism of the late Cinquecento, and they all return in one way or another to the great Renaissance masters and the first generation of Mannerists in their search for guidance to a truly emotional art. It would, therefore, be as wrong to underestimate the revolutionary character of their style and to regard it simply, as is often done, as a specific type of Late Mannerism as it would be to stress too much

its continuity into the Baroque of the mid century. The beginnings of the style date back to Lodovico Carracci of the early nineties and to Cigoli of the same period. It finds its most intense expression in Caravaggio's work around 1600; by and large it is the idiom of *Caravaggisti* like Orazio Gentileschi, Saraceni, and Borgianni, and of the Emilian and Milanese masters, mainly during the second decade; and, as has been shown again and again in these pages, it slowly comes to an end in the course of the third decade.

It is important to notice that this art is strongest, or even arises, in the provinces at a moment when the temper began to change in Rome. This is revealed not only in the Farnese Gallery but also in Annibale's religious work after 1600, where studied severity replaces emotional tension. In the provinces the enormous intensity of this style, the compound of gravity,

solemnity, mental excitation, and effervescence could not be maintained for long. To explore further the possibilities which were open to artists roughly from the beginning of Urban VIII's reign onwards will be the task of the Second Part. But meanwhile the reader may compare the change of religious temper from an early, 'Mannerist', to a late, 'Baroque', Strozzi [235, 236], a telling experience which may be repeated a hundred times with artists of the generation with which we were here concerned.

If it is at all possible to associate any one style or manner with the spirit of the great reformers, one would not hesitate to single out this art between about 1590 and 1625/30, and whether or not this will be agreed to, one thing is certain, that the period under review carries its terms of 'Late Mannerism' or 'Transitional Style' or 'Early Baroque' only *faute de mieux*.

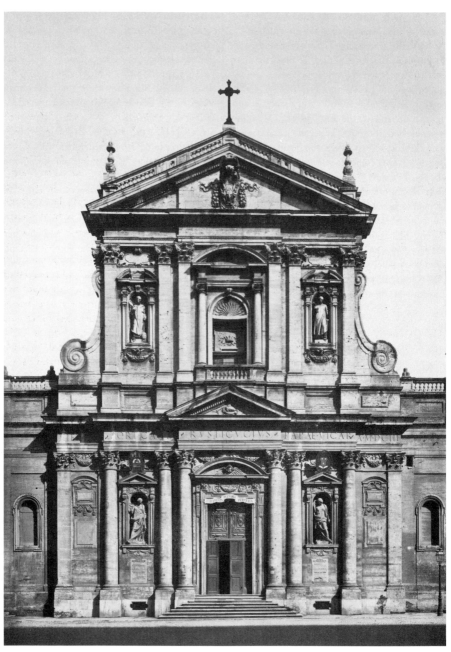

51. Carlo Maderno: Rome, S. Susanna, 1597-1603

ARCHITECTURE AND SCULPTURE

ARCHITECTURE

Rome: Carlo Maderno (1556-1629)

In the first chapter the broad pattern was sketched of the architectural position in Rome during the early years of the seventeenth century. The revolutionary character of Maderno's work has already been indicated. It was he who broke with the prevailing severe taste and replaced the refined classicism of an Ottavio Mascherino and a Flaminio Ponzio by a forceful, manly, and vigorous style, which once again, after several generations, had considerable sculptural and chiaroscuro qualities. Like so many masons and architects, Maderno came from the North; he was born in 1556 at Capolago on the Lake of Lugano, went to Rome before Sixtus V's pontificate, and together with his four brothers acquired Roman citizenship in 1588.[1] He began work in a subordinate capacity under his uncle, Domenico Fontana. After the latter's departure for Naples he was on his own, and before 1600 he had made a name for himself. But his early period and, in particular, his relationship to Francesco da Volterra remains to be clarified.[2]

The year 1603 must be regarded as a turning point in Maderno's career; he was appointed 'Architect to St Peter's' and finished the façade of S. Susanna [51].[3] To the cognoscenti this façade must have been as much of a revelation as Annibale Carracci's Farnese Gallery or Caravaggio's religious imagery. In fact, with this single work, Maderno's most outstanding performance, architecture drew abreast of the revolutionary events in painting. In contrast to so many Mannerist buildings, the principle governing this structure is easy to follow: it is

based on an almost mathematically lucid progressive concentration of bays, orders, and decoration towards the centre. The triple projection of the wall is co-ordinated with the number of bays, which are firmly framed by orders; the width of the bays increases towards the centre and the wall surface is gradually eliminated in a process reversing the thickening of the wall – from the Manneristically framed cartouches to the niches with figures and the entrance door which fills the entire central bay. The upper tier under the simple triangular pediment is conceived as a lighter realization of the lower tier, with pilasters corresponding to the half- and three-quarter-columns below. In this façade North Italian and indigenous Roman traditions are perfectly blended.[4] Maderno imparted a clearly directed, dynamic movement to the structure horizontally as well as vertically, in spite of the fact that it is built up of individual units. Neither in his façade of St Peter's nor in that of S. Andrea della Valle – in its present form mainly the work of Carlo Rainaldi (p. 283) – did Maderno achieve an equal degree of intense dynamic life or of logical integration. Nor did he find much scope to develop his individuality in the interiors of S. Maria della Vittoria and S. Andrea della Valle. But the dome of the latter church – the largest in Rome after that of St Peter's – shows Maderno's genius at its best. Obviously derived from Michelangelo's dome, it is of majestic simplicity. Compared with the dome of St Peter's Maderno raised the height of the drum at the expense of the vault and increased the area that was to be reserved for the windows, and these changes foreshadow the later Baroque development.

Long periods of his working life were spent in the service of St Peter's, where he was faced with the unenviable task of having to interfere with Michelangelo's intentions. The design of the nave, which presented immense difficulties,[5] proves that he planned with circumspection and tact, desirous to clash as little as was possible under the circumstances with the legacy of the great master. But, of course, the nave marred for ever the view of the dome from the square, with consequences which had a sequel down to our own days (p. 195). For the design of the façade [1,112, 257] he was tied more fully than is generally realized by Michelangelo's system of the choir and transepts (which he had to continue along the exterior of the nave) and, moreover, by the ritual requirement of the large Benediction Loggia above the portico. The proportions of the original design are impaired as a result of the papal decision of 1612, after the actual façade was finished, to add towers, of which only the substructures – the last bay at each end – were built [109]. These appear now to form part of the façade. Looked at without these bays, the often criticized relation of width to height in the façade is entirely satisfactory. Maderno's failure to erect the towers was to have repercussions which will be reported in a later chapter[6] (p. 190).

As a designer of palaces Maderno is best represented by the Palazzo Mattei, begun in 1598 and finished in 1616.[7] The noble, austere brick façade shows him in the grip of the strong local tradition. In the courtyard he made subtle use of ancient busts, statues, and reliefs, and the connexion with such Mannerist fronts as those of the villas Medici and Borghese is evident. But the four-flight staircase decorated with refined stuccoes is an innovation in Rome.

It remains to scrutinize more thoroughly the major problem of Maderno's career, his part in the designing of the Palazzo Barberini [52, 53]. The history of the palace is to a certain extent still obscure, in spite of much literary evidence,

memoranda and drawings, and a large amount of documents which allow the construction to be followed very closely indeed.[8] The unassailable data are quickly reported. In 1625 Cardinal Francesco Barberini bought from Alessandro Sforza Santafiora, Duke of Segni, the palace at the 'Quattro Fontane'. A year later Cardinal Francesco presented the palace to his brother Taddeo. Pope Urban VIII commissioned Maderno to redesign the existing palace and to enlarge it. The first payment for the new foundations dates from October 1628. Maderno died on 30 January 1629, and the Pope appointed Bernini his successor. To all intents and purposes the palace was completed in 1633, but minor work dragged on until 1638. It is clear from these data that Bernini (who was assisted by Borromini) was responsible for almost the entire work of execution.

Maderno's design survives in a drawing at the Uffizi which shows a long front of fifteen bays, fashioned after the model of the Palazzo Farnese, and an inscription explains that the design was to serve for all four sides of the palace. In fact, with some not unimportant alterations, it was used for the present north and east wings.[9] At this stage, in other words, Maderno made a scheme that by and large corresponded to the traditional Roman palace, consisting of a block with four equal sides and an arcaded courtyard. But there is no certainty that this was Maderno's last project. In the present palace, the plan of which may be likened to an H [52], the traditional courtyard is abandoned and replaced by a deep forecourt. The main façade consists of seven bays of arcades in three storeys, linked to the entirely different system of the projecting wings by a transitional, slightly receding bay at each side [53]. Who was responsible for the change from the traditional block form to the new plan?

At first sight, it would appear that nothing like this had been built before in Rome and, moreover, *qua* palace, the structure remained

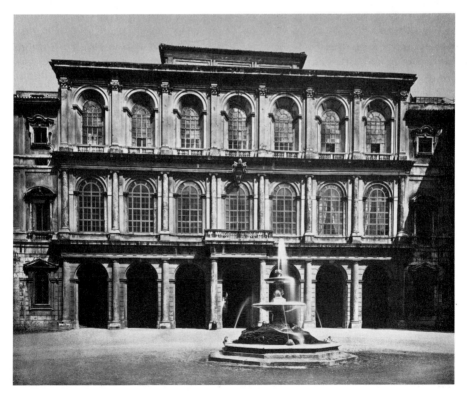

52 *(left)*. Rome, Palazzo Barberini, 1628–33.
Plan adapted from a drawing by N. Tessin
showing the palace before rebuilding of *c*. 1670

53. Carlo Maderno and Gianlorenzo Bernini:
Rome, Palazzo Barberini,
1628–33. Centre of façade

isolated in the Roman setting – it had no succession. Psychologically it is intelligible that one prefers to associate the change of plan with the young genius who took over from Maderno rather than with the aged master. Yet neither the external nor the internal evidence goes to support this. In fact, there is the irrevocable document in Vienna (Albertina) of an unfinished elevation of half the façade (drawn for Maderno by Borromini) which, apart from minor differences, corresponds with the execution. If one regards the palace, as one should, as a monumentalized 'villa suburbana', the plan loses a good deal of its revolutionary character, and to attribute it to Maderno will then no longer surprise us.

The old Sforza palace which Maderno had to incorporate into his design rose on elevated ground high above the ruins of an ancient temple.[10] The palace overlooked the Piazza Barberini but could never form one of its sides. Nor was it possible to align the west front of the new palace with the Strada Felice (the present Via Sistina). In other words, whatever the new design, it could not be organically related to the nearest thoroughfares. A block-shaped palace with arcaded courtyard cannot, however, be dissociated from an intimate relationship with the street front. It was, therefore, almost a foregone conclusion that the block-shape would have to be abandoned and replaced by the type which became traditional for the 'villa suburbana' from Peruzzi's Farnesina on and which only recently Vasanzio had used for the Villa Borghese [8]. In addition the arcaded centre between containing bays and projecting wings was familiar from such buildings as Mascherino's *cortile* of the Quirinal Palace and the garden front of the Villa Mondragone[11] [9]. There is, therefore, no valid reason why Maderno should not be credited with the final design of the Palazzo Barberini: all its elements were ready at hand, and it is the magnificent scale rather than the design as such that gives

it its grand Baroque character and places it in a class of its own. It is even questionable whether Bernini, given a free hand, would have been satisfied with designing three arcaded tiers of almost equal value.

On the other hand, it is certain that adjustments of Maderno's design outside as well as inside were made after Bernini had taken over. The celebrated windows of the third tier, set in surrounds with feigned perspective, are, however, Maderno's. The device, used by Maderno on at least one other occasion,[12] made it possible to reduce the area of the window-openings; this was necessary for reasons of internal arrangement. One may assume that even the enrichment of the orders – engaged columns in the second tier, pilasters coupled with two half-pilasters in the third tier – occurred while Maderno was still alive. Another external feature is worth mentioning. The ground floor and *piano nobile* of the long wings are articulated by framing bands, a device constantly employed by Late Mannerist architects and also by Maderno.[13] Although in a rather untraditional manner, Borromini often returned to it. It is therefore not at all unlikely that it was Borromini's idea to articulate the bare walls of Maderno's design in this way. To what extent the internal organization deviates from Maderno is difficult to determine.[14] As far as the details are concerned we are on fairly firm ground, and Bernini's as well as Borromini's contribution to the design of doors will be discussed later (p. 198). But the large staircase with the four flights ascending along the square open well, traditionally ascribed to Bernini, may well be Maderno's. It is as new as the deep portico, the enormous hall of the *piano nobile* lying at right angles to the front, and the inter-connected oval hall at its back. One is tempted to believe that Bernini assisted by Borromini had here a freer hand than on the exterior, but at present these problems are still in abeyance and may never be satisfactorily solved.

By the time Maderno died, he had directed Roman architecture into entirely new channels. He had authoritatively rejected the facile academic Mannerism which had belonged to his first impressions in Rome, and although not a revolutionary like Borromini, he left behind, largely guided by Michelangelo, monumental work of such solidity, seriousness, and substance that it was equally respected by the great antipodes Bernini and Borromini.[15]

Architecture outside Rome

In the North of Italy the architectural history of the second half of the sixteenth century is dominated by a number of great masters. The names of Palladio, Scamozzi, Sanmicheli, Galeazzo Alessi, Luca Cambiaso, Pellegrino Tibaldi, and Ascanio Vittozzi come at once to mind. By contrast, the first quarter of the seventeenth century cannot boast of names of the same rank, with the one exception of F.M. Ricchino. On the whole, what has been said about Rome also applies to the rest of Italy: the reaction against the more extravagant application of Mannerist principles, which had generally set in towards the end of the sixteenth century, led to a hardening of style, so that we are often faced in the early years of the new century with a severe form of classicism, which, however, was perfectly in keeping with the exigencies of the counter-reformatory church. On the other hand, the North Italian architects of this period also transformed their rich local tradition more imaginatively than the Romans. The work of Binago, Magenta, and Ricchino is infinitely more interesting than most of what Rome had to offer, and it was to a large extent they who prepared the stylistic position of the High Baroque.

In Venice Vincenzo Scamozzi (1552–1616) remained the leading master after the turn of the century. It is immediately apparent that his dry Late Mannerism is the Venetian counterpart to the style of Domenico Fontana and the elder Martino Longhi in Rome. Just as his great theoretical work, the *Idea dell'Architettura Universale* of 1615, with its hieratic structure and its codification of classical rules, concluded an old era rather than opened a new one, so his architecture was the strongest barrier against a turn towards Baroque principles in all the territories belonging to Venice. One should compare Sansovino's Palazzo Corner (1532) with Scamozzi's Palazzo Contarini dagli Scrigni of 1609[16] in order to realize fully that the latter's academic and linear classicism is, as far as plastic volume and chiaroscuro are concerned, a deliberate stepping back to a pre-Sansovinesque position. Moreover, in many respects Scamozzi's architecture must be regarded as a revision of his teacher Palladio by way of reverting to Serlio's conceptions. Their calculated intellectualism makes Scamozzi's buildings precursors of eighteenth-century Neo-classicism. His special brand of frigid classicism, a traditional note of Venetian art, was not lost upon his countrymen and left its mark for a long time to come.[17] But in the next generation the rising genius of Baldassare Longhena superseded the brittle, linear style of his master and reasserted the more vital, exuberant, imaginative, and painterly facet of the Venetian tradition.

Even where Scamozzi's influence did not penetrate in the *terra ferma*, architects turned in the same direction. Thus Domenico Curtoni, Sanmicheli's nephew and pupil, began in 1609 the impressive Palazzo della Gran Guardia at Verona, where he applied most rigidly the precepts of his teacher, ridding them of any Mannerist recollections.[18]

Milan, in particular, became at the turn of the century the stronghold of an uncompromising classicism. It was probably St Charles Borromeo's austere spirit rather than his counter-reformatory guide to architects, the only book of its kind,[19] that provided the keynote for the masters in his and his nephew's service. The

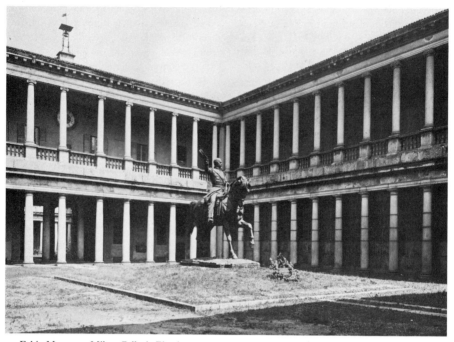

54. Fabio Mangone: Milan, Collegio Elvetico
(Archivio di Stato), first courtyard, begun 1608

Milanese Fabio Mangone (1587-1629), a pupil of Alessandro Bisnati, was the man after Cardinal Federico's heart. As a sign of his appreciation he appointed him in 1620 Professor of Architecture to the newly founded Accademia Ambrosiana. Throughout the seventeenth century the cathedral still remained the focus of Milanese artistic life, and every artist and architect tried there to climb the ladder to distinction. Mangone achieved this goal; in 1617 he succeeded Bisnati as Architect to the Cathedral and remained in charge until his death in 1629. Assisted by Ricchino, the portals were executed by him during this period (with Cerano in charge of the rich decoration, p. 99), but his severe design of the whole façade remained on paper. Mangone's earlier activity was connected with the (much rebuilt) Ambrosiana (1611), which

Lelio Buzzi had begun. The façade of the original entrance is as characteristic of his rigorous classicism as is the large courtyard of the Collegio Elvetico (now Archivio di Stato) [54] with its long rows of Doric and Ionic columns in two tiers under straight entablatures, begun in 1608.[20] His façade of S. Maria Podone (begun 1626) with a columned portico set into a larger temple motif points to a knowledge of Palladio's church façades, which he transformed and submitted to an even sterner classical discipline. Thus Milanese architects revert via Palladio to ancient architecture in search of symbols which would be *en rapport* with the prevailing harsh spirit of reform in the city.[21]

A different note was introduced into Milanese architecture by Lorenzo Binago (called Biffi, 1554-1629),[22] a Barnabite monk, who built S.

Alessandro, one of Milan's most important churches (begun 1601, still unfinished in 1661). Mangone's architecture is strictly Milanese, setting the seal, as it were, on Pellegrino Tibaldi's academic Mannerism. Binago, by contrast, created a work that has its place in an all-Italian context. Like a number of other great churches of this period, the design of S. Alessandro is dependent on the Bramante-Michelangelo scheme for St Peter's.[23] In order to be able to assess the peculiarities of Binago's work, some of the major buildings of this group may be reviewed. In chronological sequence they are: the Gesù Nuovo at Naples (Giuseppe Valeriano, S.J., 1584); S. Ambrogio at Genoa (also G. Valeriano, 1587);[24] S. Alessandro at Milan; S. Maria della Sanità, Naples (Fra Nuvolo, 1602); the Duomo Nuovo at Brescia (G.B. Lantana, 1604); and S. Carlo ai Catinari in Rome (Rosato Rosati, 1612). All these buildings are interrelated; all of them have a square or rectangular outside shape and only one façade (instead of four); and all of them link the centralized plan of St Peter's with an emphasis on the longitudinal axis: the Gesù Nuovo by adding a pair of satellite spaces to the west and east ends, S. Ambrogio by adding a smaller satellite unit to the west and extending the east end; the Duomo Nuovo at Brescia and S. Carlo ai Catinari by prolonging the choir, the latter, moreover, by using oval-shaped spaces along the main axis, S. Maria della Sanità by enriching the design by a pair of satellite units to each of the four arms; S. Alessandro, finally, by adding a smaller centralized group with saucer dome to the east [55]. S. Alessandro, therefore, is in a way the most interesting of this series of large churches. It contains another important feature: the arches of the crossing rest on freestanding columns. Binago himself recommended that these be used with discretion. The motif was immediately taken up by Lantana in the Duomo Nuovo at Brescia and had a considerable following in Italy and abroad, down to

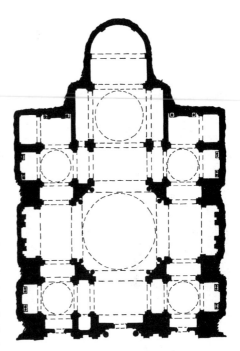

55. Lorenzo Binago: Milan, S. Alessandro, begun 1601. Plan

Jules Hardouin Mansart's dome of the Invalides in Paris.

The joining of two centralized designs in one plan had a long pedigree. In a sense, the problem was already inherent in Brunelleschi's Old Sacristy of S. Lorenzo; but it was only in the North Italian circle of Bramante that the fully developed type emerged in the form of a co-ordination of two entirely homogeneous centralized domed spaces of different size,[25] an arrangement, incidentally, which had the support of classical authority.[26] Binago's S. Alessandro represents an important step towards a merging of two previously separate units: now the far arm of the large Greek-cross unit also belongs to the smaller domed space. In addition, the spacious vaulting between the two centralized groups makes their separation im-

possible. Thus the unification of two centralized groups results in a longitudinal design of richly varied character.

It is at once evident that this form of spatial integration was a step forward into new territory, full of fascinating possibilities. For a number of reasons one may regard the whole group of churches here mentioned as Late Mannerist, not least because of the peculiar vacillation between centralization and axial direction. It is precisely in this respect that Binago's innovation must be regarded as revolutionary, for he decisively subordinated centralized contraction to axial expansion. The future lay in this direction. On the other hand, the derivations from the centralized plan of St Peter's found little following during the seventeenth century, and it was only in the eighteenth century that they saw a limited revival,[27] probably because of their Late Mannerist qualities.

The next step beyond S. Alessandro was taken by Francesco Maria Ricchino (1584-1658), through whom Milanese architecture entered a new phase. It was he, a contemporary of Mangone, who threw the classicist conventions of the reigning taste overboard and did for Milan what Carlo Maderno did for Rome. Although almost a generation younger than Maderno, his principal works, like Maderno's, fall into the first three decades of the century. Ricchino's work has never been properly studied, but it would seem that, when one day the balance sheet can be drawn up, the prize for being the most imaginative and most richly endowed Italian architect of the early seventeenth century will go to Ricchino rather than Maderno. Beginning work under Binago, he was sent by his patron, Cardinal Federico Borromeo, to Rome to finish his education. After his return in 1603 he submitted his first design for the façade of the cathedral. In 1605 he was *capomastro*, a subordinate officer under Aurelio Trezzi, who was Architect to the Cathedral in 1598 and 1604-5. Much later, between 1631

and 1638, Ricchino himself held this highest office to which a Milanese architect could aspire.

In 1607 he designed his first independent building, the church of S. Giuseppe, which was at once a masterpiece of the first rank.[28] The plan [56] consists of an extremely simple combination of two Greek-cross units. The large congregational space is a Greek cross with

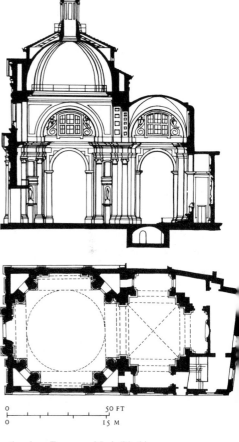

0 50 FT
0 15 M

56 and 57. Francesco Maria Ricchino:
Milan, S. Giuseppe, begun 1607.
Section and plan *(above)* and façade *(opposite)*

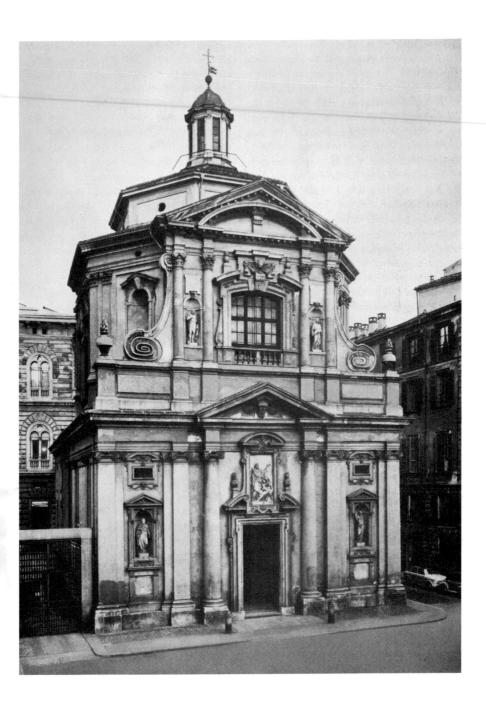

dwarfed arms and bevelled pillars which open into *coretti* above niches and are framed with three-quarter columns; four high arches carry the ring above which the dome rises. The small square sanctuary has low chapels instead of the cross arms. Not only does the same composite order unify the two spaces, but also the high arch between them seems to belong to the congregational room as well as to the sanctuary. Binago's lesson of S. Alessandro was not lost. Ricchino employed here a similar method of welding together the two centralized spaces, which disclose their ultimate derivation from Bramante even after their thorough transformation. This type of plan, the seventeenth-century version of a long native tradition, contained infinite possibilities, and it is impossible to indicate here its tremendous success. Suffice it to say that the new fusion of simple centralized units with all its consequences of spatial enrichment and scenic effects was constantly repeated and, mainly in Northern Italy, revised and further developed; but Ricchino had essentially solved the problem.

S. Giuseppe was finished in 1616; the façade, however, was not completed until 1629-30, although it was probably designed at a much earlier date[29] [57]. It represents a new departure in two respects: Ricchino attempted to give the façade a unity hitherto unknown and at the same time to co-ordinate it with the entire structure of the church. As regards the latter point, the problem had never been squarely faced. By and large the Italian church façade was an external embellishment, designed for the view from the street and rather independent of the structure lying behind it. Ricchino determined the height of the lower tier by the height of the square body of the church and that of the upper tier by the octagonal superstructure; at the same time, he carried the order of the façade over into the rest of the structure, as far as it is visible from the street. Despite this significant integration of the 'show-front' with the whole building, Ricchino could not achieve a proper dynamic relationship between inside and outside, a problem that was solved only by the architects of the High Baroque. As to the first point, the façade of S. Giuseppe has no real precursors in Milan or anywhere in the North. On the other hand, Ricchino was impressed by the façade of S. Susanna, but he replaced Maderno's stepwise arrangement of enclosed bays by one in which the vertical links take prominence, in such a way that the whole front can and should be seen as composed of two high aedicules, one set into the other. The result is very different from Maderno's: for instead of 'reading', as it were, the accretion of motifs in the façade in a temporal process, his new 'aedicule front' offers an instantaneous impression of unity in both dimensions. It was the aedicule façade that was to become the most popular type of church façade during the Baroque age.[30]

Fate has dealt roughly with most of Ricchino's buildings. He was, above all, a builder of churches, and most of them have been destroyed;[31] many are only known through his designs;[32] some have been modernized or rebuilt, while others were carried out by pupils (S. Maria alla Porta, executed by Francesco Castelli and Giuseppe Quadrio). In addition, there was his interesting occasional work[33] which needs, like the rest, further investigation. In his later centralized buildings he preferred the oval and, as far as can be judged at present, he went through the whole gamut of possible designs. Of the buildings that remain standing, five may cursorily be mentioned: the large courtyard of the Ospedale Maggiore (1625-49), impressive in size, but created in collaboration with G. B. Pessina, Fabio Mangone, and the painter G. B. Crespi, and therefore less characteristic of him than the grand aedicule façade of the monumental entrance to the Hospital; the palaces Annoni (1631) and Durini (designed 1648), which look back by way of Meda's Palazzo Visconti (1598) to Bassi's Palazzo Spinola;[34] the

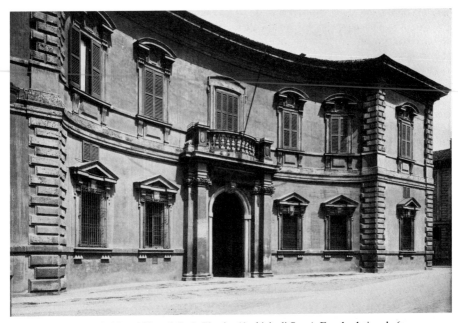

58. Francesco Maria Ricchino: Milan, Collegio Elvetico (Archivio di Stato). Façade, designed 1627

Palazzo di Brera (1651–86), built as a Jesuit College, with the finest Milanese courtyard which, having arches on double columns in two tiers, marks, after the severe phase, a return to Alessi's Palazzo Marino;[35] and finally, the façade of the Collegio Elvetico, designed in 1627, a work of great vigour which has, moreover, the distinction of being an early, perhaps the earliest, concave palazzo façade of the Baroque [58]. With Ricchino's death we have already overstepped the chronological limits of this chapter. Nobody of his stature remained in Milan to carry on the work he had so promisingly accomplished.

Mention has been made of the Sanctuary at Varese near Milan which Cardinal Federico Borromeo had very much at heart. The architectural work began in 1604 and was carried out through most of the century.[36] As one would expect, the fifteen chapels designed by Giuseppe Bernasconi from Varese correspond to the severe classicism practised in Milan at the beginning of the seventeenth century. To the modern visitor there is a peculiar contrast between the classicizing chastity of the architecture and the popular realism of the *tableaux vivants* inside the chapels. If anywhere, the lesson can here be learned that these are two complementary facets of counter-reformatory art.

In the Duomo Nuovo Brescia has an early Seicento work of imposing dimensions (p. 117). But just as so often in medieval times, the execution of the project went beyond the resources of a small city. After the competition of 1595 the design by Lantana (1581–1627) was finally chosen in 1603. The next year saw the laying of the foundation stone, but as late as 1727 only the choir was roofed. Until 1745 there was a renewed period of activity due to the initiative

of Cardinal Antonio Maria Querini. The Michelangelesque dome, however, was erected after 1821 by Luigi Cagnola, who introduced changes in the original design.[37]

To the names of the two able Barnabite architects Rosato Rosati and Lorenzo Binago, working at the beginning of the Seicento, that of Giovanni Magenta (1565-1635)[38] must be added. He was the strongest talent at Bologna during the first quarter of the century. A man of great intellectual power, engineer, mathematician, and theoretician, he even became in 1612 General of his Order. In 1605 he designed on a vast scale the cathedral of S. Pietro at Bologna, accomplishing the difficult union with Domenico Tibaldi's choir (1575), which he left untouched. The design differs from St Peter's and the great Roman congregational churches in the alternating high and low arches leading into the aisles. With its brilliant light and the eighteenth-century *coretti*, added by Alfonso Torreggiani (1765), the church looks much later than it is. The execution lay in the hands of Floriano Ambrosini and Nicolò Donati. While they changed to a certain extent Magenta's project,[39] the latter is fully responsible for the large church of S. Salvatore, designed in 1605 and erected by T. Martelli between 1613 and 1623 [59]. Inspired by the large halls of Roman thermae, Magenta here monumentalized the North Italian tradition of using free-standing columns

59. Giovanni Magenta:
Bologna, S. Salvatore, 1605-23. Plan

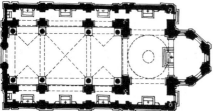

in the nave.[40] By virtue of this motif, the nave appears isolated from the domed area. In addition, the large central chapels with arches rising to the whole height of the vaulting of the nave look like a transverse axis and strengthen the impression that the nave is centred upon itself. In fact, on entering the church one may well believe oneself to be in a Greek-cross unit (without dome), to which is added a second, domed unit. Whether one may or may not want to find in Magenta's ambiguous design a Late Mannerist element, it is certain that he imaginatively transmuted North Italian conceptions. Early Baroque in its massiveness, S. Salvatore was destined to exercise an important influence on the planning of longitudinal churches. Magenta's church of S. Paolo, begun in 1606, shows that he was even capable of enlivening the traditional Gesù type, to which Roman architects of this period did not really find an alternative. By making space for confessionals with *coretti* above them between the high arches leading into the chapels, he created, more effectively than in the cathedral, a lively rhythm along the nave, reminiscent of Borromini's later handling of the same problem in S. Giovanni in Laterano.

Parma, flourishing under her Farnese princes, had in Giovan Battista Aleotti (1546-1636) and his pupil Giovan Battista Magnani (1571-1653)[41] Early Baroque architects. The former, assisted by Magnani, built the impressively simple hexagon of S. Maria del Quartiere (1604-19),[42] the exterior of which is an early example of the pagoda-like build-up of geometrical shapes taken up and developed later by Guarino Guarini (Chapter 17, Note 12). Aleotti was for twenty-two years in the service of Alfonso d'Este at Ferrara, where he erected, among others, the imposing façade of the University (1610), together with Alessandro Balbi, the architect of the Madonna della Ghiara at Reggio Emilia (1597-1619), a building dependent on the plan of St Peter's though less distinguished

than the series of buildings mentioned above. In Ferrara Aleotti also made his debut as an architect of theatres,[43] an activity that was crowned by his Teatro Farnese, built at Parma between 1618 and 1628. The Farnese theatre, exceeding in size and magnificence any other before it, superbly blends Palladio's and Scamozzi's archaeological experiments with the progressive tendencies evolved in Florence.[44] The wide-open, rectangular proscenium-arch together with the revolutionary U-shaped form of the auditorium contained the seeds of the spectacular development of the seventeenth-century theatre. Heavily damaged during the last war, it has now been largely rebuilt.

Genoa's great period of architectural development is the second half of the sixteenth century. It was Galeazzo Alessi who created the Genoese palazzo type along the Strada Nuova (now Via Garibaldi), begun by him in 1551.[45] But to his contemporary Rocco Lurago must be given pride of place for having recognized the architectural potentialities which the steeply rising ground of Genoa offered. His Palazzo Doria Tursi in Via Garibaldi (begun 1568) shows for the first time the long vista from the vestibule through the *cortile* to the staircase ascending at the far end. Bartolomeo Bianco (before 1590–1657), Genoa's greatest Baroque architect,[46] followed the lead of the Palazzo Doria Tursi. His most accomplished structure is the present University, built as a Jesuit College (planned 1630)[47] along the Via Balbi (the street which he began in 1606 and opened in 1618); it presents an ensemble of incomparable splendour [60, 61]. For the first time he unified architecturally the vestibule and courtyard, in spite of their different levels; in

60. Bartolomeo Bianco:
Genoa, University, planned 1630. Courtyard

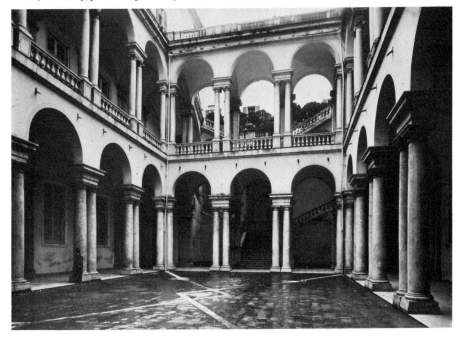

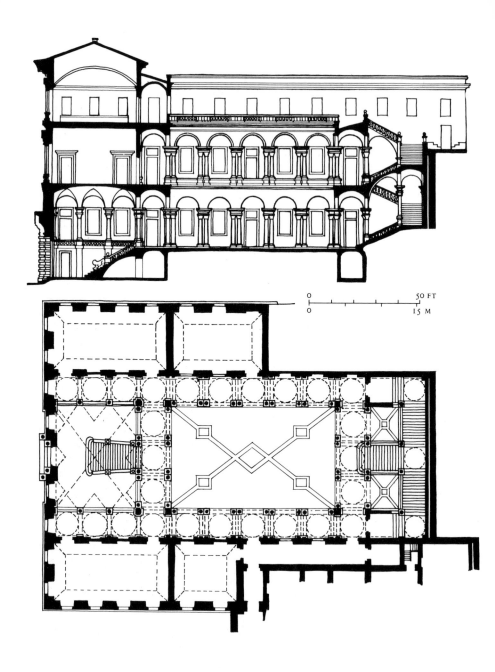

61. Bartolomeo Bianco: Genoa, University, planned 1630. Section and plan

the *cortile* he introduced two tiers of lofty arcades resting on twin columns;[48] and at the far end he carried the staircase, dividing twice, to the whole height of the building. Fully aware of the coherence of the whole design, the eye of the beholder is easily led from level to level, four in all. The exterior contrasts with the earlier Genoese palazzo tradition by the relative simplicity of the design without, however, breaking away from the use of idiomatic Genoese motifs.[49]

Compared with the University, Bianco's Palazzi Durazzo-Pallavicini (Via Balbi 1, begun 1619) and Balbi-Senarega (Via Balbi 4, after 1620) are almost an anticlimax. While the latter was finished by Pier Antonio Corradi (1613-83), the former was considerably altered in the course of the eighteenth century by Andrea Tagliafichi (1729-1811), who built the grand staircase. Apart from the balconies and the cornices resting on large brackets, both palaces are entirely bare of decoration. This is usually mentioned as characteristic of Bianco's austere manner. It is, however, much more likely that these fronts were to be painted with illusionist architectural detail (such as window surrounds, niches, etc.) and figures in keeping with a late sixteenth-century Genoese fashion.[50]

In contrast to the north of Italy, the contribution of Tuscan architects to the rise of Baroque architecture is rather limited. One is inclined to think that Buontalenti's ample and rich decorative manner might have formed a starting point for the emergence of a proper Seicento style. Yet Ammanati's precise Late Mannerism and, perhaps to a larger extent, Dosio's austere classicism corresponded more fully to the latent aspirations of the Florentines. It is hardly an overstatement to say that towards 1600 an academic classicizing reaction against Buontalenti set in. Nevertheless, Buontalenti's decorative vocabulary was never entirely forgotten; one finds it here, there, and everywhere till the late eighteenth century, and even architects outside Florence were inspired by it.

Thus the Florence of the early seventeenth century developed her own brand of a classicizing Mannerism, and this was by and large in keeping with the all-Italian position. But Florence never had a Maderno or a Ricchino, a Bianco or Longhena; she remained to all intents and purposes anti-Baroque and hardly ever broke wholly with the tenets of the early seventeenth-century style. The names of the main practitioners at the beginning of the seventeenth century are Giovanni de' Medici (d. 1621),[51] Cosimo I's natural son, who supervised the large architectural undertakings during Ferdinand I's reign (1587-1609); Lodovico Cigoli (1559-1613), the painter (pp. 97-8) and architect,[52] Maderno's unsuccessful competitor for St Peter's, the builder of the choir of S. Felicità, of a number of palaces, and according to Baldinucci also of the austere though unconventional courtyard of Buontalenti's Palazzo Nonfinito; and Giulio Parigi (1571-1635) and his son Alfonso (1600-c. 1656),[53] famous as theatrical designers of the Medici court, who imparted a scenographic quality to the *Isolotto* and the theatre in the Boboli gardens. Giulio exerted a distinct influence on his pupil Callot and also on Agostino Tassi, whose scenic paintings reveal his early training.[54] Finally, Matteo Nigetti (1560-1649),[55] Buontalenti's pupil, must be added, whose stature as an architect has long been overestimated. His contribution to the Cappella dei Principi is less original than has been believed, nor has he any share in the final design of S. Gaetano, for which Gherardo Silvani alone is responsible (p. 301).[56] His manner may best be judged from his façade of the Chiesa di Ognissanti (1635-7). Here, after forty years, he revived with certain adjustments[57] the academic Mannerism of Giovanni de' Medici's façade of S. Stefano dei Cavalieri at Pisa (1593). In order to assess the sluggish path of the Florentine development, one may compare the Ognissanti façade with that of Ascanio Vittozzi's Chiesa del Corpus Domini at Turin, where it

can be seen how by 1607 the theme of S. Stefano was handled in a vigorously sculptural Early Baroque manner.

During the first half of the seventeenth century the erection of the huge octagonal funeral chapel (Cappella dei Principi) absorbed the interest and exhausted the treasury of the Medici court. Lavishly incrusted with coloured marbles and precious stones, the chapel, lying on the main axis of S. Lorenzo, was to offer a glittering viewpoint from the entrance of the church. Since the wall between the church and the chapel remained standing, this scenic effect, essentially Baroque and wholly in keeping with the Medicean love of pageantry and the stage, was never obtained. As early as 1561 Cosimo I had planned a funeral chapel, but it was only Grand Duke Ferdinand I who brought the idea

62. Giovanni de' Medici, Alessandro Pieroni, Matteo Nigetti, Bernardo Buontalenti: Florence, S. Lorenzo, Cappella dei Principi, begun 1603

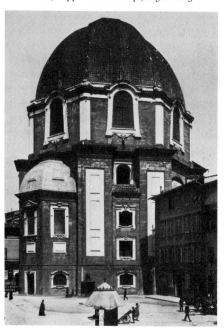

to fruition. After a competition among the most distinguished Florentine artists, Giovanni de' Medici together with his collaborator, Alessandro Pieroni, and Matteo Nigetti prepared the model which was revised by Buontalenti (1603-4). The latter was in charge of the building until his death in 1608, when Nigetti continued as clerk of works for the next forty years.[58] If in spite of such activity the chapel remained a torso for a long time to come, it yet epitomizes Medici ambition of the early seventeenth century. In the interior the flat decorative quality takes precedence over the structural organization, and by Roman standards of the time the exterior [62] must have been judged as a shapeless pile. Rather sober and dry in detail, the large drum and dome do not seem to tally with their substructure. Windows of different sizes and in different planes are squeezed in between the massive and ill-articulated 'buttresses'. There is, in fact, no end to the obvious incongruities which manifest a stubborn adherence to the outmoded principles of Mannerism.

Naples saw in the last two decades of the sixteenth century a considerable intensification of architectural activity, due to the enthusiasm of two viceroys. Lacking native talents, architects had to be called from abroad. Giovan Antonio Dosio (d. 1609) and Domenico Fontana (d. 1607) settled there for good. The former left Florence in 1589;[59] the latter, running into difficulties after Sixtus V's death, made Naples his home in 1592, where as 'Royal Engineer' he found tasks on the largest scale, among them the construction of the Royal Palace (1600-2). Thus Florentine and Roman classicism were assimilated in the southern kingdom. A new phase of Neapolitan architecture is linked to the name of Fra Francesco Grimaldi (1543-1613), a Theatine monk who came from Calabria.[60] His first important building, S. Paolo Maggiore (1581/3-1603), erected over the ancient temple of Castor and Pollux, proves him an architect of uncommon ability. In spite

of certain provincialisms, the design of S. Paolo has breadth and a sonorous quality that may well be called Early Baroque. The wide nave with alternating high and low arches, opening respectively into domed and vaulted parts of the (later) aisles, is reminiscent of Magenta's work in Bologna and more imaginative than Roman church designs of the period. In 1585 Grimaldi was called to Rome, where he had a share in the erection of S. Andrea della Valle. He must have had the reputation of being the leading Theatine architect. Among his post-Roman buildings, S. Maria della Sapienza (begun 1614, with façade by Fanzago) returns, more sophisticated, to the rhythmic articulation of S. Paolo, while S. Maria degli Angeli (1600-10), the Cappella del Tesoro, which adjoins the cathedral and is itself the size of a church (1608-after 1613), and SS. Apostoli (planned c. 1610, executed 1626-32) are all thoroughly Roman in character and succeed by their scale and the vigorous quality of the design.

Next to Grimaldi, Giovan Giacomo di Conforto (d. 1631) and the Dominican Fra Nuvolo (Giuseppe Donzelli) should be mentioned. Conforto began under Dosio, was after the latter's death architect of S. Martino until 1623, and built, apart from the campanile of the Chiesa del Carmine (1622, finished by Fra Nuvolo, 1631), three Latin-cross churches (S. Severo al Pendino, S. Agostino degli Scalzi, 1603-10, and S. Teresa, 1602-12). A more fascinating figure is Fra Nuvolo. He began his career with S. Maria di Costantinopoli (late sixteenth century), where he faced the dome with majolica, thus inaugurating the characteristic Neapolitan type of colourful decoration. His S. Maria della Sanità (1602-13) has been mentioned (p. 117); his S. Sebastiano, with a very high dome, and S. Carlo all'Arena (1631), both elliptical, are uncommonly interesting and progressive.

These brief hints indicate that by the end of the first quarter of the seventeenth century Naples had a flourishing school of architects. By that time the great master of the next generation, Cosimo Fanzago, was already working. But it was then that Rome asserted her ascendancy, and Naples as well as the cities of the North, which had contributed so much to the rise of the new style, were relegated once again to the role of provincial centres.

SCULPTURE

Rome

We have seen in the first chapter that sculpture in Rome had reached a low-water mark during the period under review. By and large the work executed in the Chapel of Paul V in S. Maria Maggiore during the second decade of the seventeenth century was still tied to the Late Mannerist standards set in Sixtus V's Chapel, and none of the sculptors of the Carracci generation - Cristoforo Stati,[61] Silla da Viggiù, Ambrogio Bonvicino, Paolo Sanquirico, Nicolò Cordier, Ippolito Buzio - showed a way out of the impasse in which sculpture found itself landed. Among this group there was hardly an indication that the tired and facile formalistic routine would so soon be broken by the rise of a young genius, Bernini, who was then already beginning to produce his juvenilia. It cannot be denied that the older masters also created solid work. In particular, some of Buzio's, Cordier's, and Valsoldo's statues and busts have undeniably high qualities, but that does not impair the assessment of the general position. In a varying degree, they all translated the models they followed into a tame and frigid style. This is true for Buzio's Sansovinesque St James of c. 1615 (S. Giacomo degli Incurabili) as well as for Cordier's Luisa Deti Aldobrandini (c. 1605, Aldobrandini Chapel, S. Maria sopra Minerva), which goes back to Guglielmo della Porta,[62] and for Valsoldo's St Jerome (c. 1612, S. Maria Maggiore), so clearly dependent on

Alessandro Vittoria. If one adds the tradition of the style of Flemish relief one has accounted, it would seem, for the primary sources of inspiration of these sculptors.

Four other artists, also engaged on the Chapel of Paul V, have not yet been discussed, namely Stefano Maderno, Pietro Bernini, Camillo Mariani, and, above all, Francesco Mochi, though it is they who had a considerable share in the revitalization of Roman sculpture after 1600. Stefano Maderno from Bissone in Lombardy (1576-1636) appeared in Rome at the end of the sixteenth century. He soon made a name for himself with the marble statue of St Cecilia (in S. Cecilia, 1600) which depicts according to a persistent legend the body of the youthful saint exactly in the position in which it was found in 1599.[63] The sentimental flavour of this story apart, which helped to secure for Maderno his lofty place in the history of sculpture, the statue is imbued with a truly moving simplicity, and many later statues of recumbent martyr saints followed this model. His later monumental work in marble for Roman churches is not particularly distinguished;[64] but in his small terracotta models, bronzes, and (rare) marbles (Cà d'Oro, Venice; Palermo; Dresden; London; Oxford; etc.),[65] which derive from famous antiques, he combines a carefully studied classicism with solid realistic observations [63]. This was the artistic climate in which Bernini's early work was to rise.

As the father of the great Gianlorenzo, Pietro Bernini (1562-1629) commands special interest.[66] His career unfolds in three stages: the early years in Florence and Rome, the twenty-odd years in Naples (1584-1605/6), and the last decades in Rome, mainly in the service of Paul V. The Neapolitan setting held no surprise for a Florence-trained sculptor, and during the full years of his sojourn he adjusted himself without reservation to the pietistic climate of the southern metropolis, notable in the work of Naccherino, with whom he also collaborated.

63 *(below)*. Stefano Maderno: Hercules and Cacus, *c*. 1610. *Dresden, Albertinum*

64 *(right)*. Pietro Bernini: St John the Baptist, 1614-15. *Rome, S. Andrea della Valle*

65 *(far right)*. Camillo Mariani: St Catherine of Alexandria, 1600. *Rome, S. Bernardo alle Terme*

In Rome he changed to a more boisterous manner, no doubt through contact with Mariani and Mochi, and produced work in which he combined the new Early Baroque *brio* with a painterly approach which is not strange to find in the pupil of Antonio Tempesta (*Assumption of the Virgin*, Baptistery, S. Maria Maggiore, 1607-10; *Coronation of Clement VIII*, Cappella Paolina, S. Maria Maggiore, 1612-13). But the bodies of his figures lack structure and seem boneless, and the texture of his Roman work is

soft and flaccid [64]. All this is still typically Late Mannerist, and indeed between his slovenly treatment of the marble and the firm and precise chiselling found in the early work of his son there is an almost unbridgeable gulf. Nor is the dash to be observed in his Roman work purposeful and clearly defined. He prefers to represent unstable attitudes which baffle the beholder: his *St John* in S. Andrea della Valle is rendered in a state between sitting, getting up and hurrying away.

Camillo Mariani's (1565?-1611) work was of greater consequence in revitalizing Roman sculpture.[67] He was born in Vicenza and had in the studio of the Rubini the inestimable advantage of going through the discipline of Alessandro Vittoria's school. Shortly after his arrival in Rome he executed his masterpieces, the eight simple and noble monumental stucco figures of saints in S. Bernardo alle Terme (1600), in which the Venetian nuance is obvious for anyone to see [65]; but it is strengthened by

66 *(above)*. Francesco Mochi:
The Virgin of the Annunciation, 1603–8.
Orvieto, Museo dell'Opera

67 *(opposite)*. Francesco Mochi:
Alessandro Farnese,
1620–5. Bronze. *Piacenza, Piazza Cavalli*

a new urgency and a fine psychological penetration which make these works stand out a mile from the average contemporary production and ally them to the intensity of the transitional style in painting in which we found crystallized the true spirit of the great reformers.

Mariani was also the strongest single factor in shaping the style of Francesco Mochi (1580–1654).[68] Born at Montevarchi near Florence, Mochi had his early training with the Late Mannerist painter Santi di Tito before studying under Mariani in Rome. His first independent work of importance, the large marble figures of the *Annunciation* at Orvieto (1603–8), show in a fascinating mixture the components of his style: linear Tuscan and realistic North Italian Mannerism. Mochi knew how to blend these elements into a manner of immense vitality; the *Annunciation* is like a fanfare raising sculpture from its slumber [66]. It is clearly more than a coincidence that on Roman soil the new invigorating impetus appears in the three arts almost simultaneously: Mochi's *Annunciation* is informed by a bold spirit, freshness, and energy similar to Caravaggio's Roman grand manner (1597–1606), Annibale's Farnese ceiling (1597–1604), and Maderno's S. Susanna (1597–1603). From 1612 to 1629 Mochi stayed with brief interruptions at Piacenza in the service of Ranuccio Farnese and created there the first dynamic equestrian statues of the Baroque, breaking decisively with the tradition of Giovanni Bologna's school. The first of the two monuments, that of Ranuccio Farnese (1612–20), is to a certain extent still linked to the past, while the later, Alessandro Farnese's (1620–5), breaks entirely new ground [67]. Imbued with a magnificent sweep, the old problem of unifying rider and horse is here solved in an unprecedented way. Never before, moreover, had the figure of the rider held its own so emphatically against the bulk of the horse's body.

After his return to Rome he executed his most spectacular work, the giant marble statue

of St Veronica (St Peter's, 1629–40), which seems to rush out of its niche driven by uncontrollable agony. In this work Mochi already reveals a peculiar nervous vehemence and strain. A stranger in the changed Roman climate, outclassed by Bernini's genius and disappointed, he protested in vain against the prevalent tide of taste. Frustrated, he renounced everything he had stood for and returned to a severe form of Mannerism. His later statues, such as the Christ [68] and St John from the Ponte Molle

68. Francesco Mochi: Christ, from the Baptism, after 1634. *Rome, formerly Ponte Molle*

(1634–*c.* 1650), the Taddaeus at Orvieto (1641–4), and the St Peter and St Paul of the Porta del Popolo (1638–52), are not only an unexpected anachronism, but are also very unequal in quality. Always alone among his contemporaries, first the sole voice of uninhibited progress, then the sole prophet of bleak despair, he was utterly out of tune with his time. His Baroque works antedate those of the young Bernini, whose superiority he refused to acknowledge – and it was this that broke him.[69]

Sculpture outside Rome

Florentine sculptors of the first half of the seventeenth century faithfully nursed the heritage of the great Giovan Bologna. Pietro Francavilla (*c.* 1553–1615) and Giovanni Caccini (1556–1612), characteristic exponents of this often very engaging *ultima maniera*, belong essentially to the late Cinquecento. The same applies to Antonio Susini (d. 1624), Bologna's collaborator, who went on selling bronzes from his master's forms, a business which his nephew Francesco Susini continued until his death in 1646.[70] The latter's 'Fountain of the Artichokes', erected between 1639 and 1641 on the terrace above the courtyard of the Palazzo Pitti, is in the draughtsman-like precision of the architectural structure closely linked to similar sixteenth-century fountains, while decorative elements such as the four shell-shaped basins derive from Buontalenti's Mannerism. Similarly, Domenico Pieratti's and Cosimo Salvestrini's Cupids on the fountains placed along the periphery of the large basin of the *Isolotto* in the Boboli, designed by the Parigi between 1618 and 1620, have the precious poses of Late Mannerist figures. Even Pietro Tacca (1577–1640),[71] certainly the greatest artist of this group and the most eminent successor to Giovanni Bologna, is not an exception to the rule. First, from 1598 onwards he was a conscientious assistant to the master; later he

finished a number of works left in various stages of execution at the latter's death.[72] Deeply steeped in Giovanni Bologna's manner, he began work on his own. His most celebrated figures are the four bronze slaves at the base of Bandini's monument to Ferdinand I de' Medici at Livorno (1615-24).[73] Such figures of subdued captives, of classical derivation, played an important part in the symbolic Renaissance representations of triumphs,[74] and we know them in Florentine sculpture from Bertoldo's battle-relief and Michelangelo's tomb of Julius II down to Giovanni Bologna's (destroyed) equestrian monument of Henry IV of France. Here too, as in the case of Tacca's work, the four chained captives at the corners of the base were a polite metaphor rather than a conceit laden with deep symbolism. Two of these captives, for which Francavilla was responsible, have survived; by comparison Tacca's figures show a fresh realism[75] and a broadness of design which seem, indeed, to inaugurate a new era. But one should not be misled. These captives not only recall the attitudes imposed on models in life drawing classes, but their complicated movement, the ornamental rhythm and linear quality of their silhouettes are still deeply indebted to the Mannerist tradition, and even older Florentine Mannerists such as the engraver Caraglio come to mind. Later works by Tacca confirm this view. The famous fountains in the Piazza Annunziata at Florence, originally made for Livorno in 1627, with their thin crossing jets of water, the over-emphasis on detail (which presupposes inspection from a near standpoint and not, as so often in the Baroque, from far away), the virtuosity of execution, and the decorative elegance of monstrous formations are as close to the spirit of Late Mannerism as the over-simplified gilt bronze statues of Ferdinand I and Cosimo II de' Medici in the Cappella dei Principi in S. Lorenzo (1627-34).[76] Even his last great work, the Philip IV of Spain on the rearing horse in

Madrid (1634-40) [69],[77] is basically akin to Giovanni Bologna's equestrian monuments with the customary trotting horse. The idea of representing the horse in a transitory position on its hindlegs – from then on *de rigueur* for monuments of sovereigns – was forced upon Tacca by Duke Olivarez, who had a Spanish painting sent to Florence to serve as model.[78] But Tacca's equestrian statue remains reserved and immobile and is composed for the silhouette. It lacks the Baroque momentum of Francesco

69. Pietro Tacca: Philip IV, 1634-40. *Madrid, Plaza de Oriente*

Mochi's Alessandro Farnese and Bernini's Constantine.

In Giovanni Bologna's wake, Florentine Mannerist sculpture of the *fin-de-siècle* had, even more than Florentine painting of the period, an international success from the Low Countries to Sicily. Also Neapolitan sculpture at the turn of the century was essentially Florentine Man-

nerist in character. Two artists, above all, were responsible for this trend: Pietro Bernini, whom we found leaving Naples for Rome in 1605/6, and Michelangelo Naccherino, a pupil of Giovanni Bologna, who was the strongest power in Naples for almost fifty years, from his arrival in 1573 till his death in 1622. He never abandoned his intimate ties with Florentine Mannerism, but owed more to the older generation of Bandinelli, Vincenzo Danti, Vincenzo de' Rossi, and even to Donatello than to his teacher, whom he accused of irreligiosity.[79] In the pietistic climate of the Spanish dominion his figures are often imbued with a wholly un-Florentine religious mood and a mystic sensibility, eloquent testimonies of the spirit of the Counter-Reformation. Characteristic examples are his tombs of Fabrizio Pignatelli in S. Maria dei Pellegrini (1590-1609), Vincenzo Carafa in SS. Severino e Sosio (1611), and Annibale Cesareo in S. Maria della Pazienza (1613). In all these tombs the deceased is represented standing or kneeling, one hand pressed against the chest in devotional fervour.[80] Naccherino anticipated here a type of sepulchral monument that was to become of vital importance in the different atmosphere of Rome during the 1630s and 1640s.

The contribution of Lombardy to the history of the Baroque consists to a considerable extent in the constant stream of stonemasons, sculptors, and architects to Rome, where they settled. In Milan itself seventeenth- as well as eighteenth-century sculpture is disappointing. The reasons are difficult to assess. They may lie in the permanent drain on talents, in the petrifying influence of the Ambrosian Academy, or in the bureaucracy which had developed in the works of the cathedral. For generations the great sculptural tasks were connected with the cathedral, and it was only there and, to a more limited degree, in the Certosa of Pavia that sculptors could find rewarding employment. Thus the academic Late Mannerist tradition of Pellegrino Tibaldi and the younger Brambilla was continued by the latter's pupil Andrea Biffi (d. 1631) and others, and by Biffi's pupils Gaspare Vismara (d. 1651) and Gian Pietro Lasagni (d. 1658), the leading masters, who perpetuated the stylistic position of about 1600 until after the middle of the seventeenth century. Even an artist like Dionigi Bussola (1612-87), whose dates correspond almost exactly with those of the romanized Lombard Ercole Ferrata (p. 307), did not radically change the position[81] in spite of his training in Rome before 1645. It seems hardly possible to talk of a Milanese High Baroque school, and we may therefore anticipate later events by mentioning Giovan Battista De Maestri, called Volpino, who executed about a dozen statues for the cathedral between 1650 and 1680. During the seventeenth and eighteenth centuries more than 150 sculptors worked in the cathedral studio. Art historians have scarcely begun to sift this material, and one may well ask whether such an undertaking would not be love's labour lost.

Like Bologna and Venice, Genoa hardly had an autonomous school of sculptors during the first half of the seventeenth century. Production was partly under the influence of Lombard academic Mannerism, partly derived from Michelangelo's pupil Montorsoli. The far-reaching impact of Florentine sculpture at this moment may be judged from the fact that Francesco Camilliani's and Naccherino's fountain in the Piazza Pretoria at Palermo, Naccherino's and Pietro Bernini's Fontana Medina at Naples, and Taddeo Carloni's (1543-1613) weak Neptune fountain of the Palazzo Doria at Genoa - all depend on Montorsoli's Orion fountain at Messina.[82]

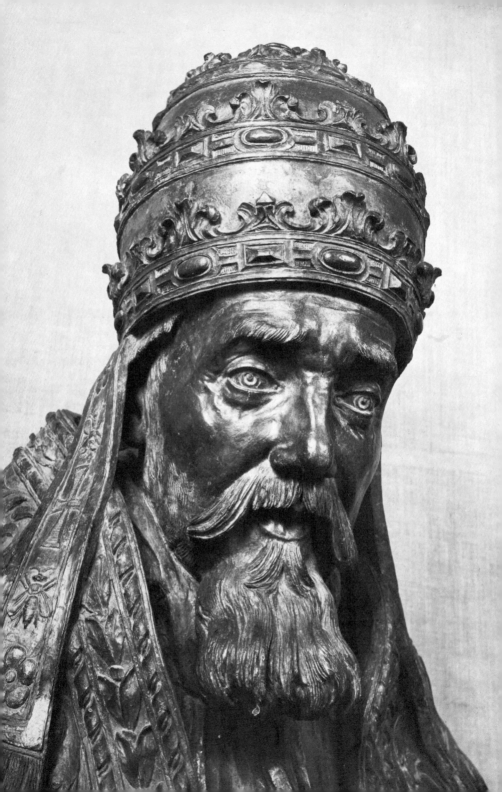

THE AGE OF THE HIGH BAROQUE

CIRCA 1625-CIRCA 1675

CHAPTER 7

INTRODUCTION

The Second Part of this book, with the generic title 'The Age of the High Baroque', comprises many different artistic tendencies; but the period receives its imprint from the over-powering figure of Bernini, who for more than half a century dominated Italian artistic life at the focal point, Rome. His success was made possible because he had the good fortune to serve five popes who showed the highest regard for his genius.

The new era begins with the pontificate of Urban VIII (1623-44), whose strong but refined features survive in a number of magnificent busts by Bernini [70]. Quite different from the austere popes of the Counter-Reformation, Urban saw himself as a Julius II re-born. In his early youth he had written poems in Latin and Italian modelled on Horace and Catullus.[1] As pope he revived the humanist interest in learning and surrounded himself with a circle of poets and scholars, and superficially his court assumed something of the freedom and grandeur of his Renaissance forerunners. But it

would be wrong to see either Urban's reign or those of his successors simply in terms of an increasing secularization. On the contrary, Urban VIII confirmed the decrees of the Council of Trent, and not only maintained the peace with the Jesuits but regarded them as his foremost allies in consolidating the results of the Counter-Reformation. The words with which he registered the memory of St Ignatius in the Roman martyrology are characteristic of his attitude: 'On the 31 July is celebrated in Rome the feast of St Ignatius, Confessor, Founder of the Society of Jesus, illustrious for his holiness, his miracles, and his zeal in propagating the Catholic religion throughout the world.'[2] It is equally characteristic that the Pamphili Pope Innocent X, Urban's successor (1644-55), was attended on his death-bed by none but the general of the Jesuit Order, Padre Oliva, who was also on intimate terms with Bernini.

Once again, therefore, the question asked in the first chapter of this book arises during the new period; did the Jesuits and, for that matter, any other of the vigorous new Orders such as the Carmelites and Theatines take an active part in shaping not only their own but also the papal art policy? No one can doubt that a considerable change occurred in artistic inter-

70. Gianlorenzo Bernini:
Bust of Urban VIII, 1640-2. Bronze. Detail.
Spoleto, Cathedral

pretation of religious experience; but it was not a change in one direction. The bow stretches from an appealing worldliness [236] to tender sensibility [169], to sentimental and mawkish devotion,[3] bigoted piety [207], and mystic elation [78, 79] – sufficient evidence that we face the artists' reactions to the protean temper of the age rather than a deliberate policy. In actual fact, religious institutions accepted whatever was in the power of the artists to offer.

Seicento Devotion and Religious Imagery

One must probe into the religious tendencies which developed in the course of the seventeenth century in order to gain an understanding of the character and diversity of religious imagery.[4] During the first half of the century, casuistry and, in its wake, the various forms of probabilism became the widely accepted patterns of theological thought and conviction, principles to which the masses of the faithful reacted by laxity of morals.[5] It would be difficult to assert that morality sank to a lower level than ever before; what took on a new and morally perilous aspect was that the Church now not only connived at, but even supported, individual decisions of convenience at variance with the letter and the spirit of dogmatic religion. This was the hard core of probabilism. To be sure, in the second half of the century probabilism lost ground, but a public figure such as Padre Oliva, General of the Jesuits from 1664 to 1681, gave it his full support.

At the same time quietism, a new form of mysticism, swept through Spain, France, and Italy. Its chief prophet was the Spanish priest Miguel de Molinos (d. 1697), whose *Guida spirituale*, published in 1675, took Rome by storm.[6] Molinos, it is true, ended his life in prison; yet quietism had come to stay. Catholic historians describe it as a perversion of the mystical doctrine of interior quiet. Molinos's 'soft and savoury sleep of nothingness' of the soul in the state of contemplation led, in the view of traditional ecclesiasticism, to the exaltation of an empty consciousness and consequently to immoral apathy. In contrast to 'classical' mysticism, quietism was theological rather than metaphysical, obscurantism rather than enlightenment, an escapist form of devotion produced at will rather than a spontaneous condition of sublime union with God.

It seems not far-fetched to conclude that the mentality which informed probabilism and quietism found an echo in religious imagery. Much that strikes the modern observer as hypocritical piety in Seicento pictures stems no doubt from the general attitude towards confession and devotion at the time of the Catholic Restoration.

It must also be emphasized that in the course of the seventeenth century the Order of the Jesuits itself went through a characteristic metamorphosis: under the generals Muzio Vitelleschi (1615–45), Vincenzo Caraffa (1645–9), and Giovan Paolo Oliva, mundane interests in wealth, luxury, and political intrigue, and a frivolity in the interpretation of the vows replaced the original zealous and austere spirit of the Order. Moreover, the Catholic Restoration had led to a consolidation of doctrine and authority, expressed by the glamour of the High Baroque papal court, which vied with those of the absolute monarchies. As a result of such developments one finds, broadly speaking, that inside the Church the anti-aesthetic approach to art of the period of the militant Counter-Reformation was now replaced by an aesthetic appreciation of artistic quality. This readiness to discriminate, which began under Pope Paul V, coincided in the pontificates of Urban VIII, Innocent X, and Alexander VII (1655–67) with the maturity of the great Baroque individualists, Bernini, Cortona, Borromini, Sacchi, and Algardi, who received full official recognition.

The turn to aestheticism in official religious circles is one of the distinguishing marks of the

new era. Even if the arts remained an important weapon in the post-counter-reformatory arsenal, they had no longer the sole function to instruct and edify, but also to delight. Every official pronouncement bears this out, beginning with Urban VIII's well-known words, which he supposedly addressed to Bernini after ascending the papal throne. 'It is your great good luck, Cavaliere,' he is reported to have said, 'to see Matteo Barberini pope; but we are even luckier in that the Cavaliere Bernini lives at the time of Our pontificate' – an unambiguous homage to artistic eminence. To what length aesthetic appreciation was carried becomes apparent from some highly interesting documents which, though rather late, yet characterize the new attitude. A controversy arose between the Jesuits and the sculptor Legros regarding the placing of his statue of the Blessed Stanislas Kostka in S. Andrea al Quirinale, Rome.[7] The Jesuits rejected the artist's request to move the statue from the little room of the Novitiate into one of the chapels of the church, advancing the argument, among others, that there would be no relationship between the size of the figure and that of the chapel and, in addition, that the figure would interfere with the uniformity of the church, a principle on which Bernini, the architect, had insisted and which Prince Camillo Pamphili, the patron, had fully accepted.

The course taken by Seicento devotion, the 'secularization' of the Jesuit Order and the papal court, the aesthetic aspirations in clerical circles – all this would seem to militate against a resurgence of mysticism in art. Yet it happened, as is evidenced by a number of Roman sculptures and paintings roughly between 1650 and 1680, from Bernini's *St Teresa* [85] to Gaulli's frescoes in the Gesù [213]. The same tendency is to be found outside Rome; as proof may be mentioned only the late paintings of Giovanni Benedetto Castiglione or the works of Mattia Preti's middle period [245]. Bernini's

late manner, in particular, reveals an intense spirituality at variance with the laxity of official devotion. I have pointed out that Bernini had close contacts with the Jesuits (p. 24) and regularly practised St Ignatius's *Spiritual Exercises*. While the *Exercises* owed their unparalleled success to the vivid appeal they made to the senses, which is also a hall-mark of Bernini's work, their practical psychology, centred in the deliberate evocation of images, was essentially non-physical.

To what extent Bernini himself and others were captivated by quietist mysticism is a question that would need further investigation. Italy produced no great mystics during the seventeenth century, but there seems to have existed a popular undercurrent which kept the mystic tradition alive. It is more than likely that Bernini had studied the writings of Dionysius the Areopagite,[8] and we have his own word for it that the *Imitation of Christ*, written by the late medieval mystic Thomas à Kempis (1380–1471), was his favourite book, from which he used to read a chapter every night.[9] It is in this direction, I believe, that one has to look in order to explain the alliance in many High Baroque works between Jesuit psycho-therapeutic directness and non-Jesuit mysticism.

Rhetoric and Baroque Procedure

Ecstasies and raptures are the psycho-physical conditions which designate the culmination of mystical activity. At many periods artists endeavoured to render not only these conditions themselves but also the visions experienced in that exalted state of perception. What distinguishes the Baroque from earlier periods and even the High from the Early Baroque is that the beholder is stimulated to participate actively in the supra-natural manifestations of the mystic art rather than to look at it 'from outside'. This is meant in a very specific sense, for it is evident that in many works from about 1640

on a dual vision is implied, since the method of representation suggests that the entire image of a saint and his vision is the spectator's supranatural experience. Bernini's St Teresa, shown in rapture, seems to be suspended in mid-air [84, 85], and this can only appear as reality by virtue of the implied visionary state of mind of the beholder. Or to give a later example: in Pozzo's ceiling of S. Ignazio [217] 'illumination' is granted to the saint in ecstasy, but to see the heavens open with the saint and his disciples riding on clouds – that is due to revelation granted to the spectator.[10] Scarcely known to the Early Baroque, the dual vision was often pressed home with all the resources of illusionism during the High Baroque and supported by drama, light, expression, and gesture. Nothing was left undone to draw the beholder into the orbit of the work of art. Miracles, wondrous events, supra-natural phenomena are given an air of verisimilitude; the improbable and unlikely is rendered plausible, indeed convincing.

Representations of dual visions are extreme cases of an attempt to captivate the spectator through an appeal to the emotions. It is worthwhile seeking a common denominator for this approach so obvious in a prominent class of High Baroque religious imagery. The technique of these artists is that of persuasion at any price. Persuasion is the central axiom of classical rhetoric. In an illuminating paper G. C. Argan[11] has therefore rightly stressed the strong influence of Aristotle's *Rhetoric* on Baroque procedure. Aristotle devotes the entire second book of his *Rhetoric* to the rendering of the emotions because they are the basic human stuff through which persuasion is effected. The transmission of emotive experience was the main object of Baroque religious imagery, even in the works of such Baroque classicists as Andrea Sacchi.[12] With his technique of persuasion the artist appeals to a public that wants to be persuaded. In rhetoric, Aristotle asserts, the principles of persuasion, in order to be persuasive, must echo common opinions. Similarly, the Baroque artist responded to the affective behaviour of the public and developed a rhetorical technique that assured easy communication. Thus the artists of this period made use of narrative conventions and a rhetorical language of gestures and expression that often strike the modern observer as hackneyed, insincere, dishonest, or hypocritical.[13]

On the other side of the balance sheet are the growing awareness of personal style and the role assigned to inspiration and imagination and consequently the value put on the sketch, the bozzetto, and the first rough idea, unchecked by the encumbrances of execution. These new values, often uncommitted to current rhetorical usage, were to attain prominence later.

Patronage

Nothing could be more misleading than to label – as has been done[14] – the art of the entire Baroque period as the art of the Counter-Reformation. The austere popes of the late sixteenth century and the great counter-reformatory saints would have been horrified by the sensuous and exuberant art of Bernini's age and would also have been out of sympathy with the art policy of the popes of the Catholic Restoration. It was mainly due to Urban VIII Barberini (1623-44), Innocent X Pamphili (1644-55), and Alexander VII Chigi (1655-67), and their families that Rome was given a new face, an appearance of festive splendour which changed the character of the city for good. In order to assess this transformation, one need only compare the gloomy 'counter-reformatory' palazzo type, exemplified by Domenico Fontana's Lateran palace and the family palace of the Borghese Pope Paul V, with such exhilarating structures as the Palazzo Barberini [53] and the Palazzo Chigi-Odescalchi [107], or the sombre church façades of the late sixteenth and early seventeenth centuries with the imagina-

tive and sparkling creations of a slightly later period, such as S. Andrea al Quirinale [105], S. Agnese [129], SS. Martina e Luca [145], and S. Maria della Pace [147]; one need only think of Bernini's fountains [92], of the elation experienced by generation after generation on the Piazza del Popolo [181], the Piazzas Navona and Campitelli, and, above all, of the jubilant grandeur pervading the Piazza of St Peter's [112,113]. These prominent examples give an idea of the character and extent of papal patronage during the period under review. They also indicate that from Urban VIII's reign on the most important building tasks were handed on to the most distinguished architects, in contrast to the lack of discrimination often to be found in the earlier period; further, that the patrons sympathetically accepted personal idiosyncrasies of style and the determination of artists and architects to solve each problem on its own merits. In contrast to the equalizing tendencies of the earlier phase, the variety of manner now becomes almost unbelievable, not only between architect and architect and not only between the early and late works of one master, but even between one master's works of the same years (cf. illustration 105 with 98 and 119 with 137). Strong-willed individualists make their entry.

If all this be true, some popular misunderstandings should yet be corrected. Contrary to general opinion, most of the new churches built in Rome during this period were small, even very small, in size; the need for large congregational churches was satisfied at an earlier period. Many of the finest structures of the Roman High Baroque, and precisely those which had also the greatest influence inside and outside Italy, are monumental only in appearance, not in scale. Moreover, compared with the extension and diversity of papal, ecclesiastical, and aristocratic patronage under Paul V, artistic enterprises under the following popes were considerably more limited. It would not be possible, for instance, to list a series of frescoes between 1630 and 1650 comparable to those of the years 1606-18 (p. 79).

The High Baroque popes lavished vast sums on their private undertakings: Urban VIII on the Palazzo Barberini and Innocent X on the 'Pamphili Centre', the Piazza Navona with the family palace and S. Agnese.[15] But their primary objective, enhancing the glamour and prestige of the papal court, remained St Peter's, and it was the magnitude of this task that depleted their resources. Immediately after Urban's accession Bernini began work on the Baldacchino [86] and was soon to be engaged on the reorganization of the whole area under the dome as well as on the pope's tomb [83]. Regarding the pictorial decoration of the basilica, Urban's policy was less clear-sighted. Although Andrea Sacchi began to paint in 1625 and was kept busy for the next ten years, at first the pope also fell back on older Florentine painters like Ciampelli and Passignano; Baglione too and even the aged and entirely outmoded Cavaliere d'Arpino received commissions for paintings. But apart from Sacchi's, the main burden lay on Lanfranco's and Cortona's shoulders. Other distinguished artists such as Domenichino, Valentin, Poussin, and Vouet had their share and, in addition, the very young Pellegrini, Camassei, and Romanelli, who held out hopes of great achievement but in the light of history must be regarded as failures.[16] In any case, during Urban's pontificate the work of decoration in St Peter's never stopped, and almost every year saw the beginning of a new enterprise. The tempo slackened under Innocent X, but Alexander VII once again pursued the continuation of the work with the utmost energy. Under him the two most prodigious contributions, the Cathedra of St Peter [87] and the Piazza, took shape.

Compared with St Peter's, the patronage bestowed on the two papal palaces, the Vatican and the Quirinal, was negligible. In the Vatican

Urban had rooms painted by Abbatini and Romanelli, and although the latter's frescoes in the Sala della Contessa Matilda[17] (1637–42) are not devoid of charm, it is obvious that they cannot vie with the monumental works of these years. On the whole, it can be stated that during this period the less distinguished commissions were in the hands of minor artists. This does not apply, however, to the one major operation in the Quirinal palace, the decoration of the Gallery, accomplished in Alexander's reign by all available talents under Pietro da Cortona's supervision (p. 330).

The outstanding achievement of the entire epoch remains Bernini's work in and around St Peter's, executed over a period of almost two generations. Though undertaken without a premeditated comprehensive programme on the part of the popes, this work embodies the spirit of the Catholic Restoration and, implicitly, that of the High Baroque more fully than any other complex of works of art in Rome, Italy, or Europe.[18] In ever new manifestations the perpetuity and triumph of the Church, the glory of faith and sacrifice are given expression, and these highly charged symbols impress themselves on the beholder's eye and mind through their intense and impetuous visual language.[19]

Yet, while this cycle of monumental works seemed to propound Rome's final victory, the authority of the Holy See had already begun to wane. The Peace of Westphalia (1648), ending the Thirty Years War in Europe, made it evident that henceforth the powers would settle their quarrels without papal intercession. Moreover, in the course of the century 'the authority of the Holy See' – in Ranke's words – 'changed inevitably, if gradually, from monarchic absolutism to the deliberative methods of constitutional aristocracy'. Not unexpectedly, therefore, after the age of Bernini, Cortona, and Borromini Rome could no longer maintain her unchallenged artistic supremacy. Although Rome preserved much of her old vitality, a centrifugal shift of gravity towards the north and south may be observed in the latter part of the seventeenth century: Venice, Genoa, Piedmont, and Naples began to take the leading roles.

GIANLORENZO BERNINI

1598–1680

INTRODUCTION

Few data are needed to outline the life's story of the greatest genius of the Italian Baroque. Bernini was born at Naples on 7 December 1598, the son of a Neapolitan mother and a Florentine father. We have seen that his father Pietro was a sculptor of more than average talent and that he moved with his family to Rome in about 1605. Until his death seventy-five years later Gianlorenzo left the city only once for any length of time, when he followed in 1665, at the height of his reputation, Louis XIV's call to Paris. With brief interruptions his career led from success to success, and for more than fifty years, willingly or unwillingly, Roman artists had to bow to his eminence. Only Michelangelo before him was held in similar esteem by the popes, the great, and the artists of his time. Like Michelangelo he regarded sculpture as his calling and was, at the same time, architect, painter, and poet; like Michelangelo he was a born craftsman and marble was his real element; like Michelangelo he was capable of almost superhuman concentration and single-mindedness in pursuing a given task. But unlike the terrible and lonely giant of the sixteenth century, he was a man of infinite charm, a brilliant and witty talker, fond of conviviality, aristocratic in demeanour, a good husband and father, a first-rate organizer, endowed with an unparalleled talent for creating rapidly and with ease.

His father's activity in Paul V's Chapel in S. Maria Maggiore determined the beginning of his career. It was thus that the pope's and Cardinal Scipione Borghese's attention was drawn to the young prodigy and that he, a mere lad of nineteen, entered the orbit of the most lavish patron of the period. Until 1624 he remained in the service of the cardinal, creating, with brief interruptions, the statues and groups which are still in the Villa Borghese. After Urban VIII's accession to the papal throne, his pre-eminent position in the artistic life of Rome was secured. Soon the most important enterprises were concentrated in his hands, and from 1624 to the end of his days he was almost exclusively engaged on religious works. In February 1629, after Maderno's death, he was appointed 'Architect to St Peter's' and, although his activity in that church began as early as 1624 with the commission of the Baldacchino [86], the majority of his sculptural, decorative, and architectural contribution lay between 1630 and his death.

In the early 1620s he was one of the most sought-after portrait sculptors, but with the accretion of monumental tasks on an unprecedented scale, less and less time was left him for distractions of this kind. In the later 1620s and in the thirties he had to employ the help of assistants for such minor commissions, and from the last thirty-five years of his life hardly half a dozen portrait busts exist by his hand. The most extensive works – tombs, statues, chapels, churches, fountains, monuments, and the Square of St Peter's – crowd into the three pontificates of Urban VIII, Innocent X, and Alexander VII. Although he was active to the very end, it was only during the last years that commissions thinned out. From all we can

gather, this was due to the general dearth of artistic activity rather than to a decline of his creative capacity in old age. His work as a painter was mainly confined to the 1620s; later he hardly touched a brush and preferred using professional painters to express his ideas. Most of his important architectural designs, on the other hand, belong to the later years of his life, particularly to the period of Alexander VII's reign.[1]

SCULPTURE

Stylistic Development

It is not quite easy in Bernini's case to ascertain with precision caesuras in the development of his style. The reason is simple: for about fifty years he worked simultaneously on a number of great enterprises and many of them were carried out over long periods, while changes and alterations were incorporated as long as the progress of the work permitted. Thus he needed nine years to finish the Baldacchino, ten years for the *Longinus*, thirteen for the Cathedra, and almost twenty for the tomb of Urban VIII. Nevertheless, his approach to sculpture underwent considerable transformations which can be associated, by and large, with definite periods of his life.

To the earliest group of works, datable between 1615 and 1617, belong the *Goat Amalthea with the Infant Jupiter and a Satyr* (Borghese Gallery), the *St Lawrence* (Florence, Contini Bonacossi Collection) and the *St Sebastian* (Lugano, Thyssen-Bornemisza Collection), and in addition the Santoni[2] and Vigevano busts (S. Prassede and S. Maria sopra Minerva, Rome). All these works show, in spite of their Mannerist ties, an extraordinary freedom, an energy and perfection of surface treatment which lift them far above the mass of mediocre contemporary productions. The next phase begins with the *Aeneas and Anchises* of 1618-19 [71], the first monumental group for Cardinal

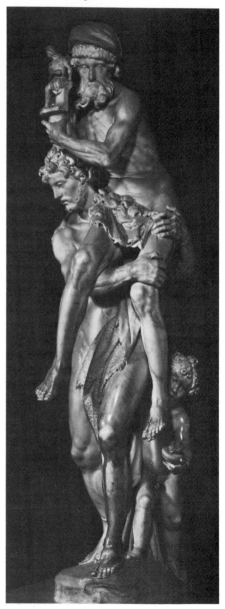

71. Gianlorenzo Bernini: Aeneas and Anchises, 1618-19. *Rome, Galleria Borghese*

Scipione Borghese. A work of this size required considerable discipline, and we see the young Bernini – probably advised by his father – returning to a composition more decidedly Mannerist than any of his previous sculptures. The screw-like build-up of the bodies has a well-established Mannerist pedigree *(figura serpentinata)*, also to be found in the father's work, while the precision, vigour, and firmness of the execution clearly represent an advance beyond the earliest phase. The next statues, following in rapid succession, demonstrate an amazing process of emancipation which is hardly equalled in the whole history of sculpture. One may follow this from the *Neptune and Triton,* made to crown a fishpond in Cardinal Montalto's garden (1620, now Victoria and Albert Museum), to the *Rape of Proserpina* (1621–2), the *David* (1623) [72], and the *Apollo and Daphne* (1622–5, all for Scipione Borghese, Borghese Gallery, Rome). A new type of sculpture had emerged. Hellenistic antiquity and Annibale Carracci's Farnese ceiling were the essential guides to Bernini's revolutionary conceptions.[3] Some of the new principles may be summarized: all these figures show a transitory moment, the climax of an action, and the beholder is drawn into their orbit by a variety of devices. Their immediacy and near-to-life quality are supported by the realism of detail and the differentiation of texture which make the dramatic incident all the more impressive. One need only compare Bernini's *David* with statues of David of previous centuries, such as Donatello's or Michelangelo's, to realize the decisive break with the past: instead of a self-contained piece of sculpture, a figure striding through space almost menacingly engages the observer.

With the *St Bibiana* (1624–6, S. Bibiana, Rome) [73] begins the long series of religious statues which required a change of spirit, if not of sculptural principles. Here for the first time Bernini expressed in sculpture the typically

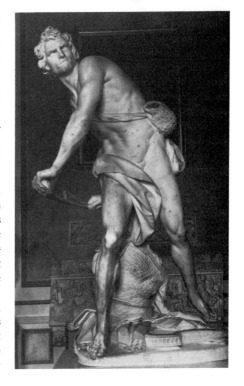

72. Gianlorenzo Bernini: David, 1623.
Rome, Galleria Borghese

seventeenth-century sensibility so well known from Reni's paintings. Here also for the first time the fall of the drapery seems to support, and to participate in, the mental attitude of the figure. Later, he increasingly regarded garments and draperies as a means to sustain a spiritual concept by an abstract play of folds and crevasses, of light and shade. The next decisive

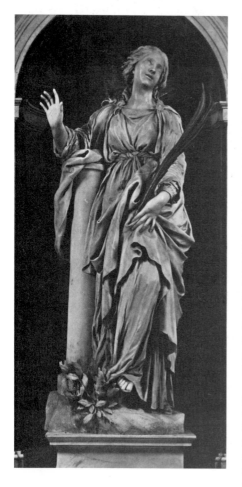

73. Gianlorenzo Bernini: St Bibiana, 1624–6.
Rome, S. Bibiana

step in the conquest of the body by the dramatically conceived drapery is the monumental *Longinus* (1629–38, St Peter's) [74]. Three strands of folds radiate from a nodal point under the left arm towards the large vertical cataract of drapery, leading the eye in a subtle way to the stone image of the Holy Lance, a relic of which is preserved in the crypt under the statue. Thus the body of St Longinus is almost smothered under the weight of the mantle, which seems to follow its own laws.

A parallel development will be found in Bernini's busts. Those of the 1620s are pensive and calm, with a simple silhouette and plastic, firm folds of draperies. A long series of these 'static' but psychologically penetrating busts survives from the small head of Paul V (1618, Borghese Gallery) [75] to the busts of Gregory XV, of Cardinal Escoubleau de Sourdis (S. Bruno, Bordeaux), of Monsignor Pedro de Foix Montoya (S. Maria di Monserrato, Rome), to the early busts of Urban VIII and that of Francesco Barberini (Washington, National Gallery, Kress Collection), to name only the most important ones. The bust of Scipione Borghese of 1632 (Rome, Borghese Gallery) [76], by contrast, has a dynamic quality;[4] the head is shown in momentary movement, the lively eye seems to fix the beholder, and the mouth half-open, as if speaking, engages him in conversation. Similarly dynamic is the arrangement of the drapery, on which the lights play and flicker and which therefore seems in permanent movement.

Thus, with this bust and the statue of Longinus a new phase begins in Bernini's work. If one wants to attach to them a terminological label, they may be called 'High Baroque'. The new importance conferred upon the drapery as a prominent factor in supporting the emotional impact of the work will be found during the same years in paintings by Cortona or Lanfranco, and even in those of an artist like Reni. One may compare the Virgin in Reni's *Assump-*

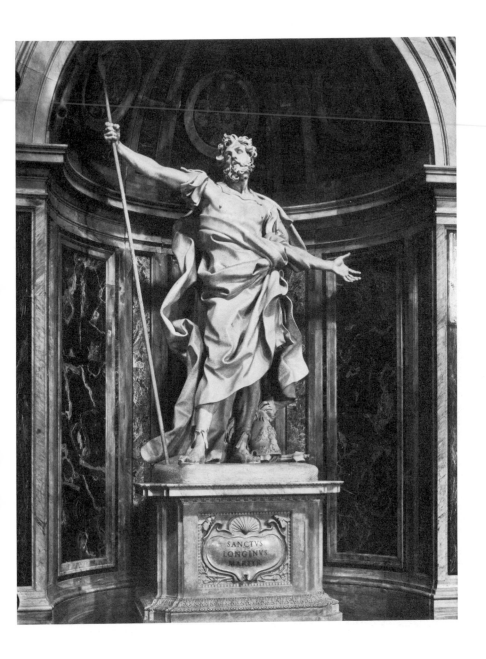

74. Gianlorenzo Bernini: St Longinus, 1629-38. *Rome, St Peter's*

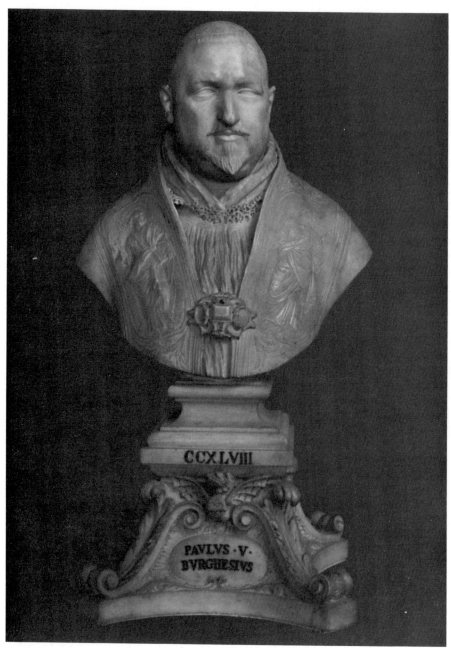

75. Gianlorenzo Bernini: Bust of Pope Paul V, 1618. *Rome, Galleria Borghese*

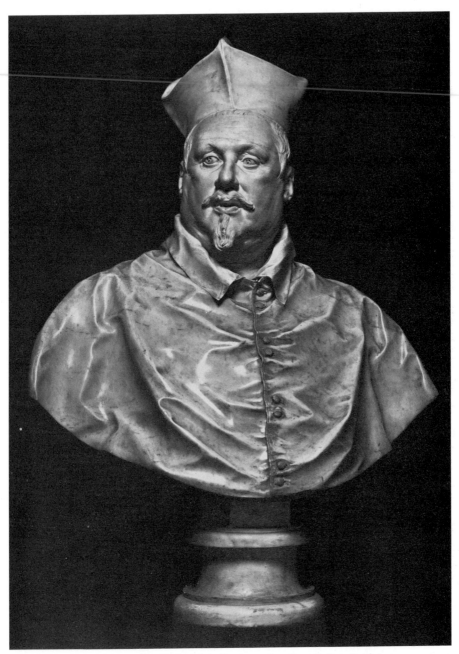

76. Gianlorenzo Bernini: Bust of Cardinal Scipione Borghese, 1632. *Rome, Galleria Borghese*

tion in Genoa of 1616–17 [33] with that of his *Madonna of the Rosary* of 1630–1 (Bologna, Pinacoteca); only the latter shows passages of heavy self-contained drapery similar to the vertical fall of Longinus's mantle.

But Bernini did not immediately pursue the newly opened path. On the contrary, during the 1630s there was a brief pause, a classical recession, probably not uninfluenced by the increasing pressure from the camp of the more emphatic upholders of the classical doctrine. To this phase belong, among others, the tomb of the Countess Matilda in St Peter's (1633–7) and the large relief of the *Pasce Oves Meas* inside the portico over the central door of the basilica (1633–46); in addition, the head of the *Medusa* (1636?, Rome, Palazzo dei Conservatori) and some portrait busts, above all those of Paolo Giordano II Orsini, Duke of Bracciano (Castle, Bracciano), and of Thomas Baker (1638, Victoria and Albert Museum); finally, some of Bernini's weakest works, such as the Memorial Inscription for Urban VIII in S. Maria in Araceli (1634) and the Memorial Statue of Urban VIII in the Palazzo dei Conservatori (1635–40). The contribution of assistants in the execution of all these works varies, and none can lay claim to complete authenticity.

What may be called Bernini's middle period, the years from about 1640 to the mid fifties, must be regarded as the most important and most creative of his whole career. It was during these years that the final design of the tomb of Urban VIII took shape (begun 1628, but carried out mainly between 1639 and 1647, St Peter's) [83], that he developed a revolutionary type of funeral monument (Maria Raggi, 1643, S. Maria sopra Minerva), and - most decisive - conceived the idea of unifying all the arts to one overwhelming effect while at the same time discovering the potentialities of concealed and directed light (Raimondi Chapel, S. Pietro in Montorio, *c.* 1642–6, and Cornaro Chapel, S. Maria della Vittoria, 1647–52) [84]. During these

years, too, he placed for the first time a monumentalized rustic fountain into the centre of a square (Four Rivers Fountain, Piazza Navona, 1648–51) [93], radically revised the classical concept of beauty (*Truth Unveiled*, 1646–52, Borghese Gallery), found a new solution for the old problem of the truncated chest in busts (*Francis I d'Este*, 1650–1, Estense Gallery, Modena), and designed the new type of the Baroque equestrian monument (*Constantine*,

77. Gianlorenzo Bernini:
St Mary Magdalen,
1661–3. *Siena, Cathedral, Cappella Chigi*

begun 1654, but not finished until 1668, Scala Regia, Vatican) [82]. It is impossible to overestimate the significance of the ideas incorporated in these works, not only for the Roman setting but for the next hundred years of Italian and, indeed, European art.

The transition to his latest manner may be observed in the works from the early sixties onwards. With the one exception of the *Habakkuk* (1655-61, S. Maria del Popolo) [80], all

from the *Daniel* (1655-7, Chigi Chapel, S. Maria del Popolo) to the *Mary Magdalen* in Siena Cathedral (1661-3) [77], further to the Angels at the sides of the Chair of the Cathedra (cast in 1665) and the Angels for the Ponte S. Angelo (1668-71, S. Andrea delle Fratte [78, 79] and Ponte S. Angelo)[5] with their ethereal bodies and extremely elongated extremities. And parallel with this 'gothicizing' tendency the treatment of garments becomes increasingly

78. Gianlorenzo Bernini:
The Angel with the Crown of Thorns, 1668-71.
Rome, S. Andrea delle Fratte

79. Gianlorenzo Bernini:
The Angel with the Superscription, 1668-71.
Rome, S. Andrea delle Fratte

his later figures show the over-long and slender limbs which he first gave to the *Truth Unveiled*. One may follow the development towards the conception of more and more attenuated bodies

impetuous, turbulent, and sophisticated. They lose more and more the character of real material and must be viewed as abstract patterns capable of conveying to the beholder a feeling of

passionate spirituality. In the case of the *Mary Magdalen*, for instance, the sweep and counter-sweep of two ropes of tightly twisted folds cutting across the body sublimely express the saint's agony and suspense. Similarly, the grief of the Ponte S. Angelo Angels over Christ's Passion is reflected in different ways in their wind-blown draperies. The Crown of Thorns held by one of them is echoed by the powerful, wavy arc of the drapery which defies all attempts at rational explanation. By contrast, the more delicate and tender mood of the Angel with the Superscription is expressed and sustained by the drapery crumpled into nervous folds which roll up restlessly at the lower end.

In the early seventies Bernini drew the last consequences. One may study the change from Constantine's horse to the similar horse of the equestrian monument of Louis XIV (1669–77, Versailles), or even from the authentic bozzetto, to be dated 1670 (Borghese Gallery), to the execution of the actual work, which was nearing completion in 1673, and it will be found that between the model and the marble there was a further and last advance in the dynamic ornamentalization of form. The garments of the bronze angels on the altar of the Cappella del Sacramento (St Peter's, 1673–4) show this tendency developed to its utmost limit. Parallel with this went an inclination to replace the diagonals, so prominent during the middle period, by horizontals and verticals, to play with meandering curves or to break angular folds abruptly, and to deepen crevices and furrows. Nobody can overlook the change from the *Ecstasy of St Teresa* (1647–52) [85] to the *Blessed Lodovica Albertoni* (1674, S. Francesco a Ripa) [81] or from the portrait bust of Francis I (1650–1) to that of Louis XIV (1665, Versailles) [91]. In his latest bust – that of Gabriele Fonseca (c. 1668–75, S. Lorenzo in Lucina) [203] – it is evident how strongly these compositional devices support the emotional tension expressed in the head.

Bernini's turn, in his later years, to an austere and, one is tempted to say, classical framework for his compositions shows that he was not independent of the prevalent tendencies of the period. But in his case it is just the contrast between violently strained plastic masses and axial control which gives his late work an unequalled dramatic and ecstatic quality.

Sculpture with One and Many Views

It is one of the strange and ineradicable misapprehensions, due, it seems, to Heinrich Woelfflin's magnetic influence, that Baroque sculpture presents many points of view.[6] The contrary is the case, and nobody has made this clearer than the greatest Baroque artist – Bernini himself. Many readers may, however, immediately recall the Borghese Gallery statues and groups which, standing free in the centre of the rooms, invite the beholder to go round them and inspect them from every side. It is usually forgotten that their present position is of fairly recent date and that each of these works was originally placed against a wall. Right from the beginning Bernini 'anchored' his statues firmly to their surroundings and with advancing years found new and characteristic devices to assure that they would be viewed from preselected points.

It is, of course, Renaissance statuary that comes to mind when we think of sculpture conceived for one main aspect. Most Renaissance figures leave not a shadow of doubt about the principal view, since by and large they are worked like reliefs with bodies and extremities extending without overlappings in an ideal forward plane. Quite different are Bernini's figures: they extend in depth and often display complex arrangements of contrasting spatial planes and movements. The difference may be studied in the Chigi Chapel of S. Maria del Popolo, where Bernini designed his *Habakkuk* [80] as a counterpart to Lorenzetti's Raffaelesque *Jonah*.

80. Gianlorenzo Bernini:
The Prophet Habakkuk, 1655–61.
Rome, S. Maria del Popolo, Cappella Chigi

In contradistinction to the latter's relief-like character, Bernini's figure, or rather group, does not offer a coherent 'relief-plane', but emphatically projects and recedes in the third dimension. In addition to the contrappostal arrangement of Habakkuk's legs, torso, and head and the pointing arm cutting across the body, there is the angel turned into the niche. And it is just when we see Habakkuk in the frontal view that the angel appears most fore-shortened. But viewing the group as a whole, we note that the angel's action (his gripping the prophet by a lock of hair and pointing across the room, in the direction of Daniel's niche) is fully defined from the exact central position facing the niche, and it is only from this stand-point that all the parts, such as the combined play of the legs and arms of the two figures, can be seen as a meaningful pattern.[7] In order to perceive the body and arms of the angel fully extended, the beholder has to step far to the right; but then Habakkuk's pose and movement are no longer co-ordinated, nor does the whole group present an integrated, coherent view. Thus, once the beholder relinquishes the prin-cipal aspect, new views may appear in his field of vision, yet they are always partial ones which reveal details otherwise hidden, without, how-ever, contributing to a clarification of the overall design.

The result of this analysis may safely be generalized; we are, in fact, concerned with an essential problem in Baroque sculpture. It ap-pears then that Bernini's statues are conceived in depth and that the sensation of their spatial organization should and will always be realized, but that they are nevertheless composed as images for a single principal viewpoint. One must even go a step further in order to get this problem into proper focus. Bernini's figures not only move freely in depth but seem to belong to the same space in which the beholder lives. Differing from Renaissance statuary, his figures need the continuum of space surrounding them

and without it they would lose their *raison d'être*. Thus the *David* aims his stone at an imaginary Goliath who must be assumed to be somewhere in space near the beholder; the *Bibiana* is shown in mute communication with God the Father, who, painted on the vault above her, spreads his arms as if to receive her into the empyrean of saints; *Longinus* looks up to the heavenly light falling in from the dome of St Peter's; *Habakkuk* points to the imaginary labourers in the field while the angel of God is about to remove him to Daniel's den across the space in which the spectator stands. The new conceptual position may now be stated more pointedly: Bernini's statues breathe, as it were, the same air as the beholder, are so 'real' that they even share the space continuum with him, and yet remain picture-like works of art in a specific and limited sense; for although they stimulate the beholder to circulate, they require the correct viewpoint not only to reveal their space-absorbing and space-penetrating qualities, but also to grasp fully the meaning of the action or theme represented. To be sure, it is Bernini's persistent rendering of a transitory moment that makes the one-view aspect unavoidable: the climax of an action can be wholly revealed from one viewpoint alone.

While Bernini accepts on a new sophisticated level the Renaissance principle of sculpture with one view, he also incorporates in his work essential features of Mannerist statuary, namely complex relationships, broken contours, and protruding extremities. He takes advantage, in other words, of the Mannerist freedom from the limitations imposed by the stone. Many of his figures and groups consist of more than one block, his *Longinus* for instance of no less than five. Mannerist practitioners and theorists, in the first place Benvenuto Cellini, discussed whether a piece of sculpture should have one or many views. Their verdict was a foregone conclusion. Giovanni Bologna in his *Rape of the Sabines* (1579–83) showed how to translate theory into practice and gave a group of several figures an infinite number of equally valid viewpoints. The propagation of multiple viewpoints in sculpture came in the wake of deep spiritual change, for the socially elevated sculptor of the sixteenth century, refusing to be a mere craftsman, thought in terms of small models of wax or clay. Thus he created, unimpeded by the material restrictions of the block. The Renaissance conception of sculpture as the art of working in stone ('the art of subtracting') began to be turned into the art of working in clay and wax ('modelling', which is done by adding – for Michelangelo a painterly occupation), and this sixteenth-century revolution ultimately led to the decay of sculpture in the nineteenth century. Although Bernini could not accept the many views of Mannerist statuary because they would interfere with his carefully planned subject–object (beholder–work) relationship and, moreover, would prevent the perception at a glance of one centre of energy and one climax of action, he did not return to the Renaissance limitations dictated by the block-form, since he wanted to wed his statues to the surrounding space. By combining the single viewpoint of Renaissance statues with the freedom achieved by the Mannerists, Bernini laid the foundation for his new, Baroque, conception of sculpture.

Only on rare occasions did he conceive works for multiple viewpoints. This happened when the conditions under which his works were to be seen were beyond his control. Such is the case of the angels for the Ponte S. Angelo, which had to have a variety of viewpoints for the people crossing the bridge. These angels clearly present three equally favourable views – from the left, the right, and the centre; but they do not offer coherent views either in pure profile or from the back, for these aspects are invisible to the passers-by.

During his middle period Bernini brought new and most important ideas to bear upon the problem of defined viewpoints. He placed the

group of *St Teresa and the Angel* in a deep niche under a protective architectural canopy [84, 85], and this makes it virtually impossible to see the work unless the beholder stands in the nave of the church exactly on the central axis of the Cornaro Chapel. Enshrined by the framing lines of the architecture, the group has an essentially pictorial character; one may liken it to a *tableau vivant*. The same is true of later designs whenever circumstances permitted. The Cathedra was conceived like an enormous colourful picture framed by the columns of the Baldacchino [86]. Similarly, the pictorial concepts of the *Constantine* and the *Blessed Lodovica* are revealed only when they are looked at from inside the portico of St Peter's and from the nave of S. Francesco a Ripa respectively [81, 82]. Indeed, the carefully contrived framing devices almost force upon the spectator the correct viewing position.

In spite of their *tableau vivant* character, all these works are still vigorously three-dimensional and vigorously 'alive'; they are neither reliefs nor relegated to a limited space. They act on a stage which is of potentially unlimited extension. They still share, therefore, our space continuum, but at the same time they are far removed from us: they are strange, visionary, unapproachable – like apparitions from another world.

81. Gianlorenzo Bernini: The Altieri Chapel with the Blessed Lodovica Albertoni, 1674. *Rome, S. Francesco a Ripa*

82. Gianlorenzo Bernini: Constantine, seen from the portico, 1654–68. *Rome, St Peter's*

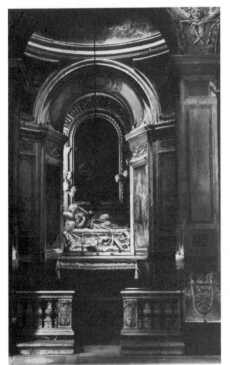

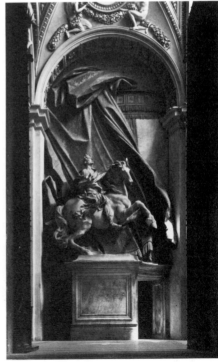

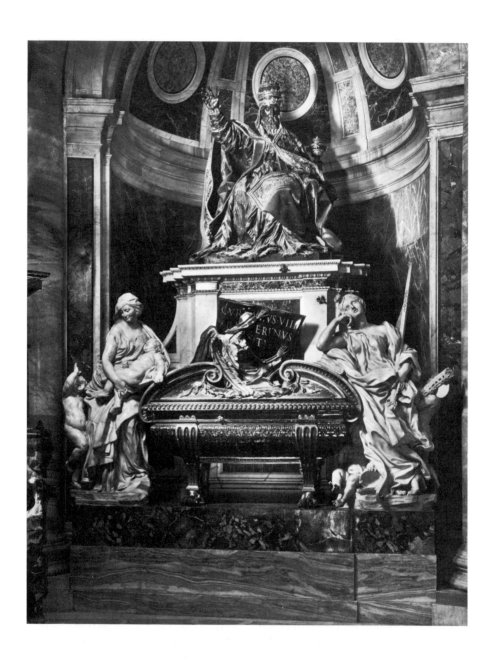

83. Gianlorenzo Bernini: Tomb of Urban VIII, 1628–47. Bronze and marble. *Rome, St Peter's*

Colour and Light

It is evident that Bernini's pictorial approach to sculpture cannot be dissociated from two other aspects, colour and light, which require special attention.

Polychrome marble sculpture is rather exceptional in the history of European art. The link with the uncoloured marbles of ancient Rome was never entirely broken, and it is characteristic that in Florence, for instance, polychromy was almost exclusively reserved for popular works made of cheap materials. But during the late sixteenth century it became fashionable in Rome and elsewhere to combine white marble heads with coloured busts, in imitation of a trend in late antique sculpture. The naturalistic element implicit in such works never had any attraction for Bernini. The use of composite or polychrome materials would have interfered with his unified conception of bust or figure. In his Diary the Sieur de Chantelou informs us that Bernini regarded it as the sculptor's most difficult task to produce the impression and effect of colour by means of the white marble alone. But in a different sense polychromy was extremely important to him. He needed polychrome settings and the alliance of bronze and marble figures as much for the articulation, emphasis, and differentiation of meaning as for the unrealistic pictorial impression of his large compositions. It may be argued that he followed an established vogue.[8] To a certain extent this is true. Yet in his hands polychromy became a device of subtlety hitherto unknown.

Bernini's tomb of Urban VIII [83] certainly follows the polychrome pattern of the older counterpart, Guglielmo della Porta's tomb of Paul III. But in Bernini's work the white and dark areas are much more carefully balanced and communicate a distinct meaning. The whole central portion is of dark, partly gilded bronze: the sarcophagus, the life-like figure of Death, and the papal statue, i.e. all the parts directly concerned with the deceased. Unlike these with their magic colour and light effects, the white marble allegories of Charity and Justice have manifestly a this-worldly quality. It is these figures with their human reactions and their sensual and appealing surface texture that form a transition between the beholder and the papal statue, which by its sombre colour alone seems far removed from our sphere of life.

More complex are the colour relationships in Bernini's later work. The Cornaro Chapel is, of course, the most perfect example [84, 85]. In the lowest, the human zone, the beholder is faced with a colour harmony of warm and glowing tones in red, green, and yellow. St Teresa's vision, the focal point of the whole composition, is dramatically accentuated by the contrast between the dark framing columns and the highly polished whiteness of the group. Other stimuli are brought into play to emphasize the unusual character of the event which shows a seraph piercing her heart with the fiery arrow of divine love, symbol of the saint's mystical union with Christ. The vision takes place in an imaginary realm on a large cloud, magically suspended in mid-air before an iridescent alabaster background. Moreover, concealed and directed light is used in support of the dramatic climax to which the beholder becomes a witness. The light falls through a window of yellow glass hidden behind the pediment and is materialized, as it were, in the golden rays encompassing the group.[9]

It is often observed that Bernini drew here on his experience as stage designer. Although this is probably correct, it distracts from the real problem. For this art is no less and no more 'theatrical' than a Late Gothic altarpiece repeating a scene from a mystery play, frozen into permanence. In another chapter the symbolic religious connotations of light have been discussed (p. 55). Bernini's approach to the problem of light is in a clearly defined pictorial

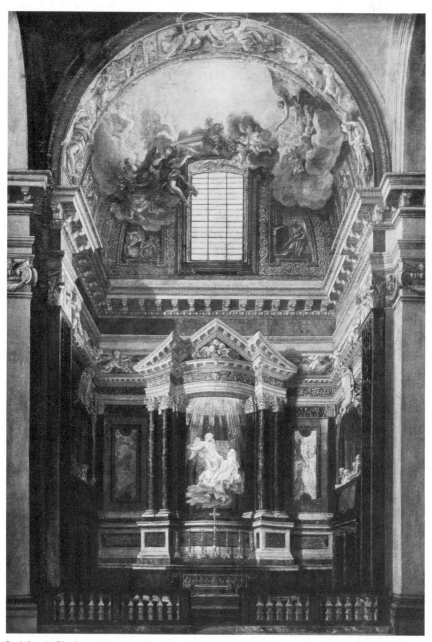

84 *(above)*. Gianlorenzo Bernini: The Cornaro Chapel. Eighteenth-century painting. *Schwerin, Museum*

85. Gianlorenzo Bernini: The Ecstasy of St Teresa, 1647–52. *Rome, S. Maria della Vittoria, Cornaro Chapel*

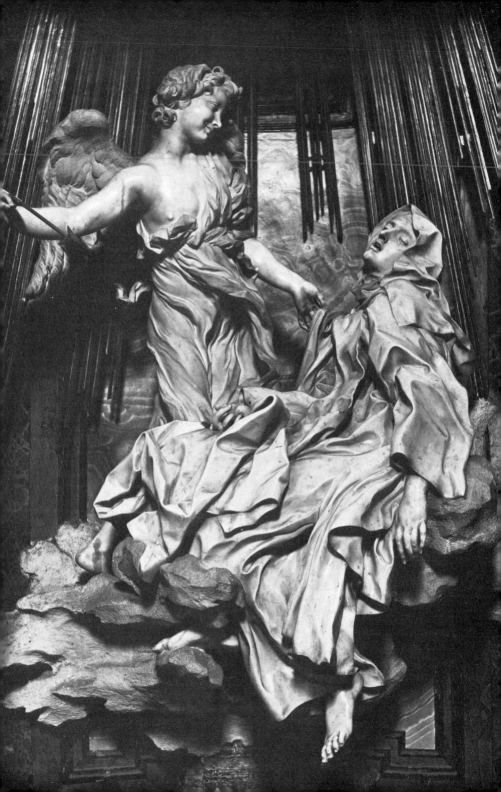

tradition of which the examples in Baroque painting are legion. The directed heavenly light, as used by Bernini, sanctifies the objects and persons struck by it and singles them out as recipients of divine Grace. The golden rays along which the light seems to travel have yet another meaning. By contrast to the calm, diffused light of the Renaissance, this directed light seems fleeting, transient, impermanent. Impermanence is its very essence. Directed light, therefore, supports the beholder's sensation of the transience of the scene represented: we realize that the moment of divine 'illumination' passes as it comes. With his directed light Bernini had found a way of bringing home to the faithful an intensified experience of the supra-natural.

No sculptor before Bernini had attempted to use real light in this way. Here in the ambient air of a chapel he did what painters tried to do in their pictures. If it is accepted that he translated back into the three dimensions of real life the illusion of reality rendered by painters in two dimensions, an important insight into the specific character of his pictorial approach to sculpture has been won. His love for chromatic settings now becomes fully intelligible. A work like the Cornaro Chapel was conceived in terms of an enormous picture.

This is true of the chapel as a whole. Higher up the colour scheme lightens and on the vaulting the painted sky opens. Angels have pushed aside the clouds so that the heavenly light issuing from the Holy Dove can reach the zone in which the mortals live. The figure of the seraph, brother of the angels painted in the clouds, has descended on the beams of light.

Along the side walls of the chapel, above the doors, appear the members of the Cornaro family kneeling behind prie-dieus and discussing the miracle that takes place on the altar. They live in an illusionist architecture which looks like an extension of the space in which the beholder moves.

In spite of the pictorial character of the design as a whole, Bernini differentiated here as in other cases between various degrees of reality. The members of the Cornaro family seem to be alive like ourselves. They belong to our space and our world. The supra-natural event of Teresa's vision is raised to a sphere of its own, removed from that of the beholder mainly by virtue of the isolating canopy and the heavenly light.[10] Finally, much less tangible is the unfathomable infinity of the luminous empyrean. The beholder is drawn into this web of relationships and becomes a witness to the mysterious hierarchy ascending from man to saint and Godhead.

In all the large works from the middle period on, directed and often concealed light plays an overwhelmingly important part in producing a convincing impression of miracle and vision. Bernini solved the problem first in the Raimondi Chapel in S. Pietro in Montorio (c. 1642–6). Standing in the dim light of the chapel, the spectator looks into the altar-recess and sees, brightly lit as if by magic, the *Ecstasy of St Francis*, Francesco Baratta's relief. Later, Bernini used essentially similar devices not only for the Cornaro Chapel and for the Cathedra, but also for the *Constantine*, the *Blessed Lodovica Albertoni*, and, on a much larger scale, in the church of S. Andrea al Quirinale [104].

At the same time, colour symphonies become increasingly opulent and impressive. Witness the tomb of Maria Raggi (1643, S. Maria sopra Minerva) with its sombre harmony of black, yellow, and gold; or the wind-swept colourful stucco curtain behind the *Constantine*, a motif that has not one but four different functions: as a forcible support of the Emperor's movement, as a device to relate the monument to the size of the niche, as the traditional 'emblem' of royalty, and as a fantastic pictorial element. Witness the jasper palls which he used only in such late works as the *Lodovica Albertoni* and the tomb of Alexander VII; or the altar in the Chapel of

the Blessed Sacrament in St Peter's (1673-4), where coloured marbles, gilt bronze, and lapis lazuli combine into a picture of sublime beauty which expresses symbolically the immaterial perfection of the angelic world and the radiance of God.

With his revolutionary approach to colour and light, Bernini opened a development of immeasurable consequences. It is not sufficiently realized that the pictorial concepts of the mature Bernini furnish the basis not only for many later Roman and North Italian works, but above all for the Austrian and German Baroque. Even the colour and light orgies of the Asam brothers add nothing essentially new to the repertory created by Bernini.

The Transcending of Traditional Modes

Bernini's way of conceiving his large works in pictorial terms had a further revolutionary result: the traditional separation of the arts into clearly defined species or categories became obsolete and even nonsensical. What is the group of *St Teresa and the Angel?* Is it sculpture in the round or is it a relief? Neither term is applicable. On the one hand, the group cannot be dissociated from the aedicule, the background, and the rays of light; on the other, it has no relief-ground in the proper sense of the word, nor is it framed as a relief should be. In other words, Bernini created a species for which no term exists in our vocabulary.

Moreover, even the borderline between painting, sculpture, and architecture becomes fluid. Whenever given the opportunity, Bernini let his imagery flow from a unified concept which makes any dissection impossible. His own time was fully aware of this. In the words of Bernini's biographer, Filippo Baldinucci, it was 'common knowledge that he was the first who undertook to unite architecture, sculpture and painting in such a way that they together make a beautiful whole'. The Cornaro Chapel is the supreme ex-

ample. We have seen how the painted sky, the sculptured group, and the real and feigned architecture are firmly interlocked. Thus, only if we view the whole are the parts fully intelligible. This is also true of Bernini's primarily architectural works, as will be shown later in this chapter. The creation of new species and the fusion of all the arts enhance the beholder's emotional participation: when all the barriers are down, life and art, real existence and apparition, melt into one.

In the Cathedra of St Peter in the apse of the basilica (1656-66) [86, 87], Bernini's most complex and, due to its place and symbolic import, most significant work, the various points here made may be fully studied. We noted before how the whole was conceived like a picturesque *fata morgana* to be seen from a distance through the columns of the Baldacchino. Only from a near standpoint is it possible to discern the subtle interplay of multicoloured marble, gilt bronze, and stucco, all bathed in the yellow light spreading from the centre of the angelic Glory. No differentiation into species is possible: the window as well as the transitions from flat to full relief and then to free-standing figures penetrating far into space make up an indivisible whole. The beholder finds himself in a world which he shares with saints and angels, and he feels magically drawn into the orbit of the work. What is image, what is reality? The very borderline between the one and the other seems to be obliterated. And yet, in spite of the vast scale and spatial extension, the composition is most carefully arranged and balanced. The colour scheme lightens progressively from the marble pedestals to the bronze throne with gilt decorations and the golden angels of the Glory.[11] The gilded rays spread their protecting fingers over the whole width of the work and enhance, at the same time, the visual concentration on the symbolic focus, the area of the throne. Movements and gestures, even in different spatial layers, are intimately related. Thus the nervous

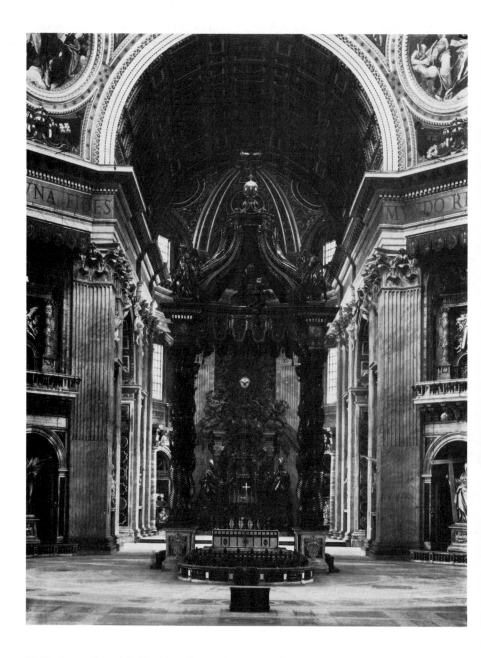

86. Gianlorenzo Bernini: Baldacchino, 1624–33. Bronze. *Rome, St Peter's*

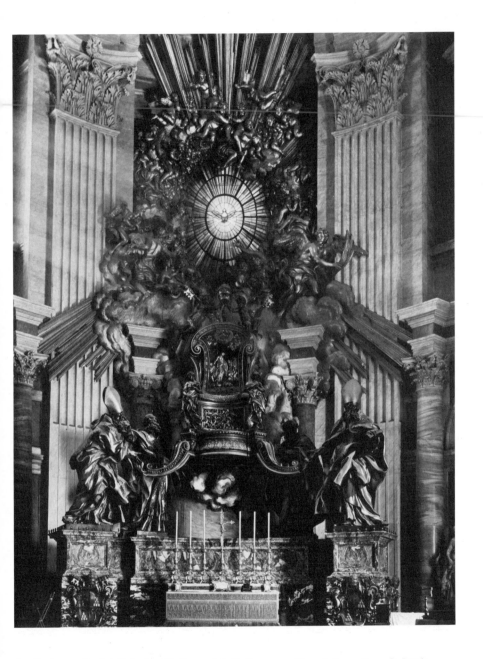

87. Gianlorenzo Bernini: Cathedra of St Peter, 1656–66. Bronze, marble, and stucco. *Rome, St Peter's*

88. Gianlorenzo Bernini:
Detail from the Cathedra of St Peter [cf. 87]

and eloquent hands of St Ambrose and St Athanasius, shown on illustration 88, appear like contrapuntal expressions of the same theme.

Bernini's new and unorthodox way of stepping across traditional boundaries and harnessing all the arts into one overwhelming effect baffles many spectators. Even those who rise in defence of similar phenomena in the case of modern art cannot forgive Bernini for having transgressed the established modes of artistic expression.[12] It is clear that his imagery will capture our imagination only if we are prepared

to break down intellectual fences and concede to him what we willingly do before a Gonzalez or a Giacometti or a Moore.

New Iconographical Types

No less important and influential than Bernini's new artistic principles and, naturally, inseparable from them were the changes he brought about over a wide choice of subjects. Only detailed studies would reveal the full range of his innovations. Although deeply conscious of, and indebted to, tradition, he approached every new task with a fresh and independent mind and developed it in a new direction. He became the greatest creator of iconographical types of the Italian Baroque and his conception of the saint, of tombs, the equestrian statue, of portraiture and fountains remained unchallenged for a hundred years.

The tomb of Urban VIII [83] established the new type of the papal monument. Looking back via Guglielmo della Porta's tomb of Paul III to Michelangelo's Medici Tombs, Bernini achieved an ideal balance between a commemorative and a ceremonial monument,[13] and it is this concept that many later sculptors endeavoured to follow with more or less success (p. 440). In the late tomb of Alexander VII (1671-8) [89], Bernini stressed the contrast between the impermanence of life (Death with hour-glass) and the unperturbed faith of the praying pope. But this idea, which corresponded so well with Bernini's own convictions on the threshold of death, was too personal to find much following. When it was taken up during the eighteenth century, the concept had changed: Death was no longer checked by the certainty of salvation through faith and held nothing but terror for those whom he threatens with permanent extinction.[14]

At the beginning of the 1640s Bernini brought a completely new approach to the problem of smaller funeral monuments with his designs of

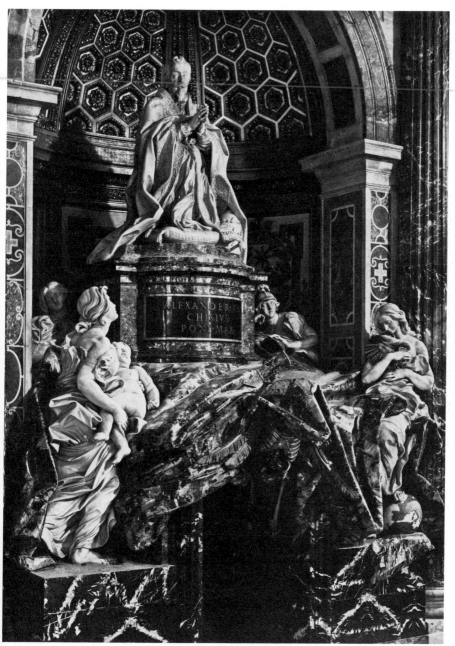

89. Gianlorenzo Bernini: Tomb of Alexander VII, 1671–8. *Rome, St Peter's*

the Valtrini and Merenda memorials, both executed by studio hands,[15] and the tomb of Maria Raggi, a work of the highest quality. He rejected the isolating architectural framework; and in the Valtrini and Raggi tombs a relief-portrait of the deceased is carried by Death and by putti respectively. It was three generations later, in the Age of Enlightenment, that this type finally supplanted that with the deceased in an attitude of devotion (p. 444).

Equally momentous in his contribution to the history of portraiture. The *Scipione Borghese* of 1632 (p. 146) may safely be regarded as the first High Baroque portrait bust. From the mid thirties dates one of the most remarkable portrait busts of the whole history of art, that of *Costanza Buonarelli* (Florence, Bargello) [90]. It is Bernini's only private portrait bust and is therefore done without the deliberate stylization of the other works of this period. One may well believe that the stormy love affair Bernini had with this fierce and sensual woman was the talk of the town. What is historically so important about this work is that it opens the history of modern portraiture in sculpture. All the barriers have fallen: here is a woman of the people, neither beautified nor heroized, and 'contact' with her is direct and instantaneous. In his busts of King Charles I (destroyed),[16] Francis I of Este, and Louis XIV [91], by contrast, Bernini created the official Baroque type of the absolute sovereign. His intentions and procedure can be fully derived from the diary entries of the Sieur de Chantelou.[17] He approached such busts with the idea of conveying nobility, pride, heroism, and majesty. In this he was so successful that no Baroque sculptor could ever forget Bernini's visual rendering of these abstract notions. Similarly, he gave the Baroque equestrian statue with the rearing horse a heroic quality and invested it with drama and dynamic movement not only in his *Constantine* but also in the ill-starred monument of Louis XIV which stands now, transformed into a Marcus Curtius, near the 'Bassin des Suisses' in the gardens of Versailles.

Even more radical than all these innovations was Bernini's contribution to the history of the

90 *(opposite)*. Gianlorenzo Bernini: Bust of Costanza Buonarelli, *c.* 1635. *Florence, Bargello*

91 *(right)*. Gianlorenzo Bernini: Bust of Louis XIV, 1665. *Versailles, Castle*

Baroque fountain. A tradition of fountains with figures existed in Florence rather than Rome, and it was this tradition that Bernini took up and revolutionized. His early *Neptune and Triton* for the Villa Montalto (1620, now Victoria and Albert Museum) is evidence of the link with Florentine fountains.[18] With his Triton Fountain in the Piazza Barberini (1642–3)[19] [92] he broke entirely with the older formal treatment. Far removed from the decorative elegance of Florentine fountains, this massive structure confronts the beholder with a sculptural entity as integral as a natural growth. Sea-god, shell, and fish are welded into an organic whole, and nobody can fail to be captivated by the fairy-tale atmosphere of such a creation.

All recollection of symmetry and architectural structure has disappeared in the Fontana del Moro in Piazza Navona (1653–5), where Bernini used the same constituent elements: maritime divinity, shell, and dolphin. But these elements are now animated by dramatic action; we witness a transitory moment in the contest between the 'Moro' and his prey. Entirely different considerations had to be taken into account for the design of the large fountain in the centre of the same Piazza [93]. Bernini had to erect a monument sufficiently large to emphasize effectively the centre of the long square without disturbing its unity. At the same time the fountain had to be related to the façade of S. Agnese without competing with it. A 'natural' rock,[20] washed by ample springs, pierced by openings in the long and short axes and crowned by the huge Egyptian needle: barrier and link, accompaniment to the towers and contrast; ex-

92. Gianlorenzo Bernini:
Triton Fountain, 1642-3. Travertine.
Rome, Piazza Barberini

93. Gianlorenzo Bernini:
The Four Rivers Fountain, 1648-51.
Travertine and marble. *Rome, Piazza Navona*

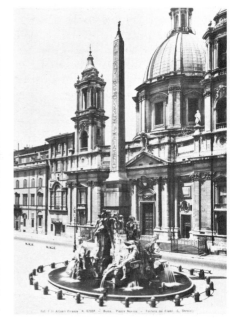

pansive and varied near the ground and soaring upwards hard, uniform, and thin; fountain and monument; improvisation and symbol of super-human permanency – these seeming contra-dictions point to the ingenious answer Bernini found to his problem.

The number of fountains created by Bernini is comparatively small. But their effect was all the greater. Contemporaries were fascinated not only by his new, truly poetical use of realistic motives like rock, shell, and natural growth, but also by his revolutionary handling of the water itself. For he replaced the traditional thin jets by an exuberant and powerful harnessing of the elements. It was the continuous movement of the rushing and murmuring water that helped to fulfil one of Bernini's most cherished dreams: to create real movement and pulsating life.

The Role of the 'Concetto'

After the foregoing pages it hardly needs stress-ing that an impressionist and aesthetic appreci-ation or stylistic approach cannot do justice to Bernini's real intentions. It must never be forgotten that Bernini's ideas of what constitutes a satisfactory solution of a given task were dependent on humanist art theory. According to this theory, which allied painting and sculp-ture to poetry, a work of art must be informed by a literary theme, a characteristic and ingeni-ous *concetto* which is applicable only to the particular case in hand. For Bernini the *concetto* was really synonymous with a grasp of the essen-tial meaning of his subject; it was never, as so often in seventeenth-century art, a cleverly contrived embroidery. Moreover the concept he chooses for representation is always the moment of dramatic climax. This is true already for his early mythological and religious works created in the service of Cardinal Scipione Borghese.

Thus David is shown at the split-second of the fateful shot and Daphne at the instant of transformation. He represented both Bibiana and Longinus at the moment of their supreme tests, the former devoutly accepting her martyr-dom and the latter in the emotional act of con-version, exclaiming while looking up at the Cross: 'Truly this was the Son of God.'[21] Simi-larly, the *Vision of St Teresa* strictly adheres to the saint's meticulous description of the event which must be regarded as the acme of her life; for it was this particular vision that played a decisive part in the acts of her canonization. Even from the story of Daniel and Habakkuk, told in 'Bel and the Dragon' (which forms part of the Greek Book of Daniel), Bernini selected the culminating moment to which reference has already been made (pp. 152–3). In all these cases Bernini gave a visual interpretation of the most fertile dramatic moment. The same is true of the *Constantine*, for this is not simply an equestrian monument representing the first Christian emperor, but a dramatic history-piece illustra-ting a precise event of his life: the historically and emotionally decisive moment of conversion in face of the miraculous appearance of the Cross.[22]

But the *concetto* was not necessarily tied to factual historical events. A 'poetical' *concetto* contained no less intrinsic historical truth if chosen with proper discrimination. This applies to such works as the fountains, the equestrian statue of Louis XIV, and the Cathedra. It is a fatal error to believe that Louis XIV on horse-back was devised as a purely dynastic monu-ment. He was to appear on top of a high rock, a second Hercules who has reached the summit of the steep mountain of Virtue [94].[23] Thus this work too is a dynamic history-piece. It is an allegorical equestrian statue, but as usual with Bernini, allegory is implied, not made explicit. The naturalistic rock, the fiery horse, and the heroic rider together express in dramatic visual terms the poetic allegorical content. In a similar way, a complex *concetto* is woven into the design of the Four Rivers Fountain. The personifica-

94. Gianlorenzo Bernini:
Monument of Louis XIV. Wash drawing, 1673.
Bassano, Museo Civico

tions of the Four Rivers, symbolizing the four parts of the world, and the dove, Innocent X's emblem which crowns the obelisk, the traditional symbol of divine light and eternity, proclaim the all-embracing power of the Church under the leadership of the reigning Pamphili pope. A further layer of meaning is hinted at by the reference, manifest in the whole arrangement, to the Rivers of Paradise at the foot of the mountain on which the Cross stands.[24] This monument of Catholic triumph and victory, therefore, also contains the idea of the salvation of mankind under the sign of the Cross.

A monument like the Elephant carrying the Obelisk, erected in the Piazza S. Maria sopra Minerva between 1666 and 1667, must also be understood as a glorification of the reigning pope, Alexander VII. Its typically Baroque

conceit is well expressed in a contemporary poem: 'The Egyptian obelisk, symbol of the rays of *Sol*, is brought by the elephant to the Seventh Alexander as a gift. Is not the animal wise? Wisdom hath given to the World *solely* thee, O Seventh Alexander, consequently thou hast the gifts of *Sol*.'[25] In this case, the inscriptions, pregnant with emblematical meaning, are prominently displayed on the pedestal and form an integral part of the composition.

Finally the Cathedra Petri, which confirms by its arrangement and design in dramatic visual terms the fundamental dogma of the primacy of papacy. The venerable wooden stool of St Peter is encased in the gorgeous bronze throne which hovers on clouds high above the ground. At its sides, on a lower level, appear the greatest Latin and Greek Fathers who supported Rome's claim to universality. On the chair-back is a relief of Christ handing the Keys to St Peter; and above the chair putti carry the papal symbols, tiara and keys. Lastly, high up in the centre of the angelic Glory is the transparent image of the Holy Dove.[26] Thus one above the other there appear symbols of Christ's entrusting the office of Vicar to St Peter; of papal power; and of divine guidance, protection, and inspiration – the whole, with the precious relic at its centre, a materialized vision, which exhibits the eternal truth of Catholic dogma for all to see.[27]

Working Procedure

Enough has been said to discard the idea, all too often voiced, that Bernini's magical transmutations of reality are the result of a creative fantasy run amok. Nothing could be farther from the truth. In fact, in addition to Bernini's own statements and a wealth of documents, sufficient drawings and bozzetti are preserved to allow more than a glimpse of his mind at work. His procedure cannot be dissociated from his convictions, his belief in the time-honoured tenets

of decorum and historical truth, in the classical doctrine that nature was imperfect, and in the unchallengeable authority of ancient art.

While preparing a work he closely attended to the requirements of decorum and historical truth. He would also be relentlessly critical when he found a breach of these basic demands. He expressed astonishment, for instance, that in his *Adoration of the Magi* the learned Poussin, for whom he had almost unreserved admiration, had given to the Kings the appearance of ordinary people. Chantelou and Lebrun defended Poussin, but Bernini insisted that one must follow the text of the Gospels where it was written that they *were* Kings. In the case of the *Constantine* one can check how far he went in pursuance of historical truth. An excerpt in his own hand, now in the Bibliothèque Nationale in Paris,[28] shows that he consulted the source which contained a description of Constantine's physiognomy, namely Nicephorus's much-used thirteenth-century *Historia ecclesiastica,* of which modern printed editions existed. The relevant passage describes Constantine as having had an aquiline nose and a rather insignificant thin beard. In an extant preparatory drawing[29] Bernini made what may be called a portrait study of the emperor's features which served as basis for the execution.

Often historical truth and decorum, the appropriate and the becoming, merge into one. Such is the case when he makes St Bibiana and the Countess Matilda wear sandals, while the Discalced Carmelite Teresa appears barefoot; or when he is meticulous about the correct dress of historical and contemporary personages and reserves idealized attires for biblical and mythological figures and personifications. In certain cases, however, the demands of decorum have to supersede those of historical fact. Louis XIV never walked about in classical armour and sandals. But the dignity and nobility – in a word, the decorum – of the imperial theme required that Constantine as well as the Louis of the equestrian monument should be dressed *all' antica* and partly covered by idealized mantles, wildly fluttering in the wind.

Concern with such problems never barred him from taking classical and preferably Hellenistic works as his guide in developing a theme. Early in his career the finished work often remained close to the antique model. The Apollo of the Apollo and Daphne group does not depart far from the Belvedere Apollo nor the David from the Borghese warrior. Even the head of the Longinus is obviously styled after a Hellenistic model, the Borghese Centaur, now in the Louvre. In late works too the classical model is sometimes discernible. The face of Louis XIV's bust is manifestly similar to that of Alexander the Great on coins, and Bernini himself supplied the information that Alexander portraits, the accepted prototype of royalty, were before his mind's eye when working on the king's bust. But as he advanced in age, Bernini transformed his classical models to an ever greater degree. Nobody looking at his figure of Daniel can possibly guess that his point of departure was the father from the Laocoon group. In this case, however, the development can be followed from the copy after that figure through a number of preparatory drawings to the final realization in marble.[30] While working from the life-model, Bernini had in the beginning the classical figure at the back of his mind, but was carried farther away from its spirit step by step. In accordance with his theoretical views, he began rationally and objectively, using a venerated antique work; not until his idea developed did he give way to imaginative and subjective impulses. When he worked himself into that state of frenzy in which he regarded himself as the tool of God's grace, he created in rapid succession numberless sketches and clay models, twenty-two in all in the case of the *Longinus.*[31]

In front of a very late work such as the ecstatic Angel holding the Superscription the conclusion seems unavoidable that he had ceased to

use classical antiquity as a cathartic agent. And yet the body under the agitated folds of the drapery derives from the so-called Antinous in the Vatican, a figure that was studied with devotion in the classical circle of Algardi, Duquesnoy, and Poussin. Bernini referred to it in his address to the Paris Academy in these words: 'In my early youth I drew a great deal from classical figures; and when I was in difficulties with my first statue, I turned to the Antinous as to the oracle.' His reliance on this figure, even for the late Angel, is strikingly evident in a preparatory drawing showing the Angel in the nude.[32] But the proportions of the figure, like those of the finished marble, differ considerably from the classical model. Slim, with extremely long legs and a head small in comparison with the rest of the body, the nude recalls Gothic figures. The process of ecstatic spiritualization began during an early stage of the preparatory work.

It is, of course, necessary to differentiate between Bernini's authentic works and those executed by studio hands. This is, however, no easy task. From the early 1620s onwards the increase of commissions in size and numbers forced him to rely more and more on the help of assistants. For that reason a precise division between his own works and those of the studio is hardly possible. There is, indeed, an indeterminable area between wholly authentic works and those for which Bernini is hardly responsible. Stylistic integration depended less on Bernini's handling the hammer and chisel himself than on the degree of his preparatory work and the subsequent control exercised by his master mind. His personal contribution to the execution of works like the Baldacchino or the tomb of Urban VIII was still considerable. Later, he often made only the sketches and small models. The tomb of Alexander VII, for instance, is the work of many hands and the division of labour, revealed by the documents, anticipates that of the industrial age. Yet the

work presents an unbroken stylistic unity and the assistants were no more than so many hands multiplying his own. It was only when the control slackened that dissonant elements crept in.

It would appear logical, therefore, to divide his production into works designed by him and executed by his hand;[33] those to a greater or lesser degree carried out by him;[34] others where he firmly held the reins but actively contributed little or nothing to the execution;[35] and finally those from which he dissociated himself after a few preliminary sketches.[36] The decision as to which of these categories a work belongs has to be made from case to case, more often than not on the basis of documents. But in the present context the problem had to be stated rather than solved.

PAINTING

Bernini's activity as a painter has attracted much attention in recent years,[37] but in spite of considerable efforts the problem still baffles the critics. A large measure of agreement exists about the part painting played in his life's work, although the riddle has not been solved as to what happened to the more than 150 pictures mentioned in Baldinucci's Life of Bernini, a figure which Domenico Bernini, in the biography of his father, raised to over two hundred. Whatever the correct number, a bare dozen pictures of this large œuvre have so far come to light. It is impossible to assume that most of these works have been lost for ever, and the discovery a short while ago of two indubitable originals in English collections[38] indicates that many more are probably hidden under wrong names. But their present anonymity conclusively proves one thing, namely that painting for Bernini was a sideline, an occupation, as Baldinucci expressed it, to which he attended for pleasure only. He never accepted any commissions of importance, he never signed any of his paintings, and to all appearances treated

the whole matter lightly – hence the anonymity. It seems therefore not chance that half the number of pictures now known are self-portraits, intimate studies of his own person undertaken in leisure hours and not destined for a patron.

Covering a period of almost thirty years, these self-portraits give a reliable insight into his stylistic idiosyncrasies and development as a painter. They are all done with short, vigorous brush-strokes which model the forms and reveal the hand of the born sculptor. This characteristic dash of handling goes with a neglect of detail, sketchy impromptu treatment of accessories such as dress, and spontaneity of expression. Most of his portraits, sculptured, painted, and drawn, show a similar turn of the head, the alert look and the mouth half-open as if about to speak. In his early paintings dating from the 1620s he seems to have been subject to the sobering influence of Andrea Sacchi.[39] Later, about 1630, he turned towards a blond, luminous palette, probably under the impression of Poussin's St Erasmus of 1629 (painted for St Peter's, now Vatican Gallery) – thus falling in with the strong wave of Venetian colourism which surged over Rome in those years.[40] Later again, paintings like the self-portraits in the Prado and the Borghese Gallery[41] show darker colours and more unified tone values, and this must have been due to Velasquez's influence.[42] In fact some of Bernini's pictures of the 1640s are superficially so similar to those of the great Spaniard that they were attributed to him.

Most of the surviving pictures date from the twenties and thirties. And this for good reasons. The more the commissions accumulated, the less time he had for such recreations as painting. No picture is known from the last decades of his life. But at this period he enjoyed producing pictorial compositions, which he created rapidly with pen and ink.[43]

Thus while Bernini's own work as a painter remains somewhat mysterious, his conceptual approach to painting from the middle period onwards can be fully gauged. From that time on he employed painters, mainly of minor stature, as willing tools of his ideas. The first whom he drew into his orbit was Carlo Pellegrini (1605-49), a native of Carrara.[44] He may have started under Sacchi and was certainly influenced by him. But in 1635 he painted the Conversion of St Paul (Church of the Propaganda Fide) and between 1636 and 1640 the Martyrdom of St Maurice (for St Peter's, later Museo Petriano), certainly both from Bernini's sketches. These works show borrowings from Pietro da Cortona and Poussin, to whose light and luminous colour scale they are also clearly indebted. Moreover, the composition of the Conversion owes not a little both to Sacchi and, unexpectedly, to Lodovico Carracci. The Martyrdom of St Maurice is the more Berninesque of the two works. The master's mind is revealed as much by the highly dramatic composition, which shows three stages of martyrdom succinctly rendered on a narrow foreground stage, as by certain devices such as showing a truncated martyr's head next to that of St Maurice who is still alive or the parallel arrangement of arms which act in opposite directions.[45]

Even before Pellegrini's death Bernini availed himself of the services of Guido Ubaldo Abbatini (1600/5-56) from Città di Castello, who began under the Cavaliere d'Arpino, but later, according to Passeri, submitted to his new master like a slave. His principal works for Bernini are the frescoes on the vault of the Cappella Raimondi, executed in collaboration with the classicizing Giovanni Francesco Romanelli (p. 321), the badly preserved frescoes on the vault of the Cappella Pio in S. Agostino, dating from c. 1644, and lastly those on the vault of the Cornaro Chapel.[46] In spite of his rather weak decorative talent, he perfectly suited Bernini's purpose. And as a participant in the execution of some of Bernini's grand schemes he was certainly more important than Pellegrini.

It was on the vault of the Cappella Pio that Bernini first mixed fresco and stucco: the painted angels rest on stucco clouds. Passeri was aware of the importance of this new departure and described it in the following words: 'he employed a new deceptive artifice and by means of certain parts in relief actually made true what was supposed to be mere illusion'.[47] In the Cappella Cornaro he carried the principle a step further. Not only did he use the mixture of fresco and stucco once again, now on a more lavish scale, but here the paintings of the vault penetrate far into the architecture. After what I have said about the elimination of traditional 'modes' (p. 161), it is only to be expected that Bernini would also transgress the established limitations of painting. Seeking a conceptual explanation of this phenomenon, it might be argued that, as sculpture for him was a kind of pictorial art in three dimensions, painting was a sculptural art projected on to a surface; and transitions from sculpture into painting and vice versa were therefore equally justified.

It is important to realize that this approach is as far removed from Pietro da Cortona's superimpositions and overlappings as from the illusionism of the *quadraturisti* (pp. 65-6). In spite of the dazzling richness of the former's designs, his definition of sculptured and painted areas always remains clear and decisive and no mixing of realities is ever intended. The *quadratura* painters, on the other hand, aimed at an illusionist expansion of real space; but the borderline between illusion and reality is not objectively abolished, it is only masked by the subjective skill of the painter.

Never again did Bernini have an opportunity to hand over fresco work to a painter in any of his large enterprises.[48] Yet his new ideas were absorbed by Giovan Battista Gaulli, called Baciccio, an artist of much greater calibre than his previous collaborators. He came from Genoa to Rome before 1660 and was soon taken up by Bernini and deeply influenced by his ideas.[49]

His greatest work, the frescoes in the Gesù (1672-83) [213], must be regarded as the fullest exposition of Bernini's revolutionary conception of painting. Here the principle of combining fresco and painted stucco and of superimposing painted parts on the architecture has been given its monumental form. In addition, the sculptural interpretation of his figures, their movements and draperies, and the urgency and intensity of their activities reveal the spirit of the late Bernini.

The Gesù frescoes are also the major Roman monument for a new departure in the organization of large ceiling decorations. The effect of these frescoes relies on the juxtaposition of extensive dark and light areas rather than on the compositional arrangement of single figures. In the frescoes of the nave the eye is led stepwise from the darkest to the lightest area, the unfathomable depth of the sky, where the Name of Christ appears amid shining rays. Bernini recommended the method of working with large coherent units[50] and employed it himself in works like the Cathedra. The method did not only satisfy his desire to create overwhelming effects and dramatic emphasis, but also appeared most conducive to communicating his mystic conception of divine light and his intense spiritualization of religious themes. Bernini's two important ideas, developed from his middle period onwards, of breaking through the frame of the painting and of embedding masses of figures in unified areas of colour found an enthusiastic following in the northern Baroque.

ARCHITECTURE

Ecclesiastical Buildings

The year 1624 is of particular importance in the history of Baroque architecture; it was then that Bernini's career as an architect began with the commissions for the façade of S. Bibiana and the Baldacchino in St Peter's. It can hardly be denied that the little church of S. Bibiana

opens a new chapter of the Baroque in all three arts: it harbours Bernini's first official religious statue and Cortona's first important fresco cycle. The design of the façade[51] is not divorced from tradition. But instead of developing further the type of Roman church façade which had led to Maderno's S. Susanna, Bernini placed a palace-like storey over an open loggia [95] – essentially

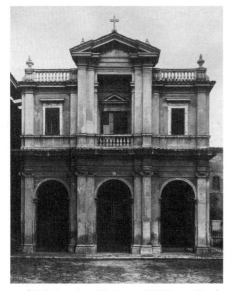

95. Gianlorenzo Bernini: Rome, S. Bibiana, 1624-6

the principle of the façade of St Peter's. In some modest early seventeenth-century façades of this type such as S. Sebastiano [7] the palace character is almost scrupulously preserved. By comparison S. Bibiana shows an important new feature: the central bay of the ground-floor arcades projects slightly, and above it, framing a deep niche, is an impressive aedicule motif which breaks through the skyline of the adjoining bays. In this way the centre of the façade has been given forceful emphasis. It should be noticed that the cornice of the side-bays seems to run on under the pilasters of the aedicule and then to turn into the depth of the

niche. Thus the aedicule is superimposed over a smaller system, the continuity of which appears to be unbroken. The interpenetration of small and large orders was a Mannerist device, familiar to Bernini not only from such buildings as Michelangelo's Capitoline palaces, but also from the church façades of Palladio, an architect whose work he never ceased to study. All the same, Bernini's first essay in architectural design constitutes a new, bold, and individualist departure which none of the architects who later used the palace type of church façade dared to imitate.

The Baldacchino in St Peter's (1624-33) [86] gave Bernini his first and at once greatest opportunity of displaying his unparalleled genius for combining an architectural structure with monumental sculpture.[52] It was a brilliant idea to repeat in the giant columns of the Baldacchino the shape of the late antique twisted columns which – sanctified by age and their use in the old Basilica of St Peter's – were now to serve as aedicules above the balconies of the pillars of the dome.[53] Thus the twisted bronze columns of the Baldacchino find a fourfold echo, and not only give proof of the continuity of tradition, but by their giant size also express symbolically the change from the simplicity of the early Christians to the splendour of the counter-reformatory Church, implying the victory of Christianity over the pagan world. Moreover, their shape helped to solve the formal problem inherent in the gigantic Baldacchino. Its size is carefully related to the architecture of the church; but instead of creating a dangerous rivalry, the dark bronze corkscrew columns establish a dramatic contrast to the straight fluted pilasters of the piers as well as to the other white marble structural members of the building. Finally, and above all, only giant columns of this peculiar shape could be placed free into space without carrying a 'normal' superstructure. The columns are topped by four large angels behind which rise the huge

scrolls of the crowning motif. Their S-shaped lines appear like a buoyant continuation of the screw-like upward tendencies of the columns. The scrolls meet under a vigorously curved entablature which is surmounted by the Cross above the golden orb.[54]

Every part of this dynamic structure is accompanied and supported by sculpture, and it may be noticed that with increasing distance from the ground the sculptural element is given ever greater freedom: starting from the Barberini coat of arms contained by the panels of the pedestals; on to the laurel branches, creeping up the columns, with putti nestling in them;[55] and further to the angels who hold garlands like ropes, with which to keep – so it seems – the scrolls in position without effort. In this area, high above the ground, sculpture in the round plays a vital part. Here, in the open spaces between the scrolls, are the putti with the symbols of papal power, here are the energetically curved palm branches which give tension to the movement of the scrolls and, finally, the realistic Barberini bees, fittingly the uppermost sculptural feature, which look as if they carry the orb. Critics have often disapproved of the realistic hangings which join the columns instead of the traditional entablature. But it is precisely this unorthodox element which gives the Baldacchino its particular meaning as a monumental canopy raised in all eternity over the tomb of St Peter, reminiscent of the real canopy held over the living pope when he is carried in state through the basilica.

Bernini's bold departure from the traditional form of baldacchinos – in the past often temple-like architectural structures[56] – had an immediate and lasting effect. Among the many repetitions and imitations[57] may be mentioned those in S. Lorenzo at Spello, erected as early as 1632, in the cathedrals at Atri, Foligno, and Trent and, much later, those in the abbey church at San Benigno, Piedmont (1770-6) and in S. Angelo at Perugia (1773, recently re-moved). Moreover, the derivations in Austria and Germany are legion; and even in France the type was widely accepted after the well-known lighter version with six columns on a circular plan had been built over the high altar of the Val-de-Grâce in Paris.[58]

Not until he was almost sixty years old had Bernini a chance of showing his skill as a designer of churches. His three churches at Castelgandolfo and Ariccia and S. Andrea al Quirinale in Rome rose almost simultaneously. In spite of their small size, they are of great importance not only for their intrinsic qualities but also because of their extraordinary influence. Modern critics tend to misinterpret them by stressing their traditional rather than their revolutionary aspect. Arguing from a purely aesthetic or pragmatic point of view, they tacitly imply that the same set of forms and motifs always expresses the same meaning. It is too often overlooked that the architecture of the past was

96 and 97. Gianlorenzo Bernini: Castelgandolfo, S. Tomaso di Villanova, 1658-61. Plan and view into dome

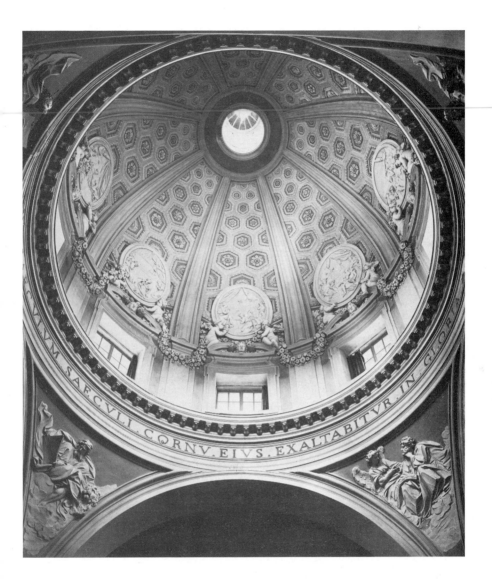

a language of visual signs and symbols which architects used in a specific context, and the same grammar of architectural forms may therefore serve entirely different purposes and convey vastly different ideas. This should be remembered during the following discussion.

Bernini erected his three churches over the three most familiar centralized plans, the Greek cross, the circle, and the oval. The earliest of them, the church at Castelgandolfo, built between 1658 and 1661,[59] is a simple Greek cross [96], reminiscent of such perfect Renaissance

churches as Giuliano da Sangallo's Madonna delle Carceri at Prato. And as in this latter church, the ratios are of utmost simplicity, the depth of the arms of the cross, for instance, being half their width. But compared with Renaissance churches the height has been considerably increased[60] and the dome has been given absolute predominance. The exterior is very restrained, in keeping with the modest character of the papal summer retreat to which the church belongs. Flat Tuscan double pilasters decorate the façade, and only minor features reveal the late date, such as the heavy door pediment and, in the zone of the capitals, the uninterrupted moulding which links the front and the arms of the church. Above the crossing rises the elegant ribbed dome which is evidently derived from that of St Peter's. But in contrast to the great model, the drum here consists of a low and unadorned cylinder, not unlike that of Raphael's S. Eligio degli Orefici in Rome, and is moreover set off against the dome by the prominent ring of the cornice. Every part of this building is clearly defined, absolutely lucid, and submitted to a classical discipline.

The same spirit of austerity prevails in the interior up to the sharply chiselled ring above the arches. But in the zone of the vaulting Bernini abandoned his self-imposed moderation [97]. Spirited putti, supporting large medallions, are seated on the broken pediments over the windows of the drum. These pediments, breaking into the dome, soften the division between drum and vault. Realistic garlands form links between the putti, and the lively and flexible girdle thus created appears like a pointed reversal of the pure geometry of the ring under the drum. This formal contrast between rigidity and freedom is paralleled by the antithesis between the monumental Roman lettering of the inscription, praising the virtues of St Thomas of Villanova to whom the church is dedicated, and the eloquent reliefs which render eight important events of his life.[61] Since the coffers

seem to continue behind the reliefs, the latter appear to hover in the wide expanse of the dome.

Whenever Bernini had previously decorated niches or semi-domes, he had followed the tradition, sanctioned by Michelangelo, of using ribs and, in the neutral areas between them, decorative roundels.[62] In Castelgandolfo Bernini retained the ribs and combined them with coffers. The classical element of the coffers seems to indicate an evenly distributed thrust (Pantheon), while the 'medieval', buttress-like system of ribs divides the dome into active carriers and passive panels. The union of these contrasting types of domical organization was not Bernini's own invention. He took up an idea first developed by Pietro da Cortona (p. 236) and, after thoroughly classicizing it, employed it from Castelgandolfo onwards for all his later vaultings and domes.[63] It was this Berninesque type of dome with ribs and coffers *all'antica* that was followed on countless occasions after 1660 by architects in Italy as well as the rest of Europe.[64]

S. Tomaso at Castelgandolfo is perhaps the least distinguished of Bernini's three churches in so far as the two others exhibit his specific approach to architecture more fully. The story of the new Ariccia dates back to 20 July 1661, when Cardinal Flavio, Don Mario, and Don Agostini Chigi acquired the little township near Castelgandolfo from Giulio Savelli, Prince of Albano. Here stood the old palace of the Savelli. Soon it was decided not only to modernize the palace,[65] but also to erect a church opposite its entrance. Bernini was commissioned in 1662, and two years later the church was finished [98-101].[66] Its basic form consists of a cylinder crowned by a hemispherical dome with a broad lantern. An arched portico of pure, classical design is placed in front of the rotunda [98], counterbalanced at the far end by the sacristy which juts out from the circle but is not perceived by the approaching visitor. Here also are the two bell-towers of which only the tops

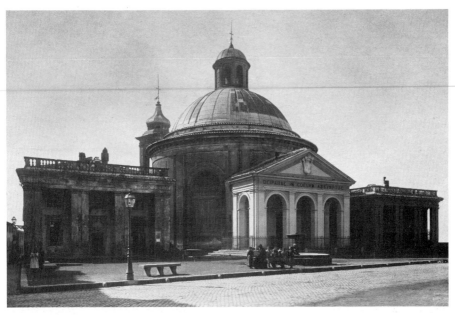

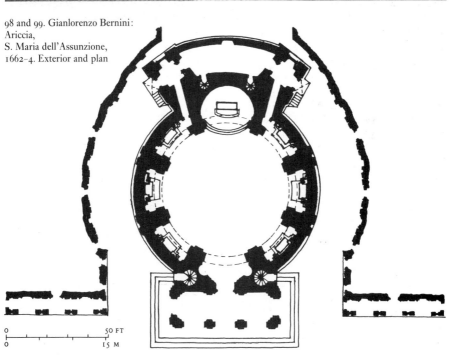

98 and 99. Gianlorenzo Bernini:
Ariccia,
S. Maria dell'Assunzione,
1662–4. Exterior and plan

0 50 FT
0 15 M

are visible from the square. In order to understand Bernini's guiding idea, reference must be made to another project.

From 1657 onwards Bernini was engaged on plans for ridding the Pantheon of later disfiguring additions; he also intended to systematize the square in front of the ancient building, but most of his ideas remained on paper.[67] Surviving sketches show that he interpreted the exterior of the 'original' Pantheon as the union of the two basic forms of vaulted cylinder and portico, and it is this combination of two simple geometric shapes, stripped of all accessories, that he realized in the church at Ariccia [99]. Straight colonnades flank the church, and these, together with the portico and the walls, which grip like arms around the body of the church, enhance the cylindrical and monolithic quality of the rotunda.

The interior too shows unexpected relations to the Pantheon [100]. There are three chapels of equal size on each side, while the entrance and the altar niche are a fraction larger, so that an almost unnoticeable axial direction exists. But the impression prevails of eight consecutive niches separated by tall Corinthian pilasters, which carry the unbroken circle of the entablature. As Andrea Palladio had done before in the little church at Maser, so here Bernini reduced the design to the two fundamental forms of the cylinder and hemisphere, and, as in Maser, the Corinthian order is as high as the cylinder itself. In contrast, however, to Palladio's rhythmic alternation of open and closed bays, Bernini gave an uninterrupted sequence of openings. The structural chastity of Ariccia was due to an attempt at recreating an imaginary Pantheon of the venerable Republican era. Bernini believed that the ancient building had originally been one of heroic simplicity and grandeur. Much later, Carlo Fontana, who in about 1660 worked as Bernini's assistant, published a reconstruction of the supposedly ori-

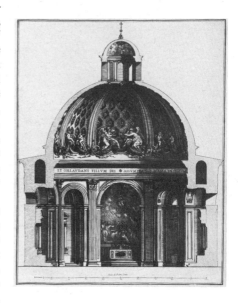

100 and 101. Gianlorenzo Bernini: Ariccia, S. Maria dell'Assunzione, 1662–4. Engraving of section and view into dome

ginal Pantheon which is remarkably close to the interior of Ariccia.[68]

But in the zone of the dome [101], which again shows the combination of coffers and ribs, we find a realistic decoration similar to that at Castelgandolfo: stucco putti and angels sit on scrolls, holding free-hanging garlands which swing from rib to rib. What do these life-like figures signify? The church is dedicated to the Virgin (S. Maria dell'Assunzione) and, according to the legend, rejoicing angels strew flowers on the day of her Assumption. The celestial messengers are seated under the 'dome of heaven' into which the ascending Virgin will be received; the mystery is adumbrated in the *Assumption* painted on the wall behind the

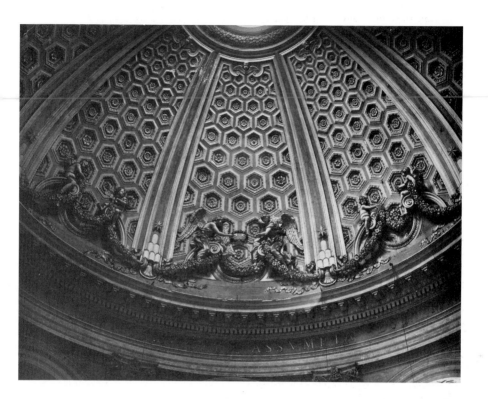

altar.[69] Since the jubilant angels, superior beings who dwell in a zone inaccessible to the faithful, are treated with extreme realism, they conjure up full and breathing life. Thus whenever he enters the church the worshipper participates in the 'mystery in action'. As in Castelgandolfo, the dedication of the church gives rise to a dramatic-historical interpretation; the entire church is submitted to, and dominated by, this particular event, and the whole interior has become its stage.

By and large, the Renaissance church had been conceived as a monumental shrine, where man, separated from everyday life, was able to communicate with God. In Bernini's churches, by contrast, the architecture is no more and no less than the setting for a stirring mystery revealed to the faithful by sculptural decoration. In spite of their close formal links with Renaissance and ancient architecture, these churches have been given an entirely non-classical meaning. Obviously, Bernini saw no contradiction between classical architecture and Baroque sculpture – a contradiction usually emphasized by modern critics who fail to understand the subjective and particular quality with which seemingly objective and timeless classical forms have been endowed.

By far the most important of the three churches is S. Andrea al Quirinale, commissioned by Cardinal Camillo Pamphili for the novices of the Jesuit Order [102–5]. Building

began simultaneously with the church at Castelgandolfo – the foundation stone was laid on 3 November 1658 – but it took much longer to complete this richly decorated church.[70] Antonio Raggi's stuccoes were carried out between 1662 and 1665, while other parts of the decoration dragged on until 1670. The particular character of the site on which most of the convent was standing induced Bernini to choose an oval ground-plan with the transverse axis longer than the main axis between entrance and altar. This in itself was not without precedent. There was Fornovo's S. Maria dell' Annunziata at Parma (1566),[71] and Bernini himself had used the type much earlier in the little church in the old Palazzo di Propaganda Fide (1634, later replaced by Borromini's structure). What is new in S. Andrea, however, is that pilasters instead of open chapels stand at both ends of the transverse axis. As a result, the oval is closed at the most critical points where otherwise, from a viewpoint near the entrance, the eye would wander off from the main room into undefined subsidiary spaces. Bernini's novel solution permits, indeed compels, the spectator's glance to sweep round the uninterrupted sequence of giant pilasters, crowned by the massive ring of the entablature, until it meets the columned aedicule in front of the altar recess [103, 104]. And here, in the concave opening of the pediment, St Andrew soars up to heaven on a cloud. All the lines of the architecture culminate in, and converge upon, this piece of sculpture. More arrestingly than in the other churches the beholder's attention is absorbed by the dramatic event, which owes its suggestive power to the way in which it dominates the severe lines of the architecture.

Colour and light assist the miraculous ascension. Below, in the human sphere, the church glows with precious multicoloured dark marble. Above, in the heavenly sphere of the dome, the colours are white and gold. The oval space is evenly lit by windows between the ribs which

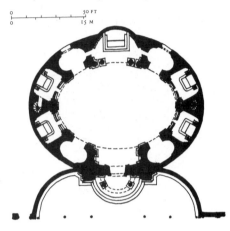

102. Gianlorenzo Bernini: Rome, S. Andrea al Quirinale, 1658–70. Plan

cut deep into the coffered parts of the dome. Bright light streams in from the lantern, in which sculptured cherubs' heads and the Dove of the Holy Ghost seem to await the ascending saint. All the chapels are considerably darker than the congregational room, so that its uniformity is doubly assured. In addition, there is a subtle differentiation in the lighting of the chapels: the large ones flanking the transverse axis have a diffused light, while the four subsidiary ones in the diagonal axes are cast in deep shadow. Thus the aedicule is adjoined by dark areas which dramatically enhance the radiance of light in the altar chapel.

In S. Andrea Bernini solved the intractable problem of directions inherent in centralized planning in a manner which only Palladio had attempted before the Baroque age.[72] By means of the aedicule, which is an ingenious adaptation of the Palladian device of the columned screen – a unique occurrence in Rome – he created a barrier against, as well as a vital link with, the altar chapel. He thus preserved and even emphasized the homogeneity of the oval form and, at the same time, succeeded in giving predomi-

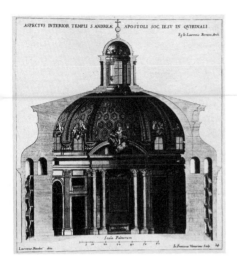

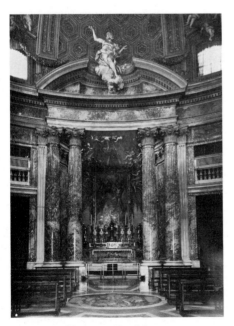

103 and 104. Gianlorenzo Bernini:
Rome, S. Andrea al Quirinale, 1658–70.
Engraving of section
and view towards the altar

nance to the altar. Translated into psychological terms, the church has two spiritual centres: the oval space, where the congregation participates in the miracle of the saint's salvation; and the carefully separated altar-recess, inaccessible to the laity, where the mystery is consummated. Here the beholder sees like an apparition the band of angelic messengers bathed in visionary golden light bearing aloft the picture of the martyred saint,[73] assured of his heavenly reward for faith unbroken by suffering.

It hardly seems necessary to reaffirm observations made in the first part of this chapter: here the whole church is subject to a coherent literary theme which informs every part of it, including the ring of figures above the windows which consists of putti carrying garlands and martyrs' palms, and nude fishermen who handle nets, oars, shells, and reeds – symbolic companions of the fisherman Andrew. Through its specific connexion with sculpture, the architecture itself serves to make the dramatic *concetto* a vital experience.

For the exterior of S. Andrea, Bernini made use of the lesson he had learned from Francesco da Volterra's S. Giacomo degli Incurabili.[74] In both churches the dome is enclosed in a cylindrical shell, and in both cases the thrust is taken up by large scrolls which fulfil the function of Gothic buttresses. But this is as far as the influence of S. Giacomo goes. In the case of S. Andrea, the scrolls rest upon the strong oval ring which encases the chapels. Its cornice seems to run on under the giant Corinthian pilasters of the façade and sweeps forward into the semicircular portico where it is supported by two Ionic columns. The portico [105], surmounted between scrolls by the free-standing Pamphili coat of arms of exuberant decorative design, is the only relieving note in an otherwise extremely austere façade. Yet this airy porch must not simply be regarded as an exhilarating feature inviting the passers-by to enter; it is also a dynamic element of vital importance in

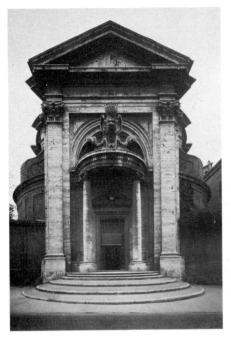

105. Gianlorenzo Bernini:
Rome, S. Andrea al Quirinale, 1658-70

the complex organization of the building. The aedicule motif framing the portico is taken up inside, on the same axis, by the aedicule framing the altar recess. But there is a reversal in the direction of movement: while in the exterior the cornice over the oval body of the church seems to move towards the approaching visitor and to come to rest in the portico, the point nearest to him, in the interior the movement is in the opposite direction and is halted at the point farthest away from the entrance. In addition, the isolated altar-room answers in reverse to the projecting portico, and this is expressive of their different functions, the latter inviting, the former excluding the faithful. Thus outside and inside appear like 'positive' and 'negative' realizations of the same theme. A word must be added about the two quadrant walls forming

the piazza.[75] They focus attention on the façade. But more than this: since they grip firmly into the 'joints' where the oval body of the church and the aedicule meet, their concave sweep reverses the convex ring of the oval and reinforces the dynamic quality of the whole structure.

Genetically speaking, the façade of S. Andrea is related to that of S. Bibiana. It might almost be said that what Bernini did was to isolate and monumentalize the revolutionary central feature of S. Bibiana and to connect it with the motif of the portico with free-standing columns which Pietro da Cortona had first introduced in S. Maria della Pace [147]. And yet this façade is highly original. In order to assess its novel character I may refer to the Early Baroque façade of S. Giacomo degli Incurabili.[76] Here the façade is orthodox, deriving from Roman Latin-cross churches, so that on entering this oval church one is aware that the exterior and the interior are not co-ordinated. In the case of S. Andrea al Quirinale nobody would expect to enter a Latin-cross church. Bernini succeeded in expressing in the façade the specific character of the church behind it: exterior and interior form an entirely homogeneous entity.

Secular Buildings

Bernini's activity in the field of domestic architecture was neither extensive nor without adversity. In the Palazzo Barberini, his earliest work, his contribution was confined to adjustments of Carlo Maderno's design and to decorative features of the interior such as the door surrounds.[77] The façade of the Collegio di Propaganda Fide facing the Piazza di Spagna was an able modernization of an old palace front (1642-4), but he acted only as consulting architect.[78] His share in the design of the Palazzo Ducale at Modena and the execution of the Palazzo del Quirinale – a work of many brains and hands – is relatively small.[79] A number of

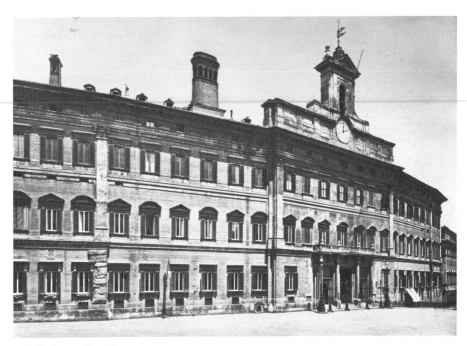

106. Gianlorenzo Bernini:
Rome, Palazzo di Montecitorio, begun 1650

designs remained on paper,[80] while some minor works survive: the decoration of the Porta del Popolo on the side of the Piazza, occasioned by the entry into Rome of Queen Christina of Sweden (1655); additions to the hospital of S. Spirito (1664-6) of which at least a gateway in the Via Penitenzieri close to the Square of St Peter's survives;[81] the renovation of the papal palace at Castelgandolfo (1660); and finally an 'industrial' work, the arsenal in the harbour of Civitavecchia (1658-63), consisting of three large halls of impressive austerity.[82] Setting all this aside, only three works of major importance remain to claim our attention, each with an ill-starred history of its own, namely the Palazzo Ludovisi in Piazza Montecitorio, the Palazzo Chigi in Piazza SS. Apostoli, and the projects for the Louvre.

Bernini designed the Palazzo Ludovisi, now Palazzo di Montecitorio [106], in 1650 for the family of Pope Innocent X.[83] In 1655, at the Pope's death, little was standing of the vast palace, and it was not until forty years later, in 1694, that Carlo Fontana resumed construction for Innocent XII. Although Fontana introduced some rather pedantic academic features, Bernini's façade was sufficiently advanced to prevent any flagrant distortion of his intentions.[84] The entire length of twenty-five windows is subdivided into separate units of 3-6-7-6-3 bays which meet at obtuse angles so that the whole front looks as if it were erected over a convex plan. Slight projections of the units at either end and the centre are important vehicles of organization. Each unit is framed by giant pilasters comprising the two principal storeys,

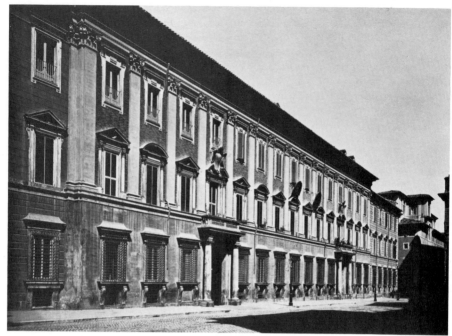

107. Gianlorenzo Bernini: Rome, Palazzo Chigi-Odescalchi, begun 1664. With N. Salvi's additions, 1745

to which the ground floor with the naturalistic rock formations under the farthest pilasters and window sills serves as a base. Apart from these attempts at articulation, the palace is essentially tied to the Roman tradition deriving from the Palazzo Farnese.

In the summer of 1664, not long before his journey to Paris, Bernini designed the palace which Cardinal Flavio Chigi had purchased in 1661 from the Colonna family [107].[85] The volte-face here is hardly foreshadowed in the façade of the Palazzo Ludovisi. Bernini placed a richly articulated central part of seven bays between simple rusticated receding wings of three bays each. More decidedly than in the Palazzo Ludovisi, the ground floor functions as a base for the two upper storeys with their giant composite pilasters which stand so close that the window tabernacles of the *piano nobile*

take up the entire open space. This finely balanced façade was disturbed in 1745 when the palace was acquired by the Odescalchi. Nicola Salvi and his assistant Luigi Vanvitelli doubled the central part, which now has sixteen pilasters instead of eight and two entrance doors instead of one. The present front is much too long in relation to its height and, standing between asymmetrical wings, no longer bears witness to Bernini's immaculate sense of proportion and scale. This, however, does not prejudice the revolutionary importance of Bernini's design, which constitutes a decisive break with the traditional Roman palace front. The older type, with no vertical articulation, has long rows of windows horizontally united by means of continuous string courses. Precedents for the use of the colossal order in palace façades existed. In Michelangelo's Capitoline Palaces

and Palladio's Palazzo Valmarana at Vicenza the colossal order rises from the ground. On the other hand, a few buildings in Rome before Bernini have a colossal order over the ground floor, and in Northern Italy the type is not rare.[86] But when all is said and done, such comparisons throw into relief rather than diminish Bernini's achievement. The relation of the ground floor to the two upper tiers; the fine gradation from simple window-frames to elaborate, heavy tabernacle frames in the *piano nobile* – deriving from the Palazzo Farnese – to the light and playful window surrounds of the second storey; the rich composite order of the pilasters; the powerful cornice with rhythmically arranged brackets crowned by an open balustrade which was meant to carry statuary; the juxtaposition of the highly organized central part with the rustic wings; and, lastly, the strong accentuation of the entrance with its free-standing Tuscan columns, balcony and window above it, the whole unit being again dependent on the Palazzo Farnese – all this was here combined in a design of authentic nobility and grandeur. Bernini had found the formula for the aristocratic Baroque palace. And its immense influence extends far beyond the borders of Italy.[87]

Bernini's third great enterprise, the Louvre, turned out to be his saddest disappointment. In the spring of 1665 Louis XIV invited him to come to Paris and suggest on the spot how to complete the great Louvre *carré* of which the west and south wings and half of the north wing were standing.[88] The east wing with the main front was still to be built. Great were the expectations on all sides when Bernini arrived in Paris on 2 June of that year. But his five months' stay there ended in dismal failure. The reasons for it were many, personal as well as national. And yet his projects might possibly have been accepted had they answered the purpose for which they were made. Before he travelled to France, he had already sent two different pro-

jects to Colbert, in whose hands as 'Surintendant des Bâtiments' rested all proceedings connected with the Louvre.

Although Bernini always worked on the whole area of the *carré*, the focus of his design was, of course, the east façade. The first project of June 1664, contemporary with the design of the Palazzo Chigi-Odescalchi, is unexpected by any standards [108].[89] He created an open rectangle with two projecting wings of four bays each, between which he placed a long colonnade consisting of a convex centre between two concave arms. The convex part of the colonnade follows the shape of the oval vestibule, above which is a grand oval hall going through two storeys. Its second storey with circular windows, articulated by double pilasters and decorated with French lilies standing out against the sky-line, rises above the uniform cornice of the whole front. In this façade Bernini followed up the theme of the Palazzo

108. Gianlorenzo Bernini:
First project for the Louvre, 1664. Plan

Barberini, an arcaded centre framed by serene wings, and applied to it the theme of Roman church façades with a convex centre between concave arms (S. Maria della Pace, S. Andrea al Quirinale). But for the details of the colonnade he turned to the festive architecture of northern Italy and combined the colossal order of Palladio's Loggia del Capitano at Vicenza with the two-storeyed arcade of Sansovino's Library at Venice.[90] The result was a palace design which has an entirely un-Roman airy quality, and though it remained on paper it seems to have had considerable influence on the development of eighteenth-century structures.

The second project, dispatched from Rome in February 1665 and preserved in a drawing at Stockholm,[91] has a giant order applied to the wall above a rusticated ground floor. One may regard this as a novel application of the Palazzo Chigi-Odescalchi design, but for the wide sweep of the concave centre part Bernini was probably indebted to an unexecuted project by Pietro da Cortona for the Piazza Colonna in Rome.[92] The third project designed in Paris survives in the engravings by Marot which were carried out under Bernini's watchful eyes. He now returned to the more conventional Roman palazzo type, and in the process of re-designing the east front he lost in originality what he gained in monumental appearance.[93] He was still faced with the typically Italian problem of harmonizing length and height in this front of prodigious extension; he therefore subdivided the traditional block shape into five distinct units, thus developing the scheme first evolved in the Palazzo Montecitorio. The central projection showing the ideal ratio of 1:2 (height to length, without the basement which was to disappear behind the moat) is emphasized not only by its size of eleven bays but also by virtue of its decoration with giant half-columns. This motif is taken up in the giant pilasters of the wings, while the receding sections have no orders at all. Following the example of the Palazzo

Farnese, Bernini retained much plain wall-space above the windows of the *piano nobile* as well as the traditional string course under the windows of the top storey. Instead of arranging the order as a simple consecutive sequence, he concentrated four half-columns in the central area, a device to emphasize the entrance.[94] This palace was to rise like a powerful fortress from the 'natural' rock;[95] this concept too was, in a way, anticipated in the Palazzo di Montecitorio.

Bernini's third east façade was the answer to previous criticism voiced by Colbert. But in spite of vital changes from one project to the next, Bernini clung with the stubbornness only to be found in a genius averse to any compromise to all the features which he regarded as essential for a royal residence although they were contrary to French taste and traditions. He retained the unifying cornice, the unbroken skyline, and the flat roof; to him a façade was a whole to which the parts were subordinated; it could never be the agglomeration of different structural units to which the French were accustomed. Moreover, in compliance with southern conceptions of decorum he insisted, in spite of Colbert's repeated protests, on transferring the King's suite from the quiet south front, facing the river, to the east wing, the most stately but also the most noisy part of the building.[96] Among his other unacceptable proposals was the idea of surrounding the *carré* with arcades after the fashion of Italian courtyards; such arcades were not only unsuitable in that they excluded the light from the rooms behind, but they also seemed aesthetically repulsive to the French.[97] Finally, he never abandoned the typically Italian staircases in the four corners of the *carré*, placed there in order not to interrupt the alignment of rooms, and their disposition as well as their enclosure by badly lit wells appeared contrary to common sense to the French, who had solved the problem of easy communication between vestibule, staircase hall, and living rooms.[98]

When Bernini returned to Italy he had not given up hope that his plans would be carried out. The French architects were bitterly antagonistic. Colbert was irresolute, but the king had taken a liking to the great Italian and supported him. Actually, the foundation stone of Bernini's Louvre was laid three days before his departure from Paris. Back in Rome, he worked out a new project, the fourth, in which he made the one concession of reducing the much criticized height of the *piano nobile*.[99] In May 1666 he sent his assistant, Mattia de' Rossi, to Paris to supervise the execution. But meanwhile the king's interest had shifted to Versailles, and that was the signal for Colbert to abandon Bernini's plans.

By this decision Paris was saved the doubtful honour of having within its walls the most monumental Roman palazzo ever designed. Splendid though Bernini's project was, the enormous, austere pile would forever have stood out as an alien growth in the serene atmosphere of Paris. In Rome, the cube of the Palazzo Farnese, the ancestor of Bernini's design, may be likened to the solo in a choir. In Paris, Bernini's overpowering Louvre would have no resonance: it would have cast an almost sombre spell over the gaiety of the city.[100]

The Piazza of St Peter's

While he was in Paris, Bernini's greatest work, the Square of St Peter's, was still rising. But by that time all the hurdles had been taken and, moreover, Bernini had a reliable studio with a long and firmly established tradition to look after his interests. His 'office' supplied, of course, no more than physical help towards the accomplishment of one of the most complex enterprises in the history of Italian architecture.[101] Bernini alone was responsible for this work which has always been universally admired, he alone had the genius and resourcefulness to find a way through a tangle of topo-

graphical and liturgical problems, and only his supreme authority in artistic matters backed by the unfailing support of Pope Alexander VII could overcome intrigues and envious opposition[102] and bring this task to a successful conclusion [1, 112, 113, 250]. Among a vast number of issues to be considered, particular importance was attached to two ritual ones right from the start. At Easter and on a few other occasions the pope blesses the people of Rome from the Benediction Loggia above the central entrance to the church. It is a blessing symbolically extended to the whole world: it is given *urbi et orbi*. The piazza, therefore, had not only to hold the maximum number of people, while the Loggia had to be visible to as many as possible, but the form of the square itself had to suggest the all-embracing character of the function. Another ceremony to be taken into account was the papal blessing given to pilgrims from a window of the private papal apartment situated in Domenico Fontana's palace on the north side of the piazza. Other hardly less vital considerations pertained to the papal palace. Its old entrance in the north-west corner of the piazza could not be shifted and yet it had to be integrated into the architecture of the whole.[103] The basilica itself required an approach on the grandest scale in keeping with its prominence among the churches of the Catholic world. In addition, covered ways of some kind were needed for processions and in particular for the solemn ceremonies of Corpus Domini; they were also necessary as protection against sun and rain, for pedestrians as well as for coaches.

Bernini began in the summer of 1656 with the design of a trapezoid piazza enclosed by the traditional type of palace fronts over round-headed arcades. This scheme was soon abandoned for a variety of reasons, not the least because it was of paramount importance to achieve greatest monumentality with as little height as possible. A palazzo front with arcades would have been higher than the present colon-

nades without attaining equal grandeur. So by March 1657 the first project was superseded by one with arcades of free-standing columns forming a large oval piazza; soon after, in the summer of the same year, Bernini replaced the arcades by colonnades of free-standing columns with a straight entablature above the columns. Only such a colonnade was devoid of any associations with palace fronts and therefore complied with the ceremonial character of the square more fully than an arcaded scheme with its reminiscences of domestic architecture. On ritualistic as well as artistic grounds the enclosure of the piazza had to be kept as low as possible. A high enclosure would have interfered with the visibility of the papal blessing given from the palace window. Moreover, a comparatively low one was also needed in order to 'correct' the unsatisfactory impression made by the proportions of the façade of St Peter's.

This requires a word of explanation. The substructures of Maderno's towers, standing without the intended superstructures,[104] look now as if they were parts of the façade, and this accounts for its excessive length [cf. 1 and 109].

A number of attempts were made in the post-Maderno period to remedy this fault,[105] before Urban VIII took the fateful decision in 1636 of accepting Bernini's grand design of high towers of three tiers.[106] Of these only the southern one was built, but owing to technical difficulties and personal intrigues construction was interrupted in 1641, and finally in 1646 the tower was altogether dismantled. Since the idea of erecting towers ever again over the present substructures had to be abandoned, Bernini submitted during Innocent X's pontificate new schemes for a radical solution of the old problem.[107] By entirely separating the towers from the façade [110], he made them structurally safe, at the same time created a rich and varied grouping, and gave the façade itself carefully balanced proportions. His proposals would have involved considerable structural changes and had therefore little chance of success. When engaged on the designs for the piazza, Bernini was once again faced with the intractable problem of the façade. Although he also made an unsuccessful attempt at reviving Michelangelo's tetrastyle portico,[108] which would have broken up the

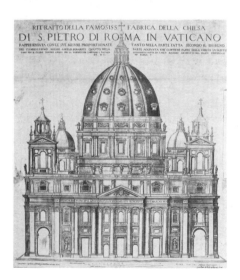

109. Carlo Maderno:
Rome, St Peter's. Façade.
M. Greuter's engraving, 1613

110 *(opposite)*. Gianlorenzo Bernini:
Rome, St Peter's. Façade with free-standing towers.
Drawing, *c.* 1650. *Rome, Vatican Library*

111. Gianlorenzo Bernini: Rome, Vatican Palace, Scala Regia, 1663–6

uniform 'wall' of the façade, he now had to use optical devices rather than structural changes as a means to rectify the appearance of the building. He evoked the impression of greater height in the façade by joining to it his long and relatively low corridors which continue the order and skyline of the colonnades.[109] The heavy and massive Doric columns of the colonnades and the high and by comparison slender Corinthian columns of the façade form a deliberate contrast. And Bernini chose the unorthodox combination of Doric columns with Ionic entablature [110] not only in order to unify the piazza horizontally but also to accentuate the vertical tendencies in the façade.

For topographical and other reasons Bernini was forced to design the so-called *piazza retta* in front of the church. The length and slant of the northern corridor, and implicitly the form of the *piazza retta*, were determined by the position of the old and venerable entrance to the

palace. Continuing the corridor, the new ceremonial staircase, the Scala Regia [111], begins at the level of the portico of the church. Here the problems seemed overwhelming. For his new staircase he had to make use of the existing north wall and the old upper landing and return flight.[111] By placing a columnar order within the 'tunnel' of the main flight and by ingeniously manipulating it, he counteracted the convergence of the walls towards the upper landing and created the impression of an ample and festive staircase.

There was no alternative to the *piazza retta*, and only beyond it was it possible to widen the square. The choice of the oval for the main piazza suggested itself by a variety of considerations. Above all the majestic repose of the widely embracing arms of the colonnades was for Bernini expressive of the dignity and grandeur here required [112, 113]. Moreover, this form contained a specific *concetto*. Bernini him-

112. Gianlorenzo Bernini:
Rome, The Piazza of St Peter's. Detail

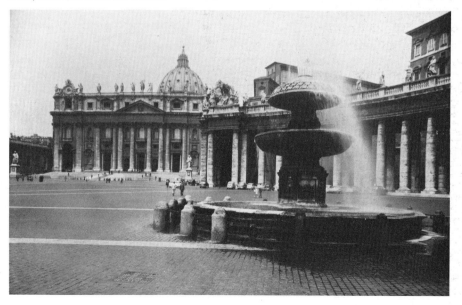

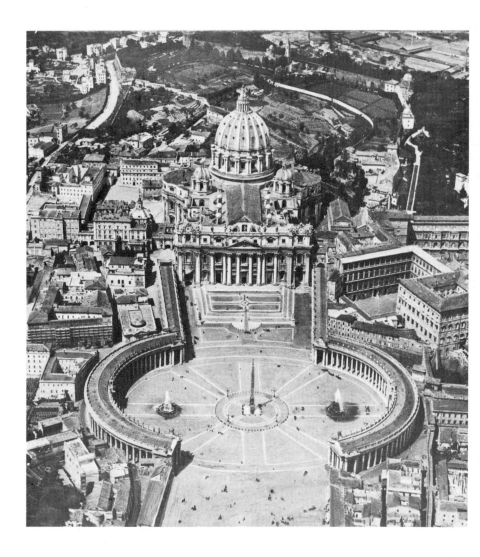

113. Gianlorenzo Bernini: Rome, The Piazza of St Peter's, begun 1656. Aerial view

self compared the colonnades to the motherly arms of the Church 'which embrace Catholics to reinforce their belief, heretics to re-unite them with the Church, and agnostics to enlighten them with the true faith'.

Until the beginning of 1667 Bernini intended to close the piazza at the far end opposite the basilica by a short arm continuing exactly the architecture of the long arms. This proves conclusively that for him the square was a kind of forecourt to the church, comparable to an immensely extended atrium. The 'third arm' which was never built would have stressed a problem that cannot escape visitors to the piazza. From a near viewpoint the drum of Michelangelo's dome, designed for a centralized building, disappears behind Maderno's long nave and even the visibility of the dome is affected. Like Maderno before him,[112] Bernini was well aware of the fact that no remedy to this problem could possibly be found. In developing his scheme for the piazza, he therefore chose to disregard this matter altogether rather than to attempt an unsatisfactory compromise solution. Early in 1667 construction of the piazza was far enough advanced to begin the 'third arm'. It was then that Bernini decided to move the 'third arm' from the perimeter of the oval back into the Piazza Rusticucci,[113] the square at one time existing at the west end of the Borghi (that is, the two streets leading from the Tiber towards the church). He was led to this last-minute change of plan certainly less by any consideration for the visibility of the dome than by the idea of creating a modest ante-piazza to the oval. By thus forming a kind of counterpart to the *piazza retta,* the whole design would have approached symmetry. In addition, the visitor who entered the piazza under the 'third arm' would have been able to embrace the entire perimeter of the oval. It may be recalled that in centralized buildings Bernini demanded a deep entrance because experience shows – so he told the Sieur de Chantelou – that people, on enter-

ing a room, take a few steps forward and unless he made allowance for this they would not be able to embrace the shape in its entirety. In S. Andrea al Quirinale he had given a practical exposition of this idea and he now intended to apply it once again to the design of the Piazza of St Peter's. In both cases the beholder was to be enabled to let his glance sweep round the full oval of the enclosure, in the church to come to rest at the aedicule before the altar and in the piazza at the façade of St Peter's. Small or large, interior or exterior, a comprehensive and unimpaired view of the whole structure belongs to Bernini's dynamic conception of architecture, which is equally far removed from the static approach of the Renaissance as from the scenic pursuits of northern Italy and the Late Baroque.

The 'third arm', this important link between the two long colonnades, remained on paper for ever, owing to the death of Alexander VII in 1667. The recent pulling down of the *spina* (the houses between the Borgo Nuovo and Borgo Vecchio), already contemplated by Bernini's pupil Carlo Fontana and, in his wake, by other eighteenth- and nineteenth-century architects,[114] has created a wide roadway from the river to the piazza. This has solved one problem, and only one, namely that of a full view of the drum and dome from the distance; may it be recalled that they were always visible in all their glory from the Ponte S. Angelo, in olden days the only access to the precincts of St Peter's. To this fictitious gain has been sacrificed Bernini's idea of the enclosed piazza and, with no hope of redress, the scale between the access to the square and the square itself has been reversed. Formerly the narrow Borgo streets opened into the wide expanse of the piazza, a dramatic contrast which intensified the beholder's surprise and feeling of elation.

The most ingenious, most revolutionary, and at the same time most influential feature of Bernini's piazza is the self-contained, free-standing colonnade.[115] Arcades with orders of

the type familiar from the Colosseum, used on innumerable occasions from the fifteenth century onwards, always contain a suggestion of a pierced wall and consequently of flatness. Bernini's isolated columns with straight entablature, by contrast, are immensely sculptural elements. When crossing the piazza, our ever-changing view of the columns standing four deep[116] seems to reveal a forest of individual units; and the unison of all these clearly defined statuesque shapes produces a sensation of irresistible mass and power. One experiences almost physically that each column displaces or absorbs some of the infinitude of space, and this impression is strengthened by the glimpses of sky between the columns. No other Italian structure of the post-Renaissance period shows an equally deep affinity with Greece. It is our preconceived ideas about Bernini that dim our vision and prevent us from seeing that this Hellenic quality of the piazza could only be produced by the greatest Baroque artist, who was a sculptor at heart.

As happens with most new and vital ideas, after initial sharp attacks the colonnades became of immense consequence for the further history of architecture. Examples of their influence from Naples to Greenwich and Leningrad need not be enumerated. The aftermath can be followed up for more than two and a half centuries.

FRANCESCO BORROMINI

1599-1667

Among the great figures of the Roman High Baroque the name of Francesco Borromini stands in a category of its own. His architecture inaugurates a new departure. Whatever their innovations, Bernini, Cortona, Rainaldi, Longhi and the rest never challenged the essence of the Renaissance tradition. Not so Borromini, in spite of the many ways in which his work is linked to ancient and sixteenth-century architecture. It was clearly felt by his contemporaries that he introduced a new and disturbing approach to old problems. When Bernini talked in Paris about Borromini, all agreed, according to the Sieur de Chantelou, that his architecture was extravagant and in striking contrast to normal procedure; whereas the design of a building, it was argued, usually depended on the proportions of the human body, Borromini had broken with this tradition and erected fantastic ('chimerical') structures. In other words, these critics maintained that Borromini had thrown overboard the classical anthropomorphic conception of architecture which since Brunelleschi's days had been implicitly accepted.

This extraordinary man, who from all reports was mentally unbalanced and voluntarily ended his life in a fit of despair, came into his own remarkably late. The son of the architect Giovanni Domenico Castelli, he was born in 1599 at Bissone on the Lake of Lugano near the birthplace of his kinsman Maderno.[1] After a brief stay in Milan, he seems to have arrived in Rome in about 1620. Much as the artisans who for hundreds of years had travelled south from that part of Italy, he began as a stone-carver, and in this capacity spent more than a decade of his life working mainly in St Peter's on coats of arms, decorative putti, festoons, and balustrades. His name is also connected with some of the finest wrought-iron railings in the basilica.[2] Moreover, the aged Maderno, who recognized the talent of his young relation, used him as an architectural draughtsman for St Peter's, the Palazzo Barberini, and the church and dome of S. Andrea della Valle.[3] Borromini willingly submitted to the older man, and the lasting veneration in which he held him is revealed by the fact that in his will he expressed the wish to be buried in Maderno's tomb.

After Maderno's death in January 1629 a new situation arose. Bernini took over as Architect to St Peter's and the Palazzo Barberini, and Borromini had to work under him. Documents permit Borromini's position to be defined: between 1631 and 1633 he received substantial payments for full-scale drawings of the scrolls of the Baldacchino and for the supervision of their execution, and in 1631 he was also officially functioning as 'assistant to the architect' of the Palazzo Barberini. The Borrominesque character of the scrolls as well as certain details in the palazzo indicate that Bernini conceded a notable freedom of action to his subordinate, and it would therefore appear that Bernini rather than Maderno paved the way for Borromini's imminent emergence as an architect in his own right. But their relationship had the making of a long-lasting conflict. Fate brought two giants together whose characters were as different as were their approaches to architecture; Bernini – man of the world, expansive and brilliant – like his Renaissance peers regarded painting

114. Francesco Borromini: Rome, Palazzo Barberini, façade. Window next to the arcaded centre, c. 1630

and sculpture as adequate preparation for architecture; Borromini - neurotic and recluse - came to achitecture as a trained specialist, a builder and first-rate technician. Almost exact contemporaries, the one was already immensely successful, the first artist in Rome, entrusted with most enviable commissions, while the other still lacked official recognition at the age of thirty. Bernini, of course, used Borromini's expert knowledge to the full. He had no reason for professional jealousy, from which, incidentally, he always remained free. For Borromini, however, these years must have been a degrading experience which always rankled with him, and when in 1645 the affair of Bernini's towers of St Peter's led to a crisis, it was he who came forward as Bernini's most dangerous critic and adversary. His guns were directed against technical inefficiency, the very point where – he knew – Bernini was most vulnerable.

At present it does not seem possible to separate with any degree of finality Borromini's active contribution to the Palazzo Barberini. His personal manner is evident, above all, in the top-floor window of the recessed bay adjoining the arcaded centre [114]. The derivation from Maderno's windows in the attic of the façade of St Peter's is obvious, but the undulating 'ears' with festoons fastened to them as well as the segmental capping with endings turned outward at an angle of 45 degrees are characteristic of Borromini's dynamic interpretation of detail. Here that Promethean force which imparts an unaccountable tension to every shape and form is already noticeable.

Original drawings for the doors of the great hall help to assess the relationship between Borromini and Bernini.[4] There was certainly a give and take on both sides, but on the whole it would appear that Borromini's new interpretation of the architectural detail made a strong impression on Bernini who, at this phase and for a short while later, tried to reconcile his own anthropomorphic with Borromini's 'bizarre' interpretation of architecture. Although the work on the Palazzo Barberini dragged on until 1638, the major part was finished in 1633. From then on the two men parted for good. It was then that Borromini set out on his own.

S. Carlo alle Quattro Fontane

His opportunity came in 1634, when the Procurator General of the Spanish Discalced Trinitarians commissioned him to build the monastery of S. Carlo alle Quattro Fontane, a couple of hundred yards from the Palazzo Barberini. Borromini first built the dormitory, the refectory (now sacristy), and the cloisters,[5] and the layout proved him a master in the rational exploitation of the scanty potentialities of the small and irregularly cut site [115]. In 1638 the foundation stone of the little church itself was laid. Except for the façade, it was

115. Francesco Borromini:
Rome, S. Carlo alle Quattro Fontane, 1638–41. Plan

finished in May 1641 and consecrated in 1646
[117]. Next to Cortona's SS. Martina e Luca,
which went up during the very same years, it
must be regarded as one of the 'incunabula' of
the Roman High Baroque and deserves the
closest attention.

The cloisters, a structure of admirable sim-
plicity, contain features which anticipate the
basic 'orchestration' in the church, such as the
ring of rhythmically arranged, immensely effec-
tive columns forming an elongated octagon, the
uniform cornice binding together the columns,
and the replacement of corners by convex
curvatures which prevent caesuras in the con-
tinuity of movement.

A number of projects in the Albertina, Vienna,
have always been – as we now know incorrectly
– referred to the planning of the church ever
since E. Hempel published them in 1924.[6] The
geometric conception of the final project is a

diamond pattern of two equilateral triangles
with a common base along the transverse axis of
the building; the undulating perimeter of the
plan follows this rhomboid geometry with great
precision.

It is of the greatest importance to realize that
in S. Carlo and in later buildings Borromini
founded his designs on geometric units. By
abnegating the classical principle of planning in
terms of modules, i.e. in terms of the multipli-
cation and division of a basic arithmetical unit
(usually the diameter of the column), Borro-
mini renounced, indeed, a central position of
anthropomorphic architecture. In order to make
clearer the difference of procedure, one might
state, perhaps too pointedly, that in the one
case the overall plan and its divisions are evolved
by adding module to module, and in the other
by dividing a coherent geometric configuration
into geometric sub-units. Borromini's geomet-

ric approach to planning was essentially medieval, and one wonders how much of the old mason's tradition had reached him before he went to Rome. For hundreds of years Lombardy had been the cradle of Italian masons, and it is quite possible that in the masons' yards medieval building practices were handed on from generation to generation. Borromini's stubborn adherence to the rule of triangulation seems to support the point.[7]

In Borromini's plan of S. Carlo extraordinary importance is given to the sculptural element of the columns [116, 117]. They are grouped in fours with larger intervals on the longitudinal and transverse axes. While the triads of undulating bays in the diagonals are unified by the wall treatment – niches and continuous mouldings – the dark gilt-framed pictures in the main axes seem to create effective caesuras. Thus, starting from the entrance bay, a rhythm of the following order exists: A|bcb|A'|bcb|A| etc. But this is clearly not the whole truth. A different

116 *(left)* and 117 *(below)*. Francesco Borromini: Rome, S. Carlo alle Quattro Fontane, 1638-41. Section and view towards high altar

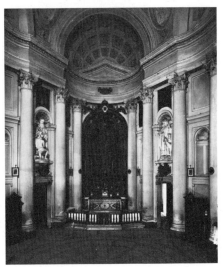

rhythm is created by the high arches and the segmental pediments above the pictures. These elements seem to tie together each group of three bays in the main axes. The reading, again from the entrance bay, would therefore be: |bAb|c|bA'b|c|bAb| etc. Where then are the real caesuras in this building? In the overlapping triads of bays there is certainly a suggestion of Mannerist complexity. However, instead of strengthening the inherent situation of conflict, as the Mannerists would have done, Borromini counteracted it by two devices: first, the powerful entablature serves, in spite of its movement, as a firm horizontal barrier which the eye follows easily and uninterruptedly all round the perimeter of the church; and secondly, the columns themselves, which by their very nature have no direction, may be seen as a continuous accentuation of the undulating walls. It is precisely the predominant bulk of the columns inside the small area of this church that helps to unify its complex shape. The overlapping triads may be regarded as the 'background rhythm' which makes for the never-tiring richness and fascination of the disposition; or, to use a simile, they may be likened to the warp and woof of the wall texture. In musical terms the arrangement may be compared to the structure of a fugue.

What kind of dome could be erected over the undulating body of the church? To place the vault directly on to it in accordance with the method known from circular and oval plans (Pantheon type) would have been a possibility which Borromini, however, excluded at this stage of his development. Instead he inserted a transitional area with pendentives which allowed him to design an oval dome of unbroken curvilinear shape [118]. He used, in other words, the transitional device necessary in plans with square or rectangular crossings. The four bays under the pendentives ('c') fulfil, therefore, the function of piers in the crossings of Greek-cross plans. And, in actual fact, in the zone of the pendentives Borromini incorporated an in-

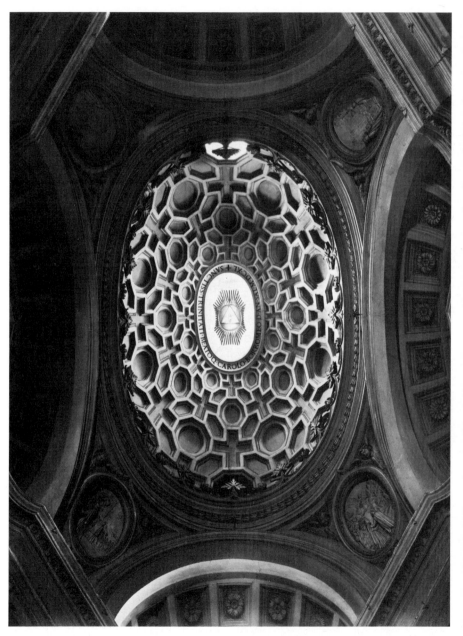

118. Francesco Borromini: Rome, S. Carlo alle Quattro Fontane, 1638–41. Dome

teresting reference to the cross-arms. The shallow transverse niches as well as the deeper entrance and altar recesses are decorated with coffers which diminish rapidly in size, not only suggesting, theoretically, a depth greater than the actual one, but also containing an illusionist hint at the arms of the Greek cross. Yet this sophisticated device was meant to be conceptually rather than visually effective. Above the pendentives is the firm ring on which the oval dome rests. The dome itself is decorated with a maze of deeply incised coffers of octagonal, hexagonal, and cross shapes.[8] They produce an exciting honeycomb impression, and the crystalline sharpness of these simple geometric forms is as far removed from the classical type of coffers in Bernini's buildings [97] as from the smooth and curvilinear ones in those by Cortona [144]. The coffers decrease considerably in size towards the lantern, so that here again an illusionist device has been incorporated into the design. Light streams in not only from above through the lantern but also from below through windows in the fillings of the coffers, partly hidden from view behind the sharply chiselled ornamental ring of stylized leaves which crowns the cornice. The idea of these windows can be traced back to a similar, but typically Mannerist, arrangement in an oval church published by Serlio in his Fifth Book. Thus the dome in its shining whiteness and its even light without deep shadows seems to hover immaterially above the massive and compact forms of the space in which the beholder moves.

Borromini reconciled in this church three different structural types: the undulating lower zone, the pedigree of which points back to such late antique plans as the domed hall of the Piazza d'Oro in Hadrian's Villa near Tivoli; the intermediate zone of the pendentives deriving from the Greek-cross plan; and the oval dome which, according to tradition, should rise over a plan of the same shape. Nowadays it is difficult to appreciate fully the audacity and freedom in manipulating three generically different structures in such a way that they appear merged into an infinitely suggestive whole. With this bold step Borromini opened up entirely new vistas which were further explored later in the century in Piedmont and northern Europe rather than in Rome.

The extraordinary character of Borromini's creation was immediately recognized. Upon the completion of the church the Procurator General wrote that 'in the opinion of everybody nothing similar with regard to artistic merit, caprice, excellence and singularity can be found anywhere in the world. This is testified by members of different nations who, on their arrival in Rome, try to procure plans of the church. We have been asked for them by Germans, Flemings, Frenchmen, Italians, Spaniards and even Indians . . .' The report also contains an adroit characterization of the buildings: 'Everything' – it says – 'is arranged in such manner that one part supplements the other and that the spectator is stimulated to let his eye wander about ceaselessly.'

The façade [119, 120] was not erected during the early building period. It was Borromini's last work, begun in 1665 and completed in 1667, though the sculptural decoration was not finished until 1682. Although Borromini's whole career as an architect lies between the building of the church and of the façade, the discussion of the latter cannot be separated from that of the former. The system of articulation, combining a small and a giant order, derives from Michelangelo's Capitoline Palaces and the façade of St Peter's where Borromini had started work as a *scarpellino* almost fifty years before. But he employed this Michelangelesque system in an entirely new way. By repeating it in two tiers of almost equal importance, he acted against the spirit in which the system had been invented, namely to unify a front throughout its whole height. Moreover, this determined repetition was devised to serve a specific, highly

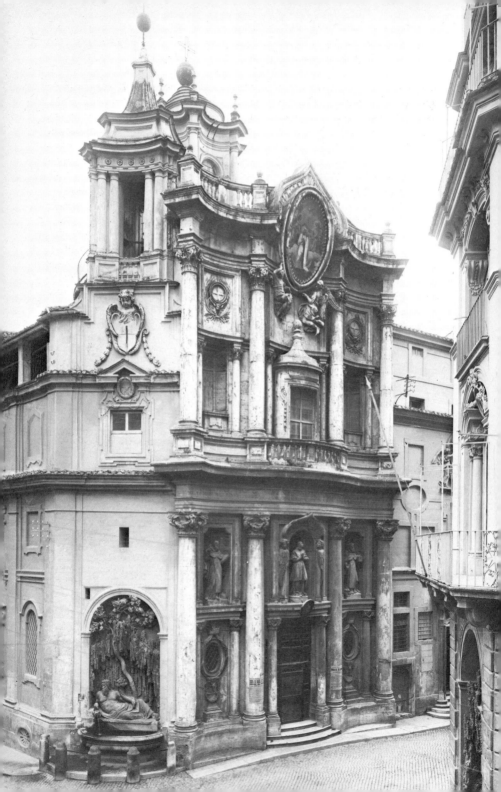

original concept; in spite of the coherent articulation, the upper tier embodies an almost complete reversal of the lower one. The façade consists of three bays; below, the two concave outside bays and the convex centre bay are tied together by the strong, unbroken, undulating entablature; above, the three bays are concave and the entablature is deployed in three separate segments. In addition, the oval medallion carried by angels and capped by the onion-shaped crowning element nullifies the effect of the entablature as a horizontal barrier. Below, the small columns of the outside bays frame a wall with small oval windows and serve as support for niches with statues; above, the small columns frame niches and support enclosed wall panels – in other words, the open and closed parts have been reversed. The opening of the door in the central bay is answered above by the 'sculptural' and projecting element of the oval 'box' in which the convex movement of the façade is

echoed. Finally, instead of the niche with the figure of St Charles, the upper tier has a medallion loosely attached to the wall. The principle underlying the design is that of diversity and even polarity inside a unifying theme, and it will be noticed that the same principle ties the façade to the interior of the church. For the façade is clearly a different realization of the triad of bays which is used for the 'instrumentalization' of the interior.

The compactness of this façade, with its minimum of wall-space, closely set with columns, sculpture, and plastic decoration where the eye is nowhere allowed to rest for long, is typical of the High Baroque. Borromini also included a visionary element, characteristic of his late style. Above the entrance there are herms ending in very large, lively cherubs' heads, whose wings form a protecting arch for the figure of St Charles Borromeo in the niche [120]. In other parts of the façade, too, realistic

119 *(opposite)*. Francesco Borromini: Rome, S. Carlo alle Quattro Fontane. Façade, 1665–7

120 *(right)*. Detail of illustration 119, with Antonio Raggi's statue of St Charles Borromeo

sculptural detail supports functional architectural forms. This strange fusion of architecture and sculpture, the growth of which can be followed over a long period, is utterly opposed to the manner of Bernini, who could never divorce sculpture from narrative connotations and therefore never surrendered it to architecture.

S. Ivo della Sapienza

Almost immediately after the completion of S. Carlo alle Quattro Fontane Borromini was given a great opportunity further to develop his ideas on ecclesiastical architecture. He began the church of the Roman Archiginnasio (later the University), S. Ivo, in 1642; by 1650 most of the structure was finished. The decoration dragged on until 1660. As early as 1632 when work in the Palazzo Barberini was still in progress, Bernini had recommended Borromini as architect to the Sapienza.[9] He began by continuing the older south wing of the palace. The two great doors of the east wing on Piazza S. Eustachio, his most important exterior contribution, were executed much later, during Alexander VII's pontificate.

The church was to be erected at the east end of Giacomo della Porta's long, arcaded *cortile* [125]. For its plan Borromini returned once again to the basic geometry of the equilateral triangle [121]. But this time the triangles interpenetrate in such a way that they form a regular star-hexagon. The points of interpenetration lie on the perimeter of a circle, and by drawing straight lines from point to point a regular hexagon is formed. The semicircular recesses replacing the angles of one triangle are determined by circles with a radius of half a side of the hexagon, while the convex endings of the other triangle result from circles with the same radius and their centres in the points of the triangle.[10] Thus recesses of a concave shape and recesses with slanting walls and convex endings alternate and face each other across the space.

Before Borromini's S. Ivo, the star-hexagon was almost entirely excluded from Renaissance and post-Renaissance planning. It may have occurred in antiquity,[11] but apart from a sketch by Peruzzi in the Uffizi and Vittozzi's SS. Trinità at Turin (begun 1598) it would be difficult to name Italian precedents. Even the simple hexagon was hardly used. The reason is not difficult to guess. In contrast to the square, the octagon, and dodecagon, where equal sides confront each other in the two main axes, in the hexagon one axis goes through two sides, the other through two angles. It is therefore evident that in plans derived from the hexagon the parts can never conform, and herein

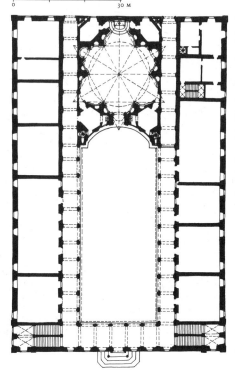

121. Francesco Borromini:
Rome, S. Ivo della Sapienza, 1642–50. Plan

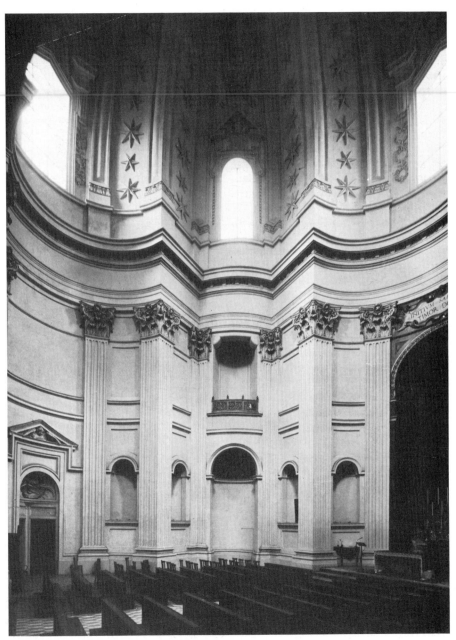

122. Francesco Borromini: Rome, S. Ivo della Sapienza, 1642-50. Interior

lies an element of unrest or even conflict. But it must be said at once that the complexities inherent in hexagonal or star-hexagonal planning were skilfully avoided by Borromini. His method was no less than revolutionary. Instead of creating, in accordance with tradition, a hexagonal main space with lower satellite spaces placed in the angles of the triangles, he encompassed the perimeter with an uninterrupted sequence of giant pilasters impelling the spectator to register the unity and homogeneity of the entire area of the church [122]. This sensation is powerfully supported by the sharply defined crowning entablature which reveals the star form of the ground-plan in all its clarity [124]. The basic approach is, therefore, close to that in S. Carlo alle Quattro Fontane; and once again a sophisticated 'background-rhythm' constantly stimulates the beholder's curiosity. Each recess is articulated by three bays, two identical small ones framing a large one ('A C A' and 'A' B A'') [123]. But these alternating triads – equal in value though entirely different in spatial deployment – are not treated as separate or separable entities, for the two small bays across each corner (A A' or A' A) are so much alike that they counteract any tendency to perceiving real caesuras. Moreover, two other overlapping rhythms are also implied. The continuous string courses at half-height are interrupted by the central bay of the semicircular altar recess (C),[12] while the continuous string course under the capitals is not carried on across the convex bays (B). Thus two alternative groups of five bays may be seen as 'super-units', either A A' B A' A or A' A C A A'. It may therefore be said that the articulation contains three interlocking themes with the intervals placed at any of the three possible points: the large round-headed bays 'C', the convex bays 'B', or at the angles between the small bays 'A A''.

In contrast to S. Carlo alle Quattro Fontane, the dome caps the body of the church without a transitional structural feature. It continues,

in fact, the star shape of the plan, each segment opening at its base into a large window. Moreover, the vertical lines of the pilasters are carried on in the gilded mouldings of the dome which repeat and accentuate the tripartite division into bays below [124]. In spite of the strong horizontal barrier of the entablature, the vertical tendencies have a terrific momentum. As the variously shaped sectors of the dome ascend, contrasts are gradually reduced until the movement comes to rest under the lantern in the pure form of the circle, which is decorated with

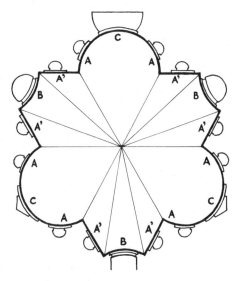

123. Francesco Borromini:
Rome, S. Ivo della Sapienza, 1642–50. Plan

twelve large stars. In this reduction of multiplicity to unity, of differentiation and variety to the simplicity of the circle, consists a good deal of the fascination of this church. Geometrical succinctness and inexhaustible imagination, technical skill and religious symbolism have rarely found such a reconciliation. One can trace the movement downward from the chastity of forms in the heavenly zone to the increasing complexity of the earthly zone. The

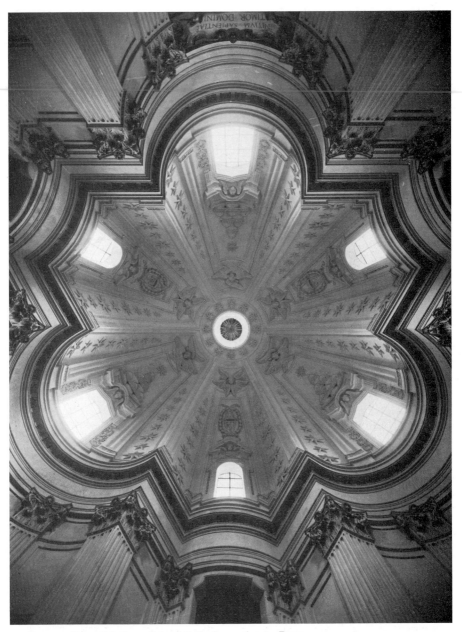

124. Francesco Borromini: Rome, S. Ivo della Sapienza, 1642–50. Dome

decorative elements of the dome – the vertical rows of stars, the papal coat of arms above alternating windows, the cherubs under the lantern – have a fantastic, unreal, and exciting quality and speak at the same time a clear emblematical language.[13]

In continuing the shape of the ground-plan into the vaulting Borromini accepted the principle normally applied to circular and oval churches. Yet neither for the particular form of the dome nor for the decoration was there a contemporary precedent. In one way or another the customary type of the Baroque dome followed the example set by Michelangelo's dome of St Peter's. In none of the great Roman domes was the vaulted surface broken up into differently shaped units. But Borromini had classical antiquity on his side; he had surely studied such buildings as the Serapeum of Hadrian's Villa near Tivoli.[14] The dome of S. Ivo found no sequel in Rome. Again it was in Piedmont that Borromini's ideas fell on fertile ground.

The exterior of S. Ivo presented an unusual task, since the main entrance had to be placed at the far end of Giacomo della Porta's courtyard. Borromini used Porta's hemicycle with closed arcades in two tiers for the façade of the church; above it towers one of the strangest domes ever invented [125]. In principle Borromini followed the North Italian tradition of encasing the dome rather than exhibiting its rising curve as had been customary in central Italy since Brunelleschi's dome of Florence Cathedral. He handled this tradition, however, in a new and entirely personal manner. His domed structure consists of four different parts: first, a high, hexagonal drum of immense weight which counters by its convex projection the concave recession of the church façade on the *cortile*. The division of each of the six equal convex sectors into two small bays and a large one prepares for the triads in the recesses of the interior. At the points where two convex sectors meet the order is strengthened; this

enhances the impression of vitality and tension. Secondly, above the drum is a stepped pyramid, divided by buttress-like ribs which transfer the thrust on to the reinforced meeting-point of two sectors of the drum; thirdly, the pyramid is crowned by a lantern with double columns and concave recessions between them. The similarity to the little temple at Baalbek cannot be overlooked and has, indeed, often been stressed.[15] Above these three zones – which in spite of their entirely different character are welded together by the strong structural 'conductors' – rises a fourth element, the spiral, monolithic and sculptural, not corresponding to any interior feature or continuing directly the external movement. Yet it seems to bind together the several fields of energy which, united, soar up in a spatial movement along the spiral and are released into the lofty iron cusp. It is futile to speculate on the exact prototypes for the spiral feature. Borromini may have developed impressions of imperial Roman columns or may have had some unexpected knowledge of a ziggurat, the Babylonian–Assyrian temple towers of which a late derivation survives in the great mosque at Samàrra.[16] In any case, it can hardly be doubted that this element has an emblematic meaning, the precise nature of which has not yet been rediscovered.

S. Ivo must be regarded as Borromini's masterpiece, where his style reached its zenith and where he played all the registers at his command. By comparison, his earlier and later buildings, ecclesiastical as well as domestic, often suffer through the fact that they are either unfinished or that he was inhibited by complexities of site and the necessity to comply with existing structures.

In contrast to Bernini, who conceived architecture as the stage for a dramatic event expressed through sculpture, the drama in S. Ivo is inherent in the dynamic architectural conception itself: in the way that the motifs unfold, expand, and contract; in the way that movement

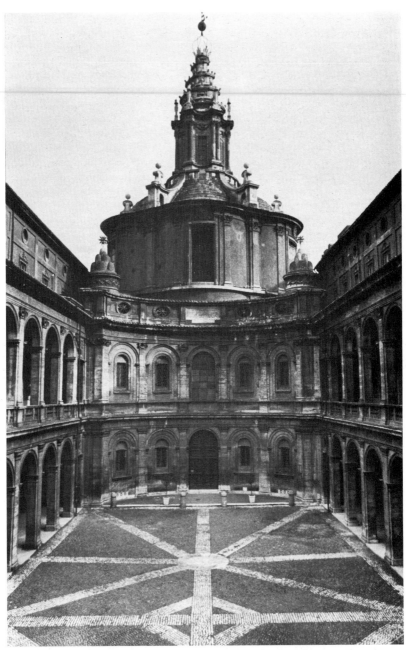

125. Francesco Borromini: Rome, S. Ivo della Sapienza, 1642–50. View from the courtyard

surges upwards and comes to rest. Ever since Baldinucci's days it has been maintained that there is an affinity to Gothic structures in Borromini's work. There is certainly truth in the observation. His interest in the cathedral at Milan is well known, and the system of buttresses in S. Ivo proves that he found inspiration in the northern medieval rather than the contemporary Roman tradition. Remarkably medieval features may be noticed in his detail, such as the angular intersection of mouldings over the doors inside S. Ivo or the pedestal of the holy water stoup in the Oratory of S. Filippo Neri. Even more interesting is his partiality for the squinch, so common in the Romanesque and Gothic architecture of northern Italy before the Byzantine pendentive replaced it in the age of the Renaissance. But he used the squinch as a transitional element between the wall and the vault only in minor structures, such as the old sacristy of S. Carlo alle Quattro Fontane, or in certain rooms of the Palazzo Falconieri and of the Collegio di Propaganda Fide. His resuscitation of the squinch was again to find a sequel in Piedmont rather than Rome.

S. Giovanni in Laterano, S. Agnese, S. Andrea delle Fratte, and Minor Ecclesiastical Works

While S. Ivo was in course of construction three large works were entrusted to Borromini: the reconstruction of S. Giovanni in Laterano, the continuation of Rainaldi's S. Agnese in Piazza Navona, and the exterior of S. Andrea delle Fratte. A thorough restoration of S. Giovanni had become necessary since the Early Christian basilica was in danger of collapse. Borromini's work was begun in May 1646 and finished by October 1649, in time for the Holy Year.[17] His task was extremely difficult because Innocent X insisted on preserving the venerable basilica. How could one produce a modern Baroque building under these circumstances?[18] Borromini solved his problem by encasing two con-

secutive columns of the old church inside one broad pillar, by framing each pillar with a colossal order of pilasters throughout the whole height of the nave, and by placing a tabernacle niche of coloured marble for statuary into the face of each pillar where originally an opening between two columns had been [126]. The alternation of pillars and open arches created a basic rhythm well known since Bramante's and even Alberti's days. Borromini, however, not only carried it across the corners of the entrance wall, thereby transforming the nave into an enclosed space, but introduced another rhythm which reverses the primary one. The spectator perceives simultaneously the continuous sequence of the high bays of the pillars and the low arches (A b A b A . . .) as well as that of the low tabernacles and the high arches (a B a B a . . .). Moreover, this second rhythm has an important chromatic and spatial quality, for the cream-coloured arches – 'openings' of the wall – are contrasted by the dark-coloured tabernacles, which break through the plane of the wall and project into the nave.

It has recently been ascertained[19] that Borromini intended to vault the nave. The present arrangement, which preserved Daniele da Volterra's heavy wooden ceiling (1564–72), must be regarded as provisional, but after the Holy Year there was no hope of continuing this costly enterprise. The articulation of the nave would have found its logical continuation in the vault, which always formed an integral part of Borromini's structures. If the execution of his scheme thus remained a fragment, he was yet given ample scope for displaying his skill as a decorator. The naturalistic palm branches in the sunken panels of the pilasters of the aisles, the lively floral ornament of the oval frames in the clerestory, the putti and cherubim forming part of the architectural design as in Late Gothic churches, and, above all, the re-arrangement in the new aisles during Alexander VII's pontificate of the old tombs and monuments of

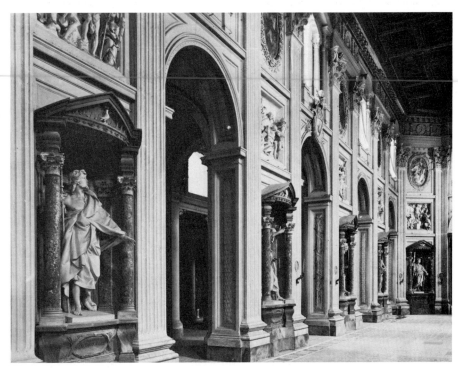

126. Francesco Borromini:
Rome, S. Giovanni in Laterano. Nave, 1646–9

popes, cardinals, and bishops – all this shows an inexhaustible wealth of original ideas and an uninhibited imagination. Although contemporaries regarded the settings of these monuments as a veritable storehouse of capriccios,[20] they are far from unsuitable for the purpose for which they were designed – on the contrary, each of the venerable relics of the past is placed into its own kind of treasure-chest, beautifully adapted to its peculiar character. It is typical of Borromini's manner that in these decorations realistic features and floral and vegetable motifs of dewy freshness merge with the sharp and crystalline architectural forms.[21]

If in S. Giovanni in Laterano Borromini had to renounce completion of his design, the handi-

cap in S. Agnese in Piazza Navona was of a different nature. Pope Innocent X wanted to turn the square on which his family palace was situated into the grandest in Rome; it was to be dominated by the new church of S. Agnese to replace an older one close to the palace. Carlo Rainaldi, in collaboration with his father Girolamo, had been commissioned to build the new structure, the foundation stone of which was laid on 15 August 1652.[22] The Rainaldis designed a Greek-cross plan with short arms and pillars of the crossing with broad bevels which were opened into large niches framed by recessed columns. While the idea of the pillars with niches derived from St Peter's, the model for the recessed columns was Cortona's SS.

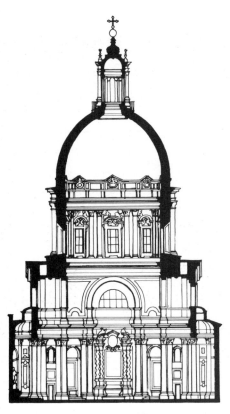

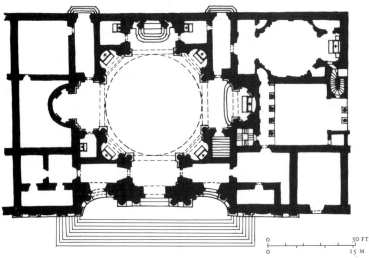

127 *(left)* and 128 *(opposite)*.
Francesco Borromini:
Rome,
S. Agnese in Piazza Navona,
begun by Girolamo
and Carlo Rainaldi in 1652.
Section and plan, and interior

0 50 FT

0 15 M

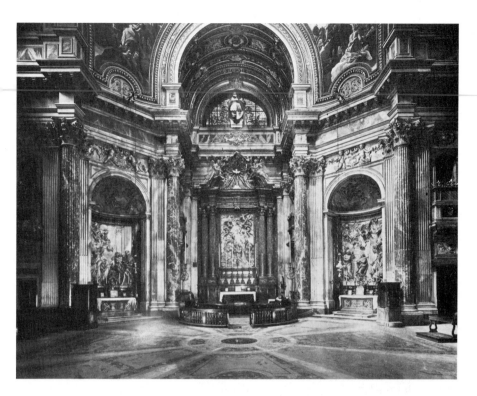

Martina e Luca. The building went up in accordance with this design, but soon criticism was voiced, particularly as regards the planned staircase, which extended too far into the piazza. A crisis became unavoidable, the Rainaldis were dismissed, and on 7 August 1653 Borromini was appointed in their place.

To all intents and purposes he had to continue building in accordance with the Rainaldi plan, for the pillars of the crossing were standing to the height of the niches. Yet by seemingly minor alterations he changed the character of the design. Above all, he abolished the recesses prepared for the columns and bevelled the pillars so that the columns look as if they were detached from the wall [127].[23] By this device the beholder is made to believe that the pillars and the cross arms have almost equal width. The

crossing, therefore, appears to the eye as a regular octagon; this is accentuated by the sculptural element of the all but free-standing columns [128]. Colour contrasts sustain this impression, for the body of the church is white (with the exception of the high altar), while the columns are of red marble. Moreover, an intense verticalism is suggested by virtue of the projecting entablature above the columns, unifying the arch with the supporting columns; and the high attic above the entablature, which appears under the crossing like a pedestal to the arch,[24] increases the vertical movement. It will now be seen that the octagonal space – also echoed in the design of the floor – is encompassed by the coherent rhythm of the alternating low bays of the pillars framed by pilasters and the high 'bays' of the cross-arms framed by the columns.

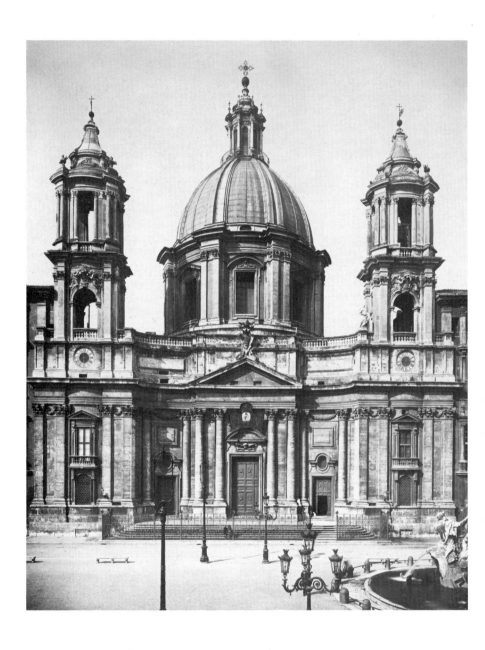

129. Francesco Borromini: Rome, S. Agnese in Piazza Navona.
Façade, 1653–5, completed 1666 by other hands

By giving the cross-arms a length much greater than that intended by Rainaldi, Borromini created a piquant tension between them and the central area. Thus a characteristically Borrominesque structure was erected over Rainaldi's traditional plan. Nor did the latter envisage a building of exceptionally high and slender design. Borromini further amplified the vertical tendencies by incorporating into his design an extraordinarily high drum and an elevated curve for the dome – which obviously adds to the importance of the area under the crossing [127]. Rainaldi, by contrast, had planned to blend a low drum with a broad, rather unwieldy dome.

In spite of the difficulties which Borromini had to face in the interior, he accomplished an almost incredible transformation of Rainaldi's project. In the handling of the exterior [129] he was less handicapped. The little that was standing of Rainaldi's façade was pulled down. By abandoning the vestibule planned by the latter, he could set the façade further back from the square and design it over a concave plan. In Rainaldi's project the insipid crowning features at both ends of the façade were entirely overshadowed by the weight of the dome. Borromini extended the width of the façade into the area of the adjoining palaces, thus creating space for freely rising towers of impressive height. But he was prevented from completing the execution of his design. After Innocent X's death on 7 January 1655, building activity stopped. Soon difficulties arose between Borromini and Prince Camillo Pamphili, and two years later Carlo Rainaldi in turn replaced Borromini. Assisted by Giovanni Maria Baratta and Antonio del Grande, Carlo proceeded to alter those parts which had not been finished: the interior decoration, the lantern of the dome, the towers, and the façade above the entablature. The high attic over the façade, the triangular pediment in the centre, and certain simplifications in the design of the towers are contrary to Borromini's intentions.[25] But, strangely enough, the exterior looks more Borrominesque than the interior. For in the interior the rich gilt stuccoes, the large marble reliefs – a veritable school of Roman High Baroque sculpture – Gaulli's and Ciro Ferri's frescoes in the pendentives and dome: all this tends to conceal the Borrominesque quality of the structure.[26] Completion dragged on for many years. The towers went up in 1666; interior stuccoes were still being paid for in 1670, and the frescoes of the dome were not finished until the end of the century.

In defiance of the limitations imposed upon Borromini, S. Agnese occupies a unique position in the history of Baroque architecture. The church must be regarded as the High Baroque revision of the centralized plan for St Peter's. The dome of S. Agnese has a distinct place in a long line of domes dependent on Michelangelo's creation (p. 422). From the late sixteenth century onwards may be observed a progressive reduction of mass and weight, a heightening of the drum at the expense of the vault, and a growing elegance of the sky-line. All this reached a kind of finality in the dome of S. Agnese. Moreover, from a viewpoint opposite the entrance the dome seems to form part of the façade, dominates it, and is firmly connected with it, since the double columns at both sides of the entrance are continued in the pilasters of the drum and the ribs of the vault. Circumstances prevented the dome of St Peter's from appearing between two framing towers. The idea found fulfilment in S. Agnese; here dome and towers form a grand unit, perfectly balanced in scale. Never before had it been possible for a beholder to view at a glance such a rich and varied group of towers and dome while at the same time experiencing the spell of the intense spatial suggestions: he feels himself drawn into the cavity of the façade, above which looms the concave mass of the drum. Nobody can overlook the fact that Borromini, although he employed the traditional grammar

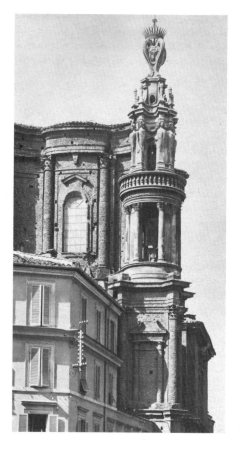

130. Francesco Borromini:
Rome, S. Andrea delle Fratte.
Tower and dome, 1653-65

of motifs, repeated here the spatial reversal of
the façade of S. Ivo.

Probably in the same year, 1653, in which
he took over S. Agnese from Rainaldi, Borro-
mini was commissioned by the Marchese Paolo
Bufalo to finish the church of S. Andrea delle
Fratte which Gaspare Guerra had begun in
1605. Although Borromini was engaged on this
work until 1665, he had to abandon it in a
fragmentary state. The transept, dome, and
choir which he added to the conventional in-
terior reveal little of his personal style. Much
more important is his contribution to the un-
finished exterior [130]. It is his extraordinary
dome and tower, designed to be seen as one
descends from Via Capo le Case, that give the
otherwise insignificant church a unique dis-
tinction. Similar to S. Ivo, the curve of the dome
is encompassed by a drumlike casing. But here
four widely projecting buttresses jut out dia-
gonally from the actual body of the 'drum'. In
this way four equal faces are created, each con-
sisting of a large convex bay of the 'drum' and
narrower concave bays of the buttresses. The
plan of each face is therefore similar to the
lower tier of the façade of S. Carlo alle Quattro
Fontane. Once again Borromini worked with
spatial evolutions of rhythmic triads, and once
again a monumental order of composite columns
placed at the salient points ensures the unbroken
coherence of the design. This extraordinary
structure was to be crowned by a lantern –
which unfortunately remained on paper – with
concave recesses above the convex walls under-
neath. Without this lantern the spatial intentions
embodied in Borromini's design cannot be
fully gauged.[27]

The tower, rising in the north-east corner
next to the choir, was conceived as a deliberate
contrast to the dome. Its three tiers form com-
pletely separate units. While the lowest is solid
and square with diagonally-projecting columned
corners, the second is open and circular and
follows the model of ancient monopteral

temples. By topping this feature with a dispro-portionately heavy balustrade the circular movement is given an emphatic, compelling quality. In the third tier the circular form is broken up into double herms with deep concave recesses between them – a new and more in-tensely modelled version of the lantern of S. Ivo. While full-blooded cherubs function as carya-tids, their wings enfold the stems of the herms. At this late stage of his development Borromini liked to soften the precise lines of architecture by the swelling forms of sculpture, and the cherub-herm, an invention of his far removed from any classical models, fascinated him in this context.[28] The uppermost element of the tower consists of four inverted scrolls of beautiful elasticity; on them a crown with sharply pointed spikes balances precariously: the whole a triumph of complex spatial relationships and a bizarre *concetto* by which the top of the tower is wedded to the sky and the air. Thus the flexible but homogeneous massive bulk of the dome is a foil for the small scale of the tower with its emphasis on minute detail (capitals of the mono-pteros!) and its radical division into contrasting shapes.[29]

Among Borromini's lesser ecclesiastical works two churches may be singled out for special con-sideration: S. Maria dei Sette Dolori and the Church of the Collegio di Propaganda Fide. In both cases the church lies at right angles to the façade, and both churches are erected over simple rectangular plans with bevelled or rounded corners. S. Maria dei Sette Dolori was begun in 1642–3 and left unfinished in 1646.[30] The exterior is an impressive mass of raw bricks and only the rather weak portal was executed in stone, but not from Borromini's design. The interior is articulated by an imposing sequence of columns arranged in triads between the larger intervals of the two main axes, which are bridged by arches rising from the uninterrupted cornice [131].[31] In spite of the difference in plan, S. Maria dei Sette Dolori is in a sense a simpli-

fied version of S. Carlo alle Quattro Fontane.[32] But above the cornice the comparison does not hold. Here there is a low clerestory and a coved vault divided by ribs, linking a pair of columns

131. Francesco Borromini: Rome, S. Maria dei Sette Dolori, begun 1642–3. Interior

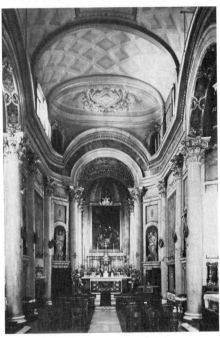

across the room.[33] This arrangement contained potentialities which were later further developed in the church of the Propaganda Fide.

In 1646 Borromini was appointed architect to the Collegio di Propaganda Fide. But it was not until 1662 that the church behind the west front of the palace was in course of construction. Two years later it was finished, with the excep-tion of the decoration.[34] At first Borromini planned to preserve the oval church built by Bernini in 1634. When it was decided to en-large it, he significantly preferred the simple hall type in analogy to S. Maria dei Sette Dolori

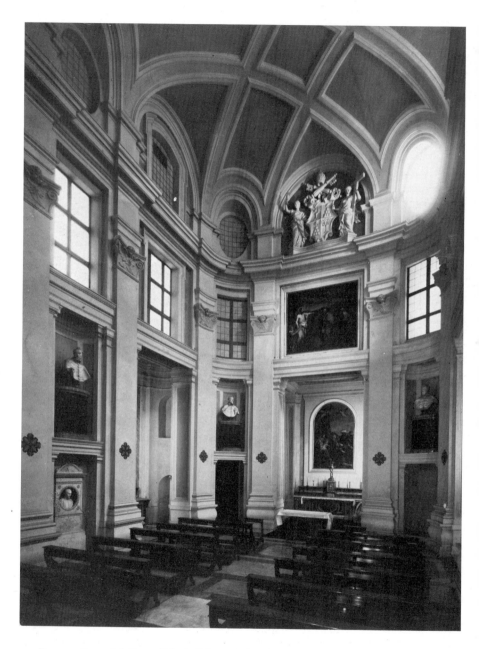

132. Francesco Borromini: Rome, Collegio di Propaganda Fide. Church, 1662-4

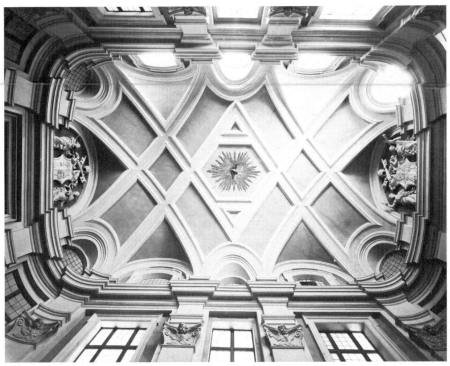

133. Francesco Borromini: Rome,
Collegio di Propaganda Fide. Vaulting of the church

and the even earlier Oratory of St Philip Neri. But the changes in design are equally illuminating. The clerestory of S. Maria dei Sette Dolori was similar to that of the Oratory. By contrast, the church of the Propaganda Fide embodies a radical revision of those earlier structures [132]. The articulation consists here of a large and small order, derived from the Capitoline palaces. The large pilasters accentuate the division of the perimeter of the church into alternating wide and narrow bays, while the cornice of the large order and the entablature of the small order on which the windows rest function as elements unifying the entire space horizontally. Different from S. Maria dei Sette Dolori, the verticalism of the large order is continued through the isolated pieces of the entablature into the coved vaulting and is taken up by the ribs, which link the centres of the long walls with the four corners diagonally across the ceiling [133]. Thus an unbroken system closely ties together all parts of the building in all directions. The coherent 'skeleton'-structure has become all-important – hardly any walls remain between the tall pilasters! – and to it even the dome has been sacrificed. The oval project, which would have required a dome, could not have embodied a similar system. No post-Renaissance building in Italy had come so close to Gothic structural principles. For thirty years Borromini had been groping in this direction. The church of the Propaganda Fide

was, indeed, a new and exciting solution, and its compelling simplicity and logic fittingly conclude Borromini's activity in the field of ecclesiastical architecture.[35]

The Oratory of St Philip Neri

The brethren of the Congregation of St Philip Neri had for a considerable time planned to build an oratory next to their church of S. Maria in Vallicella. In conjunction with this idea, plans ripened to include in the building programme a refectory, a sacristy, living quarters for the members of the Congregation, and a large library. This considerable programme was, in fact, not very different from that of a large monastery. The Congregation finally opened a competition which Borromini won in May 1637 against, among others, Paolo Maruscelli, the architect of the Congregation. Borromini replaced him forthwith and held the office for the next thirteen years. Building activity was rapid: in 1640 the oratory was in use; in 1641 the refectory was finished, between 1642 and 1643 the library above the oratory was built and between 1644 and 1650 the north-west front with the clock-tower overlooking the Piazza dell'Orologio.[36] Thus the building of the oratory coincided with that of S. Carlo alle Quattro Fontane. But although the work for the Oratorians was infinitely more important than that of the little church, as regards compactness and vitality the former cannot compete with the latter. This verdict does not, of course, refer to the brilliant façade of the oratory [134], nor do we overlook the fact that many new and ingenious ideas were brought to fruition in the buildings of the monastery.

Maruscelli, before Borromini, had already solved an intricate problem: he had designed a coherent layout for the whole area with long axes and a clear and logical disposition of the sacristy and the courtyards. Borromini accepted the essentials of this plan, which also included

the placing of the oratory itself in the western (left) half of the main wing. Many refinements were introduced there by Borromini, but it must suffice to mention that, contrary to Maruscelli's intentions, he created for the eye, rather than in actual fact, a central axis to the entire front

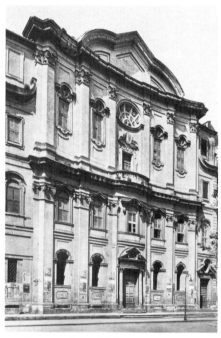

134. Francesco Borromini: Rome, Oratory of St Philip Neri. Façade, 1637–40

between S. Maria in Vallicella and the Via de' Filippini [135]. The organization of this front is entirely independent of the dispositions behind it. The central entrance does not lead straight into the oratory which lies at right angles to it and extends beyond the elaborate part of the façade, nor is the plan of the whole area symmetrical in depth, as a glance at the façade might suggest.[37]

Although the façade is reminiscent of that of a church, its rows of domestic windows seem to

ORATORY

135. Francesco Borromini: Rome, Oratory of St Philip Neri and Monastery, begun 1637. Plan

contradict this impression. This somewhat hybrid character indicates that Borromini deliberately designed it as an 'overture' for the oratory as much as for the whole monastery. By request of the Congregation the façade was not faced in stone so that it would not compete with the adjoining church of S. Maria in Vallicella. Borromini, therefore, developed a new and extremely subtle brick technique of classical ancestry, a technique which allowed for finest gradations and absolute precision of detail. The main portion of the façade consists of five bays, closely set with pilasters, arranged over a concave plan. But the central bay of the lower tier is curved outward, while that of the upper tier opens into a niche of considerable depth. Crowning the façade rises the mighty pediment which, for the first time, combines curvilinear and angular movement. The segmental part answers the rising line of the cornice above the bays, which are attached like wings to the main body of the façade, and the change of movement, comparable to an interrupted S-curve, echoes, as it were, the contrasting spatial movement of the central bays in the elevation. The form of the pediment is further conditioned by the vertical tendencies in the façade. Once that has been noticed, one will also find it compellingly logical that the important centre and the accompanying bays are not capped by a uniform pediment. The latter, in addition to suggesting a differentiated triple rhythm, also pulls together the three inner bays, which are segregated from the outer bays by a slight projection and an additional half-pilaster. Without breaking up the unity of the five bays, a triad of bays is yet singled out, and the pediment reinforces the indications contained in the façade itself. The treatment of detail further enriches the complexities of the general arrangement. Attention may be drawn to the niches below, which cast deep shadows and give the wall depth and volume; to the windows above them, which with their pediments press energetically against

the frieze of the entablature; and to the windows of the second tier, which have ample space over and under them.[38]

The interior of the oratory, carefully adapted to the needs of the Congregation, is articulated by half-columns on the altar wall and a complicated rhythm of pilasters along the other three walls.[39] Michelangelo's Capitoline palaces evidently gave rise to the use of the giant order of pilasters in the two courtyards. It is worth recalling that Palladio had introduced a giant order in the *cortile* of the Palazzo Porto-Colleoni at Vicenza (1552); but, although Borromini's simple and great forms seem superficially close to Palladio's classicism, the ultimate intentions of the two masters are utterly different. Palladio is always concerned with intrinsically plastic architectural members in their own right, while Borromini stresses the integral character of a coherent dynamic system. Thus in Borromini's courtyards the large pilasters would appear to screen an uninterrupted sequence of buttresses. This interpretation is supported by the treatment of corners.

Renaissance architects had more often than not evaded facing squarely a problem which was inherent in the use of the classical grammar of forms. The half-pilasters, quarter-pilasters, and other expedients, which abruptly break the continuity of articulation in the corners of Renaissance buildings, must be regarded as naive compromise solutions. Mannerist architects who fully understood the problem not infrequently carried on the wall decoration across the corners, thereby neutralizing the latter and at the same time producing a deliberate ambiguity between the uninterrupted decoration and the change in the direction of the walls. Borromini abolished the cause for compromise or ambiguity by eliminating the corners themselves. By rounding them off, he made the unity of the space-enclosing structural elements, and implicitly of the space itself, apparent. In the

two courtyards of the Filippini he applied to an external space the same principle that Palladio had used in a comparatively embryonic manner in the interior of the Redentore.[40] This new solution soon became the property of the whole of Europe.

In contrast to the elaborate south façade, Borromini used very simple motifs for the long western and northern fronts of the convent: band-like string courses divide the storeys and large horizontal and vertical grooves replace the cornices and corners.[41] From then on this type of design became generally accepted for utilitarian purposes in cases where no elaborate decoration was required.

Domestic Buildings

Between about 1635 and the end of his career Borromini had a hand in a great number of domestic buildings of importance, though it must be said that no palace was entirely carried out by him. At the beginning stands his work in the Palazzo Spada, where he was responsible for the erection of the garden wall, for various decorative parts inside the palace and, above all, for the well-known illusionist colonnade which appears to be very long, but is, in fact, extremely short. The idea seems to be derived from the stage (Teatro Olimpico). But one should not forget that it also had a respectable Renaissance pedigree. Bramante applied the same illusionist principle to his choir of S. Maria presso S. Satiro at Milan, which must have belonged to Borromini's earliest impressions. The concept of the Spada colonnade is, therefore, neither characteristically Baroque nor is it of more than marginal interest in Borromini's work. To over-emphasize its significance, as is often done by those who regard the Baroque mainly as a style concerned with optical illusion, leads entirely astray.[42]

Between 1646 and 1649 followed the work for the Palazzo Falconieri, where Borromini ex-tended a mid-sixteenth-century front from seven to eleven bays.[42a] He framed the façade with huge herms ending in falcons' heads, an emblematic conceit which had no precedent. He added new wings on the rear facing the river and provided decoration for porch and vestibule. But his most signal contribution is the twelve ceilings with their elaborate floral ornament,[43] and, overlooking the courtyard, the Palladian loggia, equally remarkable for its derivation and for its deviation from Palladio's Basilica at Vicenza.[44] The U-shaped river front, dominated by the loggia, gives proof of the versatility of Borromini's extraordinary genius [136]. His problem consisted in welding old and new parts together into a new unit of a specifically Borrominesque character. He solved it by progressively increasing the height of the four storeys in defiance of long established rules and by reversing the traditional gradation of the orders. The ground floor is subdivided by simple broad bands; in the next storey the same motif is given stronger relief; the third storey has Ionic pilasters; and above these are the recessed columns of the loggia. Thus instead of diminishing from the ground floor upwards, the wall divisions grow in importance and plasticity. Only in the context of the whole façade is the unconventional and anti-classical quality of the loggia motif fully revealed.

Between 1646 and 1647 Borromini helped in an advisory capacity the aged Girolamo Rainaldi, whom Innocent X had commissioned to build the extensive Palazzo Pamphili in Piazza Navona. Borromini had a tangible influence on the design, although his own plan was not accepted for execution.[45] He alone was, however, responsible for the decoration of the large salone and the building of the gallery to the right of S. Agnese, on a site which originally formed part of the Palazzo Mellini. Inside the gallery, to which Pietro da Cortona contributed the frescoes from the *Aeneid,* are to be found some of the most characteristic and brilliant

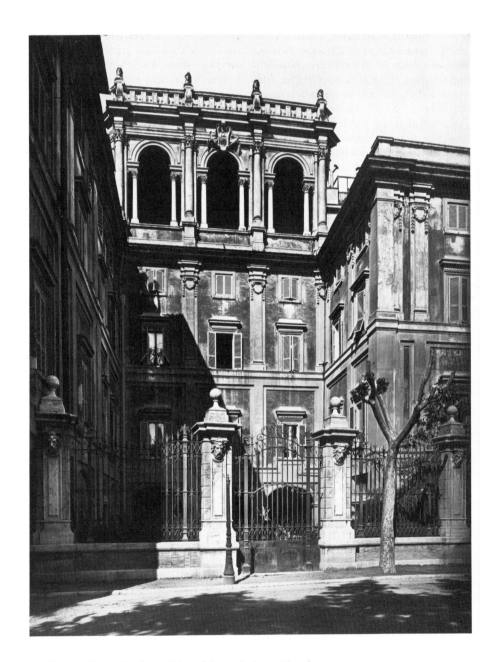

136. Francesco Borromini: Rome, Palazzo Falconieri, 1646–9. River front

door surrounds of Borromini's later style. Of his designs for the palace of Count Ambrogio Carpegna near the Fontana Trevi very little was executed,[46] but a series of daring plans survive which anticipate the eighteenth-century development of the Italian palazzo. Borromini took up all the major problems where they were left in the Palazzo Barberini and carried them much further, such as the axial alignment of the various parts of the building, the connexion of a grand vestibule with the staircase hall, and the merging of vestibule and oval courtyard. The latest drawing of the series shows two flights of stairs ascending along the perimeter of the oval courtyard and meeting on a common landing – a bold idea, heretofore unknown in Italy, which was taken up and executed by Guarini in the Palazzo Carignano at Turin.[47]

Between 1659 and 1661 Borromini was concerned with the systematization of two libraries, the Biblioteca Angelica adjoining Piazza S. Agostino and the Biblioteca Alessandrina in the north wing of the Sapienza. Of the plans for the former hardly anything was carried out, but the latter survives as Borromini had designed it. The great hall of the library is three storeys high, and the book-cases form a constituent part of the architecture. This was a new and important idea, which he had not yet conceived when he built the library above the Oratory of St Philip Neri about twenty years earlier. It was precisely this new conception which made the Biblioteca Alessandrina the prototype of the great eighteenth-century libraries.

The Collegio di Propaganda Fide

Borromini's last great palace, surpassing anything he did in that class with the exception of the convent of the Oratorians, was the Collegio di Propaganda Fide. His activity for the Jesuits spread over the long period of twenty-one years, from his appointment as architect in 1646 to

his death in 1667. At that time the Jesuits were at the zenith of their power, and a centre in keeping with the world-wide importance of the Order was an urgent requirement. They owned the vast site between Via Capo le Case, Via Due Macelli, and Piazza di Spagna, which, though large enough for all their needs, was so badly cut that no regular architectural development was possible. Moreover, some fairly recent buildings were already standing, among them Bernini's modernization of the old façade facing Piazza di Spagna and his oval church which was, however, as we have seen, replaced by Borromini. As early as 7 May 1647 Borromini submitted a development plan for the whole site; but little happened in the course of the next thirteen years. It is known that Borromini gave the main façade in front of the church its final shape in 1662, and the other much simpler façades also show characteristics of his latest manner. The execution of the major part of the palace would therefore seem to have taken place in the last years of his life. Part of the palace was reserved for administrative purposes, another large part contained the cells for the alumni. But very little of Borromini's interior arrangement and decoration survives; in fact, apart from the church, only one original room seems to have been preserved.

All the more important are the façades. The most elaborate portion rises in the narrow Via di Propaganda where its oppressive weight produces an almost nightmarish effect [137, 138]. Borromini's problem was here similar to that of the oratory, for the façade was to serve the dual purpose of church and palace. Once again the long axis of the church lies parallel with the street and extends beyond the highly decorated part of the façade, but in contrast to the oratory this front has a definite, though entirely unusual, palace character. Its seven bays are articulated by a giant order of pilasters which rise from the ground to the sharply-projecting cornice.[48] Everything here is unorthodox: the

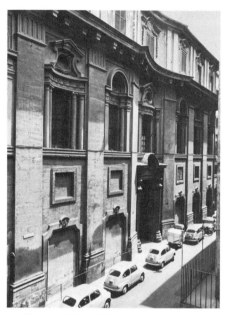

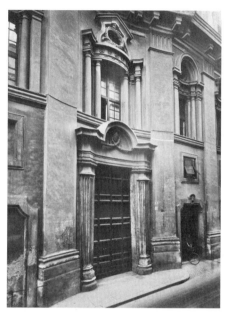

137. Francesco Borromini:
Rome, Collegio di Propaganda Fide.
Façade, 1662

138. Francesco Borromini:
Rome, Collegio di Propaganda Fide.
Centre bay, 1662

capitals are reduced to a few parallel grooves, the cornice is without a frieze, and the projecting pair of brackets over the capitals seem to belong to the latter rather than to the cornice. The central bay recedes over a segmental plan [138], and the contrast between the straight lines of the façade and the inward curve is surprising and alarming. No less startling is the juxtaposition of the austere lower tier and the *piano nobile* with its extremely rich window decoration. The windows rise without transition from the energetically drawn string course and seem to be compressed into the narrow space between the giant pilasters.

It is here that the active life in the wall itself is revealed. All the window frames curve inwards with the exception of the central one which, being convex, reverses the concave shape of the whole bay. The movement of the window frames is not dictated simply by a desire for picturesque variety but consists like a fugue of theme, answer, and variations. The theme is given in the door and window pediments of the central bay; the identical windows of the first, third, fifth, and seventh bays are variations of the door motif while the identical second and sixth windows answer the central window, also spatially. In the windows of the attic above the cornice[49] the theme of the *piano nobile* is repeated in another key: the first, third, fifth, and seventh windows are simpler variations of the second and sixth below, and the windows in the even bays of the attic vary those in the uneven ones underneath. Finally, in the undulating pediment of the fourth attic window the two movements are reconciled. By such means Borromini created a palazzo front which has neither precursors nor successors.

In the south-western and southern façades only the ground-floor arrangement and the division of the storeys was continued, which assured the unity of the entire design. Otherwise Borromini contrasted these fronts with the intensely articulated main façade. There is no division into bays by orders, nor are the windows decorated. But their sequence is interrupted at regular intervals by strong vertical accentuations. At these points Borromini united the main and mezzanine windows of the *piano nobile* under one large frame, creating a window which goes through the entire height of the tier. The boldly projecting angular pediment seems to cut into the string course of the next storey, where the framework of the window with its gently curved pediment and concave recession shows a characteristic reversal of mood.

A comparison of the façades of the Oratory and the Collegio illustrates the deep change between Borromini's early and late style. Gone is a mass of detail, gone the subtle gradations of wall surface and mouldings and the almost joyful display of a great variety of motifs. However, the impression of mass and weight has grown immensely; the windows now seem to dig themselves into the depth of the wall. And yet the basic approach hardly differed.

To summarize Borromini's life-long endeavour, it may be said that he never tired in his attempt to mould space and mass by means of the evolution and transformation of key motifs. He subordinated each structure down to the minutest detail to a dominating geometrical concept, which led him away from the Renaissance method of planning in terms of mass and modules towards an emphasis on the functionally, dynamically, and rhythmically decisive 'skeleton'. This brought him close to the structural principles of the Gothic style and enabled him, at the same time, to incorporate into his work what suited his purpose: Mannerist features of the immediate past, many ideas from Michelangelo's architecture and that of Hellenism, both equally admired by him, and even severely classical elements which he found in Palladio. Being an Italian, Borromini could not deny altogether the anthropomorphic basis of architecture. This becomes increasingly apparent during his advancing years from the stress he laid on the blending of architecture and sculpture. Nevertheless, the antagonism between him and Bernini remained unbridgeable. It was in Bernini's circle that he was reproached for having destroyed the accepted conventions of good architecture.

PIETRO DA CORTONA

1596-1669

INTRODUCTION

The genius of Pietro Berrettini, usually called Pietro da Cortona, was second only to that of Bernini. Like him he was architect, painter, decorator, and designer of tombs and sculpture although not a sculptor himself. His achievements in all these fields must be ranked among the most outstanding of the seventeenth century. Bernini and Borromini have been given back the position of eminence which is their due. Not so Cortona. When this book first appeared in 1958 no critical modern biography had been devoted to him; G. Briganti's work[1] has now at least partially satisfied this need. To be sure, Cortona's is the third name of the great trio of Roman High Baroque artists, and his work represents a new and entirely personal aspect of the style.

An almost exact contemporary of Bernini and Borromini, he was born at Cortona on 1 November 1596 of a family of artisans. He probably studied under his father, a stone-mason, before being apprenticed to the un-distinguished Florentine painter Andrea Commodi,[2] with whom he went to Rome in 1612 or 1613. He stayed on after Commodi's return to Florence in 1614 and changed over to the studio of the equally unimportant Florentine painter Baccio Ciarpi.[3] According to his biographer Passeri he studied Raphael and the antique with great devotion during these years; while this is, of course, true of every seventeenth-century artist, in Cortona's case such training has more than usual relevance since he could not profit very much from his teachers.

His copy of Raphael's *Galatea*[4] impressed Marcello Sacchetti so much that he took to the young artist who, from 1623 onwards, belonged to the Sacchetti household. It was in the service of the Sacchetti family that Cortona gave early proof of his genius as painter and architect. In the Palazzo Sacchetti he also met the Cavaliere Marino, fresh from Paris,[5] and Cardinal Francesco Barberini, Urban VIII's nephew, who became his lifelong patron; through him he obtained his early important commission as a fresco painter in S. Bibiana. At the same time he was taken on by Cassiano del Pozzo, the learned secretary to Cardinal Francesco Barberini, who employed in these years a number of young and promising artists for his collection of copies of all the remains of antiquity.[6] Thus Cortona was over twenty-six years old when his contact with the 'right' circle carried him quickly to success and prominence. As to his early development, relatively little has so far come to light.[7] More discoveries will be made in the future, but it will remain a fact of some significance that, whereas we can follow the unfolding of Bernini's talent year by year from his precocious beginnings, in Cortona we are almost suddenly faced with a distinctly individual manner in painting and, even more astonishingly, in architecture, though his training in this field can have been only rather superficial.[8]

From about the mid twenties his career can be fully gauged. From then until his death he had large architectural and pictorial commissions simultaneously in hand – he being the only seventeenth-century artist capable of such

a *tour de force*. During the 1630s, with SS. Martina e Luca rising [145] and the Barberini ceiling in progress [153], he reached the zenith of his artistic power and fame, and his colleagues acknowledged his distinction by electing him *principe* of the Accademia di San Luca for four years (1634-8). Between 1641 and 1647 he stayed in Florence painting and decorating four rooms of the Palazzo Pitti, but the architectural projects of this period remained on paper. Back in Rome, his most extensive fresco commission, the decoration of the Chiesa Nuova [157], occupied him intermittently for almost twenty years. During one of the intervals he painted the gallery of the Palazzo Pamphili in Piazza Navona (1651-4); the erection of the façade of S. Maria della Pace is contemporaneous with the frescoes in the apse of the Chiesa Nuova, that of the façade of S. Maria in Via Lata with the frescoes of the pendentives, that of the dome of S. Carlo al Corso follows three years after the frescoes of the nave. Even if it were correct, as has more than once been maintained, that the quality of his late frescoes shows a marked decline,[9] the same is certainly not true of his late architectural works. In any case, his architectural and pictorial conceptions show a parallel development, away from the exuberant style of the 1630s towards a sober, relatively classicizing idiom to which he aspired more and more from the 1650s onwards.

ARCHITECTURE

The Early Works

Before he began the church of SS. Martina e Luca, Cortona executed the so-called Villa del Pigneto near Rome for the Sacchetti and possibly also the villa at Castel Fusano, now Chigi property. The latter was built and decorated between 1626 and 1630.[10] It is a simple three-storeyed structure measuring 70 by 52 feet, rather rustic in appearance, crowned with a tower and protected by four fortress-like corner projections. The type of the building follows a long-established tradition, but the interest here lies in the pictorial decoration rather than in the architecture. The Villa del Pigneto on the other hand commands particular attention because of its architecture [139, 140]. Unfortunately little survives to bear witness to its original splendour.[11] Nor is anything certain known about its date and building history. The patron was either Cardinal Giulio or Marchese Marcello Sacchetti;[12] the former received the purple in 1626, the latter died in 1636 (not 1629). There is, therefore, room for the commission during the decade 1626-36. For stylistic reasons a date not earlier than the late twenties seems indicated.[13]

The ground floor of the building [140] with its symmetrical arrangement of rooms reveals a thorough study of Palladio's plans, but the idea of the monumental niche in the central structure, which is raised high above the low wings, derives from the Belvedere in the Vatican. It is even possible that Cortona was impressed at that early date by the ruins of the classical temple at Praeneste (Palestrina) near Rome, of which he undertook a reconstruction in 1636.[14] In any case, the large screened niches of the side fronts – a motif which has no pedigree in post-Renaissance architecture – can hardly have been conceived without the study of plans of Roman baths. While the arrangement of terraces with fountains and grottoes is reminiscent of earlier villas such as the Villa Aldobrandini at Frascati, the complicated system of staircases with sham flights recalls Buontalenti's Florentine Mannerism. If one can draw conclusions from the ground-plan, essentially Mannerist must also have been the contrast between the austere entrance front and the overdecorated garden front, a contrast well known from buildings like the Villa Medici on the Pincio. Although small in size and derived from a variety of sources, the building was a landmark

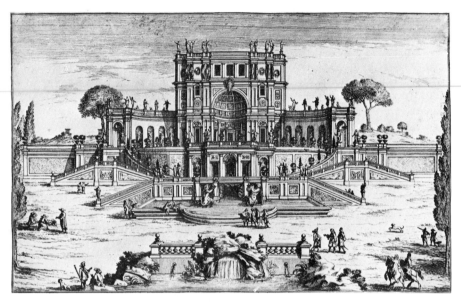

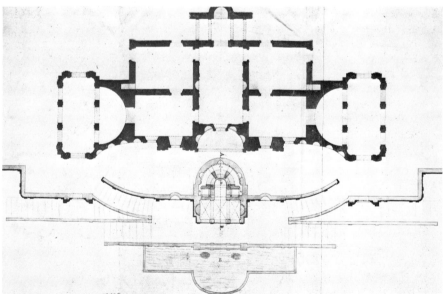

139 and 140. Pietro da Cortona: Rome (vicinity), Villa del Pigneto, before 1630. Destroyed.
Engraving, and plan drawn by P. L. Ghezzi. *London, Sir Anthony Blunt*

in the development of the Baroque villa. The magnificent silhouette, the grand staircases built up in tiers so as to emphasize the dominating central feature, and above all the advancing and receding curves which tie together staircase, terrace, and building – all this was taken up and further developed by succeeding generations of architects.

It is an indication of Cortona's growing reputation that on Maderno's death in 1629 he took part in the planning of the Palazzo Barberini. His project seems to have found the pope's approval, but the high cost prevented its acceptance.[15] Although Bernini was appointed architect of the palace, Cortona was not altogether excluded. The theatre adjoining the north-west corner of the palace was built to his design [141].[16] It would be a matter of absorbing interest to know something about Cortona's project for the palace. In earlier editions of this book I illustrated the plan of a palace which I had come across on the London art market in the 1930s and which I immediately diagnosed as by Cortona's hand. In 1969 I discussed this plan at considerable length before a group of specialists, and the critical tenor of my colleagues induced me to remove the illustration from this edition. But since I still believe in the correctness of my original conclusions, some remarks about that plan are in place. It represents only the ground floor containing a web of octagonal rooms (apparently meant to be

141. Pietro da Cortona: Rome, Palazzo Barberini. Entrance to the theatre, c. 1640

used as store-rooms), the walls of which were to serve as substructures to the rooms above.[17] In spite of the obvious difficulties of location, the colossal dimensions of the plan make it almost certain that it refers to the Palazzo Barberini. Cortona wanted to return to the traditional Roman block-shape; his design is a square of 285 by 285 feet as against the 262 feet of the present façade.[18] Even the scanty evidence of this plan reveals four rather exciting features: the palace would have had bevelled corners framed by columns; the main axes open into large rectangular vestibules articulated by columns; two vestibules give direct access to the adjoining staircase halls; finally, the double columns of the courtyard would have been carried on across the corners in an unbroken sequence. The idea of integrating vestibule and staircase hall, hardly possible without a knowledge of French designs, was new for Italy. Also the principal staircase with two opposite flights ascending from the main landing has no parallel in Rome at this time. Moreover, the arrangement of the courtyard anticipates Borromini's in the nearby monastery of S. Carlo alle Quattro Fontane, while the plan of the vestibules was taken up by Borromini in S. Maria dei Sette Dolori and the church of the Propaganda Fide. The most astonishing element, however, is the kind of structural grid system that controls every dimension of the plan.

In 1633 Cortona won his first recognition as a designer of festival decoration: for the Quarantore of that year he transformed the interior of the church of S. Lorenzo in Damaso into a rich colonnaded setting with niches and gilded statues of saints.[19] Cortona was a born 'decorator', and it is therefore all the more to be regretted that none of his occasional works seems to have come down to us in drawings or engravings. It was not until his thirty-eighth year, the year of his election as *Principe* of the Academy of St Luke, that he received his first big architectural commission. He had hardly begun painting the great Salone of the Barberini Palace when the reconstruction of the church of SS. Martina e Luca at the foot of the Capitol fell to him. This work requires an analysis.

SS. Martina e Luca

In July 1634 Cortona was granted permission to rebuild, at his own cost and according to his plans, the crypt of the church of the Academy of St Luke, in order to provide a tomb for himself.[20] During the excavations, in October of that year, the body of S. Martina was discovered. This brought an entirely new situation. Cardinal Francesco Barberini took charge of the undertaking and in January 1635 ordered the rebuilding of the entire church.[21] By about 1644 the new church was vaulted, and its completion in 1650 is recorded in an inscription in the interior.[22]

Cortona chose a Greek-cross design with apsidal endings [142-5]. The longitudinal axis is slightly longer than the transverse axis.[23] This difference in the length of the arms, significant though it seems in the plan, is hardly perceptible to the visitor who enters the church. His first sensation is that of the complete breaking up of the unified wall surface, and his attention is entirely absorbed by it. But this is not simply a painterly arrangement, designed to seduce and dazzle the eye, as many would have it who want to interpret the Baroque as nothing more than a theatrical and picturesque style. The wall so often no more than an inert division between inside and outside has here tremendous plasticity, while the interplay of wall and orders is carried through with a rigorous logic. The wall itself has been 'sliced up' into three alternating planes. The innermost plane, that nearest to the beholder, recurs in the segmental ends of the four arms, that is, at those important points where altars are placed and the eye requires a clear and solid boundary. The plane furthest away appears in the adjoining bays

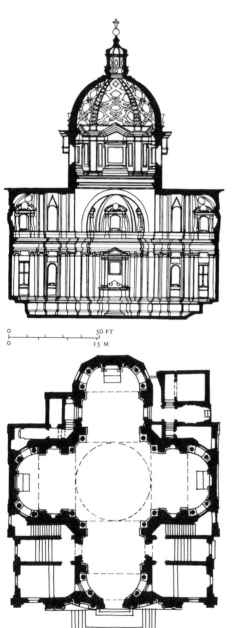

0 ⊢—————————⊣ 50 FT
0 ⊢—————————⊣ 15 M

142. Pietro da Cortona: Rome,
SS. Martina e Luca, 1635–50. Section and plan

behind screening columns. The intermediate plane is established in the bays next to the crossing. Similarly varied is the arrangement of the order: the pilasters occupy a plane before the columns, and the columns under the dome and in the apses are differently related to the wall. But all round the church pilasters and columns are homogeneous members of the same Ionic order. The overwhelming impression of unity in spite of the 'in' and 'out' movement of the wall and the variety in the placing of the order makes a uniform 'reading' of the centralized plan not only logically possible but visually imperative. Thus Cortona solved the problem of axial direction inherent in centralized planning by means entirely different from those employed by Bernini. It is also characteristic that at this period Cortona, unlike Bernini, rejected the use of colour. The church is entirely white, a neutrality which seems essential for the full impact of this richly laden, immensely plastic disposition of wall and order.

By contrast to the severe forms of the architecture below, the vaultings of the apses above the entablature are copiously decorated. The entire surface is plastically moulded and hardly an inch of the confining wall is allowed to appear. And yet the idea of working with varying wall planes is transposed into the concept of using overlapping decorative elements. The windows between the ribs are framed by stilted arches; over these arches a second frame of disproportionately large consoles is laid which support broken segmental pediments. Similarly, the system of ribs in the dome is superimposed upon the coffers. It is now apparent that the use here of what would previously have been considered two mutually exclusive methods of dome articulation is characteristic of Cortona's style in this church. We have seen (p. 178) that this idea was soon taken up by seventeenth- and eighteenth-century architects.

Despite the new plastic-dynamic interpretation of the old Greek-cross plan, Cortona's

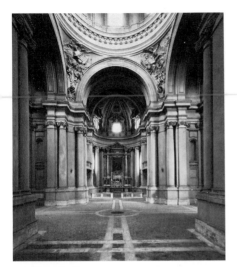

143. Pietro da Cortona:
Rome, SS. Martina e Luca, 1635-50. Interior

style is deeply rooted in the Tuscan tradition. Even such a motif as the free-standing columns which screen the recessed walls in the arms of the cross is typically Florentine. Its origin, of course, is Roman, but in antiquity the columns screen off deep chapels from the main space (Pantheon). When this motif was applied in the Baptistery of Florence, the walls were brought up close behind the columns, whereby the latter lost their specifically space-defining quality. It is this Florentine version with its obvious ambiguity that attracted Mannerist Florentine architects (Michelangelo,[24] Ammanati, etc.), and it is this version of the classical motif that was revived by Cortona. Similar solutions recur in some of his other structures, most prominently on the drum of the dome of S. Carlo al Corso [150], one of his latest works (1668), where the screening columns correspond closely to those inside SS. Martina e Luca.

An analysis of the decoration of SS. Martina e Luca supplies most striking evidence of Cortona's Florentine roots. In spite of the wealth of decoration in the upper parts of the church, figure sculpture is almost entirely excluded and indeed never plays a conspicuous part in Cortona's architecture. His decoration combines two different trends of Florentine Mannerism: the hard and angular forms of the Ammanati-Dosio idiom with the smooth, soft, and almost voluptuous elements derived from Buontalenti. It is the merging of these two traditions that gives the detail of Cortona's work its specific flavour. Florentine Mannerism, however, does not provide the whole answer to the problem of Cortona's style as a decorator, for the vigorous plasticity and the compact crowding of a great variety of different motifs – such as in the panels of the vaultings of the apses – denote not only a Roman and Baroque, but above all a highly personal transformation of his source material. This style of decoration was first evolved by Cortona not in his architecture but in his painting. He translated into three-dimensional form the lush density of pictorial decoration to be found in the Salone of the Palazzo Barberini [153]. The similarity between painted and plastic decoration is extremely close, even in details. For instance, the combination of heads in shells and rich octagonal coffers above the windows of the apses, so striking a feature of the decoration of SS. Martina e Luca, also appears at nodal points of the painted system of the Barberini ceiling. But, having pointed out the close connexion between his architectural and painted decoration, one must emphasize once again that in his built architecture Cortona eliminates the figure elements which form so integral a part of his painted architecture. No stronger contrast to Bernini's conception of architecture could be imagined. For Bernini the very meaning of his classically conceived architecture was epitomized in realistic sculpture. Such sculpture would have obscured the wealth and complexity of Cortona's work. His decorative effervescence reaches its culmination in SS. Martina

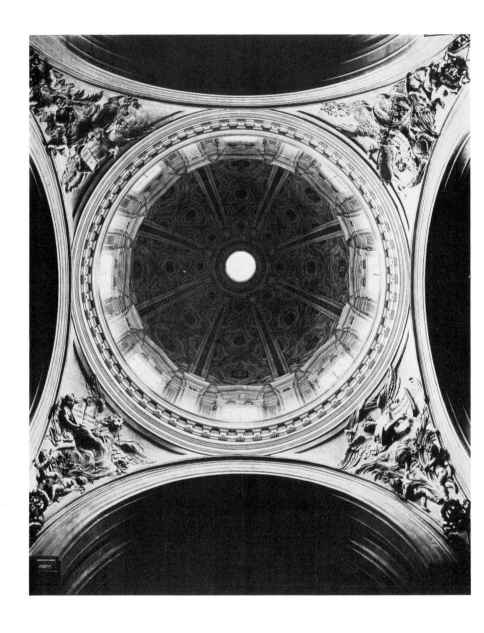

144A and B. Pietro da Cortona: Rome, SS. Martina e Luca, 1635-50. Dome, interior and *(opposite)* exterior

e Luca with the entirely unprecedented, wildly undulating forms of the dome coffering [144A]. The very personal design of these coffers found no imitators, and it was only after Bernini had restored Cortona's coffers to their classical shape that their use in combination with a ribbed vault was generally accepted.

The undulation of Cortona's coffers is countered by the severe angularity of the pediments of the windows in the drum which intrude into the zone of the dome. On the exterior of the dome a similar phenomenon can be observed [144B]. Here the austere window frames of the drum are topped by a sequence of soft, curved decorative forms at the base of the vaulting, and

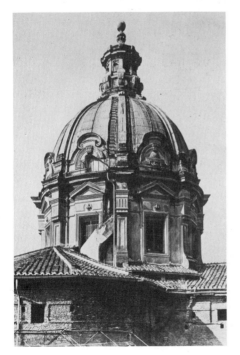

these forms are taken up in the lantern by scrolls of distinctly Mannerist derivation. The exterior of the dome is also highly original in that the drum and the foot of the vaulting are

emphasized at the expense of the curved silhouette of the dome itself. With this Cortona anticipates a development which, though differently expressed, was to come into its own in the second half of the century.

The façade of SS. Martina e Luca represents another break with tradition [145]. The two-storeyed main body of the façade is gently curved, following the precedent of the Villa Sacchetti (though the curve is here inwards). Strongly projecting piers faced with double pilasters seem to have compressed the wall between them, so that the curvature appears to be the result of a permanently active squeeze. At precisely this period Borromini designed his concave façade for the Oratory of St Philip Neri. In view of their differences of approach, however, the two architects may have arrived independently at designing these curved fronts. The peculiarity of the façade of SS. Martina e Luca lies not only in its curvature but also in that the orders have no framing function and do not divide the curved wall into clearly defined bays. In the lower tier, the columns seem to have been pressed into the soft and almost doughy mass of the wall, while in the upper tier sharply cut pilasters stand before the wall in clear relief. This principle of contrasting soft and hard features, which occurred in other parts of the building, is reversed in the projecting central bays: in the upper tier framing columns are sunk into the wall, whereas in the lower tier rigid pilaster-like formations top the door. It would be easy to describe at much greater length the almost incredibly rich variations on the same theme, but it must suffice to note that specifically Florentine Mannerist traits are very strong in the subtle reversal of architectural motifs and in the overlapping and interpenetration of elements as well as in the use of decorative features. This is true despite the carefully framed realistic palm and flower panels. Moreover, the type of the façade with two equally developed storeys and strongly

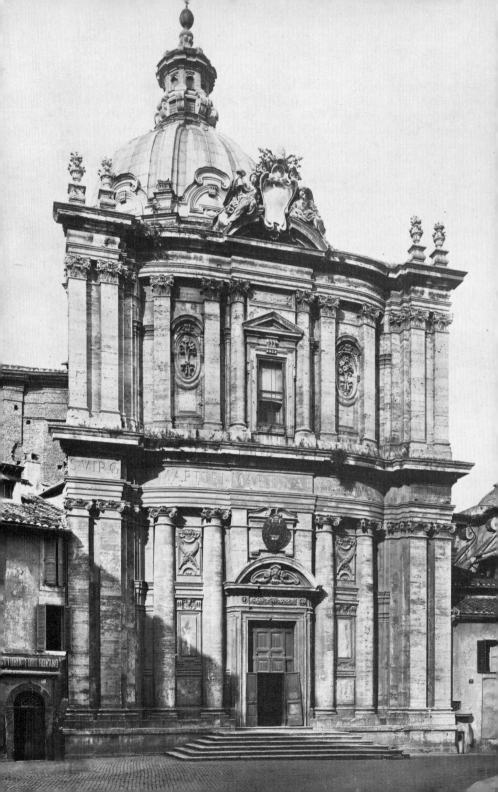

145. Pietro da Cortona:
Rome, SS. Martina e Luca, 1635–50. Façade

emphasized framing features has its roots in the Florentine rather than in the Roman tradition.[25]

Quite unlike any earlier church façade, this prepares the beholder for an understanding of the internal structure, for the wall treatment and articulation of the interior are here unfolded in a different key.[26] Cortona thinks in terms of the pliability of the plastic mass of walls: it is through this that he achieves the dynamic co-ordination of exterior and interior. To him belongs the honour of having erected the first of the great, highly personal and entirely homogeneous churches of the High Baroque.[27]

S. Maria della Pace, S. Maria in Via Lata, Projects, and Minor Works

Cortona's further development as an architect shows the progressive exclusion of Mannerist elements and a turning towards Roman simplicity, grandeur, and massiveness even though the basic tendencies of his approach to architecture remain unchanged. This is apparent in his modernization of S. Maria della Pace, carried out between 1656 and 1657 [146, 147].[28] The new façade, placed in front of the Quattrocento church, together with the systematization of the small piazza is of much greater importance than the changes in the interior.[29] Although regularly laid-out piazzas had a long tradition in Italy, Cortona's design inaugurates a new departure, for he applied the experience of the theatre to town-planning: the church appears like the stage, the piazza like the auditorium, and the flanking houses like the boxes. It is the logical corollary of such a conception that the approaches from the side of the church are through a kind of stage doors, which hide the roads for the view from the piazza.[30]

The convex upper tier of the façade, firmly framed by projecting piers, repeats the motif of the façade of SS. Martina e Luca. But in the scheme of S. Maria della Pace this tier represents only a middle field between the boldly

242

projecting semicircular portico and the large
concave wings which grip like arms round the
front, in a zone much farther removed from the
spectator.[31] The interplay of convex and con-
cave forms in the same building, foreshadowed
in a modest way in Cortona's Villa Sacchetti,
is a typically Roman High Baroque theme
which also fascinated Borromini and Bernini.

S. Maria della Pace contains many influential
ideas. The portico is one of Cortona's most
fertile inventions. By projecting far into the
small piazza and absorbing much space there,
a powerful plastic and at the same time chroma-
tically effective motif is created that mediates
between outside and inside.[32] Bernini incor-
porated it into the façade of S. Andrea al
Quirinale, and it recurs constantly in subsequent
European architecture. The detail of the por-
tico, too, had immediate repercussions. As early
as 1657 Bernini made an intermediary project
with double columns for the colonnades of St
Peter's;[33] and his final choice of a Doric order
with Ionic entablature was here anticipated by
Cortona.[34] The crowning feature of the façade
of S. Maria della Pace is a large triangular pedi-
ment encasing a segmental one. Such devices
had been used for more than a hundred years
from Michelangelo's Biblioteca Laurenziana
onwards. With the exception, however, of Mar-
tino Longhi's façade of SS. Vincenzo ed Ana-
stasio (p. 287), the motif does not occur in Rome
at this particular time. Encased pediments are
a regular feature of the North Italian type of the
aedicule façade [57], and to a certain extent
Cortona must have been influenced by it. But
he goes essentially his own way by working with
a pliable wall and by employing once again
architectural orders as an invigorating rather
than a space-(or bay-)defining motif. Moreover,
the 'screwhead' shape of the segmental pedi-
ment which breaks through the entablature so
as to create room for Alexander VII's coat of
arms adds to the unorthodox and even eccentric
quality of the façade.[35]

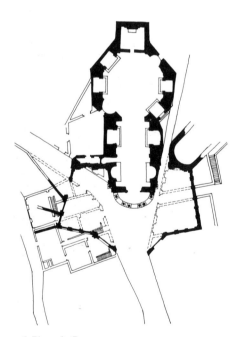

146. Pietro da Cortona:
Rome, S. Maria della Pace, 1656–7.
Plan of church and piazza

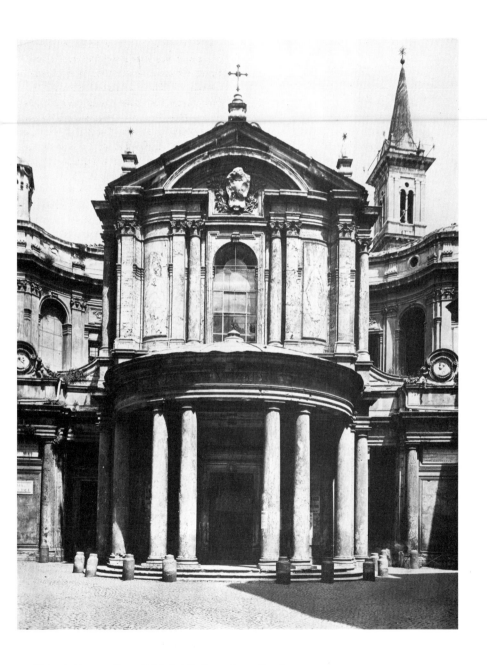

147. Pietro da Cortona: Rome, S. Maria della Pace, 1656–7. Façade

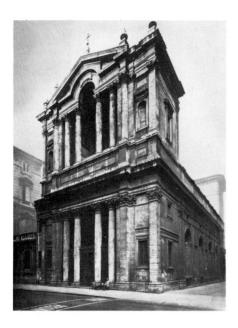

148 and 149. Pietro da Cortona:
Rome, S. Maria in Via Lata. Façade, 1658-62,
and interior of portico

In his next work, the façade of S. Maria in Via Lata, built between 1658 and 1662,[36] Cortona carried simplification and monumentality a decisive step further [148, 149]. The classicizing tendencies already apparent in the sober Doric of S. Maria della Pace are strengthened, while the complexity of SS. Martina e Luca seems to have been reduced to the crystalline clarity of a few great motifs. It is obvious that the alignment of the street did not warrant a curved façade. Nevertheless, there are connexions between Cortona's early and late work; for, like SS. Martina e Luca, the façade of S. Maria in Via Lata consists of two full storeys, but, reversing the earlier system, the central portion is wide open and is flanked by receding bays instead of projecting piers. The main part, which opens below into a portico and above into a loggia, is unified by a large triangular

pediment into which, as at S. Maria della Pace, a segmental feature has been inserted. Here, however, it is not a second smaller pediment, but an arch connecting the two halves of the broken straight entablature. The motif is well known from Hellenistic and Roman Imperial architecture (Termessus, Baalbek, Spalato, S. Lorenzo in Milan) and, although it was used in a somewhat different form in medieval as well as Renaissance buildings (e.g. Alberti's S. Sebastiano at Mantua), it is here so close to the late classical prototypes that it must have been derived from them rather than from later sources.[37] While thus the classical pedigree of the motif must be acknowledged, neither Cortona's Tuscan origin nor the continuity of his style is obscured. The design of the interior of the portico is proof of this [149]. With its coffered barrel vault carried by two rows of columns, one

of which screens the wall of the church, it clearly reveals its derivation from the vestibule of the sacristy in S. Spirito at Florence (Giuliano da Sangallo and Cronaca, begun 1489). But in contrast to the Quattrocento model, the wall screened by the columns seems to run on behind the apsidal endings, and so does the barrel vault. Cortona thus produces the illusion that the apses have been placed in a larger room, the extent of which is hidden from the beholder. Only the cornice provides a structural link between the columns and the niches of the apses. The comparison of Cortona's solution with that of S. Spirito is extraordinarily illuminating, for the 'naive' Renaissance architect ignored the fact that a screen of columns placed in front of an inside wall must produce an awkward problem at the corners. Cortona, by contrast, being heir to the analytical awareness gained in the Mannerist period, was able to segregate, as it were, the constituent elements of the Renaissance structure and reassemble them in a new synthesis. Unlike Mannerist architects, who insisted on exposing the ambiguity inherent in many Renaissance buildings, he set out to resolve any prevarication by a radical procedure: each of the three component parts – the screen of columns, the apses, and the barrel vault – has its own fully defined structural *raison d'être*. There is hardly a more revealing example in the history of architecture of the different approaches to a closely related task by a Renaissance and a Baroque architect. But only a master of Cortona's perspicacity and calibre could produce this result; it is rooted in his old love for superimpositions (to wit, the vaults of the apses upon the barrel vault), and even he himself would not have been capable of such penetrating analysis at the period of SS. Martina e Luca, a time when he had not entirely freed himself from Mannerism.

Cortona's major late architectural work is the dome of S. Carlo al Corso, which has been mentioned [150].[38] Its drum shows a brilliant,

and in this place unique, version of the motif of screening columns. Structurally, the buttresses faced with pilasters and the adjoining columns form a unit (i.e.: bab|bab|bab|...), but aesthetically the rhythm of the buttresses predominates and seems accompanied by that of the open, screened bays (i.e.: a|b-b|a|b b|a|...). A comparison of this dome with that of SS. Martina e Luca makes amply clear the long road Cortona had travelled in the course of a generation, from complexity tinged by Mannerism to serene classical magnificence. Similar qualities may be found in two minor works of the latest period, the Cappella Gavotti in S. Nicolò da Tolentino, begun in 1668, and the altar of St Francis Xavier in the Gesù, executed after the master's death.[39]

150. Pietro da Cortona:
Rome, S. Carlo al Corso. Dome, begun 1668

What would have been one of Cortona's most important ecclesiastical works, the Chiesa Nuova (S. Firenze) at Florence, remained a project. At the end of 1645 his model was finished. But as early as January 1646 there seem to have been dissensions, for Cortona writes to his friend and patron Cassiano del Pozzo that he was never lucky in matters concerning architecture.[40] The affair dragged on until late in 1666, when his plans were finally shelved. A number of drawings, now in the Uffizi, permit us to get at least a fair idea of Cortona's intentions.[41] Equally, all his major projects for secular buildings remained unexecuted, while the Villa del Pigneto and the house which he built for himself late in life in the Via della Pedacchia no longer exist.[42]

Three of his grand projects should be mentioned, namely the plans for the alterations and additions to the Palazzo Pitti at Florence, the designs for a Palazzo Chigi in the Piazza Colonna, Rome, and the plans for the Louvre. As regards the Louvre, he competed with Bernini, who again superseded him as he had thirty-five years before in the work at the Palazzo Barberini. Cortona's Louvre project has recently been traced.[43] It always was in the Cabinet des Dessins of the Louvre, but remained unrecognized because it makes important concessions to French taste and is the least 'cortonesque' of his architectural designs. The biased Ciro Ferri was certainly not correct when he maintained that Bernini had plagiarized his competitor's plan.[44] The modernization of the façade of the Palazzo Pitti was planned between 1641 and 1647, when Cortona painted his ceilings inside the palace.[45] His most notable contribution, however, would have been a theatre in the garden, for which several sketches are preserved. It was to rise high above curves and colonnaded terraces on the axis of the palace and would have formed a monumental unit with the courtyard. It is in these designs that Cortona's preoccupation with the ruins of Praeneste makes itself more clearly felt than in any of his other projects. He incorporated into his designs free-standing colonnades and a lofty 'belvedere', corresponding by and large to his reconstruction of the classical ruins made in 1636 for Cardinal Francesco Barberini and first published in Suarez's work on the ruins of Palestrina in 1655.[46] The prints probably influenced Bernini in his choice of colonnades for the Square of St Peter's. Moreover, the free-standing belvedere as a focusing point on high ground was frequently used in northern Europe, particularly for gardens. If in such cases architects were no longer aware of the debt owed to Cortona's reconstruction of Praeneste, on occasion its direct influence can yet be traced. An impressive example is the eighteenth-century Castello at Villadeati in Piedmont with its sequence of terraces and its crowning colonnaded belvedere.[47] Cortona himself drew on his reconstruction for the designs of the Palazzo Chigi, which Alexander VII wanted to have erected when he planned to transform the Piazza Colonna, on which the older family palace was situated, into the first square in Rome. The most brilliant of the projects, preserved in the Vatican Library,[48] shows, for the first time, a powerful giant order of columns screening a concave wall above a rusticated ground floor from which the waters of the Fontana Trevi were to emerge. The repercussions of this design can still be felt in Bouchardon's Fontaine de Grenelle in Paris (1739-45).

Cortona once wrote despondently that he regarded architecture only as a pastime.[49] Can we believe him? It seems impossible to say whether he was primarily painter or architect. As a painter his real gift lay in the effective manipulation of large-scale ensembles which are inseparable from their settings. One cannot, therefore, think of the painter without the architect in the same person. The study of Cortona as a painter should not be divorced from the study of Cortona as a decorator of interiors.

PAINTING AND DECORATION

The Early Works

Until recently it has been thought that Cor-
tona's first frescoes were those in S. Bibiana.[50]
The discovery of frescoes by his hand in the
Villa Muti at Frascati and in the Palazzo Mattei
makes a revision necessary. The Frascati fres-
coes, powerful though crude and weakly de-
signed, reveal the hand of the beginner,[51] while
in the frescoes of the gallery of the Palazzo
Mattei, executed between May 1622 and Dec-
ember 1623, Cortona's style appears fully deve-
loped.[52] He painted here four scenes from the
story of Solomon. They show his sense for
drama, his characteristic manner of composi-
tion, his love for archaeological detail, and his
solidity and clarity in the conception of the
main protagonists. Single figures as well as
whole scenes seem to herald his later work, and
the panel with the *Death of Joab* looks like an
anticipation of the *Iron Age* painted in the
Palazzo Pitti in 1637. And yet although the
style is formed, or rather in the process of being
formed, it lacks vigour and assurance, and the
full-bloodedness of his mature manner. Inter-
esting though these frescoes are as the first
major performance of a great master, by con-
trast to Bernini's work at the age of twenty-five
they do not reveal the hot breath of genius: it
was only in the frescoes in S. Bibiana, executed
between 1624 and 1626, that Cortona created
a new historical style in painting.

The responsibility for the pictorial decora-
tion was in the hands of the old-fashioned
Mannerist Agostino Ciampelli, and Cortona's
contribution consisted mainly of the three fres-
coes with scenes from the life of the saint above
the left-hand arches of the nave. One of these
scenes, *St Bibiana refuses to sacrifice to Idols*
[151], may be chosen to assess the change which
has taken place during the intervening decade
since Domenichino's St Cecilia frescoes [29].

The figures have grown in volume and their
immensely strong tactile values make them ap-
pear real and tangible. Thus breathing life seems
to replace the studied classicism of Domeni-
chino's work. There is also a broadening of
touch and a freer play of light and shade which,
incidentally, is in keeping with the general
development of the 1620s. Contrary to Domeni-
chino's loose, frieze-like composition, in which
every figure appears in statuesque isolation and
is given almost equal significance, Cortona
creates a diagonal surge into depth, a gradation
in the importance of figures, and a highly
dramatic focus. One diagonal is made up of the
dramatis personae, St Bibiana and St Rufina,
who press forward against the picture plane; the
other is formed by the group of priestesses,
unruffled bystanders recalling the chorus in the
classical drama. The result of all this is a virile,
bold, and poignant style which is closer in spirit
to Annibale's Farnese ceiling than to Domeni-
chino's manner and possesses qualities similar
to Bernini's sculpture of these years.

Yet Cortona's point of departure was not in
fact very different from that of Domenichino.
The figures, as well as the accessories like the
sacrificial tripod and the statue of Jupiter in
the background, meticulously follow ancient
models. Cortona's antiquarian taste was nur-
tured and determined by his early intense study
after the antique[53] and the scientific copying of
classical works for Cassiano del Pozzo, whom
he began to serve at about this time. It is often
not realized that throughout his whole career
and even during his most Baroque phase, Cor-
tona shared the erudite seventeenth-century
approach to antiquity. Thus, although there is
a world of difference between Domenichino's
rigid classicism of 1615 and Cortona's 'Baroque'
classicism of 1625, the latter's work is essentially
closer to the Carracci-Domenichino current
than it is to the bold illusionism of Lanfranco,
which asserted itself on the largest scale pre-
cisely at this moment.

151. Pietro da Cortona: St Bibiana refuses to sacrifice to Idols, 1624-6. Fresco. *Rome, S. Bibiana*

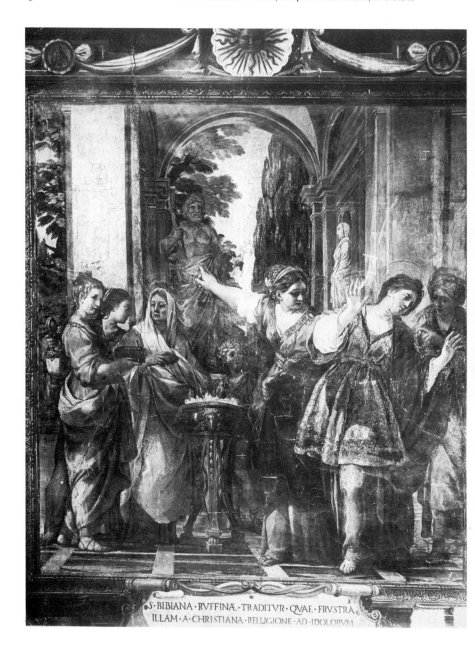

In these early years Cortona was employed primarily by the Sacchetti family.[54] The major work in the service of Marchese Marcello was the decoration of the Villa at Castel Fusano (1626–9), and this time the direction was in Cortona's hands. It is known that a number of artists worked under him, among them Domenichino's pupil Andrea Camassei (1602–49)[55] and, above all, Andrea Sacchi[56] – a fact of particular interest, since their opinions on art as well as their practice soon differed so radically. The Castel Fusano frescoes are in a poor state and largely repainted, but the chapel with Cortona's *Adoration of the Shepherds* over the altar is well preserved. Here all around the walls are brilliantly painted landscapes with small figures depicting the life of Christ; evidently derived from Domenichino, their painterly freedom is an unexpected revelation, and in a more accessible locality they would long have been given a place of honour in the development of Italian landscape painting. The principal decoration was reserved for the gallery on the second floor, and Marchese Marcello himself worked out the programme for the cycle of mythological-historical-allegorical frescoes. On entering the gallery, one is immediately aware that Cortona depends to a large extent on the Farnese ceiling, a clear indication that in these years he was still tied to the Bolognese tradition.[57]

During the same period he painted for the Sacchetti a series of large pictures (now in the Capitoline Museum) illustrating mythology and ancient history. The latest of these, *The Rape of the Sabine Women* of *c.* 1629 [152], a pendant to the earlier *Sacrifice of Polyxena*,[58] shows him amplifying the tendencies of the S. Bibiana frescoes. Once again an elaborately contrived

152. Pietro da Cortona:
The Rape of the Sabine Women, *c.* 1629.
Rome, Capitoline Museum

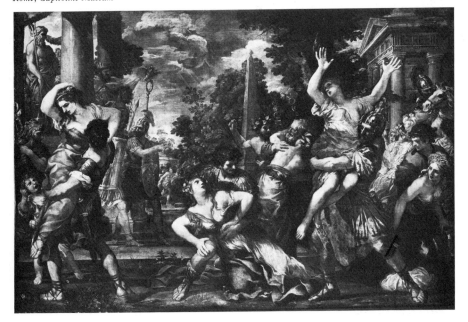

antique setting is used as a stage for the drama, and details such as armour and dress are studied with a close regard for 'historical truth'. The scene is none the less permeated by a sense of Venetian romanticism, and indeed in its colour the painting owes much to Venice.[59] Three carefully considered groups close to the observer are the main components of the composition. The one on the right is clearly dependent on Bernini's *Rape of Proserpina,* while that in the centre seems to be indebted to poses known from the stage. Despite the loose handling of the brush, these powerful groups produce almost the sensation of sculpture in the round. They are skilfully balanced on a central axis and yet they suggest a strong surge from right to left; this movement, stabilized by the three architectural motifs, is simultaneously counteracted in the middle distance by the sequence of gestures starting from the figure of Neptune and passing through Romulus to the centurion, who seems to be about to intervene on behalf of old age and virginity in their contest with brute force. Furthermore, these figures adroitly fill the gaps between the main groups in the foreground. It will be noticed how subtly the earlier frieze composition of the Domenichino type of classicism has been transformed. A dynamic flow of movement and counter-movement is integrated with a stable and organized distribution of groups and figures. The *Rape of the Sabine Women* impressed following generations almost more than any other of Cortona's canvases, and its effect can be seen, for instance, in works by Giacinto Gimignani and Luca Giordano. Nevertheless the richness of its compositional devices, typical of the Baroque trend in the years around 1630, still owes a debt to Annibale's Farnese ceiling and in particular to his *Triumph of Bacchus* [20].

The *Rape of the Sabine Women* shows both Cortona's strength as a painter and his weakness. Among his Roman contemporaries, Sacchi's characters are far more convincing, Pous-

sin lends a moral weight to his canvases of which Cortona was incapable, Guercino is superior as a colourist. But none of them matches his fiery temperament, his wealth of ideas in organizing a canvas on the largest scale, his verve in rendering incidents, and his great gift as a narrator. These virtues predestined him to become the first fresco painter in Rome and lead this branch of painting to a sudden and unparalleled climax.

The Gran Salone of the Palazzo Barberini

The years 1633–9 mark the turning point in Cortona's career, and in retrospect they must be regarded as one of the most important caesuras in the history of Baroque painting. During these years he carried out the ceiling of the Gran Salone in the Palazzo Barberini, a work of vast dimensions and a staggering performance by any standards [153].[60] There was an interruption in 1637 when he paid a visit to Florence and Venice. The Venetian painter Marco Boschini reports that, after his return, Cortona removed part of what he had done in order to apply the lessons learnt in Titian's and Veronese's city. Whether this is correct or not, the Venetian note is certainly very prominent. But we have reached the cross-roads of Baroque ceiling painting, and one source of inspiration, decisive as it may be, cannot account for the conception of this work.

Following the tradition of *quadratura* painting (p. 65), Cortona created an illusionistic architectural framework which he partly concealed beneath a wealth of garland-bearers, shells, masks, and dolphins – all painted in simulated stucco. At this juncture two points should be noted: that, in contrast to the orthodox *quadratura,* the architectural framework here is not meant to expand the actual shape of the vault; and that the feigned stuccoes take up and transform a local Roman tradition. But it was *real* stucco decoration that was fashionable

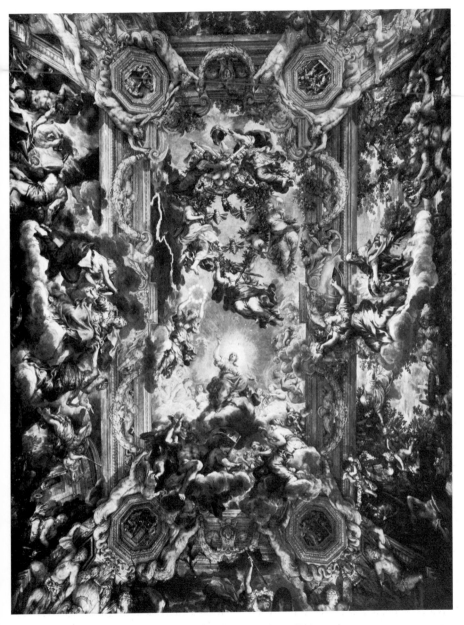

153. Pietro da Cortona: Glorification of Urban VIII's Reign, 1633-9. Fresco.
Rome, Palazzo Barberini, Gran Salone

in Rome from Raphael's Logge onwards and became increasingly abundant in the course of the sixteenth century.

The framework divides the whole ceiling into five separate areas, each showing a painted scene in its own right. Although something of the character of the *quadro riportato* can thus in fact still be sensed,[61] Cortona has created at the same time a coherent 'open' space. The illusion is a dual one: the same sky unites the various scenes behind the painted stucco framework, while on the other hand figures and clouds superimposed on it seem to hover within the vault just above the beholder. In other words, it is the existence of the framework that makes it possible to perceive both the illusionist widening and the illusionist contraction of objective space.

It is worth recalling that Mannerist ceiling and wall decoration in Central Italy was concerned primarily with figures illusionistically intruding into, but not extending, the space of the beholder.[62] By contrast the architectural constructions of the *quadratura* painters aim first and foremost at a precisely defined extension of space. A diametrically opposed method, namely the suggestion of an unlimited space continuum, was applied by Correggio to the decoration of domes. Finally, the double illusion, where figures may appear in painted space behind and in front of a feigned architecture, has also a long history, mainly in Northern Italy, from Mantegna's Camera degli Sposi onwards.

Cortona, it will now be seen, followed basically the North Italian tradition descending from Mantegna through Veronese, but he changed and amplified it by making use of the local stucco tradition, by applying to the framework *quadratura* foreshortening, and by employing and transforming Mannerist conventions of figure projection in front of the architecture. At the same time, he showed an awareness of the Correggiesque space continuum.

Moreover, he devised the middle field in the typically Venetian mode of *sotto in su*, in analogy to Veronese's *Triumph of Venice* in the Palazzo Ducale, and for colour too he relied to a large extent on Veronese.

All these diverse elements are united in a breathtaking and dynamic composition which overwhelms the beholder. At first sight throngs of figures seem to swirl above his head and to threaten him with their bulk. But soon the elaborate arrangement makes itself felt, and attention is guided through the chiaroscuro and the complex formal relationships to the cynosure of the composition, the luminous aureole surrounding the figure of Divine Providence, which is also the centre of meaning. It was to Francesco Bracciolini (1566-1645), court poet from Pistoia, a minor star of the sophisticated literary circle gathered round the pope, that the programme of the ceiling was due. Although his text has not yet been discovered, it is clear that he had devised an intricate story in terms of allegory, mythology, and emblematic conceits.[63] Divine Providence, elevated high on clouds above Time and Space (Chronos and the Fates), requests Immortality with commanding gesture to add the stellar crown to the Barberini bees. These magnificent insects (themselves emblems of Divine Providence) are flying in the formation of the Barberini coat of arms. They are surrounded by a laurel wreath held by the three theological Virtues so as to form a cartouche. The laurel is another Barberini emblem and also another symbol of Immortality. A putto in the top left corner extends the poet's crown – an allusion to Urban's literary gifts. When decoded, the visually persuasive conceit tells us that Urban, the poet-pope, chosen by Divine Providence and himself the voice of Divine Providence, is worthy of immortality. The four scenes along the cove, accessory to the central one, are like a running commentary on the temporal work of the pope. They illustrate in the traditional allegorical-

mythological style his courageous fight against heresy (Pallas destroying Insolence and Pride in the shape of the Giants), his piety which overcomes lust and intemperance (Silenus and satyrs), his justice (Hercules driving out the Harpies), and his prudence which guarantees the blessings of peace (Temple of Janus). This summary barely indicates the richness of incidents compressed into these scenes. Never again did Cortona achieve, or aspire to, an equal density and poignancy of motifs animated by an equally tempestuous passion.[64]

The Frescoes of the Palazzo Pitti and the Late Work

When passing through Florence in 1637, Cortona had been persuaded by the Grand Duke Ferdinand II to stay for a while and paint for him a small room (Camera della Stufa) with representations of the Four Ages.[65] A characteristic sign of the time: there was no painter in Florence who could have vied with Pietro da Cortona. In 1641 he returned for fully six years, first to finish the 'Ages' and then to execute the large ceilings of the grand-ducal apartment in rooms named after the planets Venus, Jupiter, Mars, Apollo, and Saturn.[66] The programme, written by Francesco Rondinelli, may be regarded as a kind of astro-mythological calendar to the life and accomplishments of Cosimo I [154].[67] Events take place, therefore, in the sky rather than on earth, giving Cortona a chance to exploit in the ceiling frescoes the painterly potentialities of the airy realm. But it is the return to real stucco decorations[68] and their particular handling that guarantee these rooms a special place in the annals of the Baroque.

The wealth of these decorations baffles accurate description. One meets the entire repertory: figures and caryatids, white stuccoes on gilt ground or gilded ones on white ground; wreaths, trophies, cornucopias, shells, and hangings; duplication, triplication, and super-impositions of architectural and decorative elements; cartouches with sprawling borders incongruously linked with lions' heads, and with palmettes, cornucopias, and inverted shells [155] - a seemingly illogical joining, interlocking, associating of motif with motif. Unrivalled is the agglomeration of plastic forms and their ebullient energy. The quintessence of the Baroque, it would appear - and in a sense this may be agreed to. There is, however, another side to these decorations. Cortona carefully observed the inviolability of the frames of the ceiling frescoes; the character of the decorations implies renunciation of illusionism; upon analysis it becomes evident that the decoration is placed before the architecture and not fused with it, that each element of the design is so clearly defined and self-contained that the figures could be taken out of their settings without leaving 'holes'; that, finally, the colour scheme of pure white and pure gold aims at stark and decisive contrasts. Thus the classicizing note is undoubtedly strong in the gamut of these High Baroque decorations. The details, too, open interesting perspectives: reminiscences of Michelangelo (corner figures, Sala di Marte [154]) appear next to Rubenesque tritons (Sala di Giove [155]) and chaste classical female caryatids (Sala di Giove); Buontalenti-like superimpositions (Sala di Apollo [156], and Sala di Venere) next to panels with trophies derived straight from antiquity (Sala di Marte). In a word, the basis for Cortona's decorative repertory is extremely broad, and yet the strange balance between effervescence and classical discipline remains unchanged.

To a certain extent these decorations epitomize Cortona's work in SS. Martina e Luca and the Palazzo Barberini, with which they are linked in many ways. But his earlier work as a decorator cannot account for the new relationship between the plastic decorations and the illusionist paintings [154] contained in heavy

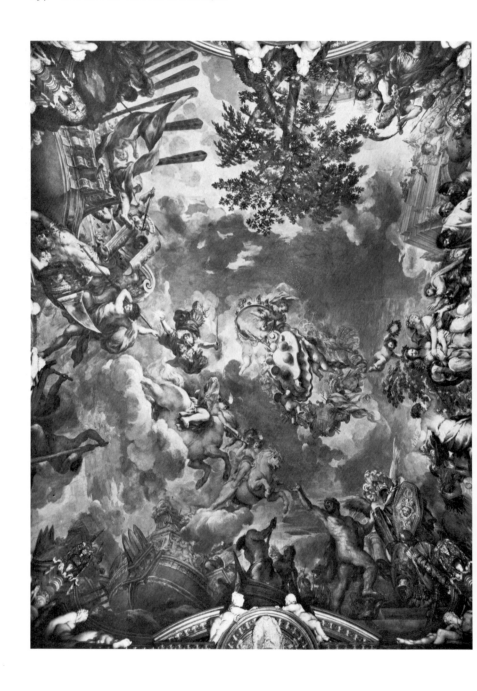

154 *(opposite)*. Pietro da Cortona: Florence, Palazzo Pitti, Sala di Marte, 1646. Ceiling. Fresco

155 *(above)*. Pietro da Cortona: Florence, Palazzo Pitti, Sala di Giove, 1643-5. Stuccoes

frames. The explanation is provided by Cortona's experience of Venice. Cinquecento ceilings such as that of the Sala delle Quattro Porte in the Palace of the Doges show essentially the same combination of stucco and painting. Here were the models which he translated into his personal luscious Seicento manner. It is the union of dignity and stateliness, of the festive, swagger, and grand, that predestined Cortona's manner to be internationally accepted as the official decorative style of aristocratic and princely dwellings. The 'style Louis XIV' owes more to the decorations of the Palazzo Pitti than to any other single source.[69]

Returning to Rome in 1647 without having finished the work in the Palazzo Pitti, Cortona immediately engaged upon his most extensive ecclesiastical undertaking, the frescoes in S. Maria in Vallicella. After the execution of the frescoes of the dome (1647–51) there was an interruption until 1655, and in the intervening years he painted for Pope Innocent X the ceiling of the long gallery in the Palazzo Pamphili in Piazza Navona (1651–4),[70] only recently (1646) built by Borromini. Here Cortona designed a rich monochrome system creating an undulating framework for the main scenes with the life and apotheosis of Aeneas. A work of infinite charm, the problem of changing viewpoints has here been approached and solved with unequalled mastery. His palette has become even more transparent and luminous than in the last

156. Pietro da Cortona: Florence,
Palazzo Pitti, Sala di Apollo, 1647. Stuccoes

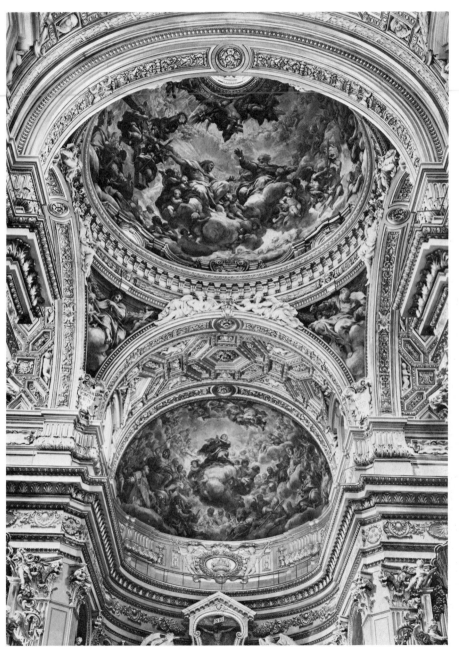

157. Pietro da Cortona: The Trinity in Glory (dome), 1647–51,
and The Assumption of the Virgin (apse), 1655–60. Frescoes. *Rome, S. Maria in Vallicella*

158. Pietro da Cortona:
Xenophon's Sacrifice to Diana, after 1653.
Rome, Palazzo Barberini (formerly)

ceilings of the Palazzo Pitti. Delicate blues, pale pinks, violet, and yellow prevail, foreshadowing the tone values used by Luca Giordano and during the eighteenth century. While this work easily reveals the study of antiquity, Raphael, and Veronese, the frescoes of S. Maria in Vallicella look back to Lanfranco and Correggio [157]; whereas the sophistication, elegance, delicacy, and decorative profuseness of the Pamphili ceiling appeal to the refined taste of the few, the work in the church speaks to the masses by its broad sweep, its dazzling multitude of figures and powerful accentuation. Once again, these frescoes form an ensemble of mesmerizing splendour with their setting, the criss-cross of heavy, gilded coffers, the richly ornamented frames (in the nave), and the white stucco figures – all designed by Cortona. But he did not attempt to transplant into the church his secular type of decoration; nor did he employ the illusionistic wizardry used in the Bernini-Gaulli circle and by the *quadraturisti*. Faithful to his old convictions, he insisted on a clear division between the painted and the decorative areas.

Compared with his great fresco cycles, his easel pictures are of secondary importance. But if they alone had survived, he would still rank as one of the leading figures of the High Baroque. Pictures like the *Virgin and Saints* in S. Agostino, Cortona (1626-8), and in the Brera (*c.* 1631), *Ananias healing St Paul* (S. Maria della Concezione, Rome, *c.* 1631), *Jacob and Laban* (1630s) and *Romulus and Remus* (*c.* 1643), both in the Louvre, and the *Martyrdom of St Lawrence* (S. Lorenzo in Miranda, Rome, 1646),

with their brilliant painterly qualities, their careful Renaissance-like grouping, their powerfully conceived main protagonists, and their concentration on the dramatic focus, belong to the highest class of 'history painting' in which the most coveted traditions of Raphael, Correggio, and Annibale Carracci find their legitimate continuation. The *Sacrifice to Diana* (after 1653, formerly Barberini Gallery, present whereabouts unknown) [158] may serve to illustrate Cortona's late manner. True to the allegorical-mythological mode of thinking, Xenophon's sacrifice after his happy return from the East (*Anabasis* V, iii) was meant to celebrate the homecoming of the Barberini after their exile. Compared with the early *Rape of the Sabine Women* [152] the classical and archaeological paraphernalia have grown in importance at the expense of the figures. The meticulous observance of classical decorum shows Cortona in step with the late Poussin. But unlike the latter, who aimed at extreme simplicity and concentration, Cortona tended to become diffuse, epic, and pastoral, and to this extent such pictures prepare the new stylistic position of the Late Baroque. At the same time, he toned down the *fortissimo* of his early manner, and with the insistence on predominant verticals, the firm framing of the composition, and the arrangement of figures in parallel layers, he confirmed that the period of the exuberant High Baroque was a thing of the past.

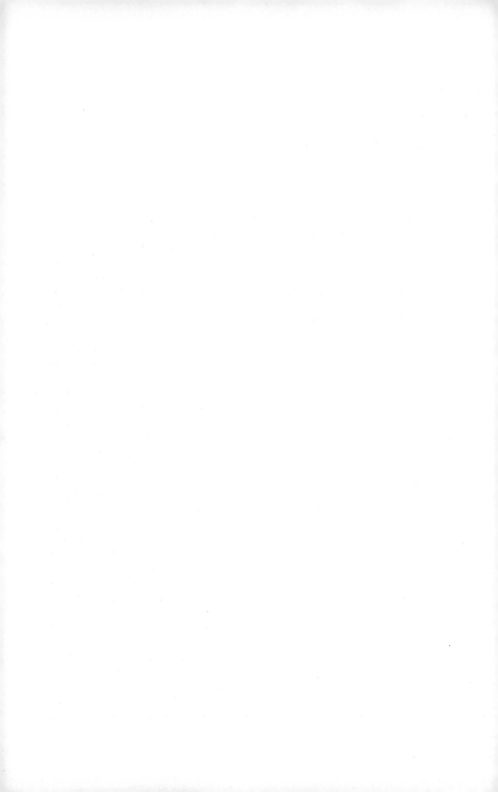

'HIGH BAROQUE CLASSICISM':

SACCHI, ALGARDI, AND DUQUESNOY

The foregoing chapters have been devoted to the three great masters of the High Baroque. Older artists, mainly Guercino and Lanfranco, had decisively contributed in the 1620s to the Baroque surge, to which the Bolognese classicism of the second decade had to yield. Although the authority of all these masters was tremendous, it remained by no means unchallenged; the voices of moderation, rationalism, and partisanship with the classical cause were not drowned for long. In the 1630s new men formed a powerful phalanx. They knew how to fight and even win their battles. The most distinguished artists of this group are the Frenchman Poussin, the Roman painter Andrea Sacchi, and two sculptors, the Bolognese Alessandro Algardi and the Fleming Francesco Duquesnoy. What they stand for is not a straight continuation of Bolognese classicism, but a revised version, tinged by the influence of the great masters and, in painting, by a new impact of Venetian colourism which was shared by the leading 'Baroque' artists, Lanfranco, Cortona, and Bernini. Compared with the Early Baroque classicism, the new classicism was first rather boisterous and painterly; it has a physiognomy of its own, and it is this style that by rights may be termed 'High Baroque classicism'.

ANDREA SACCHI (1599–1661)

For Poussin's development and the principles he believed in, the reader must be referred to Sir Anthony Blunt's masterly presentation.[1] The Italian leader of the movement was

Sacchi.[2] Reared in Rome, he was trained by Albani, first in his native city, later at Bologna; but from about 1621 he was back in Rome for good. In contrast to the dynamic Baroque artists a slow producer, critical of himself, bent on theorizing, he was by temperament and training predisposed to embrace the classical gospel. Yet his earliest large altarpiece, the *Virgin and Child appearing to St Isidore* (after 1622, S. Isidoro), is still much indebted to Lodovico Carracci. Probably less than three years later he painted the *St Gregory and the Miracle of the Corporal* (1625-7, Vatican Pinacoteca) [159], which reveals a mature and great master. With its rich and warm colours painted in a light key and its splendid loose handling, this work may be regarded as the first masterpiece of the new manner. The story, taken from Paulus Diaconus, illustrates how the cloth with which the chalice had been cleaned is pierced with a dagger by the pope and begins to bleed. The stranger who had doubted its magic quality sinks on to his knee, amazed and convinced. His two companions echo his wonderment, but the pope and his deacons are unperturbed. Sacchi had learned his lesson from Raphael's *Mass of Bolsena* and rendered the story in similar psychological terms: the calmness of those firm in their faith is contrasted to the excitement of the uninitiated. A minimum of figures, six in all, invites detailed scrutiny and enhances the effect of the silent drama. The organization of the canvas with its prominent triangle of three figures is essentially classical. But there is no central axis, and the

159 *(below)*. Andrea Sacchi:
St Gregory and the Miracle of the Corporal, 1625-7.
Rome, Vatican Pinacoteca

160 *(right)*. Andrea Sacchi:
The Vision of St Romuald, *c.* 1631.
Rome, Vatican Pinacoteca

cross of spatial diagonals allies the design to advanced compositional tendencies. Moreover the tight grouping of massive figures and the emphatic pull exercised by those turned into the picture belong to the Baroque repertory. The *St Gregory* is exactly contemporary with Cortona's Bibiana frescoes [151], and it is evident that at this moment the antagonism between the two artists, though latent, has not yet come into the open – on the contrary, both works reveal similar intense qualities and clearly form a 'common front' if compared with works of the older Bolognese or the Caravaggisti.

We have seen that shortly after the *St Gregory* Sacchi worked with and under Cortona at Castel Fusano (1627-9). At that time their ideological and artistic differences must have begun to clash. A few years later Sacchi had moved far from the position of the *St Gregory*, as is proved by his best-known work, the *Vision of St Romuald*[3] (Vatican Pinacoteca) [160]. Here under the shadow of a magnificent tree, the saint is telling the brethren his dream about the ladder leading to heaven on which the deceased members of the Order ascend to Paradise. The choice and rendering of the subject are characteristic for Sacchi: instead of employing the Baroque language of rhetoric, he creates real drama in terms of intense introspection in the faces and attitudes, and the soft Venetian gold

tone permeating this symphony in white is in perfect harmony with the pensive and deeply serious frame of mind of the listening monks. Within Sacchi's range, the *St Gregory* is by comparison 'loud' and trenchant colouristically, compositionally, and psychologically. The Baroque massiveness of the figures has now been considerably reduced; in addition they are moved away from the picture plane and face the beholder. All his later work is painted in a similar low key and with a similar attention to psychological penetration and concentration on bare essentials. In the 1640s he went a step further beyond the *St Romuald*. The principal work of this period, the eight canvases illustrating the *Life of the Baptist* painted for the lantern of S. Giovanni in Fonte (1641-9),[4] shows that he wanted to strip his style of even the slightest embroidery. Trained on Raphael, he reached a degree of classical simplicity that is the precise Italian counterpart to Poussin's development of these years.[5]

Sacchi's and Cortona's ways parted seriously during their work in the Palazzo Barberini. As Cardinal Antonio Barberini's protégé, Sacchi was given the task of painting on the ceiling of one room *Divine Wisdom* (1629-33)[6] [161], illustrating the apocryphal text from the *Wisdom of Solomon* (6:22); 'If therefore ye delight in thrones and sceptres, ye princes of peoples, honour wisdom, that ye may reign for ever.' Possibly finished in the year in which Cortona began his *Divine Providence*, the two works, with their implicit allegorical references to the Barberini Pope, supplement each other as far as the theme is concerned. But how different from Cortona's is Sacchi's approach to his task! Divine Wisdom enthroned over the world is surrounded by eleven female personifications symbolizing her qualities in accordance with the text. Sacchi represented the scene with the minimum number of figures in tranquil poses; they convey their sublime role by their being rather than by their acting. Raphael's *Parnassus*

was the model that he tried to emulate. He renounced illusionism and painted the scene as if it were a *quadro riportato* – an easel-painting. But he did not return to the position of Bolognese classicism, for the fresco is not framed and the entire ceiling has become its stage. Although the affinities with Domenichino cannot be overlooked, the light and loose handling is much closer to Lanfranco.

The Controversy between Sacchi and Cortona

Cortona's and Sacchi's vastly different interpretations of great allegorical frescoes reflect, of course, differences of principles and convictions, which were voiced in the discussions of the Accademia di S. Luca during these years.[7] The controversy centred round the old problem, whether few or many figures should be used in illustrating a historical theme. The partisans of classical art theory had good reasons to advocate compositions with few figures. According to this theory, the story in a picture should be rendered in terms of expression, gesture, and movement. These are the means at the painter's disposal to express the 'ideas in man's mind' – which Leonardo regarded as the principal concern of the good painter. It is only in compositions with few figures (Alberti admits nine or ten) that each figure can be assigned a distinct part by virtue of its expression, gesture, and movement, and can thus contribute a characteristic feature to the whole. In a crowded composition, single figures are evidently deprived of individuality and particularized meaning.

Another aspect supported these conclusions. Since painters had always borrowed their terms of reference from poetry (stimulated by Horace's 'ut pictura poesis'),[8] they maintained that a picture must be 'read' like a poem or tragedy, where not only does each person have his clearly circumscribed function, but where the Aristotelian unities also pertain.

161. Andrea Sacchi: La Divina Sapienza, 1629-33. Fresco. *Rome, Palazzo Barberini*

Pietro da Cortona fully accepted the traditional assumption that the familiar concepts of poetical theory apply to painting. But he pleaded for paintings with many figures, thus departing from classical theory. He compared the structure of painted plots to that of the epic. Like an epic, a painting must have a main theme and many episodes. These are vital, he maintained, in order to give the painting magnificence, to link up groups, and to facilitate the division into compelling areas of light and shade. The episodes in painting may be compared to the chorus in ancient tragedy, and, like the chorus, they must be subordinate to the principal theme. Sacchi, by contrast, insisted unequivocally that painting must vie with tragedy: the fewer figures the better; simplicity and unity are of the essence.[9] It is now clear that both masters made the theoretical position which they defended explicit in their work.

If we can here follow the formation or rather consolidation of two opposing camps, it is also evident that Cortona never dreamed of throwing overboard the whole intellectual framework of classical art theory. Like Bernini, he subscribed to its basic tenets but modified them in a particular direction. On the other hand, the circle round Poussin, Sacchi, Algardi, and Duquesnoy was a strong party which would never waive its convictions. His French rationalism and discipline carried Poussin even further than Sacchi; as early as the end of the 1620s he endeavoured to emulate ancient tragedy by reducing the *Massacre of the Innocents* (Chantilly) to a single dramatic group. The stiffening of the theoretical position may be assessed by comparing Poussin's *Massacre* with Reni's, of 1611.

Sacchi himself further clarified his theoretical standpoint in the studio talk given at about this time to his pupil Francesco Lauri (1610–35),[10] and later in a letter written on 28 October 1651 to his teacher, Francesco Albani.[11] In the former document he reiterated the basic repertory of the classical theory by concentrating on decorum

and the rendering of the *affetti*,[12] gestures and expression. He advocated natural movement and turned against the obscurantism produced by rhetorical embroidery and every kind of excess, such as the overdoing of draperies. In the letter to Albani, concerned with similar problems, he laments with extremely sharp words the neglect of propriety and decorum which has caused the decay of the art of painting. Albani, in his answer, strikes a new note by deriding the choice of tavern scenes and similar low subjects, for which he makes the northern artists responsible. Against their degrading of high principles, he upholds the ideals of Raphael, Michelangelo, and Annibale Carracci.[13]

Albani's targets were, of course, the Bambocci.anti. Sacchi's controversy with Cortona, by contrast, was on the level of 'high art'. Equal is speaking to equal, and the differences are fought out in the lofty atmosphere of the Academy. The theoretical rift, though, and its practical consequences are clear enough. It did not, however, prevent Cortona from frequenting the circle of artists who were opposed to his views. We are not astonished to find that Cortona, in the *Treatise*[14] which he published together with the Jesuit Ottonelli in 1652, upheld the traditional ideals of propriety and decorum and also insisted on the moral function of art. But side by side with this appears the concept of Art as pure form without an extraneous *raison d'être*. Thus the Baroque antithesis *docere-delectare*[15] makes its entry into the theory of art, and the hedonistic principle of delight as the purpose of painting comes into its own. In keeping with this, Cortona's art has an outspoken sensual quality, while Sacchi, classicist and moralist like Poussin, refrains more and more from appealing to the senses.

There is no doubt that Sacchi and his circle won the day. Not only did he and his confrères pursue relentlessly the aim of cleansing their art of Baroque reminiscences, but they extended their influence to Cortona's pupils, such as

Francesco Romanelli and Giacinto Gimignani (1611-81), and made possible in the 1640s the ascendancy in Rome of archaizing painters like Sassoferrato (1609-85) and Giovan Domenico Cerrini (1609-81). Even the great Baroque masters were touched by their ideas, and Bernini himself, after his abortive classicizing phase of the 1630s, found a new approach to this problem in his old age. The classical wave surged far beyond the confines of the artistic capital and threatened to quell a free development in such vigorous art centres as Bologna. Moreover the classical point of view received literary support, not dogmatically perhaps, from the painter and biographer of artists Giovanni Battista Passeri, the friend of Algardi and Sacchi, and most determinedly from Giovanni Bellori (1615-96), the learned antiquarian, the intimate of Poussin and Duquesnoy, and the mouthpiece and universally acclaimed promoter of the classical cause.

Even if it is correct that Monsignor Agucchi (p. 39) anticipated Bellori's ideas, the old battles were fought on new fronts. While Agucchi had turned against Caravaggio's 'naturalism' and the *maniera* painters, Sacchi, Bellori and the rest sustained the classic-idealistic theory against the Baroque masters and the Bamboccianti, the painters of the lower genre. In the light of this fact, we may once again confirm that 'Baroque classicism' dates from the beginning of the 1630s. Before that time no serious collision took place. It was only from the seventeenth century on that there existed real dissenters, and, therefore, classicism had to dig in. While at the beginning of the century there was a large degree of theoretical flexibility, the attitude of the defenders of classicism had to become, and became, less tractable after 1630; and as the century advanced the breach between the opposing camps widened – until in the wake of Poussin the French Academy turned the classical creed into a pedantic doctrine. The Italians proved more supple. Sacchi's position was taken

up by his pupil Carlo Maratti, who handed on the classical gospel to the eighteenth century and ultimately to Mengs and to Winckelmann, the real father of Neo-classicism and passionate enemy of all things Baroque. Pietro da Cortona, on the other hand, must be regarded as the ancestor of the hedonistic trend which led via Luca Giordano to the masters of the French and Italian Rococo.[16]

ALESSANDRO ALGARDI (1598-1654)[17]

No sculptor of the seventeenth century bears comparison with Bernini. Indeed, in the second quarter of the century there existed in Rome, apart from his studio, only two independent studios of some importance: those of Algardi and Duquesnoy. The latter was a solitary character; with the exception of the statue of St Andrew in St Peter's, he never had a large commission, he never had a devoted pupil, and his considerable influence was exercised through the objective qualities of his work rather than through the fascination of his personality.[18] The case of Algardi is different. For a short time his studio had some similarity to that of Bernini. During the last fifteen years of his life he had to cope with numerous and extensive commissions; and, after Bernini's, his reputation as a sculptor had no equal between about 1635 and his death in 1654. At the beginning of Innocent X's reign (1644 ff.), at a time when the greater man was temporarily out of favour, he even stepped into Bernini's place.

Algardi, coming from Bologna where he had frequented the Academy of the aged Lodovico Carracci and studied sculpture with the mediocre Giulio Cesare Conventi (1577-1640), reached Rome in 1624 after a stay of some years at Mantua. He came with a recommendation from the Duke of Mantua to Cardinal Lodovico Ludovisi, himself a Bolognese and the owner of a celebrated collection of ancient sculpture,[19] and established contact with his Bolognese

compatriots, above all with Domenichino. Cardinal Ludovisi entrusted him with the restoration of antique statues,[20] while Domenichino negotiated for him his first Roman commission of some importance: the statues of Mary Magdalen [162] and St John the Evangelist for the Cappella Bandini in S. Silvestro al Quirinale (c. 1628). These data indicate the components of his style, which derived from the classically tempered realism of the Carracci Academy, the close study of, and constant work with, ancient statuary, and his association with men like Domenichino, the staunch upholder of the classical *disegno*. As one would expect, for the rest of his life Algardi belonged to the younger circle of artists with classical inclinations; and Poussin, Duquesnoy, and Sacchi were among his friends.

Yet in spite of the difference of talent and temperament, education and artistic principles, Algardi was immediately fascinated by Bernini: witness his figure of Mary Magdalen [162], the style of which is half-way between the subjectivism of Bernini's *Bibiana* and the classicism of Duquesnoy's *Susanna* [168]. In fact Algardi remained to a certain extent dependent on his great rival. This is also apparent in his early portrait busts; that of Cardinal Giovanni Garzia Millini (d. 1629) in S. Maria del Popolo is unthinkable without Bernini's *Bellarmine*, while that of Monsignor Odoardo Santarelli in S. Maria Maggiore, probably belonging to Algardi's earliest productions in this field, follows closely Bernini's *Montoya*.

Nevertheless, Bernini's and Algardi's approach to portraiture differed considerably. A comparison between Bernini's *Scipione Borghese* of 1632 [76] and Algardi's perhaps earlier *Cardinal Laudivio Zacchia* in the Staatliche Museen, Berlin [163],[21] makes this abundantly clear. In contrast to the transitory moment chosen by Bernini, Algardi represents his sitter, with his mouth closed, in a state of permanence and tranquil existence. Scipione Borghese seems

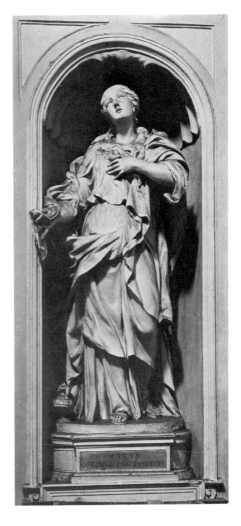

162. Alessandro Algardi:
St Mary Magdalen, c. 1628. Stucco.
Rome, S. Silvestro al Quirinale

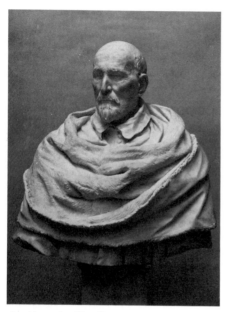

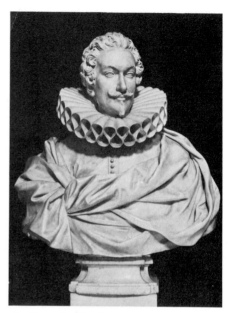

163. Alessandro Algardi:
Bust of Cardinal Laudivio Zacchia, 1626(?).
Berlin, Staatliche Museen

164. Alessandro Algardi:
Bust of Camillo (?) Pamphili, after 1644.
Rome, Palazzo Doria

to converse with us, while Algardi's cardinal remains static, immobile for ever. Even the most meticulous attention to detail, down to wrinkles and warts, and the most able treatment of skin, hair, and fur does not help to give such portraits Bernini's dynamic vitality. Compared with Bernini, who never loses sight of the whole to which every part is subordinated, Algardi's busts look like aggregates of an infinite number of careful observations made before the sitter. All forms and shapes are trenchant and precise and retain their individuality: this is a decisive aspect of Algardi's 'realist classicism'. But for solidity and seriousness his portraits are un-equalled; the mere bulk of any of his early busts brings the sitter physiologically close to us, and in this weightiness consists the High Baroque community of spirit not only with Bernini but also with Cortona and the early Sacchi.[22]

Algardi's genius for the sober representation of character has always been admired. The number of portrait busts by his hand is con-siderable, and it seems that many of them were done during his first years in Rome. In any case, it would appear that already in the course of the 1630s Algardi had begun to move away from his intense realism. Abandoning the warm and vivid treatment of the surface and the subtle differentiation of texture, he replaced the fresh-ness of the early works by a noble aloofness in his later busts. One of the finest of that period, the stylish Pamphili prince (after 1644, Rome, Palazzo Doria) [164], exhibits this classicism to perfection.[23] Thus, not unlike Sacchi, Algardi steers towards a more determined classicality.

In 1629 Algardi's reputation was not yet sufficiently established for him to be considered for one of the four monumental statues under

the dome of St Peter's. He was in his fortieth year when the first great commission, the tomb of Leo XI, fell to him; and it was not until 1640 that he was offered another monumental task: the over-life-size statue of St Philip Neri in S. Maria in Vallicella, in which he followed closely the example set by Guido Reni in the same church. Then, under Innocent X, the commissions came in quick succession.[24] Between 1649 and 1650 he executed the memorial statue of Innocent X in bronze as a counterpart to Bernini's earlier statue of Urban VIII (Palazzo dei Conservatori). Once again Algardi was impressed by Bernini; but instead of suppressing detailed characterization as Bernini had done, his pope has been rendered with minutest care and is, indeed, a great masterpiece of portraiture. Yet for all its intimate qualities the statue lacks the visionary power of its counterpart. Algardi did not accept the hieratic frontality of Bernini's *Urban*; he turned his statue in a more benevolent attitude towards the left; he considerably toned down the great diagonal of the papal cope, and transformed an energetic and commanding gesture into one of restraint and halting movement. He weakened the power of the blessing arm by the linear and decorative folds of the mantle, while Bernini enhanced the poignancy of benediction by pushing the arm forcefully forward into the beholder's space.

The execution of Leo XI's tomb [165], extending over many years,[25] ran parallel with that of Bernini's tomb of Urban VIII. But Algardi, beginning six years after Bernini, must have been familiar with Bernini's design. Leo's tomb is, in fact, the first papal tomb dependent on that of Urban VIII. All the salient features recur: the pyramidal arrangement of three figures, the blessing pope above the sarcophagus, and the allegories standing next to it in a zone before the papal figure. Algardi had to plan for an unsatisfactory position in one of the narrow passages of the left aisle of St Peter's. Bound by spatial restrictions, he reduced the

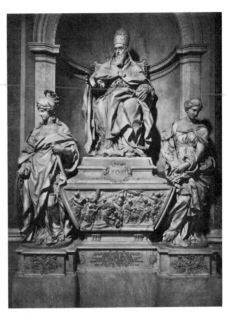

165. Alessandro Algardi:
Tomb of Leo XI, 1634-44.
Rome, St Peter's

structural parts to a minimum. At the same time, the absolute preponderance of the figures suited his classicizing stylistic tendencies. Algardi also supplied a narrative relief,[26] for which there was no room in the dynamic design of the Urban tomb. But during his classical phase Bernini did introduce a relief on the sarcophagus of the Countess Matilda monument in St Peter's (begun 1633), and slightly later on the tombs of the Raimondi Chapel in S. Pietro in Montorio.[27] Algardi made use of this device, and his debt to the Matilda monument is borne out by the fact that he fitted his narrative biographical relief into a similar trapezoid shape.

If the compositional elements of Leo XI's tomb were thus derived from Bernini, Algardi departed from him most decisively in other respects. The tomb consists entirely of white Carrara marble. Algardi avoided the use of

270

166. Alessandro Algardi:
The Meeting of Pope Leo I and Attila, 1646–53.
Rome, St Peter's

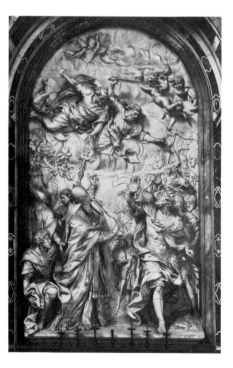

colour as emphatically as Bernini accepted it. Instead of a warm rendering of the skin and a luminous sparkle of the surface such as are found in Bernini's Urban tomb, Algardi's evenly-worked marbles have a cool, neutralized surface which is particularly evident in the head of the allegory of Courage. Instead of the transitory moment represented in Bernini's allegories, we find a permanent condition in those of Algardi. In fact, Algardi asserts his classical convictions in all and every respect, but I am far from suggesting that the result is a truly classical work. It is as far or even farther removed from Canova's classicism as Sacchi's paintings are from those of Mengs. Under the shadow of Bernini's overpowering genius, Algardi never even attempted to follow Sacchi the whole way. His tomb of Leo XI is a true monument of High Baroque classicism.

In contrast to this papal tomb, Algardi created a new Baroque species in his largest work, the relief representing the *Meeting of Leo and Attila* (1646–53, St Peter's) [166].[28] The historical event of the year A.D. 452 was always regarded as a symbol of the miraculous salvation of the Church from overwhelming danger, and it was only appropriate to give this scene pride of place in St Peter's. Much indebted to Raphael's example, Algardi's interpretation of the event is simple and convincing. As in Raphael's fresco, only pope and king perceive the miraculous apparition of the Apostles; the followers on both sides are still unaware of it. The rigidly maintained triple division of the left half, right half, and the upper zone results from the story, the protagonists of which dominate the scene. Once the traditional reserve towards this relief has been overcome, one cannot but admire its compositional logic and psychological clarity. Its unusual size of nearly 25 feet height has often led to the fallacious belief that its style, too, has no forerunners; but in fact the history of the illusionistic relief dates back to the early days of the Renaissance, to Donatello and

Ghiberti. In contrast, however, to the *rilievo schiacciato* of the Renaissance, Algardi desisted from creating a coherent optical space and used mainly gradations in the projection of figures to produce the illusion of depth. The flatter the relief grows, the more the figures seem to recede into the distance, while the more they stand out, the nearer they are to us. Those in the most forward layer of the relief are completely three-dimensional and furnish transitions between artistic and real space; the problem of spatial organization is thus turned into one of psychological import and emotional participation.

After Algardi had created this prototype, such reliefs were preferred to paintings whenever circumstances permitted it. This was probably due to the fact that a relief is a species half-way, as it were, between pictorial illusion and reality, for the bodies have real volume, there is real depth, and there is a gradual transition between the beholder's space and that of the relief. More effectively than illusionist painting, the painterly relief satisfied the Baroque desire to efface the boundaries between life and art, spectator and figure. Only periods which demand self-sufficiency of the work of art will protest against such figures as the Attila, who seems to hurry out of the relief into our space; for people of the Baroque era it was precisely this motif that allowed them fully to participate in Attila's excitement in the presence of the miracle. But now it is important to realize why it was Algardi rather than Bernini who brought into being the pictorial relief of the Baroque.

In Bernini's work, reliefs are of relatively little consequence; it seems that they did not satisfy his desire for spatial interpenetration of sculpture and life. A relief is, after all, framed like a picture, and consequently the illusion it creates cannot be complete. If we recall Bernini's handling of plastic masses which invade real space without limiting frames (p. 161), Algardi's *Attila* appears by comparison temperate, controlled, and relegated to the sphere of art.

It would not be difficult to show that this difference between Bernini's and Algardi's approach cannot be explained by the hazards or demands inherent in different commissions. While Bernini seeks to eliminate the very difference between painting, relief, and free-standing sculpture, Algardi meticulously preserves the essential character of each species.

His interpretation of a free-standing group can best be studied in his *Decapitation of St Paul* (1638-43, Bologna, S. Paolo) [167].[29] The two figures of the executioner and the saint are placed within a framing semicircle of columns behind the main altar. Entirely isolated, each figure shows an uninterrupted silhouette and preserves its block-like quality. It would have been contrary to Algardi's principles to detract from the clarity of these figures by placing them against a sculptured or 'picturesque' background. This is particularly revealing in view of the fact that he was stimulated by pictorial

167. Alessandro Algardi:
The Decapitation of St Paul, 1638-43.
Bologna, S. Paolo

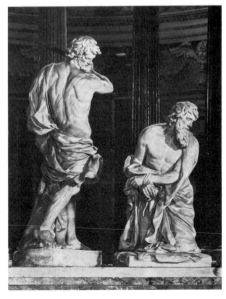

impressions: it was Sacchi's *Martyrdom of St Longinus* at Castelgandolfo that had a formative influence on his conception.[30]

The Attila relief was Algardi's most important legacy to posterity.[31] While a work like the *Decapitation of St Paul* with its Sacchesque gravity, simplicity, and psychological penetration illustrates excellently his partisanship with the classical cause, the more 'official' relief shows that, confronted with a truly monumental task, Algardi was prepared to compromise and to attempt a reconciliation between the leading trend of Bernini's grand manner and the sobriety of classicism – between the impetuous art of a genius and his own more limited talents.

FRANCESCO DUQUESNOY (1597–1643)

Duquesnoy was probably a greater artist than Algardi; in any case, he was less prepared to compromise.[32] Born in Brussels in 1597, the son of the sculptor Jerôme Duquesnoy, he came to Rome in 1618 and stayed there until shortly before his premature death in 1643.[33] He was so thoroughly acclimatized that even the discerning eye will hardly discover anything northern in his art. Soon Duquesnoy was a leading figure in the circle of the classicists; after Poussin's arrival in Rome he shared a house with him, and he was on intimate terms with Sacchi. He also soon belonged to the group of artists who worked for Cassiano del Pozzo's *corpus* of classical antiquity (p. 231). But ten years went by before he became a well-known figure in the artistic life of Rome. Between 1627 and 1628 Bernini employed him on the sculptural decoration of the Baldacchino.[34] His reputation established, he was chosen to execute the *St Andrew*, one of the four giant statues under the dome of St Peter's. And in 1629 he received the commission for his most famous work, the statue of St Susanna in the choir of S. Maria di Loreto [168, 169].[35]

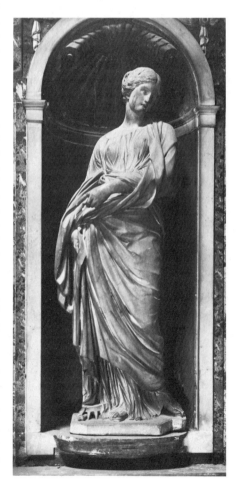

168 and 169. Francesco Duquesnoy: St Susanna, 1629–33, with detail *(opposite)*. Rome, S. Maria di Loreto

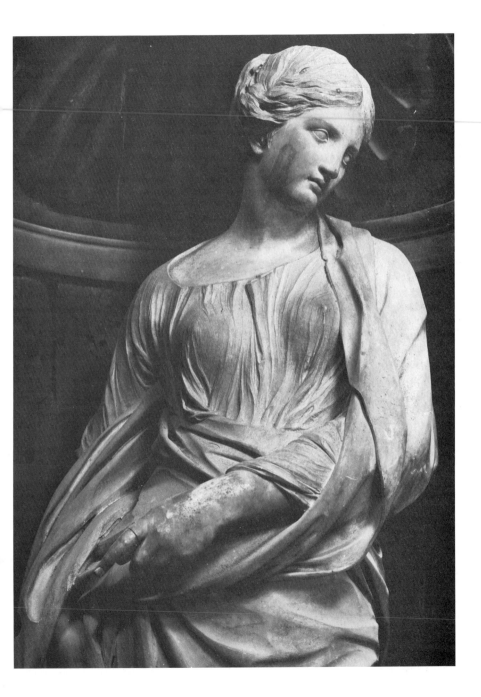

For a study of Duquesnoy, one should first turn to this celebrated figure. Susanna originally held the martyr's palm in her right hand; with the left she is making a timid gesture towards the altar, while her face is turned in the direction of the congregation.[36] Bellori, a devoted admirer of Duquesnoy's art, maintained that it was impossible to achieve a more perfect synthesis of the study of nature and the idea of antiquity. Duquesnoy, he relates, worked for years from the model, while the ancient statue of Urania on the Capitol was always before his mind's eye. The stance and the fall of the drapery are, indeed, close to the Urania and other similar ancient figures. The contour of the statue is clear and uninterrupted and the studied *contrapposto* is utterly convincing: the leg on which the weight of the body rests, the free-standing leg, the sloping line of the shoulders, the gentle turn of the head – all this is beautifully balanced and supported by the fall of dress and mantle. The folds are gathered together on the slightly protruding right hip, and it was precisely the classically poised treatment of the drapery that evoked the greatest enthusiasm at the time. Bellori regarded the *Susanna* as the canon of the modern draped figure of a saint. This judgement was perfectly justified, since there is hardly any other work in the history of sculpture, not excluding Bernini's most important statues, that had an effect as lasting as Duquesnoy's *Susanna*.

A comparison between the *Susanna* and Bernini's *Bibiana* of five years earlier [73] makes the limpid and temperate simplicity of the *Susanna* all the more obvious, particularly if one considers that the *Bibiana* was well known to Duquesnoy, and that even he could not entirely dismiss her existence from his thoughts. Coming from the *Susanna*, one finds the stance of Bernini's figure ill-defined and the mantle obscuring rather than underlining the structure of the body. In contrast to the wilfully arranged fall of the folds in the *Bibiana*, the mantle of the *Susanna* strictly follows the laws of gravity; in contrast to the individual characterization of Bibiana's dress, Susanna is shown in the timeless attire of classical antiquity. Duquesnoy abstained from any indication of time and space; a simple slab, instead of a rock with vegetation, forms the base of the statue. It was not the individual fate of a saint, but the objective state of sainthood which he desired to portray. Consequently, he represented his saint in a state of mental and physical repose instead of selecting a transitory moment as Bernini had done. He gave shape to an ideal norm with the same compelling logic with which Bernini had characterized a fleeting instant and a fluctuating movement. No light is playing on the surface, the forms are firm, clear, and unchangeable, and any departure from such objectivity is carefully avoided.[37] The face of Susanna is shown with her mouth closed and her eyes gazing into space with the blank eyeballs of Roman statues; whereas Bernini made it a point to incise the iris and pupil, which gives the look direction and individual expression. Behind these two contrasting interpretations of saints lie the two different approaches: the Baroque and the classical, a subjective as opposed to an objective conception, dynamic intensity as opposed to rational discipline. The similarity of Sacchi's and Duquesnoy's developments is more than mere coincidence; both turn over a new leaf in 1629, the one with the *Divine Wisdom*, after having worked under Cortona at Castel Fusano, the other with the *Susanna*, after having worked under Bernini in St Peter's.

So far I have treated the *Susanna* and *Bibiana* as basically antagonistic, but this is not the whole story. Nobody with any knowledge of the history of sculpture would fail to date the *Susanna* in the seventeenth century. Sacchi's and Algardi's works have shown that this 'Baroque classicism' reveals symptoms characteristic of the period. The head of the *Susanna* displays a lyrical and delicate sweetness (Bellori

called it 'un aria dolce di grazia purissima') such as is found neither in classical antiquity nor in the adored models of Raphael and his circle; but we do find the same sort of expression in paintings of the period, such as the almost exactly contemporary frescoes by Domenichino in the choir of S. Andrea della Valle; and conversely, echoes of the head of the *Susanna* are frequent in Sacchi's pictures. This essentially seventeenth-century sensibility and the stronger sensations of ecstasy and vision do not differ intrinsically, but only in degree. The blending of classical purity of form with the expression of seventeenth-century susceptibility had an immense appeal for contemporaries, a fact which is borne out by the many replicas of the head of Susanna.[38] Moreover, a direct line leads from here to the often sentimental prettiness of the 'classicist Rococo'[39] of which Filippo della Valle's *Temperance* [306] may serve as an example. Not only has the head of the Susanna a distinctly seventeenth-century flavour: the porous and soft treatment of the surface, of skin, hair, and dress, which seems to impart warm life to the statue – a life that is completely lacking in most of the ancient models known to the seventeenth century – is typical of the spirit of the Baroque. Finally, with the subtle relations between the statue, the altar, and the congregation, Duquesnoy enlarged the spiritual relevance of his figure beyond its material boundaries. Thus he advanced some steps along the path which Bernini followed to the end.

The case of the *Susanna* is closely paralleled by Duquesnoy's *St Andrew* (1629–40) [170].[40] The stance of the figure and the fall of the drapery are of almost academic classicality, adapted from ancient statues of Jupiter. A comparison with Bernini's *Longinus* [74] illustrates emphatically the deep chasm that divides the two artists. But even this figure is not self-sufficient, for St Andrew turns with pleading gesture and devotional expression towards the heavenly light streaming in from the dome,

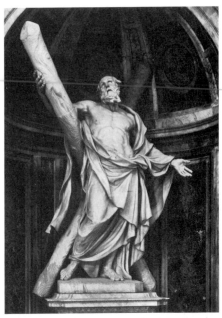

170. Francesco Duquesnoy: St Andrew, 1629–40. *Rome, St Peter's*

while the ample cloak endows him with Baroque mass and weight. Duquesnoy's eminence, however, lay in the handling of works of smaller dimensions, and this monumental statue lacks the convincing oneness which in those very years he was able to give to his *St Susanna*. The statuesque body of the figure contrasts with the emotional expression of the head; and the transference of the heroic Jupiter type to the Christian saint is as unsatisfactory as the Baroque diagonal going through shoulders and arms is petty and feeble.

During his first Roman years Duquesnoy had earned his living mainly by small sculpture in bronze and ivory, by wooden reliquaries, and by restoring ancient marbles. Nor are many of his later works in marble of large size; neither the tomb of Andrien Vryburch of 1629 [172] nor that of Ferdinand van den Eynde of 1633–

40 [171], both in S. Maria dell'Anima, nor the earlier tomb of Bernardo Guilelmi (S. Lorenzo fuori le Mura),[41] in which he followed fairly closely Bernini's Montoya bust. An endless number of small reliefs and statuettes in bronze, ivory, wax, and terracotta representing mythological, bacchic, and religious subjects continued to come from his studio to the end of his life; and it was on these little works of highest perfection that his reputation was mainly based. Artists and collectors valued them very highly and regarded them as equal to antiquity itself; and original models and casts after such works belonged to the ordinary equipment of artists' studios.[42]

Duquesnoy's special interest was focused on representations of the putto [172, 173]. He really gave something of the soul of children and modelled their bodies so round, soft, and delicate that they seem to be alive and to breathe; the subtle transitions between one form and another and the tenderness of the surface can be as little reproduced as the quivering *sfumato* of Correggio's palette. It was Duquesnoy's conception of the *bambino* that became a general European property and, consciously or unconsciously, most later representations of small children are indebted to him. But Duquesnoy's rendering of the putto was not static, and this is reflected in the differences of opinion about the Vryburch and van den Eynde tombs. Some critics regarded only the one, some only the other as original. The truth seems to be that the putti of both monuments are entirely by the hand of the master; but while the Vryburch monument, the earlier of the two, shows a type close to Titian, those of the van den Eynde monument are evidently indebted to Rubens.[43]

Even if Bellori and Passeri had not related it, it would be impossible to overlook how carefully Duquesnoy had studied Titian. We know from the sources that he was fascinated by Titian's *Children's Bacchanal*, now in the Prado, at that time in the collection of Cardinal

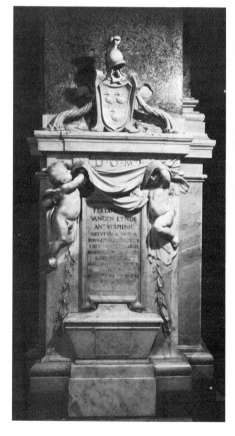

171. Francesco Duquesnoy:
Tomb of Ferdinand van den Eynde, 1633–40.
Rome, S. Maria dell'Anima

172. Francesco Duquesnoy:
A Putto from the Andrien Vryburch Tomb, 1629.
Rome, S. Maria dell'Anima

173. Francesco Duquesnoy:
A Putto, after 1630. Bronze.
London, Victoria and Albert Museum

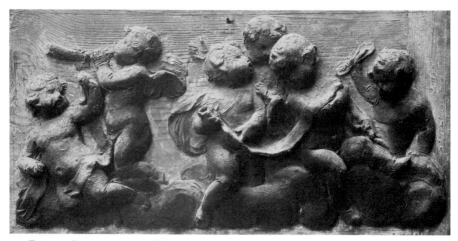

174. Francesco Duquesnoy: Putto Frieze,
1640-2. Terracotta model for SS. Apostoli (Naples).
Formerly Berlin, Deutsches Museum

Ludovisi – a fascination which he shared with Poussin. The putti of the Vryburch monument comply closely with Italian standards of beauty and show a comparatively firm treatment of the skin, while those of the van den Eynde tomb have the fat bellies and soft flexibility of children by Rubens. There are other works which testify to Duquesnoy's intimate study of Titian, and I would date these, analogous to Poussin's Venetian period, in the early years, before or about 1630.[44] On the other hand Flemish characteristics become more prominent towards the end of Duquesnoy's career, the most important

example being the relief with singing putti on Borromini's altar of the Cappella Filomarino in SS. Apostoli, Naples [174].[45]

It appears that Duquesnoy returned to his native Flemish realism, which had lain dormant under the impact of the Italian experience, and that he imparted it above all to his putti – in other words when he was not concerned with work on a large scale, and therefore felt free from the ideological limitations of the classical doctrine. He thus inaugurated a specific Baroque type, the influence of which not even Bernini and his circle could escape.[46]

ARCHITECTURAL CURRENTS

OF THE HIGH BAROQUE

Each of the three great masters of the High Baroque, Bernini, Borromini, and Pietro da Cortona, created an idiom in his own right. Since many or even most of their buildings were erected after 1650, their influence, on the whole, did not make itself felt until the later seventeenth century and extended far into the eighteenth century. The decisive factor of the new situation due to their activity lies in that, for the time being, Rome became the centre of every advanced movement. And as so often in similar circumstances, minor stars with a distinctly personal manner arose in the wake of the great masters. It is with their work in Rome that we must first be concerned. The following survey is necessarily rather cursory, and only buildings which in the author's view have more than ephemeral significance can be mentioned.

ROME

Carlo Rainaldi

By far the most important architect in Rome after the great trio was the slightly younger Carlo Rainaldi (1611-91). He commands particular interest not only because his name is connected with some of the most notable architectural tasks of the century, but also because he achieved a unique symbiosis of Mannerist and High Baroque stylistic features. Some of his buildings are, moreover, more North Italian in character than those of any other architect working in Rome at that time. This was certainly the result of his long collaboration with his father, Girolamo, who, born in Rome in 1570 and a pupil of Domenico Fontana, had

imbibed North Italian architectural conceptions during his long stays at Bologna, Parma, Piacenza, and Modena.[1] In Rome we find him as the 'Architect to the City' (1602) working on a large number of commissions,[2] and even when Innocent X appointed him 'papal architect' at the advanced age of seventy-four (1644) and entrusted him with the design of the Palazzo Pamphili in Piazza Navona,[3] he appeared unburdened by his years – and almost untouched by modern stylistic developments. Together with his son, Carlo, he later shouldered the great task of the planning of S. Agnese. But by then – he was eighty-two – the initiative seems to have slipped into Carlo's hands. The large design of the exterior of S. Agnese in the Albertina, Vienna, showing a heavy and clumsy dome and an unsatisfactory façade derived from Maderno's St Peter's, must be attributed to the son rather than to the father.[4] It illustrates, however, the extent to which Carlo accepted an outmoded fashion.

His time came after his father's death in 1655. Soon he was moving into the limelight and developed a typically Roman grand manner, though without ever ridding himself of the paternal heritage. It is mainly three works, executed during the 1660s and 1670s – S. Maria in Campitelli, the façade of S. Andrea della Valle, and the churches in the Piazza del Popolo – that warrant a more thorough discussion.

In 1660 Pope Alexander VII decided to replace the old church in the Piazza Campizucchi by a new, magnificent structure of large dimensions.[5] Two years later medals showing Rainaldi's design were buried in the foundations.

This design, a grand revision of the project for S. Agnese, had little in common with the present building: a dominating dome was to rise above a concave façade framed by powerful projecting piers. The derivation from Cortona's façade of SS. Martina e Luca is evident. Since this scheme was much too ambitious, Carlo next designed a two-storeyed façade behind which the dome, considerably reduced in size, was to disappear. While he retained from SS. Martina e Luca the concept of the convex façade between piers, he drew on another of Cortona's buildings, namely S. Maria in Via Lata, for the portico in two storeys.[6] At this stage the plan consisted of a large oval for the congregation and an architecturally isolated, circular domed sanctuary for the miraculous picture of the Virgin in honour of which the new building was to be erected [175]. The elevation of the oval room followed closely, but not entirely, Bernini's S. Andrea al Quirinale, for the strong emphasis on the transverse axis – a Mannerist motif – was derived from Francesco da Volterra's S. Giacomo degli Incurabili, and so was the shape of the dome, closed at the apex and with lunettes cutting deep into the vaulting. I have singled out this plan for a close scrutiny because the combining of the most recent High Baroque achievements of Cortona and Bernini modified by a deliberate return to a Mannerist structure is typical of Rainaldi. In the final design, which was still further reduced, Rainaldi exchanged the oval room with its low dome for a nave, and this required a straight façade. The building was begun early in 1663 and finished by the middle of 1667 [176-8].

175. Carlo Rainaldi: Rome, S. Maria in Campitelli. Project, 1662. *S. Maria in Campitelli*

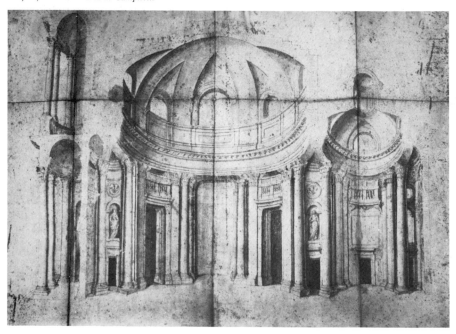

The final plan contains a number of exciting features which are adumbrated in the oval scheme. The longitudinal nave, to which the domed sanctuary is again attached, opens in the centre into large chapels placed between smaller chapels. It will be recalled that this type of plan has a distinctly North Italian pedigree. Notable among such churches is Magenta's S. Salvatore at Bologna (1605-23) [59], which was rising when Girolamo Rainaldi began to erect S. Lucia in the same city. In S. Salvatore too the transverse axis is strongly emphasized by means of chapels which open to the full height of the nave. In S. Maria in Campitelli these chapels have been given still more prominence by virtue of their decoration with free-standing columns and by the gilded decorations of the arches. By contrast, the nave is uniformly white

and has only pilasters; but an arrangement of columns identical to that of the chapels, an identical accentuation of bays, and the same type of gilded decoration recur at the near and far ends of the sanctuary. Thus there are most telling visual relations between the large chapels and the sanctuary, and the eye can easily wander from the impressive barriers of the transverse axis along the main direction to the sanctuary [176]. Moreover the bright light streaming into the sanctuary from the dome immediately attracts attention. It appears that in this church the Mannerist conflict of axial directions has been resolved and subordinated to the unifying High Baroque tendencies of direction determined by mass (columns) and light. Details, such as door and balcony surrounds and the curved pilasters standing in the corners of the

176. Carlo Rainaldi:
Rome, S. Maria in Campitelli, 1663-7. Interior

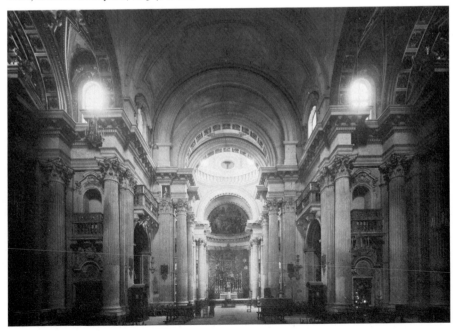

domed part, owe not a little to Borromini. But it would be a mistake to believe that there is anything Borrominesque in the basic conception of the structure.

What singles out this building and gives it a unique place among the High Baroque churches of Rome is its scenic quality, produced by the manner in which the eye is conducted from the 'cross-arm' to the sanctuary and into depth from column to column. This approach was at home in northern Italy (p. 122), but in Rome the scenic character of the architecture of S. Maria in Campitelli anticipates the development of the Late Baroque. Thus we find in this extraordinary building North Italian planning coupled with Roman gravity and Mannerist retrogressions turned into progressive tendencies. The plan of S. Maria in Campitelli had no sequel in Rome. On the other hand, one need not search long to come across similar structures in the North. In the year in which Rainaldi's church was finished Lanfranchi began to build S. Rocco in Turin, where free-standing columns arranged like those of S. Maria in Campitelli were given a similar scenic function. Moreover, the 'false' Greek cross with an added domed chapel remained common in the North throughout the eighteenth century.[7]

An interesting combination of North Italian and Roman tendencies will also be found in the façade of S. Maria in Campitelli [178]. The main characteristics of this front are the two aedicules, one set into the other and both going through the two storeys. This type, which I have called before 'aedicule façade' (p. 120), had no tradition in Rome; it was, however, common in the North of Italy and only needed the thorough Romanization brought about by Rainaldi to become generally acceptable. Preceded by his father's attempt in the design of S. Lucia

177. Carlo Rainaldi:
Rome, S. Maria in Campitelli, 1663–7. Plan

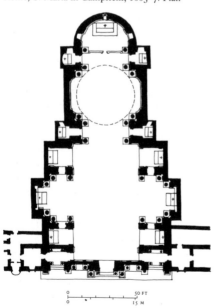

178. Carlo Rainaldi:
Rome, S. Maria in Campitelli, 1663–7. Façade

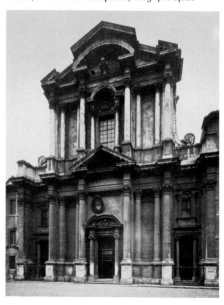

at Bologna, Carlo knew how to blend the aedicule façade with the typically Roman increase in the volume of the orders from pilasters to half-columns and free-standing columns. The Roman High Baroque quality is clearly expressed in the powerful projections of the pediments, the heavy and great forms, and the ample use of columns. Characteristically Roman, too, are the farthest bays, which derive from the Capitoline palaces;[8] and the motif of the two recessed columns in the bays between the outer and inner aedicule stems from Cortona's SS. Martina e Luca. Rainaldi's transplantation of the North Italian aedicule façade to Rome led to its most mature and most effective realization. None of the highly individual church façades by Cortona, Bernini, and Borromini lent itself freely to imitation. But Rainaldi's aedicule conception in Roman High Baroque dress was easily applicable to the longitudinal type of churches and was, therefore, constantly repeated and re-adapted to specific conditions.[9]

Almost exactly contemporary with S. Maria in Campitelli runs Rainaldi's execution of one of the great church façades in Rome, that of S. Andrea della Valle [179]. Here, however, he had not a free hand. The façade was begun in 1624 from a design of Carlo Maderno. When the latter died, it remained unfinished with only the pedestals of the order standing. Rainaldi not only turned Maderno's design into an aedicule façade but also managed by a stress on mass, weight, and verticalism to bring to bear upon the older project the stylistic tendencies of the mid seventeenth century. The façade which we see today does not, however, entirely correspond to Rainaldi's intentions.[10] As compared with his design, the present façade shows a greater severity in the treatment of detail, a simplification of niche and door surrounds, an isolation of decoration and sculpture from the structural parts, and a change in the proportions of the upper tier. All these alterations go in one and the same direction: they classicize Rai-

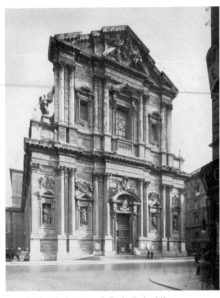

179. Carlo Maderno and Carlo Rainaldi: Rome, S. Andrea della Valle. Façade, 1624-9, 1661-5

naldi's design, and since there is proof that Carlo Fontana was Rainaldi's assistant during 1661 and 1662,[11] it must have been he who was responsible for all these modifications. The present façade of S. Andrea della Valle, therefore, is a High Baroque alteration of a Maderno design by Carlo Rainaldi, whose design in its turn was 'purified' and stripped of its ambiguities by Carlo Fontana.

Concurrently with S. Maria in Campitelli and the façade of S. Andrea della Valle ran the work of S. Maria di Monte Santo and S. Maria de' Miracoli in the Piazza del Popolo [180, 181]. Here the architect had to show his skill as a town-planner. His task consisted of creating an impressive piazza which would greet the traveller on entering Rome by the Porta del Popolo. From the Piazza del Popolo three main streets radiate between the Pincio and the Tiber, each of them leading into the heart of the city.

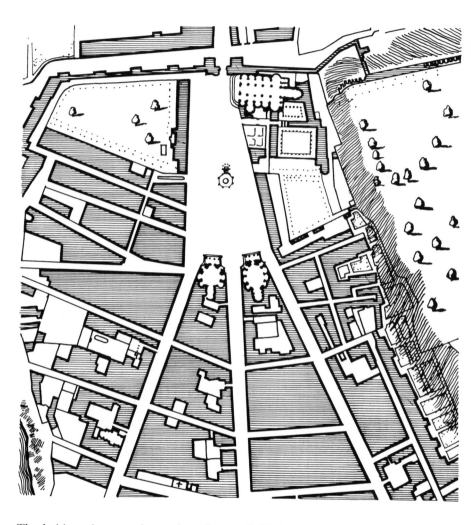

The decisive points were the two front eleva-tions, facing the piazza between these streets. At these points Rainaldi planned two sym-metrical churches with large and impressive domes as focusing-features from the Porta del Popolo. But since the sites were unequal in size, the symmetry which was here essential was not easily attained. By choosing an oval dome for the narrower site of S. Maria di Monte Santo and a circular dome for the larger one of S. Maria de' Miracoli, Rainaldi produced the impression from the square of identity of size and shape.[12] On 15 July 1662 the foundation stone of the left-hand church, S. Maria di Monte Santo, was laid. After an interruption in 1673 building activity was continued from a project by Bernini, and Carlo Fontana, as acting architect, completed the church by the Holy Year 1675. Rainaldi himself remained in charge of S. Maria de' Miracoli, which was executed

180 *(opposite)*. Rome, Piazza del Popolo, from G. B. Nolli's plan, 1748

181 *(below)*. Carlo Rainaldi and Gianlorenzo Bernini:
Rome, Piazza del Popolo. S. Maria di Monte Santo and S. Maria de' Miracoli, 1662-79

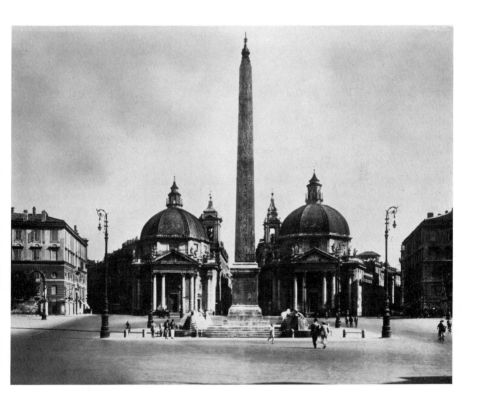

between 1675 and 1679, again with Fontana's assistance.[13] The interior of S. Maria di Monte Santo shows, of course, none of Rainaldi's idiosyncrasies. At S. Maria de' Miracoli on the other hand Rainaldi worked once again with a strong accentuation of the transverse axis but counteracted it by emphasizing at the same time the homogeneity of the circular space. He wedded Mannerist ambiguity to the High Baroque desire for spatial unification.

Much more important than the interiors are the exteriors of these churches. The façades with their classically poised porticoes, which already appear in the foundation medal of 1662, seem to contradict in many respects the peculiarities of Rainaldi's style. In fact, no reasonable doubt is possible that he was influenced by his youthful assistant, Carlo Fontana, through whom he became familiar with Bernini's approach to architecture.[14] When working for

Bernini on the plans of the Square of St Peter's, Fontana must also have been involved in Bernini's project of 1659 (which remained on paper) to erect a four-columned portico in front of Maderno's façade of the basilica. This idea of the classical temple was realized in the churches in the Piazza del Popolo.[15] But the Berninesque appearance of these porticoes has an even more tangible reason, for it was precisely here that Bernini altered Rainaldi's design in 1673. Rainaldi wanted to place the pediments of the porticoes against a high attic. For him a pediment was always an element of linear emphasis. Bernini abolished Rainaldi's attic, so that, in accordance with his own style, the free-standing pediment regained its full classical plasticity. Moreover, Bernini probably had a formative influence on the solution of Rainaldi's most pressing problem. Bernini always had the beholder foremost in mind and the optical impression a structure would make on him from a given viewpoint. One wonders, therefore, whether Rainaldi would ever have devised the pseudo-symmetrical arrangement of these churches without the impact of Bernini's approach to architecture. In any case, it is worth noting that Rainaldi began planning the two churches as corresponding 'false' Greek crosses. This would have made absolutely symmetrical structures possible, but at the expense of the size of the domes. However, the final design marks a new and important departure from the enclosed piazza, for the churches not only create a monumental front on the piazza but also crown the wedge-shaped sites, unifying and emphasizing the ends of long street fronts. The breaking-in of the streets into the piazza, or rather the weaving into one of street and square, was a new town-planning device – foreign to the High Baroque, and heralding a new age.

With the exception of the exterior of the apse of S. Maria Maggiore no work fell to Rainaldi in any way comparable with those that have been discussed. In S. Maria Maggiore he united

the older chapels of Sixtus V and Paul V and the medieval apse between them into a grand design (1673), forming an impressive viewpoint from a great distance. It is informative to compare Bernini's project of 1669 with Rainaldi's executed front. Bernini wanted to screen the apse with an open portico; his design embodied a structural organization of the utmost sculptural expressiveness, while in Rainaldi's somewhat straggling front the apse stands out from the thin and unconvincing wall of the high attic.

In the early 1670s Rainaldi was also responsible for the façade and the interior decoration of Gesù e Maria (p. 315). In addition, during the 1670s and 1680s he had a hand in a great many smaller enterprises, such as chapels in S. Lorenzo in Lucina, S. Maria in Araceli, S. Carlo ai Catinari, the design of tombs and altars, and the completion of older churches.[16] But his star was waning. Although Rainaldi's principal works belong to the 1660s, he represents a slightly later phase of the Roman High Baroque than the three great masters. In fact Cortona's and Borromini's careers came to an end in that decade, while Rainaldi worked on for almost another generation. His life-long attachment to Mannerist principles, his transplantation to Rome of North Italian conceptions of planning, his scenic use of the free-standing column, his borrowings from Bernini, Cortona, and Borromini – all this is blended in a distinctly individual manner which, however, never carries the conviction of any of the cogent High Baroque architectural systems.

Martino Longhi the Younger,
Vincenzo della Greca, Antonio del Grande,
and Giovan Antonio de' Rossi

Next to Rainaldi there were four approximately contemporary architects of some distinction working in Rome, whose names are given in the title to this section. Apart from Giovan Antonio

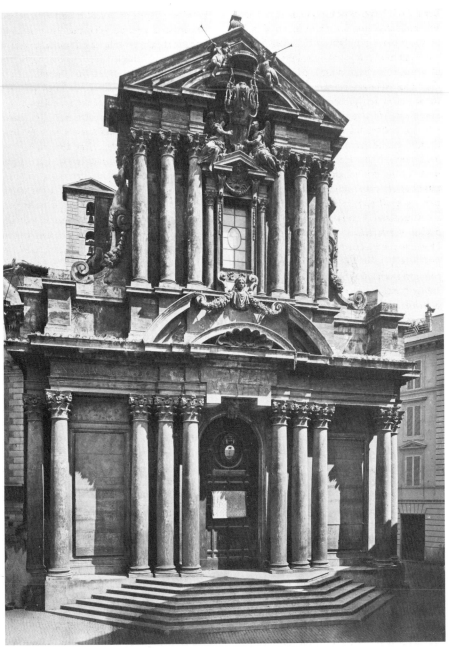

182. Martino Longhi the Younger: Rome, SS. Vincenzo ed Anastasio. Façade, 1646-50

de' Rossi, none of them has many buildings to his credit. Martino Longhi (1602-60), the son of Onorio and grandson of the elder Martino, belonged to an old family of architects who had come to Rome from Viggiù. His reputation is mainly based on one work of outstanding merit, the façade of SS. Vincenzo ed Anastasio in the Piazza di Trevi, built for Cardinal Mazarin between 1646 and 1650 [182].[17] This front, thickly set with columns, is superficially similar to that of S. Maria in Campitelli, but the similarity consists in High Baroque massiveness rather than in any actual interdependence. To be sure, SS. Vincenzo ed Anastasio is in a class of its own and is as little derived from earlier models as the façades of SS. Martina e Luca or S. Carlo alle Quattro Fontane. The principal feature of the façade is three free-standing columns at each side of the central bay, forming a closely connected triad which is repeated in both tiers. This repetition, together with the slight stepping forward of the columns towards the centre, gives the motif its brio and power.[18] The freedom which the columns have here attained is evidenced by the fact that their movement is not dependent on, or caused by, a gradation of the wall, and their impression of energetic strength is reinforced by the accumulation of massive pediments. It is further reinforced by the large caesuras between the triads and the outer columns in the lower tier.[19] But the logical arrangement of the articulation was obscured in more than one place. The farthest columns and the third columns of the lower triad frame empty wall space, and that two such columns should be regarded as complementary is emphasized by the unbroken entablature that unites them. Moreover in the lower tier, in contrast to the upper one, no structural link exists between the third columns of the triads.[20] Such a link, however, is provided for the second columns by the broken pediment, the two segments of which are connected by decorative sculpture. More problematical is the

central segmental pediment from which a compressed shell juts out energetically: instead of capping the inner pair of columns, it crowns the angularly broken tablet (with the inscription) which is superimposed on the entablature above the door. It will be noticed that the projections at the level of the entablature correspond in number, but not in structure either to the projections of the upper tier or to those of the triad of columns. But Longhi created the optical impression that the two lower pediments top the outer and inner pairs of columns.[21]

This rather cumbersome analysis has shown that the relationship between the pediments and the columns is as inconsistent as that between the lower and upper triad, and in this inconsistency may very well lie part of the peculiar attraction of the façade. Seen genetically, Longhi employed Mannerist devices but subordinated them to an overwhelmingly High Baroque effect of grandeur and mass. The character of the decoration reveals similar tendencies, for Longhi combined Berninesque free-moving, realistic sculpture with the rigid, hard, and tactually indifferent motifs of Mannerism. It appears, therefore, that Longhi, like Carlo Rainaldi, did not entirely eliminate Mannerist ambiguities, and this view is strengthened by a study of his modernization of S. Adriano (1656), where in the crossing two free-standing columns matched two pilasters as supports of the oval dome.[22] The construction of S. Carlo al Corso, one of the largest churches in Rome, begun by his father Onorio, occupied Martino for several decades. It is fair to assume that the plan with an ambulatory, quite unique for Rome, depends on northern models. But the history of S. Carlo is extremely involved, and since Cortona rather than Martino was responsible for the decoration, hardly any trace of the latter's personal style can now be discovered.[23]

Vincenzo della Greca,[24] who came to Rome from Palermo, deserves a brief note for his work in SS. Domenico e Sisto. The flat, re-

actionary façade, always attributed to him but in reality designed by Nicola Turriani in 1628,[25] would not be worth mentioning were it not for its superb position on high ground, of which Vincenzo della Greca made the most by devising an imaginative staircase (1654) which ascends in two elegant, curved flights to the height of the entrance. The idea was probably derived from Cortona's Villa del Pigneto, but it was here that a Roman architect built for the first time a Baroque staircase in an urban setting – a prelude to Specchi's Port of the Ripetta and to the grand spectacle of De Sanctis's Spanish Stairs.

Although more eminent than Vincenzo della Greca, Antonio del Grande,[26] a Roman by birth whose activity is documented between 1647 and 1671, also has nothing to show that could compare with Longhi's SS. Vincenzo ed Anastasio. Most of his work is domestic, done in the service of the Colonna and Pamphili families. His monumental Carceri Nuovi (1652-8) in Via Giulia owe not a little of their effect to Borromini's influence, as the deeply grooved cornice proves. In his great gallery of the Palazzo Colonna, of impressive dimensions and the largest in Rome, begun in 1654, and vaulted in 1665, he took up the theme of Borromini's gallery of the Palazzo Pamphili in the Piazza Navona. At both ends of the gallery he screened off adjoining rooms by free-standing columns, an idea that may have come to him from Bernini's S. Andrea al Quirinale, then rising.[27] His most important work is that part of the Palazzo Doria-Pamphili which faces the Piazza del Collegio Romano (1659-61).[28] But the large façade contains no new or important ideas. It follows Girolamo Rainaldi's design for the Palazzo Pamphili in the Piazza Navona in that the central bays are articulated by orders in two tiers resulting in an additive system which lacks the High Baroque emphasis on the *piano nobile*. The rest of the façade, outside the central bays, is in the tradition of Roman palazzo fronts; but with the unequal rhythm of the windows the architect

even returned to the Late Mannerist arrangement of Giacomo della Porta's Palazzo Chigi in the Piazza Colonna, and also truly Mannerist is the portal with its frame of pilasters superimposed on quoins. More progressive are the details of the window-frames of the second storey and some door-surrounds inside the palace, where Borromini's dynamic life of forms has been toned down to a peculiar staccato movement. The most interesting feature is perhaps the vestibule, impressively spacious and ample and with a treatment of detail of almost puritanical sobriety.[29]

Giovan Antonio de' Rossi (1616-95), a contemporary of Carlo Rainaldi, produced some works that might be described as transitional between the High and the Late Baroque. This is less obvious in his ecclesiastical than his secular buildings. Some of his ecclesiastical work belongs to the finest flower of a slightly softened High Baroque in which the influence of each of the three great masters can easily be detected. We may single out the interesting Cappella Lancellotti in S. Giovanni in Laterano,[30] built on an oval plan with projecting columns – the whole clearly a Baroque reinterpretation of Michelangelo's design of the Cappella Sforza in S. Maria Maggiore. The masterpiece of his mature style is S. Maria in Campo Marzo (1682-5),[31] an impressive Greek cross with oval dome but without drum. The way the bulk of the apse closes the view from the Via della Maddalena is devised in the best tradition of the Roman High Baroque. Still later he built the oval chapel in the Palazzo Monte di Pietà, a little jewel resplendent with coloured marble incrustation and amply decorated with reliefs, statues, and stuccoes.[32] But of the High Baroque density of space- and wall-treatment little remains.

Among Rossi's palaces, two require special mention: the Palazzo Altieri in the Piazza del Gesù and the Palazzo D'Aste-Bonaparte overlooking the Piazza Venezia. The first is his

most extensive if not his most accomplished work. Begun by Cardinal Giovan Battista Altieri in 1650, the palace was probably finished at the time of the latter's death in 1654. After the accession to the papal throne of the Altieri Pope Clement X an enlargement became necessary, which Rossi carried out between 1670 and 1676.[33] The new parts towards the Piazza Venezia continue the earlier scheme but remain architecturally unobtrusive, so that the older palace stands out unimpaired as the principal building. Although the interior rather than the traditional façade deserves attention, Rossi's skill in solving his difficult task shows that we are dealing with a resourceful architect. The Palazzo D'Aste-Bonaparte [183] is perhaps the most accomplished example of his mature manner.[34] Designed as a free-standing block, the

183. Giovan Antonio de' Rossi:
Rome, Palazzo D'Aste-Bonaparte, 1658–c. 1665

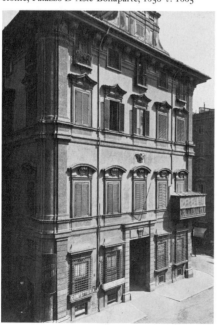

palace is essentially a revision of the traditional Roman type. Only the Borrominesque rounded-off corners and the chaste, unorthodox order in three tiers, retaining the four façades, are mildly progressive; all the motifs, including the elegant curved pediments of the windows, are rather unpretentious. Reserve and an immaculate sense of proportion are the virtues of this style. Rossi's intelligent blending of Cortonesque and Borrominesque decorative detail and its transformation into a comparatively light and pleasant personal idiom – such as we see it in the pediments of the Palazzo D'Aste and on many occasions – predestined him to play an important part in the development of eighteenth-century architecture. It is not by chance that Alessandro Specchi's Palazzo de Carolis (now Banco di Roma)[35] and Tommaso de Marchis's Palazzo Millini-Cagiati,[36] both on the Corso, vary Rossi's Palazzo D'Aste but little. A further study would show that the style of his many smaller palaces – some of which have been pulled down in recent years – determined the character of innumerable houses of the aristocracy and wealthy bourgeoisie of eighteenth-century Rome.[37]

ARCHITECTURE OUTSIDE ROME

During the roughly fifty years between 1630 and 1680 the architectural panorama in the rest of Italy is on the whole less interesting than one might be prepared to expect. Venice, it is true, had a great architect. But Lombardy, after the full and varied Borromeo era, had little to offer; Genoa was exhausted by the plague of 1657; Turin, under her progressive rulers, was only beginning to develop into an important architectural centre. To be sure, Ricchino carried on at Milan and Bianco at Genoa till after 1650, but the climax of their activity lay earlier in the century. When all is said and done, there remain only three High Baroque architects of more than average rank outside Rome: Longhena in Ve-

nice, Gherardo Silvani in Florence, and Cosimo Fanzago in Naples. Of these, Longhena seems to me by far the greatest. In addition, there is Guarino Guarini, who must be regarded in many respects as a master of the High Baroque although he belongs to a slightly later generation. There is, however, good reason not to separate his work from the survey of later Piedmontese architecture (p. 403).

During this period churches, palaces, and villas of intrinsic merit rose in great numbers all over the country, but historically speaking many of these buildings are 'provincial', since they not only rely on Roman precedent or assistance but are also often retardataire by Roman standards. The Palazzo Ducale at Modena, one of the largest palaces in Italy, may serve as an example. Attributed to the mediocre Bartolomeo Avanzini (c. 1608–58),[38] it is certain that at the beginning, between 1631 and 1634, Girolamo Rainaldi had a leading hand in the planning; the present palace shows, in fact, a distinct affinity with Rainaldi's Palazzo Pamphili in the Piazza Navona. In 1651 Avanzini's design, based on that of Rainaldi, was submitted to the criticism of Bernini, Cortona, and Borromini, and Bernini, stopping at Modena in 1665 on his return from Paris, made further suggestions. Later (1681) Guarini directed the execution. Ideas of all these masters, and particularly of Bernini, were certainly incorporated, but it is doubtful whether the history of the building can ever be fully disentangled.

Bologna, always an important centre of the arts and always a melting-pot of Central and North Italian conceptions, provides another aspect of the situation. Between 1638 and 1658 Bartolomeo Provaglia (d. 1672), the architect of the magnificent Porta Galliera (1661), built the Palazzo Davia-Bargellini with an austere and monumental façade, rather unusual for Bologna, but close to Roman palazzo types. Only the two free-moving, massive atlantes that carry the balcony above the entrance show that

we are not on Roman soil. These figures, seemingly bending under a heavy load, are the Baroque descendants of Leone Leoni's Mannerist atlantes on the façade of the Palazzo degli Omenoni at Milan and must be regarded as an important link with the use of the same motif in the Austrian and German Baroque. A similar mixture of Roman and North Italian ideas is to be found in Giovan Battista Bergonzoni's (1629–92) S. Maria della Vita, which belongs to the end of the period under discussion. The main body of the church was built between 1686 and 1688, while the oval dome was not erected until a century later.[39] The derivation from S. Agnese in Piazza Navona is evident in the elevation rather than in the plan [184]. While the latter is actually a rectangle with bevelled corners and shallow transverse chapels, the elevation is treated like a Greek cross, with the arches under the dome resting on projecting

184. Giovan Battista Bergonzoni:
Bologna, S. Maria della Vita, begun 1686. Plan

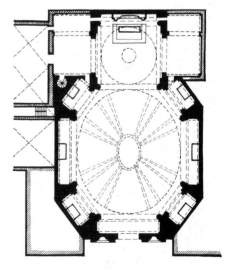

columns.[40] A square choir with dome is joined to the oval main room, and it is this that tallies with the North Italian type of plan which Ricchino had fully developed in S. Giuseppe at Milan. Yet in contrast to this church, built half a century earlier, the congregational room and the choir are here firmly interlocked, for the arch as well as the supporting columns belong to both spaces: they have exactly corresponding counterparts at the far end of the choir. Gaetano Gandolfi and Serafino Barozzi, by painting between 1776 and 1779 a domed room which extends, so it seems, behind the choir, stressed only the scenic quality contained in the architecture itself.

It was the long established interest of Bolognese *quadratura* painters in ever more daring illusions that found a response in the architects at the end of the century. The staircase hall of the Palazzo Cloetta-Fantuzzi (1680) by Paolo Canali (1618–80) is a case in point. Two broad flights open above into arcades and are lit from both sides under the painted ceiling – a scenographic spectacle which owed nothing to Rome. A new era was dawning, and later Bolognese architects found here a model that they followed and developed in the grand staircase designs of the eighteenth century (p. 391). The staircase in the Palazzo Cloetta illustrates a volte-face from Rome to Venice. It is a tribute to the genius of Longhena, who was to have a profound influence on North Italian architecture.

Baldassare Longhena (1598–1682)

Longhena's span of life corresponds almost exactly to that of Bernini, and unquestionably he is the only Venetian architect of the seventeenth century who comes close in stature to the great Romans.[41] He left one capital work, S. Maria della Salute [185–9], which occupied him in the midst of his vast activity for most of his working life.[42] During the plague of 1630 the Republic deliberated the erection of a church

as an *ex voto*. Longhena won a competition against Antonio Fracao and Zambattista Rubertini, who had suggested a Latin-cross plan, and, as a memorandum by his hand shows, he was well aware and immensely proud of the novelty of his design. Construction began on 6 September 1631, and after more than twenty years the bulk of the structure was standing though the consecration did not take place until 1687, five years after the architect's death. Venice is nowadays unthinkable without the picturesque silhouette of this church, which dominates the entrance to the Canal Grande; but it would be wrong to insist too much on the picturesqueness of the building, as is usually done, while forgetting that this is in every respect one of the most interesting and subtle structures of the entire seventeenth century. No further credentials are, therefore, needed for a detailed analysis.

The salient feature of the plan is a regular octagon surrounded by an ambulatory [185]. This seems to be unique in Renaissance and post-Renaissance architecture, but the type is of Late Antique ancestry (S. Costanza, Rome) and is common in medieval, particularly Byzantine, buildings (S. Vitale, Ravenna). Longhena reverted to these early sources only for the plan and not for the elevation. The latter is a free adaptation of a well-known North Italian type derived from Bramante,[43] S. Maria della Salute differing from the Renaissance models mainly in the decorative interpretation of the columns. Instead of continuing the columns of the octagon into the architecture of the drum, we find a large figure topping the projecting entablature of each column. It is these iconographically important figures of prophets that turn each column into an isolated unit and at the same time emphasize the enclosed centralized character of the main room. The idea may have come to Longhena from the famous woodcut in Colonna's *Hypnerotomachia Polifili*, which shows precisely this motif in a section through

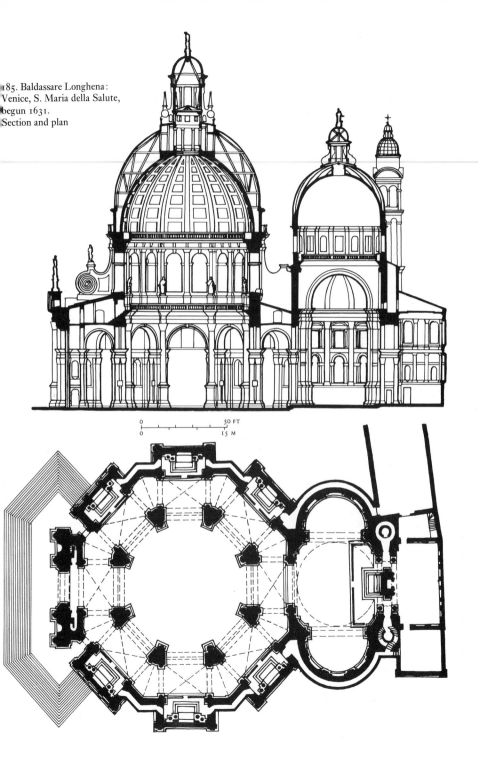

185. Baldassare Longhena:
Venice, S. Maria della Salute,
begun 1631.
Section and plan

0 50 FT
0 15 M

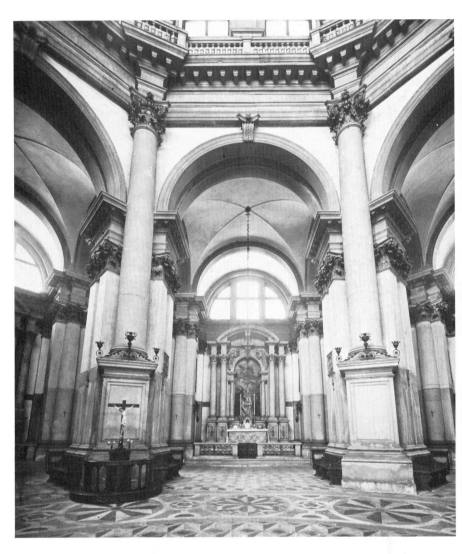

a centralized domed building with ambulatory. But the *Hypnerotomachia*, well known to every Venetian, can of course have determined only the conceptual direction, not the actual architectural planning. For it Longhena used, as we have seen, Late Antique, medieval and Bramantesque ideas and wedded them, moreover,

to the Palladian tradition with which he was linked in a hundred direct and indirect ways.

From Palladio derives the colouristic treatment: grey stone for the structural parts and whitewash for the walls and fillings. But it should be remembered that this was not Palladio's speciality; it had, in fact, a medieval

pedigree, was taken up and systematized by Brunelleschi, and after him used by most architects who were connected with the classical Florentine tradition. The architects of the Roman Baroque never employed this method of differentiation, the isolating effect of which would have interfered with the dynamic rhythms of their buildings. In contrast, however, to Florentine procedure, where colour invariably sustains a coherent metrical system, Longhena's colour scheme is not logical; colour for him was an optical device which enabled him to support or suppress elements of the composition, thereby directing the beholder's vision.

Many details of the Salute are also Palladian, such as the orders, the columns placed on high

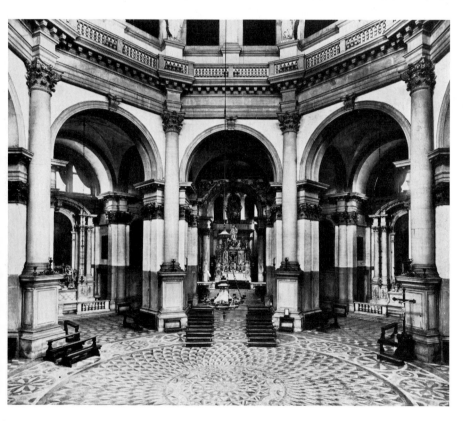

186 and 187. Baldassare Longhena:
Venice, S. Maria della Salute, begun 1631.
View towards the chapels (*opposite*)
and view towards the high altar (*above*)

pedestals (see S. Giorgio Maggiore), and the segmental windows with mullions in the chapels [186], a type derived from Roman thermae and introduced by Palladio into ecclesiastical architecture (S. Giorgio, Il Redentore). All these elements combine to give the Salute the severe and chaste appearance of a Palladian structure.

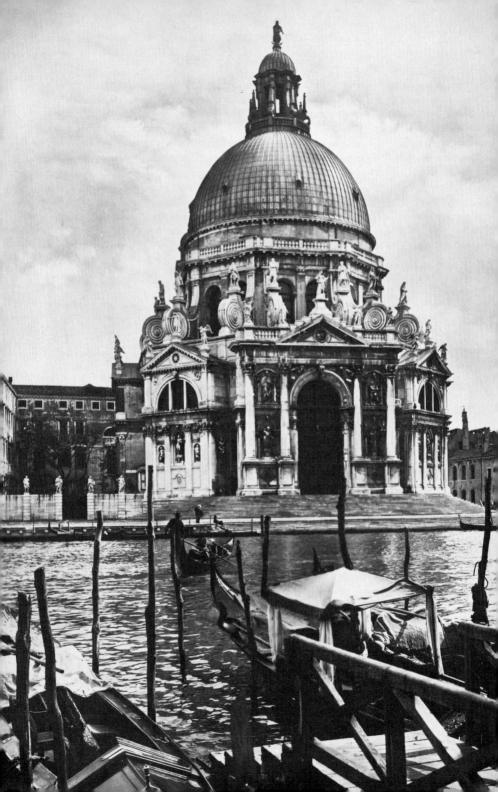

But it can be shown that Palladio's influence was even more vital.

One of Longhena's chief problems consisted in preserving the octagonal form outside without sacrificing clarity and lucidity inside. By the seemingly simple device of making the sides of two consecutive pillars parallel to each other, he succeeded in giving the optically important units of the ambulatory and the chapels regular geometrical shapes,[44] entirely in the spirit of the Renaissance. The full meaning of this organization is revealed only when one stands in the ideal and real centre of the octagon [187]. Looking from this point in any direction, the spectator will find that entirely homogeneous 'pictures' always appear in the field of vision.[45] Longhena's passionate interest in determining the beholder's field of vision is surely one of the factors which made him choose the problematical octagon with ambulatory rather than one of the traditional Renaissance designs over a centralized plan. It cannot be emphasized too strongly that no other type of plan allows only carefully integrated views to be seen; here the eye is not given a chance to wander off and make conquests of its own.

It would seem that the centralization of the octagon could not have been carried any further. Moreover, the sanctuary, which is reached over a few steps, appears only loosely connected with the octagon. Following the North Italian Renaissance tradition of centralized plans (Bramante's S. Maria di Canepanova), main room and sanctuary form almost independent units. For the two large apses of the domed sanctuary Longhena employed a system entirely different from that of the octagon: he used giant pilasters instead of columns and replaced the mullioned windows of the

chapels by normal windows in two tiers.[46] Shape and detail of the sanctuary depend on the Redentore, where Palladio had performed a similar change of system between the nave and the centralized portion.

A third room, the rectangular choir, is separated from the sanctuary by an arch resting on pairs of free-standing columns, between which rises the huge, picturesque high altar. Inside the choir the architectural system changes again: two small orders of pilasters are placed one above the other. At the far end of the choir three small arches appear in the field of vision.[47] Longhena, one is tempted to conclude, simply grouped together isolated spatial units in a Renaissance-like manner. But this would mean opening the door to a serious misinterpretation, for in actual fact he found a way of unifying these entities by creating scenic connexions between them.

From the entrance of the church the columns and arch framing the high altar lie in the field of vision – it is important that only this motif and no more is visible – and the beholder is directed to the spiritual centre of the church through a sequence of arches, one behind the other: from the octagon to the ambulatory and the altar and, concluding the vista, to the arched wall of the choir. Thus, in spite of the Renaissance-like isolation of spatial entities and in spite of the carefully calculated centralization of the octagon, there is a scenic progression along the longitudinal axis. It is often said that Baroque architecture owes a great deal to the contemporary stage. As regards Roman High Baroque architecture, it is correct only with considerable qualifications, for an architecture aiming at dynamic spatial effects is intrinsically non-scenic. Quite different Longhena: in his case a specific relation to the stage does exist. In S. Maria della Salute clearly defined prospects appear one behind the other like wings on a stage. Instead of inviting the eye – as the Roman Baroque architects did – to glide along

188. Baldassare Longhena:
Venice, S. Maria della Salute, begun 1631

the walls and savour a spatial continuum, Longhena constantly determines the vistas across the spaces.

It is apparent that the judicious grouping of self-contained units rather than the Roman concept of dynamic spatial unification was the precondition for a strictly scenographic architecture. This also explains why the Late Baroque in spite, or just because, of its classicizing tendencies was essentially a scenographic style, even in Rome.[48]

In unifying separate spaces by optical devices, Longhena once again followed Palladio's lead. The hall-like nave and the centralized domed part of the Redentore - entirely separate entities - are knit together optically for the view from the entrance,[49] and it was this principle of scenic integration that Longhena developed much further. Thus, based on Palladio, Longhena had worked out an alternative to the Roman Baroque. His Venetian Baroque was, in fact, the only high-class alternative Italy had to offer. It is not sufficiently realized that in their search for new values many architects of the late seventeenth century turned from Rome to Venice and embraced Longhena's scenographic concepts.

Like the interior, the picturesque exterior of S. Maria della Salute was the result of sober deliberations [188]. The thrust of the large dome is diverted on to pairs of buttresses (the scrolls) which rest on the arches of the ambulatory. The side walls of the chapels (aligned with these arches) are therefore abutments to the dome. It is often maintained that Longhena's Salute follows closely a design engraved by Labacco in 1558. This opinion, however, cannot be accepted without reservation.[50] Even if Longhena was attracted by the large scrolls in Labacco's engraving, he entirely transformed them and invented the imaginative decorative spirals which introduce a luxuriant note into his otherwise austere design.

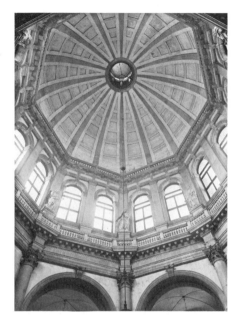

189. Baldassare Longhena:
Venice, S. Maria della Salute, begun 1631.
View into the dome

The large dome of the Salute has an inner [189] and outer vault, the outer one consisting of lead over wood, in keeping with Venetian custom (including Palladio). While the principal dome ultimately derives from that of St Peter's,[51] the subsidiary dome with its stilted form over a simple circular brick drum and framed by two campanili follows the Byzantine–Venetian tradition. The grouping together of a main and a subsidiary dome fits well into the Venetian *ambiente* – the domes of S. Marco are quite near – but never before had the silhouette been so boldly enriched by the use of entirely different types of domes and drums in one and the same building. No less important than the aspect of the domes from a distance is the near view of the lower zone from the Canal Grande. From here the chapels right and left of the main entrance are conspicuous. They are therefore elaborately treated like little church façades in their own right; in fact they are clever adaptations of the small front of Palladio's Chiesa delle Zitelle. Their small order is taken up in the gigantic triumphal arch motif of the main entrance. It is this motif that sets the seal on the entire composition.

The central arch with the framing columns corresponds exactly to the interior arches of the octagon, so that the theme is given before one enters the church. In addition, the small order also repeats the one inside, and the niches for statues in two tiers conform to the windows in the sanctuary. And more than this: the façade is, in fact, devised like a *scenae frons*, and with the central door thrown wide open, as shown in a contemporary engraving, the consecutive sequence of arches inside the church, contained by the triumphal arch, conjures up a proper stage setting. It can hardly be doubted that the *scenae frons* of Palladio's Teatro Olimpico had a decisive formative influence on Longhena's thought. In a sense entirely different from Cortona's, Borromini's, and Bernini's churches in Rome, Longhena has created in the Salute an organic whole of outside and inside, a fact which an impressionist approach to this kind of building tends to obscure.[52]

Centralized buildings with ambulatories remain exceedingly rare in Italy, even after Longhena's great masterpiece was there for anybody to see and study. The only other important church of this type, Carlo Fontana's Jesuit Sanctuary at Loyola in Spain, could not, however, have been designed without the model of S. Maria della Salute.[53] Thus a Late Antique plan, common in Byzantine architecture, revised in seventeenth-century Venice, was taken up by a Roman architect and transplanted to Spain.

Longhena's other works in Venice and on the *terra ferma* can hardly vie with his *magnum opus*. This is true of his two other large churches, the early cathedral at Chioggia (1624–47)[54] and S. Maria degli Scalzi in Venice (begun 1656);[55] the latter, a simple hall structure with large central chapels, stimulated a considerable number of later church plans. As characteristic for one facet of his late style we may mention the immensely rich façade of the little Chiesa dell'Ospedaletto near SS. Giovanni e Paolo (1670–8),[56] where the structure seems submerged under glittering sculptural decoration. In his many palaces we find him slowly turning away from the dry classicism of his teacher Scamozzi[57] and evolving a typically Venetian High Baroque manner by a premeditated regression to Sansovino's High Renaissance palaces. The formula of rusticated ground floor, ample use of columns in the upper storeys, and a far-reaching dissolution of wall surface suited him perfectly. His final triumph of sculptural accentuation, Baroque monumentality, and luminous richness will be found in the celebrated Palazzi Rezzonico and Pesaro [190],[58] which fully expose his debt to Sansovino's Palazzo Corner and, to a lesser extent, Sanmicheli's Palazzo Grimani. Thus, measured by Roman standards

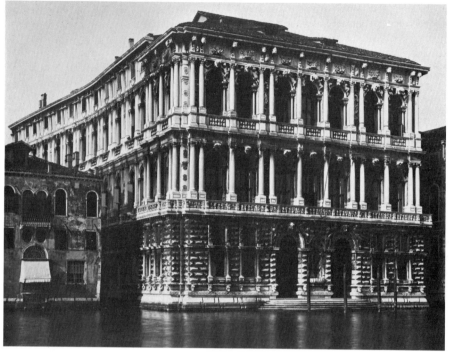

190. Baldassare Longhena:
Venice, Palazzo Pesaro, 1652/9–1710

of the 1660s, these splendid palaces must be regarded as retrogressive. On the other hand, in the staircase hall of the monastery of S. Giorgio Maggiore (1643–5) [191], where two parallel flights ascend along the walls to a common landing, Longhena once again proved his consummate skill as a master of scenic architecture. This staircase hall is far in advance of its time; it made a deep impression on architects, particularly in northern Italy, and was taken up and developed north of the Alps.

Florence and Naples: Silvani and Fanzago

It is characteristic of the situation in Florence after the first quarter of the seventeenth century

that in 1633 Grand Duke Ferdinand II planned to execute Dosio's model of 1587 for the façade of the cathedral. The members of the Accademia del Disegno opposed this idea – not because they regarded Dosio's project as too tame, but because, in their view, he had not sufficiently taken into account the older parts of the cathedral. They produced a counter-project which, in contrast to the classical dignity of Dosio's model, suffers from a breaking down of their design into many petty motifs. At the same moment, in 1635, Gherardo Silvani, who had grand-ducal support, made a model of his own (Museo dell'Opera, Florence) which was in fact an improvement on the Academy project. In his design Silvani combined mildly Baroque deco-

191. Baldassare Longhena: Venice,
Monastery of S. Giorgio Maggiore. Staircase, 1643-5

rative features with neo-Gothic elements borrowed from Giotto's Campanile. Yet the weaker and more conformist Academy model was chosen. Execution, however, never went beyond the initial stages.[59]

It is clear that in the antiquarian climate of Florence there was no room for a free Baroque development. The enlargement of the Palazzo Pitti is another case in point. In two campaigns, the first starting in 1620 and the second in 1631, Giulio Parigi enlarged the palace from its original six bays to its present width of twenty-five bays. His simple device of repeating the Quattrocento parts was preferred to Pietro da Cortona's vigorous designs for the remodelling of the entire palace front.[60]

In spite of such conservative and antiquarian tendencies, Gherardo Silvani (1579-1673)[61] gave Florence and other Tuscan cities (Volterra, Prato, Pisa, etc.) buildings of considerable distinction. For over fifty years he was in full command of the situation; he had an extraordinary capacity for work, and the list of his creations is very long. His best known ecclesiastical work is S. Gaetano, in the construction of which Nigetti is traditionally given too great a share.[62] The impressive façade [192] comes closer to a High Baroque design than any other building in Florence. But one should not be misled by the use of a massive pediment, by the bold projections, and the accumulation of sculpturally conceived architectural forms in

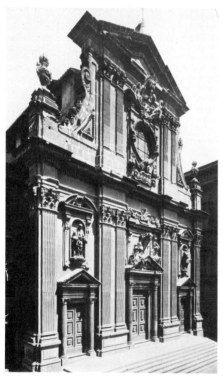

192. Gherardo Silvani:
Florence, S. Gaetano. Façade, 1645

comparatively narrow spaces: the structure it-
self, based on a simple rhythm of pilasters (the
double pilasters framing the central bay are
repeated in the upper tier), takes up the theme
of Giovanni de' Medici's cathedral model of
1587, and while the three doors under their
aedicule frames are derived from Dosio, other
features point to an influence of Buontalenti's
cathedral model. A good deal of the decoration,
in fact, consists of an ebullient reworking of
Buontalenti motifs. But much of the decoration
belongs to the late seventeenth century, and it
is this that gives the façade its flickering Late
Baroque quality. The interior shows the noble
reserve typical of the best Florentine Seicento

buildings.[63] The wide nave with three chapels
to each side separated by pillars with niches for
statues above them owes its effect to the sophisti-
cated colour scheme: the white reliefs on the
pillars and the white statues above them,[64] sil-
houetted against the blue-grey *pietra serena*
architecture, combine to give an impression of
aristocratic restraint. Nothing could be further
removed from contemporary Roman buildings
such as Borromini's S. Carlino.

Silvani's palaces, with their unadorned plaster
fronts, simple string courses, and overhanging
wooden roofs are Tuscan counterparts to the
severe Roman palace type such as Maderno's
Palazzo Mattei (e.g. Palazzi Covoni, 1623, and
Fenzi, 1634). Only the central axis is given
emphasis by a projecting balcony with a richly
designed balustrade and, in the case of the
Palazzo Fenzi, by the superb portal with Raffaele
Curradi's Harpies.[65]

Seicento architecture at Naples would seem
at the farthest remove from that of Florence,
for Naples under her Spanish rulers with their
native love for the plateresque witnessed the
rise of a decorative style of dazzling richness
and most intense polychromy produced by in-
laid coloured marbles.[66] But to see the Tuscan
and the Neapolitan Seicento in terms of abso-
lute contrasts is somewhat misleading; struc-
turally, the architecture of Naples is much
closer to that of Florence than to that of Rome:
this is revealed by such an important work as
Cosimo Fanzago's large *chiostro* of the Certosa
of S. Martino (1623–31)[67] with its elegant ar-
cades which would not be out of place in
fifteenth-century Florence. Fanzago's range is,
however, very wide. One need only step inside
from the courtyard to come face to face with
his exuberant decorative Baroque [193], show-
ing his characteristic Neapolitan style fully
developed.

In Fanzago (1591–1678)[68] Naples had a Bar-
oque master who must be ranked very high, if
not always for the quality, at least for the ver-

satility of his talent. Longevity, an incredible stamina, facility of production, and inexhaustible reserves of energy – these are some of the characteristics of this tough generation. Bernini died aged eighty-two, Longhena eighty-four,

193. Cosimo Fanzago:
Naples, S. Martino. Cloisters, detail, c. 1630

Fanzago eighty-seven, and Silvani ninety-six. In Rome, Venice, Florence, and Naples artistic events till the last quarter of the seventeenth century were largely determined by these artists. But Fanzago's position can be compared only with that of Bernini, for like the greater man he too was a master of all-round performance, being architect, sculptor, decorator, and even painter. Unlike Bernini, however, who had to struggle all his life against the competition of first-rate artists, Fanzago's supremacy at Naples seems to have been almost unchallenged. He was born in October 1591 at Clusone near Bergamo, and settled as early as 1608 in Naples, where he lived with an uncle. Trained as a

sculptor – in 1612 he calls himself 'maestro di scultura di marmo' – he makes his debut as an architect probably in 1617 with the design of S. Giuseppe dei Vecchi a S. Potito (finished 1669). It is here that he first planned a Greek-cross church, a scheme to which he returned in one form or another in most of his later churches.[69] But since he stressed the main axis, the centralization of these plans is usually not complete. Although he thus carried over into the High Baroque an essentially Mannerist conflict (p. 118), his high domes produce a new and decisive concentration. Only S. Maria Egiziaca (1651–1717) [194] is a true Greek cross and departs altogether from the more traditional plans of his other churches. The plan of this, Fanzago's finest church, is so close to that of S. Agnese in Rome that a connexion must be assumed. In addition, the design of the dome seems to be derived from Bernini's S. Andrea al Quirinale and the convex portico from other Roman models. But if the date 1651 is correct, Fanzago would have anticipated later Roman conceptions. Since building proceeded very slowly, one would prefer to believe that he adjusted his design after having become acquainted with the most recent Roman events. However, the extreme economy in detail and the emphasis laid on structural parts by painting them slightly off-white (polychromy is reserved for the high altar) help to produce an imposing effect of simplicity, which is entirely un-Roman.

The phenomenon that Fanzago was capable of such a design is revealing, for it shows that ornament was for him, in Alberti's phrase, 'something added and fastened on, rather than proper and innate'. It is precisely this that makes one aware of the deep gulf between Fanzago's and Borromini's architecture although certain of Fanzago's decorative features [193] are reminiscent of the great Roman master. None of Fanzago's designs betray dynamic concepts of planning[70] – on the contrary, he is tied to certain academic patterns, and a search for a con-

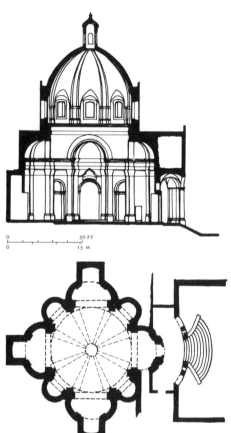

0 ———— 50 FT
0 —|—|—|—| 15 M

194. Cosimo Fanzago:
Naples, S. Maria Egiziaca, 1651-1717.
Section and plan

tinuous development from project to project
will therefore be disappointing. This is, how-
ever, not true so far as his façades for churches
and palaces are concerned; for they provided
large scope for a display of imaginative com-
binations. Here it is easy to follow the change
from the severe classicism of the portico of the
Chiesa dell'Ascensione (1622), still dependent
on Domenico Fontana, to the rich façade of
S. Maria della Sapienza (1638-41),[71] which in
spite of complexities remains classically acade-
mic, and further to the façade of S. Giuseppe
degli Scalzi with its decorative profusion and
accumulation of incongruous elements – an
early example of a Late Baroque composition,
if the traditional date 1660 is correct. Taking
also into account such strange compound crea-
tions as the Guglia di S. Gennaro (1631-60)
with its surprising mixture of Mannerist and
Baroque features, or the vast Palazzo Donn'
Anna (1642-4),[72] bristling with personal though
perhaps provincial re-interpretations of tradi-
tional motifs (never finished, and left a ruin
after the earthquake of 1688), or the decorative
abundance of the powerful portal of the Palazzo
Maddaloni – one will find that Fanzago mas-
tered in the long course of his immensely
active life the whole gamut of Seicento possi-
bilities from Early Baroque classicism to the
pictorial effervescence of the Late Baroque.[73]

★

While the prevailing inter-Italian classicism of
the first quarter of the seventeenth century had
an impersonal quality, the architectural trends
of the next fifty years are as many as there are
names of great architects. It will be granted
that in spite of the numerous cross-currents,
Rainaldi's, Longhena's, Silvani's, and Fan-
zago's buildings have as much or as little in
common as those of a Bernini and a Borromini.
Nevertheless, the generic term 'High Baroque'
retains its value, if only to circumscribe the age
of the great individualistic creators.

CHAPTER 13

TRENDS IN HIGH BAROQUE SCULPTURE

ROME

The First Generation

High Baroque sculpture came into its own with
the full expansion of Bernini's studio. This,
however, did not happen until the mid 1640s,
when Bernini had to face the gigantic task of
decorating the pilasters and chapels of St
Peter's.[1] The building up of the studio began,
of course, at a much earlier date. It was the
Baldacchino [86] that first required extensive
help by other hands. In addition to the old
Stefano Maderno, some promising sculptors of
Bernini's own generation found employment
here: his brother Luigi, Stefano Speranza, Du-
quesnoy, Giuliano Finelli, Andrea Bolgi, and
the younger Giacomo Antonio Fancelli. Not
much need be said about Luigi Bernini; he al-
ways remained a devoted amanuensis of his
great brother, supported him in a number of
enterprises (mainly in St Peter's), and never
showed a personal style.[2] Nor shall I discuss
Stefano Speranza. Bernini used him over a
number of years and his only doubtful claim to
fame is the weak and retrogressive relief on the
sarcophagus of the Matilda monument. Finelli
and Bolgi on the other hand were, after the
great masters, the most distinguished sculptors
of this generation.

Giuliano Finelli (1601-57) arrived in Rome
in 1622 and was immediately taken on by Ber-
nini as his first studio hand.[3] He did not come
direct from his home town Carrara, but from
Naples, where he had studied sculpture under
Naccherino. Finelli's association with Bernini
lasted only a few years; in 1626 another Carra-
rese, Andrea Bolgi (1605-56), who had worked

in Florence with Pietro Tacca, settled in Rome
together with his compatriot Francesco Baratta,
and soon attracted Bernini's attention. When,
in 1629, the commissions for the four giant
statues in the pillars of St Peter's were placed,
Bernini recommended him in preference to
Finelli. This virtually spelt the end of Finelli's
career in Rome; and although he was not with-
out work[4] (mainly due to the good offices of
Pietro da Cortona) he soon went back to Naples,
where he built up a large practice[5] in spite of
Cosimo Fanzago's attempts to get rid of the
dangerous rival. While in Naples Finelli main-
tained contact with Rome; and it was from
Naples that he sent to Rome the tomb of
Cardinal Domenico Ginnasi, to which we shall
return later. In his youth, Finelli had thoroughly
absorbed Bernini's grand manner. In Naples
he progressively lost his sense for the finesse
and subtlety of texture; his style became hard
and coarse. This cannot be regarded simply as a
degeneration into provincialism of a talented
artist removed from the spiritual centre, Rome;
it is after all what happened *mutatis mutandis* to
the work of a great many artists during the
1630s and 40s, but in most cases the 'petrifac-
tion' lay in the direction of a strengthened
classicism. After his return to Rome at the end
of his life, Finelli went even further in the same
direction. Like Mochi in his last phase, he en-
tirely lost interest in pleasing, warm, or sensuous
surface qualities.[6]

While Finelli worked fast in Naples, execut-
ing considerable commissions, the sluggish
Bolgi, the driest among Bernini's protégés, spent
the better part of ten years on his statue of St
Helena (1629-39) [195].[7] Its classicizing cool-

195. Andrea Bolgi: St Helena, 1629–39.
Rome, St Peter's

ness, its boring precision and slow linear rhythm would seem to run counter to Bernini's dynamic conception of mass, of which an echo may be felt in the great sweep of the mantle. One might therefore rashly conclude that Bernini and Bolgi had parted company. On the contrary, however, Bolgi's style shows remarkable affinities to Bernini's work at this period. The *St Helena* is in fact so close to Bernini's *Countess Matilda* (1633–7) that the latter has often been ascribed to Bolgi. We have seen (p. 150) that during the 1630s Bernini himself made concessions to the classical ideals held by the Poussin–Sacchi circle. It is therefore understandable that at this period he regarded Bolgi as one of his most reliable assistants.[8] He still employed him in St Peter's throughout the 1640s; but by then a new generation had arisen which responded enthusiastically to Bernini's new ideas. Before

1653 Bolgi went to Naples, and some of his work there shows a rather forced attempt to emulate Bernini's vigorous Baroque of the mid century.[9]

Among the remaining sculptors of this generation has been mentioned the unstable Francesco Baratta (*c.* 1590–1666), author of the relief above the altar in the Cappella Raimondi, S. Pietro in Montorio, and of one of the giant figures (Rio della Plata) on the Four Rivers Fountain in the Piazza Navona. Finally, Nicolò Menghini (*c.* 1610–65) should be recorded; he worked for Bernini in St Peter's during the 1640s and restored classical statues in the Palazzo Barberini. His name survives as the artist of the unsatisfactory figure of S. Martina (1635) under the high altar of SS. Martina e Luca, one of the many recumbent statues of martyrs dependent on Stefano Maderno's *St Cecilia*.[10]

This survey has shown that, apart from Bernini, Algardi, and Duquesnoy, in the second quarter of the seventeenth century the number of gifted sculptors in Rome was small. Of course, it must not be forgotten that the aged Mochi lived and worked throughout this period, and that Stefano Maderno died only in 1636. It is apparent that for the greatest task of the second quarter, the giant statues in the pillars under the dome of St Peter's, Bernini, Duquesnoy, and Mochi were the obvious choice; for the fourth figure the choice lay between Finelli and Bolgi, no better masters being at hand since Algardi's reputation had not yet been sufficiently established. This situation changed considerably about the middle of the century. The next generation was rich in talent, though there was none who approached in quality and importance the pathfinders of the High Baroque.

The Second Generation

Among the many young sculptors working in 1650, there are three or four who stand out either by the intrinsic merits of their work or

196. Melchiorre Caffà: The Ecstasy of St Catherine, finished 1667.
Rome, S. Caterina da Siena a Monte Magnanapoli

197. Melchiorre Caffà: St Thomas of Villanova distributing Alms, 1661.
Terracotta model. *La Valletta, Museum*

as heads of large studios. Their names are Ercole Ferrata (1610–86), the oldest of this group, Antonio Raggi (1624–86), and Domenico Guidi (1625–1701). The fourth sculptor who should here be mentioned is Ferrata's pupil Melchiorre Caffà. Born in Malta as late as 1635, Caffà really belongs to a Late Baroque generation. But he was extremely precocious and died at the early age of thirty-two (in 1667)[11] – too young to carry the style over into its new phase. Without any doubt, he was the most gifted of the younger sculptors, and nobody came as close as he did to the exalted style of Bernini's later period. The principal works which he executed in the short span of less than ten years are quickly mentioned; they are the *Ecstasy of St Catherine* in the choir of S. Caterina da Siena a Monte Magnanapoli [196], *St Thomas of Villanova distributing Alms* (S. Agostino) [197], the

relief of *St Eustace in the Lion's Den* (S. Agnese in Piazza Navona), and the recumbent figure of *St Rosa* in S. Domingo at Lima, Peru.[12] These works, all of considerable size, were executed concurrently over a number of years; but it seems that only the *St Catherine* was entirely finished by Caffà himself before his death.[13] The saint, in mystic exaltation, is carried heavenwards on clouds supported by angels. Higher up the sky opens (i.e., in the lantern), and a crowd of angels and putti play in the heavenly light, out of which the Trinity floats down in a radiant glory to receive the saint. The thaumaturgic character of the mystery has been emphasized by contrasting the white marble of the saint and her angelic companions with the multicoloured marble background

It seems certain that the whole choir was to form a grand unit comprising reliefs along the

side walls, which death prevented him from executing.[14] Caffà utilized fully the ideas of Bernini's Cornaro Chapel and, indeed, no other work is so close in spirit to the *St Teresa*. There is, however, a significant difference between master and disciple: an almost morbid sensibility emanates from the relief of St Catherine, and this can never be said of any of Bernini's works. This difference seems to be one of generation rather than of personal temperament, for the younger artist was able to use freely those formulas of expression which the older one had to create.

The *Ecstasy of St Catherine* belongs to the new Berninesque category of a pictorial group attached to the wall. In his *St Thomas of Villanova* Caffà produced a free-standing group which is closely integrated with the entire scheme of the chapel. The work forms the centre of a large sculptured 'altarpiece', the wings of which consist of reliefs by Andrea Bergondi (*c.* 1760) showing scenes from the life of the saint. Unlike Algardi's *Beheading of St Paul* [167], where two isolated figures are deployed in the same plane, Caffà's composition not only ties together very closely the saint and the woman receiving alms, but by placing the latter outside the central niche and turning her towards the saint, he has made her function as a link between real life and the fictitious world of art. Instead of adoring a cult image, the poor who pray here are stimulated to identify themselves with the recipient of the alms and to participate in the charitable work of the Church 'in action'. But the female figure is not an anonymous woman of the people – by an act of poetical identification of the donor with the recipient, she appears herself in the traditional role of Charity. For the composition of his group Caffà followed a pictorial model, namely Romanelli's painting of the same scene in the Convent of S. Agostino. The figures, by contrast, take their cue from Bernini, as the very attractive terracotta model [197] shows: the saint is indebted to the church

fathers of the Cathedra, and the 'Charity' to the corresponding group on the tomb of Urban VIII.[15] But once again these figures display a hypersensitive spirituality, in comparison with which Bernini's works appear solid, firm and virile.

Apart from technical skill, Caffà could have learned little from his infinitely less subtle teacher, Ercole Ferrata, who was born at Pelsotto, near Como, and worked at Naples[16] and Aquila before settling in Rome. What has survived of his early work is provincial and of little interest. He was already middle-aged when we find him in Rome, working under Bernini on the marble decoration of the pillars of St Peter's (1647). Contrary to a persistent tradition, he cannot have executed one of the allegories for Algardi's tomb of Leo XI, nor is it certain that he collaborated on the Attila relief. By 1653 his reputation was such that Bernini entrusted him with the most important figure on the tomb of Cardinal Pimentel in S. Maria sopra Minerva – that of the Cardinal himself. Ferrata was given preference here over the younger Antonio Raggi and the less distinguished Giovan Antonio Mari, each of whom executed one of the allegories in full relief.[17] A year or two later he had the main share in continuing, after Algardi's death, the latter's work for S. Nicolò da Tolentino, to which Guidi and Francesco Baratta also contributed. During the following fifteen years Bernini showed his appreciation of Ferrata's skill by employing him on a number of great undertakings;[18] in spite of such close contacts, however, Ferrata never fully absorbed Bernini's dynamic style but tended towards a classicism of Algardian derivation.

Characteristic works by Ferrata are in S. Agnese in Piazza Navona, where one can study the different manners of the four masters with whom we are at present concerned. Ferrata's free-standing statue of *St Agnes on the Pyre* (1660) [198] recalls in certain respects Duquesnoy's *St Susanna*, for here too the dress is

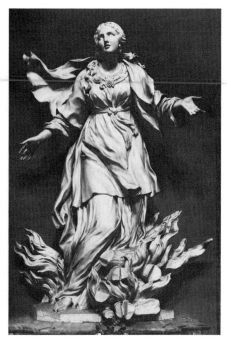

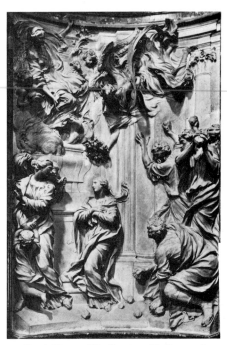

198. Ercole Ferrata:
St Agnes on the Pyre, 1660.
Rome, S. Agnese in Piazza Navona

199. Ercole Ferrata: The Stoning of S. Emerenziana,
begun 1660 (finished by Leonardo Retti,
1689-1709). *Rome, S. Agnese in Piazza Navona*

relatively unruffled and supports the structure
of the body, while the head derives as much
from Duquesnoy as from classical Niobids.
But no artist working in 1660 in Bernini's orbit
could return to Duquesnoy's classical purity of
1630. Following the example of Bernini's
statues of saints, Ferrata represented a tran-
sitory moment; we witness a dramatic climax:
the power of her prayer makes the saint im-
mune against the leaping flames. The gesture
of the extended arms, the painterly treatment of
the fire, the wind-swept gown – all these create
a formal and emotional unrest, strongly con-
trasting with the purist tendencies of the 1630s.
Along the left side of the figure will be noticed
an autonomous piece of drapery, which Ferrata
borrowed from Bernini's *Longinus.* The motif
is only a weak echo of the original; it remains

alien to the form and spirit of the statue and is
a revealing pointer to the derivative quality of
Ferrata's art.

The study of a relief, the large *Stoning of S.
Emerenziana* in the same church (begun 1660)
[199], leads to similar conclusions. In accord-
ance with current classical theory (p. 263)
Ferrata composed his work with a minimum
number of figures, each clearly differentiated by
action, gesture, and expression. The clean and
simple tripartite arrangement with the attackers
on the right, the frightened people on the left,
and the saint isolated in the centre seems to
result from a dogmatic application of Algardi's
principles. While the type of the saint again
shows a close study of Duquesnoy's Susanna,
and while certain figures are evidently inspired
by the Attila relief, Ferrata reverts for the

figures of the attackers to the most classical of
Baroque painters, Domenichino, whose *Stoning
of St Stephen* (now at Chantilly) must have been
known to him.[19] The reader may have noticed
that the sculptural principles displayed in the
upper half of the relief contrast with those of the
lower half. The figures – particularly that of the
huge shapeless angel – not only have different
proportions, small heads and elongated bodies,
but masses of picturesque drapery conceal the
structure of the bodies, and the diffuse silhou-
ettes entirely lack Ferrata's clarity and pre-
cision. It is evident that Ferrata was not respon-
sible for this part of the relief; after his death it
was handed over to Leonardo Retti,[20] who
finished it between 1689 and 1709, and only in
this year were the two parts of the relief joined.
Retti, Ferrata's pupil, worked many years under
Raggi; thus the stylistic difference in the two
halves of the Emerenziana relief is characteristic
of the two different tendencies represented by
Ferrata and Raggi and even more of the
chronological change from the High Baroque to
the picturesque and discursive manner of the
Late Baroque.

In certain respects, Antonio Raggi represents
the opposite pole to Ferrata. If Ferrata is the
Algardi, Raggi is the Bernini of the second
generation. Fourteen years younger than Fer-
rata, he also was born in the region of Como, at
Vico Morcote; in contrast to Ferrata, he went to
Rome in early youth and joined Algardi's
studio. Little is known of his activity under
Algardi[21] and, like Ferrata, we meet him first in
1647 engaged under Bernini on the decoration
of the pilasters of St Peter's. Subsequently he
became Bernini's most intimate and most pro-
lific pupil, and with the exception of Caffà there
was nobody who so fully absorbed the master's
grand manner. In addition to his extensive
activity under Bernini over a period of thirty
years,[22] Raggi carried on independent work of
great importance, among which the following

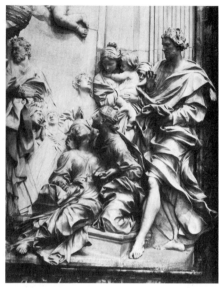

200. Antonio Raggi:
The Death of St Cecilia, 1660–7. Detail.
Rome, S. Agnese in Piazza Navona

deserve special mention: the relief with the
Death of St Cecilia in S. Agnese (1660–7)
[200], the large *Baptism of Christ* on the high
altar of S. Giovanni dei Fiorentini (*c.* 1665), the
vast cycle of stucco decorations in the clerestory
of the nave and transept of the Gesù (1669–83)
[201], the relief and statues of the Cappella
Ginetti in S. Andrea della Valle (1671–5), and
finally, at the beginning of the 1680s, the
Gastaldi monument and the decoration of the
high altar in S. Maria de' Miracoli.

It is difficult to give an adequate idea of the
high quality of Raggi's sculpture without illus-
trating many details.[23] His genius was particu-
larly suited to work in stucco, and the marble
relief in S. Agnese is perhaps not his most
engaging performance. But it commands special
interest for a number of reasons. Originally,
Giuseppe Peroni (*c.* 1626–63), one of the closest
collaborators of Algardi, was commissioned

with the relief (1660). Peroni died when the full-scale model was finished. Raggi, who was asked to take over, appears not to have entirely discarded Peroni's preparatory work; the left half of the relief in particular, with the standing figure of Pope Urban (who was present when the martyr saint died surrounded by Christians) and his kneeling attendant, corresponds closely to Algardi's Attila relief. Here, too, we find the division in the centre, and the differentiation between the calm faith of the pope and the emotional crowd on the right. This is as far as Algardi's influence goes. Raggi's individual manner is apparent in the extremely elongated proportions of the figures, their slender build and elegant movements,[24] as well as in the fall of the draperies, which betray a nervous and restless temperament. This restlessness is also noticeable in the grouping of the figures. Unlike Ferrata, Raggi rejected the lesson to be learned from Domenichino, whose classically poised fresco of the same subject in S. Luigi dei Francesi is not much farther than a stone's throw from S. Agnese. Compared with the lucid disposition of Ferrata's Emerenziana relief, the figures in Raggi's work appear crowded together in complicated, almost confused groups which reveal his disregard for the classical dogma of clarity expressed through a minimum number of figures. On the other hand, the beautiful angel with the martyr's palm, thoroughly Berninesque and obviously derived from the contemporary glory of angels on the Cathedra, shows the sweetness and tenderness of feeling characteristic of Raggi's art. These qualities, perhaps less obvious in other parts of the relief, can be observed in a great number of his works and often seem like anticipations of the lighter charms of the eighteenth century. The story of Raggi's St Cecilia relief illustrates the futility of attempting a rigid separation of the Berninesque from the Algardesque current; at the time such contrasts were not of sufficient consequence to

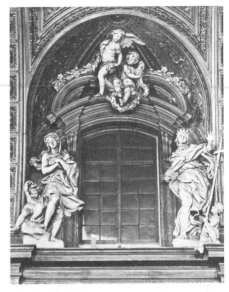

201. Antonio Raggi:
Allegorical Figures, 1669–83.
Rome, Gesù, clerestory of nave

prevent a commission's being transferred from the follower of one master to that of the other.

In his later work, especially in his stuccoes, Raggi yielded wholly to the mystical late style of Bernini, and this phase in his development is best studied in the Gesù [201]. According to contemporary sources, Gaulli, the painter of the frescoes, was also responsible for the design of the stuccoes. Whether this is entirely or only partly true, Raggi's stuccoes are a perfect sculptural parallel to Gaulli's intense response to Bernini's fervent, spiritualized late manner. The tempestuous movement and rapture of Raggi's jubilant putti on clouds, set into panels above the cornice of the nave and transept, must be understood as reactions to the main subject of the ceiling – the fresco of the *Adoration of the Name of Jesus*. As types, these putti owe not a little to Duquesnoy, but no greater contrast to the soothing composure of the latter's

creations could be imagined. Higher up, flanking the windows, are allegories[25] of monumental size, wildly gesticulating or in attitudes of deep devotion and contemplation, clad in draperies that seem to follow their own laws, wind-blown, rearing, twisting, and zigzagging across the figures. Although many of them disclose a real understanding of the late Bernini, it will be found that others must be regarded as an anticlimax, since virtuosity replaces spirituality. In other words, in this cycle of figures the decorative quality of the Late Baroque appears side by side with the purposeful tension of the High Baroque.

With the exception of the sculptural decoration of St Peter's, which was carried out by many hands over a period of 150 years, there is no other Baroque sculptural cycle in Rome that bears comparison with Raggi's, executed in the short span of little more than a decade. In order to accomplish this *tour de force*, Raggi had to use assistants on an extensive scale, and this may account for the differences in quality. The allegories on the right-hand side of the nave are on the whole weaker than the ones on the left; they seem to be by Leonardo Retti, whose large share in the decoration of the Gesù is well attested. Other collaborators were Michele Maglia (right transept) and the worthy Paolo Naldini, who was thoroughly trained in Bernini's studio and was mentioned by Bernini himself as the best sculptor in Rome after Antonio Raggi.[26]

Ferrata and Raggi stand for rival trends without being antagonists. The case of Domenico Guidi is different. It is characteristic of him that he never went through Bernini's school; and he was probably the only important artist of his generation whose services were rarely sought by Bernini. In addition, he did not often participate in common undertakings with Ferrata and Raggi but concentrated on building up a large clientele of his own. Born in Carrara, he followed his uncle Giuliano Finelli to Naples;

his career really began when, at the age of twenty-two, he fled to Rome at the time of Masaniello's revolt and joined the studio of Algardi. There he remained as a favourite pupil until the latter's death in 1654, after which he established an independent studio and evolved a rule-of-thumb method for quick success. He surrounded himself with a staff of mere craftsmen, and with their help he was able to work more quickly and more cheaply than the *professori* whom he despised. By such methods, Guidi managed to pour out a stream of works, not only for Rome and the rest of Italy,[27] but also for Germany, France, Spain, and Malta.

His early works, such as the monument to Natale Rondinini in S. Maria del Popolo (1657), are dry versions of Algardi's prototypes. During the 1650s and 60s he still shows interest in solid and careful execution, but his productions during the last quarter of the century display, with few exceptions, an unpleasant crudeness and rigidity. His figures become stocky and are criss-crossed by angularly broken masses of drapery. It was he who was mainly responsible for the change from the Roman High Baroque to the new Late Baroque idiom – a change well illustrated in his large relief over the altar of the Cappella Monte di Pietà (1667–76) [202]. In this work, Algardi's painterly relief style has been submitted to an interesting transformation. Compared with other works by Guidi, the composition, rising in a great curve from the kneeling Magdalen at the right bottom corner to the figure of God the Father at the top, is not without merits; but there is no discrimination between the degrees of spiritual importance of the holy personages, nor are the single figures sufficiently articulated to enable the beholder to follow their movements with confidence and ease, or even to decide whether drapery belongs to one figure or to another. And no longer are the superhuman and the human sphere separated. The plane of the relief is covered by figures without much qualifying differentiation,

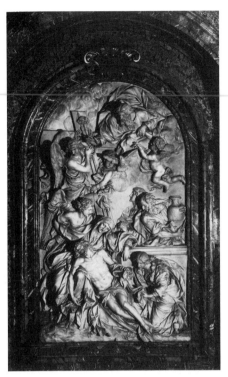

202. Domenico Guidi:
Lamentation over the Body of Christ, 1667–76.
Rome, Cappella Monte di Pietà

ties between Guidi and Algardi as regards individual forms and types, the slackened tension of the former's work is characteristic of a new period in which the passion of the High Baroque has grown cold. The breaking-down of the High Baroque sense of unity and drama may be observed not only in other works by Guidi but also, of course, in contemporary productions in the other arts. Guidi himself played a leading part in effecting this transition, of which hardly an indication was to be found in the works of Ferrata and Raggi.

Tombs with the Effigy in Prayer

Before turning to the minor masters of this period, we may single out for special consideration the most common type of the High Baroque tomb showing the portrait of the deceased, who turns in devotional attitude towards the altar. The best-known tomb of this type is that of the physician Gabriele Fonseca, one of the most moving works of the late Bernini (*c.* 1668–75, S. Lorenzo in Lucina) [203]. Fonseca's fervent devotion and spiritual surrender are called forth by the mystery of the Annunciation, painted above the altar; thus an intangible bond between Fonseca and the altar bridges the space in which the beholder moves. This idea first occurs in tombs of the fifteenth century, and from then on may be found in Spain, France, Germany, and the Low Countries.[28] With the exception of Spanish Naples, however, the type was rare in Italy, and it was not until well into the sixteenth century that the bust with praying hands turned towards the altar began to appear in Rome. The series starts with the impressive Elena Savelli by Giacomo del Duca in S. Giovanni in Laterano (1570)[29] and leads on, before the end of the century, to such works as Valsoldo's simple and sturdy Cardinal Giovan Girolamo Albani in S. Maria del Popolo (1591).[30] Bernini first took up the type in his early bust of Cardinal Bellarmine (1622, Gesù), whose

resulting in a flickering farrago of plastic form. Algardi had worked back into depth starting from the principal figures, which stand out almost three-dimensionally and thus hold the interest of the spectator. Guidi, by contrast, gave most of the figures equal relief projections, leading to a neutralization of the dramatic focus. It is mainly this change from a painterly, illusionistic relief conception to a 'picturesque' one, reminiscent of Late Antique sarcophagi, that accounts for the unaccentuated distribution of sculptural form over the surface.

Looking back from the new position, Algardi's Attila relief seems to have a powerful, dynamic quality. And although there are always close

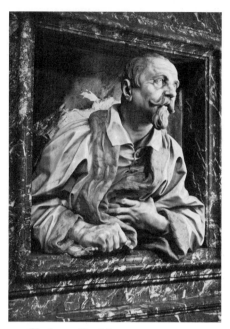

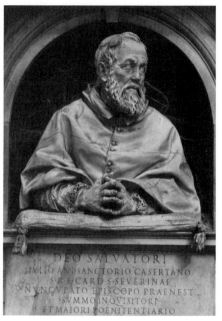

203. Gianlorenzo Bernini:
Gabriele Fonseca, *c*. 1668–75.
Rome, S. Lorenzo in Lucina

204. Giuliano Finelli:
Tomb of Cardinal Giulio Antonio Santorio,
after 1630. *Rome, S. Giovanni in Laterano*

slight turn of the face in the opposite direction from the praying hands suggests a link between the congregation and the altar.

The next step in the evolution of the High Baroque type is, unexpectedly perhaps, due to Algardi in the Millini tomb in S. Maria del Popolo (*c*. 1630): the figure of the deceased cardinal is distinctly turned towards the altar, one hand clasping the prayer-book, the other pressed to his chest in the traditional gesture of devotion. Moreover, the large rectangular tablet of the inscription serves as a parapet,[31] and, although no real illusion is here attempted or achieved, Bellori's description of the tomb shows that contemporaries were reminded of 'a kneeling figure which turns praying towards the altar'. Giuliano Finelli developed the idea further in the tomb of Cardinal Giulio Antonio

Santorio [204], placed in Onorio Longhi's large oval chapel in S. Giovanni in Laterano, dating from the early 1630s, probably just before the artist went to Naples. It is here that the figure really seems to kneel behind a prie-dieu, resting his praying hands on the cushion. The Algardesque realism of the surface treatment supports the illusion of real life. And with this goes a bolder movement of the figure towards the altar and an intensified expression of devotion. About ten years later, Finelli made the tomb of Cardinal Domenico Ginnasi for the little church of S. Lucia dei Ginnasi.[32] Although the handling is less refined, the work must be regarded as a further step towards the consolidation of the type. Finelli returned to the gestures of Algardi's Millini, but the figure is leaning out of the niche in deep agitation, the mouth

half open as if murmuring a prayer. Thus while the stone image of the dead appears in the attitude of everlasting adoration, a transient moment in his relationship with the Divine has been caught. This was the end of the development, and in future the type could only be varied. Bernini's *Fonseca* complied with it, and numberless busts in Roman chapels testify to a trend of devout piety during the Catholic Restoration. Such works began to become rarer, however, with the slackening of religious fervour at the end of the seventeenth century.

Before this happened the theme was extended, and in Gesù e Maria an entire church instead of a chapel became the field of action for the deceased. Giorgio Bolognetti, Bishop of Rieti, commissioned the work. He financed the splendid decoration and had the whole church turned into a kind of mausoleum for members of his family. Carlo Rainaldi unified the entire space not only architecturally but also colouristically; its black, brown, and reddish marbles, interrupted by the flicker of the white figures, form perhaps the last sonorous High Baroque colour symphony.[33] Sculpture was assigned a place on the two pairs of broad pillars above the confessionals; the pillars near the entrance contain double tombs with lively gesticulating half-figures behind prie-dieus, while behind those nearer the altar kneel single full-size figures. All these portrayals of the Bolognetti turn their attention to the gorgeous altar with Giacinto Brandi's *Coronation of the Virgin*. The statues are placed before a small-scale, columned architecture suggesting the opening into imaginary spaces, and above them, like heavenly protectors, are large stucco figures of saints in simple niches. As in Bernini's Cappella Cornaro there are here no sarcophagi, and hardly anything is reminiscent of death: the illusion was to be as complete as possible. The six deceased are represented in finely differentiated stages of religious enthusiasm. Near the entrance the visitor meets those who look and

listen, prepare themselves for prayer, or are absorbed in colloquy about the eucharistic miracle on the altar [205]; proceeding towards the altar, he finds himself face to face with

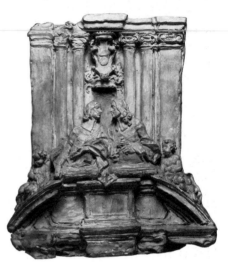

205. Francesco Aprile: Model for the tombs of Pietro and Francesco Bolognetti, after 1675. *London, Victoria and Albert Museum*

Bishop Giorgio Bolognetti, the donor, kneeling in silent prayer, and with the Maltese knight Francesco Mario, who sinks upon his knee with gestures of profound devotion. But if one compares these figures by Michele Maglia, Francesco Aprile, and Francesco Cavallini with Bernini's *Fonseca*, one cannot overlook that they carry considerably less conviction, and that the most excited of them, Francesco Mario, the one closest in style to the late Bernini, appears almost melodramatic in his reverential exuberance.[34] The spatial conceptions of the High Baroque found in this church a triumphant realization, but the religious feeling which had carried them began to flag.

The connexion across space between figures and the altar, as developed during the Roman High Baroque, weaves together art and life and

effaces the most powerful boundary of all, the one that separates life from death. Nowhere else can one pinpoint so clearly the paradoxical situation of the Baroque age: it is the dead who invite the living to join in their prayers, and while the dead seem alive and the living emotionally prepared to accept the elimination of the borderline between fiction and reality, they yet remain always conscious that commemorative portraits greet them from the walls.

Minor Masters of the later Seventeenth Century

Two of the artists responsible for the Bolognetti monuments, Aprile and Maglia, were Ferrata's pupils. There were no sculptors of importance in Guidi's studio;[35] nor was Raggi the head of a school.[36] The opposite is true of Ferrata: as well as Caffà, Retti, and the artists just mentioned, Filippo Carcani, Giuseppe Mazzuoli, Lorenzo Ottoni, the Florentine Giovan Battista Foggini, the Milanese Giuseppe Rusnati, and even Camillo Rusconi were among his pupils.[37] But Ferrata was not a great enough artist to give his school a personal stamp; most of the work turned out by his studio consisted of variations of the Berninesque idiom. The majority of his pupils belong to a later generation, and a word about them will therefore be reserved for another chapter. Francesco Aprile died young, in 1685,[38] so that it fell to his teacher Ferrata to finish his masterpiece, the recumbent statue of St Anastasia under the high altar of the church of that name, a statue in which the type of Maderno's St Cecilia was translated into the forms of Bernini's late manner. Maglia, whose earliest known works date from about 1672, adhered more closely to the manner of his master. His principal work is the decoration of the beautiful chapel in S. Maria in Araceli dedicated to St Peter of Alcantara (1682–4),[39] where above the altar the ecstatic saint hovers in the air before a vision of the Cross, while on the side walls life-size angels carry medallions with reliefs of St Stephen and St Ranieri. The convincing spirituality of these figures and the free transitions between sculpture and space make this work a legitimate descendant of Bernini's Cornaro Chapel.

Maglia often collaborated with Francesco Cavallini, an able decorator who was the third chief contributor to the sculptural decoration of Gesù e Maria. The over-life-size stucco statues of saints in S. Carlo al Corso (1678–82) were his largest commission; these are uneven in quality and on the whole show close affinities with Raggi's turbulent style. Cavallini, however, came neither from Ferrata nor Raggi: he was a pupil of Cosimo Fancelli (1620?–88), the more important brother of Giacomo Antonio (1619–71) whom we saw employed, in spite of his youth, on the Baldacchino. After beginning his career under Bernini in St Peter's, Cosimo attached himself to Pietro da Cortona; and wherever we find the latter working as architect and decorator, Cosimo Fancelli is sure to be near at hand. Thus there is decorative sculpture by him in SS. Martina e Luca (1648–50), S. Maria della Pace (1656), S. Maria in Via Lata (c. 1660), S. Carlo al Corso (after 1665), in the Cappella Gavotti in S. Nicolò da Tolentino (1668), and on the vaulting of the Chiesa Nuova (1662–5). After Cortona's death he still took part in a variety of important tasks, and since he was one of the most distinguished sculptors in Rome Bernini transferred to him the execution of an angel for the Ponte S. Angelo. This angel (1668–9) [206] shows, in the somewhat voluptuous forms and the type of the head, how indebted Fancelli was to Cortona while at the same time he paid tribute to the current Berninesque manner. Uneven in his work, he often attempted to reconcile Cortona's and Bernini's manners with an emphatic simplicity of forms which he shared with Ferrata, his collaborator on more than one occasion. It is often difficult, therefore, to distinguish between their work.[40]

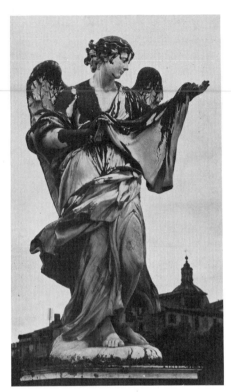

206. Cosimo Fancelli:
The Angel with the Sudary, 1668-9.
Rome, Ponte S. Angelo

The angels on the Ponte S. Angelo enable the student to assess the position of Roman sculpture in the year 1670. Bernini naturally employed the sculptors with the highest reputation and those of whom he was particularly fond. As well as the angels for which he was himself responsible, we find – as we should expect – angels by Ferrata, Raggi, and Guidi; there are those by his closest circle, Lazzaro Morelli, Giulio Cartari, and Paolo Naldini; finally there is the angel by Cosimo Fancelli, and there are others by Antonio Giorgetti and Girolamo Lucenti.[41] Gioseppe Giorgetti,[42] Antonio's brother, left one masterpiece of great

beauty: the recumbent *St Sebastian* in S. Sebastiano fuori le Mura – yet another version of Maderno's St Cecilia type – a statue derived from Michelangelo's Dying Slave in the Louvre and imbued with an exquisite Hellenistic flavour. Girolamo Lucenti (1627-92) began as a pupil of Algardi, whose influence is still traceable in the relatively unemotional angel on the Ponte S. Angelo. His tomb of Cardinal Girolamo Gastaldi (1685-6) in the choir of S. Maria de' Miracoli shows him as a weak imitator of Raggi's manner; while the bronze statue of Philip IV of Spain, under the portico of S. Maria Maggiore, dating from the last years of Lucenti's life, is hardly a shadow of the one planned by Bernini in 1667.[43]

Looking back for a moment from the statues on the Ponte S. Angelo to those placed forty years earlier under the dome of St Peter's, we realize that, in contrast to the earlier highly personal and subjective performance, we are faced with the work of epigones among whom Bernini appears like a solitary giant. His intense High Baroque did not only have an equalizing influence on most of these masters of the younger generation but also reduced their capacity for individual expression, and perhaps even their desire to attain it.

*Bernini's Studio
and the Position of Sculptors in Rome*

The last remark indicates that for good or evil Bernini's influence on the sculptors in Rome during the second half of the seventeenth century cannot be overestimated. After Algardi's death in 1654 there was, in fact, nobody seriously to challenge his authority. I cannot attempt here to reconstruct the organization and working of the studio. Suffice it to say that it became the attraction for artists from all over Europe, and such sculptors as the Englishman Nicholas Stone the younger, the Frenchman Puget,[44] and the German Permoser laid there

the foundation for their future work. Nearer home, year by year a stream of masons and sculptors, particularly from the North of Italy, went to Rome, stimulated less by the idea of acquiring there a great style than by the hope of getting a share in the gigantic commissions the Church had to offer. More often than not they were utterly disappointed, and sculptors were lucky if they found a corner for themselves in Bernini's vast organization or in one of the studios more or less dependent on him. Willy-nilly they had to submit to the established hierarchy.

The fate of the competent Lazzaro Morelli (1608–90) may be quoted as one example of many. He came to Rome from Ascoli, but in spite of excellent letters of introduction everything seemed to go wrong, and his biographer, Pascoli, makes him exclaim bitterly: 'How much better would it have been for me to stay at home, where I did not and could not earn very much, but where, eventually, I would have taken first place amongst my colleagues.' In the end, Morelli shared the fate of so many others in becoming almost entirely dependent on Bernini for work. In fact Bernini must have regarded him as one of his most reliable studio hands, for he allotted to him tasks of great responsibility in the work on the Piazza of St Peter's,[45] the Cathedra, and the tomb of Alexander VII. Morelli maintained contact with his native town and became on his part the head of a school through which Bernini's manner spread in the Marches.[46] This is the typical constellation: it was by direct transmission rather than by the independent initiative of other masters that the style was disseminated throughout Italy and Europe. Since, as I mentioned at the beginning of this chapter, the great extension of the studio did not take place until the later 1640s, it will be apparent that Bernini's Baroque was taken up in the rest of Italy not until the second half and, as a rule, only during the last quarter of the century.

It was to a large extent due to Bernini's immense authority that the profession of a sculptor had become financially rewarding. To be sure, towards the middle of the seventeenth century there was an unparalleled boom for sculptors, and yet in spite of the years of prosperity the proletariat of artists remained large in Rome. In 1656 one hundred and eleven artists lived in the borough of Campo Marzio, and no less than fifty-three of them – i.e. almost 50 per cent – were registered as poor.[47] But quality was so highly valued that the top class of sculptors, and above all Bernini, were paid star salaries, even by modern standards. As early as 1633 an original statue by Bernini was estimated as being worth between four and five thousand scudi.[48] In 1651 Francis I of Este paid as much as 3,000 scudi for his portrait bust. This was, of course, exceptional, even for Bernini. In 1634 Algardi signed his contract for the tomb of Leo XI with a fee of 2,550 scudi, but at the time the tomb was finished, eighteen years later, when both the craving for sculpture and Algardi's reputation were at a climax, he was granted an additional 1,000 scudi. Such prices were not maintained from the late seventeenth century onwards. A good comparison is offered by the 7,000 scudi Bernini was paid in 1671 for his *Constantine* as against the 4,000 scudi Cornacchini received in 1725 for its counterpart, the equestrian statue of Charlemagne.[49]

SCULPTURE OUTSIDE ROME

It has already become apparent that not much need be said about the development of sculpture outside Rome. With Rome's supremacy incontestably established, Roman sculptors catered for the need of patrons all over Italy. Naples, vigorously active, had room even for Finelli and Bolgi. But as a rule figures and busts were sent from Rome. Bernini provided work for Spoleto, Siena, Modena, Venice, and Savona (school piece); Algardi for Genoa, Piacenza,

Parma, Bologna, Perugia, and Valletta (Malta). Not Florentines or Sienese but Caffà, Ferrata, and Raggi gave Siena Cathedral monumental Seicento sculpture. Later, Giuseppe Mazzuoli, born near Siena, inundated Siena with Berninesque statuary. Ferrata also worked for Venice, Modena, and Naples; Raggi for Milan, Sassuolo, and Loreto; Naldini for Orvieto and Todi. There is no need to prolong this list.

It was not until late in the century that flourishing local schools sprang up in centres like Bologna, Genoa, and Venice. Apart from Milan with her conservative cathedral school of sculptors, a continuity was maintained only in Florence and Naples, due in each city mainly to the activity of one artist. Florentine sculpture did not enter a High Baroque phase even with Pietro Tacca's son, Ferdinando (1619-86), who remained Tuscan through and through. His bronze relief of the *Martyrdom of St Stephen* in S. Stefano, Florence (1656), points back via Francavilla and Giovanni Bologna to the illusionism of Ghiberti's Porta del Paradiso, while his fountain of the Bacchino at Prato (1665, now Museum), with the figure crowning the shaft and basin like a monument, is not developed far beyond Giovanni Bologna's prototypes in the Boboli Gardens. Compelling Baroque unification of parts remained foreign to Florentine artists. But the little bronze Bacchus on top of the fountain has High Baroque softness and roundness although one cannot overlook the faint family likeness to Verrocchio's putti. All too often the bronze relief of the Crucifixion in the Palazzo Pitti has been attributed to Pietro Tacca,[50] revealing an erroneous assessment of what was possible in Florence around 1640. As K. Lankheit has shown, the relief dates from 1675-7 and is by G. B. Foggini.[51] He at last exchanged the Florentine for the Roman relief style of the type of the reliefs at S. Agnese in Piazza Navona. The Roman High Baroque had made its entry into Florence.

Earlier than any other Italian city, Naples assimilated Roman High Baroque sculpture through the activity of Giuliano Finelli; and in the Lombard Cosimo Fanzago (p. 302) Naples had an autonomous Baroque sculptor. He began with works of late Mannerist classicism (1615-16, St Ignatius at Catanzaro; 1620, tomb of Michele Gentile, Cathedral, Barletta) and developed even before Finelli's arrival towards a High Baroque style [193], certainly not without contacts with events in Rome. Yet in contrast to the true High Baroque masters in Rome, the versatile Fanzago was capable of using side by side two idioms which would seem mutually exclusive: the Tuscan Renaissance comes to life in the chaste *Immacolata* of the Cappella Reale (1640-6) while the Roman Baroque informs a figure like the Jeremiah (1646, Cappella S. Ignazio, Gesù Nuovo) with its masses of brittle folds, its luminous surface and strong *contrapposto* movement.[52] Although by training a sculptor and mainly active as an architect, Fanzago's most lasting achievement was probably in the field of semi-decorative art, such as his fountains and pulpits, his splendid bronze gates in S. Martino and the Cappella del Tesoro, and his many polychrome altars, where he wedded flourishing sculptural ornament to inlaid marble work. As early as the 1630s this manner was fully developed (1635, high altar, SS. Severino e Sosio, Naples), and there is reason to believe that it had considerable repercussions in the rest of Italy.[53] Even the decorative style of an architect like Juvarra seems to owe a great deal to Fanzago, and the question to what extent the roots of the Rococo ornament can be traced back to Fanzago, directly or indirectly, would need further careful investigation.

HIGH BAROQUE PAINTING AND ITS AFTERMATH

Baroque Classicism; Archaizing Classicism; Crypto-Romanticism

The preceding discussion of the Cortona–Sacchi controversy supplies the background to the development of painting in Rome during most of the second and third quarters of the seventeenth century. Painters had to side with one of the two opposing camps: the general trend of their decision has already been indicated.

At the beginning of this period Rome harboured two immensely vigorous Baroque frescoes of singular importance, those by Lanfranco in the dome of S. Andrea della Valle and by Cortona in the Gran Salone of the Palazzo Barberini. One would have thought that these masterpieces would immediately have led to a revolution in taste, even among the artists of second rank, and there cannot be any doubt about the impression they made. But Lanfranco soon left Rome and settled for about twelve years in Naples (1634–46), where he continued his dense and dramatic Baroque manner in a number of large fresco cycles (p. 357). When he returned to Rome (1646), shortly before his death, the climate had considerably changed, mainly due to the ascendancy of Andrea Sacchi. Between 1640 and 1647 Cortona too was absent from Rome, and this meant that Sacchi remained in full command of the situation.

It is for this reason that among the rank and file of artists born between 1600 and 1620 the pattern of development varies but little. Andrea Camassei (1602–48/9), Francesco Cozza (1605–82), Sassoferrato (1609–85), and Giovanni Domenico Cerrini (1609–81) stem mainly from

Domenichino; G. F. Romanelli (*c.* 1610–62), Giacinto Gimignani (1611–81), and Paolo Gismondi (*c.* 1612–*c.* 1685), to name only a few, from Pietro da Cortona.[1] But Sacchi lined up all these painters behind him. It is characteristic that in the 1640s Camassei and Gimignani worked for him in the Baptistery of the Lateran, where also the young Maratti painted from the master's cartoons. Camassei, who disappointed the high hopes of his Barberini patrons, had a typical career; after his beginnings under Domenichino, he painted under Cortona in Castel Fusano, only to be associated with Sacchi towards the end of his brief life. With few exceptions his work is archaistic, like that of the whole group. In fact, Sassoferrato's stereotyped pictures of the Virgin and Child appeared so anachronistic that he was long taken for a follower of Raphael. Cozza is the most interesting and Romanelli the best-known of these practitioners who had their great moment in the decade before the mid century. While Cozza deserves being resuscitated from semi-obscurity (see below),[2] little need be said about Romanelli's career. Trained under Domenichino, he became Cortona's assistant on the Barberini ceiling, was permanently patronized by the Barberini, and was given commissions of considerable size which he executed not without decorative skill. It was he who introduced a watered-down and classicized version of Cortona's manner into Paris, where his mythological, allegorical, and historical frescoes in the gallery of the Hôtel Mazarin (1646–7)[3] and in several rooms of the Louvre (1655–7) reveal a facile routine, which is equally apparent in his Roman work of these years (frecoes, Palazzo Lante, 1653).

At the beginning of the 1630s these artists were still too young to contribute independently to important commissions. Only the oldest of them, Camassei, was allowed a share in the most interesting enterprise of this period, the decoration with paintings of S. Maria della Concezione (1631-8), undertaken on the initiative of Cardinal Antonio Barberini, the pope's brother. Here the older generation was given pride of place: Reni, Domenichino, and Lanfranco (two pictures)[4] painted mature masterpieces; the Florentine Mannerist Baccio Ciarpi, Cortona's teacher, contributed a picture as well as Alessandro Turchi (1578-1648) from Verona, who had made Rome his home and, after an early Caravaggesque phase, had moved far towards Bolognese classicism. Of the younger masters, in addition to Camassei, only Sacchi (two) and Cortona were commissioned. All in all, the church offers an excellent cross-section of the various trends of monumental easel painting in the 1630s: the old Bolognese classicism next to Sacchi's Baroque classicism and Reni's elegant and sublime late manner next to Lanfranco's and Cortona's full-blooded versions of the Baroque. The keynote of the latter's *Ananias healing St Paul of Blindness* (*c.* 1631) consists, rather typically, in a saturation of Raphaelesque reminiscences with Venetian colourism.

The reversal of values during the next decade, the return to a dry and archaizing Bolognese manner, the emphasis on design, and the almost complete turning away from Venetian colour will be found in such works as Sassoferrato's *Madonna del Rosario* (1643, S. Sabina), Cerrini's *Holy Family with St Agnes and St Catherine* (1642, S. Carlo alle Quattro Fontane), Gimignani's frescoes in S. Carlo ai Catinari (1641), and Romanelli's *Presentation in the Temple* (1638-42, S. Maria degli Angeli, from St Peter's).[5] One of the most extraordinary paintings of these years [207] illustrates this trend in absolute purity. Nazarene or Pre-Raphaelite paintings come to mind: this archaism seems to have a radical and therefore revolutionary quality. Even a man of a different calibre, the young Mattia Preti (1613-99), in spite of his originality and vigour, paints the frescoes in the apse of S. Andrea della Valle in 1650-1 essentially in the manner of Domenichino.

It is true that all these painters reflect as well as ossify in their work a development towards which Poussin, Sacchi, Algardi, and even Cortona tended, a development that had wide repercussions and links up with international Late Baroque classicism. Seen in proper perspective as an offshoot of Roman High Baroque classicism, this group of painters is therefore neither as anachronistic nor as revolutionary as it might appear.

207. Giovanni Battista Salvi, il Sassoferrato: The Virgin of the Annunciation, *c.* 1640-50. Detail. *Casperia (Rieti), S. Maria Nuova*

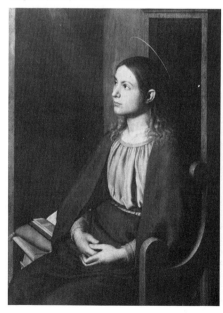

In the meantime, the lower genre, the so-called Bambocciate (p. 77), to which Pieter van Laer had given rise, found scores of partisans. These 'Bamboccianti' had become a powerful coterie even before the 1640s; apart from Michelangelo Cerquozzi (1602–60), Viviano Codazzi (1611, not 1604, –72), and a few others,[6] they were however mainly northerners, among them Jan Miel, Jan Asselyn, Andries Both, Karel Dujardin, and Johannes Lingelbach. As early as 1623 the Dutch organized themselves in the Schildersbent,[7] a guild which guarded their interests but was at the same time a centre of Bohemian life in Rome. Just like their lives, their pictures, minute and intimate records of Roman street life, always in the cabinet format, seem unprincipled when compared with official painting in Rome. In their work these Bamboc-

208. Michelangelo Cerquozzi and Viviano Codazzi: Roman Ruins, c. 1650.
Rome, Pallavicini Collection

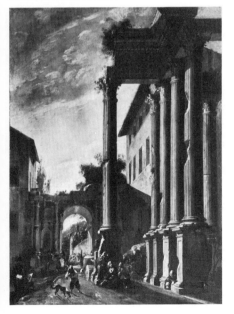

cianti would appear to represent the precise opposite to the conscious primitivism and classicism of the minor monumental painters. But the matter is not quite so simple. Codazzi's classically constructed *vedute*, which such painters as Miel, Micco Spadaro (p. 359), and, above all, Cerquozzi peopled with figures[8] [208], show that the rift concerned the choice of subject matter rather than composition and design. It was the degraded subjects of the Bamboccianti against which the attacks from the classical camp were directed (p. 265). The critics, however, were unable to realize that, unlike themselves, the Bamboccianti, with their exploration of a vast field of human and visual experience, were fighting the battles of the future.

Moreover, precisely in the years of the ascendancy of the Sacchi clique, another 'unprincipled' artist, Bernini, began his bold experiments in painting which helped to break out of the cul-de-sac of classicist dogmatism. Two other, more intimate trends counterbalanced to a certain extent the rigidity of the archaizing group: a renewed interest in the representation of landscape and, not unconnected with this, the rise of a crypto- or quasi-romantic movement. These new departures are primarily connected with the names of Pier Francesco Mola (1612–66), Pietro Testa (1611[9]–50), and Salvator Rosa (1615–73); characteristically, none of these was in the first place a fresco painter. Mola began under the Cavaliere d'Arpino but received his direction for life from a prolonged stay at Venice. Not back in Rome until 1647,[10] he used in the following two decades a rich palette of warm brownish tones and created works in which once again the landscape element often forms the hub of the composition. He gave his best in small pictures which display a quite personal idyllic and even elegiac quality.[11] His masterpiece as a fresco painter, the *Joseph making himself known to his Brethren* in the

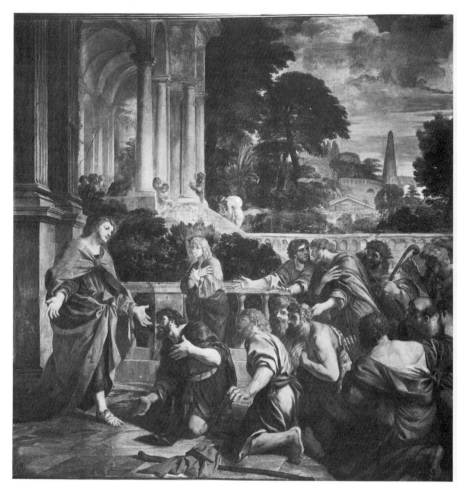

209. Pier Francesco Mola: Joseph making himself known to his Brethren, 1657. Fresco.
Rome, Palazzo del Quirinale, Gallery

Quirinal Palace (1657) [209],[12] reveals the specific problem of this group of artists. Even here the landscape plays a predominant part, but the organization of the painting with a figure composition as much indebted to Raphael as to Cortona exposes a tendency towards reconciliation with the prevailing classicism of the period.

In Testa's case the same conflict between an innate romanticism and the classical theories which he professed, takes on tragic proportions, for his brief career – he died at the age of about forty – probably ended by suicide.[13] Born at Lucca, he was in Rome before 1630, began studying with Domenichino, later worked with Cortona, and became one of the main collabo-

rators of Cassiano del Pozzo (p. 231) in the 1630s and was thus drawn into Poussin's orbit. He was also closely associated with Mola. Passeri describes him as an extreme melancholic, bent on philosophical speculations, who found that work in black-and-white was more suitable than painting to express his fantastic mythological and symbolic conceptions. His etchings [210][14] have an abstruse emblematic

Naples, he began under his brother-in-law, Francesco Fracanzano, but soon exchanged him for Aniello Falcone. From the latter stems his interest in the battle-piece.[15] He was in Rome first in 1635, was back at Naples in 1637, and returned to Rome two years later. His Satire against Bernini during the Carnival of 1639 made the leading Roman artist a formidable enemy, and so, once again, Rosa left – this time

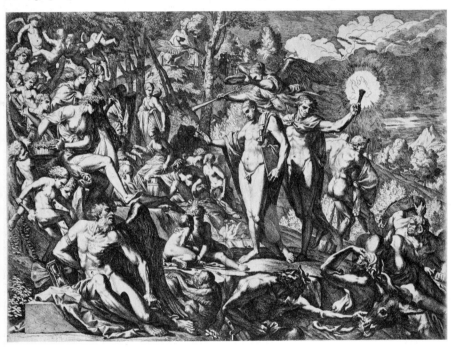

210. Pietro Testa:
Allegory of Reason, 1640–50. Etching

quality and a poetical charm only matched by his Genoese contemporary, Giovanni Benedetto Castiglione [238]. It was Passeri's opinion that Testa outdistanced every painter by the variety and nobility of his ideas and the sublimity of his inventions.

The most unorthodox and extravagant of this group was certainly Salvator Rosa. Born in

for Florence, where he nursed his genius for over eight years, writing poems and satires, composing music, acting, and painting. His house became the centre of a sophisticated circle (Accademia dei Percossi). In 1649 he finally settled in Rome and now stayed till his death in 1673. A man of brilliant talent, but a rebel in perpetuity,[16] remorseless in his criti-

cism of society, obsessed by a pre-romantic egotistic conception of genius, he took offence at being acclaimed as a painter of landscapes, marines, and battle-pieces. But it is on his achievement in this field rather than on his eenth century saw in Salvator's and Claude's landscapes the quintessential contrast between the sublime and the beautiful. In Sir Joshua Reynolds's words, Claude conducts us 'to the tranquillity of Arcadian scenes and fairy land',

211. Salvator Rosa: Landscape with the Finding of Moses, *c.* 1650. *Detroit, Institute of Art*

great historical compositions that his post-humous fame rests.[17] True to the Italian theoretical approach (p. 43), he regarded these 'minor' genres as a frivolous pastime. On the other hand, they gave him the chance of letting his hot temper run amok. Setting out from the Flemish landscape tradition of Paul and Mattheus Brill, many of his landscapes have their skies dark and laden, storms twist and turn the trees, melancholy lies over the crags and cliffs, buildings crumble into ruins, and banditti linger waiting for their prey. Painted with a tempestuous brownish and grey palette, these wild scenes were soon regarded as the opposite to Claude's enchanted elysiums. The eight- while Rosa's style possesses 'the power of inspiring sentiments of grandeur and sublimity'.

Yet it must be emphasized that the romantic quality of Rosa's landscapes is superimposed on a classical structure, a recipe of 'landscape making' which he shares with the classicists. The example of illustration 211[18] shows the repoussoir trunk and tree left and right in the foreground, the classical division into three distances, the careful balancing of light and dark areas. In addition, the arc of the group of figures, which represent the Finding of Moses, fits harmoniously into the undulating terrain, is 'protected' by the larger arc of the tree, and given prominence by the silvery storm-clouds of

the background. Based on accepted formulas, such landscapes were carefully devised in the studio; they are, moreover, 'landscapes of thought', because more often than not the figures belong to mythology or the Bible and tie the genre, sometimes by a tender link, to the great tradition of Italian painting. The quasi-romantic approach to landscape painting was shared to a lesser extent by Mola and Testa and, while the work of the minor classicists of this period was soon almost forgotten, Rosa's new landscape style opened horizons of vast consequences.[19]

It was during the very years of the rise of the 'romantic' landscape that Poussin and Claude developed their formulas of the heroic and ideal landscape and that landscapes *al fresco* were once again admitted to palace and church; and it is a memorable fact that in the late 1640s and early 1650s Poussin's brother-in-law, Gaspar Dughet (1615–75), whose early manner – not uninfluenced by Salvator – may be described as half-way between the classical and romantic conception of landscape, painted the cycle of monumental landscapes with scenes from the lives of Elijah, Elisha, and St Simon Stock in S. Martino ai Monti as well as landscape friezes in the Colonna, Costaguti, and Doria-Pamphili palaces – thus taking up a tradition for which Agostino Tassi had been famed in the second and third decades of the century.[20] At the same time, the Bolognese Gian Francesco Grimaldi (1606–80), an all-round talent, returned in his frescoes and cabinet pictures to the older tradition of Annibale Carracci's classical landscape style.[21]

On the whole, therefore, the lure of classical discipline far outweighed the attractions of the crypto-romantic movement during the fifth and sixth decades. The 'inferiority complex' from which the romantics suffered makes this doubly clear. How thoroughly they were steeped in the current classical theory is demonstrated by Testa's manuscript treatise on art[22] as well as

by Rosa's rather dreary and emphatically rhetorical history paintings. Only on occasion did he allow the fantastic and visionary-romantic elements to gain the upper hand. A case in point is the extraordinary *Temptation of St Anthony*

212. Salvator Rosa: The Temptation of St Anthony, *c.* 1645–9. *Florence, Palazzo Pitti*

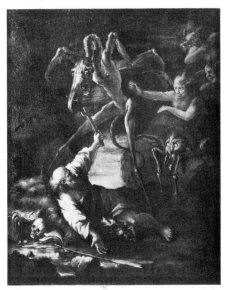

which conjures up the spirit of a Jerome Bosch [212].[23]

Not many years later – in the 1660s – the law was laid down *ex cathedra*. The prevalent taste of the 1640s and 50s had prepared the climate for Bellori's *Idea*, the supreme statement of the classic-idealist doctrine, read to the Academy of St Luke in 1664.[24] This tract, in turn, laid the theoretical foundation for the ascendancy of Maratti's Late Baroque Classicism. Soon Maratti was acclaimed the first painter in Italy. And yet Salvator and the other romantics, far from being out of touch with the spirit of their own time, struck chords which reverberated through the whole of Italy.

The Great Fresco Cycles

It is a memorable fact that none of the High Baroque churches built by Bernini, Cortona, Borromini, and Rainaldi had room for great Baroque ceiling decoration,[25] the only exception being the dome of S. Agnese, and here no indication is extant of what Borromini would have wished to do. All these churches were designed as architectural entities which would have been interfered with by an illusionistic break-through in the region of the dome. A moment's reflection will make it clear how absurd it would be to imagine the domes of S. Ivo, SS. Martina e Luca, S. Andrea al Quirinale, or the vault of S. Maria in Campitelli decorated with grandiloquent Baroque frescoes. Only Bernini admitted illusionist ceiling painting under certain conditions (e.g. Cornaro Chapel). High Baroque ecclesiastical architecture of the first order, in other words, had no use for contemporary fresco paintings, and this also applies by and large to the cities outside Rome.[26] It is doubtful whether other than artistic reasons may account for this situation, for a man like Cortona, who made it impossible for all time to have the dome of SS. Martina e Luca painted, began in the very same years of its construction the extensive fresco decoration of the Chiesa Nuova.

The paradoxical position then is this: High Baroque frescoes were only admitted on the vaults of older churches, where originally none or certainly not this kind of decoration was planned, while contemporary architecture offered no room for monumental painting. This revealing fact must be supplemented by an equally interesting one, namely that after Lanfranco's frescoes in the dome of S. Andrea della Valle, painted between 1625 and 1627, twenty years went by until another dome was similarly decorated: that by Cortona in the Chiesa Nuova (1647-51). At the same moment Lanfranco, back from Naples,[27] painted the frescoes in the

apse of S. Carlo ai Catinari (1646-7), his not entirely successful parting gift to the world; and after February 1650 followed Mattia Preti's frescoes in the apse of S. Andrea della Valle. Excepting the continuation of Cortona's work in the Chiesa Nuova during the mid fifties and mid sixties, nothing of real importance happened until 1668, when Gaulli painted the pendentives of S. Agnese (finished 1671). From then on the pace quickened. In 1670 Ciro Ferri, Cortona's faithful pupil, began the dome of S. Agnese in the tradition deriving from Lanfranco's S. Andrea della Valle (finished in 1693, after Ferri's death).[28] Antonio Gherardi's (1644-1702) remarkable frescoes on eighteen fields of the ceiling of S. Maria in Trivio – the most Venetian work in Rome at this period – also date from 1670. In 1672 Gaulli began in the Gesù the most ambitious decoration of the Roman Baroque, which kept him occupied for over a decade [213].[29] Two years later Giacinto Brandi worked on the large vault of S. Carlo al Corso and Canuti on that of SS. Domenico e Sisto (1674-5) [216]. Between 1682 and 1686 follow Brandi's ceiling frescoes in S. Silvestro in Capite, and immediately after, those in Gesù e Maria (1686-7). Filippo Gherardi's *Triumph of the Name of Mary* in S. Pantaleo dates between 1687 and 1690. Padre Pozzo's immense frescoes in S. Ignazio [217] were painted between 1691 and 1694; after 1700 fall Garzi's frescoes in S. Caterina da Siena and Calandrucci's ceiling in S. Maria dell'Orto (1703) and, finally, from 1707 date Gaulli's late frescoes in SS. Apostoli.[30]

It appears, therefore, that most of the large frescoes in Roman churches belong to the last thirty years of the seventeenth and the beginning of the eighteenth century. Gaulli's work in the Gesù and Pozzo's in S. Ignazio, which are rightly regarded as the epitome of monumental Baroque painting, were done at a time when High Baroque architecture and sculpture had long passed their zenith. This situation is

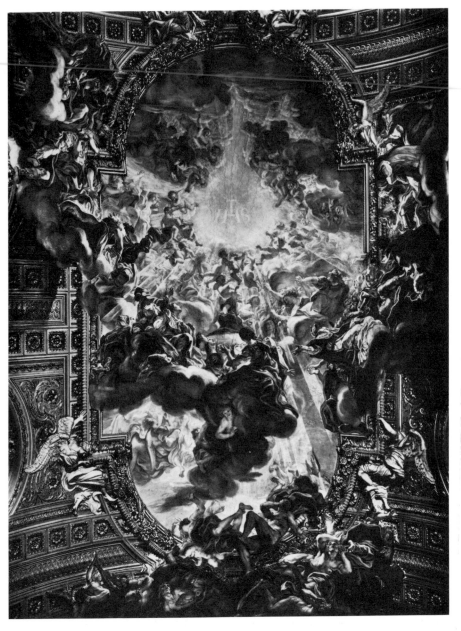

213. Giovan Battista Gaulli: Adoration of the Name of Jesus, 1674–9. Fresco. *Rome, Gesù, ceiling of nave*

not entirely paralleled as regards the decoration of palaces. But in the thirty years between about 1640 and 1670 only three major enterprises are worth mentioning, namely the decoration of the Palazzo Pamphili in Piazza Navona where Camassei (1648), Giacinto Gimignani (1649),[31] Giacinto Brandi, Francesco Allegrini[32] (c. 1650), Cortona (1651–4), and Cozza (1667–73) created the most impressive aggregate of friezes and ceilings after the Palazzo Barberini; the great Gallery of the Quirinal Palace, the most extensive work of collaboration, dated 1656–7, where, under Cortona's general direction, G. F. Grimaldi (who seems to have had an important share in the enterprise), the Schor brothers,[33] Guglielmo and Giacomo Cortese (Courtois), Lazzaro Baldi, Ciro Ferri, Mola [209], Maratti, Gaspar Dughet, and some minor *Cortoneschi* appear side by side;[34] and the cycle of frescoes in the Pamphili palace at Valmontone near Rome,[35] painted between 1657 and 1661 by Mola, Giambattista Tassi ('il Cortonese'), Guglielmo Cortese, Gaspar Dughet, Cozza, and Mattia Preti.

Once again some of the most sumptuous decorations follow after 1670. Apart from Cozza's library ceiling in the Palazzo Pamphili [214], mention must be made of the frescoes in the Palazzo Altieri by Cozza, Canuti,[36] and Maratti [219] and of Giovanni Coli's and Filippo Gherardi's immense Gallery in the Palazzo Colonna (1675–8) [218].[37] And once again, this chronological situation also prevails throughout Italy.

This survey makes it abundantly clear that monumental fresco decorations in Roman churches belong mainly to the Late Baroque. The stylistic change from the High to the Late Baroque can be traced in Preti's fresco of the Stanza dell'Aria in the Valmontone palace, dated 1661.[38] It was here for the first time that the High Baroque method of using time-honoured concepts of firm organization and clear, incisive structure as well as of stressing the individuality

and massiveness of each single figure were abandoned and replaced by a flickering dotting of the entire ceiling with seemingly casually arranged figures so that the eye seeks a focusing or resting point in vain. Compared with Preti's Valmontone fresco, even such contrasting performances as Cortona's and Sacchi's Barberini ceilings [153, 161] have basic features in common. Preti's work, on the other hand, shows stylistic idiosyncrasies which soon became current not only in painting but also in the sculpture of the Late Baroque.

Cozza was quick in accepting his friend Preti's new manner; and with the latter's Valmontone frescoes almost entirely gone, Cozza's library ceiling in the Palazzo Pamphili [214][39] takes on particular importance. Painted with an extremely light and luminous palette, the individual figures remain much indebted to Domenichino. Thus one is faced here with the attractive and almost unbelievable spectacle of a typically Late Baroque open sky peopled with masses of allegorical figures in a naive classicizing style.

In a varying degree elements of Preti's revolution will be found in the decoration of churches from about 1670 on. A generic description has to emphasize two decisive points. In the grand decorative frescoes of the High Baroque, each figure has an immense plastic vitality, seems close to the beholder, and plays a vital part in the whole composition [153]. By contrast, the figures of the later series of frescoes [213, 216, 217] have, as it were, only a collective existence; they are dependent on larger units and, what is more, get much smaller with the feigned distance from the spectator until they are lost in the immeasurable height of the empyrean. While Cortona's figures seem to act before the open sky, the figures now people the

214. Francesco Cozza:
Apotheosis of Casa Pamphili, 1667–73. Fresco.
*Rome, Palazzo Pamphili
in Piazza Navona, Library*

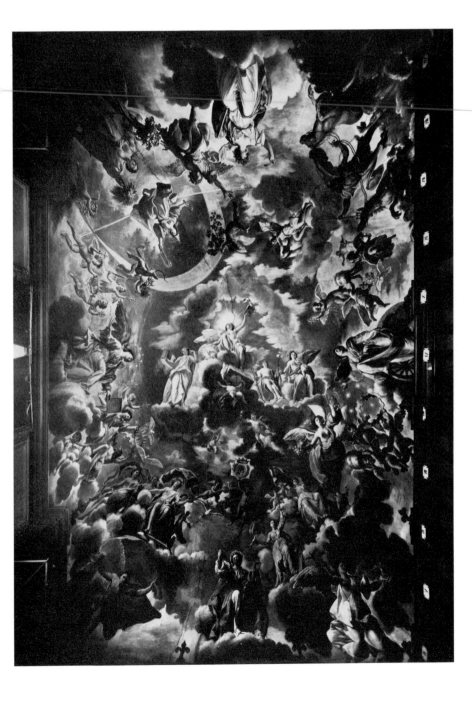

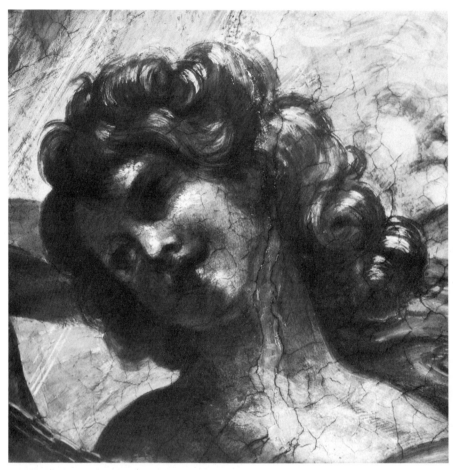

215. Giovan Battista Gaulli:
Head of an Angel, after 1679. Fresco. Detail.
Rome, Gesù, apse

sky, they inhabit it as far as the eye can see. And secondly, dazzling light envelops them. The nearer they are to the source of divine illumination, the more ethereal they become. Aerial perspective supports the diminution of figures in creating the sensation of infinitude. The Correggio-Lanfranco tradition had, of course, a considerable share in bringing about the new illusionism.

Despite such common features, some of the monumental fresco decorations are poles apart. We saw in a previous chapter (p. 174) how Gaulli in the Gesù became the mouthpiece of Bernini's ideas. Before this Genoese artist (1639-1709)[40] arrived in Rome he had laid the foundation for his style in his native city under the impression of Van Dyck and Strozzi and, above all, of Correggio during a stay at Parma.

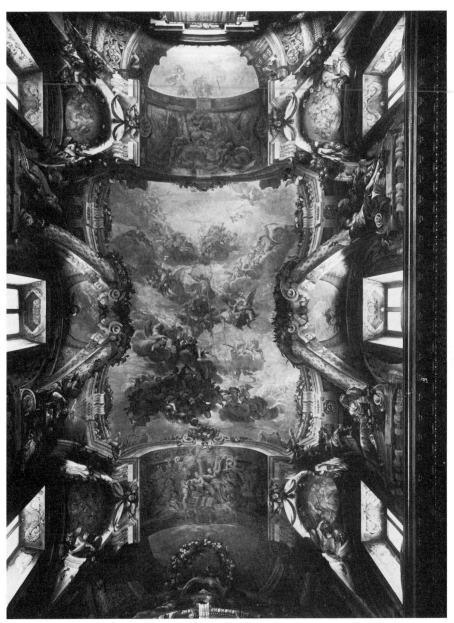

216. Domenico Maria Canuti and Enrico Haffner: Apotheosis of St Dominic, 1674–5. Fresco.
Rome, SS. Domenico e Sisto

A brilliant talent, also one of the first portrait painters of his time, he was capable of conveying drama in fresco as well as on canvas with a warm and endearing palette. The head of the Angel of illustration 215, a detail from his frescoes in the Gesù, gives a good idea of the loving care of execution, the bravura of handling, the free and easy touch, and the flickering light effects produced by the application of fresh impasto. Moreover, by painting the half-open mouth and the eyes as if seen through a haze – revealing his study of Correggio's *sfumato* – he managed to endow such a head with the languid spirituality of Bernini's latest manner (see illustrations 78 and 79). In his later work his palette got paler and the intensity of his style dwindled, no doubt under the influence of the prevailing taste of the *fin de siècle*.

The Bolognese Domenico Maria Canuti (1626-84), in his time a celebrated fresco painter, had been reared in the tradition of Reni's late manner, and came to Rome in 1672. What he saw there was not lost on him, for his dramatic *Apotheosis of St Dominic*[41] [216] in the open centre of the ceiling of SS. Domenico e Sisto discloses his familiarity with the grouping of figures and the aerial and light conquests of Gaulli's Gesù decoration, then *in statu nascendi*.[42] But Canuti also introduced a novelty. He framed the entire ceiling by a rich *quadratura* design (executed by Enrico Haffner) whereby Rome was given a type of scenographic fresco for which neither Bernini nor Cortona had any use, but which one may well expect to find in Genoa.

The greatest of all *quadratura* painters, Padre Andrea Pozzo[43] (1642-1709), also took his cue from the Bolognese masters. By contrast to the decorative profusion of Haffner's design, Pozzo's *quadratura* is always strictly architectural and in so far old-fashioned; it is only the virtuosity and hypertrophic size of his schemes – typical signs of a late phase – that give him his special stature. Within the *quadratura* frame-

217. Andrea Pozzo:
Allegory of the Missionary Work of the Jesuits,
1691-4. Fresco.
Rome, S. Ignazio, ceiling of nave

work in S. Ignazio [217], as elsewhere, he arranged his figures in loosely connected light and dark areas – proof that he too had learned his lesson from Gaulli.

Giovanni Coli (1636-81) and Filippo Gherardi (1643-1704), two artists from Lucca who always worked together, combined their Venetian training with the study of Cortona's style in the gallery of the Palazzo Colonna.[44] The Cortonesque framework, executed by G. P. Schor between 1665 and 1668, displays an enormous accretion of detail, while the strongly Venetian central panel [218] dazzles the eye by the almost unbelievable entanglement of figures, keels, and masts, all bathed in flickering light. How far this style is removed from Cortona's High Baroque needs no further comment. It is also evident that Gaulli's and Coli-Gherardi's styles have little in common, arising as they do from different sources: the one mainly from Bernini's spiritualized later manner, the other from the hedonistic Cortonesque-Venetian painterly tradition. On the other hand, compared with Maratti's Palazzo Altieri fresco [219], Gaulli and Coli-Gherardi seem to be on the same side of the fence.

Let the reader be reminded that these three contemporary works far outdistanced in importance any other fresco executed during the 1670s, and, furthermore, that Gaulli's cycle was infinitely more Roman and infinitely stronger than Coli-Gherardi's ceiling. The constellation that emerged at this historic moment was simply a struggle for primacy between Gaulli and Maratti. Forty years after the Cortona-Sacchi controversy the fronts were once again clearly defined. But neither the 'baroque' nor the 'classical' wing was the same. Gaulli's style had a distinctly metaphysical basis; often

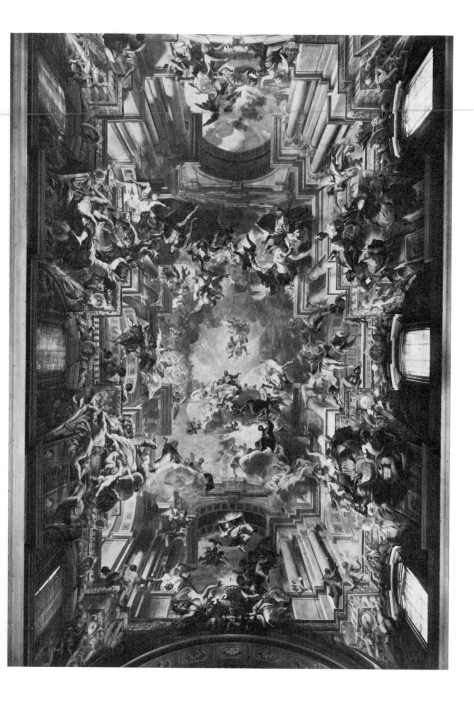

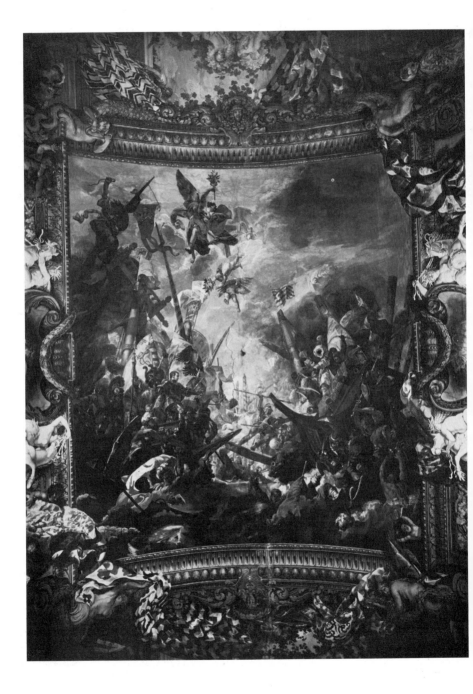

218. Giovanni Coli and Filippo Gherardi:
The Battle of Lepanto, 1675-8.
Fresco. *Rome, Palazzo Colonna, Gallery*

mystical and stirring in its appeal, it may have derived its strength from the forces lying behind Bernini's late manner: the current revival of pseudo-dionysiac mysticism[45] as well as the growing popularity of Molinos's quietism. A knowledge of the intervening history of painting makes it evident that the odds weighed heavily against Gaulli. Just as the close followers of Bernini in sculpture had not a ghost of a chance in the face of Late Baroque rationalism which was backed by the strong French party, so also in painting: Gaulli's mystical Late Baroque soon burnt itself out in the cool breeze blowing from Maratti's classicist camp.[46]

Carlo Maratti (1625-1713)

A study of Maratti's Altieri ceiling [219] plainly shows that he wanted to restore the autonomous character of the painted area: once again the fresco is clearly and simply framed.[47] He also wished to reinstate the autonomy of the individual figure; he returned to the classical principle of composing with few figures and to an even, light palette which invites attention to focus on the plastically conceived figure, its attitude and gestures; he almost relinquished the *sotto in su* but, characteristically, did not revive the austere *quadro riportato* of the Early Baroque classicism. Moreover, the figures themselves are more Baroque and less Raphaelesque than he may have believed them to be, and the composition lacks poignancy and incisive accents. It undulates over the picture plane, and the first impression is one of a perplexing mass of sodden form. The closeness of this style to Domenico Guidi's in sculpture is striking.

It is also revealing that the Early Baroque classicism of Reni's *Aurora* [32] and the High

Baroque classicism of Sacchi's *Divina Sapienza* [161] are closer to each other than either is to Maratti's Late Baroque Classicism. By comparison, Maratti had gone some way towards a reconciliation of the two opposing trends, the Baroque and the classical. In every sense he steered an agreeable middle course. His paintings contain no riddles, nothing to puzzle the beholder, nothing to stir violent emotions. His glib handling of the current allegorical language, the impersonal generalizations with which his work abounds, admission of just the right dose of festive splendour – all this predestined his grand manner to become the accepted court style in Louis XIV's Europe. Maratti was not an artist given to speculation and theory.[48] Somewhat paradoxically, it was his pragmatic approach by virtue of which he came up to the hybrid theoretical expectations of his friend Bellori who, like Agucchi before him, wanted the artist's *idea* to result from the empirical selection of beautiful parts rather than from an *a priori* concept of beauty.[49]

All this sounds perhaps scathing, yet it must be admitted that Maratti was an artist of extraordinary ability. Born at Cammerino (Marches) in 1625, he appeared as a boy of twelve in Andrea Sacchi's studio. As early as 1650 his reputation was firmly established with the Sacchesque *Adoration of the Shepherds* in S. Giuseppe dei Falegnami. From then on Maratti's career was a continuous triumph, and, indeed, one monumental masterpiece after another left his studio. Nor was he entirely partial to the manner of Sacchi and the other classicists. The paintings of the 1650s reveal the impact of Lanfranco's Baroque; he admitted influences from Cortona and Bernini and even had some sympathy with the mystic trend of the second half of the century. What impressed his contemporaries most was that he re-established a feeling for the dignity of the human figure seen in great, simple, plastic forms and rendered with a sincerity and moral conviction without

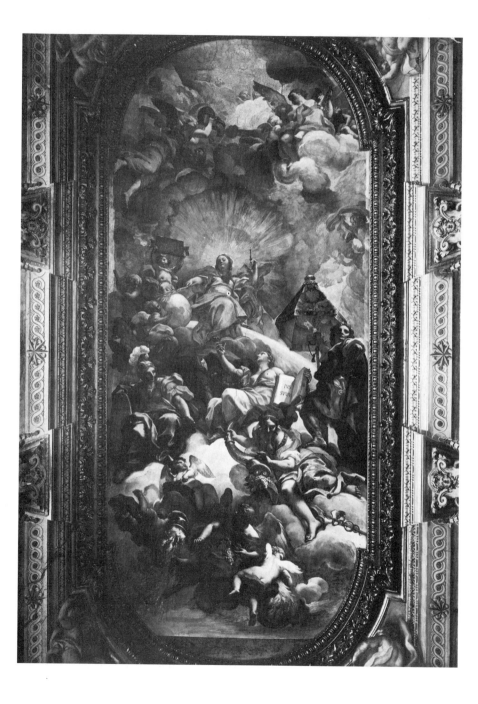

parallel at that moment [220]. As early as the mid seventies neither Gaulli nor the Cortona succession was left with a serious chance, and by the end of the century Rome had to all intents and purposes surrendered to Maratti's manner. At his death in 1713 his pupils were in full command of the situation.[50]

PAINTING OUTSIDE ROME

During the period under review the contribution of Tuscany, Lombardy, and Piedmont was rather modest. Apart from Reni's late manner, even Bologna had little to offer that would compare with the great first quarter of the century. Venice slowly began to recover, while the schools of Genoa and Naples emerged as the most productive and interesting, next to Rome.

A bird's-eye view of the entire panorama reveals that neither the classical nor the crypto-romantic trend was peculiar to Rome. In fact, the Roman constellation is closely paralleled in other centres. With Reni in an unchallenged position at Bologna, his late manner became the inescapable law during the 1630s. His influence extended far beyond the confines of his native city, bringing about, wherever it was felt, a soft, feeble, sentimental, and rather structureless classicism. One can maintain that there was almost an inverse ratio between Reni's success on the one hand and Cortona's and Lanfranco's on the other. Soon Reni's Baroque classicism filtered through to the North and South of Italy. In Milan Francesco del Cairo (1607-65),[51] who began in Morazzone's manner [221, 222], formed his style in the later 1640s on Reni and Venice, and his work became languid, thin, and classical. His contemporary, Carlo Francesco Nuvolone, called 'il Panfilo' (1608-61?), had a similar development; dependent on Reni, which earned him the epithet 'Guido lombardo', he exchanged his early *tenebroso* manner for a light tonality. In Florence, too, Reni's influence is evident; in Furini's work, superimposed on the

219 (*opposite*). Carlo Maratti:
The Triumph of Clemency, after 1673. Fresco.
Rome, Palazzo Altieri, Great Hall

220 (*above*). Carlo Maratti:
Virgin and Child with St Francis and St James,
1687. *Rome, S. Maria di Montesanto*

221. Morazzone: St Francis in Ecstasy, *c.* 1615. Milan, *Brera*

222. Francesco del Cairo: St Francis in Ecstasy, *c.* 1630. *Milan, Museo del Castello Sforzesco*

native tradition, it led to a highly sophisticated, over-refined style. On the other hand, probably impressed by Poussin's classicism, from the 1640s on an artist like Carpioni in Venice found a way out of the local academic eclecticism through elegant classicizing stylizations. The classical *détente* of the 1640s and 50s is particularly striking in Naples. During their late phase such artists as Battistello, Ribera, and Stanzioni turned towards Bolognese classicism, while Mattia Preti embraced the fashion in his early period, only to break away from it some time later. Sicily, finally, had an artist of distinction in Pietro Novelli, called 'il Monrealese' (1603–47), who abandoned his early Caravaggesque *tenebroso* in the early 1630s, not uninfluenced by Van Dyck's visit to Palermo (1624) and under the impact of a journey to Naples and Rome (1631–2).[52]

By and large, the classical reaction, which lies broadly speaking between 1630 and 1660, spells a falling off of quality. This does not, of course, apply to the two great leaders, Sacchi in Rome and Reni at Bologna, nor to the position in Venice and Florence, where Baroque classicism was to some extent a regenerative agent; yet it is certainly true of the first generation of Carracci pupils at Bologna (p. 92 ff.); it is true of Guercino's manner in the last thirty years of his life, when he was open to Reni's influence and produced works with a strong classical bias, many of which have no more than a limited interest; and it is, above all, true of Naples, where the *élan* of the early Ribera fizzles out during the fourth and fifth decades into a rather feeble academic manner.

On the other side of the fence were some artists of a slightly younger generation (most

of them born between 1615 and 1625), who reacted vigorously against the prevalent Baroque classicism. The principal names to be mentioned are Maffei from Vicenza, the Florentine Mazzoni, and the Genoese Langetti, all working in Venice and the *terra ferma;* Valerio Castello in Genoa; Mattia Preti and the early Luca Giordano in Naples. In one way or another these and other artists revitalized Caravaggio's heritage; but theirs was a new, painterly High Baroque Caravaggism [229, 230, 237, 245], the Caravaggism that was handed on to Magnasco and Crespi and through them to Piazzetta and the young Tiepolo.

There is, however, an important area where these Baroque individualists and the Baroque classicists meet. For the lightening of the palette, the most characteristic mark of those masters who turned Baroque classicists, was not simply a tactical reversal of their earlier *tenebroso* manner; it had a distinctly positive aim, namely

223. Guido Reni: Girl with a Wreath, *c.* 1635. *Rome, Capitoline Museum*

the unification of the picture plane by means of an even distribution of colour and light. These painterly tendencies, mentioned in a previous chapter (p. 261) and nowhere more evident than in Reni's late manner [223], distinguish High Baroque classicism from the classicism of the first quarter of the century. Although worlds apart, it is these painterly tendencies that form the common denominator between the Baroque classicists and the *neo-Caravaggisti.* In all other respects they differed most seriously.

To the comparatively light palette of the Baroque classicists the *neo-Caravaggisti* opposed a strong chiaroscuro; to the relatively smooth handling of paint, a *pittura di tocco* (stroke) and *di macchia* (spot) – work with the loaded brush and sketchy juxtapositions of small areas of colour; to the harmonious scale of tones, unexpected colour contrasts; to the classical types of beauty, subjective deviations; to the tedium of balanced compositions, unaccountable vagaries; to the facile rhetorical repertory, violent movement, drama, and even a new mysticism. Even though this generic list of contrasts may be too epigrammatic, it helps to clarify the entangled position of the second and third quarters of the century.

No doubt Salvator Rosa's crypto-romanticism had partisans up and down the peninsula. But allegiance to one trend or the other also changed; some artists were torn between them. Giovan Benedetto Castiglione seems the most remarkable example.

Bologna, Florence, Venice, and Lombardy

After this introduction, the Reni succession at Bologna need not detain us: Francesco Gessi (1588–1649), Giovan Giacomo Sementi (1580–1636), Giovanni Andrea Sirani (1610–70) and his daughter Elisabetta (1638–65), or Luca Ferrari from Reggio (1605–54) who transplanted his master's manner to Padua and Modena. These mediocre talents transformed

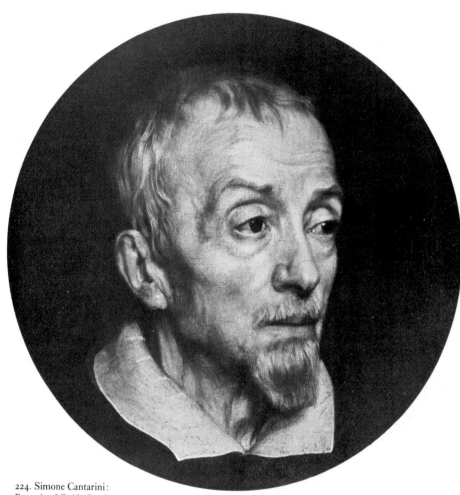

224. Simone Cantarini:
Portrait of Guido Reni,
c. 1640. Bologna, Pinacoteca

the positive qualities of Reni's late 'classicism' [223][53]: the unorthodox simplicity of his inventions into compositions of boring pedantry; his refined silvery tonality into a frigid scale of light tones; his vibrant tenderness into sentimentality; and his late 'sketchy' manner with its directness of appeal was neither understood nor followed. Among the Reni succession in Bo-

logna only two artists stand out, namely Simone Cantarini (1612–48)[54] and Guido Cagnacci (1601–63);[55] the former for having left a number of carefully constructed, serene, and strong works, in which Carraccesque elements are combined with those from Cavedoni and the early Reni to form a distinctly personal style, well illustrated by the moving portrait of his

aged teacher [224]; the latter, who sought his fortune in Vienna (c. 1657) and became court painter to Emperor Leopold I, for breaking away from the orthodox Baroque classicists and creating some works of great poignancy in strange violet and bluish tones. On the whole, the Bolognese remained faithful to their clas-

This tradition was handed on through Girolamo Curti, called il Dentone (1570-1632), to Angelo Michele Colonna (1600-87) and Agostino Mitelli (1609-60). These two artists joined forces and for a time almost monopolized *quadratura* painting, working together at Parma, Florence [225], Genoa, Rome, and even Madrid, where

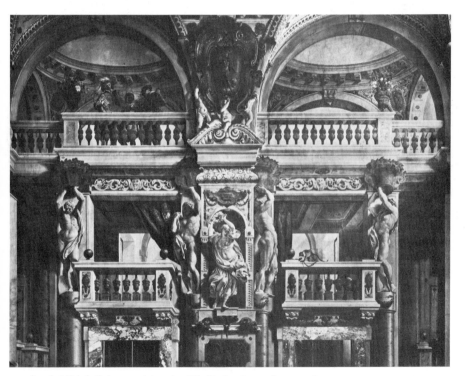

225. Angelo Michele Colonna and Agostino Mitelli: *Quadratura* frescoes, 1641.
Florence, Palazzo Pitti, Museo degli Argenti, third room

sical tradition, guarded, during the second half of the century, by the three *caposcuole*, Reni's pupil, Domenico Maria Canuti (p. 334); Cantarini's pupil, Lorenzo Pasinelli (1629-1700);[56] and Albani's pupil, Carlo Cignani, to whom I have to return in a later chapter.

At the same time, Bologna continued to be the acknowledged centre of *quadratura* painting.

Mitelli died. Their rich scenographic views, foreshadowing the Late Baroque by virtue of the complexity of motifs, form a decorative court style in its own right rather than a mere framework for figure painters. They educated a large school, and since Mitelli claimed to have invented *quadratura* with more than one vanishing point,[57] it is he who must be credited with

226. Francesco Furini: Faith, *c.* 1635.
Florence, Palazzo Pitti

having laid the foundation for the rich eighteenth-century development of this speciality.

Very different from the Bolognese was the Florentine position.[58] Matteo Rosselli, who has been mentioned (p. 98), made sure that the typically Florentine qualities of elegant design and bright local colour remained for a time unchallenged. He educated the foremost artists of the next generation, among whom may be mentioned Giovanni Mannozzi, called Giovanni da San Giovanni (1592–1636), Francesco Furini (*c.* 1600–46), Lorenzo Lippi (1606–65), Baldassare Franceschini, called Volterrano (1611–89), and Jacopo Vignali (1592–1664)[59] and his pupil Carlo Dolci (1616–86). These artists responded in various ways to the rarefied atmosphere of the Florentine court.

Furini, above all, influenced by Reni, produced paintings of a morbid sensuality [226]. The ultramarine flesh-tones together with his *sfumato* give his pictures a sweetish, sickly flavour, but nobody can deny that he had a special gift for rendering the melodious calligraphy of the female body, thus disclosing his attachment to the Mannerist tradition. Giovanni da San Giovanni had a more healthy temperament. An artist capable of handling very large fresco commissions, even the experience of Rome (fresco in the apse of SS. Quattro Coronati, 1623) did not rid him of Florentine idiosyncrasies. Although his light touch, translucent colours, and the ease and brilliance of his production make him one of the most attractive Florentine painters of the Seicento, the retardataire character of his art[60] is shown by the fresco cycle in the Sala degli Argenti of the Palazzo Pitti (1635), glorifying Lorenzo de’ Medici’s concern for art and philosophy, a work, incidentally, that was finished after Giovanni’s death by Furini, Ottavio Vannini, and Francesco Montelatici, called Cecco Bravo (1607–61).[61] The comparison with Cortona’s work in Rome and Florence reveals Giovanni’s provincialism.[62]

Giovanni da San Giovanni had been dead for some years when Cortona settled in Florence, and Furini died before he left. But a number of other artists were thrown off their course by the study of Cortona's grand manner. Volterrano's case is characteristic. He had begun as Giovanni da San Giovanni's assistant in the Palazzo Pitti (1635-6) and painted his frescoes in the Villa Petraia (1637-46)[63] in the same manner, but changed to a Cortonesque style in the Sala delle Allegorie of the Palazzo Pitti (c. 1652), a style which with modifications he maintained in his later work (e.g. the frescoes in the dome of the SS. Annunziata, 1676-80/3). A similar course was taken by Giovanni Martinelli (active between 1635 and 1668), while Furini's pupil Simone Pignoni (1611-98)[64] made few concessions to the new vogue. It was mainly Ciro Ferri (1634-89), Cortona's closest follower, who ensured the continuity of the Cortona succession in Florence. Ferri made it his home in 1659-65 in order, above all, to complete the Palazzo Pitti frescoes which his master had left unfinished when he returned to Rome in 1647.[65]

Carlo Dolci's art, the Florentine counterpart to that of Sassoferrato in Rome, deserves a special note because the languid devoutness expressed by his half-figures of Virgins and Magdalens must be regarded as the fullest realization of one side of Late Baroque mentality. These cabinet pictures, painted with the greatest care in a slick miniature technique, enjoyed a great reputation in his time, and contemporaries admired what appears to the modern spectator a false and even repulsive note of piety. A real prodigy, Dolci at the age of sixteen painted the excellent portrait of Ainolfo de' Bardi [227]. But it was not only his own vow to devote his life to religious imagery, in acceptance of Cardinal Paleotti's theoretical demand,[66] that prevented him from making headway as a portrait painter. He had no chance against the immensely successful Fleming Justus Sustermans (1597-1681), court painter in Florence from

227. Carlo Dolci: Portrait of Fra Ainolfo de' Bardi, 1632. *Florence, Palazzo Pitti*

228. Giulio Carpioni: Bacchanal, before 1650. *Columbia, South Carolina, Museum of Art*

1620 on and a master of the official international style of portraiture which developed in the wake of Van Dyck.

Finally, Stefano della Bella (1610–64)[67] must be mentioned, whose place is really outside the tissue of Florentine Seicento art. The teacher of his choice was Callot; magically attracted by the latter's etchings, della Bella preserved in his work something of their spirited elegance. His best and most productive period was the ten years in Paris, 1639–49, in the course of which his style changed under the impact of Rembrandt and the Dutch landscapists. He must rank as one of the greatest Italian etchers, but he was a typical master of the *petite manière*, his more than a thousand etchings, often peopled with tiny figures, being concerned with all aspects of popular life. The influence of his work on the further course of Italian genre painting was probably greater than is at present realized.

The development in Venice[68] shows certain parallels to that in Florence, in spite of the

exquisite work of the great triad Fetti, Lys, and Strozzi, who brought entirely new painterly values to bear on the Venetian scene between 1621 and 1644, the year of Strozzi's death. What Matteo Rosselli had been for Florence, Padovanino was for Venice. Most painters of the second and third quarter of the century stemmed from him; they carried over his academic eclecticism into a refined and often languid Seicentesque idiom. Girolamo Forabosco from Padua (1604/5–79), distinguished as a portrait painter, Pietro Muttoni, called della Vecchia[69] (1605–78), Giulio Carpioni[70] (1613–79), who worked mainly at Vicenza, and the feeble Pietro Liberi (1614–87) represent different facets of this somewhat superficial manner. The Palma Vecchio character of Forabosco's portraits, Vecchia's neo-Giorgionesque paintings, and Carpioni's Poussinesque Bacchanals would seem to be nuances of the same classicizing vogue [228].[71]

Like Cortona's appearance in Florence, Luca Giordano's stay in Venice in 1653 had a revolutionizing effect on local artists. Riberesque in his early phase, Giordano brought to Venice a Neapolitan version of Caravaggio's 'naturalism' and *tenebroso*. This dramatic manner found immediate response in the work of the Genoese Giambattista Langetti[72] (1625–76), who probably began under Assereto, then worked in Rome under Cortona,[73] and appeared in Venice towards the mid century. His work is distinguished by violent chiaroscuro applied with a loaded brush [229]. Langetti's manner was followed, above all, by the German Johan Karl Loth (1632–98), who had settled in Venice after 1655,[74] and by his competitor Antonio Zanchi from Este (1631–1722). Further, Pietro Negri, Zanchi's pupil, the Genoese Francesco Rosa, and Antonio Carneo (1637–92) from Friuli[75] should be mentioned in this context.

But long before Luca Giordano's first visit to Venice two 'foreigners', both artists of exceptional calibre, revolted against the facile

229. Giambattista Langetti:
Magdalen under the Cross, after 1650.
Venice, Palazzo Rezzonico, from Le Terese

230. Francesco Maffei: Parable of the Workers in the Vineyard, *c.* 1650. *Verona, Museo di Castelvecchio*

academic practices: Francesco Maffei[76] from Vicenza (*c.* 1600–60) and the Florentine Sebastiano Mazzoni[77] (1611–78). Soon after 1620 Maffei liberated himself from the fetters of current Mannerism. The study of Jacopo Bassano, of Tintoretto and Veronese, and, above all, of such Mannerists as Parmigianino and Bellange led to his characteristic manner, which was fully developed in the *Glorification of Gaspare Zane* (1644, Vicenza, Museum). Painting with a nervous and rapid brush, he delighted in exhibiting sophisticated dissonances. Much of his work has an uncouth and almost macabre quality, a refreshingly unorthodox style which may best be studied in such late works as the *Glorification of the Inquisitor Alvise Foscarini* (1652, Vicenza, Museum) and those in the Oratories delle Zitelle and of S. Nicola da Tolentino (Vicenza). The ghostly *Parable of the Workers in the Vineyard* (Verona, Museo di Castelvecchio) [230] exemplifies his late manner, showing in addition how he transformed his debt to Domenico Fetti. The younger Mazzoni, the only artist of this generation who took the teachings of Fetti and Strozzi to heart, was surely impressed by Maffei's work. His brilliant and free brushwork, to be found as early as 1649 in the paintings in S. Benedetto (Venice), and, slightly later, in the most remarkable *Annunciation* [231], makes him a real forerunner of the Venetian Settecento. Another Florentine, Mazzoni's contemporary Cecco Bravo, shows a similar unconventional handling of paint [232].

231. Sebastiano Mazzoni: Annunciation, c. 1650.
Venice, Accademia

232. Cecco Bravo: Apollo and Daphne, c. 1650.
Ravenna, Pinacoteca

With Giovanni Coli and Filippo Gherardi echoes of the Roman grand manner reached Venice, but the strongest impact came once again from Luca Giordano, whose pictures in S. Maria della Salute and other churches, painted in the late 1660s and the 1670s, show the light palette of his mature style, derived mainly from impressions of Veronese. The stage was set for the artists born between about 1635 and 1660. They accepted Giordano's neo-Venetian manner to a greater or lesser extent and helped to prepare the way for the great luminous art of the eighteenth century. Andrea Celesti[78] (1637–c. 1711), whose masterpieces are in the parish church at Desenzano (Lake Garda); Federico Cervelli from Milan (active 1674–c. 1700), Sebastiano Ricci's teacher; An-

tonio Bellucci (1654–1727),[79] who spent his best years abroad, and many others[80] should here be named. But neither Maffei nor the *tenebrosi* were forgotten. Thus Celesti as well as Bellucci were indebted to Maffei, while Antonio Molinari[81] (1665–1727), working in Zanchi's manner and revealing Giordano's influence, also opened the way to Piazzetta's *tenebroso* style [233].

In conclusion it must be said that, with the exception of Langetti, Mazzoni, and Maffei, few of these painters fully relinquished the facile decorative manner of a Forabosco and a Liberi, nor were they capable of a new and coherent vision – in spite of the fact that some of them lived far into the eighteenth century.

While Venice and the *terra ferma* were teeming with painters to whom magnificent oppor-

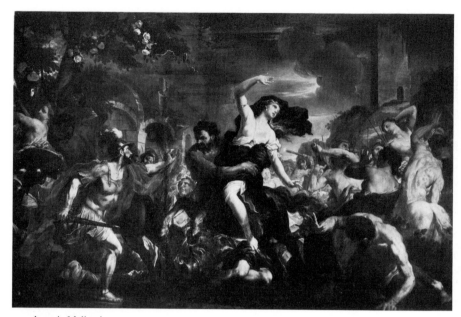

233. Antonio Molinari:
Fight of Centaurs and Lapiths, *c.* 1698.
Venice, Palazzo Rezzonico

tunities were offered, Milan's decline after the
Borromeo era was irrevocable. Apart from
Francesco del Cairo, who has been mentioned,
there were no painters of real rank. Carlo Fran-
cesco Nuvolone (1608–61), to whom reference
has also been made, a minor master, a brother
of the even weaker Giuseppe (1619–1703), had
the most flourishing school.[82] Giovanni Ghisolfi
(1623–83) contributed little to the art of his
native city. At the age of seventeen he went to
Rome, where he made his fortune as Italy's first
painter of views with fanciful ruins (p. 498).

The Lombard tradition of the unadorned
rendering of painstakingly observed facts was
kept alive in Bergamo rather than Milan. Only
recently have these qualities become apparent
in Carlo Ceresa's (1609–79)[83] portraits, painted
in an austere 'Spanish taste'. Ceresa was a
contemporary of Evaristo Baschenis (1607?–77)
and helps an understanding of the ambience in
which the latter's art flourished. Probably Italy's
greatest still-life painter, Baschenis, as is well
known, concentrated on one speciality, the
pictorial rendering of musical instruments.
What attracted him was the warm tonality of
the polished wood as much as the complex
stereometry of the shapes. By means of a dry,
almost 'photographic' realism he thus produced
abstract-cubist designs in which highly sophis-
ticated space definitions are supported by the
contrast and superimposition of flat, bulging,
smooth, broken, or meandering forms [234].
These truly monumental creations, so foreign
to northern still-life painters, have, of course,
their intellectual focus in Caravaggio's 'realistic
stylization' of the Italian still life (p. 43).

234. Evaristo Baschenis:
Still life, after 1650.
Brussels, Musée des Beaux Arts

Genoa

The beginning of the seventeenth century opened up rich possibilities for Genoese painters. A vigorous native school developed which flourished unbroken into the eighteenth century in spite of the disastrous plague of 1657. It is a sign of the innate strength of the Genoese school that it also survived the loss of its greatest Seicento painters; Bernardo Strozzi went to Venice, Castiglione spent most of his working life outside Genoa, and Gaulli settled in Rome. While at the dawn of the century Genoa had been a melting pot of various foreign trends, after 1630 her artists influenced artistic events in Venice and Rome.

To be sure, these masters belong to the broad stream of the intra-Italian development and they received as much as they gave. Strozzi is a case in point. After his early 'dark' period with strong chiaroscuro effects [235], not independent of the early seventeenth-century Lombard masters, his palette lightened while he was still in Genoa; his colours became rich, warm, glowing, and succulent, and the flesh tones ruddy. The impression the great Venetian masters, above all Veronese, made upon him after his removal to Venice in 1630 should not be underestimated [236], but the sketchy touch, the bravura of the brush-stroke, and the luminosity of his paint he owed to Fetti and Lys. In contrast, however, to the 'modernity' of these masters – Fetti's *petite manière* with its emotional intricacies and Lys's romantic extravagances – Strozzi remained essentially tied to the tradition of the grand manner with its

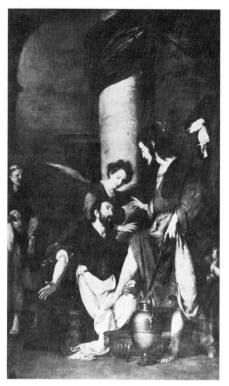

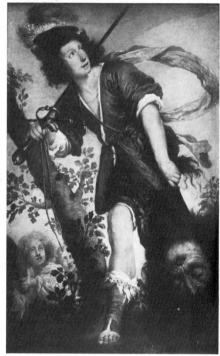

235. Bernardo Strozzi:
St Augustine washing Christ's Feet, c. 1620-5.
Genoa, Accademia Ligustica

236. Bernardo Strozzi:
David, c. 1635.
Vierhouten, Van Beuningen Collection

focus on rhetorical figure compositions.[84] On the other hand, the painterly, festive, and dynamic qualities of his Genoese-Venetian manner destined him to become the third in the triad of 'foreign' artists who rekindled the spirit of great painting in Venice.

The influence exercised by Strozzi in Genoa can hardly be overestimated. Only recently it has been shown how strongly Giovanni Andrea de Ferrari (1598-1669) leant on him.[85] This prolific artist was himself the head of a large studio through which, among others, Giovanni Bernardo Carbone, Valerio Castello, and Castiglione passed. Ferrari's work - true to the special

artistic climate at Genoa - reveals echoes of Tuscan Mannerism as well as of Caravaggism, of Rubens and Van Dyck as well as Velasquez who was in Genoa in 1629 and 1649. Unequal in quality, towards the end of his career he ridded himself of academic encumbrances and produced works of considerable depth of expression in a free and painterly style.[86]

Whether or not this happened under the influence of his pupil Valerio Castello (1624-59), son of Bernardo, is difficult to decide.[87] Valerio had also gone through Fiasella's school but soon set out on conquests of his own. Impressed by Correggio, Van Dyck, and Ru-

237. Valerio Castello:
Rape of the Sabines, c. 1655.
Genoa, Coll. Duca Nicola de Ferrari

bens, he produced a few masterpieces of extra-ordinary intensity during a career of hardly more than ten years. A real painter, he loved violent contrasts and fiery, scintillating hues; he is dramatic, sophisticated, and spontaneous at the same time. A work like the rapid oil sketch for the *Rape of the Sabines* [237], dating from his last years, clearly prepares the way for Magnasco. Under Castello was trained the gifted Bartolomeo Biscaino who died during the plague of 1657 at the age of twenty-five.[88]

As the century advanced three different trends can be clearly differentiated, all developing on the foundations of the past: first, in the wake of Van Dyck an 'aristocratic' Baroque much to the taste of the Genoese nobility, mainly kept alive in the portraits of Giovanni Bernardo Carbone (1614-83) and to a certain extent in those of Gaulli; secondly, also of Flemish derivation, the rustic genre which triumphed in Castiglione; and finally, the great decorative Baroque fresco, for which Luca Cambiaso had prepared the ground.

Giovanni Benedetto Castiglione, called il Grechetto (before 1610?-65), ran through almost the whole gamut of stylistic possibilities in the course of his astonishing career.[89] Attracted early by the Flemish animal genre, he seems to

have studied with Sinibaldo Scorza (1589–1631), who in turn depended on such Flemings as Jan Roos (1591–1638), Snyders's pupil, active in Genoa from 1614 on. At the same time a passionate student of Rubens and Van Dyck, he was also the first Italian to discover Rembrandt's etchings – as early as about 1630 – which means that Caravaggism reached him in the northern transformation. Rembrandt remained a permanent stimulus throughout his life. A stay in Rome for more than a decade from 1634 on led him to appreciate Poussin's as well as Bernini's art. In these years he evolved his fluent technique of brush drawings in oil on paper and invented the monotype technique. Back in Genoa in 1645, he painted such monumental Baroque works as the *St Bernard adoring Christ on the Cross* (S. Maria della Cella) and *St James driving the Moors from Spain* (S. Giacomo della Marina). Slightly later he treated philosophical subjects in a picturesque mood [238] which shows him close to the Testa–Rosa current in Rome. His appointment as court painter at Mantua in 1648 brought him in contact with the art of Fetti, whose freedom of touch was soon reflected in his work. At the end of his career he produced ecstatic compositions of great intensity, reminiscent of Bernini's style of these years. Perhaps more clearly than any other artist Castiglione exposes the particular problems which assailed his generation, for throughout his life he was torn between a philosophical scepticism and an ecstatic surrender.

Being equally at home in the rustic genre and the grand manner – history, mythology, and religious imagery – a brilliant draughtsman and engraver, he influenced artists as distant in time and as different in style as Tiepolo and Fragonard. Nearer home, his rustic and bucolic manner found followers in his son Francesco (d. 1716), who succeeded him as court painter at Mantua; in Anton Maria Vassallo[90] (active *c*. 1640–60); and in a number of specialists of the

238. Giovanni Benedetto Castiglione: The Genius of Castiglione, 1648. Etching

animal genre, while his grand manner had a formative influence on the younger generation of great decorative painters.

The protagonists of the older Genoese fresco style are the brothers Giovanni Andrea (1590–1630) and Giovanni Battista (1592–1677) Carlone,[91] who belong to that fertile Lombard family which had great decorators among its members for three centuries. The later fresco style is mainly represented by Domenico Piola[92] (1628–1703) and Gregorio de Ferrari[93] (1647–1726). It is they, above all, who brought about the glorious climax of this art at Genoa. In their mature works both artists influenced each other, but the younger man proved to be the stronger master. The essential character of their later style derives from a wedding of Pietro

239. Gregorio de Ferrari: Decorative Frescoes,
1684. Detail.
Genoa, Palazzo Balbi-Groppallo, Sala delle Rovine

da Cortona's grand manner with Bolognese *quadratura*[94] and of Castiglione's verve with Correggio's *sfumato* – resulting in an immensely rich, festive, and luminous manner with a strong emphasis on the ebullient decorative element [239]. The early Piola leant heavily on Castiglione, Strozzi, and Valerio Castello. It has been suggested that he turned to his Cortonesque manner under the influence of Giovanni Maria Bottalla, Cortona's assistant on the Barberini ceiling, who died, however, in 1644, the year he returned to his native Genoa. The Correggiesque note of the style was due to Gregorio de Ferrari who had spent four years at Parma (1669–73), an experience that contributed to the formation of the proto-Rococo character of Gregorio's art. His *Death of St Scolastica* [240],

one of his masterpieces on canvas, illustrates this style at its best. Still tied by a tender link to Bernini's late manner, the languor and sensibility of expression, the suppleness of the bodies, the great musical curve of the composition, the sweetness and elegant rhythms of the angels – all this presages the art of the Rococo. A manner similarly delicate and refined was practised by Bartolomeo Guidobono (1654–1709) who again had made Correggio his special study. He spent almost thirty years of his life at the court of Duke Vittorio Amedeo in Turin.

Naples

When Caravaggio came to work in Naples in 1606–7, the Mannerists were in full command

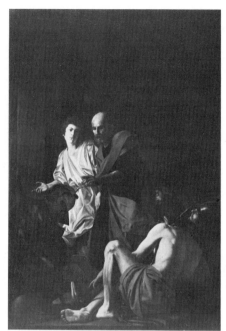

240. Gregorio de Ferrari:
Death of St Scolastica, *c.* 1700.
Genoa, S. Stefano

241. Giovanni Battista Caracciolo:
Liberation of St Peter, 1608-9.
Naples, Chiesa del Monte della Misericordia

of the situation, and he never swayed artists like Fabrizio Santafede (*c.* 1560-1634), Gian Bernardino Azzolino (*c.* 1572-1645), Gerolamo Imparato (1550-1621), and Belisario Corenzio (*c.* 1560-1643) from their course; they continued their outmoded conventions, largely indebted to the Cavaliere d'Arpino, through the first half of the seventeenth century. The only exception to the rule was Giovanni Battista Caracciolo, called Battistello (*c.* 1570-1637), [95] the solitary founder of the 'modern' Neapolitan school who, in opposition to the Mannerists, developed his new manner based on the deeply felt experience of Caravaggio. His *Liberation of St Peter* in the Chiesa del Monte della Misericordia [241], painted two or three years (1608-9) after Caravaggio's *Seven Works of Mercy* in the same

church, is not only a monument of orthodox Caravaggism, but its specific qualities, the hard contrasts, the compositional austerity and mute intensity reveal a talent of the first rank. Yet the pattern of Baroque painting in Naples was determined neither by Caracciolo's early manner nor by him alone.

He had a younger rival in the Spaniard Jusepe de Ribera (1591-1652)[96] who, after journeys through Italy, settled in Naples in 1616 and soon painted Caravaggesque pictures utterly different from those by Caracciolo. While the latter hardened and stiffened the more flexible style of the master in an attempt at rendering internalized drama, the former loosened and externalized what he had learned from Caravaggio by an aggressive and vulgar realism and a

painterly chiaroscuro with flickering light effects. Ribera found a powerful patron in the Duke of Osuna, the Viceroy of Naples, who appointed him court painter, and later viceroys and Neapolitan nobles were equally attracted by his art. It is an interesting phenomenon that Ribera's passionate and violent pictures satisfied the taste of the Neapolitan court society. What attracted them was probably the essentially Spanish sensual surface quality of Ribera's realism – his permanent contribution to European Seicento painting.[97]

From about 1630 on Naples was drawn into the main stream of Baroque painting owing to the considerable contributions made by painters coming from Rome. It is mainly three different trends that were acclimatized in Naples: Domenichino's Baroque classicism, Lanfranco's intense High Baroque, and the discursive Caravaggism of the second generation.[98] Domenichino's somewhat disappointing activity in Naples has been discussed in a previous chapter (pp. 81–2). Lanfranco was more successful; he settled in Naples in 1633 for thirteen extremely active years during which he created, among others, four large fresco cycles: the dome of the Gesù Nuovo (1635–7, only the pendentives preserved), the nave and choir of the Certosa of S. Martino (1637–8), the entire decoration of SS. Apostoli (1638–46), and finally the dome of the Cappella di S. Gennaro in the cathedral (1641–3), where he vied with the pendentives painted by his arch-enemy Domenichino. Despite the hostility of the Neapolitan artists, Domenichino was an immediate success; the dynamic orchestra of Lanfranco's Correggiesque illusionism, by contrast, appealed above all to the masters of the second half of the century[99] and made possible the grand decorative phase of Neapolitan painting which began with Mattia Preti and rose to international importance with Luca Giordano and Solimena. Contact with the younger Caravaggesque trend was made through Vouet, who sent the *Circumcision* in S.

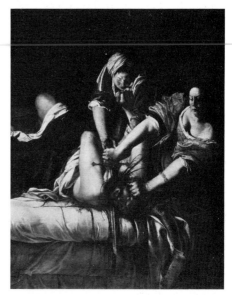

242. Artemisia Gentileschi:
Judith slaying Holofernes, *c.* 1620.
Florence, Uffizi

Arcangelo a Segno[100] from Rome in 1623 and, more important, through Artemisia Gentileschi (1593–*c.* 1652), Orazio's daughter, who was born in Rome, spent some years in Florence (1614–20) – which were not without influence on the formation of her style – and settled in Naples in 1630, to leave this city only for a brief visit to her father in London (1638–9). An artist of a high calibre and fierce temperament, she showed an inclination for gruesome scenes painted in lively translucent tones and with a meticulous attention to detail [242]. This almost romantic form of Caravaggism impressed the Neapolitans as much or even more[101] than Vouet's decorative Baroque manner, which hardly revealed his early infatuation with Caravaggio.

Long before Domenichino's coming to Naples, Caracciolo had turned to pre-Mannerist and Bolognese models, possibly stimulated by impressions he received during a hypothetical journey to Rome. In any case, his later work from the end of the second decade on, in the Certosa of S. Martino, in S. Maria la Nova, S. Diego all'Ospedaletto, and elsewhere shows the strong impact of Bolognese classicism. Equally, Ribera's early fire subsided in the 1630s, his realism mellowed, his compositions became dry and classicizing, and the chiaroscuro made way for a light palette with cool silvery tones.[102]

Although Neapolitan artists stuck tenaciously to the various facets of Caravaggism – epitomized by the names of Caracciolo, Ribera, and Artemisia Gentileschi – the swing towards Bolognese classicism from the mid 1630s on is a general phenomenon. It may be observed with minor masters such as Francesco Guarino (1611–54)[103] whose early Riberesque manner was followed by classicizing academic works, or Pacecco (Francesco) de Rosa (1607–56), a determined purist, the Sassoferrato of Naples, for whom Domenichino was specially important. Such purist tendencies may also be found in the paintings of Charles Mellin ('Carlo Lorenese', 1597–1649), a Frenchman from Nancy, who lived and died in Rome, but worked in Naples in 1643–7,[104] as well as in those of Giovanni Andrea Coppola (1597–c. 1659) who practised his art in distant Apulia.

A much greater artist than all these, the most important *caposcuola* of the mid century, Massimo Stanzioni (1586–1656), turned in a similar direction. His early development is still unclear;[105] but his Caravaggism is allied to that of Vouet, Saraceni, and Artemisia rather than to that of Caracciolo and Ribera. In his best works, belonging to the decade 1635–45, he displays a distinct sense for subtle chromatic values, melodious lines, gracefully built figures, and mellow and lyrical expressions. Stanzioni was famed as the 'Neapolitan Guido Reni'; and the

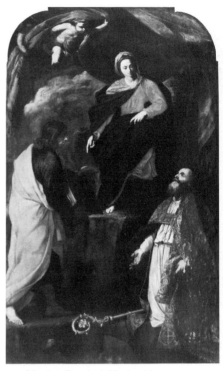

243. Massimo Stanzioni: Virgin with SS. John the Evangelist and Andrea Corsini, c. 1640. Naples, S. Paolo Maggiore

refined, somewhat tame and nerveless quality of his art, characteristic of the second quarter of the century, will be apparent if his *Virgin with SS. John the Evangelist and Andrea Corsini* [243] is compared with an equally characteristic work of the second decade such as Cavedoni's *Virgin with SS. Alò and Petronius* [38]. Stanzioni's painting also shows the Neapolitan blending of Caravaggism and Bolognese classicism. At the end of his career the Bolognese note, increasingly noticeable from the late 1630s on,[106] quelled the subtle qualities of his earlier manner (see the very late *Consecration of St Ignatius*, Naples, Palazzo Reale).

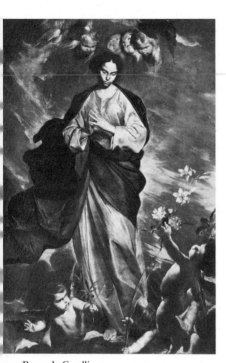

244. Bernardo Cavallino:
The Immacolata, c. 1650.
Milan, Brera

Stanzioni mediates between the art of the older generation and that of his pupil, Bernardo Cavallino (1616, not 1622, -56).[107] A Caravaggista strongly influenced by Artemisia, Cavallino gave his best in cabinet pictures. His work is in a category of its own; a great colourist, his tenderness, elegance, gracefulness, and delicacy are without parallel at this moment [244]. Yet mutatis mutandis such contemporaries as Furini in Florence and Valerio Castello in Genoa represent a similar stylistic phase. It is interesting to note that the giants of the Baroque epoch with their massive energy lived to a ripe old age (p. 303), while these effeminate artists of the

mid century died before they reached maturity. Their sophisticated art hardly contained the germs to generate a strong new style.

Other painters had a share in the rich life of the Neapolitan school during the three decades after 1630. The more important names should at least be mentioned: Andrea Vaccaro (1604, not 1598, -1670),[108] who found a rather vulgar formula of combining second-hand Caravaggism with Bolognese classicism (Reni, Domenichino), was a popular success at his time, but a master of the second rank; the Riberesque Cesare (c. 1605-53) and Francesco (1612-c. 56) Fracanzano, sons of Alessandro, the younger brother being an artist of considerable calibre;[109] Aniello Falcone (1607-56), the specialist in luminous battle-pieces 'without a hero',[110] and his pupils Andrea de Leone (1610, not 1596, -1685)[111] and Domenico Gargiulo, called Micco Spadaro (1612-75), who under Callot's influence produced the typically Neapolitan topographical genre peopled with great numbers of small figures. In addition, reference must be made to the well known 'Monsù Desiderio' - a 'pseudonym' covering at least three different artists, as recent research has revealed.[112] The major figure of this trio, François Nomé, was born at Metz in 1593, came to Rome in 1602, settled at Naples not later than 1610 and seems to have spent the rest of his life there (the year of his death is unknown). His bizarre and ghostlike paintings of architecture, often crumbling and fantastic, belong to the world of Late Mannerism rather than to that of the Seicento, and the suggestion made by R. Causa that his style is ultimately derived from the stage settings of Buontalenti and Giulio Parigi has much to recommend it. The second artist, Didier Barra,[113] also from Metz, left his native city about 1608 and followed his compatriot to Naples, where he was still active in 1647. In contrast to Nomé he was a faithful recorder of views, while the third - hitherto anonymous - artist imitated Nomé's

work. Unduly boosted in our own days, 'Monsù Desiderio'-Nomé was in fact a minor figure, but it was he who opened up a taste in Naples for the weird type of cabinet picture and thus helped to prepare Micco Spadaro's microcosmic views as well as Salvator's romantic battle-pieces.

All the Neapolitan painters so far mentioned belong essentially to the first half of the century. The social upheaval caused by Masaniello's revolt in 1647 also resulted in some artists leaving the city;[114] but more serious was the great plague of 1656 during which many of them died. Pacecco de Rosa, Falcone, and, above all, Massimo Stanzioni and Cavallino were among the victims. The year of the plague may therefore be regarded as an important turning-point.

The character of Neapolitan painting in the second half of the century differs indeed considerably from that of the first half. The change is mainly due to two masters of the first rank, Mattia Preti from Calabria ('Cavalier Calabrese' 1613-99) and Luca Giordano (1634-1705). Although belonging to two different generations, they are similar in that both show in their work an immense vigour, an innate power and dynamic quality almost without parallel in Italy or elsewhere at this moment. They are also similar in that their art received lasting stimuli from Venetian colourism as well as from the Roman grand manner. Moreover, it was with them that Neapolitan painting assumed an intra-Italian and even international status. In other respects they differ most decisively: Preti, grave, problematical, dramatic, a moralist, and throughout his life a *Caravaggista*, is a man typical of the Seicento, while Giordano, in all and everything the antithesis, truly belongs to the eighteenth century. It is for this reason that more about him will be said later (p. 462).

Preti's career took him up and down the peninsula. As early as 1630 he was in Rome painting, it seems, Caravaggesque pictures;[115] between 1640 and 1646 he stayed intermit-

tently in Venice[116] but returned to Rome in 1641-2, 1650-1, and once again, 1660-1. It was during the fifth decade that Sacchi, Domenichino, and Reni attracted him;[117] the frescoes in S. Biagio at Modena, executed between 1653 and 1656, still reveal that influence.[118] In the mature works created during his Neapolitan period (1656-60) he wedded reminiscences of Battistello, Ribera, and Guercino with those of Tintoretto and Veronese; nor was he impervious to Luca Giordano's early work. The result was a powerful dramatic style *sui generis,* the apocalyptic quality of which is well illustrated by the bozzetto [245] for one of the frescoes, now lost, painted as an ex-voto on the city gates

245. Mattia Preti: The Plague of 1656.
Naples, Museo Nazionale

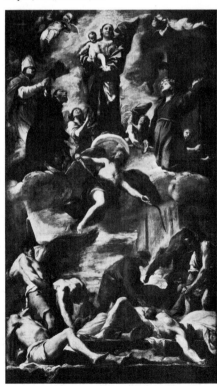

during the plague of 1656. In 1661 Preti went to Malta where he stayed, with brief interruptions,[119] to the end of his life. His major work there was the decoration of the immense vault of S. Giovanni at Valletta (1661–6) with frescoes in which Venetian luminosity prevails. But never again did Preti rise to the dramatic height of his Neapolitan period.

His contemporaries Luca Forte (active c. 1640–70) and Paolo Porpora (1617–73) open the long line of Neapolitan still-life painters by their sumptuous Caravaggesque flower-pieces, and a few pictures have now also been ascribed to Porpora's teacher, Giuseppe Recco's father Giacomo (1603–54) – with how much justifi-

cation it is still too early to say.[120] Porpora's most distinguished pupils, Giovan Battista Ruoppolo (1629, not 1620, –93) and Giuseppe Recco (1634–95),[121] both much better known than their teacher, continued the tradition to the end of the century. The name of Giovan Battista Recco, probably Giuseppe's elder brother, has to be added to theirs. A recently discovered painting (signed and dated 1654) of exceptional quality stimulated a tentative reconstruction of Giovan Battista's œuvre.[122] Ruoppolo is famed for his vigorous, succulent, and ample flower-pieces [246], monumental like Preti's paintings in the grand manner and thus utterly different from Flemish still lifes

246. Giovanni Battista Ruoppolo: Still life, late seventeenth century. *Naples, Museo di S. Martino*

with which, however, he must have been conversant.[123] Giuseppe Recco's temperament was less exuberant. His speciality was fish-pieces, painted with impeccable taste and an incomparable sense for tone values. Dominici reports that in his youth Recco spent some time in Milan working with a famous still-life painter. On this slender evidence art historians have concluded that he was trained by Baschenis. True or not, Recco's still lifes often have a Lombard quality of austerity and immobility. Intimate and noble rather than extrovert and grand, they seem to presage the age of Chardin.

No such painter arose in Rome, and this is indicative of the future course of events. In the last analysis it was the memory of Caravaggio's conquests, always treasured in Naples in contrast to Rome, that made possible the remarkable ascendancy and variety of the Neapolitan school.

LATE BAROQUE AND ROCOCO

CIRCA 1675-CIRCA 1750

CHAPTER 15

INTRODUCTION

After the death of Alexander VII (1667) papal patronage in Rome rapidly declined, and even the aged Bernini was starved of official commissions. On the other hand, it was precisely at this moment, during the last quarter of the seventeenth and the beginning of the eighteenth centuries, that the Jesuits and other Orders as well as private patrons gave painters unequalled opportunities. Yet Maratti's international Late Baroque in painting, the fashionable style of the day, had as little power to electrify and galvanize and to lead on to new ventures as Carlo Fontana's parallel manner in architecture. In fact, Rome's artistic supremacy was seriously challenged not only by much more stirring events in the north and south of Italy, but above all by the artistic renaissance in France, which followed in the wake of the amassing of power and wealth under Louis XIV's centralized autocracy. The time was close at hand when Paris rather than Rome came to be regarded as the most dynamic art centre of the western world.

None the less the Roman Baroque had an unexpectedly brilliant exodus. Under the Albani Pope Clement XI (1700-21) Rome began to rally, and the pontificates of Benedict XIII Orsini (1724-30) and Clement XII Corsini (1730-40) saw teeming activity on a monumental scale. It was under these popes that many of the finest and most cherished Roman works saw the light of day, such as the Spanish Stairs, the façade of S. Giovanni in Laterano, and the Fontana Trevi. Moreover, foreigners streamed to Rome in greater numbers than ever before, and artists from all over Europe were still magically drawn to the Eternal City. But the character of these pilgrimages slowly changed. Artists no longer came attracted by the lure of splendid opportunities as they did in the days of Bernini and Pietro da Cortona; more and more they came only to study antiquity at the fountain head.

To a certain extent the French Academy in Rome, founded as early as 1666, anticipated this development, and in the eighteenth century the students of the Academy were almost entirely concerned with the copying of ancient statuary. With the growth of French influence in all spheres of life, political, social, and artistic, the classicizing milieu of the Academy developed into a powerful force in Rome's artistic life; and it was due to this centre of French art and culture on Roman soil that countless French artists were able, often successfully, to compete for commissions with native artists.

The popes themselves nourished the growing antiquarian spirit.[1] Preservation and restoration of the remains of antiquity now became their serious concern. From the mid sixteenth century on antique statues had left Rome in considerable numbers.[2] This trade assumed such proportions that Innocent XI (1676-89) prohibited further export, and Clement XI's edicts of 1701 and 1704 confirmed this policy. Clement XI also inaugurated a new museological programme by planning the Galleria Lapidaria and the Museum of Early Christian Antiquities in the Vatican. Clement XII (1730-40) and Benedict XIV (1740-58) followed in his footsteps; under them the Museo Capitolino took shape, the first public museum of ancient art. In keeping with the trend of the time, the learned Benedict XIV opened four Academies in Rome, one of them devoted to Roman antiquities. Clement XIII (1758-69) set the seal on this whole movement in 1763 by appointing Winckelmann, the father of classical archaeology, director general of Roman antiquities, an office, incidentally, first established by Paul III in 1534. Finally, it was in 1772, during Clement XIV's pontificate (1769-74), that construction began of the present Vatican museum, the largest collection of antiquities in the world.

Archaeological enthusiasm was also guiding the greatest patron of his day, Cardinal Alessandro Albani, when he planned his villa outside Porta Salaria.[3] Built literally as a receptacle for his unequalled collection of ancient statues (now mainly in Munich), the villa, erected by Carlo Marchionni between 1746 and 1763, was yet intended as a place to be lived in – an imperial *villa suburbana* rather than a museum. The Cardinal's friend and protégé Winckelmann helped to assemble the ancient treasures; and it was on the ceiling of the sumptuous great gallery that Anton Raphael Mengs, the admired apostle of Neo-classicism, painted his *Parnassus,* vying, as his circle believed, with ancient murals.

There was, to be sure, a strong nostalgic and romantic element in the eighteenth-century fascination with the ancient world. Nowhere is this more evident than in the work of Giovanni Battista Piranesi (1720-78), who, coming from Venice, where he had studied perspective and stage design, settled permanently in Rome in 1745.[4] The drama and poetry of his etchings of Roman ruins (*Le Antichità romane,* 1756) have no equal, even at this time when other artists of considerable merit were attracted by similar subjects, stimulated, more than ever before, by a public desirous to behold the picturesque remains, true and imaginary, of Roman greatness. Although Piranesi was deeply in sympathy with the new tendencies, a devoted partisan of Roman pre-eminence and a belligerent advocate of the great variety in Roman art and architecture,[5] his vision, procedure, and technique ally him to the Late Baroque masters. Yet he never tampered with the archaeological correctness of his views in spite of his play with scale – contrasting his small, bizarre figures derived from Salvator to the colossal size of the ruins – or in spite of the warm glow of Venetian light pervading his etchings and of the boldness of his compositions, in which, true to the Baroque tradition, telling diagonals prevail. It is the Baroque picturesqueness of these plates, so different from the dry precision of Neo-classical topographical views, that determined for many generations the popular conception of ancient Rome.

Piranesi's *vedute* of ancient Rome no less than those of the contemporary city (*Vedute di Roma,* published from 1748 on) reveal the trained stage designer, whose early and most famous series of plates, the *Carceri d'Invenzione,* first issued in 1745 and re-etched in 1760-1, are romantic phantasmagorias derived from Baroque opera sets [247]. The *Carceri* and the *Vedute,* with their oblique perspectives which add a new dimension of drama and spatial expansion, reveal the influence of Ferdinando

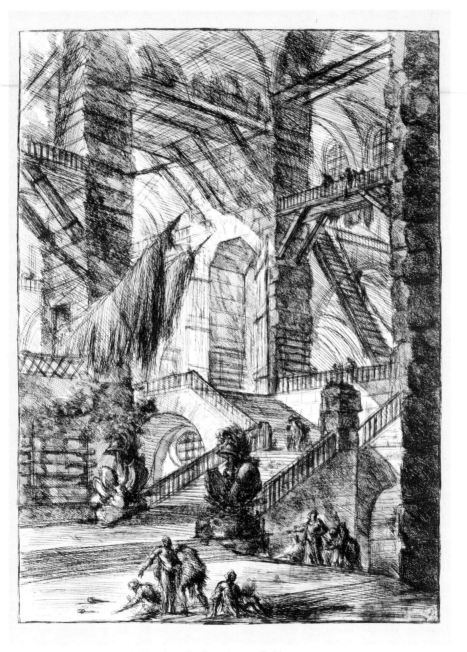

247. Giovanni Battista Piranesi: Plate from the *Carceri*, 1745. Etching

Bibiena's 'invention' of the *scena per angolo* (Chapter 19, Note 47) [335]. Thus in the *vedute* Piranesi wedded two traditions which seem mutually exclusive: that of the Baroque stage with that of topographical renderings of an 'architectural landscape'. Piranesi's case, however, was far from unique, for in the course of the eighteenth century ideas and conceptions of the stage designer invaded many sectors of the other arts.[6]

It should be recalled that during most of the seventeenth century the influence of the stage on painting and architecture was more limited than is usually believed. It is, of course, true that effects first developed for the stage were also used in works of a permanent character.[7] But the basic High Baroque concept of the unification of real and artistic space, that illusionism which blurs the borderline between image and reality, is not by its very nature a 'theatrical' device. It may be argued that the theatre and the art of the seventeenth century developed in the same direction, for in both cases an emotionally stirring and often overwhelming chain of seemingly true impressions was to induce the beholder to forget his everyday existence and to participate in the pictorial 'reality' before his eyes. Yet Roman fresco painting from Cortona's Barberini ceiling to Gaulli's work in the Gesù shows as little direct impact from the theatre as Borromini's architecture. In another chapter I have attempted to demonstrate that the Venetian Baldassare Longhena, by contrast, owed decisive impulses to the stage and that it was he who laid the foundation for the scenographic architecture of the eighteenth century. Similarly, in the history of Late Baroque painting from Padre Pozzo to Tiepolo stage requisites such as the proscenium arch, the curtain, the *quadratura* backdrop, and the painted 'actors' stepping out of the painted wings play an important and often overwhelming part. To what extent painting in the grand manner and stage design were then regarded as basically identical

operations may be gathered from Pozzo's work *Perspectiva pictorum et architectorum* (Rome, 1693) which was to serve the theatre and the Church alike. Statistical facts illuminate the growing obsession with the theatre during the Late Baroque period: in 1678, for instance, 130 comedies were represented on private stages in Rome alone.[8] In the early eighteenth century the theatre had even greater importance; it was certainly as significant for the creation of visual conventions and patterns as cinema and television are in the twentieth century.[9]

If in the new era it is pertinent to talk of the ascendancy of the stage designer over the painter (often, of course, one and the same person), the ascendancy of the painters over the sculptors seems equally characteristic. There is circumstantial documentary evidence that on many occasions painters were called upon to make designs for the sculptors to work from – a situation utterly unthinkable in Bernini's circle. Only a few examples can here be given. Maratti seems to have had a hand in the work of many sculptors. He was a close friend and constant adviser of Paolo Naldini; he made designs for four allegorical statues in S. Maria in Cosmedin,[10] for Monnot's tomb of Pope Innocent XI, and for the monumental statues to be placed in Borromini's tabernacle niches in the nave of S. Giovanni in Laterano.[11] Gaulli is credited with the designs of Raggi's rich stucco decorations in the Gesù.[12] The Genoese painter Pietro Bianchi, who settled in Rome, maintained close contacts with the sculptors Pietro Bracci, Giovanni Battista Maini, Filippo della Valle, Francesco Queirolo, and others and supplied them with sketches, as his biographer relates in detail.[13] The new custom appears also to have spread outside Rome, to mention only the Neapolitan Solimena who helped the sculptor Lorenzo Vaccaro with designs.[14] This whole trend, which of course came to an end with the dawn of Neo-classicism, was not in the first place the result of the inability of sculptors to

cope with their own problems. It was, to a certain extent in any case, connected with a re-valuation of the sketch as such, a question which must be discussed in a wider context.

In the age of the Renaissance, drawing became the basis for the experimental and scientific approach to nature. But drawing remained a means to an end, and the end was the finished painting. The latter was prepared by many stages, from the first sketches and studies from nature to the carefully executed final design and cartoon. As early as the sixteenth century artists began to feel that this laborious process maimed the freshness and vitality of the first thought. Vasari, writing in 1550, made the memorable observation that 'many painters . . . achieve in the first sketch of their work, as though guided by a sort of fire of inspiration . . . a certain measure of boldness; but afterwards, in finishing it, the boldness vanishes.' So, an academic Mannerist arose as the mouthpiece of anti-academic spontaneity of creation. Throughout the seventeenth and even the eighteenth century the Renaissance method of careful preparation, fully re-instated by Annibale Carracci, remained the foundation of academic training, but a number of progressive artists, although never working on canvas *alla prima* (possibly with the exception of Caravaggio), attempted to preserve something of the brio of spontaneous creation, with the result that the finish itself became sketchy. During the eighteenth century, from Magnasco to Guardi, the masters working with a free, rapid brush-stroke assumed steadily greater importance and foreshadowed the position of romantic painters like Delacroix, for whom the first flash of the idea was 'pure ex-pression' and 'truth issuing from the soul'. It is in the context of this development that the painter's sketch as well as the sculptor's boz-zetto were conceded the status of works of art in their own right, and even the first ideas of architects, such as the brilliant 'notes' by Juvarra, were looked upon in the same way.

All this required a high degree of sophisti-cation on the part of the public. The rapid sketches no less than the works of the masters of the loaded brush made hitherto unknown claims on sensibility and understanding, for it surely needs more active collaboration on the part of the spectator to 'decipher' a Magnasco than a Domenichino or a Bolognese academician. The eighteenth-century virtuoso was the answer. Keyed up to a purely aesthetic approach, he could savour the peculiar qualities and charac-teristics of each master; he would be steeped in the study of individual manner and style and find in the drawing, the sketch, and the boz-zetto equal or even greater merits than in the finished product. Behind this new appreciation lay not only the pending emergence of aesthetics as a philosophical discipline of sensory experi-ence, but above all the concept of the uniqueness of genius. The new interpretation of genius made its entry from about the middle of the seventeenth century on, and comparative changes in the artist as a type were not long delayed. But the early eighteenth-century artist was not the genius of the romantic age who revolted against reason and rule in favour of feeling, naiveté, and creation in sublime soli-tude. By contrast, the Late Baroque artist was a man of the world, rational and immensely versa-tile, who produced rapidly and with the greatest ease; and since he felt himself part of a living tradition, he had no compunction in using the heritage of the past as a storehouse from which to choose at will. Juvarra and Tiepolo are the supreme examples.

But now it is highly significant that none of the new terms of reference arising during the Late Baroque were of Italian origin. Aesthetics as an autonomous discipline was a German accomplishment;[15] the nature of genius was defined in England; and it was the Englishman Jonathan Richardson who laid down the rules of the 'science of connoisseurship'.[16] Nor had Italy a collector of drawings of the calibre and

discriminating taste of the Frenchman Mariette. The theory of art, that old domain of Italian thought, lay barren. In the eighteenth century the relationship between Italy and the other nations was for the first time reversed: English and French treatises appeared in Italian translations. While in England the whole structure of classical art theory was attacked and replaced by subjective criteria of sensibility, Conte Francesco Algarotti (1712–64),[17] at this period the foremost Italian critic but in fact no more than an able vulgarizer, dished up all the old premises, precepts, and maxims of the classical theory. Not only Roman, but Italian supremacy had seen its day. France and, as the century advanced, England assumed the leading roles.

It is all the more surprising that never before had Italian art attracted so many foreigners. The treasures of Italy seemed now to belong to the whole of Europe and nobody could boast a gentleman's education without having studied them. It is equally surprising that never before were Italian artists a similar international success. In an unparalleled spurt they carried the torch as far as Lisbon, London, and St Petersburg – just before it was extinguished.

ARCHITECTURE

INTRODUCTION: LATE BAROQUE CLASSICISM AND ROCOCO

An authoritative history of Italian eighteenth-century architecture cannot yet be written. Many of the monuments are not at all or only insufficiently published; the dating of many buildings is controversial or vague; the buildings without architects and the names of architects without buildings abound. It has been pointed out that in one corner of Italy, the province of Treviso alone, about 2,000 palaces, churches, and oratories were built in the course of the century. Nobody has seriously attempted to sift this enormous material, and it is only recently that a number of major architects have been made the subject of individual studies.[1] Any attempt at a coherent vision of the period would therefore appear premature. And yet it seems that certain conclusions of a general nature may safely be drawn.

From the end of the seventeenth century onwards architects looked back to a dual tradition. There was close at hand and still fresh before everybody's eyes the great work of the Roman seventeenth-century masters, which decisively altered the course of architecture and formed a large reservoir of new ideas and concepts. There was, moreover, the older tradition, that of the Cinquecento, and behind it that of classical antiquity itself. It is at once evident that from the end of the seventeenth century onwards the repertory from which an architect was able to choose had almost no limits, and it is a sign of the new period that architects were fully aware of this and regarded it as an asset. Juvarra is a case in point. His studies ranged over the whole field of ancient and Italian archi-tecture without any aesthetic blinkers – from measured drawings of the Pantheon to Brunel-leschi, Sanmicheli, the Palazzo Farnese, Ber-nini, and Borromini, among many others. This attitude is nowadays usually condemned as wicked, academic and eclectic, and, to be sure, it cannot be dissociated from the intellectualism of the academies and their steadily growing influence. Hesitatingly, however, I have to pro-nounce once more the all-too-obvious common-place that every artist and architect in so far as he works with a traditional grammar and with traditional formulas is an 'eclectic' by the very nature of his activity. It is the mixture and the interpretation of this common 'language' (and, naturally, also the reaction against it) on which not only the personal style and its quality but also the evolution of new concepts depend. The longer a homogeneous artistic culture lasts – and to all intents and purposes the Italian Renaissance in its broadest sense spanned an epoch of more than 350 years – the larger is, of course, the serviceable repertory. How did the architects from the late seventeenth century onwards handle it?

No patent answer can be given, and this characterizes the situation. On the one hand, there are those, typical of a waning epoch, who reach positions of eminence by skilfully mani-pulating the repertory without adding to it a great many original ideas, and among their number Carlo Fontana, Ferdinando Fuga, and Luigi Vanvitelli must be counted. Then there are those who fully master the repertory, choose here and there according to circumstances, and yet mould it in a new and exciting way. The greatest among these revolutionary traditional-ists is certainly Filippo Juvarra. Finally there

is the band of masters, possibly smaller in numbers, who contract the repertory, follow one distinct line, and arrive at unexpected and surprising solutions. They are still the least known and often not the most active architects of the period; thus the names of Filippo Raguzzini, Gabriele Valvassori, Ferdinando Sanfelice, and Bernardo Vittone, to mention some of the most important, convey very little even to the student of Italian architecture.

Admittedly our division is far too rigid, for architects may at different periods of their careers or in individual works tend towards one side or the other. But on the whole one may safely postulate that the first two groups drew on the store of classical forms and ideas rather than on the Borrominesque current, without, however, excluding a temperate admixture from the latter. The last group, by contrast, found its inspiration directly or indirectly mainly in Borromini. When discussing Bernini's and Cortona's architecture, I tried to assess the specific quality of their 'classicism'. Architects could follow their lead without accepting the dynamic vigour of their work. Dotti's draining of Cortona's style in the Madonna di S. Luca near Bologna is as characteristic as Vanvitelli's formalization of Bernini's S. Andrea al Quirinale in the Chiesa dei PP. delle Missioni at Naples (c. 1760). The classicism that emerged often replaced the wholeness of vision of the great masters by a method of adding motif to motif, each clearly separable from the other (p. 373); to this extent it is permissible to talk of 'academic classicism', but we shall see that the term should be used with caution.

A rather severe classicism was the leading style in Italy between about 1580 and 1625. After that date a tame classicizing architecture (e.g. S. Anastasia and Villa Doria-Pamphili in Rome; cathedral at Spoleto) was practised by some minor masters parallel to the work of the giants of the High Baroque. Towards the end of the century a new form of classicism once

again became the prevalent style. In the process of revaluation Carlo Fontana must be assigned a leading part. Venice with Tirali and Massari soon followed, and various facets of a classicizing architecture remained the accepted current until they merged into the broad stream of Neo-classicism. But by comparison with the architecture of Neo-classicism the classical architecture of pre-Neo-classicism appears varied and rich and full of unorthodox incidents. We may therefore talk with some justification of 'Late Baroque Classicism', and it would be a contradiction in terms to circumscribe this style by the generic epithet 'academic'. The process of transition from 'Late Baroque Classicism' to Neo-classicism can often be intimately followed, and before the monuments themselves there is not a shadow of doubt when to apply the terminological division.

What differentiates Late Baroque Classicism from all previous classical trends is, first, its immense versatility,[2] and to this I have already alluded. In Rome, Turin, and Naples it may be flexible enough to admit a good deal of Borrominesque and pseudo-Borrominesque decoration; even Late Mannerist elements, such as undifferentiated framing wall strips, often belong to the repertory. One of the strangest cases is the façade of S. Maria della Morte in Rome, where Fuga weds Ammanati's Mannerist façade of S. Giovanni Evangelista (Florence) with the aedicule façade stemming from Carlo Rainaldi. Venice, by contrast, steers clear of any such adventures and returns straight to Scamozzi, Palladio, and beyond, to classical antiquity. The second feature characteristic of the style is its deliberate scenic quality, which is not only aimed at by men born many years apart, like Fontana, Juvarra, and Vanvitelli, but also by the masters of the non-classical trend, as a glance at Raguzzini's Piazza S. Ignazio proves. Finally, both classicists and non-classicists favour a similar kind of colour scheme: broken colours light in tone, blues, yellows,

pinks, and much white – in a word typically eighteenth-century colours, and in Carlo Fontana's work the turning away from the warm, full, and succulent colours of the High Baroque may be observed. Thus, on a broad front the classical and non-classical currents have essential qualities in common.

In the over-all picture of eighteenth-century architecture Late Baroque Classicism appears to have the lead. But one should not underestimate the importance of the other trend, which may safely be styled 'Italian Rococo' – not only because of the free and imaginative decoration and the relinquishing of the orders as a rigid system of accentuation, but mainly because of the rich play with elegant curvilinear shapes and spatial complexities. Most of the

architects who brought about the anti-classical vogue were born between 1680 and 1700, the majority in the nineties, just like the sculptors and painters with similar tendencies. From about 1725 on and for the next twenty-five years these masters had an ample share in the production of important buildings. Next to Rome, the chief centres are Naples, Sicily, and Piedmont; but other cities can also boast a number of unorthodox Rococo designs, of which we may here remember Gianantonio Veneroni's majestic Palazzo Mezzabarba at Pavia (1728–30), so similar to Valvassori's Palazzo Doria-Pamphili,[3] the extravagant Palazzo Stanga at Cremona [248],[4] and the façade of S. Bartolomeo at Modena (1727) which recalls works of the southern German Baroque.[5]

248. Cremona, Palazzo Stanga,
early eighteenth century

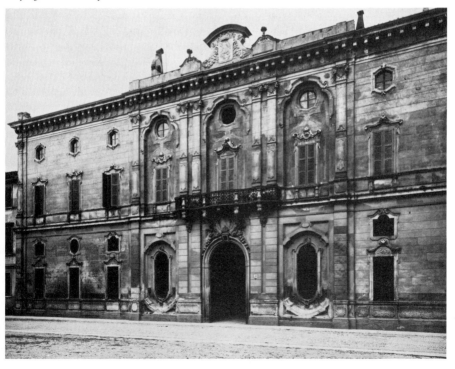

By and large it may be said that the official style of the Church and the courts was Late Baroque Classicism and that the Italian version of the Rococo found tenacious admirers among the aristocracy and the rich bourgeoisie. In Rome, in particular, numerous palaces of unknown authorship were built[6] which form a distinct and coherent group by virtue of their elegant window-frames and by the fact that the windows in different tiers are interconnected; so that for the first time in its history the Roman palace shows a primarily vertical accentuation accomplished not by the solid element of the orders but by the lights.

There cannot be any doubt that the rocaille decoration which one finds in Northern Italy rather than Rome derives from France, whence the Rococo conquered Europe. Yet it would be wrong to believe that France had an important formative influence on the style as a whole. The Italian Rococo has many facets and cannot be summed up by an easy formula; but far from being foreign transplantations, all the major works of the style, such as the Spanish Stairs in Rome or Vittone's churches in Piedmont, are firmly grounded in the Italian tradition and have little in common with French buildings of the period. It is not so strange, however, that it was the other, the classical current that often took its cue from France; for French classicism, filtered through a process of stringent rationalization, gave the world the models of stately imperial architecture. And from Juvarra's Palazzo Madama in Turin to Vanvitelli's palace at Caserta the French note makes itself strongly felt.

It was also in France that two theoretical concepts, Italian in origin, were taken up and developed which, when handed back to Italy, became instrumental in undermining the relative freedom of both the Late Baroque Classicism and the Italian Rococo. One of these, proportion in architecture, which had always fascinated the Italians, was turned into an academic subject during the seventeenth century by Frenchmen like M. Durand and F. Blondel.[7] When in the course of the eighteenth century it was taken up again by the Italians Derizet (a Frenchman by birth), Ricciolini, Galiani, F. M. Preti, G. F. Cristiani, Bertotti-Scamozzi, and others, it had the stereotyped rigidity given to it by the French. Canonical proportions can, of course, be applied only where divisions are emphatic, unambiguous, and easily readable – in a word, in a rational, i.e. classical architectural system. The age of reason was dawning, and to it also belongs the second concept in question. The Frenchman de Cordemoy (1651-1722) had first preached in his *Nouveau Traité* of 1706 that truth and simplicity must dictate an architect's approach to his subject and that the purpose of a building must be expressed in all clarity by its architecture – intellectual requirements behind which one can sense the rational concept of a 'functional' architecture.[8] Antique in origin, the principle of the correspondence between the purpose of a building and the character of its architecture had always been a cornerstone of Italian architectural theory; nothing else is adumbrated by the demand of 'decorum'. But now, interpreted as simplicity and naturalness, the concept had implicitly a strong anti-Baroque and anti-Rococo bias. The new ideas found an energetic advocate in the Venetian Padre Carlo Lodoli (1690-1761);[9] he in turn prepared the ground not only for the influential works of the French Abbé Laugier but also for the neo-classical philosophy of Francesco Milizia, who, by describing Borromini's followers as 'a delirious sect', determined the pattern of thought for more than a hundred years.

Venetian architects returned to pure classical principles at a remarkably early date, probably owing to an intellectual climate that led to the rise of Lodoli, the prophet of rationalism.[10] This helps to explain what would otherwise look like a strange paradox. Venice, where in

the eighteenth century gaiety had a permanent home, the city of festivals and carnivals as well as of polite society, the only Italian centre where the feminine element dominated – Venice seemed predestined for a broad Rococo culture, and her painters fulfil our expectations. But in contrast to most other Italian cities, Venice had no Rococo architecture. In the privacy of the palace, however, the Venetians admitted Rococo decoration. It is there that one finds rocaille ornament of a daintiness and delicacy probably without parallel in Italy.[11]

It is in keeping with the political constellation that, next to Rome, the two Italian kingdoms, Naples in the South and Sardinia in the North, absorbed most of the great architects of the period and offered them tasks worthy of their skill. While we can, therefore, discuss summarily the rest of Italy, these three centres require a closer inspection. By far the most interesting architectural events, however, took place in the Piedmontese realm of the Kings of Sardinia; for this reason a special chapter will be devoted to architecture in Piedmont.

ROME

Carlo Fontana (1638–1714)

Carlo Fontana, born in 1638[12] near Como, in Rome before 1655, was the man on whose shoulders fell the mantle of the great High Baroque architects. He began his career in the later 1650s as an architectural draughtsman and clerk of works to Cortona, Rainaldi, and Bernini. We have often come across his name in these pages. His suave and genial manners and his easy talent made him an ideal collaborator, and one soon finds him playing the role of mediator between the masters whom he served. Bernini employed him for about ten years on many of his major undertakings, and it was he who had the strongest formative influence on Fontana's style. Before 1665, he came into his own with the interesting little church of S. Biagio in

Campitelli (originally at the foot of the Capitol but now reassembled on Piazza Capizucchi). His manner is fully formed in the façade of S. Marcello al Corso (1682–3) [249], probably his most successful work, which impressed the younger generation of architects very much. This façade must be regarded as a milestone on the way to Late Baroque Classicism; it is, in fact, separated by a deep gulf from the great High Baroque façades, despite the use of such devices as the concave curvature and the illusionist niche of the upper tier. Here everything is unequivocal, proper, easily readable. Like Maderno at the beginning of the century, Fontana works again with wall projections dividing the whole front into single bays framed by orders. But by contrast to Maderno, every member of the order has its precise complement (thus a full pilaster appears at the inside of each outer bay below, behind the column, corresponding to the pilaster at the corner), and this is one of the reasons why the façade is essentially static in spite of the accumulation of columns in the centre. By contrast to Maderno, too, the wall projection corresponds exactly to the diameter of the columns, so that the encased column forms an isolated motif, clearly separated from the double columns of the central bay. The aedicule framing this bay is, as it were, easily detachable, and behind the pairs of free-standing columns are double pilasters which have their precise counterpart in the upper tier. Thus the orders in both tiers repeat, which is, however, obscured by the screening aedicule. It is precisely the 'detachability' of the aedicule motif that gives its superstructure – the broken pediment with the empty frame[13] between the segments – its scenic quality. The principle here employed corresponds to that of theatrical wings which are equally unconnected, a principle, as we have noted before (p. 297), that is foreign to Roman High Baroque structures but inherent in Late Baroque Classicism. Essentially different both from the Early and the High

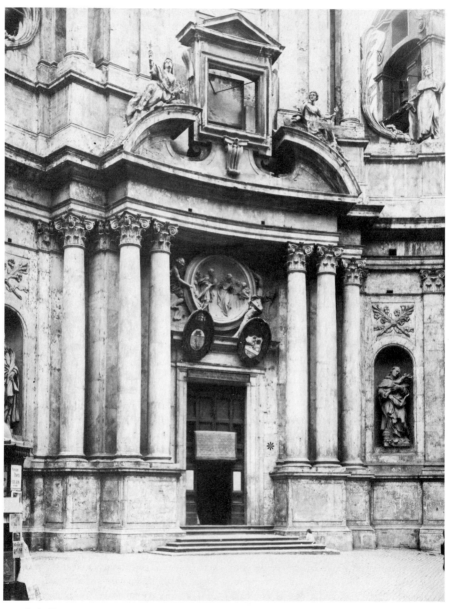

249. Carlo Fontana: Rome, S. Marcello. Façade, 1682–3. Detail

250 *(right)*. Carlo Fontana: Project for the completion of the Piazza of St Peter's, Rome, 1694

Baroque, the conception of the façade of S. Marcello provides a key to Fontana's architecture as well as to many other Late Baroque classicist buildings.

A study of Fontana's largest ecclesiastical ensemble, the Jesuit church and college at Loyola in Spain, reveals the limitations of his talent. The layout as a whole in the wide hilly landscape is impressive enough; but the church, designed over a circular plan with ambulatory (p. 299), lacks the finesse of Longhena's Salute, among others, because the shape of the pillars is determined by the radii of the circle, which makes trapezoid units in the ambulatory unavoidable.[14] In many respects the design echoes current Roman conceptions; the high drum derives from that of S. Maria de' Miracoli on the Piazza del Popolo,[15] while the façade is a classicizing adaptation of Rainaldi's unexecuted plan of 1662 for S. Maria in Campitelli. Other features,[16] besides the idea of the ambulatory, point to a study of S. Maria della Salute. Even if Fontana cannot be made responsible for the details, this gathering together of diverse ideas into a design of dubious merit is characteristic for the leading master of the new era.

Apart from some undistinguished palaces, he built many chapels in Roman churches, of which the Cappella Ginetti in S. Andrea della Valle (1671), the Cappella Cibò in S. Maria del Popolo (1683-7), the Baptismal Chapel in St Peter's (1692-8), and the Cappella Albani in S. Sebastiano (1705) may be mentioned. In these smaller works, which hark back to the rich polychrome tradition of the Roman High Baroque,[17] he gave his best. An endless number of designs for tombs (among them those of Clement XI and Innocent XII),[18] altars, fountains, festival decorations, and even statues came from his studio, and it is probably not too much to say that at the turn of the century there was hardly any major undertaking in Rome without his name attached to it. His eminence was publicly acknowledged by his election as *Principe* of the Academy of St Luke in 1686 and, again, for the eight years 1692-1700 – a mark of esteem without precedent. As a town-planner he indulged in somewhat fantastic schemes on paper, such as the building of a large semicircular piazza in front of the Palazzo Ludovisi (later Montecitorio, which he finished with classicizing alterations of Bernini's design) or the destruction of the Vatican Borghi, finally carried out in Mussolini's Rome. A second, less ambitious project for the completion of the Piazza of St Peter's [250] elaborates Bernini's idea of erecting a clock-tower outside the main oval, set back into the Piazza Rusticucci. But in contrast to Bernini's decision to make this building part and parcel of the Piazza (p.195), Fontana intended to remove it so far from the oval that the beholder, on entering the 'fore-

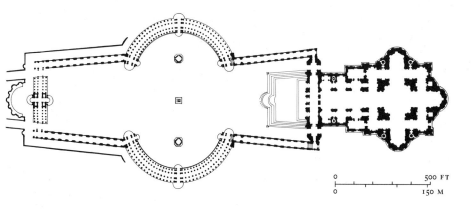

0 ——————————— 500 FT

0 ——————————— 150 M

court', would have seen the main area as a separate entity. The near and far ends of the arms of the colonnades, moreover, would have appeared in his field of vision like isolated wings on a stage – a model example of how, by seemingly slight changes, a dynamic High Baroque structure could be transformed into a scenographic Late Baroque work.[19] Theatrical in a different sense would have been Fontana's planned transformation of the Colosseum into a forum for a centralized church. A telling symbol of the supersession of the crumbled pagan world by Christianity, the ancient ruins would have formed sombre wings to the centre of the stage on which the house of God was to stand.

As an engineer, Fontana was concerned with the regulation and maintenance of water-ways and pipe-lines and, above all, with an investigation into the security of the dome of St Peter's. He supported many of his schemes and enterprises with erudite and lavishly produced publications, of which the *Templum Vaticanum* of 1694 must be given pride of place. Numberless drawings and many hundred pages of manuscript survive as a monument to his indefatigable industry.[20] It was this man, methodical and ambitious and without the genius of the great masters of the earlier generation, who brought about in Rome the turn to a classicizing, bookish, and academic manner in architecture. Nevertheless his influence was enormous, and such different masters as Juvarra in Italy, Pöppelmann and Johann Lucas von Hildebrandt in Germany and Austria, and James Gibbs in England looked up to him with veneration.

Even at the time when Carlo Fontana was the undisputed arbiter of taste in Rome, the spirit of adventure was not quite extinguished. Proof of it are Antonio Gherardi's (1644–1702) Avila and Cecilia Chapels, the former in S. Maria in Trastevere built before 1686, the latter in S. Carlo ai Catinari dating from a few years

later (1691). Both chapels are daring essays in a strange type of picturesque architecture, translations of *quadratura* painting into three dimensions (Gherardi himself was also a painter), based on a close study of Bernini's use of light and on his experiments in unifying architecture and realistic sculpture. In the S. Cecilia Chapel,[21] moreover, Gherardi fell back upon the Guarinesque idea of the truncated dome through which one looks into another differently shaped and brilliantly lit space. It is the variety and quantity of motifs, freely distributed over the broken wall surfaces, that stamp the chapel as a work of the Late Baroque.

The Eighteenth Century

Carlo Fontana had a large number of pupils and collaborators, most of whom can safely be left unrecorded. Mention may be made of his son Francesco (1668–1708), whose death preceded that of the father. He is the architect of the large but uninspired church of SS. Apostoli (1702–24). Carlo's nephew, Girolamo, designed the academic two-tower façade of the cathedral at Frascati (1697–1700, towers later); in spite of its traditional scheme it is typical for this phase of the Late Baroque by virtue of its slow rhythm and an accumulation of trifling motifs. Among Carlo's other pupils, three names stand out, that of the worthy Giovan Battista Contini (1641–1723),[22] who erected a number of tasteful chapels in Rome but had to find work mainly outside, e.g. at Montecassino and Ravenna and even in Spain (Cathedral, Saragossa); further, those of Carlo Francesco Bizzacheri (1656–1721) and Alessandro Specchi (1668–1729). The former, the architect of the façade of S. Isidoro (*c*. 1700–4), would be worth a more thorough study;[23] the latter is a better-defined personality, known to a wider public through his work as an engraver.[24] The Palazzo de Carolis (1716–22),[25] his largest building, somewhat anachronistic in 1720, has been mentioned

(p. 290). His name is connected with two more interesting enterprises: the port of the Ripetta (1704), formerly opposite S. Girolamo degli Schiavoni, and the design of the Spanish Stairs. The port no longer exists and Francesco de Sanctis superseded him as architect of the Staircase.[26] But in these designs Specchi broke with the classicizing repertory of his teacher and found new scenographic values based on an interplay of gently curved lines. Thus the pendulum began to swing back in a direction which one may associate with the name of Borromini.

At the beginning of the eighteenth century there was a dearth of monumental architectural tasks in Rome. While during the seventeenth century Rome had attracted the greatest names, it is characteristic of the early eighteenth that the real genius of the period, Filippo Juvarra, left the city in 1714, to return only on rare occasions. The whole first quarter of the new century was comparatively uneventful, and it looked as if the stagnation of the Fontana era would last for ever. But once more Rome recovered to such an extent that she seemed to reconquer her leading position. For twenty years, between about 1725 and 1745, talents as well as works of sublime beauty crowded there. A chronological list of the more important structures of the period may prove it:

1723	Francesco de Sanctis: façade of SS. Trinità de' Pellegrini[27]
1723-6	De Sanctis: the Spanish Staircase [251, 252]
1725-6	Filippo Raguzzini: Hospital and Church of S. Gallicano
1727-8	Raguzzini: Piazza S. Ignazio [253]
1728-52	Girolamo Teodoli: SS. Pietro e Marcellino[28]
1730-5	Gabriele Valvassori: Palazzo Doria-Pamphili, wing towards the Corso [254]
1732-7	Ferdinando Fuga: Palazzo della Consulta [256][29]
1732-7	Fuga: Chiesa dell'Orazione e Morte, Via Giulia[30]
1732-5	Alessandro Galilei: Cappella Corsini, S. Giovanni in Laterano
1732-62	Nicola Salvi: Fontana Trevi. After Salvi's death in 1751 finished by Giuseppe Pannini [255]
1733-6	Galilei: façade of S. Giovanni in Laterano [258]
1733-5	Carlo de Dominicis: SS. Celso e Giuliano[31]
1734	Galilei: façade of S. Giovanni de' Fiorentini[32]
1735	Giuseppe Sardi(?): façade of S. Maria Maddalena[33]
1736-41	Antonio Derizet: church of SS. Nome di Maria in Trajan's Forum[34]
1736-after 1751	Fuga: Palazzo Corsini
1741	Manoel Rodrigues dos Santos[35] (and Giuseppe Sardi): SS. Trinità de' Spagnuoli in Via Condotti
1741	Fuga: monumental entrance to the atrium of S. Cecilia
1741-3	Fuga: façade of S. Maria Maggiore
1741-4	Paolo Ameli: Palazzo Doria-Pamphili, façade towards Via del Plebiscito[36]
1741-4	Pietro Passalacqua and Domenico Gregorini:[37] façade and renovation of S. Croce in Gerusalemme
1743-63	Carlo Marchionni: Villa Albani[38]

The new flowering of architecture in Rome is mainly connected with the names of Raguzzini (c. 1680-1771),[39] Valvassori (1683-1761),[40] Galilei (1691-1737),[41] De Sanctis (1693-1731, not 1740), Salvi (1697-1751), and Fuga (1699-1782).[42] Each of the first five created one great masterpiece, namely the Piazza S. Ignazio, the façade of the Palazzo Doria-Pamphili, the façade of S. Giovanni in Laterano, the Spanish Stairs, and the Fontana Trevi, and only the sixth, Fuga, the most profuse talent of the group, secured a number of first-rate commissions for himself.

Our list opens with two major works of the Roman Rococo, the Spanish Stairs and the Piazza S. Ignazio – the one grand, imposing, fabulous in scale, aristocratic in character, comparable to the breathtaking fireworks of the Baroque age; the other intimate, small in size,

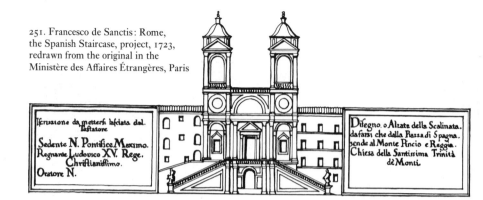

251. Francesco de Sanctis: Rome, the Spanish Staircase, project, 1723, redrawn from the original in the Ministère des Affaires Étrangères, Paris

Ifcrizione da metterfi lafciata dal.
Teftatore

Sedente N. Pontifice Maximo.
Regnante Ludovico XV. Rege.
Chriftianiffimo.
Oratore N.

Difegno. o Alzata della Scalinata.
da farfi che dalla Piazza di Spagna
fende al Monte Pincio e Reggia.
Chiefa della Santiffima Trinità
dè Monti.

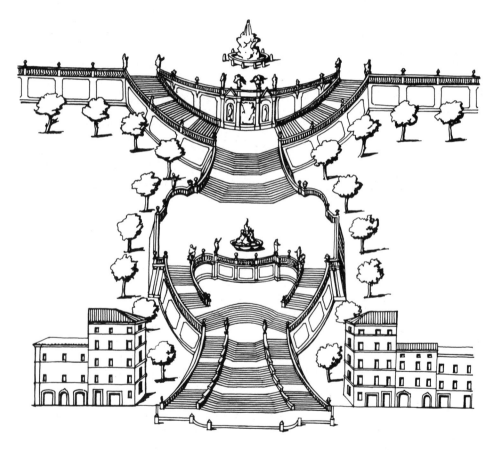

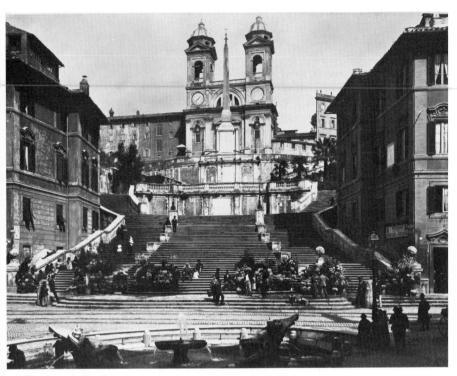

252. Francesco de Sanctis:
Rome, the Spanish Staircase, 1723-6

and with its simple middle-class dwelling-houses typical of the rising bourgeois civilization. Also, in the urban setting these works belong to diametrically opposed traditions. The Spanish Staircase [251, 252][43] is in the line of succession from Sixtus V's great town-planning schemes focused on long straight avenues and characteristic viewpoints. For seventeenth-century Roman architects the town-planner's ruler had far less attraction. But influenced by Carlo Fontana, the early eighteenth century was again smitten with the concept of long perspectives, to which the French of the seventeenth century had so enthusiastically responded. A comprehensive vision unites now the whole area from the Tiber to the Trinità de' Monti, and

although Specchi's port (unfortunately no longer existing) and De Sanctis's staircase are not on the same axis, they look on old town-plans (e.g. that by G. B. Nolli of 1748) like the overture and the finale of a vast scheme: exactly equidistant from the little piazza, a 'nodal point' widening out on the main artery, the Corso, they lie at the far ends of straight, narrow streets which cut the Corso at similar angles.

While the Spanish Staircase is composed for the far as well as the near view – the more one approaches it the richer and the more captivating are the scenic effects – the enclosed Piazza S. Ignazio [253] only offers the near view, and on entering it an act of instantaneous perception rather than of progressive revelation

determines the beholder's mood. The Roman masters of the seventeenth century preferred the enclosed court-like piazza to a wide perspective and exploited fully the psychological moment of dazzling fascination which is always experienced at the unexpected physical closeness of monumental architecture. Raguzzini's piazza is in this tradition. But he performed an interesting volte-face, for, in contrast to the square of S. Maria della Pace, it is now the dwelling houses, arranged like wings on a stage – and not the (older) church façade – that form the scenic focus.

What unites the conceptions of the Spanish Staircase and the Piazza S. Ignazio is the elegance of the curvilinear design,[44] and the same spirit may also be found in the playful movement of the window pediments, the balconies and balusters of .Valvassori's façade of the Palazzo Doria-Pamphili [254]. Works like the façade of S. Maria Maddalena or the Fontana Trevi are in a somewhat different category. In spite of its flourishing rocaille decoration, the former is structurally rather conventional; it contains, however, distinctly Borrominesque motifs, above all, the dominating central niche, so close to that of the Villa Falconieri at Frascati. The Fontana Trevi is not without marginal Rococo features such as the large rocaille shell of Neptune, but Salvi's architecture is remarkably classical [255].[45] Taking up an idea of Pietro da Cortona, who had first thought of combining palace front and fountain (p. 246), Salvi had the courage and vision to wed the classical triumphal arch with its allegorical and mythological figures to the palace front. It was he, too, who filled the larger part of the square with natural rock formations bathed by the gushing waters of the fountain. The Rococo features in the Fontana Trevi are entirely subordinated to a strong Late Baroque classical design that is as far from Fontana's formalization of Bernini's manner as it is from the puristic approach of Neo-classicism.

0 100 FT
0 30 M

253 (above). Filippo Raguzzini:
Rome, Piazza S. Ignazio, 1727-8. Plan

254 (below). Gabriele Valvassori:
Rome, Palazzo Doria-Pamphili, 1730-5. Detail

255 (above, right). Nicola Salvi:
Rome, Fontana Trevi, 1732-62

256 (below, right). Ferdinando Fuga:
Rome, Palazzo della Consulta, 1732-7

The years 1731-3 are the most varied and exciting in the history of Rome's eighteenth-century architecture. To them belongs the peak of the regeneration after the Fontana period. Next to Valvassori's Palazzo Doria-Pamphili and Salvi's Fontana Trevi, Fuga's Palazzo della Consulta was rising in these years [256]. Based on the simple rhythm of light frames and darker panels, this palace contains a superabundance of individual motifs, which to a certain extent are elegant re-interpretations of Michelangelo's Mannerism. Fuga's easy virtuosity resulted at this early phase of his career in an extremely refined style with a note of Tuscan sophistication, so different from Valvassori's deft brilliance and Salvi's sense for Roman grandeur. To the same moment belongs Galilei's reticent Cappella Corsini, a balanced Greek-cross design articulated by a uniform Corinthian order crowned by a simple hemispherical dome with classical coffers. Severely classical when compared to the other works of these years, the chapel is still far from real Neo-classicism, mainly on account of the sculptural decoration (p. 438) and the subtle colour symphony of its marbles with pale violets and mottled greens prevailing. The year 1732 also saw the most notable architectural event of the period, namely Galilei's victory in the competition for the façade of S. Giovanni in Laterano arranged by Pope Clement XII.

Never before in the history of architecture had there been such a mammoth competition.[46] Twenty-three architects, a number of them non-Romans, took part. The jury under the chairmanship of Sebastiano Conca, president of the Academy, was entirely composed of academicians, and the intrigues were fabulous. Nevertheless, it was an historic event that Galilei's model was chosen. It meant the official *placet* to a severely classical design at a time when the prevalent taste was non-classical. But a good deal that is less than half-truth has been said about Galilei's work. Critics usually believe

that it reveals the impact of English Palladianism. It is true that Galilei had spent five years in England (1714-19) before he returned to his native Florence. Although at the time of his departure from London hardly any Neo-Palladian building had gone up,[47] the façade of S. Giovanni shows a family likeness to certain projects by the aged Sir Christopher Wren. In actual fact, however, the façade is firmly rooted in the Roman tradition, combining, among others, features from Maderno's façade of St Peter's [257, 258] and Michelangelo's Capitoline palaces; features, incidentally, which belonged to the repertory of all Italian architects of the period and were usually incorporated into the highest class of monumental design. Thus some of Galilei's competitors worked with the same vocabulary. What distinguishes his façade from its great model, the façade of St Peter's, is not only its essentially static structure,

257. Carlo Maderno: Rome, St Peter's. Façade, 1605-13. Detail

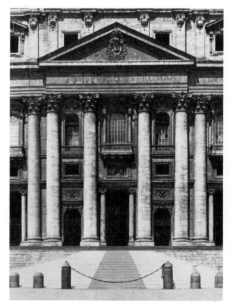

achieved by a process similar to that described in the case of Fontana's S. Marcello, but also the new relationship between open and closed parts. Here the whole front is practically opened up so that the chiaroscuro becomes most important; it helps define the orders and entablatures sharply. The effect of classical discipline and precision is partly due to this pictorial device which is an element of Late Baroque Classicism rather than of Neo-classicism. In his façade of S. Maria Maggiore, Fuga used exactly the same compositional characteristics. Add to all this Galilei's magnificent sense of scale, so similar to Maderno's in the façade of St Peter's and much superior to any of his competitors, further the crowning of the façade with the traditional Baroque figures and the freak design of the central pedestal with the blessing figure of Christ – and it must be admitted that we have before us a severe work of Late Baroque Clas-

258. Alessandro Galilei: Rome,
S. Giovanni in Laterano. Façade, 1733–6. Detail

sicism that is intrinsically less revolutionary than art historians want to make it.

Once the façade was standing (1736), the impetus of the Roman Rococo was almost broken as far as monumental structures were concerned. After Galilei's death in 1737, Fuga's predominant position was never challenged, and that alone spelled a development along Late Baroque classicist lines. Moreover, the vigour of his early manner slowly faded into a somewhat monotonous form of classicism. I do not mean his felicitous design of the façade of S. Maria Maggiore; but for this aspect one may compare S. Maria della Morte with his design for S. Apollinare or the Palazzo della Consulta [256] with the Palazzo Cenci Bolognetti (c.1745; see Chapter 8, Note 87) and with the long, rather dry front of the Palazzo Corsini. In the coffee house in the Gardens of the Quirinal (1741–3) his puristic classicism was already firmly established, but far from being Neo-classical, this style was mainly modelled on late Cinquecento examples. In 1751 Fuga left Rome for Naples – an indication how the wind was blowing – and it was there that he practised during the last decades of his life. In 1752 he began the enormous Albergo de' Poveri (length of the façade c. 1000 feet) and in 1779 the even larger Granary (destroyed). Shortly before his death he designed the Chiesa dei Gerolamini (1780), which shows that up to a point he remained faithful to the Late Baroque tradition long after the rise of Neo-classicism.

With Fuga's departure from Rome the brief and brilliant flowering of Roman eighteenth-century architecture was to all intents and purposes over. Neither Marchionni's Villa Albani with its impressive Late Baroque layout[48] nor Piranesi's few picturesque essays in architecture[49] could retrieve the situation. Contrary to what is usually said, the Late Baroque lingered on in Rome until the days of the great Valadier (1762–1839), whose work belongs mainly to the nineteenth century.

259. Andrea Tirali: Venice, S. Nicolò da Tolentino. Façade, 1706–14

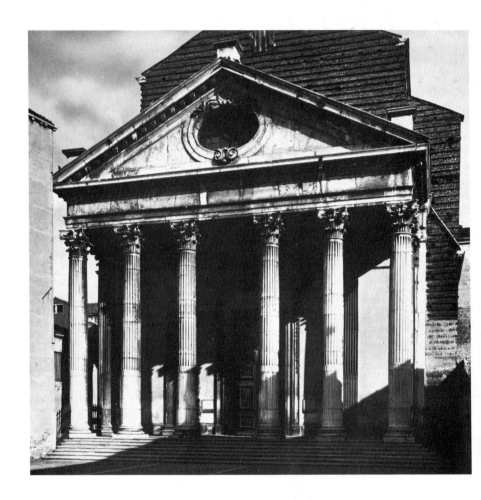

260. Giorgio Massari: Venice, Chiesa dei Gesuati, 1726-43

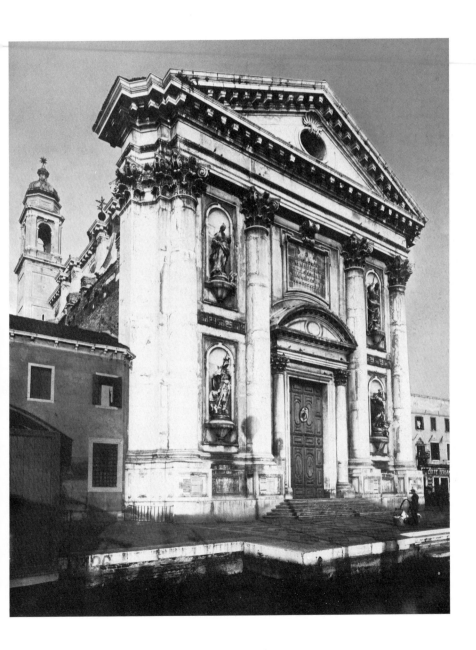

NORTHERN ITALY AND FLORENCE

Longhena's activity in Venice was not in vain.[50] Although he had no successor of the highest rank, architects vacillated for a time between the ebullient plasticity and chiaroscuro of his manner and the linear classicism of Scamozzi. This is apparent in the work of Giuseppe Sardi (*c.* 1621–99), Alessandro Tremignon, and the younger Domenico Rossi (1657–1737). They may turn Longhena's High Baroque sense for structure into typically Late Baroque diffused and flickering pictorial effects, for which only Tremignon's notorious façade of S. Moisè need

be mentioned.[51] Rossi, in particular, who built the richly decorated Baroque Chiesa dei Gesuiti (1715–29),[52] prepares in the Palazzo Corner della Regina (begun 1724) the return to a classical architecture. The real master of transition from one manner to the other is Andrea Tirali (1657–1737). Although he designed in 1690 the Late Baroque chapel of S. Domenico in SS. Giovanni e Paolo and the profuse Valier monument in the same church (1705–8),[53] he turned his back on the Baroque tradition in the façades of S. Nicolò da Tolentino [259] and S. Vidal (Vitale). Both façades are Palladian revivals: the first (1706–14) resuscitates a Vitruvian portico

261. Giorgio Massari:
Venice, Palazzo Grassi-Stucky, 1749 ff.

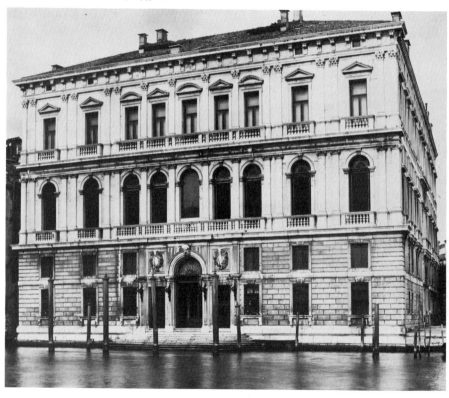

in the wake of Palladio's project of 1579 for S. Nicolò,[54] the second (datable 1734)[55] follows closely S. Giorgio Maggiore.

More important than Tirali and probably the greatest Venetian architect of the first half of the eighteenth century is Giorgio Massari (1687–1766).[56] His masterpiece, the Chiesa dei Gesuati (1726–43) [260], has a powerful temple façade derived from the central portion of Palladio's S. Giorgio Maggiore, while the interior is indebted to Palladio's Redentore, a debt hardly obscured by the typically eighteenth-century features. Massari's finest domestic work is the majestic Palazzo Grassi-Stucky (1749 ff.); its staircase hall with the frescoes formerly ascribed to Alessandro Longhi[56a] is the grandest in Venice. But the façade, faithful to the characteristics of the Venetian palazzo type, is almost as sober and flat as Scamozzi's [261].[57]

It will be noticed that, in contrast to the course of Venetian painting, Venetian architecture of the eighteenth century lived to a large extent on its tradition,[58] and this is also true for its last great practitioner, Giovanni Antonio Scalfarotto (c. 1690-1764), the architect of SS. Simeone e Giuda (also called S. Simeone Piccolo, 1718–38) [262, 263]. This church, which greets every visitor to Venice on his arrival, is clearly based on the Pantheon. But above the classical portico, to which one ascends over a staircase modelled on ancient temples, rises a stilted Byzantine-Venetian dome. The interior somewhat varies the Pantheon motifs. There is, however, one decisive change: the congregational room opens into a domed unit with semicircular apses, a formula derived via the Salute from Palladio. This blending of the Pantheon with Byzantium and Palladio is what one would expect to find in eighteenth-century Venice, and that it really happened is almost too good to be true.[59]

The analysis just made has shown that Scalfarotto did not yet take the definite step across the Neo-classical barrier. Nor can his pupil

Matteo Lucchesi (1705-76) be dissociated from a vigorous Late Baroque classicism. It was only with Tomaso Temanza (1705-89)[60] and his pupil G. Antonio Selva (1753-1819) that Venetian architecture became a branch of the general European movement. In S. Maria Maddalena (1748-63), Temanza, the friend of Milizia, produced a corrected version of his teacher's and uncle's design of SS. Simeone e Giuda: it spelled an uncompromising return to classical standards.

In Vicenza Antonio Pizzócaro (c. 1600-80), Carlo Borella, and others kept Scamozzi's classicism alive throughout the seventeenth cen-

262. Giovanni Antonio Scalfarotto: Venice, SS. Simeone e Giuda, 1718-38

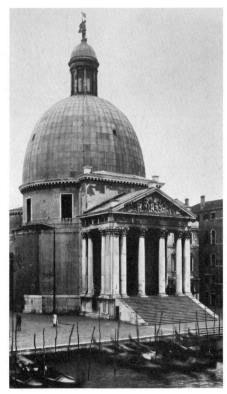

263. Giovanni Antonio Scalfarotto:
Venice,
SS. Simeone e Giuda, 1718–38.
Section and plan

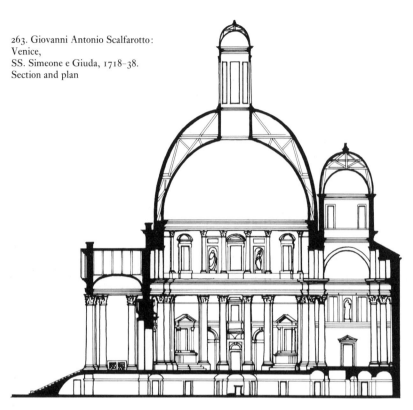

0 _____ 50 FT
0 _____ 15 M

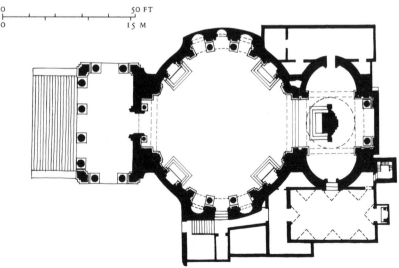

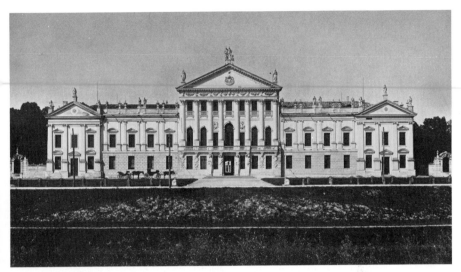

264. Francesco Maria Preti: Stra,
Villa Pisani, 1735-56

tury.[61] The eighteenth century witnessed a
splendid Palladian revival to which such a great
master as Francesco Muttoni (1668-1747) con-
tributed with sensitive works (Biblioteca Berto-
liana, 1703)[62] and which ran its course with
the Palladio scholar and architect Ottavio Ber-
totti-Scamozzi (1719-90) and Count Ottone
Calderari (1730-1803).[63]

A word must be added about the villas of the
terra ferma.[64] Most of the villas of the Venetian
hinterland, numbering at least a thousand, were
built in the eighteenth century, and although
their variety is immense, certain common fea-
tures can be found. The splendid Palladian
tradition of the aristocratic villa *all' antica* had,
of course, an indelible influence, and even in
the pearl of the Settecento villas, the imposing
pile of the Villa Pisani at Stra (1735-56) [264],
the Palladian substance is not obscured by
Baroque grandeur. A second type, no less im-
portant than the first, derives from the Venetian
palace as regards spatial organization as well
as the typically Venetian grouping of the

windows in the façade. The simple house which
Tiepolo built for himself at Zianigo may be
mentioned as an example. This type of house
also illustrates the middle-class aspect of eigh-
teenth-century civilisation, the primary reason
for the enormous growth in the number of
villas at the time. There are infinite transitions
to the princely villas, which vie in magnificence
though not in architectural style with Versailles,
such as the Villa Manin at Passariano (1738)
and the Villa Pisani, which has been mention-
ed.[65] The latter, built to a design by Francesco
Maria Preti, possesses in its rich painterly
decoration - traditional since Palladio's day - a
veritable museum of the Venetian school, a
pageantry which culminates in Tiepolo's *Glory
of the Pisani Family* painted on the ceiling of
the great hall.

Bologna had at least two Late Baroque archi-
tects of distinction, Carlo Francesco Dotti
(1670-1759)[66] and Alfonso Torreggiani. Dotti's
masterpiece is the Sancturary of the Madonna
di S. Luca, on a hill high above the city (1723-

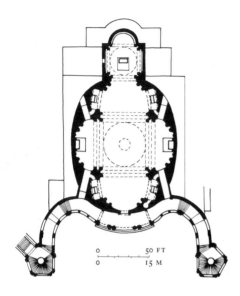

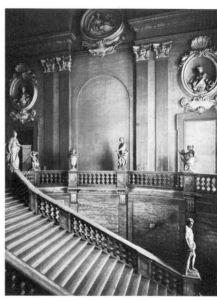

265. Carlo Francesco Dotti: Bologna,
Madonna di S. Luca, 1723–57. Plan

266. Giambattista Piacentini:
Bologna, Palazzo di Giustizia. Staircase hall, 1695

57) [265]. The Baroque age was fond of such sanctuaries. As widely visible symbols, they dominate the landscape: they suggest nature's infinitude controlled by men in the service of God. The architect's task was made particularly difficult since he had not only to emulate the grand forms of nature herself by creating a stirring silhouette for the view from afar, but had also to attract those who would ascend the hill of the sanctuary. This dual problem was solved by Dotti in a masterly way. A homogeneous elliptical shape, encasing a Greek-cross design, is crowned by the dome – an effective combination of simple geometrical forms to be seen from a distance. For the near view he placed before the approach to the church a varied, richly articulated, and undulating building, reminiscent of the work of the the eighteenth-century Bolognese *quadraturisti*. Less interesting is the interior, where Dotti followed Cortona's SS. Martina e Luca. But the changes are even more

telling than the analogies. Dotti conventionalized Cortona's dynamic motifs, returned to traditional conceptions (e.g. in the form of the drum), emphasized the vertical tendencies, and, by reducing the transverse arms to deep elliptical chapels, gave the building a distinct axial direction. The attached sanctuary, into which one looks from the congregational room, owes not a little to Rainaldi's S. Maria in Campitelli. Thus adapted to new conditions, the Roman prototypes retain their formative influence.

Alfonso Torreggiani (d. 1764), the architect of the charming Oratory of St Philip Neri (1730, partly destroyed during the war), led Bolognese architecture close to a Rococo phase. This is also apparent in his façade of the Palazzo Montanari (formerly Aldrovandi, 1744–52), which represents the nearest approach at Bologna to Valvassori's style in Rome. Like G. B. Piacentini (staircase, Palazzo di Giustizia, 1695) [266][67] and Francesco Maria Angelini (1680–1731:

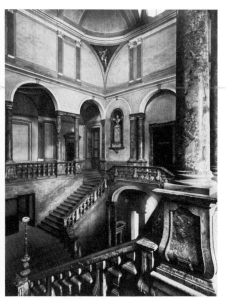

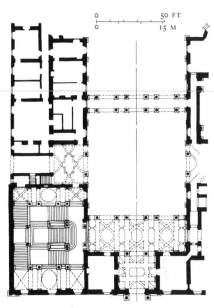

267. Antonio Arrighi:
Cremona, Palazzo Dati. Staircase hall, 1769

268. Cremona, Palazzo Dati.
Plan; staircase by Antonio Arrighi, 1769

staircases, Palazzo Montanari and Casa Zuc-chini) before him, he was a master of grand scenic staircases. He executed that of the Palazzo Davia-Bargellini, designed by Dotti in 1720 – the impressive stuccoes are by G. Borelli – and later those of the Palazzi Malvezzi-De Medici (1725) and the Liceo Musicale (1752), where the ornament has a particularly light touch. The tradition of this type of monu-mental staircase was continued at Bologna right to the end of the century, mainly by Dotti's pupil Francesco Tadolini (1723–1805),[68] and in other cities near Bologna not a few splendid examples may also be found.[69] A climax is reached in the largest and most complex of all, that of the Palazzo Dati at Cremona [267, 268], attributed to the otherwise unknown architect Antonio Arrighi (1769). Bologna also possesses in Antonio Bibiena's elegant Teatro Comunale (1756–63) one of the finest Baroque theatres in Italy.[70]

Lombardy was comparatively unproductive during this period.[71] In Milan, after the building boom of the Borromeo and post-Borromeo era, church building declined. Next to Bartolomeo Bolli's (d. 1761) Palazzo Litta (Chapter 16, Note 5) with Carlo Giuseppe Merli's impressive staircase,[72] only Giovanni Ruggeri's (d. c. 1743) Palazzo Cusani need be mentioned. Both palaces are very large in size but not as similar as they are usually believed to be: Ruggeri, the Roman, is much more reticent than the Milanese Bolli.[73] Like the latter, Marco Bianchi favoured the Rococo in his almost identical façade designs of S. Francesco di Paola (1728) and S. Pietro Celestino (1735). With Vanvitelli's pupil Giu-seppe Piermarini (1734–1808), the builder of the Scala (1776–9), the period of true Neo-clas-sicism opens at Milan.[74]

Genoa, by contrast, harbours Late Baroque work in unexpected quantity and quality. But, surprisingly, it still remains almost a *terra*

incognita. While late seventeenth-century palaces, such as the monumental Palazzo Rosso (1671-7) built by Matteo Lagomaggiore for the brothers Brignole Sale, are well known,[75] the eighteenth century has attracted little attention. Who knows the names of Antonio Ricca (*c.* 1688-*c.* 1748), the architect of S. Torpete (1730-1); of Andrea Orsolino, who built the majestic Ospedale di Pammatone (1758-80); of Gregorio Petondi, to whose genius we owe the present Via Cairolo and the rebuilding of the Palazzo Balbi with its scenographic staircase, in the same street (1780); of Andrea Tagliafichi (p. 125), who erected superb villas in the vicinity of Genoa? The city is rich in Late Baroque churches, among which the delightful Oratorio di S. Filippo Neri may be singled out, and typically eighteenth-century palace designs, usually anonymous, abound (e.g. the palace at Piazza Scuole Pie 10). But Genoa's main glory are the interior decorations. The relationship of the Genoese nobility to Paris was particularly close, and French Rococo designs are therefore common.[76] Side by side with this foreign import, however, developed an autonomous Genoese Rococo, dazzling, ebullient, and masculine. The most splendid example of this manner is the gallery in the Palazzo Carrega-Cataldi (now Camera di Commercio, Via Garibaldi) designed by Lorenzo de Ferrari, surely one of the most sublime creations of the entire eighteenth century.[77]

Equally autonomous is the development of the Genoese villa. The layout of the Villa Gavotti at Albissola, built in 1744 for Francesco Maria della Rovere, Genoa's last Doge, has few equals: terraces, grand undulating staircases, and water combine to wed the house to the landscape. Staircases and terraces extend from the house into the hilly landscape like enormous tentacles. Man's work ennobles the landscape without subduing it; this is as far from the French method of making the landscape subservient to the will of man as it is from the

'natural' English landscape garden which came into its own at precisely this moment.

Florence has some typically Late Baroque chapels built by Foggini and decorated by him and his school (p. 447). Among the late palaces that of Scipione Capponi and the Palazzo Corsini deserve special mention. The former, erected in 1705 by Ferdinando Ruggieri (d. 1741), possibly from a design by Carlo Fontana, is a reticent and noble building with a very long front. The large, airy staircase hall is placed, according to tradition, in one wing far away from the entrance. This disposition is as antiquated as the staircase itself with its four flights ascending along the walls (thereby forming a well). How different are the imaginative staircase designs in the cities of the Po valley! The extensive, sober mass of the Palazzo Corsini, designed by Pier Francesco Silvani (Note 79 to this chapter) for Marchese Filippo Corsini (d. 1706), may not appear very attractive, but the interior contains Antonio Maria Ferri's (d. 1716) masterpieces.[78] The monumental staircase (*c.* 1690), richly decorated with stuccoes by Giovanni Passardi in the manner of Raggi, is revolutionary for Florence; yet it is a clever adaptation of the new Bolognese type rather than the work of an independent talent. Equally unorthodox for Florence is the *gran salone* with its canopies formed of heavy coupled columns and, above them, the undulating entablature and gallery encompassing the entire hall. Once again Ferri's imagination was fired by foreign examples, this time by such Roman works as Borromini's nave of S. Giovanni in Laterano.

The major ecclesiastical Settecento structure in Florence is the impressive front of S. Firenze. Ruggieri executed the façade to the Chiesa Nuova (on the left-hand side) in 1715.[79] Zanobi Filippo del Rosso (1724-98), who had studied with Vanvitelli and Fuga, copied this front between 1772 and 1775 for the Oratory on the right-hand side and united the two façades by the palace-like elevation of the monastery. The

design of this remarkable front is to a certain extent still tied to Mannerist precepts; thus the inverted segments of pediments, derived from Buontalenti, provide a conspicuous crowning feature. To the end the Florentines remained faithful to their anti-Baroque tradition.[80]

NAPLES AND SICILY

For no less than two hundred years southern Italy was as a rule misgoverned by Spanish viceroys. At the Peace of Utrecht, in 1713, Philip V of Spain lost his south Italian dominion for good, but in 1734 his son was crowned King in Palermo as Charles III, and for the next sixty-four years until the Napoleonic era the Bourbons remained in possession of their throne, only to return in 1816 for another uneasy forty-five years. Charles III governed his country by enlightened despotism until 1759, when he inherited the Spanish crown. It is mainly during the twenty-five years of his reign that Naples and Sicily saw an unprecedented flowering of the arts, and to this period belong some of the largest architectural schemes ever devised in Italy. Such vast enterprises as the palaces of Capodimonte[81] and Caserta, the Albergo de' Poveri, the Granary, and the theatre of S. Carlo may be recalled.

After Fanzago's long and undisputed lead, architecture in Naples developed in two stages. A specifically Neapolitan group carried architectural design over into the style usually associated with the term 'barocchetto'. The principal practitioners of this group were pupils of the painter Francesco Solimena, who also has some architectural works to his credit. Among his followers, Giambattista Nauclerio (active 1705-37), Domenico Antonio Vaccaro (1681-1750), painter, sculptor, and architect, and Ferdinando Sanfelice (1675-1750) are the most important. The second, later phase has a more international, Late Baroque classicist character; Fuga and Vanvitelli are the architects who were responsible for most of the monumental buildings in this manner.

Excepting Sanfelice, little space can be given to the first group. Solimena's only major architectural work is the simple and dignified façade of S. Nicola alla Carità (1707?). Otherwise, his contribution to architecture consists mainly in the design of tombs (Prince and Princess of Piombino, Chiesa dell'Ospedaletto, 1701) and altars (high altar, Cappella del Tesoro, S. Gennaro, 1706) and, above all, in the influence exercised on his pupils. Nauclerio and Vaccaro[82] may be passed over in favour of Sanfelice, who is the most gifted and most prolific Neapolitan architect of the first half of the eighteenth century. His work, even more than that of Vaccaro, is the precise counterpart to Raguzzini's and Valvassori's buildings in Rome. It is spirited, light-hearted, unorthodox, infinitely imaginative, and ranges from a severe elegance to decorative profusion and richness. He produced with almost incredible ease, and the vastness of his œuvre vies with that of the most productive architects of all time. In this as in other respects he recalls Juvarra; like the latter, he was also specially gifted as a manipulator of perishable decorations,[83] and his sure instinct for scenographic effects is one of the most characteristic traits of his art. His work in ecclesiastical architecture began in 1701 (S. Maria delle Periclitanti at Pontecorvo), to be followed by innumerable additions, alterations, and renovations in Naples and smaller towns. A particular jewel is the small Chiesa delle Nunziatelle, probably dating from the mid 1730s, with a colourful façade which forms a splendid point de vue at the end of a narrow street. The simple polychrome nave with two chapels to each side blends perfectly with the lofty vault decorated with Francesco de Mura's grandiloquent fresco of the Assumption.[84]

It is as the architect of domestic buildings that Sanfelice gives his best. One of the most distinguished among the long list of palaces

attributed to him by the biographer of Neapolitan artists, de Dominici, is the Palazzo Serra Cassano (1725-6), a long structure on sloping ground with a front of sixteen bays. The rhythm given to the façade is typical of Sanfelice's free handling of the tradition. Giant pilasters over the rusticated ground floor frame

the first, fifth, twelfth, and sixteenth bays (with the pilasters of the fifth and twelfth bays over rich portals); bays 2, 3, 4, and 13, 14, 15 are evenly spaced, without orders, while bays 6, 7, 8, and 9, 10, 11 are grouped together as trios with a large gap between bays 8 and 9, that is, in the centre of the entire façade. The main glory, however, of this and other palaces by Sanfelice is the monumental staircase, which ascends in two parallel flights, each of which returns, forming a complicated system of bridges in a large vaulted vestibule.

Sanfelice's ingenuity was focused on staircase designs [269, 270];[85] in this field he is without peer. It is impossible to give even the vaguest idea of the boldness, variety, and complexity of his designs. In the crowded conditions of Naples these staircases often seem tucked away in the most unexpected places, and this adds to their surprise effect. De Dominici gives the crown to the staircase of the palace of Bartolomeo di Majo as the most 'capricious' in the whole of Naples – and there is no reason to disagree with him. This staircase ascends in convex flights

269 *(above)*. Ferdinando Sanfelice: Naples, Palazzo Sanfelice, Staircase, 1728

270. Ferdinando Sanfelice: Naples, palace in Via Foria. Double staircase and plan

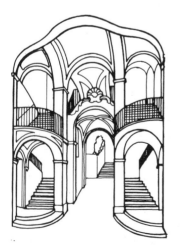

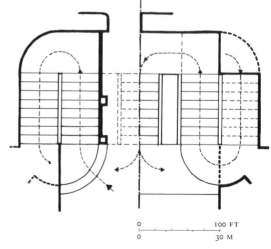

inside a vestibule reminiscent of the plan of Borromini's S. Carlo alle Quattro Fontane. There is nothing in the rest of Italy to match Sanfelice's scenographic staircases; in addition, central and northern Italy took no note of the unconventional development of staircase designs in the South. On the other hand, it has been pointed out that a link exists between some of Sanfelice's and certain Austrian staircase designs.[86] And contrary to the previous two centuries, it was the North that influenced Naples. At precisely the same time Naples and Piedmont – as will be shown – admit northern ideas, and this invites comment to which I shall turn in the next chapter.

Sanfelice and Vaccaro died in the same year, 1750. The following year the King called to Naples the two architects Fuga and Vanvitelli, who, at this historical moment, must have been regarded as the leading Italian masters, and it was to them that he entrusted the largest architectural tasks of the eighteenth century in Naples. The two architects were almost exact contemporaries, but while Fuga had passed the zenith of his creative power, Vanvitelli had still his most fertile years before him. Fuga's activity in Naples has already been briefly mentioned (p. 383). It remains to give an account of Vanvitelli's career.

Luigi Vanvitelli (1700–73),[87] born in Naples, the son of the painter Gaspar van Wittel from Utrecht, spent his youth in Rome, first studying painting under his father. He emerged as an architect of considerable distinction during the Lateran competition, to which he contributed a design. His first period of intense architectural activity coincided with the building boom in Rome (p. 377). Commissioned by Pope Clement XII, he constructed at Ancona the pentagonal utilitarian *lazzaretto*, the austerely classical Arco Clementino, began the quay and lighthouse, and erected the Gesù (1743–5), which foreshadowed the infinitely grander late Chiesa dell'Annunziata at Naples. In these years,

mainly in the 1740s, he assumed the role of an itinerant architect, so common in the eighteenth century. He worked at Pesaro, Macerata, Perugia, and Loreto (tower, Santa Casa), made a design for the façade of Milan Cathedral (1745), and practised in Siena and again in Rome, where the sober monastery of S. Agostino, the rebuilding of Michelangelo's S. Maria degli Angeli, and, under Salvi, the lengthening of Bernini's Palazzo Chigi-Odescalchi (p. 186) are mainly to be recorded.

Charles III summoned him to Naples for the express purpose of erecting the royal residence at Caserta, about 20 miles north of the capital.[88] In a sense Caserta is the overwhelmingly impressive swansong of the Italian Baroque. The scale both of the palace with its 1,200 rooms and of the entire layout is immense. For miles the landscape has been forced into the strait-jacket of formal gardening – clearly Versailles has been resuscitated on Italian soil. But it would be wrong to let the matter rest at that, for into the planning has gone the experience of Italian and French architects accumulated over a period of more than a hundred years. The palace is a high, regular block of about 600 by 500 feet, with four large courtyards formed by a cross of wings. The Louvre, the Escorial, Inigo Jones's plans for Whitehall Palace come to mind; we are obviously in this tradition. None of these great residences, however, was designed with the same compelling logic and the same love for the absolute geometrical pattern, characteristics which have a long Italian ancestry and reveal, at the same time, Vanvitelli's rationalism and classicism. A similar spirit will be found in the strict organization of the elevations. The entire structure rises above a high ground floor treated with horizontal bands of sharply cut rustication. Projecting pavilions, planned to be crowned by towers in the French tradition and articulated by a giant order, frame each of the long fronts. The pavilions are balanced in the centre of the main and garden fronts by a powerful pedi-

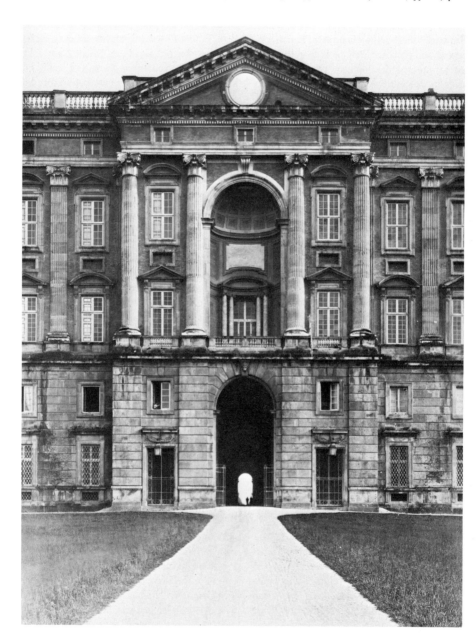

mented temple motif [271]. While the long wall of the principal front remains otherwise austere without articulating features, on the garden front the giant composite order is carried across the entire length, creating a long sequence of narrow bays. Apart from certain national idiosyncrasies, such as the density and plasticity of forms and motifs, this style was internationally in vogue during the second half of the eighteenth century. It may be found not only in France (e.g. G. Cammas' Capitole, Toulouse,

had been reared in the scenographic tradition of the Italian Late Baroque, and it was at Caserta that scenographic principles were carried farther than anywhere else. From the vestibule vistas open in several directions: courtyards appear on the diagonal axes, and, looking straight ahead, the visitor's eye is captivated by the vista through the immensely long, monumental passage which cuts right through the entire depth of the structure [272], and extends at the far end along the main avenue into the depth of the garden.

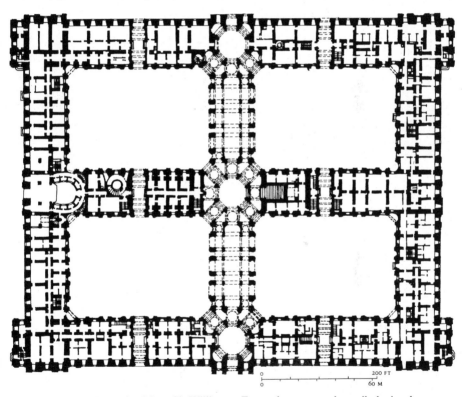

0 ⊢————⊣————⊣————⊣ 200 FT
0 ⊢——————————⊣ 60 M

1750–3), but also in England (e.g. Sir William Chambers's Somerset House, London, 1776–86) and even in Russia (Kokorinov's Academy of Art, Leningrad, 1765–72).

But in one important respect Caserta is different from all similar buildings. Vanvitelli

From the octagonal vestibule in the centre Italy's largest ceremonial staircase ascends at right angles. Its rather austere decoration may be fashioned after Versailles, but the staircase hall as such and the staircase [273] with its central flight leading to a broad landing from where

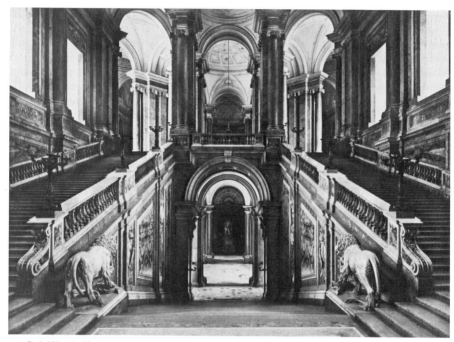

273. Luigi Vanvitelli: Caserta,
former Royal Palace, begun 1752. Staircase

two flights turn along the walls and end under a
screen of three arches – all this has a North
Italian pedigree (Bologna), which ultimately
points back to Longhena's scenographic stair-
case in S. Giorgio Maggiore [191]. The staircase
leads into a vaulted octagonal vestibule corres-
ponding to that on the lower level, and from
there doors open into the state rooms and –
opposite the staircase – into the chapel, the
similarity of which to that of Versailles has
always been pointed out.[89] Once again, from
the vestibules on both levels vistas open in all
directions, and here Vanvitelli's source of
inspiration is evident beyond doubt. These
vestibules, octagons with ambulatories, derive
from Longhena's S. Maria della Salute.[90]
Although many decorative features of the
interior are specifically Roman and even Bor-

rominesque, Vanvitelli's basic approach spells
a last great triumph for Longhena's principles.
But he emulates all that went before; for from
the return flights of the staircase the beholder
looks through the screen of arches into stage-
like scenery beyond, viewing a Piranesi or
Bibiena phantasmagoria in solid stone. The
scenographic way of planning and seeing ties
Vanvitelli firmly to the Late Baroque, and it is
in this light that his classicism takes on its
particular flavour.

The principal ecclesiastical building of Van-
vitelli's immensely active Neapolitan period is
the Chiesa dell'Annunziata (1761–82). Its con-
cave façade in two tiers is ultimately dependent
on Carlo Fontana's S. Marcello, and the sceno-
graphic interior with its severely conceived
columnar motif that encompasses the three

separate units of the church takes its cue from Rainaldi's S. Maria in Campitelli.[91] Among Vanvitelli's remaining works may be mentioned the Foro Carolino (now Piazza Dante, 1757–65). The large segmental palazzo front articulated by a giant order, reminiscent of Pietro da Cortona (p. 246), is interrupted in the centre by the dominating motif of the niche, a late retrogression to the *Nicchione* of the Vatican Belvedere. But the slow rhythm of this architecture calls to mind northern counterparts, such as J. Wood the younger's Royal Crescent at Bath (1767–75), and the similarity – in spite of all differences – once again shows to what extent Vanvitelli's style falls into line with the international classicism of the period.

Finally, a word must be said about Vanvitelli's uncommon ability as an architect of utilitarian structures. This is demonstrated not only by his cavalry barracks 'al ponte di Maddalena' (1753–74), a work of utter simplicity and compelling beauty (which seems to have had a considerable influence on Italian twentieth-century architecture), but above all by the Acquedotto Carolino (1752–64), the aqueduct of about 25 miles length which supplies Naples with water. As regards engineering skill as well as the grandeur of the bridges this work vies with Roman structures. More than anything else, such works indicate that a new age was dawning.

The last Neapolitan architect of the eighteenth century deserving attention is Mario Gioffredo (1718–85). Schooled by Solimena, he began before 1750 with works still in keeping with the Neapolitan Baroque. Overshadowed by Fuga and Vanvitelli, Gioffredo has never been given his due. After 1760 he steered determinedly towards a Neo-classical conception of architecture. His dogmatic treatise *Dell' Architettura* (1768), of which only the first volume appeared, shows this as clearly as his masterpiece, the church of Spirito Santo, completed in 1774. Unlike Vanvitelli, Gioffredo breaks here for the first time with the polychrome Neapolitan tradition. Moreover, the walls of the nave with the even, sonorous rhythm of the colossal Corinthian order usher in a new period. And yet even he paid homage to a tradition which he despised: in the interior of the church the attentive observer will discover motifs derived from S. Maria in Campitelli, while the large dome is, in fact, a memorial to Cortona's dome of S. Carlo al Corso.[92]

★

Little can here be said about the charming, volatile, and often abstruse Apulian Baroque, which has some contacts with the Neapolitan and even Venetian development. It has recently been shown that the often overstated connexions with the Plateresque and Churrigueresque Spanish Baroque are most tenuous. Examples of this highly decorative local style may be found at Barletta, Gravina, Manduria, Oria, Gallipoli, Francavilla Fontana, Galatone, Nardò, and other places. But it has its main home in the provincial capital, Lecce. For its small size Lecce can boast an unequalled number of monumental structures, which form a strikingly imposing ensemble.[93]

In spite of a building history extending from the mid sixteenth to the eighteenth century, Lecce's Baroque conveys the impression of stylistic harmony and uniformity. The reason is evident: this style is pure surface decoration, often strangely applied to local building conventions which, in this remote corner of Italy, had an extraordinarily long lease of life. What M. S. Briggs wrote in 1910 (p. 248) is still true to-day: 'All that is unique in Lecce architecture may be accounted for by the combination and fusion of these three great elements – the new Renaissance spirit slowly percolating to the remote city, the unrivalled relics of the Middle Ages standing around its gates, and the long rule of Spain.'

The strange union of what would seem incompatible is particularly evident in the façade

of S. Croce (also called Chiesa dei Celestini), the most impressive structure at Lecce, where elements of the Apulian Romanesque are happily wedded to wildly exuberant Baroque decoration. At a first glance this façade appears to be uniform, but it was begun before 1582 by Gabriele Riccardi and finished more than sixty years later (1644) by Cesare Penna (upper tier). Again, the adjoining monastery (now Prefettura) would seem of one piece with the church; its dates, however, lie between 1659 and 1695 and the architect is Giuseppe Zimbalo, who built the cathedral (1659-82), S. Agostino (1663), and the magnificent façade of the Chiesa del Rosario (begun 1691). Less bizarre than the window-frames of the monastery, but otherwise close in character, is the front of the Seminario, erected between 1694 and 1709 by Zimbalo's pupil, Giuseppe Cino. The latter was responsible, among other works, for S. Chiara (1687-91), the façade of SS. Nicola e Cataldo (1716), and the Madonna del Carmine (1711); in these buildings a spirit closer to the international Baroque may be noticed. Before taking leave of Lecce, the most eccentric building may be mentioned, namely Achille Carducci's façade of S. Matteo, which is covered over and over with scales.

The Sicilian Baroque would deserve closer attention than it can here be given.[94] Artists from the mainland supplied to a large extent pre-Seicento art and architecture in Sicily. This situation changed in the course of the seventeenth century, and for more than 150 years most major building operations in cities large and small were carried out by Sicilians, who, incidentally, were almost without exception priests. Since the eastern towns – Syracuse, Catania, and Messina – were devastated in the earthquake of 1693, it is only at Palermo that a continuous development can be followed throughout the seventeenth century.

During the first half of the new century building practice was on the whole retardataire.

Witness the three-storeyed Quattro Canti at Palermo, monumental buildings on the piazza (created in analogy to the Quattro Fontane in Rome) where the two main arteries of the city intersect;[95] or the severe Arsenal (Palermo, 1630), designed by the Palermitan Mariano Smiriglio (1569-1636), painter and architect; Giovanni Vermexio's block-shaped Palazzo Comunale at Syracuse (1629-33) with a portal lifted straight out of Vignola's treatise;[96] or, finally, Natale Masuccio's imposing Jesuit College and church at Trapani (finished 1636). With Angelo Italia (1628-1700), Paolo Amato (1633-1714) and his namesake Giacomo Amato (1643-1732), Palermitan architecture entered a new, High Baroque phase.[97] In 1682 Paolo Amato began S. Salvatore, the first Sicilian church over a curvilinear plan. The masterpieces of the Palermitan Baroque are, however, Giacomo Amato's façades of the Chiesa della Pietà (1689, church consecrated in 1723) and of S. Teresa della Kalsa (1686-1706), both with powerful orders of columns in two tiers. Giacomo had spent more than ten years in Rome (1673-85) where he had a share in the design of the monastery of S. Maria Maddalena. His work at Palermo leans heavily on Roman precedent, the façade of the Chiesa della Pietà, for instance, following closely that of S. Andrea della Valle. Thus by Roman standards this belated High Baroque is rather conservative. Angelo Italia's masterpiece is the Cappella del Crocifisso in the cathedral of Monreale, executed between 1688 and 1692, with exuberant and colourful Hispano-Sicilian stucco decorations. They seem to be on the same level of intensity as the hieratic Byzantine mosaics which were possibly a source of inspiration to Baroque architects and decorators.[98]

The stage reached by Giacomo Amato was superseded by Giovanni Biagio Amico from Trapani (1684-1754), who erected important buildings in his native city as well as in other provincial towns and in Palermo. Although his

Late Baroque façade of S. Anna in Palermo (1736)[99] with its convex and concave curvatures is superficially Borrominesque, it is additive in conception and lacks the dynamic sweep of similar Roman structures.

The glory of eighteenth-century Palermitan architecture are the villas in the vicinity, particularly at Bagheria.[100] Some of them have extravagant plans and form part of large and complex layouts, such as the villa built by Tommaso Maria Napoli (1655–1725) for Francesco Ferdinando Gravina, Principe di Palagonio (1715); the Villa Valguarnera, begun by the same architect before 1713; the Villa Partanna, erected 1722–8 for Laura La Grua, Principessa di Partanna; or the villa of the Principe di Cattolica (1737?). The Villa Palagonia is notorious for the strange 'baroque' whim of its late eighteenth-century proprietor, who had the entire place decorated with crudely carved monstrosities – the supreme example of a play with emblematical Baroque *concetti*. Goethe in his often-quoted description of the villa coined the phrase 'Palagonian paroxysm' for what seemed to him the epitome of aberration from good taste.[101]

Like Naples, Palermo abounds in scenographically effective staircases. The most famous of them in the Palazzo Bonagia, designed by Andrea Giganti (1731–87), forms a picturesque screen between the cortile and the garden. All the large villas can boast extravagant staircase designs of which V. Ziino has made an illuminating study. Once again, the thought of Austrian architecture is never far from one's mind before such works. For twenty years from 1713 to 1734, the political links between Sicily and Austria were close.[102] I do not find records of many Sicilian architects visiting Vienna, but it is known that Tommaso Maria Napoli made the journey twice.

After the earthquake of 1693 the eastern part of the island saw a fabulous reconstruction period. The Baroque Messina in turn was to a large extent destroyed in the earthquake of 1908. Syracuse had an architect of distinction in Pompeo Picherali (1668–1746), who is, however, wrongly credited with the impressive façade of the cathedral.[103] Magnificent structures arose in small towns such as Modica and Ragusa; Noto and Grammichele were entirely rebuilt on new sites; Noto, in particular, with its array of monumental structures erected by Paolo Labisi, Rosario Gagliardi (worked 1721–70), and the late, neo-classicist Vincenzo Sinatra,[104] is matched only by Catania itself. The greatest figure of the reconstruction period, Giovan Battista Vaccarini (1702–68),[105] turned Catania into one of the most fascinating eighteenth-century cities in Europe. Born in Palermo, he was educated in Rome in Carlo Fontana's studio, but, being a contemporary of the Roman 'Rococo' architects, his development parallels theirs. A protégé of Cardinal Ottoboni, he settled at Catania in 1730 and in the next two decades brought about a Sicilian Rococo by blending the Borrominesque with the local tradition. He entirely superseded the popular 'Churrigueresque' style – that effusive manner which owes so much to Spain and of which Catania has splendid examples in the Palazzo Biscari and the Benedictine monastery,[106] the largest in Europe, the impressive bulk of which dominates the town.

The list of Vaccarini's works is long and distinguished, from the façade of the cathedral (begun 1730, reminiscent of Juvarra's style), which shows an interesting play with the position of the orders, and the powerful and extravagantly imaginative design of the Palazzo Municipale (1732) to the large Collegio Cutelli (1754), where, keeping abreast with the times, he is well on the road to a new classicism. His most important ecclesiastical work, S. Agata (begun 1735), has a façade with a deep concave recession between flanking convex bays – altogether an unexpected transformation of Borrominesque ideas and wholly unorthodox in the

detail. Vaccarini's manner was continued in the second half of the eighteenth century by the festive art of the Roman Stefano Ittar. If his Chiesa Collegiata, where he combined features from Carlo Fontana's S. Marcello with some from the façade of S. Maria Maddalena, could almost have been created in Rome between 1730 and 1740, his S. Placido, a refined and subtle jewel of classicizing Rococo taste, has its nearest parallels in Piedmont. Thus it is in the two parts of Italy which are the farthest removed from each other that the resistance against the cool objectivity of the rising Neo-classicism remains strongest.

ARCHITECTURE IN PIEDMONT

THE PRELUDE

The extraordinary part played by Piedmont in the art and architecture of the Seicento and Settecento cannot be dissociated from the country's rapid political development. It began with the energetic Emanuele Filiberto, who made Turin his capital in 1563. The rebuilding and enlarging of the town gathered momentum under his successor Carlo Emanuele I (1580–1630). For about three generations building activity in Turin was mainly in the hands of three architects in succession: Ascanio Vittozzi (1539–1615), Carlo di Castellamonte, and his son Amedeo (d. 1683). Turin was a Roman *castrum* town, and its chessboard layout survived the Middle Ages. Carlo Emanuele I pursued with energy the modernization of the whole city, first with Vittozzi and, after the latter's death, with Carlo Castellamonte as his architect. Castellamonte was in charge of all building activity when in 1620 the ceremonial foundation of the new town was laid. It was he who was responsible for one of the first coherent street-fronts in Italy (Via Roma) and for the entirely unified Piazza S. Carlo (1638). While Central Italian architects hardly ever abandoned the individual palazzo front, the break with that old-established tradition in Turin suggests a strong French influence. Under Carlo Emanuele II (1638–75) Amedeo di Castellamonte carried on the enlargement of the town in the direction of the River Po (1673).[1] Next to the leading architect, Francesco Lanfranchi showed more than ordinary ability in transforming Turin after the middle of the seventeenth century into a great Baroque city.[2] Under Vittorio Amedeo II followed the third great systematization of

the city in the direction of the Porta Susina with Juvarra in charge (begun 1716). This programme was extended later in the eighteenth century, and during the twentieth century Turin's great Baroque tradition was continued by one of the most extensive town-planning schemes of modern times.[3]

These few remarks indicate that there was an adventurous and vigorous spirit alive in seventeenth-century Turin.[4] Nevertheless, what Castellamonte and Lanfranchi had to offer was somewhat provincial in spite of real distinction; they skilfully combined Roman and North Italian with French aspirations. But in 1666 Guarini appeared on the Turinese stage, with consequences of the utmost importance. In fact, in matters of architecture Turin became the most advanced Italian city almost precisely at the moment when creative energies in Rome began to decline. Guarini's settling in Turin opens the era of the extraordinary flowering of Piedmontese architecture which lasted for about a hundred years and is epitomized by the names of three men of genius: Guarini himself, Juvarra, and Vittone.

GUARINO GUARINI (1624–83)

It may be reasonably argued that Guarini's architecture belongs to a late stage of the High Baroque and that it has certain qualities in common with the Roman architecture of the mid seventeenth century, such as the full-blooded vigour and the preference for determined articulation and for strong and effective colour schemes. But while nobody will doubt that his architecture is nearer to that of Borromini and Cortona than to that of Juvarra, his

aims transcend those of the Roman masters, from whom he is separated by a deep gulf. There is considerable justification, therefore, for discussing his work at this late stage. Guarini was born at Modena on 17 January 1624.[5] In 1639 he entered the Order of the Theatines and in the same year moved to Rome, where he studied theology, philosophy, mathematics, and architecture. At this period the interior of Borromini's S. Carlino [117] as well as the façade of the Oratory of St Philip Neri [134] were finished, and these events were certainly not lost upon him. Back at Modena in 1647, he was ordained priest and soon appointed lecturer in philosophy in the house of his Order. During these years he began architectural work in a modest way at S. Vincenzo, the church of the Theatine Order.[6] When in 1655 differences arose between him and the ducal court, he left Modena. In 1660 he settled in Messina, teaching philosophy and mathematics.

It was then that he began his literary career with a tragi-comedy[7] and his architectural career with two important buildings. While his design of the church of the Padri Somaschi was never executed, the façade of the SS. Annunziata together with the adjoining Theatine palace were certainly built. What was standing of his work was destroyed in the earthquake of 1908,[8] but his designs are preserved in the plates in his *Architettura civile*, posthumously published by Vittone in 1737. The Annunziata façade, raised over a concave ground-plan, is strongly influenced by traditional Roman church façades and shows a distinct retrogression to Mannerist compositional and decorative principles. The church of the Padri Somaschi is more revealing; its regular hexagonal plan with ambulatory is strange enough.[9] Even stranger is the elevation [274], for the transition from the hexagonal body of the church to the zone of the dome is accomplished by pendentives above which is a circular cornice but not – as one would expect – a cylindrical drum. Instead of the normal drum

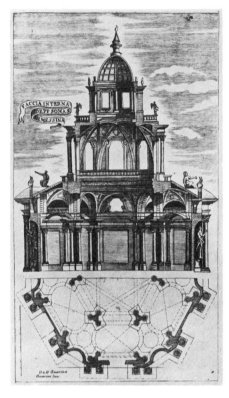

274. Guarino Guarini: Messina, Church of the Somascian Order. Project, 1660(?). Engraving from *Architettura civile*, 1737

and dome, the design shows a hybrid structure consisting of a hexagon with six large windows and parabolic ribs spanned between them in such a way that a kind of diaphanous dome is created: drum and dome are telescoped into one and the same structural zone. The novelty of this is no less surprising than Guarini's use of pendentives for the transition of the hexagon into the round, only to return to the hexagon again. Crowning the pseudo-dome is another hybrid motif, a proper small drum and dome, together exactly as high as the pseudo-dome and therefore much too large as a lantern.

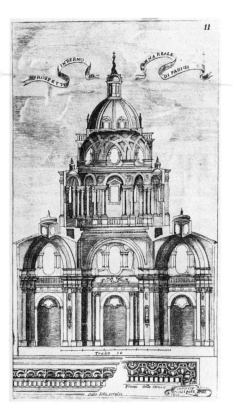

275. Guarino Guarini: Paris,
Sainte-Anne-la-Royale, begun 1662. Destroyed.
Section from *Architettura civile*, 1737

Reminiscent of centralized churches of the Renaissance, the exterior is identical on all six fronts, and this contrasts with the Roman Baroque tendency to regard the façade as an essential manifestation of the spatial movement and direction of the interior. The ample use of free-standing columns links the building superficially to the main current of Baroque architecture, but the superimposition of three unrelated tiers as well as the carpentry-like detail recall – at least in the engraving – Late Mannerist tabernacles rather than a church. Had Guarini stayed on at Messina, his buildings would probably have remained extravagant freaks.

In 1662 he was back at Modena, from where he soon moved to Paris. During his stay there he built the Theatine church, Sainte-Anne-la-Royale, and wrote an immensely learned mathematical-philosophical tome, *Placita philosophica* (1665), in which he defended, rather surprisingly at this late date, the geocentric universe against Copernicus and Galilei. The church [275], not finished until 1720 with considerable changes and entirely destroyed in 1823,[10] was erected over a fairly normal Greek-cross plan with undulating façade, similar to that of S. Carlo alle Quattro Fontane. Once again Guarini's extravagance is most apparent in the zone of the vaulting. In this case he built a real drum above pendentives but crowned it by a dwarf dome which he decorated with a system of interlaced double ribs. This dome is topped by a smaller truncated dome with lantern of traditional design, to be seen from the floor of the church through the large octagonal opening of the dwarf dome.[11] Externally the church rose pagoda-like in five tiers,[12] and the encased dwarf dome with windows reminiscent of bellies of violins looked like a second drum above the principal one. Guarini had certainly studied Borromini's use of bandlike ribs for vaults (p. 221), but while the latter introduced this device in order to tie together a whole structure, no such idea guided the former. On the contrary, each of the major units of the church strikes an entirely new note. Far from being a provincial 'atomization', it will soon be seen that this was a deliberate artistic principle.

Guarini may have travelled again before settling in Turin. Although this is unrecorded, he may have gone to Spain and Portugal, where S. Maria della Divina Providenza at Lisbon was erected from his design [276].[13] Destroyed in the earthquake of 1755, this important church is known only from the engravings of the *Architettura civile*. Like St Mary of Altötting

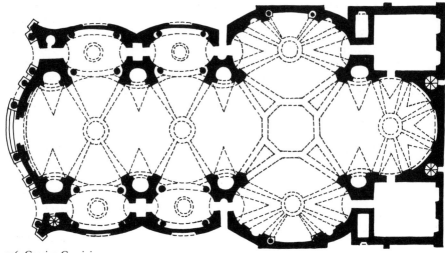

276. Guarino Guarini:
Lisbon, S. Maria della Divina Providenza.
Plan from *Architettura civile*, 1737

in Prague (1679) and S. Filippo in Turin, the church has a longitudinal plan which derives from the traditional North Italian type showing a sequence of domed units; but here the walls undulate, and the salient points across the nave are no longer linked by an arch; they contain instead, in the zone of the vaulting, windows set into lunettes. An intricate and baffling combination of spatial shapes results which one cannot easily visualize or describe in simple geometrical terms. This architecture required a new kind of mathematics, and Guarini himself laid the foundation for it by devoting long passages of his treatise to conic sections. Although they must be regarded as essential for the development of the German and Austrian Baroque, Guarini's longitudinal churches take up a place secondary in importance compared with his centralized buildings.

When Carlo Emanuele II of Savoy called him to Turin, Guarini had still seventeen years to live, and in these years he erected the structures for which he is mainly famous. Apart from

S. Filippo Neri, which remained unfinished, collapsed, and was finally replaced by Juvarra's church,[14] he built two great palaces, the Collegio dei Nobili (1678, now the Academy of Science and Art Gallery) and the magnificent Palazzo Carignano (1679),[15] and three centralized churches: the Cappella della SS. Sindone, S. Lorenzo, and the sanctuary La Consolata. The latter is the least interesting of these buildings and not much of the present structure is by Guarini.[16] His two other ecclesiastical works, however, belong to the finest class of Italian Seicento architecture.

After his arrival at Turin, Guarini was appointed architect of the Cappella della SS. Sindone, itself the size of a church [277-80]. The House of Savoy possessed one of the holiest relics, the Holy Shroud, which Emanuele Filiberto transferred from Chambéry to the new capital with the intention of having a church erected for it. But finally it was decided to build a large chapel at the east end of the cathedral and in close conjunction with the palace. In

1655 Carlo Emanuele II commissioned Amedeo di Castellamonte, and work was begun in 1657. When Guarini took over, ten years later, the structure was standing up to the entablature of the lower tier.[17] The cylindrical space of the chapel was articulated by the regular sequence of an order of giant pilasters and, placed between them, a smaller order forming the so-called Palladio motif. According to Castellamonte's design, the cylindrical body of the chapel was probably to continue into a spherical dome. Guarini disturbed this perfectly normal

design. He introduced the convex intrusions of three circular vestibules into the main space; he entirely changed the meaning of the regular articulation by creating above the cylinder a zone with pendentives; and he spanned every two bays by a large arch, three in all, and these 'enclosed' bays alternate with the 'open' bays in which lie the segmental projections of the entrances. All this led to peculiar contradictions. Now the giant pilaster in the centre of each large arch has no function; he crowned it with a complex ornamental motif. The three pendentives open into large circular windows, corresponding to those set into the arches. Thus, reversing the division into arches and pendentives, the sequence of six windows produces a regular rhythm. It is even more puzzling that

277 and 278. Guarino Guarini: Turin, Cappella SS. Sindone, 1667–90. Plan and section from *Architettura civile*, 1737

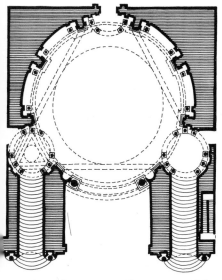

Guarini borrowed the pendentives from the Greek-cross design, adapted them to three instead of four arches – an unheard-of idea – and used them, paradoxically, as a transition between the circular body of the chapel and the circular ring of the drum.

Guarini's name is often coupled with that of Borromini. It is, indeed, not unlikely that in his design of the Sindone chapel Guarini was influenced by Borromini as regards triangular geometry, the unorthodox insertion of the pendentive zone, and even the opening up of the pendentives;[18] but even if such influence will be admitted, it has to be emphasized once again that the aims of the two architects were entirely different. Borromini strove for the creation of homogeneous structures which, in spite of all their complexities, can be 'read' along the walls without encountering difficulties. Guarini, on the other hand, worked with deliberate incongruities and surprising dissonances. One zone of his structures contains

no indication of what the next is going to reveal; and it is only safe to say that the unlikely and improbable are going to happen. The stimuli to conflict and unrest which his architecture contains link it with the Mannerist tradition, and on the level of decoration these connexions are evident beyond any doubt. He clearly returns to the doughy forms of Buontalenti and his school, but he juxtaposes these forms with the crystalline star-hexagons and cross-patterns of the arches, the pendentives, and the pavement, and the different austere, geometrical shapes placed side by side increase the impression of unrest.[19]

The next zone above the pendentives consists of a high drum where six large arched openings alternate with solid pillars which contain Borrominesque convex tabernacle niches [279]. With this unbroken rhythm of pillar and arch the turmoil of the lower tiers seems resolved, and one would expect a spherical dome above this drum. Yet once again we are faced with an entirely unexpected feature, in fact the most extraordinary of the building. Segmental ribs are spanned from centre to centre of the six arches, resulting in a hexagon. By spanning other ribs from the centre of the first series of ribs and by repeating this method six times in all, a welter of thirty-six arches is created, of which three are always on the same vertical axis. Since each rib has a vertical spine (bisecting a segmental window), no less than twelve vertical divisions result, which are clearly visible outside as the structural skeleton of the dome [280].

Objectively, Guarini's cone-shaped dome is not very high; but subjectively, seen from the floor of the chapel, the diminution of the ribs appears to be due to perspective foreshortening so that the dome looks much higher than it is [279]. This impression is supported by the judicious use of colour. The contrast between the black marble and gilding below and the grey of the dome seems to result from the softening of tone values at great distance. At the summit the dome opens into a twelve-edged star, at the centre of which there hovers the Holy Dove strongly lit by the twelve oval windows of the lantern.

No less remarkable than the interior is the exterior, where again one unexpected feature follows another [280]. The principal motif in the lower zone is the six large windows of the drum, united under an undulating cornice. Above it, without transition and even without any intelligible reason (in any case for the

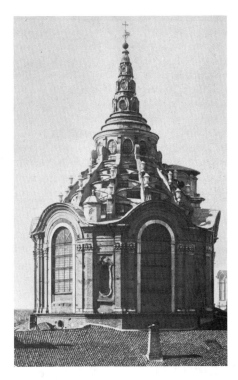

279 and 280. Guarino Guarini:
Turin, Cappella SS. Sindone, 1667–90.
View into dome *(opposite)* and
exterior of dome *(above)*

beholder who does not know the interior), appears the exciting maze of zigzag steps, which are actually the segmental ribs of the dome. Finally, there is the serene horizontal motif of rings diminishing in size, crowned by the pagoda-like structure to which nothing corresponds inside.

It may be noticed that a trinitarian concept pervades the whole building: witness the triangular geometry of the plan, the intrusion of the three satellite structures into the main space with their columns arranged in triads, the multiples of three in the drum, dome, and lantern; further the three circular steps and three-storeyed 'pagoda' of the exterior. The whole building therefore assumes an emblematical quality: in ever new geometrical realizations the all-embracing dogma of the Trinity is reasserted.[20]

Hardly less exciting than the Cappella della SS. Sindone is the nearby church of S. Lorenzo.[21] Guarini began work on it in 1668; in 1679 the building was standing, but it was not entirely finished until 1687 [281-3]. The basic form of the plan is an octagon with the eight sides curving into the main space. Each of these sides consists of a 'Palladio motif' with a wide open arch. For this reason it is difficult or even impossible to perceive the octagon as the constituent shape of the congregational room. The eye is led past the arches to the real boundary of the church. Behind the screen of sixteen red marble columns are niches with statues, white before a black background and framed by white pilasters. Thus there exists a certain continuity of motifs along the boundary, but they complicate rather than simplify an understanding of the structure; for so many different units and so many similar motifs are found side by side and at odd angles that no coherent vision is possible.[22] The strong, uninterrupted entablature above the arches emphasizes and clarifies the octagonal shape. But in the next zone there is an unexpected change of meaning

similar to that in the Cappella della SS. Sindone. Pendentives are placed in the diagonal axes, and at this level the octagon is transformed into a Greek cross with very short arms. The extraordinary fact must be clearly grasped that the pendentives and arches of the cross are functionally divorced entirely from their supports, which belong, as we have seen, to another spatial entity. How revolutionary Guarini's conception is will be realized when one compares it with the slightly earlier Greek cross of S. Agnese in Piazza Navona [128]. Above the pendentive zone there is a gallery with oval

281 and 282. Guarino Guarini:
Turin, S. Lorenzo, 1668-87.
Plan from *Architettura civile*, 1737 *(below)* and view of the interior *(opposite)*

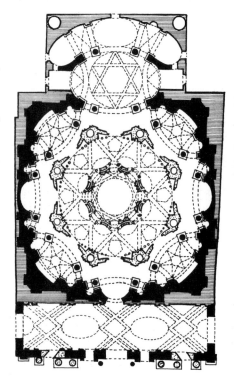

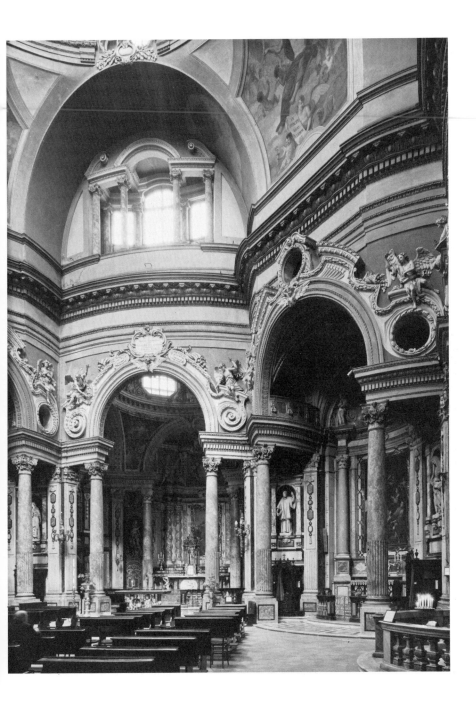

windows, and between them are eight piers from which the ribs of the vaulting spring. These ribs are arranged in such a way that they form an eight-pointed star and a regular open octagon in the centre. We are thus faced with a hybrid feature similar to that planned for the Church of the Somascian Fathers at Messina. And precisely as in the design of that church, there rises above the central opening a lantern – consisting of drum and dome – just as high as the main dome itself. Also, outside, the dome has again the appearance of a drum which is crowned by a second small drum and dome. In spite of these similarities, S. Lorenzo is infinitely more complex. Particular reference may be made to the insertion of a zone with windows between the dome and the lantern. These cast their light through an open ring of segments laid round the inner octagon of the

283. Guarino Guarini: Turin, S. Lorenzo, 1668–87. View into main dome and dome of the presbytery

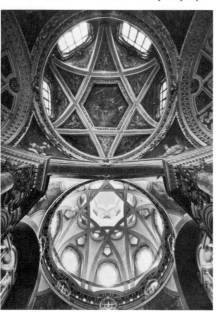

dome. By this device the diaphanous and mysterious quality of the dome is considerably enhanced.

In the longitudinal axis of the church, the circular Cappella Maggiore with a simpler ribbed dome is added to the congregational room. The chapel is delimited by two Palladio motifs, one opening into an altar recess with oval vaulting, the other into the main space. Thus the same Palladio motif which appears as a convex penetration into the main room forms the concave boundary of the chapel. In spite of such interpenetrations of different spatial entities, each of the three domed spaces forms a separate unit with architectural characteristics of its own. With this arrangement Guarini kept well within the North Italian tradition; moreover the scenic effect produced by the longitudinal vista links his plan to the tradition leading from Palladio to Longhena.

We can now summarize a few of the principles which seem to have guided Guarini. Domes have pride of place in his system of architecture. Guarini opened the chapter on vaulting in his *Architettura civile* with the remark 'Vaults are the principal part in architecture', and expressed surprise that so little had been written about them.[23] What is so new about Guarini's own domical structures? The Baroque dome, continuing and developing the formula of the dome of St Peter's, was of classical derivation. Although Borromini broke with this tradition, he too relied on classical prototypes and maintained the solidity of the domical surface. It is this principle that Guarini abandoned. Of course, the models of his diaphanous domes were not Roman. The similarity of the dome of S. Lorenzo to such Hispano-Moresque structures as the eighth-century dome in the mosque at Cordova has often been pointed out; but even if an influence from this side can be admitted,[24] it is the differences rather than the similarities that are important. The Hispano-Moresque domes are not diaphanous, for their

vaults rest on the structural skeleton of the ribs. Guarini's domes are infinitely bolder than any of the Spanish models; he eliminated the wall surface between the ribs and perched high structures on their points of intersection.

It is clear then that Guarini, far from being an imitator, turned over a new leaf of architectural history. A passage in the *Architettura civile* seems to reveal his intentions. With a perspicacity unknown at that date, he analysed the difference between Roman and Gothic architecture. He maintained that in contrast to the qualities of strength and solidity aimed at by Roman architects, Gothic builders wanted their churches to appear structurally weak so that it should seem miraculous how they could stand at all. Gothic builders – he writes – erected arches 'which seem to hang in the air; completely perforated towers crowned by pointed pyramids; enormously high windows and vaults without the support of walls. The corner of a high tower may rest on an arch or a column or on the apex of a vault. . . . Which of the two opposing methods, the Roman or the Gothic, is the more wonderful, would be a nice problem for an academic mind.' It does not appear farfetched to conclude that the idea of his daring diaphanous domes with their superstructures, which seem to defy all static principles, was suggested to Guarini by his study and analysis of Gothic architecture. And he also used the formula of Hispano-Moresque domes to display structural miracles as astonishing as those of the Gothic builders.[25]

But his domes are more than structural freaks. They seem the result of a deep-rooted urge to replace the consistent sphere of the ancient dome, the symbol of a finite dome of heaven, by the diaphanous dome with its mysterious suggestion of infinity. If this is correct, not only his domes but also the other essential characteristics of his architecture become intelligible. The element of surprise, the entirely unexpected, the seemingly illogical,

the reversal of accustomed values, the deliberate contradictions in the elevation, the interpenetration of different spatial units, the breaking up of the coherent wall boundary with the resulting difficulty of orientation – all this may be regarded as serving one and the same purpose.

It would be futile to search in Guarini's treatise for a single sentence in support of this interpretation. And yet the treatise contains an indirect clue. More than one-third of the text is concerned with a new kind of geometry, namely the plane projection of spherical surfaces and the transformation of plane surfaces of a given shape into corresponding surfaces of a different shape. Guarini was perhaps the only Italian architect who had studied Desargues's Projective Geometry,[26] first published in Paris in 1639, which was informed by the modern conception of infinity.

As a writer[27] Guarini sides with seventeenth-century rationalism, but for him as a priest[28] the suggestion of infinity by architectural devices must have been a pressing religious problem. We may surmise that it was the balance between the new rationalism and the modern mathematical mysticism epitomized in Guarini's work that made his architecture so attractive to the masters of the Late Baroque in Austria and southern Germany.

FILIPPO JUVARRA (1678–1736)

When Guarini died in 1683, Juvarra was five years old. He came to Turin as a fully fledged architect in 1714, thirty-one years after Guarini's death.[29] Thus there is no trace of continuity in Piedmontese architecture, nor do Juvarra's buildings at Turin show any Guarinesque influence. On the contrary, Juvarra's conception of architecture was diametrically opposed to that of Guarini. And yet there is a peculiar link between them, for Juvarra was born at Messina and grew up with Guarini's

buildings before his eyes. His father was a silversmith of distinction, and Juvarra's life-long interest in designing works of applied art and in rich decorative detail probably dates back to these years.[30] His early training and impressions were, however, overshadowed by a ten years' stay in Rome (1703/4–14). He joined Carlo Fontana's studio, and it is reported that his teacher advised him to forget what he had learned before. Juvarra followed this advice, absorbed Fontana's academic Late Baroque, and studied ancient, Renaissance, and contemporary architecture with enthusiasm and impartiality (p. 369). His immense gift as a draughtsman, his extraordinary imagination, and his ceaselessly active mind prevented him from perpetuating his master's manner. He gave proof of his great and original talent when in 1708 he entered the service of Cardinal Ottoboni, for whose theatre in the Cancelleria he poured out stage design after stage design of unmatched boldness.[31] Many hundreds of drawings show, moreover, that from as early as 1705 onwards he directed his creative energies towards the most diverse enterprises, such as the vast plans for the systematization of the area round the Capitol, the designs for the completion of the Palazzo Pubblico at Lucca,[32] for a palace of the Landgraf of Hesse-Cassel, and the altars in S. Martino at Naples; in addition there are designs for innumerable occasional works like the funeral decorations for Emperor Leopold I, King Peter II of Portugal, and the Dauphin; for coats of arms, cartouches, tabernacles, lamps, and even book illustrations. Very little of all this, however, was executed.

Juvarra's great opportunity came in 1714 when Vittorio Amedeo II of Savoy (recently created King of Sicily) asked him to enter his service at Messina.[33] At the end of the year we find him at Turin, and with his appointment as 'First Architect to the King' he was im-mediately raised to a position which had no equal in Italy. He soon enjoyed a unique international reputation, to be compared only with that of Tiepolo a generation later. As early as 1711 Emperor Joseph I of Austria had asked him for stage designs for the Vienna theatre. Between 1719 and 1720 he spent a year in Portugal planning the palace at Mafra for King John V.[34] The year 1720 also saw him in London[35] and Paris. He dedicated a volume with drawings to August the Strong of Saxony; finally, in 1735, he was given permission to go to Madrid in order to design a royal palace for Philip V.[36] In Madrid he suddenly died on 31 January 1736.

When Juvarra settled in Turin, he had only twenty-two years to live, but what he accomplished in this relatively brief span seems almost superhuman. It is impossible to give even a remote idea of his splendid achievement. Leaving aside the work done or planned outside Turin and its neighbourhood – at Como, Mantua, Belluno, Bergamo, Lucca, Chambéry, Vercelli, Oropa, and Chieri; leaving aside also the many important projects for Rome[37] and omitting the mass of minor and occasional work at Turin, there still remains an imposing array of buildings, all in or near the Piedmontese capital. The list contains five churches[38] apart from the façade of S. Cristina (1715–28); four royal residences;[39] four large palaces in town;[40] and finally the entire quarters of Via del Carmine-Corso Valdocco (1716–28) and Via Milano-Piazza Emanuele Filiberto (1729–33). The building periods of many of these structures are long and overlap, and it is therefore difficult to see a clear development of Juvarra's style. It would seem more to the point to differentiate between the styles used for different tasks, such as the richly articulated façade of the royal palace in town, the Palazzo Madama [284], in contrast to the classical simplicity of the royal hunting 'lodge', Stupinigi [285], or the relative

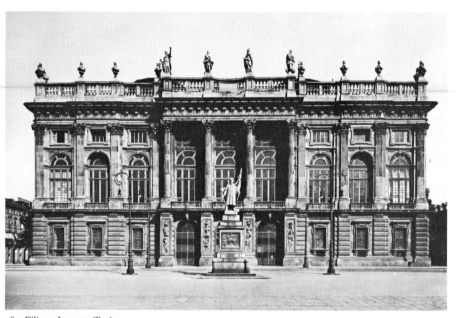

284. Filippo Juvarra: Turin,
Palazzo Madama, 1718-21. Façade

sobriety of aristocratic residences. Moreover, with his absolute mastery of historical and contemporary styles, Juvarra, with admirable ease, used what he regarded as suitable for the purpose. Thus when designing the façades of S.. Cristina or S. Andrea at Chieri (1728) he turned to Rome, while the Palazzo Madama was fashioned on the model of Versailles. The way he absorbed and transformed the models from which he took his cue shows that he was more than an immensely gifted practitioner. In this respect a comparison of the front of the Palazzo Madama with the garden front of Versailles is most illuminating. It cannot be doubted that the former is much superior to the latter. Instead of the petty co-ordination of tiers in Versailles, Juvarra's *piano nobile* dominates the design; and by introducing bold accents and a determined articulation he creates an essentially Italian palace front.[41] The interior is independent of French sources; it contains one of the grandest staircase halls in Italy, taking up almost the whole width of the present façade. It also affords an excellent opportunity for studying Juvarra's decorative style, which is entirely his own. It derives from a fusion of Cortonesque and Borrominesque conceptions; boldly treated naturalistic motifs appear next to flat dynamic stylizations; exuberant ornament next to chaste, almost Neo-classical wall treatment.

While planning Stupinigi, Juvarra wavered for a time between the French and the Italian tradition. He considered both the French château type with the staircase hall adjoining the vestibule and the Italian star-shaped plan,

285 *(below)*. Filippo Juvarra: Stupinigi, Castle, 1729-33

286 *(opposite)*. Filippo Juvarra: Stupinigi, Castle, 1729-33. Plan

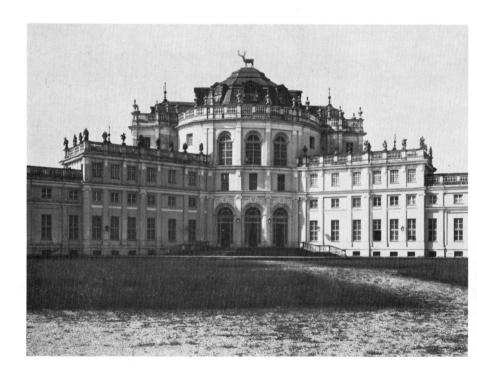

where corresponding units are grouped round a central core.[42] He chose the latter type of design [285, 286], extended it to a scale which has no parallel in northern Italy, and transformed it so thoroughly that Stupinigi is really in a class of its own.

If it is difficult to discern a development of Juvarra's architecture in the traditional sense, an evolution – or even revolution – of certain fundamental spatial conceptions may yet be observed. On the one hand, Juvarra must be

regarded as the most distinguished legatee of architectural thought accumulated in Italy in the course of the previous 300 years. On the other hand, he broke away from that tradition more decisively than any other Italian architect since the Renaissance. This may first be demonstrated by comparing his design of S. Filippo Neri (1715)[43] with that of the Chiesa del Carmine (1732-5) [287, 288].[44] Despite the ample and airy proportions, the design of S. Filippo does not depart from the old tradition which

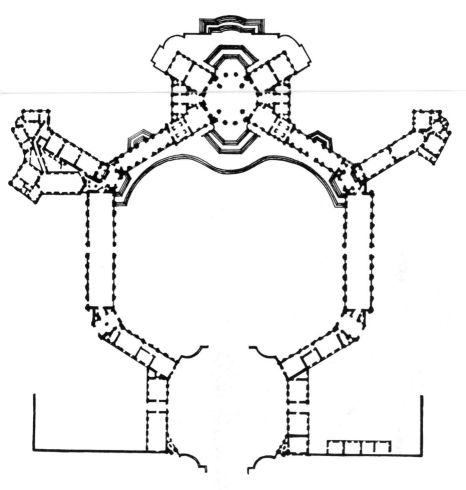

goes back through Alberti to ancient thermae and is epitomized in Palladio's Redentore. The Chiesa del Carmine also has a wide nave and three chapels to each side, but the design has been fundamentally changed. Here there are high open galleries above the chapels, creating the following result: (i) along the nave two arches always appear one above the other, that of the chapel and that of the gallery; (ii) the clerestory is eliminated, and the nave is lit through the windows of the gallery; (iii) and most important, the wall as a boundary of the nave has been replaced by a skeleton of high pillars.

All this is without precedent in Italy. No Italian architect of the Renaissance or the Baroque had wanted or dared to sacrifice the coherent enclosure of the wall and to create such immensely high openings resulting in a shift of importance from the vaulting to the slender supports. This was a thorough reversal of the Italian tradition, indeed, of the classical

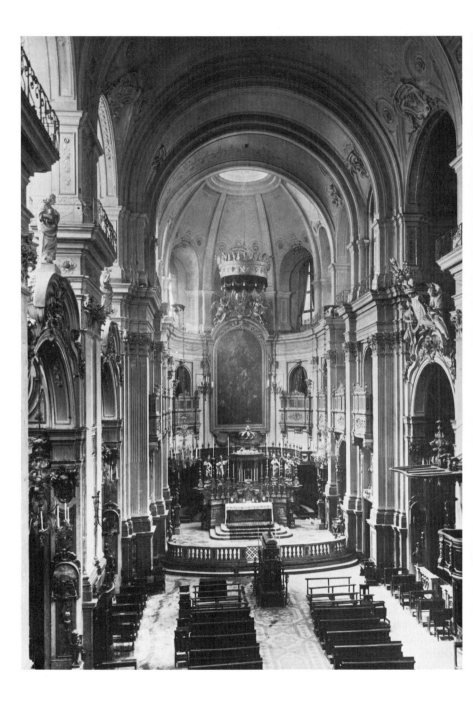

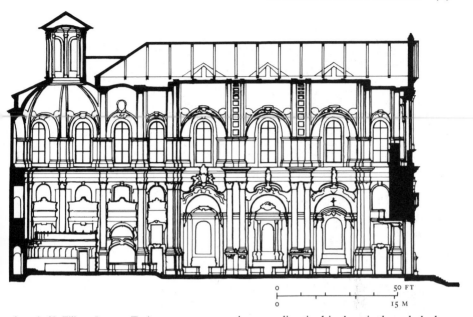

0 ———————————————— 50 FT
0 ———————————————— 15 M

287 and 288. Filippo Juvarra: Turin,
Chiesa del Carmine, 1732–5.
View towards altar *(opposite)* and section *(above)*

foundation of Renaissance architecture. Where
did Juvarra turn for inspiration? High open
galleries are well known from the architecture
of the Middle Ages, even in Italy (e.g. S. Am-
brogio, Milan); but their first monumental
appearance in Renaissance architecture in con-
nexion with the classical barrel vault is to be
found in the crypto-Gothic design of St
Michael, Munich (1583–97). The type re-
mained common in Germany, and Juvarra was
doubtless aware of it. For the first time since
the Renaissance, the North had a vital contri-
bution to make to Italian architecture.

Another point deserves close attention. The
chapels of the Chiesa del Carmine are not self-
contained units with their own source of light
but have oval openings through which light
streams from the windows of the gallery. The
idea of using hidden light and conducting it
through an opening behind or above an altar
was conceived by Bernini (St Teresa altar);

it was acclimatized in Austria through Andrea
Pozzo and Fischer von Erlach[45] and was at the
same time transferred from altars to whole
chapels. It is plausible that this happened first
in the North,[46] for the simple reason that there
was no tradition in Italy for churches with
galleries. So we see Italian ideas adapted in the
North to the traditional longitudinal nave with
galleries, and although the chapel fronts of the
Chiesa del Carmine preserve something of the
character of the Italian altar, it seems safe to
assume that Juvarra was guided also for this
device by German or Austrian examples.

The highest aspirations of Italian architects
were always focused on the centralized church
with dominating dome. True to that tradition,
Juvarra was constantly engaged on fresh solu-
tions of the old problems. Characteristically,
the series begins with an ideal project which
he presented in 1707 to the Accademia di S.
Luca on his election as academician. And typical
of his Late Baroque versatility, he integrates
in this project the most diverse tendencies
without, however, eclipsing the customary
approach to centralized planning.[47] The same

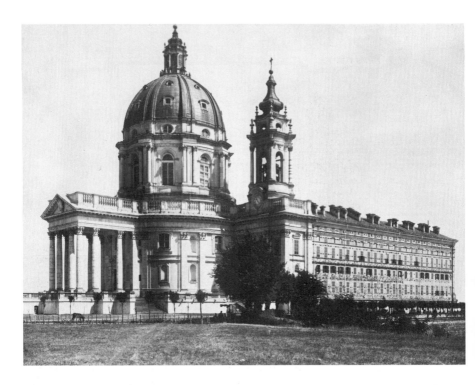

applies to his first executed centralized structure, the church of the Venaria Reale near Turin (1716-21-28). He combined here the Greek cross of St Peter's with ideas derived from S. Agnese and also introduced the scenographic element of screening columns in analogy to Palladio's Redentore.[48]

In the same year in which he was engaged on this design, he also began his masterpiece, the Superga, high up on a hill a few miles east of Turin [289, 290].[49] The Superga is by far the grandest of the great number of Baroque sanctuaries on mountains, of which I have spoken before (p. 390). Again, the church contains little that would point into the future, but it is the brilliant epitome of current ideas, brought together in an unexpected way. While a part of the church is enclosed by the short side of an extensive rectangular monastery, three-quarters of its circular exterior jut out from the straight line of this building. This side, facing the plain of Turin and a glorious range of Alpine peaks, is stone-faced and treated as a coherent unit which conceals the long brick fronts of the monastery. The principal ratios used are of utter simplicity: the square portico in front of the church has sides corresponding in length exactly to the straight walls adjoining the church, a measure which is half that of the church's diameter; the body of the church, the drum, and the dome are of equal height. Similar to the Venaria Reale, the ground plan shows large openings in the cross-axes and satellite chapels in the diagonals. One tends to read into the plan the bevelled pillars of a Greek cross with columns in recesses (reminiscent of S. Agnese). But the elevation reveals that there is no pendentive zone and that the columns

289 and 290. Filippo Juvarra:
Superga near Turin, 1717–31,
exterior *(opposite)*
and section and plan *(below)*

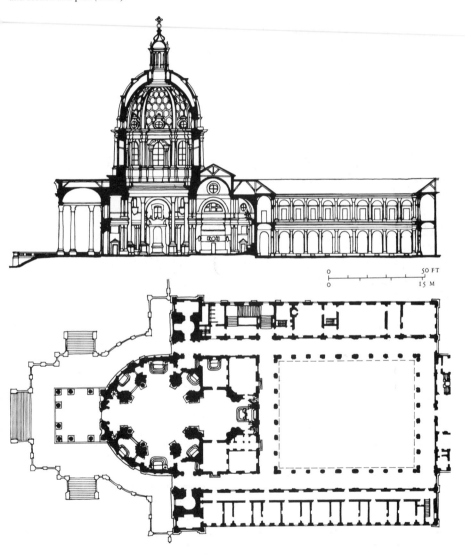

which, in analogy to S. Agnese, one would expect to support the high arches of the Greek-cross arms, carry instead the uninterrupted ring of the entablature, on which rests the high cylinder of the drum. In contrast to many of Guarini's structures, in which a pendentive zone is unexpectedly introduced, here, equally unexpectedly, it has been suppressed. But Juvarra's design lacks the quality of contradiction which we found in Guarini. Juvarra has combined in one building the two principal types of domical structure: the Pantheon type, where the dome rises from the cylindrical body, and the Greek-cross type; and these two different centralized systems remain clearly discernible. The body of the church is octagonal, as it should be in a Greek cross with bevelled pillars; and the transition from the octagon to the circle is boldly conceived,[50] for the circular entablature is set into the octagon touching it only in the centre of the four arches.

The decoration of the church owes as much to Borromini as to Bernini. Borrominesque are the undulating windows of the drum, while the combination of ribs and coffers in the dome is close to Bernini's Castelgandolfo. But the colour scheme with its prevailing light bluish and yellowish tones has no relationship to the past and is typically eighteenth-century. A small centralized altar room, attached to the congregational room, is treated as an isolated unit. Without being attracted by Guarini's pioneering interpenetration of spatial entities, Juvarra returns in this respect to the North Italian Renaissance tradition.

In the exterior he took up the old problem of the high dome between flanking towers. Although the latter are clearly indebted to those of S. Agnese, he returned to Michelangelo's design of St Peter's for the alternating rhythm of wide and narrow bays in the body of the church as well as for the vertical continuation of the pilasters into the double columns of the drum and the ribs of the dome. If Michelangelo, therefore, informed the principle of unification, the relationships are utterly different. In keeping with a Baroque tendency which has been discussed (p. 217), Juvarra increased the height of the drum and dome at the expense of the body of the church, and in this respect he went far beyond the position reached in S. Agnese.[51]

Indirectly the portico also stems from Michelangelo's St Peter's. In 1659 Bernini had tried to revive Michelangelo's idea, and from then on all classically-minded architects placed a portico in front of centralized buildings. The example of the Pantheon was, of course, close at hand, and it is characteristic of Juvarra's classicizing Late Baroque that he took his cue from the ancient masterpiece. But he went even further and endeavoured to improve upon it, firstly by integrating his portico with the body of the church, and secondly by reducing the number of columns. This enabled him to fulfil Vitruvius's demand for a wider central intercolumniation and, moreover, to create a light and airy structure, true to eighteenth-century aspirations.

It may well be said that this building represents the apogee of a long development: the problems of centralized planning, the double-tower façade, the high drum and dominating dome, the tetrastyle portico and its wedding to the church – all this was carried a step beyond previous realizations, in a direction which one might expect if the whole evolution were before one's mind. Yet there is something un-Italian about this work. It is mainly the way in which the monastic buildings have been connected with the church. One cannot avoid recalling the large monastic structures north of the Alps such as Weingarten, Einsiedeln, and Melk, the dates of which, incidentally, almost correspond with that of the Superga. It is hardly possible to doubt that Juvarra was conversant with such works. And it was precisely the impact of the North that also revolutionized his approach to centralized building.

His late centralized church designs were not executed. Most important among them are the many projects for the new cathedral, dating from 1729, in which essentially he returned to the grouping of Leonardo's schemes. But this is true only for the plans and not for the elevations. The strangest among the latter [291]

Once again German buildings provide the key to this development. When uninfluenced by Italy, German architects never accepted the southern drum and dome, not even for their centralized churches. They always preferred (essentially anti-Renaissance) skeleton structures capped by low vaults.[53] While the late

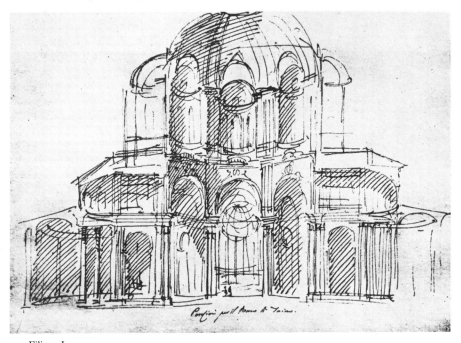

291. Filippo Juvarra:
Sketch for the Duomo Nuovo, Turin, after 1729

shows a skeleton structure with immensely high piers and arched openings in two tiers between them.[52] The dome as an independent, dominating feature has been eliminated. Nor has the drum a *raison d'être* in such a design. It is now clear that in his late work Juvarra applied the same revolutionary principles to the planning of both longitudinal and centralized buildings. The volte-face expressed in the designs for the new cathedral corresponds exactly to that of the Chiesa del Carmine.

Juvarra consented to this principle of spatial organization, he still adhered to the Italian articulation of his units and sub-units. No vaulted structures corresponding to his cathedral designs will be found in Germany.

In the central hall of Stupinigi Juvarra's new ideas reached the stage of execution [292]. And in this hall one will also understand why he was so much attracted by the northern approach to planning. These skeleton structures, with their uninterrupted vertical sweep and the unification

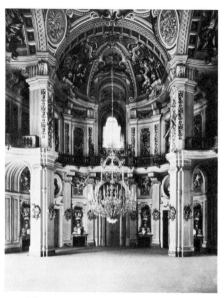

292. Filippo Juvarra:
Stupinigi, Castle, 1729-33. Great Hall

of central and subsidiary rooms, have a marked scenic quality. In spite of his classical leanings, Juvarra never ceased to think in terms of the resourceful stage designer.

When all is said and done, it remains true that Juvarra not only perfected the most treasured of Italian architectural ideals, but also abandoned them. Just because he was the greatest of his generation, this surrender is more than a matter of local or provincial import. It adumbrates the end of Italian supremacy in architecture.[54]

BERNARDO VITTONE
(1702, not 1704/5-70)

The improbable rarely happens, but it does happen sometimes. An architect arose in Turin who reconciled the manner of Guarini with that of Juvarra. His name is Bernardo Vittone, and he was, unlike Guarini and Juvarra, a Piedmon-

tese by birth.[55] Outside Piedmont Vittone is still little known, and yet he was an architect of rare ability, full of original ideas and of a creative capacity equalled only by few of the greatest masters. His relative obscurity is certainly due to the fact that most of his buildings are in small Piedmontese towns, seldom visited by the student of architecture. He studied in Rome, where he won a first prize in the Accademia di S. Luca in 1732.[56] Early next year he returned to Turin, in time to witness the rise of Juvarra's late works. The Superga had just been completed, the large hall at Stupinigi was almost finished, and the Carmine was going up. It was this architecture that made an indelible impression upon him.[57]

Shortly after his return from Rome, the Theatines who owned Guarini's papers won Vittone's collaboration in editing the *Architettura civile*, which appeared in 1737. In this way he acquired his exceptional knowledge of Guarini's work and ideas; nor did he fail to learn his lesson from the long chapters on geometry. On this firm foundation he set out on his career as a practising architect,[58] and from shortly after Juvarra's death until his own death in 1770 we can follow his activity almost year by year. His few palaces are without particular distinction. His interest was focused on ecclesiastical architecture, and it is a remarkable fact that, with one or two exceptions, his churches – and they are many – are centralized buildings or derive from centralized planning. One would therefore presume that as a rule he followed his own counsel and that the clergy of the small communities for which he worked hardly interfered with his ideas.

His first building, to our knowledge, the little Sanctuary at Vallinotto near Carignano (south of Turin), is also one of his most accomplished masterpieces [293-5]. It was erected between 1738 and 1739 as a chapel for the agricultural labourers of a rich Turin banker.[59] The exterior immediately illustrates what has just been

pointed out: it combines features of both Guarini's and Juvarra's styles. From Guarini's specific interpretation of the North Italian tradition derives the pagoda-like diminution of tiers.[60] But in contrast to Guarini's High Baroque treatment of the wall with pilasters and columns, niches and pediments, ornament and statues, we find here walls of utter simplicity, accentuated only by unobtrusive pilasters and plain frames and panels. Obviously this was done under the influence of Juvarra's classicist detail such as the exterior of Stupinigi. In spite of the utmost economy of detail, the church makes a gay and cheerful Rococo impression, and this is due not only to its brilliant whiteness, also to be found in Stupinigi, but above all to the lively silhouette and the undulating rhythm of the walls.

If anything, the impression of the interior surpasses that of the exterior. All the characteristic features of Vittone's style are here assembled – it is a climax right at the beginning. The plan consists of a regular hexagon with six segmental chapels of equal width spanned by six equal arches [294]. But the treatment of the chapels varies; for open chapels alternate with others into which convex *coretti* have been placed. Since, therefore, non-corresponding chapels face each other across the room, the geometrical simplicity and regularity of the plan is not easily grasped.[61] The glory of this little church is its dome [295]. Following Guarini, Vittone formed its first diaphanous shell of intersecting ribs. Through the large hexagonal opening appear three more vaults, one above the other: two solid ones with circular openings,

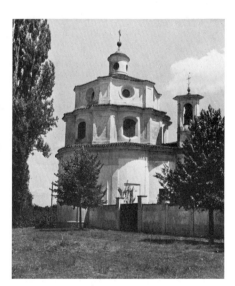

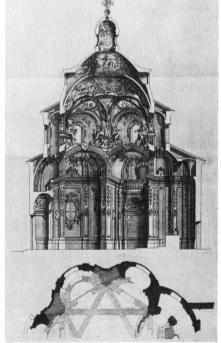

293 and 294. Bernardo Vittone:
Vallinotto near Carignano, Sanctuary, 1738-9.
Exterior, and engraving of
section and plan

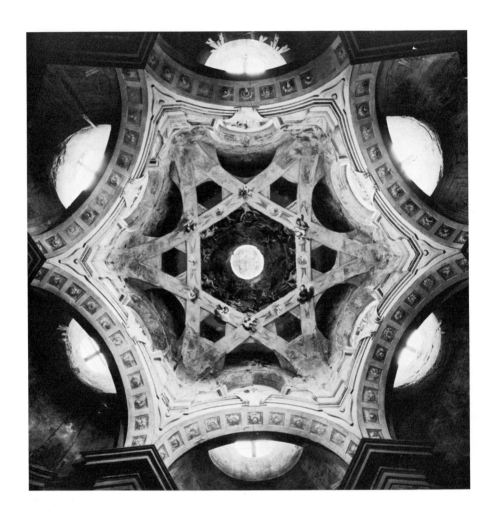

295. Bernardo Vittone: Vallinotto, Sanctuary, view into dome

diminishing in size, and, capping them, the hemisphere of the lantern.

The idea of a solid spherical dome with a large opening, allowing a view into a second dome, is also Guarini's,[62] but the latter never combined this type with the diaphanous dome, and neither Guarini nor any other architect ever produced a dome with three (or, counting the lantern, which forms part of the scheme, four) different vaults. The adaptation and fusion of Guarinesque domical structures was for Vittone a means to a different end. It will be recalled that Guarini always separated the zone of the dome from the body of the church, true to his principle of working with isolated and contrasting units. Not so Vittone; in his case the ribs of the vaulting are continuations of the pillars. He even omits the traditional entablature above the arches of the hexagon, thus avoiding any break in continuity. Instead, he introduces a second ring of high arches above the arches of the chapels. Thus he creates a lofty system of arches with which the ribbed vaulting forms a logical entity. The second ring of arches has a further purpose: it conducts the light from the large windows of the first 'drum' into the main room and under the ribbed vault. At the same time these windows supply a strong sky-light for the chapels, the vaults of which have oval apertures.

It is evident that the arrangement of the arches as well as the lighting of the main room and the chapels derive from Juvarra's Carmine. We are faced with the extraordinary fact that the northern nave type with galleries, introduced by Juvarra into a longitudinal building, has here been transferred to a centralized structure. No stranger and more imaginative union of Guarinesque and Juvarresque conceptions could be imagined.

While the ribbed dome is lit by a strong indirect light, the second dome has no source of light at all. By contrast, the third dome is directly lit by circular windows, but they are invisible to the beholder from any point in the church. Precisely the same type of lighting was used by Guarini in his design of S. Gaetano at Vicenza. The two forms of concealed lighting to be found in the Sanctuary derive therefore from Juvarra's Carmine and Guarini's S. Gaetano. Their common source is, of course, Bernini. But while Bernini focuses the concealed light on one particular area, the centre of dramatic import, no such climax is intended by Vittone. A gay and festive bright light fills the whole space and the differently lit realms of the dome are only gradations of this diffuse luminosity. Vittone himself made it clear that he wanted the different vaults to be seen as one unified impression of the infinity of heaven. On the vaults is painted the hierarchy of angels, of which Vittone writes in his *Istruzioni diverse*: 'The visitor's glance travels through the spaces created by the vaults and enjoys, supported by the concealed light, the variety of the hierarchy which gradually increases' (i.e. towards the spectator).

The altar in this church stands free between two pillars through which one looks into a space behind. Thus even Vittone, who always concerned himself with strict centralized planning, accepted the Palladian tradition of a screened-off space, a tradition with which he was conversant through both Juvarra and Guarini. But we have seen (pp. 182–3) that this device made it possible to preserve the integrity of the centralized space and, at the same time, to overcome its limitations. Vittone, in fact, more than once used and varied this motif and thoroughly exploited its scenic possibilities and mysterious implications.[63]

In a small sanctuary of this character a high standard of finish cannot be expected. All the architectural ornaments are rather roughly painted. The colours used here and in other churches by Vittone are predominantly light grey and reddish and greenish tones, in other words typical Rococo colours somewhat similar

to those used by Juvarra, but entirely different from the heavy and deep High Baroque colour contrasts with which Guarini worked.

The church of S. Chiara at Brà of 1742 is probably Vittone's most accomplished work [296, 297]. Here four identical segmental chapels are joined to a circular core. As in the Sanctuary at Vallinotto, the external elevation follows the basic shape of the plan. S. Chiara is a simple brick structure, and only the top part is whitewashed, emphasizing the richly undulating quatrefoil form of the building. Inside, four relatively fragile pillars carry the vaulting. The section [296] immediately recalls Juvarra's designs for the new cathedral [291]. But Vittone introduced a nuns' gallery with high arches

296. Bernardo Vittone: Brà, S. Chiara, 1742.
Elevation, section, and plan. Engraving

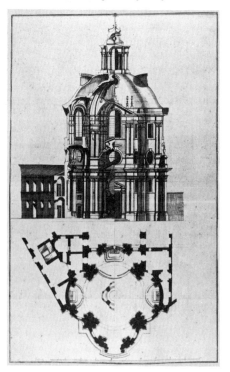

which correspond exactly to the arches of the chapels beneath and cut deeply into the lower part of the vault. Much more closely than at Vallinotto, Vittone adjusted the system of Juvarra's Carmine to his centralized plan.[64] Of the low domical vault little remains, and what there is seems to hover precariously above the head of the beholder. This impression is strengthened by an extraordinary device: each of the four sectors of the vault has a window-like opening through which one looks into the painted sky with angels and saints in the field of vision. Sky and figures are painted on the second shell, which forms the exterior silhouette of the dome, and receive direct and strong light from the nearby windows. And these windows also serve as sky-lights to the gallery.

Vittone found in this church a new and unexpected solution for Guarini's idea of the diaphanous dome: a fragile man-made shell seems to separate constructed space from the realm in which saints and angels dwell [297]. Although structurally insignificant, the dome is still the spiritual centre of the building. By means of a transformed Guarinesque conception, the anticlimax of Juvarra's late designs was here endowed with new meaning.

Also in Vittone's later work hardly any fully developed dome will be found. This is paralleled in Austrian and German church building where the native tradition led to a general acceptance of low vaults. But Vittone's designs are so different from those of the North that a direct contact must be excluded. The stimulus received from Juvarra's Chiesa del Carmine, from the latter's late centralized projects, and the great hall at Stupinigi, in combination with ideas derived from Guarini, fully account for Vittone's strange development. In his later buildings he found ever new realizations of the same problem. S. Gaetano at Nice shows the adaptation of the design of S. Chiara at Brà to an oval plan. In S. Bernardino at Chieri

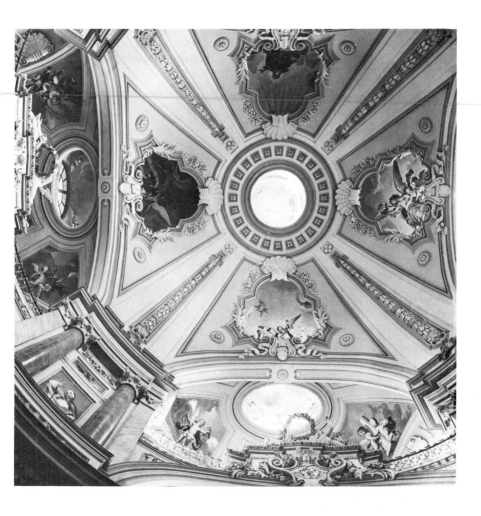

297. Bernardo Vittone: Brà, S. Chiara, 1742. View into dome

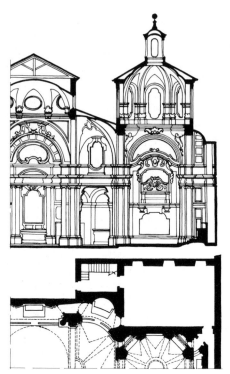

298. Bernardo Vittone: Turin,
S. Maria di Piazza, part of the church and choir,
1751-4. Section and plan

(1740-4) he was handicapped by an existing building and was forced to use a more traditional form of dome. But he made the dome appear to hang weightless in space above the chapels and created diaphanous pendentives through which fall the rays of the sun. In other designs he transformed the dome into a shaft-like feature. This may be studied in his relatively early project for S. Chiara at Alessandria:[65] its diaphanous vault owes a very great deal to Guarini and is, indeed, far removed from the broad stream of the northern development.

The next important step, which further widened the gap with northern designs, was taken by Vittone in 1744 in the church of the Ospizio di Carità at Carignano[66] which shows a new concept brought to full fruition two years later in the choir of S. Maria di Piazza at Turin (1751-4) [298]. Here he designed a normal crossing with four arches and pendentives between them. But instead of separating the zone of the pendentives from the drum by a circular ring, he fused pendentives and 'drum' indissolubly. This he achieved by hollowing out the pendentives and giving them a deep concave shape; in other words, he transformed them into a kind of inverted squinches. Thus the medieval squinch, which had been swept away by the Renaissance and was revived by Borromini in some marginal works (p. 212), found a strange resuscitation just before the close of a long epoch. As a result of the new motif it was possible to arrange the piers of the 'drum' in the form of an octagon and to let the tall windows between them return to the square of the crossing: there are two windows at right angles above each pendentive. Entirely unorthodox, Vittone's domical feature, so rich in spatial and geometrical relations, belongs in a class with Guarini's hybrid dome conceptions.

Vittone availed himself of the infinite possibilities which the inverted squinch offered, and it is remarkable that no other architect, to my knowledge, took up the idea. The maturest manifestation of the new concept is to be found in S. Croce at Villanova di Mondovì (1755) [299].[67] In this church the square of the crossing consists of very wide and high arches. By widening the 'pendentive-squinch', Vittone found an entirely new way of transforming the square into a regular octagon. Thus arches, pendentives, drum, and dome merge imperceptibly into an indivisible whole.

Towards the end of his life Vittone seems to have returned to more conventional designs (church at Riva di Chieri, begun 1766).[68] This phase is reflected in the work of pupils and followers such as Andrea Rana from Susa, the

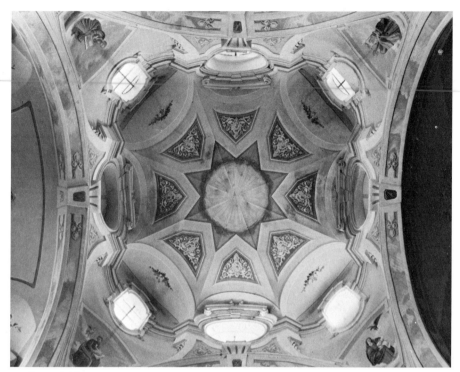

299. Bernardo Vittone:
Villanova di Mondovì, S. Croce, 1755.
View into vaulting

architect of the impressive Chiesa del Rosario at Strambino (1764–81),[69] or Pietro Bonvicini (1741–96), who built S. Michele in Turin (1784).[70] It was these men, among others, who carried on Vittone's Piedmontese Late Baroque almost to the end of the eighteenth century.

When Vittone died, Neo-classicism was conquering Europe. In historical perspective his intense Late Baroque may therefore be regarded as a provincial backwater. But judged on its own merits, his work is of rare distinction. He attacked centralized planning, that old and most urgent problem of Italian architects, with boldness and imagination; and perhaps no architect before him, not even Leonardo, had

studied it with equal devotion and ingenuity. His architecture could be conceived only on the broadest foundation. Through the merging of Guarini and Juvarra he looked back to the 'bizarre' as well as the 'sober' tradition in Italian architecture – to Borromini on the one hand; to Carlo Fontana, Bernini, and Palladio on the other. He himself differentiated between the classical trend and the architecture 'di scherzo e bizzaria', for which he named Borromini and Guarini. Moreover he incorporated in his work the scenic qualities of the North Italian Palladian tradition. Finally, Juvarra familiarized him with Germano-Austrian conceptions of planning, and Guarini with a theoretical know-

432 · LATE BAROQUE AND ROCOCO

ledge of modern French geometry. It was this knowledge that enabled him to discover the potentialities of a combination of pendentive with squinch, a combination geometrically extremely intricate, used neither by French nor German eighteenth-century architects.

What little we know about him suggests that his was an obsessed genius. This is also the impression one carries away from reading his two treatises, the *Istruzioni elementari* of 1760 and the *Istruzioni diverse* of 1766. The earlier treatise is one of the longest ever written, and the later consists to a large extent of appendices to the first. But the published work is only a small part of his literary production. Large masses of manuscripts existed which have so far not been traced. Now the extraordinary thing about his treatises is that basically he has not moved far from Alberti's position. To be sure, the language has changed: where Alberti wanted to elevate and inform the mind, Vittone wants to delight. He also incorporates recent

research – but for what purpose? Newton's splitting up of white light into the colours of the rainbow is for him the supreme confirmation of the old musical theory of proportion. Proportion is the one and all of these treatises, and Vittone's terms of reference are precisely those of Renaissance theory. He even intersperses his text with musical notations, and by squaring his paper he claims to have found an infallible method of ensuring the application of correct proportions. He concludes the second treatise with a special long paper on music which he commissioned from his assistant Giovanni Galletto, whom he never paid for the contribution.[71]

Thus in spite of all the formal development during 300 years of Italian architectural history, beginning and end meet. And it is also in the spirit of the Renaissance treatises that Vittone dedicated his first work to the 'Signore Iddio', to God Himself, and the second to 'Maria Santissima, Madre di Dio'.[72]

SCULPTURE

ROME

Towards the end of the seventeenth century French influence, particularly on sculptors, increased rapidly. The reason for it seems obvious. After the foundation of the French Academy in Rome (1666), French sculptors went to the Eternal City in great numbers, often not only to study but to stay. But this is only part of the story. It would appear that Rome was no longer strong enough to assimilate the national idiosyncrasies of the Frenchmen. It may be recalled that during the preceding 150 years hardly any Roman artist had been a Roman by birth. Bernini was half Tuscan, half Neapolitan; the Carracci, Domenichino, and Algardi came from Bologna; Duquesnoy from Brussels; Caravaggio, Borromini, and a host of others from Northern Italy; and this list could be continued indefinitely. Yet since the days of Bramante, Raphael, and Michelangelo, Rome had had a most extraordinary formative influence on artists: they imbibed that specifically Roman quality which is described by the word *gravità* - a grandeur and severity that stamp all these artists as typically Roman, however widely their personal styles may differ. In Bernini's immediate circle we find Germans and Frenchmen, but without documentary evidence[1] it would be entirely impossible to discover their non-Roman or even non-Italian origin. Now, at the end of the seventeenth century, the position changed. In the works of a Monnot, a Théodon, a Legros [300], or later of a Michelangelo Slodtz [313], we sense something of the typically French *bienséance* and linear grace. In spite of these un-Roman

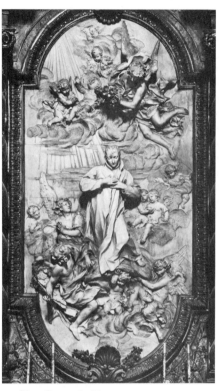

300. Pierre Legros the Younger:
St Louis Gonzaga in Glory, 1698-9.
Rome, S. Ignazio

qualities, however, the artists just mentioned absorbed so much of the Roman Baroque spirit that one feels inclined to talk of them as semi-Romans. It is not until after the middle of the eighteenth century that French works like Houdon's *St Bruno* in S. Maria degli Angeli break away from the Roman tradition entirely.

Support for French influence came from the Italians themselves, and in particular from an artist from whom we should expect it least, namely Domenico Guidi, the only important sculptor of his generation who was still alive in 1700. After the deaths of Ferrata and Raggi in the same year, 1686, he was generally acknowledged as the first sculptor in Rome. In a previous chapter we have discussed the somewhat dubious practices of this artist, whose workshop supplied the whole of Europe with sculpture. His social ambition led him into the higher regions of official academic art; he was *principe* of the Academy of St Luke in 1670 and again in 1675, while Bernini was still alive, and his position put him on an equal footing with Charles Lebrun, the embodiment of the suave and accomplished professional artist. It was Guidi who proposed Lebrun for the post of *principe* of the Academy of St Luke, an honour which the latter accepted for 1676 and 1677. But since he could not leave Paris, it was arranged that Charles Errard, the Director of the French Academy in Rome, should act as his deputy. Thus a mere decade after Bernini had made the Paris academicians and courtiers recoil in fear before Italian genius, the same academicians were, symbolically at least, the masters of Rome – due to the initiative of the unsophisticated Guidi who began as the arch-enemy of the *professori*. The academic ties between Rome and Paris were further strengthened when the French reciprocated by appointing Guidi one of the Rectors of the Paris Academy and by asking him to keep an eye on the work of the French students in Rome. Lebrun, moreover, repaid Guidi's compliment by obtaining for him in 1677 the commission for a group at Versailles. In accordance with French custom, Lebrun himself supplied a drawing from which Guidi was expected to work. The wheel had turned full circle; never before had a Roman artist taken his cue from Paris. Guidi, however, was still steeped in the

Roman grand manner, and the Baroque exuberance of his group gave little satisfaction after its arrival in Versailles.[2]

It must not be forgotten that the exchange of Academic niceties between Lebrun and Guidi took place at a time when Bernini was still vigorously active. Bernini himself was surrounded by friends, old and young, who always remained true to the art of their master. Among the older men there was Lazzaro Morelli (1608-90), the faithful collaborator on the Cathedra, the tomb of Alexander VII, and many other works; among the younger there were Giulio Cartari, who had accompanied Bernini to Paris, Michele Maglia, Filippo Carcani, and above all Giuseppe Mazzuoli. The last three were actually Ferrata's pupils, but Bernini employed them on more than one occasion and particularly for the tomb of Alexander VII. The most important artist of this group was Mazzuoli (1644-

301. Giuseppe Mazzuoli: Angels carrying the Ciborium, *c.* 1700. *Siena, S. Martino*

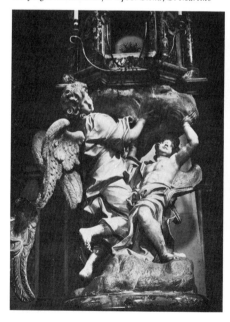

1725),[3] a slightly older contemporary of the Frenchmen Théodon, Monnot, and Legros; and it was he rather than anybody else who kept the Berninesque tradition alive into the eighteenth century and entirely by-passed fashionable French classicism. Instead of illustrating one of his many monumental works, we show as illustration 301 a detail of the two angels who carry the ciborium above the main altar in S. Martino at Siena (c. 1700); here the spirit of the Cathedra angels is still alive. Another of Ferrata's pupils, Lorenzo Ottoni, one of the most prolific artists of the generation born towards the middle of the seventeenth century (1648–1736), remained Berninesque in his many stucco works but followed the classical French trend in his monumental marbles;[4] the same observation may be made in the case of some minor artists of the period. Works by Ottoni found their way to all parts of Italy,

302. Filippo Carcani: Stucco decoration, c. 1685.
Rome, S. Giovanni in Laterano, Cappella Lancellotti

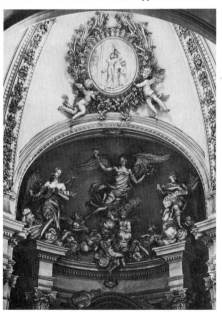

from Montecassino (destroyed) to Rieti, Pesaro, Ancona, and Mantua.

Filippo Carcani, most of whose work was carried out in the twenty years between 1670 and 1690, commands particular interest. Imbued with Bernini's late style, he was attracted by Raggi, and it was Carcani, above all, who carried on Raggi's highly-strung manner – but with this difference: in Raggi's as well as in Bernini's late style the structure of the body remained important; one can always sense the classical model even if the body is hidden under a mass of drapery and even if the drapery contrasts with the stance. Carcani, however, was no longer interested in classical structure. In his stuccoes, bodies are immensely elongated and fragile, as if they were without bones, while draperies laid in masses of parallel folds envelop them [302]. Some of Carcani's work, particularly the stuccoes in the Cappella Lancellotti in S. Giovanni in Laterano (c. 1685),[5] can only be described as a strange proto-Rococo, and the eighteenth-century charm of the sweet heads of his figures would easily deceive many a connoisseur. It is surprising that this 'Rococo' transformation of Bernini's late manner could be performed, so soon after the latter's death, by a sculptor who had worked in close association with him. Carcani's proto-Rococo, however, had no immediate following in Rome.

Despite the continuity of Bernini's late style, at the close of the century it was the French who were given the best commissions. They had the lion's share in the most important sculptural work of those years, the altar of St Ignatius in the left transept of the Gesù.[6] Confidence in the victory of Catholicism had never been expressed so vigorously in sculptural terms and with so much reliance on overpowering sensual effects. Unrivalled is the colourful opulence of the altar, its wealth of reliefs and statues; but a typically Late Baroque diffuse, picturesque pattern replaces the dynamic unity of the High Baroque. In this setting one is apt

to overlook the mediocre quality of the over-life-size marble groups supplied by the main contributors, the Frenchmen Legros and Théodon. Next to the Frenchman Monnot, the Italians Ottoni, Cametti, Bernardo Ludovisi,[7] Angelo de' Rossi, Francesco Moratti, and Camillo Rusconi were given subsidiary tasks, which show, however, more distinction than the work of their French colleagues.

Rusconi (1658-1728), who had first been selected for one of the large marble groups but was replaced by his contemporary Legros, reasserted his position at the beginning of the next century. To be sure, he was the strongest personality among Roman sculptors in the first quarter of the eighteenth century.[8] After an early and brief 'Rococo' phase (Cardinal Virtues, Cappella Ludovisi, S. Ignazio, 1685), deriving like Carcani's style from Raggi rather than from his Roman teacher Ferrata, he reverted, perhaps under the influence of his older friend Carlo Maratti, to Duquesnoy and Algardi and also absorbed the teachings of the French artists in Rome without, however, discarding the Berninesque heritage. The result can be studied in the heroic Late Baroque classicism of his four Apostles for Borromini's tabernacles in S. Giovanni in Laterano (1708-18) [303]. They form part of the series of twelve monumental marble statues, the largest sculptural task in Rome during the early eighteenth century.[9] These statues provide an opportunity of assessing the prevalent stylistic tendency between 1700 and 1715, and the distribution of commissions is, at the same time, a good yardstick for measuring the reputation of contemporary sculptors. Rusconi has pride of place with four figures. Legros and Monnot executed two statues each, and only one was assigned to each of the following: Ottoni, Mazzuoli, Angelo de' Rossi, and Francesco Moratti. Of the two latter, Angelo de' Rossi was by far the more distinguished artist.[10] Born in Genoa in 1671, he had imbibed Bernini's manner under Filippo

303. Camillo Rusconi: St Matthew, 1713-15.
Rome, S. Giovanni in Laterano

Parodi, but after his arrival in Rome in 1689 had turned more and more towards the classicizing French current. Moratti from Padua was also Parodi's pupil; he died young, in about 1720, and his *œuvre* is therefore rather small. Though not influenced by Monnot, his *Apostle Simon*, next to Mazzuoli's *Philip*, is the only other Berninesque statue of the whole series. With eight of the twelve statues the work of Rusconi, Legros, and Monnot, this survey confirms the preponderance of different facets of a Late Baroque classicism, a style anticipated in the painting of Carlo Maratti, but exactly paralleled in contemporary architecture.

The next generation (born between 1680 and 1700) did not pursue wholeheartedly the powerful Late Baroque for which Rusconi stood. Among the many practitioners of that generation four names stand out by virtue of the quality and quantity of their production: those of Agostino Cornacchini (1685-after 1754), Giovanni Battista Maini (1690-1752), Filippo della Valle, and Pietro Bracci (1700-73). Cornacchini, educated in Foggini's studio at Florence, came to Rome in 1712 working in a manner which watered down his teacher's reminiscences of Ferrata and Guidi. His work often has a mawkish flavour, and if he occasionally aspired to grandeur in the Roman artistic climate, he became guilty of grave errors of taste, as is proved by his *St Elijah* (St Peter's, 1727) with its borrowings from Michelangelo as well as by the equestrian monument of Charlemagne under the portico of St Peter's (1720-5), which is nothing but a weak and theatrical travesty of its counterpart, Bernini's *Constantine*.[11] The less pretentious Archangels Michael and Gabriel in the cathedral at Orvieto

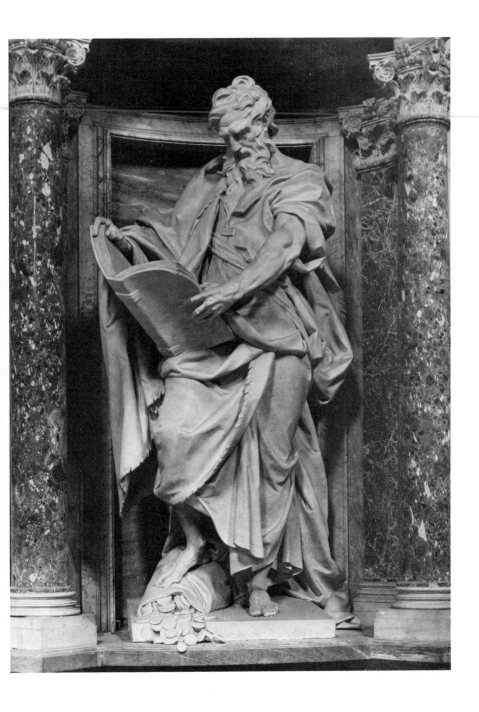

(1729) [304] show that he could command a typically eighteenth-century charm, and in such works his manner is close to that of Pietro Bracci. Giovanni Battista Maini,[12] coming from Lombardy and, like Rusconi, learning his art from Rusnati in Milan, was for a time associated in Rome with his older compatriot, and it was

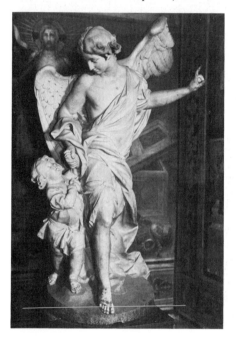

304 *(above)*. Agostino Cornacchini:
The Guardian Angel, 1729.
Orvieto, Cathedral

305 *(right)* Giovanni Battista Maini:
Monument to Cardinal Neri Corsini, 1732-5.
Rome, S. Giovanni in Laterano, Cappella Corsini

306 *(far right)*. Filippo della Valle:
Temperance, *c*. 1735.
Rome, S. Giovanni in Laterano, Cappella Corsini

he together with Giuseppe Rusconi (1687-1758, not related to Camillo) who upheld Camillo's heroic classicism during the thirties and forties of the eighteenth century. Maini's most important works are in Galilei's Cappella Corsini in S. Giovanni in Laterano: the bronze statue of Clement XII (1734), almost a straight classicizing copy after the pope of Bernini's Urban tomb, and, more characteristic, the monument to Cardinal Neri Corsini[13] (1732-5) [305], in which the Marattesque figure of the Cardinal recalls Philippe de Champaigne's Richelieu in the Louvre, while the allegory of Religion is closely related to that of Rusconi's tomb of Gregory XIII.

The rich sculptural decoration of the Cappella Corsini is as vital for our understanding of the position in the 1730s as the Lateran Apostles were for that of about 1710. No less than eleven sculptors were employed and at least six of them were directly or indirectly indebted to Rusconi.[14] But they tend to transform Rusconi's 'classicist Baroque' into a 'classicist Rococo' [306], very different from Carcani's passionate 'Rococo' of almost fifty years before. Most characteristic of this style is perhaps Filippo della Valle's *Temperance*. Like Cornacchini, this artist (1698-1768)[15] had gone through Foggini's school at Florence; in Rome he attached himself closely to Camillo Rusconi. He is certainly one of the most attractive and poetical sculptors of the Roman eighteenth century. But the French note in his work is very marked, and there cannot be any doubt that Frenchmen like his contemporary Michelangelo Slodtz - with whom he collaborated in about 1728 in S. Maria della Scala - brought him in contact with recent events in Paris.[16] His monumental relief of the Annunciation in S. Ignazio (1750), a counterpart to the relief created fifty years earlier by Legros [300], illustrates, however, that Filippo della Valle, for all his engaging and craftsmanlike qualities, was an epigone: this relief, embodying a late

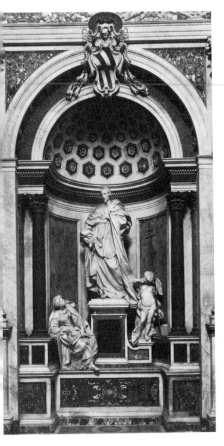

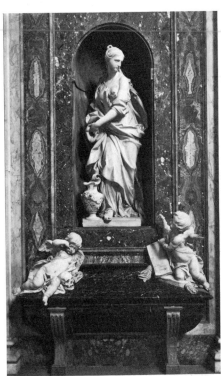

version of Algardi's painterly relief style, shows an accretion of subordinate detail not dissimilar to the manner introduced by Guidi in the first phase of the Late Baroque.

Finally, there is Pietro Bracci,[17] the most prolific artist of this group. He made a great number of tombs, among them those of the Popes Benedict XIII [310] and Benedict XIV, and many portrait busts with a fine psychological penetration and a masterly vibrating treatment of the surface. Still dependent on Bernini's idiom, he transformed it into a tender and lyrical, though sometimes sentimentalizing,

eighteenth-century style. Filippo della Valle and Bracci represent most fully the Rococo phase in Roman sculpture. They belonged to the generation of the masters who brought about the brief flowering of the Rococo in Roman architecture. Both artists were, of course, the chief contributors to the sculptural decoration of the last great collective work of the Roman Late Baroque, the Fontana Trevi [255].[18] The legend is difficult to kill that only Bernini could have designed the combination of figures, masses of rock, sculptured vegetation, and gushing waters; similarly, he is also

made responsible for the design of the figures themselves. But Bracci's slightly frivolous *Neptune*, standing like a dancing master on an enormous rocaille shell, is as far removed from the spirit of Bernini's works as is the picturesque quality of the many rivulets or the artificial union of formalized basins with natural rock. Nevertheless, the Fontana Trevi is the splendid swansong of an epoch which owed all its vital impulses to one great artist, Bernini.

Typological Changes: Tombs and Allegories

Instead of pursuing further individual contributions by minor masters, it may be well to turn to a few specific problems and discuss from another angle the change that took place from the High to the Late Baroque. The papal tomb

307. Pietro Stefano Monnot:
Tomb of Innocent XI, 1697–1704.
Rome, St Peter's

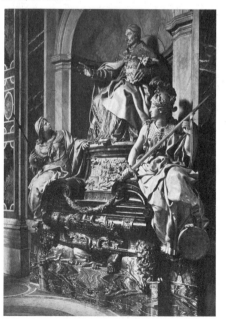

remained, of course, the most important sculptural task right to the end of the eighteenth century. Its history is a touchstone not only for assessing the contributions of the leading sculptors, their style, and the quality of their work, but also for the appreciation of the profound spiritual development that occurred at this period. Between 1697 and 1704 Pietro Stefano Monnot erected the tomb of Innocent XI [307] in a niche opposite Algardi's tomb of Leo XI.[19] Features deriving both from Bernini and Algardi are here combined: the tomb of Urban VIII served as model for the polychrome treatment, as the dark bronze sarcophagus with large scrolls clearly shows; but for the types of the allegories and the narrative relief Monnot followed Leo XI's tomb. He placed the relief, however, not on the sarcophagus itself, but on the pedestal of the papal statue. The insertion of this pedestal made it necessary to reduce considerably the size of the papal figure, compared with Algardi's. The latter's Leo XI fills the whole niche; the weak and somewhat gaunt figure of Innocent XI, by contrast, seems rather too small for its niche. To be sure, one of the statues is by a great master, the other by a mediocre follower; but apart from this, the increased importance of decorative elements at the expense of the figures illuminates the stylistic change from the High to the Late Baroque. Precisely the same observations apply to Angelo de' Rossi's tomb of Alexander VIII in St Peter's (1691–1725), the design of which closely follows that of Urban VIII; but again the addition of a high pedestal with a narrative relief results in figures of considerably shrunken volume and an undue emphasis on the architectural and decorative parts.

More interesting than these monuments is Camillo Rusconi's tomb of Gregory XIII [308], erected between 1719 and 1725 in a niche in the right aisle of St Peter's corresponding to Monnot's tomb in the left aisle. While being profoundly indebted to Bernini's conception

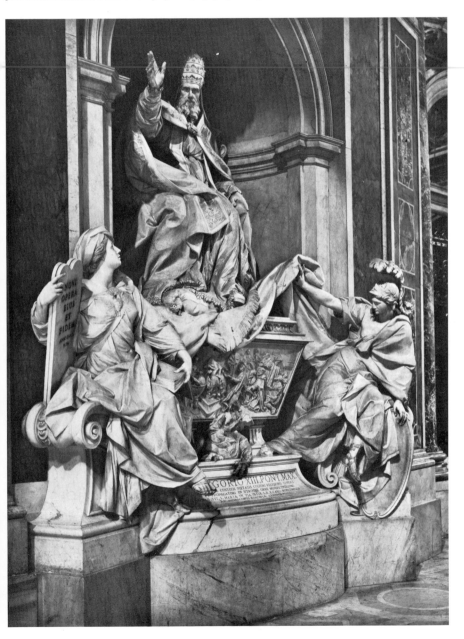

of sculpture, Rusconi blended elements from Algardi's Leo XI and Monnot's Innocent XI. The allegories and their position on the scrolls reveal Monnot's influence; from Algardi derive the unrelieved whiteness of the whole monument, the trapezoid sarcophagus with relief, and the idea of placing the seated pope on the sarcophagus without an isolating pedestal. Rusconi's design is, however, not a simple repetition of the pattern established by Algardi and modified by Monnot. His monument is asymmetrically arranged: the pope does not sit on the central axis, nor do the allegories follow the customary heraldic arrangement.[20] The tomb was evidently composed to be seen as a whole from one side. This is proved not only by the attitude and gesture of the blessing pope and the postures of the allegories, but also by such details as the direction given to the realistic dragon, the armorial animal of the Buoncompagni. Moreover, 'Courage' lifts high a large piece of drapery (the pall that had covered the sarcophagus, a motif taken from Bernini's tomb of Alexander VII); viewed from the left, this creates a dominating diagonal which links the allegory to the figure of the pope. Rusconi composed for the side view because the passage is so narrow that a comprehensive view on the central axis is not possible. By taking such issues into consideration and limiting himself to one main view, Rusconi had recourse to principles which we associate with Bernini rather than Algardi.[21] The spirit of Bernini's High Baroque has also come to life again in the powerful gesture of the blessing hand which recalls the attitude of Urban VIII. If this tomb represents a rare synthesis of the classicizing and Baroque tendencies of Algardi and Bernini, successfully accomplished only in what I have called Rusconi's 'heroic Late Baroque', it yet exhibits a new departure of great importance. Whereas in the older tombs allegories were personal attributes expressing particular virtues

of the deceased by their presence and actions, 'Courage' here raises a curtain in order to be able to study the relief celebrating Gregory's reform of the calendar. This implies a change in the meaning of allegories, to which we shall presently return.

The history of papal tombs continues with those of Clement XII by Maini and Monaldi in the Cappella Corsini of the Lateran (1734) and of Innocent XII by Filippo della Valle in St Peter's (1746) [309], the former with a tendency towards classicizing coolness, the latter showing almost Rococo elegance.[22] These monuments repeat the structure of papal tombs, by then conventionalized from the type created by Bernini at the height of the Catholic Restoration as an adequate expression of papal power. In Rusconi's work something of this spirit had

309. Filippo della Valle:
Tomb of Innocent XII, 1746.
Rome, St Peter's

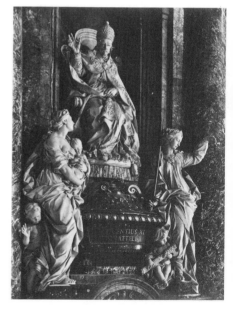

been kept alive – one might almost say – anachronistically; for in the course of the seventeenth century the political influence of the Papacy had been gradually waning, and this is reflected in the papal monuments of the period. Already Guidi's Clement IX in S. Maria Maggiore (1675) and Ferrata's Clement X in St Peter's (c. 1685) had shown a considerably weakened energy of the blessing gesture and a shrinking of volume; this process went on, though not without interruption, until Filippo della Valle made his Innocent XII a fragile old man rather than the symbolic head of Christianity. Shortly before, Pietro Bracci had replaced the ritualistic gesture by a purely human attitude. His Benedict XIII on the tomb in S. Maria sopra Minerva (1734) [310][23] is bareheaded, sinks on one knee, and turns towards

310. Pietro Bracci and others:
Tomb of Benedict XIII,
1734. *Rome, S. Maria sopra Minerva*

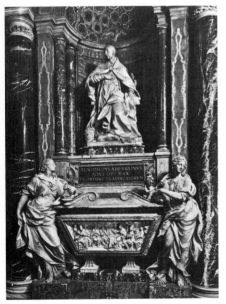

the altar of the chapel in deep veneration. The type had been anticipated about sixty years before by Bernini in the tomb of Alexander VII [89] though it had not been followed in any of the later papal tombs. But where Bernini's kneeling pope shows an unshaken confidence, an almost impersonal and eternal attitude of prayer, Bracci portrayed his Benedict XIII as a man of a less stable constitution, who seems aware of the troubles of the human heart and the frailty of man's existence. It was left to Canova to carry this development to a logical conclusion. In his tomb of Clement XIII (1788–92) he even discarded the customary Baroque allegories.[24] What remains is the unheroic figure of the custodian of Faith lost in deep prayer.

The series of papal tombs represents the most coherent group of Baroque monuments, the high political character of which did not, however, admit too many expressions of personal idiosyncrasies either of patron or artist. On the other hand, turning to the tombs of the higher and lower clergy, of aristocracy and bourgeoisie, we find that the variety of types is immense. In spite of the kaleidoscopic picture some significant changes in the broad development from the seventeenth to the eighteenth century can be discovered. The leading motif in tombs from about 1630 onwards is the figure of the deceased represented in deep adoration, turned towards the altar. This type of tomb lived on into the eighteenth century, but already in the 1670s and 80s such figures began to lose their devotional fervour, and during the eighteenth century they appear more often than not like fashionable courtiers attending a theatrical performance. A comparison between Bernini's Fonseca bust [203] and Bernardo Cametti's[25] bust of Giovan Andrea Giuseppe Muti in S. Marcello, Rome (1725) [311], illuminates the change. On the opposite wall Cametti represented Muti's much younger and equally fashionable wife. The whole chapel forms an

311. Bernardo Cametti:
Tomb of Giovan Andrea Giuseppe Muti,
1725. *Rome, S. Marcello*

architectural and colouristic unit of a light and airy character, and the new eighteenth-century spirit is as perfectly expressed by the graceful elegance of the worshippers behind their prie-dieus as was that of the seventeenth century by mystic devotees in profound contemplation.

Besides the kneeling worshipper, the seventeenth century knew the completely different type of tomb which Bernini introduced in the Valtrini and Merenda monuments. In the former, a winged skeleton, seemingly flying through space, carries a medallion with the portrait in relief to which it directs the beholder's attention by a pointing gesture. The tomb, therefore, contains two different degrees of reality, that of the 'real' skeleton and that of the 'image' of the departed. We are, as it were, given to understand that it would be anachronistic to represent a dead person 'alive' and that his likeness can be preserved for us only in a portrayal. This idea shows a new rational approach to the conception of funeral monuments, and its occurrence simultaneously with the type of the mystical worshipper is more revealing for the seventeenth-century dichotomy between reason and faith than would at first appear. It was not, however, until the end of the seventeenth century that the medallion type began to gain prominence, while in the course of the eighteenth century it entirely supplanted the tomb with the deceased in devotional attitude. At the end of this process belong tombs like that of Cardinal Calcagnini by Pietro Bracci, in S. Andrea delle Fratte (1746) [312], where even low relief seemed too realistic and so was replaced by a painted portrait[26] set in a pyramid on which a flying figure of Fame writes the memorial inscription. From about 1600 onwards the pyramid,[27] the symbol of Eternity, was used for tombs in ever-increasing numbers in Rome and Italy, and soon also in the rest of Europe; but the combination with the painted portrait hardly ever occurred before the early eighteenth century. Although in the personifi-

cation of Fame Bracci employed the traditional Baroque language of forms, the spirit of such tombs is very different from that of the High Baroque. What is expressed through the paraphernalia of Bracci's monument is the somewhat trite assurance that the memory of the deceased will be kept alive in all eternity. No longer is the monument concerned with the union of the soul with God – it is now purely commemorative, a memorial made for the living. No longer can the 'dead' worshipper and the beholder meet in the same reality. The commemorative picture is far removed from our sphere of life, it cannot step out of its frame and turn in adoration towards the altar. The magic transformation of time and space was a thing of the past. We are in the age of reason, and the new approach to the problem of death, an approach much closer to our own than to that of the broad current of the seventeenth century, admitted neither the High Baroque conception of space nor the more elaborate type of Baroque allegory.

Allegory was, of course, not banned from eighteenth-century monuments, but it underwent a characteristic change. High Baroque allegory, for all its realism, was meant to convey in visual terms notions of general moral significance. Though its realism aimed at pressing home convincingly the timeless message, the allegory never acted out a scene. This was precisely the eighteenth-century procedure and consequently allegory lost in symbolical meaning what it gained in actuality. 'Liberty' now hands a coin to her child-companion, 'Disinterestedness' refuses with violent gestures to accept any of the treasures from an overflowing cornucopia, or 'Justice' orders the little bearer of the fasces to carry his load to the place which seems proper to her. We found even in Rusconi's tomb of Gregory XIII [308] that 'Courage' was engaged in an activity which lay outside her allegorical vocation. When allegory was turned into genre, a visual mode of express-

312. Pietro Bracci:
Tomb of Cardinal Carlo Leopoldo Calcagnini, 1746. *Rome, S. Andrea delle Fratte*

ing abstract concepts – peculiar to the arts from ancient times onwards – began to disintegrate.

A similar change may be observed in eighteenth-century religious imagery. A poignant incident replaced, whenever possible, the simple rendering of devotion and vision. When Michelangelo Slodtz was commissioned to execute the statue of St Bruno for one of the niches of the nave of St Peter's (1744) [313],[28] he chose for representation the saint's dramatic refusal of the bishop's mitre and staff. Interest in the episode seems to weaken the supra-personal content. This does not mean, of course, that Slodtz's statue lacks quality. The graceful curve of the saint's body, the elegant sweep of his cowl, the precious gesture as well as the putto who forms

313. Michelangelo Slodtz: St Bruno, 1744.
Rome, St Peter's

part of the movement – all this must be valued in its own right and not judged with Bernini's work before one's mind. Such a figure illustrates extremely well the elegant French Rococo trend in Roman sculpture of the mid eighteenth century. Obviously this style was not possible without Bernini's epoch-making achievement, but it stands in a similar relation to his work as did Giambologna's refined Mannerism to Michelangelo's *terribilità* two hundred years before.

SCULPTURE OUTSIDE ROME

In contrast to the flowering of Baroque painting in many regions of Italy throughout the seventeenth century, it is peculiar to Baroque sculpture that its wide dissemination in Italy and the rest of Europe coincides with the waning of the High Baroque in Rome. It has been mentioned that no coherent school of High Baroque sculpture existed outside Rome. But from the late seventeenth century onwards we find hundreds of names of sculptors and scores of thousands of plastic works all over Italy. As before, Rome remained the centre – different from the development in the other arts. Every provincial sculptor endeavoured to receive his training there or, failing that, in the school of a master who had worked in a Rome studio. The artistic pedigree of most provincial sculptors leads back, directly or indirectly, to Bernini; he was the ancestor of the largest school of sculptors that ever existed. However, no attempt can here be made to give even a vague impression of the diffusion of the Berninesque idiom. In fact the details of this story are, with few exceptions, of no more than marginal interest.

It characterizes the situation that it remained customary for commissions of outstanding importance to be placed in Rome. Thus, when Vittorio Amedeo II wanted to decorate the Superga with large reliefs, he turned to Rome and placed the work with Cornacchini and Cametti, the former born in Tuscany, the latter

a Piedmontese, and both at the height of their reputation in about 1730. A little earlier, the monks of Montecassino asked Roman and not Neapolitan sculptors to carry out their vast sculptural programme; masters like Ottoni, Legros and his collaborator Pier Paolo Campi, Francesco Moratti, and Maini worked for them. Needless to say, all the memorial statues of popes for cities of the papal state were carved in Rome, and so were many portrait busts and tombs commissioned not only from all over Italy but also by foreign admirers of Roman art.[29]

And yet at the end of the seventeenth and the beginning of the eighteenth century most Italian centres had sculptors who were capable of satisfying up-to-date taste. These artists kept abreast of the stylistic development in Rome. The most distinguished Florentine sculptor of the period, Ferrata's pupil Giovanni Battista Foggini (1652-1737),[30] introduced to his native city a style which combined details reminiscent of his teacher with the discursive painterly compositions characteristic of Guidi's work.[31] If his Cappella Corsini in the Carmine (1677-91) [314] and his Cappella Feroni in SS. Annunziata (1691-3) were in Rome, one would regard them as somewhat exaggerated products of that rather crude, patchy, crowded, and disorderly manner which we associate with the first phase of the Late Baroque. In Florence, however, these chapels are the high-water mark of Berninesque sculpture.[32] Ferrata also instructed Massimiliano Soldani (1656, not 58, -1740), who led the native tradition of working in bronze to new heights; his rich œuvre has been masterly reconstructed by K. Lankheit.[33] The older sculptors of Foggini's school were mediocre talents.[34] The best among his younger pupils was Giovanni Baratta (1670-1747), a member of the great family of sculptors from Carrara; in his painterly Baroque a typically Florentine reserve may be detected.[35] It was a pupil of the Roman Maini, Innocenzo Spinazzi

(d. 1798), who brought about the change to Neo-classicism in Florence.

We have seen how Late Mannerist traditions in Lombardy lived on virtually into the second half of the seventeenth century. With sculptors like Giuseppe Rusnati (d. 1713), the pupil of Ferrata in Rome and teacher of Camillo Rusconi, the situation had changed. Rusnati's *Elijah* on the exterior of Milan Cathedral looks like an anticipation of Rusconi's *St Matthew* in the Lateran, while Carlo Simonetta (d. 1693) seems to have come under the influence of Puget.[36] Other slightly younger masters perform the transition to the lighter rhythm of the eighteenth century. This process may have begun with Francesco Zarabatta and can be

314. Giovanni Battista Foggini:
The Mass of S. Andrea Corsini, 1685-91.
Florence, Chiesa del Carmine

followed to the Late Baroque charm of Carlo Francesco Mellone (d. 1736), to the easy elegance of Carlo Beretta, and the typically mid-eighteenth-century fragility of Elia Vincenzo Buzzi.[37] But it cannot be maintained that all this has more than strictly limited interest.[38] A master in his own right was Andrea Fantoni from Rovetta (1659-1734) who worked exclusively in the provinces. His wooden confessional in S. Maria Maggiore, Brescia, as well as his celebrated pulpit in S. Martino at Alzano Maggiore, both richly decorated with statues, reliefs, and flying putti, have an almost un-Italian Rococo quality and are probably unmatched by anything produced at the same period in Milan.

The impact of the Roman High Baroque first came to Genoa through Algardi's work for the Cappella Franzoni in S. Carlo. In 1661 the French sculptor Pierre Puget settled in Genoa

315. Filippo Parodi:
Tomb of Bishop Francesco Morosini, 1678. Detail.
Venice, S. Nicolò da Tolentino

and stayed for six years. He had absorbed Bernini's and Cortona's style in Rome, and his works at Genoa with their Berninesque vigour and fire of expression had a decisive influence on the formation of a school of sculptors in that city.[39] But even more important was Filippo Parodi (1630-1702), Genoa's first and greatest native Baroque sculptor; he had studied for six years with Bernini (1655-61),[40] and on his return to Genoa met in Puget an artist with tendencies similar to his own. Some of his works of the 1660s and 70s still have a High Baroque flavour. They correspond to the emotional and sensitive style of Melchiorre Caffà and Raggi (see his *Ecstasy of St Martha*, S. Marta, Genoa, and *St John*, S. Maria di Carignano); he often introduced a graceful note (*Virgin and Child*, S. Carlo, Genoa) which occasionally endows his works with an un-Roman, rather French elegance. Later, in his tomb of Bishop Francesco Morosini (d. 1678) in S. Nicolò da Tolentino at Venice, he combines recollections of Bernini with proto-Rococo features [315] not unlike the style of the Roman Filippo Carcani. At the same time, the picturesque composition of this tomb is characteristic of the new tendencies of the Late Baroque.[41]

Filippo Parodi was the man of destiny for the further development of Genoese sculpture. Among his pupils were Angelo de' Rossi (whom we found working in Rome), Giacomo Antonio Ponsonelli (1651-1735) who accompanied him to Venice and Padua, his son Domenico (1668-1740), sculptor, painter, and architect, and the two Schiaffino.[42] Bernardo Schiaffino (1678-1725) and his younger brother Francesco (1689-1765) gave the style the lighter eighteenth-century touch of the Rusconi school. In fact, Francesco went to Rome, studied with Rusconi, and after his return to Genoa executed from the latter's model the celebrated *Pluto and Proserpina* group of the Palazzo Reale.[43] The last great name of the Genoese school of Baroque sculptors is Bernardo Schiaffino's pupil Fran-

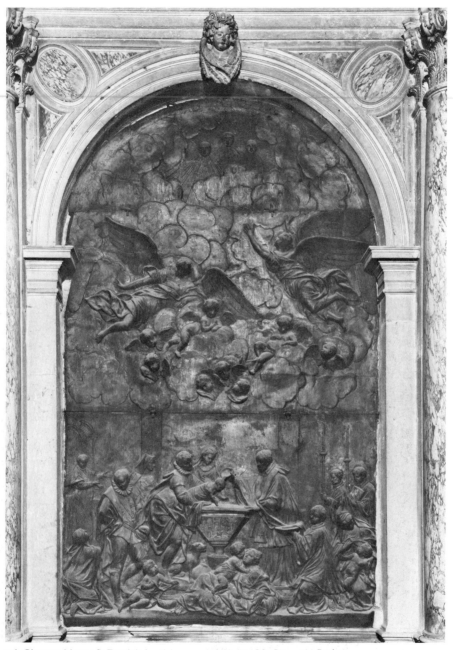

316. Giuseppe Mazza: St Dominic baptizing, *c.* 1720. *Venice, SS. Giovanni e Paolo*

cesco Queirolo (1704-62). But he hardly ever worked in his native city. He soon went to Rome where he spent some time in Giuseppe Rusconi's studio and also had independent commissions until, in 1752, he was called to Naples to take part in the sculptural decoration of the Cappella Sansevero. Genoa also had a flourishing school of woodcarvers,[44] but it was only Anton Maria Maragliano (1664-1739) who raised a popular tradition to the level of high art. He often worked from designs of his teacher, the painter Domenico Piola. The style of his many multi-figured pictorial groups is close to that of the Schiaffino: he knew how to combine the expression of ecstatic devotion with true Rococo grace.

Sculpture in wood had a home in Piedmont too. The principal practitioners were Carlo Giuseppe Plura (1655-1737)[45] and Stefano Maria Clemente (1719-94) who continued a popular Late Baroque far into the eighteenth century. In view of the architectural development in Turin, it is strange that a local school of sculptors arose only towards the end of the period with which we are concerned. Next to Francesco Ladatte (1706-87),[46] who studied in Paris and was entirely acclimatized to France but was appointed court sculptor in Turin in 1745, the most distinguished names are those of Giovanni Battista Bernero (1736-96) and of the brothers Ignazio (1724-93) and Filippo Collini;[47] but most of their work belongs to the history of Neo-classicism.

Bologna had a first-rate sculptor of Rusconi's generation in Giuseppe Mazza (1653-1741), who harmoniously fused the general stylistic tendencies with local traditions. His Late Baroque classicism has nothing of Roman grandeur and the emotional moderation of his work reveals that he had imbibed the 'academic' atmosphere of Bologna. In his many statues and reliefs in stucco, marble, and bronze, to be found not only in his native city but also at Ferrara, Modena, Pesaro, and above all Venice, he appears to perpetuate the classical current

coming down from Algardi, but it is a classicism drained of High Baroque vigour. This is fully proved by his masterpiece, the six monumental bronze reliefs of the Cappella di S. Domenico in SS. Giovanni e Paolo, Venice [316].[48]

Baroque sculpture in Venice does not begin until the middle or second half of the seventeenth century. Alessandro Vittoria (d. 1608), Tiziano Aspetti (d. 1607), and even Girolamo Campagna (d. 1623) belong to a history of sixteenth-century sculpture; with them a glorious development of almost two hundred years comes to an end. Just as in the history of Venetian painting, the continuity was broken, and hardly a bridge exists to later Seicento sculpture. The only name of distinction belonging to the first half of the century is that of Nicolò Roccatagliata (1539-1636) who, Genoese by birth, was thoroughly acclimatized to Venice; but in his many bronzes he adhered faithfully to the older tradition and even reverted to Jacopo Sansovino, in other words to pre-Vittoria tendencies in Venetian sculpture.[49]

Up-to-date ideas reached Venice belatedly through two different channels: first, through sculptors coming from North of the Alps,[50] and secondly through Italians who, for longer or shorter periods, resided in Venice. Of the latter, both the Genoese Filippo Parodi and the Bolognese Giuseppe Mazza have been mentioned; they exerted a strong influence on further events in Venice which is not yet sufficiently investigated. The most vigorous among the northern artists who settled in Venice was Josse de Corte (1627-79), in Italy called Giusto Cort or Lecurt, who was born at Ypres and, after a stay in Rome, made Venice his home from 1657 onwards. Many of his numerous works are for buildings by Longhena, who seems to have preferred him to any other sculptor. His style may best be studied in Longhena's S. Maria della Salute where Giusto's rich sculptural decoration of the high altar (1670) [317] perpetuates in marble the theme of the dedication of the church:

317. Josse de Corte: The Queen of Heaven expelling the Plague, 1670. *Venice, S. Maria della Salute, high altar*

318. Josse de Corte:
Atlas from the Morosini Monument, 1676.
Venice, S. Clemente all'Isola

'Venice' kneels as a suppliant before the Virgin who appears on clouds while the horrifying personification of the 'Plague' takes to flight, gesticulating wildly. Though the style of this *tableau vivant* is characteristically Late Baroque in the sense which we have indicated in these pages, the soft surface realism, the almost Gothic brittleness of the picturesque drapery, and the weakness in composition give this and others of his works a distinctly Flemish quality. In a detail like that of one of the caryatids from the Morosini monument in S. Clemente all'Isola (1676), shown as illustration 318, this Flemish note is very obvious.[51]

De Corte's collaborators and pupils continued his manner to a certain extent until after 1700. Among them were artists of considerable merit, such as Francesco Cavrioli from Treviso (who worked in Venice between 1645 and 1685), Francesco Penso, called Cabianca (1665?–1737),[52] Orazio Marinali (1643–1720),[53] and others. These sculptors, together with some foreigners,[54] were responsible for the rich sculptural decoration of the exterior of S. Maria della Salute. Profuse sculptural decoration of church façades became fashionable from Tremignon's S. Moisè on. Giuseppe Sardi's façades of S. Maria del Giglio (1678–83) and of the Chiesa degli Scalzi (1672–80) as well as Domenico Rossi's façades of S. Stae and the Chiesa dei Gesuiti (1714–29; executed by G. B. Fattoretto) and Massari's Chiesa dei Gesuati (1724–36) are characteristic examples. For all these commissions the collaboration of many hands was required. The large Valier monument in SS. Giovanni e Paolo, designed by Tirali in 1705, and the façade of S. Stae of 1709 give a good idea of the position at the beginning of the eighteenth century. It was mainly sculptors born in the 1660s who were responsible for the somewhat bombastic, painterly, and refreshingly unprincipled Late Baroque of these monuments.[55] Most of us no longer have the eye to see and savour the magnificent scenic spirit that

created the tightly intertwined group balancing precariously free in space upon an enormous bracket high above the portal of S. Stae.

Twenty years later the situation had changed. The sculptors born in the 1680s and 90s brought about a refined and serene style parallel to, but quite independent of, the Filippo della Valle and Bracci style in Rome. The transition to the new manner may be observed in such works as the Cappella del Rosario in SS. Giovanni e Paolo (1732) or the façade of the Gesuati (1736).[56] It was mainly three artists on whom the change depended. The oldest of them, Antonio Corradini[57] (1668–1752), belongs to the generation of the well-known Andrea Brustolon[58] (1662–1732), who never broke away from the early phase of the international Late Baroque. Corradini began in this manner, to which he still adhered in his monument of Marshal von der Schulenburg[59] in Corfù of 1718. But his allegory of *Virginity* [319] in S. Maria del Carmine, Venice, of 1721, shows the new idiom. This style is precious, harking back not to antiquity but to Alessandro Vittoria – it is, in other words, a sentimental revival of the Venetian brand of Late Mannerism. Corradini's *neo-Cinquecentismo* even led him back to Sansovino (*Archangel Raphael* and *Sarah* at Udine), but he combined this archaism with a typically post-Berninesque virtuosity of marble treatment.[60] If my analysis is correct, one cannot regard this style as an anticipation of Canova.

A similar development may be observed with Giovanni Marchiori (1696–1778) and Gian Maria Morlaiter (1699–1781).[61] Only fairly recently more than a hundred bozzetti from Morlaiter's studio were discovered: their style, highly sensitive, ranges from a light imaginative touch like German Rococo and from what might be called a sculptural interpretation of Tiepolo to an elegant classicism comparable to the early Canova. Marchiori, the pupil of Andrea Brustolon, developed towards a refined 'classicist Rococo' after a neo-Cinquecentesque

319. Antonio Corradini:
Virginity, 1721.
Venice, S. Maria del Carmine

320. Giovanni Marchiori: David, 1743.
Venice, S. Rocco

phase. Although his style seems to contain all the formal elements of Neo-classicism, it is again precious and picturesque and not unlike Serpotta's. This is shown by his figures of *St Cecilia* and *David* [320] in S. Rocco, Venice (1743). It appears, then, that the general trend in Venetian sculpture is close to that in Venetian painting. Also in sculpture is the eighteenth century more specifically Venetian than the seventeenth, and this 'home-coming' was achieved by reviving the local tradition of Vittoria and Jacopo Sansovino.

The great and notorious monument of the late Neapolitan Baroque is the Cappella Sansevero de' Sangri, called Pietatella, founded in 1590, continued in the seventeenth century, and decorated for Raimondo del Sangro between 1749 and 1766.[62] There were older monuments in the chapel, but they were entirely eclipsed by the rich sculptural decoration of the eighteenth century. At this time the chapel was transformed into a veritable Valhalla of the del Sangro family, but the allegorical statues before the pillars overshadow the medallion portraits of the dead to such an extent that the beholder is in doubt as to the primary function of the place. Nothing is left of the spiritual unity of the great Roman Baroque churches and chapels, and the monuments excel by virtue of their technical bravura rather than through Christian spirituality. Emphatically Late Baroque in character, the chaotic and unrelated impression of the chapel seems closer to the mentality of the nineteenth than that of the eighteenth century. Queirolo and Corradini, the main contributors to the sculptural decoration, have been mentioned. The former is responsible for the group of the *Disinganno* [321], representing a personification of the human mind in the shape of a winged angel who liberates a nude man, the personification of humanity, from the entangle-

321. Francesco Queirolo: Allegory of 'Deception Unmasked', after 1750. *Naples, Cappella Sansevero de' Sangri*

ment of the symbolically significant net of deception. With such a work, which is matched only by other *tours de force* in the same chapel, we have reached the end of a development. While Bernini used realism and surface refinement to express convincingly the ethics of the Catholic Restoration, here the shallow symbolical genre seems to be a pretext for a display of technical bravura. A piece of similar hypertrophic virtuosity is Corradini's *Chastity*, where the thin veil through which the body is visible as if nude, belies the theme of the figure.[63] The same device was imitated by the prolific Giuseppe Sammartino (1720?–93?) in his *Christ lying under the Shroud* (1753).[64] Sammartino's contemporary Francesco Celebrano (1729–1814) executed, among others, the heavy and crowded relief of the Pietà over the altar, concluding the stylistic epoch which began with Guidi's relief compositions. Sammartino and Celebrano had many other notable commissions which show that they retained their Late Baroque style right to the end of the eighteenth century.[65]

As in Rome, the last great Baroque achievement of the Neapolitan circle is connected with fountains. Caserta follows the example of Versailles, and the garden too with its long avenues and parterres is fashioned after this model, although an English landscape garden was added at a late date (1782). Even the mythological programme of the nineteen fountains, planned by Vanvitelli from 1752 onwards, is reminiscent of Versailles. What was eventually carried out (1776–9) under Luigi's son Carlo is much less elaborate than the original projects, but the fountains which exist surpass in extent and grandeur anything that had been done in Italy before. There are, above all, the multi-figured groups of *Diana and Actaeon* at both sides of the great cascade [322]. These elegant, pseudo-classical, white marble figures play out their roles as if in a pantomime, in a way that immediately recalls Girardon's Apollo group in the

garden at Versailles. There is, however, an important difference. Girardon's group stood originally not in a cave of natural rock (executed by Hubert Robert, 1778) but under an isolating canopy. The figures in Caserta form part of the landscape. They seem to move freely over the open rocks; water, hill, woods, rocks, and figures combine in a great Arcadian *ensemble*. Superficially it might seem that Bernini's principles of sculpture had been carried to their fullest conclusion – that this is not so is due to the lack of seriousness and organic integration. The cascade is nicely terraced, the approach laid out with ruler and square, and we cannot help being very conscious of the artifice which has gone into giving an appearance of reality: the groups of Diana and Actaeon are, in fact, *tableaux vivants*,[66] and we know we are spectators, not participants.

A few words must be added about the picturesque art of making Christmas cribs; they form part of an old tradition of popular polychrome sculpture and, though they were created in many Italian towns particularly during the seventeenth and eighteenth centuries, Naples has pride of place.[67] These cribs, often consisting of hundreds of small, even tiny, figures, gaily dressed and placed in painstakingly realistic architecture and landscape, are the last buoyant descendant from the medieval miracle plays; this truly popular art of vivid narrative power and intense liveliness developed into a great industry requiring the specialized skill of many hands. Even sculptors of repute like Celebrano, Vaccaro, Sammartino, and Matteo Bottiglieri did not hesitate to work in this modest medium. It is significant that there is no antagonism between the boundless realism of their small figures for cribs and the virtuosity of their works in marble. Their monumental sculpture may perhaps appear in a new light if regarded as no more and no less than the sophisticated realization of a style which has its roots in an old and popular traditional art.

322. Luigi Vanvitelli: Caserta, Castle. The great cascade, *c.* 1776

Sicily's one great boast during this period was the sculptor Giacomo Serpotta (1656–1732), an exact contemporary of Camillo Rusconi. Serpotta appears to us now as an isolated figure, a meteor in the Sicilian sky. This is probably not consistent with the historical facts. It is true that after the fifteenth- and sixteenth-century work of the Gaggini, immigrants from Lombardy, Sicily had no great sculptors. There were, however, local schools throughout the seventeenth century working primarily in wood and stucco, and masters like Tommaso and Orazio Ferraro, active at the turn of the sixteenth to the seventeenth century, foreshadowed the climax reached with Serpotta's activity. But that tradition alone would perhaps not have sufficed to develop Serpotta's genius. Although a stay in Rome is not documented, there are sufficient indications[68] that he spent a few years there in his youth and so studied sculpture at the fountain-head. His name first appears in Palermo in 1682 in connexion with the equestrian statue of Charles II, German Emperor and King of Spain and Sicily. Of this statue, which was cast in bronze by Gaspare Romano from Serpotta's model and destroyed in 1848, a small cast survives (Trapani, Museum), which shows that Serpotta was an artist conversant with Pietro Tacca's monument of Philip IV in Madrid as well as with Bernini's *Constantine*. Soon afterwards, with the decoration of the Oratory of S. Lorenzo at Palermo (1687?–96?) he inaugurated that long series of church interiors where he covered the walls with stucco figures, and it is for these decorations that he is famed. The highlights of his later activity are the decoration of S. Orsola (1696; much ruined and badly restored); the Chiesa dell'Ospedale dei Sacerdoti (1698; partly executed by Domenico Castelli); the Chiesa delle Stimmate (1700, now Museo Nazionale, Palermo); the Oratories of S. Cita (begun 1686–8, continued 1717–18, execution partly by Domenico Castelli), del Rosario

323. Giacomo Serpotta: Courage, 1714–17.
Palermo, S. Domenico, Oratorio del Rosario

in S. Domenico (1714-17), and di S. Caterina all'Olivella (1722-6); and the churches of S. Francesco d'Assisi (1723) and S. Agostino (1726-8, with the help of pupils).

His figures are often reminiscent of Roman Baroque sculpture, some of Raggi, others of Ferrata; some are extremely elongated, elegant, and *mouvementé*; others follow antique prototypes so closely that they look almost Neoclassical. All of them, however, are imbued with a delicacy and fragility, a simple sensual charm and grace far removed from the dynamic power of the Roman High Baroque. Possibly nowhere else has Italian sculpture come so close to a true Rococo spirit [323]. Serpotta was a great master of the putto; playing, laughing, weeping, flying, and tumbling, they accompany every one of his decorations, spreading a cheerful and festive atmosphere. If his individual figures show a connexion with Rome, the context in which they are placed does not. As a rule, his principle of organization is simple: the stuccoes – statues, reliefs, and decoration – seem to cover the walls like creepers, producing the effect of a rich and diffused pattern. A part of this pattern is often formed by deeply receding reliefs in which tiny figures appear as if in a peep-show. This, too, is entirely un-Roman and evidently continues the Lombard tradition which the Gaggini had brought to Sicily. In the course of his development Serpotta tended to an increase in the realism of his figures, coupled with a bias towards dressing them in contemporary costume. At the same time the programmes of his decorations grew more rather than less complicated, and his charming allegories show that to the end he remained deeply steeped in Baroque *concettismo*.

None of his Sicilian contemporaries comes anywhere near equalling his quality, neither his collaborator Domenico Castelli, whose figures entirely lack Serpotta's grace, nor his son Procopio who carried on the paternal tradition; nor even contemporary masters of some merit like Carlo d'Aprile and Vincenzo di Messina, although the latter's stuccoes in the church of Partanna (1698) reveal something of Serpotta's spirit. With Serpotta's school the particular Sicilian expression of the Late Baroque came to an end. Ignazio Marabitti (1710-97),[69] the last great Sicilian sculptor of the Baroque, closely imitated his master Filippo della Valle, and maintained this manner to the end of the century.

PAINTING

INTRODUCTION

The history of Italian eighteenth-century painting is, above all, the history of Venetian painting. Better known than almost any period and school discussed in this book, the names of Sebastiano Ricci and Piazzetta, Canaletto and Guardi, not to mention the greatest genius, Giambattista Tiepolo, immediately evoke lively associations. A fairly thorough treatment of this school alone would have gone far beyond the space at my disposal; nor could I have added to the researches of such pioneers as G. Fiocco, R. Pallucchini, and others, to whose works the reader must be referred for further guidance. The history of painting of the period is so rich in talents also outside Venice – a few of the first and many of the second rank – that any attempt at doing them justice within the compass of this book was from the start condemned to fail. As I have pointed out in the Foreword, I have therefore chosen to discuss eighteenth-century painting most cursorily. This course, moreover, seemed justified because it was then that France and England assumed a leading position; apart from Venetian painting and a few events in other centres, the Italian contribution ceases to be a major factor in the intra-European development.

As far as the history of painting is concerned, the seventeenth century was by and large a 'dark' century. Roughly between 1660 and 1680 a change came about and a trend towards the lightening of the palette began, culminating in Tiepolo and the Rococo masters of the Venetian school. While Venice accomplished the transition to Rococo painting through a luminosity derived from a new scale of airy, transparent colours, through new patterns of undulating or zigzag compositions which are precariously 'anchored' along the lower edge of the picture, through elegant and elongated types of figures calling to mind the Mannerist *figura serpentinata,* through the gallant or voluptuous or arcadian or even flippant interpretation of their subjects – while all this happened in Venice during the 1720s and 30s, the leading Roman and Bolognese masters continued to practise their feeble Late Baroque far into the eighteenth century. They believed themselves to be the legatees of the great Italian tradition and looked with scorn upon its perversion. How deeply this was felt may be gathered from the anti-Rococo cry raised in 1733 by Antonio Balestra (1666–1740). Himself trained by Maratti, but practising mainly in Venice, he wrote from a position of eminence: 'All the present evil derives from the pernicious habit, generally accepted, of working from the imagination without having first learned how to draw after good models and compose in accordance with the good maxims. No longer does one see young artists studying the antique; on the contrary, we have come to a point where such study is derided as useless and obnoxious.'[1]

In Rome and Bologna, however, some artists began to realize that they had followed much too long the well-trodden path of the 'good maxims' which were, in fact, the worn-out formulae of the Late Baroque. Few dared to revolt (G. M. Crespi), others sought salvation in a return to the great models of the past, doing precisely what Balestra had despaired of. Their proto-Neo-classicism, first noticeable in Rome from about 1715 on, was far from a clear-cut decision. Nor was the break with the Baroque tradition brought about by the new and broader

wave of proto-Neo-classicism which began in the 1740s. Epitomized in the figure of Anton Raphael Mengs, this Late Baroque classicism found an echo throughout the peninsula and even in Venice, where the late manner of artists like Piazzetta, Amigoni, and Pittoni seems to reflect some contact with the all-Italian movement. In the end, disastrous results followed in the wake of the academic, rationalistic, and classicizing reform. Not only did it kill the Baroque tradition, but the perennial tradition of Italian painting itself.

The champions of proto-Neo-classicism and Neo-classicism in Italy were primarily concerned with the restoration of the theory and practice of the grand manner, which had outlived its day. The present as well as the future lay, however, with those masters whom Balestra had attacked, those who tried more or less successfully to discard the ballast of the grand historical style. It was they who committed the capital sin against the letter and the spirit of the great tradition in that they destroyed clear contours and plastic form, and implicitly the customary concept of finish. Naturally, they looked back to their own tradition: the old contrast between Venice and Rome, between colour and design, also adumbrates the events of the eighteenth century. They crowned the work of the Seicento masters *di tocco*, for they painted with short, rapid, and often nervous brush-strokes and obliterated the clear borderline between sketch and execution. It seems a foregone conclusion that this development, which helped Italian painting secure a last spell of international importance, took place in Venice rather than in the centres where the fetishes of plastic form and of the classical tradition could never be discarded.

NAPLES AND ROME

In the seventeenth century Naples had emerged as an art centre of primary importance. It was also in Naples that the most vital contribution was made to the future course of grand decorative painting. Briefly, the new type of fresco-painting derived from a fusion of Venetian colourism with Pietro da Cortona's grand manner, which on its part owed much of its vitality to Venice (p. 253 ff). This synthesis of Rome and Venice was accomplished by the prodigious Luca Giordano (1634–1705),[2] who must be regarded as the quintessence of the new epoch although most of his work belongs to the seventeenth century. The prototype of the itinerant artist, he travelled up and down Italy, worked in Rome, Florence, Venice, and Bergamo, and for ten years was court painter in Madrid (1692–1702). The speed with which he produced his grand improvisations was proverbial ('Luca Fa Presto'). Perhaps the first *virtuoso* in the eighteenth-century sense, he considered the whole past an open book to be used for his own purposes. He studied Dürer as well as Lucas van Leyden, Rubens as well as Rembrandt, Ribera as well as Veronese, Titian as well as Raphael, and was capable of painting in any manner he chose. But he never copied, a fact noticed by his contemporaries (Solimena). He played with all traditions rather than being tied to one, and his personal manner is always unmistakable. Whatever he did, his light touch and the brio and verve of his performance carry conviction, while his unproblematical and joyous interpretation of subjects anticipates the spirit of the eighteenth century. Clearly, the purpose of painting for him was delight [324, 330]. In Rome and Venice his influence became extraordinarily strong, and on the international stage the effect of his art can hardly be overestimated. He immensely attracted his Neapolitan successors by his typically southern grandiloquent manner and telling rhetoric, qualities one associates with the next fifty years of grand decorative painting in his native city.[3]

Luca's heir-apparent was Francesco Solimena (1657–1747),[4] who headed the Neapolitan

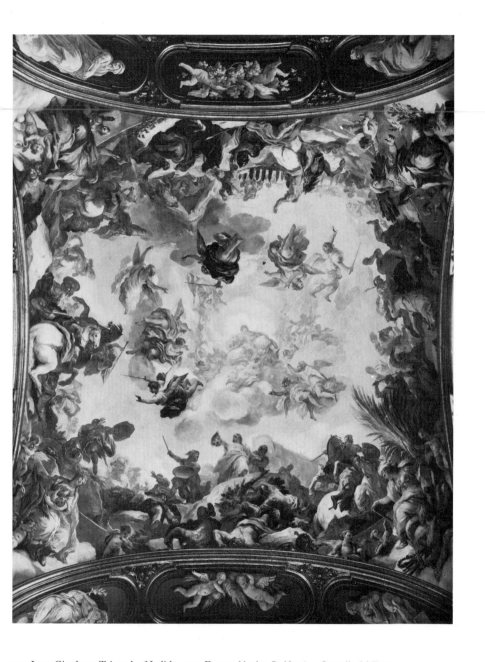

324. Luca Giordano: Triumph of Judith, 1704. Fresco. *Naples, S. Martino, Cappella del Tesoro*

school unchallenged during the first half of the eighteenth century. Next to Luca Giordano and Cortona, Lanfranco and Preti exercised the most formative influence upon his work. From the latter stem the brownish shadows of his figures – as much a mark of his style as the vivid modulation, the flickering patterning of the picture plane, and, in his later work, the

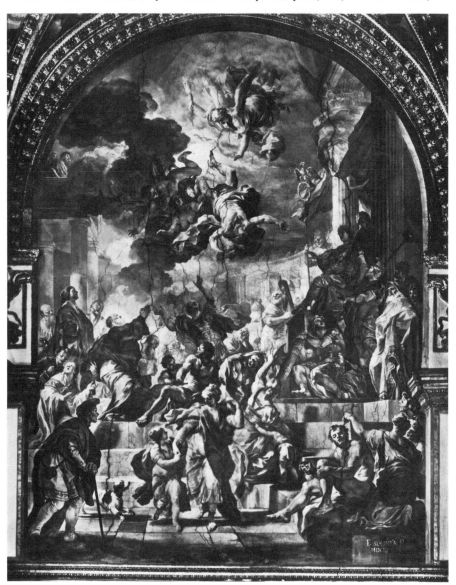

325. Francesco Solimena: The Fall of Simon Magus, 1690. Fresco. *Naples, S. Paolo Maggiore*

somewhat pompous elegance of his figures. Although carefully constructed, many of his multi-figured compositions make the impression of an inextricable mêlée, in line with the general tendencies of the Late Baroque [325].[5] But if one takes the trouble of surveying figure by figure, their studied poses and academic manner is evident, and it is easy to distinguish conventional and even canonical figures and groups deriving from such acknowledged classical authorities as Annibale Carracci, Domenichino, and even Raphael.[6] In studying the architecture and sculpture of the period we have found a similar discursive approach to the past. This rationalistic tendency was nourished in Solimena's own Academy, which became the centre of Neapolitan artistic life. Numberless painters were here educated, foremost among them Francesco de Mura (1696-1784), Corrado Giaquinto (1703-65), and Giuseppe Bonito (1707-89).[7] The latter, who ended his career as Director of the Neapolitan Academy, is now remembered less for his rather dreary academic grand manner than for his popular genre pieces (p. 495).

Solimena worked in Naples all his life, and yet became one of the most influential European painters; after Maratti's death and before the rise of Tiepolo's star he had no peer. His reputation secured large commissions abroad for his pupils. De Mura did his best work as court painter in Turin (Palazzo Reale, 1741-3). Giaquinto spent many years in Rome (1723-53), and succeeded Amigoni as court painter in Madrid (1753-61) where he was also appointed Director of the Academy of San Fernando; he left Madrid upon the arrival of Mengs.[8] Giaquinto was a more subtle artist than the often frigid de Mura.[9] Although both used typically eighteenth-century light and transparent colours, only Giaquinto carried Neapolitan painting over into a Rococo phase, and some of his work is stylistically and qualitatively a close parallel to Boucher's in France [326].[10]

When he settled in Rome, Giaquinto joined the studio of an older Neapolitan painter and pupil of Solimena, Sebastiano Conca (1679-1764),[10a] who, after Maratti's and Luti's deaths,

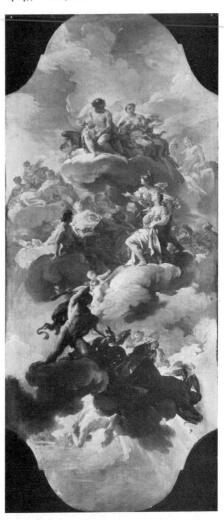

326. Corrado Giaquinto:
Minerva presenting Spain to Jupiter and Juno.
Oil sketch for a ceiling, *c.* 1751,
now in the Palazzo Sanseverino, Rome.
London, National Gallery

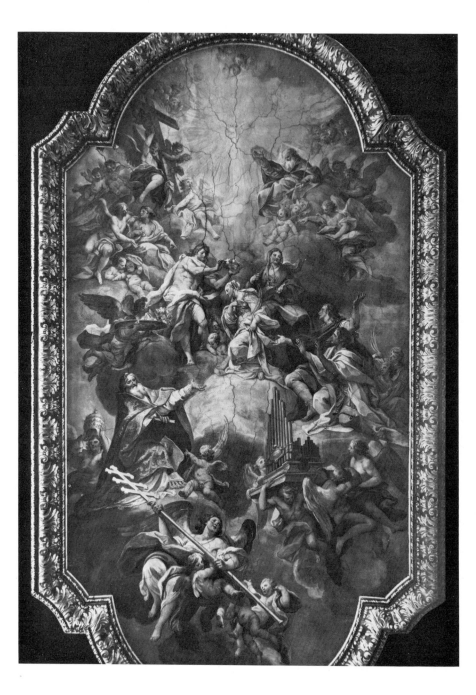

327. Sebastiano Conca:
The Crowning of St Cecilia, 1725. Fresco.
Rome, S. Cecilia

held a position of unequalled eminence. His ceiling fresco with the *Crowning of St Cecilia* in S. Cecilia, painted in 1725 [327], gives the measure of his achievement and allows an assessment of the situation in Rome after the first quarter of the eighteenth century. This work is clearly in the tradition of Maratti's fresco in the Palazzo Altieri [219], but not without a difference: here the balanced symmetrical composition belies the Baroque paraphernalia, an indication of the growing academic mentality. Of course, gone for ever are the intensity and spirituality, the hot breath and vigour, the chiaroscuro and mysticism of the Late Baroque moment represented by Gaulli [213] – what remains is the competent handling of well-worn formulae.

This had been the position for some time past: monumental painting in Rome was in the hands of facile successors. Giovanni Odazzi (1663–1731) and Lodovico Mazzanti (d. after 1760) – who also worked at Perugia, Viterbo, and Naples – continued Gaulli's manner, sapped of its strength, far into the eighteenth century.[11] But the day belonged to versions of Maratti's Late Baroque classicism. The reader will recall that the ascendancy of Maratti dates from the mid 1670s, which corresponds fairly precisely with Guidi's in sculpture and Carlo Fontana's in architecture. At about this moment artists of the second and third rank changed their manner to fall in with the new fashion. Painters such as Giuseppe Ghezzi (1634–1721), the father of the better-known Pier Leone, Lodovico Gimignani (1643–97),[12] the son of Giacinto, and the rather banal Luigi Garzi (1638–1721) may here be mentioned; and more considerable masters like Niccolò Berrettoni (1637–82) and even

Guglielmo Cortese (1627–79), who had begun as a Cortona pupil[13] and Gaulli follower, embraced the new manner. The oldest of Maratti's pupils was the Palermitan Giacinto Calandrucci (1646–1707),[14] the most faithful Giuseppe Chiari (1654–1727),[15] the most original Giuseppe Passeri (1654–1714), the biographer's nephew; but only the distinguished Benedetto Luti from Florence (1666–1724), a figure of international reputation, renowned also as a collector and teacher, accomplished the transformation of the Marattesque into an elegant and sweet eighteenth-century style. Maratti's manner was carried over even into the second half of the eighteenth century by artists like Agostino Masucci (1692–1768) and the more considerable Francesco Mancini[16] (c. 1700–58) and his pupil Stefano Pozzi (1708–68).

The general verdict on the course of Maratti's succession must be that it ended in a pleasant but purely conventional art, a soft and feeble formalism without a hope of regeneration. It is only to be expected that with the victory of Maratti's international Late Baroque, the old contrast of artistic ideals embodied in the names of Sacchi and Cortona was a thing of the past. In a more limited sense, however, and much less distinctly than in contemporary architecture, one may discover an antithesis between the Marattesque manner and a brief Rococo phase on the one hand and a classicizing Rococo trend on the other. But the camps are not clearly divided. Benedetto Luti's work is a case in point. Next to his monumental Roman manner, Francesco Trevisani (1656–1746),[16a] who never forgot his Venetian upbringing under Antonio Zanchi, produced cabinet pictures in a true Rococo style. Rivalling Sebastiano Conca's popularity, Trevisani's 'sweet Madonnas and porcelainly children' (Waterhouse) found a ready market all over Europe. But none of the Romans came closer to a French version of the Rococo than Michele Rocca (1670/5–after 1751).[17]

If the Rococo phase forms, as it were, the anti-conventional 'left wing' of Marattesque classicism, a new 'right wing' began to emerge for which that insipid manner was too Baroque and formalistic. It was mainly three artists who made heroic attempts at leading Roman painting back to a sounder foundation: Marco Benefial (1684–1764), half French, pupil of the Bolognese Bonaventura Lamberti, by an intense study of nature and by returning to the classical foundations of Raphael and Annibale Carracci (his remarkable *Transfiguration*[18] [328] shows to what extent he succeeded); the Frenchman Pierre Subleyras (1699–1749), who spent the last twenty years of his life in Rome, by introducing in his work a noble simplicity and precision of design and expression together with a limited but carefully considered light scale of tone values; and, finally, Pompeo Batoni (1708–87), by steering more decisively towards the newly rising ideal of the antique [329].[19] In a varying degree, all three artists take up special positions on the borderline between Rococo and Neo-classicism. These masters, and even Batoni in pictures farthest on the road to Neo-classicism, stuck tenaciously to Late Baroque formulae of composition. Nor is the lyric, languid, and often sentimental range of expressions really divorced from contemporary painting.[20]

It is well known that the more radical turn towards a Neo-classical mode of painting was taken by the romanized Bohemian, Anton Raphael Mengs (1728–79). A mediocre talent, but enthusiastically supported by Winckelmann, the intellectual father of Neo-classicism, he was hailed by the whole of Europe as the re-discoverer of a lost truth. The work and

328. Marco Benefial: Transfiguration, *c.* 1730. *Vetralla, S. Andrea*

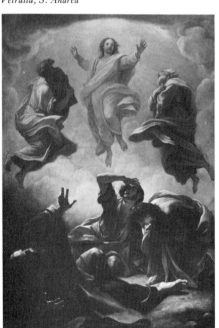

329. Pompeo Batoni: Education of Achilles, 1746. *Florence, Uffizi*

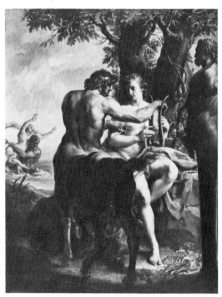

ideas of this moralist and rationalist, who saw salvation in a denial of Baroque and Rococo painterly traditions and pleaded for an unconditional return to principles of design, cannot here be discussed. Suffice it to say that the Baroque allegorical method as well as the preciosity of Rococo art linger on in Mengs's art, while elements of his style (such as the choice of clear and bright local colours) may be traced back to some of his older contemporaries. Mengs himself had started under Benefial, yet was not impervious to the qualities of Solimena's Baroque. In the last analysis he is as much an end as a beginning.

He set the seal on that characteristically Roman classic-idealistic trend, the tenets of which were constantly shaped and coloured by the ever-changing 'Baroque' antithesis. Reference to the three sets of names: Carracci – Caravaggio; Sacchi – Cortona; Maratti – Gaulli, summarizes the course of events in three consecutive generations. In the struggle of artistic convictions and sentiments the fronts remained fluid. As the theory hardened (Bellori) in the second half of the seventeenth century, the practice began to fall out of step (Maratti). Late Baroque classicism was on the whole the weak shadow of a great past. If Mengs saddled the classic-idealistic horse again, he lacked the genius and strength for a bold ride. Measured against his greater forerunners, and even Maratti, he appears a dry pedant; measured against the work of a fully-fledged Neo-classicist of real talent like Jacques-Louis David, he seems sweet, inert, sentimental, Baroque, and not without the affectation of much of the art produced on his doorstep.

The classic-idealistic theory, revived by Winckelmann in its most rigorous form, once again conquered the world from Rome, but no longer did it have the power to revitalize monumental painting on the soil which had seen its greatest triumphs in the wake of Raphael and Michelangelo.[21]

FLORENCE AND BOLOGNA

Until well after the middle of the seventeenth century Florentine painting was provincial but had a distinct character of its own. This changed later in the century. If the reasons for the loss of identity cannot be wholly accounted for, one may at least point out four different events which determined the further course of painting in Florence: Cortona's work in the Palazzo Pitti (1640-7); Luca Giordano's frescoes, executed between 1682 and 1683, in the dome of the Corsini Chapel (Chiesa del Carmine), in the Biblioteca Riccardiana, and in the long gallery of the Palazzo Riccardi – the latter a grand allegorical pageant glorifying the reign of the Medici dynasty with dazzling *élan* and strikingly fresh and vivid colours [330]; the visit in 1706-7 of Sebastiano Ricci, whose frescoes in the Palazzo Marucelli-Fenzi [338] gave Florentines their first sensational experience of modern Venetian art; and, finally, the influence of Maratti's style as well as of Bolognese classicism, particularly through the work of the leading master, Carlo Cignani. The pattern then is clear enough; there developed in Florence two different trends, both rather international in character, the one anti-classical, accepting the Cortonesque Baroque or its thinned-out Ciro Ferri version and, in turn, Luca Giordano and Ricci; the other classical, following Maratesque or Bolognese precepts.

The classical trend is most fully represented by the precise and frigid Anton Domenico Gabbiani (1652-1726), the painter dear to the heart of Grand Duke Cosimo III and the Florentine nobility, whose palaces abound in his work.[22] While Gabbiani was primarily a Maratti follower, Giovan Camillo Sagrestani (1660-1731)[23] came from Cignani, whose slick modelling he maintained; this made him as well as his pupil Matteo Bonechi (*c.* 1672-1726)[24] an easy prey to French Rococo influence. In the next generation Giovanni Domenico Ferretti (1692-

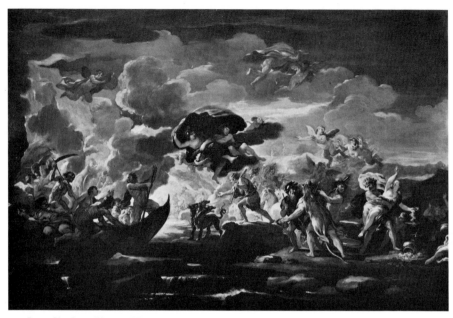

330. Luca Giordano: Pluto and Proserpina. Oil study for the Gallery of the Palazzo Medici-Riccardi, 1682.
London, D. Mahon Collection

1768), a profuse decorative talent, carried on this tradition. Once again he was mainly formed by the Bolognese Cignani and Marcantonio Franceschini and to a certain extent remained tied to their Late Baroque classicism.[25]

On the other side of the fence were the *Cortoneschi*, who have been mentioned in a previous chapter (Chapter 14, Note 65). The real rebel against the worn-out academic conventions and an artist in a class of his own was Alessandro Gherardini (1655-1726),[26] who in his transparent frescoes in S. Maria degli Angeli, Florence (1709) [331], combined the lessons learned from Giordano and Sebastiano Ricci. To what extent he mastered the new artistic language may also be seen in his principal work, the frescoes in S. Maria degli Angeli (now Università Popolare), Pistoia (after 1711), which – as M. Marangoni pointed out many years ago –

might almost have been painted by a contemporary Venetian master. Gherardini's worthy pupil, Sebastiano Galeotti (1676-1746?), also formed his style on Cortona, Giordano, and Ricci. He spent more than the last three decades of his life as a most successful fresco-painter in Liguria, Lombardy, and Piedmont, practising his truly international art.[27]

If Florence had no longer an organic school of painting with a physiognomy of its own, she could boast at least of competent painters, though some of the more enterprising ones, such as Luti, Batoni, and Galeotti, sought their fortunes permanently outside their native town. The situation at Bologna was vastly different.[28] The tradition of the Carracci 'Academy' had an extraordinary power of survival, and through all vicissitudes Bolognese classicism, even in a provincial and sometimes debased, feeble, and

331. Alessandro Gherardini: The Dream of St Romuald, 1709. Fresco.
Florence, S. Maria degli Angeli (now Circolo della Meridiana)

flabby form, continued to be a power which for good or evil made itself felt in many other centres. Not only Florentines but also Romans and Venetians were convinced that it was only in Bologna that an artist could procure a solid training in the perennial principles of good design. Carlo Cignani (1628-1719), Albani's pupil, was the celebrated guardian of this tradition and the head of an immensely active studio.[29] The late Reni and a renewed study of Correggio contributed to form his fluid and polished style, which contemporaries admired. N. Pevsner[30] indicated to what extent this versatile classicism falls in with Late Baroque principles. From Cignani comes, above all, Bologna's greatest decorative talent of the Late Baroque, Marcantonio Franceschini (1648-1729),[31] the Bolognese Maratti, whose manner was widely diffused through his works in Rome,

Genoa, Piedmont, Spain, and Germany. His great cycle of frescoes in the church of Corpus Domini, Bologna (1687-94), illustrates most fully this facet of Bolognese painting. Next to him, Gian Gioseffo dal Sole (1654-1719),[32] 'il Guido moderno', was a much sought after, dexterous practitioner of this rather sentimental kind of Late Baroque classicism.

A new situation arose in the next generation which reacted in two contrary ways to the facile conventions of the academicians. One group, led by Donato Creti (1671-1749),[33] Pasinelli's pupil, who at one time tended towards Rococo (frescoes, Palazzo Pepoli, Bologna, 1708), sought salvation in a sophisticated archaism. The Bolognese counterpart to Benefial's manner in Rome, this proto-Neo-classicism with distinct Mannerist overtones is perfectly illustrated by the small picture of illustration

332[34] which recalls works by such masters as Primaticcio. To a lesser extent some minor artists, Aurelio Milani (1675-1749),[35] Francesco Monti (1685-1768),[36] and Ercole Graziani (1688-1765),[37] fell in with Creti's radicalism.

332 *(above)*. Donato Creti: Sigismonda(?), *c.* 1740. *Bologna, Comune*

333 *(right)*. Giuseppe Maria Crespi: The Queen of Bohemia confessing to St John Nepomuc, 1743. *Turin, Pinacoteca*

334 *(opposite)*. Giuseppe Maria Crespi: The Hamlet, *c.* 1705. *Bologna, Pinacoteca*

The other reaction came from Giuseppe Maria Crespi, called lo Spagnuolo (1665-1747), the only real genius of the late Bolognese school. Rejecting the teachings of his masters Canuti and Cignani,[38] he found instruction to his taste in the study of Lodovico Carracci, Mastelletta, and, above all, the early Guercino. Moreover, it has been shown[39] that he must have had direct contacts with Sebastiano Mazzoni (p. 348), echoes of whose intense chiaroscuro and freedom of touch appear in Crespi's early work. But Crespi went a decisive step beyond his models. He swept away the last vestiges of academic formalism and opened up an immediacy of approach to his subject-matter

without parallel at this moment. Linked to the popular trend, which had had a home in Bologna since the days of the Carracci (p. 71), he applied his new vision equally to religious imagery [333], to contemporary scenes, portraiture, and genre [334]. Everything he touched is permeated with a depth of sincere feeling, a sensibility and tenderness which is as far from the ecstasy of the 'quietists' as it is from the preciosity and affectation of the academicians. Like his younger contemporary Magnasco, he is an outsider; like Magnasco, he never abandoned his chiaroscuro and remained essentially a Seicento master; but diametrically opposed to him, he chose as his theme the purely human rather

than the grotesque and demoniacal. And yet both attitudes seem to have the same root, characteristic of the Baroque age: the will to freedom, which opens the way as much to Crespi's unconditional humanism as to Magnasco's chaotic abandonment.[40]

Canuti had died in 1684, Cignani had gone to Forlì in 1686, and Pasinelli died in 1700. There remained Crespi and, next to him, Giovan Antonio Burrini (1656-1727),[41] who had studied with both Canuti and Pasinelli and became Bologna's representative of an extrovert Late Baroque style; Zanotti called him 'il nostro Cortona e il nostro Giordano'. Although Crespi opened a school in 1700, few names of his Bolognese succession are worth recording, apart from his rather trivial son, Luigi Crespi (1709-79), famed as the writer of the lives of contemporary Bolognese artists,[42] and the Paduan Antonio Gionima (1697-1732).[43] All the greater was his influence on Venetian painters; Piazzetta as well as Bencovich owed much to him.

Official painting of the Baroque era at Bologna drew to a close with such able decorators as Vittorio Maria Bigari (1692-1776),[44] whose delightful scenographic cabinet pictures in the Pinacoteca, Bologna, show him at his best, and with the brothers Ubaldo (1728-81) and Gaetano (1734-1802) Gandolfi and the lesser Domenico Pedrini (1728-1800), artists who brought about the blending of the academic Bolognese tradition with the light and freedom of Tiepolo's manner. The Gandolfi were capable of large and skilfully arranged compositions with a strong Rococo flavour. But if one measures their work against that of the great Venetians, it appears no more than the flotsam of a once proud native tradition. After two hundred years of changing fortunes Bolognese painting had run its course.

Before we leave Bologna, however, a word must be added about *quadratura* painting, which had its home in Bologna from the late sixteenth century on, and remained vigorous to the end of the eighteenth century. Scenographic painting and allied practices continued to be Bologna's most important artistic export. Truly Late Baroque, the brothers Enrico (1640-1702)[45] and Anton Maria (1654-1732) Haffner, both pupils of Canuti, amplified and diversified Colonna's and Mitelli's more architectural *quadratura* style; they form the link with the imaginative scenographers of the eighteenth century. Anton Maria worked mainly in Genoa in collaboration with G. A. Carlone, Domenico Piola, Gregorio de Ferrari, and others. Enrico assisted his teacher till the latter's death in 1684; thereafter he collaborated with Giovan Antonio Burrini (Chiesa dei Celestini, Bologna) and, above all, with Marcantonio Franceschini, for whom he painted, among others, the Corpus Domini *quadratura*. The tradition was kept alive by Marcantonio Chiarini (1652-1730) and his pupil Pietro Paltronieri, il Mirandolesi (1673-1741), who worked in Venice and also for Pittoni; by Mauro Aldrovandini (1649-80), his nephew Tommaso (1653-1736), Cignani's pupil, and his son Pompeo (1677-1739?), whose pupil Stefano Orlandi (1681-1760) collaborated with Bigari, Francesco Monti and others and, together with Gioseffo Orsoni (1691-1755), won laurels as a stage designer at Lucca and Turin; by Tiepolo's faithful associate, Girolamo Mengozzi-Colonna from Ferrara (c. 1688-c. 1772), his pupils Gianfrancesco Costa (1711-72) and Francesco Chiaruttini (1748-96), and many others.[46]

This long list goes to show that the greatest dynasty of *quadraturisti*, the Galli, called Bibiena after their place of origin, arose in a congenial artistic climate. Equally distinguished as designers and organizers of festivals, 'the most sumptuous that Europe ever witnessed' (Lanzi), as stage designers and inventors, as draughtsmen of extraordinary scenographic fantasies [335], as painters and theatre architects, four members of the family should be singled out, the brothers Ferdinando (1657-1743) and Fran-

335. Giuseppe Bibiena: Engraving from *Architetture e Prospettive*, Augsburg, 1740

cesco (1659-1739), and Ferdinando's sons, Giuseppe (1696-1757) and Antonio (1700-74). Ferdinando spent twenty-eight years in the service of Ranuccio Farnese at Parma as 'primario pittore e architetto' and in the same capacity transferred to the imperial court at Vienna in 1708. While Ferdinando was probably the most profuse genius of the family, Francesco gave Europe its finest theatres, establishing a tradition which has not yet seen its end. All the courts of Europe sought the services of the Bibiena, and Ferdinando's sons held offices at the courts of Vienna, Dresden, Berlin, and that of the Elector Palatine.[47]

The free play of the imagination as seen in the drawings of the Bibiena, and the classical tradition on which the Bolognese school thrived, seem to be incompatible with each other. And yet Ferdinando and Francesco Bibiena came from Cignani's school. The explanation lies in that the Bolognese always regarded *quadratura* – the basis of the art of the Bibiena – as a science concerned with the accurate rendering of the laws of vision. As such, *quadratura* had first been the handmaid of the grand manner. But later a paradoxical situation arose. By the mid seventeenth century, with Colonna and Mitelli, *quadratura* had reached the status of an art in its own right. In the course of the eighteenth century it was the *quadratura* artists, culminating in the Bibiena family, who held all the trumps of a truly international art, while the Bolognese grand manner was increasingly reduced to a provincial shadow existence.

NORTHERN ITALY OUTSIDE VENICE

Throughout the eighteenth century the smaller cities of northern Italy had flourishing schools of painters: Verona above all which, from the Middle Ages on, was always an important artistic centre, and Bergamo and Brescia,[48] where local traditions, however, yielded more and more to the overbearing Venetian influence.

Apart from the Bergamasque Fra Galgario and the 'Bresciano' Ceruti – artists who will be discussed later – these provincial schools need not detain us. Nor do the big centres Milan, Genoa, and Turin require much attention.

Piedmont had to rely almost entirely on artists from abroad in order to carry out the considerable undertakings which, owing to the accumulation of power and wealth under the House of Savoy, were waiting for painters. At the end of the seventeenth century it was mainly Daniel Seiter (1649-1705),[49] born in Vienna but trained in Venice under J. C. Loth, and the Genoese Bartolomeo Guidobono (1654-1709) who held for many years positions of eminence. Although later the Florentine Sebastiano Galeotti and the fashionable Charles André Vanloo from Nice (1705-65), Luti's pupil in Rome, had large commissions[50] and firmly established the international Late Baroque in Turin, it was really Neapolitan and Venetian artists who had the major share – an interesting constellation, for the two most vigorous Italian schools vied here for supremacy. The Neapolitans Conca, Giaquinto, and de Mura followed calls to Turin, and Solimena sent many canvases.[51] Yet the palm went to the Venetians; Sebastiano and Marco Ricci, Nicola Grassi, and Giambattista Pittoni accepted commissions, and Giambattista Crosato (1685-1758) and Giuseppe Nogari (1699-1763) spent years of their lives there. Crosato,[52] above all, with his charming and ample frescoes in the Castle at Stupinigi, the Villa Regina, the Palazzo Reale, and a number of Turin churches helped to transform Piedmont into an artistic province of Venice. The second-rate Mattia Bortoloni (p. 484) found a rewarding occupation in the Sanctuary at Vicoforte di Mondovì where he painted, not without skill, the enormous dome (1745-50), a commission which illness seems to have prevented Galeotti from executing. The foremost representative of what may euphemistically be called the local school was the court-painter Claudio

336. Alessandro Magnasco: The Synagogue, *c.* 1725-30. *Cleveland, Museum of Art*

Francesco Beaumont (1694–1766), of French extraction, trained in Rome under Trevisani; his facile Rococo manner, a not unattractive international court style, can best be studied in the Palazzo Reale.[53] The most successful practitioner of the next generation was Vittorio Amedeo Cignaroli (1730–1800),[54] a member of the well-known Verona family of artists, a slight talent, mainly renowned for his landscapes in the manner of Zuccarelli.

Genoese grand decorative painting still flourished throughout the first quarter of the eighteenth century (p. 354); thereafter it was on the decline and handled by successors of minor calibre.[55] Milan's painters perpetuated the international Baroque.[56] But two artists must be singled out: the Genoese Alessandro Magnasco (1667, not 77,–1749), called Lissandrino, and the Mantuan Giuseppe Bazzani (1690–1769). Both are solitary figures, tense, strange, mystic, ecstatic, grotesque, and out of touch with the triumphal course the Venetian school was taking from the second decade onwards; both delight in deformities; both are masters of the rapid, nervous brush-stroke and of magic light-effects.

Magnasco went early to Milan, where he worked under Filippo Abbiati (1640–1715). Interrupted only by a stay in Florence (c. 1709–11), he remained in Milan until 1735, when he finally settled in his native Genoa. The formation of his style is not easily accounted for. In any case, Morazzone's Early Baroque mysticism must have attracted him as much as Callot's over-sensitive Late Mannerist etchings and Rosa's tempestuous romantic landscapes. Magnasco's phantasmagorias [336], that strange diabolical world which seems the product of a morbid imagination – the fearsome woods, the tribunals and tortures, the cruel martyrdoms and macabre scenes peopled with ghostlike monks – open up problems of interpretation. For Lanzi all these were *bizarrie;* even if one cannot agree with the distinguished author, the question remains unsolved how much religious fanaticism, how much quietism or criticism or farce went into the making of his pictures. The reason for this uncertainty of interpretation lies in the peculiar unreality of his figures. Magnasco's personal idiom was inimitable, but his impromptu way of painting, the sketchy character of his canvases, the anguished, rapid brush-stroke – all this, crowning the pursuits of a distinct group of Seicento artists (p. 341), had a most invigorating effect on the development of painting in the new century, and the Venetians from Sebastiano and Marco Ricci to Guardi learned their lesson from him.[57]

Bazzani,[58] too, must have studied his work, but, characteristic of the new virtuoso type of artist, he is not easily summed up by a formula. His work vacillates between influences from Rubens, Van Dyck, and Fetti, the temperate

337. Giuseppe Bazzani:
The Imbecile (fragment?), c. 1740.
*Columbia, University of Missouri,
Museum of Art and Archaeology*

climate of Balestra's art, Dorigny's classicism, and Watteau's and Lancret's Rococo grace; and many of his canvases call to mind the eccentric world of Francesco Maffei and of his own contemporary Bencovich [337]. Apart from a few minor imitators, Bazzani's manner had no sequel in Italy,[59] though it did appeal to Austrian Baroque painters.[60]

VENICE

Politically and economically Venice had long been on the decline. After her sea and mercantile power had dwindled, she became in the eighteenth century the meeting-place of European pleasure-hunters, and, indeed, there was no city in Europe which equalled her in picturesque beauty, stately grandeur, luxury, and vice. To be sure, the foreigners brought wealth to Venice, equal or perhaps greater wealth than the industry of her inhabitants had acquired by commerce in previous centuries. It is also true that with the shift of patronage from the Venetian nobility to the rich foreigners – English, Spanish, French, German, and Russian – Venetian art became international in a new sense; for (to give only a few instances), with Sebastiano and Marco Ricci, Pellegrini, Amigoni, and Canaletto in London, with Tiepolo in Würzburg and Madrid, with Rosalba Carriera in Paris and Vienna, with Bernardo Bellotto at the courts of Dresden and Warsaw, with lesser masters like Bartolomeo Nazari at the court of the Emperor Charles VII and Fontebasso and J. B. Lampi at that of St Petersburg, the Venetians appeared as their own ambassadors. But how it happened that on the social quicksand of Venice there arose the most dynamic school of painters will for ever remain a mystery.

We know now that the rise was not so sudden as it seemed not so many years ago. But in spite of the revival of the great native tradition in the second half of the seventeenth century, it was

only at the beginning of the next that Venice far outdistanced Rome, Naples, Bologna, and Genoa: her European triumph dates from the second decade of the eighteenth century.[61]

Sebastiano Ricci and Piazzetta

This change of fortune is connected with the name of Sebastiano Ricci (1659–1734), who began as a pupil of Sebastiano Mazzoni, and then went to Bologna where he imbibed the teachings of the Bolognese school under Giovanni Gioseffo dal Sole; finally he studied at Parma and Rome. Thus he had the varied experience typical of the Late Baroque artist; at the age of twenty-five he had run through the whole gamut of possibilities: from the free brushstroke of Mazzoni and the polished classicism of the Bolognese to Correggio, Annibale Carracci, and the great decorative fresco painters in Rome. His first frescoes, in the dome of S. Bernardino dei Morti in Milan (1695–8), reflect the study of Cortona and Correggio. He returned to Venice in 1700 and worked there for twelve years, interrupted, however, by long journeys to Vienna (1701–3), Bergamo (1704), and Florence (1706–7). There in the frescoes of the Palazzo Marucelli he achieved full maturity [338]: the luminous brilliant art of the eighteenth century prepared in the work in S. Marziale, Venice (1705), is born. Ricci's new homogeneous style was the result of an intelligent rediscovery of Veronese and the study of Luca Giordano. *The Virgin enthroned with Nine Saints* in S. Giorgio Maggiore, Venice (1708), is the *chef d'œuvre* of this neo-Cinquecentesque manner, enriched, however, by a quick and nervous eighteenth-century brush-stroke. In the second decade, which saw Sebastiano in London (1712–16)[62] and Paris (1716), his brush-stroke becomes more agitated, under the influence, it has been claimed, of Magnasco's work. And this, together with a renewed study of Veronese after his

338. Sebastiano Ricci: Hercules and the Centaur, 1706-7. Fresco. *Florence, Palazzo Marucelli*

return to Venice, made him, in the third decade, change to the scintillating, colourful works, painted with a light nervous touch, which belong to the Venetian Rococo. Ricci is the typical extrovert eighteenth-century virtuoso, and as such his brilliance may appear somewhat superficial. Roberto Longhi talked about 'his paintings smacking of an able reportage of all European motives'.[63] But it needed precisely Ricci's easy and versatile talent to steer Venetian art back to a new understanding of the great past and forward towards the synthesis achieved in Tiepolo's heroic style.

Ricci's antipode, an artist of equal or even greater talent, was Giovanni Battista Piazzetta (1683–1754), whose training, life-story, and convictions as an artist were the antithesis to everything concerning his older colleague: instead of the itinerant artist, a man of steady habits; instead of the brilliant virtuoso, a slow and patient worker; instead of decorative superficiality, a new depth and intensity of expression; instead of the light and vibrant palette, recourse to chiaroscuro and plastic form; instead of new conquests to the end, a slow decline of creative powers during the last years.

After beginning in Antonio Molinari's studio, Piazzetta also made the journey to Bologna, but in order to finish his education under Giuseppe Maria Crespi. Back in Venice before 1711, he never left his native city again. His *tenebroso* art appears formed in the *St James led to his Martyrdom* (S. Stae, Venice, 1717) and reaches a climax in the *Virgin appearing to St Philip Neri* (S. Maria della Fava, 1725–7) [339], a composition of terse zigzag lines, built up of plastic bodies intense with mystic supplication and dramatized by a poignant chromatic scale of contrasting warm and cold reddish and brown tones. At the same moment he painted his only great decorative work, the ceiling (on canvas) with the *Glory of St Dominic* in SS. Giovanni e Paolo, twirling in a great sweep from the borders towards the luminous centre. In the 1730s his

339. Giovanni Battista Piazzetta:
The Virgin appearing to St Philip Neri, 1725–7.
Venice, S. Maria della Fava

chiaroscuro lightened under the influence of Lys and Strozzi, and a pastoral mood replaced the previous tension. This is particularly true of a group of pictures around 1740, of which the *Fortune Teller* (1740, Accademia, Venice)[64] is one of the most splendid examples. At that moment he was nearest a Rococo phase.

But this was also the period when great numbers of students began to assemble in his atelier. His house became a kind of private academy, and in 1750, at the foundation of the Venetian Academy, Piazzetta appeared to be the obvious choice as its first Director. To this late period belong works increasingly executed with the help of pupils, in which a rhetorical shallowness is supported by an *outré* chiaroscuro.

From the mid twenties on Piazzetta showed a growing interest in paintings of heads and half-figures; they were an enormous success with the public but at the same time contained the looming danger of academic petrifaction. This is also true of the many finished drawings with which Piazzetta flooded the market. In any case, his interest in the design of heads, plastically but luminously modelled in black chalk, reveals a master who upheld the tradition of *disegno* – and implicitly of the classical tradition – in a world that was mainly concerned with the painterly loosening of form. Despite his rich, typically Settecentesque, chromatic orchestration, the finest nuances of white, the light dabbing on to the canvas of his pinks and emerald greens, Piazzetta's attempt to persevere in an essentially Seicentesque *tenebroso* manner was bound to fail. But his dynamic reform of sound principles had a salutary effect, and even the young Tiepolo profited more from him than from anyone else.

With the antithesis Sebastiano Ricci–Piazzetta, the Venetian stage in the first decades of the eighteenth century was set for every artist to decide between the former's luminous decorative manner and the latter's rich chromatic chiaroscuro. Some artists wavered, such as Francesco Polazzo (*c.* 1683–1753),[65] who began as a Ricci follower but later switched his allegiance to Piazzetta. By and large, Tiepolo's development goes the opposite way. But among the great number of Piazzetta's pupils and followers there was, characteristically, none of major format, whereas mediocrities abound.[66] Only a few independent artists knew how to assimilate Piazzetta's manner more successfully. Giulia Lama[67] should here be mentioned and, above all, Federico Bencovich, who was probably born in Dalmatia about 1677 (d. Gorizia, 1756).[68]

His first works (Palazzo Foschi, Forlì, 1707) show the influence of his Bolognese teacher, Carlo Cignani, whose academic manner he soon abandoned for that of Giuseppe Maria Crespi. Thus Bencovich's chiaroscuro has the same pedigree as Piazzetta's, to whom he felt naturally drawn during his Venetian period. Also influenced by the powerful art of Paolo Pagani,[69] Bencovich created a manner of his own, dramatic, strange, forceful, agonized, a manner which impressed the young Tiepolo as much as the Viennese in whose city he spent many years from 1733 on [340].[69a]

Sebastiano Ricci also found a following among minor masters. But it was not they, Gaspare Diziani (1689–1767), Francesco Migliori (1684–1734), Gaetano Zompini (1700–78), and the more interesting Francesco Fontebasso (1709–69),[70] on whom the victory of the 'light trend' depended: this was due to a group of more considerable artists and, of course, to Tiepolo.

Pellegrini, Amigoni, Pittoni, Balestra

The first three names stand for a festive Rococo art of considerable charm. Antonio Pellegrini (1675–1741),[71] trained by the Milanese Paolo Pagani, found his bright palette through the study of Ricci and the late Luca Giordano. His light-hearted Rococo frescoes, painted with a fluid brush, were done in England (1708–13,

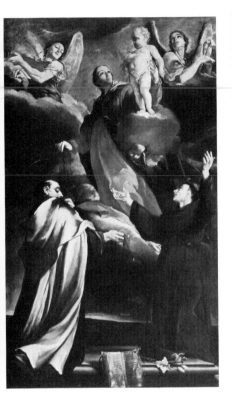

Kimbolton Castle, Castle Howard, etc.), in Bensberg Castle near Düsseldorf (1713-14), in Paris (1720, frescoes destroyed), in the Castle at Mannheim (1736-7), and elsewhere. No less an international success was the more frivolous Jacopo Amigoni (1682-1752).[72] Born in Naples, he must have arrived in Venice already experienced in Solimena's manner, but once again Giordano and Ricci exercised the most important formative influence upon him. In 1717 he was called to the Bavarian court where he painted his fresco cycles in Nymphenburg, Ottobeuren, and Schleissheim. He lived in England between 1730 and 1739, but only his frescoes in Moor Park near London survive. His last years from 1747 on he spent as court painter in Madrid. His later manner degenerated into a languid and melodramatic classicizing Rococo, a trend paralleled in the works of other artists not only in Italy but also in France and England.[73]

Although he does not seem to have left Venice, Giovanni Battista Pittoni (1687-1767) has an important share with Pellegrini and Amigoni in the international success of the Venetian Rococo. Beginning under his uncle, the weak Francesco Pittoni, he first formed his style in opposition to that of the Piazzetta-Bencovich circle. In the 1720s and 30s he produced with a nervous brush light and vibrant Rococo pictures, which reveal his attachment to Sebastiano Ricci and Tiepolo. A sophisticated colourist, he shows in his works a fragrant elegance and an arcadian mood distinctly close in feeling to the French Rococo.[74] Later, a further lightening of his palette goes hand in hand with tamer compositions, not uninfluenced by the general trend towards Neo-classicism.[75] In Pittoni's early work there are also suggestions of Roman Late Baroque influence, and these are due, as R. Pallucchini has shown, to his contact with Antonio Balestra (1666-1740),[76] from Verona.

Balestra, first trained in Venice under Antonio Bellucci, spent several years in Maratti's school

340. Federico Bencovich:
Madonna del Carmine, c. 1710.
Bergantino, Parish Church

484

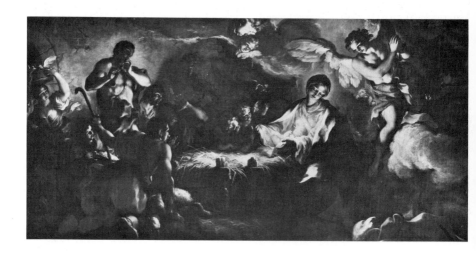

in Rome (c. 1691-4), and later divided his time about equally between Venice and Verona. Without ever deserting Maratti's Late Baroque classicism, he found, like Ricci, decisive stimuli in the art of Veronese and the late Giordano. His new formula of an equilibrium between the form-preserving academic Roman tradition and Venetian tonality prevented him from making concessions to Rococo art [341]. He found a large following, mainly among provincial painters; as a distinguished caposcuola Balestra determined the further course of the Veronese school and influenced not a few lesser Venetian artists.[77] His principal successors at Verona were his pupils Pietro Rotari (p. 578) and Giambettino Cignaroli (1706-70),[78] the latter a typical representative of the classicizing Rococo with false

sentimental and moralizing overtones à la Greuze [342], and therefore the darling of the bourgeois art-loving public of the time.[78a] Cignaroli's art is the North Italian counterpart to the trend represented by Benefial and Batoni in Rome. In Venice, Pietro Longhi began under Balestra but soon deserted him, while Giuseppe Nogari,[79] Mattia Bortoloni[80] (1695-1750), Angelo Trevisani[81] (1669-1753), and, as I have mentioned, the young Pittoni moved in his orbit.

Giambattista Tiepolo (1696-1770)

All the pictorial events in Venice during the early years of the eighteenth century look in retrospect like a preparation for the coming of the great genius, Giambattista Tiepolo.[82] From

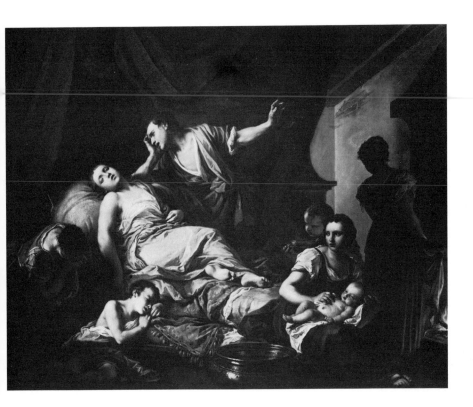

his first work, painted at the age of nineteen (Ospedaletto, Venice), his ascendancy over his older colleagues seemed a foregone conclusion. His career was meteoric; soon he had risen to the position of peerless eminence which he maintained for half a century. From the start his output was prodigious. He began under the retardataire Gregorio Lazzarini but was immediately attracted by Piazzetta's *tenebroso* and the dramatic and bizarre art of Bencovich. These attachments are discernible in his first monumental work, the *Madonna del Carmelo*, painted *c.* 1721 (now Brera, Milan). Piazzettesque reminiscences linger on in one of his first frescoes, the *Glory of St Teresa* in the Chiesa degli Scalzi, Venice (*c.* 1725). In 1726 he began his first important fresco cycle outside Venice, in

the Cathedral and the Archiepiscopal Palace at Udine, the masterpiece of his early period and a landmark on the way to his new airy and translucent art. After Udine, his work often took him outside Venice: in 1731 and again in 1740 to Milan where he painted first the ceilings in the Palazzi Archinto (destroyed during the war) and Casati-Dugna and, at the later visit, that in the Palazzo Clerici.[83] In 1732 and 1733 followed the frescoes in the Colleoni Chapel in Bergamo and between 1737 and 1739 the great ceiling with *St Dominic instituting the Rosary* in the Chiesa dei Gesuati, Venice. The next decade led him from triumph to triumph: the great canvases of the Scuola dei Carmini (1740–7); one of his grandest frescoes, the *Madonna di Loreto* on the vault of the Chiesa degli Scalzi (1743–4, des-

troyed during the first war);[84] and, c. 1744-5, the superb central saloon of the Palazzo Labia with the story of Cleopatra – these are some of the highlights of this period.

A new chapter in his career started at the beginning of the next decade, when he was commissioned to decorate the Kaisersaal and the Grand Staircase of the new Residenz at Würzburg, the capital of Franconia (December 1750-November 1753).[85] This immense task, the greatest test yet of his inexhaustible creative resources, was followed after his return to Venice by the *Triumph of Faith* on the ceiling of the Chiesa della Pietà (1754-5) and the decoration of a number of villas in the Veneto, among them the charming series of frescoes in the Villa Valmarana near Vicenza (1757). Works like the frescoes in the two rooms of the Palazzo Rezzonico, Venice (1758), the *Assumption* fresco in the Chiesa della Purità at Udine, painted in the course of one month in 1759, the *Triumph of Hercules* in the Palazzo Canossa at Verona (1761), and the *Apotheosis of the Pisani Family* in the great hall of the Villa Pisani at Stra (1761-2) occupied him during his last Italian years. In the summer of 1762, following an invitation from King Charles III, he arrived in Madrid, and it was there that he spent the last eight years of his life executing the enormous *Apotheosis of Spain* in the Throne Room of the Palace as well as two lesser ceilings,[86] and carrying out a multitude of private commissions. It was at the threshold of death that the aged painter had to face his first major defeat. At the instigation of the powerful Padre Joaquim de Electa, the King's Confessor, who was a supporter of Mengs, Tiepolo's seven canvases painted for the church of S. Pascal at Aranjuez were removed and replaced by works of his rival.

This survey indicates that Tiepolo was in the first place a painter in the grand manner, and it is in this capacity that he should be judged. In order to pinpoint his historical position, I have chosen to discuss one of his more modest fresco cycles, that of the Villa Valmarana, painted at the height of his career.[87] The programme in the five frescoed rooms is wholly in the tradition of grand history painting, illustrating scenes from Homer (probably in Valerius Maximus's version) and Virgil, from Ariosto and Tasso. Illustration 343 shows the long wall of the hall with the *Sacrifice of Iphigenia*: in the centre the high priest, ready to thrust a butcher's knife into Iphigenia's body, and a servant with a platter to receive the sacrificial blood. But the killing does not take place; led by little cupids the deer dispatched by the goddess Diana – appeased and moved by the girl's innocence – arrives post-haste on a cloud in order to take Iphigenia's place, and the high priest as well as the crowd turn astonished in the direction of the unexpected sight. Only Agamemnon, Iphigenia's father, hiding his face in his cloak,[88] is still unaware of the miracle.

The scene takes place under a portico, the painted frontal columns of which seem to carry the actual cornice. With every means at his disposal Tiepolo produced the illusion that the perspective space of the fresco is a continuation of real space.[89] The illusionist extension of space is carried over to the opposite wall, where the portico architecture is repeated as setting for Greek warriors watching the events across the room. Moreover, the cloud with the deer seems to float far inside the beholder's space. On one side of the ceiling the goddess herself turns with commanding gesture towards the sacrifice, on the other side the wind-gods begin to blow again, and they blow in the direction of the Greek fleet, lying at anchor behind the portico of the opposite wall. Thus a web of relationships is created across the room and from the ceiling to both walls, and the beholder's space is made to form an integral part of the painted story. With remarkable logic, it is also the imaginary light shining from the painted sky that determines the distribution of light and shade in the frescoes.

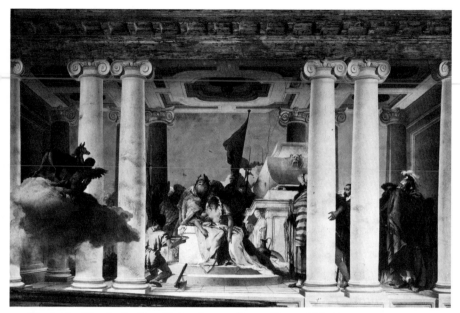

343. Giambattista Tiepolo: Sacrifice of Iphigenia, 1757. Fresco. *Vicenza, Villa Valmarana*

Similar illusionist effects are operative in the Palazzo Labia, where Antony and Cleopatra seem to step down the painted staircase as if to join the crowds in the hall. Although the same degree of illusion could rarely be applied, Tiepolo revelled in illusionist devices such as the motif of the drawn curtains in the Kaisersaal of the Würzburg Residenz. It is evident that he takes his place in the monumental Renaissance-Baroque tradition, and if he revived the kind of illusionism familiar from Veronese and his school, he needed for his stronger effects the support of Bolognese *quadratura;* it is well known that he often employed his faithful *quadraturista*, Mengozzi-Colonna.[90] Behind the illusionist totality at which he aimed lies the accumulated experience of monumental Baroque art – not only the theory and practice of the *quadraturisti*, but in various ways also that of Cortona and Bernini, who had found new concepts for breaking down the boundary between real and imaginary space.

Nobody has ever been misled by the fictitious reality of the painted world. But just as in the theatre, the Baroque spectator craved for the maximum of illusion and was prepared to surrender to it. In contrast, however, to seventeenth-century illusionism, Tiepolo's emphatically rhetorical grand manner is sophisticated and hyperbolical in a typically eighteenth-century sense. Although he uses every means of illusion to conjure up a fictitious world, he seems himself to smile at the seriousness of the attempt. In the hall of the Villa Valmarana and in front of many of his secular works John Gay's epigram comes to mind: 'Life is a jest and all things show it . . .'.

The Villa Valmarana frescoes also reveal the extent to which Tiepolo abides by the classical compositional patterns of monumental paint-

344 *(above)*. Giambattista Tiepolo: Plate from the *Varj Cappricj*, published 1749. Etching

345 *(opposite)*. Giambattista Tiepolo: Sketch, pen and wash. *New York, Pierpont Morgan Library*

ing. One finds a distinct emphasis on triangles and basic diagonals and, while this may not be so obvious in multi-figured works, a close study shows that even in these each figure is clearly defined by a network of significant compositional relationships.[91] In the last analysis the figures themselves belong to the perennial repertory of the Italian grand manner; the links with Veronese are particularly strong, but even Raphael may be sensed.

I have stressed Tiepolo's traditionalism so much because he is in every sense the last link in a long chain. He himself was well aware of the full extent of the tradition. Veronese and Titian, Raphael and Michelangelo, even Dürer, Rembrandt, and Rubens and, of course, the whole development of Italian Baroque painting were familiar to him, and he did not hesitate to use from the past whatever seemed suitable. True to the new approach first encountered in Luca Giordano, he carried the weight of this massive heritage lightly and displayed his unrivalled virtuosity with unbelievable ease. Without the least sign of inhibition he turned the accumulated experience of 250 years to his own advantage: but since he was so sure of himself, every one of his works is an unimpaired entity, strong and immensely vigorous. The virile and heroic quality of his art is apparent even where he comes closest to French Rococo. Shepherds' idylls were not for him; whatever he touched had the epic breadth of the grand manner.

But Tiepolo was not simply the last great practitioner of history painting in the classical

tradition – his particular glory and one of the reasons for his European success lies in his revolutionary palette. His early work was still relatively dark, with striking chiaroscuro effects and lights flickering over the surface. It was at this time that Rembrandt had a strong hold on him. The Udine frescoes of 1726-7 mark the decisive change: light unifies the work and penetrates into every corner. For the two other great magicians of light, Caravaggio and Rembrandt, light had always a symbolic quality and needed darkness as its complement. Tiepolo's light, by contrast, is the light of day, which resulted in the transparency and rich tonal values of all shadows. He created this light by using a silvery tone which reflects from figures as well as objects. It is this light that must be regarded as the crowning achievement of Tiepolo's art and, in a sense, of the inherent tendencies of Venetian painting. Contrary, however, to the warm palette of the older Venetian masters, Tiepolo's palette had to be cool in order to produce his daylight effect. As a result, his most brilliant accomplishment is his frescoes rather than his easel-paintings, so that his works in galleries, splendid as they may be, will never convey a full impression of his genius. This has to be emphasized, since we tend nowadays to prefer the intimate oil study, the rapid sketch in pen and wash, or the spirited etched capriccio to the rhetoric of the grand manner [344, 345]. All these are, of course, of the highest quality, but, true to tradition, to Tiepolo these were trifles to be indulged in as a pastime (unless they were preparatory studies for monumental works).[92]

Fresco-painting is the technique ideally suited to the grand manner with its requirement for monumentality, and, except in Venice, the masterpieces of Italian painting were therefore executed in this technique. It is like an act of historical propriety that the last giant of the grand manner was a Venetian and chose the fresco as his principal medium. Yet in one im-

portant respect Tiepolo broke away from customary procedure. Instead of the finish which one associates with fresco technique, he used a rapid and vigorous stroke, so that in reproductions details of his frescoes often look almost like sketches [346]. It is precisely this inimitable brush-stroke that endows his frescoes with their intensity, exuberance, and freshness.

346 (above). Giambattista Tiepolo:
Head from 'Rinaldo and Armida', 1757. Fresco.
Vicenza, Villa Valmarana

347 (opposite). Gian Domenico Tiepolo:
Peasant Women (detail), 1757. Fresco.
Vicenza, Villa Valmarana

In the guest-house of the Villa Valmarana a few rooms are decorated with idyllic and topical subjects. The change of programme corresponds to a change of style for which Gian Domenico Tiepolo was responsible. Giambattista's heroic, epic, and mythological scenes are expressed in the language and grammar of the grand manner, while Gian Domenico's masquerades and village scenes are inconsistent

with the compositional patterns of the classical tradition; the idealization of figures, too, is replaced by an anti-conventional and realistic idiom [347]. This change marks a change of generation. Gian Domenico, born in 1727, died as late as 1804: he buried the grand manner right under his father's vigilant eye.

Five years after the Villa Valmarana frescoes Tiepolo settled in Madrid. Shortly before him, Mengs had come to take up his appointment as painter to the king. When Tiepolo died, Goya was twenty-four years old – a fascinating constellation where Tiepolo as well as Mengs could

only be the losers: the last great pillar of the Baroque tradition and the most celebrated exponent of academic art had to yield to the prophetic genius who gave rise to the art of the new century.[93]

THE GENRES

In the first chapter will be found some remarks about the so-called 'secularization' of painting in the seventeenth century and the growth of various specialities. As the century advanced, the specialists of landscape painting in its various facets, of battle- and animal-pieces, popular scenes and genre, of fruit, flower, fish, and other forms of still-life, and finally of portraiture grew considerably in numbers.[94] This answered a need, because these artists catered to a rapidly growing middle-class with new ideas of domestic comfort. Nevertheless the Italian position remained vastly different from that of a Protestant bourgeois civilization such as Holland's, where the process of specialization had begun a hundred years earlier. In Italy the nobility of monumental painting was never seriously challenged, and it is for this reason that, with the exception of portraiture, artists of rank rarely made the concession of delving into the 'lower' genres; only outsiders like Crespi were equally at home in religious imagery and the *petite manière* of domestic scenes. It is for the same reason that for the modern observer some of the most exciting and refreshing paintings of the late seventeenth and eighteenth centuries came from the 'unprincipled' specialists. Yet, although much of their work may have a greater appeal than the large history-paintings of the Bolognese or Roman schools, compared with the endless number of practitioners, the real innovators, masters with a vision of their own, are few. It is mainly with these that I shall deal in the following pages, while many worthy artists of minor stature must be left unmentioned.

Portraiture

Almost all the great Late Baroque artists were excellent portrait painters - from Maratti to Batoni and Mengs, from Luca Giordano to Solimena, from Crespi to Tiepolo. It is an interesting aspect that their portraits were, as a rule, painted without theoretical encumbrances and therefore often speak to us more directly and more forcefully than their grand manner. Among the specialists in portraiture, two masters of rank may be singled out, Giuseppe Ghislandi, called Fra Vittore del Galgario (1655-1743), and Alessandro Longhi (1733-1813). Fra Galgario, born in Bergamo, studied in Venice under the portrait painter Sebastiano Bombelli (1635-1716), thus laying the foundation for his magnificent blending of Venetian colourism with the native tradition of Moroni's portraiture. From the latter he learned the secret of straightforward characterization of the sitter. It is his ability of unvarnished representation of character, to which he knew how to subordinate the pose, the often pompous or elegant contemporary dress, and the chromatic key, that makes him the most distinguished portrait painter of the Late Baroque period [348].

Alessandro Longhi, whose activity began a decade after Fra Galgario's long career had ended, represents to a certain extent the opposite pole in portrait painting.[95] Trained under his father Pietro and under Giuseppe Nogari (1699-1763), a specialist in rather facile character studies, he became the acknowledged master of Venetian state portraiture - of doges, senators, and magistrates - rendered with an infallible sense for tonal nuances; but in his portraits it is the stately robe rather than the

348. Giuseppe Ghislandi:
Portrait of Isabella Camozzi de' Gherardi, *c.* 1730.
Costa di Mezzate, Bergamo,
Conti Camozzi-Vertosa Collection

character that makes the man. His gallery of Venetian dignitaries, continued without much change of style till after 1800, shows how little Venetian Rococo culture yielded to the temper of a new age.

On a lesser level portraiture flourished during the period, particularly in Venice and the *terra ferma*. Rosalba Carriera's (1675-1758) charming Rococo pastels come to mind; in her time these made her one of the most celebrated artists in Europe. Her visits to Paris (1721) and Vienna (1730) were phenomenal successes; in Venice all the nobles of Europe flocked to her studio. But her work, mellow, fragrant, and sweet, typically female and a perfect scion of the elegant Rococo civilization of Venice, is interesting (in spite of a recent tendency to boost it)[96] as an episode in the history of taste rather than for its intrinsic quality.

The Popular and Bourgeois Genre

In recent years much stir has been made by the masters whom Roberto Longhi called 'pittori della realtà'[97] - the masters who take 'life as it really is' as their subject and paint it with unconventional freedom and directness. But as Longhi himself made abundantly clear, this happy phrase has meaning only in a metaphorical sense. The Milan Exhibition of 1953 showed that an almost abstract Lombard quality unites the portraits of Carlo Ceresa, the still-lifes of Baschenis, and the popular genre of Ceruti, a 'magic immobility' (Longhi), a sophisticated convention far removed from a 'naive' approach to reality.

Giacomo Ceruti, called 'il Pitocchetto', also a history and portrait painter, remains, in spite of intense study,[98] something of an enigma. Active mainly in the second quarter of the eighteenth century, he left us a depressing gallery of beggars and idiots, of vagabonds, cripples, and dumb folk painted sparingly in a dark key, but with such descriptive candour that

349. Giacomo Ceruti: Two Wretches, *c.* 1730–40.
Brescia, Pinacoteca

the spectre of Surrealism is not far from our minds [349]. The popular genre as such had fairly wide currency then, so that Ceruti's fascination with the forgotten and lost of humanity was not altogether unique.

Linked by many strands with the Flemish and Dutch masters, imported by them directly and indirectly into Italy, the lower genre appears during the seventeenth century in many guises: as animal pictures and rustic scenes in Genoa, as Bambocciate in Rome, as market scenes and low-class gatherings in Naples, or simply as semi-burlesque types in Annibale Carracci's *Arti di Bologna*. Yet it was only from the turn of the seventeenth to the eighteenth century on

that the common man, the anonymous crowd, their doings, behaviour, and psychology attracted many painters, among them Giuseppe Maria Crespi [334], Magnasco, and Piazzetta.

But the artists who regarded this genre as their special and sometimes only province form a group apart. Gaspare Traversi in Naples,[99] setting out from Caravaggesque sources, painted (between 1732 and 1769) episodes from the life of the middle classes with considerable temperament, psychological insight, and a lively sense for the farcical and grotesque. Concentrating entirely on the mute communication of figures often irrationally arranged on the canvas [350], his work strikes a truer note than the

350. Gaspare Traversi: A wounded Man, before 1769.
Venice, Brass Collection

more polite genre scenes of his contemporary Giuseppe Bonito (p. 465), who transferred something of the respectability of academic art into this sphere. Rome had in Antonio Amorosi (*c.* 1660–after 1736) a painter who conceived popular genre-scenes on a rather monumental scale. A revival of a certain amount of Caravaggism together with the reserve and intensity of his figures are the reason why many of his pictures went and still go under the names of Spanish artists, even of that of Velasquez. Amorosi, along with his contemporary Pier Leone Ghezzi[100] (1674–1755), was the pupil of the latter's father, Giuseppe Ghezzi (1634–1721). Pier Leone, whose frescoes and altar-pieces are now all but forgotten, survives as the witty caricaturist of hundreds of contemporary Roman notables[101] – drawn, however, in a stereotyped manner – rather than as the painter of genre scenes. Giuseppe Gambarini[102] (1680–1725) in Bologna, who always reveals his Bolognese academic background, tends in some of his pictures towards the idyllic Rococo genre. But it was mainly in Lombardy and the Venetian hinterland that the lower and bourgeois genre, even before Ceruti, had its home with such minor practitioners as Pietro Bellotto (1625, not 27,–1700), a pupil of Forabosco and painter of meticulously observed heads of old people; Bernardo Keil[103] ('Monsù Bernardo', 1624–87),

Rembrandt's pupil, working in Italy from 1651 on; Pasquale Rossi[104] called Pasqualino (1641–1725) from Vicenza, who practised mainly in Rome and may have influenced Amorosi; Antonio Cifrondi (1657–1730), Franceschini's pupil at Bologna, whose paintings are definitely related to the *Arti di Bologna* etchings; and Giacomo Francesco Cipper[105] called il Todeschini, probably a Tirolese working in the first half of the eighteenth century in a manner reminiscent of Ceruti's. These painters delight in illustrating homely or gaudy and grotesque scenes, and the beholder is entertained by the narrative. All this is different in the case of Ceruti, where it is the scrupulous 'portrayal' of misery that has our attention.

Now Annibale Carracci's *Arti di Bologna*[106] were what may be called the incunabula of 'pure representation' of low-class types, and this tradition was kept alive in Giuseppe Maria Mitelli's (1634–1718) engravings. It would seem that Ceruti's art developed against this background[107] and that his paintings, therefore, represent types rather than portraits and contain literary connotations of which the modern beholder is unaware.

This observation leads to the major problems of the entire class of genre painting. Not 'real life', but traditions of old – visual as well as literary recollections – inform the incongruously farcical as well as the imaginary idyllic genre. Upon closer inspection it appears that the choice of subjects was limited. A standardized set was endlessly repeated, such as the Schoolmistress, the Sewing School, the Musical Party, the mendicant Friar, the old Drunkard, and so forth. In not a few cases the roots lie far back in the allegorical representations of the Middle Ages (e.g. the Schoolmistress as personification of Grammar, one of the Liberal Arts), in others the pattern derives from religious imagery or history painting (e.g. the Sewing School from Reni's fresco of the Virgin sewing). Moreover, it has rightly been pointed out[108] that by and large in Italy this class of painting lacks spontaneity, that the derivation from, and connexion with, the great formal tradition can often be sensed, and that Italians concentrate on the human figure rather than on the ambience. In contrast to the painters of northern countries, many of the Italian genre painters also practised the grand manner, or tried and, disappointed, deserted it. In addition, it can probably be shown that there was a lively exchange between Naples, Rome, and Lombardy with Bologna taking up a key position; that, in other words, the painters here named and many others knew of each others' work. What would seem an impromptu reaction against the formalism of the grand manner and the established conventions of decorum, springing up in a number of centres, was in fact an art with its own formal and iconographical conventions – a kind of academic routine of 'low art', far from any improvisation.

It is only when one turns to Pietro Longhi (1702–85) that one is faced with conversation pieces in the modern, eighteenth-century sense. At the opposite pole to Ceruti's restricted formula for the rendering of low-class types, Longhi, the most versatile Italian practitioner of the pleasant and unproblematical bourgeois genre, is more interested in catching the flavour of the scene enacted than in the characters of the actors [351]. While working at Bologna under Crespi, he came into contact with Gambarini's rather polished paintings of well-mannered peasants and washerwomen, an interpretation of everyday life that struck allied chords. Back in Venice, he became the recorder of the life and entertainments of polite society, always painted in the small cabinet format. But compared with the magic of a Watteau, the charm of a Lancret, the intimacy of a Chardin, or the biting wit of a Hogarth, the limitations of his talent are obvious.

Longhi's flair for showing the public their own lives in a somewhat beautifying mirror won him enthusiastic admirers.[109] Everywhere

351. Pietro Longhi: The House Concert, *c.* 1750.
Milan, Brera

in Europe the bourgeois society of the second
half of the century craved for a descriptive,
anecdotal art, and, next to Longhi, minor artists
in Venice like Francesco Maggiotto and Antonio
Diziani catered for this taste in various ways.
It was perhaps a timely decision when Giam-
battista Tiepolo left for Spain in 1762.[110]

Landscape, Vedute, Ruins

During the seventeenth century the important
events in the history of Italian landscape paint-
ing took place on Roman soil. It was there that
the Venetian landscape of the sixteenth century
was transformed by Annibale Carracci into

the classically constructed humanist landscape
which led on to the development of Claude's
and Poussin's ideal and heroic landscape style;
it was there that through Brill and Elsheimer
the 'realistic' northern landscape got a firm
foothold, was italianized by Agostino Tassi,
and disseminated further by scores of northern
artists who had settled in Rome; it was there,
finally, that Salvator created the 'romantic'
landscape which determined to a large extent
the further history of Italian landscape painting.

For the following period it is necessary to
differentiate, at least theoretically, between the
landscapists proper and the masters of *vedute*,
i.e. of topographical views. *Vedute*, which do

not become important till the second half of the seventeenth century, are in fact a late off-shoot, often combining landscape elements with the work of the trained architectural designer as well as the *quadraturista* or scene painter. At the time one distinguished between the *vedute esatte*, precise renderings of topographical situations, and the *vedute ideate* or *di fantasia*, imaginary views, which offered the possibility of indulging in dreamlike flights into the past and, above all, of rendering romantic and nostalgic pictures of ruins.[111] In Rome the arcadian and pastoral classical landscape remained in vogue, practised mainly by the exceedingly successful italianized Fleming Jan Frans van Bloemen, called Orizzonte (1662–1749),[112] and by Andrea Locatelli (1695–c. 1741),[113] whose elegant and tidy work shows a typically eighteenth-century luminosity and transparency. Neapolitan landscapists such as Gennaro Greco,[114] called Mascacotta (1663–1714), Pietro Cappelli, a Roman (d. 1727), Leonardo Coccorante (1700–50), and even the late Carlo Bonavia (or Bonaria, active 1750–88), stem mainly from Rosa and often emphasize the bizarre and fantastic.[115] Compared with these attractive but minor specialists, Rome had at least one great master who raised both the *veduta esatta* and *ideata* to the level of a great art.

Gian Paolo Pannini,[116] born at Piacenza in 1691/2, first formed by impressions of the Bibiena and other scenographic artists, in 1711 joined the studio of the celebrated Benedetto Luti in Rome. His frescoes in the Villa Patrizi (1718–25, destroyed) established him firmly as a master in his own right. Patronized by Cardinal Polignac and married to a Frenchwoman, his relations with France became close and his influence on French artists increasingly important. During the last thirty years of his life (he died in Rome in 1765) he was primarily engaged on topographical views of Rome, real and imaginary [352], and one cannot doubt that he received vital impulses from the precise art

of Giovanni Ghisolfi (1623–83),[117] whose *vedute ideate* show the characteristically Roman scenic arrangement of ruins. The boldness of Pannini's views, the sureness with which he placed his architecture on the canvas – clear signs of the trained *quadraturista* – the handling and placing of his elegant figures, the atmosphere pervading his pictures, the crystalline clarity of his colours, the precision of his draughtsmanship – all these elements combine into an art *sui generis*, which had as much influence on the majestic visions of a Piranesi as on the arcadian world created by Hubert Robert.

Earlier than most of Pannini's *vedute*, but influenced by them at the end of his career, are the often somewhat dry topographical renderings of the city by the Dutchman Gaspar van Wittel,[118] called Vanvitelli, who was born at Amersfoort in 1653, made Italy his home in 1672, and worked mainly in Naples and Rome where he died in 1736. Deriving from the northern microcosmic tradition of a Berkheyde, in Italy he soon developed a sense for well-composed panoramic views without ever abandoning the principle of factual correctness.

With Vanvitelli and Pannini and later with the magnificent engraved work of the Venetian Giambattista Piranesi (p. 364), Rome maintained a position of eminence in the special field of topographical and imaginary *vedute*.[119] Nonetheless, Venice also asserted her ascendancy in landscape painting and the allied genres. Marco Ricci (1676–1730),[120] Sebastiano's nephew and collaborator [353], must be regarded as the initiator of the new Venetian landscape style, which through him became an immediate international success. He worked in Turin, Florence, and Milan, and visited London twice between 1708 and 1716, the second time (1712–16) in the company of his uncle. From 1717 on he made Venice his home. With his knowledge of intra-Italian developments Marco combined quick reactions and a spirit of real artistic adventure. Thus, in the first three decades of the eighteenth

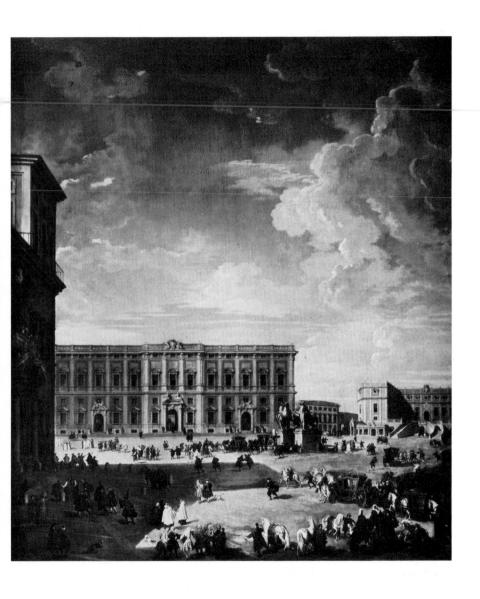

352. Gian Paolo Pannini: Piazza del Quirinale, *c.* 1743. *Rome, Quirinal Palace*

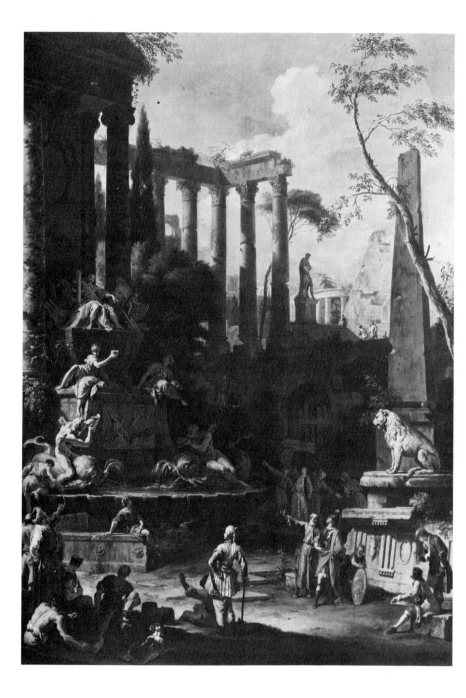

century his manner underwent many changes: the early 'scenographic' views derive from Carlevarijs, the dark, tempestuous landscapes betray the study of Salvator and Micco Spadaro, the more arcadian ones that of Claude; in the second decade his landscapes show some of the magic and nervous tension of Magnasco; later his interest in classical ruins grows; at the same time his vision broadens, his palette lightens, and the landscapes take on an eighteenth-century luminous and atmospheric character [353]. At this late moment he appears as a master of the *vedute ideate*, fantastic visions of crumbled antiquity, even before Pannini had developed his own style in this genre.

Giuseppe Zais (1709–84) formed his rustic style as a landscapist upon the art of Marco Ricci before he came into contact with the Tuscan Francesco Zuccarelli (1702–88), who settled in Venice about 1732 and soon found himself in the leading position vacated by Marco Ricci's death. Trained in Florence by Paolo Anesi and in Rome possibly by Locatelli, Zuccarelli had little of Marco's bravura although he strove to emulate the latter's atmospheric luminosity. But Tuscan that he was, his festive idylls and arcadian elysiums under their large blue skies – more in line of descent from Claude than from Marco – always retain a non-Venetian colouristic coolness. His sweet and amiable art secured him international success. He worked in Paris and London, where he became a foundation member of the Royal Academy (1768), and his influence on the history of English landscape painting is well known.

The most gifted follower of Marco Ricci, but probably Canaletto's pupil, was Michele Marieschi (1710–43);[121] with a quick brush he painted imaginary views of Venice, landscapes with ruins, and capriccios in which something of the

353. Sebastiano and Marco Ricci: Epitaph for Admiral Shovel, *c.* 1726. *Washington, National Gallery*

scenographic tradition is retained. It has long been known that his work, usually in strong chiaroscuro and glittering with the warm and brilliant light of the Venetian lagoon, had a formative influence on the greater Francesco Guardi.

To the extent that all these landscapists were also *vedutisti*, it was primarily the *veduta di fantasia* that interested them. But parallel with the *veduta esatta* by Vanvitelli and Pannini runs a development at Venice: if Luca Carlevarijs from Udine (1663–1730) was the Venetian Vanvitelli, Antonio Canale, called Canaletto (1697–1768), was the Venetian Pannini. Carlevarijs,[122] also renowned as an engraver, approached his subject with the eye and knowledge of the trained *quadraturista*. The scenic effect of his views of the Piazza S. Marco and the Canal Grande with their studied emphasis on perspective, the crowds, gondolas and accessories filling his pictures, his interest in the narrative or the festive event (e.g. the *Reception of the Fourth Earl of Manchester as Ambassador at Venice*, 1707, City Art Gallery, Birmingham) – all this shows how different his art is from that of his Roman counterpart. Yet like Vanvitelli he was mainly a 'chronicler', concerned with the factual rather than the poetical aspect of the scene recorded. It was precisely this, the poetical quality, the responsiveness to the mood of Venice, to her light and atmosphere, that Canaletto knew how to render. He began as a theatrical designer under his father. After an early visit to Rome (1719), he worked first with Carlevarijs, and his choice of views and motifs reveals it even at a much later date.

Canaletto's characteristic style was formed as early as 1725 (four pictures for Stefano Conti at Lucca, now Montreal, private collection).[123] Although he slowly turned from an early *tenebroso* manner to a brightly and warmly lit atmospheric interpretation of his *vedute*, in keeping with the general eighteenth-century trend, he remained faithful to a fluid and smooth paint;

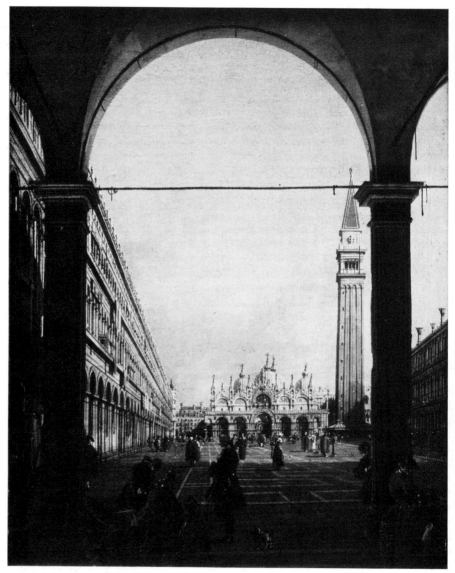

354. Canaletto: Piazza S. Marco, *c.* 1760. *London, National Gallery*

and it is this that helps to convey the impression of a dispassionate festive dignity and beatitude [354]. No eighteenth-century painter was more

to the taste of the British, and owing to the patronage of the remarkable Consul Smith at Venice there was soon a steady flow of Cana-

lettos to England, followed between 1746 and 1755 by three visits of the artist to London.[124]

A high-class imitator of Canaletto's manner was his pupil Giuseppe Moretti;[125] but only Bernardo Bellotto (1720–80), Canaletto's nephew, was capable of a personal interpretation of the older artist's work. He left Venice at the age of twenty and, after working in Rome, Turin, Milan, and Verona, sought his fortune north of the Alps. Between 1747 and 1756 he was court painter in Dresden, later he went to Vienna and Munich, and the last thirteen years of his life he spent as court painter in Warsaw, poetically ennobling cities and buildings under northern skies by the mathematical precision of his vision and the terse application of a small range of cold 'moonlight' colours.[126]

Often allied with the name of Canaletto, but in fact taking up a diametrically opposite position, Francesco Guardi (1712–93) must be given the palm among the vedutisti. His modest life-story remains almost as anonymous as that of a medieval artist. Although in 1719 his sister was married to Tiepolo, it is only after patient research that a minimum of facts has become known about him. He never attracted the attention of foreign visitors, and not till he was seventy-two was he admitted to the Venetian Academy. Until 1760 his personality was submerged in the family studio headed by his brother Gianantonio (1699, not 98,–1760).[127] In this studio Francesco plodded along like an artisan of old and never relinquished antiquated practices. As a man of over thirty he seems also to have worked in Marieschi's studio and when over forty in that of Canaletto. Moreover, he did not hesitate to repeat himself nor to use other artists' works – next to Canaletto's, compositions by Sebastiano Ricci, Fetti, Piazzetta, Strozzi, Crespi – and one of his most ravishing paintings, the Gala Concert of 1782 (Munich, Alte Pinakothek), was cribbed from a dry engraving by Antonio Baratti after a design by Giovanni Battista Canal. Finally, much of his output was the work of collaboration in the studio, where every kind of commission was accepted, from religious pictures[128] to history paintings, battle-pieces, and even frescoes (1750s, Cà Rezzonico, Venice). Only in his later years and, above all, after the death of the elder brother does he seem to have concentrated on the painting of vedute, for which he is now mainly famed.

It was his collaboration with Gianantonio that opened up a major problem of criticism. Until fairly recently it was believed that Francesco was the real and only genius in the studio. Now, however, the scales have been reversed and Gianantonio seems to emerge as an equally great figure.[129] If he – as seems likely – and not Francesco was the master of the paintings for the organ in the Chiesa dell'Angelo Raffaele (after 1753) [355], then, indeed, the palm must go to him. In spite of such re-valuation of far-reaching importance and in spite of the seeming shortcomings of Francesco's practices, his work speaks an unmistakable language.

While Canaletto stands in the old tradition of fluid and even application of paint, a tradition which was ultimately concerned with the preservation of form, Guardi stems from the 'modern' masters of the loaded brush, the masters di tocco, and the ancestry of his art goes back through Marieschi and Marco Ricci to Magnasco, and further to Maffei, Fetti, and Lys. While Canaletto is primarily concerned with the skilful manipulation of architectural prospects and therefore remains inside the great Italian tradition of firm compositional structure, Guardi drifts more and more towards so free and personal an interpretation of the material world [356] that its structure appears accidental rather than essential to his dreamlike visions. While Canaletto objectifies even the poetry of Venice, Guardi subjectifies even factual recordings. While the former, in a word, is still a child of the Renaissance tradition in so far as the thing painted is an intrinsic part of the painter's

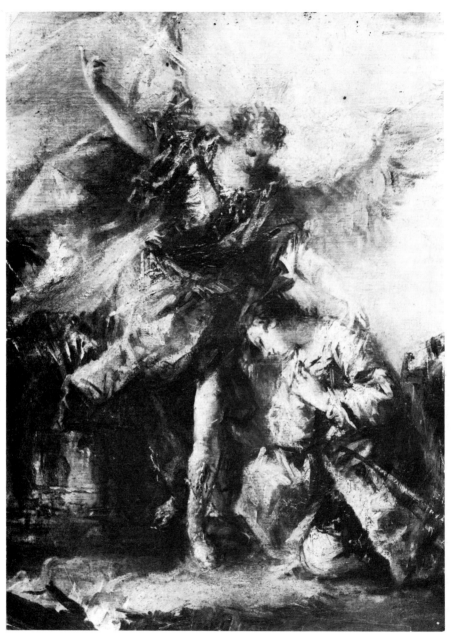

355. Gianantonio Guardi: Story of Tobit, after 1753. Detail. *Venice, S. Raffaele, parapet of organ*

performance, the latter steps outside that tradition in so far as the thing painted seems to have no more than extrinsic value.

But whether it was Gianantonio or Francesco who crowned the pursuits of the masters of the free brush-stroke, it is in their work that solid form is dissolved and dematerialized to an extent undreamed of by any precursor [355]. Between them, the two brothers opened the way to the 'pure' painters *di tocco* of the next century, the Impressionists, who like them thought that form was fleeting and conditioned by the atmosphere that surrounds it.

Thus two masters essentially of the *petite manière* had broken through the vicious circle of Renaissance ideology and vindicated the development of a free painterly expression which had started with the late Titian, with Tintoretto

and Jacopo Bassano, had constantly invigorated Italian Baroque painting at all levels, and had contributed even more to the course painting took in the Low Countries and Spain.

On this note the book might well have ended, were it not for a strange paradox. Francesco Guardi's art has often been compared with the music of Mozart. Despite his modernity, Guardi was a man of his century and, more specifically, a man of the Rococo. He continued creating his spirited capriccios and limpid visions of Venice long after the spectre of a new heroic age had broken in on Europe. When he died in the fourth year of the French Revolution, few may have known or cared that the reactionary backwater of Venice, the meeting place of the ghost-like society of the past, had harboured a great revolutionary of the brush.

356. Francesco Guardi: View of the Lagoon, *c.* 1790.
Milan, Museo Poldo Pezzoli

LIST OF THE PRINCIPAL ABBREVIATIONS USED

IN THE NOTES AND BIBLIOGRAPHY

Archivi	*Archivi d'Italia*
Art Bull.	*The Art Bulletin*
Baglione	G. Baglione, *Le Vite de' pittori, scultori, architetti* . . . Rome, 1642
Bellori	G. P. Bellori, *Le Vite de' pittori, scultori ed architetti moderni*. Rome, 1672
Boll. d'Arte	*Bollettino d'Arte*
Boll. Soc. Piemontese	*Bollettino della Società Piemontese di architettura e delle belle arti*
Bottari	G. Bottari, *Raccolta di lettere*. Milan, 1822
Brauer-Wittkower	H. Brauer and R. Wittkower, *Die Zeichnungen des Gianlorenzo Bernini*. Berlin, 1931
Burl. Mag.	*The Burlington Magazine*
Donati, *Art. Tic.*	U. Donati, *Artisti ticinesi a Roma*. Bellinzona, 1942
G.d.B.A.	*Gazette des Beaux-Arts*
Golzio, *Documenti*	V. Golzio, *Documenti artistici sul seicento nell'archivio Chigi*. Rome, 1939
Haskell, *Patrons*	F. Haskell, *Patrons and Painters: A Study in the Relations between Italian Art and Society in the Age of the Baroque*. London, 1963
Jahrb. Preuss. Kunstslg.	*Jahrbuch der Preussischen Kunstsammlungen*
J.W.C.I.	*Journal of the Warburg and Courtauld Institutes*
Lankheit	K. Lankheit, *Florentinische Barockplastik*. Munich, 1962
Mâle	É. Mâle, *L'art religieux de la fin du XVIe siècle* . . . Paris, 1951
Malvasia	C. C. Malvasia, *Felsina pittrice*. Bologna, 1678
Passeri-Hess	G. B. Passeri, *Vite de' pittori, scultori ed architetti*. Ed. J. Hess. Vienna, 1934
Pastor	L. von Pastor, *Geschichte der Päpste*. Freiburg im Breisgau, 1901 ff.
Pollak, *Kunsttätigkeit*	O. Pollak, *Die Kunsttätigkeit unter Urban VIII*. Vienna, 1927, 1931
Quaderni	*Quaderni dell'Istituto di storia dell'architettura* (Rome)
Rep. f. Kunstw.	*Repertorium für Kunstwissenschaft*
Riv. del R. Ist.	*Rivista del R. Istituto di archeologia e storia dell'arte*
Röm. Jahrb. f. Kunstg.	*Römisches Jahrbuch für Kunstgeschichte*
Titi	F. Titi, *Descrizione delle pitture, sculture e architetture* . . . *in Roma*. Rome, 1763
Venturi	A. Venturi, *Storia dell'arte italiana*. Milan, 1933 ff.
Voss	H. Voss, *Die Malerei des Barock in Rom*. Berlin, 1924
Waterhouse	E. Waterhouse, *Baroque Painting in Rome*. London, 1937
Wiener Jahrb.	*Wiener Jahrbuch für Kunstgeschichte*
Wittkower, *Bernini*	R. Wittkower, *Gian Lorenzo Bernini*. London, 1955
Zeitschr. f. b. Kunst	*Zeitschrift für bildende Kunst*
Zeitschr. f. Kunstg.	*Zeitschrift für Kunstgeschichte*

NOTES

Bold numbers indicate page references

FOREWORD

12. 1. See *Journal of Aesthetics and Art Criticism*, V (1946), 77-128, with articles by R. Wellek, W. Stechow, R. Daniells, W. Fleming; J. H. Mueller, *ibid.*, XII (1954), 421; and *ibid.*, XIV (1955), 143-74, with articles by C. J. Friedrich, M. F. Bukofzer, H. Hatzfeld, J. R. Martin, W. Stechow. Also G. Briganti, *Paragone*, I (1950), no. 1 and II (1951), no. 13; *idem, Pietro da Cortona*, Florence, 1962, 15 ff.; Wittkower in *Accademia dei Lincei*, CCLIX (1962), 319. See also Bibliography (II,A).

CHAPTER I

22. 1. Giovanni Andrea Gilio, *Due Dialogi*, Camerino, 1564 (ed. P. Barocchi, *Trattati d'arte del Cinquecento*, Bari, 1961, II, 40).

2. This belongs, of course, to the oldest tenets of the Church. The proscription reaffirms promulgations of the Nicean Council. On the origin and character of the decree, see H. Jedin in *Tübinger Theologische Quartalschrift*, CXVI (1935).

3. A full critical review of the extensive literature in C. Galassi Paluzzi, *Storia segreta dello stile dei Gesuiti*, Rome, 1951. See also F. Zeri, *Pittura e Controriforma: L'arte senza tempo di Scipio da Gaeta*, Turin, 1957, and E. Battisti, 'Riforma e Controriforma', in *Enciclopedia universale dell'arte*, XI, 366-90.

4. For the history of the word and its meaning see M. Treves in *Marsyas*, I (1941).

23. 5. L. Ponnelle and L. Bordet, *St Philip Neri and the Roman Society of his Times*, London, 1932, 576.

24. 6. Apart from the famous case of Padre Pozzo, the architects G. Tristano, G. De Rosis, Orazio Grassi, and Giacomo Briano, the painters Michele Gisberti and Rutilio Clementi, and the sculptor and engraver G. B. Fiammeri may be mentioned. During the years 1634-5 no less than fourteen Jesuit artists were working in the Gesù at Palermo. In addition, decorative wood-carving was largely in the hands of Jesuit artists, such as Bartolomeo Tronchi, Francesco Brunelli, the Taurino brothers, and Daniele Ferrari. A rich material, mainly from Jesuit archives, was published by Pietro

Pirri, S.I., in *Archivum Historicum Societatis Iesu*, XXI (1952).

7. These connexions were first discussed in the valuable but almost-forgotten book by W. Weibel, *Jesuitismus und Barockskulptur*, Strasbourg, 1909.

8. See p. 56.

25. 9. See Galassi Paluzzi (above, Note 3) and G. Rovella, S.I., in *Civiltà Cattolica*, 103, iii (1952), 53, 165. See also *Baroque Art and the Jesuit Contribution*, ed. I. Jaffe and R. Wittkower (Bibliography, II, A).

26. 10. On Ponzio see L. Crema in *Atti del IV Congresso Nazionale di storia dell'arte*, Milan, 1939, and H. Hibbard, *The Architecture of the Palazzo Borghese*, Rome, 1962, 97, the fullest biographical treatment. Born at Viggiù near the Lake of Lugano, his career in Rome seems to have started in May 1585 as architect of the Villa d'Este (D. R. Coffin, *The Villa d'Este at Tivoli*, Princeton, 1960, 101). In 1591-2 he worked as 'misuratore' in S. Andrea della Valle.

11. It should, however, be noticed that during the early nineties the Cavaliere's rich and elegant classicism with its deliberate references to Raphael and Michelangelo (to be studied in the Loggia Orsini of the 'house of Sixtus V', Via di Parione, 1589; in the vault of the Contarelli Chapel, S. Luigi de' Francesi, 1591/2; and in the Cappella Olgiati, S. Prassede, 1592-5) held promise for the future which his further development did not realize. See I. Faldi, *Boll. d'Arte*, XXXVIII (1953), 45 ff.

27. 12. F. Haskell, in his review of Zeri's *Pittura e Controriforma (Burl. Mag.*, C (1958), 396 ff.), emphasized that the poverty of the Jesuits dictated the choice of their artists.

13. *Mâle*, III.

14. For Brill's earlier work in the Vatican, see H. Hahn in *Miscellanea Bibliothecae Hertzianae*, Munich, 1961, 308.

28. 15. See the interesting remarks by H. Röttgen, 'Repräsentationsstil und Historienbild in der römischen Malerei um 1600', in *Beiträge für Hans Gerhard Evers*, Darmstadt, 1968, 71-82, who interprets, e.g., Roncalli's 'grand manner' as an autonomous Roman development.

16. The decoration of the pendentives began in 1598

from designs by Cesare Nebbia and Cristoforo Roncalli. For further details, also of the large altarpieces, see H. Siebenhüner, in *Festschrift für Hans Sedlmayr*, Munich, 1962, 292, 295, 300. For the programme of the dome mosaics, see H. Sedlmayr, *Epochen und Werke*, Vienna-Munich, 1960, ii, 13.

17. E. Durini, 'Ambrogio Bonvicino . . .', *Arte Lombarda*, iii, 2 (1958), is disappointing.

29. 18. Fullest discussion of this building by H. Egger in *Mededeelingen van het Nederlandsch historisch Instituut te Rome*, ix (1929).

30. 19. The documents of payments made to the sculptors working in the chapel between 1608 and 1615 were published by C. Dorati, *Commentari*, xviii (1967), 231-60.

33. 20. Passignano also painted the frescoes in the large new sacristy of the basilica. For the programme of the paintings of the Cappella Paolina, see Mâle. - For the payments made to the painters working in the chapel, see A. M. Corbo, in *Palatino*, xi (1967), 301 ff.

21. According to Bellori, ed. 1672, 369, he changed an angel into the Virgin.

22. Further to the complicated history of the Quirinal Palace: J. Wasserman in *Art Bull.*, xlv (1963), 205 ff., with full documentation; also G. Briganti, *Il Palazzo del Quirinale*, Rome, 1962, 1-29.

23. J. Hess, *Agostino Tassi*, Munich, 1935, believed that the frieze was executed in two campaigns, 1611-12 and 1616-17. His conclusions have been rejected by recent research; see Chiarini in *Boll. d'Arte*, xlv (1960), 367, and the full discussion by G. Briganti (last Note), 34. In addition, E. Schleier in *Burl. Mag.*, civ (1962), 255, and W. Vitzthum, *ibid.*, cvi (1964), 215.

24. W. Vitzthum, *Burl. Mag.*, cvii (1965), 468 ff. - Spadarino (see Chapter 4, Note 17) also received (relatively small) payments. R. Longhi, *Paragone*, x (1959), no. 117, 29, claims on stylistic grounds that the Veronese artists Bassetti, Ottino, and Turchi had minor shares, a view accepted by Briganti.

25. A good deal of ink has been spilled over this problem, since Longhi opened the discussion (*Vita Artistica*, i (1926), 123); see the last two Notes for further bibliographical guidance.

26. For other paintings in the palace by Tassi, Orazio Gentileschi, and Antonio Carracci, see Briganti, *op. cit.*, 41 *passim*.

27. Documents 26 September 1609-16 February 1612; see Briganti, *op. cit.*, 30.

28. See pp. 34, 35, 83 ff.

34. 29. On Scipione Borghese's collection, see J. A. F. Orbaan, *Documenti sul barocco*, Rome, 1920, and F. Noack in *Rep. f. Kunstw.*, l (1929).

30. According to Hibbard, *Palazzo Borghese* (above,

Note 10), 69, Vasanzio may be responsible for the second tier of the façade.

31. The complex building history of the palace has been disentangled by H. Hibbard (above, Note 10). He showed convincingly that the palace was begun by Vignola, 1560-5.

35. 32. Hoogewerff's articles in *Palladio*, vi (1942), and in *Archivio della R. deputazione romana di storia patria*, lxvi (1943), clarify the mystery surrounding this architect, who was born at Utrecht about 1550 and died in Rome in 1621.

33. See Guglielmi in *Boll. d'Arte*, xxxix (1954), 318: payment of 15 February 1614.

34. This casino has been destroyed; on Cigoli's frescoes, see p. 98. The report about the Pallavicini complex of decorations by F. Zeri in *Connoisseur* (1955), 185, has been superseded by H. Hibbard, *Journal of the Society of Architectural Historians*, xxiii (1964), 163.

Tassi and Gentileschi, friends who had become enemies in 1612, worked once again together in 1613 in the Villa Lante at Bagnaia (near Rome). They were joined there by the Cavaliere d'Arpino; see L. Salerno in *Connoisseur*, cxlvi (1960), 157.

35. See M. Sacripanti, *La Villa Borghese*, Rome, 1933, with new documents and full bibliography.

36. 36. The loggia [9] has incorrectly been attributed to Ponzio by Venturi, *Storia dell'Arte*, xi, ii, 905, figure 837, and others, but the new building period only started after November 1613, when the villa was purchased by Scipione Borghese. At that time Ponzio was dead.

37. 37. For the Acqua Paola and urban planning under Paul V, see C. H. Heilmann, *Burl. Mag.*, cxii (1970), 656 ff. For the dates, see Hibbard, *op. cit.*, 101 (documents). The engineering problems of this and the smaller 'Fontana di Ponte Sisto' were in the hands of Domenico Fontana's brother, Giovanni (1540-1614). The latter fountain consists of one triumphal arch, designed by Vasanzio in 1612-13; it stood at the end of Via Giulia and was moved to the other side of the Tiber in 1897. On Giovanni Fontana, the most distinguished water engineer of the period, see Donati, *Artisti ticinesi*, Bellinzona, 1942.

For these and other fountains, see also D'Onofrio, *Le fontane di Roma*, Rome, 1957, 147, 149, and *passim*.

38. 38. For the collection, see C. P. Landon, *Galerie Giustiniani*, Paris, 1812. The collection has been reconstructed in some articles by L. Salerno in *Burl. Mag.*, cii (1960), 21, 93, 135. Many of the Marchese's pictures formed the nucleus of the Berlin Museum. For the Palazzo Giustiniani in Rome, see I. Toesca in *Boll. d'Arte*, xlii (1957), 296, and *Burl. Mag.*, cii (1960), 166.

For Giustiniani and other Roman patrons see also Haskell, *Patrons*.

The decoration of Vincenzo Giustiniani's palace at Bassano di Sutri north of Rome gives an excellent idea of the catholicity of this patron's taste. During the first decade of the seventeenth century worked here side by side the Florentine Antonio Tempesta, the Genoese Bernardo Castello, the Bolognese Domenichino and Albani, and, in addition, the strange Mannerist eccentric Paolo Guidotti (*c.* 1569–1629). The palace and its decoration has been the subject of illuminating articles by P. Portoghesi, M. V. Brugnoli, and I. Faldi in *Boll. d'Arte*, XLII (1957), 222–95.

39. E. Rodocanachi, *Aventures d'un grand seigneur italien*, Paris [n.d.], and A. Banti, *Europa Milleseicentosei - diario di viaggio di Bernardo Bizoni*, Milan, 1942. On Roncalli see also P. Pouncy in *Burl. Mag.*, XCIV (1952), 356.

40. W. Friedlaender, *Caravaggio Studies*, Princeton, 1955.

39. 41. Fullest information about Agucchi and his circle in D. Mahon, *Studies in Seicento Art and Theory*, London, 1947.

42. Only a fragment of the treatise survives, incorporated into the preface of Simon Guillain's etchings after Annibale Carracci's drawings of Bolognese artisans (1646); see Mahon, *op. cit.*

43. R. Lee, *Art Bull.*, XXXIII (1951), 205.

44. W. Friedlaender, *op. cit.*, and D. Mahon, *Art Bull.*, XXXV (1953), 227.

45. Agucchi, for instance, praises Caravaggio as a colourist, although he regards his realism as vulgar. Albani looks down with utter contempt at the whole trend inaugurated by Caravaggio.

40. 46. For the full history of construction on the basis of new documents, see J. Hess in *Scritti di storia dell'arte in onore di Mario Salmi*, 1963, III, 215. - After Longhi's death (1591) Giovan Battista Guerra (1554–1627) took over. In 1605 (date of inscription) Rughesi's façade was not quite finished. All available material for Matteo di Città di Castello in Hess's Appendix I.

47. The complicated early history of the church has been clarified by H. Hibbard in *Art Bull.*, XLIII (1961), 289 (fully documented). The Theatine Francesco Grimaldi had a hand in the design, which - as Hibbard shows - must be regarded as an important step beyond the Gesù towards a typically Seicento articulated and unified conception.

48. For this and other restorations in Early Christian taste, see G. Incisa della Rocchetta, 'Cesare Baronio restauratore di luoghi sacri', in *Cesare Baronio. Scritti vari*, 1963, 323 ff., and E. Hubala, 'Roma sotterranea barocca . . .', in *Das Münster*, XVIII (1965), 157 ff. For

SS. Nereo and Achilleo also R. Krautheimer, in *Essays in the History of Art presented to R. Wittkower*, London, 1967, 174 ff.

41. 49. It is interesting in this connexion that between 1570 and 1693 twenty-five Jesuit martyrs alone were beatified or canonized, twenty of them before 1630.

50. É. Mâle, in his classic work on the art after the Council of Trent, differentiates correctly between (i) traditional subjects which live on without considerable changes, (ii) the recasting of old subjects, and (iii) the large body of entirely new themes. - See also E. Kirschbaum in *Gregorianum*, XXVI, 100 ff. and L. Réau, *Iconographie de l'art chrétien*, Paris, 1955, I, 457.

51. Ponnelle and Bordet, *op. cit.* (Note 5), 413.

42. 52. Among the Flemish artists in Rome shortly before and after 1600 were, apart from Rubens and Paul Brill, Willem van Nieulandt and his nephew of the same name, Sebastian Vranx, Jan Bruegel, and Josse de Momper. See L. van Puyvelde, *La peinture flamande à Rome*, Brussels, 1950.

43. 53. For this and the following see M. Vaes in *Mélanges Hulin de Loo*, Brussels, 1931, 309 ff.

54. Anton Mayer, *Das Leben und die Werke der Brüder Matthaeus und Paul Bril*, Leipzig, 1910; Rudolf Baer, *Paul Bril. Studien zur Entwicklungsgeschichte der Landschaftsmalerei um 1600*, Munich, 1930; G. T. Faggin, in *Paragone*, XVI, no. 185 (1965), 21 ff., with a catalogue of Paul Brill's easel paintings and a list of dated paintings between 1587 and 1626. See also above, Note 14.

55. Tassi's role as an intermediary between the northern and Italian genre has been emphasized in recent studies; see below Chapter 14, Note 20.

56. This has been pointed out by E. Gombrich in his illuminating paper 'Renaissance artistic Theory and the Development of Landscape Painting', *G.d.B.A.*, XCV (1954).

57. It is only in recent years that some progress has been made in reconstructing the careers of the two most important figures, Pietro Paolo Bonzi ('Il Gobbo dei Carracci') and Tommaso Salini. As regards the former (1576–1636), whose earliest still life in the manner of Pieter Aertsen dates from *c.* 1606 (private coll., Madrid), see E. Battisti in *Commentari*, V (1954), 290 ff. and J. Hess, *ibid.*, 303 ff. (frescoes in the Palazzo Mattei, see below, Chapter 10, Note 52). For Salini, see Salerno in *Commentari*, III (1952) and V (1954), 254, and Testori in *Paragone*, V (1954), no. 51. Salini, who died, according to Baglione, aged fifty in 1625, painted flower and fruit pieces before a dark background, with the objects close to the picture plane ('invenzioni molto capricciose e bizarre', Baglione). See also R. Longhi, *Paragone*, I (1950), no. 1, who started the recent discussions. In this context belong

also the still lifes by Fede Galizia (1578–1630); see S. Bottari, *Arte Antica e Moderna*, VI, no. 24 (1963), 309, and *idem, Fede Galizia*, Trent, 1965.

See also the older papers by Marangoni, *Riv. d'Arte*, X (1917), and Hoogewerff, *Dedalo*, IV (1923–4). Charles Sterling's *La nature morte de l'antiquité à nos jours*, Paris, 1952, contains many suggestive ideas.

58. This may be the place to refer to Ottavio Leoni (Rome, 1578–1630), whose activity in Rome in the first quarter of the seventeenth century was entirely devoted to portraiture, especially to portrait drawings in black and red chalk, to portrait engravings, and, to a lesser extent, portrait paintings. His well-known sober renderings of sitters have preserved for us a veritable pantheon of Roman artists, of professional persons and clerics. H.-W. Kruft, who published Leoni's album in the Biblioteca Marucelliana, Florence, containing 27 portrait drawings of artists (in *Storia dell'arte*, no. 4 (1969), 447 ff.), also suggested a link between Leoni's interpretation of portraiture and the aesthetic views of the Academy of St Luke, of which Leoni was Principe in 1614.

CHAPTER 2

45. 1. For a re-appraisal of both Caravaggio's and Annibale's art, prepared in many studies of the last thirty years, the reader may turn now to the books by D. Mahon, *Studies in Seicento Art and Theory*, London, 1947; W. Friedlaender, *Caravaggio Studies*, Princeton, 1955; R. Wittkower, *The Drawings of the Carracci*, London, 1952; and D. Posner, *Annibale Carracci*, London, 1971.

2. On Peterzano, see C. Baroni, *L'Arte*, N.S. XI (1940), 173 ff., with further references, and M. Calvesi, *Boll. d'Arte*, XXXIX (1954).

3. He was 'about twenty', according to Giulio Mancini, Caravaggio's earliest biographer.

4. All the documents are now available in English translation in Professor Friedlaender's book. See also S. Samek Ludovici, *Vita di Caravaggio. Dalle testimonianze del suo tempo*, Milan, 1956; annotated texts of all the sources and documents.

5. On Gramatica, see R. Longhi, *Proporzioni*, I (1943), 54, and A. Marino, in *L'Arte*, nos. 3–4 (1968), 47 ff.

6. During this period he painted the *Sick Bacchus* and the *Boy with the Fruit Basket*, both in the Borghese Gallery and originally in the possession of the Cavaliere d'Arpino.

7. Among the pictures in the Cardinal's collection were *The Musical Party* (Metropolitan Museum, New York), the *Fortune Teller* (Louvre version?), the *Card*

Sharpers (formerly Palazzo Sciarra, Rome), the *Lute Player* (Leningrad), and the *Medusa* (Uffizi). The pictures of the early Roman period are difficult to arrange in a precise sequence, and their chronology will remain, to a certain extent, the subject of controversy. Perhaps the most thorough attempt at establishing a chronology was undertaken by D. Mahon, *Burl. Mag.*, XCIV (1952), 19. Interesting revisions were proposed by E. Arslan, *Arte Antica e Moderna*, II (1959), 191; see also B. Joffroy, *Le Dossier Caravage*, Paris, 1959, especially 300 ff., 331.

46. 8. From 1599 onwards all the important pictures are datable within a fairly narrow margin. 1599–1600: the lateral paintings in the Contarelli Chapel, S. Luigi de' Francesi. There were, however, not three, but four paintings in all, since Caravaggio's first altarpiece of *St Matthew and the Angel* was rejected and bought by the Marchese Vincenzo Giustiniani. (With the rest of the Giustiniani collection it went to the Kaiser Friedrich Museum, Berlin, and was destroyed in 1945.) The second *St Matthew*, substituted for the rejected version, is *in situ*; both versions were painted between February and September 1602 (H. Röttgen, *Zeitschr. f. Kunstg.* (1965), 54 ff.). The earlier lateral panels, the *Calling of St Matthew* and the *Martyrdom of St Matthew*, particularly the 'Martyrdom', contain many revealing *pentimenti* (L. Venturi and G. Urbani, *Studi radiografici sul Caravaggio*, Rome, 1953; for the recent restoration of all the paintings of the chapel, see the detailed reports in *Boll. dell'Istituto Centrale del Restauro*, 1966). – 1600–1: *Crucifixion of St Peter* and *Conversion of St Paul*, Cerasi Chapel, S. Maria del Popolo. – 1602–4: *Deposition of Christ*, painted for St Philip Neri's church, the Chiesa Nuova, now Vatican Gallery. – 1604–5: *Madonna di Loreto*, S. Agostino, Rome. – 1605–6: the *Death of the Virgin*, now Louvre, Paris; the *Madonna of the Rosary*, painted for Modena, now Vienna Gallery (finished, according to Friedlaender's plausible suggestion, by another hand). – 1606: *Madonna dei Palafrenieri*, painted for St Peter's, now Borghese Gallery (for the date see L. Spezzaferro, 'La Pala dei Palafrenieri', *Acc. Naz. dei Lincei* (1974), no. 205, 125–37). – 1607: *The Seven Acts of Mercy*, Chiesa del Monte della Misericordia, Naples; *Flagellation of Christ*, S. Domenico Maggiore, Naples. – 1608: *Portrait of Alof de Vignacourt*, Louvre, Paris (doubted by Longhi); *Beheading of St John the Baptist*, Cathedral, La Valletta, Malta; *Burial of St Lucy*, S. Lucia, Syracuse. – 1609: *Adoration of the Shepherds* and *Raising of Lazarus*, Museo Nazionale, Messina. – 1609: *Adoration with St Francis and St Lawrence*, Oratorio di S. Lorenzo, Palermo. Apart from the Vignacourt por-

trait, this list contains only the large altarpieces.

9. Though hardly ever discussed, it is still an open question whether pictures like the *Boy with the Fruit Basket*, the *Musical Party*, or the *Boy bitten by a Lizard* (Longhi Coll.) were painted with a moralizing or allegorizing intent.

10. In his 'Life' of Caravaggio, Baglione remarks generally that the young artist was in the habit of painting self-portraits in a mirror, specifying a 'Bacchus' guise. Other early pictures such as the *Boy bitten by a Lizard* and the head of *Medusa* may confidently be regarded as self-portraits.

11. The relation of the Bacchus to 'the sensuous idealism of certain Hadrianic representations' (W. Friedlaender, *op. cit.*, 85) should not, however, be overlooked.

12. For the process of revaluing the ancient gods after the Renaissance see the admirable account in F. Saxl's *Antike Götter in der Spätrenaissance*, Leipzig, 1927.

13. A similar, though burlesque, reorientation may be observed in Nicolò Frangipani's *Bacchus and Buffoon*, which was painted in Venice at about the same moment (Venice, Querini Stampalia Gallery; Venturi, IX, 7, figure 55).

14. Still lifes of extraordinary perfection are the rule in Caravaggio's early work, see, e.g., the Borghese *Boy with the Fruit Basket*, the Leningrad *Lute Player*, and, of a slightly later date, the National Gallery *Supper at Emmaus*. It comes as no surprise, therefore, to find amongst the earliest works a self-contained still life, the *Basket of Fruit* (Milan, Ambrosiana). It has been pointed out, however, that this picture may be the fragment of a larger composition, a hypothesis borne out by the repainted buff background. See H. Swarzenski, *Boston Museum Bulletin*, LII (1954), whose attribution of the Boston still life to Caravaggio can hardly be accepted, in spite of his pertinent discussion of the whole problem of early still lifes.

48. 15. According to a stimulating hypothesis by D. Heikamp, *Paragone*, XVII, no. 199 (1966), 62 ff., the shield of Medusa has to be regarded as a tournament weapon rather than as a painting.

16. Two of the early religious pictures share the same quality: the *Repentant Magdalen* (Rome, Galleria Doria-Pamphili) and the *St Catherine* (Lugano, Thyssen Coll.). Their interest is largely focused on still life and embroidered dresses. For the iconography of the *Magdalen*, see I. Toesca, *J.W.C.I.*, XXIV (1961), 114.

17. The date of this painting is still controversial. Dates as far apart as 1594 and 1602 have been suggested. My previous assumption 'c. 1597' seems too early; the picture can hardly have been painted before 1600. See M. Levey, *National Gallery Catalogues. The*

Seventeenth and Eighteenth Century Italian Schools, London, 1971, 49-53.

18. The reader may be reminded of Mantegna's *Dead Christ* in the Brera. For the whole problem of extreme foreshortening, see Kurt Rathe, *Die Ausdrucksfunktion extrem verkürzter Figuren*, London, 1938.

49. 19. For the iconography of the *Deposition*, see G. Wright, 'Caravaggio's *Entombment* considered *in situ*', Art Bull., LX (1978), 35-42.

50. 20. Most of Caravaggio's late pictures, painted in great haste, are in poor condition. In recent years some have been carefully cleaned and restored, among them the two pictures mentioned in the text. On this occasion the extremely high quality of the *Lazarus* was revealed, whose authenticity had sometimes been doubted.

52. 21. The Borghese *David with the Head of Goliath* (c. 1605), for instance, follows a representational type which was already current in the fifteenth century and ultimately derives from illuminations in manuscripts of Perseus with the head of Medusa. For the rest, the reader must be referred to W. Friedlaender's thorough iconographical studies.

22. Bellori, in his biography of Caravaggio, mentions that he painted this picture twice over, an assertion which recent X-ray studies have proved correct (see above, Note 8).

53. 23. The line of the neck of the Virgin in the Doria *Repose on the Flight* recurs in a number of pictures, e.g. the *Penitent Magdalen* and the *Madonna di Loreto*.

54. 24. See Chapter 3, p. 68.

25. The break, of course, is not radical but was foreshadowed in early pictures.

26. Two versions are extant, one in the Doria Gallery, the other in the Capitoline Museum, Rome. D. Mahon (*Burl. Mag.*, XCV (1953), 213) tried to show that the latter picture, for long regarded as a copy, is the one mentioned by Bellori as being in the collection of Cardinal Pio. See also D. Mahon and D. Sutton, *Artists in Seventeenth-Century Rome*, Loan Exhibition, Wildenstein, London, 1955, no. 17, with a full discussion of the intricacies of the subject matter. Further, see E. Battisti in *Commentari*, VI (1955), 181 ff., whose researches in the Pio archives seem to militate against Mahon's identification. But L. Salerno, *G. Mancini. Considerazioni sulla pittura*, Rome, 1957, II, note 891, gives convincing reasons for linking the Pio and Capitoline versions.

55. 27. The better of the two existing versions seems to be that in the Wadsworth Athenaeum, Hartford, Connecticut, see *Mostra del Caravaggio, Catalogo*, 1951, no. 17.

56. 28. Dr Friedlaender in his recent book does not

quite agree with this interpretation of the sources. I cannot do more here than state his case, without being able to argue the matter out. Cf. L. Spezzaferro, *op. cit.* (Note 8).

29. For a detailed discussion of the relationship between Caravaggio's art and the reform movement the reader must be referred to W. Friedlaender's *Caravaggio Studies*, 121 ff.

CHAPTER 3

57. 1. Translation in E. G. Holt, *Literary Sources of Art History*, Princeton, 1947, 329 ff.

2. See the survey in D. Mahon's *Studies in Seicento Art and Theory*, London, 1947, 212 ff.

58. 3. Their collaboration is particularly puzzling in the cycle of frescoes of the Palazzo Fava (*c.* 1583-4) with scenes from Virgil's *Aeneid* as well as in that of the Palazzo Magnani-Salem (1588 ff.) which illustrates the early history of Rome after Livy (see J. M. Brown, *Burl. Mag.*, CIX (1967), 710 ff., and opposing Brown, A. W. A. Boschloo, *ibid.*, CX (1968), 220 f.). It is easier to differentiate between the three masters in the frescoes of the Palazzo Sampieri-Talon (*c.* 1593-4). See Bodmer, *Lodovico Carracci*, Burg, 1939, 118 ff., with further references.

The paper by S. Ostrow in *Arte Antica e Moderna*, III, no. 9 (1960), 68, is concerned with the iconography of the Palazzo Fava cycle.

4. The character and history of the Carracci Academy are discussed by H. Bodmer in the periodical *Bologna*, XIII (1935), 61 ff. Bodmer dates the foundation of the Accademia degli Incamminati in 1582. G. C. Cavalli, the compiler of the *Regesto* published in the Catalogue of the *Mostra dei Carracci*, Bologna, 1956, 76, believes the date to be 1585. See also J. H. Beck and M. Fanti, 'La sede dell'Accademia dei Carracci', *Strenna storica bolognese*, XVII (1967), 53 ff. For all dates of the *vite* of the Carracci the *Regesto* should be consulted.

5. For Agostino's development as an engraver see H. Bodmer, *Die Graphischen Künste*, IV (1939) and V (1940). Agostino's importance is nowadays generally underrated. With his systematic studies of parts of the body, of eyes, ears, arms, and feet (engraved after his death and for 150 years frequently republished), he became the ancestor of academic teaching; see R. Wittkower, *The Drawings of the Carracci at Windsor Castle*, London, 1952. The Vienna pictures, published by O. Kurz, *J.W.C.I.*, XIV (1951), reveal Agostino as a sophisticated and entertaining master of mythological allegory.

6. Tietze believed that this picture was mainly exe-

cuted by Lucio Massari. There is no reason to accept this view. The picture is signed and dated and original drawings by Annibale are extant.

7. See, e.g., E. K. Waterhouse, *Baroque Painting in Rome*, London, 1937, 7, where the term is used in spite of certain reservations.

8. The history and fallacies of the term 'eclectic' have been discussed by D. Mahon, *op. cit.* See also R. W. Lee in *Art Bull.*, XXXIII (1951), 204 ff., Mahon, *ibid.*, XXXIV (1952), 226 ff., the apt remarks by B. Berenson in his *Caravaggio*, London, 1953, 78 ff., and Wittkower in *Aspects of the Eighteenth Century*, ed. E. Wasserman, The Johns Hopkins Press, 1965.

62. 9. Even in Lodovico's most Baroque pictures there is a Mannerist undercurrent. Figures often lack a firm stance and – particularly in later works – gestures may be as ill-defined as they are *outré* and eccentric. Such figures as the donors who appear in the Cento altarpiece like intruders from outside are a well-known Mannerist formula (see, e.g., Passarotti's *Presentation in the Temple*, S. Maria della Purificazione, Bologna).

10. According to the *Mostra dei Carracci* (*op. cit.*, 128), the *Martyrdom of St Angelus* should be dated *c.* 1598-9.

63. 11. Examples: *The Calling of St Matthew* of *c.* 1605 (Bologna, Pinacoteca), the *Assumption of the Virgin*, *c.* 1605-8 (Modena, Galleria Estense), *St Charles adoring the Child*, *c.* 1615 (Forlì, Pinacoteca), and the *Paradise* of *c.* 1616 (Bologna, S. Paolo) with its immensely elongated boneless figures.

12. The iconography of the only canvas, *Hercules at the Crossroads*, now in the Naples Museum, was exhaustively discussed by E. Panofsky, *Hercules am Scheidewege*, Leipzig, Berlin, 1930. J. R. Martin, *Art Bull.*, XXXVIII (1956), 91, who threw new light on the iconography of the whole cycle, showed that the programme was conceived by Fulvio Orsini.

13. J. R. Martin, *The Farnese Gallery*, Princeton, 1965, 51 ff., with further literature on the complicated question of chronology; see also the pertinent observations by D. Posner, in *Art Bull.*, XLVIII (1966), 111 ff.

14. Martin, *op. cit.*, 52 ff.

15. *Ibid.*, 144 f.

16. For the symbolical interpretation the reader had to be referred until recently to Bellori, to Tietze's basic article, and to Panofsky in *Oud Holland*, L (1933). These earlier attempts have been superseded by the full discussion in J. R. Martin's *Farnese Gallery*. Nevertheless, today we are as far apart as ever regarding the ultimate meaning of this festive decoration. While Martin stresses the neo-Platonic overtones, C. Dempsey, in a remarkable paper (see Bibliography), submits that a punning, satirical, mock-heroic spirit informs the classical scenes of the ceiling.

64. 17. Preserved in drawings; see Tietze's article; Wittkower, *Carracci Drawings* (*op. cit.*); D. Mahon, *Mostra dei Carracci, Disegni*, Bologna, 1956, 108.

65. 18. See Karoline Lanckoronska's article in *Wiener Jahrb.*, IX (1935). For the history and development of ceiling decoration see F. Wurtemberger, 'Die Manieristische Deckenmalerei in Mittelitalien', *Röm. Jahrb. f. Kunstg.*, IV (1940), and A. F. Blunt, 'Illusionist Decorations in Central Italian Painting of the Renaissance', *Journal of the R. Society of Arts*, CVII (1959), 313. For the early history of *quadratura* painting, see the illuminating paper by J. Schulz, *Burl. Mag.*, CIII (1961), 90.

19. For the brothers Alberti in Rome, see A. C. Abromson, *Art Bull.*, LV (1973), 531-47.

66. 20. From Alberti's *De Pittura* on it was regarded as an unassailable dogma that 'history painting' (in the widest sense) stood at the top of the hierarchical scale of artistic activity.

68. 21. Later, Domenichino contributed most to the completion of the gallery (see J. R. Martin, *Boll. d'Arte*, XLIV (1959), 41; *Farnese Gallery*, 62 ff.), while the contributions of Lanfranco and Badalocchio are more problematical. D. Mahon has attempted to distribute a number of subsidiary scenes among these three hands; see 'Notes sur l'achèvement de la Galerie Farnèse et les dernières années d'Annibal Carrache', in R. Bacou, *Dessins des Carraches*, Louvre Exhibition, 1961, 57. See also below, Chapter 4, Note 20.

22. J. R. Martin wanted to identify this famous scene as 'Glaucus and Scylla' and C. Dempsey (in *Zeitschr. f. Kunstg.*, XXIX (1966), 67 ff.) as 'Thetis borne to her Wedding'.

23. J. Anderson, in *Art Bull.*, LII (1970), 41 ff., demonstrated convincingly that Agostino's cycle, dependent on classical epithalamic poetry, was painted as part of the celebrations for the arrival of the bride of Ranuccio I, Margherita Aldobrandini. The programme was probably devised by the Bolognese humanist Claudio Achillini.

24. Agostino's funeral in Bologna was a memorable occasion, during which Lucio Faberio, a member of the literary Academy of the Gelati, delivered the funeral oration. This speech, important for the creation of the 'eclectic legend', has been thoroughly analysed by D. Mahon in *Studies in Seicento Art*, 135 ff., and in *J.W.C.I.*, XVI (1953), 306.

25. For work executed during the period of Annibale's illness, mainly by studio hands, see D. Posner in *Arte Antica e Moderna*, III, no. 12 (1960), 397; and below, Chapter 4, Notes 20, 21.

26. A comparison of pictures like the early Roman *Coronation of the Virgin* (London, D. Mahon Coll.) with works dating from after 1600, like the Naples

Pietà or the Bridgewater *Danae* (destroyed), fully illustrates this development.

69. 27. See D. Mahon, *Studies*, *op. cit.*, 204.

70. 28. This is particularly impressive in the Louvre *Virgin with St Luke* of 1592.

29. The best of six lunettes, painted, according to Bellori, for the chapel of the Palazzo Aldobrandini, and executed with the help of pupils. H. Hibbard (*Burl. Mag.*, CVI (1964), 183) has found documentary proof according to which Albani together with other collaborators worked on these lunettes in 1605 and again in 1613. For the whole problem and a new attempt to distribute the execution among Annibale, Albani, Lanfranco, and Badalocchio, see Cavalli in *L'Ideale classico del Seicento in Italia e la pittura del paesaggio*, Catalogue, Bologna, 1962, 61, with further literature. E. Borea in *Paragone*, XIV (1963), no. 167, 22, gives Domenichino a share in the lunettes.

71. 30. A more thorough investigation of this problem would probably reveal that their activity in this sphere belongs to a trend current in Bologna in the circle of such artists as Calvaert (who came from Antwerp), Passarotti, Prospero Fontana, and others. The *Butcher's Shop*, published by me (*Carracci Drawings*, *op. cit.*) as Agostino, was attributed to Annibale at the Carracci Exhibition. J. R. Martin has shown (*Art Bull.*, XLV (1963), 265) that this work, far from being a 'naive' genre painting, combines figures from Michelangelo's *Sacrifice of Noah* on the Sistine Ceiling and Raphael's fresco of the same subject in the Vatican Logge.

31. Few caricatures by Annibale have so far been traced; see Wittkower, *Carracci Drawings*, 18. I cannot fully agree with some of the attributions made by W. Boeck in *Münchner Jahrbuch der bildenden Kunst*, V (1954), 154 ff. As for the problem of early caricatures, see Brauer-Wittkower, *Die Zeichnungen des Gianlorenzo Bernini*, Berlin, 1931; W. R. Juynboll, *Het komische genre in de italiaansche schilderkunst*, Leiden, 1934; E. Kris, *Psychoanalytic Explorations in Art*, London, 1953 (III, ch. 7, with E. Gombrich); also M. Gregori, 'Nuovi accertamenti in Toscana sulla pittura "caricata" e giocosa', *Arte Antica e Moderna*, nos. 13-16 (1961), 400 ff., and W. Boeck, *Inkunabeln der Bildniskarikatur bei Bologneser Zeichnern des 17. Jahrhunderts*, Stuttgart, 1968.

CHAPTER 4

73. 1. Orazio Gentileschi died on 7 February 1639. Documentary evidence found by A. M. Crinò (*Burl. Mag.*, CIII (1961), 145) settles the old dispute.

2. B. Nicolson (see Bibliography) has assembled the little we know about Manfredi.

3. 'V. Martinelli, 'Le date della nascita e dell' arrivo a Roma di Carlo Saraceni', *Studi Romani*, VII (1959), 679.

4. Valentin's Christian name is unknown. It is not Moïse, as is usually maintained, which is simply a misunderstood version of 'Monsù'. Caracciolo and Artemisia Gentileschi will be discussed with the Neapolitan school. For the Dutch, Flemish, and French *Caravaggisti* the reader must be referred to other volumes of the Pelican History of Art. For the literature on the artists mentioned in this chapter, see also Bibliography.

74. 5. See R. Longhi, *Proporzioni*, I (1943), 21 f. Before the Caravaggesque phase, which includes such works as the *Crowning with Thorns* (Varese, Lizza-Bassi Coll.), Longhi has reconstructed an earlier Elsheimer-like period. In this he placed, no doubt correctly, the small Berlin *David* and *St Christopher*, previously attributed to Elsheimer. Pictures such as the *St Cecilia and the Angel* (Dr Bloch Coll.) and the *Virgin and Child* (Florence, Contini-Bonacossi Coll.), with their strong Florentine qualities, may belong to a pre-Elsheimer period. One wonders whether the impressive *SS. Cecilia, Valerianus, and Tiburtius* in the Brera, one of Orazio's masterpieces, usually dated during his stay in the Marches (before 1617-21?), may not be a few years earlier and nearer the time when the impact of Caravaggio was most in evidence. For Orazio's work in the Marches, see Mezzetti, *L'Arte*, N.S. I (1930), 541 ff., and Emiliani, *Paragone*, IX (1958), no. 103, 38 (partly out of date); also H. Voss in *Acropoli*, I (1960-1), 99 (for the frescoes in the Cappella del Crocefisso, Fabriano Cathedral, datable between 1613 and 1617); for his stay in Paris (*c.* 1623-5), see C. Sterling, *Burl. Mag.*, C (1958), 112; for his arrival in England (document of 1626), *Burl. Mag.*, C (1958), 253. See also A. M. Crinò, *ibid.*, CII (1960), 264 (documents); Crinò and B. Nicolson, *ibid.*, CIII (1961), 144; E. Schleier, *ibid.*, CIV (1962), 432; Crinò, *ibid.*, CIX (1967), 533.

6. The pictures are mentioned here in the sequence in which they were painted according to H. Voss (*The Connoisseur*, CXLIV (1959), 163).

For Gentileschi's *Lot and his Daughters*, also dating from the early 1620s and existing in several autograph versions, see R. W. Bissell, in *Bulletin. The National Gallery of Canada*, Ottawa, XIV (1969), 16 ff.

7. See J. Hess in *English Miscellany* (1952), no. 3.

8. But Van Dyck's influence makes its appearance e.g. in the Prado *Finding of Moses*, painted in London and listed in 1636 in the inventory of Philip IV's paintings; see J. Costello, *J.W.C.I.*, XIII (1950), 252. As shown by E. Harris, *Burl. Mag.*, CIX (1967), 86, the picture was taken to Madrid in the summer of 1633.

9. Baglione's career has been reconstructed by Carla Guglielmi, *Boll. d'Arte*, XXXIX (1954). It appears that the artist vacillated between progressive trends without absorbing them fully. After his Caravaggesque phase (see V. Martinelli, *Arte antica e moderna*, II, 5 (1959), 82), he turned 'Bolognese' (second decade, *Rinaldo and Armida*, Rospigliosi); in the third decade he followed Guercino's Baroque (*St Sebastian*, S. Maria dell'Orto, 1624). From *c.* 1630 on the quality of his work rapidly declines.

For Baglione's career, see also I. Faldi in *Diz. Biografico degli Italiani*, V, 1963, 187. For the involved story of his painting of *Divine Love*, see Martinelli, *loc. cit.*, and L. Salerno, *Burl. Mag.*, CII (1960), 103; also R. Longhi, *Paragone*, XIV (1963), no. 163, 25.

75. 10. See S. Bottari, *Commentari*, VI (1955), 108, who published Borgianni's first picture, the *St Gregory* (Catania, Palazzo Cerami), signed and dated 1593. Consequently Borgianni was probably born earlier than was hitherto believed.

H. E. Wethey has successfully reconstructed Borgianni's early career (*Burl. Mag.*, CVI (1964), 148 ff.); *c.* 1595-8, Rome; *c.* 1598-1602, first Spanish trip; 1603, Rome; 1604-5, second Spanish trip. See I. Toesca's letter (378), Wethey's response (381), and Toesca's rejoinder (*ibid.*, CVII (1965), 33 f.).

11. For Saraceni see the unprinted New York University thesis by Eve Borsook, 1953, with an excellent catalogue of the artist's *œuvre*. See also Martinelli's paper (Note 3, above), and F. Arcangeli, *Paragone*, XVII, no. 199 (1966), 46 ff. Finally, the satisfactory monograph by Cavina, 1968 (see Bibliography), which contains most critical material. Some of my dating below differs slightly from that given by Cavina.

For Elsheimer's relations with Saraceni and other Italian painters, see the excellent catalogue of the Elsheimer Exhibition in the Städelsches Kunstinstitut, Frankfurt, 1966-7 (written by Jutta Held).

76. 12. Replicas in Bologna, Vienna, Hanover, Lille, etc. testify to the popularity of the picture.

13. The picture was carefully cleaned in 1968, see *Attività della Soprintendenza alle Gallerie del Lazio*, Rome (1969), 27.

14. See the famous nine mythological scenes in landscape settings (on copper) in the museum at Naples. Very close to Saraceni is the small group of impressive pictures by an anonymous artist, possibly of French origin and now assembled under the pseudonym 'Pensionante del Saraceni' (Longhi, *Proporzioni*, I (1943), 23). Saraceni's French contacts are well known. During the last year of his life he was assisted by Jean Le Clerc from Nancy (*c.* 1590-*c.* 1633). After his return to Venice Saraceni was commissioned with the large *Doge Enrico Dandolo preaching the Crusade in St*

Mark's for the Sala di Gran Consiglio in the Palazzo Ducale, but it would seem that Le Clerc was wholly responsible for the work and that he carried it out between 1620 and 1622.

According to R. Pallucchini (*Arte Veneta*, XVII (1963), 178) Le Clerc also executed the *Annunciation* in the Parish Church at Santa Giustina (Feltre), with Saraceni's signature and the date '1621' (anachronistically – for the artist had died in 1620). For Le Clerc in Italy, see N. Ivanoff in *Critica d'Arte*, IX (1962), 62, and for his post-Italian career, F. G. Pariset in *La Revue des Arts*, VIII (1958), 67.

15. For Valentin, see R. Longhi, *ibid.*, 59 (with *œuvre* catalogue) and M. Hoog, *ibid.*, X (1960), 267.

77. 16. An ethereally painted halo seems to surround the head, but the inscription proves that Serodine's father is represented.

For a revision of Longhi's chronology of Serodine's work, see B. Nicolson, *Terbrugghen*, London, 1958, 11 (note). W. Schoenenberger's *Giovanni Serodine, pittore di Ascona*, Basel, 1957, was written in 1954 as a dissertation without a knowledge of Longhi's work or of Serodine's correct birth-date (1600). Although not published until 1957, the author left his text (including patent errors) unchanged, but added some new facts in a preamble, among them documentary evidence of the artist's death on 21 December 1630. – P. Askew, 'A Melancholy Astronomer by G. S.', *Art Bull.*, XLVII (1965), 121, enlarged Serodine's small *œuvre* by a picture in Dresden and added important iconographical considerations.

17. Among other painters who came under Caravaggio's influence mainly during the second decade may be mentioned the Veronese Pasquale Ottino (1570–1630), Marcantonio Bassetti (1586–1630), and Alessandro Turchi, called L'Orbetto (1578–1648), all three Felice Brusasorci's pupils before going to Rome (R. Longhi in *Proporzioni*, I (1943), 52); the Roman Angelo Caroselli (1585–1652) and Bartolomeo Cavarozzi from Viterbo (*c.* 1590–1625) who were both influenced by Orazio Gentileschi; Giovan Antonio Galli ('Spadarino'), a painter of real distinction (d. after 1650); Nicolò Musso, who died in his home-town, Casale Monferrato, *c.* 1620 after a stay of several years in Rome; Alonso Rodriguez (1578–1648) from Messina, in Rome in 1606, who followed Caravaggio in the second decade (A. Moir, *Art Bull.*, XLIX (1962), 205); finally Nicolas Regnier (Niccolò Renieri) from Maubeuge (*c.* 1590–1667), who appeared in Rome *c.* 1615 and settled in Venice about ten years later, where he stayed to the end of his days. About his early Caravaggesque phase see Voss, *Zeitschr. f. b. Kunst*, LVIII (1924). Characteristic works of all these painters are to be seen during the 1951 Caravaggio Exhibition; see

the *Catalogo*, in addition to H. Voss, *Die Malerei des Barock in Rom*, Berlin, 1924, and Longhi, *Proporzioni*, I (1943). Other 'part-time' *Caravaggisti* will be discussed in their proper place.

18. Pieter van Laer's appearance and character earned him the name of *Bamboccio*, which can be translated as childish, simple. By referring to his work as *Bambocciata*, meaning a trifle, the pun is evident. The term remains today to designate the whole genre. On Van Laer see Hoogewerff, *Oud Holland*, L (1932) and LI (1933) and G. Briganti, *Proporzioni*, III (1950) and *idem*, *I Bamboccianti*, *Catalogo*, 1950. The Würzburg dissertation by A. Janeck on Pieter van Laer (1968, see Bibliography) supersedes the earlier literature. Janeck does not accept the painting of illustration 28 as autograph. It is here reproduced as a characteristic piece of the genre rather than as a characteristic Van Laer.

78. 19. See A. Blunt, *Art and Architecture in France 1500–1700* (Pelican History of Art), Harmondsworth, 1953 (paperback edition, based on 2nd hardback edition, Harmondsworth, 1973; references in the present volume are to the first, hardback, edition); W. R. Crelly, *The Painting of Simon Vouet*, New Haven and London, 1962 (see also the review by D. Posner, *Art Bull.*, XLV (1963), 286). For Vouet's Italian period, see now J. Thuilliers, 'Simon Vouet en Italie, Essai de catalogue critique', *Saggi e memorie di storia dell'arte*, IV (1965), 27 ff.

20. See J. Pope-Hennessy, *Drawings of Domenichino at Windsor Castle*, London, 1948, 14, and M. V. Brugnoli in *Boll. d'Arte*, XLII (1957), 274; in addition to the literature given in Chapter 3, Note 21.

79. 21. D. Posner in *Arte Antica e Moderna*, III, no. 12 (1960), 397, has dealt fully with this work and the distribution of hands. Execution did not start until 1604. The frescoes, now in rather bad condition, are in the Museum at Barcelona and in the Prado, Madrid.

22. Little is known about Tacconi apart from his having been a pupil of Annibale and active in Rome between *c.* 1607 and 1625.

23. In April 1612 Reni was in Naples; see F. Bologna in *Paragone*, XI (1960), no. 129, 54.

24. Bottari-Ticozzi, *Raccolta di lettere . . .*, Milan, 1822, I, 287.

25. The old puzzle of the attribution and dating of these scenes was finally resolved by the publication of the documents by G. Panofsky-Soergel, in *Röm. Jahrb. f. Kunstg.*, XI (1967-8), 132 ff. – The first frescoes of the new palace were executed by pupils of Cristoforo Roncalli (1600-1). Later, in 1607-8, other late Mannerists, Gaspare Celio and Francesco Nappi, painted ceilings in the palace.

26. For the chronology of this entry and the following Reni entries, see H. Hibbard, in *Burl. Mag.*, CVII (1965), 502, and CVIII (1966), 90.

27. The documents were published by M. V. Brugnoli, in *Boll. d'Arte*, XIII (1957), 266 ff.

28. The correct dating is owed to E. Borea, *Boll. d'Arte*, XLVI (1961), 237.

80. 29. Contract of 4 December 1614 published by Golzio, *Archivi*, IX (1942), 46 ff.

30. J. Hess, *Agostino Tassi*, Munich, 1935, 21 f., believed that Domenichino's *Chariot of Apollo* was painted *c.* 1610 as an isolated *quadro riportato* and that some time later (*c.* 1621) the ceiling was converted by Tassi into an open sky with a *quadratura* surround. Pope-Hennessy (*Domenichino Drawings*, 92 f.), on the basis of original drawings, refuted this view, which also seems contradicted by the iconographic evidence (Saxl in *Philosophy and History*, Essays dedicated to Ernst Cassirer, Oxford, 1936, 213 ff.). Hess reaffirmed his old view in *Commentari*, V (1954), 314, but dated *The Chariot of Apollo* in 1615.

31. L. Salerno, *Commentari*, IX (1958), 45.

32. *Ibid.*, 45 for the attribution, and *passim* for the reconstruction of Badalocchio's *œuvre*. See also *Maestri della pittura del Seicento emiliano* (1959 Exhibition), 232, with further literature for Badalocchio. The artist returned to Parma after Annibale's death. Back in Rome after 1613, he settled in Parma in 1617. His later work, after his Annibalesque Roman period, has a strong Parma flavour. See also D. Mahon, in *Bull. Wadsworth Atheneum* (1958), no. 1, 1-4; E. Schleier, in *Burl. Mag.*, CIV (1962), 246 ff.; *L'ideale classico del Seicento in Italia*, Catal., Bologna, 1962, 63, 68.

33. I. Toesca, *Boll. d'Arte*, XLIV (1959), 337, and *Burl. Mag.*, CIV (1962), 392, for the correct date of these frescoes.

34. The dating of these frescoes varies widely. Boschetto's date 1607-8 (*Proporzioni*, II (1948), 143) seems as unacceptable as that of Posse (Thieme-Becker), 1625. Tietze dates after 1609; Bodmer (*Pantheon*, XVIII (1936)), *c.* 1609-14. According to Albani himself (Malvasia, II, 125) the work was executed after Bassano di Sutri, i.e. after 1609. For reasons of style a date nearer to the middle of the second decade seems likely (see also Brugnoli (Note 20), 274). This dating has now been confirmed by L. Salerno, in *Via del Corso*, Rome (Cassa del Risparmio), 1961, 177. But his discovery of a small scene representing an event of 1617 opens a new problem, because Albani left Rome in 1616.

35. These frescoes were usually dated much earlier, in accordance with the stylistic (but as we now know, misleading) evidence; see the admirable paper by L. Salerno in *Burl. Mag.*, CV (1963), 194, who (like others before him) advocated the years 1605-6. Only E.

Borea in *Paragone*, XI (1960), no. 123, 12, and XIV (1963), no. 167, 28, favoured a date after 1611. The issue has been settled once and for all by C. D'Onofrio, *La Villa Aldobrandini di Frascati*, Rome, 1963, 126, who published the payments to Domenichino between November 1616 and June 1618. The whole question has been fully reviewed by M. Levey, *National Gallery Catalogues, The Seventeenth and Eighteenth Century Italian Schools*, London, 1971, 96-106.

81. 36. It characterizes the whole classical trend that, after Annibale's death, Raphael's influence grew rapidly.

37. See above, p. 39.

38. See H. Hibbard in *Miscellanea Bibliothecae Hertzianae*, Munich, 1961, 357 (documents); also E. Borea, *Domenichino*, Milan, 1965, 126, 184.

39. In the *Calling of St Andrew and St Peter* the figure of Christ is adapted from the Christ in Lodovico's *Calling of St Matthew* (Bologna, Pinacoteca) and the oarsman from a similar figure in the *Preaching of St John* (*ibid.*).

39a. He left behind the unfinished Cappella della Strada Cupa, a chapel in S. Maria in Trastevere, to which R. E. Spear has dedicated a fully documented article in *Burl. Mag.*, CXI (1969), 12 ff., 220 ff.

82. 40. For a different view, see Pope-Hennessy, *op. cit.*, 25, who should also be consulted for the sequence of the execution of these frescoes.

41. The traditional title of the picture is incorrect. It illustrates *Aeneid*, V, 485-518, as K. Badt has shown in an illuminating paper in *Münchner Jahrbuch d. bild. Kunst*, XIII (1962), 216.

42. It should, however, be recalled that Domenichino's arch-enemy, Lanfranco, had the picture engraved at his own expense in order to make Domenichino's 'plagiarism' as widely known as possible.

43. For Domenichino's landscapes, see M. Imdahl in *Festschrift Martin Wackernagel*, Münster, 1958, 153; E. Borea, *Paragone*, XI (1960), no. 123, 8; *L'Ideale classico del Seicento* (Bologna Exhib. Cat., 1962); M. Fagiolo dell'Arco, *Domenichino ovvero Classicismo del Primo-Seicento*, Rome, 1963, 104 (list of Domenichino's landscapes in chronological sequence).

44. Denis Calvaert (1540-1619), a northern Mannerist who had made his home at Bologna. For Albani, see the hitherto unpublished dissertation by E. Van Schaack (Columbia University, 1969) with many new documents and *œuvre* catalogue.

45. In the *Jacob's Dream* the influence of Lodovico is very strong. Albani must have known the picture of the same subject, now in the Pinacoteca, Bologna. This connexion with Lodovico is interesting in view of the fact that after his arrival in Rome Albani was Annibale's collaborator in the Herrera Chapel and the Aldo-

randini landscapes (see pp. 78–9 and Chapter 3, Note 9). For Albani's relation to Annibale Carracci, see also M. Mahoney, *Burl. Mag.*, CIV (1962), 386.

3. 46. The first example of this manner is the four *Venus* and *Diana* roundels in the Galleria Borghese which were commissioned by Cardinal Scipione Borghese in 1622.

47. Payments found by H. Hibbard allow the *Crucifixion* to be dated later than had hitherto been assumed. The Louvre *David* is another example of Reni's *Caravaggismo*. The most impressive fusion of influences from Caravaggio and Lodovico may perhaps be found in the *Colloquy between the Apostles Peter and Paul* in the Brera of c. 1605.

48. This painting is usually dated about 1611, but J. S. Pepper, *Guido Reni's Activity in Rome and Bologna, 1595–1614* (Columbia University Dissertation (unpublished), 1969, 219) argued persuasively that the picture dates from as late as 1615–16.

49. See last Note; the *Samson* should probably be dated about 1620.

4. 50. The identification of the pope is peculiarly difficult. D. Mahon (*Burl. Mag.*, XCIII (1951), 81) replaced the old name Paul V by that of Clement VIII. This would date the portrait c. 1602, which seems hard to accept. The sitter is almost certainly the Bolognese Gregory XV and the date therefore c. 1621.

51. The old title *Aurora* is not quite correct. The fresco shows Apollo in his chariot surrounded by the dancing figures of the Horae and Aurora hovering on clouds before him and strewing flowers on the dark earth below.

6. 52. Lanfranco's problematical early career has been investigated by L. Salerno, *Burl. Mag.*, XCIV (1952), 188, and *Commentari*, IX (1958), 44, 216. See also *Maestri della pittura del Seicento emiliano* (Exhib. Cat., Bologna, 1959), 214, and for Lanfranco's drawings J. Bean–W. Vitzthum, *Boll. d'Arte*, XLVI (1961), 06, R. Enggass, *Burl. Mag.*, CVI (1964), 286. For Lanfranco's ascendancy over Domenichino, above all D. Posner, in *Essays in Honor of Walter Friedlaender*, New York, 1965, 135–46.

53. First implied by Voss, then discussed by N. Pevsner, the relationship to Schedoni was further investigated by Mahon (*Burl. Mag.*, XCIII (1951), 81) and Salerno, in the papers mentioned in Note 52.

54. This dating was suggested by Mahon in the catalogue of the 1955 Wildenstein Exhibition in London *Artists in Seventeenth Century Rome*, 60).

55. Extensively repainted; see Waterhouse, 75. These frescoes, always dated too early, were painted between August 1624 and March 1625; see H. Hibbard, in *Miscellanea Bibliothecae Hertzianae*, Munich, 1961, 55.

88. 56. See Hibbard, *op. cit.*, 358.

It is worth summarizing Lanfranco's career as a fresco painter in the second and third decade. 1616–17: frescoes in S. Agostino and the Quirinal Palace. 1619–20: decoration of the Benediction Loggia over the portico of St Peter's, a commission of the greatest importance which attests to Lanfranco's reputation at this time but which, though extensively prepared, was not executed. (Reconstruction of Lanfranco's project by E. Schleier, in *Revue de l'Art*, no. 7 (1970), figure 49). 1621–3: decoration of the Cappella del Sacramento, S. Paolo fuori le Mura (ruined); fully discussed by B. L. La Penta, *Boll. d'Arte*, XLVIII (1963), 54. 1624–5: Villa Borghese. 1625–7: S. Andrea della Valle. After 1627: the newly found frescoes of the Villa Muti at Frascati; see E. Schleier, *Paragone*, XV (1964), no. 171, 59.

For the dating of Lanfranco's easel paintings, particularly of the first and second decade, see E. Schleier, *ibid.*, no. 177, 3.

At the time of the dome frescoes of S. Andrea della Valle the Frenchman François Perrier worked for Lanfranco. This artist was a success in Rome and after his first stay there in 1625–9 returned for a longer period (1635–45), during which he executed the frescoes of the gallery of the Palazzo Gaetani-Ruspoli (now Almagià) on the Corso; see E. Schleier, *Paragone*, XIX (1968), no. 217, 42 ff.

57. It has been shown by D. Mahon (*Burl. Mag.*, LXX (1937)) that the young Guercino was influenced by Scarsellino in Ferrara, where Guercino must have been in about 1616. Venetian influences, transmitted to him through Scarsellino, were reinforced by a visit to Venice in 1618. See also D. Mahon in the Catalogue of the Guercino Exhibition of 1968, especially pp. 20 ff.

89. 58. This slow change in Guercino's manner has been fully discussed by D. Mahon in *Studies in Seicento Art and Theory*.

59. It has been rightly pointed out that Guercino's chiaroscuro, North Italian in character, was developed without any appreciable influence from Caravaggio's form-preserving *tenebroso*. It is also likely that the plebeian types which appear in Guercino's early work reached him at one remove from Caravaggio.

CHAPTER 5

91. 1. This is, of course, a judgement *post festum*, looking back from the Baroque position. Around 1600 Florentine painters were vigorously active and their all-European influence on the formation of the 'international' Mannerism can hardly be over-estimated; see F. Antal, 'Zum Problem des Niederländischen Manierismus', *Kritische Berichte*, I–II (1927–9).

2. For Barocci's dates, see H. Olsen, *Federico Barocci*, Copenhagen, 1962, 20.

3. A. Emiliani, 'Andrea Lilli', *Arte Antica e Moderna*, I (1958), 65; G. Scavizzi, 'Note sull'attività romana del Lilio e del Salimbeni', *Boll. d'Arte*, XLIV (1959), 33.

4: P. A. Riedl, 'Zu Francesco Vanni und Ventura Salimbeni', *Mitt. d. Kunsthist. Inst. in Florenz*, IX (1959-60), 60 and 221 (Salimbeni's work, full bibliography).

92. 5. W. Friedlaender, *Mannerism and Anti-Mannerism in Italian Painting*, New York, 1957.

6. When this book first appeared (1958) our knowledge of these artists had hardly increased since N. Pevsner's *Die Barockmalerei in den romanischen Ländern*, published in 1928. But in connexion with the Bologna Exhibition of 1959 Bolognese Seicento painting has been intensely studied. The Catalogue (*Maestri della pittura del Seicento emiliano*) is therefore indispensable for this section. See also Bibliography under Artists.

7. A. Graziani, *Critica d'Arte*, IV (1939), 93, pointed out that Tiarini was influenced by Bartolomeo Cesi, his first teacher in Bologna (see Note 11).

8. For documented dates of all the works in the Cappella di S. Domenico, see V. Alce, *Arte Antica e Moderna*, I (1958), 394. A. Ghidiglia Quintavalle, *Paragone*, XVII (1966), no. 197, 37 ff., discusses Tiarini's documented work at Parma, where he worked from 1626 onwards.

94. 9. J. Hess's hypothesis that Spada was in Rome between 1596 and 1601/2 is unconvincing (*Commentari*, V (1954), 281).

95. 10. Mastelletta's *Triumph*, published by R. Kultzen, *Burl. Mag.*, C (1958), 352, is an early picture, painted under the influence of Polidoro da Caravaggio.

11. Four minor artists belong in this context: Francesco Brizio (1574-1623) and Lorenzo Garbieri (1580-1654), the former mainly Agostino Carracci's pupil, the latter a close follower of Lodovico; Lucio Massari (1569-1633), Albani's friend, who oscillates between painterly tendencies pointing back to Parmigianino and a stiffly wooden classicism (C. Volpe, *Paragone*, VI (1955), no. 71, 3); and Francesco Gessi (1588-1649), who began as a Lodovico follower and later capitulated to Reni. For Massari, Garbieri, and Brizio see also F. Arcangeli, *Arte Antica e Moderna*, I (1958), 236, 354. The fresco decoration of the Oratorio di S. Colombano in Bologna, where also Albani, Reni, Domenichino, and Galanino painted, is the main topic of this paper, which contains a major contribution to the Bolognese position around 1600. See also above, p. 63.

Although not connected with this group of artists, the name of Bartolomeo Cesi (1556-1629) should at least he mentioned. A Mannerist, outside the Carracci circle, yet in his masterpiece, the *Virgin in Glory with Saints* of 1595 (Bologna, S. Giacomo Maggiore), he reached a stylistic position not far from Lodovico. His later work shows progressive petrifaction. His career has been fully reconstructed by Graziani in the article quoted in Note 7.

12. M. A. Novelli, *Lo Scarsellino*, Bologna, 1955, with full bibliography.

96. 13. For Schedoni's correct place and date of birth, see *Maestri della pittura del seicento emiliano*, Bologna, 1959, 204. For Schedoni's procedure, see R. Kultzen, 'Variationen über das Thema der heiligen Familie bei B.S.', *Münchner Jb. d. bild. Kunst*, XXI (1970), 167 ff.

14. Giulio Cesare Amidano, who began under the influence of Correggio and Parmigianino, in his later work fell under the spell of Schedoni.

97. 15. In this context should be mentioned Fabrizio Boschi (*c.* 1570-1642), who hardly ever betrays that most of his working life belonged to the seventeenth century.

16. M. Bacci, 'Jacopo Ligozzi e la sua posizione nella pittura fiorentina', *Proporzioni*, IV (1963), 46-84. Full monographic treatment.

17. S. Bottari, in *Arte Antica e Moderna*, III (1960), 75.

18. See E. Panofsky's fascinating paper *Galilei as a Critic of the Arts*, The Hague, 1954.

For a fully annotated edition of Cigoli's letters to Galilei, see 'Macchie di sole e pittura; carteggio L. Cigoli-G. Galilei, 1609-1613', ed. A. Matteoli, in *Boll. della Accademia degli Eutelèti della città di San Miniato*, XXII, N.S., no. 32 (San Miniato, 1959).

The fullest information on Cigoli in the Catalogue of the 1959 Exhibition (see Bibliography); see also M. Pittaluga, *Burl. Mag.*, CI (1959), 444.

For interesting material on Sigismondo Coccapani, Cigoli's collaborator, see F. Sricchia, in *Proporzioni*, IV (1963), 249.

98. 19. G. Ewald, in *Pantheon*, XXIII (1965), 302 ff., discussed, among other Florentines, mainly Allori and Biliverti, and published a Life of Biliverti written by the latter's pupil, Francesco Bianchi.

20. For the development of Florentine painting in the first half of the seventeenth century, see F. Sricchia (Note 18); see also the frescoes in seven rooms of the Casino Mediceo, Via Cavour 63 (1621-3), illustrating Medici exploits, to which a great number of artists contributed; A. R. Masetti, *Critica d'Arte*, IX (1962), 1-27, 77-109.

21. For a new attempt at defining Manetti's stylistic development, see C. dal Bravo, in *Pantheon*, XXIV (1966), 43-51.

Francesco Rustici (d. 1626) from Pisa, who had a great reputation in his time, is still an undefined personality. According to C. Brandi (*R. Manetti*) he fol-

lowed the Bolognese and in particular Reni's manner. An equally problematical figure is the Pisan Riminaldi (1586–1631); as the Exhibition *Caravaggio e caravaggeschi nelle gallerie di Firenze*, 1970, showed, he was an artist of considerable dramatic power. The much younger Pietro Paolini (Lucca 1603-81), Caroselli's pupil in Rome, much of whose work is reminiscent of R. Manetti, has recently received some attention; see A. Marabottini Marabotti, in *Scritti di storia dell'arte in onore di Mario Salmi*, Rome, 1963, III, 307; A. Ottani in *Arte Antica e Moderna*, no. 21 (1963), 19.

22. Procaccini's birth date is taken from an unpublished document discovered by H. Bodmer.

99. 23. For details regarding the two cycles, see E. Arslan, *Le Pitture nel duomo di Milano*, Milan, 1960, 47, 63. - Cerano painted no less than ten canvases and Procaccini six. M. Rosci, *Mostra del Cerano*, Catalogue, Novara, 1964, 66, 71, claims that Cerano was the inventive genius of the entire first series (nineteen bozzetti by him in the Villa Borromeo d'Adda at Senago). Morazzone's contribution is also problematical; although his name does not appear in the documents, two paintings of the first series have always been attributed to him; further to this question M. Gregori, *Il Morazzone*, Catalogue, Milan, 1962, 7, 31.

24. The strong Gaudenzio note in the early Cerano has been emphasized by G. Testori in *Paragone*, VI (1955), no. 67.

25. See *Mostra del manierismo piemontese . . .* 1955; *Mostra del Cerano*, 46 (no. 24).

26. The results of N. Pevsner's pioneering article on Cerano, published in 1925, have been revised by G. A. Dell'Acqua in *L'Arte*, N.S. XIII (1942) and XIV (1943). Rosci's Catalogue of the Cerano Exhibition summarizes the entire research (full bibliography). For Cerano's pupil Melchiorre Gherardini (1607-75), who is often mixed up with his master, see S. Modena, *Arte Lombarda*, IV (1959), 109, and F. R. Pesenti, in *Pantheon*, XXVI (1968), 284 ff.

101. 27. For his frescoes in the Cappella di S. Rocco in S. Bartolomeo, Borgomanero (*c.* 1615-17), see M. Rosci, *Boll. d'Arte*, XLIV (1959), 451; M. Gregori's Morazzone Catalogue, 60.

28. For the Sacri Monti see, in addition to the Bibliography, Wittkower, in *L'Œil* (1959).

29. After G. Nicodemi's uncritical monograph of 1927, work on Morazzone was carried a step further by C. Baroni (1941, 1944), E. Zuppinger (1951), and M. Rosci (1959). The comprehensive Morazzone Exhibition of 1962 has clarified many problems. M. Gregori's excellent Catalogue supersedes all previous research. See also M. C. Gatti Perer in *Arte Lombarda*, VII (1962), 153, and M. Valsecchi, in *Paragone*, XXI (1970), no. 243, 12 ff.

30. For documents about the early works see S. Vigezzi in *Riv. d'Arte*, XV (1933), 483 ff. This and F. Wittgens' article, *ibid.*, 35 ff., correct some of the results of N. Pevsner's basic paper on G. C. Procaccini (*ibid.*, X (1929)).

103. 31. See F. Bologna, *Paragone*, IV (1953), no. 45.

32. See W. Arslan in *Phoebus*, II (1948). After these articles and the Caravaggio Exhibition of 1951 and the Turin Exhibition of Piedmontese and Lombard Mannerists of 1955, Tanzio began to emerge as an artist of considerable calibre. The Tanzio Exhibition of 1959 (Bibliography) brought most of his known work together; see G. Testori's Catalogue and M. Rosci, *Burl. Mag.*, CII (1960), 31.

In a 1967 paper M. Calvesi (see Bibliography) made it likely that Tanzio was in Naples about 1610 and returned home via Apulia and possibly Venice.

33. For Tanzio's collaboration with his brother, the sculptor Giovanni d'Enrico, see A. M. Brizio, in *Pinacoteca di Varallo Sesia*, Varallo, 1960, 19.

34. Moncalvo, who worked mainly in Milan, Pavia, Turin, Novara, and in small towns of Piedmont, is a typical *Neo-Cinquecentista* who, in spite of his extensive *œuvre*, may safely be omitted from this survey. Fullest discussion: V. Moccagatta in *Arte Lombarda*, VIII (1963), 185-243. See also A. Griseri, *Paragone*, XV (1964), no. 173, 17.

104. 35. M. Vaes in *Bulletin de l'institut historique belge de Rome*, IV (1925).

105. 36. Reni's *Assumption* [33] of 1616-17 was commissioned by Cardinal Durazzo.

37. R. Longhi in *Proporzioni*, I (1943), 53.

106. 38. In addition to Longhi's article in *Dedalo*, VII (1926-7), see Delogu in *Pinacotheca*, I (1929), and Longhi, *ibid.*; Marcenaro, *Emporium*, CV (1947); Grassi, *Paragone*, III (1952), no. 31; G. V. Castelnovi, *Emporium*, CXX (1954), 17.

39. After the studies by Grosso in *Emporium*, LVII (1923), and by Lazareff, in *Münchner Jahrbuch der bildenden Kunst*, N.S. VI (1929), little work has been done on the early Strozzi; but see H. MacAndrew, *Burl. Mag.*, CXIII (1971), 4 ff.

40. For these and other artists active in Venice in the first quarter of the seventeenth century - Scarsellino, Leandro Bassano, Sante Peranda, Matteo Ponzone, and Pietro Damiani - see the Catalogue of the Seicento Exhibition in Venice, 1959. - For Palma Giovane see also V. Moschini, *Arte Veneta*, XII (1958), 97, and G. Gamulin, *Arte Antica e Moderna*, IV (1961), 259, who suggests a revaluation of Palma's late period. - For Palma as draughtsman, see H. Schwarz, *Master Drawings*, III (1965), 158, and D. Rosand, *ibid.*, VIII (1970). - For Padovanino, see R. Pallucchini, *Arte Veneta*, XVI (1962), 121.

Pallucchini (*ibid.*, 126) counts Saraceni, N. Regnier, J. Heintz, and Vouet among the renovators of Venetian art next to or even before Fetti, Lys, and Strozzi. This view of the great connoisseur of Venetian painting cannot be accepted: for, first, the Venetian period of those four artists is either contemporary with or later than that of Fetti and Lys; and, secondly, none of them took up and developed further the specific Venetian colouristic tradition.

41. The best statement regarding the Venetian situation at the turn of the sixteenth to the seventeenth century is D. Rosand's paper 'The Crisis of the Venetian Renaissance Tradition', *L'Arte*, nos. 11-12 (1970), 5 ff.

107. 42. See P. Askew, in *Art Bull.*, L (1968), 1-10.

43. See J. Wilde, *Jahrbuch der kunsthistorischen Sammlungen, Wien*, N.F. X (1936).

44. P. Michelini, 'Domenico Fetti a Venezia', *Arte Veneta*, IX (1955), 123. Here also the correct date of Fetti's death: 1623 (document).

45. The unprinted University of London Ph.D. thesis by Pamela Askew (1954) contains a full and reliable *catalogue raisonné* of Fetti's works. Partly published in a new form as 'The Parable Paintings of D.F.', *Art Bull.*, XLIII (1961).

108. 46. V. Bloch, *Burl. Mag.*, XCII (1950), 278.

47. One of the few Venetians of this period who learned his lesson from Van Dyck was Tiberio Tinelli (1586-1638), but his portraits - his main claim to fame - are archaizing compared with his model. See A. Moschetti, *Burl. Mag.*, LXXII (1938), 64, and R. Pallucchini, *Arte Veneta*, XVI (1962), 126.

Of the three Veronese painters, Bassetti, Turchi, and Ottino, referred to above (Chapter 4, Note 17), the most Venetian is certainly Bassetti. He spent some time in Venice before going to Rome. On occasions he was capable of impressive creations (portrait, Museo Civico, Verona), which attest to his links with Fetti.

CHAPTER 6

111. 1. The basic monograph on Maderno by N. Caflisch (Munich, 1934) is not always reliable. U. Donati's monograph (1957) has many good illustrations.

2. W. Lotz (*Röm. Jahrb. f. Kunstg.*, VII (1955), 65) gives Maderno a larger share in the façade of S. Giacomo degli Incurabili than was hitherto believed on the strength of Baglione (ed. 1733, 196). But Francesco da Volterra, the architect of the church, designed the façade after 1592 and Maderno seems to have finished it after Volterra's death in 1594/5 (see H. Hibbard, in *Burl. Mag.* (December 1967), 713).

3. At the same moment Maderno also worked at Cardinal Pietro Aldobrandini's Villa di Belvedere at Frascati; see K. Schwager, *Röm. Jahrb. f. Kunstg.*, IX-X (1961-2), 291.

4. The emphasis on the columns derives from the North, while the conception of the enclosed bays is typically Roman. - For the façade of S. Susanna, see also below, p. 120, 373.

112. 5. A minor though considerable problem consisted in that Domenico Fontana had placed the obelisk a few degrees out of the axis of Michelangelo's St Peter's, which was not noticeable as long as the old basilica was standing. My own conclusion had been that Maderno corrected this mistake by slightly shifting the axis of his nave. A new and probably correct interpretation is given by C. Thoenes in *Zeitschr. f. Kunstg.*, XXVI (1963), 128.

Maderno's project was selected in 1607 after a competition in which the following other architects also took part: Flaminio Ponzio, Domenico and Giovanni Fontana, Girolamo Rainaldi, Niccolò Braconio, Ottavio Torrigiani, Giovan Antonio Dosio, and Lodovico Cigoli. The latter's designs (Uffizi) are particularly interesting.

6. Work on the towers stopped at Paul V's death in 1621.

7. E. Paribeni, *Il Palazzo Mattei in Roma*, Rome, 1932, has been superseded by G. Panofsky-Soergel, in *Röm. Jahrb. f. Kunstg.*, XI (1967-8), 111 ff. The new palace replacing an older one was carried out in three stages: 1598-1601, south-east sector; 1604-13, south-west part with the loggia of the cortile and the staircase; 1613-16, northern extension.

8. See, above all, O. Pollak, *Kunsttätigkeit*, I, Vienna, 1928, 251 ff.; further Hempel, *Borromini*, Vienna, 1924; Caflisch, *Carlo Maderno*; Brauer-Wittkower, *Zeichnungen des G. L. Bernini*, Berlin, 1931. Fullest discussion of all available evidence in a paper by A. Blunt, *J.W.C.I.*, XXI (1958), 256, to which the reader must be referred. I have left my original text unchanged since my results largely coincide with Blunt's.

9. H. Thelen informed Blunt (note to p. 260) that the Uffizi drawing was originally made for a different patron and a different site. Blunt reasonably suggests that it was submitted as an example of the type of palace which Maderno proposed to build.

114. 10. For the prehistory of the Palazzo Barberini, see Cardinal Ehrle, *Roma al tempo di Urbano VIII. La pianta di Roma Maggi-Maupin-Losi del 1625*, Rome, 1915.

Some of the rooms still have the Sforza coat of arms.

11. For the complicated history of the Villa Mondragone see C. Franck, *Die Barockvillen in Frascati*, Munich-Berlin, 1956, 51.

12. See the arched opening at the foot of the staircase of the Palazzo Mattei. The Albertina drawing men-

tioned in the text also shows the same type of window. In the framework of the tomb of the Countess Matilda in St Peter's Bernini returned to this type of Madernesque design. The same motif in Maderno's loggia of the Palazzo Borghese facing the Tiber is an eighteenth-century addition, see H. Hibbard, *Palazzo Borghese*, 1962, 66 f.

13. He used the motif in the courtyard of the Palazzo Mattei. Borromini's influence on the external details is ascertained by his window design [114]; see p. 198.

14. Blunt attributes to Bernini the enlargement of the *salone* and this, according to the author, led to complications in the design of the palace.

115. 15. Among the other practitioners in Rome at this period the amateur architect Rosato Rosati (*c.* 1560–1622) should be mentioned. Born near Macerata (Marches), he was appointed Rector to a small Barnabite College in Rome before 1590. In 1612 he designed S. Carlo ai Catinari with a dome of unorthodox design within the Roman setting (dome finished 1620; apse finished 1646; most of the interior decoration between 1627 and 1649; façade by Soria, 1636-8). Further for this important church, see p. 117; Vincenzo Fasolo, *La cupola di S. Carlo ai Catinari*, Istituto di Studi Romani, 1947.

16. Among the characteristics of this important palace are the elongated proportions of the windows, reminiscent of Gothic shapes, the almost complete abandonment of decoration, the emphasis on the empty wall of the wide middle bay, and the incongruous Serlio motif topping the centre.

For Scamozzi see F. Barbieri's monograph, 1952.

17. R. Pallucchini, 'Vincenzo Scamozzi e l'architettura veneta', *L'Arte*, XXXIX (1936), 3 ff.

18. For Curtoni, see P. Gazzola in *Bollettino del Centro Internaz. di Studi di Architettura*, IV (1962), 156.

19. Anthony Blunt, *Artistic Theory in Italy*, Oxford, 1940, 127. On Milanese architecture of this period see, above all, H. Hoffmann in *Wiener Jahrb.*, IX (1934), 91 ff.; C. Baroni, *Documenti per la storia dell'architettura a Milano*, Florence, 1940; *idem, L'architettura da Bramante al Ricchino*, Milan, 1941; P. Mezzanotte and G. C. Bascapé, *Milano nell'arte e storia*, Milan, 1948; P. Mezzanotte in *Storia di Milano*, X, Milan, 1957, part IV; M. L. Gatti Perer, in *Il mito del classicismo nel Seicento*, Florence, 1964, 101.

116. 20. The second court, also usually ascribed to Mangone, was built later in the century by Girolamo Quadrio.

21. The Milanese Giovan Battista Montano (1534–1621) undertook the task of charting an enormous number of ancient buildings in several publications which appeared posthumously between 1624 and 1636. The influence exercised by these books has not yet

been sufficiently studied. G. Zander's industrious paper in *Quaderni*, no. 30 (1958), I, is mainly concerned with the problem of Montano's reliability.

22. Premoli, 'Appunti su L. Binago', *Archivio storico lombardo*, XLIII (1916), 842; G. Mezzanotte, 'Gli architetti Lorenzo Binago e Giovanni Ambrogio Mazenta', *L'Arte*, LX (1961), 231-70, with much new material.

117. 23. The façade too takes up the theme, introduced by Bramante, of two towers which form the effective group with a dome between them. Binago's façade, not finished until the eighteenth century (together with the encasing of the dome), is an important link between Alessi's S. Maria di Carignano at Genoa and Borromini's S. Agnese in Rome. Further imformation on S. Alessandro in C. Baroni, *Documenti per la storia dell'architettura a Milano*, Milan, 1940, I, 3-34 (documents); see also Mezzanotte (above, Note 22), 253.

24. C. Bricarelli in *Civiltà Cattolica*, LXXXIII, iii (1932), 251; F. Zeri in *Paragone*, VI (1955), no. 61, 35; *idem, Pittura e Controriforma*, Turin, 1957, 60; M. Enrichetti, 'L'architetto Giuseppe Valeriano (1542–1596) . . .' *Archivio stor. per le prov. napoletane*, XXXIX (1960), 325.

25. Examples: S. Maria di Canepanova, Pavia (begun 1492?) or S. Magno at Legnano, 1504-18.

26. See, e.g., Fra Giocondo's drawing in the Uffizi (3932), illustrated in G. T. Rivoira, *Roman Architecture*, Oxford, 1925, figure 209. Also plans and sections in G. B. Montano's *Scielta di varj tempietti antichi*, Rome, 1624.

118. 27. See, e.g., Francesco Gallo's Duomo S. Donato at Mondovì (1743-63) and C. Corbellini's S. Geremia in Venice (1753-60).

28. E. Cattaneo, *Il San Giuseppe del Richini*, Milan, 1957, 36. The church was opened in 1616. Cardinal Federico Borromeo celebrated the first Mass. When he entered the building, he exclaimed: 'Ha del Romano.'

120. 29. Original ground-plans in the Bianconi Collection (Biblioteca Trivulziana), probably dating from 1607, prove that the façade was designed with the church; but an (undated) elevation of the façade by Ricchino shows a 'pre-aedicule' stage; see E. Cattaneo, *op. cit.*, 86 and figures 27, 28, 37.

30. It must be pointed out, however, that the façade of S. Giuseppe contains a residue of Mannerist ambiguity: only the verticals of the columns flanking the door in the lower and the window in the upper tier are carried through with consistency; the outer columns of the upper tier find no proper response in the lower tier: they rise not over columns but over pilasters; here the vertical movement is also interrupted by the unbroken horizontal of the entablature over the outer bays of the lower tier.

In addition, a chronological problem arises since Girolamo Rainaldi used the type in S. Lucia at Bologna in 1623. But, as we have mentioned, Ricchino's design is probably older and, in any case, he also planned the 'aedicule façade' of the Ospedale Maggiore in the mid twenties, see below, p. 120.

31. The following no longer exist: S. Ulderico, S. Eusebio, S. Lazaro in Pietra Santa, all built before 1619; S. Pietro in Campo Lodigiano and S. Vito al Carrobbio, both 1621; S. Vittore al Teatro, S. Giorgio al Palazzo, S. Bartolomeo, 1624; S. Pietro con la Rete and S. Salvatore, 1625; S. Maria del Lentasio, 1640; S. Giovanni alle Case Rotte, 1645; the Chiesa del Seminario di S. Maria della Canonica (c. 1651); and S. Marta, S. Agostino, S. Giovanni alle Quattro Faccie. Best survey of Ricchino's work in L. Grassi, *Province del Barocco e del Rococò*, Milan, 1966, 289 ff.

32. E.g. S. Maria della Vittoria, S. Maria Maddalena, S. Giacomo alle Vergini Spagnoli. See also M. L. Gengaro, 'Dal Pellegrini al Ricchino', *Boll. d'Arte*, xxx (1936), 202.

33. P. Mezzanotte, 'Apparati architettonici del Richino per nozze auguste', *Rassegna d'Arte*, xv (1915), 224.

34. See Hoffmann, *op. cit.*, 83. For the date of the Palazzo Durini, see P. Mezzanotte, *Raccolta Bianconi*, Milan, 1942, 93 (extremely rare).

121. 35. C. Baroni has made it probable, however, that Martino Bassi's designs of 1591 for the courtyard were still used in 1651. Most of the Brera was executed after Ricchino's death by his son Gian Domenico, Giuseppe Quadrio, and Rossone. The famous staircase, usually ascribed to Ricchino, belongs to the second half of the century.

36. See the richly illustrated work by C. Del Frate, *S. Maria del Monte sopra Varese*, Varese, 1933. For the chapel architecture by G. Bernasconi, see S. Colombo, *Profilo della architettura religiosa del Seicento. Varese . . .*, Milan, 1970.

122. 37. Antonio Morassi, *Catalogo delle cose d'arte . . . Brescia*, 1939, 144, with full bibliography.

38. A. Foratti, 'L'architetto Giov. Ambr. Magenta', in *Studi dedicati a P. C. Falletti*, Bologna, 1915. G. Mezzanotte, *L'Arte*, LX (1961), 244. The dates of Magenta's buildings given in the text are based on this author's research.

39. G. Cantagalli in *Comune di Bologna* (1934), 48, and Mezzanotte, *op. cit.* (last Note).

40. For early repercussions of the columned North Italian nave in Rome, see Ottavio Mascherino's S. Salvatore in Lauro (1591-1600). The columns in Paolo Maggi's SS. Trinità de Pellegrini (1614) belong to G. B. Contini's eighteenth-century restoration (see G. Matthiae in *Arti Figurative*, II (1946), 57, note 7).

41. Magnani rebuilt between 1622 and 1624 Bernardino Zaccagni's S. Alessandro. He was also the architect of the Palazzo del Municipio (1627), which was destroyed during the last war.

42. According to D. de Bernardi Ferrero, *I disegni d'architettura civile et ecclesiastica di G. Guarini . . .*, Turin, 1966, 63, a drawing for the church in the State Archive at Parma carries only Magnani's name and not that of Aleotti.

123. 43. Theatre of the Accademia degli Intrepidi (1606), destroyed by fire in 1679. For Aleotti's Ferrarese activity, see the well documented paper by D. R. Coffin, *Journal of the Soc. of Architectural Historians*, XXI (1962), 116.

44. L. Magagnato, *Teatri italiani del Cinquecento*, Venice, 1954, 80.

45. The history of the Strada Nuova has now been published in an exemplary cooperative work directed by L. Vagnetti, *Genova, Strada Nuova*, Genoa, 1967: next to exhaustive sections on social, urban, and other aspects, a complete documentation of each palace along the street.

46. The history of Genoese Baroque architecture remains to be written. In spite of valuable work, mainly by Mario Labò and Orlando Grosso, a large number of Genoese palaces are still anonymous, nor does a solid historical basis exist for the major structures of the Sei- and Settecento. But a start has been made with L. Profumo Müller's monograph of B. Bianco (see Bibliography) and with the fine study by G. Colmuto on a specific type of Genoese longitudinal churches with paired columns along the nave (1970, see Bibliography). – Bianco's date of birth is often given as 1604 (O. Grosso), which is not possible in view of his activity during the second decade.

47. According to M. Labò, 'Il palazzo dell'Università di Genova', *Atti della R. Università di Genova*, xxv (n.d.), Bianco planned the palace in 1630 and made his final project in 1634, when construction was begun. See also L. Profumo Müller, *B. Bianco . . .*, 1968; see Bibliography.

125. 48. Similar to the courtyard of the Palazzo Borghese in Rome (p. 34). Airy arcades resting on single or even double columns are familiar from late sixteenth-century ecclesiastical architecture at Genoa, see SS. Annunziata, S. Siro, and S. Maria della Vigna.

49. The embossed columns of the entrance have a Mannerist pedigree, and the ground-floor window surrounds are crowned by lions' heads biting the voussoirs, following the example of the Palazzo Rosso (by Rocco Lurago?).

50. See, e.g., Palazzo Pallavicini on Piazza Fontane Marose (1565) and the Palazzi Lomellini and Serra on Piazza de' Bianchi.

51. Vera Daddi Giovannozzi, in *Mitteilungen des kunsthistorischen Instituts in Florenz*, V (1937-40), 58.

52. V. Fasolo, 'Un pittore architetto: Il Cigoli', *Quaderni* (1953), nos. 1, 2; L. Berti in the Catalogue of the *Mostra del Cigoli*, 1959, 165.

53. L. Berti in *Palladio*, 1 (1951), 161; R. Linnenkamp, 'Giulio Parigi architetto', *Riv. d'Arte*, VIII (1958), 51, with list of Giulio's works and new documents.

54. J. Hess, *Agostino Tassi*, Munich, 1935.

55. L. Berti, in *Riv. d'Arte*, XXVI (1950), 157; and XXVII (1951-3), 93.

56. I follow Berti's careful assessment of the documentary material.

57. See Giovannozzi, *op. cit.*, 60.

126. 58. For the history of the chapel see W. and E. Paatz, *Die Kirchen von Florenz*, Frankfurt, 1955, II, 469, 541, etc., and Berti, *loc. cit.* (Note 55).

59. L. Wachler in *Röm. Jahrb. f. Kunstg.*, IV (1940), 194.

60. For Neapolitan Baroque architecture see Chierici's articles in *Palladio*, I (1937), and R. Pane's book (Naples, 1939), which contains the only coherent history of the subject.

For Francesco Grimaldi, see H. Hibbard, *Art Bull.*, XLIII (1961), 301, whom I follow for the dates of Grimaldi's buildings.

127. 61. For Stati's (1556-1619) stylistic position, see V. Martinelli in *Riv. d'Arte*, XXXII (1959), 233.

62. Cordier also enjoyed a reputation as restorer of antique statuary; see S. Pressouyre, in *G.d.B.A.*, LXXI (1968), 147 ff. For the sculpture in the Aldobrandini Chapel see *idem*, *Bulletin de la Société Nationale des Antiquaires de France* (1971).

128. 63. N. v. Holst in *Zeitschr. für Kunstg.*, IV (1935), 35, has deflated this legend. J. Pope-Hennessy, *Italian High Renaissance and Baroque Sculpture*, London, 1963, Catalogue, 137, does not accept Holst's conclusions.

64. Statues and reliefs in the Cappella Aldobrandini, S. Maria sopra Minerva (1598-1605); in S. Giovanni in Laterano (1600); in the Cappella Paolina, S. Maria Maggiore (1608-12); in S. Maria della Pace (1614); and S. Maria di Loreto (1628-9), etc.

65. R. Wittkower, in *Zeitschr. f. b. Kunst*, LXII (1928), 26; I. Robertson in *Burl. Mag.*, LXIX (1936), 176; A. Donati, *Stefano Maderno scultore*, Bellinzona, 1945.

66. Literature about him is fairly large. More recently P. Rotondi in *Capitolium*, XI (1933), 10, 392, and *Riv. del R. Ist.*, V (1935-6), 189, 345, and V. Martinelli in *Commentari*, IV (1953), 133, with further references.

129. 67. See G. Fiocco's basic article in *Le Arti*, III (1940-1), 74.

130. 68. V. Martinelli's articles in *Commentari*, II

(1951), 224 and III (1952), 35, list the considerable post-Thieme-Becker literature and also contain an additional list of works.

132. 69. For a different interpretation of Mochi's development the reader has to be referred to a recent paper by I. Lavin, in *Art Bull.*, LII (1970), 132 ff.

70. In some of his bronzes, however, Francesco Susini broke away from the tradition of the Giovanni Bologna studio (e.g. Rape of Helen, 1626); see E. Tietze-Conrat in *Kunstg. Jahrb. der k.k. Zentral-Kommission*, II (1917), 95.

71. See the fully documented article by S. Lo Vullo Bianchi in *Riv. d'Arte*, XIII (1931), 131-213. Also E. Lewy, *Pietro Tacca*, Cologne [1928].

133. 72. Above all the bronze equestrian statues of Ferdinand I (Florence, in the Piazza Annunziata), Henry IV of France (1604-11, Paris, destroyed), and Philip III of Spain (1606-13, Madrid).

73. Giovanni Bandini's statue was erected in 1595-9 (H. Keutner, *Münchner Jahrbuch d. bild. Kunst*, VII (1956), 158). Tacca's Slaves were executed with the help of Andrea Bolgi, Cosimo Cappelli, Cosimo Cenni, Bartolomeo Cennini, Michele Luccherini, and of Lodovico Salvetti. Soon after, Bolgi left for Rome. Cennini, too, went to Rome, where he made his name as a bronze founder in Bernini's studio. The other pupils were men of little distinction.

74. W. Weisbach, *Trionfi*, Berlin, 1919.

75. It has, however, been correctly pointed out that Hellenistic bronze statuettes of Negro slaves show attitudes extremely close to those of Tacca's slaves; see, e.g., K. A. Neugebauer, *Die Griechischen Bronzen* (Staatl. Museen), Berlin, 1951, plate 36.

76. The statue of Ferdinand I was not finished until 1642 by Pietro Tacca's son, Ferdinando.

77. Finished shortly before Pietro's death and erected by Ferdinando in 1642.

78. It is not certain whether the copy in the Palazzo Pitti after the Velasquez painting in the Prado or the Spanish copy in the Uffizi after Rubens's lost picture of 1628 was dispatched from Madrid for this purpose.

134. 79. For instance, his Virgin and Child on the tomb of Porzia Coniglia (Naples, S. Giacomo degli Spagnuoli) derives from Danti's Virgin and Child in the Cappella Baroncelli, S. Croce, Florence; and the group of Adam and Eve, which he presented to the Grand Duke Cosimo II (1616, now Boboli Gardens), from Bandinelli's group in the Bargello.

80. L. Bruhns in *Röm. Jahrb. f. Kunstg.*, IV (1940), 293. On Naccherino, see A. Maresca di Serracapriola, *Michelangelo Naccherino*, Naples, 1924.

81. His figures in the Chapel of the Crucifixion, Sacro Monte, Varese, show, however, a true sense of Baroque drama and break with the conventions of the older

Francesco Silva (1580–1641), who executed most of the groups in the chapels of the Sacro Monte.

82. Among the sculptors who worked at Genoa may be mentioned Filippo Planzoni from Sicily (d. 1636), Domenico Bissoni from Venice (d. 1639) and his son Giovan Battista (d. 1659), and Stefano Costa (d. 1657) and Pietro Andrea Torre (d. 1668). Most of these worked mainly in wood. Artists like the Bissoni have become more clearly defined personalities through the 1939 Exhibition at Genoa (see p. 450).

CHAPTER 7

137. 1. First published Perugia, 1606, and many times thereafter.

2. R. Harvey, *Ignatius Loyola*, London, 1936, 257.

138. 3. See, e.g., the many works of Guido Reni's school.

4. For the following see, above all, Hastings's *Encyclopedia of Religion and Ethics*, s.v., and I. von Döllinger and F. H. Reusch, *Geschichte der Moralstreitigkeiten in der römisch-katholischen Kirche seit dem sechzehnten Jahrhundert*, Nördlingen, 1889.

5. On laxism see M. Petrocchi, *Il problema del lassismo nel secolo XVII*, Rome, 1953 (Storia e letteratura, no. 45).

6. M. Petrocchi, *Il quietismo italiano del Seicento*, Rome, 1948 (Storia e letteratura, no. 20); also L. von Pastor, XIV, ii, 985.

139. 7. For the following see the documents published by F. Haskell in *Burl. Mag.*, XCVII (1955), 287.

8. Wittkower, *Gian Lorenzo Bernini*, London, 1955, 12.

9. M. de Chantelou, *Journal du voyage du Cav. Bernin en France*, Paris, 1885, under 23 August 1665.

140. 10. For the text illustrated by Pozzo, see E. Mâle, 442.

11. 'La "rettorica" e l'arte barocca' in *Retorica e Barocco*. Atti del III Congresso internazionale di studi umanistici, Rome, 1955, 9. The ideas of this concise paper have influenced my argumentation.

12. See Sacchi's talk to Francesco Lauri, related by L. Pascoli, *Vite de' pittori* etc., Rome, 1736, II, 82: 'lo stimo, e credo, che i pittori dagli oratori deggian pigliare i precetti'. See also H. Posse, *Andrea Sacchi*, Leipzig, 1925, 118.

13. Little work has been done on these problems. Not very helpful in this context is G. Weise and G. Otto, *Die religiöse Ausdrucksgebärde des Barock* (Schriften und Vorträge der württembergischen Ges. d. Wissensch.; Geisteswissenschaften, Abt. 5, 1938).

14. See the stimulating book by W. Weisbach, *Der Barock als Kunst der Gegenreformation*, Berlin, 1921, which had a lasting influence but also aroused a heated

controversy; see, above all, N. Pevsner in *Rep. f. Kunstw.*, XLVI (1925), 243 and XLIX (1928), 225, and Weisbach, *ibid.*, 16.

141. 15. Further for papal patronage, see the relevant chapters in Pastor's *History of the Popes*.

16. For further details see the documents in O. Pollak, *Die Kunsttätigkeit unter Urban VIII*, Vienna, 1931, II, and the catalogues in E. Waterhouse, *Baroque Painting in Rome*, London, 1937.

142. 17. J. Hess in *Illustrazione Vaticana*, VI (1935), 241.

18. For details of the entire 'programme' see Wittkower, *op. cit.*, 19.

19. For papal and other forms of patronage in Rome, see now part 1 of the excellent work by F. Haskell, *Patrons and Painters*, London, 1963.

CHAPTER 8

144. 1. For this chapter see the author's book on Bernini (*Gian Lorenzo Bernini the Sculptor of the Roman Baroque*, London, 1966), with critical œuvre catalogue. References will therefore be kept to a minimum.

2. I can neither agree to the attribution of the Santoni bust to Pietro Bernini, as suggested by C. D'Onofrio (*Roma vista da Roma*, 1967, 114 ff.), nor to the dating of the bust to 1610 as I. Lavin (*Art Bull.*, L (1968), 223 ff.) assumes. H. Kauffmann, *G. L. Bernini*, 1970, 11, also refutes such an early date.

145. 3. The stone-coloured caryatids of the Farnese Gallery had a formative influence on Bernini's conception of antiquity while he was engaged on the Pluto. The somewhat cold beauty of Proserpina's body is also derived from Annibale Carracci's ceiling. Furthermore, the David is indebted to the figure of Polyphemus in the fresco of *Polyphemus killing Acis*. For further details, see Wittkower, 5 f.

Recently L. Grassi, *Burl. Mag.*, CVI (1964), 170, emphasized Polidoro da Caravaggio's influence on *the Neptune and Triton* and to a lesser extent on the *Pluto* and *David*.

146. 4. Two almost identical busts exist in the Borghese Gallery. Bernini copied his first bust himself because the marble showed a crack across the forehead shortly before its completion. But the second version lacks the intense animation of the first.

151. 5. It is not generally known that the Angel with the Superscription standing on Ponte S. Angelo is also Bernini's work. For the complicated history of these Angels, see Wittkower, 248 ff.

152. 6. However, a passage in *Kunstgeschichtliche Grundbegriffe*, first published in 1918, shows that Woelfflin was very well aware that Baroque sculpture

has a 'picture-like' character and is therefore composed for one viewpoint.

153. 7. Attention may be drawn to the Angel's right leg and Habakkuk's right arm, clearly designed to counterbalance each other; or to the cross of spatial diagonals created by the Angel's arms and his right wing, whose direction is continued in the prophet's right arm.

157. 8. Polychrome settings became common after Sixtus V's chapel in S. Maria Maggiore, see pp. 29-30.

9. This device is fully effective only in the afternoon, when the sun is in the west.

160. 10. In the Teresa group, as in the allegories of the tomb of Pope Urban, marble seems to turn into flesh. But the psychological effect is different; for while here the group has its own mysterious setting, there the allegories stand before the niche, in the spectator's space.

161. 11. A good analysis of the colour scheme in R. Battaglia, *La cattedra berniniana*, Rome, 1943, 75, 80 f.

164. 12. On this and other grounds Bernini's art found a severe critic in Sir Herbert Read (*The Listener*, 24 November 1955). Sir Herbert voiced here opinions held by many.

13. For a further analysis, see Wittkower, 21.

14. See, e.g., Roubiliac's tomb of Lady Elizabeth Nightingale in Westminster Abbey (1761). Roubiliac's dependence on the tomb of Alexander VII cannot be doubted.

167. 15. The former in S. Lorenzo in Damaso, the latter in S. Giacomo alla Lungarna. Further to the history of these monuments, Wittkower, 210 f.

16. The bust was lost in the Whitehall Palace fire of 1698. The best idea of the bust is conveyed by the eighteenth-century copy made from a cast, now at Windsor Castle (Wittkower, figure 48).

17. *Journal du voyage du Cav. Bernin*, ed. Lalanne, Paris, 1885; see Wittkower, *Bernini's Bust of Louis XIV*, London, 1951.

168. 18. Particular reference may be made to Stoldo Lorenzi's Neptune in the Boboli gardens. See B. H. Wiles, *The Fountains of Florentine Sculptors and their Followers from Donatello to Bernini*, Cambridge, Mass., 1933.

Since the *Neptune and Triton* will not again be mentioned, I may add here that the problem of its *concetto* has aroused much controversy. I first submitted (*Burl. Mag.*, XCIV (1952), 75) that Bernini here intended to illustrate the Virgilian 'Quos Ego' (*Aeneid*, I, 145 f.); J. Pope-Hennessy (*Catal. Ital. Sculpt. in the Victoria & Albert Mus.*, 1964, II, 600) believed that his text was Ovid, *Met.*, I, 330 ff., while W. Collier (in *J.W.C.I.*, XXXI (1968), 438 ff.) thought Ovid, *Met.*, I, 283-4 was shown. H. Kauffmann, *G. L. Bernini*, Berlin, 1970, 39, returned with new arguments to my original interpretation.

19. For the correct date, see D'Onofrio, *Le Fontane di Roma*, Rome, 1957, 191, and H. Hibbard, *Burl. Mag.*, CVI (1964), 168 note.

20. Surviving drawings prove that the rock was designed with great care (Brauer-Wittkower, 47 ff.).

169. 21. Further for the Longinus, see H. Kauffmann, in *Miscellanea Bibliothecae Hertzianae*, 1961, 366.

22. Judging from an illustration only, the terracotta bozzetto of the Constantine published by K. Rossacher, in *Alte und Neue Kunst*, XII, 90 (1967), 2 ff., seems to be suspect.

23. For a full exposition of the *concetto*, see Wittkower in *De Artibus Opuscula XL. Essays in Honor of Erwin Panofsky*, New York, 1961, 497.

170. 24. Further for the iconography of the Four Rivers Fountain, H. Kauffmann in *Jahresberichte der Max Planck Gesellschaft* (1953-4), 55 ff., and more recently, N. Huse, in *Revue de l'Art*, no. 7 (1970), 7 ff., where conclusions are drawn from a text by Michelangelo Lualdi who may have been Bernini's adviser.

For the *concetto* of the Barcaccia in Piazza di Spagna, see H. Hibbard–I. Jaffe, *Burl. Mag.*, CVI (1964), 159.

25. See W. S. Heckscher in *Art Bull.*, XXIX (1947), 155 ff.

26. K. Rossacher ('Das fehlende Zielbild des Petersdomes, Berninis Gesamtprojekt für die Cathedra Petri', *Alte und Moderne Kunst* (Nov.-Dec. 1967)) argued eloquently that Bernini had planned a representation of the Transfiguration in the window of the Cathedra and claims to have found Bernini's bozzetto for this project, but the author's assumptions do not seem to be supported by historical evidence.

27. Further for the ideas underlying the Cathedra Petri, see H. von Einem in *Nachrichten der Akademie der Wissenschaften in Göttingen*. Philolog.-Hist. Klasse, 1955, 93. For the *concetto* of the Baldacchino see H. Kauffmann in *Münchner Jahrbuch der bildenden Kunst*, VI (1955), 222.

171. 28. *Cod. Ital.* 2084, fol. 195, referred to in Wittkower, 254.

29. Brauer-Wittkower, plate 71A.

30. See Brauer-Wittkower, plates 42-7.

31. See also Wittkower, 'The Role of classical Models in Bernini's and Poussin's preparatory Work', in *Studies in Western Art* (Acts of the 20th Internat. Congr. of the Hist. of Art), Princeton, 1963, III, 41.

172. 32. Wittkower, figure 107.

33. E.g. all the early works and the busts of Scipione Borghese, Costanza Buonarelli, Francis I of Este, Louis XIV; further, the Longinus, Daniel, and Habakkuk, S. Bibiana and S. Teresa, and the Angels for the Ponte S. Angelo. These are some examples. No attempt at completeness is made in this and the following notes.

34. The Baldacchino, tomb of Urban VIII.

35. Monument of Countess Matilda; Cappella Raimondi; statues of Urban VIII, Capitol, and of Alexander VII, Siena Cathedral; Angels above the main altar of S. Agostino; balconies in the pillars of St Peter's; decoration of S. Maria del Popolo; chapel of the De Silva family, S. Isidoro; Valtrini and Merenda monuments; tomb of Alexander VII. This group, to which many more works belong, is by no means coherent.

36. St Barbara, Rieti Cathedral; Visitation, Cappella Siri, Savona.

37. L. Grassi, *Bernini pittore*, Rome, 1945, with bibliography up to that date. Further, Martinelli in *Commentari*, 1 (1950), with brief critical but not entirely reliable *œuvre* catalogue, and Wittkower in *Burl. Mag.*, XCIII (1951), 51 ff.

38. The portrait now in the Ashmolean Museum, Oxford (see Wittkower, *op. cit.*), and the self-portrait formerly in the collection of Mrs Richard Ford (D. Mahon and D. Sutton, *Artists in Seventeenth Century Rome*, Exhib. Wildenstein, 1955, no. 5).

173. 39. Early self-portrait, Borghese Gallery, and the half-figures of *St Andrew and St Thomas*, formerly Palazzo Barberini, now National Gallery, London, documented 1627; see Martinelli, *op. cit.*, 99, 104.

40. The most important document of this phase is the *David with the Head of Goliath*, Coll. Marchesa Eleonora Incisa della Rocchetta, Rome. See the pertinent remarks in Mahon's and Sutton's *Catalogue*, no. 7.

41. Between the first self-portrait in the Borghese Gallery of about 1620 and the second in the same museum lie at least twenty years.

42. Grassi's reversal of this relationship (p. 28) is unacceptable.

43. For a full discussion of these compositions and also for the engravings made after Bernini's designs, see Brauer-Wittkower, 151 ff.

44. Waterhouse, 86; Grassi, *op. cit.*, 37 ff.; H. Posse, *Der römische Maler Andrea Sacchi*, Leipzig, 1925, 53 f.

45. The same device is used, e.g., in the group of *Pluto and Proserpina*.

46. Further for Abbatini's works, Passeri-Hess, 234 ff., Waterhouse, 44, Grassi, *op. cit.*, 44 ff., Martinelli, *Commentari*, IX (1958), 99, B. Toscano, *Paragone*, XV (1964), no. 177, 36.

174. 47. Passeri-Hess, 234 ff. The pun '. . . ha fatto parere vero effettivo quel falso, che è finto', is difficult to translate.

48. Guglielmo Cortese (Guillaume Courtois) painted in the 1660s in Bernini's churches (see Note 69) but cannot be regarded as one of his studio hands.

49. For Bernini's influence on Gaulli see Pascoli, *Vite*, Rome, 1730-6, I, 195, and R. Soprani and C. G. Ratti,

Vite de' pittori . . . genovesi, Genoa, 1768-9, 76.

50. See Chantelou's *Diary* on 10 October 1665.

175. 51. The work was finished in 1626; see O. Pollak, *Kunsttätigkeit*, I, 22 ff. Bernini was also responsible for the restoration of the interior. Particularly impressive is the classicizing aedicule above the high altar (Wittkower, *Bernini*, figure 27).

52. For historical data, see Brauer-Wittkower, 19-22, and Wittkower, *Bernini*, 189 f.; for the iconography, H. Kauffmann, 'Das Tabernakel in St Peter', *Kunstgeschichtliche Gesellschaft zu Berlin, Sitzungsberichte* (1954-5), 5-8; also Note 27 above.

53. Bernini designed the decoration of the pillars in 1628. The balconies serve for the exhibition of the most venerable relics on certain festive occasions. Further to this question, Wittkower, *Bernini*, 197 f., and Kauffmann, *loc. cit.*

176. 54. On Borromini's probable contribution to the design, see p. 197.

55. Prototypes for the motif were Early Christian sarcophagi with vines, a reference to the blood of Christ. By substituting laurels (a Barberini emblem) for vines, Bernini turned the traditional into personal symbolism.

56. Shortly before Bernini, Ferrabosco planned such a structure in lieu of the present Baldacchino; see Costaguti-Ferrabosco, *Architettura della basilica di S. Pietro in Vaticano*, Rome, 1684, plate 27.

57. See A. Muñoz in *Vita d'Arte*, VIII (1911), 33; Pulignani in *Illustr. Vaticana*, II, 12 (1931), 23 ff.

58. For the master of the Val-de-Grâce baldacchino, usually wrongly attributed to Bernini, see M. Beaulieu, 'G. Le Duc, M. Anguier et le maître-autel du Val-de-Grâce', *Bulletin de la société de l'histoire de l'art français, année 1945-46* (1948), 150 and A. Blunt, *Art and Architecture in France*, 250, note 22. For French high altars dependent on Bernini's Baldacchino, see M. Reymond in *G.d.B.A.*, IX (1913), 207 ff.

177. 59. The fullest account of the history of this church and Bernini's other architectural works in Brauer-Wittkower. The book by R. Pane, *Bernini architetto*, Venice, 1953, is uncritical and contains no serious contribution. For Castelgandolfo see also V. Golzio, *Documenti artistici*, Rome, 1939, 402. The church was first dedicated to St Nicholas and, after a change of plan in 1659, to the newly canonized St Thomas of Villanova.

178. 60. The whole height is $1\frac{1}{2}$ times the length of the axis of the church.

61. The medallions reproduce the pictures hung in St Peter's on the day of the saint's canonization, see Brauer-Wittkower, 125.

62. See, e.g., the niche of the tomb of Urban VIII [83] or the apse of the Raimondi Chapel in S. Pietro in Montorio.

63. The niche of Alexander VII's tomb (1671-8) [89] is also decorated in this way.

64. A few eighteenth-century examples may be given: Fuga's Chiesa di S. Maria dell' Orazione e Morte in Via Giulia, Rome; Luigi Vanvitelli's Chiesa dei PP. delle Missioni at Naples; and Juvarra's Superga near Turin.

65. B. M. Apolloni-Ghetti, 'Il Palazzo Chigi all' Ariccia', *Quaderni* (1953), no. 2, 10, with plans and a not very helpful historical note.

66. G. Incisa della Rocchetta, 'Notizie sulla fabbrica della chiesa collegiata di Ariccia', *Riv. del R. Ist.*, I (1929), 281-5. Brauer-Wittkower, 115 ff.

180. 67. *Ibid.*, 120 ff. See also S. Bordini, in *Quaderni*, XIV, 79-84 (1967), 53-84; extracts from a Roman doctoral thesis on Bernini and the Pantheon (1965-6).

68. C. Fontana, *Il tempio vaticano*, Rome, 1694, 451 ff., illustrations on pages 457, 467.

181. 69. The painting is by Guillaume Courtois, who also supplied the altarpieces in S. Tomaso at Castelgandolfo and S. Andrea al Quirinale.

182. 70. Documents published by Donati in *Riv. del R. Ist.*, VIII (1941), 144, 445, 501. For the history of the church see Brauer-Wittkower, 110 ff.; also F. Borsi, *La chiesa di S. Andrea al Quirinale*, Rome, 1967.

71. W. Lotz, 'Die ovalen Kirchenräume des Cinquecento', *Röm. Jahrb. f. Kunstg.*, VII (1955), 55 ff.

72. Wittkower, *Architectural Principles in the Age of Humanism*, 3rd ed., London, 1962, 97 f.

183. 73. See Note 69.

74. About this important church see now W. Lotz, *op. cit.*, 58, and above Chapter 6, Note 2.

184. 75. It is important to realize that the ground was originally considerably higher. Only three steps led up to the portico; see G. B. Falda's engraving in *Il terzo libro del novo teatro delle chiese di Roma*, Rome [n.d.], 13.

76. See above, Note 74.

77. See p. 114.

78. Pollak, *Kunsttätigkeit*, I, 237-40.

79. For the palace at Modena Bernini mainly functioned as consulting architect in 1651; see L. Zanugg, 'Il Palazzo ducale di Modena', *Riv. del R. Ist.*, IX (1942), 212-52.

His contribution to the Quirinal Palace, part of the so-called *manica lunga* (1656-9) along the Via del Quirinale, has now been clarified by J. Wasserman, *Art Bull.*, XLV (1963), 240.

185. 80. Such as the projects for the Piazza del Quirinale (Brauer-Wittkower, 134), for the monument of Philip IV of Spain to be erected under the old portico of S. Maria Maggiore (*ibid.*, 157), and for the apse of S. Maria Maggiore (1669), later executed by C. Rainaldi (*ibid.*, 163; S. Fraschetti, *Il Bernini*, Milan, 1900, 379-

84; A. Mercati in *Roma*, XXII (1944), 18, documents).

81. Illustrated in Falda, *Il nuovo teatro delle fabbriche*, I, Rome, 1665, plate 30.

82. Brauer-Wittkower, 126; A. Busiri Vici in *Palladio*, VI (1956), 127.

83. Built for Niccolò Ludovisi, the nephew of Gregory XV, who had married a niece of the Pamphili Pope Innocent X. For the palace, see now the monumental, fully documented work by F. Borsi (and others), *Il Palazzo di Montecitorio*, Rome, 1967.

84. E. Coudenhove-Erthal, *Carlo Fontana*, 71 ff., figure 25, shows what was standing when Fontana began working. It is mainly the central area that must be assigned to him. Vol. 168 of the Fontana papers in the Royal Library at Windsor contains documents and drawings referring to the palace.

186. 85. At the time large parts of the palace were standing. For its history, see Thomas Ashby, 'The Palazzo Odescalchi in Rome', *Papers of the British School at Rome*, VIII (1916), 87 ff.; Brauer-Wittkower, 127; A. Schiavo, *La Fontana di Trevi*, Rome, 1956, 239.

187. 86. In Rome, mainly Antonio da Sangallo's Palazzo del Banco di S. Spirito (1523-34) and Girolamo Rainaldi's Palazzo Senatorio on the Capitol.

87. Examples of indirect derivation: Fuga's Palazzo Cenci-Bolognetti, Piazza del Gesù, Rome (*c.* 1745); G. A. Veneroni's Palazzo Mezzabarba at Pavia (1728-30); and Juvarra's Palazzo Ferrero d'Ormea at Turin. Outside Italy, among numerous examples, Martinelli's Liechtenstein Palace and Fischer von Erlach's palace of Prince Eugen, both in Vienna, and the Marble Palais in Leningrad.

88. For the history of the Louvre, see L. Hautecœur, *Le Louvre et les Tuileries de Louis XIV*, Paris, 1927; *idem*, *Histoire du Louvre*, Paris, 1928. For Bernini's contribution, Josephson, *G.d.B.A.*, XVII (1928), 75-91, and Brauer-Wittkower, 129-33. The whole story summarized in Blunt, *Art and Architecture in France*, 230 ff. See also A. Schiavo in *Bollettino del Centro di Studi per la Storia dell'Architettura*, no. 10 (1956), 23.

For the Louvre projects by Candiani, Rainaldi, and Cortona, see P. Portoghesi, in *Quaderni* (1961), 243.

89. Plan: Brauer-Wittkower, plate 175; east front: Hautecœur, *Le Louvre*, plate 33. Another drawing in Blunt, plate 155B.

188. 90. R. W. Berger, in *Journal Soc. Architect. Historians*, XXV (1966), 170 ff., regards Bernini's first Louvre project as a direct offspring of Antoine Le Pautre's design for an ideal château, published in the latter's *Desseins de plusieurs palais* (1652). But no one who has eyes to see will be able to accept this hypothesis.

91. See Brauer-Wittkower and Josephson, *op. cit.*, 81 (illustration).

92. Illustrated in Muñoz, *Pietro da Cortona* (Bibl. d'arte ill.), Rome, 1921, 15. - See below, p. 246.

93. The east front and the plan illustrated in Blunt, plate 155C and figure 24.

94. This was an insufficient answer to the criticism of Colbert, who held that the entrance of the earlier projects was too insignificant.

95. The conversations reported by the Sieur de Chantelou show that Bernini regarded this feature as immensely important (1 July 1665).

96. Bernini regarded the old rooms of the south front as too small and artistically too insignificant to serve as a royal apartment.

97. It is evident that Bernini also wanted to hide the old court façades, the pride of French architecture.

98. See A. Blunt, *op. cit.*

189. 99. Josephson, *op. cit.*, 82-9.

100. But the influence of Bernini's project on general principles of design in France should not be underestimated. The traditional high-pitched roof and the pavilion system disappear after his visit. In addition, his project found a sequel in other countries. Examples: the Czernin Palace in Prague (1669), Sacchetti's Royal Palace in Madrid (1739), and Tessin's Royal Palace in Stockholm (see H. Rose in *Festschrift Heinrich Wölfflin*, Munich, 1924, 245).

101. The only detailed discussion of the history of the Piazza is in Brauer-Wittkower, 64-102. See also V. Mariani, *Significato del portico berniniano di S. Pietro*, Rome, 1935, and the more recent interesting contribution by C. Thoenes, *Zeitschr. f. Kunstg.*, XXVI (1963), 97-145. Bernini's principal assistants were his brother Luigi, Mattia de' Rossi, Lazzaro Morelli, and the young Carlo Fontana.

102. Opposition was centred in reactionary ecclesiastical circles. They supported an elaborate counterproject of which twenty-five drawings survive which time and again are attributed to Bernini himself. For the whole problem see Wittkower in *J.W.C.I.*, III (1939-40). Also Brauer-Wittkower, 96 ff.

103. This made it necessary to pull down Ferrabosco's tower, see above, p. 29.

190. 104. See above, p. 112.

105. Mainly by Ferrabosco; see D. Frey, 'Berninis Entwürfe für die Glockentürme von St Peter in Rom', *Jahrbuch der kunsthistorischen Sammlungen, Wien*, XII (1938), 220 f., figures 243-5.

106. The complex history of these towers is discussed in Brauer-Wittkower, 37-43; see also Frey, *op. cit.*, and Underwood in *Art Bull.*, XXI (1939), 283; H. Millon in *Art Quarterly*, XXV (1962), 229, summarized the whole question.

107. Brauer-Wittkower, 41 ff., plates 156-7; D. Frey, *op. cit.*, 224 f.

108. Brauer-Wittkower, plate 164B, and Wittkower in *Boll. d'Arte*, XXXIV (1949), 129 ff.

193. 109. Bernini himself talked about this in Paris (Chantelou, ed. Lalanne, 42). Similar arguments also in Bernini's report of 1659-60 (fol. 107v, see Brauer-Wittkower, 70).

110. First used by Pietro da Cortona in S. Maria della Pace.

111. Brauer-Wittkower, 88 ff. Previous discussion of the Scala Regia with partly different results, Panofsky, *Jahrb. Preuss. Kunstslg.*, XL (1919) and Voss, *ibid.*, XLIII (1922).

195. 112. D. Frey, *op. cit.*, 217.

113. The whole material for this question in Wittkower, *Boll. d'Arte, loc. cit.* Also H. Hager, in *Commentari*, XIX (1968), 299 ff.

114. For Carlo Fontana's projects see Coudenhove-Erthal, *op. cit.*, 91 ff. and plate 39. For later and similar projects see T. A. Polazzo, *Da Castel S. Angelo alla basilica di S. Pietro*, Rome, 1948.

115. This statement is true in spite of the fact that this type of colonnade was first devised by Pietro da Cortona, see below, p. 246.

196. 116. There are two passages for pedestrians and between them a wider one for coaches.

CHAPTER 9

197. 1. The name Borromini (without Castelli) does not appear in documents before 1628. For portraits of Borromini, see P. Portoghesi, *Burl. Mag.*, CIX (1967), 709 f.

2. His activity can be followed in documents dating between 1624 and 1633; see Pollak, *Kunsttätigkeit*, II, Muñoz in *Rassegna d'Arte*, XIX (1919), 107 ff., and *ibid.*, 'Francesco Borromini nei lavori della Fabbrica di S. Pietro', *Scritti in onore di B. Nogara*, Rome, 1937, 319.

3. Between 1621 and 1623, see N. Caflisch, *Carlo Maderno*, Munich, 1934, 141.

198. 4. Brauer-Wittkower, 27 f.

5. Exact date of the execution of the cloisters: 6 February 1635 to 28 October 1644: see A. Contri in *L'Architettura*, I (1955), 229, with valuable measured drawings.

199. 6. See E. Hempel, *Borromini*, Vienna, 1924, figures 6-9.

201. 7. P. Portoghesi, in *Quaderni* (1954), no. 6, 16, has come to somewhat similar conclusions. See also below, Note 27.

For the wider issues involved see Wittkower, 'Systems of Proportion', in *Architects' Year Book*, V (1953).

203. 8. The pattern is derived from S. Costanza, via the illustration in Serlio's Fourth Book.

206. 9. The name derived from the motto 'Initium sapientiae timor Domini' engraved over the main entrance.

H. Thelen, in his thorough reconstruction of the history of the building (*Miscellanea Bibl. Hertzianae*, 1961, 285–307), convincingly shows that Giacomo della Porta had built the closed arcades of the hemicycle long before Borromini took over.

10. An exhaustive geometrical analysis by L. Benevolo, 'Il tema geometrico di S. Ivo alla Sapienza', *Quaderni* (1953), no. 3.

11. See, e.g., the illustration in Serlio, *Tutte l'opere d'architettura*, Venice, 1566, 62, of a temple 'fuori di Roma'.

208. 12. The string-courses run on across the two other bays C.

210. 13. The feigned coloured marble effect that was given the church under Pius IX in 1859 was removed in a recent restoration and the church was given back its original white appearance.

For the emblematic character of the architecture, see the papers by H. Ost and P. de la Ruffinière du Prey (Bibliography).

For S. Ivo, see also C. Brandi, *Struttura e architettura*, Turin, 1967, 94 ff.

14. Other examples are the 'nymphaeum' in the garden of Sallust (Flavian), perhaps the earliest building of this type; the vestibule, Piazza d'Oro, Hadrian's Villa, Tivoli (*c.* A.D. 125–35); and, of the same period, the Tempio di Siepe, Campo Marzo, Rome. Illustrations in G. T. Rivoira, *Roman Architecture*, Oxford, 1925.

15. The ruins of Baalbek were already known in the sixteenth century. The 'Grand Marot' of about 1660–70 has a reconstruction of the great temple.

16. W. Born, 'Spiral Towers in Europe and their oriental Prototypes', *G.d.B.A.*, XXIV (1943), 233 ff., has shown that, through the tradition of the Tower of Babel, spiral towers were more common in sixteenth- to eighteenth-century Europe than is generally realized.

212. 17. The twelve Apostles in the tabernacles of the nave (see p. 436) and the oval paintings above them belong to the Pontificate of Clement XI. Borromini's plans for portico and façade remained on paper. They were later executed by Alessandro Galilei (p. 382).

18. For the development of Borromini's project see, above all, K. Cassirer, 'Zu Borromini's Umbau der Lateransbasilika', *Jahrb. Preuss. Kunstslg.*, XLII (1921), 55 ff. In addition, H. Egger in *Beiträge zur Kunstgeschichte Franz Wickhoff gewidmet*, Vienna, 1903, and M. Dvořák, 'Francesco Borromini als Restaurator', *Kunstgeschichtliches Jahrbuch der k.k. Zentral-Kommission*, Vienna, 1907 (Beiblatt), 89 ff.

19. H. Thelen, *Kunstchronik*, VII (1954), 264 ff.

213. 20. On the meaning of the capriccio in seventeenth-century art, see Argan, *Borromini*, 40.

21. For a detailed discussion of all the monuments, see P. Portoghesi, 'I monumenti borrominiani della basilica lateranense', *Quaderni* (1955), no. 11, and R. U. Montini in *Palladio*, V (1955), 88 ff.

22. New documents for the history of the church were published by L. Montalto in *Studi Romani*, V (1957), and *Palladio*, VIII (1958). See also F. Fasolo, *L'opera di Hieronimo e Carlo Rainaldi*, Rome, 1960, chapter X, who makes it probable that the planning of the church began as early as 1645–7.

215. 23. See K. Noehles in *Zeitschr. f. Kunstg.*, XXV (1962), 173.

I find a rather high-handed though unspecific critique of my analysis of S. Agnese in G. Eimer's book on S. Agnese (Bibliography under Rome), 114; hence I saw no reason for any changes.

24. This is due to the fact that the frames of the painted pendentives are carried down through the area of the attic. It is worthwhile to compare Borromini's solution with that in St Peter's, where the entablature over the pilasters of the pillars does not project and where the arch of the vault rests on the entablature without an attic – thus producing neither the unifying verticalism nor the slender proportions of S. Agnese.

217. 25. For a further analysis, see Wittkower, *Art Bull.*, XIX (1937), 256 ff.

26. Even Bernini had a hand in some of the decoration; he was responsible for the details of the entablature.

218. 27. For a different opinion, see A. de Rinaldis, *L'arte in Roma dal Seicento al Novecento*, Bologna, 1948, 197. The lantern appears in a ground plan in the Albertina (Hempel, figure 61) drawn into the plan of the 'drum'. This drawing is one of the most interesting documents for Borromini's medievalizing approach to planning. His procedure can be fully reconstructed, since the design contains the complete geometrical pattern carefully drawn. It appears, first, that the essential points of the construction are determined by incommensurable magnitudes and, secondly, that the shape of the lantern is geometrically derived from the drum, and it is this – the geometrical unification of different storeys drawn into one plan – that reveals the closest contact with late medieval principles.

219. 28. For other cherub-herms in Borromini's late work, see the monument of Pope Sergius IV in S. Giovanni in Laterano and the façade of S. Carlo alle Quattro Fontane [119].

29. The coherence of the tiers of the tower is stressed, however, by the placing of all the supporting elements

in the diagonals, corresponding to the buttresses of the 'drum'.

Of the whole exterior only the two upper tiers and the crowning feature of the tower were stone-faced and finished.

30. Until recently the design of the church had always been dated in the early 1650s. The revision of the date is due to Paolo Marconi, in *Palatino*, X (1966), 194–200; see also *idem* in *Studi sul Borromini. Atti del Convegno*, Rome, 1967, I, 98.

31. The motif of the straight entablature *cum* arch derives from Hellenistic sources (familiar to Quattrocento architects) and was here first used by Borromini. In 1646 he incorporated it in his project for the Palazzo Pamphili in Piazza Navona and executed it in the gallery of the same palace (see below, Note 45). It is not impossible that more than ten years later this stimulated Pietro da Cortona to his use of the same motif in the façade of S. Maria in Via Lata [148].

32. Here too Borromini worked with similar overlapping rhythms which, starting with the entrance bay, may be expressed as:

A | b′ b b′ | A | b′ b b′ | A | . . .

or: b′ A b′ | b | b′ A b′ | b | . . .

33. It is not certain that anything above the cornice corresponds to Borromini's design. In any case, the interior decoration, including the diamond-shaped simple coffers of the vault (painted), belongs to the restorations of 1845 and 1928–9. See Marconi (above, Note 30) and M. Bosi, *S. Maria de' Sette Dolori*, Rome, 1953.

34. Interior decoration after Borromini's death, mainly by Carlo Fontana's son, Francesco. Complete restoration of the interior in 1815.

222. 35. For the sake of completeness, the following list of minor ecclesiastical works may supplement the buildings discussed in the text: 1638–43, decoration, S. Lucia in Selci, Rome (discussion and documents in P. Portoghesi, *Quaderni*, nos. 25–6 (1958), 2). – 1640–2, altar of the Annunciation, SS. Apostoli, Naples, closely resembling the system used for the façade of the Oratory of St Philip Neri. – 1656 (not 1664), design of high altar chapel, S. Giovanni de' Fiorentini, with the Falconieri tombs (document published by M. V. Brugnoli, *Boll. d'Arte*, XLV (1960), 341. The high altar of S. Giovanni de' Fiorentini, begun much earlier by Pietro da Cortona (1634), shows (the latter's style). Borromini's Falconieri crypt in the same church, only recently discovered, should also be mentioned; see E. Rufini, *S. Giovanni de' Fiorentini* (Le chiese di Roma

illustrate, 39), Rome, 1957, 67, 103 (document). – 1658, rebuilding of the little chapel S. Giovanni in Oleo near Porta Latina, with a dome hidden behind a cylindrical feature (decorated with a classicizing frieze) and a cone-shaped roof. – For other minor work, see Portoghesi, *Quaderni*, nos. 25–6 (1958). – For Cappella Spada, see Heimbürger Ravalli, *Architettura, scultura, ed arti minori nel barocco italiano. Ricerche nell' archivio Spada* (Florence, 1977).

36. A. Pernièr, 'La Torre dell' Orologio dei Filippini', *Capitolium*, X (1934), and *idem*, 'Documenti inediti sopra un' opera del Borromini: La fabbrica dei Filippini', *Archivi*, II (1935), 204. See also G. Incisa della Rocchetta, 'Un dialogo del P. Virgilio Spada sulla fabbrica dei Filippini', *Arch. della Soc. romana di storia patria*, XC (1967), 165–211.

37. Borromini laid the main axis through the centre of the courtyards [135], but the long western wing along the Via de' Filippini has no correspondence on the side adjoining S. Maria in Vallicella. Consequently the façade left (west) of the central axis consists of five bays, while the right-hand side (near the church) has only three bays. But the eye does not notice the asymmetry, since the two farthest bays on the left lie outside the quoined edge of the façade proper.

224. 38. We must abstain from a further analysis, particularly of the complex treatment of the walls. Reference may be made to Argan's pertinent remarks about the transformation of functional into decorative elements and vice versa (*Borromini*, 53).

39. In the clerestory above the cornice the wall articulation is taken up and continued in the bands of the flat vaulting – a first step towards the late solution of the church of the Collegio di Propaganda Fide.

225. 40. For the small cloister of S. Carlo, Borromini had chosen a different design: he carried an extremely simple form of the 'Palladio motif' without any interruption across the bevelled corners. See p. 199.

41. For the clock-tower see A. Pernièr in *Capitolium*, X (1934), 413.

42. See also the design in G. B. Montano, *Scelta di varj tempietti antichi*, Rome, 1624, plate 3, which was certainly known to Borromini and which he must have regarded as authentically antique. Heimbürger Ravalli, *op. cit.*, 131 ff., suggests influence of the *quarantore* decorations.

42a. See P. Portoghesi, *Borromini*, Rome, 1967, 174.

43. See O. Pollak's classic article 'Die Decken des Palazzo Falconieri in Rom', *Kunstgeschichtliches Jahrbuch der k.k. Zentral-Kommission* (1911). The whole problem of Borromini's decoration has been discussed

by P. Portoghesi in *Boll. d'Arte*, XL (1955), 12–38.

44. Borromini, of course, had knowledge of Vasanzio's loggia in the garden of the Villa Mondragone at Frascati (pp. 36–7).

45. Full discussion of the various plans for the palace by D. Frey, 'Beiträge', *Wiener Jahrb.*, III (1924), 43 ff. Here, too, publication of Borromini's alternative project for the whole palace.

227. 46. A loggia of the courtyard with the richly decorated doorway at its end and the simple spiral staircase behind it, dating from before 1643, were incorporated into the later building. No less than thirty-eight drawings by Borromini for the palace survive (Vienna, Albertina). Full discussion by G. Giovannoni, 'Il Palazzo Carpegna', in *La Reale Insigne Accademia di S. Luca*, Rome, 1934, 35–66. M. Tafuri (in *Quaderni*, XIV, 79–84 (1967), 85 ff.) examined Borromini's contribution again on the basis of documents in the Falconieri–Carpegna archive; Borromini's alterations were executed between 1643 and 1647.

47. A similar idea is to be found in a drawing in the Uffizi, attributed to Borromini, published by Portoghesi, *Quaderni* (1954), no. 6, 28.

Among other domestic buildings by Borromini mention may be made of the Palazzo di Spagna (1640s) where, according to Hempel (133), the vestibule and staircase of three flights survive. The later Palazzo Spada in Piazza di Monte Giordano (about 1660) lost its Borrominesque character in a modernization of the nineteenth century, but the courtyard is extant with alterations. Hempel's attribution of the Palazzo Barberini alli Giubbonari has to be abandoned; see B. Maria Apollonj in *Capitolium*, VIII (1932), 451. Borromini's precise contribution to the Villa Falconieri at Frascati has not yet been determined. An interesting project for the villa of Cardinal Pamphili near Porta S. Pancrazio has been published by Portoghesi in *Quaderni* (1954), no. 6.

48. The inspiration for the giant order probably came once again from Michelangelo's Capitoline Palaces, which influenced Borromini throughout his lifetime; but the closely-set pilasters and narrow bays are reminiscent of Palladio's late style of the Palazzo Valmarana and the Loggia del Capitano.

228. 49. It is true that the attic is later (1704), a fact hitherto overlooked, but use must have been made of a design by Borromini. At the time of Borromini's death there was an iron railing over the cornice; see L. Cruyl's drawing of 1665 in the Albertina (H. Egger, *Römische Veduten*, Vienna, 1931, II, plate 75); G. B. Falda's engraving in *Il nuovo teatro delle fabbriche . . .*, I, [Rome], 1665, plate 9; Falda's plan of Rome of 1676; and the drawing in the Library of Windsor Castle, Albani volume 185, no. 10328.

CHAPTER 10

231. 1. *Pietro da Cortona*, Florence, 1962.

2. See G. Briganti in *Paragone*, XI (1960), no. 123, 33; also Toesca (next Note).

3. His biography in Passeri–Hess, 75; see also I. Toesca in *Boll. d'Arte*, XLVI (1961), 177.

4. Now in the Accademia di S. Luca, Rome. For Marcello Sacchetti's patronage of Cortona, see Haskell, *Patrons*, 38.

5. Marino had been in Paris for eight years until 1623. He died in 1625. The *Rinaldo and Armida* painted for Marino (Passeri–Hess, 375) has not yet been traced. For Marino, see G. Ackerman, *Art Bull.*, XLIII (1961), 326.

6. For Cassiano del Pozzo and his collection, see C. C. Vermeule, *Art Bull.*, XXXVIII (1956), 31; *idem*, *Proceedings of the American Philos. Soc.*, CII (1958), 193, and *Transactions of the American Philos. Soc.*, N.S. L, pt 5; F. Haskell and S. Rinehart, *Burl. Mag.*, CII (1960), 318, and the able summary in Haskell's *Patrons*, 98 ff. For Cassiano in Spain, see E. Harris, *Burl. Mag.*, CXII (1970), 364 ff.

7. The frescoes at Frascati and in the Palazzo Mattei, to be discussed later, are the only memorable exception.

8. He may have had some training at Cortona with his uncle Francesco, who was an architect.

232. 9. Voss, 543. – Briganti, 111, on the contrary, emphasizes Cortona's unbroken powers as a painter to the very last.

10. Payments to Cortona begin in 1626 and run until 1630. The attribution of the building to Pietro da Cortona is maintained in a series of eighteenth-century drawings by Pier Leone Ghezzi (1674–1755) which gives a valuable general view and plans of the three storeys (London, Coll. Sir Anthony Blunt). In his brief description, Ghezzi calls the house 'casino fatto ad uso di fortezza'.

See also G. Tomassetti, 'Della Campagna Romana: Castelfusano', *Archivio della R. Società Romana di storia patria*, XX (1897); Francesco Chigi, 'La pineta di Castel Fusano', *Vie d'Italia*, XXXVIII (1932).

11. Only the grotto is preserved (see Luigi Càllari, *Le ville di Roma*, Rome, 1943, 266). Views of the villa exist in A. Specchi's *Quarto libro del nuovo teatro . . . di Roma* (1699), plate 44; G. Vasi's *Delle magnificenze di Roma antica e moderna*, V, Rome, 1754, and Percier and Fontaine's *Choix des plus célèbres maisons de plaisance de Rome*, Paris, 1809, plates 39–41. Our knowledge of the villa is considerably furthered by some Ghezzi drawings in the Blunt collection (see last Note): (i) the ground-plan [140], only published once in [Blunt–Wittkower], *Exhibition of Architectural and*

Decorative Drawings, The Courtauld Institute (February, 1941), No. 15, plate 1; (ii) the section and plan of the grotto; (iii) one of the windows on the first floor at the sides of the central niche. See also Incisa della Rocchetta in *L'Urbe* (1949), no. 3, 9–16.

12. According to Vasi, Cardinal Giulio commissioned the building; according to Specchi's caption it was the Marchese Marcello.

13. A. Marabottini (*Mostra di Pietro da Cortona*, 1956, 34) believes that the pictorial decoration points to a date not earlier than 1630. A. Blunt in *Burl. Mag.*, XCVIII (1956), even suggested 1634-5. Briganti, 191, does not commit himself.

14. Wittkower, 'Pietro da Cortonas Ergänzungsprojekt des Tempels in Palestrina', *Festschrift Adolph Goldschmidt*, Berlin, 1935, 137. For Praeneste, see C. Severati (and others), in *L'Architettura*, XVI (1970), no. 6, 398, and no. 8, 540; valuable for the many illustrations.

234. 15. See the letter written by Cortona's nephew, Luca Berrettini, to Ciro Ferri, 24 March 1679, in G. Campori, *Lettere artistiche inedite*, Modena, 1866, 510.

16. Only the front with the portal and two windows of characteristically Cortonesque design is standing. A. Blunt, *J.W.C.I.*, XXI (1958), 281, suggests that the theatre was executed between 1638 and 1642.

Also, one of the 'Quattro Fontane', on the side of the Palazzo Barberini, is by Cortona, but it was not finished until the reign of Alexander VII (probably after 1665).

235. 17. Along the main front Cortona indicated in pencil the rooms of the *piano nobile*. The 'sala' occupies 4 octagons, the 'salone' 4 octagons plus the vestibule, and the 'anticamera' 2 octagons. The length of Cortona's Salone would have been 125 feet compared with the 85 feet of the executed one. – The note in ink on the left mentions that a corridor should run above from which one could reach all the rooms.

18. A scale in Roman palmi is at the bottom of the sheet. Cortona's ground floor would have been *c*. 3 feet higher than the present one, judging from the diameter of the columns in his plan.

19. O. Pollak in *Kunstchronik*, XXIII (1912) and *idem*, *Kunsttätigkeit*, I, 163.

20. The documents published by O. Pollak, *op. cit.*, 185 ff. See also G. Giovannoni, 'La Chiesa di S. Luca e il suo restauro', in *La Reale Insigne Accademia di S. Luca*, Rome, 1934, 19–25, with measured ground plan. All earlier work on the church has now been superseded by K. Noehles' excellent monograph (see next Note).

21. An important drawing by Cortona in Munich (Graphische Sammlung), revealing that at first a sepulchral church was planned, was published by H. Keller,

in *Miscellanea Bibl. Hertzianae* (1961), 375. E. Hubala, in *Zeitschr. f. Kunstg.*, XXV (1962), 125, enriched the discussion by publishing some drawings in the Castello Sforzesco, Milan. Keller's and Hubala's results have been corrected by K. Noehles, *La chiesa dei SS. Luca e Martina*, Rome, 1969, 58 ff., who convincingly dates the 'mausoleum' project as early as 1623-4.

22. K. Noehles, *op. cit.*, has, however, shown that the completion of the church dragged on until 1669.

23. The bays adjoining the crossing in the longitudinal axis are wide enough to accommodate doors which have balconies above them. The corresponding bays in the transverse axis contain only niches.

237. 24. Michelangelo's influence was stressed by Hubala, *op. cit.*

241. 25. See, e.g., Michelangelo's projects for the façade of S. Lorenzo, Florence.

26. The plan [142] illustrates that the whole front may be likened to one of the apses flattened out and reversed. The position and motif of the columns corresponds, but while the wall is recessed inside, outside it seems to bulge outward.

27. S. Carlino, begun in the same year, remained for a long time without façade; see p. 203.

28. O. Pollak in *Kunstchronik*, XXIII (1912), 565.

29. In the interior Cortona was above all responsible for the modernization of the old dome. There is good reason to believe that this was not finished in 1657, the date of the inscription of the consecration (see Brauer-Wittkower, 112, note 3). The dome shows once again the combination of ribs and coffers, but the coffers are classical in shape and un-Cortonesque. Since Cortona was absent from Rome in 1658, it is not at all unlikely that the work was left in the hands of the young Carlo Fontana who, at precisely this period, also began to assist Bernini. It is therefore possible that Cortona's design was classicized under Bernini's influence.

30. Illustration 146, redrawn from a preparatory drawing by Cortona in the Vatican Library, shows one street flanking the church on the right and another at an angle to the church on the left. The dotted lines indicate what had to be demolished in order to create the small piazza.

242. 31. The quadrant wing on the right-hand side is a sham structure.

32. The portico is also an impressive landmark when approached from the Via di Parione Pace.

33. Brauer-Wittkower, 74.

34. In actual fact, Cortona permitted himself considerable freedom. The column is not 'correct' Doric, nor is the entablature 'correct' Ionic.

35. The break at right angles of a coherent moulding is essentially a Borrominesque motif. It first occurs at the garden front of the Palazzo Barberini.

For a somewhat different interpretation of the façade of S. Maria della Pace, see H. Sedlmayr, *Epochen und Werke*, 1960, II, 66.

244. 36. N. Fabbrini, *Vita del Cav. Pietro da Cortona*, Cortona, 1896, 118; Luigi Cavazzi, *La Diacona di S. Maria in Via Lata*, Rome, 1908, 130 ff.

37. I have mentioned before that Borromini used the motif more than once (Chapter 9, Note 31) and that Cortona may have been stimulated by him. I have also pointed out that the Hellenistic architecture of the Near East was known during the seventeenth century (Chapter 9, Note 15).

245. 38. Cortona's dome was begun in 1668 but finished after his death, as testified by Luca Berrettini (see above, Note 15). This probably accounts for certain rather dry Cortonesque details which induced some scholars to deny Cortona's authorship of the design altogether. There is no reason to doubt that Cortona also made designs for the interior decoration of the church. For further data relating to S. Carlo al Corso, see Chapter 12, Note 23.

39. The Cappella Gavotti, with powerful motifs compressed into a small area and richly decorated with sculpture by Raggi, Ferrata, and Cosimo Fancelli, is Cortona's latest masterpiece. But he did not live to see it finished: Ciro Ferri completed it after his death. The classicizing altar of St Francis Xavier was completed as late as 1678.

For Ciro Ferri as designer of sculptural and architectural decorations, see K. Noehles in *Miscell. Bibl. Hertzianae* (1961), 429. Also H. W. Kruft, *Burl. Mag.*, CXII (1970), 692 ff.

246. 40. Bottari, I, 418, 419.

41. The problems presented by these drawings are rather complex. Cortona's principal design seems to be Uffizi 2231. K. Janet Hoffman in an unprinted thesis (New York University, 1941) tried to establish the authentic drawings and their chronological sequence.

42. Erected in 1660 and pulled down in the nineteenth century. V. Lugari, *La Via della Pedacchia e la casa di Pietro da Cortona*, Rome, 1885, contains some illustrations.

43. K. Noehles, 'Die Louvre-Projekte von Pietro da Cortona und Carlo Rainaldi', *Zeitschr. f. Kunstg.*, XXIV (1961), 40; see also P. Portoghesi in *Quaderni* (1961), nos. 31-48, 249.

44. Chantelou (ed. Lalanne), 257, and Bottari, II, 51 f. (Ciro Ferri's letter to Lorenzo Magalotti, 17 February 1666.)

45. G. Giovannoni, 'Il restauro architettonico di Palazzo Pitti nei disegni di Pietro da Cortona', *Rassegna d'Arte*, XX (1920), 290; E. Vodoz in *Mitteilungen des kunsthistorischen Instituts in Florenz*, VI (1941), no. 3-4, 50.

46. See Note 14. Cortona's original drawing is in a volume once belonging to John Talman, purchased before the war by the Victoria and Albert Museum.

47. Illustrated in A. E. Brinckmann, *Theatrum Novum Pedemontii*, Düsseldorf, 1931; see also L. Hoctin in *L'Œil*, no. 97 (1963), 70. Excellent illustrations in A. Pedrini, *Ville ... in Piemonte*, Turin, 1965, 367 ff.

48. Brauer-Wittkower, 148.

49. Bottari, I, 419.

247. 50. This was, among others, Luca Berrettini's opinion stated in the letter mentioned above, Note 15.

51. Dated, probably correctly, *c.* 1616 by Briganti, 153, who discovered these frescoes. For an early work, perhaps of the same period, see E. Schleier, *Burl. Mag.*, CXII (1970), 752 ff.

52. J. Hess, 'Tassi, Bonzi e Cortona a Palazzo Mattei', *Commentari*, V (1954), 303. For the correct dates (documents), see K. Noehles in *Kunstchronik*, XVI (1963), 99, and G. Panofsky-Soergel, in *Röm. Jahrb. f. Kunstg.*, XI (1967-8), 142 ff.

Hess attributes the decorative organization of the ceiling to Bonzi, while Noehles believes that Cortona rather than Bonzi was responsible for it.

53. Luca Berrettini reports that Cortona drew all the reliefs of Trajan's Column no less than three times. One of these drawings is preserved in the Gab. Naz. delle Stampe, Rome (*Mostra di Pietro da Cortona*, Rome, 1956, plate 51); others are in a sketchbook by Cortona in the R. Ontario Museum, Toronto, see G. Brett in *Bulletin R. Ontario Mus.* (December 1957), no. 26, 5. According to the sources, Cortona was particularly interested in the engravings of Polidoro da Caravaggio, and echoes of his work are evident in the later Cortona.

249. 54. For the Sacchetti and Barberini patronage of Cortona, see the documents published by I. Lavin (with M. Aronberg Lavin), *Burl. Mag.*, CXII (1970), 446 ff.

55. His life in Passeri-Hess, 168. A list of his paintings in Waterhouse, 51, superseded by A. Sutherland Harris's study (see Bibliography).

56. For Sacchi's contribution see G. Incisa della Rocchetta in *L'Arte*, XXVII (1924), 60, and H. Posse, *Der römische Maler Andrea Sacchi*, Leipzig, 1925, 27. See also A. Sutherland Harris and E. Schaar, *Die Handzeichnungen von Andrea Sacchi und Carlo Maratta*, Kunstmuseum Düsseldorf, 1967, 26.

57. Further to the Castel Fusano frescoes, Note 56 and Posse in *Jahrb. Preuss. Kunstslg.*, XL (1919), 153; Briganti, 177.

58. Before 1625; see Jane Costello in *J.W.C.I.*, XIII (1950), 244; *Mostra di Pietro da Cortona*, Rome, 1956, 3, 25. For the date, see Briganti, 164.

250. 59. Cortona copied after Titian for his patron, Marcello Sacchetti. Sandrart (ed. Peltzer, p. 270) reports that he himself and Cortona, Duquesnoy, Poussin, and Claude studied Titian's *Bacchanals*, then in the Casino Ludovisi. See also above, p. 276.

60. Posse's masterly discussion of the ceiling has not yet been superseded (*Jahrb. Preuss. Kunstlg.*, XL, 1919), and, although we cannot fully agree with him on all points, the reader must be referred to it for further study.

252. 61. The only known preparatory drawing for the system of the ceiling (Munich; Posse, figure 26) shows that Cortona first envisaged it with clearly defined frames for *quadri riportati* still close to the Farnese ceiling.

The large bozzetto in oil in the Galleria Nazionale, Rome (E. Lavagnino, *Boll. d'Arte*, XXIX (1935), 82), corresponds so closely to the execution that it must be a copy rather than a preliminary study.

62. This is already true for Michelangelo's Sistine Ceiling. Characteristic later examples: Pierino del Vaga's Sala del Consiglio, Castel S. Angelo, and Salviati's frescoes in the great hall of the Palazzo Farnese.

63. Detailed description in H. Tetius, *Aedes Barberinae*, Rome, 1642. For an illuminating revision of previous interpretations, see W. Vitzthum, *Burl. Mag.*, CIII (1961), 427, whom I follow.

For the various levels of allegorical meaning read into such works in the seventeenth century, see J. Montagu, in *J.W.C.I.*, XXXI (1968), 334 f.

253. 64. In addition to the frescoes of the Gran Salone, Cortona in the Palazzo Barberini decorated the Chapel and two rooms on the first floor (1632-3). To the same period also belongs the beginning of his work for the Chiesa Nuova (S. Maria in Vallicella, fresco on ceiling of sacristy, 1633-4). Further, in 1633 he began the large cartoons of Constantine's life for the Barberini tapestry works, which he directed from 1630 on (Urbano Barberini, in *Boll. d'Arte*, XXXV (1950), 43, 145). For these tapestries, see now D. Dubon, *Tapestries from the Samuel H. Kress Collection at the Philadelphia Museum of Art*, London, 1964, and the critical review by W. Vitzthum, *Burl. Mag.*, CVII (1965), 262 f.

65. For this and the following see H. Geisenheimer, *Pietro da Cortona e gli affreschi di Palazzo Pitti*, Florence, 1909. Also D. R. Coffin in *Record of the Art Museum Princeton University*, XIII (1954), 33, M. Campbell and M. Laskin, Jr, in *Burl. Mag.*, CIII (1961), 423, W. Vitzthum, *Burl. Mag.*, CVII (1965), 522, and Campbell, *ibid.*, 526 f.

66. The first room – Sala di Venere – was executed in 1641-2. He carried on with the fourth room, the Sala di Giove (1643-5), then with the third, the Sala di Marte (1646), and finally with the second, the Sala di

Apollo, which he began only in 1647 shortly before returning to Rome (for a different interpretation of the documents, see Briganti, 236, who believes that Cortona began the Sala di Apollo in 1642-3). It was finished by Ciro Ferri in 1659-60. The latter was entirely responsible for the Sala di Saturno, 1663-5, the decoration of which is only a faint echo of that of the other rooms.

67. The fresco of the Sala di Marte, here illustrated, is the most developed of the series. In the centre, the Medici coat of arms floating through the air like a sumptuous trophy; along the borders the prince's victorious exploits are rewarded by Justice and Peace.

68. According to Baldinucci (*Notizie de' professori*, Florence, ed. 1846, IV, 428), Raffaello Curradi's pupil, Cosimo Salvestrini, executed the stuccoes of the first room and some of the following ones. On the other hand, James Holderbaum found payments in the Archivio di Stato to the *stuccatori* Battista Frisone, Santi Castellaccio (or Cartellaccio), and Gio. Maria Sorrisi. The latter was one of the *stuccatori* who worked in the Villa Doria-Pamphili in Rome (Chapter 11, Note 24) – proof that Cortona did not find in Florence the specialists he needed.

256. 69. See A. Blunt, *Art and Architecture in France*, 161, 173, 206, 253.

70. M. Lenzi in *Roma*, V (1927), 495; L. Grassi in *Boll. d'Arte*, XLII (1957), 28.

CHAPTER 11

261. 1. *Art and Architecture in France*, 182.

2. H. Posse's biography of Sacchi (Leipzig, 1925) and his article in Thieme-Becker are first-rate contributions and have not been superseded, but an extensive monograph by A. Sutherland Harris is in the press.

For Sacchi's work in the Collegio Romano, see *idem*, *Burl. Mag.*, CX (1968), 249 ff.

262. 3. A. Sutherland Harris (*Burl. Mag.*, CX (1968), 489 ff.) has made it likely that the *St Romuald* was painted in the early 1630s rather than during the last years of the decade, as was generally assumed.

263. 4. O. Pollak, *Kunsttätigkeit*, I, 141. Waterhouse, plates 10, 11; D. Mahon, *G.d.B.A.*, LX (1962), 65; Harris-Schaar (see above, Chapter 10, Note 56), 45 ff.

5. The most important altarpiece of the 1640s, the *Death of St Anne* (S. Carlo ai Catinari, 1649; see Waterhouse, 91) shows that he preserved his rich and warm palette, in contrast to Poussin.

6. G. Incisa della Rocchetta in *L'Arte*, XXVII (1924), 65. For the problems connected with the dating and with the small replicas, see Jane Costello in *J.W.C.I.*, XIII (1950), 242. For the subject, see Passeri-Hess, 29;

H. Tetius, *Aedes Barberinae*, Rome, 1642, 83; Incisa, *loc. cit.*; Posse, *op. cit.*, 38; Haskell, *Patrons*, 50. For this type of allegorical fresco, see E. Gombrich in *J.W.C.I.*, XI (1948), 186. For drawing related to *Divine Wisdom*, see Harris-Schaar, *op. cit.*, 29.

7. M. Missirini, *Memorie per servire alla storia della romana Accademia di S. Luca*, Rome, 1823, 111. Mahon (see Note 4), 97, reasonably suggests the year 1636 for these discussions.

8. R. Lee in *Art Bull.*, XXII (1940), 197.

265. 9. The question whether tragic or epic poetry is the higher form of art goes, of course, back to Aristotle's *Poetics*, XXVI.

10. Pascoli, II, 77. See E. Battisti in *Rendiconti Accademia dei Lincei*, VIII (1933), 139.

11. Malvasia (ed. 1678), II, 267.

12. On this point see p. 140.

13. Albani had planned to write an art theoretical treatise together with a Dr Orazio Zamboni (b. 7 January 1606), about whom little is known. Notes for this work, which can be dated between the early 1640s and Albani's death in 1660, were incorporated by Malvasia in his *Felsina pittrice* (II, 244-58).

14. *Trattato della pittura*, Florence, 1652.

15. G. M. Tagliabue, 'Aristotelismo e Barocco', *Atti del III Congresso Internazionale di Studi Umanistici*, Rome, 1955, 119.

266. 16. It will be noticed that Cortona as a decorator (see p. 253) and as a painter had his following on different sides of the fence.

17. The traditional birth-date 1595 has to be changed to 1598; see the document published by A. Arfelli, *Arte Antica e Moderna*, II, no. 8 (1959), 462.

18. There were, however, many in his own generation who held him in high esteem: I mean not only the small circle of close friends, such as Poussin and Sacchi, but foreigners like Blanchard and Van Dyck, who painted his portrait, and Rubens, who wrote him a most flattering letter. R. S. Magurn, *The Letters of P. P. Rubens*, Cambridge, Mass., 1955, 413, 509, rightly refutes J. Hess's opinion that this letter was a seventeenth-century forgery (see *Revue de l'art ancien et moderne*, LXIX (1936), 21).

19. The entire inventory of 1633 of the Ludovisi collection was published by K. Garas, *Burl. Mag.*, CIX (1967), 287 ff., 339 ff.

267. 20. On Algardi as restorer of antiques see M. Neusser in *Belvedere*, XIII (1928). Apart from the unprinted Harvard thesis by E. Barton (1952), no recent study of Algardi exists and reference must be made to the articles by Posse in *Jahrb. Preuss. Kunstslg.*, XXV (1905), 169 and A. Muñoz in *Atti e Memorie della Reale Accademia di S. Luca*, II (1912), 37.

21. If the apocryphal date is correct, the bust was made as early as 1626. In any case, it dates from before - and probably some years before - the Cardinal's death on 7 August 1637. For this bust, see H. Posse, *Jahrb. Preuss. Kunstslg.*, XXV (1905), and J. Pope-Hennessy, *Italian High Renaissance and Baroque Sculpture*, London, 1963, Catalogue, 142, with further references.

268. 22. In the first (hardback) edition I showed on Plate 96A the bust of Francesco Bracciolini (Victoria and Albert Museum), traditionally and - as it seemed to me - correctly attributed to Algardi. A. Nava Cellini, in *Paragone*, VIII (1957), no. 84, 67, attributed this bust to Finelli and reasserted her attribution *ibid.*, XI (1960), no. 131, 19. It now appears that she is right, for there is contemporary evidence for this attribution (see J. Pope-Hennessy, *Catal. of Ital. Sculpture in the Victoria and Albert Museum*, London, 1964, II, 609 ff., no. 643). The bust shows to what extent Finelli was dependent on Algardi. Together with the bust of Michelangelo Buonarroti the Younger, the Bracciolini must be regarded as his highest achievement as a portrait sculptor.

23. After A. Muñoz's generic discussion of Algardi's portrait busts (*Dedalo*, I (1920), 289), the problem was not treated for forty years. In 1956 O. Raggio (*The Connoisseur*, CXXXVIII (1956), 203) published Algardi's bust of Cardinal Scipione Borghese in the Metropolitan Museum, New York, with some pertinent remarks. Few of the busts are dated and the following sequence, taking into account only part of Algardi's production, is an attempt at a chronological order. The Santarelli seems to be quite early, perhaps the earliest Roman portrait. A group of busts is close to the Millini and should be dated about 1630; mainly the Cardinal Laudivio Zacchia [163] and the so-called Cardinal Paolo Emilio Zacchia Rondanini (Ugo Ojetti, Florence). In contrast to these, the later busts are not only more classical in handling but also show a more balanced relation between the head and the lower part. A date for the later series is supplied by the magnificent busts of Donna Olimpia Pamphili and of the Pamphili prince [164], after 1644, the year of Innocent X's accession to the papal throne. (Bellori called the latter bust 'Benedetto Pamphili', who was the Pope's brother; it is now usually called Panfilo Pamphili but may represent Camillo, the son of Panfilo and Olimpia.) The three posthumous Frangipani busts in S. Marcello al Corso (first mentioned in P. Totti, *Ritratto di Roma moderna*, Rome, 1638) seem to mediate between the early and late group of busts: they clearly display strong classicizing tendencies. Finally, the bust of Mario Millini in S. Maria del Popolo obviously echoes Bernini's Francis I of Este and must date from after 1650; but it was probably executed by a studio

hand. My chronology of Algardi's busts is at variance with that suggested by V. Martinelli in *Il Seicento europeo*, Rome, 1957, Catalogue, 246 ff. Another chronology has been attempted by A. Nava Cellini in *Dizionario Biogr. degli Italiani*, 11 (1960), 350, and *idem, Paragone*, xv (1964), no. 177, 15. For Algardi's busts of Innocent X in the Palazzo Doria, formerly attributed to Bernini, see Wittkower, *Bernini*, 211.

269. 24. The list of Algardi's principal commissions during these years is impressive: 1644–8: building and decoration of the Villa Doria-Pamphili (Belrespiro) (Chapter 12, Note 37; the stuccoes of the villa have now been studied in an exemplary paper by O. Raggio, *Paragone*, no. 251 (1971), 3 ff.); 1645–9: fountain, Cortile S. Damaso, Vatican; *bozzetto* for the fountain's relief with *Pope Liberius baptizing Neophytes* in the Minneapolis Institute of Arts, see Wittkower in *The Minneapolis Inst. of Arts Bulletin* (1960), 29; 1646–53: Attila relief, St Peter's; 1649–50: entire stucco decoration of S. Ignazio; statue of Innocent X, Capitol; 1651–4: sculptural decoration of the main altar, S. Nicolò da Tolentino (finished after Algardi's death by Guidi, Ferrata, and Francesco Baratta).

25. Documents in O. Pollak, *Kunsttätigkeit*, 11. Contract 21 July 1634; the figures were finished in 1644, but the monument was not unveiled until 1652. Peroni and Ferrata, on the strength of Passeri traditionally quoted as the artists responsible for the execution of the two allegories, did not join Algardi's studio until the tomb was practically completed.

26. The relief celebrates a papal triumph over worldly powers. Leo's reign had lasted only twenty-seven days (1605) and offered little scope for a suitable subject. The scene chosen shows Henry IV of France signing the peace with Spain. With one hand on the Gospels, the king affirms the sanctity of the treaty in the presence of Leo XI, then papal legate at the French court.

27. The idea was derived from ancient or Early Christian sarcophagi, but the trapezoid shape was a novelty.

270. 28. The great model was finished for the Holy Year 1650 and placed in position. It is one of the few such models that have survived (now Biblioteca Vallicelliana). Domenico Guidi's collaboration (Passeri) seems to be noticeable in the right half of the relief. It is less certain whether Ferrata had a share in the execution, as Baldinucci maintains.

271. 29. See Heimbürger Ravalli, *op. cit.* (Chapter 9, Note 35), 37 ff.

272. 30. See also Correggio's *Martyrdom of S. Placidus and S. Flavia* (Parma, Gallery).

31. In an illuminating paper, J. Montagu convincingly demonstrated the novelty of Algardi's last work, the high altar in S. Nicolò da Tolentino, where he showed 'a deep niche containing figures carved in varying degrees of relief' (*Burl. Mag.*, CXII (1970), 282 ff.).

32. Fulvio Testi, in a letter of 1633 to the Duke of Modena, called him the best sculptor in Rome after Bernini (Fraschetti, *Bernini*, 75). – On Duquesnoy see M. Fransolet's monograph (Brussels, 1942), which is far from being conclusive.

How difficult it sometimes still is to keep Algardi and Duquesnoy apart has been demonstrated in a model paper by J. Montagu (in *Bulletin des Musées royaux d'art et d'histoire*, Brussels, XXXVIII–XXXIX (1966–7), 153 ff.) in which she investigates the well-known bronze group of the *Flagellation of Christ*, known in many similar versions, some of which (she claims) are attributable to Duquesnoy and others to Algardi.

33. He died at Leghorn, on his way to Paris, where he was travelling in response to the offer of a position as court sculptor and director of the Academy of Sculpture.

34. According to Passeri he was responsible for some of the putti in the foliage of the columns. Payments refer to the models of the angels above the columns, in which, among others, Finelli also had a share (see O. Pollak, *Kunsttätigkeit*, 11).

35. Finished in 1633. Documents published by E. Dony, 'François Duquesnoy', *Bulletin de l'institut historique belge de Rome*, 11 (1922), 114. See also Fransolet, *op. cit.*

274. 36. The figure is now standing in the wrong niche, on the left-hand and not on the right-hand side of the altar. Consequently the gesture of the hand, pointing away from the altar, has lost its meaning.

37. Compare, for instance, the left hands on the two statues; the one with dimples, agile and supple, the other neutral, a hand of stone.

275. 38. See Sobotka in Thieme-Becker; also A. Muñoz in *L'Arte*, XIX (1916), 137. For the famous, often discussed bust in wax in the Musée Wicar in Lille, see Sobotka in *Berliner Kunstgeschichtliche Gesellschaft, Sitzungsberichte* (1910), no. vii, 40. In this context the marble bust in the Museo Estense, Modena, should also be mentioned; see R. Salvini in *Burl. Mag.*, XC (1948), 93.

39. B. Lossky, 'La Ste Suzanne de Duquesnoy et les statues du 18e s.', *Revue belge archéologique et historique de l'art*, IX (1939), 333.

40. M. Fransolet, 'Le Saint André de François Duquesnoy', *Bulletin de l'institut belge de Rome*, IV (1933). Duquesnoy made a small bozzetto for the St Andrew between June 1627 and March 1628. The large model was in position as early as November 1629, while work on the Susanna did not begin until a month later.

276. 41. J. Hess in *Revue de l'art ancien et moderne*, LXIX (1936), 34.

For other busts by Duquesnoy, see A. Nava Cellini, *Paragone*, VII (1956), no. 65, 27 f., K. Noehles, *Arte Antica e Moderna*, no. 25 (1964), S. and H. Röttgen, *The Connoisseur* (Feb. 1968), 94 ff.

42. A reflection of this can be found in the many pictures, particularly of the Dutch school, in which works by Duquesnoy are shown; see, for instance, Frans van Mieris, Detroit; Adriaen van der Werff, Heylshof Coll., Worms; Netscher, The Hague (No. 127); and above all G. Dou's pictures, Altman Coll., New York; Duke of Rutland, Belvoir Castle; Uffizi, Vienna, Dresden, Louvre; Nat. Gall., London, etc. Still in the late eighteenth century Nollekens valued his Duquesnoy models very highly; see. J. T. Smith, *Nollekens and his Times*, London, 1949, 234.

43. However, the design of the Vryburch monument with the spread-out skin, on which the inscription is placed, is comparatively Baroque, while that of the later van den Eynde monument is comparatively classical [171].

D. Mahon, *G.d.B.A.*, LX (1962), 73, read into my text that I regard the Vryburch putti as less 'painterly' than those of the van den Eynde monument, while I was, in fact, concerned with Duquesnoy's turn from an Italian (Titianesque) to a native (Rubenesque) taste. For Duquesnoy's stylistic development, see also K. Noehles, 'Francesco Duquesnoy; un busto ignoto e la cronologia delle sue opere', *Arte Antica e Moderna*, VII, no. 25 (1964), 86.

278. 44. As an example we may mention the *Cupid as Archer* (described by Bellori; ivory, Musées Royaux d'Art et d'Histoire, Brussels) which corresponds almost exactly in reverse to the archer in Titian's *Bacchanal of Children*; the same figure was used by Poussin in the Dresden *Venus and Cupid* of about 1630.

45. Date: 1640-2. We show in illustration 174 the charming bozzetto in Berlin. The similarity of these putti to those of Rubens was first pointed out by A. E. Brinckmann.

It need hardly be emphasized that Duquesnoy's small representations of children are not genre. Just like Rubens, he drew constantly on ancient texts and ancient prototypes, see, for example, the *Cupid chipping the Bow* (marble, Berlin) in which he corrected Parmigianino's painting of the same subject in Vienna by reference to the Lysippian Eros; or the relief of *Putti and Nymph mocking Silenus* (illustrating Virgil's sixth Eclogue), which was in the collection of Cassiano del Pozzo (versions Berlin, Brussels (private coll.), Dresden, Victoria and Albert Museum); or the *Amor divino e profano* after Philostratus's text (original

model Palazzo Spada, Rome; original marble Villa Doria Pamphili, Rome, see I. Faldi, *Arte Antica e Moderna*, II (1959), 52; replicas Victoria and Albert Museum, Detroit, Prado, etc.).

46. Among Duquesnoy's few pupils there was Orfeo Boselli (c. 1600-67), who venerated his master as the 'angelic sculptor' and the 'phoenix of our age'. Boselli is of particular interest because he left a (still unpublished) manuscript of absorbing interest for the history of sculpture entitled 'Osservazioni della Scultura Antica' (Bibl. Corsiniana, Rome, MS. 1391); see M. Piacentini, in *Boll. del R. Istituto di Archeologia e Storia dell'Arte*, IX, i-vi (1939), and P. Dent Weil, in *Studies in Conservation*, XII (1967), 81 ff., with a partial translation of Boselli's Fifth Book on the restoration of antique sculpture.

CHAPTER 12

279. 1. In Bologna he executed the vaulting of S. Petronio, S. Lucia with unfinished façade (1623), and SS. Girolamo ed Eustachio, of which little survives. His is also a project for the façade of S. Petronio, a fantastic cross-breed between Mannerism and Gothic (1626). In Parma the vaulting of Fornovo's SS. Annunziata was due to him, and in Modena he had an important share in the design of the Palazzo Ducale (1631-4), see p. 291. For Girolamo and Carlo Rainaldi, see now the somewhat unwieldy monograph by F. Fasolo (1961), which contains, however, a great deal of material and should be consulted for this section.

2. See the synopsis in Fasolo, *op. cit.*, 420. Girolamo's most important work is the Carmelite church of S. Silvestro at Caprarola near Rome (1621, Fasolo, 65).

3. See D. Frey in *Wiener Jahrb.*, III (1924), 43 ff.

4. Wittkower in *Art Bull.*, XIX (1937), 256. Some scholars disagree with me and attribute the project to Girolamo; see L. Montalto in *Palladio*, VIII (1958), 144, and K. Noehles, *Zeitschr. f. Kunstg.*, XXV (1962), 168.

We can follow Carlo's career from 1633 onwards (G. Matthiae in *Arti Figurative*, II (1946), 49). His project for the towers of St Peter's and the modernization of the façade, dating from 1645, shows him dependent on his father's Mannerism. Between 1650 and 1653 he made a number of plans for the Square of St Peter's which are rather pedestrian and traditional (Brauer-Wittkower, 67).

5. Further on the history of S. Maria in Campitelli, Wittkower in *Art Bull.*, XIX (1937). See also Bassi in *Riv. d'Arte*, XX (1938), 193, and Argan, *Commentari*, XI (1960), 74.

280. 6. In addition, for the motif of the double columns he was indebted to Cortona's S. Maria della Pace.

282. 7. See, e.g., Gallo da Mondovi's S. Maria dell' Assunta at Carrù (1703-18).

283. 8. Carlo had a special interest in the Capitol. His father was in charge of the construction of the palace on the left (1646), which was completed by the son in the reign of Alexander VII.

It is worth observing how the outside bays of S. Maria in Campitelli are integrated with the rest of the façade: Rainaldi used the small order also for the main entrance and repeated the shape of the pediment of the windows over the central window of the upper tier. At the same time, he gave the pilasters at both ends of the front a typically Mannerist double function: they belong as much to the church as to the adjoining palaces.

9. In Rome itself, see, e.g., the façades of S. Apollinare, S. Caterina della Ruota, and SS. Trinità in Via Condotti. Rainaldi's own unfinished façade of S. Angelo Custode at Ascoli Piceno (1684-5) was planned on the same scheme but with a colossal order; the Chiesa del Carmine also at Ascoli Piceno has a simple aedicule façade in two tiers (1687); for these churches, see Fasolo, 372.

An interesting adaptation of the façade of S. Maria in Campitelli is that of the cathedral at Syracuse (1728), probably designed by Don Andrea Palma from Palermo and not by Pompeo Picherali as usually maintained (see F. Meli, *Archivio Storico per la Sicilia*, IV-V (1938-9), 341). The grandest example in Venice is S. Maria degli Scalzi by Giuseppe Sardi (1672-80), who gave the type a characteristically Venetian note.

For the history of the aedicule façade, see now also N. T. Whitman, in *Journal Soc. Architect. Historians*, XXVII (1968), 108 ff.

10. The façade was executed between 1661 and 1665. For illustrations of the various designs, see Wittkower, *Art Bull.*, XIX (1937), figures 17, 20-3, and F. Fasolo in *Palladio*, I (1951), 34-8.

11. Fontana, in fact, received payments in January 1662; see Fasolo, *loc. cit.* Fasolo, *Rainaldi*, 1961, 379 f., objects to Fontana's participation without valid reasons. K. Noehles, *Zeitschr. f. Kunstg.*, XXV (1962), 175, returns to my interpretation of the evidence.

284. 12. The greatest width of the oval dome lies further back in the wedge-shaped area than that of the circular dome, namely at a point where the diameter of the oval equals that of the circle.

285. 13. Carlo Fontana was responsible for parts of the drum, the dome, and the choir.

14. I have tried (in *Art Bull.*, XIX (1937), 245) to disentangle the complex history of these churches. V. Golzio published new documents (*Archivi*, VIII (1941), 122) which allow the establishment of correct dates,

but he obscured the whole problem by insisting on the exclusion of Fontana's participation in 1662 because at that time his name does not appear in the documents. Golzio overlooked, however, that the façade of S. Andrea della Valle is evidence of a collaboration of Rainaldi and Fontana at this period. These and other problems have now been resolved by H. Hager in his fully documented history of the two churches, in *Röm. Jahrb. f. Kunstg.*, XII (1967-8), 191 ff.

Bernini's name appears in the documents for the first time on 18 December 1674. But there can be little doubt that it was he who provided the *disegno nuovo* for S. Maria di Monte Santo which was used after the fall of 1673.

286. 15. Rainaldi used the columns from Bernini's dismantled tower of St Peter's (Golzio, *Archivi*, X (1943), 58).

16. I mention the tomb of Clement IX in S. Maria Maggiore (1671), the Ceva (1672) and Bonelli (1673) tombs in S. Venanzio and S. Maria sopra Minerva respectively; the richly decorated fountains in the garden of the Palazzo Borghese (1672-3, see Chapter 13, Note 40) and the loggia facing the Tiber in the same palace (1675); the high altars in S. Lorenzo in Lucina (1675) and SS. Angeli Custodi (1681, destroyed); the completion of the façade of S. Maria in Via (1681), and the little church of S. Sudario (about 1685); finally, the undistinguished Palazzo Mancini-Salviati al Corso, executed, according to L. Salerno's suggestion (in *Via del Corso*, Rome, 1961, 244), by Sebastiano Cipriani after Rainaldi's death in 1690. The Borrominesque entrance doors to the Palazzo Grillo have always been attributed to Carlo Rainaldi. The addition of the domed portion to Soria's cathedral of Monte Compatri, usually attributed to C. Rainaldi (Hempel, Mandl, Matthiae, Wittkower), was executed in the nineteenth century, as Howard Hibbard has convincingly pointed out to me.

K. Noehles, *loc. cit.*, 176 (see above, Note 11), has correctly observed that Rainaldi's late work is flat rather than spatial and sculptural. In this respect Rainaldi leads on to the classicizing tendencies of the end of the century.

288. 17. Archivio di Stato, Rome, Cart. 80, R. 537. See also *Roma*, XVI (1938), 477. The church itself is not by Longhi, as has wrongly been maintained. An interesting project by Longhi for the façade of S. Giovanni Calibita over a concave columnar plan in the Albertina, Vienna, dating from 1644, and thus preceding SS. Vincenzo ed Anastasio, was published by J. Varriano, in *Art Bull.*, LII (1970), 71.

18. It is precisely the relatively little projection from one column to the next that forces the eye to see the triad as a unit.

19. If, according to the well-informed Passeri (Hess, 235), some sculptural decoration was planned on the large scale wall surfaces, now bare, it would certainly not have been reliefs of excessive dimensions, for the appearance of plain wall at these points is very important to set off the columnar motif.

20. The staircase has, of course, an articulating function. It not only stresses the unity of the whole front, but also knits together the columns framing the outside bays (rising steps) as well as the whole central area (landing).

21. It is interesting that such a shrewd observer as Gurlitt (*Geschichte des Barockstiles*, Stuttgart, 1887, 400) describes the façade as if this were so. - If the arch of the larger pediment is prolonged downwards, it meets exactly the edge of the capital of the third column. See also H. Sedlmayr's interpretation of this façade (*Epochen und Werke*, 1960, II, 57).

22. Recently destroyed. For an illustration see Wittkower, *Art Bull.*, XIX (1937), figure 64.

23. For the history of S. Carlo, see mainly B. Nogara, *SS. Ambrogio e Carlo al Corso* (Chiese di Roma illustr.), Rome, 1923. Foundation stone: 29 January 1612. Onorio Longhi died in 1619. In 1635 the nave is vaulted (*Roma*, XVI (1938), 119). 1651: the high altar unveiled (*ibid.*, 528). *c.* 1656: cessation of Martino Longhi's activity. 1662: Tommaso Zanoli and Fra Mario da Canepina appointed as architects (see documents published by L. Salerno in *Via del Corso*, 1961, 146 ff., also for the following. Salerno denies any participation of Carlo Fontana who, according to O. Pollak's unusually reliable Cortona article in Thieme-Becker, received payments from 1660 onwards). 1665 ff.: Cortona directs construction of transept and choir. 1668-72: drum and dome executed from Cortona's design, who also designed the stucco decorations of nave, transept, and choir. Payments for C. Fancelli's stuccoes between 1674 and 1677 (see also Titi, ed. 1674, 403). 1672: church mainly completed, but finally in 1679 (Pastor, XIV, ii, 691). 1682-4: façade (insignificant) by Giovan Battista Menicucci from Cardinal Omodei's design.

Longhi's façade of S. Antonio de' Portoghesi, begun after 15 December 1629 (Hibbard, *Boll. d'Arte*, LII (1967), 113, no. 167), but left unfinished when he moved during the last years of his life to Milan, shows a considerable increase in sculptural decoration as compared with SS. Vincenzo ed Anastasio but is architecturally less remarkable, in part because he refrained entirely from the use of columns (finished 1695 by Cristoforo Schor, son of Giovan Paolo; see *Descrizione di Roma moderna*, 1697, 486; also Ansaldi in *Capitolium*, IX (1933), 611 ff., and U. Vichi, in *Il Santo*, VII (1967), 339-54).

Of importance among Longhi's work are the staircase (*c.* 1640) in Ammanati's Palazzo Caetani (now Ruspoli) on the Corso and, above all, the even more interesting staircase hall in the Palazzo Ginetti at Velletri (after 1644, largely destroyed during the last war). Longhi's will was published by V. Golzio in *Archivi*, V (1938), 140.

24. Vincenzo, who was a papal architect, had an architect son, Felice (*c.* 1626-77). It was Felice (and not Vincenzo, as usually maintained, also in the first ed. of this book) who worked in the Palazzo Chigi on the Piazza Colonna (courtyard and staircase) and was concerned with a systematization of the Piazza Colonna for Alexander VII; see Incisa della Rocchetta in *Via del Corso*, 1961, 185. He was also employed by the Chigi for their palace in Piazza SS. Apostoli (Brauer-Wittkower, 127 ff.; Golzio, *Documenti*, 4 ff.; also above, Chapter 8, Note 85).

289. 25. See Bianca Rosa Ontini, *La Chiesa di S. Domenico in Roma*, Rome [n.d., *c.* 1952]. Nicola Turriani was probably the brother of the better-known Orazio (Donati, *Art Tic.*, 355). Vincenzo della Greca only added the portal, without any regard for the architecture of Turriani's façade.

26. O. Pollak in *Kunstg. Jahrb. der k.k. Zentral-Kommission*, III (1909), 133 ff.

27. The decoration of the gallery by Carlo Fontana's nephew, Girolamo, was not finished until 1703. The gallery makes, therefore, a later impression than is warranted by its architecture. For the frescoes of the vaulting, see p. 334.

28. I. Faldi, *Il Palazzo Pamphily al Collegio Romano*, Rome (Associazione Aziende Ordinarie di Credito), 1957, with good illustrations.

29. About 1665 Antonio del Grande was engaged on the rebuilding of the Colonna palaces at Genazzano and Paliano. In 1666 and 1667 he was paid for work in S. Agnese in Piazza Navona. On his part in the Palazzo di Spagna, see E. Hempel, *Borromini*, Vienna, 1924, 129 f.

30. For Carcani's stucco decoration, see below, p. 435. It must be pointed out that the traditional date 'after 1650' for Rossi's architecture is probably too early. Titi, in his edition of 1674, 244, still mentions Maderno's chapel and only in the edition of 1686, 195, remarks that it has been replaced by that of G. A. de' Rossi. For all works by G. A. de' Rossi, the monograph by G. Spagnesi (see Bibliography) has now to be consulted.

Rossi's earliest work was probably the little church S. Maria in Publicolis.

31. Titi, ed. 1686, 332. - Worthy of note is the little forecourt, skilfully squeezed in on the restricted site. M. Bosi, *S. Maria in Campo Marzio* (Le chiese di

Roma illustrate, 61), Rome, 1961, is not very useful so far as Rossi's architecture is concerned. But new material (drawings and documents) has been published by H. Hager, in *Commentari*, XVIII (1967), 329 ff.

32. On the site was an older chapel built by Maderno. Rossi's authorship of the present chapel is attested by Pascoli (I, 317) and Titi (ed. 1686, 98), who saw it in course of construction and mentions the splendid incrustation with coloured marbles. Carlo Francesco Bizzacheri finished the chapel, especially the decoration of the oval dome, between 1695 and 1707.

290. 33. A. Mezzetti, *Palazzo Altieri*, Rome, 1951; V. Martinelli, *Commentari*, X (1959), 206. Also A. Schiavo, *The Altieri Palace*, Rome, 1965. The older palace alone is shown in Lieven Cruyl's drawing in the Albertina (H. Egger, *Römische Veduten*, II, plate 89); see also Falda, *Nuovi disegni dell'architettura* (before 1677), plate 38. The important staircase was finished in 1673 (Pastor, XIV, i, 626). Carlo Fontana also made projects for the extension of this building (Coudenhove-Erthal, *Carlo Fontana*, 30). - Fontana's Palazzo Bigazzini on Piazza S. Marco (before 1677, pulled down 1900) was dependent on the Palazzo Altieri.

34. The palace, overlooking the Piazza Venezia, was built for Francesco D'Aste: contract 7 June 1658 (see L. Salerno, in *Via del Corso*, 1961, 256). Finished probably before 1665 (Cruyl's drawing, Egger, *Römische Veduten*, II, plate 90).

Worthy of note also De' Rossi's Palazzo Carpegna at Carpegna, published by M. Tafuri, in *Palatino*, XI (1967), 133 ff.

35. See below, p. 376.

36. See *Roma antica e moderna*, Rome, 1765, II, 254; also Salerno, *op. cit.*, 220.

37. Among the lesser figures active in Rome at this period may be mentioned:

i. *Paolo Maruscelli* (1594-1649), architect of the Congregation of St Philip Neri until 1637 (Pollak, *Kunsttätigkeit*, I, 423), whom we have mentioned as Borromini's competitor. He has to his credit the Palazzo Madama (according to Ferrerio, *Palazzi di Roma*, Rome [n.d.], plate 11, to be dated 1642) with top-heavy window frames and a decorative arrangement of the mezzanine under the cornice; remarkable because the top floor is more important than the *piano nobile*.

ii. *Mattia de' Rossi* (1637-95), although much younger, may here be mentioned because he worked for Bernini for almost a whole generation, serving many times as his clerk of works. As an architect in his own right he built mainly chapels and altars without special distinction. His largest work, the façade of S. Francesco a Ripa (1692 f.), is a frigid, classicizing affair.

iii, iv. The names of the papal architects, *Luigi Arigucci* and *Domenico Castelli*, often recur in documents, but they were officials rather than creative masters. Arigucci's most notable building is the dry double tower façade of S. Anastasia, often wrongly ascribed to Bernini (Battaglia in *Palladio*, VII (1942), 174-83). Castelli (d. 1658), in the papal office of works from 1623 to 1657, is responsible for the rebuilding of S. Girolamo della Carità (1652-8, docs. in Fasolo, *Rainaldi*, 1961).

v. *Domenichino* had pretensions as an architect and architectural drawings by him for S. Ignazio and other schemes (J. Pope-Hennessy, *The Drawings of Domenichino*, London, 1948, 121) are not without proficiency.

vi. *Andrea Sacchi* also regarded architecture as a sideline. In 1637 he is first called 'architect'. N. Wibiral (*Palladio*, V (1955), 56-65) has made it probable that he designed the Acqua Acetosa, often attributed to Bernini.

vii. The Jesuit *Orazio Grassi* (1583-1654), depending on a Maderno-Borromini project, designed and executed the church of S. Ignazio, one of the largest in Rome (1626-50). At different stages of the erection, commissions of specialists were called in: 1627 for the plan; 1639 for the sacristy; 1642 for the façade, which has often been wrongly attributed to Algardi; and 1677 for the dome, which remained unexecuted. See C. Bricarelli, 'O. G. architetto', *Civiltà Cattolica*, LXXIII (1922), 13 ff.; D. Frey in *Wiener Jahrb.*, III (1924), 11 ff.; C. Montalto in *Boll. del Centro di studi per la storia dell'architettura*, no. 11 (1957), 33.

viii. Although O. Pollak (*Zeitschrift f. Geschichte d. Architektur*, V, 1910-11) seemed to have deflated the view, going back to Passeri, that *Alessandro Algardi* was a practising architect, more recent research has vindicated the contemporary tradition. In any case, the Villa Doria-Pamphili outside Porta S. Pancrazio (executed mainly in 1646-8) is owed to him, while the Bolognese painter Giovan Francesco Grimaldi served as his clerk. Apart from its size - the villa is the largest in Rome - the building has not much to recommend it. It is a rather dry, unimaginative structure, distinguished, however, by its high-class stucco decoration. The question of the Villa Pamphili and its stuccoes has now been fully investigated in a brilliant paper by O. Raggio, in *Paragone*, no. 251 (1971), 3-38. Recently F. Fasolo (*Fede ed Arte*, XI (1963), 66 ff.) suggested that Algardi made the plans for S. Nicolò da Tolentino, previously attributed to G. M. Baratta.

ix. *Giovan Battista Mola* (1585-1665), born at Coldrerio near Como; from 1612 to 1616 in Rome; in 1616 appointed 'architetto della camera apostolica'. His few buildings in a retardataire style are discussed by K.

Noehles in the Introduction to his edition of Mola's important Roman guide-book published from the signed Viterbo manuscript of 1663 (*Roma l'anno 1663 di Giov. Batt. Mola*, Berlin, 1966).

291. 38. Avanzini's most important work is the rather charming modernization of the Ducal Palace at Sassuolo.

The problems concerning the Palazzo Ducale at Modena have been discussed with great circumspection by L. Zanugg in *Riv. del R. Ist.*, IX (1942), 212.

39. By Giuseppe Tubertini, 1787. Luigi Acquisti's sculptural decoration also dates from this period. The façade was built in 1905.

292. 40. Bergonzoni goes a step beyond Borromini by opening up the pillars under the pendentives into chapels and *coretti*. Also the decorative detail of the *coretti* has a Late Baroque quality.

41. The biography of Longhena by C. Semenzato (*L'architettura di B. Longhena*, Padua, 1954) is not very satisfactory. E. Bassi's chapter on Longhena in *Architettura del Sei e Settecento a Venezia*, 1962, 83–185 (the backbone of her book), is infinitely better.

42. See among others the old but still basic work by G. A. Moschini, *La chiesa e il seminario di S. Maria della Salute*, Venice, 1842; further V. Piva, *Il tempio della Salute*, Venice, 1930, and R. Wittkower, 'S. Maria della Salute: scenographic Architecture and the Venetian Baroque', *Journal of the Society of Architectural Historians*, XVI (1957), and *idem* in *Saggi e Memorie di storia dell'arte*, III (1963).

43. See Bramante's S. Maria di Canepanova at Pavia (begun 1492?) or Battaglio's S. Maria della Croce near Crema (1490–1500). - Even the high drum with two round-headed windows to each wall section stems from this tradition.

R. Pallucchini, in a review of my book in *Arte Veneta*, XIII–XIV (1959–60), 250, seems to infer that I overlooked the importance of Sanmicheli's S. Maria di Campagna near Verona as prototype of the Salute. But S. Maria di Campagna is not closer to the Salute than churches of the Bramantesque tradition and, like them, moreover, lacks the ambulatory. E. Bassi, too (*op. cit.*, 174), rejects the influence of the Madonna di Campagna on Longhena.

The reader may also be referred to G. Fiocco's critical remarks in *Barocco europeo e Barocco veneziano*, Florence, 1963, 89.

297. 44. The oddly shaped units lie behind the large pillars of the octagon and are, therefore, visually of no consequence whatsoever.

45. For instance, the arch of the octagon is repeated in the arch of each chapel and again in that of the segmental window. Moreover, all the orders tally and supplement each other; see illustration 186.

46. The window below is contained in an arched 'Palladio motif', the rectangular one above by an aedicule frame.

47. See Palladio's S. Giorgio Maggiore, where a system of small orders is seen through the screen of columns framing the altar.

298. 48. P. Bjurström in his informative and thoughtful book *Giacomo Torelli and Baroque Stage Design*, Stockholm, 1961, 104, 106, has discussed the close affinity of Torelli's stage sets to Longhena's architecture. Torelli, born at Fano in 1608, worked in Venice from 1640 to 1645; for the next fifteen years he was stage designer at the Paris court. In 1661 he returned to Fano, where he died in 1678.

49. Wittkower, *Architectural Principles in the Age of Humanism*, 3rd ed., London, 1962, 97.

50. The conception of both churches is basically different: the one is a typical Renaissance 'wall structure', the other (as shown in the text) a 'skeleton structure'. In a very direct sense the Salute is constructed like a Gothic building. W. Lotz (*Röm. Jahrb. f. Kunstg.*, VII (1955), 22) has demonstrated that Labacco published Antonio da Sangallo's project for S. Giovanni de' Fiorentini, Rome.

299. 51. It is likely that Longhena followed Michelangelo's design for the dome of St Peter's also for the false inner lantern which lies between the two shells of the dome. But it may be recalled that there was a long North Italian tradition for treating the inner and outer lantern independently of each other.

52. I have left unmentioned that the rich sculptural decoration contributes considerably to the picturesque impression of the building. For a full understanding of the structure, the programme of the decoration must be considered.

53. See p. 375.

54. J. Tiozzo, *La Cattedrale di Chioggia*, Chioggia, 1929.

55. C. Montibeller, 'La Pianta originale inedita della chiesa dei Padri Carmelitani Scalzi di B. Longhena', *Arte Veneta*, VII (1953), 172. For the façade by G. Sardi, see above, Note 9.

56. E. Bassi, 'Gli architetti dell'Ospedaletto', *Arte Veneta*, VI (1952), 175.

57. An example of his early Scamozzesque style is the Palazzo Giustinian-Lolin (after 1625).

58. The Palazzo Rezzonico, the more restrained of the two, was going up in 1667. The top floor was built by Giorgio Massari, 1752–6 (see G. Mariacher, in *Boll. Musei Civici Veneziani*, IX (1964), no. 3, 4 ff.). The Palazzo Pesaro was begun between 1652 and 1659. Progress was slow. In 1676 the façade was begun. In 1679 the *piano nobile* was finished, but the palace was completed by Antonio Gaspari only in 1710. See G.

Fiocco, 'Palazzo Pesaro', *Riv. mensile di Venezia* (1925), 377; also G. Mariacher in *Ateneo Veneto*, CXXXV (1951); G. Badile in *Arte Veneta*, VI (1952), 166; and, above all, E. Bassi in *Saggi e Memorie di storia dell'arte*, III (1963), 88 (with new documents). For other works by Longhena, see E. Bassi, in *Critica d'Arte*, XI (1964), 31; XII (1965), no. 70, 43 and no. 73, 42.

For Gaspari (*c.* 1660-1749), see Bassi's basic study, in *Saggi e Memorie* (above), 55-108.

301. 59 D. Giovannozzi in *L'Arte*, XXXIX (1936), 33, and W. and E. Paatz, *Die Kirchen von Florenz*, Frankfurt-on-Main, 1940-54, III, 335, 471, where the whole question is lucidly summarized. See also Panofsky's interesting remarks on Silvani's 'compromise solution' (*Meaning in the Visual Arts*, New York, 1955, 193).

60. Documents for Parigi's share in R. Linnenkamp, *Riv. d'Arte*, VIII (1958), 55, 59. Giuseppe Ruggieri added the northern and southern wings in 1764 and 1783 respectively; the latter was not finished until the beginning of the nineteenth century. See also F. Morandini, 'Palazzo Pitti, la sua costruzione e i successivi ingrandimenti', *Commentari*, XVI (1965), 35 ff. On the strength of a Callot drawing of 1630, Sir Anthony Blunt (*The French Drawings at Windsor Castle*, London, 1945, 19) has made it probable that all the extensions were derived from a Buontalenti project made for Ferdinand I.

61. There is no satisfactory modern work on Silvani. Apart from the brief chapter in Venturi (XI, 2, 624), the reader must be referred to R. Linnenkamp's publication of a contemporary Life of Silvani (*Riv. d'Arte*, VIII (1958), 73-111) which Baldinucci used for his *Vita*.

62. Foundation stone: 1604. The general lines of the plan seem to have been worked out by the Theatine Don Anselmo Cangiani. Some time between 1604 and 1628 Nigetti worked on the structure, without much effect. The present church is to all intents and purposes Gherardo Silvani's work; see Baldinucci, ed. 1846, IV, 353; Paatz, *Kirchen von Florenz*, IV, 181; Berti in *Riv. d'Arte*, XXVI (1950), 157. Inscription on the façade: 1645. Consecration of the church: 1649. The ornamental detail of the façade is by Alessandro Neri Malavisti. The statues of the 1680s are by Balthasar Permoser, Anton Francesco Andreozzi, and Carlo Marcellini. Lankheit, 172, dates them 1687-8.

302. 63. A particularly good example of this style is the Badia, rebuilt between 1627 and 1631 (Paatz, *op. cit.*, I, 267) by Matteo Segaloni, about whom little is known. Here also the characteristic screening-off of the monks' choir by the so-called Palladio-motif, which had a home in Florence from the mid sixteenth century onwards. Prominent examples before the

Badia: Giambologna's Cappella di S. Antonio in S. Marco (1578-89) and Giovanni Caccini's chancel of S. Domenico at Fiesole (1603-6).

64. Reliefs and figures are later, mainly by Foggini and his school. S. Gaetano is the best place to study Florentine sculpture of the late Seicento. For the names of the sculptors and the problem of dating, see Lankheit, 71 f.

65. Baldinucci, ed. 1846, IV, 427.

66. The technique had been developed in Rome. It was introduced into Naples by Dosio, who probably began the marble incrustation of the Certosa of S. Martino (Wachler in *Röm. Jahrb. f. Kunstg.*, IV (1940), 194). It was Fanzago and others such as Dionisio Lazzari (d. 1690), the architect of the dome of St Philip Neri, who gave this decorative technique the Neapolitan imprint. Thus transformed, it was assimilated through Fanzago in other Italian cities (Venice, Bergamo).

67. Documents prove that Fanzago, and not Dosio, made the design; see P. Fogaccia, *Cosimo Fanzago*, Bergamo, 1945.

68. For Fanzago see the unsatisfactory work by Fogaccia, with further references.

303. 69. Chiesa dell'Ascensione a Chiaia (1622-45), S. Maria dei Monti (early), S. Trinità delle Monache (after 1630, destroyed), S. Teresa a Chiaia (1650-62), S. Maria Maggiore ('La Pietrasanta', 1653-67), an improved version of the Ascensione plan with oval satellite chapels instead of square ones, S. Maria Egiziaca (1651-1717).

70. This is supported by his Latin-cross plans, such as S. Maria degli Angeli alle Croci (1639) and the even more interesting S. Giorgio Maggiore (1640-78), the design of which owes much to Venice.

304. 71. U. Prota-Giurleo, 'Lazare veni Foras', *Il Fuidoro*, IV (1957), 90 ff., published a list dated 1653 from the Naples notarial archive enumerating works of the Lazzari shop (above Note 66), and this list includes the façades of both the Sapienza and the Palazzo Firrao.

72. U. Prota-Giurleo, 'Alcuni dubbi su Fanzago architetto', *Il Fuidoro*, III (1956), 117 ff., attributes the Palazzo Donn'Anna to Bartolomeo Picchiati (see next Note). On the latter's death Onofrio Gisolfi continued the palace; see F. Strazzullo, *Architetti e ingegneri napoletani dal '500 al '700*, Naples, 1969, 181 f. I owe the last two notes to the kindness of Fred Brauen.

73. Among other Neapolitan architects of this period the names of Bartolomeo Picchiati (d. 1643) and his son, Francesco Antonio (1619-94), should at least be mentioned. The former began as Domenico Fontana's clerk of works and designed later S. Giorgio dei Genovesi (1626) and S. Agostino alla Zecca (1641), which

was given its extravagant apse a hundred years later (1756-61) by Giuseppe Astarita and Giuseppe de Vita. The son designed the Guglia di S. Domenico (1658, finished 1737 by D. A. Vaccaro), the church and palace of the Monte della Misericordia (1658-70), and the churches of S. Giovanni Battista and S. Maria dei Miracoli (1661-75).

CHAPTER 13

305. 1. No less than thirty-nine masons and sculptors were employed, among them all the well-known names of the Bernini studio - Giacomo Balsimello, Matteo Bonarelli, Francesco Baratta, and Niccolò Sale; further the more distinguished Bolgi, Ferrata, Raggi, Cosimo and Giacomo Antonio Fancelli, Girolamo Lucenti, Lazzaro Morelli, Giuseppe Peroni, and others.

2. Among other works, he carried out the four winged victories for Bernini's tower of St Peter's (1640-2), which were later used for Innocent X's coats of arms in the aisles of the basilica. A catalogue of his œuvre was published by V. Martinelli in Commentari, IV (1953), 154.

3. He joined, in fact, Pietro Bernini's studio, but was straightaway employed by Gianlorenzo on the Apollo and Daphne group.

4. Finelli in these years executed mainly the bust of Cardinal Ottavio Bandini (1628, S. Silvestro al Quirinale) and the Cortonesque St Cecilia (1629-33, S. Maria di Loreto), the counterpart to Duquesnoy's Susanna.

Passeri (ed. Hess, 248), in his well-informed Life of Finelli, writes in detail about the cabals in Rome, and later in Naples.

5. His most important works in Naples are the two marble statues of St Peter and St Paul, left and right of the entrance to the Cappella del Tesoro, Cathedral (1634-c. 1640), and eleven bronze statues inside the same chapel (finished 1646; see A. Bellucci, Memorie stor. ed artistiche del Tesoro etc., Naples, 1915); the figures of Cesare and Antonino Firrao, princes of S. Agata, in the left transept of S. Paolo Maggiore (1640), which follow the type of Naccherino's Pignatelli tomb in S. Maria Mater Domini; and the sculptural decoration of the Cappella Filomarini is SS. Apostoli, with the exception of Duquesnoy's putto relief (c. 1642-7). In addition, he made the kneeling figures of the viceroy, the Count of Monterey, and his wife for the church of the Agustinas Recoletas at Salamanca (1636), which also follow Naccherino's Pignatelli.

6. See his tombs of Giuseppe and Virginia Bonanni in S. Caterina da Siena a Monte Magnanapoli (A. Muñoz in Vita d'Arte, XI (1913), 33, and Dedalo, III (1922), 688). The male portrait is the better of the two;

it dates, according to inscription, from 1648, and the weaker female portrait from 1650.

For Finelli's portrait busts, see the informative article by A. Nava Cellini in Paragone, XI (1960), 9-30.

7. Documents in O. Pollak, Kunsttätigkeit, II.

306. 8. For Bolgi's work under and with Bernini, see Wittkower, Bernini, Catalogue, nos 21, 25, 29, 33, 36, 40, 46, 47. For Bolgi's portrait busts, see A. Nava Cellini in Paragone, XIII (1962), no. 147, 24.

9. See the bust of Francesco de Caro and the praying figure of Giuseppe de Caro (signed and dated 1653) in the Cappella Cacace in S. Lorenzo.

V. Martinelli in Commentari, X (1959), 137, judges Bolgi's Neapolitan career rather more positively. Martinelli's paper (with œuvre catalogue) contains a number of attributions and suggestions (mainly regarding the collaboration with Bernini) to which I cannot fully agree. Cellini's criticism in Paragone (last Note) seems to me entirely justified.

10. Taking up an eighteenth-century tradition, John Pope-Hennessy (in Stil und Überlieferung in der Kunst des Abendlandes, Akten des 21. Internat. Kongresses für Kunstgeschichte, Bonn, 1964, II, 105) attributed the Palestrina Pietà (as by Michelangelo in the Accademia, Florence) to Menghini. I doubt the correctness of this attribution and also that suggested by Ettore Sestieri (in Commentari, XX (1969), 75 ff.), who varied Pope-Hennessy's hypothesis; he does not exclude Menghini's participation, but introduces as deus ex machina Bernini, who would have invented this piece in imitation of Michelangelo and started it.

307. 11. There is no reason to doubt Pascoli's information in his Life of Caffà (I, 256) that the artist was born in 1635. The date of his death (before 10 September 1667) has been established by E. Sammut in Scientia, XXIII (1957), 136.

12. A bozzetto for this figure in the Palazzo Venezia, Rome, was published by R. Preimesberger, Wiener Jahrb., XXII (1969), 178 ff.

13. The St Catherine was probably finished in 1667. (A drawing for the St Catherine at Darmstadt was published by G. Bergsträsser, in Revue de l'Art, no. 6 (1969), 88 f.). The St Thomas of Villanova Chapel in S. Agostino was begun in 1661, and Caffà's group was finished by Ferrata after 1668 (see Note 15). The relief in S. Agnese, begun in 1660, was also finished by Ferrata with the assistance of the weak Giovan Francesco Rossi. The date 1669 which appears with Caffà's signature on the St Rosa at Lima (see J. Fleming, Burl. Mag., LXXXIX (1947), 89) must have been added by another hand since Caffà was dead at the time, and consequently the figure was probably not finished by the artist himself. In addition, the impressive memorial statue of Alexander VII in the cathedral at Siena

was once again finished by Ferrata (W. Hager, *Die Ehrenstatuen der Päpste*, Leipzig, 1925, 25), while G. Mazzuoli, Caffà's only pupil, executed the commission given to Caffà for the *Baptism of Christ* for the high altar of the cathedral at Valletta, Malta (Wittkower, *Zeitschr. f. b. Kunst*, LXII (1928-9), 227). Caffà's signed bronze bust of Alexander VII has been acquired by the Metropolitan Museum, New York; see Wittkower in *The Metrop. Mus. of Art Bulletin* (April 1959). Another fine version in Siena Cathedral; see V. Martinelli, *I ritratti di pontefici di G. L. Bernini*, Rome, 1956, 45.

308. 14. The present reliefs by Pietro Bracci (1755) are isolated features and cannot accord with Caffà's original project.

15. The female figure in the execution is considerably more classical than in the bozzetto, and this change was certainly due to Ferrata after Caffà's death. I cannot agree with A. N. Cellini (*Paragone*, VII (1956), no. 83, 23) who attributes the execution of the 'Charity' to Caffà. In fact, Ferrata finished the 'Charity' only in May 1669, because it had been merely roughed out by Caffà.

16. A. Nava Cellini, 'Contributo al periodo napoletano di Ercole Ferrata', *Paragone*, XII (1961), no. 137, 37.

17. The two lesser allegories in flat relief are also by Ferrata. - Mari worked for Bernini mainly in the 1650s. His principal work is the *Moro* in the Piazza Navona (1653-5) from Bernini's design.

18. Participation in the decoration of S. Maria del Popolo (1655-9); collaboration on the Cathedra (1658-60); statue of St Catherine for the Cappella Chigi in the cathedral at Siena as counterpart to Bernini's, Magdalen and Jerome and Raggi's St Bernard (1662-3); execution of the Elephant carrying the Obelisk, Piazza S. Maria sopra Minerva (1666-7); Angel with the Cross for Ponte S. Angelo (1667-9).

310. 19. The mother and child in the left-hand corner are also types borrowed from Domenichino.

20. V. Golzio in *Archivi*, I (1933-4), 304; L. Montalto in *Commentari*, VIII (1957), 47.

21. Payments to Raggi for work on Algardi's sculptural decoration of the Villa Doria-Pamphili have recently come to light; see A. Nava Cellini in *Paragone*, XIV (1963), no. 161, 31. (For the villa, see Chapter 12, Note 37.)

22. Important work for Bernini includes the *Noli me Tangere* in SS. Domenico e Sisto (1649); the figure of Danube for the Four Rivers Fountain in Piazza Navona (1650-1); the Virgin and Child, Notre-Dame, Paris (c. 1652); Charity on the tomb of Cardinal Pimentel, S. Maria sopra Minerva (1653); a large part of the decoration in S. Maria del Popolo (1655-9); the

stucco decoration in the Sala Ducale, Vatican (1656); collaboration on the Cathedra (1658-64); the sculptural decoration of the church at Castel Gandolfo (1660-1); statue of Alexander VII, Cathedral, Siena (1661-3); St Bernard, Chigi Chapel, Cathedral, Siena (1662-3); most of the stuccoes in S. Andrea al Quirinale (1662-5); the Angel with the Column on the Ponte S. Angelo (1667-70); etc.

23. Since the publication of the article by A. Nava in *L'Arte*, N.S. VIII (1937), it has become customary to underestimate Raggi's achievement, and also to find in his work a 'neo-Cinquecentesque' revivalism, which should, however, be considered with due caution. Good illustrations in Donati, *Art. Tic.*

311. 24. It is this that may be interpreted as a Mannerist revival.

312. 25. They represent different countries paying homage to the Name of Jesus (Philippians, 2, 10).

26. Retti (active 1670-1709), whom I have mentioned before (p. 310), can best be studied in the curiously brittle, luminous relief with over-long, boneless figures on the tomb of Clement X (c. 1686, St Peter's). - For Michele Maglia, see p. 316. - Naldini (1619, not 1615, -91) first belonged to the circle of Sacchi and Maratti and was in opposition to Bernini. His main work at this period is the many stuccoes in S. Martino ai Monti (payments between 1649 and 1652; see A. B. Sutherland, *Burl. Mag.*, CVI (1964), 116). Later he became closely associated with Bernini. He was responsible for the sculptural decoration of Bernini's church at Ariccia (1664) and on the upper landing of the Scala Regia (1665). He also had a share in the Cathedra (1665). In the Gesù the colossal figures of Temperance and Justice under the dome are his work.

27. Works by him are at Bologna, Faenza, Forlì, Genoa, Modena, Naples, Perugia, Pisa, and Torano.

313. 28. L. Bruhns has studied exhaustively the history of tombs with the dead in 'eternal adoration'; see *Röm. Jahrb. f. Kunstg.*, IV (1940).

29. A. Grisebach, *Römische Porträtbüsten der Gegenreformation*, Leipzig, 1936, 162.

30. *Ibid.*, 170.

314. 31. The architectural setting, also designed by Algardi, is flat, additive, and classicizing.

32. The figure was sent from Naples; the setting, made in Rome, is extraordinarily retrogressive. The church of S. Lucia was demolished in 1938 but has recently been rebuilt.

315. 33. The architectural detail, however, is classicizing. Execution before 1675.

34. The sculptural decoration was not finished until after 1686. The first tomb on the left, representing Ercole and Luigi Bolognetti, is by Michele Maglia; the first on the right of Pietro and Francesco is by Fran-

cesco Aprile (the lively bozzetto for it is shown as illustration 205). The second tombs left and right of Giorgio and Francesco Maria Bolognetti are by Francesco Cavallini. The stucco statues of saints above the tombs are by Cavallini, Maglia, and Ottoni; the sculptural decoration of the high altar by Cavallini, Naldini, and Mazzuoli.

316. 35. His only pupil of any standing was Vincenzo Felici, his son-in-law, who inherited his studio. Other sculptors like Michele Maglia and Filippo Carcani occasionally worked for Guidi.

36. Pascoli (I, 251) says of him that 'he had no luck with pupils, few coming out of his school and none of particular talent'.

37. Ferrata's studio abounded in study material. The elaborate, highly interesting inventory of the studio was published by V. Golzio, *Archivi*, II (1935), 64.

38. Aprile's *œuvre* is small but distinguished. He seems to have worked for no more than a decade. The information in Thieme-Becker that he was active from 1642 onwards is incorrect.

39. See M. Nicaud in *L'Urbe*, IV (1939), 13. See also below, Chapter 18, Note 1.

40. In S. Maria della Pace, for instance, where Ferrata's kneeling St Bernard and Fancelli's St Catherine frame the latter's Cortonesque bronze relief. Equally close in style are Ferrata's Charity and Fancelli's Faith on the tomb of Clement IX in S. Maria Maggiore (1671). - Giacomo Antonio's masterpiece is the decoration of the Cappella Nobili in S. Bernardo alle Terme with busts of the family in Cortonesque frameworks and the over life-size statue on the altar of St Francis receiving the stigmata.

Most of the minor masters here mentioned collaborated in 1672-3 on the fountains in the garden of the Palazzo Borghese, namely Cosimo and Francesco Fancelli, Retti, Cavallini, Maglia, and Carcani (see p. 435). Giovan Paolo Schor (see Chapter 14, Note 33), who worked under Carlo Rainaldi, was probably responsible for the design. H. Hibbard has published the documents for this enterprise (*Burl. Mag.*, C (1958), 205) and also for the Galleria of the palace (*ibid.*, CIV (1962), 9), where Cosimo Fancelli executed the stucco reliefs between 1674 and 1676 in the Cortonesque setting designed by Giovan Francesco Grimaldi.

317. 41. Since the distribution of these angels among the different hands is often confused, a list may be helpful: Bernini, Angels with the Crown of Thorns and the Superscription (now in S. Andrea delle Fratte); replacement, now on the bridge, of the first by Naldini, of the second by Bernini himself (this angel was prepared by Cartari); Ferrata, Angel with the Cross; Raggi, Angel with the Column; Guidi, Angel with the Lance; Naldini, Angel with Garment and

Dice; Fancelli, Angel with the Sudarium; Morelli, Angel with the Scourge; A. Giorgetti, Angel with the Sponge; Lucenti, Angel with the Nails. See H. G. Evers, *Die Engelsbrücke in Rom*, Berlin, 1948; Wittkower, *Bernini*, 232.

42. So far as possible, Jennifer Montagu (*Art Bull.*, LII (1970), 278 ff.) has disentangled the lives, works, and styles of Antonio and Giuseppe Giorgetti. Antonio died young, in 1669, before his angel for the bridge was entirely finished. His more mediocre younger brother Gioseppe, who made a living mainly from the restoration of antique sculpture, worked his St Sebastian (J. Montagu convincingly argues) from a design by Ciro Ferri.

43. Lucenti was a highly qualified bronze caster. He cast all the bronzes of Bernini's altar of the Cappella del Sacramento in St Peter's (1673-4) and the figure of Death of the tomb of Alexander VII (1675-6). The strange, archaic, and picturesque Sicilian sculptor Francesco Grassia is a completely isolated phenomenon in Bernini's Rome. Little is known about him. He probably died in 1683. His few known works have been published by L. Lopresti in *L'Arte*, XXX (1927), 89, and I. Faldi in *Paragone*, IX (1958), no. 99, 36.

44. G. Walton, 'Pierre Puget in Rome: 1662', *Burl. Mag.*, CXI (1969), 582 ff.

318. 45. Between 1659 and 1660 he executed a large wooden model of the porticoes and between 1661 and 1672 at least twenty statues above the porticoes.

46. His best pupil was his cousin Giuseppe Giosafatti (1643-1731) who handed on the tradition to his son, Lazzaro (1694-1781). The continuity of Bernini's manner can be traced here in a direct line over a period of almost 150 years. Lazzaro Giosafatti renewed contact with Rome by studying under Camillo Rusconi. G. Rosenthal (*Journal of the Walters Art Gallery*, V, 1942) published a relief by Lazzaro. For the Giosafatti, see G. Fabiani, *Artisti del Sei- Settecento in Ascoli*, Ascoli-Piceno, 1961, 35-54.

47. Among them was Paolo Naldini; see Narducci in *Buonarroti*, V (1870), 122. Failing proper statistics, we do not know how many of them were painters, sculptors, or artisans, nor how poor they were.

48. G. Campori, *Artisti estensi*, Modena, 1855, 66. - The Roman scudo was probably worth at least £1 (present value).

49. Archivio della Fabbr. di S. Pietro, Giustific. 369 (14 December 1671) and Uscità 417 (7 June 1725). Cornacchini drew additional payment for work connected with the monument.

319. 50. Venturi, X, iii, 873.

51. Lankheit, 36. - Without a knowledge of the correct attribution, I had stated in the first ed. that 'the relief can hardly date from before 1670'.

52. See illustrations in P. Fogaccia, *Cosimo Fanzago*, 1945, figures 8 and 9.

53. See above, Chapter 12, Note 66.

CHAPTER 14

321. 1. For G. Gimignani, see the full treatment by G. di Domenico Cortese, in *Commentari*, XVIII (1967), 186-206. – The number of Cortona's pupils, and of those directly and indirectly influenced by him, is legion. The most important Roman *Cortoneschi* of the next generation are Lazzaro Baldi (1623-1703), Guglielmo Cortese (Guillaume Courtois, 1627-79), Ciro Ferri (1628/34-89), and the pair Giovanni Coli (1636-80) and Filippo Gherardi (1643-1704). Even the Sienese Raffaello Vanni (1587-1673), pupil and son of Francesco, came later under Cortona's influence.

Among his minor pupils, responsible for spreading his manner, may be mentioned Adriano Zabarelli, called Palladino, from Cortona (1610-81), Carlo Cesi from Rieti (1626-86), Pietro Paolo Baldini (active *c.* 1660), Pietro Locatelli (*c.* 1634-1710), Francesco Bonifazio (b. 1637), who painted mainly at Viterbo, Giovanni Marracci (1637-1704), whose work is to be found at Lucca, and Camillo Gabbrielli, Ciro Ferri's pupil, who painted at Pisa. Of the above-mentioned Pietro Locatelli (or Lucatelli) several hundred drawings have been identified in the Berlin Print Room; these have been discussed in a splendid paper by P. Dreyer (*Jahrb. d. Berliner Museen*, IX (1967), 232-73), who also concerns himself with the close cooperation between Ciro Ferri and Lucatelli.

For other Tuscan *Cortoneschi*, see below, Note 65.

2. For the early Cozza, see his *St Joseph and Angels* in S. Andrea delle Fratte with signature and date 1632 which appeared when the painting was cleaned; see *Attività della Soprintendenza alle Gallerie del Lazio*, X, Settimana dei Musei, Rome, 2-9 aprile 1967, no. 11, figure 15.

3. See R.-A. Weigert in *Art de France*, II (1962), 165. Perhaps Romanelli's series of Dido and Aeneas cartoons for the tapestries woven by Michel Wauters belong to the Paris period. Six Romanelli cartoons were sold at Sotheby's in March 1969 and purchased by the Norton Simon, Inc. Museum of Art, California; see the scholarly paper by R. Rubinstein, in *Art at Auction: The Year at Sotheby's & Parke Bernet, 1968-69*, London, 1969, 116 ff.

322. 4. Only fragments are preserved of Lanfranco's *Immaculate Conception*, once over the high altar and finished as early as 1630.

5. E. Waterhouse, *Baroque Painting*, 25, 27, first discussed the archaizing tendencies of the 1640s. For Giacinto Gimignani's later style, see his frescoes in the Palazzo Cavallerini a via dei Barbieri; L. Salerno, in *Palatino*, VIII (1964), 13 f.

323. 6. For the Bamboccianti, see Briganti's contributions. For Codazzi, R. Longhi, *Paragone*, VI (1955), no. 71, 40, E. Brunetti, *ibid.*, VII (1956), no. 79, 61 and *idem*, *Burl. Mag.*, C (1958), 311; also H. Voss, *ibid.*, CI (1959), 443, and U. Prota-Giurleo, *Pitt. nap.*, Naples, 1953, 76.

7. G. J. Hoogewerff, *De Bentveughels*, The Hague, 1952.

8. According to Haskell, *Patrons*, 139 (note), the collaboration between Cerquozzi and Codazzi began after 1647.

9. See A. Sutherland Harris, in *Paragone*, XVIII (1967), no. 213, 42.

10. L. Montalto, *Commentari*, VI (1955), 224. For different interpretations of Mola's early itinerary see E. Schaar, *Zeitschr. f. Kunstg.*, XXIV (1961), 184, and A. B. Sutherland, *Burl. Mag.*, CVI (1964), 363 (new documents), and 378, in reply to S. Heideman, 377 f.

11. His most famous painting of this class is the *St Bruno*, existing in many versions, a work not uninfluenced by Sacchi's *St Romuald*. For Mola, see Arslan, *Boll. d'Arte*, VIII (1928), 55; Wibiral, *ibid.*, XL (1960), 143; Martinelli, *Commentari*, IX (1958), 102; and Sutherland's revised chronology (last Note). The important problem of various versions of the same subject in Mola's work has been discussed by A. Czobor, *Burl. Mag.*, CX (1968), 565 ff., 633.

324. 12. A. S. Harris published a number of studies for this work in *Revue de l'Art*, no. 6 (1969), 82-7.

13. Wittkower, *Born under Saturn*, 1963, 142.

325. 14. The etching shows a young man reaching Parnassus by the torch of Wisdom which disperses Ignorance, Envy, and other vices. The contrast between the classicality of individual figures and the non-classical *horror vacui* should be observed. On Testa's etchings, P. Petrucci, *Boll. d'Arte*, XV (1935-6), 409. For the problem of interpretation, see, e.g., T.S.R. Boase, *J.W.C.I.*, III (1939-40), 111. The most penetrating discussion of some of Testa's etchings in A. Sutherland Harris and C. Lord, *Burl. Mag.*, CXII (1970), 15 ff., 400. For Testa's chronology, see A. Sutherland Harris, *Paragone*, XVIII (1967), no. 213, 35 ff., and E. Schleier, *Burl. Mag.*, CXII (1970), 665 ff.

15. Rosa's early education is still a problem, and above all his relation to Falcone. A teacher–pupil relationship probably existed, although Falcone's rather restrained battle-pieces are very different from Rosa's fiery mêlées; see F. Saxl, *J.W.C.I.*, III (1939-40), 70; also A. Blunt, *Burl. Mag.*, CXI (1969), 215.

16. Rosa's anticlericalism was emphasized by L. Salerno, *Salvator Rosa*, 1963, 23. – It can, however, not be maintained that Rosa, despite all his extravagance,

created 'almost single-handed the image of the artist as being apart' (Haskell, *Patrons*, 22). For the history of this concept, see Wittkower, *Born under Saturn*. For Rosa's conception of his genius, see R. W. Wallace, in *Art Bull.*, XLVII (1965), 471 ff. For his stoicism, *ibid.*, and Haskell, 143.

326. 17. R. Wallace, *Burl. Mag.*, CIX (1967), 395 ff., has shown that Rosa selected the unusual theme of the 'Death of Atilius Regulus' for a painting in support of his claim that he was above all a history painter.

18. Institute of Art, Detroit, from the Palazzo Colonna, Rome; see Paul L. Grigaut, *Bull. Detroit Inst. of Art*, XXVII (1948), 63.
Rosa's classicism was emphasized in a remarkable note by B. Nicolson, *Burl. Mag.*, C (1958), 402.

327. 19. H. W. Schmidt, *Die Landschaftsmalerei Salvator Rosas*, Halle, 1930, gives an account of Salvator's relation to the landscape tradition and his development as a landscapist.

20. Further to G. Dughet's development, A. Blunt, *French Art etc.*, 201; Wibiral, *Boll. d'Arte*, XL (1960), 134; the important paper by D. Sutton, *G.d.B.A.*, LX (1962), 268–312; M. R. Waddingham, *Paragone*, XIV (1963), no. 161, 37; Sutherland, *Burl. Mag.*, CVI (1964), 63. Here the correct date for the S. Martino ai Monti frescoes is given: 1649–51. See also A. Sutherland Harris, *Burl. Mag.*, CX (1968), 142 ff., and M. Chiarini, *Burl. Mag.*, CXI (1969), 750 ff.
For Gaspar's pupil, Crescenzio Onofri (1632–98), see I. Toesca, *Paragone*, XI (1960), no. 125, 51.
After J. Hess's pioneering book, the literature on Tassi has steadily grown; see E. Schaar in *Mitteilungen des Florent. Inst.*, IX (1959–60), 136; E. Knab in *Jahrb. d. kunsthist. Slg. Wien*, XX (1960), 84; M. R. Waddingham, *Paragone*, XII (1961), no. 139, 9, and *ibid.*, XIII (1962), no. 147, 13.

21. See, among others, his frescoes in the Palazzo Santacroce (Waterhouse, 74), in the Villa Doria-Pamphili (1644–8), where he also worked as architect (Chapter 12, Note 37), and in S. Martino ai Monti (1648; Sutherland, *loc. cit.*). For Grimaldi as decorator in the Palazzo Borghese, see Chapter 13, Note 40.
For the connexion between Grimaldi and Dughet, see Wibiral, *op. cit.*, 137.

22. This manuscript, now at Düsseldorf, was skilfully discussed by A. Marabottini, *Commentari*, V (1954), 217. For Testa's art theory, see also M. Winner, *Jahrb. Preuss. Kunstslg.*, IV (1962), 174.

23. It may be noted that the *Blind Belisarius* in the Palazzo Pamphili, until recently always attributed to Salvator, has been shown to be a work by Francesco Rosa (1681), whose activity between 1638 and 1687 has been reconstructed by L. Montaltò, *Riv. dell'*

Istituto, III (1954), 228. See also E. Battisti, *Commentari*, IV (1953), 41.
Some of Rosa's most interesting works are concerned with stoic, macabre, and proto-romantic subjects; for this side of his activity, see the stimulating papers by R. W. Wallace (Bibliography) and N. R. Fabbri, in *J.W.C.I.*, XXXIII (1970), 328–30.

24. On Bellori, see Schlosser, *Kunstliteratur*; E. Panofsky, *Idea*, Florence, 1952; K. Donahue, *Marsyas*, III (1943–5), 107; F. Ulivi, *Galleria di scrittori d'arte*, Florence, 1953, 165.

328. 25. I believe this has never been commented on.
26. E.g. Guarini's churches or S. Maria della Salute. The oil paintings planned for the dome of the latter church were clearly a last afterthought; see, however, E. Bassi, *Critica d'Arte*, XI (1964), fasc. 62, 4.

27. For his intense desire to return to Rome as early as 1640, see E. Schleier, in *Master Drawings*, V (1967), 35 ff.
28. See B. Canestro Chiovenda, *Commentari*, X (1959), 16.
29. 1672–4: frescoes of the dome; in 1679 the frescoes of the nave were unveiled; those of the apse after 1679; see A. M. Brugnoli, *Boll. d'Arte*, XXXIV (1949), 236; P. Pecchiai, *Il Gesù di Roma*, Rome, 1952, 126 ff.; also R. Enggass, *Baciccio*, 1964, 31.
For Antonio Gherardi, Mola's pupil, who had spent years in Venice and distinguished himself also as an architect (p. 376), see A. Mezzetti, *Boll. d'Arte*, XXXIII (1948), 157.
To the same period belong Giovanni Coli's and Filippo Gherardi's frescoes in the dome of S. Nicolò da Tolentino (1669–70, dependent on Cortona's dome of S. Maria in Vallicella) and their paintings inserted in the ceiling of S. Croce dei Lucchesi (c. 1674). Lodovico Gimignani's dome frescoes in S. Maria delle Vergini date from 1682; G. D. Cerrini's frescoes in the dome of S. Maria della Vittoria (undated) may belong in the 1670s.

30. The frescoes in the apse are by Gaulli's pupil, Giovanni Odazzi; see H. Voss, 328.
330. 31. Waterhouse, 71.
32. Giacinto Brandi (1623–91), Lanfranco's pupil, a prolific but facile painter who remained faithful to his master's style, contributed little that deserves special attention.
Francesco Allegrini (1624–63) was one of the minor Cortona followers.

33. Of German descent, Egidio and Giovan Paolo (1615–74); the latter, the more important of the two, was a versatile artist whose paintings as well as designs for applied art have a Cortonesque flavour; on a number of occasions he worked for Bernini (see Chapter 18, Note 1). G. P. Schor has recently been given the atten-

tion he deserves, see G. Aurenhammer, *Die Hand-zeichnungen des 17. Jahrhunderts in Österreich*, Vienna, 1958, 13, 103; H. Hibbard, *Burl. Mag.*, C (1958), 205; A. Blunt-H. L. Cooke, *The Roman Drawings at Windsor Castle*, London, 1960, 110. Interesting additions in Wibiral, *Boll. d'Arte*, XL (1960), 144.

34. Their names are Angelo Canini, Carlo Cesi, Fabrizio Chiari, Bartolomeo Colombo, Filippo Lauri, Francesco Murgia, and, in addition, the more considerable Jan Miel (*c.* 1599–1663), a Fleming, who first belonged to the circle of the Bamboccianti in Rome, but turned in Turin to the grand manner in fresco and came under Cortona's influence in the last years of his life.

The complicated history of the Quirinal Gallery has been disentangled in an excellent paper by N. Wibiral, *op. cit.*, 123–65, which also contains valuable new information on all the participating artists. See also W. Vitzthum in *Boll. d'Arte*, XLVIII (1963), 96, who warns against over-estimating Grimaldi's rôle. – For Lauri (1623–94), Caroselli's pupil, see B. Riccio, *Commentari*, X (1959), 3.

35. See the fully documented article by L. Montalto, *Commentari*, VI (1955), 267. For Mola's destroyed *Stanza dell'aria* frescoes of the Pamphili villa at Valmontone, see R. Cocke, *Burl. Mag.*, CX (1968), 558 ff.

36. By him the Jupiter ceiling of the large room on the first floor (1675), attributed by Waterhouse, 48, to N. Berrettoni, and correctly named Canuti by E. Feinblatt, *Art Quarterly*, XV (1952), 51.

37. In addition to these may be mentioned Romanelli's frescoes in the Palazzi Lante (1653) and Barberini (1660), Antonio Gherardi's impressive Stories of Esther in the Palazzo Naro (1665–70?) and the frescoes in the Villa Falconieri, Frascati, by Ciro Ferri, N. Berrettoni, and C. Maratti (before 1680).

38. See N. Pevsner, 'Die Wandlung um 1650 in der italienischen Malerei', *Wiener Jahrb.*, VIII (1932), 69. C. Refice Taschetta, *Mattia Preti*, Brindisi, 1961, 83, dates these frescoes incorrectly in 1653. She overlooked that the date 1661 is assured by Preti's own statement (see Ruffo, *Boll. d'Arte*, X (1916), 255). He painted the frescoes in the Palazzo Doria Pamphili at Valmontone on the occasion of his brief visit to Rome, before going to Malta.

39. L. Montalto, *Commentari*, VII (1956), 41, with documents. See also L. Mortari, *Paragone*, VII (1956), no. 73, 17, and J. Offerhaus in *Bull. van het Rijksmuseum*, X (1962), 5.

332. 40. Gaulli has been thoroughly studied after the Second World War, mainly by A. M. Brugnoli, R. Enggass, and F. Zeri. All the older research in Enggass's recent monograph (1964). In addition, see R. Enggass, *Burl. Mag.*, CVIII (1966), 365 f., and R. E.

Spear, *ibid.*, CX (1968), 37 f. Of the older literature may be mentioned Brugnoli's article in *Boll. d'Arte*, XXXIV (1949), 236 (with *œuvre* catalogue).

334. 41. Documents published by E. Feinblatt (see Note 36).

For Canuti, see Malvasia, *Vite di pittori bolognesi*, ed. A. Arfelli, Bologna, 1961, 13–35. – Canuti had been in Rome in 1651 (or earlier) and stayed on until 1655 (see unpublished thesis by L. Zurzolo, University of Bologna, 1958–9, 31) before he returned in 1672.

42. Despite chronological difficulties I still believe that Canuti learned the new mode of organizing a large fresco (stimulated by Bernini's genius) in Rome rather than vice versa. Meanwhile E. Feinblatt (*Art Quarterly*, 1961) has shown that Canuti operated with large dark and light areas in his fresco of the hall of the Palazzo Pepoli, Bologna, as early as 1669; after his Roman interlude, he practised similar principles in the frescoes of the library (1677–80) and dome of S. Michele in Bosco (1682–4) in Bologna. Gaulli on the other hand, did not begin the Gesù frescoes until 1672.

43. For Pozzo's work on perspective, see G. Fiocco, *Emporium*, XLIX (1943), no. 1, 3. For his work in Tuscany, P. della Pergola, *Riv. del R. Istituto*, V (1935/6), 203.

On Pozzo as painter, see Marini's monograph (1959) and his paper in *Arte Veneta*, XII–XIV (1959–60), 106, and on Pozzo as architect, Carboneri's monograph (1961). See also A. de Angelis, 'La Scenografia sacra di A. P. a Roma e a Frascati', *Studi romani*, VI, 2 (1958), 160; L. Montalto, 'A. P. nella chiesa di Sant'Ignazio', *ibid.*, VI, 6; A. M. Cerrato in *Commentari*, X (1959), 24 (with *œuvre* catalogue).

B. Kerber's monograph (1971; see Bibliography) has now to be consulted for all questions concerning Pozzo.

For the problem of the viewpoint of the S. Ignazio frescoes and other Baroque ceilings, see W. Schöne in *Festschrift Kurt Badt*, Berlin, 1961, 344, and Kerber's objections (102 ff.) to Schöne.

In 1703 Pozzo settled in Vienna and his work there (Jesuit church; Liechtenstein Garden Palace) had a strong influence on Austrian and German fresco painting.

Pozzo's frescoes in S. Ignazio found immediate following; see, e.g., Giuseppe Barbieri's frescoes in the dome, nave, and transept of S. Bartolomeo at Modena, executed 1694–8 (N. Carboneri, in *Arte in Europa. Scritti di Storia dell'Arte in onore di Edoardo Arslan*, Milan, 1966, 737 ff.).

44. On the ceiling three scenes illustrating events in the life of Marcantonio Colonna. The victory of Lepanto shown in our illustration was won under him.

For Coli and Gherardi, see A. M. Cerrato in *Commentari*, X (1959), 159 (with *œuvre* catalogue).

337. 45. See the otherwise irrelevant article by E. Feinblatt, *Art Quarterly*, X (1947), 237.

46. This may be the place to mention Giovanni Maria Morandi (1622–1717), who has recently attracted attention (Waterhouse, see Bibliography). Born in Florence, he settled early in Rome and paintings by him are known from the late 1650s onwards. While as a portrait painter he competed with Gaulli, his altarpieces are often close to Maratti's.

47. The high cove of the ceiling is now white and one is reminded of the contrast between the painted field and the surrounding whiteness at the period of Reni's *Aurora*, but surviving drawings (and Bellori's text) prove that Maratti planned frescoes also for the vaulted part of the ceiling; see F. H. Dowley, *Burl. Mag.*, CI (1959), 71; W. Vitzthum, *ibid.*, CV (1963), 367; J. Bean, *ibid.*, 511; Harris-Schaar, Düsseldorf Catalogue, 1967, nos. 256–76.

48. See the excellent article by O. Kutschera-Woborsky, 'Ein kunsttheoretisches Thesenblatt des Carlo Maratti', *Graphische Künste, Mitteilungen* (1919), 9.

49. On Agucchi and his theory, see above, p. 39, with further references.

339. 50. A fully documented modern treatment of Maratti (with *œuvre* catalogue) is now available; see A. Mezzetti, *Riv. dell' Istituto*, IV (1955). For the painting shown as illustration 220 see F. H. Dowley, 'Some Maratti Drawings at Düsseldorf', *Art Quarterly*, XX (1957), 174.

51. I. Matalon, *Riv. d'Arte*, XII (1930), 497; G. Testori, *Paragone*, III (1952), no. 27, 24.

Del Cairo, court artist in Turin from 1633 onwards, is now a well-defined artistic personality of considerable importance. New ground was broken at the *Mostra del manierismo piemontese . . .* 1955, where the often reproduced *St Francis* in the Castello Sforzesco, previously attributed to Morazzone, was given to Del Cairo. The whole question is reviewed in M. Gregori's Morazzone Catalogue of 1962, 48, 108, with other valuable material for Del Cairo; see also the *St Francis* paintings by Cerano (*Mostra del Cerano*, 1964, 100).

340. 52. E. S. Natali's paper on the artist in *Commentari*, XIV (1963), 171, is disappointing.

342. 53. The new assessment of Reni's late manner, foreshadowed as early as 1937 in O. Kurz's pioneering article (see Bibliography), was one of the important results of the Reni Exhibition of 1954.

'Sbozzata solo' (i.e. left unfinished) according to Malvasia, the *Girl with a Wreath* shows the characteristic condition of a number of pictures of this period, for which see comment in C. Gnudi-G. C. Cavalli, *Guido Reni*, Florence, 1955, 100.

For all the painters mentioned in this paragraph, see the Exhibition Catalogue of the *Seicento Emiliano*, Bologna, 1959, and Bibliography under individual painters.

54. F. Arcangeli, *Paragone*, I (1950), no. 7, 38. Cantarini's pupil, the strong Flaminio Torri (1621–61), may here also be mentioned; see G. Raimondi in *Studi in onore di Matteo Marangoni*, Florence, 1957, 260. – The weak Reni follower Francesco Torriani (1612–81), who worked mainly in Mendrisio, was given the undeserved honour of a one-man Exhibition; see G. Martinola, *Francesco Torriani. Catalogo della mostra*, Mendrisio, Palazzo Nobili Torriani, 1958.

55. M. Zuffa in *Arte Antica e Moderna*, VI, no. 24 (1963), 358, has reconstructed the artist's itinerary from documents and has established that his name is Cagnacci (not Canlassi, Thieme-Becker) and that he died in 1663 (not 1681).

For Cagnacci's Viennese career, see G. Heinz in *Jahrb. d. kunsthist. Slg. in Wien*, LIV (1958), 173, 183.

343. 56. For Pasinelli, whose art is attracting increasing attention, see C. Volpe, *Paragone*, VIII (1957), no. 91, 30, 36; C. Baroncini, *Arte Antica e Moderna*, no. 2 (1958); D. C. Miller in *Burl. Mag.*, CI (1959), 106. – For Canuti's pupil Giuseppe Rolli (1643–1727), the painter of the important ceiling of S. Paolo in Bologna (1695), see F. de' Maffei, in *Scritti di storia dell' arte in onore di Mario Salmi*, Rome, 1963, III, 325, and E. Feinblatt in *Burl. Mag.*, CVI (1964), 569 ff. Also *idem*, in *Master Drawings*, VII (1969), 164 ff.

57. According to Baldinucci (ed. 1846, IV, 682), he called this type of perspective 'vedute non regolate da un sol punto'. Further to this problem, J. Schulz in *Burl. Mag.*, CIII (1961), 101, according to whom the *quadratura* painters Cristoforo and Stefano Rosa from Brescia used multiple vanishing points as early as the sixteenth century. – Colonna worked in the Palazzo Pitti between November 1637 and June 1639 and again in 1641; see M. Campbell, *Art Bull.*, XLVIII (1966), 135 f. Further for Colonna see S. de Vito Battaglia, *L'Arte*, XXXI (1928), 13. E. Feinblatt, *Art Quarterly*, XXI (1958), 265, discusses the ceilings in the Villa Albergati-Theodoli at Zola Predosa (near Bologna); Colonna's most extensive work during the period of collaboration with Giacomo Alboresi (1632–77), Mitelli's pupil, whom he took on as collaborator after Mitelli's death.

For Mitelli, see now E. Feinblatt's Introduction to the Mitelli Exhibition in Los Angeles (see Bibliography).

344. 58. For the following F. Sricchia, 'Lorenzo Lippi nello svolgimento della pittura fiorentina della prima metà del '600', *Proporzioni*, IV (1963), 243–70; M. Gregori in *Paragone*, XV (1964) no. 169, 16; and *idem*, *70 pitture e sculture del '600 e '700 fiorentino*, Florence,

1965; also Hibbard-Nissman, *Florentine Baroque Art*, 1969 (see Bibliography).

59. C. del Bravo in *Paragone*, XII (1961), no. 135, 28.

60. See G. Briganti, *Paragone*, I (1950), no. 7, 52.

61. Cecco Bravo is emerging as one of the most unconventional Florentine artists of his generation. G. Ewald was the first to give back to him a number of pictures previously attributed to S. Mazzoni (*Burl. Mag.*, CII (1960), 343, CIII (1961), 347). A. R. Masetti's monograph (1962) with *œuvre* catalogue and bibliography contains a document for Bravo's hitherto unknown birth-date. The painting of illustration 232 has previously been attributed to S. Mazzoni, but Ewald and others are in agreement that it has to be given back to Cecco Bravo.

For Pietro Ricchi (1606–75) and Mario Balassi (1604–67), the first from Lucca, the second from Florence, who both owed Venice a formative influence, see H. Voss in *Kunstchronik*, XIV (1961), 211. Further for Ricchi, see R. Pallucchini, *Arte Veneta*, XVI (1962), 132, and A. Rizzi, *ibid.*, 171.

62. M. Gregori (Note 58) offers a more positive assessment of Giovanni da San Giovanni's art; see also M. Campbell, *Art Bull.*, XLVIII (1966), 133 ff.

345. 63. M. Winner, *Mitteilg. d. kunsthist. Instit. Florenz*, X (1963), 219, discusses the interesting iconography of this cycle (documents).

64. His *œuvre* has first been reconstructed by G. Ewald, *Burl. Mag.*, CVI (1964), 218.

65. Among the Cortona followers in Florence worth mentioning are the Fleming Lieven Mehus (1630–91); Vincenzo Dandini (1607–75) and his nephew, Pier Dandini (1646–1712), who in his later work, however, broke away from his early Cortonesque manner; in addition Salvi Castellucci from Arezzo (1608–72) and Lorenzo Berrettini, Cortona's nephew and pupil, who worked mainly at Aquila. See also Berti, *Mostra di Pietro da Cortona*, Rome, 1956.

66. Demonstrated in a thoughtful article by G. Heinz in *Jahrb. d. kunsth. Slg. in Wien*, LVI (1960), 197.

346. 67. See A. Blunt, *The Drawings of G. B. Castiglione and Stefano della Bella at Windsor Castle*, London, 1954, 89, with further references. See also Alexandre de Vesme's standard catalogue of Stefano della Bella's prints, reprinted with corrections and annotations by P. Dearborn Massar, New York, 1970; also the same author's 'Stefano d. B.'s Illustrations for a Fireworks Treatise', *Master Drawings*, VII (1969), 294 ff., dating from 1649; and F. Viatte and W. Vitzthum, *Arte Illustrata*, III, nos. 34–6 (1970), 66 ff., who offer new material to the question of Stefano della Bella's journey to the Levant.

68. For the following see mainly G. Fiocco's pioneering work, published in 1929; also the challenging remarks by E. Arslan, *Il concetto di l'uminismo . . .*,

Milan, 1946; and *La Pittura del Seicento a Venezia*, Catalogue, Venice, 1959, with full bibliography.

347. 69. Arslan, *op. cit.*, 24; G. Fiocco, *Arte Veneta*, IV (1950), 150; L. Fröhlich-Bum and R. Longhi, *Paragone*, III (1952), no. 31, 34; N. Ivanoff, 'Giorgione nel Seicento', in *Venezia e l'Europa*, Venice, 1956, 323.

70. Arslan, 29, 42. For Carpioni's dates, see Zorzi, *Arte Veneta*, XV (1961), 219. G. M. Pilo's monograph (1962) contains all previous research. See also *idem*, 'Giulio Carpioni e Vicenza', *Odeo Olimpico*, V (Vicenza, 1964–5), 55 ff.

71. See also G. M. Pilo, in *Il mito del classicismo nel seicento*, Florence, 1964, 227.

72. G. Fiocco, *Dedalo*, III (1922), 275; J. Zarnowski and F. Baumgart, *Boll. d'Arte* (1931–2), 97; R. Pallucchini, *ibid.*, XXVIII (1934), 251.

73. N. Ivanoff, *Boll. d'Arte*, XXXVIII (1953), 321.

74. G. Ewald in *Critica d'Arte*, VI (1959), 43, and *Boll. Musei Civici Veneziani*, 1959, 1.

75. A. Rizzi's monograph (1960) with *œuvre* catalogue (completely illustrated) supersedes all previous research.

348. 76. See Ivanoff's Catalogue of the Maffei Exhibition, 1956, with further bibliography. In addition, R. Marini, 'Il dare e l'avere tra Pietro Vecchia e Maffei', *Arte Veneta*, X (1956), 133; L. Magagnato's excellent review of the Exhibition, *ibid.*, 245; F. Valcanover, *Emporium*, CXXIII (1956), 150; Haskell, *Burl. Mag.*, XCVIII (1956), 340; R. Marini, *Arte Veneta*, XV (1961), 144 (attempt to clarify chronology).

77. C. Gnudi, *Critica d'Arte*, I (1935–6), 181; N. Ivanoff, *Arte Veneta*, I (1947), 42, and *idem* in *Saggi e Memorie di storia dell'arte*, II (1958–9), 211–79 (basic study).

349. 78. A. M. Mucchi and C. della Croce, *Il pittore Andrea Celesti*, Milan, 1954, with *œuvre* catalogue and contribution by N. Ivanoff.

79. G. M. Pilo, *Arte Veneta*, XVII (1963), 128.

80. See Arslan, *op. cit.*, 32.

81. A. M. Pappalardo, *Atti dell'Istituto Veneto di Scienze . . .*, CXII (1953–4), 439.

Two artists who came under Bolognese influence should at least be mentioned: Giannantonio Fumiani (1650 (not 1643)–1710, see Arslan, 44) and Gregorio Lazzarini (*c.* 1660/2–1720), Tiepolo's first teacher. For Lazzarini, see G. M. Pilo in *Arte Veneta*, XI (1957), and *Critica d'Arte*, V (1958), 233.

350. 82. The equally mediocre Antonio Busca (1625–86), director of the Accademia Ambrosiana in 1686, may at least be mentioned; see C. Rossi o.p., in *Arte Lombarda*, IV (1959), 314. For C. F. Nuvolone, see U. Ruggeri, in *Arte Lombarda*, XII (1967), 67 ff. For the Nuvolone family, see N. Ward Neilson, *Burl. Mag.*, CXI (1969), 219 f.

83. Longhi-Cipriani-Testori, *I pittori della realtà in*

Lombardia, Milan, 1953, with bibliography; G. Testori, *Paragone*, IV (1953), no. 39, 19.
352. 84. See Arslan's (Note 68, 24) relatively negative assessment of Strozzi; also A. M. Matteucci, *Arte Veneta*, IX (1955), 138.
85. E. Falletti, *Commentari*, VII (1956), 158.
86. A. M. Goffredo, *ibid.*, 147. – Among Strozzi's pupils in Genoa may be mentioned Antonio Travi (1608–65), who later made his name by concentrating on the popular genre and on landscapes with ruins.
87. B. Riccio, *Commentari*, VIII (1957), 39.
353. 88. M. Bonzi, *Pellegro Piola e Bartolomeo Biscaino*, Genoa, 1963. – Pellegro or Pellegrino Piola (1616–40), who had been apprenticed with Gio. Domenico Cappellino, practised an antiquated, cinquecentesque manner; see also *Mostra dei pittori genovesi ...*, Genoa, 1969, nos. 41, 42.
Of other painters who died of the plague, I mention Orazio de Ferrari (1606–57), who stems from Ansaldo and Assereto (M. Labò, *Emporium*, CI (1945), 3), and Silvestro Chiesa (1623–57), whose only known picture (S. Maria dei Servi, Genoa) reveals him as a master of uncommon power (A. Morassi, *Mostra della pittura ... Liguria*, 1947, 57).
89. I am following mainly Anthony Blunt's reconstruction of Castiglione's career; see *J.W.C.I.*, VIII (1945), 161 and *The Drawings of G.B.C. at Windsor*, London, 1954. For interesting new results, see A. Percy, *Burl. Mag.*, CIX (1967), 672 ff. See also E. Waterhouse, 'An *Immaculate Conception* by G.B.C.', *The Minneapolis Institute of Arts Bulletin*, LVI (1967), 5 ff., with new ideas on Castiglione's chronology.
354. 90. O. Grosso, *Dedalo*, III (1922–3), 502.
91. M. Marangoni, *I Carloni*, Florence, 1925. Giovanni Battista, the more important of the two brothers, was a prolific fresco painter. His work is to be found in the Gesù, S. Siro, the Chiesa dell'Annunziata where he collaborated with Giovanni Andrea, etc. Trained under Passignano in Florence, he was later strongly influenced by Rubens. His son Andrea (1639–97), who worked in Maratti's studio in Rome, brought back to Genoa (1678) a fluid Cortonesque manner. For his work in the Palazzo Altieri, Rome (1674–7), see E. Gavazza, *Arte Lombarda*, VIII (1963), 246.
Giulio Benso (1601–68) may also be mentioned; his frescoes in the Annunziata (partly destroyed during the war) reveal him as an able painter with a special interest in *quadratura* and determined *sotto in su* compositions.
92. For Piola see G. V. Castelnovi, *I dipinti di S. Giacomo alla Marina* (Quaderni della Soprintendenza alle Gallerie ... della Liguria), Genoa, 1953; also E. Malagoli, *Burl. Mag.*, CVIII (1966), 503 ff.
93. A. Griseri, *Paragone*, VI (1955), no. 67, 22. E. Gavazza in *Arte Antica e Moderna*, VI, no. 24 (1963),

326, makes the tentative suggestion that de Ferrari met Gaulli at Parma in 1669. – See also *Disegni di G. de F.*, Exhibition, Palazzo Rosso, Genoa, 1963, and A. Griseri, *Gregorio de Ferrari* (I maestri del colore, 135), Milan, 1966.
355. 94. Bolognese *quadratura* had been introduced in Genoa by Colonna's fresco decoration in the ex-Palazzo Reale (formerly Balbi) in 1650.
356. 95. In addition to the basic articles by R. Longhi (1915) and H. Voss (1927), see R. Causa, *Paragone*, I (1950), no. 9, 42, R. Carità, *ibid.*, II (1951), no. 19, 50, and F. Bologna, *ibid.*, XI (1960), no. 129, 45.
For the following, see, apart from A. de Rinaldis's book (1929), S. Ortolani's remarkably perceptive Introduction to *La mostra della pittura napol.*, Naples, 1938, and R. Causa's excellent survey (1957).
96. See E. du Gué Trapier's monograph (1952) and D. F. Darby's review, *Art Bull.*, XXXV (1953), 68. Also U. Prota-Giurleo, *Pitt. nap.*, 1953, 91. Ribera's date of birth is usually wrongly given as 1588. J. Chenault, *Burl. Mag.*, CXI (1969), 561 ff., has published documentary proof of Ribera's stay in Rome in 1615 and 1616 (the year he probably returned to Naples) and of his trip north about 1630.
357. 97. Giovanni Dò (1604–56), like Ribera born at Játiba in Spain, settled in Italy *c.* 1623 and married the sister of Pacecco de Rosa (1626). His impressive *Adoration of the Shepherds* (Chiesa della Pietà dei Turchini, Naples) – the only picture known by him – is entirely Riberesque. Among the minor Ribera pupils Bartolomeo Passante (1618–48) from Brindisi may be mentioned. On Passante, see J. H. Perera, *Archivo Español de Arte*, XXVIII (1955), 266, and the criticism by F. Bologna, *F. Solimena*, 1958, 30. On these artists R. Longhi wrote one of his last papers (*Paragone*, XX (1969), no. 227, 42), in which he also revived the almost forgotten 'naturalista' Giovan Battistà Spinelli (d. *c.* 1647).
98. Reni's abortive stay at Naples in 1622 lasted about a month. His magnificent *Adoration of the Shepherds* in the Certosa di S. Martino, painted shortly before his death (1641?), came after the critical moment in the history of Neapolitan painting. But less important works of an earlier period (*c.* 1622) were in the Chiesa di S. Filippo Neri.
99. A list of frescoes painted by minor artists in Lanfranco's manner in Ortolani, *op. cit.*, 79.
100. According to W. R. Crelly, *The Painting of Simon Vouet*, New Haven and London, 1962, this 'first full announcement of his post-Italian altarpieces' (p. 36) is signed and dated 1623 (184, no. 79).
But if it were correct that in 1620 Vouet had painted the *Virgin appearing to St Bruno* for the Certosa di S. Martino, as Crelly and others (A. Blunt, *Art and Architecture in France*, 167; Briganti, *P. da Cortona*, 1962,

49) believed, he would already then have drifted away from Caravaggio. Critical opinion, however, now dates this painting later: D. Posner, *Art Bull.*, XLV (1963), 291, c. 1623; B. Nicolson, *Burl. Mag.*, CV (1963), 310, c. 1627; G. Darquet and J. Thuillier, *Saggi e Memorie di storia dell'arte*, IV (1965), 47, no. A31, c. 1624-6.

101. All the major Neapolitan artists felt her influence, but she also took from them. Among the second-rate artists, Paolo Finoglia (c. 1590-1656), who had started his career under Battistello in the Certosa of S. Martino, was much indebted to her; see M. d'Orsi, *Paolo Finoglia, pittore napolitano*, Bari, 1938.

Another 'belated' *Caravaggista* should here be mentioned, Matthias Stomer from Amersvoort, Holland (c. 1600-c. 1650), who appeared in the early 1630s in Rome and soon transferred his activity to Naples and Sicily. Reputedly closely connected with Honthorst, his style shows affinities with Terbrugghen, Baburen, and even Vouet; see R. Longhi, *Proporzioni*, I (1943), 60.

358. 102. F. Bologna (in *Bulletin, Musées Royaux des Beaux-Arts, Bruxelles* (1952), no. 2, 47) stressed the influence of van Dyck's palette on Ribera and other Neapolitan painters from about 1635 on. Ribera's *Communion of the Apostles* (Certosa of S. Martino) with the disproportionately large putti in the sky and the large empty areas is an example of his weak late manner (dated 1651).

103. His career has been reconstructed by F. Bologna, *Opere d'arte nel Salernitano*, Naples, 1955; M. Grieco, *Francesco Guarini da Solofra*, Avellino, 1963.

104. For Mellin, see J. Bousquet in *Revue des Arts*, V (1955), 55.

105. In his otherwise unsatisfactory monograph on Stanzioni (1937), H. Schwanenberg established the date 1623 for the *St Anthony in Glory* in S. Lorenzo in Lucina, Rome. But Stanzioni was working in Rome even five years earlier. E. Borsook (*Burl. Mag.*, XCVI (1954), 272) published payments to him between October 1617 and April 1618 for a (lost) picture for S. Maria della Scala. Stanzioni's large dated cycles begin in 1631 with the decoration of the Bruno Chapel in the Certosa of S. Martino, finished 1637. Stanzioni had a large school; among his pupils were Agostino Beltrami and Giacinto de Popoli (see Ortolani, *op. cit.*, 72).

106. His 'classicism' is fully developed in the *Rest on the Flight into Egypt* and the *Annunciation of the Birth of the Virgin*, both in S. Paolo Maggiore, dated 1643-4 by R. Causa, *La Madonna nella pitt. del '600 a Napoli*, Naples, 1954, 33.

359. 107. In addition to the older literature, see C. Refice, *Emporium*, CXIII (1951), 259.

108. M. Commodo Izzo, *Andrea Vaccaro*, Naples, 1951, with *œuvre* catalogue and bibliography.

109. For the Fracanzano problem see F. Bologna (Note 103), 55, and *idem*, *F. Solimena*, 1958, 28.

110. The phrase is F. Saxl's, *J.W.C.I.*, III (1939-40), 70.

111. M. S. Soria, *Art Quarterly*, XXIII (1960), 23.

It seems appropriate to mention here the German painter Johann Heinrich Schönfeld (1609-82/3), who was in Italy from 1633 to 1651 and spent twelve years in Naples. In his early Neapolitan years (about 1640) his work is close to that of Gargiulo and Aniello Falcone; later his palette darkens and his style approaches Bernardo Cavallino's (mid 1640s). Like Elsheimer, Schönfeld excelled by virtue of the intensity of poetical narration and there can be little doubt that he left his mark on Neapolitan painting. This great artist was rediscovered in the 1920s, primarily through H. Voss (monograph Biberach, 1964) and has now acquired fuller contours through a splendid exhibition; see H. Pée, *J. H. Schönfeld*, Ulm, 1967.

112. R. Causa, *Paragone*, VII (1956), no. 75, 30. This article makes the older literature on Monsù Desiderio obsolete (see A. Scharf's *Catalogue* of the Sarasota Exhibition, 1950; G. Urbano's monograph, Rome, 1950; F. G. Pariset, *Commentari*, III (1952), 261). See also next Note.

113. F. Sluys, *Les Beaux Arts*, Brussels, 4 June 1954; *idem, Didier Barra et François de Nomé*, Paris and New York, 1961.

360. 114. Codazzi, e.g., went to Rome and Ribera fled.

115. Longhi, *Proporzioni*, I (1943), 60: reconstruction of this phase with *œuvre* catalogue. C. Refice Taschetta, *Mattia Preti*, Brindisi, 1961, 45, does not accept such an early Caravaggesque phase; she is certainly correct in claiming a strong impact of Guercino on the early Preti. Her monograph, however, is far from being definitive; see above, Note 38.

116. M. Fantuzzo, *Boll. d'Arte*, XL (1955), 275.

117. See above, p. 322. The *St Charles Borromeo giving Alms* of 1642 in S. Carlo ai Catinari, Rome, already shows his dependence on Sacchi and Domenichino.

118. R. Causa, *Emporium*, CXVI (1952), 201. C. Refice Taschetta, *op. cit.*, 54, favours the older dating: not later than 1650.

361. 119. In 1664 (not 1653) he painted the badly preserved frescoes in the dome of S. Domenico Soriano, Naples, which abound with Correggiesque reminiscences; see C. Refice, *Boll. d'Arte*, XXXIX (1954), 141.

120. For Porpora, see R. Causa, *Paragone*, II (1951), no. 15, 30; for Luca Forte, *idem, ibid.*, XIII (1962), no. 145, 41; for Giacomo Recco, *idem*, *Arte Antica e Moderna*, IV (1961), 344; for Giacomo and Giuseppe Recco, S. Bottari, *ibid.*, 354; further attributions to Forte and Giacomo Recco in Bottari, *ibid.*, VI, no. 23 (1963), 242.

121. See last Note, and also Zeri, *ibid.*, III (1952), no.

33, 37; N. di Carpegna in *Boll. d'Arte*, XLVI (1961), 123.
122. Carpegna, *loc. cit.*
362. 123. Dominici (ed. 1844, III, 558) records that Ruoppolo painted many pictures for Gaspar Roomer, which the latter sent to Flanders. Roomer, an immensely rich Flemish merchant, had made Naples his home; he had a large gallery and patronized contemporary artists (M. Vaes, *Bull. inst. hist. belge*, V (1925), 184; F. Saxl, *J.W.C.I.*, III (1939-40), 80). It was in his gallery that Ruoppolo and the other Neapolitan still-life painters had excellent opportunities of studying Flemish still lifes.

CHAPTER 15

364. 1. For the following see the relevant passages in Pastor, vols 14-16, and in Carl Justi, *Winckelmann und seine Zeitgenossen*, Leipzig, 1898, vols 2 and 3.
2. A. Bertolotti in *Archivio storico artistico . . .* ed. F. Gori, I (1875) and P. G. Hübner, *Le statue di Roma*, Leipzig, 1912, 73.
3. M. Praz in *Magazine of Art*, XXXII (1939), 684.
4. The best recent study of Piranesi is by A. H. Mayor (1952); see Bibliography.
J. Harris ('Le Geay, Piranesi and International Neoclassicism in Rome 1740-1750', *Essays in the History of Architecture presented to R. Wittkower*, London, 1967, 189 ff.) ingeniously reconstructed the Roman career of Jean Laurent Le Geay, who probably had a formative influence on the young Piranesi.
5. R. Wittkower, 'Piranesi's "Parere su l'architettura"', *J.W.C.I.*, II (1938-9), 147.
366. 6. See, above all, H. Tintelnot's remarkable but not always reliable study *Barocktheater und barocke Kunst*, Berlin, 1939.
7. R. Bernheimer in *Art Bull.*, XXXVIII (1956), 239, finds that as early as 1600 in the performance directed by Buontalenti in Florence on the occasion of Maria de' Medici's wedding with Henry IV of France the barriers which separate the stage from the audience had been abolished. Spectators were placed on the stage and 'continued the court into the world of make-believe and thus provided that element of illusion, at which many artists of the Baroque were to try their hand'.
K. Schwager has made some acute observations on the Baroque notion of the theatre, in *Röm. Jahrb. f. Kunstgesch.*, IX-X (1961-2), 379.
8. A. Ademollo, *I teatri di Roma nel secolo decimosettimo*, Rome, 1888, 36.
9. Tintelnot, *op. cit.*, 151, 215 refuses to acknowledge a major influence from the stage on Tiepolo and finds it mainly among such eighteenth-century painters and engravers of *vedute* and ruins as Pannini, Francesco

Fontanesi, Luca Carlevarijs, Vittorio Bigari, and others.
10. G. M. Crescimbeni, *L'istoria della basilica . . . di S. Maria in Cosmedin di Roma*, Rome, 1715, 159. - For Naldini see above, p. 312.
11. Monnot did not accept Maratti's design, nor does it seem that the sculptors of the statues in S. Giovanni in Laterano were delighted (see also p. 436 and Chapter 18, Note 9). Although it was not till slightly later that sculptors welcomed the collaboration of painters, it is almost certain that Padre Andrea Pozzo made oil sketches for reliefs on the altar of St Ignatius in the Gesù; see B. Kerber, in *Art Bull.*, XLVII (1965), 499.
12. Titi, ed. 1686, 155. - At the same time C. Fancelli worked from designs of Gio. Francesco Grimaldi in the Palazzo Borghese; see above, Chapter 13, Note 40.
13. C. G. Ratti and R. Soprani, *Delle vite de' pittori . . . genovesi*, Genoa, 1769, II, 303.
The almost forgotten Pietro Bianchi, Luti's student in Rome, produced Arcadian Rococo pictures of great charm; see A. M. Clark in *Paragone*, XV (1964), no. 169, 42.
14. B. de Dominici, *Vite de' pittori . . . napoletani*, Naples, 1742-3, 458.
K. Lankheit (70 and *Mitteilungen d. Flor. Inst.*, VIII (1957-9), 48) has shown that Foggini used the help of the painter Anton Domenico Gabbiani in the Corsini Chapel in S. Maria del Carmine, Florence, before 1680.
367. 15. Baumgarten's *Aesthetica* appeared in 1750.
16. *The Connoisseur; an Essay on the whole Art of Criticism . . .*, London, 1719.
368. 17. A. Gabrielli, 'L'Algarotti e la critica d'arte in Italia nel Settecento', *Critica d'Arte*, III (1938), 155, IV (1939), 24. For Algarotti, see also Haskell, *Patrons*, 347 (and index).

CHAPTER 16

369. 1. Juvarra, Fuga, Vanvitelli, Salvi, Raguzzini, Galilei, and Preti.
370. 2. For the concept of stylistic liberty and fast changes of style at this period, see the pertinent remarks by R. Berliner in *Münchner Jarhb. d. bild. Kunst*, IX-X (1958-9), 282.
371. 3. The Palazzo Mezzabarba is the earliest of four interconnected palaces of supreme importance. To the group belong, apart from the Doria-Pamphili, the exactly contemporary façades of the Palazzi Litta at Milan (Note 5) and Montanari at Bologna (p. 390). - Veneroni (*c.* 1680-after 1745), almost unknown a few years ago, is emerging as a major figure of North Italian Baroque architecture. A pupil of Giuseppe Quadrio in Milan, he was appointed 'engineer' of the province of

Pavia in 1707. The Borrominesque façade of S. Marco (1735-8) remains, next to the remarkably sophisticated Palazzo Mezzabarba, as a witness to the high quality of Veneroni's architecture at Pavia; see C. Thoenes in *Atti dello VIII convegno nazionale di storia dell'architettura*, Rome, 1956, 179, and S. Colombo in *Commentari*, XIV (1963), 186; also M. G. Albertini, *Considerazioni sull'architettura lodigiana del primo Settecento*, dissertation, Pavia University, 1963-4 (unpublished). For other works by him, see L. Grassi, *Province del Barocco e del Rococò*, Milan, 1966, 443 ff. Veneroni's Pavia contemporary, Lorenzo Cassani (1687-c. 1765), has been studied by A. Casali, *Boll. d'Arte*, LI (1966), 58 ff.; less progressive than Veneroni, Cassani reveals a belated attachment to Ricchino's architecture.

4. The architect of the façade, one of the most original creations of the eighteenth century, seems to be unknown. The staircase hall, too, was later remodelled (by Faustino Rodi, 1780s). It has an oval dome with gallery, through which appears a second ceiling, a design which is probably indebted to Guarini. See G. Mezzanotte, *Architettura neoclassica in Lombardia*, Naples, 1966, 219.

5. Other examples are: *Bologna*: Torreggiani's buildings, see below; *Carpi*: Santuario del SS. Crocifisso; *Cesena*: Madonna del Monte (staircase hall); *Crema*: SS. Trinità by Andrea Nono (1737); *Forlì*; Palazzo Reggiani (staircase hall); *Milan*: Palazzo Litta, façade by Bartolomeo Bolli, 1743-60, also interior ('Sala degli Specchi'); *Ravenna*: S. Maria in Porto; *Santa Maria di Sala* (Veneto): Villa Farsetti, the richest French Rococo villa in North Italy, but for the classicizing exterior forty-two columns from the Temple of Concord in Rome were used; *Stra*: Villa 'La Barbariga'. See also Ferdinando Bibiena's diaphanous vaulting in the choir of S. Antonio at Parma (1714 ff.), in the parish church at Villa Pasquali (1734), and in a chapel of S. Maria Assunta at Sabbioneta. The two latter consist of curvilinear gratings through which the painted blue sky appears. For the church at Villa Pasquali, see D. de Bernardi, *Arte Lombarda*, XI (1966), 51 ff. For Venice, see pp. 372-3.

372. 6. A. Neppi, 'Aspetti dell'architettura del Settecento a Roma', *Dedalo*, XV (1934), 18-34; M. Loret, 'L'Architetto Raguzzini e il rococò in Roma', *Boll. d'Arte*, XXVII (1933-4), 313-21; *Associazione fra i cultori di architettura*, 'Architettura minore in Italia', Rome [n.d.]; M. Rotili, *Raguzzini*, Rome, 1951, 103.

7. For the following, Wittkower, *Architectural Principles*, 3rd ed., 1962, 144.

8. Schlosser, *Kunstliteratur*, 578. Massimo Petrocchi, *Razionalismo architettonico e razionalismo storiografico*, Rome, 1947.

9. He never wrote himself. His ideas were later published by his admirer Andrea Memmo, *Elementi d'architettura lodoliana*, Venice, 1786, and second ed. 1834. Count Francesco Algarotti (1712-64), the well-known Venetian courtier, writer, and patron of the arts, was one of the first to write about Lodoli's theories (*Saggio sopra l'architettura*, Pisa, 1753). Piranesi, too, the steadfast upholder of the supremacy of Roman architecture, came under Lodoli's influence, as the text of his *Della magnificenza ed architettura de' Romani*, Rome, 1761, reveals. See Wittkower, 'Piranesi's "Parere su l'architettura"', *J.W.C.I.*, II (1938-9), 147.

10. This judgement seems to me correct, although Lodoli attacked, of course, the tenets of classical architecture. Haskell, *Patrons*, 321, underestimates perhaps Lodoli's influence on architects. See also E. Kaufmann Jr, in *Art Bull.*, XLVI (1964), 172.

373. 11. A. Ravà, 'Appartamenti e arredi Veneziani del Settecento', *Dedalo*, I (1920), 452 ff., 730 ff. Rocaille stuccoes, among others, in the Palazzi Barbarigo, Foscarini, Rezzonico (particularly good quality), Vendramin, and the Casino Venier, the latter two published in *Dedalo*.

12. Correct birth-date in Donati, *Art. Tic.*, 263.

13. The frame, probably intended for a relief, was never filled.

375. 14. On this problem, see above, p. 297. Fontana's plan dates from 1681. Foundation stone of the church 1689; in 1710 the convent into which the church is incorporated was partly finished. 1738: consecration of the church without the decorations. The latter executed by Spaniards, after that date. O. Schubert, *Gesch. des Barock in Spanien*, Esslingen, 1908, 263; Coudenhove-Erthal, *C. Fontana*, Vienna, 1930, 133.

15. Fontana himself was partly responsible for it; see above pp. 284-5.

16. E.g., the high pedestals on which the pilasters of the interior stand; further, the gallery above the pilasters and the (admittedly later) statues crowning the pilasters of the drum. Also the open balustrade, on which the pediment of the façade is superimposed, is to be found in the Salute.

17. The most concise assessment of the development of polychromy between the sixteenth and the eighteenth centuries in L. Bruhns, *Die Kunst der Stadt Rom*, Vienna, 1951, 575.

18. Not everybody agreed with his designs. The diarist Valesio calls Fontana's design of the tomb of Queen Christina of Sweden in St Peter's, finished in 1702, 'in extremely poor taste'. He, moreover, talks about the architect as 'the liar Carlo Fontana'. See Scatassa in *Rassegna bibliografica*, XVII (1914), 179 f. For the history of this tomb, see now A. Braham and H. Hager (Bibliography).

376. 19. Further to this problem, Coudenhove-Erthal (in *Festschrift H. Egger*, Graz, 1933, 95), who makes the point that in contrast to Bernini and his generation Fontana dealt with comprehensive urban projects.

20. Twenty-seven volumes from Fontana's estate were purchased for King George III from Cardinal Albani and are now in the Royal Library at Windsor. When writing his biography of Fontana, Coudenhove-Erthal was unaware of their existence.

21. The painting of the altar with the *Inspiration of S. Cecilia* is also by his hand.

22. On Contini as well as all the members of the Fontana family, see U. Donati, *Art. Tic.*, with further bibliography. See also H. Hager, 'G. B. Contini e la loggia del Paradiso dell'Abbazia di Montecassino', *Commentari*, XXI (1970).

There seems now to be a measure of agreement to attribute the delightful Borrominesque façade of the little church of S. Maria della Neve (S. Andrea in Portogallo) to Francesco Fontana and date it 1707-8; see N. J. Mallory, in *J. Soc. Arch. Hist.*, XXVI (1967), 89.

23. He is, for instance, responsible for the rebuilding of the interesting Palazzo di S. Luigi de' Francesi (1709-12), which foreshadows the Rococo palace in Rome. See also above, Chapter 12, Note 32.

For Bizzacheri, see M. Tafuri, in *Diz. Biograf. degli Italiani*, x, 1968.

24. For Specchi, Thomas Ashby and Stephen Welsh in *The Town Planning Review*, XII (1927), 237-48. Specchi illustrated many of Fontana's works and collaborated in works on Roman topography and architecture.

25. Alessandro Bocca, *Il Palazzo del Banco di Roma*, Rome, 1950 (last ed. 1967).

377. 26. But W. Lotz, in *Röm. Jahrb. f. Kunstg.*, XII (1969), has made it likely that Specchi had a formative influence on De Sanctis' final project.

It may also be mentioned that between 1718 and 1720 Specchi skilfully completed the façade of S. Anna de' Palafrenieri, which had been left unfinished in 1575, after Vignola's death; see M. Lewine, in *Art Bull.*, XLVII (1965), 217.

27. This façade shows an interesting development away from Fontana's S. Marcello in the direction of Juvarra's S. Cristina at Turin - but probably without a knowledge of the latter.

28. Teodoli, also Theodoli (1677-1766), philosopher, poet, and architect, three times *principe* of the Academy of St Luke (1734-5, 1742, 1750) and therefore a figure of considerable standing, has to our present knowledge only this one church to his credit. The interior is without special merit, but the exterior with the stepped dome reveals an interesting personality.

Nibby ascribes to him the campanile and monastery of S. Maria di Monte Santo (pp. 283 ff.), dated 1765, which is, however, by Cav. F. Navona (see H. Hager, *Röm. Jahrb. f. Kunstg.*, XI (1967-8), 282). Teodoli's contribution to the design of the Teatro Argentina is problematical; see F. Milizia, *Memorie degli architetti*, II, Bassano, 1785, 257.

29. A. Agosteo and A. Pasquini, *Il Palazzo della Consulta*, Rome, 1959.

30. H. Hager, *S. Maria dell'Orazione e Morte* (Chiese di Roma illustrate, 79), Rome, 1964 contains a thoughtful discussion of the church, with new documents.

31. For De Dominicis, a minor architect in the orbit of Raguzzini, see V. Golzio in *L'Urbe* (1938), no. 7, 7 ff.; F. Fasolo in *Quaderni* (1953), no. 4, 1. Also G. Segni - C. Thoenes - L. Mortari, *SS. Celso e Giuliano* (Chiese di Roma illustrate, 88), Rome, 1966.

32. Neo-Cinquescentesque, not without dignity, but astonishingly tame for the architect of S. Giovanni in Laterano. Documents for the façade published by V. Moschini in *Roma*, III (1925), no. 6.

33. Sardi (*c*. 1680-1753, not to be mixed up with the Venetian architect of the same name, *c*. 1621-99) often acted as clerk of the works to other architects. The complicated history of S. Maria Maddalena, to which G. A. Rossi and Carlo Quadrio contributed, has been cleared up by V. Golzio in *Dedalo*, XII (1932), 58, but the façade still presents a puzzle. It is usually attributed to Sardi; it was, however, built by Carlo Giulio Quadrio between 1697 and 1699 and only the facing and the extravagant stucco decoration date from 1735. N. A. Mallory (see Bibliography under Sardi) argued rather convincingly that there are no indications in Sardi's documented work that would favour an attribution of Rococo frames and rich floral decoration to him. By contrast, P. Portoghesi (*Roma barocca*, Rome, 1966, 348) eloquently advocates Sardi's authorship. Even the richly and elegantly decorated church of the SS. Rosario at Marino near Rome, the attribution of which to Sardi is supported by contemporary tradition (see S. Benedetti, in *Quaderni*, XII, 67-70 (1965), 7 ff.), has nothing in common with the Rococo decoration of S. Maria Maddalena.

34. Derizet (1697-1768), born at Lyons, came to Rome as a student of the French Academy (1723) and stayed there until his death. See A. Martini-M. L. Casanova, *SS. Nome di Maria* (Chiese di Roma illustrate, 70), Rome, 1962, 23 (with documents). A paper on Derizet by W. Oechslin is about to appear in *Quaderni*.

35. The architect was a Portuguese who had made Rome his home as early as 1728 (Lidia Bianchi, *Disegni di Ferdinando Fuga*, Rome, 1955, 110) and was still

there in 1772. Sardi acted as his clerk of works at SS. Trinità. M. Tafuri, in *Quaderni*, XI, 61 (1964), 1 ff., gives the history of the church and monastery from documents and the drawings preserved in the Archivio di Stato.

36. Ameli's design is graceful, but infinitely less powerful and original than Valvassori's.

37. V. Golzio in *L'Urbe* (1938), no. 7, 7 ff. On P. Passalacqua from Messina, see M. Accascina in *Archivio storico messinese*, L–LI (1949–50).

38. The material assembled by R. Berliner in *Münchner Jahrb. f. bild. Kunst*, IX–X (1958–9), 302 ff., shows that both beginning and end of the building are difficult to determine. The dates given in the text are approximations. According to J. Gaus (*Marchionni*, 1967, 23, 25, see Bibliography) the planning began in 1748 and the villa was completed in 1762.

39. Mario Rotili, *Filippo Raguzzini e il rococò romano*, Rome, 1951, with further literature.

40. M. Loret in *Illustrazione Vaticana*, IV (1933), 303, and A. Rava in *Capitolium*, X (1934), 385–98. See also F. Fasolo, *Le chiese di Roma nel '700*, Rome, 1949, 70.

41. Ilaria Toesca in *English Miscellany*, III (1952), 189–220.

42. Guglielmo Matthiae, *Ferdinando Fuga e la sua opera romana*, Rome, 1951; L. Bianchi's *Catalogue* (see Note 35); R. Pane, *F. Fuga*, Naples, 1956.

379. 43. For its history, see mainly E. Hempel in *Festschrift H. Woelfflin*, Munich, 1924, 283 ff.; C. Bandini in *Capitolium*, VII (1931), 327; P. Pecchiai, *La scalinata di piazza di Spagna*, Rome, 1941; and the exhaustive paper by W. Lotz (quoted above, Note 26).

380. 44. Raguzzini's undulating façade of S. Maria della Quercia reveals the same spirit; see A. Martini, *S. Maria della Quercia* (Chiese di Roma illustrate, 67), Rome, 1961.

45. Clement XII arranged a competition in 1732. Sixteen designs were exhibited in the Quirinal and Salvi's was chosen. After the latter's death, Giuseppe Pannini was appointed architect of the fountain (1752). The major change he introduced is the three formal basins under Neptune.

The literature on the Fontana Trevi is vast. The most recent studies by Armando Schiavo (*La Fontana di Trevi e le altre opere di Nicola Salvi*, Rome, 1956) and H. Lester Cooke, Jr (*Art Bull.*, XXXVIII (1956)) are fuller than any previous treatment without, however, presenting the entire material on the history of the fountain. In addition, Cooke's article should be used with caution. See also C. d'Onofrio, *Le Fontane di Roma*, 1957, 225–62, with some new material, but also unacceptable assertions and attributions.

382. 46. The history of this most important event has not yet been fully reconstructed. For information see

F. Cerroti, *Lettere e memorie autografe*, Rome, 1860; A. Prandi, 'Antonio Derizet e il concorso per la facciata di S. Giovanni in Laterano', *Roma*, XXII (1944), 23; Rotili, *Raguzzini* (Note 39); L. Bianchi's *Catalogue* (Note 35); A. Schiavo, *op. cit.* (Note 45), 37, and *idem*, 'Il Concorso per la facciata di S. Giovanni in Laterano e il parere della Congregazione', *Bollettino dell'Unione Storia ed Arte*, Rome, May–June 1959, 3. V. Golzio has published Galilei's own memorandum about his design in *Miscellanea Bibl. Hertzianae*, 1961, 450. See also the New York University M.A. thesis by Virginia Schendler (summary in *Marsyas*, XIV (1968–9), 78).

Only seventeen of the twenty-three competitors are mentioned in the literature, amongst them the Bolognese Ferdinando Galli Bibiena and C. F. Dotti, the Venetian Domenico Rossi, the Sienese Lelio Cosatti, and the Neapolitan L. Vanvitelli. Two other competitors, overlooked by all those who have written about this matter, were Pietro Carattoli (1703–60) from Perugia, the architect of the Palazzo Antinori (Gallenga Stuart, 1748–58), the most impressive Baroque palace of his native city; and Bernardo Vittone from Turin (see his *Istruzioni elementari*, Lugano, 1760, 443 and plate 74). Another competitor, rediscovered by H. Hager, was Ludovico Rusconi Sassi (1678–1736), about whom see Donati, *Art. Tic.*, 393.

47. It was not until January 1726 that Galilei, then in Florence, was advised from London that 'the reigning taste is Palladio's style of building', a fact of which he was obviously unaware. See I. Toesca, *op. cit.*, 220.

Just before leaving London in 1719, Galilei may have designed Castletown, Co. Kildare, near Dublin in a vaguely Palladian manner; see M. Craig and the Knight of Glyn, in *Country Life*, CXLV (27 March 1969), 722 ff.

383. 48. Marchionni's second great work is the well-known Sacristy of St Peter's (1776–87). New documents in the important paper by Berliner (Note 38, 368, 395), who published the extensive œuvre of drawings for a great variety of purposes by Carlo (1702–86) and his son Filippo (1732–1805). For the Sacristy of St Peter's also H. Hager, *Juvarra*, 1970, 49 (see Bibliography), and the extensive chapter in Gaus's book on Marchionni (Bibliography), 67 ff.

49. W. Körte, 'Piranesi als praktischer Architekt', *Zeitschr. f. Kunstg.*, II (1933), 16–33. Wittkower in *Piranesi*, Smith College Museum of Art, Northampton, Mass., 1961, 99, has reconstructed the history of Piranesi's S. Maria del Priorato on the Aventine (1764–6) from documents and original drawings.

The mediocre Alessandro Dori, architect of the Palazzo Rondanini (*c.* 1760; see L. Salerno, in *Via del Corso*, 1961, 124), indicates the relatively low standard of Roman architecture at this moment.

386. 50. For the history of Venetian Baroque architecture see E. Bassi's basic work (1962). For the survival and transformation of the Palladian tradition, see Wittkower in *Barocco europeo e Barocco veneziano*, Florence, 1962, 77, and *Bollettino del Centro Internaz. di Studi di Architettura*, V (1964).

51. S. Moisè is early, 1668. The undifferentiated Late Baroque quality ensues from the profusion of Meyring's ('Arrigo Merengo's') later sculptural decoration rather than from the structural pattern, which is basically Palladian.

For Tremignon, see C. Semenzato in *Atti della Accademia Patavina di scienze, lettere ed arti*, N.S. LXIV (1952), and G. B. Alvarez in *Boll. del Museo Civico di Padova*, L (1961), 59.

52. The entire interior of the Chiesa dei Gesuiti is spun over with inlaid marble imitating tapestry. The high altar is by Andrea Pozzo's brother, Jacopo Antonio (1645-1725), a specialist in altar designs, whose importance has only recently been discovered; see F. Pilo Casagrande in *Palladio*, VIII (1958), 78. The façade, closely set with free-standing columns, is Rossi's largest work. His earlier façade of S. Stae (1709) is more interesting, for its structure is based on an unorthodox handling of Palladio's interpenetration of a large and a small order.

53. Yet a comparison of Tirali's Valier with Longhena's Pesaro monument of 1669 in the Frari shows that the classical element of the column has been given new weight, while the statues, the principal feature of the Pesaro, are disproportionately small.

The principal source for Tirali's life is Temanza's *Zibaldon*, ed. N. Ivanoff, Venice-Rome, 1963, 17.

387. 54. For Palladio's project, see W. Timofiewitsch in *Arte Veneta*, XIII-XIV (1959-60), 79.

55. D. Lewis, 'Notes on XVIII Century Venetian Architecture', *Boll. dei Musei Civici Veneziani*, XII (1967), no. 3, has given rather convincing arguments in favour of this late date in preference to the previously accepted dating of 1700.

56. E. Bassi's chapter (Note 50) on Massari supersedes the studies by V. Moschini in *Dedalo*, XII (1932), 198-229, and C. Semenzato in *Arte Veneta*, XI (1957), I.

56a. G. Fiocco, in *Saggi e Memorie di storia dell'arte*, VI (1968), 118 ff., attributes the painted architecture to Francesco Zanchi, the chiaroscuri to Michelangelo Morlaiter, and the figures to Giacomo Antonio Ceruti.

57. Massari's chief assistant, Bernardo Maccaruzzi (*c.* 1728-1800), the architect of S. Giovanni Evangelista in Venice (*c.* 1755-9) and of the Cathedral at Cividale (1767 ff.), deserves mention; see D. Lewis (above, Note 55), 1 ff.

58. We may add the name of Andrea Cominelli, who enlarged the Palazzo Labia before 1703 (E. Bassi,

Architettura . . . a Venezia, 1962 (see Bibliography), 236 ff., and that of the priest Carlo Corbellini from Brescia, who in the large church of S. Geremia (1753-60) returned to a classicizing Greek-cross type with additional satellite chapels at the west. His use of a giant order of half-columns all round the interior is in the tradition coming down from Palladio, but the type as such belongs to the eighteenth-century revival of similar late sixteenth-century churches (p. 117). The strong Baroque façade of Corbellini's S. Lorenzo Martire at Brescia (1751-63) also contains neo-cinquecentesque elements.

For the continuity of the Palladian tradition in Venice, see R. Wittkower, in *Boll. del Centro Internaz. di Studi di Architettura*, V (1964), 61 ff.

59. For the carefully calculated system of proportion (p. 372), see Cicognara-Diedo-Selva, *Le fabbriche e i monumenti cospicui di Venezia*, Venice, 1858, II, 95. D. Lewis (above, Note 55), 40, emphasized the reliance of SS. Simeone e Giuda on Palladio's Tempietto at Maser.

60. D. Lewis, *op. cit.*, has skilfully reconstructed the small but important *œuvre* of M. Lucchesi. – For Temanza's life, see Ivanoff's Introduction to T. Temanza, *Zibaldon* (Note 53). Temanza or, more likely, his uncle Scalfarotto was the teacher of Giovanni Battista Novello, the architect of the mid-eighteenth-century Palazzo Papafava at Padua, which displays surprising originality; A. Rowan, *Burl. Mag.*, CVIII (1966), 184 ff.

389. 61. Fausto Franco, 'La scuola architettonica di Vicenza', *I Monumenti Italiani*, III (1934), and *idem*, 'La scuola Scamozziana "di stile severo" a Vicenza', *Palladio*, I (1937), 59 ff.

For the continuity of Scamozzi's classical formulas at Vicenza, see, e.g., Pizzócaro's Istituto dei Proti and Palazzo Piovini-Beltrame, both 1658, and his masterpiece, the Villa Ghellini Dall'Olmo at Villaverla (1664-79; for Pizzócaro, see L. Puppi in *Prospettive*, no. 23 (1960-1), 42, and R. Cevese in *Boll. del Centro Internaz. di Studi di Architettura*, IV (1962), 135), and Carlo Borella's Palazzo Barbieri-Piovene (1676-80), also attributed to Tremignon and Giacomo Borella. Carlo Borella, the architect of the Sanctuary on Monte Berico (1688-1703), was not averse to using a certain amount of Baroque paraphernalia. But the Chiesa dell' Araceli (began in 1675), always attributed to him, was based on a design by Guarini; see P. Portoghesi in *Critica d'Arte*, no. 20 (1957), 108 and no. 21, 214. For Borella, see Cevese, *op. cit.*, 140.

62. Francesco Muttoni (see F. Franco, *ibid.*, 147), the tireless builder of villas (Villa Fracanzan, Comune di Orgiano, 1710; 'La Favorita' at Monticello di Fara, 1714-15; Villa Valmarana at Altavilla Vicentina, 1724; etc.), is famed for his creations in a mildly Baroque

taste: principal example, his well known Palazzo Repeta at Vicenza (now Banca d'Italia, 1701-11) with a large scenic staircase. Yet he never denied his Palladian derivation (see F. Barbieri in *Quaderni*, VI-VIII (1961), 287; also M. Tafuri, 'Il parco della Villa Trissino a Trissino e l'opera di Francesco Muttoni', in *L'Architettura, cronache e storia*, X, no. 114 (1965), 832 ff.). It is interesting for the rise of Palladianism in England that he maintained close contact with Lord Burlington.

The Villa Cordellina at Montecchio Maggiore, previously attributed to Muttoni, is by Massari (1735), see C. Semenzato in *Arte Veneta*, XI (1957), 6; see also *Connoisseur*, CXL (1957), 151.

63. F. Barbieri in *Arte Veneta*, VII (1953), 63. Also R. Cevese, 'Palladianità di Ottone Calderari', in *Odeo Olimpico*, V (1964-5), 45 ff.

For a survey of Baroque architecture at Verona, Padua, Treviso, and Bassano, see the papers by P. Gazzola, G. M. Pio, M. T. Pavan, and C. Semenzato in *Boll. del Centro Internaz. di Studi di Architettura*, IV (1962).

For the Veronese Neo-classicist Alessandro Pompei, see Semenzato, *Arte Veneta*, XV (1961), 192.

64. See *Le ville venete*. Catalogo a cura di Giuseppe Mazzotti (many collaborators), Treviso, 1954, with full bibliography.

65. Giovanni Ziborghi who is otherwise unknown signed as architect of the Villa Manin (1738). The monograph by C. Grassi, *La Villa Manin di Passariano*, Udine, 1961, is disappointing. See also A. Rizzi, in *Boll. Ufficiale della Camera di Commercio, Industria . . . di Udine* (March 1964), 3-10.

The Villa Pisani is usually incorrectly attributed to Girolamo Frigimelica. M. Favaro-Fabris, *L'architetto F. M. Preti*, Treviso, 1954, has proved that Preti's design was executed. It must, however, be pointed out that this work is of infinitely higher quality than the unusually dry Palladian buildings of the architect from Castelfranco (1701-74).

Frigimelica (1653-1732), who worked in his native Padua (S. Maria del Pianto, 1718-26), at Rovigo, Modena, Vicenza, Stra, etc., would deserve more attention. See Bibliography.

66. Fogolari in *L'Arte*, XVI (1913), 401-18. See also now the book by A. M. Matteucci, 1969 (Bibliography under Bologna).

390. 67. See *Commune di Bologna*, XI (1933), 69.

391. 68. See the Palazzo del Credito Italiano (Via Monte Grappa 5), 1770; the Casa del Linificio Nazionale (formerly Palazzo Ghisilieri); and the Palazzo Scagliarini (Via Riva di Reno 77), 1796, where the entrance, the courtyards, and the staircase form a picturesque ensemble. In Angelo Venturoli's (1749-

1821) staircase of the Palazzo Hercolani (Via Mazzini 45) of 1792 the Baroque tradition is also continued without a break.

69. See, e.g., Tommaso Mattei's mid-eighteenth-century staircase of the Palazzo Arcivescovile at Ferrara or G. F. Buonamici's grand staircase of the Palazzo Baronio (now Rasponi Bonanzi) at Ravenna (the palace was built by Domenico Barbiani, 1744). The Palazzo Albergoni at Crema has a superb eighteenth-century staircase on the pattern of Longhena's staircase in S. Giorgio Maggiore.

70. C. Ricci, *I teatri di Bologna*, Bologna, 1888, 176 ff.

71. For a fuller survey, see P. Mezzanotte's chapters in *Storia di Milano*, 1958, XI, 441; and 1959, XII, 659.

72. For Merli or Merlo, see now the excellent monograph by M. L. Gatti Perer (Bibliography).

73. The contemporary tradition as to Ruggeri's place of birth is ambiguous, but he was born in Rome rather than Milan; see G. Mezzanotte, 'G. R. e le ville di delizia lombarde', *Boll. Centro Internaz. Studi di Archit.*, XI (1969), 243.

The façade of the Palazzo Litta is often wrongly attributed to Ruggeri, who is the architect of the splendid Villa Alari-Visconti at Cernusco. His pupil Giacomo Muttone (1662-1742) built the well-known Villa Belgioioso (now Trivulzio) at Merate. Among the minor Milanese practitioners may be mentioned Federico Pietrasanta (1656-c. 1708, see M. L. Gengaro in *Riv. d'Arte*, XX (1938), 89), Francesco Croce (Gengaro in *Boll. d'Arte*, XXX (1936), 383), Giovan Battista Quadrio and his pupil, Bernardo Maria Quarantini (1679-1755); see M. L. Gatti Perer in *Arte Lombarda*, VIII (1963), 161, and XI (1966), 43 ff.

Lodi had Late Baroque architects in Michele and Pier Giacomo Sartorio, and Bergamo in Achille and Marco Alessandri. For other names, see L. Angelini, 'Architettura settecentesca a Bergamo', *Atti dello VIII convegno nazionale di storia dell'architettura*, Rome, 1956, 159.

Giuseppe Antonio Torri's (1655-1713) S. Domenico at Modena (1708-31) is a remarkable centralized building. The façade is an interesting version of the aedicule façade, consisting of a closely set colossal order of pilasters applied to a red-brick wall.

Brescia had native Baroque architects in Antonio Turbini and his son Gaspare and in Giovan Battista Marchetti and his son Antonio (1724-91). The latter built the Palazzo Gambara (now Seminario Vescovile) and the Palazzo Soncini (1760s), both with impressive staircase halls, and the Villa Negroboni, now Feltrinelli, at Gerolanuova (1772-92) in an international Baroque style; see G. Cappelletto in *Arte Lombarda*, III (1958), 51.

74. For Piermarini and other neo-classical Lombard

architects and their revealing connexions with the earlier eighteenth-century manner, see G. Mezzanotte, *Architettura neoclassica in Lombardia*, Naples, 1966.

392. 75. M. Labò, 'Studi di architettura Genovese', *L'Arte*, XXIV (1921), 139-51, repeats the traditional attribution of the palace to Pier Antonio Corradi. C. Marcenaro in *Paragone*, XII (1961), no. 139, 24, has corrected the attribution on the basis of documents. - The splendid pictorial decoration of the palace by Gregorio de Ferrari, Giovan Andrea Carlone, Bartolomeo Guidobono, and others began in 1679.

76. See, among others, rooms in the Palazzo Durazzo (formerly Reale), which - according to tradition - was given its final shape towards the garden from designs by Carlo Fontana (1705); further rooms in the Palazzi Granello (Piazza Giustiniani) and Saluzzo (Via Albaro) and, above all, in the Palazzo Balbi Cattaneo (Via Balbi).

77. According to Soprani, *Vite*, II, 271, De Ferrari's last work, executed shortly before his death in 1744 at the age of 64. There is now a satisfactory monograph by E. Gavazza on L. de Ferrari (see Bibliography).

78. Hugh Honour, 'The Palazzo Corsini, Florence', *Connoisseur*, CXXXVIII (1956), 160.

79. For the early history of S. Firenze, above p. 246. The church itself was built by Pier Francesco Silvani after 1668, and not by Ferri, as is usually said. See Paatz, *Kirchen von Florenz*, II, 115.

393. 80. Buontalenti influence is also to be found in the work of Ignazio Pellegrini (1715-90), who was born in Verona but practised in Florence between 1753 and 1776; see R. Chiarelli in *Riv. d'Arte*, XXXI (1958), 157; also *idem*, *Architetture fiorentine e toscane di I.P. (1715-1790)*, 1966, and *Architetture pisane di I.P. nei disegni dell'archivio Pellegrini di Verona*, Università di Pisa, 1966.

81. Begun in 1738 by Giovanni Antonio Medrano with the assistance of Antonio Canevari (1681-*c*. 1750), and not yet finished in 1759. Medrano also built the theatre of S. Carlo (1737) to which later Fuga and G. M. Bibiena contributed. It was destroyed by fire in 1816. See A. Venditti, *Architettura neoclassica a Napoli*, Naples, 1961, 237.

For the following see mainly R. Pane, *Architettura dell'età barocca in Napoli*, Naples, 1939, and *idem*, *Napoli imprevista*, Turin, 1949; also Bibliography.

82. R. Mormone, 'D. A. Vaccaro architetto', *Napoli Nobilissima*, I (1961-2), 135.

83. He was responsible in 1701 for the funeral decorations for King Charles II in the Cappella del Tesoro; in 1702 for the festival decorations on the occasion of Philip V's visit to Naples; in 1731 for the funeral decorations of the Duke Gaetano Argento; in 1734 he designed the festival decorations for the entry into

Naples of the new King, Charles III, in 1738 those for the King's wedding, etc.

84. Other churches by him: Chiesa delle Crocelle; S. Maria succurre miseris; façade of S. Lorenzo, 1743; chiostro, monastery of Donnaregina together with the restoration and enlargement of the church and monastery, etc.

394. 85. Further on his staircases, Pane, *op. cit.*, 182 ff. Illustration 270 after Pane, 187, illustrates the double staircase in the palace in Via Foria 234. (This address given by Pane is no longer correct.) The charming staircase of the Palazzo Fernandez, attributed to Nauclerio, follows the type shown in illustration 269.

395. 86. By Sir Anthony Blunt in lectures given at the Courtauld Institute. Fuga's staircase of the Palazzo della Consulta (p. 382), unique in Rome, derives from staircases by Sanfelice (see Pane, *Fuga* (Note 42), 41) - thus an Austrian conception makes its entry into Rome via Naples.

87. See mainly L. Vanvitelli Jr, *Vita dell'architetto L. Vanvitelli*, Naples, 1823; F. Fichera, *Luigi Vanvitelli*, Rome, 1937, with further literature. On Vanvitelli's work at Ancona, L. Serra in *Dedalo*, X (1929). The eighth Congress of the History of Architecture was to a large extent devoted to Vanvitelli; see *Atti dello VIII convegno nazionale di storia dell'architettura*, Rome, 1956, with many valuable contributions.

88. G. Chierici, *La Regia di Caserta*, Rome, 1937; F. de Filippis, *Caserta e la sua reggia*, Naples, 1954 (also the same author's *Il Palazzo Reale di Caserta e i Borboni di Napoli*, Naples, 1968); Marcello Fagiolo-Dell' Arco, *Funzioni simboli valori della Reggia di Caserta*, Rome, 1963, with full bibliography. The foundation stone of Caserta was laid on 20 January 1752; between 1759 and 1764 interruption; after Luigi's death in 1773 the work was continued by his son, Carlo. The exterior was finished in 1774, not entirely in accordance with Luigi's plans. E. Rufini, 'L'importanza di un epistolario inedito di L. Vanvitelli', in *Studi in memoria di G. Chierici*, Rome, 1965, 281 ff., reports an extensive find (in the Archive of S. Giovanni de' Fiorentini, Rome) of letters which Vanvitelli addressed to his brother Don Urbano between 1751 and 1768, written from Caserta and to a large extent concerned with the building of the castle.

398. 89. But the differences are not negligible; see Fichera, *op. cit.*, 42.

90. Fagiolo-Dell'Arco, *op. cit.*, 46, wants to derive the Caserta octagons from Early Christian or Byzantine sources (precisely what I have claimed for S. Maria della Salute) and, without supporting his argument, refuses to accept the obvious: the direct impact of the Salute, a building well known to Vanvitelli.

399. 91. It is noteworthy not only that Vanvitelli in

this church made use of Borrominesque detail but that he fashioned the design of the dome after Cortona's SS. Martina e Luca. In keeping with his rationalism, however, he did not superimpose the ribs of the vault upon the coffers and gave the latter a severely geometrical octagonal star-form.

92. For Neapolitan architecture of the second half of the eighteenth century, see A. Venditti, *Architettura neoclassica a Napoli*, Naples, 1961, 51 and *passim*.

93. Work on Apulian architecture of the seventeenth and eighteenth centuries is in its beginnings. The older book by M. S. Briggs, *In the Heel of Italy*, London, 1910, is still useful. In his article in *Commentari*, v (1954), 316, M. Calvesi applies historical methods to the investigation of the architecture of Lecce for the first time. M. Calvesi and M. Manieri-Elia, *Architettura barocca a Lecce . . .*, 1971, replaces the previous literature on the subject.

Interesting contributions by G. Bresciani Alvarez, M. Calvesi, and M. Manieri-Elia appeared in the *Atti del IX Congresso Nazionale di storia dell'architettura*, Rome, 1959, 155, 177, 189. These authors turn against the legend of the Spanish influence and emphasize the importance of Naples and Sicily for Apulia.

400. 94. For the literature see Bibliography, section SICILY.

95. The Quattro Canti are traditionally attributed to the Roman (?) Giulio Lasso, 1608; Mariano Smiriglio directed the work in 1617 and Giovanni de Avanzato in 1621; see F. Meli, *Arch. Stor. per la Sicilia*, IV–V (1938-9), 318. For Smiriglio, *ibid.*, 354; G. B. Comandè in *Atti del VII Congresso Naz. di storia dell' arch.*, Palermo, 1956, 307.

96. Many features of this palace derive from the stock of Mannerist motifs, but the balcony surrounding the entire structure and the large supporting brackets superimposed on the triglyphs of the entablature underneath are typically Sicilian.

For Vermexio, see E. Mauceri, *Giovanni Vermexio*, Syracuse, 1928; G. Agnello, 'Il tempio vermexiano di S. Lucia a Siracusa', *Arch. Stor. per la Sicilia orientale*, VII (1954), 153; and *idem, I Vermexio*, Florence, 1959 (also A. Blunt's review in *Burl. Mag.*, CII (1960), 124).

97. I have been unable to find out whether the book by V. Grazia Pezzini, *Giacomo Amato e l'architettura barocca a Palermo*, announced in 1961, has ever appeared. L. Biagi's 'Giacomo Amati e la sua posizione nell'architettura palermitana', *L'Arte*, XLII (1939), 29, gives less than the title promises. Documentary material for Paolo and Giacomo Amato in Meli, *op. cit.*, 359, 367. Paolo Amato's *La nuova pratica della prospettiva* (Palermo, 1736), published posthumously by his friend Giuseppe de Miteli, is prefaced by a life of the architect (presumably written by De Miteli) which includes a list of works with dates.

Giuseppe Mariani from Pistoia (1681-1731), probably Giacomo Amato's pupil, whose work has a Borrominesque flavour, became court architect in Palermo in 1722; see V. Scuderi in *Commentari*, XI (1960), 260.

98. A. Chastel in *Revue des sciences humaines*, fasc. 55-6 (1949), 202.

401. 99. E. Calandra, *Breve storia dell'architettura in Sicilia*, Bari, 1938, 134, reports nineteenth-century alterations to this façade. The only monographic treatment of G. B. Amico is by V. Scuderi, *Palladio*, XI (1961), 56 (with chronological work catalogue). G. B. Comandè (in *Quaderni*, XII, 67-70 (1965), 33 ff.) published a summary of Amico's rare book *L'Architetto pratico* of 1726.

100. For these villas, see the fine study by V. Ziino, *Contributi allo studio dell'architettura del'700 in Sicilia*, Palermo, 1950. For the correct dating of the Villa Valguarnera, see V. Ziino in *Atti* (see Note 95), 329.

101. Monstrosities always exercise a particular fascination and, therefore, more has been written about this villa than about any other Sicilian monument. The most recent book on the subject is by K. Lohmeyer, *Palagonisches Barock*, Frankfurt, 1943; see also Brassaï in *G.d.B.A.*, LXI (1960), 351, and G. Levitine, *ibid.*, LXIII (1964), 13, with further references.

102. Later, Maria Carolina, Maria Theresa's daughter, became the Queen of Bourbon Naples, and her daughter, Maria Theresa, Princess of Naples and Sicily, married the Hapsburg Emperor Francis II.

103. See above, Chapter 12, Note 9. For Picherali, see G. Agnelli in *Arch. stor. per la Sicilia*, II–III (1936-7), VI (1939), and series III, vol. II (1947), 281. For Luciano Alì, the architect of the remarkable Palazzo Beneventano at Syracuse (1779), see S. L. Agnello in *Atti dello VIII convegno nazionale di storia dell'architettura*, Rome, 1956, 213.

104. O. Sitwell, 'Noto, a Baroque City', *Architectural Review*, LXXVI (1934), 129; N. Pisani, *Noto, la Città d'Oro*, ed. Ciranna, 1953; J.-J. Ide in *Journal R.I.B.A.*, LXVI (1958), 11; F. Popelier in *G.d.B.A.*, LIX (1962), 81. S. Bottari in *Palladio*, VIII (1958), 69, is mainly concerned with Gagliardi's work.

Gagliardi's and other Sicilian architects' church façades with high central tower are un-Italian and point once again to Austrian prototypes. To this class belong Gagliardi's Cathedral and S. Giuseppe at Ragusa and S. Giorgio at Modica.

105. F. Fichera, *G. B. Vaccarini e l'architettura del Settecento in Sicilia*, Rome, 1934.

106. The Benedictine monastery has a long and complicated building history for which see Fichera, *op. cit.*, 80, 143, etc. The main contributors were Antonino Amato and his sons Lorenzo and Andrea (until 1735), Francesco Battaglia (1747-56), Giuseppe Palazzotto (until 1763), and Stefano Ittar (1768).

CHAPTER 17

403. 1. For Vittozzi, see Bibliography. On the Castellamonte see C. Boggio, *Gli architetti Carlo ed Amedeo di Castellamonte*, Turin, 1896, and G. Brino (and others), *L'opera di Carlo e Amedeo di Castellamonte*, Turin, 1966. Buildings by Amedeo: S. Salvario in via Nizza (1646–53), Chiesa di Lucento (1654), S. Martiniano (1678, destroyed), Palazzo della Curia Maxima (1672), Hospital of S. Giovanni (now containing also collections of the University, begun 1680), and, above all, the Palazzo Reale, begun in 1646. The architect and engraver Giovenale Boetto (1640–*c.* 1678) reveals close links with Vittozzi and Carlo di Castellamonte in his buildings in Piedmont; see monograph by N. Carboneri–A. Griseri (Bibliography).

2. His most important buildings: the extensive Palazzo di Città (1659–63, enlarged by Alfieri; see E. Olivero in *Torino*, v (1927), 373 ff.), Chiesa della Visitazione (1661, façade 1765), S. Rocco (1667–91, façade 1890), SS. Maurizio e Lazzaro (1679 dome and façade 1835), the latter church according to Olivero by Lanfranchi's son, Carlo Emanuele. All these churches are centralized buildings, S. Rocco and SS. Maurizio e Lazzaro with impressive use of free-standing columns. For Lanfranchi, see A. Cavallari-Murat in *Boll. Soc. Piemontese di archeologia e di belle arti*, XIV–XV (1960–1), 47–82.

3. For the whole question of Turin's urban development, see P. Gribaudi, 'Lo sviluppo edilizio di Torino dall'epoca romana ai giorni nostri', *Torino*, XI (1933), no. 8; also M. Passanti, 'Le trasformazioni barocche entro l'area della Torino antica', *Atti del X Congresso di storia dell'architettura*, Rome, 1959, 69–100.

4. Further for seventeenth-century Piedmontese architecture: A. E. Brinckmann, *Theatrum Novum Pedemontii*, Düsseldorf, 1931; A. Ressa, 'L'architettura religiosa in Piemonte nei secoli XVII e XVIII)', *Torino*, XIX (1941); M. Passanti, *Architettura in Piemonte*, Turin, 1945. - On the richly decorated Castello del Valentino, the planning of which is essentially French, see the monograph by Cognasso, Bernardi, Brinckmann, Brizio, and Viale, Turin, 1949. - On the Baroque architecture at Carignano near Turin, see G. Rodolfo, in *Atti del II° congresso della Società Piemontese di Archeologia e Belle Arti* (A cura della R. Deput. subalpina di storia patria), Turin, 1937, 130–86. - See also Bibliography, III.

404. 5. Apart from P. Portoghesi's monograph on Guarini (Milan, 1956), which is useful in spite of the brief text, see T. Sandonnini, 'Il Padre Guarino Guarini', *Atti e mem. R. Deput. di storia patria . . . provincie modenesi e parmensi*, ser. 3, v (1888), 483; E. Olivero, 'La vita e l'arte del P. Guarino Guarini', in *Il Duomo di Torino*, II, no. 5 (1928); W. Hager in *Miscellanea*

Bibl. Hertzianae, 1961, 418; M. Passanti, *Nel mondo magico di Guarino Guarini*, Turin, 1963 (an architect's study who follows up the genesis of Guarini's motifs). The pedestrian dissertation by M. Anderegg-Tille, *Die Schule Guarinis*, Winterthur, 1962, contains little information of interest. For the enormous increase of Guarini studies in recent years the reader is referred to the Bibliography.

6. T. Sandonnini, *op. cit.*, 489, and Portoghesi, *op. cit.*

7. On Guarini's writings, E. Olivero in *Il Duomo di Torino*, II, no. 6 (1928).

8. M. Accascina in *Boll. d'Arte*, XLI (1956), 48, published an old photograph of the façade of the Annunziata; see also W. Hager, 'Guarinis Theatinerfassade in Messina' in *Das Werk des Künstlers. Hubert Schrade zum 60. Geburtstag dargebracht*, Stuttgart, 1960, 230. The picturesque façade of S. Gregorio, destroyed in 1908, is often illustrated as a characteristic example of Guarini's style. But documents prove (Accascina, *ibid.*, XLII (1957), 153) that the façade was not finished until 1743. The strange campanile 'a lumaca' was finished in 1717, M. Accascina suggests from a design by Juvarra; this does not seem convincing.

9. Portoghesi, *op. cit.*, wants to date the design about 1670, and Hager (last Note), 232, follows Portoghesi's late dating. There seems to be a general inclination to favour the late date.

405. 10. L. Hautecœur, *Histoire de l'architecture classique en France*, II, Paris, 1948, 245, with further literature. The history of the church has now been clarified by D. R. Coffin in *Journal of the Society of Architectural Historians*, XV (1956), no. 2.

11. The correspondence with similar devices used by François Mansart at an earlier date (A. Blunt, *Art and Architecture in France*, 148; P. Smith, *Burl. Mag.*, CVI (1964), 114, figure 20, suggests that Mansart had devised a cut-off dome design for the Val de Grâce as early as 1645) is striking. There seems to have been an interesting give and take between Guarini and the French. While Guarini's truncated dome of Sainte-Anne-la-Royale (1662) was in all likelihood developed from Mansart's staircase at Blois, the latter in turn followed Guarini's version of Sainte-Anne for the design of the Bourbon Chapel at Saint-Denis (1665). In his church of the Invalides (1679 ff.), J. Hardouin-Mansart used the same type of dome, but adjusted the curve of the second vault, which he closed in the centre (instead of opening it into a lantern). Once again Guarini incorporated this latest version into his project for S. Gaetano at Vicenza (last period).

12. The pagoda-like build-up, for which precedents exist in Northern Italy (p. 122), was often used by Guarini and developed much further than ever before. The most advanced example: his design for the Sanctuary at Oropa (1680).

13. A. Terraghi in *Atti del X Congresso di storia dell' arch.*, Rome, 1959, 373, suggests a date between 1656 and 1659 for the church and offers a hypothesis regarding Guarini's likely stay in Portugal. But at the Guarini Congress in Turin (1968) F. Chuecas suggested that Guarini's church was not built until 1698.

406. 14. Begun later by Michelangelo Garove (1650-1713). Further for the history of the church, G. Chevalley, 'Vicende costruttive della Chiesa di San Filippo Neri', *Bollettino del Centro di studi archeologici . . . del Piemonte*, fasc. II (1942). Here, too, further information on Garove's work. See now R. Pommer, *Eighteenth-Century Architecture in Piedmont*, New York-London, 1967, 79-84.

15. The Palazzo Carignano (1679-92) is by far the most important of Guarini's domestic buildings. Its plan combines motifs from Borromini's designs for the Palazzo Carpegna and Bernini's first Louvre project, but in the treatment of detail and of the decoration Guarini is highly original. Much material in O. Cravero, 'Il Palazzo Carignano', *Atti e Rass. tecnica della Soc. Ingegneri e Architetti in Torino*, XVII (1963). A fine analysis of the palace in H. A. Millon, *Baroque and Rococo Architecture*, New York, 1961, 22. Guarini also made designs for the royal castle at Racconigi (between 1679 and 1683; C. Merlini in *Torino*, XIX (1941), 35) and for other palaces (see Portoghesi, *op. cit.*). We leave a discussion of all this aside in favour of an analysis of his major ecclesiastical work at Turin.

16. His design of 1678 had to incorporate an older church; the dome of 1703 does not correspond to Guarini's design; enlargement by Juvarra, 1714. Decoration finished in 1740. Façade, 1854-60. Addition of four elliptical chapels, 1899-1904. See P. Buscalioni, *La Consolata nella storia di Torino*, Turin, 1938. See also A. Lange, 'Turin: La Consolata', *Congrès Archéologique du Piémont* (1978), 107-12.

407. 17. According to documents in the State Archive, Turin (available in the Soprintendenza), Bernardino Quadri directed the work until 1667, supported by Antonio Bettino (1659-64). 1660-3: construction of the sacristy and the communication with the Palazzo Reale. 1667: the carpenter G. Rosso is paid for the wooden model of Guarini's project. Guarini had to use marble and bronze which had already been worked. The altar, planned by Guarini, was executed by Antonio Bertola. 1690: execution of the pavement. 1694: transfer of the relic into the finished chapel. See also Olivero in *Il Duomo di Torino*, II (1928), no. 3 (*ibid.*, no. 7, material about Bertola, 1647-1719, who was mainly a military architect); A. Midana, 'Il Duomo di Torino', in *Italia Sacra*, V (1929); and above all M. Passanti, 'Real Cappella della S. Sindone', in *Torino*, XX (1941), nos. 10, 11; and *idem*, *Nel mondo magico* (above, Note 5). For Antonio Bertola, see N. Carboneri, in *Studi di*

Storia dell' Arte in onore di Vittorio Viale, Turin, 1967, 48 ff.

408. 18. See the oval reliefs in the pendentives of S. Carlo alle Quattro Fontane.

409. 19. The Palazzo Carignano may illustrate how he applied similar contrasts to a palace; see the undulating window frames (produced as if by chance) contained by hard geometrical forms, particularly the constantly repeated star-pattern of the court front.

410. 20. See also E. Battisti, 'Note sul significato della Cappella della S. Sindone', *Atti del X Congresso di storia dell'arch.*, Rome, 1959, 359.

21. S. Lorenzo is a Theatine church. Its foundation stone had been laid, long before Guarini, in 1634. See G. M. Crepaldi, *La Real Chiesa di San Lorenzo in Torino*, Turin, 1963.

22. Reference may be made to the fact that two adjoining niches with statues always vary in depth and stand at angles to each other which cannot easily be perceived. Moreover, since the sides of the octagon are not equally curved (the curves are flatter in the main axes than in the diagonals), the relationships differ between two adjoining columns and the niches behind.

412. 23. The *Architettura civile* contains, however, no chapter on domes. This omission suggests that the MS. was unfinished at the time of Guarini's death.

24. With Naples and Sicily belonging to the Kingdom of Castile, it seems unnecessary to speculate about Guarini's early contacts with Hispano-Moresque architecture.

The eight-pointed star-shaped dome above the crossing of the cathedral of Saragossa probably comes nearest to the dome of S. Lorenzo. The extraordinary twelfth-century vestibule of the cathedral at Casale Monferrato near Turin with a vault consisting of intersecting ribs was, of course, known to Guarini. In 1671 Guarini himself designed S. Filippo at Casale Monferrato, based on a complex interpenetration of circular spaces. This church was completely altered in 1877. See also Terraghi (above, Note 13), 369.

413. 25. Similarly, the system of the dome of the Cappella della SS. Sindone may have been stimulated by the stalactite work in Islamic architecture.

26. But see W. Müller, 'The Authenticity of Guarini's Stereotomy in his *Architettura Civile*', *Journal Soc. Architect. Historians*, XXVII (1968), 202 ff., and *idem*, in *Guarino Guarini e l'internazionalità del Barocco*, Turin, 1970, I, 531 ff.

27. His publications of the 1670s and 80s are mainly concerned with mathematics and astronomy.

28. Guarini celebrated the first Mass in S. Lorenzo - probably a unique case of the alliance of architect and priest in the same person.

In the same year, 1680, Emanuele Filiberto Amedeo, Prince of Carignano, appointed him his 'teologo'. The

revealing document mentions that in him 'are united the highest philosophical, moral and theological sciences, which befit a zealous priest'. See Olivero in *Il Duomo di Torino*, II (1928), no. 4.

29. For Piedmontese architecture between the death of Guarini and the arrival of Juvarra, see H. Millon, 'Michelangelo Garove and the Chapel of the Beato Amedeo of Savoy in the Cathedral of Vercelli', *Essays in the History of Architecture presented to R. Wittkower*, London, 1967, 134 ff. Next to Garove, the most gifted successor to Amedeo Castellamonte and Guarini (see above, Note 14), the following minor architects were active: Maurizio Valperga, Giovanni Francesco Baroncelli (d. 1694), who built the Palazzo Barolo (1692-3) and to whom the Palazzo Graneri (1682-3) is traditionally attributed, Carlo Emanuele Lanfranchi (1632-1721) and Antonio Bertola (1647-1719) who worked on three of the buildings left unfinished by Guarini. For Bertola, see also above Note 17; for Garove, R. Pommer, *Eighteenth-Century Architecture in Piedmont*, New York-London, 1967, *passim*.

414. 30. The principal publication on Juvarra is that by L. Rovere, V. Viale, and A. E. Brinckmann ('A cura del Comitato per le onoranze a F.J.'), of which only the first volume appeared in 1937. See now the recent full monograph by Boscarino.

For the early Juvarra see G. Chevalley in *Boll. Soc. Piemontese*, N.S. I (1947), 72, and, above all, M. Accascina in *Boll. d'Arte*, XLI (1956), 38; XLII (1957), 50. For the work in Piedmont see A. Telluccini, *L'arte dell' architetto Filippo Juvara in Piemonte*, Turin, 1926.

31. Sketchbooks in the Victoria and Albert Museum, London, and the Biblioteca Nazionale, Turin. For the theatre, see A. Rava, *Il Teatro Ottoboni nel Palazzo della Cancelleria* (R. Istituto di Studi Romani, III), Rome, 1942.

32. Brinckmann, *Theatrum Ped.* (above, Note 4), 31. - A. A. Tait, *Burl. Mag.*, CVIII (1966), 133 f., attributes the work on the Palazzo Pubblico at Lucca to Francesco Pini on the basis of documents. But see now S. Benedetti, *Palladio* (1973), 145-83, who restores the design to Juvarra, and M. Paoli, *Provincia di Lucca*, XV (1975), 106-11.

33. Here Juvarra planned an enlargement of the old royal palace, which was, however, not executed; see Augusta Lange in *Bollettino storico-bibliografico subalpino*, XLIV (1942), nos. 1-4; M. Accascina, *Boll. d'Arte*, XLII (1957), 158.

34. Juvarra's project remained on paper; the palace was built by Johann Friedrich Ludwig and his son Johann Peter.

Juvarra also designed the lighthouse in the harbour of Lisbon and the church and palace of the Patriarch.

35. In 1730 he dedicated a volume with architectural fantasies to Lord Burlington, now at Chatsworth; see

Wittkower in *Boll. Soc. Piemontese*, N.S. III (1949).

36. The wooden model of Juvarra's design in the Museo de Artilleria, Madrid. The palace was executed between 1738 and 1764 by Juvarra's pupil, Giovanni Battista Sacchetti, who reduced its size and admitted a strong influence from Bernini's Louvre project. Sacchetti followed Juvarra's design more closely in the execution of the garden front of the palace of La Granja at S. Ildefonso near Segovia. New documents for this work, published by E. Battisti in *Commentari*, IX (1958), 273. See also A. Scotti, *Colóquio*, XXVIII (1976), 51-63.

37. None of his great projects for Rome (Sacristy of St Peter's, Spanish Staircase, façade of S. Giovanni in Laterano) were executed. Juvarra was not an official participant in the Lateran competition of 1732, but his early biographers mention that he was invited to send a project; for this sketches survive (Turin). As regards his other work in Rome, see M. Loret in *Critica d'Arte*, I (1936), 198, and R. Battaglia in *Boll. d'Arte*, XXX (1937), 485, and also *Arti Figurative*, III (1947), 130.

38. With the exception of S. Croce, Turin (1718 ff.), these churches will be discussed later.

39. The palace of the Venaria Reale (1714-26), Palazzo Madama (1718-21), the castles at Rivoli (1718-25; see A. Telluccini in *Boll. d'Arte*, X (1930/1), 145, 193) and at Stupinigi (begun 1729).

40. Palazzi Birago, now Della Valle; Martini di Cigala, now Belgrano (both 1716); Richa di Covasolo; and Guarene, now d'Ormea (both 1730).

415. 41. This would have been even more evident if the wings had been built. The palace, which screens the medieval castle, was erected for the widow of Carlo Emanuele II. Construction was interrupted in 1721. A. Telluccini, *Il Palazzo Madama di Torino*, Turin, 1928.

I cannot always follow W. Collier's analyses ('French Influence on the Architecture of Filippo Juvarra', *Architectural History*, VI, 1963, 41), but he is certainly not correct in maintaining that the French influence on Juvarra has been overlooked. See also L. Mallé, *Il Palazzo Madama di Torino*, I, Turin, 1970.

416. 42. It should, however, be pointed out that the type with radiating wings was also developed in eighteenth-century Austria and France. Boffrand even maintained in his *Livre d'architecture*, Paris, 1745, where he published the Château La Malgrange near Nancy with a plan similar to Stupinigi, that the latter was designed by him. A. E. Brinckmann (*Baukunst des 17. und 18. Jahrhunderts in den romanischen Ländern*, Berlin, 1919, 316) has shown that Boffrand's assertion is without foundation. But J. Garms, in *Wiener Jahrb.*, XXII (1969), 184 ff., accepts Boffrand's X-shaped plan as a genuine product of 1711-12. M. Passanti in *L'Architettura*, III (1957), 268, published good measured drawings. After Juvarra's death Alfieri (see

Note 72) was probably responsible for the planning of the considerable extension of Juvarra's project (1739). The park was begun in 1740 by the Frenchman F. Bernard. For further information, see M. Bernardi, *La Palazzina di Caccia di Stupinigi*, Turin, 1958. N. Gabrielli (with M. Tagliapietra Rasi and L. Tamburini), *Museo dell'Arredamento Stupinigi. La Palazzina di caccia*, Catalogo, Turin, 1966, contains the history of Stupinigi and its decoration based on a wealth of new documents. The same documentation was used by Pommer for his comprehensive analysis of Stupinigi in *Eighteenth-Century Architecture in Piedmont*, New York–London, 1967, 61–78, 188–218. The apogee of Stupinigi studies is L. Mallè's folio of over 500 pages, *Stupinigi. Un capolavoro del Settecento europeo tra barocchetto e classicismo*, Turin, 1968.

43. The original great design, published by Tavigliano in 1758, was influenced by Rainaldi's S. Maria in Campitelli. In 1730 it was reduced to its present form without crossing and dome. On the complex history of this church, see G. Chevalley's paper, and R. Pommer, quoted above, Note 14.

44. L. Tamburini, *Le chiese di Torino dal rinascimento al barocco*, Turin, 1968, 339–50. The church was gutted during the last war.

In 1734 Juvarra made a design similar to that of the Carmine for the church of the Padri Gesuiti at Vercelli; execution later (1741–73), with considerable changes. See V. Viale in *Atti del X Congresso di storia dell'arte*, Rome, 1959, 427.

419. 45. See Pozzo's altars in S. Maria degli Scalzi, Venice, and, later, in the Jesuitenkirche, Vienna (1703–5). Fischer von Erlach used the motif first in a design for the high altar in the church at Strassengel (*c.* 1690, Albertina).

46. The earliest example seems to be the Stiftskirche Waldsassen, Oberpfalz, 1685–1704, designed by the Italianizing A. Leutner from Prague, with Georg Dientzenhofer as clerk of works.

47. Rovere–Viale–Brinckmann, *op. cit.*, plates 31 and 32. One will easily recognize the features deriving from Borromini, Bernini, Rainaldi, Carlo Fontana, and even from Longhena's Salute (figures above columns inside). In view of Juvarra's further development, the change of proportion as compared with S. Agnese is notable. In S. Agnese the body of the church is related to drum and dome as 1:1, in Juvarra's project as $1:1\frac{2}{3}$, i.e. the importance of drum and dome has grown.

420. 48. Another scenic feature (without pedigree) is the perforating of the pillars with three openings in the balcony zone through which one can look into the domes of the satellite chapels. – The detail of the church combines classical tabernacle frames with ornament that shows almost a Rococo tinge.

49. The church was intended as a thanksgiving by

King Vittorio Amedeo II for the support given by the Virgin to the royal house. In May 1717 the wooden model, still existing in the monastery, was paid for; by 1726 the structure had been carried as high as the lantern; in 1727 the campanili were built, and in 1731 the decoration of the interior was finished. See also G. A. Belloni in *Torino*, XI (1931), nos 9, 10, and M. Paroletti, *Description historique de la ... Superga*, Turin, 1808. See now N. Carboneri, *Superga*, Turin, 1979.

422. 50. By horizontal segments of masonry. The same method was used in the satellite chapels. The probable source is Borromini's doors in S. Ivo.

51. The ratio is now $1:1\frac{2}{3}$; see Note 47. The body of the church looks therefore like a base to drum and dome.

Similar relationships prevail in Fischer von Erlach's Karlskirche in Vienna (designed 1715, begun 1716, executed until 1722, but drum and dome finished after Fischer's death, 1739). The not unlikely connexion between the two churches would need further investigation.

423. 52. The designs for S. Raffaello are similar. They are usually dated as early as 1718, which seems to be untenable in view of Juvarra's other production at that period.

53. See W. Herrmann in *Jahrbuch für Kunstwissenschaft*, IV (1927), 129 ff.

424. 54. Among Juvarra's contemporaries and followers should be mentioned Gian Giacomo Planteri, the architect of the Chiesa della Pietà and S. Maria dell' Assunta at Savigliano (both begun 1708) and of the magnificent Palazzo Saluzzo-Paesana at Turin (1715–22); for Planteri, see A. Cavallari Murat in *Atti e Rassegna tecnica Soc. Ingegneri e Architetti in Torino*, XI (1957), 313, and S. J. Woolf, *ibid.*, XV (1961, September issue); further G. B. Sacchetti (see Note 36) and the Conte Ignazio Tavigliano (Note 43). The most extensive architectural practice next to Juvarra's was that of Francesco Gallo from Mondovì (1672–1750); he was, however, infinitely less imaginative than either Juvarra or Vittone. Among his more distinguished works may be named the Chiesa Parrocchiale at Carrù (1703–18; see Chapter 12, Note 7), with a characteristic centralized plan, often varied by him; the Chiesa della Misericordia (1708–17) and the cathedral at Mondovì (1743–63); S. Giovanni at Racconigi (1719–30); SS. Trinità at Fossano (1730–9); and the oval S. Croce (also called S. Bernardino) at Cavallermaggiore (1737–43), which is perhaps his masterpiece and betrays Vittone's influence. He was also responsible for the completion of Vittozzi's Sanctuary at Vicoforte di Mondovì (1701–33). All his buildings excel in the richness, harmony, and taste of their decoration. A fully documented monograph about him was published by Nino Carbonieri, Turin, 1954.

55. On Vittone see the monograph by E. Olivero (Turin, 1920) which is useful for the collection of factual material. Further: G. Rodolfo, 'Notizie inedite dell'architetto Bernardo Vittone' in *Atti della Soc. Piemontese di Arch. e Belle Arti*, XV (1933); C. Baracco, 'Bernardo Vittone e l'architettura Guariniana' in *Torino*, XVI (1938), 22; Olivero in *Palladio*, VI (1942), 120; C. Brayda, 'Opere inedite di Bernardo Vittone' in *Boll. Soc. Piemontese*, N.S. I (1947); P. Portoghesi, *ibid.*, XIV-XV (1960-1). P. Portoghesi published a very well-illustrated monograph in 1966; it also contains the long inventory of Vittone's estate and other documents. R. Pommer, *op. cit.* (Note 14), made it likely that Vittone was born in about 1702 rather than in 1704 or 1705 as is usually assumed.
See now the proceedings of the Vittone congress (ed. V. Viale), 2 vols. (1972).

56. H. A. Millon (*Boll. Soc. Piemontese*, N.S. XII-XIII, 1958-9) has shown that Vittone was a practising architect before going to Rome and that he was still in Turin on 29 July 1730.

57. Vittone himself calls Juvarra his teacher; see *Istruzioni elementari*, Lugano, 1760, 285.

58. Very little of his pre-Roman activity is known, see Note 56.

59. Height less than 70 feet, diameter *c.* 50 feet. The exterior was whitewashed in 1939.

425. 60. It is particularly close to Guarini's unexecuted design for S. Gaetano, Nice, later built by Vittone himself.

61. See our discussion of hexagonal planning in relation to Borromini's S. Ivo (p. 206). The plan of S. Ivo with alternating concave and convex recesses probably influenced Vittone.
Hexagonal plans occur often in Vittone's *œuvre*; see the Chiesa Parrocchiale at Grignasco (1752-67), the designs for S. Chiara, Alessandria, and the church of the Collegio dei Chierici Regolari, Turin; also S. Chiara at Vercelli, the Chiesa Parrocchiale at Borgo d'Ale (1770), and others.

427. 62. Again, the closest analogy is to be found in the design of S. Gaetano, Nice.

63. See, e.g., S. Maria Maddalena at Alba, 1749, and the project for S. Chiara at Alessandria.

428. 64. It should be mentioned that there is a close connexion between the architectural conception of S. Chiara at Brà and the *quadratura* frescoes in the dome of the Consolata, Turin, executed by Giambattista Alberoni from designs by Giuseppe Bibiena, with figures by Giambattista Crosato; to be dated, according to F. Fiocco, *Giambattista Crosato*, Padua, 1944, 49, in 1740, i.e. just before Vittone planned his church. The relationship of Vittone's architecture to Piedmontese *quadratura* painting would need further investigation.

430. 65. Millon (Note 56) suggests as date 1738-40

and places correctly in the same period the little jewel, S. Luigi Gonzaga at Corteranzo.

66. The first stone of the Hospital was laid in 1744. It was erected at the expense of Antonio Faccio, who was also responsible for the Sanctuary at Vallinotto. The church was consecrated in 1749. See G. Rodolfo, *Barocco a Carignano* (above, Note 4), 139.

67. Badly redecorated in 1945.

68. E. Olivero in *Boll. Soc. Piemontese*, IX (1925), nos 1-2.

431. 69. On Rana, see C. Brayda, *Torino*, XIX (1939), 16.

70. On Bonvicini, see Augusta Lange in *Bollettino storico-bibliografico subalpino*, XLIV (1942), no. 1.

432. 71. Like some other great men, Vittone was extraordinarily mean. His heirs had to pay large sums to some of his collaborators who had not received any money for a long time.

72. Vittone's most distinguished contemporary among Piedmontese architects was the Conte Benedetto Alfieri (1700-67), who succeeded Juvarra as 'First Architect to the King'. Outstanding among his palaces are the Palazzo Ghilini at Alessandria (now Palazzo del Governo) executed in 1732 from a design by Juvarra; his own palace at Asti (1749); and the Palazzo Caraglio (now Accademia Filarmonica) at Turin. He is particularly remembered for his share in the decoration of the Palazzo Reale, Turin, and, above all, for S. Giovanni Battista at Carignano (1757-64) with its extraordinary horseshoe plan. For Alfieri, see now A. Bellini (1978), D. de Bernardi Ferrero in *Atti e Rassegna tecnica Soc. Ingegneri e Architetti in Torino*, XIII (1959), and V. Moccagatta in *Atti e Memorie del Congresso di Varallo Sesia*, Turin, 1960, 151.
Among those influenced by Vittone's manner may be mentioned, apart from Rana and Bonvicini (Notes 69, 70), Costanzo Michela who was responsible for the undulating plan of S. Marta at Agliè (1760; R. Pommer, *Art Bull.*, L (1968), 169 ff.); Giovan Battista Maria Morari (d. *c.* 1758), who built the parish church at Cumiana (Olivero, *Miscellanea di archit. Piemontese del Settecento*, Turin, 1937, 5); the spirited G. B. Ferroggio, the architect of the church at San Germano Vercellese (1754-64), of the Chiesa dello Spirito Santo at Turin (1764-7, Olivero in *Torino*, XII (1934), no. 12; bombed during the war) and the interesting oval S. Caterina at Asti (1766-73); and the Conte Filippo di Robilant (1723-83), the builder of S. Pelagia at Turin (1770; for this and his other works, see Olivero in *Torino*, X (1932), 42, and N. Carboneri, 'Per un profilo dell'architetto Filippo Nicolis di Robilant', in *Studi in memoria di G. Chierici*, Rome, 1965, 183 ff.).
With Vittone's devoted pupil Mario Quarini, Piedmontese architecture turns towards Neo-classicism (see his large cathedral at Fossano, 1779-91, after the model of St Peter's).

CHAPTER 18

433. 1. See, e.g., the German brothers Schor, in particular Giovan Paolo, whom we recognize now as an important artist in Bernini's studio; until fairly recently he was almost entirely unknown (see above, Chapter 14, Note 33). Among the Frenchmen of Bernini's circle may be mentioned Claude Poussin ('Claudio Francese' or 'Claudio Porissimo' in Italian documents), who was responsible for the River Ganges on Bernini's Four Rivers Fountain (the statue is usually wrongly given to another Frenchman, Claude Adam); Niccolò Sale, whom Bernini employed very often, e.g. on the tomb of the Countess Matilda, for the Cappella Raimondi in S. Pietro in Montorio, and the Four Rivers Fountain; and Michel Maille ('Michele Maglia', 'Monsù Michele', 'Monsù Michel Borgognone' in documents), who worked the figure of Alexander VII of the pope's tomb (1675-6); he belonged to Ferrata's studio and carried on the Berninesque tradition in independent works until 1702, when he seems to have died.

434. 2. This group, known as *La Renommée*, shows Fame writing the deeds of the King into the Book of History which is carried by Time, together with a medallion portrait of Louis XIV. The work was not finished until 1686. Its present position is near the Bassin de Neptune in the garden of Versailles. For the relations of Guidi with Lebrun, see A. de Montaiglon, *Correspondance des directeurs de l'Académie de France à Rome*, I, 76 ff.; L. Hautecœur in *G.d.B.A.*, IV, vii (1912), 46; Wittkower in *J.W.C.I.*, II (1938-9), 188.

435. 3. For Mazzuoli see, above all, V. Suboff in *Jahrb. Preuss. Kunstslg.* IIL (1928), 33, and F. Pansecchi in *Commentari*, X (1959), 33, with new material, mainly at Siena.

4. Wittkower in *Rep. f. Kunstw.*, L (1929), 6. Ottoni's best friend was the French sculptor Théodon, who cunningly managed to take over Bernini's studio behind St Peter's which the Congregation had promised to Ottoni. Ottoni's most extensive stucco work is in St Peter's, particularly above the arcades of choir and transept (1713-26).

5. The illustration shows the stuccoes above the altar and one of the four medallions of the vault with scenes from the life of St Francis. They are surrounded with realistic palm leaves and roses and carried by putti; the chapel is entirely white. All this lends support to the rather gay and light quality of Carcani's art. In his marbles Carcani followed Berninesque prototypes more closely. The allegory of Charity on the Bonelli tomb in S. Maria sopra Minerva (1674), for instance, derives directly from the tomb of Urban VIII. Similar observations may be made in regard to later works, e.g.

the tomb of Monsignor Agostino Favoriti in S. Maria Maggiore (1682-6).

6. Design of the altar by Andrea Pozzo. The sculptural work, begun in 1695, was mainly finished in 1699. For the altar, see now Pio Pecchiai, *Il Gesù di Roma*, Rome, 1952, with further literature. See also C. Bricarelli in *Civiltà Cattolica*, LXXIII (1922), 401, and G. M. March in *Archivum Historicum Societatis Jesu*, III (1934), 300. For the contribution of the Florentine bronze sculptor Lorenzo Merlini, see Lankheit, 183. For Pozzo's oil sketches preparing the small bronze reliefs by René Fremin, Angelo de'Rossi, Peter Paul Reiff, and Pierre Étienne Monnot, see B. Kerber, in *Art Bull.*, XLVII (1965), 499. Altogether over a hundred artists and artisans worked for the altar. Fullest discussion, based on new documents, in Kerber, *A. Pozzo*, 1971, 140-80.

436. 7. For Ludovisi, see U. Schlegel, *Mitteilg. des kunsthist. Inst. in Florenz*, X (1963), 265. The author wants to exclude Ludovisi's collaboration on the St Ignatius altar and argues that the sculptor was probably not born before 1700. But see E. Lavagnino, *Altari barocchi in Roma*, 1959, 174, and R. Enggass, *Burl. Mag.*, CX (1968), 438 ff., 494 ff., and 613 ff.

8. He had come to Rome from Milan, where he had worked for twelve years under Giuseppe Rusnati. For Rusconi, see A. L. Elkan, Thesis, Cologne, 1924; Wittkower in *Zeitschr. f. b. Kunst*, LX (1926-7), 43; S. Baumgarten in *Revue de l'art*, LXX (1936), 233; Donati, *Art. Tic.*, 1942; Samek Ludovici in *Archivi*, XVII (1950), 209; V. Martinelli in *Commentari*, IV (1953), 231; I. Lavin in *Boll. d'Arte*, XLII (1957), 46.

9. Carlo Maratti supplied designs for these statues; see M. Loret in *Archivi*, II (1935), 140; L. Montalto, *Un Mecenato in Roma barocca*, Florence, 1955, 279, 442, 530, 545.

10. Suboff, *Zeitschr. f. b. Kunst*, LXII (1928-9), 111.

11. For Cornacchini, see H. Keutner in *North Carolina Museum of Art Bulletin*, I (1957-8) and II (1958); Lankheit, 188; Wittkower in *Miscellanea Bibl. Hertzianae*, 1961, 464: full documentation for the Charlemagne. Also C. Facciolo, in *Studi Romani*, XVI (1968), 431 ff.

In the context of the relationship of such Late Baroque works to the theatre (see above, p. 366), it is worth noting that a copy of Cornacchini's Charlemagne was shown on the stage of Cardinal Ottoboni's theatre in 1729 on the occasion of the opera *Carlo Magno* performed in honour of the birth of the Dauphin (engraving by Gabbuggiani). See A. Rava, *I Teatri di Roma*, Rome, 1953, 83.

For Cornacchini's statue of Clement XII in Ancona, see W. E. Stoppel, in *Röm. Jahrb. f. Kunstg.*, XII (1969), 203 ff.

438. 12. See Wahl in *Rep. f. Kunstw.*, XXXIV (1911), 15, and J. Fleming and H. Honour, in *Essays in the History of Art presented to R. Wittkower*, London, 1967, 255 ff.

13. Erected by Clement XII to his uncle's memory. It is not without interest in our context that Cardinal Neri Corsini was papal Nunzio in Paris in 1652.

14. Apart from Maini, the principal contributors were Cornacchini (marbles and stuccoes), Filippo della Valle, Pietro Bracci, Giuseppe Rusconi (the classicizing allegory of *Courage*), Giuseppe Lironi (1679, not 1689,-1749; for Lironi, see U. Schlegel, above, Note 7, 259), another pupil of Camillo Rusconi (his is the cool allegory of *Justice*), and Carlo Monaldi (1691–1760), who is more Baroque in his allegories in S. Maria Maddalena (1727) than in the figures which accompany Maini's statue of Clement XII in the Corsini Chapel (for Monaldi see R. Chyurlia in *Commentari*, I (1950), 222). In addition, there worked the less important Bartolomeo Pincellotti and Paolo Benaglia and, unconnected with the Rusconi circle, the Frenchmen Pierre Lestache and Lambert-Sigisbert Adam.

Between 1731 and 1733 most of these sculptors, among a host of others, supplied important works for the cathedral at Mafra (Portugal); see A. de Carvalho, *A escultura em Mafra*, Mafra, 1956.

15. V. Moschini in *L'Arte*, XXVIII (1925); H. Honour in *Connoisseur*, CXLIV (1959), 172 (with œuvre catalogue); Lankheit, 190.

16. It should also be recalled that Bouchardon worked in Rome between 1723 and 1732.

439. 17. See the monograph by K. v. Domarus (Strasbourg, 1915) and C. Gradara (Milan, 1920).

18. The history of the Fontana Trevi is long and complicated. It began in the reign of Pope Nicholas V as early as 1453 and developed through many stages from 1629 onwards for fully a hundred years. After Nicolò Salvi's project was chosen in 1732, the execution progressed fairly quickly. The four statues of the attic by Bartolomeo Pincellotti, Agostino Corsini, Bernardo Ludovisi, and Francesco Queirolo were finished in 1735 (see inscription). The second period of the execution began under Salvi's successor, Giuseppe Pannini (further for the history of the fountain, see Chapter 16, Note 45). To this period belongs the sculptural decoration of the lower part: 1759–62, Bracci's Neptune and Tritons, Filippo della Valle's Health and Fecundity, and the reliefs illustrating legendary episodes of the origin of the Fontana Trevi by Giovanni Battista Grossi and Andrea Bergondi.

440. 19. See O. Sobotka's classic article in *Jahrb. Preuss. Kunstslg.*, XXXV (1914), which can, however, no longer entirely be followed; see also M. V. Brugnoli, *Boll. d'Arte*, XLV (1960), 342.

442. 20. A preparatory sketch in the Düsseldorf Aka-

demie (I. Budde, *Katal. der Handzeichnungen*, no. 449, plate 66) shows that Rusconi began with a symmetrical composition.

21. Algardi's tomb of Leo XI is centrally composed but affords a number of satisfactory views, while Rusconi's tomb offers a coherent view only if one approaches it coming from the transept (compare the illustration here with the wrong view published by Donati, *Art. Tic.*, figure 461).

22. Filippo della Valle departs slightly from tradition by placing the sarcophagus in an isolated zone under the triangle of the figures; but for the latter, he reverts to Bernini, his *Charity* being derived from that of the tomb of Alexander VII, but he translates Bernini's drama into calm graciousness.

443. 23. The architecture of the chapel is by Raguzzini. The tomb was designed by Carlo Marchionni (1704–80), the architect of the Villa Albani and the Sacristy of St Peter's, who also executed the relief. The allegory of Humility is by Bracci's collaborator, Bartolomeo Pincellotti. According to Soprani (*Vite de' pittori . . . genovesi*) it was the painter Pietro Bianchi who helped Marchionni on this and other occasions. For Bianchi, see Chapter 15, Note 13.

24. It is true, however, that he used *one* allegory, Faith (and not the customary two). Together with the Angel of Death and the lions, it belongs to a zone compositionally and spiritually entirely divorced from the praying pope.

25. This interesting artist, who was born at Cattinara in Piedmont in 1669 (not 1682) and died in Rome in 1736, worked for fifteen years in the studio of Lorenzo Ottoni. His most important works are the four Barberini tombs in S. Rosalia, Palestrina, of which the two earlier ones of 1704 show Baroque angels related to Raggi's style. C. Pericoli in *Capitolium*, XXXVIII (1963), 131, contributes some new material for Cametti but erroneously believes that he was born in Rome in 1670. For a full monographic treatment of Cametti with reliable œuvre catalogue, see U. Schlegel in *Jahrb. Preuss. Kunstslg.*, N.F. V (1963), 44, 151.

444. 26. Painted portraits on tombs occur, of course, before the eighteenth century. The most interesting is perhaps the one which Giovan Battista Ghisleri erected for himself in 1670 in S. Maria del Popolo with the figure of Death looking out of his vault. The inscriptions under the portrait NEQUE HIC VIVUS and under Death NEQUE ILLIC MORTUUS (Mâle, 221) point out that 'he (Ghisleri) is neither alive here nor dead in the beyond'.

27. This feature was introduced by Raphael in the memorial chapel of the Chigi family in S. Maria del Popolo. During the sixteenth and the first half of the seventeenth centuries, however, tombs with pyramids

remained rare. It was once again Bernini who, with the redecoration of the Chigi Chapel (1652 ff.), opened the way to using the pyramid as a Baroque sepulchral element. For Raphael's Chigi Chapel and later changes, see J. Shearman in *J.W.C.I.*, XXIV (1961), 129 (134, on pyramid tombs), and J. Pope-Hennessy, *Italian High Renaissance and Baroque Sculpture*, London, 1963, Catalogue, 43.

446. 28. Michelangelo Slodtz (1705–64), member of a family of Flemish artists who had settled in Paris, went to Rome in 1728 and remained there for seventeen years. The St Bruno is his masterpiece in Rome. See Bibliography.

447. 29. The first important examples of Italian export of Baroque sculpture are works by Bernini: the bust of Cardinal Melchior Klesl in the cathedral of Wiener Neustadt (Austria), the (destroyed) bust of King Charles I of England, and the portrait of Mr Baker (Victoria and Albert Museum). (For these see Wittkower, *Bernini*, Cat. nos 22, 39, 40.) Also fairly early is Algardi's marble relief of Mary Magdalen carried up to Heaven (1640) in the church at Saint-Maximin in Provence. Among later exports may be mentioned Ferrata's and Guidi's figures for the memorial chapel of Cardinal Friedrich, Landgraf of Hesse Darmstadt, in the cathedral at Bratislava (1679–83; see B. Patzak, *Die Elisabethkapelle des Breslauer Doms*, Bratislava, 1922); Guidi's monument to Louis Phélypeaux de la Vrillière in the church of Châteauneuf-sur-Loire (1681; see Sobotka in *Amtliche Ber. d. kgl. Pr. Kunstslg.*, XXXII (1910/11), 235); Raggi's tomb of Lady Jane Cheyne in Chelsea Old Church, London (1671, partly destroyed); and Monnot's tomb of John Cecil and his wife in St Martin's at Stamford (1704).

30. For Foggini and the following, see Lankheit, 47 ff. and *passim*. Foggini was with Ferrata for three years (1673–6). In 1687, after Ferdinando Tacca's death, he was appointed court sculptor and slightly later also court architect. His all-powerful position was therefore assured. His 'Giornale', a sketchbook of almost 300 drawings (Uffizi and Victoria and Albert Museum; see Lankheit, 51–9 and *idem*, *Riv. d'Arte*, XXXIV (1961), 55), gives an excellent idea of the great variety of enterprises on which the artist was engaged in the years 1713–18. See also K. A. Piacenti, in *Festschrift Ulrich Middeldorf*, Berlin, 1968, 488 ff.

31. Foggini's tomb of Donato dell'Antella in SS. Annunziata (1702), according to Lankheit, 73, by an assistant, is particularly close to Guidi.

32. Corsini Chapel: Lankheit (70, 83, and *Mitteilungen des Flor. Inst.*, VIII (1957), 35) believes that of the three large pictorial reliefs of the chapel only that over the altar with the *Apotheosis of S. Andrea Corsini* (1677–83) is by Foggini's hand. – Feroni Chapel:

Lankheit, 88. The execution lay in the hands of twelve collaborators, among whom Marcellini, Andreozzi, Giuseppe Piamontini, Giovacchino Fortini, and Soldani may be mentioned.

Even though Lankheit (77) claims that these as well as other works executed with the help of assistants should not be used to assess Foggini's potentialities as a sculptor, they were his responsibility and demonstrate, moreover, how in Florence the few major sculptural tasks were handled in which all the available talent joined forces.

Foggini himself, in the finest of his portrait busts (Cosimo III de' Medici and Gran Principe Ferdinando de'Medici, both *c*. 1685, Donaueschingen; Lankheit, figures 175, 176), despite his reliance on Bernini's busts of Charles I, Francis I of Este, and Louis XIV, smothered the heads in emphatically suggestive accessories and played havoc with the 'amputated' arm.

33. Lankheit, 110–60, with further literature. For Soldani as architect, see U. Procacci, in *Festschrift Ulrich Middeldorf*, Berlin, 1968, 476 ff.

34. Lankheit, 162. Carlo Marcellini, Anton Francesco Andreozzi, Francesco Ciaminghi, Giovanni Camillo Cateni, Giuseppe Piamontini are hardly mentioned in art historical writing before Lankheit. All these sculptors studied in the Florentine Academy in Rome before it closed its doors in 1686.

35. For Giovanni Baratta and his brothers Pietro and Francesco, see H. Honour in *The Connoisseur*, CXLII (1958), 170 (with *œuvre* catalogue); also *idem* in *Diz. Biogr. degli Italiani*, 1963, V, 790; and Lankheit, 172. Giovanni's best known work is the very Florentine monumental *Tobias and Angel* relief in S. Spirito, Florence (1697–8). Later, Giovanni had a distinguished career as sculptor to the Turin court. The Florentine note is also very strong in Giovacchino Fortini, who is the sculptor of the tomb of General Degenhard of Hochkirchen in the cathedral of Cologne; see F. Schottmueller in *Boll. d'Arte*, XXVI (1932–3), and Lankheit, 175.

Among the sculptors of this generation Girolamo Ticciati, Antonio Montauti (the artist of the *Pietà* in the crypt of the Corsini Chapel, S. Giovanni in Laterano, Rome, a work of doubtful merit but traditionally attributed to Bernini), and the skilful bronze sculptor Lorenzo Merlini (see above, Note 6) are worth mentioning. For these artists, see Lankheit, *passim*.

36. Another (reputed) pupil of Ferrata, Giovan Battista Barberini (*c*. 1625–91), deserves a note. Like Ferrata and so many others born in the Lake Como region, he became one of the most sought after stucco sculptors in northern Italy. His work is to be found at Cremona, Bologna, Genoa, Mantua, Bergamo, Como, and elsewhere and, in addition, in Vienna, Krems-

münster, and Linz. His emotional, typically Lombard realism shows few links with his master. The almost forgotten book by H. Hoffmann, *Der Stuckplastiker G. B. Barberini (1625-91)*, Augsburg, 1928, is unusually informative (many documents). See also E. Gavazza in *Arte Lombarda*, VII (1962), 63.

448. 37. See G. Piccaluga Ferri, in *Commentari*, XVIII (1967), 207-24. Buzzi was born in Viggiù in 1708 and died there in 1780.

38. Further on Lombard sculpture: S. Vigezzi, *La scultura lombarda nell'età barocca*, Milan, 1930, and G. Nicodemi, *I Caligari scultori bresciani del Settecento*, Brescia, 1924. The work of the Caligari often has real Rococo charm.

39. F. Ingersoll-Smouse, 'La Sculpture à Gènes au XVIIe siècle', *G.d.B.A.*, LVI, ii (1914).

40. P. Rotondi, 'La prima attività di Filippo Parodi scultore', *Arte Antica e Moderna*, II, no. 5 (1959), 63 (and *idem, F. Parodi*, 1962, 24), suggests that Parodi studied with Ferrata rather than Bernini, but this is supported neither by the sources nor by the evidence of Parodi's Genoese work. Moreover, in her not entirely satisfactory book (p. 66) she offers the improbable hypothesis that Parodi was in Rome not only from 1655 to 1661 but again from 1668 to 1674.

41. Parodi's main work in the territory of Venice and one of the principal monuments of the Late Baroque in northern Italy is the Cappella del Tesoro in the Santo at Padua; he executed the rich multi-figured decoration between 1689 and 1692 with the help of pupils. A late Genoese work, S. Pancratius, was published by R. Preimesberger, in *Pantheon*, XXVII (1969), 48 ff.

Reference should also be made to Parodi's magnificent decorative sculpture and furniture, to which P. Rotondi has drawn attention (*Boll. d'Arte*, XLIV (1959), 46).

42. Another collaborator was Francesco Biggi, who executed the famous lions at the foot of the staircase of the Palazzo dell'Università from Parodi's models.

43. V. Martinelli in *Commentari*, IV (1953), 231. For Francesco Schiaffino's and Diego Carlone's collaboration in the twelve large stucco figures in S. Maria di Carignano (1739-40), executed in a post-Rusconi nervous quasi-Rococo manner, see E. Gavazza, *Arte Lombarda*, VII (1962), 105.

450. 44. *Le casacce e la scultura lignea sacra genovese del Seicento e del Settecento* (Catalogue of the Genoese Exhibition, 1939).

45. J. Fleming in *Connoisseur*, CXXXVIII (1956), 176. See also E. Olivero, *La chiesa di S. Francesco di Assisi in Torino*, Chieri, 1935, with much documentary material for C. Giuseppe and his son Giovan Battista Plura (who died in London in 1757), for Clemente and G. B. Bernero (1736-96).

46. The latest summing up of Ladatte's career is by L. Mallè, in *Essays in the History of Art presented to R. Wittkower*, London, 1967, 242 ff., with bibliography.

47. A. Telluccini, 'Ignazio e Filippo Collini e la scultura in Piemonte nel secolo XVIII', *Boll. d'Arte*, II (1922-3), 201, 254; M. Strambi, 'La cultura dei Collino', in *Boll. Società Piemontese Arch. e Belle Arti*, 1964; L. Rosso, *La pittura e la scultura del '700 a Torino*, Turin, 1934.

For Piedmontese sculpture, see also J. Fleming, *Apollo*, LXIV (1963, i), 188, and L. Mallè's chapter in the Catalogue of the Turin Baroque Exhibition, 1963.

48. In his stucco work Mazza was capable of displaying a luscious Late Baroque manner (Palazzo Biancocini, Bologna), which vies with the richest decorations anywhere in Italy. For Mazza, see J. Fleming in *Connoisseur*, CXLVIII (1961), 206 (with *œuvre* catalogue). Giuseppe Mazza, who began his career as a painter, was the son of Camillo Mazza (1602-72), Algardi's pupil. Giuseppe's pupil, Andrea Ferreri (1673-1744), settled at Ferrara, where he was appointed director of the Academy (1737). Angelo Piò (1690-1770), a pupil of Ferreri and Mazza, followed the general trend by going to Rome in 1718, where he worked under Camillo Rusconi; see E. Riccòmini, *Arte Antica e Moderna*, VI, no. 21 (1963), 52, and *idem, Paragone*, XVIII (1967), no. 213, 60. Filippo Scandellari (1717-1802) continued the Late Baroque tradition of Mazza and Piò to the end of the century. Best information on Bolognese sculpture of the eighteenth century in Riccòmini's exhibition Catalogue (1965, see Bibliography).

49. See L. Planiscig, *Venezianische Bildhauer der Renaissance*, Vienna, 1921, 597. Nicolò's *antependium* in the sacristy of S. Moisè, Venice (executed together with his son, Sebastiano; signed and dated 1633), deserves special mention. It is a work of fascinating beauty. Its strange iconography would require detailed investigation, but the depth of sensibility and devotion expressed by the many small bronze figures ally it closely to the religious temper of counter-reformatory art.

50. The following names may be mentioned: Melchior Barthel (1625-72) from Dresden and the Tirolese Thomas Ruer and Heinrich Meyring, all three notorious for their facile handling of the Berninesque idiom (Meyring's clumsy imitation of Bernini's S. Teresa in the Chiesa degli Scalzi, 1699, is well known); and the Hungarian Michele Fabris, called 'Ongaro' or 'Ungheri', whose painterly and diffused style may be studied in the chapel of Cardinal Francesco Vendramin built by Longhena in S. Pietro di Castello (*c.* 1670-4). Also John Bushnell (b. *c.* 1630) may be mentioned; he left England after 1660, spent some time in Rome, and settled in Venice for about six years where

under Josse de Corte he executed parts of the large Mocenigo monument in S. Lazzaro dei Mendicanti. For Meyring, see D. Lewis, in *Boll. dei Musei Civici Veneziani*, XII (1967), 15 f. Lewis removed the large Holy Family in the Scalzi from the work of Giuseppe Torretti and attributed it to Meyring (1700–2).

452. 51. For de Corte see N. Ivanoff, 'Monsù Giusto ed altri collaboratori del Longhena', *Arte Veneta*, II (1948), 115. De Corte's tomb of Caterino Cornaro in the Santo at Padua shows a standing figure of the admiral, baton in hand, surrounded by trophies with prisoners at his feet; it became the prototype of many similar tombs. The pictorial tendencies of the main altar of S. Maria della Salute were further developed in his last work, the sculptural decoration of the main altar of S. Andrea della Zirada (1679).

For de Corte and the other Venetian Baroque sculptors mentioned below, see C. Semenzato, *La scultura veneta del seicento e del settecento*, Venice, 1966.

52. Knowledge of this sculptor's work is based on Temanza, *Zibaldon*, ed. N. Ivanoff, Venice, 1963, 42. The *Zibaldon* should also be consulted for Michele Fabris, Thomas Ruer, and Antonio Tarsia.

53. Marinali was also influenced by Parodi. His *œuvre* has been collected by Carmela Tua in *Riv. d'Arte*, XVII (1935), 281. His most important commission was the sculptural decoration of the Sanctuary on Monte Berico near Vicenza (1700 ff.); see F. Barbieri's monograph, 1960 (Bibliography). Barbieri also published Marinali's work in the Museo Civico, Vicenza, in *Studi in onore di Federico M. Mistrorigo*, Vicenza, 1958, 111. See also L. Puppi, 'Nuovi documenti sui Marinali', *Atti dell'Istituto Veneto di scienze, lettere ed arti* (cl. di scienze morali, lettere ed arti), CXXV (1966–7), 195 ff.

54. The above-mentioned Thomas Ruer and Michele Fabris, see Note 50.

55. On the Valier monument were engaged the Carrarese Pietro Baratta, Giovanni Bonazza (*c.* 1654–1736), the head of a family of sculptors, Antonio Tarsia (1663–1739), and Marino Groppelli (1662–1721). On the façade of S. Stae worked the same Pietro Baratta and Antonio Tarsia and, in addition, Paolo and Giuseppe Groppelli, Paolo Callalo, Matteo Calderoni, Francesco Cabianca, and two more significant artists, Giuseppe Torretti (*c.* 1661–1743) and Antonio Corradini (on whom see below).

For Pietro Baratta (1688–*c.* 1773), see C. Semenzato, *Critica d'Arte*, V (1958), 150, and H. Honour in *Dizionario biografico degli Italiani*, 1963, V, 793. For Antonio Tarsia (*c.* 1663–1739), see H. Honour, *Connoisseur*, CXLVI (1960), 27 (with *œuvre* catalogue). For Giuseppe Bernardi, called il Torretti, see C. Semenzato, *Arte Veneta*, XII (1958), 169.

453. 56. The older and younger generation collaborated on these works. The façade of the Gesuati has sculpture by Antonio Tarsia, Francesco Cabianca, Giuseppe Torretti, Francesco Bonazza, Alvise Tagliapietra, Gaetano Fusali, and Gian Maria Morlaiter; in the Cappella del Rosario, which suffered in the fire of 1867, worked Giovanni Bonazza and his sons, Giuseppe Torretti, Alvise Tagliapietra and his son Carlo, and, above all, Gian Maria Morlaiter.

Giovanni Bonazza and his sons spent most of their lives at Padua. The best known of his sons is Antonio (1698–1763), who is famed for the garden figures in the Villa Widmann at Bagnoli di Sopra (Padua), executed in a charming realistic Rococo style (1742); see C. Semenzato, *Antonio Bonazza*, Padua, 1957.

57. Corradini has been fairly well studied; see G. Biasuz in *Boll. d'Arte*, XXIX (1935–6); A. Callegari, *ibid.*, XXX (1936–7); G. Mariacher in *Arte Veneta*, I (1947), and A. Riccoboni, *ibid.*, VI (1952) with *œuvre* catalogue; T. Hodgkinson, in *Victoria and Albert Museum Bulletin*, IV (1968), 37.

58. G. Biasuz and A. Lacchin, *A. Brustolon*, Venice, 1928.

59. For Schulenburg as a collector and patron see A. Binion, *Burl. Mag.*, CXII (1970), 297 ff.

60. He specialized in veiled figures in which all the forms under the veil are discernible; see Note 63. Corradini had the typical career of the migrant eighteenth-century Venetian artist; it took him to Vienna, Prague, Dresden, Rome, and Naples.

Giuseppe Torretti (see above, Notes 50, 55) practised a highly sophisticated Rococo style; see his excellent statues in the crossing at the Chiesa de'Gesuiti. For Torretti's work at Udine (mainly Cappella Manin, 1732–6), see H. Tietze *Zeitschr. f. b. Kunst*, XXXIX (1917–18), 243. Torretti's nephew, Giuseppe Bernardi-Torretti (*c.* 1694–1774), was Canova's first teacher (A. Muñoz, *Boll. d'Arte*, IV (1924–5), 103).

61. For Marchiori, see W. Arslan in *Boll. d'Arte*, (1925–6) and VI (1926–7), and L. Menegazzi, *Arte Veneta*, XIII–XIV (1959–60), 147 (a sketchbook *after*, not by Marchiori, as the author believes); for Morlaiter, see G. Lorenzetti in *Dedalo*, XI (1930–1) and W. Arslan in *Riv. di Venezia*, XI (1932). L. Coletti, *Arte Veneta*, XIII–XIV (1959–60), 138, makes the point that the bozzetti mentioned in the text need not necessarily be by Morlaiter. See also G. Mariacher, 'G. M. Morlaiter e la scultura veneziana del Rococò', in *Sensibilità e Razionalità del Settecento*, ed. V. Branca, Venice, 1967, II, 591 ff.

454. 62. M. Picone, *La Cappella Sansevero*, Naples, 1959, with full documentation.

456. 63. Other similar veiled figures by him are: the *Sarah* in S. Giacomo, Udine; a female bust, Museo

Correr, Venice; *Faith* of the altar of the Sacrament, Cathedral, Este; a similar figure from the Manin Monument, Cathedral, Udine, *c.* 1720; *Time and Truth*, Grosser Garten, Dresden; *Tuccia*, Staatl. Skulpturenslg., Dresden; etc. See also G. Matzulevitsch, 'La "Donna Velata" del Giardino d'Estate di Pietro il Grande', *Boll. d'Arte*, L (1965), 80 ff.

64. The relationship of Sammartino's marble to Corradini's model in the Museo Nazionale di S. Martino was discussed by G. Alparone in *Boll. d'Arte*, XLII (1957), 179. See also M. Picone (Note 62), 108 ff.

65. Among other Late Baroque sculpture at Naples may be mentioned the decoration of the nave of S. Angelo a Nilo with a number of symmetrically arranged tombs (1709), a coherent programme echoing the influence of churches like Gesù e Maria in Rome. Attention may also be drawn to the following names: Paolo Persico, who worked in the Cappella Sanseverino and at Caserta; the versatile Domenico Antonio Vaccaro (1681-1750), prominent member of the well-known family of artists, whose work in the Certosa di S. Martino is worth a more thorough study; and Matteo Bottiglieri and Francesco Pagano, both pupils of Lorenzo Vaccaro who collaborated in the decoration of the Guglia dell'Immacolata (1747-51) designed by Giuseppe di Fiore.

66. The artists responsible for the figures are, above all, Paolo Persico, Angiolo Brunelli, and Pietro Solari.

67. R. Berliner, *Denkmäler der Krippenkunst*, Augsburg [1925-30]; idem, *Die Weihnachtskrippe*, Munich, 1955.
Mention should here at least be made of the macabre wax allegories of the Sicilian sculptor Gaetano Giulio Zumbo (1656-1701); they tie up with the South Italian taste for supra-realistic popular imagery, but it is telling that Zumbo worked for the Florentine Court (see R. W. Lightbown, Bibliography).

458. 68. A. Sorrentini in *Boll. d'Arte*, VII (1913), 379.
459. 69. G. Agnello, 'Il prospetto della cattedrale di Siracusa e l'opera dello scultore palermitano Ignazio Marabitti', *Archivi*, IV (1937), 63, 127, with bibliography concerning Sicilian Baroque, and *ibid.*, XXII (1955), 228 with further literature.
According to documents published by R. Giudice, *F. Ignazio Marabitti*, Palermo, 1937, 12, the sculptor was born in 1719; he went to Rome in 1740/1 and stayed there for fully five years.

CHAPTER 19

461. 1. Letter to Cav. Gabburi, 10 September 1733. Bottari, *Lettere*, II, 404.
462. 2. Good surveys of Neapolitan eighteenth-century painting by L. Lorenzetti in *La pittura napoletana*

dei secoli XVII, XVIII, XIX. Mostra, Naples, 1938, and R. Causa, *Pittura napoletana dal XV al XIX secolo*, Bergamo, 1957. See also Bibliography.
For Luca Giordano see, above all, Posse's excellent article in Thieme-Becker. Also A. Griseri, *Paragone*, VII (1956), no. 81, 33; G. Heinz, *Arte Veneta*, X (1956), 146; F. Bologna, *Solimena*, 1958, 34; Y. Bottineau, *G.d.B.A.*, LVI (1960), 249; M. Milkovich, *L.G. in America* (loan exhib., Brooks Gallery), Memphis, Tennessee, 1964 (with full bibliography). The three-volume monograph by O. Ferrari and G. Scavizzi (1966) supersedes most of the older literature; see Bibliography. See also O. Ferrari, *Burl. Mag.*, CVIII (1966), 298 ff., and H. E. Wethey, *ibid.*, CIX (1967), 678 ff.

3. Among Luca's pupils may be mentioned Solimena's competitor, the facile and academic Paolo de Matteis (1662-1728), whom Lord Shaftesbury chose as a congenial painter to translate into visual terms the directives given in his dogmatic essay, the *Choice of Hercules*; further, the Fleming Willem Borremans (*c.* 1670-1744), who brought his master's style to Sicily (principal work: the frescoes in the cathedral of Caltanisetta, 1720); and Nicola Malinconico (1663-1722), who endeavoured to emulate his teacher (U. Prota-Giurleo, *Pitt. nap. del Seic.*, 1953, 38).
A special place must be assigned to Giacomo del Po, who was born in Rome in 1659, moved to Naples in 1683, and worked there until his death in 1726. Under Giordano's and Solimena's influence but never forgetting the lesson learned from Cortona and Gaulli in Rome, he developed in his late works towards a free, painterly, quasi-Rococo manner; see M. Picone in *Boll. d'Arte*, XLII (1957), 163, 309.

4. See F. Bologna's fine monograph, with a preliminary *œuvre* catalogue and full bibliography. For Giordano's influence, see *idem*, in *Art Quarterly*, XXXI (1968), 35 ff.

465. 5. An early work, dated 1690, *The Fall of Simon Magus*, S. Paolo Maggiore [325], shows the characteristic arrangement of figures radiating from a nodal point in the centre like spokes of a wheel.

6. E.g., the nude man in the right-hand corner of illustration 325 and the soldier with the fasces above him derive from the *Ignudi* of the Farnese Gallery; the mother seen from the back with her child clinging to her is a standard group coming down from Domenichino, etc. Solimena's *Heliodorus* in the Gesù Nuovo, Naples, combines features from Raphael's Vatican *Heliodorus* and *School of Athens*.

7. Many painters of the Solimena succession are at present not much more than names, but work on them is proceeding; see R. Enggass, *Burl. Mag.*, CIII (1961), 304, for Andrea dell'Aste (*c.* 1673-*c.* 1721) and Matteo

Siscara (1705-65), and M. Volpi, *Paragone*, x (1959), no. 119, 51, for Domenico Mondo (*c.* 1717-1806), whose paintings are often mixed up with those by Giaquinto. Also H. Voss, in *Festschrift Ulrich Middeldorf*, Berlin, 1968, 494 ff., for Lorenzo de Caro.

8. For Giaquinto's career, see M. Volpi, *Boll. d'Arte*, XLIII (1958), 263, and d'Orsi's monograph (Bibliography); for Amigoni and Giaquinto in Madrid, see the documents published by E. Battisti, *Arte Antica e Moderna*, III, no. 9 (1960), 62. See also the book by A. Videtta (Bibliography).

9. For a full study of de Mura's attractive decoration of the Chiesa della Nunziatella at Naples with the large ceiling fresco of the Assumption of the Virgin (1751), see R. Enggass, *Boll. d'Arte*, XLIX (1964), 133 ff. De Mura's manner was continued by his pupil Giacinto Diano (1730-1800), who enjoyed a considerable reputation.

10. The problems connected with our illustration 326 were solved by I. Faldi, *Burl. Mag.*, CI (1959), 143. The illustration represents the oil sketch for a ceiling of *c.* 1751, originally in the Palazzo Santa Croce, Palermo, and installed in the Palazzo Rondanini-Sanseverino, Rome, more than fifty years ago.

10a. G. Sestieri, 'Contributi a Sebastiano Conca', *Commentari*, XX (1969), 317-41; XXI (1970), 122-38, with *œuvre* catalogue.

467. 11. Mazzanti's paintings are sometimes mixed up with those by Francesco Fernandi, called Imperiali (b. Milan, 1679), whose pleasant Marattesque pictures were fashionable in early-eighteenth-century Rome; reconstruction of his *œuvre* by E. Waterhouse, *Arte Lombarda*, III (1958), 101, and A. M. Clark, *Burl. Mag.*, CVI (1964), 226.

12. F. Zeri, *Paragone*, VI (1955), no. 61, 55, discussed this artist's links with Gaulli's manner. For a fuller treatment, see G. di Domenico Cortese, *Commentari*, XIV (1963), 254.

13. See above, Chapter 14, Note 1. On Cortese, see F. A. Salvagnini's work (1937).

14. An interesting contribution by E. Schaar to the artist's preparation in sketches of his 'Sacrifice of Ceres' in the Villa Falconieri at Frascati, in *Festschrift für Ulrich Middeldorf*, Berlin, 1968, 422 ff.

15. Chiari's biographer, B. Kerber (see Bibliography), shows that the artist also drew inspiration from the Carracci, Reni, Cortona, and Sacchi.

16. For Masucci, see Bibliography. Mancini began as a pupil of the Bolognese Carlo Cignani and painted mainly in the Marches and Umbria. His principal work in Rome is the frescoes in the 'Kaffeehaus' of the Palazzo Colonna (1735-40; see E. Toesca, *L'Arte*, XLVI (1943), 7), the attractive architecture of which is due to Niccolò Michetti (1731).

16a. See F. R. di Federico, 'Documentation for Francesco Trevisani's Decorations for the Vestibule of the Baptismal Chapel in St Peter's', in *Storia dell' Arte*, no. 6 (1970), 155 ff.; this monumental commission occupied Trevisani for almost the last 35 years of his life.

17. G. V. Castelnovi, in *Studies in the History of Art. Dedicated to William E. Suida*, London, 1959, 333, with further references.

468. 18. The picture is a fascinating re-interpretation of Raphael's *Transfiguration* in a Correggio-Lanfranco manner. For Benefial, see G. Falcidia, *Boll. d'Arte*, XLVIII (1963), 111: discusses decoration of the salone in the Palazzo Massimo, Arsoli (1750). See also A. M. Clark, *Paragone*, XVII (1966), no. 199, 21 ff., and M. G. Paolini, *ibid.*, XVI (1965), no. 181, 70 ff.

Benefial's contemporary, Placido Costanzi (probably 1701-59), pupil of Trevisani and Luti, may here be mentioned. He has become a tangible figure owing to A. M. Clark's paper in *Paragone*, XIX (1968), no. 219, 39 ff.; his great ceiling fresco in S. Gregorio Magno, dated 1727, reveals a classicizing sobriety which is scarcely independent of Conca's style in his S. Cecilia fresco of two years earlier.

19. E. Emmerling, *P. Batoni*, Darmstadt, 1932; L. Marcucci, *Emporium*, XCIX (1944), 95; L. Cochetti, *Commentari*, III (1952), 274; R. Chyurlia, *Emporium*, CXVII (1953), 56; A. M. Clark, *Burl. Mag.*, CI (1959), 233. Much of the older literature has been superseded by the Catalogue of the Batoni Exhibition at Lucca in 1967; see Bibliography. – Also F. Russell, *Burl. Mag.*, CXII (1970), 817.

A lesser name, that of Gregorio Guglielmi (1714-73), may here be mentioned. Born in Rome, he worked at the courts of Dresden (1752-3), Vienna (Schönbrunn, 1760-1), Berlin, Turin (1765-6), and St Petersburg in a classicizing Rococo manner; see S. Beguin in *Paragone*, VI (1955), no. 63, 10; A. Griseri, *ibid.*, no. 69, 29; and, above all, Klára Garas in *Acta Hist. Artium*, IX (1963), 269. See also M. Demus in *Almanach der Österreichischen Akademie der Wissenschaften*, CXV (1965), I ff., about the restoration of Guglielmi's ceiling painting of 1755-6 in the large hall of the Vienna Academy.

20. Just as Bellori in his *Life of Maratti* had extolled the latter's artistic genealogy back through Sacchi and Albani to Annibale Carracci, so Benefial saw himself proudly in line of descent, from Annibale to Albani and Carlo Cignani (Bottari, *Lettere*, V, 10) – an indication how such an artist interpreted the high road of the classical tradition.

469. 21. It should be recalled, however, that true classicists judged differently. Winckelmann regarded Mengs's *Parnassus* in the Villa Albani (1760-1) as the

most beautiful work of modern art; even for Burck-hardt Mengs was the rejuvenator of modern painting.

22. M. Marangoni's article in *Riv. d'Arte* (1912, re-printed in *Arte barocca*, Florence, 1953, 205) is still the foundation of any study of Florentine Settecento painting.
For Gabbiani, see A. Bartarelli, *Riv. d'Arte*, XXVII (1951-2), 105. Gabbiani was in Rome between 1673 and 1678 studying with Ciro Ferri. Although he suc-cumbed to the influence of Maratti, Cortonesque remi-niscences linger on, for instance, in his masterpiece, the *Apotheosis of Cosimo the Elder* at Poggio a Caiano (1698).
From the large number of Gabbiani's pupils and fol-lowers may be singled out Tomaso Redi (1665-1726), who later worked with Maratti in Rome; Giovanna Fratellini (1666-1731), famed in her time for her pastels; and Giovanni Battista Cipriani (1727-85), who made his fortune in England.

23. G. Arrigucci, *Commentari*, V (1954), 40.

24. Bonechi may be studied in the Palazzo Capponi (after 1705), where Sagrestani, Lapi (Note 26), and Antonio Puglieschi (1660-1732) also worked. The latter stemmed from Cortona through his teacher Pier Dandini.

470. 25. L. Berti, *Commentari*, I (1950), 105; Edward A. Maser, *The Disguises of Harlequin by G. D. Ferretti*, The University of Kansas Museum of Art, 1956. The same author has now published a full monograph on Ferretti (see Bibliography).
Mention may be made of Vincenzo Meucci (1694-1766), Ferretti's contemporary, who studied at Bo-logna with dal Sole and came later under the influence of S. Ricci; his main work is the frescoes in the dome of S. Lorenzo, 1742.

26. M. M. Pieracci, 'La difficile poesia di un ribelle all'Accademia; Alessandro Gherardini', *Commentari*, IV (1953), 299. For a richly illustrated monographic treatment of Gherardini, see G. Ewald in *Acropoli*, III (1963), 81-132 (with a hitherto unpublished Life of the artist by Baldinucci). In the allegoric-mythological cycle of frescoes in the Palazzo Corsini, Gherardini worked next to Gabbiani (they had the lion's share), Pier Dandini, Bonechi, and minor masters.
A modest follower of Luca Giordano was Niccolò Lapi (1661-1732). Francesco Conti (1681-1760) be-gan in Maratti's manner, but later became a Ricci follower.

27. N. Carboneri, *Sebastiano Galeotti*, Venice, 1955; P. Torriti, *Attività di S.G. in Liguria*, Genoa, 1956. Galeotti's most important work at Genoa is the cycle of frescoes in the Chiesa della Maddalena (1729-30; with G. B. Natali (1698-1765) as *quadraturista*), where the transition from Giordano's manner to Domenico

Piola's and Gregorio de Ferrari's proto-Rococo may be observed. The full fruit of this change is to be seen in Galeotti's frescoes in the Palazzo Spinola (1736).

28. For older bibliographical references see H. Bod-mer, *Mitteilungen des kunsthistorischen Instituts in Florenz*, V (1937), 91. See also *Maestri della pittura del Seicento emiliano*, Catalogue, Bologna, 1959.

471. 29. S. V. Buscaroli, *Carlo Cignani*, Bologna, 1953. Of the Albani pupils who reached fame, only Cignani continued to produce the small cabinet painting in Al-bani's manner. Cignani's masterpiece is the *Assump-tion* in the dome of the cathedral at Forlì, 1702-6. Among his pupils may be named Luigi Quaini (1643-1717) and his two sons, Felice and Filippo Cignani. His grandson, Paolo (1709-64), continued the school into the second half of the century. See Emiliani, in *Maestri della pittura del Seicento emiliano*, Bologna, 1959, 146 ff.

30. *Wiener Jahrb.*, VIII (1932), 89.

31. A. Arfelli, *Comune di Bologna*, XXI (1934), no. 11; D. C. Miller, *Boll. d'Arte*, XLI (1956), 318; *idem, Burl. Mag.*, XCIX (1957), 231, and *ibid.*, CII (1960), 32; E. Feinblatt, *ibid.*, CIII (1961), 312; P. Torriti, *ibid.*, CIV (1962), 423. D. C. Miller published a *Toilet of Venus* (*Münchner Jahrb. d. bild. Kunst*, IX-X (1958-9), 263) which illustrates very well Franceschini's reliance on Albani. For his relationship with Pope Clement XI, *idem, Burl. Mag.*, CXII (1970), 373 ff.
For Giulio Quaglio (1668-1751), Franceschini's pupil, a highly successful fresco painter, see R. Marini, *Arte Veneta*, IX (1955), 155; XII (1958), 141.

32. E. Mauceri, *Comune di Bologna*, XIX (1932), no. 6, 35; G. Lippi Bruni, *Arte Antica e Moderna*, II (1959), 109 (with *œuvre* catalogue).
Dal Sole's pupil, Felice Torelli (1667-1748), though less distinguished than his master, was yet a figure of importance in his day; see D. C. Miller, *Boll. d Arte*, XLIX (1964), 54 ff. (with *œuvre* catalogue).

33. C. Alcsuti, *Comune di Bologna*, XIX (1932), no. 9, 17; R. Roli, *Arte Antica e Moderna*, II (1959), 328, and VI, no. 23 (1963), 247; for Roli's monograph of 1967, see Bibliography. Also L. Lloyd, *Burl. Mag.*, CXI (1969), 374 ff. Creti's style has many facets, as the pic-tures painted for Owen McSwiny prove. On this interesting set of paintings, see Note 63.
Creti's style as a draughtsman, subtle, refined, and elegant, was fashioned on Reni, see O. Kurz, *Bolognese Drawings at Windsor Castle*, London, 1955, and R. Roli, *Boll. d'Arte*, XLVII (1962), 241.
H. Bodmer (Note 28) claims that Benedetto Gennaro the younger, nephew and pupil of Guercino, whose Bolognese activity lies between 1692 and his death in 1715, forms the link between the older generation of Franceschini and the younger of D. Creti.

472. 34. There is a puzzling connexion between our picture and an almost identical but more extensive composition in the National Museum, Lisbon (no. 294), there attributed – for reasons unknown to me – to Charles Alphonse Dufresnoy (1611–68). The reference to the Lisbon painting escaped the attention of R. Roli, *D. Creti*, 1967, 87, nos. 21-8. Roli dates the picture here illustrated in the second decade of the eighteenth century (which appears to me too early).

35. H. Voss, *Paragone*, IX (1958), no. 97, 53, and R. Roli, *Arte Antica e Moderna*, III, no. 10 (1960), 189.

36. Not to be mixed up with his namesake from Brescia (1646-1713), a master of battle-pieces in the manner of Borgognone. For Francesco Monti, see R. Roli, in *Arte Antica e Moderna*, no. 17 (1962), 86 ff.; D. C. Miller, *ibid.*, no. 25 (1965), 97 ff.; and *Art Quarterly*, XXXI (1968), 423 ff. In addition, U. Ruggeri's monograph, *Francesco Monti Bolognese*, Bergamo, 1968.

37. R. Roli in *Arte Antica e Moderna*, VI, no. 22 (1963), 166.

473. 38. Crespi worked under them in 1680-4 and 1684-6 respectively.

39. C. Gnudi, *Bologna* (Riv. del Comune), XXII (1935), 18.

474. 40. V. Constantini, *La pittura italiana del Seicento*, Milan, 1930, II, 202.

41. Between 1686 and 1688 Crespi worked in his studio. See E. Riccòmini, *Arte Antica e Moderna*, II, no. 6 (1959), 219. For Burrini, see H. Brigstocke, *Burl. Mag.*, CXII (1970), 760.

42. He continued Malvasia's *Felsina pittrice*, Rome, 1769.

43. H. Voss, *Zeitschr. f. Kunstg.*, II (1933), 202; R. Roli, *Arte Antica e Moderna*, III, no. 11 (1960), 300.

44. D. C. Miller, in *Art Quarterly*, XXXI (1968), 421 ff., emphasized Donato Creti's influence on Bigari.

45. E. Feinblatt, 'A Letter by Enrico Haffner', *Burl. Mag.*, CXII (1970), 229 ff.

46. An authoritative work on the *quadraturisti* is still wanting. Some material in C. Ricci, *La Scenografia italiana*, Milan, 1930 (with comprehensive bibliography) and V. Mariani, *Storia della scenografia italiana*, Florence, 1930; see also H. Tintelnot, *Barocktheater*, Berlin, 1939.

476. 47. Apart from the works by C. Ricci and Hyatt Mayor, see *I Bibiena scenografi. Mostra dei loro disegni, schizzi e bozzetti*, Florence, 1940.

In 1711 Ferdinando published his important *L'Architettura civile preparata sulla geometria e ridotta alle prospettive*, where he discussed at length his 'scene vedute in angolo', stage designs seen from an acute angle. It was this not entirely new device (Marcantonio Chiarini had staged his *La Forza della Virtù* in Bologna showing a prison as a *scena per angolo* as early as 1694)

that revolutionized the Baroque stage. Giuseppe's design, shown as illustration 335, gives an idea of the rich and restless effect of diagonal perspective.

Yet the purpose of the design is in the tradition of the medieval mystery plays. It reproduces one of 'the intricate peepshows, or *theatra sacra*, that Giuseppe constructed yearly for the court chapel at Vienna. Each feast of Corpus Christi brought a fresh variation on the theme of wide ramps of stairs converging on a balustraded platform where the Man of Sorrows stood under a vast arch opening on lofty architectural distances' (Hyatt Mayor, *op. cit.*, 12).

Giuseppe was famed for his opera sets at Vienna, Dresden, Munich, Prague, Venice, and Berlin. The exuberant decoration of the opera house at Bayreuth is his work (1748).

Francesco's main theatre buildings (only partly surviving) are the Opera House in Vienna and the theatres at Nancy, Verona (Teatro Filarmonico), and Rome (Teatro Aliberti, 1720). Antonio distinguished himself as theatre architect (Teatro Comunale, Bologna; above, p. 391) and as painter of illusionist frescoes (Vienna, Pressburg, etc.).

The Bibiena had a large school. Mention may be made of an outsider, Mauro Tesi (1730-66), an excellent draughtsman in the manner of the Bibiena, who was at an astonishingly early date attracted by Egyptian archaeology as subjects for his designs. His special claim to fame lies in that Count Algarotti patronized and advertised him.

48. For Verona, see below, p. 484. Best survey of the school of Brescia: Emma Calabi, *La pittura a B. nel Seicento e Settecento*, Catalogue, Brescia, 1935. Brescia excelled in minor genre painters such as Faustino Bocchi (1659-1729), a Bambocciante who introduced the trick of showing people with large heads and small deformed bodies; Giorgio and Faustino Duranti (1683-1755, 1695-1766), who made birds and hens their speciality; Francesco Monti (see Note 36), internationally known for his battle-pieces; and the landscapist Giuseppe Zola (1672-1743; see E. Calabi, *Riv. d'Arte*, XII (1934), 84). See also for this whole section G. Delogu, *Pittori minori liguri, lombardi, piemontesi del '600 e '700*, Venice, 1931.

49. Voss, 589. Seiter left Rome in 1688 and practised a Cortonesque manner in Turin to the end of his life. Before Seiter's arrival in Turin, Giovan Paolo Recchi and his nephew Giovan Antonio handled large fresco commissions; see A. M. Brizio in *Arte Lombarda*, II (1956), 122.

For Piedmontese painting, see the older works by L. Rosso and by V. Viale, and Andreina Griseri's Catalogue of the Turin Baroque Exhibition, 1963 (references in the Bibliography).

For the position in Turin at the beginning of the seventeenth century, see A. Griseri, *Paragone*, XII (1961), no. 141, 19.

50. A. Vesme, 'I Van Loo in Piemonte', *Arch. stor. dell'arte*, VI (1893), 333. Other members of this large family of painters, above all Giovanni Battista (1684-1745), also painted in Turin.

51. Conca and Giaquinto were, of course, 'romanized' Neapolitans. Conca was in Turin off and on during the 1720s painting in the Venaria Reale, the Superga, and the Palazzo Reale; Giaquinto came twice, first in 1733 and again in 1740-2 (frescoes Villa della Regina and S. Teresa). De Mura worked in the Palazzo Reale in 1741-3, and in the late forties, the fifties and sixties received payments for work executed in Naples and sent to Turin; see A. Griseri, 'Francesco Mura fra le corti di Napoli, Madrid e Torino', *Paragone*, XIII (1962), no. 155, 22.

52. G. Fiocco, *G. B. Crosato*, Venice, 1941; 2nd ed. 1944; A. Griseri, 'Il "Rococó" a Torino e Giovan Battista Crosato', *Paragone*, XII (1961), no. 135, 42. Crosato came first in 1733 and again in 1740.

478. 53. A. Griseri, 'Opere giovanili di Cl. Fr. Beaumont e alcune note in margine alla pittura barocca', in *Scritti vari*, II (a cura della Facoltà di Magistero di Torino), Turin, 1951, with much valuable material; also *idem, Connoisseur*, CXL (1957), 145 (documents). For further references to Beaumont, see Catalogue of the Baroque Exhibition, II, 81.

54. Delogu, *op. cit.*, 235. - Mention should also be made of the brothers Domenico (d. before 1771) and Giuseppe (d. 1761) Valeriani who had come from Rome to Venice in about 1720 and painted between 1731 and 1733 the Gran Salone at Stupinigi [292] in a manner reminiscent of contemporary Genoese decorations. For their work and that of Crosato, Carlo Andrea Van Loo, and V. A. Cignaroli at Stupinigi, see A. Telluccini, *Le decorazioni della già Reale Palazzina di Caccia di St.*, Turin, 1924, M. Bernardi's book of 1958, and L. Mallè's *Stupinigi*, Turin, 1969.

For the Galliari, the distinguished Piedmontese family of *quadraturisti* and theatrical designers, see Tintelnot (Note 46), 95; M. Ferrero Viale, *Disegni scenografici dei Galliari*, Catalogue, Turin, 1956, and *idem, La scenografia del Settecento e i fratelli Galliari*, Turin, 1963; for the frescoes of the three brothers Bernardino, Fabrizio, and Giovanni Antonio and of Fabrizio's son's, Giovanni and Giuseppino, see the papers by R. Bossaglia in *Arte Lombarda*, III (1958), 105; IV (1959), 131; *Critica d'Arte*, VII (1960), 377; and her book *I fratelli Galliari pittori*, Milan, 1962. The best frescoes of the Galliari are in the Salone of the Villa Crivelli at Castellazzo di Bollate, where the exuberant *quadratura* unifies walls and vault.

55. Lorenzo de Ferrari (1680-1744) has already been mentioned (p. 392). For Domenico Parodi (1668-1740), Filippo's son, see S. Soldani, 'Profilo di Domenico Parodi', *Critica d'Arte*, XIV, no. 87 (1967), 60 ff. Paolo Girolamo Piola (1666-1724), Domenico's son, who switched over to Maratti's international style, deserves a note, and so do Giovan Maria delle Piane, 'il Mulinaretto' (1660-1745), who painted grandiloquent portraits reminiscent of Rigaud (M. Bonzi, *Il Mulinaretto*, Genoa, 1962), and Carlo Antonio Tavella (1668-1738), a landscapist, who began as friend and follower of the romantic Haarlem master, Pieter Mulier (called 'il Tempesta', *c.* 1637-1701), then followed Claude and Gaspar Dughet, but also collaborated with Magnasco. On Pietro Tempesta, see C. Roethlisberger, *Burl. Mag.*, CIX (1967), 12 ff.

56. Among them Andrea Lanzani (1639-1712), Filippo Abbiati (1640-1715; F. Renzo Pesenti, *Commentari*, XVII (1966), 343 ff.), and Stefano Maria Legnani (1660-1713/15) have pride of place. Lanzani's career is typical. He followed the fashionable course of study by going to Rome and working under Maratti. But his work shows that he was much impressed by Lanfranco. In 1697 he accepted a call to Vienna; later he went to Spain. He returned home shortly before his death; see M. G. Turchi in *L'Arte*, LIX (1960), 99 (with *œuvre* catalogue).

Among other Lombard painters may be mentioned (1) Pietro Gilardi, who studied with Dal Sole in Bologna and became a *quadraturista* of distinction (his fresco of 1715 in the Oratory of S. Angelo, Milan, is a *tour de force*, derived from Pozzo's S. Ignazio ceiling); see M. Bussolera in *Arte Lombarda*, VI (1961), 43; (2) P. Antonio Magatti (1691-1767), who was oriented towards Venice (Pittoni) and shows close connexions with the Piazzetta follower Petrini; see E. Arslan in *Commentari*, VIII (1957), 211, and S. Colombo in *Arte Lombarda*, VIII, 2 (1963), 253; (3) the minor Rococo masters Gian Pietro and Cesare Ligari; see R. Bossaglia in *Commentari*, X (1959), 228; (4) Pier Francesco Guala (1698-1757), who appeared with unconventional and impressive portraits at the Turin Baroque Exhibition, 1963, and won laurels as an arcadian painter in the manner of Crosato (see Bibliography); (5) Carlo Innocenzo Carloni (1686-1775), probably the most gifted Lombard Rococo painter, who was ceaselessly active in many places of Central Europe, above all in Vienna, Prague, southern Germany, and northern Italy; see A. B. Brini and K. Garas (Bibliography). Characteristic for his manner are the hypertrophic *quadratura* frescoes in the Villa Lechi at Montirone near Brescia, painted together with Giacomo Lecchi in 1746; see *Connoisseur*, CXLVI (1960), 153; also A. Barigozzi Brini in *Arte Lombarda*, VI (1961), 256.

For these and other Lombard painters, see the excellent chapter by A. M. Romanini in *Storia di Milano*, 1959, XII, 713.

57. The Piedmontese Giuseppe Antonio Pianca (1703-after 1755) was to a certain extent dependent on Magnasco. This long forgotten artist has recently aroused much interest; see C. Debiaggi in *Boll. Soc. Piemontese di archeol. e di belle arti*, XII-XIII (1958-9), 158; M. Rosci in *Atti e Memorie del Congresso di Varallo Sesia*, Turin, 1962, 115; idem, *G. A. Pianca. Catalogo*, Varallo Sesia, 1962 (exhibition catalogue with many illustrations).

58. N. Ivanoff, *Mostra del Bazzani in Mantova*, Bergamo, 1950, with full documentary material and bibliography.

479. 59. Francesco Maria Raineri, called Schivenoglia (1676-1758), whose work is similar to Bazzani's, is just beginning to become a defined personality; see C. Volpe and N. Clerici Bagozzi, *Arte Antica e Moderna*, VI, no. 24 (1963), 337, 339.

60. O. Benesch, *Staedel Jahrbuch*, III-IV (1924), 136, discussed Bazzani's influence on Maulpertsch.

61. For the following I am much indebted to G. Fiocco's work (1929) and, above all, to R. Pallucchini's *La pittura veneziana del '700*, Bologna, 1951, 1952. His *La pittura veneziana del Settecento*, Venice, 1960, contains the latest summary of current research. - Part III of Haskell's *Patrons* contains a great deal of new material for eighteenth-century Venice in an eminently readable form.

62. B. Nicolson, *Burl. Mag.*, CV (1963), 121, has collected all data referring to Ricci's relation to Lord Burlington in London.

481. 63. *Viatico per cinque secoli di pitt. ven.*, 1946, 34. Illustration 353 represents a work of collaboration of Sebastiano and Marco Ricci (pp. 498-501). It is unusually brilliant and commands special interest because it belongs to the set of twenty-four allegories commissioned by the impresario Owen McSwiny from the foremost Bolognese and Venetian painters. This series of pictures has been intensely studied; see H. Voss, *Rep. f. Kunstw.*, XLVII (1926), 32; W. Arslan, *Riv. d'Arte*, XIV (1932), 128; ibid., XV (1933), 244, and *Commentari*, VI (1955), 189; T. Borenius, *Burl. Mag.*, LXIX (1936), 245; F. J. B. Watson, ibid., XCV (1953), 362; W. G. Constable, ibid., XCVI (1954), 154; idem, *Canaletto*, 1963, 172 (documents), 432. Best summary in Haskell, *Patrons*, 287.

482. 64. D. M. White and A. C. Sewter, *Art Quarterly*, XXIII (1960), 125, attempted (to my mind, not wholly successfully) to interpret this picture allegorically.

65. R. Pallucchini, *Riv. di Venezia*, XIII (1934), 327; W. Arslan, *Critica d'Arte*, I (1935-6), 188.

66. Of the more important pupils may be mentioned Giuseppe Angeli (1710-98), Francesco Daggiù, called il Cappella (1714-84), Antonio Marinetti, called il Chiozzotto (1720-1803), and Domenico Fedeli, called il Maggiotto (1713-93). About all these artists, see Pallucchini, *Riv. di Venezia*, X (1931), XI (1932). Maggiotto's pupil Ludovico Gallina from Brescia (1752-87) also worked in Piazzetta's academic manner.

The Ticinese painter Giuseppe Antonio Petrini (1667-1758/9) has recently attracted much attention owing to a comprehensive exhibition at Lugano. A pupil of Bartolomeo Guidobono, he came later under Piazzetta's influence, whose manner he imitated with varying success; see W. Arslan, *G. A. Petrini*, Lugano, 1960 (with œuvre catalogue); L. Salmina, *Burl. Mag.*, CII (1960), 118; S. Colombo, *Arte Antica e Moderna*, V (1962), 294 (new documents).

67. M. Goering, *Jahrb. Preuss. Kunstslg.*, LVI (1935), 152, with œuvre catalogue.

68. R. Pallucchini, *Riv. d'Arte*, XIV (1932), 301 (with œuvre catalogue) and *Critica d'Arte*, I (1935-6), 205; Goering, ibid., II (1937), 177. E. Arslan, *Emporium*, XCVIII (1943), 158, claims Lombard influence on Bencovich through Filippo Abbiati, Magnasco's teacher.

69. On Pagani, see H. Voss, *Belvedere*, VIII (1929), 41; N. Ivanoff, *Paragone*, VIII (1957), no. 89, 52, claims that Giulia Lama also belongs to the circle of Pagani, who has his place on the way which 'leads from the Venetian Caravaggeschi to Piazzetta'.

69a. The painting of illustration 340 belongs to Bencovich's early period and shows him strongly influenced by G. M. Crespi; in fact, until fairly recently the work had been attributed to the latter.

70. Fontebasso, an untiring worker, came under Tiepolo's influence and ended his career in a rather tired Tiepolesque manner. At the beginning of the 1760s he followed a call to St Petersburg. Recent studies on Fontebasso by A. Pigler, *Arte Veneta*, XIII-XIV (1959-60), 155, and R. Pallucchini, ibid., XV (1961), 182.

For G. Diziani, see F. Valcanover, *Mostra di pitture del Settecento nel Bellunese*, Venice, 1954, 85; A. Rizi in *Acropoli*, II (1962), 111. For Zompini, O. Battistella, *Della vita e delle opere di G.G.Z.*, Bologna, 1930, with œuvre catalogue.

For the Veronese painter Giovan Battista Marcola (c. 1701-80), whose style as draughtsman shows undeniable links with Sebastiano Ricci, see U. Ruggeri, *Critica d'Arte*, XVII, no. 110 (1970), 35 ff., and ibid., no. 112, 49 ff., with further literature on the artist.

71. M. Goering, *Münchner Jahrbuch der bildenden Kunst*, XII (1937-8), 233; A. Bettagno, *Disegni e dipinti di Antonio Pellegrini*, Venice, 1959 (basic study).

483. 72. H. Voss, *Jahrb. Preuss. Kunstslg.*, XXXIX (1918), 145; Arslan, *Critica d'Arte*, I (1935-6), 238; J. Woodward, *Burl. Mag.*, XCIX (1957), 21; G. M. Pilo, *Arte*

Veneta, XII (1958), 158 (review of older literature); *idem*, *Arte Antica e Moderna*, III, no. 9 (1960), 174 (also for connexions with Ricci and Pellegrini); A. Griseri, 'L'ultimo tempo dell'Amigoni e il Nogari', *Paragone*, XI (1960), no. 123, 21.

73. From Amigoni's school came Pier Antonio Novelli (1729–1804), much of whose work belongs to the history of Neo-classicism (see M. Voltolina, *Riv. di Venezia*, XI (1932)), also Antonio Zucchi (1726–95), Angelica Kauffmann's husband, and the sculptor Michelangelo Morlaiter.

74. L. Coggiola-Pittoni, 'Pseudo influenza francese nell'arte di G.B.P.', *Riv. di Venezia*, XII (1933), with *œuvre* catalogue and bibliography.

75. A development similar to that of Pittoni was taken by Nicola Grassi (1682–1748) from Friuli who began his career in Venice under Nicolò Cassana (d. 1713). An artist of distinction, he was drawn in his late phase to Pittoni's manner; see G. Fiocco, *Dedalo*, X (1929), 427; L. Grossato, *Arte Veneta*, II (1948), 130; G. Gallo, *Mostra di Nicola Grassi*, Catalogue, Udine, 1961.

76. E. Battisti, *Commentari*, V (1954), 26 (with *œuvre* catalogue).

484. 77. G. Fiocco, *Pitt. venez.*, 1929, 47 (English ed.), pointed out that Balestra's influence extended from Mantua to the Trentino and the Austrain Baroque.

78. F. R. Presenti, *Arte Antica e Moderna*, III, no. 12 (1960), 418.

78a. Cignaroli's *Death of Rachel* caused a sensation. In 1770 it was exhibited in the Piazza S. Marco and was, according to a contemporary observer, studied by one and all with admiration and amazement.

79. Hugh Honour, 'Giuseppe Nogari', *Connoisseur*, CXL (1957), 154. For Nogari's connexion with Amigoni, see Griseri (above, Note 72).

80. Derivation from Balestra made Bortoloni an easy prey to the influence of the Frenchman Louis Dorigny (1654–1742), who painted in Venice, Verona, and Udine in Lebrun's cool academic manner. That influence will be noticed in Bortoloni's remarkable decoration of Palladio's Villa Cornaro at Piombino Dese (N. Ivanoff, *Arte Veneta*, IV (1950), 123). Another Balestra pupil, Giambattista Mariotti (1690–1765), adhered later to the Bencovich-Piazzetta current; see N. Ivanoff, *Boll. Museo Civico Padova*, XXXI–XLIII (1942–54), 145.

81. N. Ivanoff, *Boll. d'Arte*, XXXVIII (1953), 58.

82. See the excellent introduction by Antonio Morassi, *G. B. Tiepolo*, London, 1955, with bibliography; and the accompanying *œuvre* catalogue, London, 1962.

485. 83. P. d'Ancona, *Tiepolo in Milan: The Palazzo Clerici Frescoes*, Milan, 1956. It has been suggested that the drawing reproduced as illustration 345 might

be a preliminary sketch for the group of a river god, naiad, and fisher boy at the far end of the south portion of the Clerici ceiling; see J. Bean and F. Stampfle, *Drawings from New York Collections III. The Eighteenth Century in Italy*, New York, 1971, 47, no. 82.

486. 84. G. Knox, 'G. B. Tiepolo and the Ceiling of the Scalzi', *Burl. Mag.*, CX (1968), 394 ff.

85. M. H. von Freden and C. Lamb, *Die Fresken der Würzburger Residenz*, Munich, 1956.

86. Assisted by his sons, Gian Domenico and Lorenzo, who had accompanied him to Madrid.

87. A. Morassi, *Tiepolo e la Villa Valmarana*, Milan, 1945; R. Pallucchini, *Gli Affreschi di G. B. e G. D. Tiepolo alla Villa Valmarana*, Bergamo, 1945. M. Levey, *J.W.C.I.*, XX (1957), 298, has analysed brilliantly the iconography of the Valmarana cycle.

88. This feature derives from Valerius Maximus ('Agamemnon saw Iphigenia advance towards the fatal altar, he groaned, he turned aside his head, he shed tears, and covered his face with his robe'); classical authors assert that in his famous (lost) painting Timanthes of Sikyon represented Agamemnon in this way; thus he appears on Greek vases and in a Pompeian fresco.

In a learned dispute of his day, Tiepolo sides here with textual fidelity and decorum, as did Lessing in his *Laocoon*, 1766 ('Timanthes knew the limits which the Graces had fixed to his Art'). The opposite viewpoint is epitomized in Falconet's words (1775): 'You think of veiling Agamemnon; you have unveiled your own ignorance . . .'. Reynolds (*Eighth Discourse*, 1778) takes up an empirical, common-sense position: The veiling 'appears now to be so much connected with the subject, that the spectator would, perhaps, be disappointed in not finding united in the picture what he always united in his mind, and considered as indispensably belonging to the subject'.

89. Mengozzi-Colonna was responsible for the *quadratura*.

487. 90. For Tiepolo's help to Mengozzi-Colonna, see A. Morassi, *Burl. Mag.*, CI (1959), 228.

489. 91. See T. Hetzer, *Die Fresken Tiepolos in der Würzburger Residenz*, Frankfurt, 1943.

490. 92. See G. Reynolds, *Burl. Mag.*, LXXXII (1940), 44.

491. 93. For the minor pupils of Tiepolo, Giovanni Raggi, Giustino Menescardi, Francesco Lorenzi, Fabio Canal, and others, see R. Pallucchini, *La pitt. venez.*, II, 25. For Francesco Zugno (1709–87), see the monograph by G. M. Pilo, Venice, 1958; *idem* in *Saggi e Memorie di storia dell'arte*, II (1958–9), 323 (with *œuvre* catalogue), and *Paragone*, X (1959), no. 111, 33. Jacopo Guarana (1720–1808) continued the Tiepolesque tradition into the nineteenth century.

94. As early as 1678 Malvasia (*Fels. pitt.*, II, 129) criticized this specialization.

493. 95. For the chronology of Longhi's portraits, see V. Moschini, *L'Arte*, XXXV (1932), 110; also W. Arslan, *Emporium*, XCVIII (1943), 51.

96. See R. Longhi, *Viatico*, etc., 35. It is true that Rosalba had a formative influence on Maurice Quentin de la Tour, Liotard, and others.

Of other portrait painters may be mentioned Francesco Pavona (1692-1777), one of Rosalba's imitators; Bartolomeo Nazari (1699-1758), who began as a follower of Fra Galgario and later embraced Amigoni's more elegant manner (F. J. B. Watson, *Burl. Mag.*, XCI (1949), 75); and Ludovico Gallina (Note 66) from Brescia, whose work has affinities with A. Longhi's and Rosalba's.

97. *I pittori della realtà in Lombardia*, Catalogue. Milan, 1953.

98. Bibliography in the Catalogue quoted in the preceding Note. In addition G. Testori, *Paragone*, V (1954), no. 57.

Owing to fairly recent research and exhibitions (see Bibliography) the number of works now known by Ceruti has almost doubled in recent years; his career can be followed from 1724 to 1761 and perhaps even beyond this date. Unexpectedly, some landscapes and some remarkable still lifes by him have been found; see A. Morassi, in *Pantheon*, XXV (1967), 348 ff.

494. 99. Traversi's career was reconstructed by R. Longhi, *Vita Artistica*, II (1927), 145. Dated religious paintings by him are in Naples (1749), Rome (1752), and Parma (1753). See also Longhi, *Paragone*, I (1950), no. 1, 44, and A. G. Quintavalle, *ibid.*, VII (1956), no. 81, 39.

495. 100. M. Abbruzzese, *Commentari*, VI (1955), 303; A. M. Clark, *Paragone*, XIV (1963), no. 165, 11. See also F. Negri Arnoldi, *ibid.*, XXI (1970), no. 239, 67 ff.

101. M. Loret, *Capitolium*, XI (1935), 291, with notes on all his sketch-books with caricatures. See also A. Blunt and E. Croft-Murray, *Venetian Drawings of the XVII & XVIII Centuries ... at Windsor Castle*, London, 1957, 138 ff., with a detailed analysis of Consul Smith's album of caricatures. Also D. Bodart, 'Disegni giovanili inediti di P. L. Ghezzi nella Bibl. Vaticana', *Palatino*, XI (1967), 141 ff.

Ghezzi's Venetian counterpart as a caricaturist was Antonio Maria Zanetti the Elder (1680-1767), distinguished collector, engraver, and draughtsman, whose 'Album Cini' (now belonging to the Fondazione Cini, Venice) with about 350 caricatures gives an enchanting impression of the society of eighteenth-century Venice; see A. Bettagno, *Caricature di Anton Maria Zanetti*, Venice, 1969.

102. H. Voss, *Pantheon*, II (1928), 512.

103. R. Longhi, *Critica d'Arte*, III (1938), 121.
496. 104. Longhi, *op. cit.*

105. W. Arslan, *L'Arte*, XXXVI (1933), 255; M. Mojzer, *Acta Historiae Artium* (Budapest), IV (1956), 77.

106. The *Arti di Bologna* appeared several times between 1646 and 1740 and had a wide circulation.

107. The connexion is particularly clear in those cases where the figure, large and isolated in the foreground, is not co-ordinated with the indication of landscape or architecture.

A. Griseri, *Paragone*, XII (1961), no. 143, 24, has pointed out that the Lombard Giovenale Boetto (1604-78) etched popular types (1633 ff.) similar to the *Arti di Bologna* even before the latter appeared and that Boetto may have influenced Ceruti. Griseri studied these problems further in the Boetto monograph of 1966 (see Bibliography), 42 ff.

108. Arslan, *op. cit.*, 256.

109. Longhi's pupil, the Frenchman Giuseppe Flipart (1721-97), found a ready public for this type of genre in Spain, where he settled as court painter. A rather facile genre of a similar kind was practised by Marco Marcola (1740-93) from Verona.

In this context I may come back to another Veronese artist, Pietro Rotari (1707-62), who was a considerable success in his day. His teachers were Balestra in Verona, Piazzetta in Venice, Trevisani in Rome, and Solimena in Naples - a typical eighteenth-century curriculum. He specialized in sweetish heads rendered with great precision in clear, cold colours; see G. Fiocco, *Emporium*, XLVIII (1942), 277.

497. 110. I cannot discuss the battle-piece, animal genre, and still life. All these had their great period during the seventeenth century. The many eighteenth-century painters go the trodden path.

For the battle-piece, see L. Ozzola, *I pittori di battaglie nel Seicento e nel Settecento*, Mantua, 1951, with brief comments on all the practitioners. Francesco Simonini from Parma (1686-1753), who worked in Venice in the 1740s, has been more carefully studied; see A. Morassi in *Pantheon*, XIX (1961), 1; G. M. Zuccolo Padrono, *Arte Veneta*, XXI (1967), 185 ff.

In Naples the brilliant Andrea Belvedere (1652-1732) and others followed in the footsteps of Ruoppolo. Felice Boselli (1651-1732) from Piacenza excelled in animal, bird, and fish still lifes; see G. Bocchia Casoni in *Parma per l'Arte*, XIV (1964), 31. Bologna had in the Cittadini a whole family specializing in fruit and flower still lifes. For Pier Francesco Cittadini, see E. Riccòmini, *Arte Antica e Moderna*, IV (1961), 362, and A. G. Quintavalle, *Artisti alla corte di Francesco d'Este*, Modena, 1963, 32. Arcangelo Resani (1668/70-1740), the painter of impressively compact still lifes, may here be mentioned. Born in Rome, he moved early to Bologna

and on to Forlì and Ravenna, where he died; see A. Corbara, in *Paragone*, XVI (1965), no. 183, 52 ff., and L. Zauli Naldi, *ibid.*, 55 ff.

Carlo Magini (1720–1806) from Forlì painted homely still lifes with a Caravaggesque flavour; see A. Servolini, *Commentari*, VIII (1957), 125, with further literature.

For still life painting in Emilia, see A. G. Quintavalle, *Christoforo Munari e la natura morta emiliana*: Catalogue of the 1964 Parma Exhibition of this painter (1667-1720).

498. 111. The lure of Roman ruins has a long history of its own going back to Petrarch and, in visual terms, to the *Hypnerotomachia Polifili* (1499). Their early 'romantic' inclusion in landscapes by Brill, the antiquarian tendencies of northern artists, such as Heemskerck, and the appearance of ruins in the work of the Bamboccianti and northern landscapists of the mid seventeenth century cannot here be discussed. For the early history of the cult of ruins see W. G. Heckscher, *Die Romruinen*, Würzburg, 1936; for the general problem Rose Macaulay's excellent book *The Pleasure of Ruins*, London, 1953; for the particular problems under review, L. Ozzola, 'Le rovine romane nella pittura del XVII e XVIII secolo', *L'Arte*, XVI (1913), I, 112.

112. See A. M. Clark in *Paragone*, XII (1961), no. 139, 51.

113. A. Busiri Vici, 'La prima maniera di Andrea Locatelli', *Palatino*, XI (1967), 366 ff., and M. M. Mosco, 'Les trois manières d'Andrea Locatelli', *Revue de l'Art*, no. 7 (1970), 19-39. This is the fullest discussion of Locatelli's art; with *œuvre* catalogue. See also 'Monsù Alto, le maître de Locatelli', *ibid.*, 18.

114. H. Voss, *Apollo*, III (1926), 332.

115. O. Ferrari, 'Leonardo Coccorante e la "veduta ideata" napoletana', *Emporium*, CXIX (1954), 9; W. G. Constable, 'Carlo Bonavia and some Painters of Vedute in Naples', *Essays in Honor of G. Swarzenski*, Chicago, 1952, 198. For Bonavia, see also the same author in *Art Quarterly*, 1959, 1960, 1962.

Mention may also be made of the anonymous northerner 'Monsù X', an artist reconstructed by R. Longhi (*Paragone*, V (1954), no. 53, 39) who worked mostly in Rome and combined influences from Rosa and Courtois with those from Seghers, Rembrandt, and other Dutch painters.

Pandolfo Reschi, born in Danzig in 1643, who spent most of his life in Italy, imitated Salvator and Courtois. He died in 1699 in Florence where he mainly worked.

116. F. Arisi's monograph (1961) with elaborate, fully illustrated *œuvre* catalogue supersedes L. Ozzola's monograph of 1921 and must be consulted for all questions concerning Pannini. The author established that Pannini was in Rome as early as 1711.

Paintings by the little-known Alberto Carlini (1672-after 1720) are often attributed to Pannini; see H. Voss, *Burl. Mag.*, CI (1959), 443.

117. M. G. Rossi, *Commentari*, XIV (1963), 54. A fine study of Ghisolfi with much new material was published by A. Busiri Vici, in *Palatino*, VIII (1964), 212-20.

118. C. Lorenzetti, *G. Vanvitelli*, Milan, 1934, with *œuvre* catalogue and bibliography; G. Briganti in *Critica d'Arte*, V (1940), 129; *idem, Gaspar Van Wittel*, Rome, 1966 (see Bibliography).

119. Gaspar Vanvitelli had followers in Rome, above all the Dutchman Hendrik Frans van Lint (1684-1763), who spent most of his life in Italy, and Giovanni Battista Busiri (1698-1757), who had a penchant for the small format and whose work was immensely popular with eighteenth-century English 'Grand Tourists'. See the fully illustrated monograph by Andrea Busiri Vici, *G. B. Busiri. Vedutista romano del '700*, Rome, 1966.

120. See G. M. Pilo's excellent Catalogue of the Marco Ricci Exhibition, 1963 (Introduction by R. Pallucchini), with bibliography listing all previous research.

501. 121. For Marieschi, see, apart from the 1967 Catalogue *I vedutisti veneziani*, A. Morassi, *M. Marieschi. Catalogo*, Bergamo, 1966, and *idem* in *Festschrift U. Middeldorf*, Berlin, 1968, 497 ff.

122. Apart from C. Mauroner's monograph, see H. Voss, *Rep. f. Kunstw.*, XLVII (1926), I. On Carlevarijs's Swedish pupil, Johan Richter (1665-1745), who lived in Venice from 1717 on, see G. Fiocco, *L'Arte*, XXXV (1932).

123. W. G. Constable, *Canaletto*, 1962, 102, 265. J. G. Links, *Burl. Mag.*, CIX (1967), 405 ff., published some paintings unknown to Constable.

503. 124. See the basic article by H. F. Finberg, *Walpole Society*, IX (1920-1), 21; also Constable, *op. cit.*, 32. For Consul Smith, see Haskell, *Patrons*, 299.

Canaletto's later work deteriorated in quality. Mass production and the growing demands made upon him by tourists led to a progressive mechanization of his style.

125. Other minor *vedutisti*, such as Antonio Visentini (1688-1782), famed as architect and engraver, Antonio Jolli (*c.* 1700-77), Pietro Gaspari (1720-85), and Francesco Battaglioli (b. *c.* 1722), can only be mentioned; for the whole trend, R. Pallucchini, *Pitt. ven.*, II, and *Pitt. ven. Settecento*, 1960, 205.

126. It is well known that Canaletto as well as Bellotto and other painters before and after them, among them G. M. Crespi and even Guardi, regarded the *camera obscura* as a convenient aid for rendering 'correct' views. Best survey of this problem in H. Allwill Fritzsche, *B. Bellotto*, Burg, 1936; see also J. Byam Shaw,

The Drawings of F. Guardi, London, 1951, 22; T. Pignatti, *Il quaderno di disegni del Canaletto alle Gallerie di Venezia*, Milan, 1958, 20; and the penetrating analysis by D. Gioseffi, *Canaletto*, Trieste, 1959, who based his research on the same *quaderno*, a sketchbook with 138 original Canaletto drawings, now in the Accademia, Venice. Constable, *Canaletto*, 1962, 162, seems to have been unaware of Gioseffi's publication.

127. See M. Muraro, *Burl. Mag.*, CII (1960), 421.

128. *Idem, ibid.*, C (1958), 3.

129. The question was opened up in a penetrating article by W. Arslan (*Emporium*, C (1944), July–Dec., 3) and first summarized by A. Morassi, *ibid.*, CXIV (1951), 195; see also T. Pignatti, *Arte Veneta*, IV (1950), 144. In 1951 appeared also F. de Maffei's partisan *Gian Antonio Guardi pittore di figure* (Verona), which aroused considerable controversy. G. Fiocco valiantly defends the old position of Francesco's primacy, first defined by him in his classic monograph of 1923 (see *Mostra delle opere di Francesco e Gianantonio Guardi esistenti nel Trentino*, Trent, 1949; also *Arte Veneta*, VI

(1952), 99, and, more recently, *Francesco Guardi. L'Angelo Raffaele*, Turin, 1958). Once again, Morassi summarized the problem in *Burl. Mag.*, XCV (1953), 263, where he tried to round off Gianantonio's *œuvre*. A 'conciliatory' position was taken up by J. Byam Shaw (*op. cit.*, Note 126, 46) and R. Pallucchini, *Pitt. venez.*, II, 196, and *Pittura venez. del Settecento*, 1960, 131 (full discussion), who do not accept the encomium of Gianantonio at the expense of Francesco. See also N. Rasmo's balanced assessment in *Cultura Atesina*, IX (1955), 150.

D. Gioseffi in *Emporium*, CXXVI (1957), 99, once again attributes the S. Raffaele paintings to Francesco and advances reasons for dating them as late as 1780–90, while A. Morassi, *ibid.*, CXXXI (1960), 147, 199, offers new arguments for the attribution to Gianantonio. See also S. Sinding-Larsen, in *Acta ad archaeologiam et artium historiam pertinentia* (Institutum Romanum Norvegiae), I (1962), 171–93. The Bibliography (pp. 608–9) should be consulted for later writings on the Guardi brothers.

BIBLIOGRAPHY

The Bibliography cannot aim at completeness. As a rule, I have excluded the literature listed in Thieme-Becker's *Künstler-Lexikon*. Only those older articles and books which are still standard works to-day are here included. Moreover, to a certain extent the footnotes and the Bibliography supplement each other: I had to exclude from the Bibliography many references given in the footnotes; conversely, many important studies will appear only in the Bibliography.

Titles of articles are quoted only if they contain a specific key to the content.

In a few exceptional cases book reviews of special merit are mentioned.

I have tried to characterize a number of important items by brief comments. For reasons of space these had to be selective.

Initials of artists are given only in cases where the identity would otherwise be doubtful.

For older bibliographies, see N. Pevsner, *Die italienische Malerei vom Ende der Renaissance bis zum ausgehenden Rokoko*, Wildpark-Potsdam, 1928 (painting); A. De Rinaldis, *L'arte in Roma ...* Bologna, 1948 (full bibliography for Rome); V. Golzio, *Il Seicento e il Settecento*, Turin, 1950 (selection). Indispensable for the sources and art theory: J. Schlosser-Magnino, *La letteratura artistica*, Florence-Vienna, 1964. The best up-to-date bibliographies are in the current issues of *Commentari, Arte Veneta, Zeitschrift für Kunstgeschichte*. The *Dizionario Biografico degli Italiani*, Rome, 1960 ff., should also be consulted. At the time of concluding this revision only twelve volumes have appeared.

The bibliographical material is arranged under the following headings:

LIST OF PRINCIPAL ABBREVIATIONS: *see* p. 506

I. SOURCES

A. DOCUMENTS AND LETTERS

BARONI, C. *Documenti per la storia dell'architettura a Milano nel rinascimento e nel barocco*. I: *Edifici sacri*. Florence, 1940.

BOTTARI, M. G., and TICOZZI, S. *Raccolta di lettere sulla pittura, scultura ed architettura*. Milan, 1822.

CELIO, G. *Memoria delli nomi dell'artefici delle pitture che sono in alcune chiese, facciate e palazzi di Roma*. Ed. Emma Zocca, Milan, 1967.

CERROTI, F. *Lettere e memorie autografe ed inedite di artisti tratte dai manoscritti della Corsiniana*. Rome, 1860.

FOGOLARI, G. 'Lettere pittoriche del Gran principe Ferdinando di Toscana a Niccolò Cassana (1698–1709)', *Riv. del R. Ist.*, VI (1937–8).

GARMS, J., ed. *Quellen aus dem Archiv Doria-Pamphili zur Kunsttätigkeit in Rom unter Innozenz X (Quellenschriften der Barockkunst in Rom, Bd 4)*. Rome, Vienna, 1972.

GOLZIO, V. *Documenti artistici sul Seicento nell' archivio Chigi*. Rome, 1939.

GUHL, E. *Künstlerbriefe*. 2nd ed. by A. Rosenberg. Berlin, 1880.

LAVIN, M. A. *Seventeenth-Century Bernini Documents and Inventories of Art.* New York, 1975.

ORBAAN, J. A. F. *Documenti sul barocco in Roma.* Rome, 1920.

POLLAK, O. *Die Kunsttätigkeit unter Urban VIII.* Vienna, 1927, 1931.

POLLAK, O. 'Italienische Künstlerbriefe aus der Barockzeit', *Jahrb. Preuss. Kunstslg.*, XXXIV (1913), Beiheft.

B. LIVES OF ARTISTS

BAGLIONE, G. *Le vite de' pittori, scultori, architetti, ed intagliatori, dal pontificato di Gregorio XIII del 1572, fino a' tempi di Papa Urbano VIII nel 1642.* Rome, 1642. Facsimile ed. with marginal notes by Bellori (ed. V. Mariani). Rome, 1935.

BALDINUCCI, F. *Notizie de' professori del disegno da Cimabue in qua.* Florence, 1681–1728.

BELLORI, G. P. *Le vite de' pittori scultori ed architetti moderni.* Rome, 1672. Ed. E. Borea, Turin, 1976. Extensively annotated; includes unpublished lives of Reni, Sacchi, and Maratti. See also E. Battisti on 'Bellori as Critic', A Life and Catalogue of Works, with Indices by Elena Caciagli, in *Quaderni dell' Istituto di Storia dell' Arte della Università di Genova* (1969), no. 4.

CRESPI, L. *Vite de' pittori bolognesi non descritte nella Felsina Pittrice.* Rome, 1769.

DE DOMINICI, B. *Vite de' pittori, scultori ed architetti napoletani.* Naples, 1742–3.

GIANNONE, O. *Giunte sulle vite dei pittori napoletani* (ed. O. Morisani). Naples, 1941.

MALVASIA, C. C. *Felsina pittrice. Vite de pittori bolognesi.* Bologna, 1678; aiso *Vite di pittori Bolognesi (Appunti inediti).* Ed. A. Arfelli, Bologna, 1961.

MANCINI, G. *Considerazioni sulla pittura* (ed. A. Marucchi and L. Salerno). Rome, 1956–7. Written between 1614 and 1621, wtih additions until 1630. See also J. Hess, 'Note Manciniane', *Münchner Jahrb.*, XIX (1968), 103 ff.

ORLANDI, P. A. *Abecedario pittorico.* Bologna, 1704. An encyclopedia of artists. Many later editions with additions.

PASCOLI, L. *Vite de' pittori, scultori, ed architetti moderni.* Rome, 1730–6.

PASSERI, G. B. *Vite de' pittori, scultori ed architetti che hanno lavorato in Roma, morti dal 1641 fino al 1673.* Rome, 1772. Re-issued with notes by J. Hess. Vienna, 1934.

RIDOLFI, C. *Le maraviglie dell'arte o vero le vite degl' illustri pittori veneti e dello stato.* Venice, 1648. New critical ed. with notes by D. von Hadeln. Berlin, 1914–24.

SANDRART, J. von. *L'academia todesca della architectura, scultura & pittura.* Nürnberg-Frankfurt, 1675–9. Modern ed. with notes by A. Peltzer. Munich, 1925.

SOPRANI, R., and RATTI, C. G. *Vite de' pittori, scultori, ed architetti genovesi.* Genoa, 1768–9.

SUSINO, F. *Le vite dei pittori messinesi, 1724.* Ed. V. Martinelli, Florence, 1960.

II. GENERAL STUDIES

A. INTERPRETATIONS OF THE BAROQUE

ANCESCHI, L. *Del barocco ed altre prove.* Florence, 1953.

Atti del III Congresso Internazionale di Studi Umanistici: 'Retorica e Barocco'. Rome, 1955. Collection of important papers, above all, C. G. Argan, 'La "Rettorica" e l'arte barocca', and G. M. Tagliabue, 'Aristotelismo e Barocco'.

Baroque Art: the Jesuit Contribution. A Symposium ed. by I. Jaffe and R. Wittkower, New York, 1971, with contributions by J. Ackerman, P. Bjurström, T. Culley, S. J. F. Haskell, H. Hibbard, R. Taylor, R. Wittkower.

BIALOSTOCKI, J. 'Le "Baroque": style, époque, attitude', in *L'Information d'Histoire de l'Art*, VII (1962).

BRIGANTI, G., in *Paragone*, I (1950), nos I, 3; II (1951), no. 13.

CROCE, B. *Storia dell'età barocca in Italia.* Bari, 1929.

FRANCASTEL, P. 'La contre-réforme et les arts en Italie à la fin du XVIe siècle', *À travers l'art italien du XVe au XXe siècle.* Paris, 1949.

GALASSI PALUZZI, C. *Storia segreta dello stile dei Gesuiti.* Rome, 1951.

GRASSI, L. 'Barocco e arti figurative', *Emporium*, CI (1945).

GRASSI, L. *Costruzione della critica d'arte.* Rome, 1955. With interesting chapters on Baroque art theory and good bibliography.

IVANOFF, N. 'Stile e maniera', in *Saggi e Memorie di storia dell'arte*, I (1957). Investigation of how writers from the Renaissance onwards interpreted 'style' and *maniera*.

KURZ, O. 'Barocco: storia di una parola', in *Lettere Italiane*, XII (1960). Best terminological study.

LEE, R. W. '"Ut pictura poesis": the Humanistic Theory of Painting', *Art Bull.*, XXII (1940).

MAHON, D. *Studies in Seicento Art and Theory.* London, 1947.

MAHON, D. 'Eclecticism and the Carracci: Further Reflections on the Validity of a Label', *J.W.C.I.*, XVI (1953).

MARTIN, J. R. *Baroque.* New York, 1977.

PANOFSKY, E. *'Idea', ein Beitrag zur Begriffsgeschichte der älteren Kunsttheorie.* Leipzig-Berlin, 1924; Italian ed., 1952.

RIEGL, A. *Die Entstehung der Barockkunst in Rom.* Vienna, 1908.

STAMM, R. (ed.). *Die Kunstformen des Barockzeitalters.* Munich, 1956.
 A collection of papers by fourteen authors.

TINTELNOT, H. *Barocktheater und barocke Kunst.* Berlin, 1929.

WEISBACH, W. *Der Barock als Kunst der Gegenreformation.* Berlin, 1921.

WITTKOWER, R. 'Il barocco in Italia', *and* CANTIMORI, D., 'L'età barocca', in *Manierismo, Barocco, Rococò: concetti e termini, Accademia dei Lincei,* CCCLIX (1962), 319, 395.

WÖLFFLIN, H. *Renaissance und Barock.* Munich, 1888. Eng. ed., Glasgow, 1964.

B. ICONOGRAPHY

ASKEW, P. 'The Angelic Consolation of St Francis of Assisi in Post-Tridentine Italian Painting', *J.W.C.I.*, XXXII (1969), 280–306.
 An exemplary iconographical study.

DEJOB, C. *De l'influence du Concile de Trente sur la litérature et les beaux arts chez les peuples catholiques.* Paris, 1884.

MÂLE, E. *L'art religieux de la fin du XVIe siècle, du XVIIe siècle et du XVIIIe siècle.* Paris, 1951.
 The indispensable study.

MRAZEK, W. 'Ikonologie der barocken Deckenmalerei', *Sitzungsberichte der phil. hist. Klasse der Oesterr. Akademie der Wissenschaften,* 1952.

MRAZEK, W., in *Kunstchronik,* IX (1956).
 Plan of an analytical index of Baroque iconography.

MUÑOZ, A., in *Rassegna d'Arte,* III (1916), IV (1917), V (1918).

PIGLER, A. *Barockthemen.* Budapest, 1956. New enlarged ed., New York, 1971.

SALERNO, L. 'Il dissenso nella pittura. Intorno a Filippo Napoletano, Caroselli, Salvator Rosa e altri', *Storia dell'Arte,* no. 6 (1970), 34–65.
 A discussion of the interest in magic on one hand and stoicism on the other by a group of seventeenth-century painters.

VOSS, H. 'Die Flucht nach Ägypten', *Saggi e Memorie di storia dell'arte,* I (1957).
 Supplements Pigler, who does not mention the theme.

C. HISTORIES AND STUDIES OF BAROQUE ART AND ARCHITECTURE

1. The Three Arts

FAGIOLO DELL'ARCO, M. 'Il barocco romano (rassegna degli studi 1970–74)', *Storia dell'Arte,* XXIV/XXV (1975), 125–43.

FAGIOLO DELL'ARCO, M., and CARANDINI, S. *L'effimero barocco: strutture della festa nella Roma del '600,* I, Rome, 1977; II, Rome, 1978.

GOLZIO, V. *Il Seicento e il Settecento.* Turin, 1950. Third ed., 1968.
 An encyclopedic attempt with close to a thousand illustrations.

GRISERI, A. *Le metamorfosi del barocco.* Turin, 1967.
 An unusual and fascinating work, containing many challenging ideas; concentration on Piedmont.

HASKELL, F. *Patrons and Painters: A Study in the Relations between Italian Art and Society in the Age of the Baroque.* London, 1963.
 An important work; supplements ideally the present book.

HEIMBÜRGER RAVALLI, M. *Architettura, scultura ed arti minori nel barocco italiano. Ricerche nell'archivio Spada.* Florence, 1977.

HUBALA, E. *Die Kunst des 17. Jahrhunderts* (*Propyläen Kunstgeschichte,* IX). Berlin, 1970.

LEES-MILNE, J. *Baroque in Italy.* London, 1959.
 Useful as an introduction.

SALMI, M. *L'arte italiana,* III. Florence, 1944.

TAPIÉ, V.-L. *The Age of Grandeur. Baroque and Classicism in Europe.* London, 1960 (first French ed., 1957).
 Emphasis on historical aspects. Italy takes up a relatively small section. Poor English translation.

VENTURI, A. *Storia dell'arte italiana,* IX–XI. Milan, 1933 ff. IX, 6–7 Painting; X, 3 Sculpture; XI, 2–3 Architecture.
 These volumes should be used for the transition from the sixteenth to the seventeenth century.

WEISBACH, W. *Die Kunst des Barock in Italien, Frankreich, Deutschland und Spanien.* Berlin, 1924.
 Volume XI of the 'Propyläen Kunstgeschichte'.

WITTKOWER, R. *Studies in the Italian Baroque.* London, 1975.

2. *Painting*

ARSLAN, E. *Il concetto di luminismo e la pittura veneta barocca.* Milan, 1946.
Suggestive ideas.

Art in Italy, 1600–1700. Ed. F. Cummings, Introduction R. Wittkower. Detroit, 1965.
The Detroit Exhibition brought together the best of Italian Seicento painting, drawing, and sculpture in American collections. Learned catalogue entries by seven experts.

BUSCAROLI, R. *La pittura di paesaggio in Italia.* Bologna, 1935.
The only comprehensive study.

COSTANTINI, V. *La pittura italiana del '600.* Milan, 1930.
Contribution to the history of ideas rather than style.

DELOGU, G. *La pittura italiana del Seicento.* Florence, 1931.

FRIEDLAENDER, W. *Mannerism and Anti-Mannerism in Italian Painting.* New York, 1957.
Reprint of classic articles, first publ. 1925, 1929.

GALETTI, U., and CAMESASCA, E. *Enciclopedia della pittura italiana.* Milan, 1951.
Valuable articles on seventeenth- and eighteenth-century painters, with bibliographies.

GERSTENBERG, K. *Die ideale Landschaftsmalerei.* Halle, 1923.

GNUDI, C., and others. *L'ideale classico del Seicento in Italia e la pittura di paesaggio.* Bologna, 1962.
Exhibition catalogue with a number of essays of great value. Review by E. Schaar, *Zeitschr.f. Kunstg.*, XXVI (1963), 52.

LANZI, L. *Storia pittorica dell' Italia.* Bassano, 1795–6 (first complete ed.). First English transl. by Roscoe, 1828.
Still unequalled for knowledge of the material and breadth of approach.

LORENZETTI, G. *La pittura italiana del Settecento.* Novara, 1948.
The best general treatment of the subject.

MARANGONI, M. *Arte barocca.* Florence, 1953 (first ed. 1927).
Reprint of articles on still life, Guercino, G. M. Crespi, Caravaggio, Florentine Settecento painting, etc.

MCCOMB, A. *Baroque Painters in Italy.* Harvard, 1934.
The only general study in English. Limited usefulness.

Masters of the Loaded Brush. Oil Sketches from Rubens to Tiepolo. Columbia University Exhibition Catalogue. New York, 1967.
Introduction by R. Wittkower on the history of the oil sketch. A number of bozzetti never shown before are discussed and illustrated. Review D. Posner, *Burl. Mag.*, CIX (1967), 360 ff.

MOSCHINI, V. *La pittura italiana del Settecento.* Florence, 1931.
Brief text.

Mostra – Il Seicento europeo. Rome, 1957.
With contributions by various authors. Catalogue prepared by L. Salerno and A. Marabottini.

NEBBIA, U. *La pittura italiana del Seicento.* Novara, 1946.

NICOLSON, B. *The International Caravaggesque Movement.* Oxford, 1979.

OJETTI, U., DAMI, L., and TARCHIANI, N. *La pittura italiana del Seicento e del Settecento alla mostra di Palazzo Pitti.* Milan–Rome, 1924.
Still basic.

OJETTI, U., and others. *Il ritratto italiano dal Caravaggio al Tiepolo.* Bergamo, 1927.
A monumental work.

PÉREZ SÁNCHEZ, A. E. *Pintura italiana del s. XVII en España.* Madrid, 1965.
First serious attempt to catalogue and illustrate all Italian Seicento paintings in Spain. Review E. Harris, *Burl. Mag.*, CX (1968), 159 f.

Petit Palais. La peinture italienne au XVIIIe siècle. Nov. 1960–Jan. 1961.
Exhibition catalogue with good bibliographies. See M. Levey, *Burl. Mag.*, CIII (1961), 139.

PEVSNER, N. *Die italienische Malerei vom Ende der Renaissance bis zum ausgehenden Rokoko* (Handbuch der Kunstwissenschaft). Wildpark–Potsdam, 1928.
A pioneering work.

PEVSNER, N. 'Die Wandlung um 1650 in der italienischen Malerei', *Wiener Jahrb.*, VIII (1932).

WATERHOUSE, E. *Italian Baroque Painting.* London, 1962.
An eminently readable introduction.

3. *Sculpture*

BRINCKMANN, A. E. *Barockskulptur.* Berlin-Neubabelsberg, 1919.
A spirited enterprise, now largely antiquated.

BRINCKMANN, A. E. *Barock-Bozzetti.* Frankfurt, 1923–4.
A vast and still important collection of material.

DELOGU, G. *La scultura italiana del Seicento e del Settecento.* Florence, 1932, 1933.
Useful brief compilation, not always reliable.

FALDI, I. *La scultura barocca in Italia*. Milan, 1958.
Brief, competent text.

FERRARI, G. *La tomba nell' arte italiana*. Milan, [1916].

FERRARI, G. *Lo stucco nell' arte italiana*. Milan, [1910].
These two volumes are handy collections of illustrations.

MARTINELLI, V. *Scultura italiana dal manierismo al rococò*. Milan, 1968.
Useful introduction with good illustrations.

POPE-HENNESSY, J. *Italian High Renaissance and Baroque Sculpture*. London, 1970.
An excellent introduction, though the space allotted to the Baroque is relatively brief. Scholarly catalogue entries.

SOBOTKA, G. *Die Bildhauerei der Barockzeit* (ed. H. Tietze). Vienna, 1927.

WITTKOWER, R. *Sculpture: Processes and Principles*. London, 1977.

4. Architecture

ARGAN, G. C. *L'architettura barocca in Italia*. Milan, 1957.
Brief, stimulating text.

ARGAN, G. C. *L'architettura barocca in Italia*. Appunti delle lezioni tenute durante l'anno accademico 1959–60, raccolti dal prof. Maurizio Bonicatti. Rome (ed. dell'Ateneo), 1960.

BRANDI, C. *La prima architettura barocca. Pietro da Cortona, Borromini, Bernini*. Bari, 1970.
A paperback well worth while studying.

BRIGGS, M. G. *Baroque Architecture*. London, 1913.
Antiquated.

BRINCKMANN, A. E. *Baukunst des 17. und 18. Jahrhunderts in den romanischen Ländern* (Handbuch der Kunstwissenschaft). Berlin-Neubabelsberg, 1919 (and later editions).
Stimulating, but difficult to digest.

CATTAVI, G. *L'architettura barocca*. Rome, 1962.
A brief summary.

CHIERICI, G. *Il palazzo italiano dal secolo XVII al XIX*. Milan, 1957.
General, useful illustrations.

DELOGU, G. *L'architettura italiana del Seicento e del Settecento*. Florence, 1935.
General survey.

FREY, D. *Architettura barocca*. Rome–Milan, 1926.
Brief, but interesting text.

GURLITT, C. *Geschichte des Barockstiles in Italien*. Stuttgart, 1887.
A revolutionary work; still useful.

HAGER, W. *Barock Architektur*. Baden–Baden, 1968.

A thoughtful, all-European history with bibliography and chronological tables.

MILIZIA, F. *Memorie degli architetti antichi e moderni*. 4th ed. Bassano, 1785.
A primary source for eighteenth-century architects.

NORBERG-SCHULZ, C. *Baroque Architecture*. New York, 1971.

NORBERG-SCHULZ, C. *Late Baroque and Rococo Architecture*. New York, 1974.

POLLAK, O. 'Der Architekt im 17. Jahrhundert in Rom', *Zeitschr. für Gesch. d. Architektur*, III (1909–10).
Problems of the profession and terminology based on documents.

RICCI, C. *L'architettura barocca in Italia*. Turin, 1922.
Collection of illustrations.

5. Drawing

BEAN, J., and STAMPFLE, F. *Drawings from New York Collections III. The Eighteenth Century in Italy*. New York, 1971.

IVANOFF, N. *I disegni italiani del Seicento. Scuole veneta, lombarda, ligure, napoletana*. Venice, 1959.
Examples also of minor artists.

ROLI, R. *I disegni italiani del Seicento scuola emiliana, toscana, romana, marchigiana e umbra*. Treviso, 1969.
Reviews by W. Vitzthum, *Arte Illustrata*, III, 34–6 (1970), 88 ff., and, most detailed, by A. S. Harris, *Art Bull.*, LIII (1971).

STAMPFLE, F., and BEAN, J. *Drawings from New York Collections II. The Seventeenth Century in Italy*. New York, 1967.
An important catalogue containing much new material. Review W. Vitzthum, *Burl. Mag.*, CIX (1967), 253.

Much work has been done on drawings of the Baroque in recent years. See entries under BOLOGNA, MILAN, and, above all, VENICE.

III. CITIES AND PROVINCES

BOLOGNA AND EMILIA

BODMER, H. 'Studien über die bologneser Malerei des 18. Jahrhunderts', *Mitteilungen des kunsthistorischen Instituts in Florenz*, V (1951).

EMILIANI, A. *Mostra di disegni del seicento emiliano nella Pinacoteca di Brera*. Milan, 1959.

FORATTI, A. 'Aspetti dell'architettura bolognese della seconda metà del secolo XVI alla fine del

Seicento', *Il Comune di Bologna*, XVIII (1931), XIX (1932).

GNUDI, C., and others. *Maestri della pittura del Seicento emiliano.* Catalogue. Bologna, 1959.
The learned Catalogue, which accompanied one of the most stimulating exhibitions of the decade, must be consulted for all questions concerning the Bolognese seventeenth century.

KURZ, O. *Bolognese Drawings of the XVII & XVIII Centuries ... at Windsor Castle.* London, 1955.

LONGHI, R. 'Momenti della pittura bolognese', *L'Archiginnasio*, XXX (1935).

MALAGUZZI-VALERI, F. *Arte gaia.* Bologna, 1926.
On Bolognese festivals, drawings, caricatures, etc.

MALVASIA, C. *Le pitture di Bologna.* Bologna, 1686 (also eighteenth-century editions). New ed. by A. Emiliani, Bologna, 1969.
The most important contemporary guide-book.

MATTEUCCI, A. M. *Carlo Francesco Dotti e l'architettura bolognese del Settecento.* Bologna, 1969.
Foundation for a long-neglected field of study. Biographical material, *œuvre* catalogues, documents, a chronological table.

Mostra del Settecento bolognese. Bologna, 1935.
Essential.

RICCI, C., and ZUCCHINI, G. *Guida di Bologna.* 6th ed. Bologna, 1930.
The best modern guide-book.

RICCÒMINI, E. *Mostra della scultura bolognese del Settecento.* Bologna, 1965.
Contains the only coherent history of eighteenth-century Bolognese sculpture.

RICCÒMINI, E. *Il Seicento ferrarese.* Milan, 1969.
A great deal of new material. Many painters, hitherto entirely unknown, are discussed.

ZANOTTI, F. M. C. *Storia dell'Accademia Clementina.* Bologna, 1739.

ZUCCHINI, G. *Edifici di Bologna. Repertorio bibliografico e iconografico.* Rome, 1931.

ZUCCHINI, G. *Paesaggi e rovine nella pittura bolognese del Settecento.* Bologna, 1947.

FLORENCE AND TUSCANY

BOCCHI, F., and CINELLI, G. *Le bellezze della città di Firenze.* Florence, 1677.
Best contemporary guide-book.

CAMPBELL, M. 'Medici Patronage and the Baroque: A Reappraisal', *Art Bull.*, XLVIII (1966), 133 ff.

CHIARINI, M. *Artisti alla corte granducale.* Florence, 1969.

Fully documented catalogue of an exhibition in the Palazzo Pitti. Revealing for the taste of the Florentine court.

DAL POGGETTO, P. *Arte in Valdelsa dal sec. XII al sec. XVIII.* Exhibition Catalogue. Certaldo, 1963.
Interesting for a number of minor Tuscan Baroque painters.

GREGORI, M. *70 pitture e sculture del '600 e '700 fiorentino.* Florence, 1965.
Catalogue of an important Exhibition in the Palazzo Strozzi. The Introduction contains an excellent survey of Florentine Baroque painting.
See also Gregori, *Paragone*, no. 145, 21 ff., and no. 169, 11 ff.

HIBBARD, H., and NISSMAN, J. *Florentine Baroque Art from American Collections.* New York, 1969.
A Columbia University Exhibition at the Metropolitan Museum. The first attempt in America to present a coherent picture of Florentine seventeenth-century painting.

INGERSOLL-SMOUSE, F. 'La sculpture florentine à la fin du XVIIe siècle', *G.d.B.A.*, 5 pèr., I (1920).

LANKHEIT, K. *Florentinische Barockplastik.* Munich, 1962.
A monumental standard work opening up a field to which little attention had been paid before.

MARANGONI, M. 'Settecentisti fiorentini', *Riv. d'Arte*, VIII (1912); reprinted in *Arte barocca*, Florence, 1953.
The only survey of Florentine eighteenth-century painting.

NOEHLES, K. 'Der Hauptaltar von Santo Stefano in Pisa: Cortona, Ferri, Silvani, Foggini', in *Giessener Beiträge zur Kunstgeschichte, Festschrift G. Fiensch*, 87 ff. Giessen, 1970.
An important episode reconstructed with the help of many drawings.

PAATZ, W. and E. *Die Kirchen von Florenz.* Frankfurt, 1940–54.
Indispensable.

The Twilight of the Medici: Late Baroque Art in Florence, 1670–1743. Ed. S. F. Rossen, Detroit, 1974.

GENOA AND LIGURIA

ALIZERI, F. *Guida illustrativa ... per la città di Genova.* Genoa, 1875.
Best older guide-book.

COLMUTO, G. 'Chiese barocche liguri a colonne binate', *Quaderno n. 3* (Università degli Studi di Genova) (1970), 99–184.

DELOGU, G. *Pittori minori liguri, lombardi e piemontesi del '600 e '700.* Venice, 1931.

Indispensable for the study of minor masters.

DE NEGRI, E. 'Chiese settecentesche a pianta ellittica del Genovesato', *Bollettino Ligustico* (1967), 43 ff.

FIESCHI BOSSOLO, G. 'Aspetti dell'architettura settecentesca in Liguria', *Palladio*, XV (1965), 129 ff.

Discussion of some scarcely known, but interesting Baroque churches such as the Sanctuary 'La Madonetta' at Genoa, the parish church at Arenzano, S. Giovanni Battista at Cervo, and S. Matteo at Laigueglia.

GROSSO, O. *Portali e palazzi di Genova.* Milan [n.d.].

GROSSO, O. *Decoratori genovesi.* Rome, 1921.

GROSSO, O. *Dimori genovesi.* Milan, 1956.

INGERSOLL-SMOUSE, F. 'La sculpture à Gènes au XVIIIe siècle', *G.d.B.A.*, LVI, ii (1914).

MANNING, R. and B. *Genoese Masters. Cambiaso to Magnasco 1550–1750.* Exhibition at the Dayton Art Institute, Ringling Museum of Art, and Wadsworth Atheneum. Dayton, Ohio, 1962.

A fine catalogue; many pictures from American private collections.

MARCENARO, C. (and others). *Mostra dei pittori genovesi a Genova nel '600 e nel '700.* Genoa, 1969.

Scholarly catalogue of a great exhibition which constitutes a landmark despite some harsh criticism (e.g., C. Volpe, in *Arte Illustrata*, II, 1969).

MORASSI, A. *Mostra della pittura del Seicento e Settecento in Liguria.* Catalogo. Milan, 1947.

So far the fullest presentation of this material.

MORAZZONI, G. *Stucchi italiani. Maestri genovesi sec. XVI–XIX.* Milan, 1950.

Mostra di pittori genovesi del Seicento e del Settecento. Catalogue by O. Grosso, M. Bonzi, and C. Marcenaro. Milan, 1938.

Still very useful; good bibliographies.

RATTI, C. G. *Instruzione di quanto può vedersi di più bello in Genova.* Genoa, 1780.

ROSSI, A. *L'architettura religiosa barocca a Genova.* Genoa, 1959.

Good photographic survey.

ROTONDI, P. *Catalogo della mostra della Madonna nell'arte in Liguria.* Genoa, 1952.

RUBENS, P. P. *Palazzi di Genova.* 1622; ed. H. Gurlitt, Berlin, 1924.

Le ville genovesi. Published by the Genoese Section of 'Italia Nostra'. Genoa, 1967.

A cooperative enterprise by E. De Negri, C. Fera, L. Grossi Bianchi, E. Poleggi. Reliable guide to about 150 seventeenth- and eighteenth-century villas in and near Genoa.

MILAN AND LOMBARDY

BARELLI, E. S. *Disegni di maestri lombardi del primo Seicento.* Catalogo. Milan, 1959.

BARONI, C. *L'architettura da Bramante al Ricchino.* Milan, 1941.

BASCAPÈ, G. C. *I palazzi della vecchia Milano.* Milan, 1945.

CALABI, E. *La pittura di Brescia nel Seicento e Settecento.* Catalogo. Brescia, 1935.

Still very useful.

COLOMBO, S. *Profilo della architettura religiosa del Seicento. Varese e il suo territorio.* Milan, 1970.

Scholarly publication that focuses on important, scarcely studied buildings.

DEL FRATE, C. *S. Maria del Monte sopra Varese.* Varese, 1933.

Full monograph on the 'Sacro Monte'.

GATTI PERER, M. L. (ed.). *Il Duomo di Milano. Atti Congresso Internazionale.* 2 vols. Milan, 1969.

With important contributions to the sculpture and the planning of the façade in the Baroque period.

GRASSI, L. *Province del barocco e del rococò. Proposta di un lessico bio-bibliografico di architetti in Lombardia.* Milan, 1966.

Dictionary of architects working in Lombardy between the late sixteenth and the second half of the eighteenth century. First-rate.

HOFFMANN, H. 'Die Entwicklung der Architektur Mailands von 1550–1650', *Wiener Jahrb.*, IX (1934).

One of the few satisfactory studies of Milanese architecture.

LONGHI, R., CIPRIANI, R. and TESTORI, G. *I pittori della realtà in Lombardia.* Catalogo. Milan, 1953.

Important catalogue. Full bibliographies.

LONGHI, R. 'Dal Moroni al Ceruti', *Paragone*, IV (1953), no. 41.

MAZZINI, F. *Mostra di Fra Galgario e del Settecento in Bergamo.* Catalogo. Milan, 1955.

With full bibliography.

NICODEMI, G. *Pittori lombardi* (Bibl. d'arte illustrata). Rome, 1922.

Limited usefulness.

Storia di Milano. Milan, vol. X 1957; XI, 1958; XII, 1959.

The three volumes contain the most up-to-date history of Milanese art during the Baroque period. X, part iv: P. Mezzanotte, Milanese architecture to the mid seventeenth century; part vi: G. A. Dell'Acqua, Milanese painting to 1630; part vii: G. Nicodemi, Sculpture to 1630.

XI, part viii: Mezzanotte, Architecture from Ricchino to Ruggeri; part ix, x: Nicodemi, Painting and Sculpture 1630–1706. XII is concerned with the eighteenth century. Part ix: Mezzanotte, Architecture; parts x, xi: A. M. Romanini, Painting and Sculpture. The section on painting, in particular, is the result of a great deal of new research.

TESTORI, G. *Mostra del manierismo piemontese e lombardo del Seicento.* Turin, 1955.
Concerned with the masters of the early seventeenth century including Del Cairo. Bibliography.

VIGEZZI, S. *La scultura lombarda nell'età barocca.* Milan. 1930.
General, but the only book on the subject.

WITTKOWER, R. *Gothic versus Classic: Architectural Projects in Seventeenth-Century Italy.* New York and London, 1974.
On baroque plans for the façades of Bologna, Florence, and especially Milan cathedrals.

NAPLES AND THE SOUTH

Atti del IX Congresso Nazionale di storia dell' architettura. Rome, 1959.
Contains papers by B. Calza, 'Il Barocco salentino'; G. Bresciani Alvarez, 'Accostamenti e proposte per un'impostazione critica dell' architettura Leccese'; M. Calvesi, 'Influenze napoletane e siciliane sull'architettura barocca del Salento'; M. Manieri Elia, 'Il Barocco Salentino nel suo quadro storico'.

BLUNT, A. *Neapolitan Baroque and Rococo Architecture.* London, 1975.

BLUNT, A. *Sicilian Baroque.* New York, 1968.

BOLOGNA, F., and DORIA, G. *Mostra del ritratto storico napolitano.* Naples, 1954.

BRIGGS, M. S. *In the Heel of Italy.* London, 1910.

CALVESI, M., and MANIERI-ELIA, M. *Architettura barocca a Lecce e in terra di Puglia.* Rome, 1971.
First full modern study of Apulian Baroque; excellent illustrations; bibliography.

CARPEGNA, N. DI. *Pittori napolitani del '600 e del '700.* Catalogue. Rome, 1958.
Exhibition in the Palazzo Barberini. Good biographical notes and bibliography.

CAUSA, R. *Mostra dei bozzetti napoletani del '600 e del '700.* Catalogue. Naples, 1947.

CAUSA, R. *La Madonna nella pittura del '600 a Napoli.* Catalogue (with bibliography). Naples, 1954.

CAUSA, R. *Pittura napoletana dal XV al XIX secolo.* Bergamo, 1957.
An excellent survey, with full bibliography.

CAUSA, R. 'La pittura del seicento a Napoli dal naturalismo al barocco', *Storia di Napoli*, V, 2 (1972).

CECI, G. 'Notizie e documenti su artisti napolitani', *Archivi*, IV (1937).

CELANO, C. *Notizie del bello dell'antico e del curioso della città di Napoli.* Naples, 1856–60 (first ed. 1692).
Most important Neapolitan guide-book.

CHIERICI, G. 'Architettura religiosa a Napoli nei secoli XVII e XVIII', *Palladio*, I (1937).

CONSTABLE, W. G. 'C. Bonaria and some Painters of Vedute in Naples', *Essays in Honor of Georg Swarzenski.* Chicago, 1952.

D'ELIA, M. *Mostra dell'arte in Puglia dal tardo antico al Rococò.* Rome, 1964.
Important for Baroque painters working in Apulia.

DE RINALDIS, A. *Neapolitan Painting of the Seicento.* New York, 1929.
Rhetorical.

GILBERT, C. *Baroque Painters of Naples.* Catalogue. Sarasota, Florida, 1961.
An interesting catalogue; many pictures from American collections.

HAUTECŒUR, L. 'Les arts à Naples au XVIIIe siècle', *G.d.B.A.*, 4 pèr., V (1911).

MANCINI, F. *Scenografia napoletana dell' età barocca.* Naples, 1964.
A scholarly work that breaks much new ground.

ORTOLANI, S., LORENZETTI, C., and BIANCALE, M. *Mostra della pittura napoletana dei secoli XVII–XVIII–XIX.* Naples, 1938.
The best comprehensive history of Neapolitan painting before Causa's book.

PANE, R. *Napoli imprevista.* Turin, 1949.

PANE, R. *Ville vesuviane del settecento.* Naples, 1959.
Rich material concerning very little known and rapidly disappearing buildings. Contributions by several authors.

PROTA-GIURLEO, U. *Pittori napoletani del Seicento.* Naples, 1913.
Biographical, based on documents.

SCHIPA, M. *Il regno di Napoli al tempo di Carlo di Borbone.* Milan, 1923.

SITWELL, S. *Southern Baroque Art.* London, 1924.

VITZTHUM, W. *Disegni napoletani del Sei- e Settecento.* Catalogue. Naples, 1966.
A pioneering enterprise.
See also *idem, Cento disegni napolitani*, Florence, 1967 (Uffizi Exhibition), and *idem* and C. Monbeig-Goguel, *Le dessin à Naples du XVI au XVIIIe siècle*, Louvre, Paris, 1967.

VITZTHUM, W., and CAUSA, R. *Disegni napoletani del Sei- e del Settecento.* Rome, 1970.

Exhibition of 80 drawings in the Palazzo Barberini, partially identical with those exhibited at Naples, 1966.

ROME

BLUNT, A., and COOKE, H. L. *The Roman Drawings of the XVII and XVIII Centuries at Windsor Castle.* London, 1960.

BONNEFOY, Y. *Rome 1630. L'horizon du premier baroque.* Paris, 1970.
Attempt at sketching contemporary events in Rome about 1630 with special emphasis on the French contribution.

BOSTICCO, S. (and others). *Piazza Navona, Isola dei Pamphilj.* Rome, 1970.
A monumental work with excellent photographs by L. von Matt. Of special value the sections on the painted decoration of the Palazzo Pamphili, by D. Redig de Campos.

BRIGANTI, G. *I Bamboccianti. Pittori della vita popolare nel Seicento.* Catalogue. Rome, 1950.
Concerned almost entirely with Rome. Fully documented.

BRIGANTI, G. *Il Palazzo del Quirinale.* Rome, 1962.
Documented and fully illustrated. Particularly important for the fresco decorations.

BRUHNS, L. 'Das Motiv der ewigen Anbetung in der römischen Grabplastik des 16., 17. und 18. Jahrhunderts', *Röm. Jahrb. f. Kunstg.,* IV (1940).
An important publication.

BRUHNS, L. *Die Kunst der Stadt Rom.* Vienna, 1951.
With good chapters on the Baroque city.

CARPEGNA, N. di. *Paesisti e vedutisti a Roma nel '600 e nel '700.* Catalogue. Rome, 1956.

CHAPPELL, M. L., and KIRWIN, C. W. 'A Petrine Triumph: The Decoration of the Navi Piccole in San Pietro under Clement VIII', *Storia dell'Arte,* XXI (1974), 119–70.
On altarpieces by Laureti, Cigoli, Roncalli, Passignano, and Baglione. New documents and interpretation.

CHIARINI, M. *Paesisti bamboccianti e vedutisti nella Roma seicentesca.* Florence, 1967.
Catalogue of 53 paintings, originally Medici property, now Palazzo Pitti.

CHYURLIA, R. 'Di alcune tendenze della scultura settecentesca a Roma e Carlo Monaldi', *Commentari,* I (1950).

COLASANTI, A. *Case e palazzi barocchi di Roma.* Milan, 1913.

DE RINALDIS, A. *L'arte in Roma dal Seicento al Novecento.* Bologna, 1948.
Controversial; full bibliography.

DONATI, U. *Artisti ticinesi a Roma.* Bellinzona, 1942.
Interesting illustrations; little original research; extensive bibliographies.

D'ONOFRIO, C. *Le Fontane di Roma.* Rome, 1957.
Much new documentary material. The basic work to be consulted for Roman fountains.

D'ONOFRIO, C. *Roma vista da Roma.* Rome, 1967.
See BERNINI.

D'ONOFRIO, C. *Roma nel Seicento: 'Roma ornata dall'Architettura, Pittura e Scoltura' di Fioravante Martinelli.* Florence, 1969.
Publication of the manuscript (Bibl. Casanatense 4984) of a Roman guidebook by Martinelli written between 1660 and 1663; with notes by Borromini, who 'edited' the text for his friend M.

DREYER, P. *Römische Barockzeichnungen.* Berlin-Dahlem, 1969.
Catalogue of 150 Berlin drawings dating mainly between 1650 and 1750.

EIMER, G. *La Fabbrica di S. Agnese in Piazza Navona.* 2 vols. Stockholm, 1970 and 1971.
A standard publication with much new material for Rainaldi and Borromini.

ELLING, C. 'Function and Form of the Roman Belvedere', *Det. Kgl. Danske Videnskab. Selskab. Arkaeol.-Kunsth. Meddel.,* Kopenhagen, III, no. 4 (1950).

ELLING, C. *Rom. Arkitekturens Liv fra Bernini til Thorvaldsen.* Gyldendal, 1956. Eng. transl. by B. and I. Gosney. Boulder, Colorado, 1975.
The first comprehensive treatment of Rome's architecture of this period.

ENGGASS, R. *Early Eighteenth-Century Sculpture in Rome: An Illustrated Catalogue Raisonné.* University Park, Penn., 1976.

ESCHER, K. *Barock und Klassizismus. Studien zur Geschichte der Architektur Roms.* Leipzig, 1910.

FASOLO, F. *Le chiese di Roma nel '700. 1: Trastevere.* Rome, 1949.
The volume, which had no sequel, contains much documentary material for minor eighteenth-century churches and artists.

FASOLO, V. 'Classicismo romano nel Settecento', *Quaderni* (1953), no. 3.

FOKKER, T. H. *Roman Baroque Art. The History of a Style.* Oxford, 1938.
A cumbersome study, biased and difficult to read.

FRANCK, C. *Die Barockvillen in Frascati.* Munich-Berlin, 1956.

FREY, D. 'Beiträge zur Geschichte der römischen Barockarchitektur', *Wiener Jahrb.,* III (1924).
Important.

GERLINI, E. *Piazza Navona. Catalogo.* Rome, 1943. With contributions, among others, by G. Matthiae and R. Battaglia.

GLOTON, M. C. *Trompe-l'œil et décor plafonnant dans les églises romaines de l'âge baroque.* Rome, 1965.

GOLZIO, V. 'Pitture e sculture nella chiesa di S. Agnese a Piazza Navona', *Archivi,* I (1933–4). Documents.

HAGER, H. 'Zur Planungs- und Baugeschichte der Zwillingskirchen auf der Piazza del Popolo', *Röm. Jahrb. f. Kunstg.,* XI (1967–8), 191 ff.
A most detailed monographic treatment with new archival material.

HAUTECŒUR, L. *Rome et la renaissance de l'antiquité à la fin du XVIIIᵉ siècle.* Paris, 1912.
Review by H. Tietze in *Kunstgeschichtliche Anzeigen,* 1912.

HESS, J. *Kunstgeschichtliche Studien zu Renaissance und Barock.* 2 vols. Rome, 1967.
Collection of widely dispersed papers written over a period of 40 years and concerning mainly the Early Baroque in Rome.

HIBBARD, H. *The Architecture of the Palazzo Borghese.* Rome, 1962.
Richly documented. Important for early-seventeenth-century architecture in Rome.

HIBBARD, H. *Boll. d'Arte,* LII (1967), 99 ff.
177 documents from the Archivio Storico Capitolino referring to Roman buildings between 1586–9 and 1602–34.

HIBBARD, H. 'Recent Books on Earlier Baroque Architecture in Rome', *Art. Bull.,* LV (1973), 127–34.

JÜRGENS, R. *Die Entwicklung des Barockaltars in Rom.* Dissertation. Hamburg, 1956.

KRAUTHEIMER, R., and JONES, R. B. S. 'The Diary of Alexander VII. Notes on Art, Artists, and Buildings', *Röm. Jahrb. f. Kunstg.,* XV (1975), 199–225.

LAVAGNINO, E., ANSALDI, G. R., and SALERNO, L. *Altari barocchi in Roma.* Rome (Banco di Roma), 1959.
Splendid publication with colour plates.

LOTZ, W. 'Die Spanische Treppe als Mittel der Diplomatie', *Röm. Jahrb. f. Kunstg.,* XII (1969), 39 ff.
The final word on the Spanish stairs, with complete documentation.
See also T. A. Marder, *Art Bull.,* LXII (1980), 286 ff.

MAGNI, G. *Il barocco a Roma nell'architettura e nella scultura decorativa.* Turin, 1911–13.
Still invaluable for the many excellent plates.

MAHON, D., and SUTTON, D. *Artists in 17th Century Rome.* Exhibition, Wildenstein. London, 1955.

MALLORY, N. 'Notizie sulla scultura a Roma nel XVIII secolo (1719–1760)', *Boll. d'Arte,* LIX (1974),

164 ff., and 'Notizie sulla pittura a Roma nel XVIII secolo (1718–1760)', *ibid.,* LXI (1976), 102 ff.

MARDER, T. A., 'The Porto di Ripetta in Rome', *Journal of the Society of Architectural Historians,* XXXIX (1980), 28 ff.

MISSIRINI, M. *Memorie per servire alla storia della romana Accademia di S. Luca.* Rome, 1823.

MOLA, G. B. 'Breve racconto delle miglior opere ...', in *Quellen und Schriften für bildende Kunst,* I. Ed. K. Noehles, Berlin, 1966.

Mostra di Roma secentesca. (A cura dell'Istituto di studi Romani). Rome, 1930.
Catalogue of 871 exhibits.

MUÑOZ, A. *Roma barocca.* Milan, 1928.

NOACK, F. 'Kunstpflege und Kunstbesitz der Familie Borghese', *Rep. f. Kunstw.,* L (1929).

OZZOLA, L. 'Le rovine romane nella pittura del XVII e XVIII secolo', *L'Arte,* XVI (1913).

PASTOR, L. VON. *Geschichte der Päpste.* Freiburg im Breisgau, 1901 ff. (also English ed.).
The seventeenth-century popes begin with vol. XIII. The chapters on their patronage are indispensable.

PECCHIAI, P. *La scalinata di Spagna e Villa Medici.* Rome, 1941.
With rich documentation.

PORTOGHESI, P. *Roma barocca. Storia di una civiltà architettonica.* Rome, 1966.
A most ambitious enterprise with almost 500 illustrations, pursuing the story to the late eighteenth century, attending to general viewpoints as much as to the work catalogues of individual architects.

PUYVELDE, L. VAN. *La peinture flamande à Rome.* Brussels, 1950.

RÉAU, L. 'Les sculpteurs français à Rome', *Bull. de la société de l'histoire et de l'art français,* année 1933.
With a catalogue of works.

RICCOBONI, A. *Roma nell'arte. La scultura nell'evo moderno.* Rome, 1942.
Œuvre catalogues of all Roman Baroque sculptors.

SALERNO, L. *Piazza di Spagna.* Naples, 1967.

Il Settecento a Roma. Catalogue. Rome, 1959.

SPEAR, R. *Renaissance and Baroque Paintings from the Sciarra and Fiano Collections.* London, 1972.

TITI, F. *Descrizione delle pitture, sculture e architetture esposte al pubblico in Roma.* Rome, 1763.
Still the best guide to Baroque works of art in Rome.

Via del Corso. Rome (Cassa di Risparmio), 1961.

VOSS, H. *Die Malerei des Barock in Rom.* Berlin, 1924.
The basic study without which no work in the field can be undertaken.

WATERHOUSE, E. *Baroque Painting in Rome. The Seventeenth Century.* Oxford, 1976.
Revision of classic lists of 1937; Lanfranco is omitted.

ZOCCA, M. *La cupola di S. Giacomo in Augusta e le cupole elittiche in Roma.* Rome, 1945.

SICILY

ACCASCINA, M. *Profilo dell'architettura a Messina dal 1600 al 1800.* Rome, 1964.
Basic study.

AGNELLO, G. 'Preliminari della storia dell'architettura barocca a Siracusa', *Boll. Stor. Catanese*, XI–XII (1947–8).

AGNELLO, G. 'Architetti ignorati del Settecento a Siracusa', *Arch. Stor. per la Sicilia orientale*, IV (1951).
Documents.

Atti del VII Congresso Nazionale di storia dell'architettura. Palermo, 1956.
Contains papers by S. Caronia Roberti (historiography of Sicilian Baroque studies); R. Guccione Scaglione (extensive bibliography for Sicilian Baroque); G. Di Stefano (drawings by Palermitan architects with full bibliographical references).

BLUNT, A, *Sicilian Baroque.* London, 1968.
The best study of Sicilian architecture. Good illustrations. Bibliography. Review D. M. Smith, *Burl. Mag.*, CXI (1969), 569 ff.

BOTTARI, S. *La cultura figurativa in Sicilia.* Messina-Florence, 1954.
Pp. 71–90. The Baroque period.

BOTTARI, S. 'Contributi alla conoscenza dell'architettura del '700 in Sicilia', *Palladio*, VIII (1958).
Important study for the south-eastern part of the island.

CALANDRA, E. *Breve storia dell'architettura in Sicilia.* Bari, 1938.
Best survey.

CARONIA ROBERTI, S. *Il Barocco in Palermo.* Palermo, 1935.
Unsatisfactory.

CHASTEL, A. 'Notes sur le baroque méridional', *Revue des sciences humaines*, fasc. 55–56 (1949).

DE SIMONE, M. *Ville palermitane dei sec. XVII e XVIII.* Genoa, 1968.

EPIFANIO, L. *Schemi compositivi dell'architettura sacra palermitana del Seicento e del Settecento.* Palermo, 1950.

FICHERA, F. *G. B. Vaccarini e l'architettura del Settecento in Sicilia.* Rome, 1934.

Text difficult to use. Large corpus of illustrations.

GANGI, G. *Il Barocco nella Sicilia orientale.* Rome, 1964.
Good photographs.

LOCHMEYER, K. *Palagonisches Barock.* Frankfurt, 1943.
Questionable hypotheses on connexion with German rococo.

LO JACONO, G. *Studi e rilievi di palazzi palermitani dell'età barocca.* Palermo, 1962.
Plans and elevations of eight palaces.

LO MONACO, I. DI. *Pittori e scultori siciliani dal Seicento al primo Ottocento.* Palermo, 1940.
Reliable dictionary; extensive bibliographies.

MELI, F. 'Degli architetti del senato di Palermo nei secoli XVII e XVIII', *Arch. storico per la Sicilia*, IV–V (1938–9).
Important. Documents.

MINISSI, F. *Aspetti dell'architettura religiosa del Settecento in Sicilia.* Rome, 1958.
Plans and photographs of churches in provincial towns. Bibliography.

PISANI, N. *Barocco in Sicilia.* Syracuse, 1958.
A weak work.

POLICASTRO, G. *Catania nel Settecento.* Catania, 1950.

ZANCA, A. *La cattedrale di Palermo.* Palermo, 1952.

ZIINO, V. *Contributi allo studio dell'architettura del '700 in Sicilia.* Palermo, 1950.
Mainly concerned with villas. Important study.

TURIN AND PIEDMONT

BAUDI DI VESME, A. 'L'arte negli stati sabaudi', *Atti d. Società Piemontese di archeologia e belle arti*, 1932.

BENEVOLO, L. 'L'architettura della Valsesia superiore durante l'età barocca', *Palladio*, N.S. III (1953); also *Quaderni*, nos 22–4 (1957).
Competent survey of buildings in the valleys west of Varallo.

BERNARDI, M. *La Palazzina di Caccia di Stupinigi.* Turin, 1958.

BERNARDI, M. *Il Palazzo Reale di Torino.* Turin, 1959.

BERNARDI, M. *Il Sacro Monte di Varallo.* Turin, 1960.

BERNARDI, M. *Tre palazzi a Torino.* Turin, 1963.
Palazzi Carignano and dell'Accademia Filarmonica and Villa della Regina. All these publications with scholarly texts and excellent reproductions.

BRAYDA, C., COLI, L., and SESIA, D. 'Ingegneri e architetti del Sei e Settecento in Piemonte', *Atti e Rassegna tecnica della Società degli ingegneri e architetti in Torino*, XVII (1963).
Appeared also as a separate publication. 731 names with brief biographies and chronological œuvre catalogues. Extremely useful.

BRINCKMANN, A. E. *Theatrum Novum Pedemontii.* Düsseldorf, 1931.
Baroque architecture in Piedmont. Indispensable.

BRINCKMANN, A. E. *Von Guarino Guarini bis Balthasar Neumann.* Berlin, 1932.

BRIZIO, A. M. *L'architettura barocca in Piemonte.* Turin, 1953.

CARBONERI, N. 'Il barocco piemontese', *Barocco europeo, Barocco italiano, Barocco salentino*, 281–7. Lecce, 1971.

CAVALLARI-MURAT, A. (ed.). *Forma urbana ed architettura nella Torino barocca.* 3 vols. 1968–.
Includes hundreds of documents and transcriptions of building edicts as well as original drawings and maps.

CHEVALLEY, G. *Gli architetti, l'architettura e la decorazione delle ville piemontesi nel XVIII secolo.* Turin, 1912.

Congrès archéologique du Piémont.
The proceedings of the 129th French Archaeological Congress (held in 1971 and published in 1978) contain numerous papers covering many aspects of architecture and planning in Piedmont in the seventeenth and eighteenth centuries.

DE ROSSI, O. *Nuova guida per la città di Torino.* Turin, 1781.
The best guide-book.

GALLONI, P. *Il Sacro Monte di Varallo.* Varallo, 1909–14.
Basic study.

MALLÉ, L. *Le arti figurative in Piemonte.* Turin (n.d., 1961/2).
A comprehensive up-to-date survey in considerable detail, without notes but with extensive bibliography.

MALLÉ, L. *Palazzo Madama in Torino.* 2 vols. Turin, 1970.

MARINI, G. L. *L'architettura barocca in Piemonte.* Turin, 1963.
A not always reliable, but nevertheless useful survey, with bibliography. Review by H. A. Millon, in *Art Bull.*, XLVII (1965), 532.

OLIVERO, E. *La chiesa di S. Francesco di Assisi in Torino e le sue opere d'arte.* Chieri, 1935.

Contains much biographical and documentary material on many Piedmontese artists.

OLIVERO, E. *Miscellanea di architettura piemontese del Settecento.* Turin, 1937.

PASSANTI, M. *Architettura in Piemonte.* Turin, 1945.

PEDRINI, A. *Ville dei secoli XVII e XVIII in Piemonte.* Turin, 1965.
Most valuable material, especially the illustrations.

PEYROT, A. *Torino nei secoli.* 2 vols. Turin, 1965.
A useful, fully illustrated catalogue of maps and views of Turin.

POMMER, R. *Eighteenth-Century Architecture in Piedmont.* New York–London, 1967.
An industrious, useful study with much new archival material, especially for Juvarra and Vittone, and with challenging and controversial ideas.

RESSA, A. 'L'architettura religiosa in Piemonte nei secoli XVII e XVIII', *Torino*, XIX (1941).
A good collection of plans.

ROSSO, L. *La pittura e la scultura del '700 a Torino.* Turin, 1934.

TAMBURINI, L. *Le chiese di Torino dal rinascimento al barocco.* Turin, 1968.
An excellent critical study.

TESTORI, G. *Mostra del manierismo piemontese e lombardo del Seicento.* Turin, 1955.

TESTORI, G. *Manieristi piemontesi e lombardi del '600.* Milan, 1967.
Discusses painters from Moncalvo to Francesco del Cairo, with emphasis on Cerano and Morazzone.

VIALE, V. 'La pittura in Piemonte nel Settecento', *Torino*, XX (1942).
An excellent survey of eighteenth-century painting in Piedmont.

VIALE, V. *Mostra del barocco piemontese. Catalogo.* 3 vols. Turin, 1963.
An indispensable work, with rich bibliographies. Collaborators: M. Bernardi, N. Carboneri, M. Viale Ferrero, A. Griseri, L. Mallè.

VENICE AND THE VENETO

ARSLAN, E. 'Studi sulla pittura del primo Settecento veneziano', *Critica d'Arte*, I (1935–6).

BARBIERI, F., CEVESE, R., and MAGAGNATO, L. *Guida di Vicenza.* Vicenza, 1956.
A model guide-book, with full bibliography.

BASSI, E. *Architettura del Sei- e Settecento a Venezia.* Naples, 1962.

Standard work, superseding most previous studies of Venetian Baroque architecture.

BETTAGNO, A. *Disegni veneti del settecento della Fondazione G. Cini.* Venice, 1963.

The latest of a series of books concerning Venetian drawings; the previous volumes by M. Muraro, K. T. Parker, M. Mrozinska, and A. Morassi discuss the drawings in the Janos Scholz and Paul Wallraf Collections and in Oxford and Poland.

BLUNT, A., and CROFT-MURRAY, E. *Venetian Drawings of the XVII and XVIII Centuries ... at Windsor Castle.* London, 1957.

BRUNELLI, B., and CALLEGARI, A. *Ville del Brenta e degli Euganei.* Milan, 1931.

A splendid publication.

DAMERINI, G. *I pittori veneziani del '600 e '700.* Bologna, 1928.

Unsatisfactory; see review N. Pevsner, *Göttinger Gel. Anzeigen,* 1929.

DELOGU, G. *Pittori veneti minori del Settecento.* Venice, 1930.

Still indispensable.

DONZELLI, C. *I pittori veneti del Settecento.* Florence, 1957.

With *œuvre* catalogues and full bibliographies.

DONZELLI, C., and PILO, G. M. *I pittori del Seicento veneto.* Florence, 1967.

270 artists are discussed in dictionary form.

FIOCCO, G. *La pittura veneziana del Seicento e del Settecento.* Verona, 1929 (also English ed., Florence–Paris).

The basic study, summarizing previous research.

FOGOLARI, G. 'L'Accademia veneziana di pittura e scultura del '700', *L'Arte,* XVI (1913).

GARAS, K. 'Allegorie und Geschichte in der venezianischen Malerei des 18. Jahrhunderts', *Acta Historiae Artium,* XI (1965), 275 ff.

GIOSEFFI, D. *Pittura veneziana del Settecento.* Bergamo, 1956.

GOERING, M. 'Paolo Veronese und das Settecento', *Jahrb. Preuss. Kunstslg.,* LXI (1940).

HEINZ, G. 'Studien zu den Quellen der dekorativen Malerei im Venezianischen Settecento', *Arte Veneta,* X (1956).

LEVEY, M. *Painting in XVIII Century Venice.* London, 1959.

A general, very readable introduction. G. M. Pilo's condemning review in *Arte Veneta,* XIII–XIV (1959–60), 250, is not quite justified.

LONGHI, R. *Viatico per cinque secoli di pittura veneziana.* Florence, 1946.

LORENZETTI, G. *Le feste e le maschere veneziane.* Venice, 1937.

Catalogue. An important contribution.

LORENZETTI, G. *Venezia e il suo estuario.* Rome, 1956.

The best Venetian guide-book.

MARTINI, E. *La pittura veneziana del Settecento.* Venice, 1964.

Written by a restorer who has an excellent knowledge of Venetian painting.

MAZZOTTI, G., and others. *Le ville venete.* Treviso, 1954. Second ed., 1967.

About a thousand villas are listed and described; full bibliographies.

NOVELLO, A. ALPAGO. *Ville della provincia di Belluno.* Venice, 1968.

PALLUCCHINI, R. *Gli incisori veneti del Settecento.* Venice, 1941.

PALLUCCHINI, R. *La pittura veneziana del '700.* Bologna, 1951–2.

Important publication, based on courses of lectures. The content of this work was incorporated into the next item.

PALLUCCHINI, R. *La pittura veneziana del Settecento.* Venice, 1960.

Standard work. Must be consulted for all painters of the Venetian eighteenth century. Bibliographies only up to 1957/8.

La pittura del Seicento a Venezia. Catalogo. Venice, 1959.

Authors: P. Zampetti, G. Mariacher, G. M. Pilo. The first exhibition devoted to the Venetian seventeenth century. Extensive catalogue with full bibliography. The controversial nature of some of the pictures shown is reflected in the reviews; see, above all, B. Nicolson, *Burl. Mag.,* CI (1959), 286, and A. Morassi, *Arte Veneta,* XIII–XIV (1959–60), 269.

PRECERUTTI GARBERI, M. *Affreschi settecenteschi delle ville venete.* Milan, 1968. English ed., London, 1971.

The first coherent study of this important subject. Contains many unpublished fresco cycles.

RIZZI, A. *Storia dell'arte in Friuli. Il Seicento.* Udine, 1969.

RIZZI, A. *Storia dell'arte in Friuli. Il Settecento.* Udine, 1967.

Although the names of artists discussed in these two volumes are predominantly Venetian, they contain much unknown or scarcely known material.

RIZZI, A. *Mostra della pittura veneta del Settecento in Friuli.* Udine, 1966.

RIZZI, A. *Mostra della pittura veneta del Seicento in Friuli.* Udine, 1968.

Two excellent catalogues; both exhibitions contained many unpublished paintings by such artists as Bombelli, Carneo, Celesti, Cosattini, Maffei, Mazzoni, Fontebasso, Grassi, *et al.*

ROBINSON, F. W. 'Rembrandt's Influence in Eighteenth Century Venice', *Nederlands Kunsthistorisch Jaarboek*, XVIII (1967), 167 ff.

So far the fullest investigation of this important question.

ROSAND, D. 'The Crisis of the Venetian Renaissance Tradition', *L'Arte*, nos. 11–12 (1970), 5 ff.

A brilliant study.

RUGGIERI, U. *Disegni piazzatteschi. Disegni inediti di raccolte bergamasche.* Bergamo, 1968.

Publishes a large group of drawings by Giulia Lama; also drawings by such minor artists as Francesco Migliori.

SEMENZATO, G. *La scultura veneta del Seicento e del Settecento.* Venice, 1966.

The first systematic attempt to master the *terra incognita* of Venetian Baroque sculpture: biographies and *œuvre* catalogues.

TEMANZA, T. *Zibaldon.* Ed. N. Ivanoff. Venice–Rome, 1963.

Many of Temanza's notes are a primary source, particularly for minor Baroque artists in Venice.

VALCANOVER, F. *Mostra di pitture del Settecento nel Bellunese.* Venice, 1954.

With bibliography.

VALSECCHI, M. *Venezia 700.* Bergamo, 1969.

A Gallery Lorenzetti Exhibition of eighteenth-century Venetian painting in Bergamo private collections.

VOSS, H. 'Studien zur venezianischen Vedutenmalerei des 18. Jahrhunderts', *Rep. f. Kunstw.*, XLVII (1926).

WATSON, F. J. B. *Eighteenth Century Venice, An Exhibition.* London, 1951.

See R. Pallucchini, *Arte Veneta*, V (1951).

ZAMPETTI, P. *I vedutisti veneziani del Settecento.* Venice, 1967.

Critical catalogue of the extensive Venice Exhibition, with over 30 pp. of bibliography. See also R. Pallucchini, in *Atti dell'Istituto veneto di scienze, lettere ed arti*, Classe di scienze morali, lettere ed arti, CXXV (1966–7), 397 ff.; G. M. Pilo, in *Arte Veneta*, XXI (1967), 269 ff.; R. Longhi, in *Paragone*, XIX (1968), no. 217, 37 ff.

ZAMPETTI, P. *Dal Ricci al Tiepolo. I pittori di figura del Settecento a Venezia.* Venice, 1969.

This Exhibition did not have an enthusiastic reception, but was illuminating for such artists as Bencovich, Grassi, Diziani, and Fontebasso. Even for the major masters the contribution of the Exhibition was considerable.

IV. ARTISTS

ALBANI

Bodmer, H., in *Pantheon*, XVIII (1936).

Frescoes in the Palazzo Verospi.

Boschetto, A., in *Proporzioni*, II (1948).

Unreliable.

Harris, A. S., in *Master Drawings*, VII (1969), 152 ff.

Publications of chalk drawings by Albani.

Van Schaack, E. 'Un'opera tarda di F.A.', *Arte Antica e Moderna*, no. 21 (1963), 49.

See also *idem*, 'An Unpublished Letter by F.A.', *Art Bull.*, LI (1969), 72.

ALFIERI

Bellini, A. *Benedetto Alfieri.* Milan, 1978.

Chevalley, G. *Un avvocato architetto il conte Benedetto Alfieri.* Turin, 1916.

Rosci, M. 'Benedetto Alfieri e l'architettura del '700 in Piemonte', *Palladio*, N.S. III (1953).

ALGARDI

A monograph by J. Montagu is in an advanced state of preparation.

Cellini, A. Nava. 'L'Algardi restauratore a Villa Pamphilj', *Paragone*, XIV (1963), no. 161.

Cellini, A. Nava. 'Note per l'Algardi, il Bernini, e il Reni', *Paragone*, XVIII (1967), no. 207, 35 ff.

The 'Pallavicini Crucifix' as a work by Algardi.

Heimbürger Ravalli, M. *Alessandro Algardi scultore.* Rome, 1973.

Johnston, C. 'Drawings for Algardi's "Cristo Vivo"', *Burl. Mag.*, CX (1968), 458 ff.

Montagu, J. 'Alessandro Algardi's Altar of S. Nicola da Tolentino and Some Related Models', *Burl. Mag.*, CXII (1970), 282 ff.

Muñoz, A., in *Atti e memorie della R. Accademia di S. Luca.* Annuario 1912.

Muñoz, A. 'Alessandro Algardi ritrattista', *Dedalo*, I (1920).

Pollak, O. 'Alessandro Algardi als Architekt', *Zeitschr. f. Gesch. der Architektur*, IV (1910–11).

Posse, H., in *Jahrb. Preuss. Kunstslg.*, XXV (1905).

Still the basic article on the sculptor.

Raggio, O. 'Alessandro Algardi e gli stucchi di Villa Pamphili', *Paragone* (1971), no. 251, 3 ff.

Vitzthum, W. 'Disegni di Alessandro Algardi', *Boll. d'Arte*, XLVIII (1963).

AMIGONI
Griseri, A., in *Paragone*, XI (1960), no. 123.
Pilo, G. M., in *Arte Veneta*, XII (1958).
Voss, H., in *Jahrb. Preuss. Kunstslg.*, XXXIX (1918).
The pioneering study.

ARIGUCCI
Battaglia, R. 'Luigi Arigucci architetto camerale di Urbano VIII', *Palladio*, VII (1942).

ARPINO
Röttgen, H. *Il Cavalier d'Arpino*. Rome, 1973.
Basic catalogue with important text.

ASSERETO
Castelnovi, G. F., in *Emporium*, CXX (1954).
Grassi, L., in *Paragone*, III (1952), no. 31.
Longhi, R., in *Dedalo*, VII (1926–7).
The basic study.

BACICCIO *see* GAULLI

BADALOCCHIO
Salerno, L., in *Commentari*, IX (1958).

BAGLIONE, G.
Guglielmi, C., in *Boll. d'Arte*, XXXIX (1954).
Longhi, R., in *Paragone*, XIV (1963), no. 163.
Pepper, S., in *Paragone*, XVIII (1967), no. 211.

BALESTRA
Battisti, E., in *Commentari*, V (1954).
With *œuvre* catalogue.

BAMBOCCIO, IL *see* LAER, P. VAN

BARBIERI, G. F. *see* GUERCINO

BASCHENIS
Angelini, L. *I Baschenis*. Bergamo, 1943; 2nd ed., 1946.
Evaristo Baschenis (*1607–1677*). Exhibition Catalogue, Galleria Lorenzelli. Bergamo, 1965.
Geddo, A. *Evaristo Baschenis*. Milan, 1965.
A brief monograph.
See also MILAN AND LOMBARDY, LONGHI a. o., *Mostra*, 1953, under heading CITIES AND PROVINCES.

BATONI
Barsali, I. B. *Mostra di Pompeo Batoni*. Catalogo. Lucca, 1967.
An excellent catalogue with contributions by A. M. Clark, A. Marabottini, F. Haskell, I. Belli Barsali, and a dossier of 65 Batoni letters.
A. Busiri Vici, *Le 'donne' del Batoni*, Lucca, 1968, contains reprints of all the reviews of the Exhibition.
Borelli, E. *Pompeo Batoni* (*1708–1787*). Lucca, 1967.
A brief but excellent study.
Chyurlia, R., in *Emporium*, CXVII (1953).
Clark, A. M., in *Burl. Mag.*, CI (1959).
Cochetti, L., in *Commentari*, III (1952).
Emmerling, E. *Pompeo Batoni*. Darmstadt, 1932.

BAZZANI
Ivanoff, N. *Mostra del Bazzani in Mantova*. Bergamo, 1950.
Full documentation, *œuvre* catalogue and bibliography.
Tellin, C. Perina. 'Precisazioni sul Bazzani', *Arte Lombardo*, XIII, ii (1968), 103 ff.

BEAUMONT
Griseri, A., in *Scritti vari*, II (1951) (a cura della Facolta di Magistero di Torino).
Mainly on the early work.
Zucchi, M. *La vita e le opere di Cl. Fr. Beaumont*. Turin, 1921.

BELLOTTO
Bernardo Bellotto genannt Canaletto in Dresden und Warschau. Exhibition Catalogue. Dresden, 1963.
Review J. Bialostocki, *Burl. Mag.*, CVI (1964), 289 f.; S. Kozakiewicz, *Bulletin du Musée National de Varsovie*, VI (1965), 17 ff.
See also the Catalogue of the Bellotto Exhibition in Vienna in 1965, with Introduction by V. Oberhammer.
Europäische Veduten des Bernardo Bellotto. Exhibition. Villa Hügel, Essen, 1966.
62 paintings and 65 drawings; bibliography of previous Bellotto exhibitions.
Fritzsche, H. A. *Bernardo Bellotto*. Burg, 1936.
Kozakiewicz, S. *Bernardo Bellotto*. 2 vols. 1969.
First vol. biographical, second *œuvre* catalogue.
Lorentz, S., and Kozakiewicz, S. *Mostra di Bernardo Bellotto 1720–80. Opere provenienti della Polonia*. Exhibition, Venice, 1955.
An almost identical exhibition (with Catalogue in English) at the Walker Art Gallery, Liverpool, 1957.

Wallis, M. *Canaletto, the Painter of Warsaw*. Warsaw, 1954.
> A monograph on Bellotto's Polish views.

BENCOVICH
Goering, M., in *Critica d'Arte*, II (1937).
Pallucchini, R., in *Riv. d'Arte*, XIV (1932), with *œuvre* catalogue, and *Critica d'Arte*, I (1935–6), III (1938).

BENEFIAL
Falcidia, G., in *Boll. d'Arte*, XLVIII (1963).

BERNINI, G. L.
> The Bernini literature is steadily growing. To supplement the list below the following may be summarily mentioned: 1957: O. P. Berendson, *Marsyas*, VIII; R. Enggass, *Art Bull.*; E. Sestieri, *Commentari*. 1958: E. Battisti, *ibid.*; C. Gould, *Art Quarterly*. 1959: F. Zeri, *Paragone*, no. 115. 1960: A. J. Braham, *Burl. Mag.* 1961: M. V. Brugnoli and I. Faldi, *Arte Antica e Moderna*. 1962: P. della Pergola, *Capitolium*, no. 11. 1963; G. Matzulevitsch, *Boll. d' Arte*.
Baldinucci, F. *Vita di Gian Lorenzo Bernini*. Florence, 1682. Modern ed. by Sergio Samek Ludovici, Milan, 1948.
> Main source for Bernini's life.
Bernini, D. *Vita del Cav. Gio. Lorenzo Bernini*. Rome, 1713.
> Written by the artist's son Domenico.
Bernini, G. L. *Fontana di Trevi, Commedia inedita*. Introduction and commentary by C. d'Onofrio. Rome, 1963.
> Review by I. Lavin, *Art Bull.*, XLVI (1964), 568 ff.
Brauer, H., and Wittkower, R. *Die Zeichnungen des Gianlorenzo Bernini*. Berlin, 1931.
Chantelou, M. de. *Journal du voyage du Cav. Bernin en France* (ed. Lalanne). Paris, 1885.
> A contemporary diary, invaluable as a source.
D'Onofrio, C., in *Palatino*, X (1966), 201.
> The author makes it probable that Baldinucci's monograph of Bernini was dependent on that written by Domenico Bernini.
D'Onofrio, C. *Roma vista da Roma*. Rome, 1967.
> Three parts: (i) Maffeo Barberini (later Urban VIII), (ii) Scipione Borghese, (iii) the 'Barraccia' in Piazza di Spagna. The book is almost exclusively concerned with Bernini. The author's attempt to ascribe a number of works of Gianlorenzo's youth to Pietro Bernini will scarcely find wide acceptance, but this book contains many suggestive ideas.

Einem, H. von. 'Bemerkungen zur Cathedra Petri', *Nachrichten der Wissenschaften in Göttingen*. Philol.-Hist. Klasse (1955), no. 4.
Fagiolo dell'Arco, Maurizio and Marcello. *Bernini, Una introduzione al gran teatro del barocco*. Rome, 1967.
> An almost complete, intelligent survey of Bernini's entire activity, based on a remarkable knowledge of the literature; bibliography of almost 700 items.
Fraschetti, S. *Il Bernini*. Milan, 1900.
> Standard work.
Gonzalez-Palacios, A. 'Bernini as a Furniture Designer', *Burl. Mag.*, CXII (1970), 719 ff.
Grassi, L. *Bernini pittore*. Rome, 1945.
> See also *Burl. Mag.*, CVI (1964).
Harris, A. S., in *Master Drawings*, VI (1968), 383 ff.
> Important addition to Bernini's corpus of drawings.
Harris, A. S. *Selected Drawings of Gian Lorenzo Bernini*. New York, 1977.
Hibbard, H., and Jaffe, I. 'Bernini's Barcaccia', *Burl. Mag.*, CVI (1964).
> An exemplary iconographical study. – See also Hibbard, in *Boll. d'Arte*, XLIII (1958) and XLVI (1961).
Hibbard, H. *Bernini*. Harmondsworth, 1965.
> An excellent introduction to B., with learned notes.
Kauffmann, H. *Giovanni Lorenzo Bernini. Die figürlichen Kompositionen*. Berlin, 1970.
> Tendency towards iconographic investigations. The author's earlier Bernini papers are incorporated. See review by H. Hibbard, *Art Quarterly*, XXXVI (1973), 414–16.
Kitao, T. K. 'Bernini's Church Façades: Method of Design and the *Contrapposti*', *Journal Soc. Architect. Historians*, XXIV (1965), 263 ff.
Kruft, H.-W., and Larsson, L. O. 'Entwürfe Berninis für die Engelsbrücke in Rom', *Münchner Jahrb. der bildenden Kunst*, XVII (1966), 145 ff.
Kruft, H.-W., and Larsson, L. O. 'Porträtzeichnungen Berninis und seiner Werkstatt', *Pantheon*, XXVI (1968), 130 ff.
Laurain-Portemer. 'Mazarin et le Bernin à propos du "Temps qui découvre la vérité"', *G.d.B.A.*, LXXIV (1969), 185.
> Important new documents.
Lavin, I. 'Five New Youthful Sculptures by G.L.B. and a Revised Chronology of his Early Works', *Art Bull.*, L (1968), 223 ff.
> Revolutionary discoveries and controversial ideas about chronology.

Lavin, I. *Bernini and the Crossing of Saint Peter's.* New York, 1968.

A full discussion of Bernini's decoration and the stages of its development.

Lavin, I. 'Bernini's Death', *Art Bull.*, LIV (1972), 159–86; LV (1973), 429–36; LX (1978), 548–9.

Lavin, I. *Bernini and the Unity of the Visual Arts.* New York, London, 1980.

Basic for the 1630s and 1640s.

Martinelli, V. *Bernini.* Milan, 1953.

A brief biography.

Martinelli, V. *I ritratti di pontefici di G. L. Bernini.* Rome, 1956; see also *Studi Romani*, III (1955) and *Commentari*, VII (1956), X (1959), XIII (1962).

Montagu, J. 'Two Small Bronzes from the Studio of Bernini', *Burl. Mag.*, CIX (1967), 566 ff.

Petersson, R. T. *The Art of Ecstasy. Teresa, Bernini, and Crashaw.* New York, 1970.

An unusual book in which mystical experience, Baroque art, and poetry are sensitively interpreted.

Pochat, G. 'Über Berninis "Concetto" zum Vierströmebrunnen auf Piazza Navona', *Konsthistorisk Tidskrift*, XXXV (1966), 72 ff.

Interpretation stimulated by H. Kauffmann's.

Preimesberger, R. 'Obeliscus Pamphilius', *Münchner Jahrbuch der Bildenden Kunst*, XXV (1974), 77–162.

Sacchetti Sassetti, A. 'Bernini a Rieti', *Archivi*, XXII (1955).

Documents.

Schiavo, A. 'Il viaggio del Bernini in Francia nei documenti dell'Archivio Segreto Vaticano', *Boll. del centro di studi per la storia dell'architettura*, no. 10 (1956).

Schlegel, U., in *Jahrbuch der Berliner Museen*, IX (1967), 274 ff.

Publication of the small marble *Putto with Dolphin*, a fine work of Bernini's early period, purchased by the Berlin Museum.

Sommer, F. H., in *Art Quarterly*, XXXIII (1970), 30 ff.

Suggestion of influence of a Jesuit emblem book, H. Hugo's *Pia desideria* (1624), on Bernini's Lodovica Albertoni.

Thelen, H. *Zur Entstehungsgeschichte der Hochaltar-Architektur von St Peter in Rom.* Berlin, 1967.

Thelen's and Lavin's works (see above) supplement each other to a certain extent. Review of both works by M. S. Weil, *Burl. Mag.*, CXIII (1971), 98 ff.

Weil, M. S., in *Journal of the Walters Art Gallery*, XXIX–XXX (1966–7), 7 ff.

Identification of a bronze statuette corresponding to that over the ciborium of the altar of the Cappella del Sacramento in St Peter's and documents for Bernini's work in the chapel.

Weil, M. S. *The History and Decoration of the Ponte S. Angelo.* University Park, Penn., 1974.

Winner, M. 'Berninis Verità', *Festschrift H. Kauffmann. Minuscula Discipulorum.* Berlin, 1968, 393 ff.

An important iconological study.

Wittkower, R. *Gian Lorenzo Bernini, The Sculptor of the Roman Baroque.* London, 1955. Second reworked and enlarged ed., 1966.

With bibliography and critical *œuvre* catalogue. Second ed., review H. Kauffmann, in *Zeitschr. f. Kunstg.*, XXX (1967), 326 ff.

Wittkower, R., in *Burl. Mag.*, CXI (1969), 60 ff.

Publication of the first version of the bust of Urban VIII known from the version formerly in the coll. of Principe Enrico Barberini.

Zamboni, S. *Da Bernini a Pinelli.* Bologna, 1968.

Publication of the modello for the Four Rivers Fountain in the Accademia di Belle Arti, Bologna.

BERNINI, P.

Rotondi, P., in *Riv. del R. Ist.*, V (1935–6).

Martinelli, V., in *Commentari*, IV (1953).

BERRETTINI *see* CORTONA

BIANCO, B.

Profumo Müller, L. 'Bartolomeo Bianco architetto e il barocco genovese', *Bollettino del Centro di Studi per la Storia dell'Architettura*, no. 22 (1968).

The first monograph of Genoa's greatest Baroque architect.

BIBIENA

Madamowsky, F. *Die Familie Bibiena in Wien. Leben und Werk für das Theater.* Vienna, 1962.

A great treasury of documents and recorded drawings.

Mayor, A. H. *The Bibiena Family.* New York, 1945.

The best survey, with further references.

Ricci, C. *I Bibiena.* Milan, 1915.

BINAGO

Mezzanotte, G., in *L'Arte*, LX (1961).

BOETTO, G.

Carboneri, N., and Griseri, A. *Giovenale Boetto.* Fossano (Cassa di Risparmio), 1966.

An excellent study of this little known architect and engraver, with documents and *œuvre* catalogues.

BOLGI
Martinelli, V., in *Commentari*, x (1959).
 With *œuvre* catalogue. – See also A. N. Cellini,
 in *Paragone*, XIII (1962), no. 147.

BOMBELLI
Rizzi, A. *Mostra del Bombelli e del Carneo*. Udine,
 1964.
 Important exhibition catalogue. Introduction
 by R. Pallucchini.

BONAVIA
Constable, W. G., in *Art Quarterly*, XXII (1959).
 With *œuvre* catalogue.

BONAZZA
Semenzato, C. *Antonio Bonazza* (*1698–1763*). Padua,
 1957.
 Œuvre catalogue, documents, bibliography.

BONONI
Emiliani, A. *Carlo Bononi*. Ferrara, 1962.
Schleier, E. 'C.B. and Antonio Gherardi', *Master
 Drawings*, VII (1969), 413 ff.

BORGIANNI
Bottari, S., in *Commentari*, VI (1955).
 Borgianni's first signed and dated work.
Longhi, R., in *L'Arte*, XVII (1914).
 The fundamental study.
Wethey, H. E., in *Burl. Mag.*, CVI (1964).
 Reconstruction of early Borgianni.

BORROMINI
Argan, G. C. *Borromini*. Verona, 1952.
 Concise and forcible in style.
Benevolo, L. 'Il tema geometrico di S. Ivo della
 Sapienza', *Quaderni*, no. 3 (1953).
Bernardi Ferrero, D. de. *L'opera di F.B. nella lettera-
 tura artistica e nelle incisioni dell'età barocca*. Turin,
 1967.
Bianconi, P. *Francesco Borromini. Vita, opere, fortuna*.
 Bellinzona, 1967.
 A relatively brief, but well informed intro-
 duction to Borromini.
Blunt, A. *Francesco Borromini*. London, 1978, and
 Cambridge, Mass., 1979.
Borromini. *Opus Architectonicum*. Republication of
 the 1725 ed. with introduction and notes by P.
 Portoghesi. Rome, 1964.
 Review H. Millon, *Burl. Mag.*, CVIII (1966),
 433. See also the facsimile reprint by the
 Gregg Press.
Borromini, Studi sul B. Atti del Convegno promosso

dall'Accademia Nazionale di San Luca, Rome, 1967.
 I, Rome, 1970; II, Rome, 1972.
Brizio, A. M. 'Nel terzo centenario della morte di
 F. B.', *Accademia Naz. dei Lincei, Celebrazioni
 Lincee*. Rome, 1968.
 Of interest for Borromini's Milanese years.
Connors, J. *Borromini and the Roman Oratory*.
 M.I.T., Mass., 1980.
Fagiolo dell'Arco, M. 'Francesco Borromini', *Storia
 dell'Arte*, 1–2 (1969), 200.
 Critical survey of Borromini literature of
 1967, 1968.
Hempel, E. *Francesco Borromini*. Vienna, 1924.
 Standard work, listing fully older literature.
Marconi, P. *La Roma del Borromini*. Rome, 1968.
 A fine survey with many revealing illustra-
 tions.
 See also Marconi's paper in *Palatino*, x (1966).
Ost, H. 'Borrominis römische Universitätskirche S.
 Ivo', *Zeitschr. f. Kunstg.*, XXX (1967), 101 ff.
 A serious attempt at an iconological inter-
 pretation.
Piazzo, M. del. *Ragguagli Borrominiani*. Rome, 1968.
 Catalogue of the 1967 Exhibition of Borro-
 mini documents by the Director of the Roman
 State Archive. Basic for many aspects of
 Borromini's life and work.
Portoghesi, P., in *Quaderni*, no. 4 (1953), no. 6 (1954),
 no. 11 (1955), nos. 25–9 (1958); *Palladio*, IV (1954),
 Boll. d'Arte, XL (1955).
Portoghesi, P. *Borromini nella cultura europa*. Rome,
 1964.
 A collection of earlier papers enlarged. Appen-
 dices containing B.'s will, the inventory of
 his house, *et al.*
Portoghesi, P. *The Rome of Borromini*. New York,
 1968. Translation by B. L. La Penta from the Italian
 ed., Rome, 1967.
 Supplements the author's monograph of 1964.
 Stress on an interpretation of B.'s architec-
 tural language, supported by splendid photo-
 graphs.
Ruffinière du Prey, P. de la. 'Solomonic Symbolism
 in Borromini's Church of S. Ivo della Sapienza',
 Zeitschr. f. Kunstg., XXXI (1968), 216 ff.
 Interesting ideas that carry conviction.
Sedlmayr, H. *Die Architektur Borrominis*. Berlin,
 1930; Munich, 1939.
 A challenging but often controversial work.
Steinberg, L. *Borromini's S. Carlo alle Quattro Fon-
 tane: A Study in Multiple Forms and Architectural
 Symbolism*. New York, 1977.
Tafuri, M. 'Inediti borrominiani', *Palatino*, XI (1967),
 255 ff. See also *idem, ibid.*, x (1966).

Thelen, H. *70 disegni di Francesco B. dalle collezioni dell' Albertina di Vienna.* Catalogue. Rome, 1958–9.
Thelen, H. *Francesco Borromini. Die Handzeichnungen. 1. Abteilung: Zeitraum von 1620–32.* Graz, 1967.
First volume of the corpus of Borromini drawings. Basis for all further study of B. But although the author is guided by the most meticulous scholarship, he also opens up many controversial problems. Reviews by H. Brauer, *Zeitschr. f. Kunstg.*, XXXII (1969), 74 ff. and A. Blunt, in *Kunstchronik* (March 1969), 87 ff.

BRACCI
Domarus, K. von. *Pietro Bracci. Beiträge zur römischen Kunstgeschichte des XVIII. Jahrhunderts.* Strasbourg, 1915.
A very important contribution, generally overlooked.
Gradara, C. *Pietro Bracci scultore romano 1700–1773.* Milan–Rome, 1920.
Based on Bracci's own diary.

BRUSTOLON
Biasuz, G., and Lacchin, A. *Andrea Brustolon.* Venice, 1928.

CAFFÀ
Cellini, A. N., in *Paragone*, VII (1956).
Fleming, J., in *Burl. Mag.*, LXXXIX (1947).
Wittkower, R., in *Metropolitan Museum of Art Bulletin*, April, 1959.
Bust of Alexander VII.

CAGNACCI
Buscaroli, R. *Il pittore Guido Cagnacci.* Forlì, 1962.
To be consulted for earlier literature.
Pasini, P. 'Note ed aggiunte a G.C.', *Boll. d'Arte*, LII (1967), 78 ff.
Zuffa, M., in *Arte Antica e Moderna*, VI, no. 24 (1963). Documents.

CAIRO, F. del
Brunori, M. 'Considerazioni sul primo tempo di Francesco del Cairo', *Boll. d'Arte*, XLIX (1964), 236 ff. See also Brunori, in *Pantheon*, XXV (1967), 105 ff.
Matalon, S., in *Riv. d'Arte*, XII (1930).
Testori, G., in *Paragone*, III (1952), no. 27.

CALIGARI
Nicodemi, G. *I Caligari scultori bresciani del Settecento.* Brescia, 1924.

CAMASSEI
Domenico Cortese, G. di. 'La vicenda artistica di A.C.', *Commentari*, XIX (1968), 281 ff.
Harris, A. S. 'A Contribution to Andrea Camassei Studies', *Art Bull.*, LII (1970), 49–70.
The first biographical survey and critical catalogue of this rather neglected artist.

CAMETTI
Schlegel, U., in *Jahrb. Preuss. Kunstslg*, N.F. V (1963).
Fully documented *œuvre* catalogue.

CANALETTO
Constable, W. G. *Giovanni Antonio Canal, 1697–1768.* Oxford, 1976.
Second edition of the classic monograph revised by J. Links, who contributed much valuable material.
Corboz, A. 'Sur la prétendue objectivité de Canaletto', *Arte Veneta*, XXVIII (1974), 205–18.
Finberg, H. F. 'Canaletto in England', *Walpole Society*, IX (1920–1).
The basic study.
Gioseffi, D. *Canaletto. Il quaderno delle gallerie veneziane e l'impiego della camera ottica.* Trieste, 1959.
An ingenious study.
Hadeln, D. von. *Die Zeichnungen von A. Canal, genannt Canaletto.* Vienna, 1930.
Moschini, V. *Canaletto.* Milan, 1954 (also London, 1955).
With chronological table and bibliography.
Parker, K. T. *The Drawings of Antonio Canaletto ... at Windsor Castle.* London, 1948.
Parker, K. T., and Shaw, J. Byam. *Canaletto e Guardi.* Catalogue. Venice, 1962.
Fifty Canaletto drawings from Windsor Castle and Guardi drawings from various collections, exhibited at the Fondazione Cini. See T. Pignatti, in *Master Drawings*, I (1963).
Pignatti, T. *Il quaderno di disegni del Canaletto alle gallerie di Venezia.* Milan, 1958.
A text volume and a volume with 74 pp. of facsimile reproductions of the sketchbook.
Watson, F. J. B. *Canaletto.* London, 1949.

CANTARINI
Arcangeli, F., in *Paragone*, I (1950), no. 7.
Emiliani, E., in *Arte Antica e Moderna*, II, no. 8 (1959).
Catalogue of Cantarini's drawings and etchings.
Lavallée, M., in *À travers l'art italien du XV^e au XX^e siècle.* Paris, 1949.

CANUTI

Feinblatt, E., in *Art Quarterly*, XV (1952), and *ibid.*, XXIV (1961).

 Also *idem*, in *Master Drawings*, VII (1969), 164, and T. Poensgen, *ibid.*, V (1967), 165 ff.

CARACCIOLO (Battistello)

Longhi, R., in *L'Arte*, XVIII (1915).

 Fundamental study.

Voss, H., in *Jahrb. Preuss. Kunstslg.*, IIL (1927).

 Important.

CARAVAGGIO

 Important articles by C. L. Frommel, L. Spezzaferro, and others in *Storia dell'Arte*, IX-X (1971).

Argan, C. G. 'Il "realismo" nella poetica del Caravaggio', *Scritti di storia dell'arte in onore di L. Venturi*. Rome, 1956.

Aronberg Lavin, M. 'Caravaggio Documents from the Barberini Archive', *Burl. Mag.*, CIX (1967), 470 f.

 1603 as date of the Sacrifice of Isaac (Uffizi).

Bousquet, J. 'Documents inédits sur C.: la date des tableaux de la chapelle Saint-Matthieu ...', *Revue des Arts* (1953).

Cinotti, M. *Immagine del Caravaggio: Mostra didattica itinerante, Catalogo*. Cinisello Balsamo, 1973.

 With new birth and other documents.

Cinotti, M., et al. *Novità sul Caravaggio*. Regione Lombarda, 1975.

Colloquio sul tema Caravaggio e i Caravaggeschi. Accademia Nazionale dei Lincei, Anno CCCLXXI (1974), Quaderno 205.

 Important articles by L. Spezzaferro, F. Bologna, G. C. Argan, *et al.*

Dell'Acqua, G. A., and Cinotti, M. *Il Caravaggio e le sue grande opere da San Luigi dei Francesi*. Milan, 1971.

 With all documents reprinted.

Fagiolo dell'Arco, M. 'Le "Opere di misericordia": Contributo alla poetica del Caravaggio', *L'Arte*, no. 1 (1968), 37 ff.

 An ambitious and, it seems, on the whole successful attempt to clarify the iconography of C.'s *Seven Works of Mercy*.

Friedlaender, W. *Caravaggio Studies*. Princeton, 1955.

Hess, J. 'Modelle e modelli del Caravaggio', *Commentari*, V (1954).

Hibbard, H. *Caravaggio*. New York and London, 1982.

 Up-to-date monograph with catalogue and bibliography.

Lavin, I. 'Divine Inspiration in Caravaggio's two *St Matthews*', *Art Bull.*, LVI (1974), 59–81, 590–1.

Longhi, R., and others. *Mostra del Caravaggio e dei caravaggeschi*. Milan, 1951.

 With full bibliography, 1603–1951.

Longhi, R. 'Ultimi studi sul Caravaggio e la sua cerchia', *Proporzioni*, I (1943).

 Very important for the Caravaggeschi.

Longhi, R. *Il Caravaggio*. Milan, 1952. Reprint with slight changes, Rome–Dresden, 1968.

 See D. Mahon, *Burl. Mag.*, XCV (1953).

 See also Longhi's contributions in *Paragone*, X (1959), no. 111; XI (1960), no. 121; XIV (1963), no. 165.

Mahon, D. 'A Late Caravaggio Rediscovered', *Burl. Mag.*, XCVIII (1956).

 See also basic articles in *Burl. Mag.*, XCIII (1951) and XCIV (1952).

Marini, M. *Io, Michelangelo da Caravaggio*. Rome, 1974.

Moir, A. *The Italian Followers of Caravaggio*. 2 vols. Cambridge, Mass., 1966.

Moir, A. *Caravaggio and his Copyists*. New York, 1967.

Posner, D. 'Caravaggio's Homo-Erotic Early Works', *Art Quarterly*, XXXIV (1971), 301–24.

Röttgen, H. *Il Caravaggio: Ricerche e interpretazioni*. Rome, 1974.

Salerno, L., Kinkead, D. T., Wilson, W. H. 'Poesia e simboli nel C. I dipinti emblematici', *Palatino*, X (1966), 106 ff.

Scavizzi, G. *Caravaggio e caravaggeschi. Catalogo della Mostra. Palazzo Reale, Napoli*. Naples, 1963.

Spear, R. E. *Caravaggio and his Followers*. 2nd ed. New York, 1975.

Steinberg, L. 'Observations in the Cerasi Chapel', *Art Bull.*, XLI (1959).

Tzeutschler Lurie, A., and Mahon, D. 'Caravaggio's Crucifixion of Saint Andrew from Valladolid', *Bulletin of the Cleveland Museum of Art*, LXIV, 1 (1977), 3–24.

Wright, G. 'Caravaggio's *Entombment* considered *in situ*', *Art Bull.*, LX (1978), 35–42.

CARLEVARIJS, L.

Mauroner, F. *Luca Carlevarijs*. Padua, 1945.

 With *œuvre* catalogue and bibliography.

Rizzi, A. *Disegni, incisioni e bozzetti del Carlevarijs*. Catalogo della Mostra. Udine, 1964.

 Discussion of 122 items. Bibliography.

Rizzi, A. *Luca Carlevaris*. Venice, 1967.

CARLONI
Brigozzi Brini, A., and Garas, K. *Carlo Innocenzo Carloni*. Milan, 1967.
 Exhaustive monograph.
Marangoni, M. *I Carloni*. Florence, 1925.
 The only comprehensive work on this dynasty of artists.

CARNEO
Geiger, B. *Antonio Carneo*. Udine, 1940.
Rizzi, A. *Antonio Carneo*. Udine, 1960.
 Preface by I. Coletti. With *œuvre* catalogue, completely illustrated. See also BOMBELLI.

CARPIONI
Pilo, G. M. *Carpioni*. Venice, 1962.
 Œuvre catalogue and bibliography.

CARRACCI
Anderson, J. 'The "Sala di Agostino Carracci" in the Palazzo del Giardino', *Art Bull.*, LII (1970).
Bacou, R. *Dessins des Carraches*. Louvre Exhibition. Paris, 1961.
 With an important essay by D. Mahon on the late Annibale.
Bellori, G. P. *The Lives of Annibale and Agostino C.* (transl. C. Enggass). University Park and London, 1968.
Bodmer, H. *Lodovico Carracci*. Burg, 1939.
 See W. Friedlaender's review in *Art Bull.*, XXIV (1942).
Bohlin, D. De G. *Prints and Related Drawings by the Carracci Family*. Washington, D.C., 1979.
Calvesi, M., and Casale, V. *Le incisioni dei Carracci*. Catalogue. Rome, 1965.
Dempsey, C. '"Et Nos Cedamus Amori": Observations on the Farnese Gallery', *Art Bull.*, L (1968), 363.
Dempsey, C. *Annibale Carracci and the Beginnings of Baroque Style*. Glückstadt and New York, 1977.
 But see the review by C. Goldstein in *Art Quarterly* (Winter 1979), 112 ff.
Foratti, A. *I Carracci nella teoria e nell'arte*. Città di Castello, 1913.
 A very good book.
Kurz, O. 'Engravings on Silver by Annibale Carracci', *Burl. Mag.*, XCVII (1955).
Mahon, D. *Mostra dei Carracci. Disegni*. Bologna, 1956.
 Forms the critical basis for further study.
Mahon, D. 'Afterthoughts on the Carracci Exhibition', *G.d.B.A.*, XLIX (1957).
Martin, J. R. *The Farnese Gallery*. Princeton, 1965.
 A monumental study with a complete catalogue of drawings and extensive discussion of the iconography. Reviews by D. Posner, in *Art Bull.*, XLVIII (1966), 109; W. Vitzthum, in *Master Drawings*, IV (1966), 47.
Miller, D. C. 'A Drawing by Agostino Carracci for his Christ and the Adulteress in the Brera', *Master Drawings*, VII (1969), 410.
Mostra dei Carracci. Catalogo critico. Bologna, 1956.
 A critical work of collaboration, with an introductory essay by C. Gnudi. Basic, with full bibliography.
Ostrow, S., in *Arte Antica e Moderna*, III, no. 9 (1960).
 Iconography of the Palazzo Fava frescoes.
Ottani, A. *Gli affreschi Carracci in Palazzo Fava*. Bologna, 1966.
 Reviews in *Master Drawings*, IV, 3 (1966), 311; C. Johnston, *Burl. Mag.*, CIX (1967), 596 f.
Posner, D. *Annibale Carracci: A Study in the Reform of Italian Painting Around 1590*. 2 vols. London, 1971.
 Contains an *œuvre* catalogue.
Salerno, L. 'L'opera di Antonio Carracci', *Boll. d'Arte*, XLI (1956).
Tietze, H. 'Annibale Carraccis Galerie im Palazzo Farnese und seine römische Werkstätte', *Jahrb. d. kunsthist. Slg. des Allerhöchsten Kaiserh.*, XXVI (1906).
 Opens modern research; a masterly work.
Wittkower, R. *The Drawings of the Carracci at Windsor Castle*. London, 1952.
Zamboni, S. 'Ludovico Carracci e Francesco Gessi: due dipinti inediti', *Antichità Viva*, VII (1968), no. 1, 3 ff.

CARRIERA
Malamani, V. *Rosalba Carriera*. Bergamo, 1910.

CASTELLAMONTE
Boggio, C. *Gli architetti Carlo e Amedeo di Castellamonte e lo sviluppo edilizio Torino nel secolo XVII*. Turin, 1896.
Brino, G., a.o. *L'opera di Carlo e Amadeo di Castellamonte*. Turin, 1966.
Collobi, L., in *Boll. storico bibliografico subalpino*, XXXIX (1937).

CASTELLO, V.
Labò, M., in *Emporium*, XCVI (1942).
Riccio, B., in *Commentari*, VIII (1957).

CASTIGLIONE
Blunt, A. *The Drawings of Giovanni Battista Castiglione and Stefano della Bella ... at Windsor Castle*. London, 1954.

Contains new critical assessment of Castiglione's career; also *J.W.C.I.*, VIII (1945).
Calabi, A. 'The Monotypes of Gio. Battista Castiglione', *The Print Collector's Quarterly*, X (1923), XII (1925), XVII (1930).
Delogu, G. *Giovan Battista Castiglione detto il Grechetto*. Bologna, 1928.
Percy, A., in *Burl. Mag.*, CIX (1967), 672 ff.
 Contribution to C.'s life and chronology, with documents.
Percy, A., in *Master Drawings*, VI (1968), 144 ff.
 Attempted reconstruction of a large Castiglione 'album' of drawings of which so far at least 13 have been identified.
Wunder, R. P., in *Art Bull.*, XLII (1960).

CAVALLINO
Benesch, O., in *Jahrb. der kunsth. Slg. Vienna*, N.F. I (1926).
De Rinaldis, A. *Cavallino*. Rome, 1921.
Liebmann, M. P., in *Burl. Mag.*, CX (1968), 456 ff.
 Picture in the Pushkin Museum, Moscow.
Milicua, J., in *Goya*, II (1954).
Percy, A. *The Paintings of Bernardo Cavallino*. Pennsylvania University Press, appearance imminent.
 Only full monograph of Cavallino with *catalogue raisonné*.
Refice, C., in *Emporium*, CXIII (1951).
 Brief text.
Sestieri, E., in *L'Arte*, XXIII (1920) and *Dedalo*, II (1921).
Tzeutscher Lurie, A. 'Bernardo Cavallino: Adoration of the Shepherds', *Bull. Cleveland Museum of Art*, LVI (1969), 136 ff.

CAVEDONI
Bodmer, H., in *Die Graphischen Künste*, V (1940).
 On drawings.
Roli, R., in *Paragone*, VII (1956), no. 77.

CECCO BRAVO *see* MONTELATICI

CELESTI, A.
Mucchi, A. M., and Della Croce, C. *Il pittore Andrea Celesti*. Milan, 1954.
 Œuvre catalogue and bibliography.

CERANO (G. B. Crespi).
Dell' Acqua, G. A., in *L'Arte*, XLV (1942), XLVI (1943).
Pevsner, N., in *Jahrb. Preuss. Kunstslg.*, XLVI (1925).
Rosci, M. *Mostra del Cerano*. Cat. Novara, 1964.
 Fullest treatment of Cerano, summarizing all previous research.
Testori, G., in *Paragone*, VI (1955), no. 67.

Valsecchi, M., in *Paragone*, XV (1964), no. 173.

CERESA
Longhi, R., Cipriani, R., and Testori, G. *I pittori della realtà in Lombardia*. Catalogo. Milan, 1953.
Testori, G., in *Paragone*, IV (1953), no. 39.

CERQUOZZI
Briganti, G. 'Michelangelo Cerquozzi, pittore di nature morte', *Paragone*, V (1954), no. 53.
 See also LAER, P. VAN.

CERUTI
Boschetti, A., in *Paragone*, XIX (1968), no. 219, 55 ff.
Fiocco, G. 'Giacomo Antonio Ceruti a Padova', *Saggi e Memorie di storia dell'arte*, VI (1968), 113 ff.
Longhi, R., Cipriani, R., and Testori, G. *I pittori della realtà in Lombardia*. Catalogo. Milan, 1953.
Also Longhi, in *L'Œil*, no. 73, Jan. 1961.
Mallè, L., and Testori, G. *Giacomo Ceruti e la ritrattistica del suo tempo nell'Italia settentrionale*. Turin, 1967.
 Catalogue of an exhibition in which next to Ceruti paintings by R. Carriera, G. B. Crosato, V. Ghislandi, P. F. Guala, F. Guardi, and others were shown.
Marini, O., in *Paragone*, XVII (1966), no. 199, 34 ff.
 On Ceruti's patrons at Brescia.
Testori, G., in *Paragone*, V (1954), no. 57.
Testori, G. *Giacomo Ceruti. Mostra di 32 opere inedite 30 Oct.–14 Nov. 1966*. 'Finarte', Milan, 1966.
 Bibliography. Emphasis on connexions with older painters in Brescia.

CESI
Graziani, A., in *Critica d'Arte*, IV (1939).
 An excellent paper.

CHIARI, G. B.
Kerber, B. in *Art Bull.*, L (1968), 75.
 An entirely satisfactory monograph of this Late Baroque Roman painter.

CIGNANI
Buscaroli, S. V. *Carlo Cignani (1628–1719)*. Bologna, 1953.
 A fine monograph, with bibliography.

CIGOLI (L. Cardi)
Cigoli, G. B. *Vita di Lodovico Cigoli, per cura della Commune della città di S. Miniato*. Florence, 1913.
 Biography by Cigoli's nephew.
Cigoli, Lodovico Cardi da. 'Macchie di sole e pittura; carteggio L. Cigoli–G. Galilei, 1609–1613', ed. A.

Matteoli, in *Bollettino della Accademia degli Euteleti della città di San Miniato*, XXII, N.S. no. 32 (1959).
Fully annotated edition of Cigoli's letters.

Bucci, M., and others. *Catalogo della mostra del Cigoli e del suo ambiente*. San Miniato, 1959.
Indispensable for the study of Cigoli. M. Gregori contributed a section on artists in Cigoli's circle and L. Berti a paper on Cigoli as architect.

Fasolo, V., in *Quaderni*, nos. 1, 2 (1953).
On Cigoli as architect.

Panofsky, E. *Galileo as a Critic of the Arts*. The Hague, 1954.
Fascinating comment on Galileo's letter to Cigoli, 1612.

CIPPER (Todeschini)
Arslan, W., in *L'Arte*, XXXVI (1933).

COCCORANTE
Ferrari, O. 'Leonardo Coccorante e la "veduta ideata" napoletana', *Emporium*, CXIX (1954).

CODAZZI
Brunetti, E., in *Paragone*, VII (1956), no. 79.
Longhi, R. 'Codazzi e l'invenzione della veduta realistica', *Paragone*, VI (1955), no. 71.

CORNACCHINI
Keutner, H., in *North Carolina Museum of Art Bulletin*, I (1957–8), II (1958).
Monographic treatment.
Wittkower, R., in *Miscellanea Bibl. Hertzianae*, 1961.
Full documentation for the Charlemagne in St Peter's.

CORRADINI
Biasuz, G., in *Boll. d'Arte*, XXIX (1935–6).
Callegari, A., in *Boll. d'Arte*, XXX (1936–7).
Mariacher, G., in *Arte Veneta*, I (1947).
Riccoboni, A., in *Arte Veneta*, VI (1952).
With *œuvre* catalogue.

CORTE, J. de (Lecurt)
Ivanoff, N., in *Arte Veneta*, II (1948).

CORTONA, P, da
Briganti, G. *Pietro da Cortona e della pittura barocca*. Florence, 1962.
Considers only Cortona as painter. Indispensable. Broad critical analysis and *œuvre* catalogue. Reviews by K. Noehles in *Kunstchronik*, XVI (1963); W. Vitzthum, *Burl. Mag.*, CV (1963).

Campbell, M. *Mostra di disegni di P. da C. per gli affreschi di Palazzo Pitti*. Exhibition, Uffizi, Florence, 1965.

Campbell, M. *Pietro da Cortona at the Pitti Palace: A Study of the Planetary Rooms and Related Projects*. Princeton, N.J., 1977.

Casale, V. 'P.d.C. e la cappella del Sacramento in San Marco a Roma', *Commentari*, XX (1969), 93 ff.
Publication of documents.

Chiarini, M., and Noehles, K. 'P. da C. a Palazzo Pitti: un episodio ritrovato', *Boll. d'Arte*, LII (1967), 233 ff.

Del Piazzo, M. *Pietro da Cortona. Mostra documentaria*. Rome, 1969.
A brief guide through the exhibition of Cortona documents organized in the Archivio di Stato, Rome, on the occasion of the tricentenary of Cortona's death.

Fabbrini, N. *Vita del Cav. Pietro da Cortona*. Cortona, 1896.
Still useful.

Lavin, I. 'Pietro da Cortona and the Frame', *The Art Quarterly*, XIX (1956), 55.

Moschini, V. 'Le architetture di Pietro da Cortona', *L'Arte*, XXIV (1921).

Mostra di Pietro da Cortona. Catalogue by A. Marabottini and L. Berti. Rome, 1956.
Fullest study of Cortona as painter before Briganti's book.

Muñoz, A. *P. da Cortona* (Bibl. d'Arte). Rome, 1921.
First study of Cortona as architect.

Noehles, K. 'Die Louvre-Projekte von P. da C. und Carlo Rainaldi', *Zeitschr. f. Kunstg.*, XXIV (1961).
See also P. Portoghesi, in *Quaderni*, nos. 31–48 (1961), with similar results.

Noehles, K. 'Architekturprojekte Cortonas', *Münchner Jahrb. d. bild. Kunst*, XX (1969), 171 ff.
A bird's eye view of C. as architect with some new material.

Noehles, K. *La chiesa dei SS. Luca e Martina nell'opera di Pietro da Cortona*. Rome, 1969.
Masterly investigation of a great Roman Baroque structure. A new standard of detailed and circumspect presentation.

Ost, K. 'Studien zu Pietro da Cortonas Umbau von S. Maria della Pace', *Röm. Jahrb. f. Kunstg.*, XIII (1971), 231 ff.

Pollak, O. 'Neue Regesten zum Leben und Schaffen des römischen Malers und Architekten Pietro da Cortona', *Kunstchronik*, XXIII (1912).

Posse, H. 'Das Deckenfresco des P. da C. im Palazzo Barberini ...', *Jahrb. Preuss. Kunstslg.*, XL (1919).
Basic study.

Samek-Ludovici, S. 'F. S. Baldinucci, Vita mano-scritta di Pietro da C.', *Archivi*, XVII (1950).

Vitzthum, W. 'Inventar eines Sammelbandes des späten Seicento mit Zeichnungen von P. da Cortona und Ciro Ferri', in *Studies in Renaissance and Baroque Art presented to Anthony Blunt*, no. XXII. London, 1967.

Wibiral, N. 'Contributi alle ricerche sul Cortonismo in Roma. I pittori della Galleria di Alessandro VII nel Palazzo del Quirinale', *Boll. d'Arte*, XL (1960).
 A first-rate study based on a wealth of new documents.

Wittkower, R. 'Pietro da Cortonas Ergänzungsprojekt des Tempels in Palestrina', *Festschrift Adolph Goldschmidt*. Berlin, 1935. Eng. transl. in *Studies in the Italian Baroque*. London, 1975.

COURTOIS (CORTESE)

Holt, E. L. 'The British Museum's Phillips-Fenwick Collection of Jacques Courtois's Drawings and a partial Reconstruction of the Bellori Volume', *Burl. Mag.*, CVIII (1966), 345 ff.

Salvagnini, F. A. *I pittori borgognoni Cortese*. Rome, 1937.

COZZA, F.

Lopresti, L., in *Pinacoteca*, I (1928).

Montalto, L., in *Commentari*, VI (1955), VII (1956).

Mortari, L., in *Paragone*, VII (1956), no. 73.

CRESPI, D.

Nicodemi, G. *Daniele Crespi*. Busto Arsizio, 1915; 2nd ed. 1930.
 See R. Longhi's review in *L'Arte*, XX (1917).

Ruggeri, U. 'Per Daniele Crespi', *Critica d'Arte*, XIV, no. 90 (1967), 45 ff.; XV, no. 93 (1968), 43 ff.

CRESPI, G. M.

Arcangeli, F., and Gnudi, C. *Mostra celebrativa di Giuseppe Maria Crespi. Catalogo*. Bologna–Milan, 1948.
 Preface by R. Longhi. Important catalogue, with bibliography.

Arcangeli, F. 'Nature morte di G. M. C.', *Paragone*, XIII (1962), no. 149.

Gnudi, C. 'Mazzoni e le origini del Crespi', *Bologna, Riv. del Commune*, XXII (1935).

Lasareff, V., in *Art in America*, XVII (1929).

Merriman, M. P. 'Two late Works by G. M. Crespi', *Burl. Mag.*, CX (1968), 120 ff.
 A full monograph of Crespi with *œuvre* catalogue by the same author is in the press.

Volpi, C., in *Paragone*, VIII (1957), no. 91.
 On the beginnings of G. M. Crespi.

Voss, H. *Giuseppe Maria Crespi*. Rome, 1921.

CRETI

Roli, R. *Donato Creti*. Milan, 1967.
 Based on the author's own earlier papers. An important, richly illustrated publication; *œuvre* catalogue and bibliography. Review by D. C. Miller, *Burl. Mag.*, CXI (1969), 306 f.

CROSATO

Fiocco, G. *G. B. Crosato*. Venice, 1941; 2nd ed. 1944.

DAL SOLE

Bruni, G. Lippi, in *Arte Antica e Moderna*, II (1959).
 With *œuvre* catalogue.

DE FERRARI, G. A.

Falletti, E., in *Commentari*, VII (1956) and Goffredo, A. M., *ibid.*

Rotondi, P., in *Boll. d'Arte*, XXXVI (1951).

DE FERRARI, G.

De Masi, Y. *La vita e le opere di Gregorio de Ferrari*. Genoa, 1945.

Griseri, A., in *Paragone*, VI (1955), no. 67.

DE FERRARI, L.

Gavazza, E. *Lorenzo de Ferrari (1680–1744)*. Milan, 1965.
 An important publication, because one of the great but not sufficiently known Genoese decorative talents has for the first time been given a monographic treatment with *œuvre* catalogue.

DEL GRANDE, A.

Pollak, O., in *Kunsth. Jahrb. der K. K. Zentralkommission*, III (1909).

DELLA BELLA, S. *see* CASTIGLIONE

DERIZET

Prandi, A. 'Antonio Derizet e il concorso per la facciata di S. Giovanni in Laterano', *Roma*, XXII (1944).

DIZIANI

Zugni-Tauro, A. P. *Gaspare Diziani*. Venice, 1971.
 Full monograph with *œuvre* catalogue.

DOLCI

Del Bravo, C., in *Paragone*, XIV (1963), no. 163.
 Discusses Dolci's stylistic development.

Heinz, G., in *Jahrb. d. kunsthist. Slg. in Wien*, LVI (1960).

An excellent study; concerns Dolci's religious convictions.

DOMENICHINO

Borea, E. 'Domenichino a Fano', *Arte Antica e Moderna*, II, no. 8 (1959).
 With documents.
Borea, E. *Domenichino*. Milan, 1965.
 Offers valuable information particularly for D.'s early career, but contains weaknesses and inaccuracies. R. E. Spear's remarkable review (*Art Bull.*, XLIX (1967), 360) should be read with the book.
Borea, E., and Cellini, P., in *Boll. d'Arte*, XLVI (1961).
 Important for the frescoes in S. Luigi de' Francesi.
Fagiolo-Dell'Arco, M. *Domenichino ovvero Classicismo del Primo-Seicento*. Rome, 1963.
 With well considered critical apparatus.
Keller, H. 'Das Jünglingsbild des Domenichino in Darmstadt', *Festschrift Ulrich Middeldorf*, Berlin, 1968, 408.
Neppi, A. *Gli affreschi del D. a Roma*. Rome, 1958.
 A brief, pedestrian book.
Pope-Hennessy, J. *The Drawings of Domenichino in the Collection of His Majesty the King at Windsor Castle*. London, 1948.
 With a stimulating introduction.
Serra, L. *Domenico Zampieri detto il Domenichino*. Rome, 1909.
 Standard work.
Spear, R. E. 'The Early Drawings of Domenichino at Windsor Castle and some Drawings by the Carracci', *Art Bull.*, XLIX (1967), 52.
 New identification and changes of attribution, the majority of which is certainly correct.
Spear, R. E., in *Master Drawings*, VI (1968), 111 ff.
 A significant contribution to Domenichino's preparatory drawings (but see A. Sutherland Harris, *Burl. Mag.*, CXII (1970), 47 f.). See also Spear's paper on Domenichino cartoons, *ibid.*, V (1967), 144, and C. Johnston, *Revue de l'Art*, no. 8 (1970), 56 ff.; six new drawings.
Wittkower, R., in *Burl. Mag.*, XC (1948).

DOTTI

Foratti, A., in *L'Arte*, XVI (1913).
See also above, Part III of Bibliography (under Bologna).

DUQUESNOY, F.

Faldi, I., in *Arte Antica e Moderna*, II (1959).
 Rediscovery of the original *Amor divino e profano* relief.

Fransolet, M. *François du Quesnoy sculpteur d'Urbain VIII*. Brussels, 1942.
Huse, N. 'Zur "S. Susanna" des Duquesnoy', in *Argo. Festschrift für Kurt Badt*, Cologne, 1970, 324 ff.
Lavin, I. 'Duquesnoy's "Nano di Créqui" and Two Busts by Francesco Mochi', *Art Bull.*, LII (1970), 132 ff.
 Lavin solved once and for all the problem of a small bust in the coll. of Prince Urbano Barberini that had been attributed to Bernini (Sestieri), and suggests a new vision of Mochi's stylistic development.
Martinelli, V., in *Commentari*, XIII (1962).
Noehles, K., in *Arte Antica e Moderna*, VII, no. 25 (1964).
 Contains observations on Duquesnoy's stylistic development.
Schlegel, U., in *Pantheon*, XXVII (1969), 390.

EMPOLI (J. Chimenti da)

De Vries, S., in *Riv. d'Arte*, XV (1933).
Forlani, A. *Mostra di disegni di J. da E*. Florence, 1962.

FACCINI

Marangoni, M., in *L'Arte*, XIII (1910). Reprinted in *Arte Barocca*, 1953.
Posner, D., in *Paragone*, XI (1960), no. 131.
 Faccini's relation to and break with the Carracci.

FALCONE

Saxl, F., in *J.W.C.I.*, III (1939-40).
Soria, M. S., in *Art Quarterly*, XVII (1954).

FANZAGO

Cunzo, M. A. de. 'I documenti sull'opera di C. F. nella Certosa di San Martino', *Napoli Nobilissima*, VI (1967), 98 ff.
Fogaccia, P. *Cosimo Fanzago*. Bergamo, 1945.
Strazzullo, F. 'La vertenza tra Cosimo Fanzago e la deputazione del tesoro di S. Gennaro', *Arch. stor. per le prov. napolitane*, XXXIV (1955).
 Documents.

FERRATA

Cellini, A. N. 'Contributo al periodo napoletano di Ercole Ferrata', *Paragone*, XII (1961), no. 137.
Golzio, V. 'Lo "studio" di Ercole Ferrata', *Archivi*, II (1935).
 Important inventory.

FERRETTI, G. D.

Maser, E. A. *The Disguises of Harlequin*. An Exhibi-

tion organized and presented by the University of Kansas Museum of Art. Lawrence, 1956.

Maser, E. A. *Gian Domenico Ferretti*. Florence, 1968.
Monograph with *œuvre* catalogue and bibliography.

FETTI

Askew, P. 'The Parable Paintings of D. F.', *Art Bull.*, XLIII (1961).
An important study. See also *Burl. Mag.*, CIII (1961).

De Logu, G. 'An Unknown Portrait of Monteverdi by Domenico Feti', *Burl. Mag.*, CIX (1967), 706 ff.

Michelini, P. 'Domenico Fetti a Venezia', *Arte Veneta*, IX (1955).

Oldenbourg, R. *Domenico Feti*. Rome, 1921.

Wilde, J., in *Jahrb. der kunsth. Slg.*, Vienna, N.F. X (1936).

FINELLI

Cellini, A. N., in *Paragone*, XI (1960), no. 131.
On Finelli's portrait busts.

FOGGINI

Lankheit, K., in *Riv. d'Arte*, XXXIV (1959).
On the Uffizi sketchbook of 170 pp. For Lankheit's monographic treatment of Foggini, see *Florentinische Barockplastik*.

FONTANA, C.

Braham, A., and Hager, H., 'The Tomb of Christina', in *Analecta Reginensia 1. Queen Christina of Sweden. Documents and Studies*, Stockholm, 1966, 48 ff.
History of the tomb based on drawings and documents.

Braham, A., and Hager, H. *The Drawings by Carlo Fontana in the Royal Library in Windsor Castle*. London, 1978.

Coudenhove-Erthal, E. *Carlo Fontana und die Architektur des römischen Spätbarock*. Vienna, 1930.

FRANCESCHINI, M. A.

Arfelli, A., in *Comune di Bologna*, XXI (1934), no. 11.

Miller, D. C., in *Boll. d'Arte*, XLI (1956) and *Burl. Mag.*, XCIX (1957), CII (1960), CVI (1964).

FRIGIMELICA

Zaccaria, M., in *Bollettino del Museo Civico di Padova*, XXIX–XXX (1939–40).

FUGA

Agosteo, A., and Pasquini, A. *Il Palazzo della Consulta*. Rome, 1959.

Bianchi, L. *Disegni di Ferdinando Fuga e di altri architetti del Settecento*. Rome, 1955.
Scholarly exhibition catalogue with entirely new material.

Matthiae, G. *Ferdinando Fuga e la sua opera romana*. Rome, 1951.

Pane, R. *Ferdinando Fuga*. Naples, 1956.
Fully documented. Compilation of documents by R. Mormone.

FURINI

Bürkel, L., in *Jahrb. ... des Allerhöchsten Kaiserhauses*, XXVII (1907–8).

Stanghellini, A., in *Vita d'Arte*, XII (1914).

Toesca, E. *Francesco Furini*. Rome, 1950.

GABBIANI

Bartarelli, A., in *Riv. d'Arte*, XXVII (1951–2).
With *œuvre* catalogue.

GALEOTTI

Carboneri, N. *Sebastiano Galeotti*. Venice, 1955.

Torri, P. *Attività di Sebastiano Galeotti in Liguria*. Genoa, 1956.

GALILEI

Kieven, E. (Bonn University) is preparing a monograph on A. Galilei.

Toesca, I. 'Alessandro Galilei in Inghilterra', *English Miscellany*, III (1952).

GALLI see BIBIENA

GALLIARI

Bossaglia, R. *I fratelli Galliari pittori*. Milan, 1962.
Review A. Griseri, *Burl. Mag.*, CVIII (1966), 528 ff.

GALLO, F.

Carboneri, N. *L'architetto Francesco Gallo*. Turin, 1954.
Exhaustive documentation.

GANDOLFI

Bianchi, L. *I Gandolfi pittori del Settecento bolognese*. Rome, 1938.

Zucchini, G., in *Atti e memorie dell'Accademia Clementina*, V (1953).
On Gaetano Gandolfi.

GAULLI (Baciccio)

'An Exhibition of Paintings, Bozzetti and Drawings by Giovanni Battista Gaulli', *Allen Memorial Art Museum Bulletin*, XXIV, 2 (1967).

With contributions by J. Spencer, E. Waterhouse, and H. L. Cooke. The first comprehensive exhibition dedicated to G. See review by R. Enggass, *Burl. Mag.*, CIX (1967), 184 ff.

Brugnoli, M. V., in *Boll. d'Arte*, XXXIV (1949).
With *œuvre* catalogue.

Enggass, R. *The Painting of Baciccio. Giovan Battista Gaulli 1639–1709.* The Pennsylvania State University Press, 1964.
Standard work with *œuvre* catalogue. Reviews by F. H. Dowley, *Art Bull.*, XLVII (1965), 294, E. Waterhouse, *Burl. Mag.*, CVII (1965), 530.

Tacchi-Venturi, P. 'La convenzione tra G. B. Gaulli e ... G. P. Oliva per le pitture del Tempio Farnesiano', *Roma*, XIII (1935).

GENTILESCHI, A. and O.

Bissell, R. W. 'Dipinti giovanili di O. G. a Farfa (1597–1598)', *Palatino*, VIII (1964), 197 ff.
Documented works, revealing for the Mannerist beginnings of O. G.

Bissell, R. W. 'Artemisia Gentileschi – A new Documented Chronology', *Art Bull.*, L (1968), 153 ff.
The basic study for A. G. See also Bissell in *Bull. Detroit Inst. of Arts*, XLVI (1967), 71 ff., and M. Gregori, in *Festschrift U. Middeldorf*, Berlin, 1968, 414.

Campos, R. de, in *Riv. d'Arte*, XXI (1939).
With full bibliography.

Crinò, A. M., in *Burl. Mag.*, CII (1960); CIII (1961), with B. Nicolson.

Emiliani, A., in *Paragone*, IX (1958), no. 103.
For the stay in the Marches.

Longhi, R., in *L'Arte*, XIX (1916).
The basic work.

Rosci, M. *Orazio Gentileschi* (I maestri del colore, 83). Milan, 1965.

Sterling, C., in *Burl. Mag.*, C (1958).
Discusses the stay in Paris.

GESSI, F.

Roli, R., in *Arte Antica e Moderna*, I, no. 1 (1958).

GHERARDI, A.

Mezzetti, A., in *Boll. d'Arte*, XXXIII (1948).

GHERARDI, F.

Cerrato, A. M. 'Giovanni Coli e Filippo Gherardi', *Commentari*, X (1959).
With *œuvre* catalogue.

GHISLANDI (FRA GALGARIO)

Fra Galgario (1655–1743) nelle collezioni private Bergamasche. Bergamo, 1967.
This fine catalogue of 37 paintings is introduced by a paper by R. Pallucchini.

Locatelli Milesi, A. *Fra Galgario.* Bergamo, 1945.

Longhi, R., Cipriani, R., and Testori, G. *I pittori della realtà in Lombardia.* Catalogo. Milan, 1953.

Mazzini, F. *Mostra di Fra Galgario e del Settecento a Bergamo.* Catalogo. Milan, 1955.

GIAQUINTO

Dania, L., in *Paragone*, XX (1969), no. 235.

Orsi, M. d'. *Corrado Giaquinto.* Rome, 1958.
Œuvre catalogue; bibliography.

Videtta, A. *Considerazioni su Corrado Giaquinto in rapporto ai disegni del Museo di S. Martino.* Naples, 1965.
Mainly an attempt to define the graphic principles of Giaquinto's drawings.

Volpi, M. 'C. G. e alcuni aspetti della cultura figurativa del '700 in Italia', *Boll. d'Arte*, XLIII (1958).

GIORDANO, L.

Ferrari, O. 'Una "vita" inedita di Luca Giordano', *Napoli Nobilissima*, V (1966), 89 ff., 129 ff.
Publication of the 'Life' written by Francesco Saverio Baldinucci from the MS. in the Bibl. Naz., Florence.

Ferrari, O., and Scavizzi, G. *Luca Giordano.* 3 vols. Naples, 1966.
A *tour de force* breaking much new ground, this work will be for a long time to come the basis for further Giordano studies. Review W. Vitzthum, *Burl. Mag.*, CXII (1970), 239 ff.

Griseri, A., in *Paragone*, VII (1956), no. 81.
On the work in Spain.

Griseri, A., in *Arte Antica e Moderna*, IV (1961).

Lurie, A. T. 'L.G. The Apparition of the Virgin to Saint Francis of Assisi', *Bull. Cleveland Mus. of Art*, LV (1968), 39 ff.

GIORGETTI, A. and G.

Montagu, J. 'Antonio and Guiseppe Giorgetti: Sculptors to Cardinal Francesco Barberini', *Art Bull.*, LII (1970), 278 ff.
The first scholarly treatment of these sculptors, based on documents in the Barberini Archive.

GIOVANNI DA SAN GIOVANNI

Campbell, M. 'The Original Program of the Salone di Giovanni da S. Giovanni', *Antichità Viva*, XV (1976), 3–25.

Giglioli, O. H. *Giovanni da San Giovanni*. Florence, 1949.
>Review by G. Briganti in *Paragone*, I (1950), no. 7.
Zeri, F., in *Paragone*, III (1952), no. 31.

GRASSI
Gallo, G. *Mostra di Nicola Grassi*. Catalogue. Udine, 1961.
>80 works illustrated. See also M. Gregori, in *Paragone*, XIII (1962), no. 147.

GUALA
Carità, R., in *Atti Soc. Piemontese d'Archeologia e Belle Arti*, N.S. I (1949).
>Basic paper with all earlier literature.
Castelnovi, G. V., in *Studies in the History of Art. Dedicated to William E. Suida*. London, 1959.

GUARDI, F. and G. A.
Binion, A. *Giovanni Antonio and Francesco Guardi: Their Life and Milieu, with a Catalogue of their Drawings*. Dissertation, Columbia University, New York, 1971. Also *idem*, *Burl. Mag.*, CX (1968), 519.
Fenyö, I., in *Burl. Mag.*, CX (1968), 65 ff.
>Discovery of a processional banner of the 'Madonna of the Rosary' by Francesco and Giovanni Antonio Guardi.
Fiocco, G. *Francesco Guardi*. Florence, 1923.
>The classic biography. Also articles by Fiocco in *Burl. Mag.*, XLVI (1925), *Dedalo*, XIII (1933), and *Critica d'Arte*, II (1937).
Goering, M. *Francesco Guardi*. Vienna, 1944.
Haskell, F., in *J.W.C.I.*, XXIII (1960).
Kultzen, R. *Francesco Guardi in der Alten Pinakothek*. Munich, 1967.
Maffei, F. de. *Gian Antonio Guardi pittore di figure*. Verona, 1951.
>Contains challenging hypotheses and valuable new documents.
Mahon, D., in *Burl. Mag.*, CX (1968), 69 ff.
>Mahon claims 1750 as the date at which F. Guardi began painting *vedute esatte*.
Morassi, A. *Guardi*, Venice, 1973, and *Guardi, Tutti i disegni*, Venice, 1975.
>Both works especially useful for their high-quality illustrations.
Moschini, V. *Francesco Guardi*. London, 1957.
Muraro, M., in *Burl. Mag.*, C (1958) and *Emporium*, CXXX (1959).
>On figure paintings by Francesco.
Nicolson, B., in *Burl. Mag.*, CVII (1965), 471 f.
Pallucchini, R. *I disegni del Guardi al museo Correr di Venezia*. Venice, 1942.

Pignatti, T. *Disegni dei Guardi*. Florence, 1967.
Problemi guardeschi. Atti del convegno di studi promosso dalla mostra dei Guardi. Venice, 1967.
>With 20 contributions, some of them provocative, especially D. Mahon's (66–155).
Rasmo, N., in *Cultura Atesina*, IX (1955).
>Valuable summary of Guardi problems.
Shaw, J. Byam. *The Drawings of Francesco Guardi*. London, 1951.
>An excellent book.
Zampetti, P. *Mostra dei Guardi*. Venice, 1965.
>An expert catalogue with exhaustive bibliography. See also *idem*, *Bibliografia della mostra*, Venice, 1966, listing the publications discussing the Exhibition.

GUARINI
Anderegg-Tille, M. *Die Schule Guarinis*. Winterthur, 1962.
>A somewhat pedantic work, based on the categories developed by A. E. Brinckmann half a century before.
Brinckmann, A. E. *Von Guarino Guarino bis Balthasar Neumann*. Berlin, 1932.
Crepaldi, G. M. *La Real Chiesa di San Lorenzo in Torino*. Turin, 1963.
>Primarily a social and cultural study. Important review by H. A. Millon, in *Art Bull.*, XLVII (1965), 531.
De Bernardi Ferrero, D. 'Il conte I. Caramuel de Lobkowitz, vescovo di Vigevano, architetto e teorico dell'architettura', *Palladio*, XV (1965), 91 ff.
>First modern discussion of Caramuel's theories, which influenced Guarini so deeply.
De Bernardi Ferrero, D. *I 'Disegni d'architettura civile et ecclesiastica' di Guarino Guarini e l'arte del maestro*. Turin, 1966.
>Interesting observations introducing a facsimile ed. of the plates of Guarini's treatise.
Gabrielli, N. (with A. Lange). *Racconigi*. Turin, 1971.
Guarini, G. *Architettura civile*. Turin, 1737.
Guarini, G. *Architettura civile*. Milan, 1968.
>Modern critical edition with brilliant introduction by N. Carboneri, full bibliography and notes, and appendix by B. Tavassi La Greca. A facsimile reprint of the Treatise was published by the Gregg Press in 1964.
Guarino Guarini e l'internazionalità del barocco. Atti del convegno internazionale ... 1968. 2 vols. Turin, 1970.
>43 contributions, partly of considerable length, covering every aspect of Guarini's architectural work and theory, his contributions to various fields of learning, and his influence.

Hager, W., in *Miscellanea Bibliothecae Hertzianae*, 1961.

Oechslin, W. 'Bemerkungen zu Guarino Guarini und Juan Caramuel de Lobkowitz', *Raggi* (Journal of Art History and Archaeology), IX, 3 (1969), 91 ff.

Important investigation of Guarini's relationship to Caramuel and his unorthodox ideas.

Passanti, M. *Nel mondo magico di Guarino Guarini*. Turin, 1963.

A revealing study by an architect.

Portoghesi, P. *Guarino Guarini*. Milan, 1956.

A fine, though brief monograph; bibliography.

Portoghesi, P. 'Guarini a Vicenza: La chiesa di S. Maria d'Araceli', *Critica d'Arte*, nos. 20, 21 (1957).

Sandonnini, T., in *Atti e memorie R. Dep. di storia patria ... provincie modenesi e parmensi*, ser. 3, V (1888).

An important study.

Torretta, G. *Un'analisi della cappella di S. Lorenzo di Guarino Guarini*. Turin, 1968.

Published by the Turin 'Istituto di Elementi di Arch. e Rilievo dei Monumenti'. By an architect who continues the style of M. Passanti's investigations. Most valuable measured drawings.

GUERCINO

De Grazia, D. *Guercino Drawings in the Art Museum Princeton University*. Princeton, 1969.

Grimaldi, N. *Il Guercino. Gian Francesco Barbieri, 1591–1666*. Bologna [n.d. 1957?]. Improved 2nd ed. 1968.

A work of little distinction.

Mahon, D. 'Notes on the young Guercino', *Burl. Mag.*, LXX (1937).

Mahon, D. *Studies in Seicento Art and Theory*. London, 1947.

Mahon, D. *Il Guercino. Catalogo critico dei dipinti*. Bologna, 1968.

The best critical work on Guercino: reviews D. Posner, *Burl. Mag.*, CX (1968), 596 ff., R. Longhi, *Paragone*, XIX (1968), no. 225, 63 ff.

Mahon, D. *Il Guercino. Catalogo critico dei disegni*. Bologna, 1969.

The standard work on G. as draughtsman.

Mezzetti, A., and Mahon, D. *Omaggio al Guercino. Mostra di dipinti restaurati e dei disegni della collezione Denis Mahon di Londra*. Cento, 1967.

Important especially for G.'s early paintings at Cento. D. Mahon supplied 50 learned entries for drawings from his collection. This Catalogue also appeared separately as *Disegni del Guercino della collezione Mahon*, Bologna, 1967.

Roli, R. *I fregi centesi del Guercino*. Bologna, 1968.

Reliable account of G.'s frescoes in his hometown of Cento. Review Posner, *Art Bull.*, LI (1969), 297.

Vivian, F., in *Burl. Mag.*, CXIII (1971), 22 ff.

Works by Guercino recorded in the Barberini archive.

GUIDI, D.

Bershad, D. L. 'A Series of Papal Busts by Domenico Guidi', *Burl. Mag.*, CXII (1970), 805 ff.

Cellini, A. N., in *Paragone*, XI (1960), no. 121.

Wittkower, R. 'Domenico Guidi and French Classicism', *J.W.C.I.*, II (1938–9).

JUVARRA

Accascina, A. 'La formazione artistica di Filippo Juvara', *Boll. d'Arte*, XLI (1956), XLII (1957).

Careful study of Juvarra's beginnings at Messina.

Atti del X Congresso di storia dell'architettura. Rome, 1959.

Papers by T. Bianchi, L. Angelini, V. Viale.

Bellini, A. 'Documenti e disegni inediti di Filippo Juvarra', *Storia architettura*, I, no. 1 (1974), 30–47.

Boscarino, S. *Juvarra architetto*. Rome, 1973.

Carboneri, N. 'Filippo J. e il problema delle facciate "alla gotica" del Duomo di Milano', *Arte Lombarda*, VII (1962).

Hager, H. *Filippo Juvarra e il concorso di modelli bandito da Clemente XI per la nuova sacrestia di S. Pietro*. Rome, 1970.

Rediscovery of Juvarra's wooden model as well as of other models believed burned during World War II. Informative text.

Mandracci, V. Comoli. *Le invenzioni di F.J. per la chiesa di S. Filippo Neri in Torino*. Turin, 1967.

Contains facsimile reproduction of 'Modello della chiesa di S. Filippo ... Torino 1758'.

Millon, H. 'Drawings by Juvarra and an Unknown Draftsman for the Autamoro Chapel in S. Girolamo della Carità in Rome', *Studies in Italian Art and Architecture Fifteenth through Eighteenth Centuries*. Rome/Cambridge, Mass., 1980.

Rovere, L., Viale, V., and Brinckmann, A. E. *Filippo Juvarra*. Milan, 1937.

Standard work; full bibliography.

Telluccini, A. *L'arte dell'architetto Filippo Juvara in Piemonte*. Turin, 1926.

Still very useful.

Viale, V. *Mostra di Filippo Juvarra*. Messina, 1966.

An indispensable work; contains Maffei's *Elogio*, the contemporary *Vita*, Sacchetti's Catalogue of Drawings, biographical data, a

modern catalogue of drawings and models, and bibliography.

Viale, V. 'I disegni di F. J. per il palazzo del conclave', *Atti della Accademia delle Scienze di Torino*, CIII (1968–9).

Publication of J.'s alternative projects of 1725 for a Palazzo del Conclave near the Lateran and near St Peter's.

Viale Ferrero, M. *Filippo Juvarra scenografo e architetto teatrale*. Turin, 1970.

A monumental work containing a complete catalogue of J.'s theatre drawings and reproductions of every drawing.

Wittkower, R. 'A Sketchbook of Filippo Juvarra at Chatsworth', in *Studies in the Italian Baroque*. London, 1975.

Title page and all thirty sketches are reproduced in full.

LAER, P. van

Briganti, G. 'P. van Laer and M. Cerquozzi', *Proporzioni*, III (1950).

Briganti, G.; *see* ROME.

Janeck, A. *Untersuchung über den holländischen Maler Pieter van Laer, genannt Bamboccio*. Dissertation, Würzburg, 1968.

A careful, fully documented study with *œuvre* catalogue.

LANFRANCO

In addition to the literature given below, see also E. Schleier, *Burl. Mag.*, CIV (1962); *idem*, *Art Bull.*, L (1968); M. Heimbürger, *Paragone*, no. 243 (1970).

Faldi, I., in *Paragone*, VI (1955), no. 65.

Hibbard, H. 'The Date of Lanfranco's Fresco in the Villa Borghese', in *Miscellanea Bibl. Hertzianae*, 1961.

La Penta, B. L. 'La decorazione della Cappella del Sacramento a San Paolo', *Boll. d'Arte*, XLVIII (1963).

Pergola, P. della, in *Il Vasari*, VI (1933–4).

Posner, D. 'Domenichino and Lanfranco: The Early Development of Baroque Painting in Rome', in *Essays in Honor of Walter Friedlaender*, 135 ff. New York, 1965.

New assessment of the importance of Lanfranco's early style.

Salerno, L. 'The early Work of Giovanni Lanfranco', *Burl. Mag.*, XCIV (1952); *idem*, *Commentari*, V (1954) and IX (1958): chronology of Lanfranco.

Schleier, E. 'Lanfranco's Malereien in der Sakramentskapelle in S. Paolo fuori le mura in Rom: Das wiedergefundene Bild des Wachtelfalls', *Arte*

Antica e Moderna, no. 19 (1965), 62 ff.; no. 30 (1965), 188 ff.; nos 31–2 (1965), 343 ff.

Detailed investigation of the chapel (most of its decoration destroyed), originally Lanfranco's most important work before S. Andrea della Valle. *The Rain of Quails* (Exodus, XVI, 13) is now in a private collection.

Schleier, E. 'Les projets de Lanfranc pour le décor de la Sala Regia au Quirinal et pour la Loge des Bénédictions a Saint-Pierre', *Revue de l'Art*, no. 7 (1970), 40 ff.

A fundamental study. – E. Schleier is preparing a full Lanfranco monograph.

Toesca, I., in *Boll. d'Arte*, XLIV (1959).

Frescoes in S. Agostino, Rome.

LANGETTI

Fiocco, G. 'G. B. Langetti e il naturalismo a Venezia', *Dedalo*, III (1922).

The basic study.

Pallucchini, R., in *Boll. d'Arte*, XXVIII (1934).

LANZANI

Turchi, M. G., in *L'Arte*, LIX (1960).

With *œuvre* catalogue.

LAZZARINI

Pilo, G. M. 'Lazzarini e Tiepolo', *Arte Veneta*, XI (1957), and 'Fortuna critica di Gregorio L.', *Critica d'Arte*, V (1958).

LEGROS

Baumgarten, S. *Pierre Legros artiste romain*. Paris, 1933.

D'Espezel, P., in *G.d.B.A.*, XII (1934).

Correction of Baumgarten; important contribution.

Haskell, F. 'P. Legros and a Statue of the Blessed Stanislas Kostka', *Burl. Mag.*, XCVII (1955).

Documents.

March, G. M., in *Archivum Historicum Soc. Jesu*, III (1934).

Documents, altar of St Ignatius, Gesù.

Preimesberger, R. 'Entwürfe Pierre Legros' für Filippo Juvarras Cappella Antamore', *Röm. historische Mitteilungen*, X (1966–7), 200 ff.

Rovere, L. 'Le statue di Pietro Legros nel Duomo di Torino', *Il Duomo di Torino*, I (1927), no. 9.

LIGOZZI

Bacci, M., in *Proporzioni*, IV (1963).

Full monographic treatment.

LIPPI
Sricchia, F. 'Lorenzo Lippi nello svolgimento della pittura fiorentina della prima metà del '600', *Proporzioni*, IV (1963).

LONGHENA
Semenzato, C. *L'architettura di Baldassare Longhena*. Padua, 1954.
Wittkower, R. 'S. Maria della Salute: Scenographic Architecture and the Venetian Baroque', *Journal of the Society of Architectural Historians*, XVI (1957) and *Saggi e Memorie di storia dell'arte*, III (1963); see also *Studies in the Italian Baroque*. London, 1975.
A fully documented monograph by C. Douglas Lewis Jr. is in preparation.

LONGHI, A.
Arslan, W., in *Emporium*, XCVIII (1943).
Moschini, V., in *L'Arte*, XXXV (1932).

LONGHI, P.
Pignatti, T. *Pietro Longhi*. Venice, 1968. English ed. London–New York, 1969.
Standard work with over 500 illustrations; supersedes V. Moschini's monograph of 1956. Reviews by M. Levey, *Art Bull.*, LII (1970), 463, J. Cailleux, *Burl. Mag.*, CXI (1969), 567 ff.

LUNGHI, M.
Pugliese, A., and Rigano, S. *Martino Lunghi il Giovane*. Rome, 1974.

LUTI
Dowley, F. H., in *Art Bull.*, XLIV (1962).
Moschini, V., in *L'Arte*, XXVI (1923).

LYS (LISS)
Bloch, V., in *Burl. Mag.*, XCVII (1955).
Steinbart, K. *Johann Liss. Der Maler aus Holstein*. Berlin, 1940.
Standard work.
Steinbart, K., in *Saggi e Memorie di storia dell'arte*, II (1958–9).
Summarizes all recent research.

MADERNO, C.
Hibbard, H. *Carlo Maderno*. London, 1972.
A monograph based on a broad foundation of new documents.
Panofsky-Soergel, G. 'Zur Geschichte des Palazzo Mattei di Giove', *Röm. Jahrb. f. Kunstg.*, XI (1967–8), 111–88.
An important, fully documented study.

MADERNO, St.
Cellini, A. Nava. *Maderno* (I maestri della scultura). Milan, 1966.
Cellini, A. Nava. 'Stefano Maderno, Francesco Vanni e Guido Reni a S. Cecilia in Trastevere', *Paragone*, XX (1969), no. 227, 18 ff.
Donati, A. *S.M. scultore*. Bellinzona, 1945.
Holst, N. v., in *Zeitschr. f. Kunstg.*, IV (1935).
Illuminating study of the St Cecilia.
Robertson, J., in *Burl. Mag.*, LXIX (1936).

MAFFEI
Ivanoff, N. *Francesco Maffei*. Padua, 1947.
Ivanoff, N. *Catalogo della mostra di Francesco Maffei*. Venice, 1956.
With full bibliography.
Marini, R., in *Arte Veneta*, XV (1961).
Attempt to clarify influences and chronology.

MAGENTA
Foratti, A., in *Studi dedicati a P. C. Falletti*. Bologna, 1915.
Mezzanotte, G., in *L'Arte*, LX (1961).
Important study.

MAGNASCO
Bonzi, M. *Saggi sul Magnasco*. Genoa, 1947.
Dürst, H. *Alessandro Magnasco*. Teufen-Basel, 1966.
Attempt at an analysis in depth of the phenomenon Magnasco.
Geiger, B. *Alessandro Magnasco*. Berlin, 1914.
Standard work.
Geiger, B. *Saggio d'un catalogo delle pitture di Alessandro Magnasco. Regesti e bibliografia*. Venice, 1945.
Geiger, B. *I disegni del Magnasco*. Padua, 1945.
Alessandro Magnasco (1667–1749). An Exhibition held at the J. B. Speed Art Museum and the University of Michigan Museum of Art. Catalogue. 1967.
A fine catalogue with an Introduction by A. Morassi.
Morassi, A. *Mostra del Magnasco*. Genoa, 1949.
With bibliography.
Pospisil, M. *Magnasco*. Florence, 1945.
Syamken, G. *Die Bildinhalte des A. M.* Hamburg, 1965.
Originally a Hamburg dissertation, the book represents the first serious investigation of the themes of M.'s paintings.

MANCINI
Berti Toesca, E. 'Francesco Mancini a Palazzo Colonna', *L'Arte*, XLVI (1943).

MANETTI, R.
Brandi, C. *Rutilio Manetti*. Siena, 1931.

MANFREDI
Cuzin, J. P. 'Manfredi's *Fortune Teller* and Some Problems of "Manfrediana Methods"', *Bulletin of the Detroit Institute of Arts*, LVIII, 1 (1980), 15–25. Fundamental.

MARABITTI
Agnello, G., in *Archivi*, IV (1937) and XXII (1955).
Giudice, R. *Francesco Ignazio Marabitti*. Palermo, 1937.

MARATTI
Bellori, G. P. *Vita di Guido Reni, Andrea Sacchi e Carlo Maratti* (ed. M. Piacentini). Rome, 1942.
Dowley, F. H., in *Art Quarterly*. XX (1957).
Drawings at Düsseldorf.
Dowley, F. H. 'Carlo Maratti, Carlo Fontana, and the Baptismal Chapel in Saint Peter's', *Art Bull.*, XLVII (1965).
An important contribution, also to art theoretical problems, supplemented by E. Schaar, in *Art Bull.*, XLVIII (1966), 414, and F.R. di Federico, *ibid.*, L (1968), 194.
Kutschera-Woborski, O. 'Ein kunsttheoretisches Thesenblatt Carlo Marattas und seine ästhetischen Anschauungen', *Mitteilungen der Ges. f. vervielfält. Kunst*, XLII (1919).
A classic paper.
Mezzetti, A., in *Riv. del Ist.*, IV (1955).
Standard work, with critical *œuvre* catalogue. See also *Arte Antica e Moderna*, IV (1961).
Nieto Alcaide, V. M. *Dibujos de la R. Academia de San Fernando: Carlo Maratti, 43 Dibujos de tema religioso*. Madrid, 1965.
The attribution of 10 of these 43 drawings is doubted by F. H. Dowley in an informative review in *Art Bull.*, LII (1970), 456 ff.
Raffaele, E. *Notizie della familia del pittore Carlo Maratti*. Monza, 1943.
Schaar, E. 'C.M.'s "Tod des heiligen Franz Xaver" im Gesù', *Festschrift H. Kauffmann*, 247 ff. Berlin, 1968.

MARCHIONNI, C.
Berliner, R. 'Le sedie settecentesche della statua di S. Pietro nella Basilica Vaticana', *Studi Romani*, IV (1956).
Berliner, R., in *Münchner Jahrb. der bild. Kunst*, IX–X (1958–9).
Drawings by Carlo and Filippo Marchionni.

A very rich study with a wealth of new documents.
Gaus, J. *Carlo Marchionni. Ein Beitrag zur römischen Architektur des Settecento*. Cologne, 1967.
A fully documented monograph. Review A. Blunt, *Burl. Mag.*, CXI (1969), 162 ff.

MARCHIORI
Arslan, W., in *Boll. d'Arte*, V (1925–6) and VI (1926–7).

MARIANI
Fiocco, G., in *Le Arti*, III (1940–1).
The basic study.

MARIESCHI
Michele Marieschi (1710–1743). Bergamo, 1966.
Exhibition Catalogue with preface by A. Morassi. The first comprehensive appreciation of this *vedutista*. – See also M. Precerutti-Garberi, in *Pantheon*, XXVI (1968), 37 ff.

MARINALI
Barbieri, F. *L'attività dei Marinali per la decorazione della basilica di Monte Berico*. Vicenza, 1960.
New documents.
Puppi, L. 'Nuovi documenti sui Marinali', *Atti dell'Istituto Veneto di scienze, lettere ed arti*, Classe di scienze morali, lettere ed arti, CXXV (1966–7), 195 ff.
Tua, C., in *Riv. d'Arte*, XVII (1935).
With *œuvre* catalogue.

MASSARI, G.
Bassi, E., in *Boll. Centro Internaz. Studi di Architettura*, IV (1962).
Moschini, V., in *Dedalo*, XII (1932).
Semenzato, C., in *Arte Veneta*, XI (1957).

MASSARI, L.
Volpe, C., in *Paragone*, VI (1955), no. 71.

MASTELLETTA
Marangoni, M., in *L'Arte*, XV (1912), reprinted in *Arte barocca*, Florence, 1953.

MASUCCI
Clark, A. M. 'A.M.: A Conclusion and a Reformation of the Roman Baroque', *Essays in the History of Art presented to R. Wittkower*, 259 ff. London, 1967.
The only attempt at providing a richly documented account of the life and style of Masucci.

MAZZA
Fleming, J., in *Connoisseur*, CXLVIII (1961).
With *œuvre* catalogue.
Riccòmini, E. 'Opere veneziane di Giuseppe Maria Mazza', *Arte Veneta*, XXI (1967), 173 ff.

MAZZONI
Gnudi, C., in *Critica d'Arte*, I (1935–6).
Ivanoff, N., in *Saggi e Memorie di storia dell'arte*, II (1958–9).
Basic study with *œuvre* catalogue and bibliography.

MAZZUOLI
Pansecchi, F., in *Commentari*, X (1959).
Schlegel, U., in *Burl. Mag.*, CIX (1967), 388 ff.
Caritas bozzetto in the Victoria and Albert Museum.
Suboff, V., in *Jahrb. Preuss. Kunstslg.*, III (1928).

MEDICI, G. DE'
Daddi Giovannozzi, V., in *Mitteilungen des kunsthistorischen Instituts in Florenz*, V (1937).

MERLO
Gatti Perer, M. L. *Carlo Giuseppe Merlo architetto.* Milan, 1966.
First comprehensive study of this architect based on documents and drawings.

MITELLI, A.
Feinblatt, E. *Agostino Mitelli. Drawings. Loan Exhibition from the Kunstbibliothek, Berlin.* Los Angeles County Museum of Art, 1965.
An important addition to the scarce literature on Mitelli.

MITELLI, G. M.
Buscaroli, R. *G.M. Mitelli.* Bologna, 1931.

MOCHI
See also DUQUESNOY.
Martinelli, V., in *Commentari*, II (1951) and III (1952).
With *œuvre* catalogue and full bibliography.

MOLA
Arslan, W., in *Boll. d'Arte*, VIII (1928–9).
Arslan, E. 'Disegni del M. a Stoccolma', *Essays in the History of Art presented to R. Wittkower*, 197. London, 1967.
Lee, R. W. 'Mola and Tasso', in *Studies in Renaissance and Baroque Art presented to Anthony Blunt*, no. XXVI. London, 1967.
A stimulating contribution.

Rudolph, S., in *Arte Illustrata*, nos 15–16 (1969), 10 ff.
Critical essay, containing also a survey of all previous Mola literature. See also R. Cocke, in *Burl. Mag.*, CXI (1969), 712 ff., *idem*, *ibid.*, CX (1968), 558 ff., and A. Czobor, *ibid.*, 565 ff.
Sutherland, A. B., in *Burl. Mag.*, CVI (1964).

MOLINARI
Pappalardo, A. M., in *Atti dell'Istituto Veneto di Scienze . . .*, CXII (1953–4).

MONNOT
Sobotka, G. 'Ein Entwurf Marattas zum Grabmal Innocenz XI', *Jahrb. Preuss. Kunstslg.*, XXXV (1914).

MONTELATICI (Cecco Bravo)
Masetti, A. R. *Cecco Bravo.* Venice, 1962.
With *œuvre* catalogue and bibliography.

MONTI, F.
Ruggeri, U. *Francesco Monti bolognese.* Bergamo, 1968.
A monumental work with a catalogue of almost 500 drawings.
Ruggeri, U. 'Francesco Monti bolognese a Brescia', *Critica d'Arte*, XVI, no. 108 (1969), 35 ff.; XVII, no. 109 (1970), 37 ff.

MORANDI, G. M.
Waterhouse, E. 'A Note on G.M.M.', *Studies in Renaissance and Baroque Art presented to Anthony Blunt*, 117. London, 1967.
The fullest statement on this rather neglected painter, with work catalogue.

MORAZZONE (Mazzucchelli, P. F.)
Baroni, C., in *L'Arte*, XLIV (1941).
Gregori, M. *Il Morazzone.* Milan, 1962.
Exhibition catalogue, with complete documentation, *œuvre* catalogue, and bibliography. Supersedes previous studies.
Nicodemi, G. *Il Morazzone.* Varese, 1927.
Uncritical, see review N. Pevsner, *Rep. f. Kunstw.*, L (1929).
Zuppinger, E., in *Commentari*, II (1951).

MORLAITER
Arslan, W., in *Riv. di Venezia*, XI (1932).
Lorenzetti, G., in *Dedalo*, XI (1930–1).

NACCHERINO
Maresca di Serracapriola, A. *M. Naccherino scultore fiorentino.* Naples, 1924.

NIGETTI
Berti, L., in *Riv. d'Arte*, XXVI (1950) and XXVII (1951–3).

NOMÉ (Monsù Desiderio)
Causa, R., in *Paragone*, VII (1956), no. 75.
Sluys, F. *Didier Barra et François de Nomé dits Monsù Desiderio*. Paris, 1961.
The final statement with full references and *œuvre* catalogue.

NOVELLI
Di Stefano, G. *Pietro Novelli*. Palermo, 1940.

PAGANI, P.
Ivanoff, N., in *Paragone*, VIII (1957), no. 89.
Voss, H., in *Belvedere*, VIII (1929).

PALMA GIOVANE
Forlani, A. *Mostra di disegni di Jacopo Palma il Giovane*. Florence, 1958.

PANNINI
Arisi, F. *G. P. Panini*. Cassa di Risparmio di Piacenza, 1961.
A monumental work, with *œuvre* catalogue; fully illustrated.
Ozzola, L. *G. P. Pannini*. Turin, 1921.

PARIGI, A. and G.
Berti, L., in *Palladio*, I (1951).
Linnenkamp, R., in *Riv. d'Arte*, XXXIII (1960).

PARODI, F.
Grossi, O., in *Dedalo*, II (1921).
Rotondi Briasco, P. *Filippo Parodi*. Genoa, 1962.
Not yet the final monograph.

PASINELLI
Baroncini, C., in *Arte Antica e Moderna*, II (1958).

PELLEGRINI
Bettagno, A. *Disegni e dipinti di G. A. Pellegrini*. Venice, 1959.
Exhibition catalogue. Basic study. See also T. Pignatti, in *Burl. Mag.*, CI (1959), 451; R. Pallucchini, in *Pantheon*, XVIII (1960), 182, 245.
Goering, M., in *Münchner Jahrb.*, XII (1937–8).

PETRINI
Arslan, E. *Giuseppe Antonio Petrini*. Lugano, 1960.
First comprehensive study, with *œuvre* catalogue and bibliography.

PIAZZETTA
Maxwell White, D., and Sewter, A. C. *I disegni di Giovan Battista Piazzetta nella Biblioteca Reale di Torino*. Rome, 1969.
Scholarly catalogue of the two Piazzetta albums in Turin.
Pallucchini, R. *L'arte di Giambattista Piazzetta*. Bologna, 1934.
Standard work.
Pallucchini, R. *Piazzetta*. Milan, 1956.

PICHERALI
Agnello, G., in *Archivio Stor. per la Sicilia*, II–III (1936–7), VI (1940), and serie III, II (1947).

PIOLA
Castelnovi, G. V. *I dipinti di S. Giacomo alla Marina*. Genoa, 1953.

PIRANESI
Cochetti, L. 'L'opera teorica di Piranesi', *Commentari*, VI (1955).
Fischer, M. F. 'Die Umbaupläne des G. B. Piranesi für den Chor von S. Giovanni in Laterano', *Münchner Jahrb. d. bild. Kunst*, XIX (1968), 207ff.
Focillon, H. *Giovanni Battista Piranesi*. Paris, 1928.
Hind, A. M. *Giovanni Battista Piranesi*. London, 1922.
Both Hind and Focillon are standard works.
Körte, W. 'G. B. Piranesi als praktischer Architekt', *Zeitschr. f. Kunstg.*, II (1933).
Mayor, A. H. *Giovanni Battista Piranesi*. New York, 1952.
Best modern study.
Mostra di incisioni di G. B. Piranesi. Catalogue. Bologna, 1963.
Introduction by S. Bottari. Useful survey.
Thomas, H. *The Drawings of Giovanni Battista Piranesi*. New York, 1954.
Vogt-Göknil, U. *Giovanni Battista Piranesi. Carceri*. Zürich, 1958.
Some interesting material, but to be used with caution.
Wilton-Ely, J. *The Mind and Art of Giovanni Battista Piranesi*. London, 1978.
Wittkower, R. 'Piranesi's "Parere su l'Architettura"', *J.W.C.I.*, II (1938–9).
Wittkower, R. 'Piranesi as Architect', in *Studies in the Italian Baroque*. London, 1975.
Wittkower, R. 'Piranesi and Eighteenth-Century Egyptomania', in *Studies in the Italian Baroque*. London, 1975.

PITTONI
Coggiola Pittoni, L. *Dei Pittoni*. Bergamo, 1970.

Goering, M., in *Mitteilungen des kunsthistorischen Instituts in Florenz*, IV (1934).
Pallucchini, R. *I disegni di G. B. Pittoni*. Padua, 1945.
Zava Bocazzi, F. *Giambattista Pittoni*. Venice, 1978.

PIZZOCARO
Puppi, L. 'Antonio Pizzocaro architetto vicentino', in *Prospettive* (Milan), no. 23 (1961).

PONZIO
Crema, L. *Flaminio Ponzio architetto milanese a Roma* (Atti del IV Congresso Nazionale di storia dell' architettura). Milan, 1939.

PORPORA
Causa, R. 'Paolo Porpora e il primo tempo della natura morta a Napoli', *Paragone*, II (1951), no. 15.

POZZO
Carboneri, N. *Andrea Pozzo architetto*. Trent, 1961.
 With full bibliography.
Kerber, B. 'Bibliographie zu Andrea Pozzo', *Archivum Hist. Soc. Jesu*, XXXIV (1956).
 An exemplary study.
Kerber, B. *Andrea Pozzo*. Berlin–New York, 1971.
 A full study of Pozzo as painter and architect, incorporating all previous research.
Marini, R. *Andrea Pozzo pittore*. Trent, 1959.
Pergola, P. della. 'Le opere toscane di A. Pozzo', *Riv. del R. Ist.*, V (1935–6).
Pozzo, A. *Perspectiva pictorum et architectorum*. Rome, 1693.

PRETI, F. M.
Favaro-Fabris, M. *L'architetto Francesco Maria Preti*. Treviso, 1954.

PRETI, M.
Causa, R., in *Emporium*, CXVI (1952).
Fantuzzo, M., in *Boll. d'Arte*, XL (1955).
Frangipane, A. *Mattia Preti, 'il cavalier calabrese'*. Milan, 1929.
Mariani, V. *Mattia Preti a Malta*. Rome, 1929.
Refice, C. 'Gli affreschi di Mattia Preti nella chiesa di S. Domenico Soriano', *Boll. d'Arte*, XXXIX (1954).
Refice Taschetta, C. *Mattia Preti*. Brindisi, 1961.
 Professional, but too brief and not always reliable.

PROCACCINI, G. C.
Pevsner, N., in *Riv. d'Arte*, XI (1929).
Valsecchi, M., in *Paragone*, XXI (1970), no. 243, 12 ff.
Vigezzi, S. 'I primi anni d'attività di G. C. Procaccini', *Riv. d'Arte*, XV (1933).

Wittgens, F., in *Riv. d'Arte*, XV (1933).

RAGGI
Donati, U., in *L'Urbe*, VI (1941), ii.
 Fountains at Sassuolo.
Nava, A., in *L'Arte*, XL (1937).
Sorrentino, A., in *Riv. d'Arte*, XX (1938).
 Farnese busts.

RAGUZZINI
Rotili, M. *Filippo Raguzzini e il rococò romano*. Rome, 1951.
 A well documented study with further literature.

RAINALDI, C.
Fasolo, F., in *Quaderni*, no. 2 (1953).
 On the latest period, with documents.
Fasolo, F. *L'opera di Hieronimo e Carlo Rainaldi*. Rome, 1961.
 Important; many new documents, but somewhat chaotic and difficult to use. Constructive review by K. Noehles, *Zeitschr. f. Kunstg.*, XXV (1962).
Hempel, E. *Carlo Rainaldi*. Munich, 1919.
Matthiae, G., in *Arti Figurative*, II (1946).
Wittkower, R. 'Carlo Rainaldi and the Architecture of the High Baroque', in *Studies in the Italian Baroque*. London, 1975.
 Revised transl. of the essay first publ. in *Art Bull.*, XIX (1937).

RECCO, G.
Zeri, F., in *Paragone*, III (1952), no. 33.

RENI
Bellori, G. P., *see* MARATTI
Cuppini, L., in *Commentari*, III (1952).
 On Reni's late manner.
Giondo, G. 'La critica su Guido Reni', *Riv. del Ist.*, II (1953).
Gnudi, C., and Cavalli, G. C. *Mostra di Guido Reni*. Bologna, 1954.
 Very important, with full bibliography.
Gnudi, C., and Cavalli, G. C. *Guido Reni*. Florence, 1955.
 Standard work with *catalogue raisonné* and bibliography. See D. Mahon, *Burl. Mag.*, XCIX (1957), 238.
Heinz, G., in *Jahrb. d. kunsthist. Sammlungen, Vienna*, XV (1955).
Hibbard, H. 'Guido Reni's Painting of the Immaculate Conception', *The Metropolitan Museum of Art Bulletin*, XXVIII (1969), 19 ff.

A sensitive contribution to R.'s iconography and stylistic development.

Johnston, C. 'Reni Landscape Drawings in the Mariette Coll.', *Burl. Mag.*, CXI (1969), 377 ff.

Kurz, O., in *Jahrb. d. kunsthist. Sammlungen, Vienna*, XI (1937).
Basic study.

Kurz, O. 'A Sculpture by Guido Reni', *Burl. Mag.*, LXXXI (1942).

Pepper, D. S. 'Guido Reni's early Drawing Style', *Master Drawings*, VI (1968), 364 ff.

Pepper, D. S. 'Guido Reni's early Style: His Activity in Bologna 1595–1601', *Burl. Mag.*, CXI (1969), 472 ff.

RIBERA

Bédarida, H., in *À travers l'art italien du XVᵉ au XXᵉ siècle*. Paris, 1949.
Iconographical.

Brown, J. *Jusepe de Ribera: Prints and Drawings*. Princeton, N.J., 1973.

Mayer, A. L. *Jusepe de Ribera*. Leipzig, 1923.
The standard biography.

Trapier, E. du Gué. *Ribera*. New York, 1952.

RICCHINO

Cataneo, E. *Il San Giuseppe del Richini*. Milan, 1957.

Gengaro, M. L. 'Dal Pellegrini al Ricchino', *Boll. d'Arte*, XXX (1936).

Mezzanotte, P. 'Apparati architettonici del Richino per nozze auguste', *Rassegna d'Arte*, XV (1915).

RICCI, M. and S.

Czobor, A., in *Acta Historiae Artium*, I (1954).

Daniels, J. *Sebastiano Ricci*. Hove, 1976.
With catalogue of Ricci's paintings and extensive bibliography.

Derschau, J. *Sebastiano Ricci*. Heidelberg, 1922.
Standard work.

Milkovich, M. *Sebastiano and Marco Ricci in America*. University of Kentucky, 1966.
Catalogue of a loan exhibition illustrating 98 paintings and drawings.

Osti, O. 'Sebastiano Ricci in Inghilterra', *Commentari*, II (1951).

Pilo, G. M. *Marco Ricci. Catalogo della mostra*. Venice, 1963.
Introduction by R. Pallucchini. Fullest study of Marco Ricci. Discussion of 250 works; rich bibliography. See also Pilo, in *Paragone*, XIV (1963), no. 165.

Marco Ricci e gli incisori bellunesi del '700 e '800. Venice, 1968.
Catalogue of an Exhibition at Belluno based on material from the Alpago-Novello collection.

Rizzi, A. *Sebastiano Ricci, disegnatore*. Udine, 1975.
Catalogue of exhibition.

ROSA, S.

Cecil, R. A. 'Apollo and the Sibyl of Cumaea by S. R.', *Apollo*, LXXXI (1965), 464 ff.

De Rinaldis, A. *Lettere inedite di Salvator Rosa a G. B. Ricciardi*. Rome, 1939.

Limentani, U. *Poesie e lettere inedite di Salvator Rosa*. Florence, 1950; idem, *Bibliografia della vita e delle opere di S.R.* Florence, 1955.

Mahoney, M. 'S.R.'s Saint Humphrey', *The Minneapolis Inst. of Arts Bulletin*, LIII, 3 (1964), 55 ff.

Mahoney, M. *The Drawings of Salvator Rosa*. Unpublished dissertation, Courtauld Institute, University of London, 1965.
See the author's paper on Rosa, in *Master Drawings*, III (1965), 383 ff.

Morgan, Lady Sydney. *The Life and Times of Salvator Rosa*. Paris, 1824.
The classic biography.

Oertel, R. 'Die Vergänglichkeit der Künste', *Münchner Jahrb. d. bild. Kunst*, XIV (1963).
Valuable contribution to Rosa's *vanitas* conceptions.

Ozzola, L. *Vita e opere di Salvator Rosa*. Strasbourg, 1908.
Standard work.

Prota-Giurleo, U. *La famiglia e la giovinezza di Salvator Rosa*. Naples, 1929.
Biographical.

Salerno, L. *Salvator Rosa*. Milan, 1963.
The only modern monograph, with œuvre catalogue. Review F. Haskell, *Burl. Mag.*, CVII (1965), 263.

Wallace, R. W. 'The Genius of S.R.', *Art Bull.*, XLVII (1965), 471.
An exploration of Rosa's conception of genius based on an iconological study of his etching 'Genius of Rosa'.

Wallace, R. W. 'Salvator Rosa's "Justice appearing to the Peasants"', *J.W.C.I.*, XXX (1967), 431.

Wallace, R. W. 'Salvator Rosa's "Democritus" and "L'Umana Fragiltà"', *Art Bull.*, L (1968), 21.
See also the same author's 'Salvator Rosa's "Death of Atilius Regulus"', *Burl. Mag.*, CIX (1967), 395.

ROSSI, A. DE

Martinelli, V., in *Studi Romani*, VII (1959).

ROSSI, G. A. DE
Spagnesi, G. *Giovanni Antonio De Rossi architetto romano*. Rome, 1964.
 Full monographic treatment; many new documents.

ROTARI
Barbarini, E. *Pietro Rotari*. Verona, 1941.
 Fully documented.

RUSCONI
Baumgarten, S., in *La Revue de l'Art*, LXX (1936).
Martinelli, V., in *Commentari*, IV (1953).
 With further literature.
Samek Ludovici, S., in *Archivi*, XVII (1950).
 Publication of F. S. Baldinucci's 'Life' of Rusconi.
Webb, M. J., in *Burl. Mag.*, XCVIII (1956).

SACCHI
Harris, A. S., and Schaar, E. *Die Handzeichnungen von Andrea Sacchi und Carlo Maratta*. Katalog Kunstmuseum Düsseldorf. Düsseldorf, 1967.
Harris, A. S. 'Andrea Sacchi and Emilio Savonanzi at the Collegio Romano', *Burl. Mag.*, CX (1968), 249 ff.; also *idem*, 'The Date of A.S.'s "Vision of St Romuald"', *ibid.*, 489 ff.
Harris, A. S. *Andrea Sacchi*. London, 1977.
 A fully documented monograph with *œuvre* catalogue.
Incisa della Rocchetta, G., in *L'Arte*, XXVII (1924).
 Documents.
Posse, H. *Der römische Maler Andrea Sacchi. Ein Beitrag zur Geschichte der klassizistischen Bewegung im Barock*. Leipzig, 1925.
 Indispensable.
Wibiral, N., in *Palladio*, V (1955).
 On Sacchi as architect.

SALINI, T.
Salerno, L., in *Commentari*, III (1952).
Zeri, F., in *Paragone*, VI (1955), no. 61.

SALVI, N.
Schiavo, A. *La Fontana di Trevi e le altre opere di Nicola Salvi*. Rome, 1956.

SARACENI
Cavina, A. Ottani. *Carlo Saraceni*. Milan, 1968.
 Brief text; curriculum; documents; *œuvre* catalogue. Supersedes the author's paper in *Arte Veneta*, XXI (1967), 218 ff. Review B. Nicolson, *Burl. Mag.*, CXII (1970), 312 ff.

Porcella, A., in *Riv. mensile della città di Venezia*, VII (1928).

SARDI, G.
Mallory, N. A., in *Journal Soc. Architect. Historians*, XXVI (1967), 83 ff.
 First critical monograph treatment of this eighteenth-century Roman architect.

SCAMOZZI
Barbieri, F. *Vincenzo Scamozzi*. Vicenza, 1952.
 With detailed 'regesto' and full bibliography.
Zorzi, G., in *Arte Veneta*, X (1956).
 Documents.

SERODINE
Askew, P. 'A Melancholy Astronomer by G.S.', *Art Bull.*, XLVII (1965), 121.
Longhi, R. *Giovanni Serodine*. Florence [1954].
 Œuvre catalogue, documents, bibliography.
Schoenenberger, W. *Giovanni Serodine pittore di Ascona*. Basel, 1957.
 Partly superseded by Longhi's book, not yet known to the author at the time of writing.

SERPOTTA
Caradente, G. *Giacomo Serpotta*. Turin, 1967.
 Excellent monograph.
Meli, F. *Giacomo Serpotta*. Palermo, 1934.
 Basic work, published as vol. II to 'Giacomo Serpotta. Secondo centenario serpottiano 1732–1932'.

SLODTZ, M.
Golzio, V., in *Dedalo*, XI (1930–1).
Souchal, F. *Les Slodtz, sculpteurs et décorateurs du roi*. Paris, 1967.
 Exhaustive treatment of all the members of the family.

SOLIMENA
Bologna, F. *Francesco Solimena*. Naples, 1958.
 First modern monograph, with *œuvre* catalogue and bibliography.

STANZIONI
Schwanenberg, H. *Leben und Werk des Massimo Stanzioni*. Bonn, 1937.
 A dissertation, not satisfactory.

STROZZI
Lazareff, V., in *Münchner Jahrb. der bild. Kunst*, VI, ii (1929).
 The best study of the early Strozzi.

Matteucci, A. M. 'L'attività veneziana di Bernardo Strozzi', *Arte Veneta*, IX (1955).
Milkovich, M. *B. Strozzi*. Catalogue. Binghamton, N.Y., 1967.
Paintings by Strozzi in America.
Mortari, L. *Bernardo Strozzi*. Rome, 1966.
Full monograph with *œuvre* catalogue. See V. Antonov, *Paragone*, XIX (1968), no. 223, 74 ff.

TACCA, P. and F.
Bianchi, E. S. 'Pietro and Ferdinando Tacca', *Riv. d'Arte*, XIII (1931).
Fully documented.
Lewy, E. *Pietro Tacca*. Cologne, 1928.
Unsatisfactory; see review by E. S. Bianchi, *Riv. d'Arte*, XI (1929).

TANZIO
Arslan, W. 'Affreschi del Tanzio a Milano', *Phoebus*, II (1948).
Bologna, F., in *Paragone*, IV (1953), no. 45.
Calvesi, M. 'Considerazioni su Tanzio da Varallo', in *Studi di Storia dell'Arte in onore di Vittorio Viale*, 35. Turin, 1967.
Previtali, G. 'Frammenti del Tanzio a Napoli', *Paragone*, XX (1969), no. 229, 42 ff.
Full bibliography of the decade after the Tanzio Exhibition.
Testori, G. *Tanzio da Varallo*. Catalogue. Turin, 1959.
The fullest treatment of Tanzio; bibliography.

TASSI
Hess, J. *Agostino Tassi, der Lehrer des Claude Lorrain*. Munich, 1935.
Salerno, L. 'Il vero Filippo Napoletano e il vero Tassi', *Storia dell'Arte*, no. 6 (1970), 139 ff.
Revolutionary hypotheses concerning the two artists.
Waddingham, M. R., in *Paragone*, XII (1961), no. 139; XIII (1962), no. 147.

TESTA
Cropper, E. 'Virtue's Wintry Reward: Pietro Testa's Etchings of the Seasons', *J.W.C.I.*, XXXVII (1974), 249.
Harris, A. Sutherland, in *Paragone*, XVIII (1967), no. 213, 35 ff.
First attempt at chronology of Testa's work.
Harris, A. S., and Lord, C. 'Pietro Testa and Parnassus', *Burl. Mag.*, CXII (1970), 15 ff.
First opening up of Testa's difficult iconography.

Lopresti, L., in *L'Arte*, XXIV (1921).
The basic study.
Marabottini, A., in *Commentari*, V (1954).
Important paper, with an account of Testa's art theory.

TIARINI
Fiori, T., in *Commentari*, VIII (1957).
Malaguzzi Valeri, F., in *Cronache d'Arte*, I (1924).
Szöllösi, M. *Andrea Tiarini pittore bolognese*. Budapest, 1936.

TIEPOLO, G. B. and G. D.
D'Ancona, P. *Tiepolo in Milan: The Palazzo Clerici Frescoes*. Milan, 1956.
Hetzer, T. *Die Fresken Tiepolos in der Würzburger Residenz*. Frankfurt, 1943.
A very sensitive study.
Knox, G. *Catalogue of the Tiepolo Drawings in the Victoria and Albert Museum*. London, 1960.
Fundamental for the study of Tiepolo as draughtsman.
Knox, G. 'The Orloff Album of Tiepolo Drawings', *Burl. Mag.*, CIII (1961).
Catalogue of 96 drawings.
Knox, G. 'Giambattista – Domenico Tiepolo: "The Supplementary Drawings of the Quaderno Gatteri"', *Bollettino dei Musei Civici Veneziani*, XI (1966), no. 3, 3 ff.
225 sheets of drawings in the Museo Correr, supplementary to the publication of the Gatteri Album published in 1946 by G. Lorenzetti.
Knox, G. *Tiepolo. A Bicentenary Exhibition 1770–1970*. Fogg Art Museum, Harvard Univ., 1970.
Indispensable for students of Tiepolo as draughtsman.
Knox, G., and Thiem, C. *Tiepolo. Zeichnungen von Giambattista, Domenico und Lorenzo Tiepolo aus der Graphischen Sammlung der Staatsgalerie Stuttgart ...* Stuttgart, 1970.
An excellent, fully illustrated catalogue of 210 numbers.
Lorenzetti, G. *Mostra del Tiepolo. Catalogo*. Venice, 1951.
With chronological survey and full bibliography.
Mariuz, A. *G. D. Tiepolo*. Venice, 1971.
Monograph and *catalogue raisonné* of Domenico's works.
Molmenti, P. *G. B. Tiepolo*. Milan, 1909.
The classic monograph.
Morassi, A. *A Complete Catalogue of the Paintings of G. B. Tiepolo*. London, 1962.

Basic, despite the harsh criticism by M. Levey, in *Art Bull.*, XLV (1963), 293.

Puppi, L. 'I Tiepolo a Vicenza e le statue dei "Nanni" di villa Valmarana a S. Bertiano', *Atti dell'Istituto Veneto di Scienze, Lettere ed Arti* (Classe di scienze morali ...), CXXVII (1967–8), 211–50.
 A thoughtful study based on diligent archival work and a wide knowledge of literature. See also *idem*, in *Antichità Viva* (1968), 2, 34 ff.

Rizzi, A. *L'opera grafica dei Tiepoli. Le acquaforti.* Milan, 1971.

Sack, E. *Giambattista und Domenico Tiepolo.* Hamburg, 1910.
 Still an important monograph.

Shaw, J. Byam. *The Drawings of Domenico Tiepolo.* London, 1962.
 A brilliant study.

TORELLI

Bjurström, P. *Giacomo Torelli and Baroque Stage Design.* Stockholm, 1961.
 An important contribution.

TRAVERSI

Longhi, R., in *Vita Artistica*, II (1927).
 Reconstruction of Traversi's career.

Quintavalle, A. G., in *Paragone*, VII (1956), no. 81.

TREVISANI

Di Federico, F. R. *Francesco Trevisani.* Washington, 1977.
 A *catalogue raisonné.*

VACCARINI: *see* SICILY under heading CITIES AND PROVINCES

VACCARO, A.

Commodo Izzo, M. *Andrea Vaccaro pittore.* Naples, 1951.

VALENTIN

Ivanoff, N. *Valentin de Boulogne.* Milan, 1966.

Longhi, R., in *La Revue des Arts*, VIII (1958).
 With *œuvre* catalogue.

VALERI

Valeri, U. *L'ultimo allievo del Bernini: Antonio Valeri.* Rome, 1946.
 Monograph on the uninteresting teacher of Canevari, Salvi, and Vanvitelli.

VALLE, F. della

Honour, H., in *Connoisseur*, CXLIV (1959).
 With *œuvre* catalogue.

Moschini, V., in *L'Arte*, XXVIII (1925).

VANVITELLI, G.

Briganti, G. *Gaspar Van Wittel e l'origine della veduta settecentesca.* Rome, 1966.
 A broad study of topographical landscape painting. *Œuvre* catalogue; richly illustrated. Supersedes all previous writings on G. v. W. Review W. Vitzthum, *Burl. Mag.*, CIX (1967), 317 f.

VANVITELLI, L.

Atti dello VIII convegno nazionale di storia dell'architettura. Rome, 1956.
 The first half of the volume with contributions by many authors is dedicated to L. Vanvitelli.

Caroselli, M. R. *La Reggia di Caserta. Lavori costo effetti della costruzione.* Milan, 1968.
 Important study by a social historian based on new documents.

Chierici, G. *La Reggia di Caserta.* Rome, 1937. New ed., 1969.

Fagiolo-dell'Arco, M. *Funzioni simboli valori della Reggia di Caserta.* Rome, 1963.

Fichera, F. *Luigi Vanvitelli.* Rome, 1937.
 Not very satisfactory; some documents, bibliography.

Galasso, E. *Vanvitelli a Benevento.* Benevento, 1959.
 New documents.

Garms, J. 'Beiträge zu Vanvitellis Leven, Werk und Milieu', *Römische historische Mitteilungen*, XVI (1974), 107–90.

Stoppel, W. E. 'Der Arco Clementino Vanvitellis und die Statue Cornacchinis im Ehrenbogen für Clemens XII in Ancona', *Röm. Jahrb. f. Kunstg.*, XII (1969), 203 ff.

Vanvitelli, L. *Dichiarazione dei disegni del real palazzo di Caserta.* Naples, 1756.
 With engravings of Vanvitelli's project.

VASANZIO (Van Santen)

Hoogewerff, G. J., in *Roma*, VI (1928), *Palladio*, VI (1942), and *Arch. della R. Dep. romana di storia patria*, LXVI (1943).

VASSALLO

Grosso, O. 'A. M. Vassallo e la pittura d'animali nei primi del '600 a Genova', *Dedalo*, III (1922–3).

VERMEXIO

Agnello, G. *I Vermexio.* Florence, 1959.

VITTONE

Baracca, C. 'Bernardo Vittone e l'architettura guariniana', *Torino*, XVI (1938).

Brayda, C., in *Boll. Soc. Piemontese*, N.S. I (1947).

Carboneri, N., in *Quaderni*, X (1963), nos 55–60, 59–74.
> Discussion of the Turin volume of drawings preparatory to V.'s publication of his Treatise of 1766 and publication of drawings for the church at Pecetto Torinese.

Carboneri, N., and Viale, V. *Bernardo Vittone architetto*. Vercelli, 1967.
> First-rate exhibition catalogue, published on the occasion of the restoration of Vittone's S. Chiara at Vercelli.

Oechslin, W. 'Un tempio di Mosè. I disegni offerti da B. A. Vittone all'Accademia di San Luca nel 1733', *Boll. d'Arte*, LII (1967), 167 ff.

Oechslin, W. *Bildungsgut und Antikenrezeption des frühen Settecento in Rom*. Zürich, 1972.
> With dates and documents for Vittone's stay in Rome.

Olivero, E. *Le opere di Bernardo Antonio Vittone*. Turin, 1920.
> A valuable collection of facts.

Panizza. A., a.o. *S. Luigi Gonzaga di Corteranzo*. Turin, 1970.
> A co-operative enterprise published by the Istituto di Elementi di Architettura e Rilievo Monumenti. Scholarly work by architects, of considerable interest.

Portoghesi, P. *Bernardo Vittone. Un architetto tra Illuminismo e Rococò*. Rome, 1966.

Rodolfo, G., in *Atti della soc. piemontese di arch. e belle arti*, XV (1933).
> Documents.

Viale, V. (ed.). *Bernardo Vittone e la disputà fra classicismo e barocco nel settecento*. 2 vols. Turin, 1972–5.
> Contributions covering many aspects of Vittone's work.

Wittkower, R. 'Vittone's Drawings in the Musée des Arts Décoratifs', in *Studies in Renaissance and Baroque Art presented to Anthony Blunt*. London, 1967.

VITTOZZI

Carboneri, N. *Ascanio Vitozzi. Un architetto tra Manierismo e Barocco*. Rome, 1966.
> A fully documented critical monograph. Review by V. Moccagatta in *Palladio*, XVI (1966), 183 ff.

Scotti, A. *Ascanio Vitozzi ingegnere ducale a Torino* (publication of the Istituto di storia dell'arte medievale e moderna all'Università di Milano). Florence, 1970.

WITTEL, G. VAN *see* VANVITELLI, G.

ZANCHI, A.

Riccoboni, A. 'Antonio Zanchi e la pittura veneziana del Seicento', *Saggi e Memorie di storia dell'arte*, V (1966), 55–134.
> Full biography, *catalogue raisonné*, and bibliography.

ZUCCARELLI

Bassi Rathgeb, R. *Un album inedito di Francesco Zuccarelli*. Bergamo, 1948.

Levey, M. 'F. Z. in England', *Italian Studies*, XIV (1959).

Rosa, G. *Zuccarelli*. Milan, 1952.
> Slight text.

ZUMBO

Lightbown, R. W., in *Burl. Mag.*, CVI (1964), 486 ff., 563 ff.
> First professional attempt at assessing the work in wax of this remarkable artist.

LIST OF ILLUSTRATIONS

Sculpture: If the medium is not given, it is always marble

Painting: If the medium is not given, it is always oil

Abbreviation: G.F.N. Gabinetto Fotografico Nazionale, Rome

172. Francesco Duquesnoy : A Putto from the Andrien Vryburch Tomb, 1629. *Rome, S. Maria dell' Anima* (G.F.N.)

173. Francesco Duquesnoy: A Putto, after 1630. Bronze. *London, Victoria and Albert Museum* (Victoria and Albert Museum)

174. Francesco Duquesnoy: Putto Frieze, 1640-2. Terracotta model for SS. Apostoli (Naples). *Formerly Berlin, Deutsches Museum* (Berlin Museum)

175. Carlo Rainaldi: Rome, S. Maria in Campitelli. Project, 1662. *S. Maria in Campitelli* (Foto Vasari, Rome; author's copyright)

176. Carlo Rainaldi: Rome, S. Maria in Campitelli, 1663-7. Interior (Marburg)

177. Carlo Rainaldi: Rome, S. Maria in Campitelli, 1663-7. Plan (From *Insignium Romae Templorum prospectus*, 1684)

178. Carlo Rainaldi: Rome, S. Maria in Campitelli, 1663-7. Façade (Marburg)

179. Carlo Maderno and Carlo Rainaldi: Rome, S. Andrea della Valle. Façade, 1624-9, 1661-5 (Marburg)

180. Rome, Piazza del Popolo, from G. B. Nolli's plan, 1748

181. Carlo Rainaldi and Gianlorenzo Bernini: Rome, Piazza del Popolo. S. Maria di Monte Santo and S. Maria de' Miracoli, 1662-79 (Alinari)

182. Martino Longhi the Younger: Rome, SS. Vincenzo ed Anastasio, façade, 1646-50 (Anderson)

183. Giovan Antonio de' Rossi : Rome, Palazzo D'Aste-Bonaparte, 1658-*c*. 1665 (Alinari)

184. Giovan Battista Bergonzoni: Bologna, S. Maria della Vita, begun 1686. Plan (H. Strack, *Central-und Kuppelkirchen der Renaissance in Italien*, plate 30)

185. Baldassare Longhena: Venice, S. Maria della Salute, begun 1631. Section and plan (C. Santamaria, *L'Architettura*, I (1955), and Cicogna-Diedo-Selva, *Le fabbriche e i monumenti cospicui di Venezia*, II)

186. Baldassare Longhena: Venice, S. Maria della Salute, begun 1631. View towards the chapels (Giorgio Cini Foundation)

187. Baldassare Longhena: Venice, S. Maria della Salute, begun 1631. View towards the high altar (Osvaldo Böhm)

188. Baldassare Longhena: Venice, S. Maria della Salute, begun 1631 (Alinari)

189. Baldassare Longhena: Venice, S. Maria della Salute, begun 1631. View into the dome (Giorgio Cini Foundation)

190. Baldassare Longhena: Venice, Palazzo Pesaro, 1652/9-1710 (Alinari)

191. Baldassare Longhena: Venice, Monastery of S. Giorgio Maggiore. Staircase, 1643-5 (Giorgio Cini Foundation)

192. Gherardo Silvani: Florence, S. Gaetano. Façade, 1645 (Brogi)

193. Cosimo Fanzago: Naples, S. Martino. Cloisters, detail, *c*. 1630 (Alinari)

194. Cosimo Fanzago: Naples, S. Maria Egiziaca, 1651-1717. Section and plan (Pane, *Architettura dell'età barocca a Napoli*, 107, 108)

195. Andrea Bolgi: St Helena, 1629-39. *Rome, St Peter's* (Anderson)

196. Melchiorre Caffà: The Ecstasy of St Catherine, finished 1667. *Rome, S. Caterina da Siena a Monte Magnanapoli* (G.F.N.)

197. Melchiorre Caffà: St Thomas of Villanova distributing Alms, 1661. Terracotta model. *La Valletta, Museum* (Author's photograph)

198. Ercole Ferrata: St Agnes on the Pyre, 1660. *Rome, S. Agnese in Piazza Navona* (Alinari)

199. Ercole Ferrata: The Stoning of S. Emerenziana, begun 1660 (finished by Leonardo Retti, 1689-1709). *Rome, S. Agnese in Piazza Navona* (Anderson)

200. Antonio Raggi: The Death of St Cecilia, 1660-7. Detail. *Rome, S. Agnese in Piazza Navona* (Alinari)

201. Antonio Raggi: Allegorical Figures, 1669-83. *Rome, Gesù, clerestory of nave* (Anderson)

202. Domenico Guidi: Lamentation over the Body of Christ, 1667-76. *Rome, Cappella Monte di Pietà* (G.F.N.)

203. Gianlorenzo Bernini: Gabriele Fonseca, *c*. 1668-75. *Rome, S. Lorenzo in Lucina* (Leonard von Matt)

204. Giuliano Finelli: Tomb of Cardinal Giulio Antonio Santorio, after 1630. *Rome, S. Giovanni in Laterano* (Anderson)

205. Francesco Aprile: Model for the tombs of Pietro and Francesco Bolognetti, after 1675. *London, Victoria and Albert Museum* (Victoria and Albert Museum)

206. Cosimo Fancelli: The Angel with the Sudary, 1668-9. *Rome, Ponte S. Angelo* (R. Moscioni)

207. Giovanni Battista Salvi, il Sassoferrato: The Virgin of the Annunciation, *c*. 1640-50. Detail. *Casperia (Rieti), S. Maria Nuova* (G.F.N.)

208. Michelangelo Cerquozzi and Viviano Codazzi: Roman Ruins, *c*. 1650. *Rome, Pallavicini Collection* (G.F.N.)

209. Pier Francesco Mola: Joseph making himself known to his Brethren, 1657. Fresco. *Rome, Palazzo del Quirinale, Gallery* (G.F.N.)

210. Pietro Testa: Allegory of Reason, 1640-50. Etching

211. Salvator Rosa: Landscape with the Finding of Moses, *c*. 1650. *Detroit, Institute of Art* (Detroit Institute of Art)

The drawings and adaptations in the text were made by Sheila Gibson. The map was executed by Donald Bell-Scott.

The drawings and adaptations in the text were made by Sheila Gibson. The map was executed by Donald Bell-Scott.

INDEX

References to the notes are given to the page on which the note occurs, followed by the number of the note. Thus 575[56] indicates page 575, note 56. Artists' names are always indexed under the final element of the surname: thus Filippo della Valle will be found under Valle. Where names of places or buildings are followed by the name of an artist in brackets, the entry refers to work by that artist in such buildings or places; thus Florence, Villa Petraia (Volterrano) refers to the frescoes by Volterrano at the Villa Petraia. Names of architects appear in brackets in this way in a few cases, where they were responsible for only part of the building.